The Arts of Industry in the
Age of Enlightenment

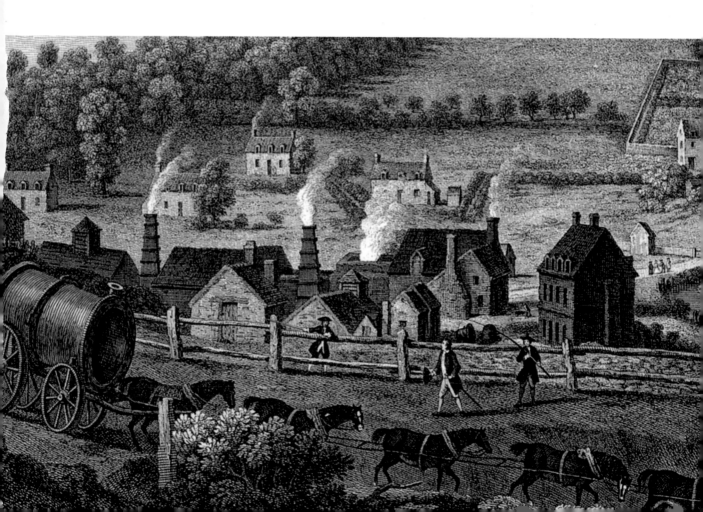

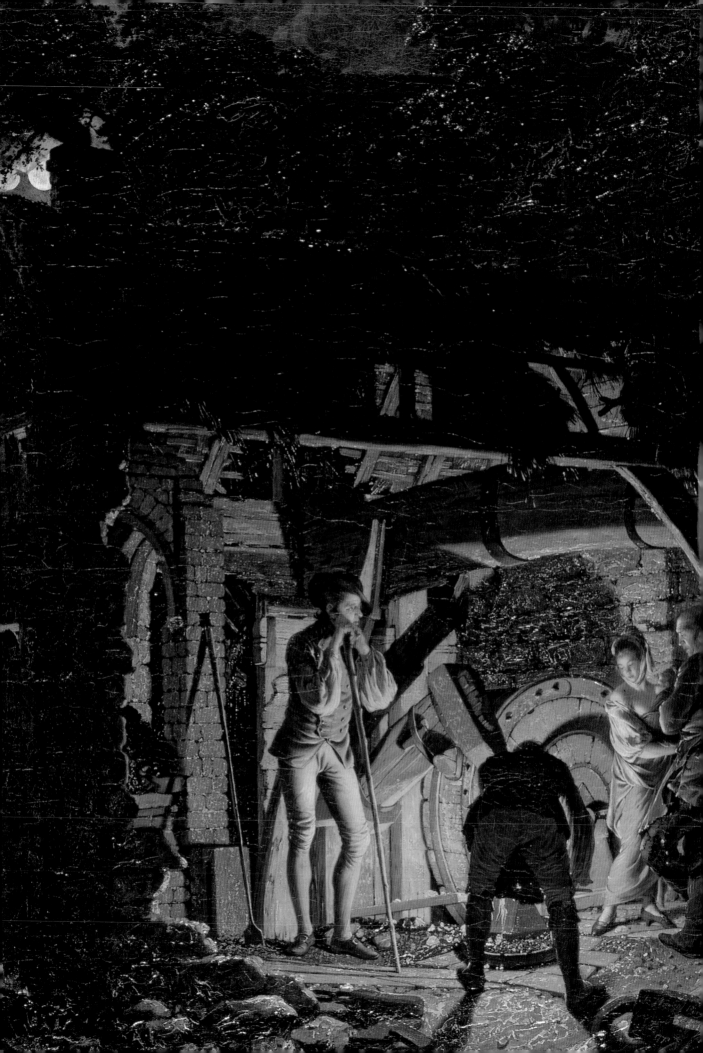

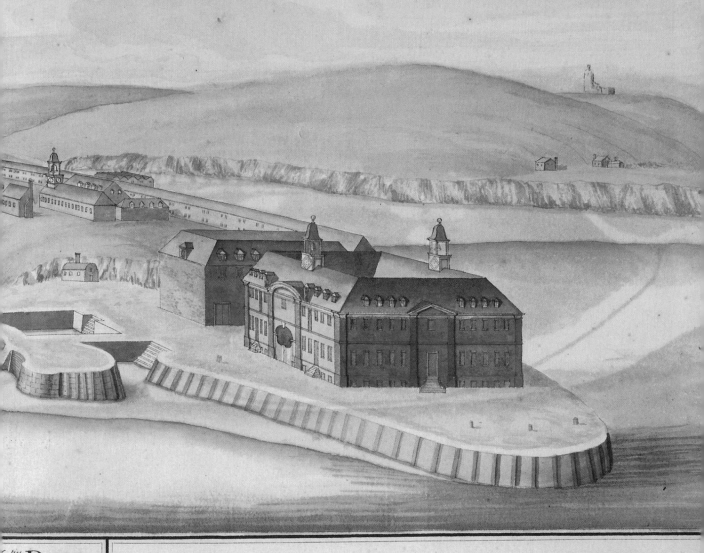

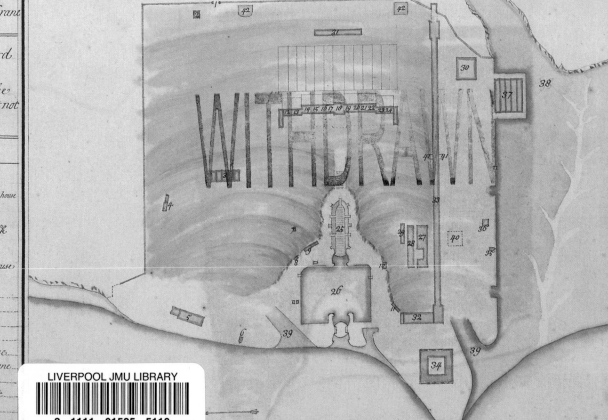

The Arts of Industry in the

Age of Enlightenment

CELINA FOX

PUBLISHED FOR THE PAUL MELLON CENTRE FOR STUDIES IN BRITISH ART

BY YALE UNIVERSITY PRESS – NEW HAVEN & LONDON

In memory of my parents who practised the arts of industry

Designed by Sarah Faulks

Printed in China

Library of Congress Cataloging-in-Publication Data

Fox, Celina.
The arts of industry in the Age of Enlightenment / Celina Fox.
p. cm.
Includes bibliographical references and index.
ISBN 978-0-300-16042-0 (cl : alk. paper)
1. Art and technology–Europe–History–18th century. I. Title.
N72.T4F69 2009
709.4'09033–DC22

2009036498

A catalogue record for this book is available from The British Library

Front endpapers: Edmund Dummer, 'A View of his Ma'ties Dock Yard at Plymouth', detail, 1698. British Library, King's MS 43, f. 130. © British Library Board. All Rights Reserved

Back endpapers: Marc Brunel, 'Block press adjusting stops for slide &c. Large Boring Machine', detail, 1816. The National Archives, ADM 140/637. The National Archives

Pg. i: François Vivares after Thomas Smith and George Perry, *The Upper Works at Coalbrookdale*, detail, 1758. Ironbridge Gorge Museum Trust, Coalbrookdale

Frontispiece: Joseph Wright, *An Iron Forge viewed from without*, detail, 1773. State Hermitage Museum, St. Petersburg

Contents

Acknowledgements

A host of librarians, archivists and curators, those guardians of the gates of knowledge, facilitated my entry into the world of industry described in this book. They and their predecessors have conserved the stuff of history, catalogued it and made it available to everyone. While records have been computerised and digitised over the last few years, greatly speeding the processes of retrieval and access, unsung heroes and heroines have had to undertake the laborious task of transferring data to the new media. Moreover, computers are no substitute for knowledge of collections acquired through years of experience handling them. The National Archives at Kew and the County Record Offices have proved to be extraordinarily rich resources. I should also like to pay tribute to the kind and patient assistance I received over many years from staff in the libraries and archives of the Royal Society, the Royal Society of Arts, the Science Museum and the Manuscripts, Maps and Rare Books Reading Rooms of the British Library.

The Paul Mellon Centre for Studies in British Art awarded me a Senior Fellowship in 2002–3, thereby providing a treasured opportunity for extended periods of research and travel. In 2004 I was awarded a Wingate Scholarship which secured further study time. I was able to visit archives and collections in Stockholm, Uppsala and Falun thanks in part to a grant from the Svenska Institutet (The Swedish Institute).

I owe an enormous debt of gratitude to A. P. (Tony) Woolrich who read my manuscript, corrected mistakes and kept my spirits up, a crucial role for anyone rashly attempting to cross disciplines, in my case, between the fine and mechanical arts and science. Two anonymous referees provided valuable suggestions and critical insights which influenced the final revisions to my text. At various points on the long journey of exploration I received generous help from the following: Brian Allen, Peter Barber, Hugh Belsey, Jonathan Betts, David Bindman, Frances Carey, David Connell, Andrew Edmunds, Chris Ellmers, Elisabeth Fairman, David Fraser, Philippa Glanville, Nicholas Goodison, Jeremy Greenwood, David de Haan, Frances Harris, Niall Hobhouse, Libby Howie, Peter Huber, Michael Hunter, Gillian Hutchinson, Franz Kirchweger, Alastair Laing, Lowell Libson, Svante Lindqvist, Peter Lord, Richard Luckett, Arthur MacGregor, Christine MacLeod, Jonathan Marsden, Debora Meijers, Alan Midleton, Philip

Mould, Sheila O'Connell, Alan and Kate Ryan, Joseph and Anne Rykwert, Susan Sloman, Helen Smailes, David Solkin, Gill Sutherland, Barry Taylor, Penny Treadwell, Anthony Turner, David Tyler, David Willacy, Michael Wright and Thomas Wright.

More decades ago than I care to remember, John Nicoll, then Managing Director of Yale University Press, received with enthusiasm my first tentative proposal to write a book about art and industry. Subsequently, The Paul Mellon Centre for Studies in British Art, under the beneficent directorship of Brian Allen, agreed to co-publish my book with Yale University Press. Within the Press, Gillian Malpass has been a wonderfully supportive editor, taking on the lengthy manuscript with a reassuring aura of calm. Sarah Faulks has gallantly shouldered the burden of design and production while Katharine Ridler has been a meticulous copy-editor. I wish to thank them all.

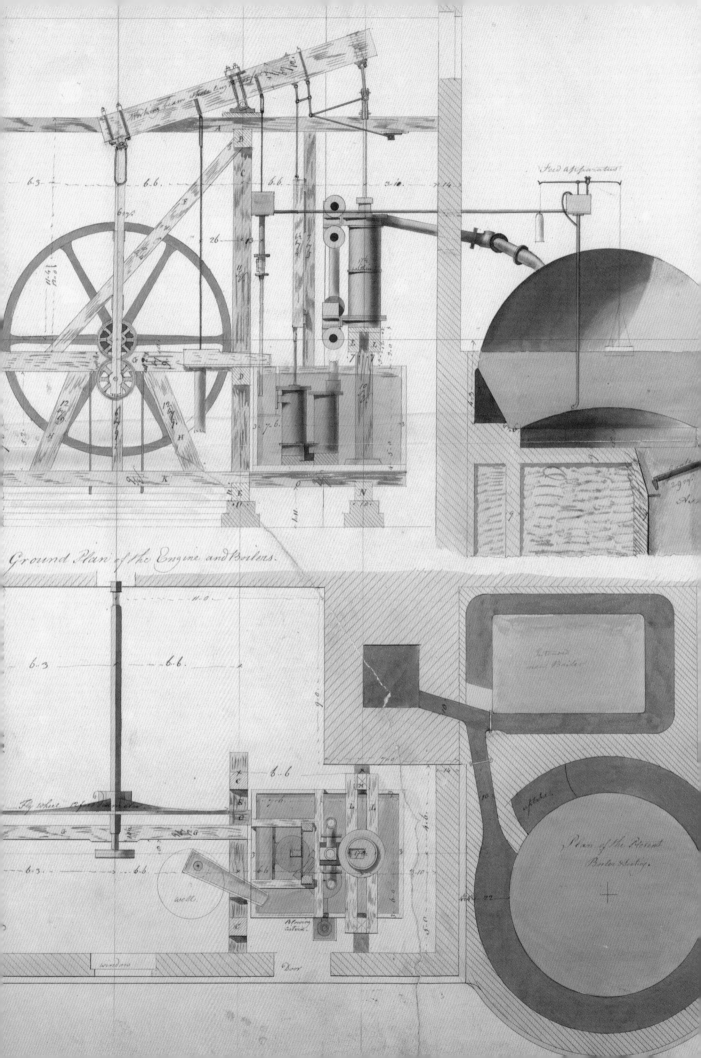

Ground Plan of the Engine and Boilers.

Introduction

Two hundred and fifty years ago, the arts of industry had much richer connotations than they do today. They were not confined to products displaying sufficient evidence of taste and elegance to be deemed ornamental – what is now called decorative or applied art. They did not readily suggest aesthetic features incorporated into the sites, machines and tools of productive labour. They would not necessarily have conjured up representations of work in the liberal or polite art – later the fine art – of painting. The arts of industry were taken to refer principally to the skills involved in the processes of industry itself.

In the dictionaries and encyclopaedias of the day, the arts and sciences were seen as an inclusive whole, encompassing all knowledge. A general distinction was made between theory, observation or speculation, thought of as 'science', and practice, action and application, considered 'art'. Within art, a further distinction was made between the liberal professions and the mechanical trades – between the liberal man who used his reason and enlarged vision to pursue general principles and the vulgar mechanic whose experience was confined to a narrow field, working by rote, habit or applied calculation. For this book, it seemed essential to consider 'art' as it would have been comprehended at the time, covering both liberal and mechanical realms. These arts needed to be related to science. As was confirmed repeatedly in the sources I explored, they were all interconnected.

Nevertheless, the mechanical arts, the processes of manufacture, lie at the heart of the book. Like a disciple of Denis Diderot, I should like to raise their status or at least to reassert their claim to attention. Too often, modern historians of science and art have underrated them or annexed them for their own purposes, without considering the depth of empirical, practical knowledge they represented and the language evolved *sui generis* to describe and rationalise, improve and communicate their skills. Practical men might have looked to both the liberal arts and sciences for endorsement or as a calculated means of obtaining patronage or for help with modes of expression for polite effect. Yet although such boundaries were fluid and the interchange was fruitful, industrial innovation in the eighteenth century was undertaken by men – and they were overwhelmingly men[1] – who were, first and foremost, practitioners of the mechanical arts. Essentially, this book is about the people who did the work.

Facing page: detail of fig. 49

I have come to write about the subject by a lengthy and circuitous route. One cata-
lyst was a visit I made in the early 1970s to Sir Arthur Elton at his home, Clevedon
Court, Somerset, in connection with the thesis I was then writing on nineteenth-century
graphic journalism. During the inter-war and post-war decades, Elton was one of the
country's foremost documentary film-makers.[2] From his youth he had been fascinated
by railways, canals and gasworks, forming an unrivalled collection of visual material doc-
umenting technical innovation in the eighteenth and nineteenth centuries. In 1968 he
used these works to enrich the only book on the subject then available, *Art and the Indus-
trial Revolution* by Francis D. Klingender, first published in 1947. Klingender's publica-
tion had grown out of an exhibition on 'The Engineer in British Art' which the
Amalgamated Engineering Union had asked the Artists' International Association to
arrange at Whitechapel Art Gallery in 1945, to celebrate the Union's silver jubilee. This
'first art exhibition sponsored by a British trade union' suggested to Klingender the need
for a wider study of the effect of the industrial revolution on the arts as a whole.[3] The
result was dedicated to the students and tutors of the North Staffordshire Workers' Edu-
cational Association, where he taught at weekend and summer schools.

As a Marxist economist, Klingender believed that technological advance fuelled eco-
nomic development and that economic forces shaped society and culture.[4] In his book,
industry was conflated with science, while art encompassed poetry and novels as well as
paintings and prints. Essentially, Klingender conceived of his subject as a one-way
process whereby artists and writers reflected industrial change, offering at best a paral-
lel commentary on the advancing science of industry. He outlined a 'revolution in tech-
nique', dependent on steam power, iron, machines and factories, canals and roads, and
then described reactions to the phenomena as illustrated in various media. He did not
consider the possibility that the arts, broadly considered, might also have affected the
course of industry or that they could be bound in more subtle and intimate ways to the
technical processes he was describing. Today, parts of the text read as simple techno-
logical determinism.

Yet Klingender frequently escaped the Marxist straitjacket to follow his own ideas and
enthusiasms and these were enlarged on and occasionally challenged by Elton. To secure
the text with a scholarly apparatus, Elton footnoted the references and updated the bib-
liography, adding material published since the first edition which, he believed, Klin-
gender would have incorporated himself, while 'taking pains not to depart from and
wherever possible to illuminate his attitude to the changing historico-economic situa-
tion'.[5] By adding sections on the sublime and the picturesque, on print-making methods
and on particular artists, Elton was not destroying the coherence of the original, as has
sometimes been argued, for Klingender's text had little unity to start with. The breadth
of Klingender's source material militated against the retention of a rigid Marxist
framework.

Apart from Elton, Klingender had few followers. In 1968, Manchester City Art Gallery
organised an exhibition entitled 'Art and the Industrial Revolution', drawing extensively
on the Elton collection, and the Arts Council of Great Britain staged a series of shows
devoted to different facets of art and society, including the topic of work.[6] The 1960s
and 70s were a time when a particular kind of Marxist social history thrived, dubbed
'history from below' and associated above all with E. P. Thompson whose seminal work,
The Making of the English Working Class, appeared in 1963. Like Klingender, Thompson
came from the world of adult education and could range beyond narrow academic spe-
cialisations. He too was steeped in the literature which illuminated the moral climate
of the Industrial Revolution. In his writings he also condemned the values of industrial
capitalism which had deprived the working classes of their cultural traditions. But
although Thompson had collected visual material relating to early working-class move-

ments, he did not engage with it in print. Social historians were uneasy about dealing with visual sources and their interpretation was usually one-dimensional, treating them merely as illustrative of technological, economic and social change. Barrie Trinder was unusual when, in focusing on the east Shropshire coalfield as a microcosm of the early Industrial Revolution, he produced an economic and social history based not only on documents deposited in local record offices but also on industrial archaeology.[7] Raphael Samuel realised that the increasingly hybrid nature of historical culture (in other words, the growth of cultural studies) would eventually place 'graphics' on the research agenda, but his own contribution was limited to old photographs, warning of the dangers of treating them simply as records of documentary truth.[8]

If social historians have been slow to engage with the arts of industry in the sixty years since the publication of Klingender's book, economic historians have found the Industrial Revolution an irresistible topic. Yet their elaboration of its causes and processes, using the vocabulary, taxonomies and theories of modern economics and social science, appears to raise more questions than it answers.[9] According to the traditional interpretation, between the mid-eighteenth and mid-nineteenth centuries Britain witnessed: the invention and development of novel means of production; the building of engines to harness new sources of energy, above all steam; the improvement and extension of internal transportation through turnpikes, canals and railways; the development of sophisticated forms of financial and commercial exchange, backed by the rule of law and secure property rights; increasing social mobility; and the expansion of the market for a vastly enlarged range of consumer goods. The growth in production was also fuelled by cheap labour, resulting in social disruption and poverty on an unprecedented scale. More recently, explanations for Britain's accelerated industrial productivity have moved back to basics to encompass not only technical innovation but also the successful exploitation of natural endowments through agricultural improvement, the mining of abundant and accessible supplies of minerals, especially coal, and foreign trade, promoted and protected by the massive state investment in naval power.

Shifts of emphasis have undermined the possibility of there being any consensus of interpretation. If accidents of geography are regarded as the prime cause of Britain's industrial lead, then the role played by technical innovation is somewhat diminished. Furthermore, micro-studies have been thought to demonstrate that inventions improved processes in only some sectors, notably cotton textiles, metallurgy, machine tools and other industries which could benefit from steam power. Even their impact was felt at widely different rates in different places, depending in part on the varied input of capital and labour. For many trades and manufactures, techniques and the organisation of labour remained stable, although not necessarily static, often experiencing an increase in specialisation. In effect, the diversity of regional economies limits the capacity of historians to draw broader conclusions. Nevertheless, it is generally accepted that the 'First Industrial Revolution' – the transformation of Britain from an agrarian to an industrial economy – was not as revolutionary in a global context as had for long been represented. With the benefit of hindsight and international comparators, it seems that, overall, British manufacturers were not especially entrepreneurial. Rather, they 'promoted and managed one of the slowest, and for the working classes more miserable transitions to an industrial economy in world history'.[10]

If the heroic image of Britain's Industrial Revolution has been knocked off its pedestal, it would be excessively reductive to conclude that its only legacy was the unprecedented suffering of the workers, crowded into towns lacking the most basic infrastructure for healthy living. That would be to risk limiting the contents of this book to representations of 'hard times' in art.[11] Fortunately, a more cheerful picture of Britain is painted by those who have concentrated on the Georgian rather than the Victorian period. Over

the last thirty years, in place of the supply-side factors which long dominated studies of the Industrial Revolution, more attention has been paid to theories of consumer demand as a driver of economic growth, stimulating product as much as process innovation in the early decades of the period supposedly covered by the Industrial Revolution.[12] This demand, it is maintained, went beyond needs to the more amorphous realm of desires. Traditional moral reservations as to the corrupting effects of luxury and excess were set aside by eighteenth-century theorists to legitimise the expansion of an international trade in consumer goods.[13] Initially identified with imports, these covetable luxuries became the subject of invention at home as part of a sustained mercantilist strategy of import-substitution. Industrialisation and commercial modernity in the eighteenth century, it is argued, were triggered mainly by consumption, a revolution brought about by inventors and manufacturers, merchants, retailers and advertisers. Product imitation and innovation, encouraged by rising consumer demand for items of novelty and utility, taste and convenience, were claimed as an essential feature of technical invention and economic improvement, a sort of 'Industrial Revolution Lite', or in Jan de Vries's phrase, an 'industrious revolution' in demand, driven by commercial incentives that preceded and paved the way for the Industrial Revolution proper.[14]

In exploring the history of product innovation, economic historians have reached out beyond the boundaries of their own discipline to engage with cultural practice, 'theories of material culture' and 'principles of aesthetics and taste, as these were understood during the eighteenth century'.[15] The Luxury Project was organised at the University of Warwick in the 1990s to investigate how aesthetic qualities of taste and design met and became linked with invention and manufacture in the creation of new consumer goods in the period.[16] The studies that emerged related not only to the history of culture and pleasure in a general sense but also to the material world of consumption, the actual products – what they were, how they were designed and made and what they were used for.[17]

One conclusion was that the connection needed to be restored between consumption and production and that production depended, above all, on the prior accumulation of a skilled and mobile industrial workforce of artisans and craftsmen. Again in the 1990s, the Achievement Project and within it the Skilled Workforce Project at the Centre for Metropolitan History, University of London, attempted to bridge the gap between the making of things and the making of ideas. Like the Warwick project, it brought together curators and other 'object-based' people – conservators, collectors, makers – with academics who had hitherto addressed material culture in intellectual terms but were not used to interpreting objects, let alone empathising with artisans. Seminars held at the Museum of London and the Science Museum centred on artefacts and covered the sites of production, workshop practice, skills transfer and technical innovation. Material culture, it was realised somewhat belatedly by academics, might provide a useful way of understanding social behaviour, hence the importance of collections and artefacts for a study of innovation and achievement.

At the Museum of London, where I worked from 1975, this approach was taken for granted. Colleagues came from the fields of archaeology, industrial archaeology and social history, for whom the site-specific interpretation of objects – from Mithraic shrines to medieval shoes and goldsmiths' hoards to dockland warehouses – was second nature. As goods were made by labour, tools and machines in factories, workshops and domestic houses, considerable efforts were made to rescue, store and sometimes display entire manufacturing contexts. It took longer for curators in the national art galleries and museums to catch up, not least those at the Victoria and Albert Museum whose philosophy had been tied for a century or more to traditions of connoisseurship and formal style analysis. Only in the late 1980s, after the Museum started a post-graduate

course on the history of design in association with the Royal College of Art, did its intellectual horizons broaden to consider the contexts of consumption and even production. Research inspired by the Museum's unrivalled collections of British decorative and applied arts subverted crude notions of a consumer revolution and emphasised instead more gradual, complex processes of design development and product innovation. The redisplay of the new British Galleries, opened in 2001, was informed not only by concepts of style but also topics arising from consumption – 'fashionable living' and 'who led taste' – as well as 'what was new', in other words, material, product, technical and organisational innovation. Engagement with consumption encouraged the display of artefacts in a social context. Flirtation with technical invention resulted in the emblematic display of a model of a rotative steam engine loaned by the Science Museum, but once part of the South Kensington Museum's collections which encompassed art, science, machinery and manufactures.

This symbolic gesture signalled the possibility of reconnecting the world of goods with the process of work that created them, a link that has proved fruitful for research in recent years. Curators and academics have investigated the material culture of the Renaissance and seventeenth century to reveal rich repositories of empirical knowledge – the knowledge of nature and matter arising from artisans' skills.[18] Workshop practices have been exposed not as the mindless following of rules or recipes but as processes of knowledge-making that involved extensive experimentation and observation. There is an increasing consensus that the knowledge of artisans, hitherto overlooked, needs to be understood and valued in its own right, overcoming crude dichotomies of knowledge and practice, contemplation and action.

This renewed emphasis on *praxis* is shared by those economic historians who believe that the Industrial Revolution cannot be explained simply in terms of inexorable economic, social or demographic forces.[19] Without returning to heroic accounts of invention, they concede that ingenious, practical, mechanically minded men came up with ideas that changed the world. Of course such ideas took time and persistence to apply, there being no distinction in the period between invention and development. Ability was not enough; unusual energy and tenacity were required to launch inventions successfully on the market. Successful usage in the field was all-important. Furthermore, far more people were involved in achieving that goal than a handful of major inventors. The first wave was followed by a second generation who spread innovation to new and many more industries and sectors. Beyond them there were hundreds of entrepreneurs, engineers, mechanics and artisans. Moreover, technical knowledge was transmitted through the apprenticeship system which combined instruction with emulation. By adapting, modifying, improving and extending earlier inventions, all these men played their part in contributing to the uncoordinated, yet unconsciously collaborative project called the Industrial Revolution.

Therefore, despite the diversity of progress in different trades during the years 1750–1850, the Industrial Revolution can still be considered in terms of accelerating technical improvement. The wave of inventions, ideas and insights that made it possible to produce more and better goods, and to do so more efficiently, was marked by a sharp increase in patenting activity. Furthermore, although Britain had no monopoly on invention, it was good at borrowing, imitating and stealing the technical know-how of others, displaying an ability and a willingness to absorb and apply useful ideas generated elsewhere. In effect, the importance of British invention lay in its development, improvement and diffusion, not least through utilising the skills and technical competence of a great variety of artisans and mechanics.[20]

The terms in which this empirical knowledge base should be described have been much debated, focusing on the role played by what came to be called abstract or theo-

retical science.[21] As will be shown in the conclusion, nineteenth-century gentlemen of science who wished to boost their own case for government support grossly exaggerated both the degree to which technical advances had been made through the application of science in the late eighteenth century and the so-called 'scientific' expertise of industrial inventors. The role of science in stimulating economic growth became the subject of academic controversy in the mid-twentieth century, again at a time when scientists were claiming that the neglect of science was leading to the irreversible decline of the nation. Yet, as was wisely observed by Neil McKendrick, if such historical controversies are to do justice to the reality of the eighteenth century, 'they must allow for a greater variety in the gradations of scientific knowledge and expertise, and they must not, in assessing the impact of science, exclude a consideration of the levels of scientific interest, endeavour and motivation, or an examination of the adoption and spread of scientific method and technics, or an acceptance of the importance of, growing confidence in, and growing expectations from science'.[22] With such strictures in mind, historians of culture and science in the 1980s and 90s identified 'a vast army of lecturers, experimenters, engineers, schoolteachers and professors' in eighteenth-century Britain who argued the case for applying Newtonian mechanical science to practical ends. It is maintained that these men had a profound impact on early industrial development and that the diffusion of a buoyant 'scientific culture' among entrepreneurs, engineers and agents of the state constituted an essential precondition for the success of the Industrial Revolution.[23]

Although these studies have shed considerable light on the risky world of 'projectors' and inventors, they still tend to rely on a catch-all definition of what is meant by science. Admittedly, the word technology – literally the science of art or the application of scientific knowledge to practical purposes[24] – was not employed in the eighteenth century and, as already stated, the boundaries between science and art were fluid. Nevertheless, the rhetoric of scientific lecturers who made extravagant claims for the practical application of their knowledge should not be confused with technical practice, what actually happened on the ground. Natural philosophers might have promoted themselves in the market as builders of models and even of machines but they were largely ineffectual.[25] As Gulliver found out in Laputa, it mattered whether things were fit for purpose – whether they really worked. Making things work was not simply a matter of tacit know-how, or intuitive semi-literate tinkering, divorced from any basis in knowledge. It depended on traditional craft practices of observation and experimentation, trial and error. It involved precision skills, a basic capacity to measure, quantify and calculate. It developed its own forms of rationalisation and communication, employing geometrically based drawing and the making of mechanical models. The principles by which processes were described and illustrated arose from practice. Science might assist but could never replace experience.

If, as Larry Stewart has concluded, 'Policing the science–technology boundary has proved ultimately futile', it does not follow that the latter should be subsumed in the former.[26] To be sure, the role of the natural philosopher became more clearly articulated across Europe in the seventeenth century with the growth of academies such as the Royal Society and in the eighteenth century through the role of scientific lecturers, while those who practised the mechanical arts were much less clearly defined. The identity of these men, variously described as mechanics or mechanists or artisans or artists, may even be problematic when viewed from the vantage point of today's boxed-in specialisations and secure professional distinctions. However, it seems illogical to note the ambiguity of their status and to appreciate that for them the distinction between theory and practice did not pertain, yet still to claim such men for science, I would judge, before their time. Few of them prior to the late eighteenth century assumed the status of men of science or mechanical philosophers or even would have aspired to such roles. Nor have I found

any evidence that they needed a scientific vocabulary derived from Newtonian mechanics in order to understand one another. Their work might involve some mathematics and mechanics but these sciences were by no means the core of their technical practice.[27] The origins of their methods long predated the activities of Newtonian philosophers. Mechanics did not have to spend time contemplating the mysteries of the universe to master in an orderly, quantifiable, empirical manner the ways in which nature worked. In fact, the so-called scientific methodology of systematic experimentation and validation was derived from the pragmatic methods of artisan culture, not vice versa.

While historians of science have had problems with vocabulary when considering the progress of the mechanical arts, so too have art historians. It is not as if, these days, many claim that works of art are disembodied products and achievements intended for deracinated contemplation, divorced from the structures and processes that created them. Few would concentrate on formal analysis to the extent of pushing the historical context entirely into the shadows. Nor are they likely to cling to the outdated view that the social history of art necessarily considers the work of art to be secondary, a mere reflection of ideas and ideologies produced elsewhere. Art history today is awash with discourses and matrices, embedding a work in a dense network of historical reference. Nevertheless, as far as the study of eighteenth-century British art is concerned, it has not hitherto extended to taxonomical deconstruction, exploring what was meant by art at the time and the fluid boundaries that existed between the polite and mechanical, encompassing many arts of a 'mixed' nature. Instead, while historians of science have sought to colonise the territory of the mechanical arts, historians of art have rendered what they mean by art so exclusive as to fail to notice them at all. They have taken their cue from the privileging of fine art over mechanical art which gathered pace in Britain with the founding in 1768 of the Royal Academy of Art. This realm was reinforced by Romantic notions of artistic genius as a form of self-expression and had become common currency by the mid-nineteenth century. The relatively modern discipline of art history took the narrow parameters of the subject and applied them with hindsight to ages when they did not pertain, downgrading the mechanical arts to the status of crafts, unworthy of serious study.

In the 1980s, if anything the study of eighteenth-century British art took on an even more elitist tinge, the significance of works being read within the context of the political theory of civic humanism and, in particular, the vesting of authority on all matters of taste in those whose property and education elevated them above the realms of corrupt commercialism.[28] Such an approach provided many insights into the landscape painting of the period, drawing on contemporary debates about farm labour and rural conditions in a period of change.[29] More recently, it has been argued that during the course of the century the elite 'republic of taste' was gradually extended to encompass figures from the middling orders, including painters themselves, working in an enlarged 'public sphere' and involved in negotiation with the marketplace in an increasing variety of London and provincial settings. The age-old antagonism between morality and commerce was for a time reconciled through codes of gentility expressed in terms of conversation, agreeableness, politeness and refinement.[30] However, the tolerance of a range of styles and subjects developed in the middle decades of the eighteenth century and directed at a broad range of consumers was challenged by Sir Joshua Reynolds, who sought to revive and reinforce a narrow elite aesthetic and to revitalise the cause of grand manner historical art with the official backing of the Academy.

The anti-academic tradition in British art has proved to be a more fruitful vehicle for industrial subject matter, linking high and low art in a developing commercial and industrial culture. Since Klingender though, no general studies have been produced in English relating the representation of industrial subject matter in the fine arts to the

mechanical arts, or as Klingender preferred, science.[31] This book is an attempt to make good the omission, thereby providing a missing link, even the linchpin, for our understanding of the relationship between eighteenth-century British art and science.

My work has been abundantly informed by the researches of social and economic historians, historians of science and of art. Most of all, I have benefited inestimably from those historians of technology and practising engineers centred on the Newcomen Society and the Society for the History of Technology. The approach embodied in the Social Construction of Technology (SCOT) has reinforced my concern with the social context of industrial design, production, marketing and consumption.[32] None the less, when I finally started to write, I tried to leave as many modern concepts and methodologies as I could behind. In sympathy with the subject matter, my approach was appropriately empirical, arising from the records of what was said and done at the time. I tried to avoid the backwards projection of neat modes of categorisation or expression used in the history of art or science today. Wrestling with the range and complexity of the archives, with local contexts and particular circumstances, I sought to explain how skills were built up which enabled improvements and innovations in technical knowledge to be carried through stages of development to the point of commercial production.

On the basis of the material explored, I have concluded that there were four principal means by which the mechanical arts were described, rationalised and communicated: firstly drawing and secondly model-making, methods closest to the innate skills of artisans in terms of spatial cognition and representation; thirdly, through the clubs and economic societies that served as nodal points for discussion and communication; and fourthly, through specialised treatises and general encyclopaedias which sought to incorporate readily accessible descriptions of the mechanical arts into the world of knowledge. Societies and publications were frequently initiated by members of the established professions who had access to the resources needed to embark on such ventures, but they provided opportunities for the more articulate artisans to engage in constructive dialogue and make contributions based on material knowledge, enhancing their professional standing.

There was of course much overlap between these different modes of operation: drawings and models were sometimes designed to be used together; societies built up collections of models; mechanical men were adept at 'multi-tasking', drawing and making models, gathering together in company and contributing to publications. Collectively, these four channels form the central core of my book. They did not simply describe and represent the mechanical arts, they also provided the basis for experimentation and invention, for explanation and classification, for validation and authorisation, promotion and celebration, thus bringing them into the public domain and rendering them a true part of the Enlightenment. By ordering, discussing and publishing their work, by travelling across frontiers and chancing their skills in cities and countries remote from their places of origin, the men I describe proved themselves to be worthy citizens of an enlightened world, practitioners of the rhetoric of improvement, progress and commitment to the public good that were essential characteristics of the movement.

Yet fascinating as the details of their work may be to the industrious researcher, it can be overwhelming for the reader who cannot view the stuff of evidence at first hand. It helps to draw out broader patterns and suggest a conceptual framework which makes sense of discrete facts. At the risk of appearing to have recourse to the unfashionable notion of spirit of the age, the material I have found seems to substantiate the phenomenon Joel Mokyr has termed the 'Industrial Enlightenment'.[33] Mokyr sees the Industrial Enlightenment as a set of social changes founded on the rational, open knowledge culture of the seventeenth-century Scientific Revolution and specifically, the Bacon-

ian belief in the combination of theory and practice, the rational and empirical, as an essential prerequisite to industrial progress. The Industrial Enlightenment realised these ends by surveying and cataloguing artisan practices; by generalising from them to form theoretical principles which would speed up the process of invention and lead to extensions, refinements and improvements; and by encouraging dialogue between practical men and gentlemen of science. The end result was, eventually, the Industrial Revolution.

My central section is introduced by a chapter which considers the efforts made by gentlemen of science in the seventeenth century to encompass the mechanical arts within their intellectual agenda, starting with Francis Bacon and culminating in the Royal Society's History of Trades project. If the central section is prefaced by the realms of science, it is followed by two chapters which relate its findings to the fine arts. I believe this link greatly enriches understanding of the means by which entrepreneurs, mechanics and artisans sought to present themselves to the world in portraits and the manner in which industry was depicted in landscape and genre painting. Even familiar images of industry and industrial society gain unexpected inflections when viewed in the light cast by mechanical arts' practice, adding new dimensions to an understanding of their significance. In fact, the mechanical skills of close observation and accurate draughtsmanship served as the foundation for both portrait and landscape painting in Britain, and a strong empirical element was retained in the development of both genres, despite the system of liberal values espoused by artists who championed the authority of the Royal Academy in the late eighteenth century.

In the conclusion, I reach the early nineteenth century when, despite the drive by gentlemen of science and fine artists towards specialisation and exclusivity, not to mention the rise of the profession of engineers, the broad sweep of the mechanical arts retained a distinct identity in a somewhat chaotic world of knowledge for far longer than has generally been recognised. The debates their presence provoked concerning the relationship of theory to practice and the problematic nature of art and technical education are still current today. I hope that by clarifying their epistemological roots and opening out their historical practice the arts of industry can be of interest and relevance to a readership which extends beyond narrow specialists.

Can lessons can be learnt from this exercise in remapping the territory encompassed by the arts to embrace both fine and mechanical realms? I believe so. Firstly, in reflecting more accurately the lie of the land in the eighteenth century, it accords respect to artisan and artist, mechanic, mechanist and engineer in equal measure. In so doing it represents a plea on behalf of ingenuity and inventiveness, for the recognition of skills based on experience and for the abolition, once and for all, of the dangerously reductive division between theory and practice, the mind and the hand. Above all, it rejects the simplistic arts/science divide through which mechanical artists have been ignored or patronised, downgraded, treated with contempt and all but eliminated. It also challenges the naively romantic view of the arts today as vehicles for self-expression without skill, and theory without substance. I hope my contribution is timely in a country where the status of skilled trades is uncertain, the number of engineering graduates falls each year and three-quarters of our engineering firms are struggling to recruit staff.

Secondly, paradoxically, it is a plea for keeping the map of knowledge open and not limiting its possibilities through ever-increasing cartographic exactitude. If anything is demonstrated by the enlightened world of knowledge, it was a willingness to cross boundaries, to follow tracks hitherto unexplored, to explore freely and not be confined within safe, neatly demarcated zones. Today, these sentiments are scarcely novel. The digital age and the microprocessor have loosened many chains, freeing engineers in particular to tackle broader problems and the social implications of technological advance-

ment, co-operating with people who have other skills and experience. This collaboration has embraced not only allied disciplines like sculpture and architecture but also communities in developing countries, hoping to realise the potential of their own ideas and innovations. Those working together to achieve sustainable solutions in a world of increasingly scarce resources may find that the means adopted to develop the arts of industry in the age of Enlightenment provide a useful and even an inspiring precedent.

History is always, to a greater or lesser extent, an act of imagination, involving a return to a world which no longer exists. Yet the physical remains of my subject matter are still here, although often taken for granted. Among the many pleasures of writing this book have been the visits it entailed to the sites of eighteenth-century industry from Cornwall to Northumberland and from Whitehaven to Chatham, from the mines of Sweden to those of Slovakia, and the societies of St Petersburg to those of Philadelphia. I crisscrossed Britain by rail, accompanied by canals which threaded themselves under, over and alongside the tracks in sympathetic companionship. I frequently returned home to the southern part of the Lake District, a landscape of natural beauty celebrated by the Romantic movement. Yet the more I worked on my book, the more it seemed to be populated by ghosts whose lifetime activities were eminently worthy of a place in the industrious society I wanted to describe.

The main market town, Kendal, where I went to school, was more noted in the eighteenth century for its merchants than its gentry and was linked into extensive internal and overseas trading systems.[34] Even before the arrival of the turnpike, Kendalians could lift up their eyes and see beyond the horizons of the mountains that surrounded them. Ephraim Chambers (c.1680–1740), who was born in Kendal and attended Heversham Grammar School nearby, moved to London in about 1714 to work as an apprentice to a globe-maker and compile the materials for his celebrated *Cyclopaedia, or Universal Dictionary of Arts and Sciences*, first published in 1728. A decade later, the son of a Cumberland ironfounder, John Wilkinson (1728–1808), was being educated in mathematics and natural philosophy at Kendal's famous dissenting academy, run between 1733 and 1752 by Dr Caleb Rotherham (1694–1752). He too moved south, rising to become 'king of ironmasters'. Without his expertise in precision boring, James Watt (1736–1819) would have been unable to perfect his steam-engine. Wilkinson's final resting place, in an iron coffin of his own design, is in the churchyard at Lindale, a few miles south of Kendal, and an iron obelisk to his memory stands on a knoll beside the road.

Impressive remains of an eighteenth-century charcoal-fired blast furnace can be found in the woods further along the Barrow road, at Duddon Bridge on the Furness peninsula. At Beckside nearby, George Romney (1734–1802) was born to a furniture-maker and apprenticed to him at the age of ten. The manual dexterity and skill in construction thus acquired were not wasted when he turned to portrait painting. Before seeking fame and fortune in London, between 1756 and 1762 he had a studio in Kendal and he carved the frames for some of his early paintings. In the 1760s the Kendal Quaker woollen merchant and energetic entrepreneur, John Wakefield (1738–1811), with his partners harnessed the power of the river Kent – as every Kendalian knows, the fastest river in England – to work gunpowder mills below Sedgwick, the village where my parents lived. To speed up supplies and distribution, he promoted turnpikes and an extension to the Lancaster Canal, which eventually opened in 1819, intersecting the village on its way to Kendal. It had been surveyed in 1791 by no less a figure than John Rennie (1761–1821), who also served as its chief engineer, creating the longest 'contour' or one level, lock-free navigation in the country. While walking near Keswick, James Watt first encountered the Kendal-born brothers William (1770–1831) and Henry Creighton (d. 1820), who became valued superintending engineers for Boulton & Watt. Charles Babbage's engineer Joseph Clement (1779–1844) was the son of a Westmorland hand-

loom weaver. He made looms in Kirkby Stephen, some twenty-five miles north-east of Kendal, before training in Scotland and moving to London, where he worked for Joseph Bramah and Henry Maudslay and then set up on his own as a highly regarded tool-maker and technical draughtsman. The district can also claim two leading men of science. John Dalton (1766–1844) taught at the Quaker Academy in Kendal for ten years before moving in 1793 to Manchester, the city most identified with his discoveries. The scientific polymath William Whewell (1794–1866) was another alumnus of Heversham Grammar School and was sent off on his illustrious career at Trinity College, Cambridge, with the help of a closed exhibition and a public subscription.

Probably every part of the country can muster an equally impressive array of genius (in the pre-Romantic sense) and the imprint of their achievements may be found in the wealth of roads, canals and railways, the bridges, mills and engine-houses, the drawings, paintings, models, books and manuscript records that survive. I still remember part of the conversation I had with Sir Arthur Elton which sparked my interest in the field. The M5 motorway was then about to be extended past Clevedon and I said I thought that great engineering works could enhance the landscape, a sentiment with which he agreed. I gave the example of the new section of the M6 which had just been built near where I grew up, curving through the Lune Gorge like a big snake, following and empha-sising the line of the valley itself. Little did I realise I was echoing the sentiments voiced by Josiah Wedgwood who, two hundred years earlier, had hoped that the route of the Trent and Mersey Canal would run gracefully in a serpentine line of beauty past his new factory with its Palladian front (although in the event the fields were so flat that the canal could run straight). I would not be so bold as to claim to be bringing together the aesthetics of technology and the technology of aesthetics but I hope that if I can admire and enjoy the arts of eighteenth-century industry, then so can you.

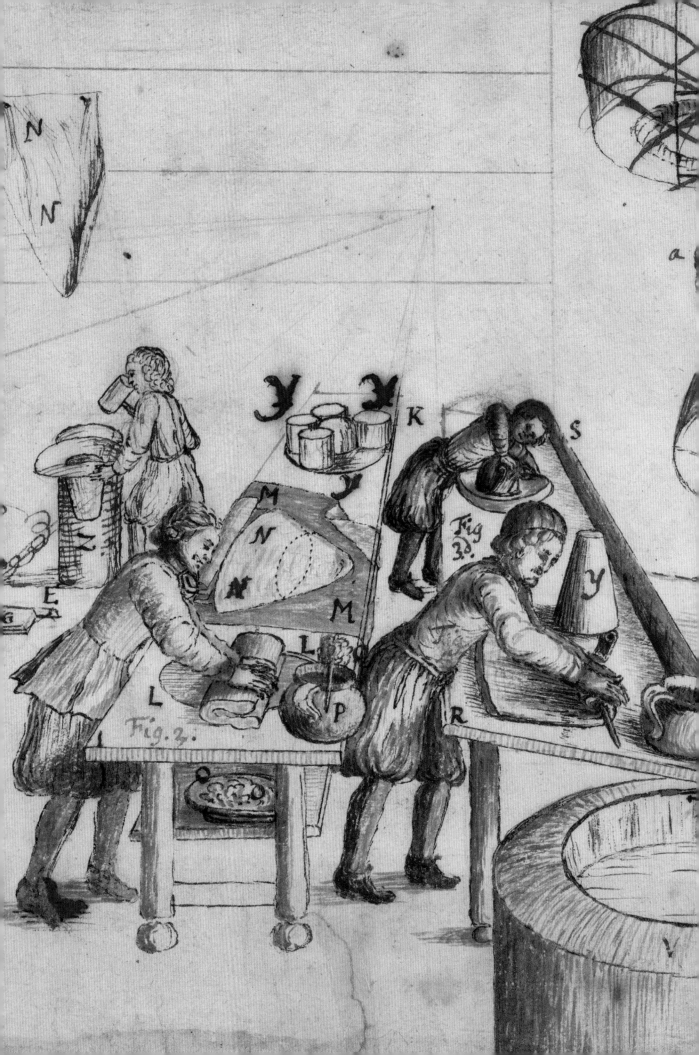

I

The History of Trades

I learned more of . . . the nature of stones by conversing with two or three masons and stone-cutters, than ever I did from Pliny or Aristotle.

Robert Boyle, *Some Considerations Touching the Usefulnesse of Experimental Naturall Philosophy* (1671)

Their houses are very ill built, the walls bevil, without one right angle in any apartment, and this defect ariseth from the contempt they bear to practical geometry; which they despise as vulgar and mechanic, those instructions they give being too refined for the intellectuals of their workmen, which occasions perpetual mistakes.

Jonathan Swift, *Gulliver's Travels, A Voyage to Laputa* (1726)

In the medieval period, the mechanical arts were recognised as a special category in the world of knowledge, distinguished from the liberal arts and from science.[1] The term was used as a synonym for trades in general, not simply the arts connected with the original Greek meaning of *mechanica*, the mathematical discipline concerned with the problem of moving objects, hence the arts involved in constructing and operating machines. According to Christian teaching, after the Fall the seven liberal arts led the mind and soul back to grace, while the seven mechanical arts relieved the body from subjugation to necessity. The liberal arts were those which, because of their more thoughtful conduct, were worthy of being cultivated for pleasure not profit, such as poetry, music, painting or architecture. In contrast, the mechanical arts were trades which furnished the necessities of life, employing the hand and body rather than the mind, and were chiefly undertaken for gain. The usage could be contemptuous, the Greek stem suggesting that mechanical artists worked in a machine-like way, with no independence of thought or action. Even more pejoratively, their practice could be considered vulgar, low or banausic, lacking the education, polish and refinement associated with the liberal arts. Such disdain had its roots in the classical dichotomy of mind and body, the trades being relegated to the inferior corporeal realm, dissociated from the exercise of the mind. Yet this hostility was far from all-pervasive and the inclusion of

the mechanical arts by medieval scholars within the canon of knowledge served as recognition of the role they played in the material and even the moral improvement of humanity.[2]

Acknowledgement of their importance was not confined to the writings of cloistered scholars but was visible in the very fabric of Christian life. The mechanical arts were represented in the sculpture, stained glass and paintings of cathedrals and churches throughout Europe, especially where they had been financed by guilds. Saints were portrayed practising the arts they had supposedly plied in the world – Joseph the carpenter, Luke the painter, Eligius the goldsmith, Crispin the shoemaker – and for which, canonised, they served as patrons. The trades were memorialised in the *Hausbuch* of the home for twelve elderly craftsmen founded in 1388 according to the rules of the Carthusian order by the Mendel family of Nuremberg. From about 1425 to 1549, more than three hundred pictures were drawn of members practising their former trades, providing a remarkable record of tools and techniques.[3] Rustic labours of the month were illuminated in books of hours, inextricably bound into the liturgical calendar. Guild ordinances were sometimes decorated with views of the activities practised by their members. However, the limits of work were clearly demarcated in 'Christ of the Trades', a popular subject for church wall painting in which the figure of Christ surrounded by an array of implements utilised in the mechanical arts served as an admonition to all craftsmen not to work on the Sabbath.[4]

Art was distinguished from nature and from the disinterested acquisition of knowledge about nature, which was called science or natural philosophy. Science was knowledge gleaned through theory, contemplation and speculation; art implied action and application, practice and production. The distinction made between mental and manual industry, between people concerned with theoretical knowledge pursued for its own sake and valued as truth, and the subordinate role of those involved in practical execution for useful ends, was a powerful determinant of social and intellectual hierarchies. Yet given that all fields of knowledge were interconnected and part of a unified whole, the boundaries between art and science were never rigidly demarcated.[5]

During the Renaissance, there was growing acceptance of the need for a dialogue between them. In many aspects of the arts – painting, architecture, navigation, cartography and engineering – ingenious skill and contrivance benefited from rational analysis based on science, as expressed in quantifiable mathematical methods. The science of geometry formed the basis for a wealth of illustrated treatises on the arts of war, including gunnery, surveying, fortification and troop formation. Leading artists claimed authorship of their products and wrote treatises stressing the foundation of their work in mathematics, as well as the importance of practical workshop experiment and experience. By these means they achieved legitimacy and status, already boosted through privileged relationships with elite patrons and increasingly buoyant markets for their high-quality goods and services.[6]

Standards of clarity and accuracy in drawing and illustration improved in early fifteenth-century Florence with the adoption of linear perspective by Filippo Brunelleschi's circle of artists and engineers.[7] The Sienese notary and engineer Mariano di Jacopo, called Il Taccola, used the technique to elucidate his two treatises on the arts of war, *De Ingeneis* (1433) and *De Machinis* (1449), also employing the graphic conventions of chiaroscuro and cutaway views.[8] In the 1480s, his fellow Sienese, Francesco di Giorgio Martini, completed a seven-volume manuscript *Trattato di Architettura, Ingegneria e Arte Militare*, which further exploited mathematically based drawing techniques. A prodigiously gifted painter, sculptor, architect and engineer, Francesco di Giorgio ranged far beyond his starting point of Vitruvius to encompass, in the last volume, mills, machines and other devices, both real and fanciful, ancient and modern.[9]

Copied and circulated round a small elite, these treatises were known to Leonardo da Vinci whose activities as a military engineer were recorded in his notebooks, which encompassed not only drawings relating to specific commissions but speculative projects, notes on the experiments of others and investigations of the general causes or theoretical laws of mechanics.[10]

In the second half of the fifteenth century, the spread of printing with movable type increased the opportunities for diffusing technical information. Roberto Valturio's *De Re Militari* (Verona, 1472) is considered to be the first printed engineering treatise. As a classical scholar and antiquarian, Valturio was principally concerned with Roman war machines, but he also included some modern weapons and military machinery. Illustrated with bold woodcuts, more decoratively fanciful than mechanically accurate – a battering ram in the guise of a giant tortoise is especially appealing – the work proved popular and made its way into princely libraries across Europe. Nevertheless, it took time to dislodge the age-old view that current mechanical practices were closely guarded secrets or mysteries, known only to those who had been initiated into them during lengthy apprenticeships in masters' workshops. Furthermore, it required considerable capital and organisational ability to bring together the requisite writers, artists, engravers and paper-makers involved in the production of an ambitious illustrated book and then to market it successfully.

The first extensive treatises relating to specific trades were published in the middle decades of the sixteenth century. Mining and metallurgy led the field, with the publication of Vanuccio Biringuccio's *Pirotechnia* (Venice, 1540), Georgius Agricola's *De Re Metallica* (Basel, 1556) and Lazarus Ercker's *Beschreibung Allerfürnemisten Mineralischen Ertzt und Berckwerksarten* (Prague, 1574). But the most conspicuous presentations of technical matter were the theatres of machines – so named after the first to be produced, Jacques Besson's *Theatrum Instrumentorum et Machinarum* (c.1570) – which covered instruments and machines, some of the author's own devising, in a lavish visual format. Besson was a Huguenot teacher of mathematics with a strong inventive streak, who was encouraged by his appointment by Charles IX of France as Master of the King's Engines to produce the work with sixty illustrations, promoting the prospect of a kingdom well regulated by machines. His dreams were shattered by religious strife and his book was first published without indication of date or publisher and with minimal text. Yet after the author's death in London in 1573, his seductive vision of a mechanically aided future proved sufficiently attractive for an enlarged version to be published in Lyons in 1578 and for it to go through at least eleven editions by 1602, with translations into French, Spanish, Italian and German.[11] Agostino Ramelli's *Le Diverse et Artificiose Machine* (Paris, 1588) was even more comprehensive, with a text in French and Italian and 195 engravings subsidised by Henri III and other patrons, covering a range of water-raising devices, weight-moving and earth-lifting machines, coffer dams and fountains, screw jacks and trebuchets.[12] As an experienced military engineer, Ramelli ensured that his machines, though depicted with pictorial elegance in fine plates, made mechanical sense and did not exceed the outer bounds of possibility, even if they had yet to be constructed. Cutaway and exploded views were carefully integrated into the image and letters of the alphabet keyed details into the descriptions.

Humanist scholars generally assumed that theoretical analysis of an accurate quantitative kind and rational design took precedence over material analysis and manufacture and indeed was the only kind of knowledge worth knowing. Equally, though, the empirical and experimental methods derived from the hands-on practices of artisans were crucial as the means of verifying theories. There were even those like the physician and alchemist Paracelsus (1493–1541) who reversed the priority, asserting that the methods of

the artisan based on observation and experience were the ideal mode for acquiring all knowledge. Mathematical models were not enough; knowledge depended on close interaction with and understanding of the raw materials of nature in all their range and variety. Knowledge did not come from passive writing or reading but had to be gained actively by doing and making.[13]

Although Ramelli stressed the utility of mathematics in the preface, his work was grounded in engineering practice and the text was free of numerical calculation and mathematical analysis. On a more popular level, the Paracelsian world view was represented in *Eygentliche Beschreibung Aller Stände auff Erden* (Nuremberg, 1588), known as the *Ständebuch*, composed by the shoemaker poet Hans Sachs and the artist Jost Amman. Combining Amman's 114 woodcuts showing different ranks, professions and trades with Sachs's rhyming couplets, the work grew out of the medieval tradition of celebrating the virtues of honest labour. Yet it was also designed to have educational appeal for an increasingly literate society, satisfying curiosity about other people's lives. By concentrating mainly on the mechanical arts, it presented an extraordinary range of skilled artisans at their workbenches, in workshops, forges and furnaces, mills and breweries, shops and streets. Amman himself, the son of a Zürich classics teacher, moved in the circles of Nuremberg's leading craftsmen and citizens. The *Ständebuch* was dedicated to his friend Wenzel Jamnitzer, the city's most highly regarded goldsmith, whose virtuoso skills included casting from live specimens, making scientific instruments and composing an illustrated treatise on perspective, *Perspectiva Corporum Regularium* (Nuremberg, 1568).[14] Amman also designed the frontispiece for the 1565 edition of Paracelsus' *Opus Chyrurgicum*, based on his own experience of witnessing a public dissection. For the craftsman as much as for the natural philosopher, close observation was crucial for comprehension.

This vigorous urban culture was not confined to Germany's foremost commercial city but developed wherever local economies benefited from buoyant trade networks. During the Elizabethan period in England, the aggressive pursuit of new trade routes and a growing population ensured that London too could boast communities of highly skilled, literate craftsmen. Although the court did not indulge in patronage on the scale of the Habsburgs or Medicis, Queen Elizabeth awarded monopolies on improvements and inventions. In Armada year, 1588, the military engineer Ralph Rabbards drew up a manuscript theatre of machines, illustrated with seventy-one coloured sketches of engines and implements and twenty-three diagrams of fortifications with written descriptions.[15] Less ambitious works were published which promoted practical mathematics as an aid to surveying, navigation and military engineering.[16] 'Books of secrets' disclosed formulae and recipes based on artisan practice.[17] For *The Jewel House of Arte and Nature* (1594), Hugh Plat amassed an impressive array of information on tools and inventions, recipes and experiments, culled from his questioning of artisans, housewives and fellow virtuosi, as well as observation and practice.[18]

By the end of the sixteenth century the combination of mathematical rationalism in design with practical skill in execution offered the prospect of a fresh model for experiment both in the natural world and in the mechanical arts.[19] It is the central contention of this book that the drive to describe and rationalise the mechanical arts, or the arts of industry, opening them up to a broader, more dynamic public sphere as an essential condition for their progress, reached its peak in the age of Enlightenment. Yet it was given a substantial boost in the seventeenth century, initiated by Sir Francis Bacon's influential attempt to claim the practices of the mechanical arts for science.

Francis Bacon

In his philosophical writings, Bacon advocated uniting the rational and empirical faculties, theory and practice, to create a truly active science operating in the world at large, not isolated in the study. This science would be based on what Antonio Pérez-Ramos has called the maker's knowledge tradition.[20] In *The Advancement of Learning* (1605) Bacon criticised those who thought it dishonourable 'to descend to inquiry or meditation upon matters mechanical, except they be such as may be thought secrets, rarities, and special subtleties'. On the contrary, histories – meaning descriptions – of the mechanical arts provided the most 'radical and fundamental' basis for natural philosophy, for they were 'operative to the endowment and benefit of man's life'. The results would 'not only minister and suggest for the present many ingenious practices in all trades, by a connexion and transferring of the observations of one art to the use of another, when the experiences of several mysteries shall fall under the consideration of one man's mind', but they would also 'give a more true and real illumination concerning causes and axioms than is hitherto attained'.[21]

Bacon elaborated his argument in *Instauratio Magna* (*The Great Instauration* or 'Great Renewal'), ambitiously designed to place the whole of natural philosophy on a new footing. Published in an unfinished state in Latin in 1620, the second most complete part, entitled *Novum Organum* (*The New Organon*, from Aristotle's main contributions to logic grouped together as the Organon, meaning tool or instrument, for the accurate expression of rational thought), was intended to provide a methodological infrastructure for the new philosophy. Book I was devoted to clearing away past methods of reasoning, above all Aristotle's inferential system based on syllogisms, whereby conclusions were only valid if they confirmed premises, or in its cruder manifestations incontrovertible *a priori* truths. Instead, Bacon employed inductive methods dependent on the observation of nature that would eventually lead, through the process outlined in Book II of practice and experiment, elimination and refinement, collation, tabulation and interpretation, to universal laws and theories about how the world really worked.

The *Novum Organum* is wholly informed by Bacon's recognition that his prescriptions were based on the working practices of the mechanical arts – observation, experimentation and collaboration – to achieve progress.[22] Nevertheless, he maintained, there was a distinction between the larger concerns of science and those of the mechanic 'who is by no means anxious about the investigation of truth, does not direct his mind or stretch his hand to anything but what is useful for his task'. Science was concerned with '*illuminating* experiments', the mechanic merely with '*profitable* experiments'.[23] Yet among the 'privileged instances' or kinds of support that would guide the investigator in the later stages of induction, Bacon included 'man's contrivances or tools'. These extended to outstanding works of art, the peaks of human endeavour:

> For as the chief thing is that nature should contribute to human affairs and human advantage, the first step towards this end is to note and enumerate the works that are already within man's power (the provinces already occupied and subdued); particularly the most refined and finished works, because they provide the easiest and quickest route to new things not yet discovered. If one were to reflect carefully on them and then make a keen and persistent effort to develop the design, he would surely either improve it in some way, or modify it to something closely related, or even apply and transfer it to a still nobler purpose.

Bacon asserted that these *chefs-d'oeuvre*, like rare and unusual works of nature, stimulated the intellect, not least because the means of creating them were usually quite plain

whereas for the wonders of nature they were often obscure. Yet, perhaps too familiar with dazzling displays of technical virtuosity in princely cabinets of curiosities, he warned that there was a danger they might stun the intellect into believing there was nothing more to be discovered. Furthermore, a hair-line crack of doubt is detectable in the monumental edifice he was proposing when he fleetingly observed that the most remarkable inventions came to light by chance, 'and not through little refinements and extensions of arts'.

Nevertheless, he believed it was absolutely necessary 'to do a thorough survey and examination of all the mechanical arts, and of the liberal arts too (so far as they may result in works), and then to make a compilation of particular history of the great accomplishments, the magisterial achievements and finished works, in each art, together with their modes of working or operation'. These arts should include not only wonders but also more common products like paper which were unique in their material make-up and even tricks and toys: 'Their applications are trivial and frivolous, but', he allowed, 'some of them may be useful for information.'[24]

Bacon included with *Novum Organum* the draft *Parasceve ad Historiam Naturalem et Experimentalem* (*Outline of a Natural and Experimental History*), covering material intended for a third part of *Instauratio Magna*. He envisaged that the data would be compiled through a major collaborative enterprise supported by the state, tackling natural phenomena and material from all existing academic disciplines, as well as the mechanical and experimental arts. Artisans working with natural materials were closely attuned to their properties, Bacon recognised, 'And the manipulations of art are like the bonds and shackles of Proteus, which reveal the ultimate strivings and struggles of matter ... Therefore we must put aside our arrogance and scorn, and give our full attention to this history, despite the fact that it is a mechanics' art (as it may seem), illiberal and mean.'

Bacon drew up a sliding scale of arts for the philosopher to study. The most useful were those 'which present, alter and prepare natural bodies and the materials of things, like agriculture, cookery, chemistry, dyeing, the manufacture of glass, enamel, sugar, gunpowder, fireworks, paper and such like'. Arts which were based essentially on the 'subtle motion of hands and tools' were of less value, 'such as weaving, carpentry and metalwork, building, the manufacture of mill-wheels, clocks and so on; though they are certainly not to be ignored either, both because many things occur in them which relate to the alteration of natural bodies, and because they give accurate information about local motion, which is of the highest importance for many things'. Thus Bacon prioritised those trades capable of revealing the laws of nature over those merely demonstrating mechanical ingenuity.

Nearly fifty useful arts were included in the list of 'Histories of Man' that followed. They are loosely organised, starting with the basic necessities of life – those arts involved in the production of food and drink, washing, clothing and shelter – and progressing to transport, printing, wax-, basket- and mat-making, agriculture, gardening, fishing, hunting, the arts of war and of navigation, athletics, horsemanship and other sports and entertainments, the manufacture of artificial materials such as porcelain, the history of salts, the history of different machines and motions and 'common experiments' which had yet to become an art.

To be on the safe side, Bacon advised, 'we must accept not only experiments which are relevant to the purpose of art, but any experiments which happen to come up'. So once more he conceded the role that could be played by chance. And perhaps aware of appearances to the contrary, he stressed that the programme he had drawn up was not compilation for its own sake, with the sole aim of improving individual arts: 'our plan is that the streams of all mechanical experiments should run from all directions into the

sea of philosophy'. Again he emphasised that when particular histories fell under two or more headings, 'the most beneficial thing is to investigate by arts, but classify by bodies. For we have little concern with the mechanical arts in themselves, but only with those which contribute to constructing philosophy.'[25] This admission underscores Bacon's hierarchical belief that producers of the new knowledge would be philosophers capable of generalised classification leading to universal truths, not artisans who dealt only in the particular and contingent. The point was reinforced in the ideal society outlined in his unfinished fable, *New Atlantis* (first published posthumously in 1627). He envisaged that three of the fellows of the all-embracing research academy named 'Salomon's House' would collect 'the experiments of all mechanical arts; and also of liberal sciences; and also of practices which are not brought into arts. These we call Mystery-Men.'[26] The rest would remain uncontaminated by commercial reality – or, in effect, by direct involvement with those networks of craftsmen whose multifarious activities in London's protean economy habitually involved observation, experimentation and collaboration without the guidance of philosophers.

The Royal Society

Bacon's key proposals were taken forward during the Interregnum by scholars and projectors who proposed a variety of more or less utopian schemes for artisans' education and scientific progress.[27] In his description of the kingdom of *Macaria* (1641), Gabriel Plattes advocated the endowment of a state-run 'college of experience' for research into trades, agriculture and medicine, the results of which would be disseminated to the public at large.[28] Samuel Hartlib, the leading Puritan advocate of useful learning, established a state Office of Address or headquarters for 'universal learning' in 1647 to supervise technical innovation, to receive and disseminate news on the latest improvements at home and abroad, and to act as a venue for meetings on scientific and technical subjects.[29] The young physician William Petty proposed to Hartlib the formation of workhouses for poor children where they could acquire craft skills and a *gymnasium mechanicum* or vocational school for the most highly skilled artisans which would also serve as a vehicle for compiling a history of trades.[30] Although such populist schemes did not progress, they are indicative of a broader desire by the middle decades of the seventeenth century to realise Bacon's paper prescriptions in one institutional form or another.

The motivation behind these projects did not fade into oblivion with the Restoration in 1660, even if their more radical features were tactfully downplayed. The founders of the Royal Society supported the furtherance of the Baconian cause of active, systematic, collaborative experimentation in pursuit of knowledge.[31] Nevertheless, there were differences of view among the Fellows as to what kind of knowledge the Society was intended to promote. In its early years, these differences centred on the Society's projected 'History of Trades', the furtherance of which was espoused most enthusiastically by those who had been associates of Hartlib.[32]

In September 1661, the Society's first secretary, Henry Oldenburg, reported to his friend, Benedict de Spinoza,

> In our philosophical society we indulge, as far as our means permit, in diligently making experiments and observations, and we spend much time in preparing a history of the mechanical arts, feeling certain that the forms and qualities of things can best be explained by mechanical principles, and that all the effects of nature are produced by motion, figure, and texture, and the varying combinations of these, and there is no need to have recourse to inexplicable forms and occult qualities, as a refuge for ignorance.[33]

In Oldenburg's view, the Royal Society's 'History of Trades' programme was a means to the end of demonstrating the science of mechanics or motion and other forms of natural knowledge, narrowing down the conventional meaning of mechanical to its mathematical core.

Other Fellows seemed less concerned with contributing to the Baconian 'sea of philosophy' and more with following particular streams to satisfy their own curiosity about individual trades. Endless wish-lists were produced detailing potential channels of enquiry, few of which were ever explored. John Evelyn helpfully presented his 'List for the History of Arts Illiberall and Mechanick' to the Royal Society in January 1661.[34] He had been working on it throughout the 1650s and a volume entitled 'Trades Secrets & Receipts Mechanical, as they came casualy to hand' survives among his papers.[35] As the title suggests, its contents had more in common with traditional 'books of secrets', based on custom and practice rather than on Baconian experimentation. For most of the trades Evelyn listed he never got beyond the heading, some trades presumably coming more readily to hand than others. There is a long entry on the 'Lime Burner' illustrated with three pen-and-ink sketches of kilns; Evelyn could easily have observed them along the south bank of the Thames near his home in Deptford.[36] Likewise, the lengthy entry headed 'Ship-Wright', consisting of rudimentary calculations and tables on the correct rules relating to the proportions of vessels, masts and timber, was the sort of information he could have picked up from a master shipwright in the royal dockyards of Deptford or Woolwich.[37] Other notes related to his own more or less 'polite' interests in painting, enamelling, marbled paper and varnishes.

A single page from another volume in Evelyn's papers, from a section entitled 'Artes Illiberales et Mechanicae', vividly conveys his scatter-shot approach, the dabbling of a dilettante in whatever caught his fancy (fig. 1).[38] It is covered in notes and diagrams on making vintage wine; cradles; ferry boats; a flea-trap; a sleeping chair with extending footrests and a trap chair to hold men which Evelyn had spotted in a cardinal's palace in Rome ('I suppose it was invented not for sport only, but to entrap some body that might come to visit some person without suspicion, and betray him, agreeable enough to the vindictive humour of the *Italians*'); a 'table and chair for an impotent person who cannot rise out of bed'; a table he had also seen in Rome with chairs which slotted neatly into each side; a gamester's shuffling box; an exact balance; a folding letter-carrier 'to put letters up to the window of a prison without a ladder'; and a magical Roman banqueting or summer house complete with watery and musical effects. On the page opposite, Evelyn listed the following recipes: for size and glue; taking spots and stains out of silk, cloth, silver and gold lace; to recover discoloured ivory or any bone; for cement to mend broken china; to make writing seem old; for a solder for latten plate (an alloy of copper and zinc resembling brass); to refresh gloves; for portable perfume; to remedy vermin stink; and for sweets to kill moths in chests of cloth.[39]

The 'List for the History of Arts . . .' he presented to the Royal Society was more fully worked out, dividing trades into a hierarchy, the roots of which went back to antiquity. 'Usefull and purely Mechanic' comprised skilled traders ranging from the baker, brewer and brick-maker to the goldsmith, silk-weaver, upholsterer and wheelwright. 'Mean Trades' mostly involved contact with dirt, such as the chimney-sweeper, cobbler, rat-catcher and sow-gelder. 'Servile' referred to servants, divided into vehicular – such as the porter or carter – and others, including the packer, tankard-bearer, ostler and porter. 'Rusticall' naturally referred to the gardener, grazier, shepherd and so on, while the 'Female Artificer' encompassed various kinds of specialised women's work: sewing, spinning, bleaching, midwifery and cosmetics. Evelyn also had a category of 'Polite and more Liberall' trades, many of which involved elements of mathematics – the merchant (who employed arithmetic in exchange and bookkeeping); navigation; the military arts of

1 John Evelyn, 'Artes Illiberales et Mechanicae', 1650s. British Library, Add MS 78340, f.326

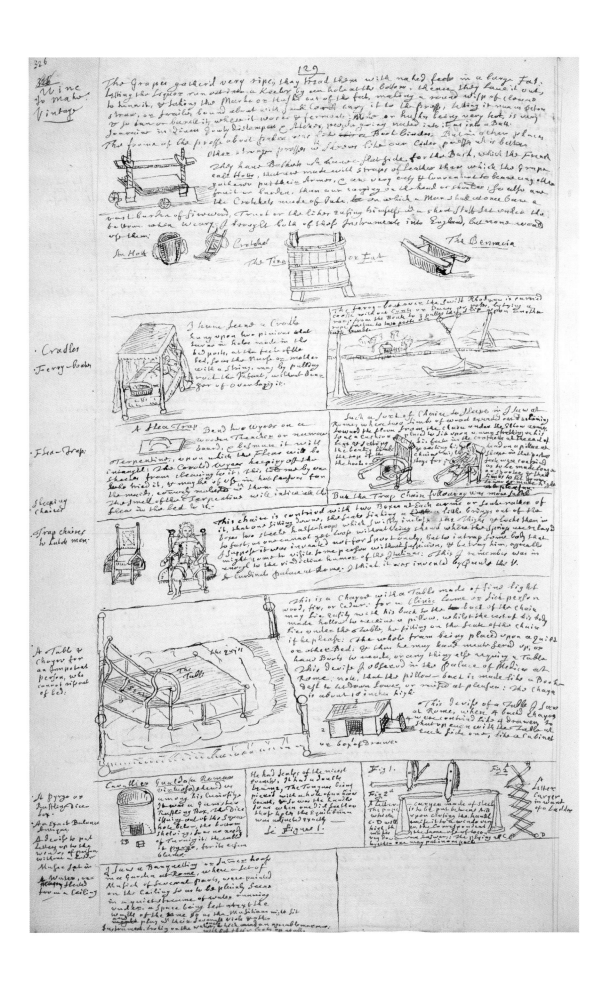

129

Wine
to Make.
Vintage

· Cradles

· Ferry-boats

· Flea-Trap:

· Sleeping chaires

· Trap chaires to Catch men:

· A Table & Chayre for an Imperfect person, who cannot rise out of bed:

· A Bygo or Rattling dice box

· An Exact Balance Antique

· A device to put Livery up to the weare of burden without hand...

· Muse John...

· A Water... from a Ceiling

drilling, fortification, pioneering and gunnery; the engineer – as well as those undertaken for pleasure, such as dancing, gymnastics and sports.

Evelyn's final category, 'Curious', was devoted to the arts closest to his heart as a virtuoso. They included enamelling; painting – in oil, miniature, mosaic and fresco; annealing glass and glass manufacture; printing; the gilding of frames, both leather and metal; bronzing; engraving and etching; sculpture in brass, casting and plaster; the making of spectacles, optical and mathematical instruments, clocks, watches, dials and all automata; lapidary; gunpowder and firework manufacture and alchemy. The last section within 'Curious' was entitled 'Exotick and very rare seacret trades'. It encompassed 'mosaic work, varnishes, porcelain, vessels of twigs &c, inventions to take spots out of cloth & silk, armour and coats of mail, mirrors, Indian waxworks, Chinese ink, thermometers, artificial colours of the rarest sort' and 'Pr Rupert's new way of engraving', in other words, the art of mezzotint. The four pages end with an aspiration to form 'A Booke of the Tooles Modells and all the Utensils pertaining to the severall trades &c designed in perspective, and exactly proportioned'.[40]

The polymathic William Petty presented another such synopsis to the Royal Society, dashed off in a semi-illegible scrawl possibly in the late 1640s with Hartlib's encouragement but never finished. Petty's projected 'History of Trades' started with objects made of iron, including pumps, mills and other wheelworks, before covering basic mechanics – wedges, screws, hawsers, pulleys – and a host of applied skills ranging from those which were loosely based on chemicals or minerals to the products of agriculture, forestry and animal husbandry. Anticipating his later reputation as a surveyor, pioneer statistician and political economist, Petty displayed a keen awareness of the benefits arising from improvements in manufactures. Government-backed research and the dissemination of new techniques would boost England's wealth and power in the face of competition from France and Holland. He proposed that the history should include basic economic data: 'A list of all native commodities . . . and near what city or town the chief manufactures are made and spent; with the season of the year for each', as well as civil engineering projects: 'all highways, causeways, harbours, moles, moorings'.[41] Other related documents – 'An Explication of Trade & its Increase' and 'Observations of England' – traced the evolution of industry from an agricultural economy concerned only with the bare necessities for life to a country trading with the whole world.[42]

True to his gifts as an outstanding instrument-maker and experimental demonstrator, Robert Hooke also seemed of the persuasion that the improvement of trades was the Society's first priority. In the preface to his most celebrated work, *Micrographia* (1665), he proclaimed that the end of the Society's enquiries was 'above all, the ease and dispatch of the labours of men's hands'. Although Fellows did not wholly reject theoretical experiments, he asserted that 'they principally aim at such, whose applications will improve and facilitate the present way of manual arts'.[43] Hooke had a vested interest in adopting such a stance. In 1664, the wealthy London grocer Sir John Cutler had offered to pay him £50 annually to give lectures 'for the promotion of mechanic arts', to be established in Cutler's name at Gresham College. Hooke fulsomely praised his patron's munificence: 'This gentleman had well observed, that the arts of life have been too long imprisoned in the dark shops of mechanics themselves, and there hindered from growth, either by ignorance, or self-interest: and he has bravely freed them from these inconveniences.' He applauded Cutler for the way in which, 'He hath not only obliged tradesmen, but trade itself: he has done a work that is worthy of London, and has taught the chief city of commerce in the world the right way how commerce is to be improved.'[44]

Nevertheless, Hooke's own efforts to shed light on the dark confines of specific trades were not sustained. Papers on 'The Way of Making Felts' survive, accompanied by a lively drawing in perspective of the felt-makers at work with close-ups of the tools they

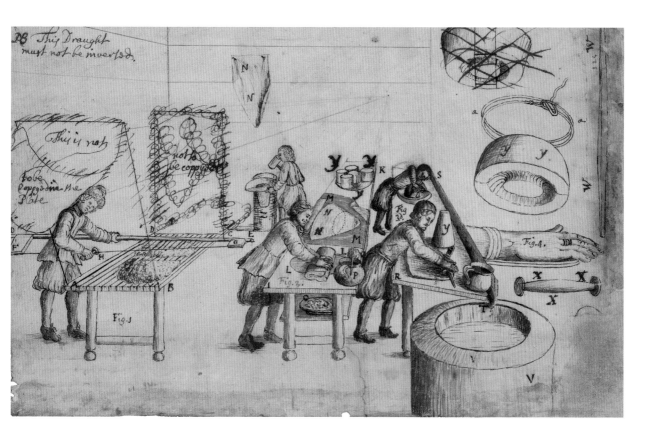

2 Robert Hooke, 'The Way of Making Felts', 1666. The Royal Society, CL.P/20/96

used, meant for publication as an engraving (fig. 2).[45] He intended to proceed in an exemplary Baconian manner. With the help of the illustrations, he first explained the tools and instruments which interested him, 'having not met with them in any other trade', and next the materials and manner of working. He then proposed

> to draw some inferences from my observations and show what information they afford us for the finding out the operations of nature. Lastly some conjectures or attempts how this art may be varied or improved either as to the materials on which they work, or as to the instruments and manner of their working, or both.

However, he did not commit to paper any technical improvements, postponed the drawing up of general observations and instructions 'for the promoting natural knowledge and . . . axioms and corollaries for the further proceeding to other experiments' and never wrote anything more on the subject.[46]

After a visit in 1665 to his birthplace on the Isle of Wight, Hooke also contributed 'A Description of the manner of making Salt at Saltern in Hampshire', two and a half pages of text, complete with a perspective in ink and wash of the site, with the different parts keyed alphabetically into the description (fig. 3). The roof of the boiling-house is cut away in the drawing to show the boiler, furnace and salt in the strainer.[47] When he gave his lecture on the subject in July 1666, as part of a series on 'the promoting and collecting of natural and artificial history', he began by outlining the natural processes of fossilisation and petrifaction, explaining the different kinds of salt and the chemical reaction that produced them, before describing the 'artificial' method of making salt out of sea water.[48] Again, though, he failed to suggest modifications or improvements, nor did he draw any scientific principles from the process. He simply ended his on-the-spot report by making inquiries as to the health of the workers which, he was surprised to learn, was remarkably good given the strong smell of 'spirit of salt' he had noted in the boiling-house.

23

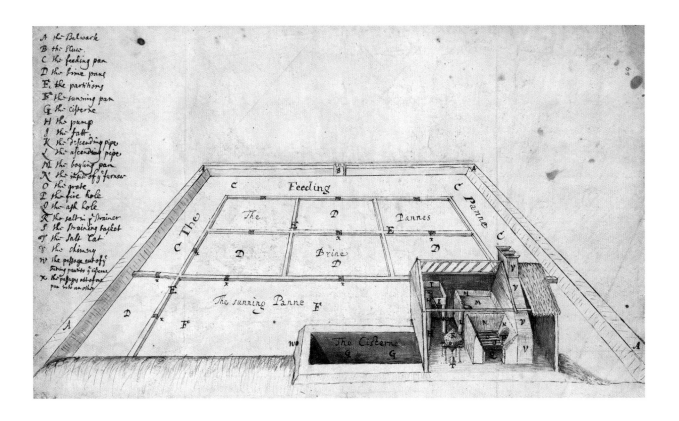

The labels on the left side of the image read:

A the Bulwark
B the Sluce
C the feeding pan
D the brine pans
E the partitions
F the sunning pan
G the cisterne
H the pump
I the salt
K the descending pipe
L the ascending pipe
M the boyling pan
N the insid of y furnace
O the grate
P the fire hole
Q the ash hole
R the salt in y strainer
S the straining basket
T the salt vat
V the chimny
W the passage cut off
 runing pan into y cisterne
X the passages cut off one
 pan into another

3 Robert Hooke, 'A Description of the manner of making Salt at Saltern in Hampshire', c.1665–6. The Royal Society, CL.P/20/40

In other Cutlerian lectures, Hooke enlarged on the relationship between natural and artificial history. When lecturing on natural history in about 1665–6, he followed Bacon in asserting that the operations of tradesmen in preparing, refining, curing, dressing, scouring and dyeing natural materials provided the first-hand empirical information which formed the basis of both practical and speculative knowledge. The natural or philosophical historian should describe and perform these operations, take note of the recipes, examine and record the tools used, the defects and improvements, and even suggest improved methods used in another trade. He claimed to know 'very understanding and ingenious men in their own trade highly gratified by being shown by one very much a stranger to it, though known in other kinds, some expedients which seemed sufficiently obvious when once known to them'. In fact, he asserted, 'most trades have received their greatest inventions from such as have not been of it' and tradesmen should not fear having their trades taken from others or 'the mysteries of their art discovered to their disadvantage'. By adopting the methodology and state of mind recommended by Hooke, the natural or philosophical historian could arrive at axioms 'for the perfecting both of speculative and practical knowledge, for the improving and advancing of trade and manufactures and indeed for the universal good of mankind'.[49]

The fullest exposition of his argument is to be found in 'A General Scheme, or Idea of the Natural State of Natural Philosophy, and How its Defects may be Remedied by a Methodical Proceeding in the making Experiments and collecting Observations. Whereby to Compile a Natural History, the Solid Basis for the Superstructure of True Philosophy', probably written in 1666 but not completed and only published after his death, in 1705.[50] There is no need here to explore his theory of science and what he meant by 'philosophical algebra'.[51] But in setting down his 'true method of improving natural philosophy', he first listed at length the histories of natural things and then proceeded to do the same for the histories of artificial and mechanical operations, enumerating 'all the trades, arts, manufactures, and operations, about which men are employed, espe-

cially such as either contain some physical operation, or some extraordinary mechanical contrivance, for such as these will very much enrich a philosophical treasury'.

Hooke divided these operations under different headings, related to the four elements and then under animal, vegetable and mineral. The first object in writing their histories was simply description, 'whereby inquisitive persons that are ignorant of them, may come to a more perfect knowledge of them; in order to some other design as for curiosity, or discourse, or profit, and gain, or the like'. The second, Hooke's main concern, was for philosophical inquiry, 'the invention of causes, and for the finding out the ways and means nature uses, and the laws by which she is restrained in producing diverse effects'.[52]

Several features distinguish Hooke's plan for a history of trades. There is none of Evelyn's class distinction between more or less polite arts. Under 'mineral', for example, painters are listed alongside enamellers, varnishers, colour-sellers, 'makers of baby heads, and bowling stones or marbles, counterfeit marble, wax-work and casters'; sculptors and architects alongside masons, stone- and crystal-cutters; etchers and engravers together with brass founders and tinkers; gold- and silversmiths with spangle-makers. In undertaking his history of trades, Hooke was not satisfying a gentlemanly curiosity but attempting to abstract physical properties, 'to observe the manner of nature's proceeding, where she is imposed on by art'. In what might have been a subtle dig at Evelyn's approach, he noted that there were practices which had not yet become trades but which might be of great importance, affording much information, even though they were usually regarded as vile, trivial or foolish: 'and therefore, nothing in this design is to be looked on with the eye of the vulgar, and with prejudice, according to the esteem it has obtained in the world with the generality of men, who generally judge or esteem things only for the immediate pleasure or profit they afford, and look no further'. The diligent naturalist should go everywhere, 'but especially in such places as are most or least frequented, for the obviousness in the one, and difficulty in the other, has made multitudes of considerable observations to be neglected'.

Furthermore, given his own remarkable skills, Hooke made sure he emphasised the role played by mechanical contrivance: 'We ought also, to take notice of the various sorts of mechanical engines, which serve to assist and direct the hand in performing many operations together, with ease and speed and certainty; which are not otherwise done without much uncertainty, time and difficulty; and of the several slights and contrivances in operations, and the order of them, which precede and which follow, and the efficaciousness of them in this or that method.'[53]

Hooke went to considerable lengths to explain the steps involved in his 'methodical proceeding'. First he listed some questions relating to nature, the properties of which would be discovered not only by the 'naked senses' but with the help of instruments and engines, through induction and by comparing the collected observations and rationalising from them.[54] Then a full account of 'all the productions of art, such as are dispersed up and down in several trades and occupations of men, whether for profit or pleasure' would enable the productions of art and nature to be observed and compared. Further discoveries could be made by observing: where and by what means art caused nature to deviate or alter its usual course; the natural and artificial ways of producing the same effects; the differences between the products and materials of nature and those of art; and the circumstances when one exceeded the other. He also enumerated a number of mechanical ways which might help in working on and altering the properties of bodies, separating them and joining them together.[55]

The 'General Scheme' was completed down to proposals for the manner and order of registering the histories, 'because of the frailty of memory, and the great significancy there may be in some of the meanest and smallest circumstances'. They ought to be

reviewed, refined and summarised in the least space possible on fine paper and then stuck into a large book, such as those used for keeping prints, pictures and drawings, and altered, added to or removed over time. Queries, doubts, conjectures or deductions arising from these histories should be interposed using a differently coloured ink. Hooke also specified the type of illustration that might be useful because often much more could be expressed fully and clearly in a small picture than through verbal description. But, he warned, 'in the doing of this, as a great art and circumspection is to be used in the delineation, so ought there to be very much judgment and caution in the use of it'. Pictures which only served for ornament or pleasure, or for the explanation of things which could be better described in words, were 'noxious' rather than useful, and served 'to divert and disturb the mind, and sways it with a kind of partiality or respect', taking up space with irrelevant thoughts. Not that Hooke was opposed to 'those kind of pictures of the outward forms and beauties, and varieties of the species of nature', but they were 'to be referred to another head, where indeed they will prove very significant, but to a peculiar kind of inquiry, as I shall show more at large in my second part'.[56] Unfortunately, he never wrote the second part and his grand and coherent plan for a history of trades was never executed.

In his *History of the Royal Society* (1667), Thomas Sprat went so far as to assert that the true natural philosophy was principally intended for 'mechanics and artificers'.[57] Sprat was a Fellow of Wadham College, Oxford, with literary pretensions. He also served as chaplain to George Villiers, the second Duke of Buckingham, a post which afforded him the leisure to commence work on the *History* soon after his election in 1663 as a Fellow of the Royal Society, on the nomination of Dr John Wilkins, who supervised and heavily influenced the project. Wilkins's *Mathematicall Magick: or the Wonders that may be performed by Mechanical Geometry*, first published in 1648, the year he became Warden of Wadham, covered the development of classical machines and the mechanical principles involved in their operation. Wilkins claimed that not only pleasure but also real benefit could be gained from the work by

> such gentlemen as employ their estates in those chargeable adventures of draining, mines, coal-pits, &c, who may from hence learn the chief grounds and nature of engines, and thereby more easily avoid the delusions of any cheating impostor. And also for such common artificers, as are well skilled in the practice of these arts, who may be much advantaged by the right understanding of their grounds and theory.[58]

Following the Restoration, Wilkins encouraged the Society's espousal of a conspicuously utilitarian agenda, keenly aware that the promise of contributing to the nation's economic productivity and social stability was calculated to appeal to the state and commercial interests which could secure the Society's own future.[59] The frontispiece of the *History*, designed by Evelyn and engraved by Wenceslaus Hollar, reinforced this theme by including the figure of Francis Bacon, seated on the right-hand side of a bust of Charles II and pointing to an assortment of scientific instruments, navigational and military aids, indicative of the Society's range of practical concerns (fig. 4).

Seeking to avoid political and religious controversy, Sprat grounded the Society in Baconian empiricism, emphasising the role played in its business by experiment and co-operative scientific effort. In the third part of his work, he wrote at considerable length about the aims of the Society and the probable beneficial effects of experiments with regard to the manual trades.[60] New inventions in the 'mechanic arts', he maintained like Hooke, were frequently made by men not trained in the particular trades concerned. The latter found it difficult to alter customs, tools and materials, nor could they afford to wait on deferred rewards. However, the minds of men of freer lives, in other words Fellows of the Society, had not been dulled: 'Invention is an heroic thing, and placed

4 Wenceslaus Hollar after John Evelyn, frontispiece to Thomas Sprat, *History of the Royal Society*, 1667. The Royal Society

above reach of a low, and vulgar genius.' Inevitably, the surest improvements to the manual arts would be achieved through experimental philosophy. Whereas all previous arts were driven by luxury, chance or necessity, these were 'mean and ignoble' motives. In future, they would attain perfection when 'mechanic labourers shall have philosophical heads; or the philosophers shall have mechanical hands'. Tradesmen should not be suspicious or jealous of the interventions made by the Society: improvements in traditional trades would prevent them from falling into decline. The new mechanics would improve old arts through reviving their warmth and vigour: 'by disgracing the laziness of other artisans, and provoking them to emulation, they are wont to bring an universal light and beauty on those inventions into whose company they are brought'.

Sprat placed faith in the growth of manufactures, the benefits of free trade and an open-doors policy for skilled immigrant workers. He also appealed to gentlemen to espouse the new science, asserting that experimental knowledge was a proper realm of study for them. They might become superior leaders of armies and navies if they could accurately observe 'the advantages of different arms, and ammunitions, the passages of rivers, the straights of mountains, the course of tides, the signs of weather, the air, the sun, the wind, and the like'. Although their country residences, surrounded by nature, provided an appropriate setting for a life of philosophical enquiry, given the increasing range of their education and conversation, they ought also to get involved in trade, commerce and the experimental philosophy of knowledge, epitomised by the Royal Society.[61]

It was indeed the patrician Robert Boyle who published the most enthusiastic and extensive apologia for the positive role that the new science could play in relation to the mechanical arts, in the second tome of *Some Considerations Touching the Usefulnesse of Experimental Naturall Philosophy* (1671). Once again, it was intended as a popular work of promotion, Boyle stating that he had deliberately chosen to include experiments for their 'variety and easiness' to make his case, rather than 'a few choice and elaborate experiments' which were too difficult for readers to put into practice.[62] Like Sprat, Boyle asserted that natural philosophers were best placed to describe and rationalise the mechanical arts, not least because of the inability of most artisans to undertake such a role for themselves:

> I have found by long and unwelcome experience, that very few tradesmen will and can give a man a clear and full account of their own practices; partly out of envy, partly out of want of skill to deliver a relation intelligibly enough and partly (to which I may add *chiefly*) because they omit generally, to express either at all or at least clearly some important circumstance, which because long use hath made very familiar to them, they presume also to be known to others: and yet the omission of such circumstances, doth often render the accounts they give of such practices, so dark and so defective, that, if their experiments be anything intricate or difficult (for if they be simple and easy, they are not liable to produce mistakes) I seldom think myself sure of their truth, and that I sufficiently comprehend them, till I have either tried them at home, or caused the artificers to make them in my presence.[63]

Despite such lordly sentiments, Boyle was far from unsympathetic to artisans. He sought to reconcile them to his project of recording their practices faithfully, strenuously

maintaining at far greater length than Hooke or Sprat that they were not harmed by disclosing the 'mysteries of their arts'. Firstly, he said, he never divulged all the secrets and practices of any one trade, only a few particular experiments for his purpose. In doing so he contrasted his work with comprehensive guides to trades, some of which had been published by artificers themselves, like Cellini's 'much esteemed Italian tracts of the lapidaries and goldsmiths trades' or Agricola's volume 'of the more practical part of mineralogy, wherein he largely and particularly describes experiments, tools, and other things that belong to the callings of mein men [miners]'.[64] Secondly, tradesmen did not usually buy books, especially those not intended for them, dealing mainly with 'things either beyond their reach or wherein they seem not likely to be concerned'. The tests and trials made by gentlemen and scholars on the basis of such publications would scarcely be prejudicial to tradesmen, as the former would not invest in the tools and materials involved when it cost less to buy the end products. Boyle made a distinction between the generalised type of treatise he intended to write and the technical virtuosity needed to make objects of added value which was not his province. The latter goods appealed mostly to the 'more curious sort of buyers by a certain politeness, and other ornaments (comprised by many under the name of *finishing*) which require either an instructed and dexterous hand, or at least some little peculiar directions, which I did not always think myself obliged to mention, in a treatise designed to assist my friend to become a philosopher, not a tradesman and published to help the reader to gain knowledge not to get money'. Thirdly, he was not concerned with the 'craft' or business sense which tradesmen needed to operate efficiently in the market.[65]

Boyle did not disdain to talk to craftsmen in their places of work, maintaining: 'he deserves not the knowledge of nature, that scorns to converse even with mean persons, that have the opportunity to be very conversant with her; so oftentimes from those, that have neither fine language nor fine clothes to amuse him with, the naturalist may obtain information, that may be very useful to his design, and that upon several scores'. Qualifying, even contradicting, his initial assertion that artisans' accounts were unreliable, he enumerated at length the positive benefits arising from this dialogue. Tradesmen, he said, were more diligent about the particular things they handled than other experimenters were wont to be, for their livelihood depended on it. Necessity was the mother of invention: 'experience daily shows, that the want of a subsistence, or of tools and accommodations, makes craftsmen very industrious and inventive, and puts them upon employing such things to serve their present turns . . . By which means, they discover new uses and applications of things, and consequently new attributes of them; which are not wont to be taken notice of by others, and some of which, I confess, I have not looked upon without wonder.' They made use of natural materials which were unknown to classical writers and put others to uses not met with in famous works. He also conceded that tradesmen, 'being unacquainted with books, and with the theories and opinions of the schools, examine the goodness and other qualities of the things they deal with, by mechanical ways, which their own sagacity or casual experiments make them light upon'. Although such experiments might appear 'extravagant' (meaning uncodified, irregular and hence absurd) to the bookman, yet 'if they really serve the craftsman's turn, must be true and useful, their being extravagant will but make them the more new and instructive, and consequently the more fit to be admitted into the history of nature'. The observations of tradesmen might not at any one time be as accurate as those of a learned man, yet that defect was recompensed by their being 'more frequently repeated, and more assiduously made'. Some observed diverse circumstances unobserved by others, 'both relating to the nature of the things they manage, and to the operations performable upon them'. Boyle expanded upon this point by considering what tradesmen meant by the goodness or badness of the materials they dealt with, such as the seasonal factors which influenced

the qualities of particular types of wood. Finally, by frequenting the workhouses and shops of craftsmen, a naturalist might often learn of related phenomena other than those strictly of use to the particular trade.[66]

This was generous recognition of the wealth of artisans' knowledge but Boyle still maintained that the philosopher was king. The small inconvenience that might happen to tradesmen by disclosing some of their experiments to practical naturalists would be more than compensated by improvements made to those experiments and by the new inventions which might arise from the 'diffused knowledge and sagacity of philosophers': 'For these inventions of ingenious heads do, when once grown into request, set many mechanical hands a work, and supply tradesmen with new means of getting a livelihood or even enriching themselves.' To demonstrate his point, Boyle referred to the speculative sciences based on pure mathematics which had resulted in the manufacture of a whole range of instruments relating to astronomy, navigation, geography and music, supplied to virtuosi at home and abroad. He also cited inventions made by those outside the trades which had benefited: Cornelis Drebbel's discovery of a new scarlet dye (produced by corroding cochineal with tin chloride) and Christiaan Huygens's invention of the pendulum clock.[67] Even though the artificer gave the ultimate form to his products, he could be much assisted by the naturalist's knowledge of the quality and characteristics of raw materials – the choice of marble and stone supplied to the mason, the best mixture for cement or the best method of tempering iron and steel – a belief he did nothing to reconcile with his earlier recognition of artisans' knowledge of materials.[68] Above all, Boyle asserted that the philosopher could improve the mechanical arts by uniting the observations and practices of different trades into one 'body of collections'. He suggested 'some knowing and experimental persons appointed by the public' should take an exact survey of trades, their secrets and practices, 'that thus discerning the errors and deficiencies of each, they may rectify the one, and supply the other, partly by the hints afforded by the analogous experiments of some other trades, and partly by their own notions and trials'.[69]

Although Boyle was on the committee appointed in 1664 to oversee the progress of the Society's 'History of Trades' programme, he makes no specific reference to it in *Some Considerations Touching the Usefulnesse of Experimental Naturall Philosophy*. Perhaps by 1671 he was somewhat disenchanted with its progress. The task of finding men of science to observe particular trades, let alone to make useful inductive connections between them, was proving difficult. Despite Boyle's disclaimer that *Some Considerations* was intended as a popular work, not a specialist treatise describing 'choice and elaborate experiments', the examples he selected to demonstrate the utility of experimental philosophy were diffuse and not particularly impressive or even reassuring. In promoting physical knowledge to replace manual skill, for example, Boyle advocated the use of an under-arm depilatory based on 'rusma' (orpiment or arsenic trisulphide) and quicklime (calcium hydroxide) which, he maintained, was quicker and more effective than shaving.[70]

Nevertheless, in the Society's early years, the 'History of Trades' programme was pursued with some vigour. Six histories were begun in 1660, a further eleven in 1661 and five more in 1662.[71] Papers on different trades were read at meetings, discussed and recorded in the Society's register. Related experiments were performed. Trade and mineral samples were stored in a rudimentary museum. A few histories or part histories were published, some appended to Sprat's *History of the Royal Society*: Jonathan Goddard's 'A Proposal for Making Wine', Thomas Henshaw's 'The History of the Making of Salt-Peter' and 'The History of Making Gunpowder', as well as Sir William Petty's 'An Apparatus to the History of the Common Practices of Dying' and his succinct, systematic 'General Observations upon Dying' which was first read to the Society on 7 May 1662.[72] Later the same month Evelyn read part of his pioneering work on engrav-

ing, *Sculptura* (1662), the first guide to the subject to be published in any language.[73] On 25 May 1663, John Beale read a paper on the art of making 'parchment, vellum, glue &c', illustrated with diagrammatic figures of the drawing or shaving knife and of the frame used for stretching parchment.[74] There were papers on bread-making in France where 'by universal consent, the best bread in the world is eaten', on cheese-making and on the art of the tallow chandler.[75] Evelyn's *Sylva, or a Discourse of Forest Trees, and the Propagation of Timber in His Majesties Dominions* was published in 1664 with the lengthy appendix *Pomona* 'concerning fruit-trees, in relation to cider', which included observations contributed by other Fellows.

Some of the histories were concerned with the chemistry of dyeing and tanning, mining or metallurgy – subjects close to 'natural bodies', as privileged by Bacon and Boyle. Petty's history of dyeing began with theoretical problems relating to colours, then went on to list all known dyes according to their animal, vegetable or mineral origins and to describe best practice at home and abroad. Christopher Merrett's *The Art of Glass* (1662), a translation of Antonio Neri's *De Arte Vitraria* (1612), was supplemented with material on English glass manufactures. 'Brief Directions how to prepare and tan Leather, according to the new invention of the Honourable Charles Howard of Norfolk, experimented and approved of by diverse of the principal Masters of that trade; together with a description of the Engin for beating and cutting the materials of tanning' was published in *Philosophical Transactions* in July 1674.[76]

Boyle himself set the agenda for mining histories with his 'Articles of Inquiries touching Mines', a lengthy series of questions which appeared in *Philosophical Transactions* in 1666. Based (without acknowledgement) on Agricola, Boyle reduced the subject to six geographical and geological heads and appended a few 'promiscuous enquiries' relating to temperature, wind, weather and water, the laws and customs pertaining to mines and, somewhat surprisingly, 'Whether the diggers do ever really meet with any subterranean daemons; and if they do, in what shape and manner they appear; what they portend; and what they do, &c.' The question was probably intended to be sceptical, arising from the assertion made by the normally rational Agricola, in Book 6 of *De Re Metallica*, that miners did indeed encounter 'demons of ferocious aspect' down mines, which could be put to flight by prayer and fasting.[77]

Although Oldenburg, the editor, knew that Boyle's proposed mining enquiries were unfinished, nevertheless he published them to encourage 'several foreigners of his acquaintance' to make enquiries about the mines in their own countries and to send descriptions to the Society along the lines suggested by Boyle.[78] Over the next few years several accounts of mines in France, Hungary and Poland did appear in *Philosophical Transactions*.[79] An 'inquisitive person' (Samuel Colepresse) provided a useful description of the Devon and Cornwall tin mines in 1671, accompanied by an illustrated 'scheme' of the workings on Dartmoor (fig. 5). Dr Christopher Merrett provided a shorter account of the tin mines of Cornwall in 1678.[80] John Ray's 'Account of the preparing and refining some of our English Metals and Minerals' appeared in an appendix to his *Collection of English Words* (1674).[81] Letters dating from the 1670s to Dr Martin Lister relating to the Lancashire iron and Cumberland copper industries, as well as Lister's own observations on making steel, eventually appeared in *Philosophical Transactions* in 1693.[82]

Oldenburg also published extracts from letters received from correspondents abroad about curious trades or techniques; for example, Colepresse's account from Leiden on the making of opalescent, amethyst, sapphire and red glass in Haarlem, or Evelyn's illustrated account of a Spanish plough or *sembrador* which could sow seeds and harrow at the same time (fig. 6). He had written to the English ambassador to Spain, Lord Sandwich, for further details and the Earl helpfully supplied him with the engine itself and a full description of it and its use 'all of it written with his own noble hand'. Evelyn

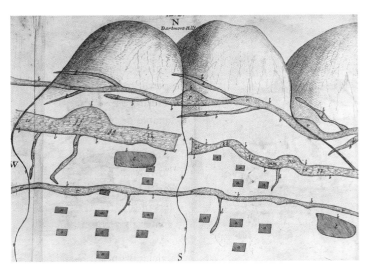

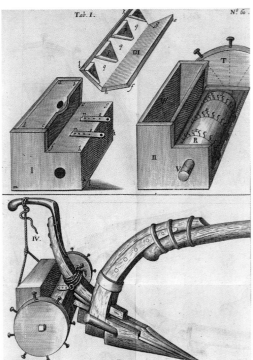

5 (left) Anon., scheme of tin mines on Dartmoor, *Philosophical Transactions*, 6 (1671). The Royal Society

6 (right) Spanish plough or 'sembrador' observed by the Earl of Sandwich, English Ambassador to the Court of Spain, *Philosophical Transactions*, 5 (1670). The Royal Society

extolled the public spiritedness of this gesture which was, apparently, one of many: 'And it is to me a shining instance of both your Lordship's happy talents, and great comprehension, that in the throng of so many and so weighty employments, you can think of cultivating the arts, and of doubly obliging your country.'[83]

Granted these excursions into the arts, much more space in *Philosophical Transactions* was given over to medicine, natural philosophy and natural history and to descriptions of the latest developments in associated instrumentation. Significantly, when Hooke published his *Lectiones Cutlerianae, or a Collection of Lectures: Physical, Mechanical, Geographical and Astronomical* in 1679, he did not include his accounts of either felt-making or salt manufacture. Investing the lectures with a broader purpose, no less than the 'History of Nature and Art', he described the practical devices and instruments which he had invented, such as the spring-regulated watch, as well as telescopes, microscopes and mechanical improvements to lamps and his observations on the comet. Other lectures have come to light more particularly concerned with natural philosophy and history. He rationalised this change in emphasis by asserting 'how lame and imperfect the study of art doth often prove without the conjunction of the study of nature' and, claiming that Cutler had instigated the lectures on such a basis, proceeded 'in joining the contemplation of them both together'.[84] In fact, Cutler had ceased to pay Hooke, at least in part because the lectures Hooke had given in his name were not strictly on trade subjects.[85]

Mechanick Exercises

Closer to the Society's original stated intent was Joseph Moxon's *Mechanick Exercises*, the first volume of which came out in monthly parts between 1677 and 1680 and the second, better known, devoted to the 'whole Art of Printing', between 1683 and 1684. Moxon was the son of a Yorkshire printer who had worked in Delft. After going into a

printing partnership with his father in London, he underwent specialist training in the making of mathematical instruments, globes, maps and charts. In 1653 he opened a shop in Cornhill, at the sign of Atlas, selling these goods and manuals on mathematics, architecture, navigation, astrology, astronomy, geography, waterworks, perspective and lettering. He was appointed Hydrographer to the King in 1662. His astronomical interests as well as his work for and friendship with Pepys, Evelyn, Hooke and other Fellows of the Royal Society resulted in his own election as a Fellow in January 1678.[86]

By July the same year, through a letter of introduction from Evelyn, he was able to present the first six instalments of *Mechanick Exercises* to the President of the Royal Society, Sir Joseph Williamson. Williamson was editor of the *London Gazette* and advertisements appeared in that paper which demonstrate the manner in which Moxon, as a highly skilled master printer and globe-maker, approached the subject: 'Forasmuch as all natural knowledge was originally produced (and still eminently depends) upon experiments, and all or most experiments are couched among the handicrafts; and also that handiworks themselves may be improved.'[87] In other words, unlike the Society's gentlemanly philosophers, Moxon gave precedence to the experimental methods of artisans in the quest for natural knowledge.

The first three instalments were devoted to 'Teaching the Art of Smithing, wherein is handled the Use of Smiths Tools, the Setting up a Smiths Forge, the manner of Forging, Filing, making of Screws and Worms, Brasing and Soldering, Case hardening of Iron, Softning, Hardening, and Tempering of Steel, &c'. The next three covered 'the Art of Joynery; its Tools and the manner of working with them, as in Plaining, Glewing, Shooting of Joints, Framing, Mortessing and Tennanting, Moldings &c.' These Arts would be described, he promised, 'in Workmens Phrases, and their Several Terms explained'. Each instalment was illustrated with plates depicting the tools employed.

In the preface to the first volume (which was intended to stand for all subsequent volumes), Moxon again championed the artisan, responding to the assumptions eloquently expressed by the leading lights of the Royal Society. Moxon even implicated them in his argument: 'I see no more reason why the sordidness of some workmen should be the cause of contempt upon manual operations, than that the excellent invention of a mill should be despised, because a blind horse draws in it. And though the mechanics be by some accounted ignoble and scandalous, yet it is very well known, that many gentlemen in this nation of good rank and high quality are conversant in handiworks, and other nations exceed us in numbers of such. How pleasant and healthy this their diversion is, their minds and bodies find; and how harmless and honest all sober men may judge.'

Moxon allowed that there were excellent sciences but emphasised that their value depended on a two-way relationship with the arts:

> to what purpose would geometry serve, were it not to contrive rules for handiworks? Or how could astronomy be known to any perfection, but by instruments made by hand? What perspective should we have to delight out sight? What music to ravish our ears? What navigation to guard and enrich our country? Or what architecture to defend us from the inconveniences of different weather, without manual operations? Or how waste and useless would many of the productions of this and other countries be, were it not for manufactures?

Practical geometry underlay the smith's work, with which he started his *Exercises*, despite being thought by some a vulgar art:

> but I am not of their opinion; for smithing is (in all its parts) as curious a handicraft as any is. Besides, it is a great introduction to most other handiworks, as joinery, turning, founding, printing, &c. they (all with the smith) working upon the straight,

square or circle, though with different tools upon different matter; and they all have dependence upon the smith's trade, and not the smith upon them.

His preface emphasised his own practical expertise, especially in 'those trades wherein the chief knowledge of all handiworks lies' – namely, the metal trades, joinery, engraving, printing, mathematical instrument, globe- and map-making – and his willingness to communicate this knowledge to the public. Yet in explaining his choice of title, *Mechanick Exercises* in preference to 'The Doctrine of Handicrafts', Moxon unwittingly touched on a flaw in his argument, not to mention his marketing strategy. Handicraft, he said, 'signified cunning or sleight, or craft of the hand, which cannot be taught by words, but is only gained by practice and exercise'. Contrarily, he maintained that his *Exercises* were rules which, if followed as opposed to being merely read, would enable everyone wishing to, in time, to perform the handicraft.[88] Yet if artisans did not learn their crafts from books, why should they bother to buy his? As for the gentlemen of rank and quality whom Moxon must have hoped to attract, few evidently felt the urge to take up smithing, joinery or printing according to his rules, let alone to distil useful scientific principles from them. Only the first three instalments sold out from a small edition.

The second volume, devoted to printing, was probably completed in the summer of 1684. In the preface to this volume, where he outlined the history of the invention, Moxon made further claims for the dignity of trade, comparing typography to architecture in both being mathematical sciences. A typographer ought to be a man of science, equally qualified in all the sciences pertaining to an architect, as argued in John Dee's mathematical preface to Euclid's *Elements of Geometrie* (1570) with reference to the authority of Vitruvius and Alberti:

> By a typographer, I do not mean a printer, as he is vulgarly accounted, any more than Dr Dee means a carpenter or mason to be an architect; but by a typographer I mean such a one, who by his own judgement, from solid reasoning with himself, can either perform or direct others to perform from the beginning to the end, all the handiworks and physical operations relating to typography.

Clearly, Moxon had in mind someone like himself who could pass muster as a member of the scientific fraternity through his wide-ranging knowledge if not his birth.

In his detailed breakdown of the practices of the different printing trades Moxon wrote from the point of view of the master printer, 'who is as the soul of printing', and of all workmen as members of the body governed by that soul and subservient to him. The printing house, he specified, should be organised along rational, convenient lines. Moxon displayed his authority and sophisticated technical expertise by recommending the use of 'new-fashioned presses', introduced to the Low Countries by the famous globe- and map-maker Willem Jansen Blaeu of Amsterdam who, as instrument-maker to the noble astronomer Tycho Brahe, would presumably also have qualified, in Moxon's view, as a man of science. He praised the letters cut by Christophel van Dijck of Amsterdam, with a skill which had been executed according to geometric rules. As the overseer of every branch of the trade, Moxon drew up sets of such rules – the proportions to be used for cutting Roman, italic and black English (gothic) letters, for casting and dressing letters, for compositors and correctors. In a strict sense, he pronounced, a good compositor

> need be no more than an English scholar, or indeed scarce so much; for if he know but his letters and characters he shall meet with in his printed or written copy, and have otherwise a good natural capacity, he may be a better compositor than another man whose education has adorned him with Latin, Greek, Hebrew, and other languages, and shall want a good natural genius: for by the laws of printing, a compositor is strictly to follow his copy . . .

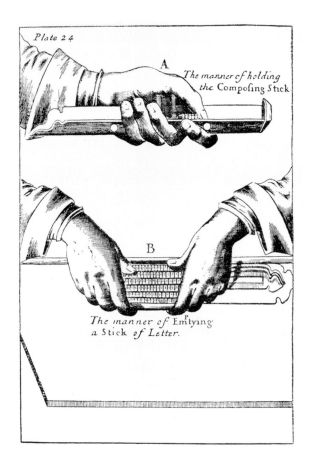

7 (left) 'The manner of holding the Composing Stick' and 'The manner of Emptying a Stick of Letter' from Joseph Moxon, *Mechanick Exercises*, 1683, plate 24. The Royal Society

8 (right) 'Knocking up ink-balls' from Joseph Moxon, *Mechanick Exercises*, 1683, plate 30. The Royal Society

Having thus cast aspersions on the applied capabilities of the learned, he built up the role of the practical compositor: 'Yet it is necessary the compositor's judgement should know where the author has been deficient, that so his care may not suffer such work to go out of his hands as may bring scandal upon himself, and scandal and prejudice upon the master printer.' Moxon ended his treatise with an account of the ancient customs used in a print-ing-house (or 'chapel') and a 'Dictionary, Alphabetically explaining the abstruse Words and Phrases that are used in Typography. Which also may serve as an Index'.

Adrian Johns has argued that Moxon's claims for the art of printing were part of a battle for status waged by master printers against booksellers' domination of the Sta-tioners' Company.[89] Yet, as in the *Exercises* on smiths' and carpenters' work, the greater part of the text was concerned with practical information, derived from the author's deep understanding of the contribution made by the eye and the hand, and his command of empirical detail. He took great care to describe the presses, tools and skilled movements which produced the best results. For example, he gave instructions on the precise position of a workman's fingers and thumbs, even his feet. The presses, tools and the different workmen were illustrated with thirty-three plates keyed into the text. Neatly cuffed disembodied hands provided close-up demonstrations of the correct manner of handling the types and other manual operations (fig. 7). Although little sug-gesting the callused, ink-ingrained reality of printers' hands, they underlined the impor-tance Moxon placed on the tacit knowledge displayed by an artisan in his touch, grasp, coordination and general dexterity. The caster was shown standing beside the furnace holding the metal ladle and other workers were depicted wetting paper, knocking up ink balls (fig. 8), taking up printed sheets from the press, hanging them up to dry and pressing books.

Trade Decline

Following Moxon's death in 1691, further editions of *Mechanick Exercises* were published by his son James in 1694, 1700 and 1703, with additional sections applied to bricklaying and sundialling; then, presumably from loss of momentum and lack of demand, the series came to a halt. Moxon's publications were not part of the Royal Society's 'History of Trades' programme, being published independently by their author without its imprimatur. The most comprehensive coverage of late seventeenth-century trades was provided, serendipitously, by Randle Holme's *The Academy of Armory* (Chester, 1688), a pictorial encyclopaedia of all manner of motifs used in heraldry. Its incomplete third book, devoted to 'artificial things', extended to tradesmen and tools but their classification was little short of chaotic. Compiled over three decades by Holme, who came from a long line of Chester genealogists and heraldry painters, drawing on published sources like Moxon (unacknowledged) as well as first-hand information from artisans, the work was driven by antiquarian zeal rather than scientific methodology.[90] Yet the 'costs and pains' experienced by the author in getting it published are indicative of the practical problems which stood in the way of producing and promoting any large-scale history of trades at the time.

As early as 1670 some of the momentum had gone out of the Society's own enterprise and the number of articles related to trades in *Philosophical Transactions* was on the wane.[91] The reasons are not hard to surmise. As was feared from the start, the project was too vast and too complex for the Royal Society's size of membership. There was already a note of ruefulness in a letter Hooke wrote in October 1664 to Boyle apropos his Cutlerian lectureship: 'I am now engaged in a very great design, which I fear I shall find a very hard, difficult and tedious task, and that is, the compiling a history of trades and manufactures.'[92] The assumption that Fellows could quickly and easily master any art and suggest improvements overlooked by ignorant artisans proved to be wildly misjudged. Optimistic drawing up of lists of good intentions was a different matter from extracting information on site and recording it in an appropriate and useful form.

Furthermore, as was anticipated by Boyle and conceded by Sprat, craftsmen were reluctant to disclose the 'profitable secrets' of their trades which gave them a competitive edge.[93] Evelyn certainly knew what was at stake when in 1657 he postponed publication of *Sculptura* 'lest by it, I should also disoblige some, who make those professions their living; or at least, debase much of their esteem, by prostituting them to the vulgar'.[94] Not that he was in sympathy with the generality of artisans, famously complaining to Boyle two years later in 1659 of the 'many subjections . . . of conversing with mechanical capricious persons'.[95] Although Boyle encouraged the potential experimental philosopher to overcome false notions of pride and prejudice and take artisans' knowledge seriously, from the 1660s he was well aware of the difficulties involved. Extracting such information was 'if it be duly prosecuted, a very troublesome and laborious employment' and a philosopher would need to apply himself,

> to such a variety of mechanic people (as distillers, drugsters, smiths, turners, &c) that a great part of his time, and perhaps all his patience, shall be spent in waiting upon tradesmen, and repairing the losses he sustains by their disappointments, which is a drudgery greater than any, who has not tried it, will imagine, and which yet being as inevitable as unwelcome, does very much counter-balance and allay the delightfulness of the study we are treating of.[96]

Boyle's own incursions into the world of projecting – notably the attempt to make salt water sweet, a scheme for which his nephew Captain Robert Fitzgerald obtained a patent in 1683 – certainly proved troublesome, dwindling at most to arm's-length involvement.[97]

If a dialogue was perchance achieved, there remained the problem of how the information thus gleaned should be rationalised, improved on and presented in an appropriate form, so as to have a positive effect. Hooke's efforts demonstrate the problem and he was better qualified than most to solve it. He could certainly describe trades but he did not have the time, inclination or sometimes the capacity to suggest improvements or deduce general theories from them. Furthermore, although he recognised the worth of illustrations of an informative, as opposed to ornamental, kind and could put to use his natural ability as a draughtsman (and the brief early training in drawing and perspective he had received in Peter Lely's studio), the results were scarcely impressive. He used a mixture of empirical and diagrammatic figures to illustrate his trade histories as if he were not quite sure which method was best suited to elucidate them – and of course neither drawing was ever published. Hooke's best-known excursion into scientific illustration, *Micrographia*, went beyond depicting 'the outward forms and beauties and varieties of the species of nature', to reveal close-up or inner forms of such species, invisible to the naked eye.[98] However, delineating specimens which were pinned down inert under the microscope was a different matter from recording the constant activity of men, tools and machines in the workshop.

Looking back with hindsight in the 1680s, Hooke vigorously defended his move away from presenting histories of the mechanical arts in the Cutlerian lectures on the grounds that they were emphatically not part of 'natural history'. He compared the 'perpetual and universal knowledge' to which the Royal Society aspired with the 'hic & nunc' of the mechanical arts. Nevertheless, although they were a low priority for him compared with the study of nature, he did not spurn them out of hand. It was only the operative part that could not be taught by words alone, while the speculative and rational part – which he still presumed they contained – provided the principles on which experiments, theories and new inventions could be based. Lectures on the mechanical arts needed to be appropriately presented, otherwise 'Jealousies will be put in tradesmen's minds that this [such lectures] may prejudice them, unless some philosophical introduction vindicate it from contempt of gentlemen and contumely of the vulgar, and this suits with promoting natural science, the work of R S [the Royal Society].'[99]

Secrecy was also an issue within circles of virtuosi. Learned men customarily traded secrets but only on a reciprocal basis. While paying lip service to the ideal of openness and collaboration, Fellows of the Royal Society regarded science as a special form of knowledge which conferred status and the Society itself as an exclusive club which they were reluctant to vulgarise. Even before the Society's foundation, Evelyn voiced attitudes typical of the dilettante when he ascribed his delay in publishing *Sculptura* and other works on applied arts to fear that publication might 'debase much of their esteem, by prostituting them to the vulgar'. The same caste exclusivity, at least with regard to Evelyn's category of 'curious and exotic arts', was demonstrated when in 1661 he was shown by Prince Rupert the technique of engraving in mezzotint using a rocker, which the Prince introduced to Britain from the Netherlands. The Prince was prevailed on to supply a mezzotint plate to preface chapter 6 of Evelyn's *Sculptura* in which the author gave a deliberately 'enigmatical' account of the process, not wishing it 'to be prostituted at so cheap a rate; as the more naked describing of it here, would too soon have exposed it to'. Prince Rupert had in fact forbidden the distribution of the 'secret' beyond a small circle of gentlemen amateurs and not sanctioned its disclosure to professional artists and engravers.[100]

The collaborative nature of the new science counted for little when individual claims to invention were at stake and patent protection was insecure, as well as difficult and expensive to obtain.[101] Although *Philosophical Transactions* seemed the ideal vehicle for circulating news of inventions among the scientific community, its editor Henry Old-

enburg was not wholly trusted. Hooke believed that his paper on the balance spring-regulator for a pocket watch had deliberately not been published because Oldenburg supported Huygens's rival claims to the invention and had leaked Hooke's ideas to Huygens. He chose eventually to register his invention as a postscript to his *Description of Helioscopes* (1675), accompanied by an encrypted description which ensured that although he had set down his claim, nobody else would be able to gain from it.[102]

There were those like Wilkins and Sprat who believed that the Society should have an open, non-hierarchical attitude to membership to prevent the whole business becoming 'a matter of noise and pomp', rather than of real benefit. To forestall this eventuality Sprat envisaged that useful information and 'noble rarities' would come not only from the hands of 'learned and professed philosophers' but from 'the shops of mechanics; from the voyages of merchants; from the ploughs of husbandmen; from the sports, the fishponds, the parks, the gardens of gentlemen'.[103] Thomas Hobbes, on the contrary, was adamant that experimentation and invention should be restricted, denying practitioners access to the circle of those entitled to be called philosophers: 'Not every one that brings from beyond the sea a new gin, or other jaunty device, is therefore a philosopher. For if you reckon that way, not only apothecaries and gardeners, but many other sorts of workmen, will put in for, and get the prize.'[104] The Society should act as disinterested judge of the discoveries and inventions of others, a role which might be compromised were it to dilute its ranks with Fellows who had no scientific competence.

The membership profile of the Society may also help to explain its waning interest in the 'History of Trades' project, although it is impossible from today's vantage point to identify a close correlation of the decline with any particular group. From the start, the Society was scarcely socially inclusive, with a high proportion of courtiers, politicians and members of the aristocracy whose presence was needed to attain status and sustainability. A mere seven per cent were merchants or tradesmen and few of London's leading mathematical practitioners and instrument-makers joined. The annual subscription of £2 12s might have dissuaded some; the relatively exclusive social tone put off others.[105] None the less, there is no reason to suppose that merchants and tradesmen would have been any more in favour of compiling histories of trades than the upper echelons of society and indeed, given traditions of trade secrecy, they might have been less inclined to support such a programme.

On at least one occasion, in the case of Petty's manuscript treatise on shipbuilding, national security was advanced as a reason for maintaining secrecy.[106] Probably, though, the risk of adverse judgement from peers, not to mention the ridicule of artisans with generations of experience behind them, lay behind some protestations by virtuosi against open disclosure.[107] Despite the claims airily made by the Society's first President, the mathematically inclined Viscount Brouncker, that he could supplant shipbuilding by 'guess and custom' with exact rules so as to make 'the whole business become a complete and regular science',[108] theories did not go down well in the Navy. The military engineer Sir Henry Sheeres argued the case for experienced seamen, dismissing the role of theoreticians: 'to discourse speculatively on points practicable and of demonstration is like a blind man's treating about colours'.[109]

'Whimsies of contemplative persons' were rarely taken seriously in the wider world.[110] In his comedy *The Virtuoso* (1676), Thomas Shadwell mocked the Royal Society's pretensions to utility through the character of the natural philosopher Sir Nicholas Gimcrack, a foolishly vainglorious gentleman virtuoso who occupied himself, with the aid of a microscope, in making trivial claims and discoveries. When his house was besieged by a mob of ribbon-weavers who mistakenly believed him to have invented an 'engine-loom' that would put them out of work, he expostulated, 'I never invented so much as an engine to pare cream-cheese with. We virtuosos never find anything of use; 'tis not

our way.' Hooke saw the play in June 1676 and was mortified: 'Damned dogs. *Vindica me Deus.* People almost pointed.'[111]

The joke received its most devastating reprise in Swift's *Gulliver's Travels* (1726). The Royal Society was mercilessly satirised in the kingdom of Laputa's academies of projectors:

> In these colleges, the professors contrive new rules and methods of agriculture and building, and new instruments and tools for all trades and manufactures, whereby, as they undertake, one man shall do the work of ten; a palace may be built in a week, or materials so durable as to last for ever without repairing. All the fruits of the earth shall come to maturity at whatever season we think fit to choose, and increase an hundred fold more than they do at present, with innumerable other happy proposals. The only inconvenience is, that none of these projects are yet brought to perfection, and in the mean time the whole country lies miserably waste, the houses in ruins, and the people without food or clothes . . .[112]

Ingenious Men

Given the heavy weather made by some Fellows of the Royal Society regarding contact with artisans, it might be assumed that gentlemen of science had little to do with mechanical artists. Undoubtedly, the Society wished to construct its identity free from any taint of the vulgar. It conducted its affairs according to polite codes of etiquette. Its publications were consciously produced in a style designed to make its concerns socially and intellectually respectable. Above all, as has been argued by Steven Shapin, its genteel status guaranteed not only its civility but also its veracity, on account of the trust that could be placed in gentlemen to testify to the truth. Only those of independent means, not beholden to others, were sufficiently disinterested to be trusted.[113]

The supposed authority of gentlemen philosophers was, however, more rhetorical ideal than reality. Personal character and skills – a facility with applied mathematics and instrumentation – could count for something, if not for anything like as much as social rank. It is now generally accepted that the crude polarisation of scholars and craftsmen, or intellectuals and mechanics, even gentlemen and servants, has impoverished and distorted historical understanding of the period.[114] A man like Hooke moved in many London circles, from those of gentlemanly natural philosophers to City politicians and merchants, and through the range of 'mechanical artists', as defined by Evelyn, from skilled instrument-makers and other leading craftsmen to servants and labourers.[115] His diaries confirm his constant activity, leaving the shelter of his rooms in Gresham College to survey the ruins of the post-Fire city in 1666, to comb workshops, checking craftsmanship and haggling over prices, to visit bookshops and repair to coffee-houses where business and trade met in suitably convivial surroundings.

Hooke's own mechanical ingenuity and his early position as Curator of Experiments at the Society (from 1662 to 1677) ensured that for him instruments were not simply adjuncts to his programme for natural philosophy but were inseparable from its practice. As Jim Bennett has pointed out, the invention of hitherto unknown types of object for use in experimentation required not only an appreciation of the needs of the client as natural philosopher but, crucially, the ability to communicate effectively with artisans with regard to the precise manufacture of components. Moreover, Hooke was perfectly capable of inventing for himself mills, engines and devices of practical utility for trades.[116] The distinction he made increasingly between natural philosophy and mechanical arts might have been maintained in polite circles but it did not stop him from

showing off his mechanical expertise, especially if there was a chance to make a profit. His relationship with his technical assistants was more akin to that of a master crafts-man with his apprentices than a gentleman with his servants. He vigorously defended his own interests when he thought they were threatened and, all in all, behaved like a player rather than a gentleman.[117]

Given his ambiguous social identity and dependence on paid employment by others, notably as the Society's Curator of Experiments, it is doubtful whether the leisured Fellows of the Society regarded Hooke as a gentleman or even a philosopher. So at home was he in artisan surroundings that his sometime collaborator, the first Astronomer Royal, John Flamsteed, spoke of 'the impudence of this mechanic artist'.[118] Yet so valu-able was his work that he was elected a Fellow in 1663, although his membership fees were waived and he continued in the Society's pay. His election was a unique achieve-ment for an instrument-maker in the seventeenth century (unless Moxon as a globe-maker is so described), although of course Hooke was much more than this and his social standing undoubtedly increased when in 1677 he succeeded Oldenburg as the Society's Secretary.

Prejudice against practitioners cast a long shadow. Moxon might well have had votes cast against his election on account of his trade as a printer.[119] The business of con-ducting experiments smacked of mechanical service. Those who took on the work might possess experience but rarely the disinterested authority that qualified them to be recog-nised as experimental philosophers worthy of the Fellowship. Denis Papin, Hooke's suc-cessor as remunerated assistant to Boyle and then to Hooke himself, found such attitudes so frustrating that he returned to the continent in 1680, the year he was elected a Fellow. He had come highly recommended by Huygens and was deemed a gentleman but he received little encouragement for his inventions. Most of Boyle's assistants remain anony-mous and, as with those used by the Royal Society, their input was often blamed for the failure of experiments.[120] By the early eighteenth century, curators of experiments at the Royal Society were in the main paid employees from a trade or middling back-ground. Despite the ambitious intentions of some early Fellows to perform experiments themselves,[121] there is little evidence that they did so. With the partial exception of Newton, Fellows did not risk jeopardising their status by getting their own hands dirty.[122] Even dabbling in experimental philosophy was considered eccentric behaviour for English gentlemen, given their limited educational horizons and the time-honoured divide between scholarship and the world.[123]

So what can be learnt from this early excursion by the Royal Society into the arts of industry? Firstly, while artisan methods of observation and experiment were adopted for application to natural phenomena, and scientific instruments made by artisans played a crucial role in furthering this endeavour, the Society's Fellows more or less compre-hensively failed to suggest or apply modifications and improvements to the few trades they investigated. Theirs was the rhetoric of aspiration, not the reality of achievement. They barely nibbled at the ambitious lists of trades optimistically compiled by Bacon, Evelyn, Petty and Hooke and then only in a random and idiosyncratic fashion, depend-ing on the particular Fellow responsible for the particular history. Only horticultural subjects like cider-making and tree-planting attracted collective endeavour through net-works of correspondents, both amateur and professional. Overall, the Society's early promise of utility for the world of trade and commerce was never realised. Despite the claims made by Hooke and Boyle to the contrary, they did not make meaningful com-parisons between trades or draw axioms from them which benefited natural philosophy.

Nevertheless, the Baconian drive to harness the mechanical arts to the purposes of science cannot be readily dismissed. Crucially, the arts of industry were put on the intel-lectual agenda and the drive to describe and rationalise their practices was in fact taken

forward by others in the eighteenth century. I have quoted from the writings of scientific luminaries so extensively in order to emphasise that the mechanical arts were seen to be a potent force, holding the key to knowledge unattainable in the confines of the study. The stance adopted by the Royal Society in its early years with regard to industry rendered respectable a broader impulse in society to open trades up, even if Fellows contributed little to the actual process or practice of doing so.

It is apparent that those most capable of making such a contribution were men like Hooke or Moxon with pronounced mechanical interests and usually, but not necessarily, from comparatively humble backgrounds. They were frequently described by contemporaries as 'ingenious'. The Latin *ingenium* denotes not only natural ability and intellectual capacity as in *genius* but also the gift for invention and construction, from *ingenio*, a kind of mill which provided the root for the Old French *engin* and Middle English *gin*. 'Ingenious' could have negative connotations as in artful, tricking or too clever by half. But ingenious men were more often thought to be talented in a practical way, with engines, machines and mechanics in general. Petty, Wren and Hooke were all described as 'ingenious'. They all possessed exceptional natural talent as draughtsmen. A reader is never far into their biographies before finding them, at an improbably young age, successfully taking models and machines apart and putting them back together again, a set-piece reprised in the lives of engineers well into the nineteenth century.

William Petty, the son of a poor Romsey cloth-dyer, told John Aubrey that his greatest delight as a boy had been to watch tradesmen 'e.g. smiths, the watchmaker, carpenters, joiners, etc' and maintained that at twelve years old he could have worked at any of them. Marooned as a young seaman on the coast of France, he furthered his education in a school of geography at Caen and the Jesuit college at La Fresshe. By the time he got to Paris he had developed 'a fine hand in drawing and limning, and drew Mr Hobbes' optical schemes for him, which he was pleased to like'.[124] After his return to England around 1647 he took up a fellowship at Brasenose College, Oxford, and took out patents on a mechanical seed-drill and a double-writing machine. However, lacking the inclination or possibly the ability to undertake further research and development, he commissioned the young, mechanically dextrous Christopher Wren to help him.[125]

In 1649, Christopher Wren, fresh up at Oxford, was prevailed on by John Wilkins, then Warden of Wadham and Chaplain to Charles, Elector Palatine, to present the advanced versions of Petty's inventions and drawings based on Wilkins's own microscopical investigations to the Elector, who was 'a great lover and encourager of mathematics, and useful experiments'. With a self-conscious display of genteel amateurism, Wren described the works in a letter to 'His Most Illustrious Highness', possibly with the goal of attaining preferment: 'I must needs have called the first device, but a rustic thing concerning agriculture only [the seed drill], and therefore an illiberal art, tending only to the saving of corn, improper in that glorious prodigal soil of yours, where every shower of hail must necessarily press from the hills even torrents of wine.' The second, the device for double writing, Wren dismissed as a 'tardy invention, impertinently now coming into the world, after the divine *German art* of printing'. Finally, there were two drawings of mites, magnified under a microscope, 'two living nothings, nay, two painted nothings'.[126]

Yet there was nothing amateur about the way Wren developed Petty's inventions. By 1651, he had refined Petty's initial design to produce a cheaper, more efficient prototype of the double-writing machine, of considerable diplomatic, commercial and architectural potential, which was shown to Oliver Cromwell and for which he received £80 in 1653. When Evelyn dined with Wilkins at Wadham in 1654 he was taken round the Warden's garden and lodgings which were dotted with examples of Wren's inventiveness.

Predictably, Evelyn was particularly struck by the transparent beehives built like miniature castles and palaces, adorned with sundials, weathervanes and little statues. Inside the lodgings there were many other 'artificial, mathematical, magical curiosities' and Wren, by now a Fellow of All Souls, presented Evelyn 'with a piece of white marble, which had been stained with a lively red, very deep, as if it had been natural'.[127]

'Mechanic genius' was also noticed in the young Hooke. From biographical notes found in Hooke's pocket diary for 1697, Robert Waller described how the frail young child, left to his own devices:

> spent his time in making little mechanical 'toys, (as he says) in which he was very intent, and for the tools he had, successful; so that there was nothing he saw done by any mechanic, but he endeavoured to imitate, and in some particulars could exceed (which are his own words).' His father observing by these indications, his great inclination to mechanics, thought to put him to some easy trade (as a watchmaker's or limner's) he showing most inclinations to those or the like curious mechanical performances; for making use of such tools as he could procure, 'seeing an old brass clock taken to pieces, he attempted to imitate it, and made a wooden one that would go. Much about the same time he made a small ship about a yard long, fitly shaping it, adding its rigging of ropes, pulleys, masts, &c. with a contrivance to make it fire off some small guns, as it was sailing cross a haven of a pretty breadth. He had also a great fancy for drawing, having much about the same age copied several prints with a pen, that Mr Hoskins (son to the famous Hoskins, Cowper's master) much admired one not instructed could so well imitate them.'[128]

A predilection for technical tinkering was to stay with these men into adulthood. In the late summer of 1665, Evelyn found Wilkins and Hooke at Durdans, Lord Berkeley's seat at Epsom, to which they had retired to escape the plague, hard at work 'contriving chariots, new rigs for ships, a wheel for one to run races in, and other mechanical inventions'.[129] Of course mechanical ingenuity was not confined to the circle of the Royal Society; it transcended social boundaries. Throughout the land there were philosophical mechanics as well as mechanical philosophers, capable of uniting the mind and the hand. They possessed that inventive cast of mind which is still immediately recognisable. Its workings cannot be reduced to verbal descriptions and mathematical formulae but are essentially visual and non-verbal, finding their natural form of expression in an open-ended process of drawing and model-making.[130] In the eighteenth century, they tended to call themselves mechanics or mechanists, or were known by the trades in which they had been apprenticed – millwright, ironmonger, instrument-maker – rarely natural or mechanical philosophers. By the nineteenth century, they had become engineers or manufacturers, as brilliantly parodied by Dickens in *Bleak House* (1852–3) chapter 7, in the form of the ironmaster Mr Rouncewell, who 'took, when he was a schoolboy, to constructing steam engines out of saucepans, and setting birds to draw their own water, with the least possible amount of labour; so assisting them with artful contrivance of hydraulic pressure, that a thirsty canary had only, in a literal sense, to put his shoulder to the wheel, and the job was done'.

Ingenious men were to be found working on similar types of object, sometimes serving a useful purpose, sometimes of a more fanciful bent. They ranged from pumps for draining mines and wind- and water-mills to ingenious automata. Many devices were intended to speed up life, such as improved carriages and other forms of vehicle, and double-writing or copying machines which duplicated manuscripts and drawings by mechanical or chemical means. The utilitarian mixed with the visionary, the humdrum with the magical but in the increasingly commercialised society of eighteenth-century Britain, it was the utility of application rather than ingenuity for ingenuity's sake that

promised reward. Nehemiah Grew's 1707 manuscript treatise 'The Meanes of a most Ample Encrease of the Wealth and Strength of England in a few years' brought the literature of economic improvement most closely associated with Petty into the new century.[131] Grew was a prominent physician and the author of *The Anatomy of Vegetables* (1672) and *The Anatomy of Plants* (1682). A Fellow of the Royal Society from 1671, he served briefly as its Secretary and editor of *Philosophical Transactions*, as well as producing the first catalogue of its collections. 'The Meanes' was a late work (Grew died in 1712) divided into four parts: agriculture including minerals, manufactures, 'merchantrye' and people. In it he expressed approval for accurate surveys, enclosure and fenland drainage, canals and navigation schemes. To improve manufactures he proposed sending artisans abroad to master crafts as well as importing skilled foreign workers, granting them privileges including the tax concessions they enjoyed in France. He envisaged the encouragement of invention and home-produced goods within a regulatory framework which, nevertheless, did not stifle competition. But Grew was sternly opposed to the more conspicuous non-essential forms of consumption, setting himself against the affection of foreign baubles and trifles, gambling, drinking, dancing, quacks, ballad sellers, perfumers, pastry-cooks and others who served only to promote 'idleness, pride and luxury'.[132]

In the early decades of the eighteenth century, claims to commercial and industrial utility were also made by lecturers who gave public courses on natural philosophy, refashioning the earlier rhetoric of the Royal Society and ultimately of Bacon. Such rhetoric reflected an optimistic aspiration to control nature but also, more immediately, responded to perceived needs.[133] It has been argued that by the 1730s the services provided by these men rendered the distinction between interested tradesmen and disinterested virtuosi unworkable.[134] Carrying on in the footsteps of Hooke, lecturers inevitably maintained close ties with the instrument-makers who provided them with their equipment. At the same time, their knowledge of mathematically grounded science was, they argued, crucial when devising ways of draining land and mines, or supplying water to towns and great estates. Although such claims had been around since the Renaissance, in the first half of the eighteenth century as commercial opportunities grew, itinerant scientific lecturers broadened public exposure to them.

For the purposes of industrial development, however, who did the work is a crucial question. Pumping and drainage schemes could not be executed on site without the hands-on experience of mechanics. Only by doing were hypotheses tested and fraudulent promoters exposed. The rhetoric of industrial utility employed by scientific publicists was usually skin-deep. Involvement in potentially profitable schemes was not encouraged by the Royal Society itself, which sought to retain a disinterested stance with regard to particular claims and projects by potential charlatans.[135] In the real world, few clients appear to have placed much reliance on the claims of science. Aristocrats and landed gentry did not seek the imprimatur of the Royal Society before employing millwrights or blacksmiths capable of extracting commercial benefit from their estates; they looked for men of experience who could achieve visible results. The ardent Newtonian, Jean Theophilus Desaguliers, was employed on various hydraulic schemes by the Duke of Chandos on account of his mechanical skills, not his experimental philosophy.[136] Even then, both Chandos and Desaguliers had to call on practising 'artisan engineers' to boost the chances of making their schemes work.[137]

Desaguliers was reluctant to acknowledge the input of these men. In *A Course of Experimental Philosophy* (1744) he complained:

> I have known some persons of fortune, who being covetous, but unwilling to own it,
> full of the notion of the difference between theory and practice (or excused by it)

have hearkened to the most ignorant pretenders, who have called themselves men of practice, in order to save money, when they have wanted water to be raised, which they supposed those who were eminent for their knowledge that way would expect; and thought that work done well enough and very cheap might be sufficient, as if raising of water required no more skill than hedging and ditching. Thus many people employ the apothecary to save the charge of the physician.[138]

Then nearing the end of his life, Desaguliers was bitter about greedy capitalists, fraudulent projectors and incompetent mechanics. Yet he himself was unwilling to admit that his own pumping schemes had not met with unalloyed success. While promoting the convergence of theory and practice, he naturally gave precedence to the views of those capable of the former. The work, however, was done by practitioners and the next four chapters are devoted to explaining how they executed, described and rationalised, presented and promoted their operations.

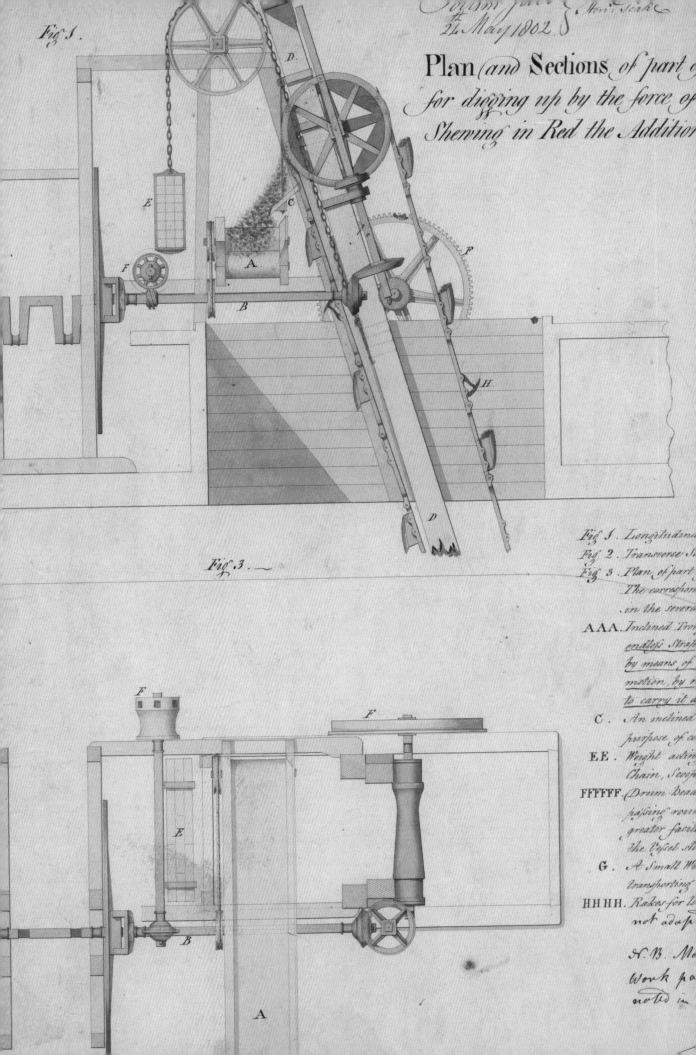

Fig. 1.

24 May 1802

Plan (and **Sections** of part...
for digging up by the force of...
Shewing in Red the Addition...

Fig. 3. —

Fig. 1. Longitudina...
Fig. 2. Transverse S...
Fig. 3. Plan of part...
The corresp...
in the sever...

AAA. Inclined Tro...
endless Stra...
by means of...
motion, by...
to carry it a...

C. An inclined...
purpose, of a...

EE. Weight actin...
Chain, Scoop...

FFFFFF. Drum-hea...
passing rou...
greater facil...
the Vessel sl...

G. A Small W...
transporting...

HHHH. Rakes for lo...
not adap...

N.B. Mo...
Work pa...
noted in...

E C D B A F D H F E F B A

II

Drawing

Surveying the Scene, Engineering the Machine

I am not very fond of lying under the scandal of a bare projector; and, therefore, present you here with a draught of my machine, and lay before you the uses of it, and leave it to your consideration, whether it be worth your while to make use of it or not.

Thomas Savery, 'To the Gentlemen Adventurers in the Mines of England', *The Miner's Friend* (1702)

The tool-maker wants not a verbal description of the thing he is asked to make but a careful picture of it . . . Certainly, without pictures most of our modern highly developed technologies could not exist. Without them we could have neither the tools we require nor the data about which we think.

William M. Ivins Jr, *Prints and Visual Communication* (1953)

For centuries, drawing constituted the easiest and most immediate form of expression across a whole spectrum of the mechanical arts. It required simply the eye and hand, pen or pencil and paper. But in order to understand its crucial role at the cutting edge of industrial development, it is necessary to examine the part it played in the more circumscribed fields of surveying and engineering as they evolved in eighteenth-century Britain.

The occupations of surveying and engineering had long been contiguous. Surveying's traditional function was to oversee property and the duties of the civilian surveyor were those of an administrator whose main task was to set rents. In the military sphere, the Surveyor General, one of the five principal officers who, with the Master General, constituted the Board of Ordnance, surveyed and maintained Ordnance buildings, works and fortifications, and was in charge of all the Ordnance stores and manufacturing departments. The Surveyor of the Navy, a member of the Navy Board and always a former shipwright, was responsible not only for the design and construction of the fleet but also for the royal dockyards.

In the seventeenth century, the term engineer usually denoted a military engineer and therefore was primarily associated with fortifications, including the gunpowder, weaponry and works used in their attack and defence. As the exploitation of natural

terrain was the first principle of fortress design, the engineer's initial task was to explore the territory and survey its potential. Equally, Ordnance surveyors needed to be familiar with the practices of engineers and with gunners' arms and fireworks. They collaborated closely with engineers, helping to make the preliminary surveys, as well as measuring and drawing up estimates in order to cost the works. Ordnance surveyors often served first as engineers.

The complementary skills of surveying and engineering took longer to come together in civilian life but by the 1740s some estate surveyors were beginning to describe themselves as engineers, mainly on the strength of the mathematical calculations associated with military engineering introduced into planning drainage and navigation schemes, wind- and water-mills and steam engines. By the closing decade of the eighteenth century, even naval surveyors – who were notoriously resistant to change – were having to confront the problem of accommodating an increasing number of engines and machines, first in the royal dockyards and later on board His Majesty's ships.

The technical skills of leading surveyors, both military and civilian, were demonstrated in drawn surveys, plans, maps and views executed from the sixteenth century with the assistance of applied geometry using new types of surveying instruments. At their most basic, these draughts, together with numerical calculations, provided reference points for establishing costs. They also constituted the only means of presenting a reasoned exposition of territory in its overall extent and particular features. The introduction of signs denoting the man-made ways of controlling the terrain – whether by fortifications, roads, bridges, canals or various kinds of machine – enabled such projects to progress from conception to execution. Therefore learning to draw surveys could also extend to learning the rudiments of engineering.

Engineering drawings were primarily expository, intended to convey with clarity, order and definition an increasingly varied and complex array of technical processes and products. Like surveys, in their execution they relied not only on direct observation but also on mathematical calculation which provided rules for drawing objects in perspective as if viewed from somewhere, or in projection – plan, elevation, profile and section – as if viewed from nowhere, free of human intervention. Yet in both surveying and engineering drawing there was a tension between the desire for rationalisation and precision and the diversity of local or particular circumstances. Eighteenth-century surveyors and engineers realised the inability of mathematical theory fully to encompass the behaviour of the material world. They had to shape both the content and context of innovations, to consider the external environment and to bring its potentially disruptive forces into their domain. In other words, they had to bridge the gap between an ideal conception of the mind and its practical execution on the ground. Drawing provided the means of doing so because at its most primal it lies at the boundary between mind and hand, idea and form. As Eugene Ferguson has emphasised, many features an engineer thinks about cannot be reduced to unambiguous verbal descriptions or mathematical formulae. They are dealt with in the mind by a visual, non-verbal process.[1] Engineers use drawings to experiment and plan, to clarify the tentative and convert their visions into practical specifications in the world.

Yet the visual language employed for the purpose evolved slowly in Britain. Surveyors, engineers and their draughtsmen endlessly oscillated between the need to establish conventions and to imitate nature, between geometrical abstraction and empirical observation. The retention in drawings of idiosyncratic naturalistic features based on direct observation was not simply a response to particular circumstances, the inevitable result of undeveloped systematics or even personal preference. Engineering is always social engineering, intended to fulfil a particular application or purpose in the real world. The successful accomplishment of the task involved a series of negotiations with different

people of varying levels of skill and understanding. Designs and specifications were products of social processes. Surveyors and engineers were well aware of the need to present their drawings to clients in a manner that was most likely to be comprehended, to gain approval or help raise the necessary funds. This usually meant retaining a degree of informal pictorial expression and even the incorporation of various forms of polite embellishment to make the case, without compromising the display of professional authority.

Pictorial elements also helped workers who were not necessarily well versed in geometry to understand what was required. Artisans had long used freehand sketches as a bridge between knowledge and manual dexterity. As Ferguson has pointed out, the difference between the design drawing of an engineer and the direct design of an artisan was one of format rather than conception. By the late seventeenth century, the need to improve the drawing skills of artisans was recognised in some elite circles. When in 1692 the Governors of Christ's Hospital asked Sir Christopher Wren whether he thought that drawing lessons should be extended beyond the Royal Mathematical School to all the boys, he replied that English artisans needed

> education in that which is the foundation of all mechanic arts, a practice in designing or drawing, which everybody in Italy, France and the Low Countries pretend to more or less . . . I cannot imagine that next to good writing, anything could be more usefully taught your children, especially such as will naturally take to it . . . it will prepare them for many trades, and they will be more useful and profitable to their masters . . . No art but will be mended and improved; by which not only the charity of the house will be enlarged, but the nation advantaged, and this I am confident is obvious to any ingenious person who hath been abroad.

Samuel Pepys, whose advice was also sought, although generally in favour, 'from my general inclination to the advancement of arts and the propagating of them positively among these children', reminded the Governors that their boys were bred for 'honest and plainer callings' and warned that if the training was too advanced, it might thereby enable them to get employment as tutors or clerks, leading to a 'knowledge of liberty, and thoughts above their condition, and so to wantonness, and an early forgetting to provide for old age'.[2] Thus Pepys qualified his approval by voicing the fear that technical drawing might be confused with drawing as the polite accomplishment prized by the genteel.

More straightforwardly, drawings served as formal instructions. They were a means of attempting to control the potentially uncontrollable across distance and time, demonstrating an enlarged conceptual span. At their most meticulous, drawn in projection with the help of mathematical instruments, they provided master patterns to which far-flung suppliers were supposed to conform, enabling different tasks to be allotted to different groups. Through the use of drawings, it was hoped that the parts made by subcontractors would fit and work at the point of assembly. Drawings could also be used, if necessary, as a means of guaranteeing the end results in contracts or as a way of settling disputes. Yet the limits of drawings as working tools were understood at a time when even rulers were not standardised with any precision. Surveyors and engineers did not merely sit in their offices, like gentlemen in their studies, draughting dream projects and hoping they would be executed by remote control. One finds them travelling along pot-holed tracks in all weathers at all times of year to survey dank fenlands and highland passes or to supervise the construction of windmills and pumping engines. They toiled away in remote inns on their drawings and reports, before presenting them with a flourish of confidence to estate owners and agents, committees of proprietors and investors.

Drawings made on the basis of site visits would, it was hoped, forestall expensive mistakes in the actual construction. Although they could be used to transmit information from a chief engineer to a resident engineer and thereon down the chain of command,

problems inevitably cropped up on site which required further visits and more draw-ings. It took an experienced mechanic, familiar with the methods involved, to repro-duce a device from a drawing alone. Direct personal contact was crucial for the productive interchange of the overt and the tacit knowledge needed to construct a novel machine. No drawing could represent the tactile skills required to make the thing work. The hands-on experience of mechanics, millwrights, carpenters, smiths and other skilled men was still crucial for the successful completion of the task.

It is the insistence on empirical data-gathering and continual experimentation as well as theoretical knowledge that marks the eighteenth-century surveyors and engineers as the true heirs of Francis Bacon.[3] By placing heavy reliance on exhaustive description and rationalisation, collating the data on a project and presenting it in the form of drawings and written reports which exuded an air of authority yet were grounded in reality, they carved out careers which increasingly distinguished them not only from the realm of the artisans with their dark trade secrets but also from that of dilettante amateurs with their fantasy sunbeam schemes. Drawings empowered surveyors and engineers. They provided visual evidence of correct modes of reasoning, of systematic research and sober experi-mental enquiry. They testified to the increasing scale and sophistication of the work undertaken. The fact that such material was increasingly retained supported the claims made by their makers of belonging to professions apart.

Surveying the Navy

The task of building, maintaining, manning and provisioning a fleet required extraor-dinary feats of administration, memorialised in the dauntingly vast naval archives still conserved by leading maritime powers. The Royal Navy was so large and so technically complex that today it is usually left to naval historians to explore it as a world apart. Given that it was by far the greatest industry in seventeenth- and eighteenth-century Britain, it cannot be overlooked here. Naval operations in and around the royal dock-yards dwarfed civilian enterprises because of the capital investment required, running costs incurred and the logistical problems encountered.

Like most state services, the Navy was not famed as a model of efficiency and inno-vation. Its day-to-day running was in the hands of the Navy Board which by 1700 employed at least three thousand men in the royal dockyards, while a small Admiralty Board secretariat dealt with discipline and strategy.[4] The provision of ships' munitions and construction of naval fortifications was the business of the Board of Ordnance, with an entirely separate channel of communication to the Admiralty.[5] The Navy Board was responsible for the industrial organisation of the Navy including the six royal dockyards, the design, construction and repair of ships and the supply of naval stores. In practice its systems more or less worked, although they were cumbersome, heavily dependent on personal relationships and there were endless opportunities for confusion, delay and cor-ruption. Virtually all significant decisions of the Navy Board or its officers had to be agreed in writing by at least three of them, albeit not necessarily before the event. Specifi-cally charged with the construction and maintenance of all the ships and dockyards, the Surveyor of the Navy should have acted as coordinator but rarely did so.[6] The labour force worked mainly on day rates and therefore had no incentive to be efficient, although a certain *esprit de corps* could be relied on in emergencies.[7]

The ambition of seventeenth-century natural philosophers to rationalise the labyrinthine collectivity of arts and trades represented by the Navy was, on the face of it, foolhardy. None the less, the Navy was of such fundamental importance to the security and prosperity of the nation that it was a tempting proposition for men of science, anxious

to demonstrate they could be of useful service to the state. Moreover, interventions of a 'physico-mathematical' nature seemed particularly apposite in the world of navigation and shipbuilding, which had long been based on custom and practice. The sciences of geometry, astronomy, geography, mechanics, hydraulics and experimentation on materials could all be roped in to assist an eminently worthy cause. Many Fellows of the Royal Society took an interest in maritime affairs besides the President, Viscount Brouncker (a member of the Navy Board) and John Evelyn.[8] During the early decades of the Society's existence, William Petty's efforts were probably the most sustained, for he conducted lengthy trials on a prototype 'double-bottomed boat' or catamaran.[9] Robert Hooke invented a wide range of marine and navigational instruments.[10] The Society wrestled with methods of determining longitude accurately, a theoretical problem of immense practical significance.[11] Throughout his see-saw career in naval administration, Pepys retained an optimistic view of the potential contribution that science could make, even if in reality he had time for only the most pragmatic means of improving management.

My focus here is not on any of these luminaries but the Surveyor of the Navy from 1692 to 1699, Edmund Dummer (1651–1713) who, though never a Fellow of the Society himself, knew men like Pepys and Evelyn who were. Using elements of mathematical calculation and meticulously honed standards of empirical observation, Dummer tried to introduce a more planned, rational approach to the task of building and managing ships and dockyards, with the help of his extraordinary draughting skills. Operating on the margins of what was technically possible, meeting with opposition from vested interests and traditional work patterns, he struggled to succeed. Today he is little recognised outside the circle of naval historians and his grandest building projects were almost wholly destroyed by later dockyard developments or bombing. Yet if, unlike Pepys and Evelyn, he left no diaries, the magnificent visual records and the written reports of his endeavours survive. His career demonstrates what happened when theoretical knowledge confronted practical experience. He knew how to employ the language of the Royal Society and that of the polite arts for the purposes of explanation, self-justification and promotion, while in order to achieve anything on the ground he had to operate in a world of mechanical arts whose operators used other, more practical disciplines and forms of communication.

The eldest son of a Hampshire gentleman farmer, Dummer joined the Navy in 1668.[12] Although trained as a shipwright under Sir John Tippetts at Portsmouth,[13] he was 'mostly employed as his clerk in writing and drawing'.[14] He was an artist of exceptional skill, although it is not known where he received his early training, and was certainly acquainted with Sir Anthony Deane, master shipwright, whose 'Doctrine of Naval Architecture', written in 1670 for his friend Pepys (who was then Clerk of the Acts at the Navy Board), contained instructions on how to draw sheer draughts, or draughts of the ship seen from the side.[15] Having been appointed Controller of the Victualling Accounts on the Navy Board, in 1677 Deane was given responsibility, with the Dummer's master, Tippetts, who had become Surveyor of the Navy, for establishing for the first time standardised sets of dimensions for ships of the line to be applied to the 'thirty new ships', the largest single shipbuilding programme hitherto undertaken. By achieving uniformity within each rate, the Admiralty hoped to ease problems of supply by standardising sizes of masts, rigging, equipment and stores.[16] Dummer helped with this Establishment, 'singled out by the Navy Board for his extraordinary ingenuity to lay down the bodies of all the thirty new ships'.[17]

At the same time Dummer sought preferment from Pepys who, in 1673, had been made Secretary to the Admiralty Board. In the Pepys Library at Magdalene College, Cambridge, there is a group of Dummer's drawings in grisaille on vellum, bound together in a volume entitled 'Draught of the Body of an English Man of War'.[18] The draughtsmanship is most appealing, designed to catch the eye of a potential patron, even

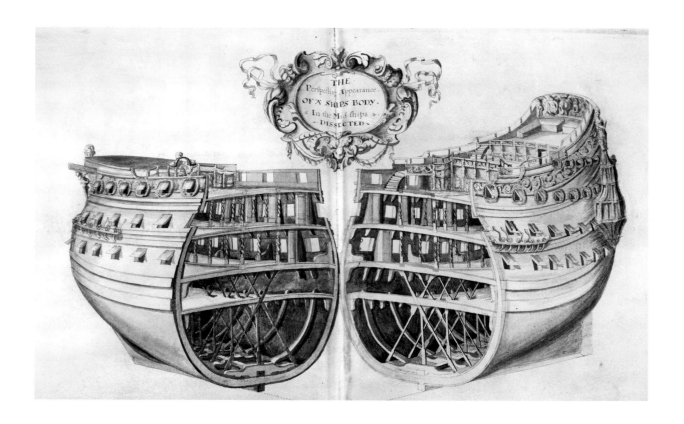

9 Edmund Dummer, 'The Perspective Appearance of A Ships Body – In the Mid-ships Dissected', c.1679. The Pepys Library, Magdalene College, Cambridge: Pepys Sea MS 2934

if – typically for the period – the descriptive terms are used somewhat loosely and 'geometric' elements are jumbled up with more empirical forms of visual description. The 'Ichnographies' are deck plans, conforming to the standard usage of the term at the time as synonymous with views from above, but the 'Orthographick Symetry' of the ship is not a strict projection onto a vertical plane as scholarly geometers would have understood its meaning. Instead, it is a sectional ship's model which superficially appears to be drawn in perspective (but with several shifts of viewpoint), so that the companionways, guns, panelling and even carved picture frames are visible and carefully shaded to create little 'Scenographick Appearances' on each deck. The 'Perspective Appearance of A Ships Body', opened out like two halves of a walnut, is also drawn from no fixed perspective base (fig. 9). Nevertheless, the work demonstrates Dummer's capacity for visual expression that was to mark his progress towards the surveyorship.

In February 1679, Dummer sent Pepys a short treatise 'about Improving the Art of Building Ships', which reveals the young man's keen interest in the science or principles of building ships and organising dockyards.[19] It is set out in language with which Pepys, as a Fellow of the Royal Society from 1665, would have readily identified. Dummer began by pointing out the 'many false axioms' masquerading as 'certain and undoubted truths' even in the '*mathematical* and *mechanical arts*' that were most useful and necessary, following imagination and opinion rather than balanced judgement based on experiments made with due and careful observation:

Your Honour knows that *naval architecture*, or the art of building ships hath had but too large a share of this epidemical disease in the empire of arts and learning. It hath obscurely and erroneously been delivered from man to man: been practised by custom and tradition only and few (that I know of) have sought the reasons of their art, or endeavoured the true perfecting of it by settling it on positive and unerring maxims deduced from *reason* and *experiments*.

50

Although sensible of his 'incapacity to so great a work', Dummer proceeded to submit to Pepys's *most exquisite judgement* his own ideas for 'tracing the secrets of this art to their spring and head', in the hope that the King might enable him to be of service. His proposal was to compile a history (meaning description) of ships' hulls, both ancient and modern, foreign and domestic. He would have exact models of these hulls made to the same scale and then would observe their water displacement, fore and aft, when first waterborne, when their bilge-ways were cleared and with or without ballast. The ship's name, measurements and the name of the builder would be fixed to the model, together with a line circumscribing the body marking the first draught of water on the ship: 'Thus may bodies be made fit to experiment the natures of the fabrics they represent: thus may steps be made to the discovering of an excellent *philosophy* in *naval architecture*; and to the demonstrating of that *physical* and *geometrical* knowledge of ships' bodies that remain as yet entirely mysterious.'

The degree to which such empirical methods would have been an advance on the geometrical means already evolved by Deane and others to calculate the displacement of a ship is a moot point.[20] To set his proposals in context, however, Dummer humbly offered Pepys what he called an essay or 'platform of an opera within which all that to ships are pertinent may have enclosure'. This was a handwritten diagram or 'tree of knowledge', organised loosely along Baconian lines, by which Dummer sought to illustrate the branches and bifurcations of the discipline of shipbuilding. He divided ships into two classes, 'imaginative and representative' and 'real and operative'; the former category depended on reason, the latter on practical skill. The rational branch called on knowledge of historical and international example, the teaching by instrument and demonstration the terms of all the lines of a ship, real and imaginary, and the rudiments of practical drawing of all its parts. The latter empirical branch – how ships had traditionally been built – depended on use, practice and judgement acquired through experience, such as the use of moulds 'graduated for the building of ships according to the custom of the builders in HM yards', the quality and dimensions of masts, rigging, blocks and dead-eyes, sails, guns, stores and victuals.

Dummer was by no means alone in attempting to break down the complex range of variables affecting the Navy into constituent parts and to bring them together to form an all-encompassing unity. Two near-contemporary naval abstracts were produced by Fellows of the Royal Society: the 'Treatise of Navall Philosophy' outlined by William Petty in 1671 and the tree of knowledge devised by Robert Hooke some fourteen years later.[21] Petty's view of the Navy was more comprehensive than that of Dummer, covering political and economic considerations, as well as placing emphasis on 'physico-mathematical' experiments, but he never got beyond the outline.[22] In his tree of knowledge, Hooke slotted 'Navigation, Ship Art or Ship Craft' into the much broader scientific framework of hydrography, being 'a full description of the nature and use of water'. He also stressed the importance of seeking the basic qualities of materials, utilising practical mathematics and employing precision instruments.[23] Furthermore, in 1675, the Portsmouth shipwright William Keltridge (possibly another protégé of Deane and Tippetts) produced a manuscript book which went some way towards accomplishing Dummer's concept of empirical codification as part of 'real and operative' shipbuilding. It contained tables of measurements and costs for each rate of ship, rules for drawing draughts and a list of every ship in the Royal Navy in 1674, with its complement of men and guns.[24] Dummer's 'platform' is modest by comparison with these works, lacking the theoretical reach of Hooke or Petty and the applied mathematical detail of Keltridge.

In the short term, Dummer's efforts at preferment proved abortive. Following the 'Popish Plot' and Exclusion Crisis, the Admiralty Board was dismissed, Pepys and Deane were arrested and Dummer implicated – through his draughts of the thirty new ships –

in the accusations made against them of spying for the French government. Yet, after keeping a low profile for a couple of years, 'from divers instances given by him of his knowledge in, and addiction to the further improvement of the theory of ship-building', Dummer was sent by Charles II to the Mediterranean on an espionage mission: 'in order to his collecting what useful observations should arise to him, in his enquiries through the several foreign ports there, relating either to the said art of ship-building, or the nature and order of the said ports, appearances of land, or ought else than might conduce to our service'.[25] The result is the splendid volume, Manuscript 40, in the King's Library part of the British Library, entitled, 'A Voyage into the Mediterranean Seas, containing (by way of Journall) the Viewes and Descriptions of such remarkable Lands, Cities, Towns, and Arsenalls, their severall Planes, & Fortifications, with divers Perspectives of particular Buildings which came within the compass of the said Voyage; Together with the Description of 24 Sorts of Vessells, of common use in those Seas, Designed in Measurable Parts, with an Artificiall Shew of their Bodies, not before so accurately done, Finished in the Yeare 1685, by E. Dummer'.

It was self-consciously designed in a *grand-luxe* format not merely to be technically informative but to gain royal notice and preferment. From the title-page of the 'Voyage' onwards, it is clear that Dummer was conversant with sophisticated forms of ornamental decoration, typical of an age when there was no absolute distinction between the geometric skills required for all forms of surveying and their pictorial embellishment. Maps produced in Antwerp and Amsterdam late in the sixteenth and into the seventeenth centuries were richly decorated with complex cartouches containing symbolic devices borrowed from ornamental prints, a practice followed by English map-makers.[26] The journey was described in a succession of pen-and-wash panoramas drawn like a strip cartoon, in the artist's words a 'lineal visible demonstration' showing the ship as it passed various coastlines, accompanied by notes on the time, weather and daily occurrences, like an illustrated pilot book. Dummer also used his leave ashore productively, making detailed perspectives and measured plans of the arsenals of Naples, Leghorn, Pisa, Venice, Genoa and Toulon, Marseilles, Gibraltar and Cadiz. Finally, he diligently fulfilled the King's orders to make 'observations upon all foreign shipping', from Cadiz to Constantinople. He recorded the various vessels not only under sail in pictorial views, but also as 'geometrical designs', in other words ships' profiles, and in three-dimensional skeleton models, 'by the position and concurrences of diverse papers proportionally cut and raised on edge or upright by a thread', creating what must be among the earliest pop-up illustrations.[27]

Dummer arrived back in England at the end of March 1684 and, while completing the fair copy of his journal, put himself forward for shipwright positions in part on the strength of his skills as a draughtsman. In September 1685, on the recommendation of Pepys (re-appointed Secretary to the Admiralty Board), he visited John Evelyn, who was 'so charmed with his ingenuity', Evelyn wrote to Pepys, 'that I look on it as a new obligation to you; and if you find I cultivate it for my own sake a little; you will let him understand . . . how much I wish him the improvement of your favours'.[28] Yet, despite Evelyn's best efforts on Dummer's behalf, by this time Pepys was less willing to favour Dummer, particularly when he threatened the chances of his close friend Deane being appointed to a special commission to rebuild the Navy. Pepys lost no opportunity to belittle Dummer's abilities (and those of Deane's other potential rivals), granting that he was 'an ingenious young man' who had travelled abroad and was skilled as a draughtsman but alleging he had rarely 'handled a tool in his life, nor knows judiciously how to convert a piece of timber'.[29] Ironically, in view of Pepys's avowed commitment to the 'science of shipbuilding', Dummer was seemingly condemned for being too much the philosopher draughtsman and not enough the practical shipwright.

Instead, Tippetts looked after his protégé: in 1689 Dummer was appointed Assistant Surveyor of the Navy and on the death of Tippetts in 1692, he succeeded him as Surveyor. It was an auspicious moment: public and parliamentary support for a strong Navy surged around 1690, when the defeat of the Anglo-Dutch fleet by the French off Beachy Head drove a government threatened with invasion to vote for a special fund to build men-of-war, authorise the construction of a new dockyard at Plymouth and attempt to reform naval administration. By 1694 Parliament was spending extraordinary sums on the Navy which, in William III's wars against Louis XIV, was firmly identified with the defence of English political and religious freedom. The annual vote rose from under £1.2 million in 1689 to £2.5 million in 1694 and seamen borne from 22,332 to 47,710.[30] At the same time, Dummer was engaged on his greatest works and his career seemed to be riding high: in 1695 he was returned Member of Parliament for Arundel on the court interest and the same year he became a Governor of the new Greenwich Hospital, a position he held until his death.

Whatever shortcomings Dummer might have had as a practical shipwright, he could scarcely be accused of idleness and insufficiency in his duties as Surveyor. He did his best to strengthen the Navy by furthering that measure of uniformity in ship construction initiated by the thirty new ships project, which he had also sought to promote in his theoretical writings. Despite the avowed desire for standardisation, it seems that even the thirty new ships differed in size and tonnage, shipwrights taking the dimensions specified as being minimum rather than absolute measures.[31] To end these disparities, in 1693 Dummer wrote to the men appointed to survey and measure the ships then under construction, enclosing a small printed sketch, with measurement points keyed into letters, 'to serve for one common rule of direction and information, whereby the parts necessary to be truly measure[d] and known are at one view made intelligible to every man alike: and the numbers to be set down are to respect the letters in the manner following'.[32] So once again, Dummer expressed his rationalising bent in visual form. His method of measurement was adopted as official practice on 22 April 1696.[33] According to a near-contemporary, he was the first 'that brought the proportions to exact standards, sending each builder with his warrant for building a new ship, the length on the lower deck, breadth extreme and depth in hold . . . Mr Dummer caused every master builder, at docking a ship, to measure the body and compare the figure, and also ordered blocks [models] to be made for almost every ship.'[34] Reports reached Holland of these attempts at standardisation and brought Tsar Peter the Great to London in 1698, bent on learning the skills involved to facilitate the speedy construction of ships in Russia.[35]

Dummer's greatest achievement as Surveyor was his development of the royal dockyards at Plymouth and Portsmouth. On 23 September 1689 he was ordered as newly appointed Assistant Surveyor to report on the most suitable site for a single dry-dock at Plymouth. He returned to London in November with details of three possible locations, giving estimates of the cost of building on each both in timber and stone. After some debate, the small inlet behind Point Froward was selected; the work was to be done in stone with a protective wet-dock in front and, at the King's insistence, the dry-dock made large enough to hold first-rate ships, creating one of the earliest stepped stone dry-docks in Europe.[36] In 1693–4 Dummer was busy both at Portsmouth and Plymouth, for work had begun on enlarging the former in 1689. By September 1694, he could write from Plymouth to Robert Harley at the Office of Public Accounts that the docks were completed and his report would follow.[37]

That report, Dummer's 'Account of the Generall Progress and Advancement of his Majestie's New Docks and Yard at Plymouth', was presented to the Principal Officers and Commissioners of the Navy in December 1694.[38] It gives a clear idea of the logical thinking behind his planning of the works, influenced by his extensive travels. Typically,

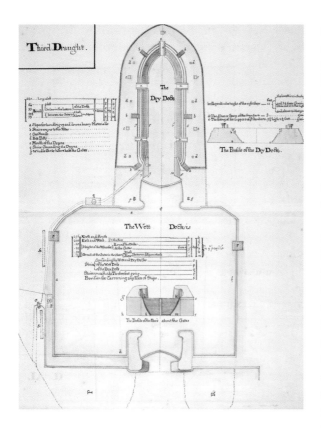

The Dry Dock

The Profile of the Dry Dock.

The Wett Deck is

The Profile of the Bowis about the Gates

10 Edmund Dummer, 'Third Draught. The Dry Dock and the Wett Dock', Plymouth Royal Dockyard, 1694. British Library, Lansdowne MS 847, f. 45 (original foliation f. 83)

to the description of works undertaken he appended eight draughts: plans of the site, the yard and the dry-dock, plans and elevations for the officers' dwellings, the great store-house, hemp-house, rope-house and rope-yard buildings, for 'by representations and descriptions of works of this nature, when they are disposed in a manner most familiar and easy of the understanding, one finds at once both encouragement in the contemplation, and satisfaction in the judging of them'.[39] The drawings therefore served as a means of explanation and a form of advocacy, as well as evidence of and pride in his achievement (figs 10 and 11).

Dummer was at pains to point out the ways in which the new yard would answer the 'great abuses committed in their Majesties' yards'.[40] He displayed his grasp of logistics by placing particular emphasis on space-planning to counter the malpractices that occurred in other yards: 'Namely the tedious and expensive practices of carrying all things afloat for expediting of ship works, and which are many times very remote from the places where material are kept and workmen resort.' This, he recognised, led to time-wasting and obstruction and presented opportunities for embezzling ships' stores, 'for men are not such mathematical movements to be governed exactly by one common force, or rule, but have separate passions and springs prompting them to do what they like best themselves and how moral, or severe soever our laws and instructions be, they are ever more observed with some as the temptation to break them'. Since there were innumerable abuses, 'too many to be named, and some too subtle to be discovered', he ensured that men and material were placed close together under the constant eye of command, saving time and costs. The thirteen officers' dwelling-houses were similarly sited 'on a most eminent spot of ground for the officers' better observance of things abroad, and readier communication and conference with one another, on all occasions'. Their design was intended to unite in harmony 'utility, proportion, strength and ornament'. The ornamental part was represented in the pediments decorated with the arms and trophies of the King, Admiralty and Navy.

Again, when describing the way in which the hemp-store and rope-house, sail-making and sail-mending were contiguous, freed from interruption by other business, he spelt out the advantages:

For nothing giveth greater ease in works of the Navy (the busiest, most intricate, and chargeable of any other office of this Government, and which also aboundeth with numerous and different artificers) than providing due space, and separation of them from the intercourse of one another, for carrying and recarrying many things in one track, is like a multitude (from some violent agitation) crowding themselves through a narrow space, where they choke and disable one another.

Fit accommodation had to be devised for the hemp as, 'barring the means and occasion of temptation, are the fast and chief securities against the inventions and designs of wicked men'. Dummer's experience of working in the dockyards had evidently not advanced a belief in the mechanistic view of human nature espoused by some of his more philosophically minded contemporaries.

Rather, the views Dummer held as a surveyor are remarkably close to those of the greatest engineer of the French *ancien régime*, Sébastien le Prestre de Vauban who, in

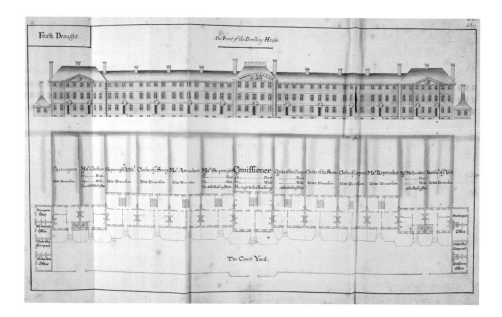

The text inside the drawing reads:

Fourth Draught.

The Front of the Dwelling Houses.

The Court Yard.

11 Edmund Dummer, 'Fourth Draught. The Front of the Dwelling Houses', Plymouth Royal Dockyard, 1694. British Library, Lansdowne MS 847, f. 46 (original foliation f. 85)

1679, was called on to repair the fortifications of the port of Toulon. From 1669 numerous plans for the port had been proposed and rejected and it was only on Vauban's third attempt in 1682 that matters were put in hand according to his abiding principle of symmetry, tempered by convenience and fitness for purpose. Like Dummer, he believed the key to security lay in placing everything in view of the *intendant* and that all shifting should be reduced to a minimum. To Colbert's architectural watchwords of simplicity and beauty, he added *commodité* and *solidité* derived, presumably, from the ideal qualities of the building art as stated by Vitruvius – 'firmness, commodity and delight'.[41] Their proximity to Dummer's sentiments of 'utility, proportion, strength and ornament' suggests that the Englishman knew his Vitruvius and might have learnt something of the rationale behind the construction of the new dockyard when he was in Toulon in 1683.

Dummer conceded that there had been difficulties in executing his designs but believed that these had now been overcome, 'for the beginnings of things always meet with obstruction or misrepresentation'. He proved to be over-optimistic. Objections to his drawn designs for sluice-gates had been made in 1693 by no less a mechanist than Robert Hooke.[42] Dummer was particularly proud of the sluices which were, he wrote, 'as new as they are secure and easy to be used . . . For being under the command of a very large screw, they are raised and depressed with little strength and great exactness.' He had a design model made of the gates for the Board's approbation and sought the opinion of the 'best judges' he could find in town. Still, the gates needed much adaptation before they could withstand the pressure of the water, as calculated by Dummer. The Commissioner at Plymouth, the short-tempered Captain George St Lo, was extremely sceptical, while Dummer in turn blamed the delays on his discouragement. In February 1697 St Lo was driven to complain directly to the Lords of the Admiralty of the 'tottering condition' of the new rope-house and tar-house, not to mention the new dry-dock, which had become a wet-dock. When he had complained to Dummer, he said, Dummer had told him it was not his business to investigate such matters and the Navy Board too had ignored him. Dummer denied he had ever addressed the Commissioner in such a manner and attributed the Commissioner's charges to malice.[43]

An abstract in Dummer's 1694 'Account' put the costs at £50,000 but Dummer was at pains to point out that this was because of the greatness and novelty of the works, which overcame the deficiencies of the other yards. Problems had arisen because of the

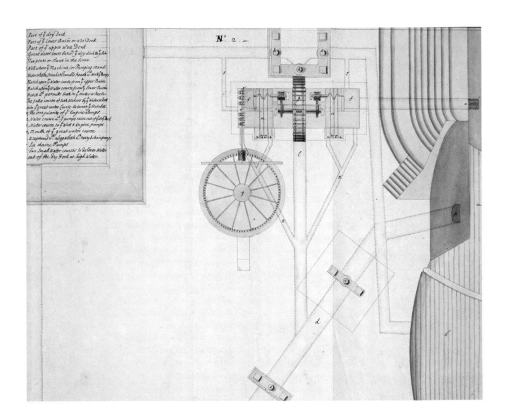

irregular flow of cash and the weakness of contractors, not to mention the fact that the country was at war. Increases from the original estimate (£23,406 in 1692, which nearly tripled by 1698) had, he maintained with some aplomb, been made purposefully by stealth so that they would be borne more easily, rather than by demanding too great a sum and getting rejected at the outset. He even had an answer for those who questioned the utility of Plymouth as a harbour, given its notoriously difficult entrance. Skilful pilots and buoys would lessen accidents for the home fleet while the dangers of gaining entry would protect it from the enemy.[44]

Further evidence of Dummer's pioneering designs for docks is found in an account he made in 1698 of the new docks at Portsmouth, 'setting forth the uncommon properties of the dry-dock, the several contrivances of the parts, and the usefulness of the whole design for the repairs and despatch of all ship works in a letter to the Navy Board'.[45] Once more the works were dogged by controversy on site, as opposed to in plan, and the account reads, ominously, like an apologia:

> For time and labour have at last obtained full testimony of their accomplishment, and shown without contradiction that undertaking (though the most hazardous in its nature *that could be imagined*) was grounded upon as solid reason, as the fruits and advantages which are already seen, and are hereafter to be received there from, will be found considerable to this kingdom.

Dummer had again been criticised for the expense of the works but despite the malice, prejudice, knavery, envy, provocations and injustice suffered through a mixture of 'ignorance and design', he claimed his purpose had never been to mislead the Board or to misapply their trust in him.

The main body of the account is devoted to the successful docking of the *Royal William*, the first great ship to be brought into the dry-dock, with particular emphasis being placed on the speed and economy of manpower with which the new twin-leaf

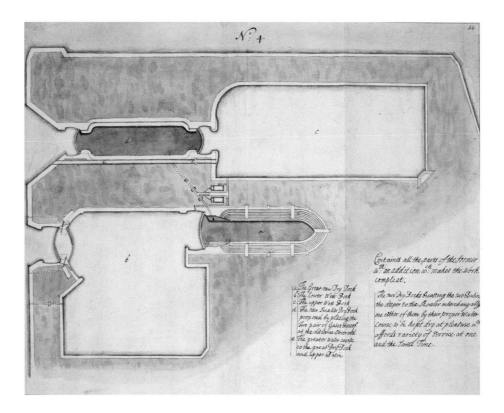

a. The Great new Dry Dock
b. The Lower Wett Dock
c. The upper Wett Dock
d. The new Smaller Dry Dock
 proposed by placing the
 Two pair of Gates thereof
 at the distance Observed
e. The greater water course
 to the great Dry Dock
 and upper Bason

Contains all the parts of the former
w.th an addition w.ch makes the work
compleat.

The two Dry Docks fronting the two Basin,
the deeper to the Theater interchangeably
are either of them by their proper Water
Course to be kept dry at pleasure w.ch
affords variety of Service at one
and the Same Time.

13 Edmund Dummer, 'No.4, Containes all the parts of the former with an addition which makes the Work compleat', 1698. British Library, Harley MS 4318, f. 44

gates could be opened. Furthermore, although most of the water drained out on the ebb tide, Dummer had introduced horse-driven pumps to empty the dock, a technical advance on the manually operated chain pumps hitherto employed. To his account he appended drawn plans of the wet and dry-docks (fig. 12), the watercourses, pumps, waterwheel and capstan. He also offered his thoughts on what would be necessary to complete the works in the foreseeable future, given that the 'ill performance of the contracts and abuses therein' were preventing the use of the upper wet-dock until it was rebuilt. The fourth and final drawing showed not only what had been done but an addition which Dummer believed would make the work complete: 'a new smaller dry-dock proposed by placing two pair of gates thereof at the distance observed', at the west end of the channel leading to the upper wet-dock (fig. 13). The two dry-docks could then be used interchangeably, he believed, affording a variety of service at one and the same time.[46]

Nowhere is Dummer's skill as a surveyor and draughtsman more in evidence than the work which represents the culmination of all his efforts in the Navy (preserved in the British Library as King's Manuscript 43), 'A Survey and Description of the Principal Harbours with their Accomodations & Conveniences for Erecting Moaring Secureing and refitting the Navy Royall of England . . .' of 1698. It provided

An Account of the Emprovements which have been made at Each Yard since the Revolution 1688 giving a Numericall Account of the Severall Kinds of Building with their Quantity and value which by an Estimate Rate they may be Accounted worth to the Nation. Also An Account of the Nature and usefullness of the Late Erected New Docks at Portsmouth and the Yard at Plymouth.[47]

Thus it was designed to record, cost and value the improvements made to the royal dockyards during the first ten years of William III's reign. Typically, Dummer's presentation was lavish, with the letters of the title-page set against the lining of a rich cloak

held aloft by putti flying over the fleet and Neptune in his chariot in the foreground, bearing the royal ensign (fig. 14).[48]

The circumstances of its commission are unclear, but it was undoubtedly part of a general effort on his part and that of a handful of colleagues on the Navy Board to get to grips with the management of the massive business under their charge. When Charles Sergison, Clerk of the Acts, had a private interview with William III on 24 May 1699, principally to complain about the difficulties he had experienced from colleagues' self-interest, faction and favour, neglect and downright corruption, he produced a 'book in marble paper' containing a detailed account of the state of his department, with lists of the sailing Navy, the commanders, men and guns, which ships were fitting out, the condition of others and an abstract of the whole, 'thinking it for your Majesty's service to have always by you the state of your Navy, for as much as your curiosity, if not your occasions may lead you sometimes to look into it'.[49] After the King had examined the book closely with seeming satisfaction, Sergison ventured to point out that he had maintained the Navy at sea for nine years, adding to it three hundred ships, and the docks and building yards had more than doubled in the same period: 'Draughts and descriptions were drawing for Your Majesty by Mr Dummer in an extraordinary manner fit for Your Majesty's perusal, but are unluckily stopped by that gentleman's misfortune, though I hope they will not be lost, but that at one time or other they will be perfected and presented to Your Majesty.'[50]

I shall come on to the misfortune suffered by Dummer but at least he managed to perfect the draughts and descriptions, which were duly presented to the King. They certainly constitute an extraordinary feat of surveyorship. In the volume, each royal dockyard is treated separately and its description given in the same order, each of the four types of drawing employed being made to the same scale so that comparisons can be made. A brass rule was even included at the front of the volume (now lost), marked with the four scales, to be used 'as artificers do their rules in lineal measure, whereby any harbour, yard, fortification, or particular building whatsoever, may be measured without applying a pair of compasses there'. Exact measurement was key but again Dummer combined geometrical precision with great artistry which in this case he was loath to have damaged with pinholes.

The first type of drawing relating to each dockyard gives the general situation of the port and harbour; the second focuses on the situation of the yard; the third compares the plan of the yard at the Revolution with its development ten years on, the parts coloured red showing the improvements or new buildings added; the fourth – by far the most extensive section – gives in plan and elevation every single building in each yard. Dummer was justifiably proud of this last feature, for 'Hereby the room or space for accommodating the ships in each harbour and the magnitude of the buildings, dwelling or stores &c may be compared to each other by inspection which is the best demonstration though a thing not used in any of our common surveys.' Furthermore, by a calculation of the size of each building by linear foot and the materials used to build it by linear rate per foot, its value was quantified, contributing to the total value of the dockyard and carried over to a complete reckoning at the end of the book 'where may be seen the full value of all the said docks and buildings &c which were before the said Revolution together with additions and improvements since'.[51]

Dummer's Survey commences with a map of the Thames and Medway, thereby including four of the royal dockyards – Chatham, Sheerness, Woolwich and Deptford – as well as the Navy Office. This is followed by a long watercolour view, dated September 1698, representing the River Medway from Rochester Bridge to Sheerness, taken from the Steeple at Finsbury Church opposite Chatham, showing the mooring of the ships of the Royal Navy. The next illustration is a prospect of Chatham dockyard taken

14 Edmund Dummer, 'A Survey and Description of the Principal Harbours with their Accomodations & Conveniences for Erecting Moaring Secureing and Refitting the Navy Royall of England...', 1698, titlepage. British Library, King's MS 43, f. 1

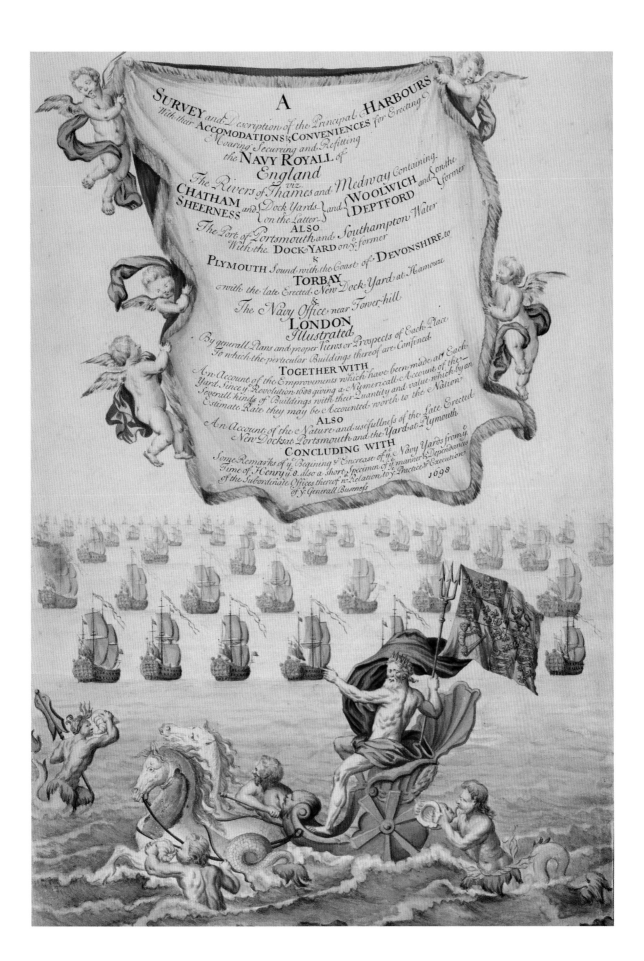

from the other side of the Medway and below it two plans of the dockyard, one showing its extent in 1688 and the same in 1698. They reveal that a new mast-house, various docks, shops and offices, a capstan crane, anchor-forge and spinning-house had been built. After that, twenty-five pages present a visual account of all the buildings within the yard, in plan and elevation, all duly quantified and revealing a medley of styles and standards. The old yard was an amalgam of different workplaces, each section dealing with different aspects of or stages in shipbuilding, without any obvious 'assembly line'. Proximity of work and home for the dockyard officers is vividly brought to life in descriptions of their 'dwelling houses'. The Commissioner's house was cramped (a spacious new house was built in 1705 which still survives) but its garden included a fountain and a banqueting house, while the Clerk of the Cheque's home had a summer house and a shed for fowls; the Master Caulker had a shed for fowls and a hog-sty; the Boatswain had a pigsty.

Next, the forts and castles of the Medway are detailed in profile and elevation, followed by the survey of Sheerness. The dockyards of Woolwich and Deptford are then covered, the classical style of new storehouses contrasting with the assemblage of Elizabethan dwelling-houses – with their associated wash-houses, drying-houses, wood-, coal-, bake- and brew-houses – where the principal officers lived (fig. 15). However, the greatest changes were made at Portsmouth and Plymouth. The Portsmouth section begins with a map (completed in October 1698) of the Solent and the Isle of Wight, followed by a long prospect of the scene, taken from the high land of Post Down, showing how the ships of the Royal Navy were moored and secured from Portsmouth to Fareham. For the dockyard at Portsmouth, the prospect is taken from on board a hulk riding opposite the new dock. There had been huge developments here after 1688, ranging from the two new wet-docks and two new dry-docks, built of stone at the massive cost of £46,001 13s, down to an ornamental column with a spherical dial on a terrestrial globe above its capital, built in Portland stone for £46 4s (fig. 16). Detailed plans, sections and descriptions of the nature and use of these new docks underline the pride Dummer took in their completion. The plan of the lower wet-dock and single dry-dock, large enough to receive ships of the first rate, shows the engines employed to empty the latter and clean part of the former. Portsmouth's Commissioner's House was a splendid Jacobean pile built of brick with a large garden containing a banqueting house (not replaced until 1785). The new 1133-foot-long rope-walk was built of brick at a cost of £2991 2s 4d (fig. 17); the new mast dock cost nearly £4000.

Perhaps the finest prospect in the volume is taken of the new dockyard at Plymouth, viewed from on board a vessel moored offshore (fig. 18). Almost everything on the plan had been built after 1688 although the works had yet to be completed. The dwelling-houses of the officers, built to a French- or Dutch-influenced design, are a model of orderliness compared with those in the other dockyards.[52] Each has its own porch, privy, brew- and wash-house, yard and garden but none of the sties to be found at Chatham. According to Dummer, works on the new docks cost a total of £34,891 9s 8d, the single dry-dock was costed at £12,245 and the wet-dock £17,489 9s 8d, as well as £5157 for the gates. Dummer glossed over the difficulties he had encountered on the building works: the rope-walk needed to be rebuilt and the outer gates of the dock were not successfully closed until 1700.[53]

The work was completed with a view and plans of the relatively new (1674) Navy Office in Crutched Friars in London, for which Sir Christopher Wren as Surveyor General was ultimately responsible. In total it was estimated that the value of His Majesty's Dockyards was £291,124 2s 8¾d, of which £166,799 had been spent in the previous ten years, more than doubling the original value. The greatest investment had been made at Plymouth – from a standing start – of £67,095 6s, followed by Portsmouth

15 Edmund Dummer, new store-house [numbered 9] and assorted dwelling-houses [10-13] in elevation and plan, Woolwich Royal Dockyard, 1698. British Library, King's MS 43, f. 54

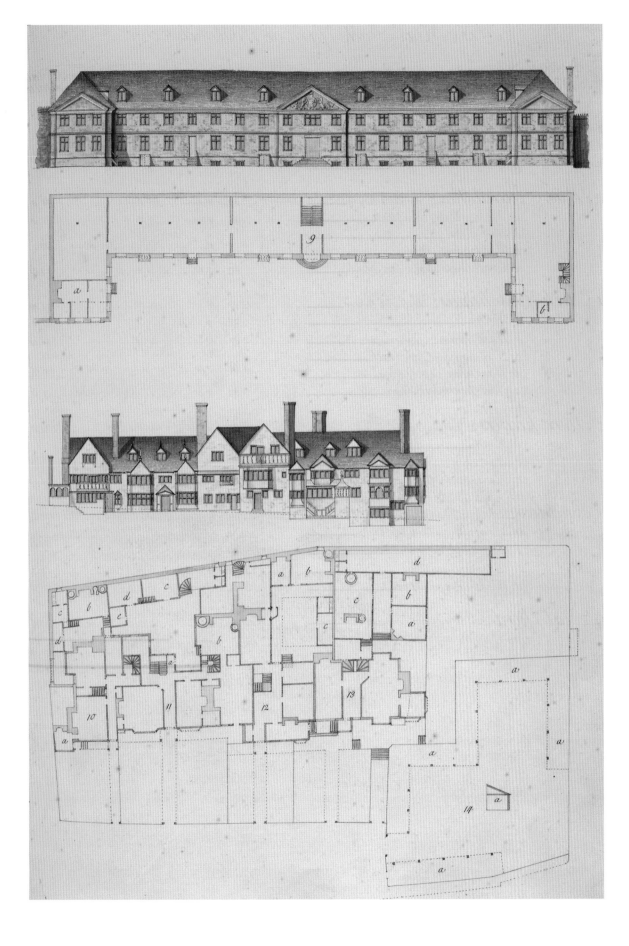

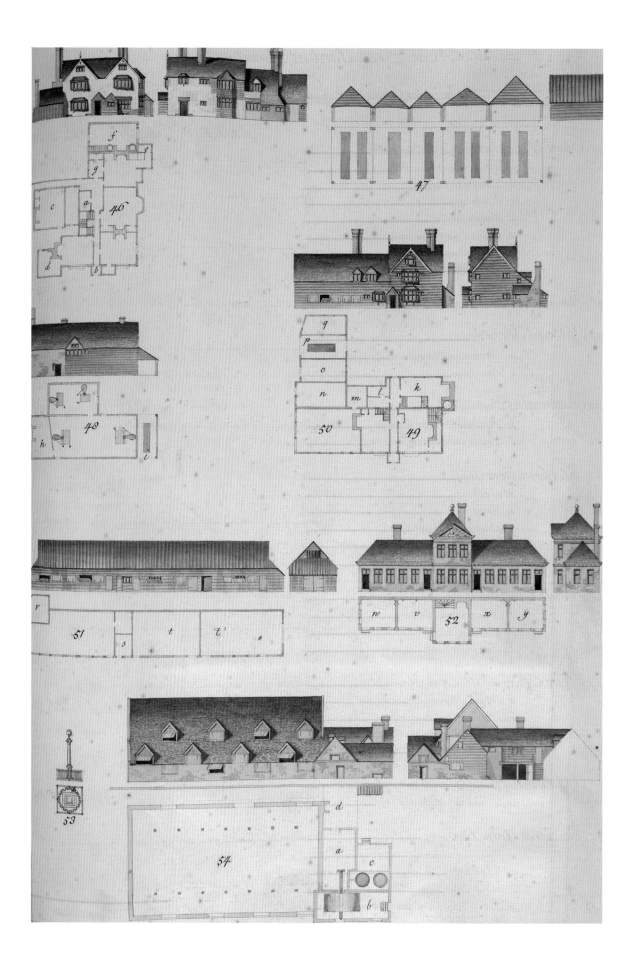

(£63,384 18s 7¾d), Deptford (£12,880 9s 4¾d), Chatham (£11,155 11s 9d), Woolwich including the rope-walk (£10,477 13s 10½d), Sheerness (£1566 14s 8d) and finally the Navy Office (£239).

Dummer's career with the Royal Navy came to an abrupt end when he was suspended without warning on 24 December 1698. At the root of the problem was the situation to which he had obliquely referred in his account of the new docks at Portsmouth. The main contractor for the building works was John Fitch, a long-established supplier of New Forest timber to the Navy and the monopoly building contractor to the Board of Ordnance.[54] At first, Dummer seems to have been pleased with his work, writing in January 1693 to Thomas Deane, the overseer at Portsmouth, that it was moving on 'like German clockwork'. He refused to take sides when Deane expressed severe doubts about Fitch's working methods, not to mention the surliness of his men.[55] But suspicions had grown by the spring of 1693 over Fitch's claims and the amount of extra work undertaken.[56] There were endless construction problems, caused not least because the new docks were built on unstable reclaimed land. In 1695 Fitch was ejected by Deane from the site because of fraudulent claims for payment and terrible workmanship, an experience not without precedent in relation to his Ordnance contracts.[57] He proceeded to bring a case for compensation against the Attorney General, Richard Haddock. This dragged on in the Court of Exchequer until the summer of 1698 with neither side achieving full satisfaction.

Fitch also exacted his revenge by complaining to the Admiralty that Dummer had asked for bribes in return for awarding him Navy contracts, contending specifically that Dummer had told him he would get an immediate certificate for his bill if he made him a present of £500 and helped him with the sale of timber for Plymouth.[58] Dummer was suspended and vigorously contested the charge but he was not re-instated, possibly more on account of Tory and Whig fighting than any serious concern for probity on the part of the notoriously corrupt Admiralty Board.[59] On 31 July 1699, Dummer came to take his leave of his colleagues at the Navy Board, telling them, 'that he had left all the public papers, books, models and other things in that office . . . only some particular models of his own invention and not used, to be taken with him, of which he left a paper . . . to be delivered to the Surveyor's office for his successor'.[60] On 10 August, exactly seven years after his appointment, Dummer was formally dismissed from the Surveyorship and Daniel Furzer, Master Shipwright at Chatham, was appointed in his place.[61] He brought an action of defamation against Fitch, claiming damages of £5000 for loss of place. When the case was heard in May 1700 before Lord Justice Holt, Fitch brought Admiralty lords and even some of the Navy Board to speak for him and although the jury found for the plaintiff, Dummer was awarded a mere £300 damages.[62]

Against charges of incompetence Dummer had defended himself by citing the greatness, novelty and danger of the works at Plymouth and Portsmouth. He referred to their changeable nature and the ill-performance of the contracts. Possibly he attempted to deal with Fitch using some form of 'contracting in gross'[63] which failed through the changes the Surveyor or Overseer had been forced to make on the ground, or through the lack of constant management and supervision that would have been necessary to implement successfully such novel feats of construction. For whatever reason – technical over-ambition, personality flaws and bad man-management, political intrigue – thus ended the official Navy career of a visionary inventor, sophisticated in his awareness of the desirability of applying reason to industry, highly skilled at expressing his schemes for design and control on paper, yet perhaps on account of these same remarkable qualities, fatally flawed when it came to executing his plans in practice. Perhaps the Commissioners were simply tired of hearing about the endless problems involved in building the new docks, not to mention Dummer's endless excuses and promises of what turned out to be false dawns.

16 Edmund Dummer, new offices for the Clerk of the Cheque & co [52], assorted shops and dwelling-houses, the dial column [53] and tarred yarnhouse [54] in elevation and plan, Portsmouth Royal Dockyard, 1698. British Library, King's MS 43, f. 116

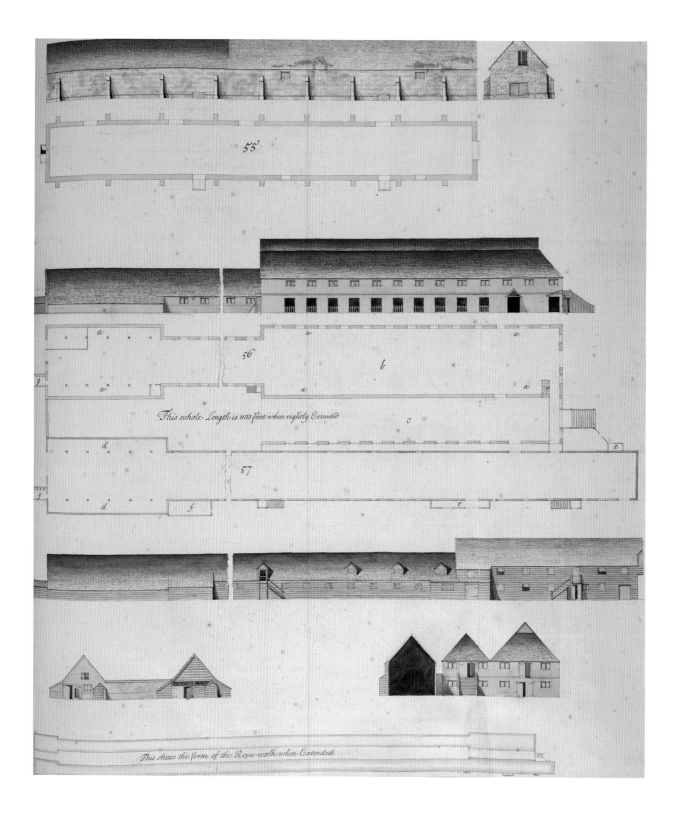

This whole Length is 1133 foot when rightly Extended

This shews the form of the Rope-walk when Extended

17 Edmund Dummer, hemp store-house [55], new rope walk [56] and old rope walk [57] in elevation and plan, Portsmouth Royal Dockyard, 1698. British Library, King's MS 43, f. 118

Even so, Dummer did not entirely lose hope of being employed by the Navy again. On 24 September 1702 he wrote to his protector Robert Harley suggesting that he might succeed Captain Wiltshaw, the Comptroller of the Storekeepers' Accounts, who had died the previous evening. In so doing he drew a distinction between his own knowledge and experience and that of the Clerk-Commissioners of the Navy Board (one of whom had already been recommended for the office), who might understand accounts 'but the pru-

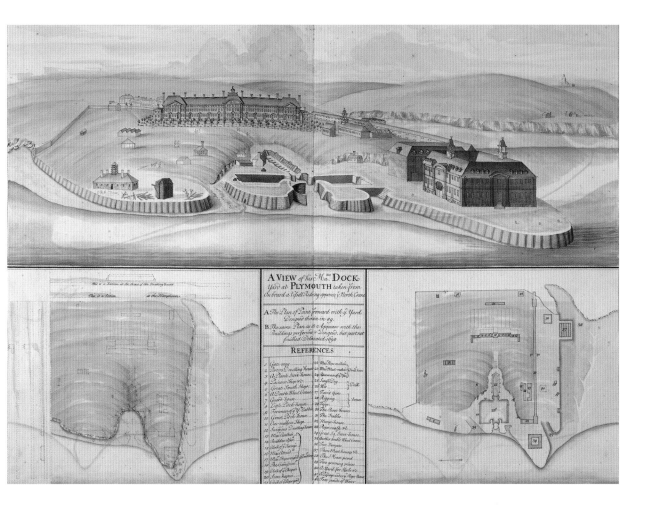

18 Edmund Dummer, 'A View
of his Ma'ties Dock Yard at
Plymouth', 1698. British
Library, king's ms 43, f. 130

dential judgement with relation to the bulk of that business is a science they are great
strangers to, a knowledge of mechanics and crafts of various natures wherein the hus-
bandry of great treasures consists'.[64] Nothing came of his suggestion and, ever enter-
prising, from 1702 he initiated the first transatlantic mail service by packet boat, built
his own ships and ran an iron business, albeit ultimately to his financial ruin.[65] After
his death in 1713, reputedly bankrupt in Fleet prison, his widow and only daughter peti-
tioned Queen Anne successfully for a pension.[66]

Dummer's career demonstrates the limited utility of the new science in the last part
of the seventeenth century to the task of running the Royal Navy. The circulation of
speculative papers was a long way from the practical business of building real ships and
dockyards. Certainly, although only on the fringes of Royal Society circles, Dummer
was infected by the high ambitions of its members to be of use to the state. This was
the language in which he couched his applications for preferment. Equally, he employed
his superlative draughting skills, which combined geometric exactitude with polite
embellishment, to attract the notice of the great powers in the land. Dummer's visual
surveys were not working drawings in the sense that they were utilised as instructions
to further building in the dockyards. Instead, they recorded his observations and ratio-
nalised his plans for presentation to his superiors and, one suspects, for posterity. As
opposed to financial accounts of impenetrable comprehension and dubious relevance,
they provided reassuring visual confirmation of where a high percentage of the country's
revenues had gone. They confidently reflected Dummer's own 'knowledge of mechan-
ics and crafts of various natures'.

Today Dummer might be regarded as a man who straddled the arts and sciences, the worlds of artisan mechanics and mechanical philosophers, but in the seventeenth century, as his career demonstrates, there was no rigid distinction between them. He was sufficiently genteel to move without too much difficulty among the nobility and newly ennobled, gentlemanly virtuosi, diplomats and top civil servants, but his day-to-day business would have been with Royal Navy captains and yard commissioners, master shipwrights, trade suppliers and skilled dockyard workers, no doubt switching persona as the occasion demanded. His methods only took him so far and he was constantly thwarted by the unmathematical and frankly corrupt nature of men.

On the face of it, Dummer's attempts to rationalise the practice of shipbuilding and the organisation of the yards had a negligible long-term impact. In the first half of the eighteenth century, the Navy continued to be run on conservative lines, with little attempt to introduce scientific principles either to ship design or the organisation of the royal dockyards.[67] Sir Jacob Acworth, Surveyor of the Navy from 1715 to 1749, designed a number of ships whose underwater lines were based on Newtonian theory but evidently they were not a success.[68] The observations made by the French master shipwright Blaise Ollivier, on his tour of the dockyards in 1737, might have been a source of comfort for Versailles but not for the Admiralty, had its members stirred themselves to follow in his footsteps. Ollivier considered that there were scarcely six out of the two hundred shipwrights at Deptford who were good craftsmen and all seemed extremely lazy. With regard to ship design, he concluded that 'all their theory can be reduced to a few working practices . . . which lead to no demonstrated method nor are founded on any principle'.[69]

A spot-check on the state of the royal dockyards around 1750 is provided by two surveys, one written, the other visual, which highlight the yawning gap between theoretical control and industrial practice. Following the failures and frustrations experienced during the War of Austrian Succession, in June 1749 the lords of the Admiralty, 'taking into their consideration the number of men borne in the several dock and ropeyards, the great expense attending the same, and that the works are not carried on with the expedition that might be expected from them, which must arise from the remissness of the officers, or insufficiency of the workmen, or both', decided to visit the royal dockyards themselves.[70] Predictably, they discovered that, as Dummer had intimated, men were not performing their tasks like clockwork. At Woolwich the Admiralty lords 'walked around the yard to observe the workmen, many of whom were idle, which the officers were directed to take notice of, found the timber and plank not regularly sorted, in many places that which had been longest in store, being undermost'. The ships in reserve were in bad condition, their cabins used as kitchens and living quarters for women and children. At Deptford, the victualling stores were falling down and most of the senior officers were away. At Sheerness the chaplain of the yard had been absent without leave for more than a year and the storekeeper was too gouty for duty. At Chatham they saw shipwrights 'carrying out top ends and slabs [of timber] in the officers' presence, notwithstanding the strict orders to the contrary'. Everywhere (with the laudable exception of Portsmouth) the buildings and docks were decayed, the stores in confusion, the yard officers too old, drunk or ill for duty, the accounts in arrears, the ships in reserve neglected and the artificers diverted from proper work to offices, if not private houses.[71]

This was not the image that the Navy wanted to project abroad and in 1753 a series of six prints devoted to the royal dockyards commenced publication, finely engraved by Pierre Charles Canot, after 'correct surveys' measured and drawn by Thomas Milton, who was also responsible for its publication (fig. 19).[72] In contrast to the Admiralty's findings, Milton's designs present an orderly image of the state of the royal dockyards.

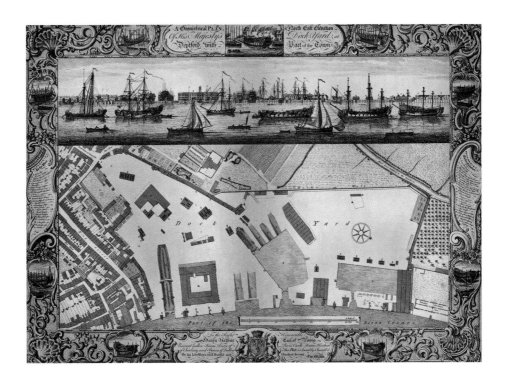

19 Pierre Charles Canot after Thomas Milton and John Cleveley the Elder, 'A Geometrical Plan and North East Elevation of His Majesty's Dockyard at Deptford…', published 30 July 1753. British Museum, Department of Prints and Drawings

Each 'Geometrical Plan' is surmounted by a prospect of the yard from the water and both plan and prospect are keyed into explanations printed respectively on the left and right border of the image. Furthermore, the elaborate Rococo border encompasses a series of vignettes depicting different stages in shipbuilding or manoeuvres at sea by the marine artist John Cleveley the Elder. Milton dedicated the prints to representatives of the nobility and gentry, including the Right Honourable John Montagu, the fourth Earl of Sandwich (1718–1792, who had been on the Admiralty tour) and the Earl of Macclesfield, the President of the Royal Society.

Clearly it was a prestige venture. The neatness of the plans suggested a desire to impose rational order and control on the wayward yards, just as Dummer had attempted more than half a century earlier. Milton's series would surely have found a ready market among those in the Admiralty or Navy Board, not only for use as decoration but also perhaps as a working tool. Each yard's layout was clearly delineated and each element in the mass of buildings identifiable. The prospects gave every indication of topicality, with vessels lately captured from the French being shown in use as guardships. Moreover, Cleveley's vignettes were captioned, providing not only an education in shipbuilding and sailing but a glossary of dockyard expressions. As coded propaganda for British naval power at the start of the Seven Years War, the series could scarcely be bettered. As a reflection of the state of the royal dockyards, it was far from accurate.

The Navy had grown enormously since Dummer's day. Wartime expenditure increased from an average of £1.8 million in the period 1689–97 to £4.6 million during the Seven Years War.[73] British naval tonnage increased from less than 200,000 in 1700 to 350,000 in 1770.[74] Yet despite Britain's ultimate victory, the war exposed the inadequacies of the Navy and the need was recognised for the thorough reorganisation and systematic expansion that took place under Lords Anson, Egmont and Sandwich, successive First Lords of the Admiralty. The Earl of Sandwich was appointed First Lord of the Admiralty for the third time in 1771. When first appointed to the Admiralty Board in 1744 he had had no experience but being a man of polymathic talents and immense application, he came to understand more about Navy administration than any civilian

had managed since the reign of James II, mastering the minutiae of stocks, timber supplies and reserves. According to his biographer, the Navy was his first love and in many ways his life's work.[75] Sandwich resumed the practice of an annual dockyards visitation that had not taken place for twenty-two years. No detail was too small to escape his attention. Under his guidance, George III also developed an informed enthusiasm for his Fleet and conscientiously sought to learn as much as possible. The royal visit to Portsmouth and review of the Fleet at Spithead in June 1773 marked the climax of this induction process, a tour de force of organisation and promotion which advertised to the world the King's interest in and support for the Royal Navy and, by extension, for Sandwich himself. George relished the prospect of the dockyard tour, in particular, as it would enable him to 'form some idea of the wonderful mechanism that is concerned in forming the amazing machines that float on the sea'.[76]

In the wake of the visit, on 5 July 1773, Sandwich wrote from Plymouth to the King to thank him for a book he had lent him. It was, he said, 'a very curious and valuable work' which would 'be particularly useful in pointing out the original design of the several structures in the different yards; and give us better grounds for ascertaining the utility of the improvements that have been made from time to time since the Revolution'.[77] The King's response makes it clear that the book in question was none other than Dummer's Survey: 'I am glad the description of the yards in 1698 has proved some amusement, and it may have given birth to some new ideas from seeing the improvements that have been made, and suggesting what further may be done.'[78] In the run-up to the Portsmouth visit, it seems that the King found the 1698 Survey in the royal library and showed it to Sandwich, perhaps while he was still at Portsmouth. In August the King intimated he would be 'much pleased at having added to it the subsequent improvements that have been made'.[79] By the following March a sample account and drafts relating to Sheerness had been prepared for comment.[80]

Superficially, King's Manuscript 44, the 1774 'Supplement to the . . . Survey . . . taken in the year 1698', was a continuation of its predecessor, although the frontispiece was more overtly patriotic. Prominently placed is the *Royal Charlotte* yacht, used by the King to review the Fleet at Spithead the previous year, with the fanciful addition of Neptune in the foreground emerging from the sea in his chariot, surrounded by nereids and bowing to the royal standard of Great Britain. The explanation on the facing page is placed in a cartouche replete with patriotic motifs, signed by Thomas Mitchell (1735–1790), whose career as a shipwright and artist suggests he might have been responsible for much of the succeeding matter.[81] However, despite the decorative title-page, the Supplement was more business like and less visually arresting than the Dummer Survey, giving only an overview of the advantages and disadvantages of each dockyard and port from the sailing Navy's viewpoint.[82] This was because the dockyards' expansion was being recorded in other ways.

On his visit to Plymouth in June 1771, Sandwich had been keen to see progress on the great plan commissioned by his predecessor, Lord Anson, in 1761 and 'by a very ingenious model of the whole carved in wood by the foreman of the yard'. Made on a scale of one inch to forty feet, the work was detailed down to the named model ships in the docks and slips. To promote the possibility of further government investment, it had two sections with brass handles which could be lifted out and substituted with projected developments: one, a new dry-dock and the other, for new warehouses. Notes in the margin of Sandwich's report indicate that as a result, models of the same type were ordered for the Admiralty from the other royal dockyards (now in the collection of the National Maritime Museum).[83] They may be seen as the naval equivalent of the great relief maps of military fortifications commissioned from 1668 onwards by the Marquis de Louvois, Louis XIV's Minister of War, and initially used to plan improvements and simulate sieges.[84]

By the time the models of all the yards were completed, in 1774, so was the Supplement.[85] In fact, the Supplement states that its plans of 1774 (drawn to the same scale as the plans in the 1698 volume, of one inch to 220 feet) 'agree with the models of the yards prepared and herewith sent for His Majesty's use showing all the buildings, docks, slips &c in their due proportions and each distinguished whether of brick, stone or timber'. In other words, the models were intended to serve as a substitute for the plans and elevations of all the buildings included in the 1698 Survey. Furthermore, the King's Geographical Collection, now in the British Library, contains large-scale plans drawn to the same one-inch to forty-foot scale as the models themselves and also dated 1774.

Somewhere between 1771 and 1774, the decision was made not to keep the models and plans in the Admiralty but to present them, along with the Supplement, to the King to form part of what he would describe as his 'Naval Collection'. Sandwich had commanded the manufacture of the models on the grounds that it was 'proper' to have them made. He had agreed to have the Supplement to Dummer's Survey made to show subsequent alterations and additions, a process achieved to a larger scale and in greater detail through the models and plans. It therefore made sense to keep them all together. Perhaps Sandwich realised the impracticality of housing six huge horizontal models – three of which were more than six feet in length – within the confines of the Admiralty or the Navy Office. Presumably he saw them more as a means of maintaining royal support for his proposals and their financial implications than as useful management tools for the Navy. Displayed at Buckingham House, they were objects of prestige, works of art which demonstrated the country's naval power to distinguished foreign visitors. The German novelist Sophie von la Roche saw them in 1786, displayed together with models of ships and the fortifications of Gibraltar, in a room above the library, and concluded, 'The great care bestowed on the preservation of these works proves that the owners can appreciate art.'[86]

From the information given in the Supplement, in 1774 – when the country was not at war – the six royal dockyards employed a total of 10,631 men. The Supplement went on to list all the ships in the Royal Navy as of 31 August 1774, including those taken from the French and Spanish. It came to a total of 131 ships of the line (that is, first to fourth rate) and a grand total including fifth- and sixth-rate frigates, sloops, store-ships and yachts of 338 vessels. The greatest number of men at sea, in November 1759, was given as 88,990. Thus at full stretch the Navy employed about 100,000 men. The conjunction of surveys, plans and models, keyed into descriptions, gave the Admiralty and the Navy Board at least the illusion that they were in control of the vast enterprise under their management. In the case of Plymouth, they acted as a form of advocacy for further government investment. Above all, they enabled the King to identify with his Navy, acted as a useful reference point and served as propaganda, promoting in tangible form the dockyards as key industrial sites for the forging of the armoury of the state.

Surveying the Land

The progress of land surveying was closely related to improvements in instrumentation. Traditional methods of linear measurement using ropes or poles between two points were overtaken in the mid-sixteenth century by a chain of one statute rod measuring sixty-six feet, devised by Edmund Gunter, Gresham Professor of Astronomy. The technique of triangulation was also introduced in the sixteenth century, creating an applied geometry of surveying and range-finding. A remote station could be located by sighting from either end of a measured baseline; its distance could then be determined by measuring the angles formed with the baseline and by subsequent calculation, using a variety of instruments

including the altazimuth theodolite, plane table, circumferentor and surveyor's wheel or waywiser.[87] The innovation of triangulating several features from a single linear measurement was promoted in ordinary surveying on the grounds of improved efficiency and convenience. In the military sphere, range-finding provided crucial information impossible to gain by other means, given the lack of access to the target.[88]

There was no shortage of treatises on surveying, written by men who were often practising surveyors in summer and teachers of mathematics in winter. They were part of a larger category of works on measuring and practical arithmetic, applied to the history of tithes, land stewardship, husbandry and forestry, as well as to building, architecture and antiquities. The most popular surveying works went into many editions over the decades, the trickle from the mid-sixteenth century becoming a flood by 1750.[89] They usually stuck to a standard format: first some arithmetic, theorems and geometrical problems, then a description of the instruments and their use, followed by instruction on how to measure different plots, how to make fair copies and colour the results, with digressions into the measurement of latitude or levelling and sometimes appendices on mensuration as applied to different trades, such as carpentry. The development of surveying instruments and professional practice can also be traced in these works, which were often intended as advertisements for instruments made by particular makers. Lord Huntingdon's land surveyor, William Gardiner, used his treatise on *Practical Surveying Improved* (1737) to promote, as the full title put it, 'the Construction, Uses, and Excellency of Mr. Sisson's latest improved Theodolite, new-invented Protractor, Scale of equal Parts, and Spirit-Level'. This work was printed for Jonathan Sisson, mathematical instrument-maker to the Prince of Wales. Such 'product placement' was not always condoned. In his preface Henry Wilson justified the publication of *Surveying Improv'd* (1732) on the grounds that others 'seem to be calculated to serve as an advertisement to promote the maker's instruments, rather than for the information and advantage of the public'.

Most works included instructions on how to complete surveys for presentation, using polite forms of embellishment. The 1674 edition of William Leybourn's *The Compleat Surveyor* contained a new section, 'How to draw a perfect draught of a whole Manor or Lordship; and to furnish it with all necessary ornaments; also to adorn and beautify the same with colours: in which, (as in a map) the Lord of the Manor may at any time see the symmetry, situation and content of any parcel of his land'. Leybourn described how to colour the terrain and also instructed his readers to include a compass rose with a fleur-de-lys pointing north, a scale with a pair of compasses above it and the coat of arms belonging to the landowner in the correct colours with all the accoutrements: 'These things being well performed, your plot will be a neat ornament for the Lord of the Manor to hang in his study, or other private place, so that at pleasure he may see his land before him, and the quantity of all or every parcel thereof without any further trouble.'[90] The decoration was part of the message, symbolising the owner's place in an ordered society and promoting the image of his territorial power, rights and status.

Yet estate surveys were more than instruments designed to buttress the self-esteem of the landed classes. As surveying guides pointed out, they were needed to establish costs and rents.[91] George Atwell (alias Wells), a Cambridge mathematics teacher, wrote in a versifed conceit addressed to his book by its author: 'Thou teachest them [the nobility and gentry] to measure all their ground;/Which, certainly, will save them many a pound'.[92] William Gardiner made a strong economic case against surveys that used inferior methods and instruments. In advocating the use of Sisson's products, he reflected on the carelessness of many gentlemen, 'who are much pleased with very incorrect surveys of their estates, who seeing their maps picture-like drawn, and the writing in them neat, from thence infer they are plans, though they can't be justly called such'. In fact, he reported, 'the tenants by their mowing, ploughing, &c. have found it also, and

some have told me, it is not for them to tell their landlords, where the quantities are given too little.' Naturally, Sisson's theodolite produced results that were so near the truth that no error could be detected, 'but if gentlemen will not pay answerable to the care and industry requisite, they may suffer very considerable damage by either new or old surveys'.[93]

On the grandest scale, there were political and economic reasons of state for taking surveys. The new Protestant land settlement in Ireland was made on the basis of the so-called Down Survey of the Catholic estates forfeited in the aftermath of Oliver Cromwell's campaign of 1649–50. This immense collaborative exercise of surveying twenty-two counties was masterminded by William Petty and completed after only thirteen months in 1656. A contemporary manuscript account of the project gives an overview of the different qualities and gradations of expertise required. Undertaking the basic fieldwork were:

> certain persons, such as were able to endure travail, ill lodgings and diet, as also heats and colds, being also men of activity, that could leap hedge and ditch, and could also ruffle with the several rude persons in the country, from whom they might expect to be often crossed and opposed. (The which qualifications happened to be found among several of the ordinary soldiers, many of whom, having been bred to trades, could write and read sufficiently for the purposes intended.)

These men 'if they were but heedful and steady minded, though not of the nimblest wits' were taught to use surveying instruments, to choose and mark stations and value land. 'Another sort of men, especially such as had been of trades into which painting, drawing, or any other kind of designing is necessary, were instructed in the art of protracting for the field books, that is, in drawing a model or plot of the lands admeasured'. The plots were then reduced to a single scale, coloured and ornamented. Finally, 'a few of the most astute and sagacious persons' checked the entire process for errors.[94]

Elsewhere in the country, some surprisingly nimble wits undertook core empirical fieldwork. In the aftermath of the Great Fire of London, Robert Hooke tramped the streets as one of the three Surveyors appointed by the City to stake out, measure and survey foundations before rebuilding, to allow for whatever street widening or improvement had been agreed and to decide on compensation, and to settle disputes. Unfortunately, all the original survey books have been lost but they must have included drawn site-plans as well as text and tables of calculations.[95]

There was considerable movement in both directions between state and private, military and civilian surveying. Sir Jonas Moore published his first work, *Arithmetick*, in 1650, the year he was appointed surveyor to the fifth Earl of Bedford's Fen Drainage Company. His sixteen-sheet map of the Great Level, completed by 1658, is remarkable for its accuracy and rich ornamentation, although only one copy is known of the original printed version, probably because the 87 members of the Adventurers' Company, whose arms were represented by Moore in the margin, gave the map an inappropriate political complexion after the Restoration.[96] In 1661, Moore surveyed the manor of Woburn for the Earl, producing a map and survey book which again were elaborately coloured and gilded. Then in 1665 he was appointed Assistant Surveyor of Ordnance and finally in 1669 Surveyor General, a post he held until his death ten years later. He was the leading exponent of practical mathematics in the Restoration era and the driving force behind the Royal Observatory at Greenwich.[97] Sir William Petty moved in the opposite direction, applying the knowledge and profits he had accrued when supervising the Down Survey to his own estates in Kerry. Here in 1665 he established an 'industrial colony' providing employment for three hundred artisans and labourers until its demise during the rebellion of 1687.[98]

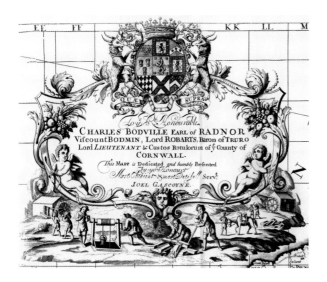

20 Cartouche enclosing dedication from *A Map of the County of Cornwall newly surveyed by Joel Gascoyne*, 1699. Cornish Studies Library, Cornwall Centre, Redruth

In the eighteenth century, state surveying initiatives in Scotland and the north of England provided opportunities for John Smeaton, James Watt and others. In 1764, Smeaton was appointed co-receiver with Nicholas Walton for the estates in Northumberland and Cumberland of the third Earl of Derwentwater which, following the first Jacobite uprising, were forfeited in 1716 to Greenwich Hospital. A comprehensive survey undertaken in 1736 by Isaac Thompson on thirty-six sheets, 'copied from the things themselves and the names affixed', demonstrated that the land was overwhelmingly rural, but the amendments made by Walton and Smeaton in 1763 and again by Walton – who was based at Gateshead – in 1797–8, graphically record the growth of enclosures over common land, allotments made to different parties, the construction of turnpikes and some signs of increased industrial activity.[99]

The famous Survey of Scotland, made between 1747 and 1755 at a scale of one inch to a thousand yards by the Board of Ordnance, marked the culmination of the strategy that had developed since the 1715 uprising to gain military control of the Highlands of Scotland, one which acquired new urgency in the aftermath of the Battle of Culloden in 1745.[100] It gave a grand impression of state power and has been much discussed for its aesthetic qualities (a theme taken up in Chapter 7) but it was also intended to make a positive contribution to the economic improvement and industrial progress of Scotland.[101] Progress was slow. In the wake of the Annexing Act (25 George II, *c*.41) of 1752, which confirmed the inalienable annexation of the thirteen forfeited Highland estates to the Crown, a start was made with the commission of detailed estate surveys and reports on their economic potential.[102] However, the Annexed Estates Commission's hopes of civilising the inhabitants and improving vast tracts of open country, ranging over mountains, marshes, moors and disputed ground, met for the most part with opposition and failure.[103] Some improvements were made to roads, bridges and harbours; small-scale industry such as linen manufacture was encouraged. But only after the Disannexing Act of 1784 were funds raised from the heirs of the former owners (whose estates were restored provided debts were cleared) for important public works: Register House in Edinburgh, the Forth and Clyde Canal, the Crinan Canal and Leith docks, which provided more work for civil surveyors.

The practice of marking signs of industry on county maps had been established by the second half of the sixteenth century but on a fairly random basis.[104] The nine-sheet 'Map of the County of Cornwall newly surveyed', published in 1699 by the professional London-trained surveyor and map-maker Joel Gascoyne, is generally seen as heralding a new age of county map-making.[105] It included windmills and water-mills but, surprisingly, it did not specifically identify tin and copper mines, although in the dedication cartouche to the Earl of Radnor, water-powered stamping mills were depicted with figures winching a bucket of tin ore out of a mineshaft and others stacking the finished ingots (fig. 20).[106] Thomas Martyn's 1748 map of the same county, dedicated to Frederick, Prince of Wales, registered mines with little mounds and seams with broken parallel lines, distinguished by the alchemical signs for tin, lead and copper.[107] More commonly, small circles represented coal-pits and triangles, iron and lead mines; (water) wheels were used for mills and forges, while windmills were shown pictorially. Richard Budgen's map of Sussex (1724) used a hammer sign to represent forges, a smoking building for furnaces and an unusual geometrical sign for 'smiths forges'. Scenes of industry were frequently included in the cartouches.[108]

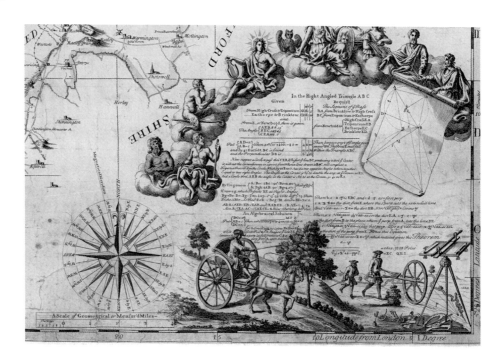

21 Elisha Kirkall after Henry Beighton, *A Map of Warwickshire actually surveyed in the years 1722, 23, 24, 25, 1726* (detail). Warwickshire County Record Office

Despite improvements in instrumentation and the superficial appearance of integrity, county maps were usually too generalised to plot industry accurately, let alone to be updated with new developments.[109] There were exceptions. Henry Beighton (1687–1743), a Warwickshire yeoman farmer, skilled mechanic and the editor from 1713 of the *Ladies' Diary* – the only mathematical periodical of its day – was also a part-time surveyor, developing his own instruments to help him in his work.[110] Through taking on the task of revising the maps and sketching the local buildings and landmarks for an edition of the *Antiquities of Warwickshire*, first published by William Dugdale in 1656, he made his own survey of the county between 1722 and 1725. The master copy completed in 1726 was the first of the county maps to be based on triangulation.[111] Beighton worked without subsidy, characterising his work as a magnanimous intellectual endeavour, 'a great satisfaction to my curiosity' commensurate with his status from 1720 as a Fellow of the Royal Society. Given his mechanical interests, on his map he distinguished between different types of mill and included three 'fire engines' attached to coal mines, marked along the outcrop of the thick coal from Coventry to the county's north-western boundary.[112] So proud was he of his instruments and methodology that they were introduced into the border of the map, emphasising not only the hard work and professional skills involved but also its accuracy. The surveyor is shown using horse-drawn and pedestrian versions of a perambulator device. His invention of the plane or plotting table is surrounded by other surveying instruments, a chart marked with triangulation lines and sets of geometric and algebraic calculations (fig. 21).

Later in the century, the part-time surveyor Peter Perez Burdett drew attention to his technical skills on the map he made for his county of Derbyshire (1767), describing his surveying methods with a diagram of his triangulation network in the margin.[113] He also created his own code to mark different industrial features: smelting cupolae, lead mines, coal-pits, wind- and water-mills, listed in the explanation alongside the signs for settlements, turnpikes and crossroads, and the division of the hundreds. By the second half of the eighteenth century, maps focusing on cities encompassed their industrial hinterland in considerable detail. Benjamin Donn's *Map of the Country Eleven Miles round the City of Bristol* (Bristol, 1769), 'printed for and sold by the author B. Donn at the

22 George Withiell, 'A true Plott of the Mannor of Perron-Arwothall...', 1691 (detail). Royal Institution of Cornwall. MMP/95

Mathematical Academy in King Street, Bristol', marked the sites of mines and atmospheric engines in the Bristol coalfield, as well as copper, brass, wood, paper, gunpowder and snuff mills. The *Plan of the Collieries on the Rivers Tyne and Wear, also Blyth, Bedlington, and Hartley, with the Country eleven Miles round Newcastle* (1788), taken from surveys made by John Gibson in 1787, included the depth of pits and length of wagonways, the latter coloured in red.[114]

Private economic interests loomed large in a society increasingly bent on improvement and encouraged by numerous manuals, purporting to boost agricultural, commercial and industrial productivity. Signs of success were most conspicuous in the landscaping of parks and gardens, recorded in manuscript surveys, engraved prospects and bird's-eye-view paintings.[115] The profit motive also encouraged investment in land drainage, enclosure, forestry and mining. Maps and surveys recorded permanent land boundaries, provided a spatial overview which aided efficient management and could be used to record change and to progress improvement schemes. Surveyors were needed not only to survey land as a means of establishing its revenue potential from agricultural rents but also to plot its industrial potential and development.

Whereas surveys of state property have been preserved in national archives and engraved county maps are readily available, surveys of private property remain for the most part buried in solicitors' offices or have been consigned to county record offices, where they languish, often in an extremely battered condition, separated from associated documentation and largely forgotten. What follows can only be a torch-lit tour of rich resources scattered in archives throughout the country but which collectively indicate a growing desire on the part of landowners to control and exploit their property.

As in the county maps, the means used to denote the presence of industry in estate surveys had yet to be formalised, most surveyors using a mixture of conventional signs and pictorial devices. An early map of Miln Close grooves (or lead mine shafts), at Wensley, Derbyshire, dating from 1688, represented some shafts with circles, others with a frame structure and many with coes (huts) alongside.[116] The West Country surveyor George Withiell included signs of tin mining on his Cornish estate maps. On 'A true Plott of the Mannor of Perron-Arwothall – situate in the Parishes of Perron Gwennap and Stithians, the whole belonging to Alexander Pendarvis of Roskrow Esq', surveyed by Withiell in 1691, delightful details can be made out: miners working a bucket-winch, a surveyor and his assistants with a gunter chain, walkers, riders, heaps of waste, 'a great tynn worke', 'a rych tynn myne', burning and blowing-houses, used to purify and smelt the ore (fig. 22). Pendarvis himself was Surveyor General of Crown and Duchy of Cornwall lands during the reign of Queen Anne and a Member of Parliament for most of his life. He would doubtless have appreciated the value of an accurate yet decorative survey of his lands which included field names, acreages, names of tenants, manor and farm buildings, roads with packhorses, the river Caron busy with ships and boats, as well as the mines, that testified to the economic activity on his estate.[117]

Maps were useful for denoting rights where several owners were involved. The Newdigate archive in Warwickshire Record Office contains a long 'Mapp of the Mines and Veins of Coal as they lie dispers'd through the landes of Lord Paget, Sir Thomas Aston & Francis Stratford Esq. From Chilvers-Cotton to Ansley Common, shewing how they have been already gotten, by the year 1731'.[118] The boundaries and lines of seams were

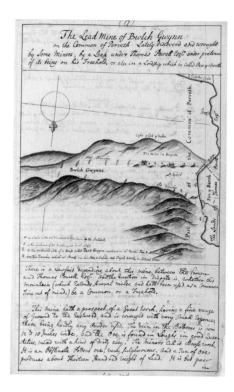 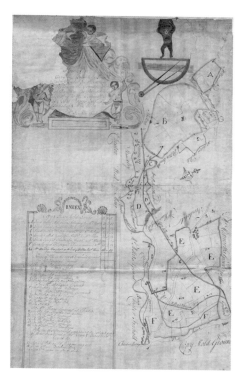

measured by Henry Beighton and, following his and other reports that indicated a lack of further potential, mining ceased on Sir Roger Newdigate's Arbury estate, except on a small scale for domestic use, until the 1770s.[119] In Cornwall, maps were drawn to show watercourses, recording the principal landowners and also the owners of the particular 'stamps' used for crushing tin ore, marked by circles with a cross in the middle, as a rough guide for anyone wanting to identify a particular holding, in order to assess and collect dues.[120] Several were clearly drawn up to provide ammunition in lawsuits, bundled up with papers setting forth a landowner's title to a watercourse or ownership of tin bounds.[121] Estate surveys survive for the Bristol coalfield, notably for pits belonging to the Duke of Beaufort.[122]

In 1744, the Anglesey-born surveyor Lewis Morris was authorised by Thomas Walker, Surveyor General of His Majesty's Land Revenues, to prepare a correct survey and plans of the Crown manor of Cwmmwd y Perveth in Cardiganshire, with particular reference to its lead and silver mines. The commission was provoked by encroachments made by neighbouring freeholders who were, it was claimed in Exchequer court suits, working mines on the unenclosed land or common belonging to the Crown. Besides drawing up a written account and history of the manor, Morris made a series of plans, marking in semi-pictorial fashion the boundaries, rivers and hills as well as the course of the veins with dotted lines, buildings, wind-engines and the occasional horse-whim or windlass used for drainage or raising the ore (fig. 23). He also made sections and prospects and even drew a Stone Age tool which demonstrated that some mines had been worked since 'the beginning of times, and before the use of iron was found out'.[123]

As in the county maps, estate surveyors embellished their cartouches with pictorial representations of industry. The copy and leasehold lands at Chester-le-Street and Pelton, 'the royalty belonging to the committee of John Rogers Esq. Lunatick and Mrs Allen', were drawn by William Donkin in 1746 in rough and fair copy, the latter adorned with broadly humorous examples of vernacular art, including putti and, unusually, a miner carrying a sack of coal on his back surmounting the compass and scale (fig. 24).[124] The

26 (below) Isaac Thompson, 'A
Plan of the several Coal-Staiths,
at Darwent Haugh, in the
County of Durham...', 1750
(detail). Royal Institution of
Chartered Surveyors, Kenney
Collection

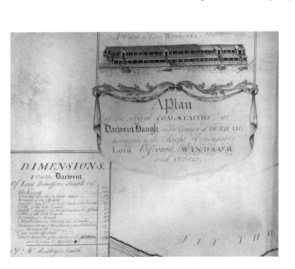

'true and exact map or form of the sough at Calver [Derbyshire] with all the vains apper-
taining or belonging to that hon Society of partners whom God grant success', is a par-
ticularly zany example, devised by Thomas Atkinson in 1728 as a parody of calligraphy
and numeracy – in effect mensuration gone mad – possibly in connection with a legal
dispute (fig. 25). Its lead veins are treated like tape measures and their arrangement is
inscribed with curious figures, *memento mori* and odd sayings – 'Greatness except with
goodness qualified/Is but at most eye-dazzling peacocks pride'. At the top left-hand
corner, there is 'A scale of time to find any number of days in a year at one subtraction
for ever'.[125] The 'Plan of the Mitle Works in Cowleknowle', a section of Miln Close lead
mine, Derbyshire, drawn by J. Dawson and dated 1750, includes quaint figures of miners
supporting the cartouche and the Newcomen engine, for which the Coalbrookdale
Company had supplied the ironwork in 1748, proudly represented.[126] A Rococo car-
touche of one 1767 plan on vellum of the mines and veins of lead ore in the possession
of the partners and proprietors of Calf Tail, Derbyshire, was surmounted by a fictitious
coat of arms incorporating tiny figures of miners at work.[127]

Isaac Thompson of Newcastle surveyed and 'plan'd' the
'several Coal-Staithes, at Darwent Haugh, in the County of
Durham, Belonging to the Rt. Hon. Lord Viscount Windsor
and others' in 1750 and it was 'plan'd' again by Joseph King in
May 1751, presumably for one of the other partners. They show
the staithemen's houses, stores and gardens, the different wag-
onways, some raised on stilts and coloured according to owner,
with the on-gates for loaded wagons and off-gates for the
empties and turn-rails connecting them. In the corner there is
a vignette showing the staithes themselves drawn in perspec-
tive, long buildings with spouts from the gables to channel the
coal directly into boats on the river Derwent (fig. 26).[128]

The degree to which local agents and surveyors were ex-
pected to be acquainted with the industrial potential of estates

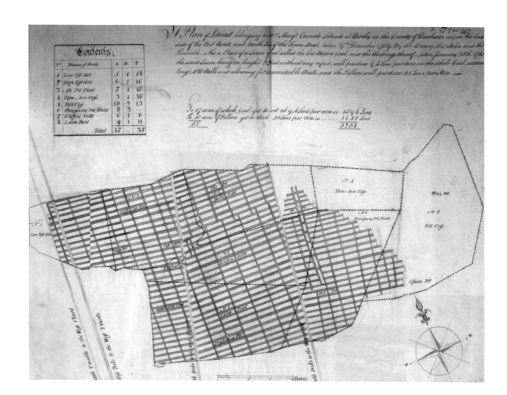

is demonstrated perhaps on the grandest scale by the records of Northumberland coal viewers, who advised on and directed colliery design, construction and development in close association with the mine managers.[129] For example, the papers of John Watson senior (who died in 1797) reveal an increasingly sophisticated grasp of what was required. A 1749 plan of Long Benton estate, then belonging to Lord Carlisle, showed the borings, pits, water levels, wagonways and lines of the great dyke (hard rock cutting across coal). Winding engines and horses and carts travelling along the wagonways are also depicted.[130] The Watson collection contains not only working drawings with triangulation lines and calculations but also finished drawings reversed, presumably for engraving, and decorated for their aristocratic and ecclesiastical owners with calligraphic flourishes, elaborate Rococo cartouches and houses drawn in elevation rather than in plan.[131]

Surveys of mines mark the boreholes, water levels, dykes, wagonways, gins and pits, the last pinpointed with a dot in the middle of a circle and individually named. The earliest show the extent of the workings conveyed simply with parallel lines, then crossed to make rectangles and later, as a network of joined parallelograms representing the pillars and stalls or winnings (known in Scotland as stoops and rooms), crossed by dykes. Over time, the keys provided an increasing amount of information on the geology, workings and water levels and could be used to calculate the amount of coal still to be worked, for essentially the viewers were still undertaking the basic work of valuation (fig. 27).[132] More ominously, mines' surveys provided the means of identifying the location of explosions and their retention was in part a safety measure.

By the late eighteenth century, plans of the workings, apportioned to different landowners, had grown into enormous drawings, now kept folded in the North of England Institute of Mining and Mechanical Engineers, Newcastle upon Tyne but opening out to reveal the system of parallelograms forming a relentless grid, sometimes part-shaded, extending over the terrain like a vast underground city, with pin marks round the edge, suggesting that they had once hung in a pit-head office. Some plans

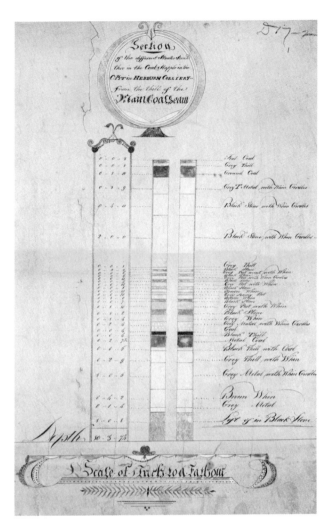

show the different ground to be passed over by intended wagonways. Other drawings show sections of the strata sunk through in the engine pit, marked up in fathoms, yards, feet and inches through the seams of coal of different types, and blue and grey metal.[133] Still others show the linings, in other words, the survey measurements taken in the pits to ascertain the extent of the workings, which provided the basis for plans.[134] Together with plans of wagonways and staithes, they provide an overview of the spread of industry in the coalfields of the north-east.

So skilled were the Northumberland coal viewers at surveying seams of coal underground that they travelled far afield to report on mines. In 1770, for example, John Barnes visited Griff Colliery on Newdigate's Arbury estate in Warwickshire, for which he drew up a plan and section of a new double steam engine, 'A Description of the Different Veins or Seams of Coal . . . shewing how the Under Veins to the Rise may be won by a Drift or Levell, from the upper veins in the Deep', and another section showing the new pit extending 106 yards down below the steam engine and waterwheel, where it met the seams of coal, and indicating how it related to the level of the Coventry Canal.[135]

Not all was reduced to bald calculation. The sections and plans drawn by John Watson junior (who died in 1837) are executed with a decorative flourish, such as the strata of C pit, Hebburn Colliery, from the thill (the floor of a coal seam) of the main seam, complete with foliate and calligraphic ornamentation (fig. 28).[136] He

28 Attributed to John Watson junior, 'Section of the different Strates sunk thro in the Coal Stapple in the C Pit in Hebburn Colliery from the thill of the Main Coal Seam', undated. North of England Institute of Mining and Mechanical Engineers, MS 3410/Wat/30/1

was sufficiently conscious of the importance of the family business to gather together 114 volumes of their work, including nineteen volumes of colliery and estate plans, organised by parish.[137] An index of the contents and rough pencil drawing shows how the plans were shelved in a special cabinet.[138] The most famous collection of colliery records comes from the Buddle family of colliery viewers. The fifty-six bound volumes of manuscripts contain the reports, correspondence, accounts and borings of John Buddle senior (1743–1806) and junior (1773–1843). Collectively they provide a record of the increasing power and professionalism of the viewers as their tasks became more complex, achieving the status of engineers.[139]

Buddle senior was a schoolmaster who taught mathematics but also had extensive practical experience of working in mines: his reports relating to Washington Colliery start in 1764 and extend over thirty-one years to 1795. They include maps of the ground to indicate ownership and wagonways to the river Wear, as well as sections of the seams drawn to scale.[140] Having been initiated by his father into 'the mysteries of pit work when not quite six years old', Buddle junior served as assistant to his father at Wallsend Colliery before establishing his own practice as viewer for numerous collieries in the north-east and, from 1819 until his death, as general manager and agent to the third Marquis of Londonderry. Although he grew to be a man of wealth and status, a Fellow of the Geological Society of London and a member of the Institution of Civil Engineers, he never left his roots in practical mining, telling a parliamentary Select Committee in 1836 that he knew his native county of Durham 'better underground than

29 John Buddle junior, 'Sketch to elucidate the proportion of Coal wrought, and left in Pillars', Washington New Colliery, 1819. North of England Institute of Mining and Mechanical Engineers, MS 3410/Bud/3

above'.[141] His reports list the date of works and measurements through the seams, carefully distinguished by name, together with rough plans or 'eye sketches' keyed into the directions and sections but not drawn to scale. They also contain suggestions for improved working methods, with estimates of the probable production and specifications for works such as inclined planes.[142]

Reports and valuations were sometimes illustrated, to explain particular problems to clients, as on the occasion when in June 1810 the Duke of Northumberland's agent, D. W. Smith, asked Buddle for his opinion as to whether the lessees should be allowed to remove the fire clay (refractory clay or shale) which constituted the thill at the bottom of the pit, without payment, for, Smith pointed out, their lease was restricted to coal alone. He acknowledged that it kept the men in work when trade was flat but was it safe or would it accelerate creeps (the rising or lifting up of the floor)? With judicious care Buddle reported the findings of his inspection, including a section of the seam, and having considered all the factors he decided that it was safe. He went on to calculate that a shilling a wagon was the utmost rent that could be charged and recommended an annual agreement be made on this basis.

Again in 1819, a report on Washington New Colliery was accompanied by illustrated sections of the seams as well as a sketch to elucidate the proportion of coal wrought to that left in pillars, presumably intended for owners who were not conversant with life below ground. As Buddle carefully spelt out, 'The workings of a coal pit form a succession of parallelograms, as represented in the annexed sketch, each of which from a, to c, is called a *winning*, and from a, to b, a *pillar*' (fig. 29).[143] For themselves, the Buddles usually relied on boring and sinking accounts which accumulated data over the decades listed in tabular form, with measurements of the depth of the strata and short descriptions based on empirical observation, noting the differently coloured stones, the clay, coal, thill and so on.[144] Other small notebooks contain rough working notes of the linings, which were listed with remarks on their direction.[145] Such methods were standard practice, judging from the other reports and plans eventually donated to the North of England Institute of Mining and Mechanical Engineers (founded in 1852).[146] This was the kind of stratigraphical expertise which the surveyor William Smith acquired on the north Som-

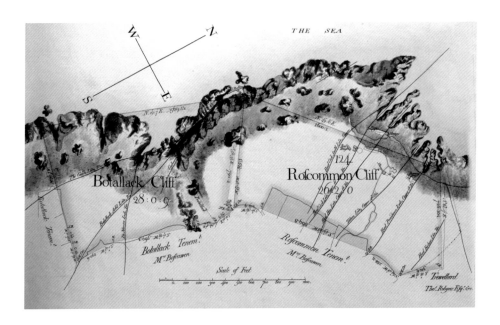

30 Charles Moody,
'Botallack Cliff' and
'Roscommon Cliff' from *A
Survey of Tin Bounds...*, 1782.
Royal Institution of Cornwall,
B/16/1

31 (below) Charles Moody, *A
Survey of Tin Bounds... in the
County of Cornwall*, title page,
1782. Royal Institution of
Cornwall, B/16/1

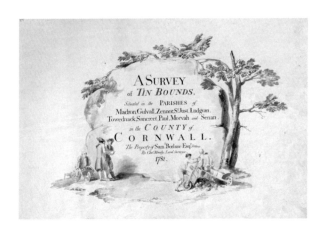

erset coalfield, leading to his production of subterranean surveys and the publication of
his first geological map, *A Map of Five Miles round the City of Bath* (Bath, 1799).[147]

The surveyors of Cornwall specialised in tracing the lodes or veins of tin and copper
and demarcating the limits of the tin bounds in books or maps. It was the custom for
tinners to remove the turf at the four corners of a plot to claim the right to work for
tin within the bounds, privileges which were renewed annually on a specified day by
the landowners. Their maps were sometimes certified by the tinners.[148] An early example
of a bounds map survives in the Arundell family archive, dating from about 1698 and
entitled 'Plan of Polgooth, Mulvra, St Martins, the Crane, Van Vean and nearby tin-
bounds', belonging to the Edgcombe family. It also shows the lodes marked with straight
lines and the shafts, using the alchemical symbols for tin and copper. Below the plan a
cross-section of the land is drawn, ingeniously connecting each feature with the plan by
means of dotted lines.[149]

'A Survey of Tin Bounds, Situate in the Parishes of Madron . . . in the County of
Cornwall', the property of Samuel Borlase and others, is a particularly good example of
a bounds book. It was drawn and compiled with care in 1782 by the land surveyor
Charles Moody, prefaced by a short explanation of the history of the boundaries, and
with tables of references giving the days of renewing, where situated, statute measures
and so on. The maps themselves were finely drawn, the bounds given with exact meas-
urements and compass readings, based on just visible tri-
angulation lines, with the lodes of tin and copper
identified as named diagonal lines across each page (fig.
30). Moody's title-page was embellished with grisaille
drawings of miners at work pushing wheelbarrows of ore
and the album was bound with marbled boards and a
leather spine, as if destined for a place of honour in the
Borlase library at Madron (fig. 31).[150] Just as the Northum-
berland coal viewers kept small notebooks in which they
jotted down their on-the-spot measurements, the Cornish
surveyors kept notebooks in which they recorded in metic-
ulous detail and descriptive topography the direction and
extent of tin bounds, not least to assist the process of

checking on the days when they were renewed.[151] By the end of the eighteenth century, large-scale maps were being made of whole districts, covering the 'setts' of mines belonging to different owners, the tin and copper lodes indicated with a mass of straight lines and the shafts with circles.[152]

If mining represents a key field in which surveying skills were becoming increasingly technical, drainage and navigation schemes constitute another. The river navigations were the most natural form of inland communication with sea ports, through which all foreign trade and the important coastal trade were handled. Before the age of steam locomotion, water transport was the only satisfactory means of carrying heavy and bulky goods.[153] By the time of the canal boom in the late 1760s, surveyors involved in drainage and navigation schemes could make a decent living all year round. Engraved plans of proposed improvements to river navigation and for the construction of canals were produced to win shareholders' support and parliamentary approval. Those conveniently gathered together in George III's Geographical Collection give some idea of the growth of such enterprises in the second half of the eighteenth and early in the nineteenth centuries.[154]

The careers of John Grundy senior (1697–1749) and junior (1719–1783) were founded on these developments. John senior was a self-taught mathematician who, like Buddle senior, earned a living as a teacher of mathematics and a surveyor. Based first in Leicestershire, in the early 1730s he moved to Spalding, Lincolnshire, presumably of account of the town's dependence on fen drainage and river navigation. In a prospectus of 1734 addressed to the nobility and gentry who owned land in need of drainage, and endorsed by the leading exponent of Newtonian philosophy, Jean Desaguliers, Grundy set out his stall, advancing

> some propositions, which plainly show the necessity of mathematical and philosophical knowledge, in the draining of lands that lie near the sea (or low fen-land;) from whence corollaries are drawn, which fully prove, it is next to an impossibility to do any thing with judgement towards draining those lands effectually; except such attempts are grounded upon philosophical experiments, and mathematical calculations. And likewise some scholiums, to prove that all the attempts that have hitherto been made . . . for draining the same, have not been grounded upon any such principles; and consequently cannot succeed, till some new method is put into practice wholly depending on the foresaid knowledge.[155]

The Spalding Gentlemen's Society, to which Grundy was elected a member in June 1731, kept Minute Books that help track his career, for he used its well connected membership as an audience to promote his increasingly ambitious drainage proposals. On 1 March 1733 he presented his own scheme for draining Deeping Great Fen: a folio manuscript 'attended with a curious sheet of designs of instruments and models to illustrate the propositions and therein referred to'.[156] On 5 July 1733 he showed the Society an engraved plan drawn by Henry Beighton of George Gerves's 'multiplying-wheel bucket engine for raising water to supply gentlemen's seats'.[157] In January and again in April he was demonstrating his proposals for draining lands 'showing the necessity of mathematical and philosophical knowledge thereto required approved by J. J. Desaguliers L.L.D., F.R.S., as also a new and large map of Leicestershire [in fact, Warwickshire] surveyed by Mr Beighton, Author of the Lady's Diary, and a plate of a new invented fire engine by the same author'.[158]

In March 1735 Grundy produced a large map he had made of the lordship of Bushmead, Bedfordshire, the estate of William Gery Esq., 'drawn and stained with his arms and emblazoned in proper colours', taking the opportunity to show off drawings made by his son, John junior, of 'heads and human bodies neatly done in Indian ink'.[159] Then

in December Grundy contributed observations on Mr Kinderly's scheme to make the river Dee navigable to Chester. The following year, in April, he presented his own alternative proposals by a 'new method of draining', together with new methods of jettying. By September he had devised a new type of 'hedgehog or porcupine to tear away sands and gain a channel in an open bay in nearly half the time it can be done by any in use with us' and an improved 'battering ram' or pile-driver. He also informed the Society that he was making experiments 'hoping thereby to raise such data as shall inform him in an universal theorem to make the banks of any manner of different strata of earth to resist and overcome any given pressure'.[160]

Grundy evidently kept a pocket notebook of drawings and observations and on the basis of these and his own experiments, he began to work on a full-scale treatise on embanking and drainage 'mathematically demonstrating the nature and velocity of streams in rivers', citing historical authorities and accompanied by plans and figures. Over the years, he presented to the Society extracts from this treatise – in November 1742 part of its introduction which contained an account of mathematical learning 'from the beginning of the world to Newton' and four years later, chapter 8 on mechanics – for their comments and corrections but evidently he never completed it.[161] At the same time he kept members up to date with his navigation and drainage schemes. Naturally, he had proposals for Spalding's own river Welland and on the Norfolk coast near Yarmouth he erected 'parabolical jettys in the banks there to save the shore from being farther devoured'.[162] By 1739 he was describing himself as an engineer, working in partnership either with other surveyors or by 1740 with his son.

Both Grundys published another leaflet in 1740, billing themselves as Surveyors and Engineers and advertising their wide-ranging services:

> Noblemen's and Gentlemen's *Estates* Survey'd, and beautiful fair *Maps*, either in Books or at large, delineated of the same . . . All *low Morass, Boggy* or *Fenny Ground drained*, where it is practicable to make *Improvements* therefrom, with a just *Estimation* of the Charge of doing such Works before they are begun, &c. *Schemes* drawn up, *Estimations* made, and the Works conducted in the best Manner for draining large Tracts of Land in *Fenny Countries*, or inclosing of *Salt Marshes*, by *Imbarkation, Rivers* made *Navigable*, or decay'd *Navigation* restored in all such Cases where there are not Impossibilities to surmount; which from the *Maps* and *Levels* taken will be made self-evident to a Demonstration before the *Estimations* are given. *Grand Sluices, Locks, Goats, Stanches* or *Bridges*, either in *Stone, Brick*, or *Timber*, laid down and maintained for any Time agreed upon, and that upon any Foundation, from the soundest Ground to the greatest Quicksand. *New Rivers, Canals, Ponds*, and all manner of Imbankations, projected, estimated, taken or conducted . . .[163]

In December 1743 father and son presented their 'history and scheme with calculations for restoring the navigation of the river Wytham from Boston to Lincoln' and draining the adjacent lands. To make the scheme more intelligible to their audience, they produced a 'fair map' on fine vellum, some six by two feet in size and on a scale of half an inch to the mile, 'neatly drawn and decorated' and annotated with about four hundred water levels.[164] Their 1744 map of proposals for Deeping Fen was 'an actual survey there by them taken with the most accurate instruments and very carefully adjusted by geometrical and trigonometrical constructions'.[165]

The training Grundy junior received from his father was reinforced by his skill as a draughtsman and through attending Desaguliers's lectures on the principles of mechanics in London in 1740.[166] Like his father, Grundy junior worked as an estate surveyor, notably at Grimsthorpe Castle, Lincolnshire, where he carried out a number of schemes for the third Duke of Ancaster, including an earth dam for an ornamental lake. He

32 John Grundy junior, 'Plans, Schemes, Reports & Estimates in Engineering...', title page, undated. Leeds University Library, Brotherton Collection, MS SCI

regraded a slope to afford a better view of the lake, brought piped water to the castle and created new fish ponds.[167] John junior also produced 'terriers' (books or rent rolls recording the site and boundaries of estates) – including one for Grimsthorpe in 1759 – with plans of each tenant farm facing a page with the information as to individual tenancies. To advertise this service he produced a specimen book for a fictitious estate with a frontispiece which showed surveyors using different instruments.[168]

So extensive and well regarded was Grundy junior's work on fen drainage, river navigation and canals that in the mid-1770s he gathered all his projects in seventeen quarto volumes, entitled 'Plans, Schemes, Reports & Estimates in Engineering by John Grundy of Spalding in Lincolnshire'.[169] A degree of justifiable pride and satisfaction in his achievement is suggested by the elaborate Rococo decoration of the title-page of the first volume, further adorned with appropriate iconography: a house to one side and fountain to the other, with various books and surveying instruments along the bottom (he himself owned a telescope, theodolite, spirit-levels, folding stands to support them and a camera obscura; fig. 32).[170]

The volumes contain fair copies of his engineering reports arranged in a loosely chronological order, complicated by the fact that several major schemes continued with intervals over many years. Although ten of the volumes contain tables of contents and sixteen are paginated, giving an impression of orderliness, they were written by a number of hands, including Grundy himself, using a range of papers. The earlier volumes contain reduced copies of what were presumably the office copies of diagrams and plans, while the later volumes more often contain the office copies themselves, folded to fit the page size of the quarto volume. The neatest drawings, dating from 1775–6, appear to have been the work of T. Tinkler, presumably a draughtsman working in Grundy's office; the broader hand is that of Grundy.[171] Totalling more than five thousand pages, the volumes include much more than the formal schemes and reports that Grundy gave to his clients. They contain his preliminary observations, often in the form of a day-to-day record of his activities on site or his meetings with landowners and agents, emphasising the difference between the guesswork of a preliminary visit – which at least had the advantage of ruling out the impracticable before any serious money was wasted – and the professional service he could provide through a full survey.

In the journal he prepared for the Earl of Egremont in 1757, relating to a drainage scheme at Leconfield and Arram, near Beverley, East Yorkshire, he spelt out the extent of his superior expertise. Following a preliminary visit in October, he cautioned the noble lord:

as the aforegoing opinion is only founded upon occular views and informations I can only introduce it as a speculative one; and before I can undertake to give in any regular or well founded scheme of drainage I must be allowed sufficient time for taking regular surveys and plans of the respective rivers, becks, drains, watercourses and slades in order truly to ascertain their lengths, bearings, positions and directions; and from

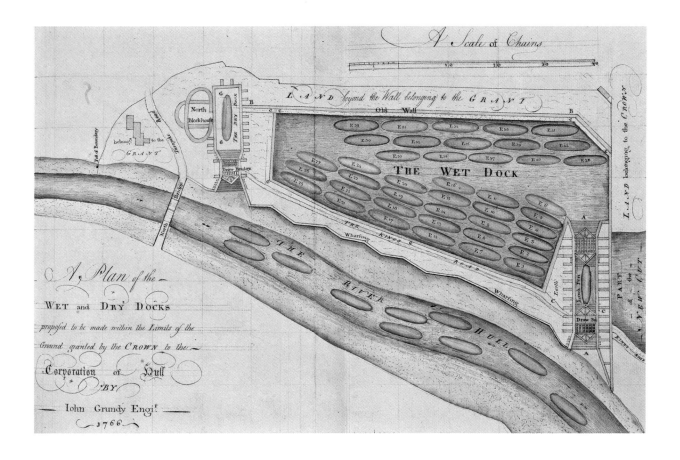

The image shows text within the plan including: "A Scale of Chains", "LAND beyond the Wall belonging to the GRANT", "Old Wall", "North Blockhouse", "The Dry Dock", "belongs to the NAVY", "GRANT", "THE WET DOCK", "Draw Bridge", "North Bridge", "THE KINGS ROAD", "Wharfing", "THE RIVER HULL", "Wharfing", "Lock Pen", "Earth", "Draw Bo", "LAND belonging to the CROWN", "PART of the NEW CUT", "Rivers End", "A, Plan of the — WET and DRY DOCKS proposed to be made within the Limits of the Ground granted by the CROWN to the — Corporation of Hull BY — Iohn Grundy Engi! — 1766"

33 John Grundy junior, 'A Plan of the Wet and Dry Docks proposed to be made within the Limits of the Ground granted by the Crown to the Corporation of Hull', 1766. Leeds University Library, Brotherton Collection, MS SC3

accurate instruments to take the levels of the said rivers, becks, drains, watercourses, slades and the respective surfaces of the said low grounds, in order to discover where and in what manner and direction the several new drains ought from the best fall and most convenient direction to be placed the most conveniently and efficaciously to convey their waters to the engine or engines, and in order truly to proportion the power and dimensions of the said engines; from which surveys and levels I shall also be able to give an estimate of the probable expense that is likely to attend such a scheme; but without which nothing of this nature can be otherwise than guessed at.

The cranking of the wheels of professional aggrandisement is still audible. Having received permission from a doubtless impressed Lord Egremont, he started the survey proper on 20 December 1758, breaking for two days over Christmas. Armed with his instruments he took to a boat while his assistant surveyed the other bank. However, by 28 December, 'Having received a cold from being so long on the water and being a good deal out of order I stayed in the house reducing my field notes, drawing the rough plan &c' which he worked on for another two days. By 18 January, the survey was complete.[172]

Grundy could also draft proposals for large-scale engineering schemes, such as 'A Plan of the Wet and Dry Docks proposed to be made within the Limits of the Ground granted by the Crown to the Corporation of Hull' of 1766 (fig. 33).[173] This was the first indication of his involvement in the construction in 1774–8 of what became, until the new London docks were built at the start of the nineteenth century, the largest commercial docks in the country with accommodation for up to a hundred ships. In engineering the building of the massive brick walls of the dock and locks, Grundy was at the very edge of his expertise for, as A. W. Skempton pointed out, in 1774 construction on this

84

scale in soft ground was unprecedented and (despite Grundy senior's supposed attempts to calculate a 'universal theorem') there were no reliable methods for calculating the forces involved under such conditions.[174]

From Civil Surveying to Civil Engineering

The growth in the number of collections of drawings by surveyors and engineers that survive from the second half of the eighteenth century is symptomatic of the increasing scale of works and the improvement in professional skills and status. John Smeaton (1724–1792), who became the country's leading civil engineer, abandoned a legal career to become a scientific instrument-maker, having been attracted to all things mechanical from childhood in Yorkshire.[175] His exceptional talents were recognised early, for he was nominated a Fellow of the Royal Society by Lord Charles Cavendish as a 'maker of philosophical instruments, a gentleman well known to the Society for his great skill in the theory and practice of mechanics' and duly elected in 1753. Smeaton accomplished an extraordinary amount of work, including designs for wind- and water-mills, atmospheric steam engines, bridges, harbours, river and canal navigations and fen drainage schemes. He wrote about two hundred reports, published after his death in three large volumes, and more than 1200 drawings survive in the Royal Society, sorted into different sections – windmills, water-mills, steam engines and so on – but not chronologically ordered. Although Smeaton's manuscript reports were physically separated from the drawings during the nineteenth century, the two were meant to be read together.

Smeaton thought of himself as an independent professional, who designed schemes for which others would contract to supply materials and carry out the construction.[176] On 14 March 1768 in connection with the Forth and Clyde Navigation in Scotland, he laid out different duties of engineers and surveyors, the engineer-in-chief being the only one who made the plans.[177] In October the same year, having been asked to consider the reports on his work by fellow engineers (James Brindley, Thomas Yeoman and John Golborne), he started by describing his own role with commendable restraint, given the implied loss of faith in his own abilities:

> I consider myself in no other light than as a private artist who works for hire for those who are pleased to employ me, and those whom I can conveniently and consistently serve. They who send for me to take my advice upon a scheme, I consider as my pay-masters; from them I receive my propositions of what they are desirous of effecting; work with rule and compass, pen, ink, and paper, and figures, and give them my best advice thereupon. If the proposition be of a public nature, and such as involves the interest of others, I endeavour to deliver myself with all the plainness and perspicuity I am able, that those who may have an interest of a contrary kind may have an opportunity of declaring and defending themselves. I do not look upon the report of an engineer to be a law, at least not my own. As a proposition, everyone has a right to object to it, and to endeavour to prevent its passing into law, or to oppose its execution in such a way as may be detrimental to others.

However, he added, it was not right to question a scheme after it had been assented to and passed; that, he considered, was 'a very extraordinary evolution, and a sort of proceeding which, as I think, every well-wisher to the success of the scheme should set his face against'.[178]

Drawing was crucial for Smeaton's work – as he said, 'the rudest draft will explain visible things better than many words'.[179] Having done the rough drawing himself, he had two copies made, one for the office, one for the client. At the end of his life he

wrote, 'I do not think it within the compass of human knowledge, to form the best possible design at once. Things are far better finished by touching and retouching as is usual, and necessary to the greatest painter.'[180] But he did not think of himself as an artist in the polite sense of the term. As he stated in its preface, he regarded the plates to his most sumptuous published work, *A Narrative of the Building and a Description of the Construction of the Edystone Lighthouse with Stone* (1791), as 'in reality little more than *geometrical lines*, drawn to explain *geometrical* and *mechanical* subjects. If any of them puts on the appearance of any thing further, it is to render it more *explanatory* and *descriptive*. They are in reality not meant as *pictures*.' Nevertheless, he insisted that they rest flat and not be folded, so that their meaning was not compromised – hence the size of the volume. He saw the plates as examples of practical geometry and mechanics, yet his pride in the precision of their execution was such that he was loath to have their physical state compromised.

Smeaton kept the record drawings of virtually all his projects and on his death they were inherited by his daughters who sold them to Sir Joseph Banks in 1793, passing thence to the Farey family who bequeathed them to the Royal Society in 1913.[181] The six bulky volumes (now rebound as eleven) constitute an astonishingly rich record of his professional career, mainly comprising those copy drawings retained by his office in Austhorpe, outside Leeds. Their subsequent safekeeping and cataloguing from 1821 by the engineer John Farey junior (1791–1851) was undertaken for professional rather than aesthetic purposes. Farey frequently made his own identifications, with references to Smeaton's published *Reports*, on the drawings themselves.[182] According to Farey's manuscript note in the first volume:

> Mr Smeaton was a man of laborious habits and made all his drawings with his own hands . . . After he became more established and employed a draughtsman he still continued to draw the lines of all his drawings to the proper scale in pencil line on cartridge paper. These he called sketches . . . [They] were fair copied on drawing paper, by the draughtsman Mr W[illia]m Jessop at first and afterwards, Mr Henry Eastburn, and Mrs Smeaton's daughters frequently assisted in the shadowing and finishing, in Indian ink which was very well executed.[183]

Smeaton's civil surveying and engineering projects extended from Ireland and Scotland through England to the Channel Islands. In 1760 he was appointed engineer on the Calder and Hebble Navigation, from Wakefield to Sowerby Bridge near Halifax, making all the necessary drawings for the seventeen locks along its eighteen-mile stretch, as well as the weirs, flood-gates and so on. For the first eighteen months, Joseph Nickalls was resident engineer but Smeaton made frequent site visits and from autumn 1761 was wholly in charge of construction, with two superintendents of carpentry and masonry. John Gwyn and Matthias Scott were appointed resident engineers and Gwyn remained Smeaton's principal site engineer for the rest of his life. Smeaton acted as consulting engineer on other navigation projects. Also in 1760, he met John Grundy junior (who became a close friend) and gave a second opinion on the Louth Canal, as he did for James Brindley in connection with proposals for the Trent and Mersey Canal, on which he wrote reports.

In 1768, Smeaton started on the largest of all his works, the Forth and Clyde Canal, working as chief engineer, with sub-engineers or resident engineers on site and three surveyors for the different departments of digging, carpentry and masonry, to each of which was attached a foreman.[184] Robert Mackell, the sub-engineer, and his assistant John Laurie began the detailed surveying work; Smeaton staked out the eastern end of the canal line and submitted nine typical cross-sections of the canal in level and sloping ground. By the end of 1768 he had prepared drawings for swing-bridges and drawbridges,

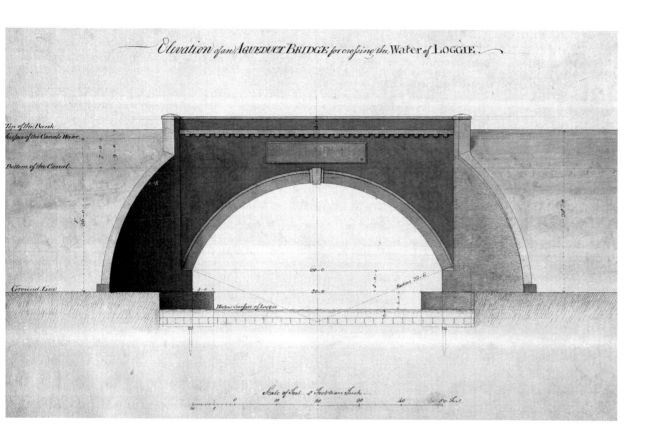

Elevation of an AQUEDUCT BRIDGE for crossing the Water of LOGGIE.

34 John Smeaton, 'Elevation of an Aqueduct Bridge for crossing the Water of Loggie', Forth and Clyde Canal, 1772. The Royal Society, Smeaton, volume 5, f.26v

tunnels, locks and aqueducts. His letter books on the scheme covered 770 pages; he submitted at least fifty plans and working drawings and attended twenty meetings.[185] The set of presentation record drawings is numbered up to eighteen, dated 1768–70; they even include details of the gate heels and collars and a profile of the aqueduct balustrade (fig. 34).

Smeaton's numerous plans for improvements to Scottish harbours date mainly from the 1770s, some made at the behest of the Annexed Estates Commission and in one instance, at Peterhead in 1775, produced in connection with a petition by the town's merchants to the Lords Commissioners of the Treasury for aid in completing their harbour.[186] They reveal the way in which Smeaton worked with local surveyors, improving on their original designs with confidence and fluency. For example, in 1771, Smeaton took the primitive survey of proposed improvements to Ayr harbour drawn by a Mr James Gregg and first corrected it in red, adding his own soundings as well as an elegant hand-drawn compass rose or 'Magnetic meridian as observed by Mr Smeaton'. Then he made a fair copy annotated in fine script and signed with a flourish, 'J. Smeaton Engineer'. He was well aware of the dangers of relying on the drawings of others and in a pointed note added to his report stated:

> The quantities in respect to length are taken from the plans of Mr. Gregg to me delivered, upon a supposition of its being laid down by a scale of 3 chains to 2 inches, there being no scale annexed to the plan; but if I happen to have taken my measures from a wrong scale, the expense [for raising the pier and lengthening the dyke] must be increased or diminished in proportion as the real measures turn out greater or less than I have supposed them.[187]

The surveying background of the most famous mechanical engineer of the century, James Watt (1736–1810), is usually underplayed. His father, James Watt senior of

Greenock on the Clyde, was a merchant and shipowner, ship's chandler, shipwright, builder, cabinet-maker and part-time inventor, who designed the first crane in Greenock for unloading tobacco and had a special line in pulley blocks.[188] His uncle, John Watt, was a teacher of mathematics and navigation as well as practising as a land surveyor in the Strathclyde area before his early death at the age of forty-three. His grandfather, Thomas Watt of Crawfordsdyke, apprenticed as a carpenter and mason in Aberdeenshire, moved to Clydeside and became a teacher of navigation and owner of a successful mathematics school. Thus Watt was aware of the arts of surveying and navigation from an early age, making notes while still a child on how to use an azimuth compass, as well as on dialling and scientific instruments.

Like Smeaton, and before him Hooke, Petty and Wren, Watt was precocious mechanically and his father put together a workshop for him, with a bench, tools and a forge. An inquiring mind and a family connection led him into the orbit of the University of Glasgow and thence, in 1755–6, to London to train as a scientific instrument-maker. He returned to Scotland and established a workshop within the university, then a shop selling his own instruments and those of others in partnership from 1759 with John Craig, a merchant and architect who supplied capital and did the accounts. When Craig died in 1765 Watt switched careers to become a surveyor and engineer, probably instigated by a partnership with Robert Mackell to build Newcomen engines. However, as civil engineering initially offered greater financial rewards than building steam engines, he got involved in the business of surveying canals, harbours, roads and water supplies.

His first serious job in 1767 was to help Mackell survey a possible canal route joining the rivers Forth and Clyde. He accompanied Mackell to London to promote the necessary bill through Parliament, making detours to see Smeaton's Calder Navigation and Brindley's Bridgewater Canal on the way. But their scheme was withdrawn in favour of Smeaton's, on which Mackell was appointed resident engineer. Nevertheless, Watt had learnt enough to be considered for other jobs. His principal achievement was the Monkland Canal, built to serve the collieries twenty miles east of Glasgow.[189] He started his survey in the autumn of 1769 but made an error, 'thro' my having mistaken some thing else for the index on the assistant's pole in the mist', which was discovered on a second survey made by Smeaton in 1770. An embarrassed Watt conceded his mistake to Smeaton: 'You will no doubt blame me for committing so considerable an error as four feet in nine miles. But upon making allowance for bad weather and a bad headache I had that day it is possible I may not appear so blameable.'[190] Though a potential rival on occasion, Smeaton always helped Watt and appreciated his straightforwardness: 'it is always best to be clear; that ill founded jealousies may not interrupt these public undertakings'.[191] In turn, Watt regarded Smeaton as something of a mentor, deferred to his greater experience and signed the letter of 8 February 1770, in which he was again obliged to Smeaton for correcting another error he had made in computing the tonnage of the boats, 'Whatever is the event of this Canal I shall be always proud of Mr Smeaton's countenance and friendship.'[192]

Watt was highly conscious of his own lack of experience. The need to gain more practical know-how as well as a regular income probably made him decide to venture beyond surveying and accept the post of resident engineer on the Monkland Canal. He concluded his second report with some diffidence:

I must however beg leave to observe on my own part, that though I have seen and observed works of this kind, which have been done by others, yet I do not pretend to any practical knowledge of my own on this subject, and if more able or experienced artists should have reason to find any fault with what I have proposed, I hope

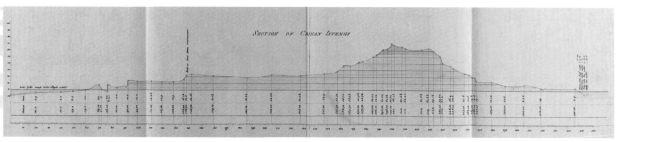

SECTION OF CRINAN ISTHMUS

35 James Watt, 'Section of
Crinan Isthmus', 1771.
Birmingham Archives and
Heritage, MSS 3219/4/204

the subscribers will excuse me, as I have laid before them the best judgement I have
been able to form of this matter in the time, and have spared no pains to make myself
master of it.[193]

In the spring of 1770, after parliamentary assent had been received, he began to stake
out the ground. When submitting his time sheets for levelling, he wrote:

> I have not yet taken upon me to determine in what rank I stand as an engineer and
> shall only observe that what knowledge I have in that way has not been acquired
> without great loss of time and money and that it is not every day that a man is fit
> either for the business of the field or closet. These things being laid before them, I
> refer the price of my labour to the Gentlemen concerned as I do not wish them to
> pay me in such a manner as may deter them from employing me afterwards and I
> trust they will do it so that I shall remain willing to serve them.[194]

He usually charged a guinea a day compared with Smeaton's normal charge from 1768
of five guineas when on site.

Besides the technical problems he encountered, Watt had difficulties in running the
labour force and hated the management tasks of dealing with wages and accounts. He
resolved in future only to undertake surveys, planning and write reports, not directly to
supervise the layout and physical execution of contracts. 'Nothing is more contrary to
my disposition', he wrote in September 1770, 'than bustling and bargaining with
mankind, yet that is the life I now constantly lead . . . I am also in a constant fear that
my want of experience may betray me into some scrape, or that I shall be imposed upon
by the workmen, both which I take all the care my nature allows to prevent.'[195]

Watt's surveying notebooks contain the odd elevation of a site with rough calculations
and thumbnail sketches of details. Yet, overwhelmingly they convey what a tough job it
was to survey in Scotland, particularly if, like Watt, you were prone to migraine attacks.
When the Annexed Estates Commissioners wanted a canal survey made up the vale of
Strathmore to Forfar, they approached Smeaton who in turn recommended William Keir,
Brindley or Mackell, who in turn recommended Watt. He found himself surveying in
indifferent health and terrible weather in the Grampian mountains, with snow a foot
thick in the valley even in May.[196] Another abortive scheme undertaken for the Com-
mission in 1771 was to compare and contrast two canal routes in Argyll, via Crinan or
Tarbert. He made plans, shading the upper land with parallel brushstrokes and grada-
tions of tone in the manner adopted on the Survey of Scotland, as well as meticulous
sections of the same territory. Great care was taken in laying them before the Board 'in
a proper dress' (fig. 35).[197] His efforts were rewarded for, on submitting his report in 1772,
he received high praise from George Clerk, secretary to the Commissioners:

> I have the pleasure to observe that these surveys appear to be extremely accurate, and
> that his manner of drawing and shading his plans communicates a very strong idea
> of the nature of the country and form of the hills through the interstices of which

the Canals are proposed to be conducted. His sections of these tracts are very usefully conceived and neatly executed.

Clerk approved of Watt's methodology, his estimates and his conclusion that the Crinan route was preferable: 'The reading Mr Watt's papers and considering his plans and sections has taken up a good deal of time but I esteem myself fully repaid for this loss by the entertainment and instruction I have received in reading and examining so masterly a performance which does great honour to the author and his country.'[198] Indeed, Watt was fully aware of the importance of clarity in reports and drawings, later advising his cousin with regard to the choice of career for her son:

> a civil engineer requires invention, discriminating judgement in mechanical matters, boldness of enterprise and perseverance, ability to explain his ideas clearly by words and drawing, a good constitution to bear fatigue and vexation, a knowledge of, and ability to treat with one part and govern with another part of mankind. With these qualifications joined to experience, a man may get a comfortable livelihood . . .[199]

The importance of drawings as the best means of describing a proposed scheme to a client, providing reassurance as to professional expertise as well as directions sufficiently detailed for execution, is again demonstrated when in 1773 Watt was asked to survey a canal for Charles MacDowall, who had leased the coal and salt works at Campbeltown on the Mull of Kintyre from the Duke of Argyll. His reports gave first an account of the variety of problems faced, secondly an outline remedy and thirdly instructions as to how to execute it. However, there were legal problems which caused delays and the canal was not finished until 1791. In August 1782 MacDowall wrote to Watt asking him for a complete drawing of the aqueduct bridge, to go with the estimates and directions he had sent six years earlier: 'It will require a full explanation, for I have no engineer but my own overseer. Hitherto it has gone on pretty well and without any undertaker . . . and I believe I shall be within your estimate, which indeed you gave me reason to expect.'[200] As Richard Hills comments, that the canal could be built from his instructions without a resident engineer reflected credit on Watt, as does the supposition that it could be completed within the estimates.

Like Smeaton, Watt was called on to make harbour improvements. In 1771, he tendered unsuccessfully, along with Smeaton and John Golborne, for the Ayr harbour scheme and in 1772–4 worked on the harbour and water supply of his native Greenock. After the Monkland Canal, his most important civil engineering project was Port Glasgow for which in 1771 he made a survey and recommended improvements, drew up estimates and checked the work when it was finished in 1773.[201] Watt's last task of civil engineering was a survey undertaken in 1773 for a Caledonian Canal to extend from Inverness to Fort William but he was called back from Fort William to Dumbarton where he learnt that his pregnant wife had died. Watt later wrote to his friend William Small, 'I had a miserable journey home, through the wildest country I ever saw, and the worst conducted roads: an incessant rain kept me for three days as wet as water could make me. I could hardly preserve my journal-book. Nothing supported me but whisky and rum which in those countries are drunk like water.'[202] Watt's assistant James Morrison completed the survey alone, still in constant rain; the project was revived in 1784 but nothing came of it, for Watt by this period was too heavily committed to steam.

By the 1770s there had emerged at least half a dozen men who were well known as consulting engineers and many others in regular employment as resident engineers and land surveyors engaged on canals, fen drainage, bridges and harbours. Given the social customs of the age, the formation of the Society of Civil Engineers in 1771 was a natural outcome and although it was primarily a dining club, nevertheless it affirmed the increas-

ingly professional cohesion of its members.[203] Their authority in the wider world was acknowledged in the use made of them by fellow professionals. Smeaton was asked to act as expert witness in water disputes which came to court. His opinion in the trial between Sir Martin Folkes and the Trustees of Wells harbour, who blamed Folkes's embankment for the harbour's silting up, resulted in the judgement of Lord Mansfield on 21 November 1782 endorsing the validity of Smeaton's opinion as science:

> It is objected that Mr Smeaton is going to speak, not as to facts, but as to opinion. That opinion, however, is deduced from facts which are not disputed . . . His opinion, deduced from all these facts, is, that, mathematically speaking, the bank may contribute to the mischief, but not sensibly. Mr Smeaton understands the construction of harbours, the cause of their destruction, and how remedied. In matters of science, no other witnesses can be called . . . I cannot believe that where the question is, whether a defect arises from a natural or an artificial cause, the opinions of men of science are not to be received . . . I have myself received the opinion of Mr Smeaton respecting mills, as a matter of science. The cause of the decay of the harbour is also a matter of science, and still more so, whether the removal of the bank can be beneficial. Of this, such men as Mr Smeaton alone can judge. Therefore we are of opinion that his judgement, formed on facts, was very proper evidence.[204]

The civil surveyors had travelled a hard path from producing 'neat ornaments' for lords of the manor to becoming civil engineers with a professional authority established in law.

From Civil Engineering to Mechanical Engineering

Even in the early decades of the eighteenth century, drawings served as a means of transmitting technical information on machinery from one end of the country to the other. John Spedding was Sir James Lowther's agent on his estates around Whitehaven, Cumberland, which were being exploited for coal. Since the pits were extremely near the sea and even extended under it, they were particularly prone to flooding.[205] On 5 October 1712, Spedding suggested to Lowther, then in London, that the atmospheric engine invented by the military engineer Thomas Savery and improved by the Dartmouth ironmonger Thomas Newcomen should be used to drain Bell Pit, a deep shaft at Howgill Colliery: 'Capt. Savery's invention is the only thing of that kind than can do us any service, of which you will be able to judge after you have seen some experiments of it.' Lowther seems to have taken his time to reach a decision for it was nearly three years later that Spedding acknowledged receipt of his letter 'with Mr Newcomen's proposals which is mighty cheap, to what it were possible to do it for with horses, and he has taken up the thing so well upon our first scheme that you can hardly disagree about things'. Spedding then went into technical detail about the different levels adding, 'The enclosed draft will in some measure explain this matter to you.' By 7 October 1715, he had evidently received drawings from Newcomen, for he wrote reassuringly to Lowther: 'the articles are drawn so very clear in every particular, that I cannot think of anything that is wanting to be explained, or . . . can be admit of disputes afterwards'. On 1 February 1716 he thanked Sir James for his letter 'enclosing the draught and directions of a house for the engine [for] which we shall be preparing stones and materials . . . the description is so very plain that I cannot think of any thing that wants to be explained'. In March the pumps were lowered to the bottom of the pit and the building of the engine house commenced.[206]

Further insight can be gained into the relationship between engine-maker, agent and client on the same estate some ten years later. On 1 January 1726, Sir James wrote to

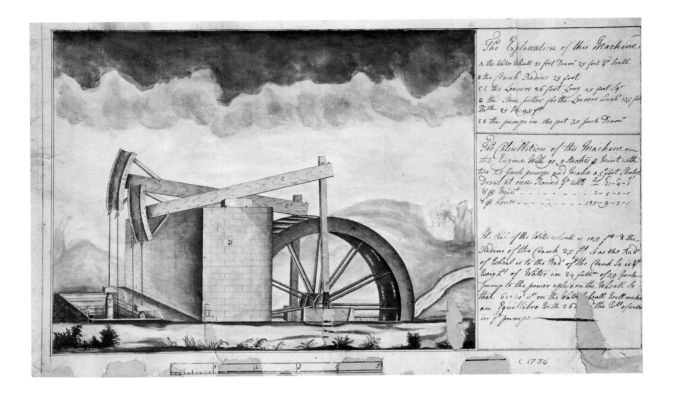

The Explanation of this Machine

A the Water wheall 21 feet Diam 25 feet ye boall
B the Crank Radius 25 feet
C C the Leavers 26 feet Long 15 feet Sqr
D the Stone piller for the Leavers Leigh 135 feet Brth 25 bй 9.5 ft
E E the pumps in the pit 7.5 Inch Diam

The Calcullation of this Machine

this Engine Will go. 9 Strokes p Minit with two 7.5 Inch pumps and make a 5 foot Stroke Draw'd at once Round ye wheel ——— 21-4-1
8 p Minit ——————————————— 3-5-0-0
p hour ——————————————— 185-9-3-1

The Rad of the Water wheall is 12.5 ft & the Radius of the Crank 25 ft Soe the Rad of wheal is to the Rad of the Crank So is ye Weight of Water in 24 fathm of 7.5 Inch Pumps to the power aplied on the Wheall So that 620.0 ℔ on the Water wheall Will make an Eguillibro with 26 ℔ the Cill of serts in ye pumps

C 1736

36 Robert Anise, machine to pump water from mines, c.1736. Fife Council Archive Centre, Rothes Papers

John Spedding about his brother Carlisle Spedding, who was Lowther's colliery steward, having trained in the Newcastle mines as a hewer: 'You may tell your brother I have this post [received his] draught of [an] engine to settle with Mr Newsham which I shall go about forthwith; to be sure it will take up time to settle any thing and a great while to get it round to Whitehaven [by ship] but the best way of dealing with Mr Newsham will be to give him an account of the water we shall want to raise and how high the per-pendicular and the length of the slope and so let him have some hand in the contrivance or at least improving your brother's draught.'[207] On this occasion it seems that Lowther placed more trust in the drawings of the outside engine specialist than his own employee. Local viewers in the Northumberland and Scottish coalfields also made suggestions for pumps and winding machinery in reports, supported with drawings of steam engines, waterwheels and windmills such as those made for the tenth Earl of Rothes's coal mine at Easter Strathore in Fife (fig. 36).[208]

Drawings were used to spread information about the latest machines. Henry Beighton was the first to publish, in 1717, an engraving of Newcomen's atmospheric fire- or steam engine, after his own drawing probably of Newcomen's second engine, constructed in 1711 at Griff on the Arbury estate in Warwickshire (fig. 37). Beighton's own interest was sufficiently stirred to develop an improved safety valve for the engines on which he became something of an authority, adapting them for use in the coal mines he leased round Newcastle upon Tyne as well as in Warwickshire.[209] Copies of the print served as the means of diffusing information about atmospheric steam engines across Europe. On an informal level, in 1767 the Coalbrookdale ironmaster Richard Reynolds enclosed a pen-and-ink sketch diagram with measurements and a key, but not drawn to scale, of Blakey's fire-engine (patent no. 848, 1766) in a letter to an 'Esteemed Friend' in Corn-wall: 'I have copied the drawing if it may be called such which he [Blakey] sent me, exactly and I hope it will be intelligible to thee though it is not done with any degree of exactness nor from a scale of even parts.' He went on to explain the different features and concluded, 'if thou would choose to know more of it I will procure thee a drawing

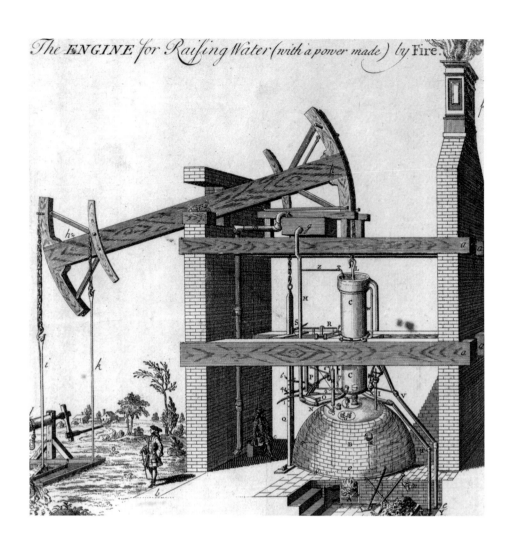

The ENGINE for Raising Water (with a power made) by Fire.

37 Henry Beighton, 'The Engine for Raising Water (with a power made) by Fire', 1717. Science Museum London

from him with a calculation of the size he thinks necessary but then I should know the depth of the mine and the quantity of the water to be raised in a given time'.[210]

By the second half of the eighteenth century, land surveys led inexorably to machine construction, as is apparent from John Grundy junior's surveys of drainage and navigation schemes. Detailed drawings for sluices and wharfing, brick or swing-bridges, were used as the basis for consultation with fellow engineers or instructions to craftsmen, for setting down measurements or keying into costs itemised in the reports (fig. 38). They also provided the basis for tenders: for instance, a plan and section of a Dutch-style water-mill, designed by Grundy for Laneham drainage, Nottinghamshire, around 1770, was sent to millwrights who were then checked 'as to their skill and practice in mechanics'; the job went to Henry Bennett, a Spalding carpenter and millwright.[211] Furthermore, drawings were used as records of the opinions (often conflicting) of interested parties, such as the unfinished plan of Magdalen Fen near Lynn Regis in Norfolk, dating from 1756, where the point at issue was whether the land was being flooded by the activity of two water-mills or through defective barrier banks.[212]

In style, Grundy's drawings combined both empirical and geometrical features, frequently making little or no distinction between an elevation or section and plan.[213] With some drawings, such as the one of a three-throw crank engine for raising water out of Bishop-Hall Well at Grimsthorpe, Lincolnshire, the plan joins up with the section (fig. 39).[214] In another, of the Dutch mill proposed for Laneham drainage, the walls are drawn in section with a projected brick base and the water in plan (fig. 40).[215] The drawings

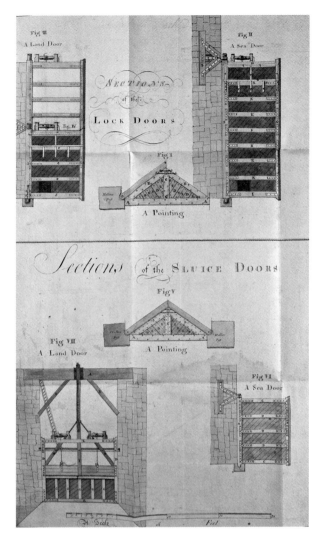

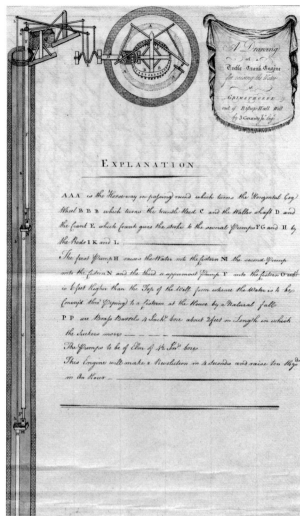

38 (left) John Grundy junior, 'Sections of the Lock Doors' and 'Sections of the Sluice Doors' for a Canal from Market Weight to the Humber, 1772. Leeds University Library, Brotherton Collection, MS SC12

39 (right) John Grundy junior, 'A Drawing of a Treble Crank Engine for raising the Water at Grimsthorpe out of Bishop-Hall Well', undated. Institution of Civil Engineers

are neatly coloured, the brickwork in pale red, the stonework in grey, the ground in beige and the water in short blue parallel strokes.

Like Grundy, John Smeaton made drawings of the engineering machinery required in his civil surveying projects – locks, weirs, flood-gates, swing- and drawbridges, tunnels and aqueducts – but his most impressive drawings are those relating to mills, driven by wind, water and steam. The usual arrangement was for Smeaton to examine the site and produce a report, using precise legal language with an estimate of costs and accompanied by a general design. Drawings for the different parts were made with the help of his assistants and dispatched to ironworks for manufacture. He left construction largely in the hands of a resident engineer, millwright, viewer or engine erector, assisted by local masons and carpenters, following up with one or two site visits during the progress of works and producing additional drawings for details as required.[216] Smeaton's draughtsmanship confirms, in particular, his mastery of engineering detail. The overall scheme was the main consideration yet its success depended on getting these details right. Sometimes they were left to the craftsmen on site but in many instances Smeaton provided these drawings too. A typical set of twelve to fifteen drawings comprised an overall plan of the site, a ground plan and section of the mill or engine-house, a plan, sections and elevations of the machinery overall, as well as particular sections of parts, especially if they were to be made of cast iron.

94

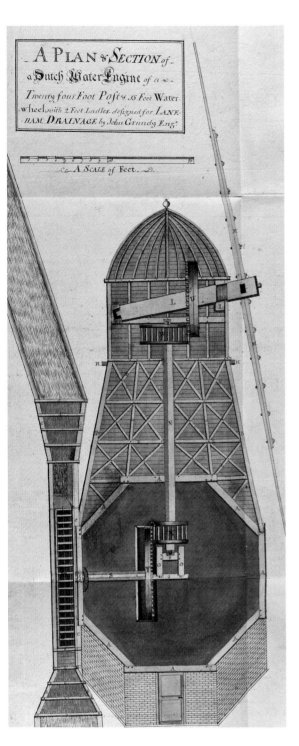

A PLAN & SECTION of a Dutch Water Engine of a

Twenty four Foot Post & 15 Feet Water wheel with 2 Feet Ladles. designed for LANE HAM DRAINAGE by John Grundy Engr

A SCALE of Feet.

40 John Grundy junior, 'A Plan & Section of a Dutch Water Engine...for Laneham Drainage', *c.*1770. Leeds University Library, Brotherton Collection, MS SCII

Smeaton's early drawings were heavily hatched and washed in different tones to give a sense of texture and depth to improve their legibility. The sectional elevation of a water-driven corn mill, executed for Sir Lionel Pilkington at Wakefield in 1754, included a drawing of the hirst or frame of the spur wheel 'pinned' on a rolled sheet to the elevation (fig. 41).[217] Such a picturesque *trompe-l'oeil* conceit, surely intended to captivate the gentrified owner, was not adopted on any other occasion, a sign perhaps of Smeaton's increasing confidence in the authority of his own chaste projective drawings, and later those of his assistants, to command attention on their own terms, as works of order and discipline, unencumbered by perspectival embellishment. Significantly, Smeaton often referred to Dutch books on mills and was familiar with them even before he toured the Low Countries in 1755.[218] His own plans and sections adopted the pattern of representation set by the Dutch, his use of hatching following the usual method for representing tone in engravings.

The Royal Society volumes track Smeaton's innovations in the field of windmills and water-mills, although it takes specialist historians of engineering to order and interpret them correctly.[219] The earliest drawing made for a windmill, to produce rape oil, again at Wakefield, executed for a Mr Roodhouse in 1754–5, is evidently the earliest working drawing of an English windmill, drawn to scale, that has come to light. It was also the first time that Smeaton used cast iron for the windshaft and also possibly for a spur pinion.[220] The drawings record further innovations which were subsequently adopted elsewhere: the first recorded five-sailed mill in England, for a flint (for china or pottery) mill at Leeds in 1774, and the first known representation of a fantail on a tower mill, Chimney Mill at Newcastle upon Tyne, the drawings for which are dated 1782 (fig. 42). Through Farey's engraved versions in Smeaton's *Reports*, *Pantologia* and Rees's *Cyclopaedia*, Chimney Mill became the archetypal image of a sectioned windmill.[221] Smeaton attained the upper limits of the windmill's evolution in the eighteenth century, before the steam engine took over as the prime mover for cheap energy.

Smeaton was responsible for nearly sixty water-mills, a reflection of the fact that eighteenth-century industry relied on water power far more than it did on wind or steam. He was also involved in planning and supervising modifications to existing mills and occasionally was asked to arbitrate in disputes. His earliest design for a water-mill was made in 1753 and the last in 1791. He used drawings as a means of mediating between his scientific investigations into improving the design and efficiency of waterwheels and their execution in the field. Smeaton firmly believed that there was a rational, numerical basis for design work. Writing to a client in 1786 to explain his objective of getting the maximum power possible out of a given quantity of water in dry seasons, he asserted that 'the construction of mills, as to their power, is not with me a matter of *opinion* it is a matter of *calculation*'. To assess a prospective site for a mill he needed to know the fall and quantity of available water and, through

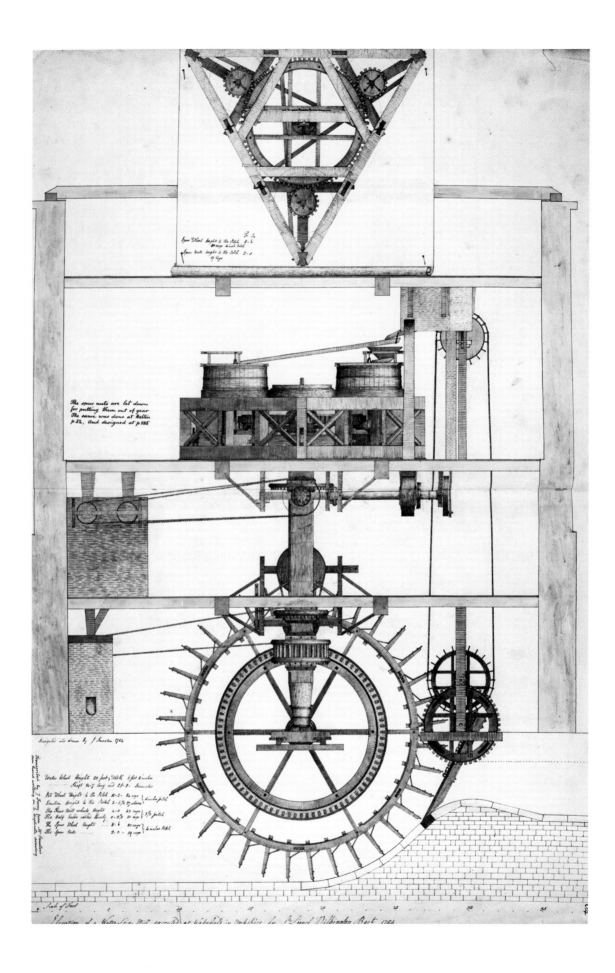

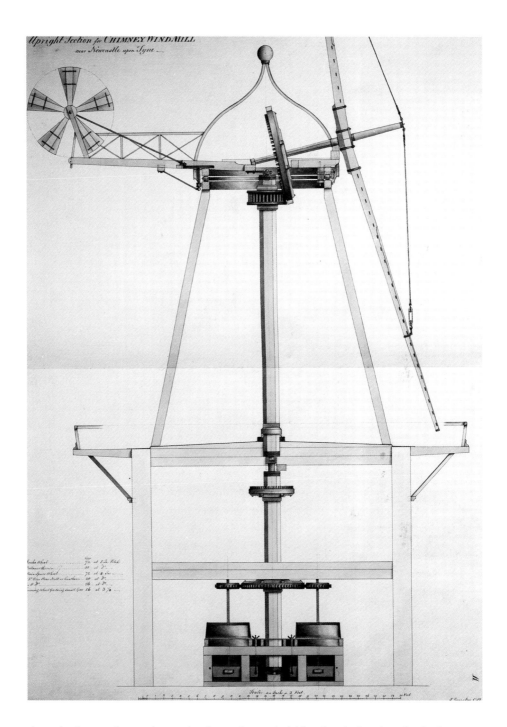

Upright Section for CHIMNEY WINDMILL
near Newcastle upon Tyne

the calculations he made on this basis, he settled 'the sketch for the wheel, the water trough, and the shuttle'.[222]

Nevertheless, he did not ignore the men who would carry out the scheme, making due allowance for their specialist skills. In a report to the owner of a fulling mill at Bocking, Essex, which required adaptation, he wrote:

in regard to the placing of the stocks, you must judge for yourself, and in regard to the thickness and strength of the parts, your millwright will, I doubt not, judge properly, but you must strictly adhere to the proportions I have given, because the performance depends upon it, and which done, you will find that the mill will not only go with much less water than it now does in dry seasons, but will also bear much more tail water in time of floods.[223]

97

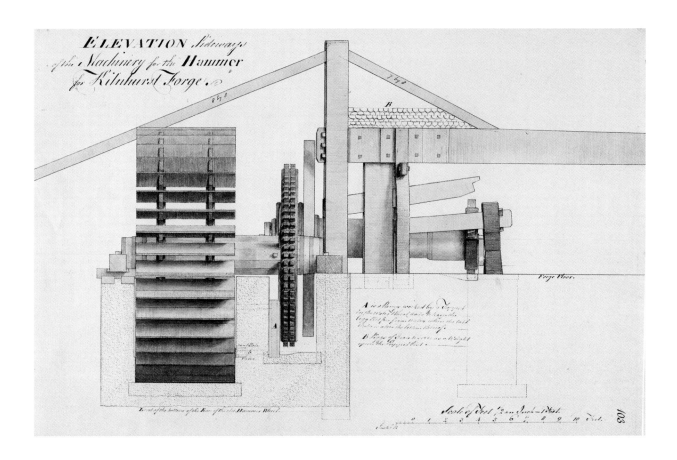

43 John Smeaton,
'Elevation Sideways of the
Machinery for the Hammer
for Kilnhurst Forge', 1765.
The Royal Society, Smeaton,
vol.2, f.103

Again, with regard to Kilnhurst Forge, a hammer mill constructed near Rotherham in 1765, he wrote: 'The rest of the machinery, being framing or harness for the hammer, is supposed to be subject to the corrections of the forge carpenter, and are only shown in the design to mark their relative places.'[224] Smeaton's drawings for the mill reveal the various stages in the evolution of the final design, starting with general plans of the forge and then plans and elevations for the waterwheel and machinery for the hammer (fig. 43). The collection also includes drawings for the harness made by John Cockshutt, the manager of the nearby Wortley Forge, with the different parts identified by name.[225]

Once Smeaton had become a consulting engineer to Carron Company's ironworks in Falkirk, he was able to experiment with and develop the use of cast-iron parts for machinery, one of his major contributions to mechanical engineering.[226] Orders for Carron came mainly through the recommendation of engineers. The Company itself disclaimed any specialised skill in design, or even construction off-site, and was dependent on drawings to be able to produce the parts: 'We are not engineers by profession. Our business is solely that of the founder, executing all kinds of machinery when we are furnished with drawings and dimensions but that of erecting engines by contract we never attempt.'[227] Smeaton acted as their intermediary and interpreter to the outside world. Between 1769 and 1789 he designed cast-iron axles for eight waterwheels, against the prevailing wisdom that they would break because they were so brittle, marking the end of an era of wooden waterwheel construction that had lasted for centuries.[228]

He was also responsible for the design of Carron's water-powered machinery which was beyond the capability of the average millwright, comprising the blast furnace, blowing engines, forge-hammers, rolling and slitting mills, edge-tool grinders and cylinder-boring machines. The last posed a particularly complex problem because of the unpredictable and intermittent nature of the load; in Smeaton's words, 'the circum-

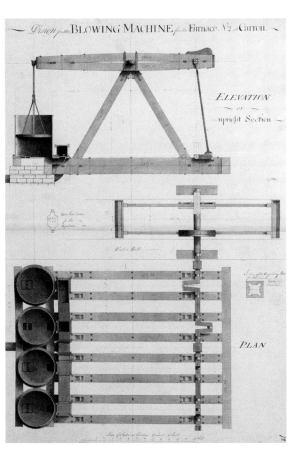

Design for the BLOWING MACHINE *for the* Furnace. N 2 *Carron.*

ELEVATION
~ or ~
upright Section

PLAN

44 John Smeaton, 'Design for the Blowing Machine for the Furnace N 2 at Carron', 1769. The Royal Society, Smeaton, vol.2, ff.71v-72

stances of the thing to be bored, that it is a matter that cannot be reduced to any exact calculation'.[229] Smeaton made observations on the performance of the different furnaces and the most efficient method of distributing the water among the four of them.[230] His mechanical improvements and innovations can be traced through drawings in the second Royal Society volume, relating to everything from dams to shot moulds and buckets (fig. 44). Smeaton worked with the resident engineer, George Mathews, but it seems that their collaboration was not always seamless. A note (added later by Farey) on the design for a leather collar for the cylindrical rods of No. 4 furnace, to make them airtight and reduce the friction, states that the blowing engine was 'Made under directions of Mr Geo. Mathews who had Mr Smeaton's plans [of] 1764 for guidance but did not follow them – either for machine No. 3 1766 or 4'. In the same report Smeaton also recommended that a fourth cylinder be added to No. 4 furnace but it still had only three cylinders in 1776.[231]

In his youth, Smeaton had become interested in the New-comen engine installed at a colliery close to the family home in Yorkshire: a sketch of a fire-engine of about 1741 appears to be the earliest drawing made by him in the Royal Society collection.[232] Late in the 1760s, perhaps prompted by the atmospheric engines he had encountered as one of the receivers of Greenwich Hospital's estates in Northumberland and Durham, he returned to work on the machine, constructing an experimental engine in his workshop and conducting systematic engine trials in the Newcastle area. Smeaton obtained performance data on Newcomen engines in use in the north of England and Cornwall, with their average lifting power per bushel of coal. He conducted 130 tests himself, which formed the basis for the improved performance of his steam engines, through the better proportioning of the working parts. Smeaton almost doubled the efficiency of steam engines but the power produced was still low due to the heat wasted through using the working cylinder also as a condenser. By 1771, Watt had confided in him his proposals for a separate condenser and Smeaton generously acknowledged the invention, later heading the proposal form for Watt's election to the Royal Society.[233] Yet, while helping to promote it in some localities, he anticipated correctly that the high capital cost together with the heavy premiums Watt proposed to charge for using his patent would delay or inhibit its acceptance in coalfields.

Drawings by Smeaton for atmospheric steam engines again helped to convert theory into practice. He still needed, of course, to take into consideration the topography of different sites. Thus in a letter dated 13 May 1777, asking Smeaton to erect a pumping engine at Great and Little Lumley Collieries, County Durham, on behalf of Lord Scarbrough, Edward Smith stated the quantity of water to be drawn in an hour and the depth to be drawn but also requested him 'to take a view of the ground, and to give his opinion in the manner it is desired to be done'.[234] The set of drawings produced for the engine at Prosperous Pit, Long Benton, Northumberland, in 1776–7 begin with a general plan encompassing the site where the machine was intended to be erected, the wagonway from it, the engine water course and the engine itself. A more detailed plan of the pit showed the rise of ground. There were also plans of the foundations for the water-gin used to draw coal and of the old steam engine used for draining the mine. These

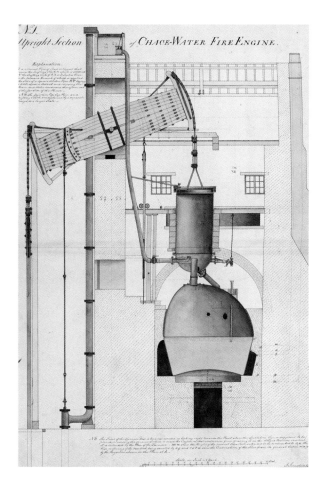

Upright Section of Chace-Water Fire Engine, with detailed engineering drawing

all provided the context for the elevation and plan of the new steam engine and designs for the cylinder bottom and piston, working-gear and pump (which bears a note on the reverse stating Carron Company's charge for the castings of £161 14s 8d), the water-gin, waterwheel, cast-iron shaft and an upright of the pit-head frame.[235]

Smeaton's most powerful engine was the massive 72-inch cylinder engine at Chacewater mine in Cornwall.[236] The drawings he made for it in 1774–5 are exemplary. The first is an upright section of the engine house, with an explanation, scale and measurements and dotted lines to represent the parts hidden from view (figs 45 and 46). Smeaton went out of his way to assist his client – in this instance the Yorkshire Copper Company and its new manager Thomas Wilson[237] – taking considerable care with the architectural form of the engine-house itself and bending over backwards to ensure that his drawing would be understood: 'The front of the furnace door is here represented as looking right towards the point where the spectator is supposed to be placed in viewing the general section to avoid the confusion that would arise from drawing it in the oblique position in which it is intended by the plan of the furnace.' The subsequent drawings gave some scope for decision-making on site. Thus he wrote on the plan of the engine-house: 'Another communication pipe might go off to a third boiler in a direction from L to M the corner N being occupied by the fire door.' Further

45 John Smeaton, 'Upright section of Chace-Water Fire Engine', 1775. The Royal Society, Smeaton, vol.3, part ii, ff.111v–112

explanations are given on drawing number eight for the regulator valve to the on-site erector: 'NB The space that may in setting the cylinder and boiler be left between the regulator and steam pipe may be filled with an iron or lead ring of the same thickness'. On drawing number eleven, of the outside and section of the wooden injection pipe, with a plan of the injection cap and section of the snifting clack, instructions were given even with regard to the type of wood to be used: 'box if not crabtree, holly, beach or other hard wood'.

Although individual drawings were made for each commission, Smeaton attempted a certain amount of standardisation. In a letter written from Austhorpe on 11 February 1775, he provides an explanation of the design for the working-gear for the Chacewater engine, 'with notes, whereby it may be adapted to an engine of any size down to a 24-inch cylinder': 'NB what is scored under in red ink being the parts to be altered should be therefore left blank, and those dotted under in red ink, in some cases may need alteration as by the notes thereon.' It was unnecessary to make a minute description of parts that were common – the cylinder, boiler, regulator and beam; they could be exactly measured and scaled up so that 'all the pieces will come together and do their respective offices without material alteration'. In the accompanying report he again observed: 'Once for all, that where I have given no particular directions, as I suppose myself addressing my designs to ingenious engineers, acquainted with the usual practice, I suppose the thing to be done in the usual way, or subjected to convenience and their discretion.'[238] In 1779, Smeaton based most of the designs for the engine at Middleton on those made for Dunmore Park the previous year.[239]

As was endorsed by the Secretary to the Annexed Estates Commissioners, James Watt was also extremely capable of explaining his ideas in words and drawings. While still

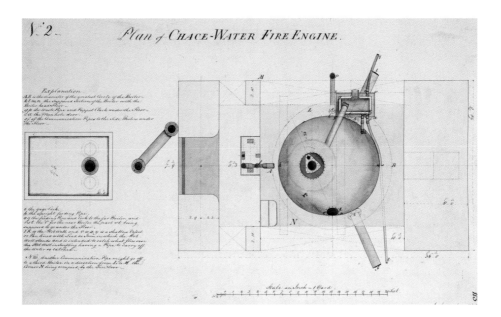

46 John Smeaton, 'Plan of Chace-Water Fire Engine', 1775. The Royal Society, Smeaton, vol.3, part ii, f.113

living in Scotland, Watt was involved – like Smeaton but on nothing like the same scale – with water-powered mills at Delftfield Pottery and assorted bleach fields and corn mills. In 1770, he was consulted on the water-pumping engine at Clunie Bridge coal mine, making drawings for it, although the millwright on site ignored his recommendations. The following year, when asked by Lord Cochrane about the potential for a tide mill at Culross, Watt used Smeaton's experiments to recommend against constructing one.[240] He also designed Newcomen engines, some in partnership with Mackell: an engine for Lord Kennet, near Clackmannan, and another for Carron Ironworks. The drawings and estimate he made in 1765–6 for Leadhills mines, Lanarkshire, show his willingness to adapt his designs and venture into new forms of construction. In this instance, by reducing the height of the boiler and hot well, he proposed to save on construction costs for a large engine-house, replacing the long level beam with a wheel.[241]

For the purposes of experimentation, Watt seems to have worked mainly on different scale models, making sketches of his designs in letters to trusted friends and supporters. The first relating to his own design for a steam engine occurs in a letter of 16 October 1765 to John Roebuck of the Carron ironworks, who was his original backer.[242] The earliest surviving sketch of his double condenser and air pump is dated 10 May 1768 (fig. 47).[243] Six months later, Watt proposed to his friend William Small to make drawings to accompany his patent specification, fearing it would be rejected if 'the specification was not clear enough to enable other people to execute the schemes'.[244] But Small and Matthew Boulton both agreed that Watt 'should neither give drawings nor descriptions of any particular machinery'. Small went on to suggest a suitable form of

47 (below) James Watt, sketch of double condenser and pump in a letter to John Roebuck, 10 May 1768. Birmingham Archives and Heritage, MS 3219/4/58

specification concentrating on the principles alone: 'I am certain that, from such a specification as I have written, any skilful mechanic may make your engines, although it wants correction; and you are certainly not obliged to teach every blockhead in the nation to construct masterly engines.'[245] It nevertheless proved extremely difficult for even Watt to put his principles into practice and build a successful full-scale condensing engine. The accurate boring of the cylinder was crucial and it was only in April 1775 when John Wilkinson sent a cylinder bored on his new machine, facilitating a tighter seal between the cylinder and piston, that the engine worked.[246]

The Boulton & Watt partnership faced further problems in developing and coordinating their overall production system. Drawings again played a vital role in the process. Instead of incurring a large capital outlay by manufacturing the engines themselves at Boulton's Soho headquarters on the outskirts of Birmingham, they chose the manufacturer-suppliers and gave them the designs drawn to Watt's specifications. The buyers of the engines paid the bills not only of the engine parts but also the wages of the engineers, millwrights, smiths and carpenters who put them together. General confirmation of the importance of the drawings was confirmed, albeit in a backhanded manner, when in the summer of 1776 a group of Cornish copper mining managers visited Soho, after which Watt discovered that a key drawing was missing. Boulton wrote angrily to Thomas Ennis of Redruth who had led the group: 'We do not keep a school to teach fire-engine making, but profess the making of them ourselves.' The drawing was returned, having been taken 'under a misapprehension' by Richard Trevithick senior.[247] The Boulton & Watt archive, conserved by Birmingham Archives and Heritage, now contains approximately 36,000 engine drawings in 1382 numbered portfolios, providing ample testimony of their importance for the firm.

The first two orders received by the new Boulton & Watt partnership were for a steam engine with a 38-inch cylinder for Wilkinson's own furnaces at New Willey, Shropshire, and another with a 50-inch cylinder for a pumping-engine at Bloomfield Colliery, near Tipton, Staffordshire. Both cylinders were bored and cast by Wilkinson but the pioneering process of their manufacture did not run smoothly. Smaller parts took more time, especially when the parts were novel, and this factor was not allowed for in the order in which the drawings were sent to the manufacturer. The engine commissioned for Hawkesbury Colliery, Bedworth, near Coventry, the largest the firm had taken on hitherto, with a 58-inch cylinder, caused endless problems. On 26 May 1776 Watt made meticulous drawings of some of the parts with detailed notes on variations on the 'common form' of the condenser for Wilkinson to follow.[248] By 9 August, Wilkinson was complaining mildly to Watt:

> Had all the order been given at once the whole would have been up together with the cylinder. In future I wish to have orders for all together – a cylinder is the soonest got ready – the small articles for which instructions have been last sent take up most time. But in these matters a little more practice will put every department in a more expeditious mode.

On 23 November, he wrote in less conciliatory vein: 'I observe your complaints of Bedworth condensers. I own they were not so complete as they should be but the constant hurry we were in over 'em owing to Mr Bolton's writing for 'em almost as soon as you sent us the drawings did not leave us room to execute 'em properly.'[249] Watt went over to Bedworth on several occasions between January and March 1777 to supervise the erection of the engine which started working on 10 March. However, by April the packing of the novel condenser joints had given way; then the martingale of the lower regulator broke; next the top pump-rod broke off, causing all the rods to collapse. In July 1778, new valves, nozzles and working-gear were supplied.

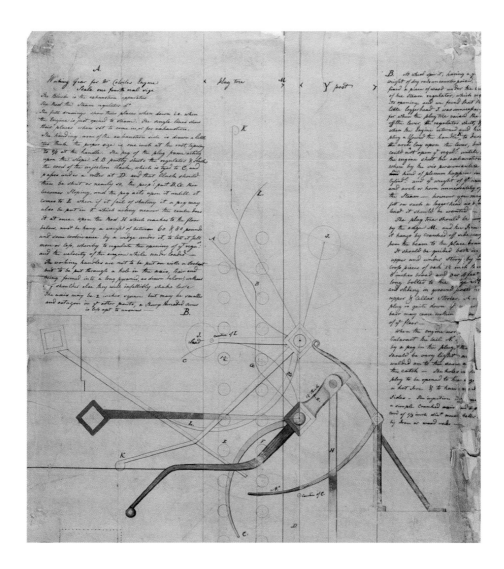

48 James Watt, 'Working Gear for Mr Coleviles Engine', 1776. Birmingham Heritage and Archives, MS 3147/5/624

There was a steep learning curve between the drawn design and its successful execution. Watt's own account of the erection he oversaw of an engine for pumping brine at the Lawton salt works, Thirlewood, Cheshire, in 1778 is full of references to chiselling and cutting, unsoldering and resoldering, remaking and overhauling in order to get it to work.[250] As he complained ruefully to Smeaton, it proved extremely difficult to find skilled men to 'put engines together according to plan as clockmakers do clocks [in other words, through batch production methods] . . . partly owing to the inaccuracy with which they have been used to proceed and partly to their prejudices against anything new'.[251] Nevertheless, like Smeaton, Watt bent over backwards to clarify the operation of novel parts through his draughting skills and by writing detailed notes on the designs.

The drawings he made in 1776 for Peter Coleville's engine at Torryburn, near Dumfermline, Fifeshire, make the point.[252] They include the standard sections and plans of floors of the engine-house and the engine itself, as well as of particular parts. The most complicated drawing is of the working-gear, drawn on a quarter life-size scale (fig. 48). Watt differentiated between the 'exhaustion apparatus' (exhaust-valve gear), which he coloured black, and the 'steam regulator apparatus' (equilibrium-valve gear), which was red. Furthermore, he showed the valves in both positions on the same sheet: in the foreground, so to speak, 'the full drawings show their places when down i.e. when the engine is just opened to steam' (on the up-stroke of the piston). The fainter single lines 'show

their places when set to come in, or for exhaustion'. His text corrected any visual errors: 'The handing arm of the exhaustion size is drawn a little too thick the proper size is one inch at the root, tapering to ⅜ at the handle.' There followed a detailed description of the working process, tied into the letters on the parts. Yet changes still needed to be made during the course of manufacture and erection.[253]

By 1777, three engines were under erection in Cornish copper mines. Despite the expense of transporting the coal needed to power them, it was hoped their efficiency and capacity to drain mines would help increase output to compete with the rich copper mountain of Parys in Anglesey. The first to be completed was Wheal Busy (or Wheal Spirit) mine, Chacewater, which had a 30-inch cylinder and was ordered by the manager, Thomas Wilson, to replace Smeaton's massive 72-inch atmospheric engine, which was not draining the mine sufficiently and cost a fortune to run. The first order actually received was from Tingtang mines near Redruth for an engine with a 52-inch cylinder, constructed under the supervision of Jonathan Hornblower senior; the third 63-inch cylinder engine was erected at Tregurtha Downs, Marazion. Working in Cornwall, Watt again gave detailed instructions on drawings for novel parts. For example, on a 1780 drawing of a nozzle for the engine of the Poldice Eastern mine, he noted: 'The exhaustion regulator is to be of a new construction, instead of being a flat disk it is to be a hollow cylinder of good yellow brass turned very true on the inside, the outside not requiring so much accuracy.'[254]

As early as 1778, a system had been developed for processing orders. Printed lists were made specifying parts belonging to the cylinder, working-beam, condenser and boiler, against which Watt itemised in script the manufacturer (sometimes just by initial), variations on standard measurements and odd sketches.[255] Printed proposals were made for potential customers, specifying the terms and conditions of the licence, and in 1779 a handbook of 'Directions for erecting and working the newly-invented steam engines by Boulton & Watt' was printed and distributed to private clients. It consisted of four sections, the first comprising general directions for building the engine-house, the second for putting the engine together, the third for working the engine and the fourth additional directions, complete with six plates.[256] In the early years, on receipt of an order, Watt himself assessed the customer's technical requirements and produced the design drawings for an appropriate engine. Working out of an office at home in Harper's Hill, he was assisted from 1778 until 1781 by William Playfair, who proved unsatisfactory. His replacement, John Southern, initially impressed Boulton on account of being good-humoured, obliging and drawing 'tolerably neat'. He stayed a loyal employee and became a partner in the business until his death in 1815.

Like Smeaton, Watt sent a set of drawings to the client and kept copies in the firm. The former 'full drawings' were shaded and coloured to aid their interpretation, the brick-work and the graining of the wooden parts marked in, and the curve of the iron boilers, pumps and cisterns carefully shaded (fig. 49).[257] Frequently, the parts and framework were not only measured but, helpfully, identified by name.[258] Many are inscribed on the reverse: 'This drawing is the property of Boulton & Watt, who beg that it may be kept clean, not permitted to be copied, and returned to them as soon as the engine is finished', but judging from the patchy contents of many portfolios, it appears that this injunction was not always followed. The purpose of retaining the drawings was ostensibly to protect Boulton & Watt's patents but probably the intention was also practical, for the drawings could serve as general sources of information to develop products and train staff; they were an essential point of departure for further work on the same engine, for other engines in the same location or even for the transfer of the engine to another spot. Thus the engine made in 1796 for J. R. Pease, a Hull oil manufacturer, was bought in 1803 by John Rennie for the East India Dock, Blackwall, and the engine drawings were copied 'for Mr Rennie'.[259]

49 Boulton & Watt, 'General View of the Engine & Section of the Boiler' for Benjamin and William Sandford, Manchester, 1796. Birmingham Archives and Heritage, MS 3147/5/132

General View of the Engine & section of the Boiler. Mess.rs B.d W. Sandford.

⅓ Inch to the foot.

2.d May 1796.

Feed apparatus

Ash pit.

Ground Plan of the Engine and Boilers.

Fly wheel

well

window

Door

Plan of the Steam
Boiler Seating.

The pure line drawings of the second copy predominate in the archive, giving a possibly exaggerated impression of the rise of austere machine drawing over the more informal, colourful and personal methods of draughting used in earlier decades. Around 1780 Watt devised a method of making 'reverse drawings' or press copies of the originals using a type of gelatinous ink, which increased their utilitarian appearance.[260] Even Smeaton was impressed, although he himself found it difficult to achieve successful results using Watt's technique. In a letter to Watt of 23 April 1783, he wrote apropos the trial he had made on his Austhorpe press of copying drawings in reverse, using the method and ink that Watt had showed him in Birmingham: 'I succeeded tolerably; but nothing equal in point of distinctness to the sample done with you.' Smeaton puzzled over the paleness of the ink and the broken detached character of the line, asking Watt:

> Can anything be done to blacken the ink? Did I wet or use the wrong side of the [Whatman] paper? Is the fault greater to take the impression too soon after the glare of the lines begins to appear, or to wait too long? Was it a wrong kind of paper? I remember something about Voltaire paper. Upon the whole I should have thought I had done pretty well, and satisfactorily, had I not seen you do much better, as the copy can be repaired and washed up equally with the original.[261]

To install engines and other machines in the confined space of factories presented as great a challenge for the entrepreneur as for Boulton & Watt. It was a chicken-and-egg situation requiring the successful coordination of engineering and surveying skills. The owner had to make decisions over the choice of site, the design and layout of the building, the type of machinery to be installed and management of its construction, the methods of lighting and heating, the type and output of the power system and its application to best effect. Frequently he did not start with a tabula rasa but attempted to adapt buildings already in existence. The drawings in the Boulton & Watt archive help to explain how the process of getting the infrastructure right was first attempted, mediating between the particular nature of the site and the principles of engine manufacture which the company had to convert into working practice. An entrepreneur's millwright or engineer would prepare plans, sections and elevations of the factories which would then be lent to Boulton & Watt to seek their advice on the size and position of the engine. As these drawings were often not returned, those that remain in the Birmingham archive provide evidence of the type of factory buildings that were being developed, as well as the negotiations involved in ensuring their plant functioned efficiently.[262]

In 1784, for example, the plans and elevations of Whitbread's brewery in Chiswell Street, London, were supplied, as the insertion of a 20 hp rotative engine necessitated the removal of an entire first floor in one building and affected others.[263] Three years later, also in London, Gifford's brewery in Castle Street, Long Acre, decided to remove the old malt lofts, to rearrange two coppers and the mash tun (or fermenting vat) and to set the mills against the engine-house:

> Agreeable to these intentions we sent you four plans and sections taken by Mr Cooper – No. 1 a *proposed* ground plan of the disposition of the several utensils and erections. No. 2 a section of the mill loft elevated agreeable to the situation of the mills as laid down on the Plan No. 1. No. 3 section of the two remaining horse wheels. No. 4 the approved ground plan of the disposition of the several utensils and erections with the mills thrown farther from the engine house, which as well for the convenience of occupying the space between them and the engine . . . for a hop loft, as for other considerations we have ultimately determined to adopt. In consequence of this, the mills being farther removed from the tuns, Mr Cooper says the section No. 2 must have

an elevation three feet higher . . . By this plan our engine house will be only of a cus-
tomary height . . . and the arrangement of our utensils made much more convenient.

Gifford's asked Boulton & Watt for their observations on the whole 'suggesting to us
such alterations as may improve the design; or whether it meets your approbation in its
present shape; if so we request your giving immediate directions for forwarding the
engine'.[264]

That drawings were crucial in planning the location of machines in a factory is further
demonstrated in correspondence of 1783–4 between the architect Samuel Wyatt and
Boulton & Watt and their newly hired engineer, the young John Rennie, about the con-
struction of Albion Mills, Blackfriars, the largest corn mills ever built in London.[265]
While Wyatt made the site surveys, followed by plans, elevations and sections of the
mill itself, Watt made drawings for the rotative engine. Over succeeding months as the
mill walls were rising, in order to plan the general assembly of the engine, the shafting,
millstones and other machinery, Wyatt sent Watt a section of the mill with the heights
of the storeys drawn to scale, as well as details of the organisation of the mill itself. These
drawings show the adjustments Wyatt made to his original plans, proposing to move
the stones to the third floor to allow the millers to work on the floor below because he
realised that the engine, millworks and boiler would make the first floor 'dark and
unpleasant'.

A Liverpool ironfounder and millwright, Henry Gardner, was especially diligent in
corresponding with John Southern over the erection of engines. On 26 July 1789 he sent
him a line and 'a bit of a sketch' relating to the framework for an engine he was erecting
for the British Cast Plate Glass Company at Ravenhead, near Prescot: 'now as I wish to
have every part of the frame exactly right and to your directions I find something not
quite clear in this [Southern's own sketch] so request you will immediately make a drawing
of that part of the frame exact as it is to be and can be going on with the other parts'.
Not that Gardner was wholly subservient to Boulton & Watt's instructions. In the same
letter he said he had yet to determine whether to construct the crank according to the
form Southern had proposed or 'as the sketch below with a flat at the top end of the
spindle part'.[266] In 1798 he was writing to the firm with regard to Ridgway's bleachery at
Wallsuches near Bolton, enclosing a sketch drawn to scale of the 'Gingam [gingham?]
house and wheel and the situation where the engine will be fixed . . . Mr Ridgway by his
letter is determined to have a new engine of 10 horse power, and the sooner you can send
me the drawings for the framing the better I can get forward with them'.[267]

The millwrights, agents and entrepreneurs on the spot drew attention to their own
needs. For example, a ground-plan of the outbuildings of the Manchester factory belong-
ing to Robert Owen, Jonathan Scarth and Richard Moulson is marked, 'The boiler
house is not placed central with the engine house that the counting house lights may
not be injured.'[268] William Horrocks wrote from Stockport on 20 February 1797 annex-
ing a plan of the end of the engine-house which corrected the position of a doorway
and the bottom of the flues, as placed on the drawing received from Boulton & Watt.[269]
One observant client, John Brockless of Sulgrave flourmill near Banbury, pointed out
the mistaken interpretation of Watt's instructions by the firm's draughtsmen:

I having received the drawings of the different views of the engine. It appears that
the boiler is placed close to the end of the cistern which is a situation that Mr Watt
in particular objected to on an account that the heat of the brick work would dry the
same and cause a leakage of the water. I have therefore provided against that, and
proposed the place for the boiler at the other corner of the building, as you will see
from below . . .[270]

Yet, other commissions could be extremely fluid, one of Southern's notes attached to a rough sketch dated 14 August 1797 stating: 'The present ordered engine is intended to be erected at the south *end* of the mill (which mill is yet to erect) if he [Mr Hope, a Stockport hatmaker and cotton mill owner] can purchase the piece of ground there – if he cannot the engine must be erected at the east side of the house.'[271]

Sometimes, the millwright on site asked Boulton & Watt to mediate with the owners as the firm evidently had more clout. A 1791 elevation of the intended millwork for Messrs Goodwin, Platt, Goodwin's dye-house is inscribed:

N.B. since drawing of this, Mr Goodwin says he should not like to have any part of the machinery go above 2 or 3 feet below the ground, on account of water; this will bring the intended floor so high, as to have little room for the millwork between it and the floor G [on the plan]. I would therefore advise you therefore recommend it to Mr Goodwin to make a complete new building which I am sure will cost him little more than the reparations and additions that will be required to this and will render the whole much more complete – and as the present building is entirely of wood it will turn out to advantage in constructing the new building.[272]

The standard of draughtsmanship on the information received varied from the fine detailed drawings of John Sutcliffe, a Halifax millwright, to rough sketch plans. Sutcliffe was engaged by two of the largest cloth manufacturers in the district, Fountaine and Gott, and Markland, Cookson and Fawcett (fig. 50). In preparing two sets of plans for a new Gott factory he wrote: 'The reason why so much time was spent upon them was because Mr Gott desired they might be drawn two or three times over that no improvements may be omitted. I told Mr Gott that I had spent near 7 weeks in drawing the plans.' Gott sent Sutcliffe to London to examine the different kinds of steam engine then in use and to visit factories. When Sutcliffe sent his charges to Gott of £162 13s at the end of 1792 he felt obliged to defend them:

I believe there be few engineers perhaps none but myself in the same situation but what would have charged from £30 to £40 for the design of the plans, over and above the time spent in drawing them. This Mr Wyate [Wyatt] of London and Mr Car [Carr] of York have always done. If I did myself justice in this charge the sum ought to be three times as much as I have set down for it.

Sutcliffe, in his own bid for professional recognition with commensurate fees, was comparing himself to well known architects. Gott called in John Rennie as a professional assessor and he deemed the drawing charges excessive. Sutcliffe resigned in a huff when a Boulton & Watt engine was selected rather than his choice of a common rotary engine.[273]

Boulton & Watt tried to overcome the country's shortage of technical knowledge and skilled engineers by sending their own men to construct the engine itself on site. They also sent written instructions for repairs on the boilers, due to the variable quality of the wrought-iron plates, as well as the sun- and planet-gearing system of the rotative motion steam engines, while entrepreneurs often underestimated the amount of power required. The firm attempted to produce as much as possible in prefabricated form in an effort to lessen the danger of parts being ruined on site through clumsy or over-confident fitters. Thus a 1786 drawing of the working-gear of an engine constructed for Felix Calvert's brewery in Upper Thames Street, London, is sternly inscribed: 'N.B. All the working gear was fitted together and adjusted to the proper lengths and angles at Soho, and must not be altered but the plug frame to suit it as by this drawing.'[274] On 8 June 1790, John Southern cautioned Edward Eardley, Sir Nigel Boyer's agent, with reference to the winding engine for Apedale Colliery in Staffordshire: 'On the other page we send

50 John Sutcliffe, elevation of Messrs Markland, Cookson and Fawcett's spinning mill, Leeds, 1791. Birmingham Archives and Heritage, MS 3147/5/91

you a drawing of your damper and frame to regulate the draught of the fire; if your people do not understand it we wish it to remain till the engineer comes to put up the engine.'[275] Sometimes, however, acknowledgement was made on the drawings that their own standards of draughtsmanship were at fault. The plans made in May 1792 of the engine, boiler and parts for Strutt & Sons' new fireproof mill at Derby were annotated: 'N.B. The boilers are drawn too long, but are figured right.'[276]

It was impossible to achieve total organisational efficiency in this period of industrial development. As Wilkinson had discovered early on, if drawings for parts were not dispatched all together, synchronisation at the subcontractor's manufactory was virtually impossible. Direct employees encountered similar problems, even after the opening of Soho's own foundry in 1795. The Creighton brothers, William and Henry, were first employed by Watt as assistants at Soho; they rose to become superintending engineers whose major role was to supply estimates, supervise the erection of engines, answer technical queries, recommend the position and layout of the engine-house and, on occasion, to collect payment.[277] William was sent to superintend the erection of engines in Scotland but returned to become head of the drawings and design office at Soho. Henry replaced his brother in Scotland but by 1815 was travelling regularly to Manchester to supervise the installation of machines there. Both were widely read in the arts and sciences and regarded their employers with a sardonic eye, referring to Soho as 'Pandemonium', Manchester as 'Mud City' and the owners and senior employees as satans and devils.

The general air of disorganisation and last-minute fire-fighting is captured in Henry's letters from Manchester:

Be it known to somebody by these presents, that the great Mr Geo Murray is in a great rage at a great Satan for neglecting to send a Plan and Elevation of a certain 'thing' or things called a Mill & Engine house which drawing he the said GM and his workmen are in great want of – the front & ends of the building are not at 1½ storeys high but the back side is not begun for want of the said d[rawing]s.

The design office at Soho was not running smoothly: 'Most drawings of parts are wrong for all engines', William wrote to Henry from Soho, 'unless the said drawings are made after . . . have tried to scrape some dr[awing]s into shape but 'tis a vile job and temporary joins exist in abundance in the press copy way, and will take the d[evi]l and diverse Hangels [angels] to put into legitimate form.'[278]

While the Boulton & Watt archive remains the largest repository of eighteenth-century engineering drawings in Britain, by 1800 many drawings were being retained by the firm's clients and by other manufacturers. The replacement of the old atmospheric steam engines by those of the Boulton & Watt type can be tracked in the records kept by Northumberland coal viewers.[279] In Cumbria Record Office the Lowther archive contains engineering drawings in portfolios dating from about 1800 onwards, many by the colliery engineer Taylor Swainson. He was employed by the colliery agents John Bateman (who took over from John Spedding's son James in 1781) and his successor from 1811, John Peile, who sank an increasing number of ever deeper pits with levels driven out under the sea to intersect with the main band.[280] The drawings include ground-plans and sections of pumping and winding engines, saw mills and foundries, details of parts and equipment such as capstans and wagons, as well as sectional views of the coal strata.[281] They also reveal that Swainson undertook the design of domestic ironwork on behalf of the Lowthers, such as railings, trusses for the roof of a conservatory, a cast-iron lamp-post for Castle Lawn and even a wicket-gate for the library. The relatively small world of engineering is demonstrated by the presence in the archive of a drawing for a cast-iron steam engine boiler, sent in 1817 by Mr Buddle of Newcastle.[282]

Four large-scale plans and sections of Collycroft worsted mill dating from 1791 survive in the Newdigate archive in Warwickshire Record Office, the work of a French émigré artist, L. Lequesne (fig. 51).[283] Having developed a private canal system and revived coal mining on his estate, in 1788 Sir Roger Newdigate sought to exploit his water power by granting a succession of leases on the mills he constructed at Bedworth, most of which seem to have ended badly. Yet Lequesne's drawings give no hint that anything was amiss.

51 (below and facing page top, bottom) L. Lesquesne, cross section, end section and plan of Collycroft worsted mill, Bedworth, 1791. Warwickshire County Record Office, CR 136/V64-6 .

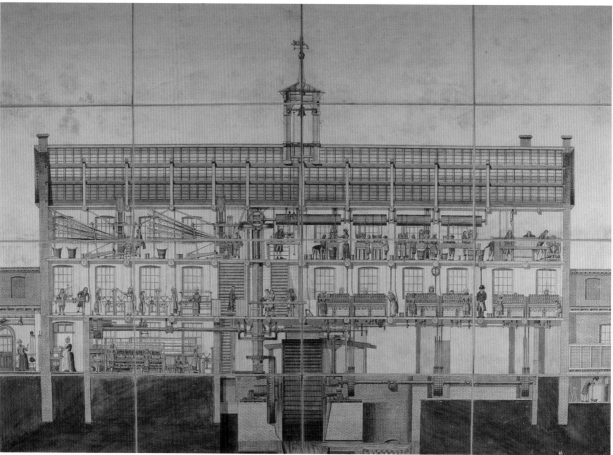

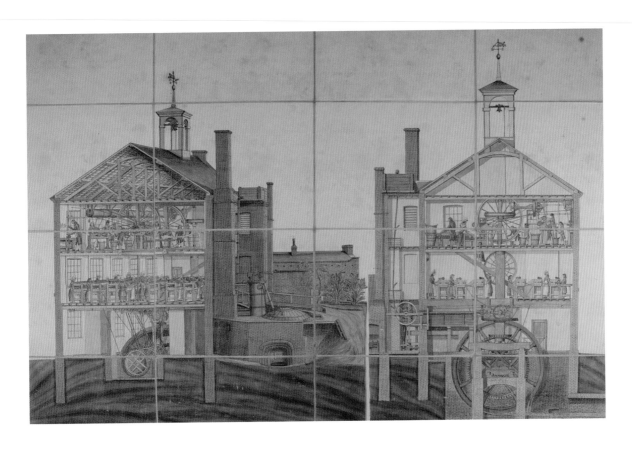

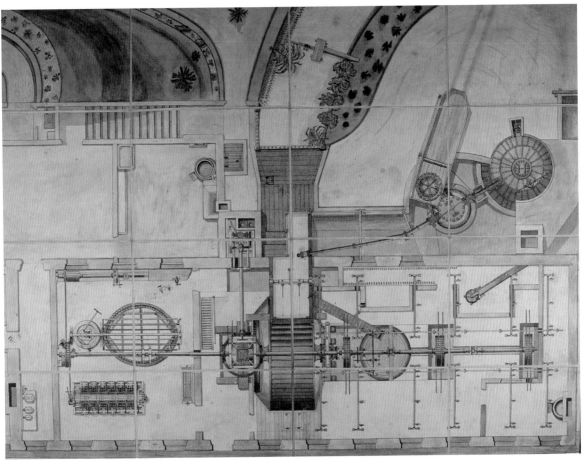

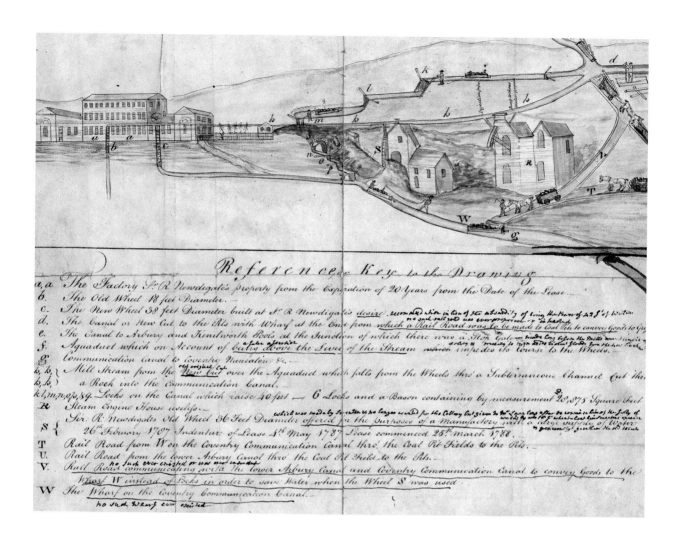

Reference Key to the Drawing

a,a The Factory Sr. R. Newdigate's property from the Expiration of 20 Years from the Date of the Lease
b. The Old Wheel 18 feet Diameter.
c. The New Wheel 38 feet Diameter built at Sr. R. Newdigate's desire...
d. The Canal or New Cut to the Pits with Wharf at the End from which a Rail Road was to be made to Coal Pits to convey Goods to...
e. The Canal to Arbury and Kenilworth Pools at the Junction of which there was a Stop Gate...
f. Aquaduct which on Account of being above the Level of the Stream which impedes its course to the Wheels
g. Communication Canal to Coventry Nuneaton &c
h,h, Mill Stream from the New Cut over the Aquaduct which falls from the Wheels thro' a Subterraneous Channel Cut thr...
h,h, a Rock into the Communication Canal.
k,l,m,n,o,p,s,9. Locks on the Canal which raise 40 feet — 6 Locks and a Bason containing by measurement 28,875 Square Feet
R Steam Engine House useless.
S{ Sir. R. Newdigate's Old Wheel 36 feet Diameter offered for the purposes of a Manufactory...
26th February 1787 Indenture of Lease 4th May 1787 Lease commenced 25th March 1788.
T Rail Road from W on the Coventry Communication Canal thro' the Coal Pit Fields to the Pits.
U. Rail Road from the lower Arbury Canal thro' the Coal Pit Fields to the Pits.
V. Rail Road communicating with the lower Arbury Canal and Coventry Communication Canal to convey Goods to the Wharf W instead of Locks in order to save Water when the Wheel S was used.
W The Wharf on the Coventry Communication Canal.

52 Attributed to Henry Lane, panorama of Collycroft mill, Bedworth, 1803. Warwickshire County Record Office, CR 136/M24

Instead, they stress the rationality of the design of the handsome brick building. Its haystack boiler is encased in neat brickwork and a steam engine feeds the reservoir for the eighteen-foot-high breast waterwheel which powered the spinning looms on the ground and first floor, with the weaving looms and fulling machines above them on the second floor. Order and regularity were presumably maintained through the central bell-tower and the clock prominently placed on the wall on the first floor. Unusually for engineering drawings of this date, small figures of men, mop-capped women and children are depicted at work in the mill under the watchful eyes of an overseer.[284] It is hard to know what purpose these drawings can have served other than to boost the claims of the landowner to be a man of enlightenment, commissioning work from a foreigner who happened to be passing through and who possessed skills which commended themselves to patronage.

In the same collection, the purpose of a panoramic drawing of the mill, the water supply from the Coventry Communication Canal with barges transporting coal from the adjacent mine, its engine-houses and railroads, is more obvious.[285] The worsted spinner Henry Lane, to whom a lease of twenty-one years on the mill had been granted in 1789, started litigation in 1803 over the water supply, which he pursued even after Newdigate's death in 1806. Evidently, Sir Roger had given Lane a second 36-foot water-wheel, made by Smeaton, which was no longer needed at his colliery but, once installed, it became apparent that the water supply at the mill was not sufficient to turn it. This drawing was made by or for Lane in pursuance of his claim. The reference key is copi-

No 2.

Plan of Framing to the Plate.

53 William Reynolds and Thomas Telford, 'Plan of Framing to the Plate' for a canal aqueduct, undated. Science Museum Library and Archives, Science Museum, Swindon, Reynolds, 117

ously corrected by Sir Roger with the sentiments 'absolutely false' and 'strangely confused'. Notwithstanding, the Lord Chancellor awarded Lane the essentials of his case (fig. 52).[286]

Engineering drawings also survive in the archives of ironmasters. William Reynolds (1758–1803), the master of Ketley Ironworks, Shropshire, accumulated a series of thirty manuscript volumes 'beautifully written and containing suggestions, inventions and drawings, but chiefly copies from the transactions of the Royal Society and other sources'.[287] These have disappeared but a single scrapbook survives, the contents of which are now deposited in the Science Museum Library and Archives.[288] Dating mainly from the 1790s, they range over Reynolds's spheres of activity, encompassing designs for steam engines, particularly those intended to give rotative motion for winding from pits; the manufacture of iron; methods of winning coal; excavating plant for canals, as well as bridges and viaducts. The drawings come in all shapes and forms on a wide variety of papers – some folded as if communicated by letter, some as pages from sketchbooks, some printed and others large finished drawings. Collectively they suggest a frenzy of inventive activity in the last decades of the eighteenth century, much of it subsequently more or less forgotten, steamrolled out of existence by the Boulton & Watt promotional machine.

Reynolds was the first to build, in 1788, a successful inclined plane on the private Ketley Canal to take the place of locks, so it is not surprising to find a coloured drawing of its pulley mechanism.[289] Several drawings show different methods of raising earth out of excavated canals and there is an aquatint of a machine for cutting weeds in rivers and canals, given to Reynolds by the Spanish engineer and (according to Boulton) industrial spy, Augustin de Bétancourt, who was in England in 1796 on a lengthy tour across Europe that eventually took him to Russia.[290] A few drawings relate to Reynolds's work with Thomas Telford on the introduction of cast-iron troughing for canal aqueducts, the first being completed on the Shrewsbury Canal over the river Tern at Longdon in 1795. A drawing showing the plan of the framing to the plate presumably relates to the trough used for the aqueduct and is signed by both Reynolds and Telford. The verso shows 'how the ribs may be put together with double ties' and is signed by Telford (fig. 53).[291] In 1793 Telford had been brought in as resident engineer (despite being known hitherto only as county surveyor) to work on the Ellesmere Canal under Smeaton's first assistant, William Jessop, who had become a prominent civil engineer in his own right.[292] Reynolds's collection also contains an early design for what became Telford's famous Pontcysyllte aqueduct over the Dee – an elevation and cross-section comprising three tiers of arches with the middle row inverted to form dramatic ovals, dated April 1794 and attributed to the assistant engineer John Duncombe (fig. 54).[293] In August 1795 the proprietors decided on Jessop's recommendation to use stone with iron troughing, the latter probably at Telford's suggestion. The inclusion of these works in Reynolds's collection indicates his alertness to feats of engineering being built in the neighbourhood.

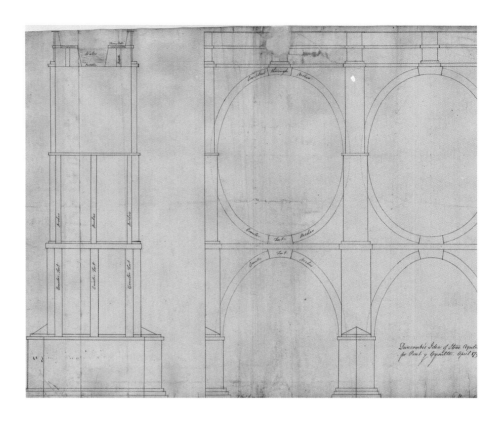

Records of comparatively old inventions were also kept by Reynolds – or possibly he retained those belonging to his father – including several versions of the Newcomen engine. Some drawings relate specifically to his iron foundries, such as the sketches of a 'new method of boring used by T. Price at the Bumble Hole Colliery near the Level', dated March 1803, and of an 'Elephant's jaw for extracting rods when broken, made by Thos. Price of Oaken Gates', dated 13 March from the same year.[294] There is a sectional elevation with plans drawn to scale of a Coalbrookdale cupola furnace, signed with a calligraphic flourish by John Hornblower and dated January 1801. Another engineering luminary, the ironmaster John Wilkinson, produced a bold pen-and-ink section, elevation and plan representing his 'idea of Chimney Boiler given to WR. November 1799'.[295] From the multiple copies of some drawings, it seems that Reynolds might have encouraged his apprentices to undertake freehand drawings of surrounding plant. In stark contrast to the ruled lines and elegant abstractions of Smeaton's drawings of engine-houses, these works convey the improvised character of much engineering activity in the period. The winding engines are only partly sheltered from the elements behind clapboard walls, with the massive beams poking out of timber roofs and odd pipes bending to meet the partly buried haystack boilers (figs 55 and 56).[296] A number of these constructions even survived into the mid-twentieth century.[297]

Reynolds's keen interest in the latest steam innovations, particularly those that could be used for rotative motion as in winding-gear, is also evident in the drawings. Many are signed by Samuel Venables, who was presumably an engineer or draughtsman working in Reynolds's firm. They are carefully executed and coloured and when he was particularly proud of one, he signed and dated it in large calligraphic letters. The collection includes plans, elevation and details of 'Mr Watt's steam wheel' and of a Watt's-type double-acting engine.[298] There are variations on the atmospheric engine, such as Venables's drawing of Adam Heslop's engine for rotative motion 'to work without a beam' (patent no. 1760, 1790).[299]

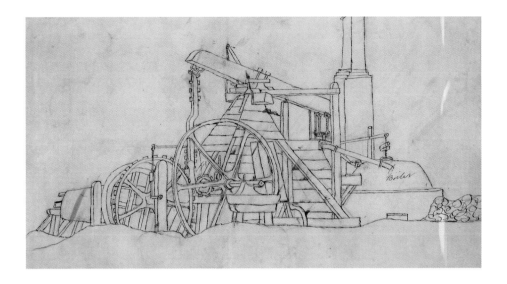

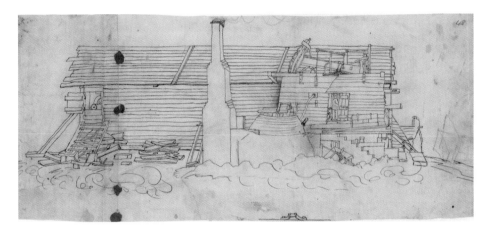

A sequence of drawings relates to the improvements to the atmospheric engine made by James Sadler. He is chiefly remembered as the 'aeronaut' who completed a historic flight in a balloon over Oxford on 4 October 1784. His knowledge of the qualities of gasses and skill in instrument-making eminently qualified him to assist Thomas Beddoes as his 'operator', when Beddoes was appointed reader in chemistry at Oxford in 1788. Three years later, Sadler told Beddoes about his invention of a rotative steam engine which did not condense in the cylinder and was much cheaper than Boulton & Watt's engines, but he was in dispute with Boulton & Watt over their patent. Beddoes evidently then tried to further Sadler's interests with his good friend Reynolds, sending him sketches of Sadler's engines and then the man himself.[300] Matthew Boulton was less than impressed, writing on 15 October 1792 to his agent in Cornwall, Thomas Wilson, that he could prove Sadler's rotative steam engine was invented two thousand years before by Heron of Alexandria 'and revived by modern blockheads'.[301] Nevertheless, from the series of drawings of engines in the Reynolds collection, it looks as if Sadler came to Coalbrookdale at intervals in the period 1792–4 and at least one field engine was erected to his design.[302] He intended to finish or develop it further but, after Beddoes gave up his readership at Oxford in 1793, instead moved with him to London and Bristol (where Beddoes's 'pneumatic institute' was to be based) and his engine was introduced elsewhere – on the Bridgewater Canal and, as will be seen, in the royal dockyard at Portsmouth.[303]

The collection also contains a coloured sectional elevation drawn to scale of an engine under James Glazebrook's patent (no. 2164, 1797), dated 1798, and a section, plan and elevation of his steam-wheel, dated 1799.[304] In December the same year, the naval mechanist Simon Goodrich (1773–1847) first heard a 'wonderful account' of this new kind of engine from workmen in a pub in Oaken Gates. Later, in February 1803, on another visit to Coalbrookdale, he learnt from Joseph Reynolds (William's half brother) more about the Reynolds patronage of Glazebrook's 'air engine'. A small version was erected at their works and 'Mr R observed that by the performance of the experimental engine he should suppose that it would do the same work as one of B&W with one third less fuel, the prime cost about the same and would stand in less compass.' Goodrich heard that a Glazebrook engine was being erected at Gloucester but when he went to see it at a new corn mill, Glazebrook was sick and Goodrich could only get a 'very imperfect account of it from the workmen who were about it substituting a new pipe in lieu of the broken one'. Goodrich was doubtful 'whether this kind of engine can be made equal to the steam engine with the same quantity of fuel. It certainly at present seems not so practical and would require a considerable saving to make it equally useful.'[305] Drawings could go far but only practical experience and usage in the field could prove the ultimate worth of the engines delineated.

Engineering the Navy

On 25 December 1796, Goodrich was appointed draughtsman to the mechanist Samuel Rehe, in the office of Samuel Bentham, Inspector General of Naval Works. It was the first step in a career with the Royal Navy that spanned nearly thirty-five years, during which time Goodrich rose from being draughtsman to 'mechanist' and eventually to 'engineer'. His progress is closely bound in with the push to introduce steam-driven machinery into the royal dockyards to improve efficiency, within Bentham's overall programme of naval reform.[306]

The son of a City lawyer and the younger brother of the philosopher Jeremy Bentham, Samuel Bentham (1757–1831) was allowed to pursue practical rather than professional training, on account of his pronounced mechanical bent as a child. After school at Westminster, at the age of thirteen, he started a seven-year apprenticeship under a master shipwright at Woolwich and then moved with him to Chatham. Realising, however, that he needed to supplement his practical skills with a knowledge of mechanical theory and the principles underlying ship and dockyard design, he broadened his education at the Royal Naval Academy, Portsmouth, and on travels round the Baltic. His most spectacular feats were accomplished in Russia between 1780 and 1791, from 1784 in the service of Prince Potemkin, who employed him to establish industries on his vast estates at Krichev in White Russia – including sailcloth and rope manufactories, a distillery and brewery, leather works, glasshouses and a pottery, a crucible manufactory and copper works – as well as to improve the fire power of the Russian navy in the war against the Turks, for which services he was awarded a knighthood of the Russian order of St George.[307]

In Russia, Bentham's inventive streak first manifested itself in 1781 when, pausing at the Demidov Ironworks at Nizhnii Tagil on a tour of the Urals and Siberia, he designed a planing machine to speed the construction of an amphibious vehicle (essentially a boat mounted on a three-wheel chassis) which would enable him to cross rivers. It is probable that he further developed the machine in the mid-1780s at Krichev, constructing river transport including *baidaks* (single-masted vessels used on the Dnieper and its tributaries) and his own invention, the 'vermicular', a series of vessels coupled end to end

like a floating articulated train, powered by oars. In the autumn of 1786, to maintain discipline over the labour force of Russian serfs, not to mention their British supervisors, he conceived of a circular inspection-house, soon named a 'panopticon', in which workers using his woodworking machines would be under constant scrutiny from the inspector based in a central lodge.

The design has been seen in the context of Russian absolutism and even the architecture of the Orthodox Church, in its embodiment of an invisible yet omniscient power. Within the setting of the model estate of Krichev, it would have represented a dramatic *coup de théâtre*, another diversion of enlightened ingenuity conjured up with miraculous speed prior to the visit of the Empress Catherine. Yet from the days of his apprenticeship in England, Bentham would also have been familiar with the underlying motivation of surveillance, if not the built panoptic form, implicit in the dockyard designs of Dummer. Despite this range of reference, the project did not progress in Russia, for in 1787 Potemkin sold his Krichev estates and Bentham's schemes vanished as suddenly as they had appeared. Instead, the panoptic principle was used as the basis for the Bentham brothers' competition designs to build a Middlesex penitentiary.[308]

As part of the Benthams' drive to make convict labour profitable in their panoptic prison, on his return to London Samuel patented two of his wood-cutting machines which could be worked by unskilled labour. The first of 1791 (no. 1838) related to planing techniques; the second of 1793 (no. 1951) was more comprehensive, including detailed notes on the use of circular saws, rotary cutters and reciprocating chisels. Full-scale versions of these machines were placed on display in 1794, in the outbuildings of Jeremy Bentham's house in Queen Square Place. Worked by manpower by means of a treadle or a winch to turn an axis, they planed, rebated, mortised, shaped and sawed in curved, winding and transverse directions, turning out parts for sash windows and carriage wheels before an admiring audience of 'numberless persons of rank, of science, and of manufacturing intelligence', including government ministers. But their most immediate use, as plans for getting the prison built were endlessly delayed, was to further Samuel's job application to the Admiralty, demonstrating that he was the man to be trusted with modernising and mechanising the Royal Navy.[309]

In April 1795, he was instructed by the Admiralty to visit the royal dockyards with a view to recommending improvements, particularly 'in the application of mechanical powers, that modern discoveries have brought to light', namely Bentham's own machinery which seemed capable of adaptation to dockyard work.[310] By June he had produced plans for the radical redesign of the construction already under way at Portsmouth, which were agreed. By March 1796 he had succeeded in persuading the Admiralty to establish an Office of Naval Works, headed by himself as Inspector General. His establishment included an architect who also acted as a structural engineer, a mechanist or mechanical engineer, a chemist, draughtsman, two clerks and assorted assistants. Not surprisingly, when he sought radically to reorder the management of the royal dockyards, he encountered considerable opposition. Used to getting his own way in Russia, he soon chafed under the restrictions he encountered.[311] His abrasive personality increased tension between the Admiralty, who had appointed him, and the Navy Board, whose territory he had invaded, to breaking point.[312]

In 1800 he published a refutation of the objections made to his proposals by the Comptroller of the Navy, the chief accounting officer on the Navy Board. Citing the opposition he had encountered, based on vested interests and personal animosity, he condemned the whole system for its 'radical unsoundness' and set out his clear intention of changing the way in which the Navy was run. The job descriptions of the dockyard officers should be redefined, he believed, from the Commissioners downwards. True

to the panoptic principles he had developed in Russia, he proposed that the administration of each yard should be made visible, systematic and readily accountable, not obscured by the irregularities of custom and practice. The master shipwrights should become surveyors, directing the business of the yard – shipbuilding, repairing and all other management works.[313] So far, his opinions might have been voiced by Dummer a century earlier, yet Bentham also proposed the installation of an additional officer, the master engine-maker, conversant in the principles of mechanics as well as the business of a millwright, to assist the surveyor on all mechanical subjects.[314] Just as his wood-working machinery, categorised according to the nature of the operation and operated by steam power, literally cut across the skills of particular trades, the introduction of machinery and engines on a large scale would necessitate the reclassification of manufacturing operations, without regard to traditional divisions of labour and rendered transparent through the new spatial organisation of the yards.

Bentham was fortunate that in Goodrich he had someone who was able to bridge the gap between scientific principles and mechanical practice. The archive Goodrich accumulated during his period in office, comprising letters, journals and memoirs, drawings and printed material, was deposited with South Kensington Museum in 1873 (it is now in the Science Museum Library and Archives).[315] Goodrich's career straddles the worlds of the eighteenth-century mechanic and the nineteenth-century engineer. Like his boss, he exhibited delight – characteristic of the eighteenth century – in all things mechanical and he continued throughout his life to display an insatiable curiosity in discovering how things worked, in improvements and new inventions. The earliest drawing that survives is in a bundle of memoranda relating to the pendulum of a clock and the balance of a watch worked by a crank of his own invention, for which in 1799 he obtained a fifty-guinea premium from the Society of Arts.[316] The last sketches were made in Portugal in 1835 to instruct a carpenter to make a movable commode (or 'night stool') and bedstead.[317] Although not outstandingly original himself, Goodrich was forever noting the inventions of others and improving on them.[318] He was keenly aware of the latest technical feats, collecting prints of new iron bridges and dock-gates throughout his career.[319]

As a young employee, Goodrich saw himself primarily as a practical man with a latent distrust of consultant engineers, albeit conscious that their status was higher than his as an obscure mechanist.[320] Nevertheless, Goodrich's job brought him into contact with most of the leading engineers of the day and he earned their respect.[321] The great bulk of his work was concerned with projects within the royal dockyards, above all at Portsmouth, the smooth running of which, as the Navy's largest refitting yard, was crucial in wartime for the effectiveness of the fleet. Here Bentham's major civil engineering works comprised the enlargement of the enclosed No. 1 (or Great) Basin and the addition of two deep dry docks, completed in 1805.[322] By these means, the yard's capacity was enlarged: four ships could be docked and undocked regardless of the tide, saving time and money. To relieve the strain that the improvements placed on the North Basin reservoir (Dummer's redundant Upper Wet-Dock), into which all four dry docks round No. 1 Basin drained by gravity, Bentham proposed to replace the horse-gins used to pump the collected water into the harbour with a steam engine. From the outset, he envisaged the efficient use of steam power through interconnected operations: to pump water out of the reservoir at night, to power his woodworking machinery by day and to lift fresh water from a well to a water main serving the whole dockyard. A start was made in April 1798 when the Admiralty authorised the installation by the then mechanist, Samuel Rehe, of a 12 hp table engine designed by James Sadler, who had been appointed chemist in Bentham's office.[323] Housed in a single-storey brick building, the engine powered a large lifting pump capable of raising seven tons of water a minute for draining the docks and reduced the reliance on horses' power.

The tasks undertaken from 1799 by Goodrich, as Rehe's successor as mechanist, were much more extensive and technically challenging. His 'General Statement of the Services which have been performed by the late and present mechanists under the directions of the Inspector General of Naval Works since their appointments', drawn up on 16 April 1806, can be corroborated through the mass of papers and drawings that he accumulated.[324] Read in conjunction with Admiralty records, they provide a unique insight into the theory and practice of industrial development in the early nineteenth century, when Watt & Boulton's patent had expired, when steam engines were produced in increasing numbers and their application to industry in general was much accelerated. They provide evidence of the means whereby Goodrich kept a grip on the complexity of tasks he was asked to perform, combining the spatial and accounting skills of a surveyor with the detailed knowledge of and experience in the mechanics needed to connect the new machinery.

Firstly, Goodrich made sure that he was well acquainted with what was already there by way of buildings and plant. In his collection there are copies of drawings relating to previous construction work in the Old North (No. 6) Dock and the King's Mills.[325] Plans of the dockyard made by him around 1800 provided the basis of proposals for later changes.[326] He drew a front and side elevation to scale of Sadler's engine, duly inscribed the 'First Steam Engine erected at Portsmouth Yard'.[327] The archives also include drawings, signed off by Bentham, which demonstrate how the Director-General's grand scheme for the dockyard was implemented by accretion, as drawings of proposals were submitted alongside plans and elevations of the existing fabric. Drawings provided the principal means of communicating with the Admiralty, in the same way that civil engineers used them to communicate with their clients. Finished drawings to scale were submitted for each scheme, made by Goodrich, the draughtsman and clerk William Heard and other draughtsmen in the department, copies of which remained with Goodrich. Bentham was well aware of the capacity of drawings to convince sceptical superiors. Having submitted one general plan of the drainage pipes proposed for Portsmouth Yard, he wrote to the Admiralty on 31 March 1802: 'But as this plan alone would be very insufficient for enabling the Navy Board to cause this work to be carried into execution, I likewise enclose detailed drawings, tables, and such other descriptions as appear necessary for that purpose.'[328] They often came in a set and were attractively presented, tinted to make the parts and materials more legible, numbered in sequence of elevation, section and plan, enclosed in a black framing line and signed off by Bentham or, during his absence, by Goodrich.

As he reported in his General Statement, Goodrich completed plans, drawings, estimates and directions for the construction of a wide range of machines, connecting operations and buildings at Portsmouth. In 1800, he was responsible for making the ground-plan and cross-section of the engine-house and framing needed to house a 30 hp Boulton & Watt steam engine, to serve as back-up to the Sadler engine should it fail and to power the machinery in Bentham's projected wood mills.[329] Goodrich was at pains to point out that it was not simply a question of buying an engine but of housing it and connecting it up with the machinery it would power on site. He also made drawings of six pumps – in line with Bentham's initial plan – serving the drains and penstocks, connecting all the docks and basins with the well and reservoir 'so that the whole drainage thereof is performed by the steam engine working there and use of horses discontinued'. Goodrich furnished detailed drawings and directions to the millwright and engine-makers for the execution and erection of this machinery and attended to all the details of the work during its progress to completion. The plans and section of the Boulton & Watt engine survive in the archives of Boulton & Watt, Goodrich and the Admiralty, in the last instance alongside the first record of the wood mills.[330] As the

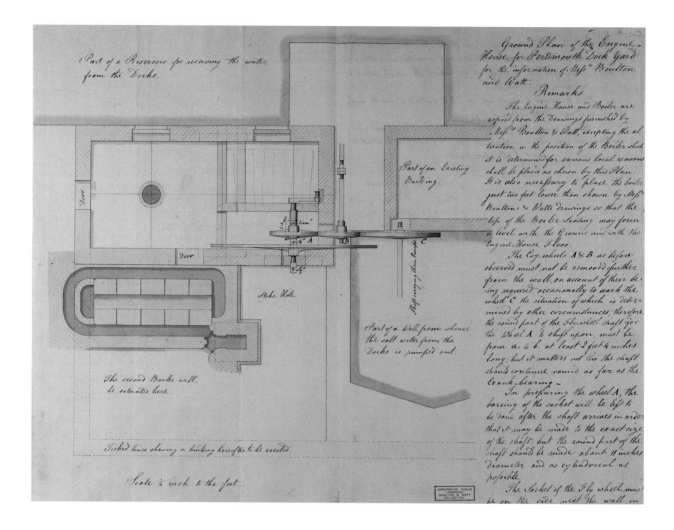

The following handwritten text appears within the drawing:

Part of a Reservoir for receiving the water from the Docks.

Ground Plan of the Engine-House, for Portsmouth Dock Yard for the information of Mess.rs Boulton and Watt. Remarks

The Engine House and Boiler are copied from the Drawings furnished by Mess.rs Boulton & Watt, excepting the alteration in the position of the Boiler which it is determined for various local reasons shall be placed as shown by this Plan. It is also necessary to place the boiler just two feet lower than shown by Mess.rs Boulton & Watts drawings so that the top of the Boiler Seating may form a level with the Ground and with the Engine House Floor.

Part of an Existing Building

The Cog-wheels A & B as before observed must not be removed further from the wall, on account of their being required occasionally to work the wheel C the situation of which is determined by other circumstances, therefore the round part of the Fly-wheel shaft for the Wheel A to shift upon, must be from a. to b. at least 2 feet 4 inches long, but it matters not tho the shaft should continue round as far as the Crank-bearing.

In preparing the wheel A, the boring of the socket will be left to be done after the shaft arrives in order that it may be made to the exact size of the shaft: but the round part of the shaft should be made about 11 inches Diameter and as cylindrical as possible.

The Socket of the Fly wheel must be on the side next the wall in

Door

Door

Stoke Hole

Part of a Well from whence the salt water from the Docks is pumped out.

The second Boiler will be situated here

Ticked lines shewing a building hereafter to be erected.

Scale ¼ inch to the foot.

57 Simon Goodrich, 'Ground Plan of the Engine House, for Portsmouth Dockyard, for the information of Messrs. Boulton and Watt', 22 April 1800. Birmingham Archives and Heritage, MS 3147/5/278

case is so well documented from every angle – yard, client and outside manufacturer – and Goodrich gave possibly the clearest instructions of any client to Boulton & Watt, it bears closer inspection.

On 25 February 1800, Boulton & Watt submitted an estimate in which they undertook to deliver to Portsmouth all the metal materials of a 30 hp steam engine for the sum of £1070, not including the cost of carriage from Birmingham to Portsmouth. On 4 March, Goodrich sent his own drawing of the three-storey engine-house to Boulton & Watt for their information, as they needed to know the site to be able to arrange the different parts of the engine. Goodrich pointed out that a solid foundation already existed and specified that the boilers were to be fixed outside the engine-house. The red lines on the plan showed part of a building to be erected afterwards to cover the boilers: 'It is absolutely necessary upon account of the other machinery that the fly wheel shaft should be situated as in the drawing.' Only Goodrich could ensure that the new engine was successfully linked to the pumps and the Sadler engine, so that the two could work in tandem or one at a time.

A month later, on 6 April, he commented on the drawings and remarks sent by Boulton & Watt, observing that 'a connection with the other machinery already fixed, does not permit the cog-wheels to be removed as therein proposed, but they must remain in the same line as shown by the drawing sent from the Inspector General's Office'. Other variations 'would be attended with no inconvenience . . . In a few days a more particular drawing for the fly-wheel shaft may be sent, and then also the position of the

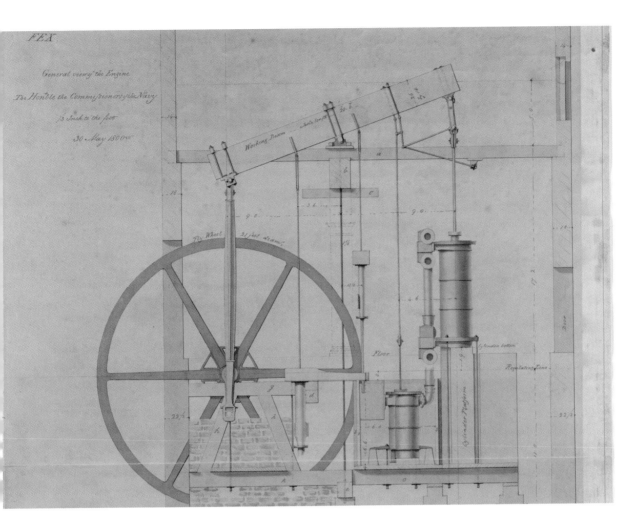

58 Boulton & Watt, 'General View of the Engine, The Honorable the Commissioners of the Navy, 30 May 1800'. Birmingham Archives and Heritage, MS 3147/5/278

boilers may be determined.' On 22 April, Goodrich drafted further remarks on the ground-plan of the engine-house for the information of the manufacturers (fig. 57), confirming the alteration in the position of the boiler 'which it is determined for various local reasons shall be placed as shown by this plan', reinforcing the point made in a letter of 11 May, in which he also proposed (on Boulton & Watt's advice) widening the fire door and redesigning the grate to take wood and cinders from the smiths' forges. The finished drawings in the Boulton & Watt archive, dated 30 May–17 June, show that the firm acceded to Goodrich's wishes (fig. 58). In other words, the process of design and installation went both ways and could only be accomplished through a combination of internal and external know-how. Even then, part of the iron boiler sent to the dockyard proved to be deficient and had to be replaced.[331]

The steam engine houses were built on the south side of the reservoir and over 1800–02 two tiers of vaults were constructed in the reservoir itself so that it could be roofed level with the surrounding land for the construction of the new wood mills. In his General Statement, Goodrich reported that he made the first ground-plans for the mills, intended to house the 12 hp and 30 hp steam engines and pumping machinery in the south range and Bentham's cutting and planning machinery in the north range. The new wood mills were built in 1802–3, probably to the design of the office architect, Samuel Bunce, and Bentham's steam-powered machine-saws of various types – circular, reciprocating and swing – installed.[332] Goodrich made plans, sections and elevations of two circular sawing machines and the first reciprocating saw engine for splitting logs of

121

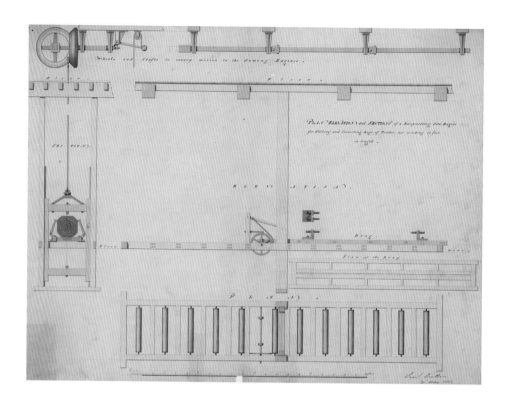

59 Simon Goodrich, 'Plan,
Elevation and Section of a
Reciprocrating Saw Engine',
signed off by Samuel Bentham,
31 May 1805. The National
Archives, ADM 140/501

timber (fig. 59).[333] At a time when it took about three thousand trees to build a first-rate man of war, mechanical assistance in preparing all the timber, down to the companionways and furniture, constituted a major innovation.

Pulley blocks channelling ropes were essential to the smooth running and manoeuvrability of the ship – for controlling sails, positioning guns and many other hoisting and hauling operations. Their secure supply was crucial at a time of war. A 74-gun ship needed about a thousand blocks of various sizes and types and the annual block consumption of the Navy was estimated at a hundred thousand, supplied by a small number of independent contractors.[334] Bentham's machines covered all the operations up to shaping the blocks and, evidently, he was hoping to design block-making machines also. However, in 1802 he was approached by a young French émigré engineer Marc Isambard Brunel, who had been working on models of his own patented block-making machines with the London-based mechanical engineer Henry Maudslay. Bentham was encouraging and referred Brunel to the Admiralty. Brunel duly showed a model to the Commissioners, who were also left in no doubt as to Bentham's support. Having seen a full-scale version of the machine for making real blocks, Bentham proposed that Brunel should be directed

> to confer with the mechanist in my office, respecting the best mode of fixing up the different engines and apparatus which may appear requisite for the manufacture of the different sorts and sizes of blocks, so that this apparatus should combine with the other machinery already provided, or which it may seem advisable to erect in that dockyard; and that Mr Brunel may be likewise directed to give into my office drawings, and estimates of the expense of the whole of the machinery which may appear to him necessary for this purpose.[335]

Brunel worked closely with both Bentham and the manufacturer Henry Maudslay in refining and modifying his designs for block-making machines, producing by 1803 the world's first all-metal machine tools for mass production. They were mainly installed in

122

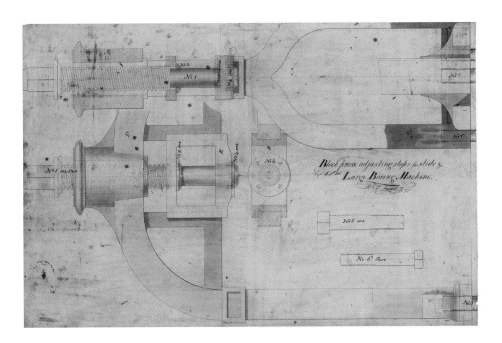

a newly constructed single-storey infill building between the north and south ranges of the wood mills. In contrast to the functional plainness of the latter, the block mill had some modest design pretensions – simple brick pediments on the east and west elevations and turned wooden Tuscan columns to support the roof trusses within – which suggest that Bentham already envisaged it as a showplace.[336] Goodrich served a vital role in the chain of communication between Brunel, Maudslay and Bentham, recommending how best to ensure the implementation of Brunel's designs. According to Lady Bentham, writing half a century later, 'a pleasing and convenient arrangement of block machinery, whereby a regular sequence of operations is obtained, was devised by Bentham, contrived in his office, under his immediate superintendence, and principally by Mr Goodrich, the mechanist'.[337] The process of achieving this happy state of affairs did not run smoothly, as Goodrich's diary confirms, especially when Brunel started to test new inventions in the wood mills without consulting anyone else.[338] Even so, by March 1805 sets of machines for manufacturing blocks of different sizes had been delivered by Maudslay and were in production. By September 1807 the machinery could supply all the needs of the Royal Navy and the following year, the forty-five machines produced 130,000 blocks.

Drawings as well as models were used by Brunel. Two early presentation drawings survive, showing part of the power transmission system, signed by Brunel on Christmas Eve 1802 and approved by Bentham on 2 January 1803. There is an undated notebook entitled 'Block Machinery' in the National Maritime Museum which appears to be an aide-memoire, containing small neat elevations of the block-making machinery with measurements, the size of blocks made, revolutions of the machine per minute and number of blocks bored in about 11½ hours. In 1816 Brunel also completed a set of working drawings, incorporating improvements and modifications, for a reserve set of machines to be manufactured in case of fire. He used large sheets of cartridge paper on which each machine was drawn in pen and black ink to a scale generally of three inches to one foot and each part at full size (fig. 60).[339] The impression given is of a confident French-trained professional engineer, as able to make precise records for the Admiralty as to instruct his machine-maker Maudslay.

In the eyes of admiring contemporaries, little aware of the complex logistics involved in coordinating the workings of the system, the chaste logic of the drawings seems to

have been transmitted to the machines themselves. The whole of the entry on 'Machinery' in Rees's *Cyclopaedia* of 1812 was devoted to the block-making engines, as the 'best example of practical machinery, of any we could select from the numerous manufactures our country contains, being adapted to perform operations which are generally understood, but which have hitherto been executed by manual labour and dexterity only'. The author, John Farey junior, praised Brunel for having

> displayed as much judgement in the division of the operations by the several machines, as ingenuity in the contrivance of their parts, which are admirably well calculated to produce their intended effects. The greatest attention has been every where paid to that form of construction which would admit of the most perfect workmanship in the execution.

In this endeavour the ideas of the 'ingenious inventor' had been seconded by Maudslay, 'who had made these machines with the most scrupulous attention to accuracy and durability, at the same time preserving an elegant proportion in their form, which is very agreeable to the eye'. Despite their expense, the machines were cheaper in the long run, particularly as workmen were induced to take as much care of them as if they were their own property, attending to the 'neatness' in their appearance, preserving them from the slightest injury and keeping them clean from dust.[340]

On 14 September 1805, while Lord Nelson was being shown round the dockyard including the newly built wood mills, Goodrich was hard at work making a plan, elevations and drawings of particular parts for a 30 hp table engine to replace the Sadler engine. These were signed off by the Director-General before he left for Russia to explore the possibility of building ships there for the Royal Navy.[341] A plan on a smaller scale showed the proposed situation of the engine and its connection with all the pumping and wood mill machinery driven by the existing 30 hp Boulton & Watt engine. Goodrich provided the Admiralty with good reasons for the replacement. Sadler's engine only powered a down-stroke adequate for working the lifting pump but its rotary motion was not sufficiently steady for powering the wood mill machinery, nor was it capable of larger pumping operations. If their Lordships approved, it would be necessary for Goodrich to 'furnish drawings more in detail and other information to the engine maker, who may be applied to, and also a list of the articles to be furnished by him in order that he may be agreed with accordingly, as some of the usual articles are dispensed with, and others can with greater convenience be provided in the Dockyard'.[342] A more powerful double-acting 30 hp engine was duly commissioned to Goodrich's design from Fenton & Murray of Leeds.

According to his General Statement, two other large projects occupied Goodrich. Bentham proposed that the Navy's first metal mills be built at Portsmouth, for manufacturing sheets from old copper gudgeons and bolts to sheathe ships' hulls, for turning old iron into bolts and eventually for producing the metal coaks and pins needed for the blocks.[343] Following consultation with metal masters, on 20 April 1804 Goodrich completed a detailed plan to scale with measurements of the layout of the metal mills showing the site of a proposed 56 hp engine and boiler-house, and the elevation, with substantial foundations (fig. 61).[344] His drawings provided the basis for specifications for the guidance of and liaison with outside contractors, as well as the millwrights or engine-makers in the yard. The archive contains a mass of designs for the machinery used in the metal mills: boilers for the 56 hp engine, for furnaces to heat the copper to be rolled into bolts and for welding, a double pump for the copper mill, as well as overall plans of the mills with the hammers and boilers and furnaces *in situ* and sections of the building and the roof.[345] On 23 May 1805 he made a precisely measured drawing of a wrought-iron tilt hammer, calculating its weight at 130 lb and asking the Birmingham ironmaster

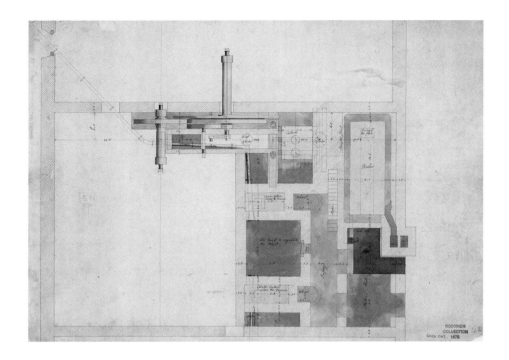

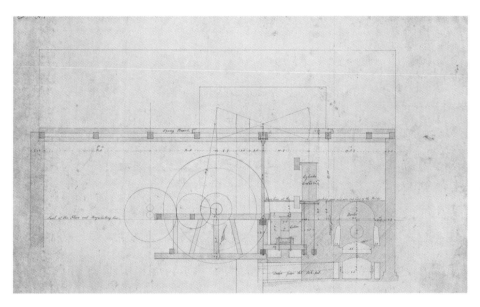

William Whitmore 'to prepare a hammer according to the above drawing and send it
by wagon as soon as possible'.[346]

At the same time, Goodrich was considering how to introduce the best system of
machinery for manufacturing cordage. On the basis of reports on proposals made by
different projectors and visits to the most noted manufacturers, in 1804 he drew up esti-
mates for erecting a rope manufactory and associated storehouses at Woolwich for spin-
ning and laying cordage by steam engines and machinery, according to the plans of
Grimshaw, Webster and Company of Sunderland, expecting that he would have to make
detailed plans, elevations and sections for the Admiralty.[347] However, as no order had
been received by May 1804, Bentham proposed that in order to speed the anticipated
building work,

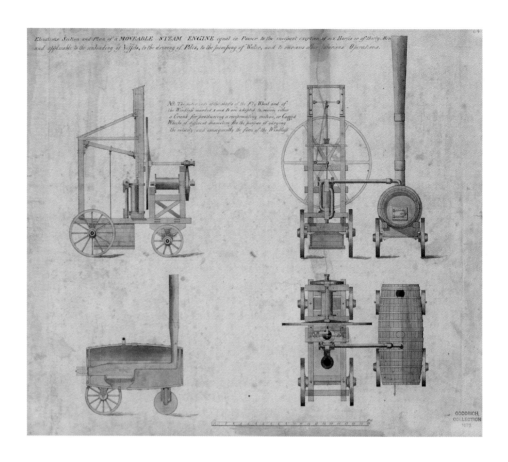

in the mean time three small kilns, on a plan similar to those used with much success at the West India Docks should be erected in Woolwich for the purpose of burning lime, so that it may be used fresh from the kiln; and also three separate mortar mills each of one pair of stones, nearly similar to those in use at Portsmouth Dockyard, capable of making together a sufficient quantity of mortar in twelve hours for five rods of brick work.

Drawings of the lime kilns in the docks on the Isle of Dogs and the mortar mills were duly made.[348]

Smaller projects undertaken by Goodrich included making the elevation, section, plan and estimates for a 6 hp movable steam engine of Bentham's invention, proposed in September 1801, 'applicable to the unloading of vessels, to the driving of piles, to the pumping of water, and to various other laborious operations'. Essentially, it consisted of two four-wheeled carriages: one conveyed a barrel-shaped wooden boiler with an internal metal fireplace, flue and chimney, the steam escaping through a pipe connected to the engine borne on the other carriage, comprising a steam cylinder, separate condensing cylinder and large flywheel, windlass and shifting cog (fig. 62).[349] Goodrich also made the drawings and estimates for a 'ballast heaving' engine or steam dredging machine, again designed by Bentham, which comprised a 12 hp steam engine and machinery erected on board a vessel and intended for use in Portsmouth harbour. He provided the millwright with detailed drawings for its execution and erection and attended to its progress to completion. A 'plan and section of part of the apparatus and floating vessel for digging up by the force of a steam engine shingle, sand &c showing in red the additional apparatus proposed' was annotated and signed by Bentham on 16 May 1802 (fig. 63). Evidently, the shaft carrying the arm broke, for another drawing

126

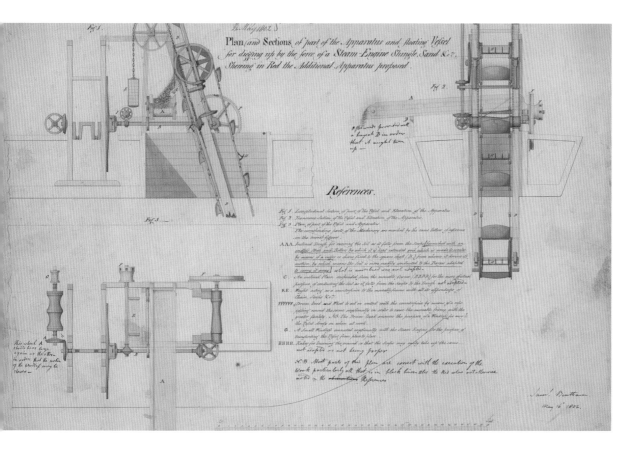

dated 18 December 1802 shows a detailed section and plan of it drawn to scale with the spot where it broke marked in red, presumably prior to repair.[350] Nevertheless, the dredger proved to be a success, especially at Chatham, where it prolonged the life of the dockyard on a river which had long been plagued by shoaling.[351]

In his General Statement Goodrich pointed out that he was deeply involved in the logistical planning of other dockyards. He also had fiduciary duties, examining tradesmen's bills for the jobs that had been executed and controlling the rates and weekly payment of wages. He helped the Inspector General with advice on mechanical subjects and acted for him during his absence in the general superintendence of the office. There was the continual work of repairing the existing fabric of the yards. Around 1810, for example, Goodrich produced a plan and sections for rebuilding the decayed wooden No. 1 slip at Chatham with a stepped stone dock.[352] In 1812–13, he drew up plans for a new well at Sheerness dockyard, worked by a steam engine, which were executed by John Kingston, a journeyman millwright and brother of the master millwright at Portsmouth. The drawings Goodrich supplied provided the key means of controlling the progress of the works, given that he was not on site.[353]

Goodrich was of course not the only source of drawings within the naval dockyards. John Kingston was no mean draughtsman and supplied Goodrich with his own 'scetches'.[354] In 1815 and again in 1817 they corresponded with attached sketches on the design for an additional pump for the Sheerness well before reaching a mutually satisfactory conclusion.[355] The archive contains one drawing of 1814 by a bricklayer showing the arrangement in plan and section for a stove in the Commissioner's House in Portsmouth Yard.[356] On 29 September 1821, the master rope-maker at Chatham yard responded to Goodrich's request by sending him 'a very rough sketch of our beating machine and hope that you will be able to comprehend it. You will excuse its imper-

fections. I shall be glad to hear of any improvements that you may suggest on this machine – at the same time ours works very well.'[357]

The crucial nature of Goodrich's role in providing support on large-scale building projects for dockyard officers is well illustrated in a letter the Portsmouth officers wrote to Goodrich on 25 September 1813. Having examined the plans proposed for erecting the brass foundry, iron foundry and millwright's shop in their yard, as directed to be carried into effect by an Admiralty order dated 25 October 1810, 'and finding that the proceeding upon these works is delayed for the want of detailed plans drawings and estimates – we desire that you will immediately prepare them'. Goodrich was in an awkward position, for the Office of Naval Works had been abolished on 25 December 1812 and he was working as a mechanist without warrant, but the letter was signed 'Your affectionate friends'.[358] The Navy Board had opposed the abolition of his post, all too conscious of the need for his opinion and advice, 'to assist our judgement in the consideration of mechanical subjects . . . and in the application of machinery whenever it may be thought expedient'.[359] In April 1814 he was re-appointed as engineer and mechanist at Portsmouth at an increased salary of £600.

Not all the schemes dreamt up by the Office of Naval Works succeeded in convincing the Navy Board hierarchy. Despite a mass of research and development on the proposed ropery, undertaken mainly by Goodrich, it did not get the go-ahead. His detailed plans and sections of Bentham's proposal for a second steam dredger for Deptford dockyard, with a wooden boiler and Trevithick 14 hp high-pressure engine, never came to fruition, probably through a loss of nerve following the explosion of the Trevithick engine at Greenwich.[360] Nor did the plans Goodrich made around 1811, dangerously close to the demise of the Office, for enlarging the metal mills and foundries at Portsmouth with the addition of a grand new millwright's shop (fig. 64).[361]

The Navy Board kept a close eye on costs. In June 1813 they quibbled at the somewhat vague estimate ('not to exceed £800') supplied in response to Goodrich's drawn and written specification for a cast-iron cistern, which Goodrich had to defend on the grounds that, despite the execution of such works from the best drawings, 'it is still possible to make a very considerable difference on the cast, arising from the weight and quality of the materials, and the quality of the workmanship'.[362] The Board also carefully scrutinised Goodrich's designs. On 20 October 1815 he wrote to them about the rebuilding of the steam-boiler chimneys at the wood mills, his drawing having been returned with alterations made in red ink so that their shape was square to the top, as opposed to octagonal in form and round at the top, as Goodrich had wished. He respectfully submitted that the change of form he had proposed was for a purpose, based on direct observation of the action of the wind on square chimneys: the round form presented the least diameter or surface for obstructing the wind which would consequently not cause the smoke to beat down on the water in the cistern. He added a rueful note to his letter nearly twenty years later, in February 1834:

> I was fully sensible when I made this remonstrance that the alternative of my design for the chimneys was by Mr [Edward] Holl the Surveyor of Buildings though the Board in ordering it did not so specify. The Board however persisted in ordering the alteration – and I was obliged to comply – I think they were very unwise in doing so as even if my plan was no better than the other or not so good (which I do not think) it was a matter of indifference in itself, and this acted as a damper upon my volunteering any think [sic].[363]

Nevertheless, Goodrich continued to work for the Navy until his retirement in 1831 on a pension of £400. He moved to Lisbon in 1834 to advise on the reconstruction of its docks and died there on 3 September 1847.

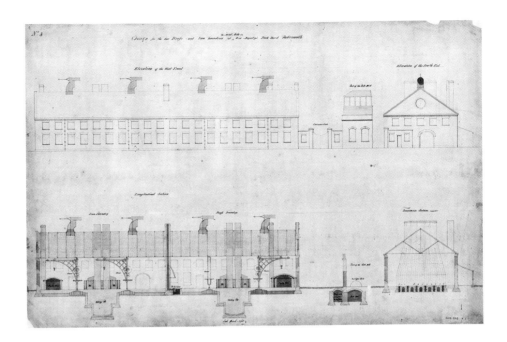

Goodrich's status and reputation in the wider world were marked by his election in December 1820 as a member of the Institution of Civil Engineers, two years after its foundation. He proudly added 'Civil Engineer' to his name on a particularly fine, large coloured drawing he made for a well at Chatham.[364] This token of recognition reflected practical achievement and sound theoretical grasp. Following Bentham's lead, he believed in the importance of chemical and mechanical theory as part of the new technical skills required in the dockyard, in 1807 urging Mr Vernon, the newly appointed master of the Portsmouth metal mills, to acquire such knowledge, from reading and study, consultation with others and travel. As he wrote to Rogers, the acting master, 'He appears to understand the iron business practically, not chemically, for he seems unacquainted with the terms of the science, but that part would be easy to acquire. He seems also to understand furnace work, brick and sand, has mechanical invention without science or a sufficient knowledge of first principles.' Yet Goodrich was keenly aware of the two-way relationship between principles and practice, for he emphasised that Vernon should

> never to be above consulting and learning any thing from experienced workmen or to refuse to listen to and weigh well their suggestions, and this he can always do by good management without lessening his weight and credit with them. In fact I consider it the business of a good manager to draw forth by proper encouragement, and to apply to the best advantage the abilities of all the persons employed under him.

In his reply, Rogers confirmed that Vernon happily concurred with Goodrich's proposals for his professional development, not only as a matter of duty but for his own pleasure and information, 'which he would endeavour to do both by reading and practical experiments, independently of the information to be obtained in seeing the business as it is now conducted'.[365]

Goodrich's zeal for mechanical and scientific education was not confined to his workforce. In December 1813, he drew up a set of exercises on assorted topics for students of naval architecture at the Royal Naval College in Portsmouth which sounded remarkably like Hooke's proposals more than a century earlier, covering the principles of mechanics and hydrostatics, the strength and stress of timber, the pressure of beams, the use of sci-

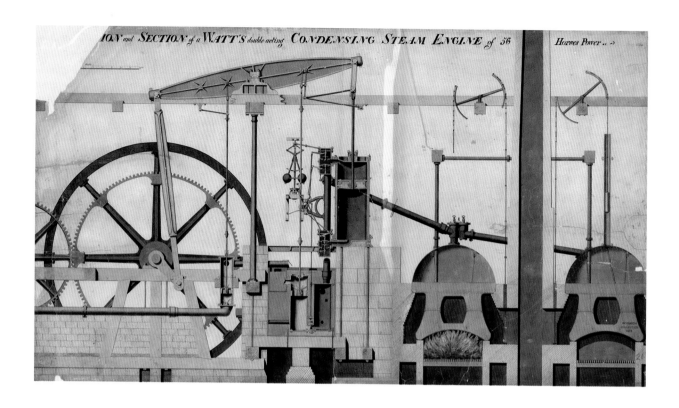

65 Simon Goodrich, '[Elevat]ion and Section of a Watt's double acting Condensing Steam Engine of 56 Horse Power', built by Whitmore of Birmingham for Portsmouth Dockyard Metal Mills in 1804. Science Museum Library and Archives, Science Museum, Swindon, Goodrich, C261

entific instruments and machines.[366] In the mid-1820s and early 1830s, he delivered several series of illustrated lectures on the history of the steam engine at Portsmouth Philosophical Society. He prepared thirty-three drawings for his lecture, ranging from a 'natural' steam engine (presumably, an Icelandic geyser, as described in Sir George Mackenzie's *Travels in . . . Iceland in . . . 1810*[367]) through to Savery's engine, Newcomen's engine, a modern atmospheric engine, an atmospheric engine with an air pump and condenser, Boulton & Watt's 56 hp condensing engine at the metal mills, Trevithick's high-pressure engine, Losh & Stevenson's locomotive and so on, including different types of boiler, pipes, valves and cisterns. The drawings are on a large scale, in sequences of elevation, section and plan, with details of strategic valves and other parts. They are also attractively coloured in shades of blue, pink and mauve and attempt to show the engines in action with fire heating the water, which gushes out of the tank. Dotted lines indicating the movement of levers further aided the understanding of the lay audience (fig. 65).[368] The hard lines of mechanical exactitude were softened to render the machines palatable. In the notes and observations he made for his third lecture, a faint whiff of the eighteenth century can still be detected amid the utilitarian language of the new machine age. Goodrich volunteered to answer any questions 'what may serve somehow or other to pass away the time you have allotted this evening to the rational amusement of learning and discussing something on subjects of natural and mechanical philosophy'.[369]

Mechanical Dreams

When Bentham returned from Russia in December 1807, the first letter he opened informed him of the abolition of his post and the intention of placing him and some of his assistants in the Navy Office. During his absence, the Navy Board, exasperated by the disruptions caused by his mechanical and managerial innovations at a time of war, had seized the opportunity to sideline him. His influence with the Admiralty had

been weakened in 1804 when Pitt's new ministry replaced Bentham's ally Lord St Vincent with Viscount Melville as First Lord and established a Commission for Revising and Digesting the Civil Affairs of the Navy under Sir Charles Middleton. In submissions to the Admiralty, Bentham ruefully expressed his regrets that he had been away while the Commissioners (comprising Rennie, Watt junior, Southern and Mr Whidbey, Master Attendant of Woolwich Yard) were drawing up their reports, preventing consultation with him. Their Fifteenth Report, completed in manuscript in 1807, but never published, condemned the piecemeal innovations introduced into the royal dockyards 'without a well digested plan', instead of in a 'scientific and systematic manner' according to a master plan, as was the practice in the private yards – at least the vast new private docks being constructed by Rennie downstream from the Pool of London.[370] They also recommended that Bentham should be appointed Civil Architect and Engineer to the Navy Board, a suggestion he challenged.

Firstly, he considered it impossible to serve as a professional officer on the Navy Board and at the same time be responsible for the planning if not the execution of works, for the lines of responsibility would be confused. Secondly, everything in his previous career pointed to his expertise as a naval not a civil engineer. Thirdly, he defended his own Office at length against the charge made by his enemies in the Navy Board as to its inefficiency. He enumerated the improvements made to the civil architecture of the dockyards, the building of ships and the manufacture of articles at less expense within the dockyards by means of the wood mills and metal mills established at Portsmouth. Moreover, further works were in train: a ropery and a sailcloth manufactory were about to be introduced. A millwright's shop for the repair of engines and machinery had been agreed, under the direction of a master millwright or engine-maker, who would also be in charge of the pumping machinery. Such a post should be established in every dockyard where mechanical knowledge was necessary: 'I looked forward to the introduction of general mechanical knowledge, as well as of the practice of so many ingenious manufactories in the Dockyards, as of more extensive utility . . . to those who may in future be brought up there.' The whole of the management of these improvements had been conducted under his sole direction or that of Mr Goodrich. This was the progressive agenda based on both theory and practice that Bentham – like Dummer more than a century earlier – was attempting to push through.

Moreover, driven like Dummer by opposing forces to make an apologia, Bentham did not hesitate to stress the obstacles he had encountered on the path to success:

> if their Lordships could but be aware how much consideration in such undertakings as these is necessary to contrive the details of plans and regulations suited to the local circumstances; how great the pains it is necessary to take to find persons competent in every respect to direct the details of the several branches of business requisite in such manufacturing establishments, how difficult it must be in regard to masters as well as workmen transplanted into a Dockyard, where the regulations as well as habits and ideas are in many respect repugnant to good economy; to secure the continuation of those frugal habits on which the success of private undertakings are known to depend, and which therefore are equally essential to produce a similar degree of success in a Dockyard, their Lordships would doubtless be satisfied that the bringing the establishments in question to their present state could not have been effected without the facilities afforded by a discretionary power lodged in the hands of a single individual, or that any individual could have been expected to have preserved in the use of that discretionary power to so good effect without a very powerful motive for exertion.[371]

Bentham was unusual in having such power vested in him alone but the problems of introducing for the first time plans and regulations on which to ground industrial proj-

ects, and of finding competent engineers and mechanics capable of carrying forward such projects from conception to execution, were familiar to every surveyor and engineer encountered in this chapter. As is now evident, the drawings they produced in pursuit of their goals reconciled clients, guided progress, secured co-operation, settled disputes and forestalled mistakes.

Drawings helped surveyors and engineers move with increasing ease between mechanical knowledge and empirical experience. Grundy junior imbibed the world of philosophical experiment and mathematical calculation from his father before wading forth to drain the fens, as did Buddle junior in relation to the mines. Smeaton was famously described as a philosopher among engineers and an engineer among philosophers. He was as much at home on construction sites, working at a drawing board, discussing a job with clients or the resident engineer as he was in making scientific experiments or reading a paper at the Royal Society. He referred to himself as an 'artist' but was deferred to by Lord Mansfield as a 'man of science'. Watt's old friend John Robison, who met Watt while an undergraduate at Glasgow University, in 1796 famously recalled their first meeting: 'I saw a workman, and expected no more, but was surprised to find a philosopher as young as myself, and always ready to instruct me.' Four years later, when Robison returned to academic life from the Navy, their acquaintance ripened into friendship: 'Every thing became to him the beginning of a new and serious study. Every thing became science in his hands'.[372]

The surveying and engineering drawings of such men were increasingly tied to methods of mathematical analysis, reflecting their accumulated experience and growing professionalism in the second half of the eighteenth century. At the same time in the French state artillery and engineering schools, programmes of descriptive geometry were rigorously enforced in order to master details of construction, free from the manual skills of the trades or involvement in the processes of manufacture. Cadets were taught a common language of formal rules through which they practised their eye and imbibed the value of precision.[373] This command of theoretical expertise at the expense of practical know-how was seen at the time to mark out the French from British engineers. Although the latter were increasingly in possession of mathematical sciences, they still worked empirically utilising mechanical skills. Their combination of knowledge and practice impressed foreigners and was believed to give the British a competitive edge.

With his cosmopolitan training and experience, Samuel Bentham was more attuned to French methods of industrial control. He wanted to reorganise the Navy on a rigorously formalised, thoroughly systematic, visibly accountable basis, not one dependent on irregular customs and traditional crafts. In his published account, *Services Rendered in the Civil Department of the Navy . . .* (1813), he restated his determination to introduce 'machinery, engines and implements adapted to the performing manufactory operations, as classed according to the nature of the operation, without regard to the popular division of trades'.[374] Once the processes of production and the organisation of labour were thus reconfigured, they would be brought together by sound management and accountancy practice to work as part of one great efficient machine.

In 1814, Bentham published his *Desiderata in a Naval Arsenal*, 'or an Indication, as officially presented, of the several particulars proper to be attended to in the formation or improvement of Naval Arsenals; together with an outline of a plan, formed by order of the Admiralty, for the Improvement of the Naval Arsenal, Sheerness'.[375] This port and dockyard had taxed successive generations of officials through its exposed position and unstable ground, prone to erosion and flooding. In 1808 Bentham had suggested a certain degree of rationalisation and a further plan was made in 1812 by a committee of the Navy Board, assisted by Joseph Huddart, James Watt junior and Josiah Jessop.[376] Yet their proposals were modest compared with Bentham's extraordinary scheme for an ideal

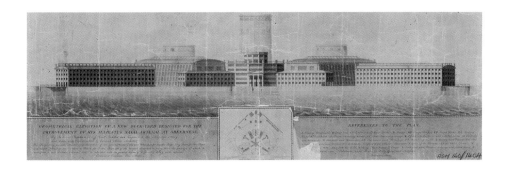

dockyard, evidently first dreamt up while he was still Civil Architect and Engineer to the Navy.[377] By the time of publication, however, he was out of office and was unconstrained by practical considerations.

Bentham's vision was of a dockyard where the waters of the harbour were smooth, the landing places accessible at all times and the wharfage so sited as to take maximum advantage of the directions of tides and currents. There would be ample uncovered space for stores which could be safely exposed, and enclosed, warm, well lit and ventilated receiving rooms for spreading out and examining articles that might be injured or embezzled. The dockyard would contain the best apparatus for measuring, weighing and for testing mechanical strength. The general stores would be fireproof and efficient. There would be drying places for seasoning timber, dry docks, covered docks and workshops which were enclosed, heated, ventilated and lit to overcome objections to night work. Machinery would be constructed to obviate the need for and expense of skilled and manual labour, speeding up unloading and loading, as well as the organisation, transport and distribution of materials.

The most revolutionary aspect of his proposals was the design of the dockyard itself, costed at a million pounds. Bentham envisaged it as a panopticon, in which men would be efficiently managed by placing them and their work practices under constant surveillance: 'To effect this desirable purpose, what may be called a Central Spot, was fixed on the site for the offices of the principal officers, round which was arranged the several businesses in the order of preference that seemed most desirable'. The inner circle would be devoted to stores, the next to ship repairs, sails and rigging, while the boat cove and landing place opposite the principal entrance to the central building would afford uninterrupted views out to the basin and wharfs. In effect, the design was a reworking of his plans made in the 1780s while employed by Prince Potemkin and taken up by his brother as the ideal instrument for managing prisons. The scheme had foundered by this date on the government's unwillingness to support the principle of private contract management of prisons and Samuel here applied the panoptic principle to a royal dockyard.

Now lacking an office headed by Goodrich, however, Bentham was unable to produce the 'details of plans and regulations suited to the local circumstances' crucial for the realisation of his scheme. Instead, a utopian 'Geometrical Elevation' was drawn up by the architect Edmund Aikin, under Bentham's directions, with a rough plan (fig. 66).[378] The central building looms up, banded in grey and blue stone, as grandiosely monumental and spatially rational as the 1773–6 plans of Claude-Nicolas Ledoux for the salt works town of Chaux.[379] Elements were undoubtedly inspired by the Gwilts' vast warehouses at the new West India Docks. Yet when work did commence on a new dockyard for Sheerness in 1813, they were under the direction of John Rennie and Edward Holl, Bentham having left the Navy in December 1812. It was a massive work of construction and involved sinking more than a million piles, took more than ten years to complete and cost more than £2.5 million.[380]

III

Models

Polite Toys, Useful Tools

It may sometimes happen that the greatest efforts of ingenuity have been
exerted in trifles, yet the same principles and expedients may be applied to
more valuable purposes, and the movements which put into action machines of
no use but to raise the wonder of ignorance may be employed to drain fens, or
manufacture metals, to assist the architect or preserve the sailor.

<div align="right">Samuel Johnson, The Rambler, no. 83, 1 January 1751</div>

We have model farms, model towns, even model factories . . . soon we will have
model families. We are a model family.

<div align="right">George III in Alan Bennett, The Madness of George III (1991)</div>

The word 'model', then as now, possessed a multitude of meanings suggestive of stages
in the process of creation. In Ephraim Chambers's *Cyclopaedia* of 1727, 'model' is first
defined as 'an original, or pattern proposed for any one to copy or imitate', with the
example given of St Paul's Cathedral being 'built on the model of St Peter's at Rome'.
Then the use of a working model is defined, as an 'artificial pattern . . . for better con-
ducting and executing of some great work, and to give an idea of the effect it will have
in large', with mechanical examples cited of 'models for the building of ships, etc. for
extraordinary stair-cases, etc.' Finally, the term is defined in relation to the fine arts. A
model can be 'a naked man, disposed in several postures, to give an opportunity for the
scholars to design him in various views and attitudes'. It can also be in 'clay and wax'
employed by sculptors and 'statuaries'. Here again a distinction is made between models
after existing works, 'designs of others that are larger in marble', and those relating to
proposed schemes, 'figures in clay or wax which are but just fashioned, to serve by way
of guide for the making of larger, whether of marble or other matter'.

Therefore, under the generic term 'model' Chambers made some distinction between
an original and a subsequent stage in production, as well as between its use in relation
to the fine arts and the mechanical arts. 'Modelling' reinforces the sense of the model's
three-dimensional form, created by being shaped out of raw materials, or framed by
putting parts together, for little difference existed between modelling and construction.

The skills employed for both were primarily tactile, involving handling and muscular action, or the substitution of this work by machines. Modelling skills were infinitely adaptable, as is demonstrated by the motion proposed by the Russia merchant Robert Dingley, in March 1757, at the Society for the Encouragement of Arts, Manufactures and Commerce in London. He suggested that the Society should offer a premium for modelling in wax and clay, confidently asserting that it would have a vast range of applications. Considering 'the benefit of modelling in a commercial national light', he argued the case for economic self-sufficiency and even exports in three-dimensional goods across a wide variety of trades: the manufacture of pottery and chinaware; carving in wood for joinery, furniture and picture frames as well as coach- and cart-building; glass manufacture; the improvement of machines and the cutting of dyes for their manufacture; the production of 'toys' or fancy goods in Birmingham, Sheffield, Pontypool and London; children's toys; wrought plate, jewellery and the cutting of jewels; clocks and watches, optical instruments, swords, snuff-boxes, belt-buckles, even plumes for turbans. He also viewed modelling as an art 'useful and ornamental' – although the distinction appears arbitrary – citing upholstery and cabinet-making, improvements in equipages, ironwork, papier-mâché work and even shipbuilding.[1]

Models had been common currency in the fields of architecture, engineering and shipbuilding since the Middle Ages, if not earlier. The belief that models of widely different kinds might be gathered together to further the understanding of nature can be traced back to the Renaissance *Kunstkammer*.[2] Bacon recognised the phenomenon when he allowed that outstanding works of art or, rather, displays of technical virtuosity might stimulate improvement and invention and ultimately discoveries in the realm of natural philosophy. In an anonymous contribution he probably made to *Gesta Grayorum*, the 1594–5 Christmas revels of Gray's Inn, London, one of the Prince of Purpoole's councillors suggests four aids to the study of philosophy: a library, garden, laboratory and 'a goodly huge cabinet, wherein whatsover the hand of man by exquisite art or engine, hath made rare in stuff, form, or motion; whatsoever singularity, chance and the shuffle of things hath produced; whatsoever nature hath wrought in things that want life and may be kept; shall be sorted and included'.[3] Thirty years later, in *New Atlantis*, these princely research facilities had grown into an academy of universal learning, Salomon's House, for 'the knowledge of causes, and secret motions of things; and the enlarging of the bounds of human empire, to the effecting of all things possible'. Among its rich resources were collections of 'diverse mechanical arts . . . and stuffs made by them; as papers, linen, silks, tissues, dainty works of feathers of wonderful lustre; excellent dies and many others'. There were also 'engine-houses, where are prepared engines and instruments for all sorts of motions'. Two 'very long and fair galleries' were set aside for formal use; one contained 'patterns and samples of all manner of the most rare and excellent inventions' and the other, statues 'of all principal inventors'.[4]

Seventeenth-century museum collections were formed on loosely Baconian lines.[5] In his 1681 catalogue of the 'natural and artificial rarities' belonging to the Royal Society, their curator, Dr Nehemiah Grew, recorded an extraordinary assortment of different types of object and model among the *artificialia*: Boyle's air pump and other scientific and navigational instruments and apparatus, a weathercock begun by Wren with a motion added by Hooke, Petty's twin-hulled ship and several architectural models. In the section on mechanics relating chiefly to trade, he listed Evelyn's donation of the Spanish *sembrador*, a cider press contrived by Hooke, Wren's beehive and an instrument designed by him to draw perspective, an 'optique box used as a help in drawings', as well as assorted knick-knacks turned in ivory, shell- and waxworks.[6] By the first decade of the eighteenth century Grew was advocating that in every county, as well as repositories for agricultural knowledge and practice, there should be others

wherein may be presented a pattern of all the manufactures already made here or else-where, together with the material engines and tools used in the making, or models of them, if very large . . . the viewing of which would often given occasion to ingenious men either to think of a new invention or improve an old one. And so though some of those we have may be stolen by foreigners yet we shall have others to succeed them. For in that no bounds can be set to the variety of matters and motion nor to human wit in the managing hereof, there will be inventions new and infinite to the end of the world.[7]

As the eighteenth century advanced, the utility of models as visual manifestations of progress and stimuli for new inventions was widely promoted. At their most fundamental, models, like drawings, bridged the gap between the mind and the hand, the idea and form, memory and muscle. Yet, as with drawings, the status of the model was not fixed but dependent on social context – the particular circumstances in which it was made and shown. Like drawings, models could incorporate various forms of polite embellishment in order to attract the attention of potential clients, while still presenting the illusion of utility. The fluidity of this boundary between utility and ornament, the mechanical and polite, though no less a feature of the model in the eighteenth century than of drawings, was more open to challenge. Three-dimensional models were seen to replicate in miniature the end products. Yet, being more readily comprehensible, they invited closer scrutiny and raised more questions.

Was a model merely ornamental, a trifling 'executive toy' intended simply to divert and entertain a growing urban society, bent on the indiscriminate consumption of an increasing range of attractions, or could it genuinely be of value in representing progress? Was it designed to explain natural laws and reveal the processes of manufacture and production or did it in effect hide them, the better to provoke wonder over the mysteries of nature? A model might work on a small scale but was it a reliable guide to the utility or success of the final full-scale product? Secreted from the realms of external display as a private experimental device, could it mediate successfully between the subjective mind and objective world or, even more ambitiously, between smooth theoretical principles and awkward, frictional, unpredictable reality? In Britain, at least, there was a strong current of unease, if not downright scepticism, as to the purpose of models, usually allied to their association on the one hand with conspicuous display and on the other with abstract untested principles. The suspicion was that matters mechanical were being attached to the higher arts and sciences in order to gain cachet and patronage, but not necessarily to serious effect. From Jonathan Swift to Fanny Burney, the purported utility of polite and scientific models was mocked by those who refused to be dazzled by spurious claims to progress.[8]

Models were social constructs. As vehicles for ideas as well as for skills, their reception depended on the theatres or spaces in which they were first framed and experienced. At one extreme were 'polite' models of industry which symbolised princely possession and which were lavishly embellished accordingly, as were their more popular manifestations intended for urban shows. Then there were models which were more closely allied to and indeed claimed to embody the theoretical principles of mechanics and philosophy, intended for pedagogic purposes first within private cabinets, academies and universities and later for more widespread consumption in city clubs and taverns. Finally, the model could serve as an essential means for the maker of progressing industry and invention, not only demonstrating the successful application of both empirical skill and theoretical principles but also serving more intimately and with much less certainty as a working tool. In each arena, as with drawings, there remained considerable scope for ambiguity of interpretation, for mistrust and misunderstanding.

Overall, though, from the salon and cabinet to the lecture theatre and workshop, models articulated the theory and practice of industry.

Princely Possessions

There are records from the sixteenth century of models of fortifications and artillery pieces, serving as prestige toys and planning tools for European rulers, often displayed alongside other models, instruments and mechanical devices in their *Kunstkammern*.[9] A 1645 inventory of the copper and brass foundry in Vauxhall owned by the second Marquis of Worcester, which produced ordnance for Charles I, refers to two model rooms.[10] They contained models of wheels 'made for a perpetual motion', water works and fountains, fortifications, ammunition wagons and guns, a scaling ladder, ships and boats, locks, mills, cranes, pumps, an engine for cutting tobacco and even the model for a tomb or monument. Most of the engines and models were made by the engineer William Joulden under the direction of the Dutch master mechanic Caspar Calthoff. The model rooms were strategically sited over the King's dining room.

While these models have long since disappeared, the great relief maps of military fortifications commissioned from 1668 by the Marquis de Louvois, Louis xiv's Minister of War, have survived. Originally intended to help plan improvements and prepare sieges, when moved to the Louvre in the eighteenth century they became objects of prestige which provided tangible evidence of royal authority to visiting foreign dignitaries.[11] Models of the royal dockyards and a large plaster-of-Paris model of Gibraltar with all its fortifications played a similar role when they featured in George iii's Marine Gallery, built in the early 1770s above the East Library in Buckingham House, London.[12] Most of the dockyard models were made by shipwrights and carpenters who represented not only the buildings but a wealth of industrial detail: racks of anchors and piles of wood, model ships in the docks and slips and at Plymouth and Portsmouth schematic pro-

67 George Stockwell, model of Sheerness Dockyard, *c*.1774. National Maritime Museum, Greenwich, London, inv. SLR2148

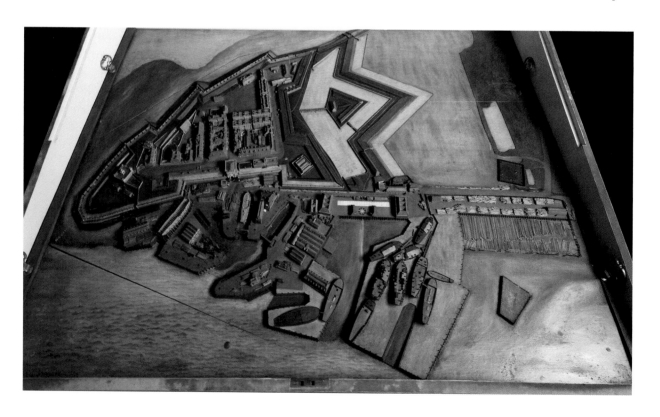

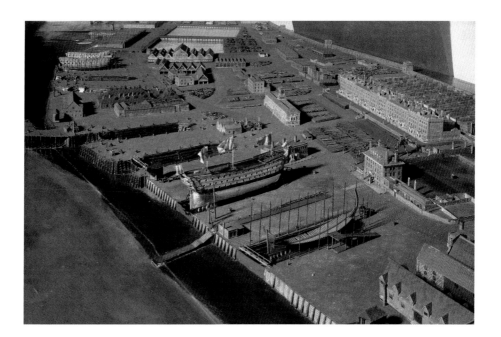

68 William Phillips and John Monk, model of Chatham Dockyard, detail showing ships on the stocks, the Officers' Terrace and Commissioner's House, *c.*1774. National Maritime Museum, Greenwich, London, inv. SLR2151

jected developments.[13] The Sheerness model, made by a professional model-maker, George Stockwell, included piles of rope and shot, two teams of bullock and even tiny men wearing cocked hats (fig. 67).[14] That of Chatham so pleased the dockyard Commissioner that, according to a contemporary report in the *Kentish Gazette*, it was placed on display before being sent to the Admiralty.[15] It showed the Commissioner's mansion and Officers' houses with their gardens, several ships under construction or repair and a first-rate ready for launching (fig. 68).

George III's Marine Gallery also contained assorted model ships, which had long served as a means of gaining approval for naval policy in general or for the building of a particular ship, as well as providing a vehicle for polite instruction in the art of ship-building. In 1607 the shipwright Phineas Pett built a ship model as a preliminary design which, 'being most fairly garnished with carving and painting, and placed in a frame arched, covered, and curtained with crimson taffety', was presented first for approval to the Lord High Admiral and then to James I and his son Prince Henry. Pett reported that the king was 'exceedingly delighted with the sight of the model, and spent some time in questioning me divers material things concerning the same, and demanding whether I would build the great ship in all points like to the same'. The *Prince Royal* was duly launched at Woolwich in 1610.[16] In 1634 Pett also made a model ship on a wheeled carriage 'resembling the sea' for Prince Charles (later Charles II), then aged four, 'who entertained it with a great deal of joy, being purposely made for him to disport himself withal'. A more serious model of a hundred-gun ship was carried the same year to Hampton Court and placed on display in the Privy Gallery there and later in Whitehall.[17] The large and splendidly decorated ship constructed after it by Peter Pett, under the direction of his father Phineas, was launched as the *Royal Sovereign* or *Sovereign of the Seas* three years later. In the 1660s, Charles's brother, James, Duke of York, had ship models in his apartment, as befitted one who was Lord High Admiral.

Under the Hanoverian monarchs the tradition continued: a model of the *Royal Oak*, a third-rate of seventy guns launched in 1741, is known to have been in the possession of George II, who gave it to his brother the Duke of York.[18] The finely carved model of the *Bellona* (1760) was probably made by George Stockwell to convince George III of the advantages of a copper-sheathed hull, primarily to protect the wood from worm but

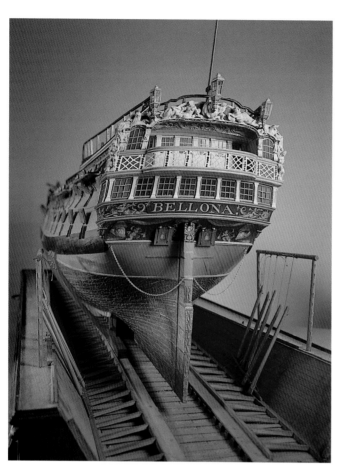

69 Attributed to George
Stockwell, model of the 74-gun
'Bellona', stern detail showing
copper sheathing, 1770.
National Maritime Museum,
Greenwich, London, inv.
SLR0338

coincidentally to increase the ship's speed (fig. 69).[19] Following the King's review of the Fleet off Spithead in 1773, the First Lord of the Admiralty, the Earl of Sandwich, bombarded him with ship models and plans to sustain his interest in the Navy. In September George received a model of a third-rate: 'the timbers are all marked with their proper appellations, and Lord Sandwich flatters himself that nothing can be more likely to give your Majesty a thorough idea of a ship's construction than this model', especially when explained by its maker, Joseph Williams, a Navy Board draughtsman on the books at Deptford.[20] At the same time, Sandwich sent a model of ship masts (including a mainmast which could be taken to pieces), made by the master mastbuilder in consequence of orders given to him on the King's visit to Portsmouth.[21] In July 1774, another Williams model arrived in London with its maker, this time of the frigate *Winchelsea*, as a present for the Prince of Wales.[22] By August 1775 twelve painted panel perspectives of different ship models had been completed at George's behest to complete his 'naval collection'.[23]

The British royal family was not alone in receiving gifts of models, plans and paintings of ships. In April 1698 Tzar Peter of Russia left London with a thorough knowledge of English shipbuilding, experienced first hand in Deptford, and with a collection of models, including a completely planked 1:32 scale model of the new first-rate *Royal Sovereign*, then under construction at Woolwich, and a model of the yacht William III had given him, the *Royal Transport*. Five models – including the *Royal Sovereign* – survive in the State Naval Museum in St Petersburg.[24] In the collection of the Musée de la Marine in Paris there is a 1:26 scale model of a hundred-gun ship, elaborately carved and gilded, made around 1720–25 for the instruction of the young Louis xv,[25] and similar vessels were made for the instruction of his son, Louis xvi. The French Inspecteur Général de la Marine, Duhamel du Monceau, built up a collection of models of dockyard equipment: a drying oven used to bend frames, a bucket dredger, gun-boring machine, revolving crane, a careening ship and the rope-house and masting machine at Toulon, made from the timber of the *Entreprenant* (a third-rate built at Brest in 1678, which ended its career in Toulon in 1722).[26] Although intended for pedagogic purposes connected with his creation in 1741 of a naval school, Duhamel did not have the space to display them and in 1748 he presented them to the state for installation in a Salle de Marine in the Louvre, next to the collections of the Académie des Sciences and where the grand relief plans of fortifications were already displayed in the Galerie du Bord-de-l'Eau (now the Grand Galerie). They could be viewed by apprentice shipwrights but their location ensured they retained a connection with princely authority.[27]

From one end of the coastline of Europe to the other, displays of model ships, dockyards and maritime inventions served to exemplify royal leadership in the defence of the realm and thus in industrial progress. In 1786, Bailli Frey D. Antonio Valdés, the Spanish minister for the Navy, wrote to Tomas Muñoz, the engineer in charge of the works at La Carraca, Andalucia, asking for

A wooden model executed in fine detail of the dry-dock and the pumps, so arranged that one may clearly see in a vertical plane the whole of its interior from the piles driven into the mud to the uppermost portion of the structure, and showing on a reduced scale the shape of the dock at present in use, including the pump house, so that His Majesty might see it in just as much detail as if he were looking at the real installation itself.[28]

In Sweden around the same time, a dedicated museum was created on the upper floor of the dockyard hiring hall at Karlskrona to house the magnificent collection of the foremost ship designer of his age, Fredrik Henrik Chapman, comprising a hundred models of the ships of his design – the largest on a 1:16 scale – as well as those of his predecessors, Charles and Francis Sheldon, and assorted technical innovations such as bow- and stern-moulding cradles. These were all sold to King Gustav III.[29]

Ship models were also commissioned by or presented to naval administrators, retiring captains and admirals. During his tenure as Clerk of the Acts and later Secretary of the Navy, Samuel Pepys accumulated a collection of ship models initially as aids to instruction on rigging and so on from sailing masters and later perhaps simply from pride in association. His successor as Clerk of the Acts to the Navy Board, Charles Sergison, seems to have regarded naval papers and models as the perks of office and kept them in a special room at Cuckfield Park, Sussex, where they remained for two hundred years. In 1732 a model of a twenty-gun ship was made at Deptford for Lord Torrington, First Lord of the Admiralty, on his retirement and paid for by his son, Captain Byng. A 1:48 fully rigged model of the first-rate *Victory*, launched at Portsmouth in 1737, was finally completed after four years work in Woolwich dockyard in 1744 for display in the Admiralty boardroom. Similarly, in 1747 a model of the fourth-rate *Centurion* of 1732 was made by Benjamin Slade of Plymouth dockyard for presentation to Lord Anson, who had formerly commanded the ship.[30]

Rulers without navies collected models relating to the most prestigious forms of industry under their patronage. On 8 June 1751, the Emperor Franz I Stephan of Lorraine, the husband of Empress Maria Theresa of Austria, received a gift from the mining towns of upper Hungary (fig. 70). It took the form of a *Handstein*, a presentation model set on a silver base of Rococo form, borne on the back of four small silver-gilt sphinxes. A mass of glittering metals and minerals mined in the region of Schemnitz (now Banská Štiavnica, Slovakia), Kremnitz (Kremnica) and Neusohl (Banská Bystrica) was arranged in the form of a miniature mountain, surmounted by a crucifix. The slopes of the mountain were alive with activity in the form of mining plant and equipment worked by tiny miners, all modelled in silver.

Similar examples to this work are displayed with it in the Kunsthistorisches Museum, Vienna.[31] The earliest on show, dating from the mid-sixteenth century and made in Joachimsthal, Bohemia (now Jáchymov, Czech Republic), are shaped like standing cups or chalices, the crucifix being prominently placed on the apex of a pyramid of ores.[32] In effect, *Handsteine* represented the cosmos in miniature, microcosms encompassing naturalia and artificialia in a single *Gesamtkunstwerk*. They were status symbols, in part works of art, in part instruments for learning and reflection. In the early modern period, precious metals were still being mined in the mountain ranges of Central Europe – the Harz, the Erzgebirge (ore mountains) and the Carpathians – despite the discovery of much greater deposits in the New World. Yet the conflation of mining with Calvary scenes suggests that remnants of the medieval Christian ambivalence towards wealth lingered on. In the classic Renaissance treatise on mining, *De Re Metallica* (1556), Georgius Agricola (Georg Bauer, one-time physician of Joachimsthal, later the mayor of Chemnitz) refuted the traditional view that mining encouraged avarice, vanity and violence

with the argument that minerals were produced by the Creator and their removal from
the earth was no more evil than taking fish from the sea. Gold did not create greed, nor
iron war; it was the wickedness of men that did so. Thus the presence of the crucifix on
a *Handstein* served to remind the viewer of the ultimate source of all riches and, equally,
of the Saviour's sacrifice for humanity's sins.

Many of the machines which adorn the *Handsteine* can be identified from the wood-
cuts that accompanied Agricola's text: furnaces set in huts, troughs and waterwheels, as
well as the winding, ventilating and pumping machinery. All were modelled with varying
degrees of accuracy, depending on the *Handstein*-maker's skill. *Handsteine* were first dis-
played with other confections of *naturalia* and *artificialia* in princely cabinets of curiosi-
ties, notably those of Ferdinand II of Tirol (1529–1595) and his nephew the Emperor
Rudolph II of Prague (1552–1612). The religious character of the earliest *Handsteine* was
gradually diluted by virtuoso displays of the goldsmith's and jeweller's art, designed to
give pleasure to the owner or viewer in the attainment of technical mastery on a minia-
turised scale. Some served as receptacles for condiments and sweetmeats. Others
exploited even more directly the fascination of the age for all things mechanical.[33] In
the Franz Stephan presentation model, there is one large piece of equipment set in a
prominent framing structure, halfway down the mountain, with which Agricola would
not have been familiar: it is a miniature Newcomen steam engine.

The atmospheric Savery engine improved by Thomas Newcomen was designed to
answer the problem of how to drain water from a mine sunk far below the level of free

drainage. It was particularly useful in areas that were so dry that it was virtually impossible, without constructing huge reservoirs, to procure enough water for waterwheels to drive the pumping engines. The Windschacht and Siglisberg mines near Schemnitz were sited in just such a place since, owing to their position on spurs of the Tatra mountains, they were extremely dry except during the spring thaw. They had to depend on horse-driven hydraulic machines, which were expensive and almost useless, while catchment reservoirs did little to ease the problem.[34]

Newcomen's improvements to the Savery pumping engine were in use in England by 1712 and news spread quickly. John O'Kelly's drawing of the Newcomen engine built near Liège in 1720–22, the first to be constructed on the continent, had found its way via the Swedish ambassador at the The Hague to the Board of Mines in Stockholm by 1725.[35] Meanwhile in London, Jean Desaguliers was initiating a series of European visitors into the engine's mode of operation. They included Johann Emmanuel Fischer von Erlach, godson of the Austrian Imperial Court Chancellor and heir to the Viennese court architect, who was instructed by the Vienna Hofkammer to investigate its workings during his stay in London on a European grand tour. In January 1719 von Erlach attended a lecture at the Royal Society given by Desaguliers on the subject, employing a small-scale model. He also travelled north disguised as a workman and saw for himself the full-scale machines in action.

Having negotiated a monopoly on the construction of the engine in the Austrian Empire, von Erlach managed to entice a Durham millwright, Isaac Potter, to enter the imperial service. By June 1720, Potter was in Vienna and in July he travelled to Hungary to select the best site for his engine. He chose Königsberg (Nová Baňa), south-west of Schemnitz, but there were endless problems before the first engine was completed in 1723. The Hofkammer was not convinced by his choice of site and delayed for a year its approval, a moment marked by the production of a large perspective drawing of the machine.[36] An engraving of Potter's machine was also included in the second volume of Jacob Leupold's *Theatri Machinarum Hydraulicum* (Leipzig, 1725), showing its key working parts in section, with an explanation and letter of endorsement from von Erlach.[37] On site, however, Potter's engine disturbed vested interests: it was seen as a threat to livelihoods, especially those of the horse-dealers. Furthermore, the raw materials supplied for the engine were substandard, as were the brass-founding and clock-making skills needed to make the copper boiler and associated valves; Potter's contract ran out and the Ungarische Gewerkschaft exploiting the mine went bankrupt. Potter died in 1735 but by 1740 there were five machines up and running, if only intermittently, pumping water from extraordinary depths.[38]

The representation of one of the engines within a Calvary scene, albeit populated by miners, would not necessarily have seemed like a rationalist intrusion from another world. Mårten Triewald, who built the first Newcomen engine in Sweden at Dannemora in 1726, claimed the discovery for divine providence, a stroke of luck which proved the existence of an almighty and benevolent God.[39] By the middle of the eighteenth century the status of mining and mineralogy in Central Europe had never been higher, stimulated by a deepening basis of practical study and investigation which provoked debate regarding the structure and composition of the earth, the nature of time and ultimately the meaning of life.[40] The imperial family of Austria had more than a token interest in mining as a source of their wealth. Franz Stephan's informed knowledge of mines and mineralogy was well known and an academy of mining was opened in Schemnitz in 1763, the first of its kind in the world.[41]

To the north-west, the Electors of Saxony had lived for centuries off the wealth derived from the silver mines of the Erzgebirge. Their *Kunstkammer* at the Residenzschloss in Dresden contained *Handsteine* made of concentrated silver ore. The electors participated

in mining parades and masquerades. In the new stable complex, built by Christian I between 1586 and 1590, two tiered display buffets in the form of mountain ranges, covered with ore matrices, held twenty-six silver-gilt vessels on their ledges. From a side opening, watched over by the figure of a miner, a rider would emerge on a set of tracks and offer the astonished guest a *Wilkomm* goblet.[42] Early in the eighteenth century, reforms to the Saxon administrative regulations, working conditions and training of miners under Augustus the Strong led to the mines' revitalisation, a process that culminated in the founding of the Freiberg Bergakademie in 1765. It was of course mining expertise that lay behind the discovery in Saxony of the secret of porcelain manufacture and the establishment in 1710 of the first European porcelain factory, in Schloss Albrechtsburg at Meissen.[43] Not surprisingly, from the earliest experiments utilising the new material, tribute was paid to its origins in mining know-how through the introduction of mining figures and mining motifs in porcelain.[44]

Mechanical Marvels

Automata – models of humans, birds and beasts which moved apparently through their own volition – had existed since classical times. From the medieval period, clockwork figures appeared in cathedral timekeepers, courtly entertainments and peep shows. From the late sixteenth into the seventeenth century, mannerist gardens frequently incorporated small water-driven automata in their overall plan, cunningly designed to astonish visitors with an infinite variety of fountains and grottoes. Here statues of Perseus, Orpheus and other classical heroes were introduced and the water set in motion figures of smiths, weavers, millers, carpenters and knife-grinders working steadily at their trades, and powered miniature mills. Thus the *dei ex machina* were artfully underscored by more commonplace mechanics.[45]

By the eighteenth century, mechanical entrepreneurs were promoting the sophisticated skills of clock-makers in urban centres, with their markets, theatres, taverns and coffee-houses, capitalising on the growing demand for commodities, attractions and diversions of all kinds. Mechanical contrivances provided both an entertainment and a talking point. 'Mechanical' attached to any diversion in this popular context stood for technical wizardry and up-to-the-minuteness. It gave the gloss of fashion to skills which had hitherto been considered humdrum and unworthy of notice. In London, Christopher Pinchbeck senior (who died in 1732) was one of the first to combine the utilitarian clock trade with show-business, exhibiting allegorical or landscape pictures which moved to music. His 'Grand Theatre of the Muses' was presented at Bartholomew Fair in summer and at assorted coffee-houses and theatres in winter during the late 1720s. His sons, Edward and Christopher Pinchbeck junior (1710–83), continued the tradition, exhibiting a 'Panopticon' around 1742, a musical clock which showed an all-in-one view of a shipyard, foundry, smithy, stonemason's yard and a landscape depicting mills, carriages and a hunting scene, which would swing into action on the striking of the hour.[46] Henry Bridges' 'Microcosm' was a grandiose astronomical clock constructed at Waltham Abbey, the seat of the Duke of Chandos, and shown at the Mitre tavern in Charing Cross in 1741. Below the clock-faces showing solar time, lunar phases and the Copernican system, there were animated scenes of workers about their various tasks. It was indeed a 'world in miniature', combining representations of high art in its form, loosely based on a classical temple, science in its astronomical instrumentation and mechanical skills. Underlining its maker's pretensions, an engraving of the clock produced in 1734 and dedicated to the entrepreneurial Duke included two roundels featuring Bridges himself and Sir Isaac Newton (fig. 71).[47]

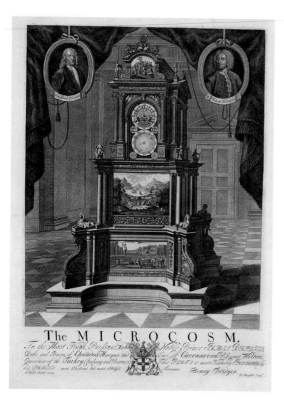

The M I C R O C O S M.
To the Most Noble Puissant and Noble Prince JAMES BRIDGES, Duke and Baron of Chandos, Marquis and Earl of Caernarvon, Esq. and Wilton, Governor of the Turkey Company and Carmarthen, this PRINT is most Humbly Dedicated by his Grace's most Obedient and most Obliged Servant, Henry Bridges. R. Sheppard Sculp.

71 R. Sheppard after R.
West, *The Microcosm*, 1734.
Andrew Edmunds

Bridges' Microcosm appeared to celebrate the well regulated workshop, both its exterior decoration and hidden works. On the most obvious level, the imagery of such contrivances reinforced the belief that clocks were mechanical models of the universe, marking time through following the movements of the heavenly bodies.[48] A commonsense view would see the rhythmic, rocking motion of artisans sawing, grinding and generally plying their trades as smooth-running cogs in the larger mechanism of life. More ominously, the model labourers could be regarded as machines and machines as sources of power, a connection made by scientific lecturers and engineers, seemingly supported in their interpretation by the masterly illusion of life purveyed by the most celebrated free-standing automata.[49] For the naive, these figures in their uncanny verisimilitude provoked fears that they were indeed alive. For the more sophisticated, they drew admiration on account of their technical ingenuity which might, it was hoped, lead to more useful applications. Automaton models raised the possibility of the duplication or even the replacement of human labour.

The celebrated automata produced by Jacques de Vaucanson fuelled the debate.[50] They represented a shepherd playing a flute, a tambourine- and flageolet-player and, most strikingly, a gilded copper duck capable of 'eating, drinking, macerating the food, and voiding excrements; pluming her wings, picking her feathers, and performing several operations in imitation of a living duck'. They were first shown in Paris in 1738 and inspected by a committee from the Académie Royale des Sciences. Four years later, they were presented to popular acclaim in the Long Room at the Opera House in Haymarket, London. In the accounts Vaucanson gave of his automata he strenuously countered the notion that he was merely out to make money from show business sensations. He addressed himself to members of the Académie, asserting that he was motivated more by their approbation than by the applause of the public, for his automata were based on the solid principles of mechanics. The flautist demonstrated how the sound of wind instruments was modified by human respiration. The duck's digestive system was based on anatomy and further lessons could be learnt from inspection of the bird's wing. Vaucanson maintained that his duck was nothing like 'those wonderful pieces of art', cocks moved by cathedral clocks at Lyons or Strasbourg: 'the whole mechanism of our artificial duck is exposed to view; my design being rather to demonstrate the manner of the actions, than to show a machine'. He desired to make every thing visible so 'I would not be thought to impose upon the spectators by any concealed or juggling contrivance.'

When Desaguliers published the English edition of Vaucanson's work, he took care to stress his own scholarly qualifications and prestigious connections as LL.D., F.R.S. and Chaplain to his Royal Highness the Prince of Wales. In his preface to the reader he sought, somewhat defensively, to explain why he had bothered. It was, he believed, 'very mean to cry up trifling performances and commend what amuses the great and small vulgar, by confederacy, such as the pretended mathematical figures, &c. But on the other hand, it is laudable to encourage those who are truly ingenious, by doing justice to the most curious pieces of art that perhaps have ever been performed.' In a few words Vaucanson had given a better and more intelligible theory of wind instruments than could be found in large volumes: 'In giving this paper an English dress, I am still acting in my province, which has been for many years to explain the works of

art, as well as the phenomena of nature.' For Desaguliers, Vaucanson's automata qualified under every head in the spectrum of knowledge: as works of fine art or sculpture, as exhibitions of mechanical art or skill and as demonstrations of the natural laws of mechanics and anatomy. Yet William Hogarth, for one, was unable to see either their artistic or mechanical merits, commenting sourly on the duck in *The Analysis of Beauty* (1753):

> this silly, but much extolled machine, being uncovered, appeared a most complicated, confused, and disagreeable object: nor would its being covered with a skin closely adhering to its parts, as that of a real duck's doth, have much mended its figure; at best, a bag of hob-nails, broken hinges, and patten-rings, would have looked as well, unless by other means it had been stuffed out to bring it into form.[51]

Nevertheless, the potential utility of Vaucanson's mechanics was demonstrated in his designs for silk-weaving machinery, using a rotating drum, similar to the one which powered his mechanical flautist, timed to manage the weaving rate. The loom featured a number of innovations relating to automation, programming and the movement of the shuttle.[52] He boasted that his automatic silk machine, powered by a horse, ox or ass, could make cloth of a higher quality and at quicker rate than the most able silk-worker at full stretch. But when in the early 1750s he tried installing these machines at a new-style silk mill in the Ardèche, he found that he still needed skilled workmen and they resisted his plans.[53] Having retreated from the front line to the safety of Paris, he built up at the Hôtel de Mortagne in the Rue de Charonne an extensive collection of models representing textile machinery and mills, which was open to the public.[54] On his death in 1782 Vaucanson left his collection of mechanical models, which included those for the machines he had invented, to Queen Marie Antoinette. The following year, Louis XVI named Alexandre-Théophile Vandermonde as its administrator and opened it to inventors and artisans as the Cabinet des Machines du Roi. It formed the foundation collection of the Conservatoire des Arts et Métiers.

Other devisers of automata moved easily between practical mechanics and popular showmanship. Wolfgang von Kempelen, a court counsellor in Vienna, first employed his talent for invention by installing drainage pumps in the imperial salt mines of Transylvania and water works in the castle of his native city, Pressburg (Bratislava), before creating his infamous chess-player.[55] The Swiss mechanics Henry-Louis and Pierrre-Jaquet Droz invented spring-loaded artificial hands and arms to compensate for the loss of natural limbs, besides an array of figures writing, dancing and playing musical instruments.[56] Yet it was harder to see the instrinsic utility of automata as they trundled round Europe in the wake of Vaucanson's example. They might invite speculation as to the potential of a mechanically ordered universe but scarcely served as practical applications to assist or replace manual labour on any scale.

When in 1771 the goldsmith and jeweller James Cox advertised his museum of bejewelled animated *objets de luxe* – encompassing vibrating butterflies, birds, animals, flowers and an entire mechanical orchestra – at the Great Room, Spring Gardens in London, he confidently asserted that his pieces performed a more valuable function than that of merely 'delighting the senses': 'the use made of natural and mechanical powers in several of these pieces offer[s] surely ideas *useful* and even *philosophical* enough to defend them from the reproach of being only glittering gewgaws'.[57] Some of Cox's smaller items did have a scintilla of practical utility, combining timepieces with *nécessaires* packed with items for personal grooming.[58] Yet Fanny Burney, for example, judging from her novel *Evelina* (1778), was not persuaded. While her more trivial characters were impressed by the brilliance of the spectacle, deeming it the 'grandest, prettiest, finest sight in England', the eponymous heroine felt something was missing. Although she allowed it to be 'very

astonishing, and very superb; yet it afforded me but little pleasure, for it is a mere show, though a wonderful one'. Captain Mirvan brusquely condemned it as *kick-shaw* work in the French taste, asking their guide what was the use of it all:

> 'Why, Sir, as to that, Sir,' said our conductor, 'the ingenuity of the mechanism, – the beauty of the workmanship, – the – undoubtedly, Sir, any person of taste may easily discern the utility of such extraordinary performances.'

> 'Why then, Sir,' answered the Captain, 'your person of taste must be either a coxcomb, or a Frenchman; though for the matter of that, 'tis the same thing.'

The hero, Lord Orville, probably best summarised Fanny Burney's own opinion: 'The mechanism . . . is wonderfully ingenious: I am sorry it is turned to no better account; but its purport is so frivolous, so very remote from all aim at instruction or utility, that the sight of so fine a show, leaves only a regret on the mind, that so much work, and so much ingenuity, should not be better bestowed.'

Suspicions as to the gimcrack nature of such spectacles were reinforced by satirical references to Cox's Museum as a byword for manipulation by outward show to disguise inner political corruption. Not for the first time was the mechanical metaphor used to stand for authoritarian government.[59] The appeal of Cox's Museum lasted for little more than a couple of seasons: by 1773 he was petitioning Parliament to stage a lottery, one which finally appears to have taken place in 1775.[60] In October 1777 a visitor from New England found it 'in dishabille and dusty; but there is elegance enough remaining, to give a spectator an idea of what it was at its best estate'.[61] Cox's successor Thomas Weeks never managed to revive interest in the contents, despite attempting to promote their value on the basis of both entertainment and utility.[62]

Nevertheless, Cox's one-time assistant John Joseph Merlin made great efforts to elevate the status of this kind of show.[63] Trained in Paris under the auspices of the Académie des Sciences, he came to London in 1760 in the suite of the Spanish ambassador and by the mid-1760s he was probably working for Cox. In later patent applications Merlin described himself as a maker of mathematical instruments, while a near contemporary called him an engineer and watch- and clock-maker. Given his undoubted skills, he might have been the power behind the automata clocks that Cox exported to China via the East India Company,[64] as well as his famous museum automata. Cox's Perpetual Motion Clock (now in the Victoria and Albert Museum, London), a chastely restrained invention in the neo-classical style, was probably also Merlin's handiwork. It displays, like the later clocks signed by Merlin himself, the highest order of workmanship and original design. Moreover, as it was glazed on all sides the mercury barometer which gave motion to the clock could be seen, as well as the movement itself.[65] He made and signed the earliest dated skeleton table-clock which exhibited an eight-day movement using as few wheels as possible.[66] In contrast to the simulated ingenuousness of some automata, the mechanics of Merlin's finest creations had come completely out of the closet.

In the late 1780s Merlin opened his own Mechanical Exhibition (subsequently known as Merlin's Mechanical Museum) in Princes Street off Hanover Square. Its contents comprised sophisticated variations on the usual mixture of mechanical marvels and practical inventions for sale.[67] The catalogue mentions a rotating mechanical tea-table worked by pedals, a 'Sanctorius balance' or personal weighing machine, a 'Valetudinarian bedstead' as well as a Morpheus or 'gouty chair', a 'Hygeian air-pump' or ventilator for ships and hospitals and a 'Prophetic bell' or telegraph system which registered orders on domestic bell-pulls. Alongside whispering busts and a gambling machine there was Merlin's own 'mechanical chariot', decorated with various figures emblematic of his legendary namesake, which could be steered from inside by means of a mechanical whip.

Although designed more particularly to appeal to the buoyant market in medical aids, such pieces were part of a vogue for dynamic or metamorphic furniture, notably that made by Abraham Roentgen in Germany, with hidden drawers and other secret components mechanically triggered by springs.[68]

When she visited London in 1786, Sophie von la Roche recognised the feminine appeal of Merlin's 'pretty, but curious inventions': 'Neat little writing- reading- or working-tables, combined with charming, soft-toned pianos, also earned my whole-hearted approval; I hoped they might be presented by kindly fathers, a brother, uncle, or generous husband to a daughter, sister, or quiet but busy wife'. These were mechanical models intended for polite consumption, not for serious study, let alone industrial progress. She praised the mechanical temple of Apollo, with machines dressed as waiters and waitresses, which Merlin was then working on, as 'an example of inventiveness, industry and good taste' coupled with 'an understanding of the infinite thirst for pleasure of the rich'.[69]

Mechanical Cabinets

If mechanical models of human beings and a whole gamut of ingenious devices illustrative of mechanical capability, though not always industrial utility, were more or less integrated into polite theatres of art and entertainment, they were increasingly at home in the realms of science. Scientific instruments and mechanical models had long formed part of princely cabinets of artificial curiosities. As historians of science have emphasised, they 'embodied' scientific theories and symbolised the possession, if not necessarily the understandings of that theory. They made mathematical abstractions concrete by visualising them in three dimensions. Observing them in action would, it was thought, reveal the principles of nature. They could be mastered without any prior knowledge of the principles behind them, the principles being precisely what they were designed to illustrate. In the eighteenth century, they moved out of the close confines of the aristocratic or scholarly cabinet to the open arena of the public show.

In June 1718 Willem Jacob 's Gravesande, Professor of Mathematics and Astronomy at Leiden University, explained the purpose of such models to Newton:

> as I talk to people who have made very little progress in mathematics, I have been obliged to have several machines constructed to convey the force of propositions whose demonstrations they had not understood. By experiment I give a direct proof of the nature of compounded motions, oblique collisions, and the effect of oblique forces and the principal proposition respecting central forces.[70]

Yet experimentation with these machines and models had its limits. They could be used to demonstrate rational scientific methods, not as a stage in furthering invention. Mechanical cabinets might stimulate enlightened discussion, as could *Handsteine* or bejewelled automata, but their connection with industry was also at one remove. At best they acquainted their audiences with tried and tested examples of mechanical progress, without actually contributing to it. Nevertheless, the importance of this process of elucidation and familiarisation should not be underestimated, given the limited means available for diffusing knowledge about industry.[71] Encounters with models of watermills and steam engines in the safe, comparatively clean environs of the cabinet or museum, tavern or lecture theatre, must have helped to reconcile audiences with the massive brick and stone mills and engine-houses, hiding the hissing, steaming, thumping machines, that were going up around them. As every developer knows, a neat model viewed in congenial surroundings provides reassurance and even docile acceptance of potentially monstrous intrusions.

The basic principles of classical mechanics were demonstrated to polite audiences across Europe through models of levers, pulleys, balances and screws and larger set-pieces for measuring conditions of equilibrium on an inclined plane and calculating the centre of gravity. They were supplemented by models of practical devices that operated under the laws of mechanics, such as the capstan, crane, pile-driver and various mills. These were presented as trials of strength alongside other models that demonstrated, with varying degrees of showmanship, elementary pneumatics, hydrostatics and hydraulics, astronomy and optics, electricity and magnetism. For a predominantly aristocratic and haut-bourgeois audience in France, models and instruments were often embellished the better to fit elegantly into grand cabinets of knowledge. From the 1730s, the Abbé Jean-Antoine Nollet was a prolific producer and demonstrator of scientific instruments which even now can be identified by their distinctive decorative finish, with gilded floral motifs on a red or black ground of *vernis Martin*, the finest French japanning varnish.[72]

Possibly the best recorded example of a grand eighteenth-century mechanical cabinet is that formed by the rich amateur Joseph Bonnier de la Mosson and housed in the 1730s at his Paris residence, the Hôtel du Lude.[73] A room was set aside for it in the first-floor enfilade, between his library and his natural history and medical collections, which progressed to spaces reserved for an ornamental lathe, pharmacy and laboratory. The polite and useful models, serious applications and frivolous diversions, inhabited the same world of knowledge, judging from the set of drawings commissioned by Bonnier from his architect Jean-Baptiste Courtonne in 1739–40 and the Gersaint sale catalogue of 1744.[74] Its shelves were lined with models which embodied the principles of mechanics and optics, or represented mills, ships, fortifications and artillery pieces, enlivened by moving pictures and automata. The cabinet was decorated with allegorical overdoors painted by Jacques de Lajoüe, representing artillery, astronomy, optics and mechanics, which related the contents of the shelves to a broader philosophical agenda.[75]

For 'Mechanics', the figure of a sage sits surrounded by his collection, a volume of designs on his lap, in a Rococo cabinet adorned with representations of the muses.[76] Perhaps Lajoüe intended to suggest to his viewers that old prejudices and superstitions could be overthrown by rational experiment, for the sage looks out towards projects of bridge building and other forms of construction in the greater world beyond, where progress would be advanced by mechanics on a grand scale. Nevertheless, he remains safely within the environs of his study – as presumably did Bonnier. He did not take part in the activities of the Paris Societé des Arts which, at its twice weekly meetings in the Hôtel du Petit Luxembourg, attempted to mediate between polite and mechanical improvements in art. His cabinet seems to have served as a token of social position and educational accomplishment rather than as the basis for serious experiment. He died comparatively young in 1744 and his collections were sold the same year.[77]

Britain was not lacking in grandees capable of appreciating and indeed practising applied mechanics, as is demonstrated in the range of the interests pursued by one of the richest and most powerful men in Scotland in the first half of the eighteenth century, Archibald Campbell, the first Earl of Islay and third Duke of Argyll (1682–1761).[78] Educated at the universities of Glasgow and Utrecht, Campbell was probably urged by his brother's tutor, the historian Alexander Cunningham, to study mathematics, medicine and the sciences. His studies were not limited to perusing the 3500 volumes devoted to science and mathematics in his library, for he involved himself in their application, promoting improvements in agriculture and industry, mining and fisheries. According to one of his obituaries, 'He could talk with every man in his own profession, from the deepest philosopher to the meanest but ingenious mechanic.'[79] He himself was a skilled mechanic, fascinated with clocks and capable of repairing his own watches. This is con-

firmed by Thomas Grignion's acknowledgement of the help the Duke gave him in suggesting an increase in the number of wheels in a 'great watch' made for him in the mid-1750s.[80]

At his home The Whim, in Peeblesshire, he amassed an impressive array of scientific instruments, machines, toys and models. Besides microscopes, lodestones and magnets, at least eight telescopes, thermometers, barometers, navigational and surveying equipment, he acquired models of the latest improvements in agricultural machinery from London and Glasgow as guides for their construction full-size by local millwrights and carpenters. Among them was a four-wheeled low carriage for moving stones or logs of wood, as well as machinery for milling, assorted farm tools – ploughs, seeders, threshing machines – a model pump and equipment for use in quarries, coal mines, lime kilns and salt pans. Robert Mackell, who worked at Rosneath and Inverary, also made models of the machines and mills the Duke intended to use when he launched new industries in these towns. Having had a laboratory installed in 1723 at his London home, Whitton, near Hounslow Heath, in about 1740 Argyll constructed another at The Whim, fitted with furnaces, stills, mortars and crucibles where he undertook various chemical experiments.

Argyll's collection was dispersed on his death and none of his models appears to have survived but many of the instruments were acquired by his scientifically minded nephew, John Stuart, the third Earl of Bute (1713–1792).[81] At his Luton estate, Bute accumulated a cabinet of mathematical and physical apparatus which, according to one visitor, 'may be reckoned the most comprehensive of the kind in Europe'.[82] In 1739–40, the leading London instrument-maker, George Adams, was asked by Bute's agent the price of a machine for cutting clock-wheel teeth, which suggests that his interest went beyond the academic, and Bute might even have assisted Adams in the construction of a variable microscope.[83] Through his close relationship with Princess Augusta, the widow of Frederick, Prince of Wales, Bute helped prepare the foundations for the future George III's interest in scientific instruments. From 1749, George had been tutored by George Lewis Scott, a mathematician of repute, who grounded him in mathematics and science.[84] Probably under instruction from the drawing master Joshua Kirby, he made copies of Sébastien Leclerc's *Pratique de la Géometrie*.[85] In 1755 Bute arranged for George and his brother Edward to follow the course of lectures given by Stephen Demainbray, one of the leading lecturers of the day on natural philosophy. Having succeeded to the throne, the young king demonstrated wide-ranging interests in architecture and design, astronomy and clock-making, turning and naval architecture.[86] On 15 December 1760, he appointed Adams to be his Mathematical Instrument Maker and by the end of the year had commissioned him to make the pneumatic and mechanical apparatus that still forms a large part of the collection now deposited in the Science Museum.

The George III collection is exceptional for its size and quality, aesthetics being integral to its appeal.[87] Adams catered for a genteel clientele, a new machine being described in his catalogue as 'a most beautiful, instructive and ornamental piece of furniture, not unworthy of the grandest apartment in any gentleman's or nobleman's house'. The star pieces were inevitably the microscopes on account of their decorative embellishment.[88] Nevertheless, other works fed George's strong practical and mechanical bent. Together with the King's apparatus, Adams provided an illustrated manuscript on pneumatics and mechanics, giving sufficient detail for 'intelligent workmen' to copy, as well as instructions on use.[89] He was also summoned on at least one occasion to provide a demonstration to a distinguished foreign visitor of Smeaton's double-barrelled air pump.[90] Adams constructed a philosophical table in mahogany for the King on which mechanical experiments could be made.[91] The model experimental cart on an incline, designed to test the performance of various wheels' diameters in relation to different weights, rep-

resents a particuarly refined variation on basic mechanics (fig. 72). It could be used in an abstract manner to demonstrate weight and power on an inclined plane but it could also serve as a model representation of road travel, complete with obstacles and ruts: the angle of elevation could be changed and a cobbled surface added, as well as a strip which could be removed to create a gutter. Brass rods were fitted into holes round the body of the carriage chassis to hold bulky loads like hay: 'If it [the hay] be wrapped in a sheet of paper and put between these wires and then a cubical weight laid thereon . . . we can see how easily carriages loaded with hay or any other light substances are liable to be overturned.' The carriage could be fitted with different pairs of brass wheels which were spoked and dished (setting the spokes out from the vertical to give lateral strength), with the weight in ounces engraved on each wheel. A model experimental cart could also be used with the detachable fore-axle tree of the model carriage.[92] Thus complete with all its appendages in the polite form of an exquisitely accessorised toy, the piece mediated between mechanical abstraction and humdrum reality. A miscellany of other items of a loosely scientific and mechanical nature were added to Adams's core pneumatic and mechanical works. Compasses and surveying instruments were possibly used by the Duke of Cumberland for the survey of Scotland and inherited by the King in 1765. There were also two model cranes: Christopher Pinchbeck's model for a treadwheel crane and a mahogany model of James Ferguson's crane which followed the description given in *Philosophical Transactions* in 1764.[93]

Mechanical cabinets were formed not only for the edification of princes but were also seen as an essential part of the European scientific academy. In the academic world-view, philosophers claimed authority over both speculative and useful mechanics. An engraving produced in 1698 by Sebastien Leclerc presents an idealised picture of the mechanical model collection or physical laboratory of the Académie Royale des Sciences, housed in the Louvre. It covers the whole range of arts and sciences: from models demonstrating basic mechanical principles, to those of practical hoisting equipment, windlasses, pulleys and screws and on to artillery and architectural models, relief plans of fortifications, optical and musical instruments and even casts after antique and écorché figures.[94] However, unlike most of the mechanical wonders already described, meant to amaze and sometimes even to trick, the mechanical models in the academic cabinet were intended, like Vaucanson's duck, to be participatory – a central aim of rational education – to demonstrate empirical skills validated by mathematics. Unlike the revelatory

tricks and special effects of many mechanical devices intended for polite audiences, within the academic teaching environment there had to be transparency, clarity and simplicity in order for lessons to be learnt and basic principles understood.

The first European university to introduce experiments into scientific teaching and thus the first to form a collection of instruments for the purpose was the University of Leiden. Its Cabinet of Physics (or collection of physical apparatus) was initiated in 1675 by Burchard de Volder who, as professor of philosophy, was apparently inspired by the demonstrations he had witnessed on a visit to the Royal Society in London.[95] The brass founder Samuel van Musschenbroek supplied him with scientific devices – including an air pump, microscopes, telescopes, anatomical syringes – for teaching experimental physics. When Willem Jacob 's Gravesande was appointed Professor of Mathematics and Astronomy in 1717 he acquired more apparatus from van Musschenbroek's nephew, Jan van Musschenbroek, for the purpose of diffusing Newtonian philosophy. In his textbook, *Physices elementa mathematica, experimentis confirmata: sive Introductio ad Philosophiam Newtonianam* (1720, translated the same year into English by Desaguliers as *Mathematical Elements of Natural Philosophy confirmed by Experiments, or an Introduction to Sir Isaac Newton's Philosophy*), he discussed the mathematical theory of mechanics with the help of model levers and wedges, but he also introduced a new element – applied mechanics in the form of scale models of scoop and polder mills.

Leiden University acquired 's Gravesande's entire private collection in 1742 and under his successors, Petrus van Musschenbroek and his pupil, Jean Nicolas Sébastien Allamand, scale models continued to play an important role. In 1742, Allamand also brought out a third edition of 's Gravesande's *Mathematical Elements* which gave the scale of every engraving 'for the convenience of those who may wish to make the machines illustrated therein'.[96] The later models were often made by the Leiden instrument-maker Jan Paauw, notably the model of a ship-portage – the means of hauling a vessel from one waterway to another – and a ship camel, an invention perfected in Amsterdam around 1690 comprising two long wooden caissons, shaped to fit round a ship's hull and filled with water which when pumped dry, raised the vessel sufficiently for it to be towed over the shoals obstructing the approaches to Amsterdam and Rotterdam.[97]

These models were of course relevant to the particular circumstances of Dutch geography, commerce and industry but Allamand was also a keen advocate of steam power to replace windmills: in 1775 he added to the model of a steam machine after Savery, made around 1730 by J. S. Meijer of Amsterdam and purchased by the university in 1762, a large model of a Newcomen engine, made by Paauw with a finely carved mahogany support of Rococo form.[98] Other industrial models included one made around 1760 of James Vauloué's pile-driver as first employed in the 1730s for driving the piles of the new Westminster Bridge in London,[99] a dredging mill with a barge bought at auction in 1788 from Allamand's private collection and a model saw mill, probably from the same source.[100] Thirty models of everyday mechanical applications from the Leiden University Cabinet of Physics have survived and are now displayed in the Museum Boerhaave in Leiden.

Swedish philosophers also grasped the educational benefits of relating theoretical mechanics to practical applications through the use of models, a teaching method which was initiated by Christopher Polhem (1661–1751), dubbed the 'father of Swedish technology'.[101] Having received training in forge and lathe work and in carpentry, at the age of twenty-five he went to the University of Uppsala to study experimental physics. Thereby armed with both a practical and theoretical education, he swiftly gained a reputation for mechanical genius, which was chiefly applied to the Swedish mining industry.[102] In 1694–6 he travelled abroad to Germany, Holland, England and France and on his return in 1697, inspired by the inventions he had seen, proposed the establishment

of a Laboratorium Mechanicum for the construction and demonstration of 'all kinds of machine and technical apparatus'. The laboratory was intended as a school to teach those with hidden mechanical talents, an experimental centre where theory and practice met, with a permanent exhibition of inventions. Polhem maintained that machines could be built there which might eventually be of use to the government or to private individuals, while the craftsmen employed could supervise other institutions. The prestige of the king and of the nation would be raised when foreigners learnt of the project.[103]

Polhem's laboratory was duly established in Gripenhielm House on the island of Kungsholmen in Stockholm and he proceeded to construct a mechanical alphabet, comprising about eighty wooden models demonstrating various basic elements of mechanics – gears, wheels, pinions and cams – which could be combined to produce simple movements, so that pupils would become familiar with the elements of mechanics through play.[104] It would, he hoped, constitute a new universal language, a philosophical language of construction. To this he added different classes of models of machines and instruments used in mining, manufactures, war, experimental instruments for physics (air and water pumps) and mechanics, anticipating that 'unusual technical instruments, astronomical clocks, globes, chimes, and other things [that] could be developed'. However, Polhem's ambitions for his laboratory were never fully realised, as he was taken up with other business and his assistant, Samuel Buschenfelt, a skilled carpenter and blacksmith, died in 1706. Nevertheless, the surviving notebooks of his students indicate that later in life he was still using the mechanical alphabet as the basis of all his practical teaching.[105]

Collections of models were also formed in different departments at the University of Uppsala in order to relate mathematical theory to practical skills connected with agriculture, trade and manufacture.[106] In 1754, Anders Berch (1711–1774), the holder of the first chair of economics in Europe (established in 1738–9 by the Swedish government), set up a Theatrum-Oeconomico-Mechanicum, comprising a collection of models of tools and samples of raw materials, illustrative of manufacturing processes and agriculture.[107] Like Polhem, Berch was a mercantilist with a strong interest in trade. In order to measure and control the economic activity of the country, he arranged his collection according to a Linnaean method of classification, dividing – for instance – thirty examples of Swedish ploughs into different family types. By establishing this 'technical encyclopaedia' and testing every stage in manufacture, he hoped to ensure that the national economy never declined and to diffuse the example of best practice throughout the country. When an inventory was first made of the collection in 1770, it contained models relating to agriculture, manufacture and trade, as well as specimens of raw materials, half-finished and finished products and samples from textile and book manufacture, metal goods, wooden products including furniture, ceramics, glass, leather, coins, compasses, playing-cards, types of cart and much more. In the manner of a natural history cabinet, there was also a collection of defective specimens. More that 35,000 samples survive in the Nordiska Museet in Stockholm, while many of the agricultural models can be seen today at the Royal Agricultural College at Ultuna, Uppsala, including several that are probably based on the plates in Jethro Tull's *The New Horse-Hoeing Husbandry* (1731).[108]

By 1750, there were numerous cabinets of models in Stockholm: Polhem's Laboratorium Mechanicum and that formed by his pupil, Carl John Cronstedt, as well as those in the Board of Commerce, War Office, Fortifications Corps, the Royal Swedish Academy of Sciences and the Swedish Ironmongers' Association. In 1754, Carl Knutberg, a captain in the Fortifications Corps, proposed bringing these collections together on the grounds that they provided the best way of learning the theory and practice of mechanics. He argued that the different movements and their laws, the assemblage of parts and the outcomes could thereby be more easily and conveniently described and shown than they could be through visiting workshops, which in any case entailed exten-

sive and costly travel.[109] Two years later, the Kungliga Modellkammern (Royal Chamber of Models) was established on the top floor of the old royal palace on Riddarholmen.[110] By 1779, the chamber contained 212 examples, arranged according to the technical problems they were designed to solve: the mechanisation of manual work (both in agriculture and textiles), the conservation of wood fuel and the efficiency of mechanical power. Many examples are now held by the Tekniska Museet in Stockholm, ranging from miniature carts for carrying stones to heating stoves and cooking ovens, as well as bellows for forges and blast furnaces.

The Royal Chamber of Models was aspirational, intended to impress foreign contemporaries, to inspire improvement and to enable posterity to see what had been achieved. As possibly the largest collection of mechanical models in Europe on public view, it became one of the sights of Stockholm which diverted visitors more on account of its size and the quality of workmanship than its range of invention.[111] By the second half of the eighteenth century, mechanical cabinets formed in Sweden and elsewhere in continental Europe – Florence, Prague, Vienna and Munich – encompassed private collections, academic teaching collections and state-supported ventures.[112]

In London the Royal Society acquired a dedicated repository for its own collections in 1712, designed by Sir Christopher Wren as an annex to its Crane Court building. Along with natural history specimens and instruments for undertaking experiments, it doubtless contained mechanical models, building on those described by Grew in 1681, but the collection has almost entirely vanished.[113] In Oxford, the Museum built between 1679 and 1683 to house the rarities that Elias Ashmole had acquired from John Tradescant also contained a laboratory for chemistry experiments in the basement and a lecture theatre on the ground floor. From 1714, when John Whiteside was appointed Keeper, the teaching extended beyond natural history to encompass mechanics, hydrostatics, pneumatics, optics, architecture, magnetics and astronomy. Demonstrations accompanied the lectures to emphasise the practical application of science and Whiteside built up a collection of instruments for the purpose. The laws of motion were followed by experiments in gunnery; hydrostatics were illustrated by pumps and syringes.[114]

Whiteside's successors followed his example, notably Thomas Hornsby, who took over in 1763, and his collection was acquired by Oxford University in 1790. According to the catalogue drawn up that year by the scientific instrument-maker Edward Nairne, it contained a predictable range of simple machines as well as practical models, including a machine for breaking pieces of wood, 'Smeaton's pulley with a three-legged stand', a common steelyard, the fusee of a watch with an adjusting lever, models of a crane, a coal gin ('very large') and a coal wagon, as well as models of assorted pumps and mills.[115] They were used for teaching purposes, as at least one student's lecture notes testify,[116] and although they did not survive as a collection to the extent of those elsewhere in Europe, a model of Vauloué's pile-driver, made by Benjamin Cole around 1750, is still displayed in Ashmole's original museum building, now the Museum of the History of Science (fig. 73).[117]

Models of ships served as a standard form of instruction for boys destined to follow careers at sea and models were also a standard element in artillery instruction. The Repository for Military Machines, formally established at the Woolwich Warren in 1778 under Captain William Congreve, Superintendent of Military Machines, imposed some order on pieces of ordnance which had been lying around the site for decades. Therefore the Repository included a large collection of models of guns, carriages and artillery trains of historical as well as of contemporary interest. One of the highlights was a complete artillery train probably of Dutch manufacture, as used by William III, to transport guns to a battlefield or siege. Another impressive piece was the 1767 travelling carriage with broad iron wheels and two mounted 12-pounder brass guns, with a mechanical

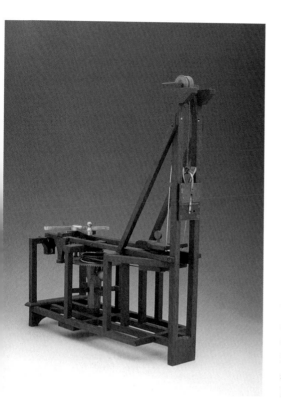

73 Benjamin Cole, model of Vauloué pile-driver, c.1750. Museum of the History of Science, Oxford, inv. 19551

raising device. Such models served as reference material or as a means of instructing apprentices. Others were clearly intended for presentation purposes, such as the range of Hanoverian artillery dating from 1793.[118]

The most widely diffused mechanical models were those trundled round the country by itinerant public lecturers, as tools for bringing their scientific theories to life and even bringing them into the realms of practical application. One such figure was Stephen Demainbray, who came from a Huguenot family, was educated at Westminster School and learnt mathematics and natural philosophy from Jean Desaguliers, with whose family he lodged. After a spell on the continent in the late 1720s, he became a teacher and through the courses of lectures he gave on natural philosophy in Edinburgh, the north of England and Ireland, his reputation spread.

Demainbray's response in 1752 to the offer of an introduction to give a paper to the Royal Society reveals how he rated his own role: 'Conscious of my own incapacity, I shall never presume on a task so unequal. What my numerous warm friends may call improvements in the practical way of arts, might be deemed amusing when viewed in the models or executed, but these are in no manner worthy of being laid before so learned a body of gentlemen.'[119] Demainbray made a social distinction between himself and the gentlemanly Fellows of the Society, as well as a distinction of activity between his concern with promoting practical matters and theirs with high theory.

Nevertheless, Demainbray was probably protesting more as a matter of form than as an accurate reflection of reality, for in the early decades of the eighteenth century Newtonianism in England was becoming, in the words of Larry Stewart, aggressively practical.[120] In common with 's Gravesande in the Netherlands, Desaguliers and his disciples believed that there was a close relationship between the mathematical and mechanical in experimental courses, and lecturers used mechanical devices of increasing complexity to illustrate not only the Newtonian laws of motion but also their application to trade and industry. Outside the closeted world of the study or academy, men needed to move goods, improve road and water transport and drain fens and mines. This dictated the content of public lectures, the practical interests and mathematical limitations of the audience shaping their articulation.

As early as 1719 Desaguliers made a point of advertising that his course of experimental philosophy included improvements to the Savery (Newcomen) engine on the grounds that it was 'of the greatest use for draining mines, supplying towns with water and gentlemen's houses'.[121] Isaac Thompson underlined the role played by models in bridging theory and practice when he proposed a course on mechanics, hydrostatics and pneumatics in Newcastle in 1731, with specific reference to coal mining. He intended that, 'models may be contrived and made answering the structure of those machines employed in the said work; so that the whole may be fully illustrated and explained, and the theory of natural philosophy not only laid down, and demonstrated from physical reasons, but the practice of it may be clearly inculcated and applied to the affairs of life'.[122] Forty years later, Adam Walker, an intinerant lecturer based in Manchester, could advertise in the *York Courant* what had become by 1772 standard kit, comprising astronomical and optical apparatus, besides 'All the mechanical powers, with working models of various cranes, pumps, water-mills, pile-drivers, engines, the centrifugal machine, and a working fire-engine for draining mines, of the latest construction.'[123]

Demainbray's practical bent, like Desaguliers's before him, was widely recognised, Sir James Lowther even inviting him to Whitehaven to oversee his colliery works. In 1753, in response to an invitation from the Académie Royale des Sciences of Bordeaux, he visited the city and then toured France promoting Newtonian philosophy. He had models made of local machinery in Lyons, including some copied from the Marquis de Grollier de Servière's collection. In 1754, he returned to London where he encountered a generation of lecturers vying with one another for the public's attention: Erasmus King, Benjamin Martin and James Ferguson. Martin sold scientific instruments in Fleet Street as well as lecturing.[124] Ferguson specialised in explaining astronomy to lay audiences with no knowledge of mathematics and in 1757–8 branched out to encompass 'the most interesting parts of mechanics, pneumatics, and astronomy which will be read on several working models of hand-mills, water-mills, wheel-carriages, the pile engine, the air pump, the orrery, cometarium, &c.'[125] Having established himself in rooms in Panton Street near Haymarket, in 1755 Demainbray delivered thirty-four lectures at the Concert Room in the same street. He married the daughter of a Mr Horne, poulterer to the King, and shortly after gave his lectures to George, Prince of Wales, and his brother Prince Edward.

By accident rather than design, the apparatus Demainbray had used as a travelling lecturer in the 1740s and 50s became inextricably bound to George III's own collection when in 1769 he was appointed superintendent of the new Royal Observatory in Richmond (now the Kew Observatory).[126] The workaday Demainbray models were displayed together with the King's high-quality, ornate instruments made from much more expensive materials.[127] Those items used by Demainbray for demonstrations are of the standard type and design for courses on natural philosophy, covering mechanics, pneumatics, optics, electricity, magnetism and hydrostatics. They are mostly made of painted tin-plate or dull brass with a high tin content and the workmanship is relatively rough, in contrast to the expensive, skilfully worked mahogany or silver of Adams's instruments. Such models were made to be used and packed up for travel.

The models of mechanical devices conveyed basic principles as well as pertaining to real life, notably methods of transport. Widths and diameters of wheel rims, their dishing and cladding were subjects of topical interest following the Broad Wheels Act of 1753, which permitted payment of lower tolls on carts and wagons with broad wheels on the grounds that as they travelled more slowly, they did not churn up the road as much as fast narrow-wheeled carriages. In Demainbray's examples, as in those made by Adams for George III, calculations as to the velocity ratios and frictions are written on the wheel. Again, a model experimental carriage was used on an inclined plane to compare performances of large and small diameters of wheels carrying varying weights. Nevertheless, such models were principally illustrations of mathematical laws, not pertinent contributions to the broader economic debate in which factors of cost and convenience were of major concern.[128]

Some pieces did demonstrate modest improvements in design, such as the model of an Irish four-wheeled wagon which could be split in two parts, making a vehicle with all the advantages of a four-wheeled carriage but easier to turn (fig. 74).[129] There were also models of tipping carts, axles and springs, the last presented by Mr Pease, the most notable spring-maker in London, and as such completed with considerable artistry.[130] Other models represented the different ways of raising water. One, the so-called 'Maximum Machine', used manpower and was designed by Desaguliers to measure and even to demonstrate the meaning of work. Set in the open framework of a two-storey building connected by a ladder, it showed how a man standing on a platform lift could act as a counterweight to a bucket of water which was raised while he descended, by means of connecting pulleys. The bucket was emptied at the top into a cistern, at which point the man ran up the ladder from the bottom; the empty bucket descended, and

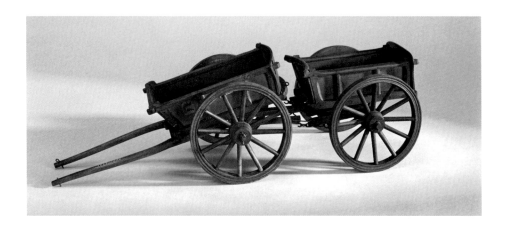

the whole cycle was repeated.[131] Among the model waterwheels was an example coupled to two beams, intended for working two mine pumps, used in Demainbray's lecture on pulleys.[132] His model of the 'great [water-] wheel' used at Newcastle for raising coal out of mines has not survived. The sixth lecture out of eight on mechanics was devoted to compound engines, combinations of simple machines; it included assorted models of cranes and Vauloué's famous pile-driver.[133]

From the twelve lectures on hydrostatics and pneumatics, the last four covered various topics of contemporary interest including a 'fire engine' or Newcomen atmospheric engine.[134] This large model was based on Desaguliers's description in the second illustrated edition of *A Course of Experimental Philosophy* (1744–5) of the engine at Griff near Coventry, used in the 1720s to remove water from a coal mine. It might even have been made by Desaguliers. Its framework was constructed of beech with a brass cylinder and pipes and copper housing for the boiler, standing on a painted iron base. Demainbray's third syllabus included models of French machines which he made a point of promoting but which were scarcely in the van of progress, being based on seventeenth-century examples of mills and waterwheels. A model of Savery's engine for draining water from mines was also demonstrated in Demainbray's final lecture.[135]

By the 1750s the pattern of lecture-demonstrations had begun to change, for the market was close to saturation point and the lecturers had to resort to new promotional tools to attract audiences. In 1755 Demainbray advertised that every gentleman subscriber would receive a free ticket for a lady. His advertisements also stressed that his apparatus was superior or unique, the model of the water-mill at the Bazacle in Toulouse being described as 'the only model to be brought to England'. Other lecturers specialised, James Ferguson concentrating on astronomy and globes. Some played the topical card. In the lead-up to the Seven Years War, Erasmus King lectured on naval and military architecture, maintaining: 'every person should be acquainted with [the subject] that proposes to distinguish himself in the service of his king and country'. Both Demainbray and King lectured on earthquakes in the month following the 1755 Lisbon earthquake. Demainbray lectured on natural history so that 'Auditors may view, with an intelligent eye, the [newly founded] British Museum.'[136]

Nevertheless, the market could not sustain so many lecturers and their number declined in the 1760s, presumably through competition from rival attractions, ranging from the meetings of the Society of Arts to the increasingly kaleidoscopic variety of the shows of London. Elementary aspects of natural philosophy began to be seen more suitable for children. Although Demainbray eventually managed to gain the sinecure of superintendent at the Royal Observatory, little use seems to have been made of the collection he brought with him and neither it nor the King's collection appears to have

been displayed in the eighteenth century for public benefit, although probably genteel visitors would have been able to gain access in much the same way that they could view country houses. Increasingly, the works would have been of antiquarian rather than experimental interest.[137] After Demainbray's death in 1782, his son Stephen Demainbray was appointed superintendent of the Observatory, a post he held with little distinction for fifty-eight years until his retirement in 1840. The following year, the bulk of the collection went to King's College, London, where it was housed in a George III Museum, opened in 1843. Thus for a few years the George III Museum and the Society of Arts' model collection – to be examined shortly – were near neighbours off the Strand. Some additions were made; other pieces – notably the microscopes – were scattered and in 1927 the George III collection was added to the Science Museum, where the Society of Arts collection had already arrived by a different route.

By the second half of the eighteenth century, cabinets of philosophical instruments including mechanical models were being acquired by English country gentry with pretensions to knowledge in the arts and sciences. The collection formed by William Constable, F.R.S., F.S.A.S. (1721–1791), at the family seat of Burton Constable in the East Riding of Yorkshire, included microscopes, telescopes, a barometer, a double-barrel air pump with a vacuum jar and electrical machines of various sorts. Besides the inevitable Vauloué engine, for which he paid Benjamin Cole £3 13s 6d, and a model carriage to test wheels on road surfaces, he acquired models of fire-engine pumps, made in glass with brass fittings so that the working of the water jets could be seen, and models of a seed drill and a furrow plough in mahogany.[138]

In the same decades, cabinets of instruments and mechanical models had also become part of the standard repertoire of reformed universities across Europe, in line with Enlightenment ideals, albeit with varying results. After the Marquis de Pombal had expelled the Jesuits from Portugal in 1759, among his educational reforms was the establishment of a Colégio dos Nobres in Lisbon for the children (aged seven to thirteen) of the nobility, where experimental physics was taught, subdivided into mechanics, statics, hydrostatics, hydraulics and optics. However, because the students lacked the necessary mathematics, the physics course (and the teaching of mathematics) ceased after less than two years and the collection of machines, apparatus and instruments which had been accumulated was passed to the Real Gabinete de Física (Royal Cabinet of Physics), established at the University of Coimbra in 1772. The Statutes of 1772 also marked a stricter focus in the collecting policy: 'Since a certain level of excess has been noted in this part, with considerable sums being spent on machines that have no use whatsoever, except for spectacle and pastime', it was ordered that 'no machine should be built for any experimental physics without prior thought being given to its usefulness.'[139] Nevertheless, the cabinet acquired a silver centaur automaton, made by George Adams, equipped with a wheel mechanism for shooting arrows.[140]

The Director and first Professor of Physics at the university, Giovanni Antonio dalla Bella, who came originally from Padua to teach at the Colégio dos Nobres, was able to build a remarkable collection, 562 pieces in all by the time he prepared the first catalogue, the *Index Instrumentorum* of 1788.[141] Its contents were heavily influenced by the Dutch example, particularly the models made by the Musschenbroek family, and many instruments were imported from makers based in London: Francis Watkins, George Adams, Edward Nairne, John Dollond and Benjamin Martin. The section devoted to applied mechanics naturally included examples of pulleys, levers, a capstan and a jack, an inclined plane, diving bell and pile-driver, cranes and carts. Yet the benefits bestowed by the university collection were not apparent to potential students, for the Coimbra course could find few takers – four between 1772 and 1777. The rector was forced to take a sternly vocational line, warning the students that unless they matriculated in the

philosophy faculty, which covered physics and mathematics in the third year of the course, they would not be employed as 'managers of agriculture, factories and mills, gold mining, purveyors in official mints, and many other similar professions, all of which rely on a solid grounding in this science'.[142]

In fact, the relationship between mechanical cabinets and the world of industrial practice was always a contested one, so long as traditional views as to what constituted a polite education held sway. The point is made vividly by the early history of the Teylers Stichting (Teyler Foundation) in Haarlem, one of a number of new learned societies which led scientific activities in the Netherlands in the later decades of the eighteenth century.[143] Pieter Teyler van der Hulst (1702–1778), a Mennonite textile merchant and banker, stipulated in his will that a foundation be formed from his estate incorporating two societies, the Godgeleerd Genootschap (Theological Society) to be used to encourage religion and the Tweede Genootschap (Second Society) to promote art and science, both by means of prize competitions.[144] In 1779, his executors, the directors of the Teyler Foundation, decided to construct a building in which scientific knowledge could be demonstrated and where art collections could be displayed. The Teyler Museum, which opened in 1784, presented the collections in a neo-classical oval room, designed by the Amsterdam architect Leendert Viervant. Display cases on the ground floor held scientific instruments and models, not just for viewing but for demonstration in the centre of the room, on top of the large central case which housed the art collection. The first-floor gallery held the natural science library, arranged according to encyclopaedic principles.

The management of the Museum was largely left to the mathematics and philosophy lecturer Martinus van Marum, who served as librarian and director from 1784 to 1837. Its lavish funds enabled him to develop the new Museum into an impressive scientific institute. Besides a wealth of natural history books and specimens, van Marum's principal acquisitions were those he obtained for the Cabinet of Physics. In 1784 a large electrostatic engine was constructed according to his own specifications by John Cuthbertson, a Mennonite instrument-maker then living in Amsterdam, with a neo-classical substructure designed by Viervant to harmonise with the rest of the oval room. Instruments and devices required for public lectures were ordered from leading instrument-makers and suppliers not only in the Netherlands but also in France, England and Germany and were bought at auction.[145]

Besides the usual collection of apparatus for the demonstration of mechanical principles, there was also a selection of models of particular relevance to the Netherlands: capstans, hoists, cranes, pile-drivers, polder mills, a saw mill, a bucket dredger, water-lift and lock-gate. Naturally, the collection included a model Newcomen engine, made by Edward Nairne in the 1760s or early 70s.[146] Other models were made in the 1790s on commission from Jochem Cats of Amsterdam. A number of special features confirm that they were intended for demonstration. The housing of a beautifully finished model crane in mahogany and brass could be removed to show the internal working mechanism. For Cats's models of polder mills – one with an internal scoop wheel, the other fitted with an Archimedean screw – the bases were painted so as to resist water. In his model of a saw mill only the main structural timbers were shown, not the weatherboard housing. Under van Marum's direction, the collection grew to an almost unprecedented size, the 1812 catalogue of the model section of the Museum listing 435 items.

Nevertheless, van Marum's vision and energy brought him into conflict with the more conservative directors of the Foundation, who saw the Cabinet of Physics as a means to enlighten laymen such as themselves about the miraculous laws of nature and to inspire awe in the perfection of creation. Van Marum's outlook was more utilitarian and even egalitarian, for he believed that the resources of the Foundation should be turned towards experimental work and made available to a wider audience through public demonstra-

tion lectures. From 1792 to 1797, boosted by the revolutionary spirit of the times, he was able to deliver public lectures on domestic chemistry but when it became clear that the directors did not intend to provide funds for a larger auditorium or more instruments, the lectures petered out. Public lectures only began again in 1803, the directors then insisting that the content be physico-theological rather than directed towards social improvement.[147] After 1791, instead of buying more scientific instruments, van Marum was forced to concentrate on purchases for the palaeontological and mineralogical cabinet and later concentrated on his own private passion of botany. Moreover, there was conflict with successive keepers of the art collection whenever they made purchases with money van Marum thought would have been better spent on the scientific collections. In effect, mechanical cabinets in a public and polite context ran into difficulties when they served as anything more than symbolic representations of mechanical knowledge. The liberal arts and sciences still took precedence. For models which related more closely to industry one has to look to societies founded with a specifically commercial agenda.

Models of Invention

While the models of industry in mechanical cabinets remained in the possession of an aristocratic or intellectual elite, or those closely connected to the instrument-making trade, they neverthelesss acquainted a much wider public with their utility and the underlying principles they represented. A greater sense of involvement was necessary if this broader constituency was to be anything more than passive spectators to industrial progress. The opportunity arose in 1754 for more widespread particpation in the improvement of both polite and mechanical arts with the foundation in London of the Society for the Encouragement of Arts, Manufactures and Commerce, which awarded premiums for innovation and invention across a broad range of categories. Membership of the Society was also a more cost-effective proposition than subscribing to a lecture series: it cost two guineas annually to join compared with the two and a half guineas charged for a season ticket to Demainbray's lectures.[148]

The Society's overall role in promoting industrial progress will be considered in the next chapter but it makes sense to review here how models played a part in that endeavour. On 30 April 1760 the Society's Committee of Premiums recommended that 'all models of machines which gain premiums for the future be the property of the Society', a motion which was agreed by the Society as a whole. The intention was to display them in a mechanical cabinet for general educational benefit, no doubt inspired in part by the practice of the Dublin Society of Arts which, some thirty years previously, had opened its own model collection to the public.[149] The Society's minutes of 15 April 1761 record agreement to lease a room for a fortnight from Mr Woodin, the landlord of adjacent premises in Denmark Court, 'to exhibit the premium machines there, and that some person or persons be authorised to attend from morning till night during the same time to demonstrate them to all gentlemen who come to see them in case the candidates themselves cannot attend for that purpose'.[150] Advertisements were placed in the papers and the exhibition opened on 27 April but the lease expired two days later and by 4 May Woodin was making it clear he wanted his room back. Nevertheless, the show carried on for seven weeks in all, with the ingenious but indigent William Bailey acting as demonstrator. At the end of May, Woodin intimated that he was willing to let the Society a room 72 feet in length and 15½ feet wide for £30 per annum, provided that he and his foremen were allowed occasional access through to their workshop. The terms were agreed, the new 'machine room' cleaned and fitted out with shelves, brackets and furniture for the meetings of the Mechanics' Committee.[151]

Over the next twenty years the collection grew, with a model room set aside for display on the ground floor of the Society's new purpose-built residence, designed by the Adam brothers and opened in 1774. On 19 February 1783 it was agreed that a descriptive catalogue should be prepared for publication. In the first volume of the Society's printed *Transactions* of 1783 there duly appeared 'A Catalogue of the Machines and Models in the Repositories of the Society'. The classes comprised: Agriculture (63 models in all); Chemistry (2); machines and models belonging to Manufactures, including spinning wheels, looms and so on, models of mills, cranes, machines for raising water, carriages and other machines (20); and 'Implements, not reducible to any particular class' (82). Other Society records provide insight into the variety of purposes served by the models before their display. In effect, the reader begins to get closer to the role of models from the point of view of the maker, as opposed to the viewpoint explored so far, that of the consumer. The authentic voice of the inventive artisan can be heard.

Models sent in by applicants for premiums served initially as a potential guarantee of seriousness, particularly for those classes who could not call on any other form of introduction. This is made clear in the letter received from John Pitt, based at Mr Lawson's, peruke-maker, opposite the Crown, Long Acre, and dated 3 January 1761: 'Pardon my boldness in offering those proposals, to your lordships inspection, having no friend to interduce me. It is the invention of severall new invented machines, usefull in the art of war & military affairs.' Pitt proceeded to describe 'those modles I have made' comprising six pieces of ordnance and concluded: 'If any of those proposals should be worthy your attention & would incurage an injenious artice I should be ever bound to pray I am with the greates respect your lordships obeident searvant John Pitt.'[152]

Again, on 16 December 1774, John Holman sent a model of his invention of a machine for raising ore to the Society, with an accompanying letter:

> Gentm, I hope no offence in trubbling you with this to lett you know that I am a carpinter by trade and workt in most part of Corwell at ingin work and have taking a great delight on it ever sence I cam from there and have made many improvements that neaver has been in force witch wil be of a great benefit to the owners of the tin mines first for draughting of water eather by men horses or by water witch . . .

He directed the response be sent to the Artichoke, Radcliffe Highway, but by 18 January had received no answer so he wrote again. A week later five guineas was voted as bounty to John Hulman for the invention of his machine and the model of the same.[153]

Lacking the mathematical formulae, artisans also made models as a crucial aid to describing their inventions in words, as is apparent in a letter of 20 March 1763 to the Committee of Mechanics from John Sansom, a turner based near the Bell Alehouse in Noble Street, off Cheapside:

> The number of accidents in the wheelds cranes upon ye river syde has putt me upon thinking of several ways to remedy thise misfortunes which I hope I have done in a model I have made with ye following contrivances.
> Firstly have left one side of the wheel quite open without any timbers that ye men may get out hurt in case of to grate a rotation.
> Secondly by ye healp of a fly and wheel work the whole machane is regulated.
> Thirdly by a grub which goes half round ye wheel and has the full command to stop it by the help of one or two men.
> Fourthly by a frame that is fixk on to the floor and has two poles that lies in the wheel for ye men to have firm hand by which meanes tha worke ye machane with their feet.
> Lastly for yr inclosed wheel as the common cranes are now I have contrived a ladder that hangs on ye axis which will be a safe for two or three men.

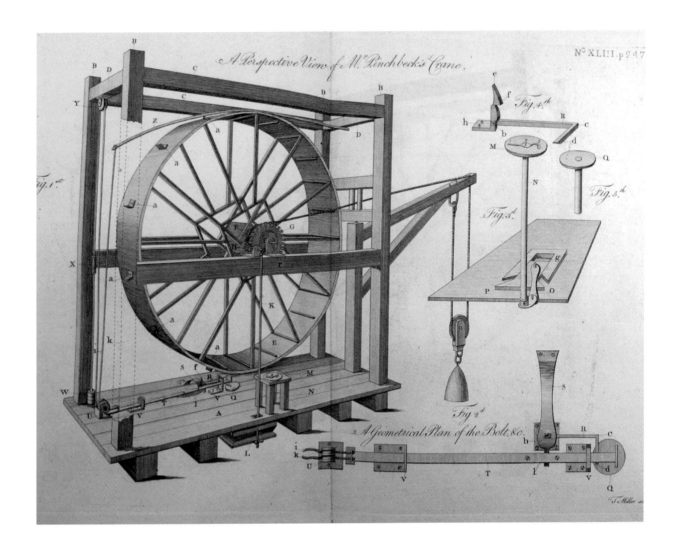

75 T. Miller after Alexander Mabyn Bailey, 'A Perspective View of Mr Pinchbeck's Crane' from Alexander Mabyn Bailey *The Advancement of Arts, Manufactures and Commerce*, 1776

These gentlemen are yr methods I have put in my moddle and submit to your jugment and am genteelmen your very humble servant John Sansom.[154]

Models were effective promotional tools. The famous clock-maker and inventor Christopher Pinchbeck appeared before the Committee of Mechanics on 27 February 1764 to explain his model of a safety crane, to which was attached a pair of calfskin bellows operated by a treadmill under the crane which, when the motion of the wheel became dangerously fast, threw up a catch and stopped the whole machine. As it was deemed ingenious and effective, Pinchbeck was awarded a gold medal and a model was ordered to be made for the Society on a scale of one inch to a foot at an expense not exceeding £5 (fig. 75). It was also recommended to the Society that Mr Pinchbeck's contrivance be added to a crane on the Legal Quays, between London Bridge and the Tower, or elsewhere at an expense not exceeding £20.[155] In the self-serving manner which was evidently typical of the man, Pinchbeck had already presented a model of his safety crane to the King 'in whose Royal Cabinet his model has been permitted to be placed', before showing it to the Society.[156]

The promotional benefits were evident in the case of the large model made by Thomas Gregory of the Coalbrookdale Bridge which Abraham Darby III, a good friend of the Society's Secretary, Samuel More, donated to the Society in 1787 (fig. 76).[157] On 3 July 1787 Darby wrote to More from Hay near Coalbrookdale:

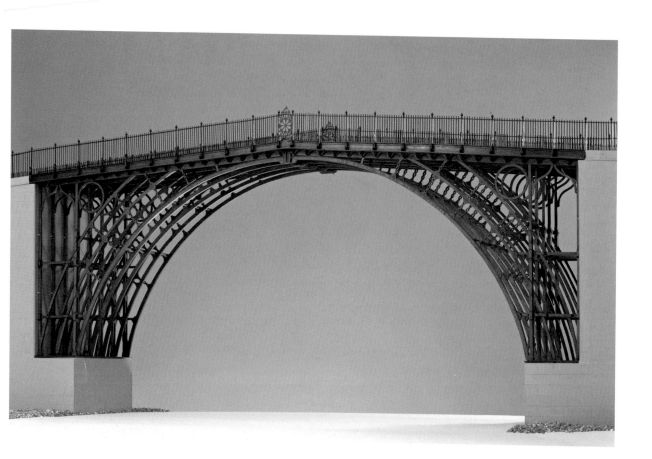

76 Thomas Gregory, model of
the Iron Bridge, Coalbrookdale,
1787. Science Museum,
London, inv. 1882-29

I mentioned to thee when I had the pleasure of seeing thee in town, that in case the model of the bridge was not disposed of I should wish it to be received at the Adelphi, and preserved in the Society's large room of models &c. It is still at my friends in Fleet Street . . . I hope it may be taken down without injury and be favorably received by the Society.

On 11 November the same year, Darby wrote again to say it had given him 'much satisfaction, in finding the model of the bridge was favorably received by the Society; – and I am pleased it is placed in their repository of curious & valuable pieces of art, the preserving of which, with their many judicious premiums, is no doubt great encouragement to genius and of public utility'.[158] The *Transactions* of 28 November 1787 record that a gold medal was voted to Darby for the model of the iron bridge.

Meanwhile, the Mechanics' Committee was contemplating 'the repairs necessary to be done to the model and the best mode of preserving and exhibiting [it] to advantage'. On 15 November 1787 they resolved, 'that this model be properly repaired and a glass case made for the preservation of it. Mr Lumley being present obligingly offered to repair the model without expense to the Society.' It was also resolved that an inscription be engraved on a brass plate and fixed to the case, to read: 'A Model of the Cast Iron Bridge on a scale of half an Inch to the Foot erected over the Severn in the Year 1779 presented to the Society by Mr Darby the Builder and Proprietor of the Bridge'. On 20 February 1788 the Committee resumed the consideration of preparing a case for the model: 'Mr Lumley produced a design for a case and stand seven feet long and six feet high to be made of mahogany and glazed on both sides the price of the case and stand not to exceed sixteen guineas.' Doubtless largely on account of this protective case, the model is one of only two that survive in the Science Museum today from the Society of Arts' collection.

The Society archives also throw light on the role which models played in the process of manufacture. A young gentleman amateur, Richard Lovell Edgeworth, wrote from Oxfordshire on 19 December 1763 regarding the portable camera obscura he had designed which would fit 'with the greatest ease in a man's pocket' and was intended for travellers wishing to obtain sketches of foreign curiosities, from fortifications and situation of harbours to the proportions and exact outline of antique statutes. If acceptable to the Society, he would have a camera obscura on this plan sent to them 'with the greatest pleasure', at the same time asking the secretary, Mr Templeman, whether he had any instrument-maker whom he could recommend, for he would be in town in a few days and would let him have a model of it.[159] It was common practice for inventors to make rough models on which they tinkered before commissioning or making a perfectly turned presentation model. While in St Petersburg in 1783–4, Samuel Bentham invented his own pile-driver to help on the works to the Fontanka Canal. Entries in his diary detail the care he took in having a model made from his drawing by a cabinet-maker, improvising on it as it progressed, and then commissioning a neater model to tout round the court.[160]

On such occasions the initial model was intended to serve as the means of instruction for an artisan. Some applicants to the Society of Arts went to considerable lengths to get their prototype made. One D. Lyle wrote from Port Glasgow on 5 April 1765, enclosing a description keyed into a charming drawing of his perspective instrument for which he hoped the Society would award him a premium, 'as it is an invention I began more than ten years ago, and as I was greatly distressed for money the time I was in England'. The brass and steel part of the instrument was, he said, made by Mr Dalton, mathematical instrument-maker, in Green Arbour Court, Little Old Bailey, and the wood part by Mr Melvil, cabinet-maker in Theobald Court, the Strand, 'where I beg the favour you would send for it if they do not bring it soon. What improvements I have by means of glasses and to make it portable must be deferred till I come to London.'[161]

Other submissions were more rough and ready, such as a pump designed by Thomas Reeve. On 17 September 1763 he wrote, not entirely reassuringly, 'When I have got my model of ye double pump ready (for I had pulled it to peices) I will sent it.' On 29 December, writing from Holliport near Maidenhead, he announced he had finished it and proposed sending it by the Maidenhead wagon: 'You must not expect to see a neat eleganty thing, for it is not only my own invention but likewise my own workmanship. My chief study has been to make it as simple as possible agreeable to the plan given by the Society.'[162]

The purpose of all the models described so far was to help market the invention to potential consumers, represented by the Society. To what extent did models serve as useful aids to production? As far as the Society is concerned, it usually showed itself to be thrifty when asked for a contribution towards product development. On 18 November 1779 the Committee of Mechanics took into consideration a 'model of a machine for towing barges against the stream by a fire engine', read the letter sent by the inventor, a Mr Hunt, and examined his model. Hunt also appeared in person and was questioned as to the size of his steam engine cylinder. They were not averse to the principle but doubted the efficacy of Hunt's invention and baulked at paying the £200 needed to test a full-scale prototype with a cylinder 2½ feet in diameter.[163]

It is almost inevitable that the best-known case of the Society's sponsorship of research and development relates to model ships. The utility of ship models for prestige and educational purposes had long been established and some argued, like Dummer, that they could also serve a practical function in ship design. Peter Pett famously considered his collection of models so important that in 1677 he sought to secure them before the

King's ships during the disastrous raid by the Dutch on the Medway. Hauled before the King's Council he maintained that 'he did believe the Dutch would have made more advantage of the models than of the ships, and the King had greater loss thereby'.[164] At the very least, as Dummer realised, they were useful in helping to standardise the proportions of vessels. Charles Bentam, one of the English shipwrights who worked in the Amsterdam Admiralty yard from 1736 to 1758, designed three types of model to standardise production in the yard, for the Dutch had no ship model-building tradition comparable to that of the English royal dockyards.[165]

In Britain, it was the less exciting solid block and half-block models, rather than the fine fully rigged vessels in miniature, that served a practical function, being sent with the draught design to the Navy Board for approval and slowly effecting changes in the design of ships.[166] Model hulls were used to test water displacement (as Dummer had proposed) and water resistance. In 1667 the Royal Society attempted to measure the latter through the experiments made by Sir Henry Sheeres, the engineer of the Tangiers mole, on models of ships of different nationalities powered by a weight and pulley system in an eighty-foot water tank.[167] So when between 1758 and 1763 the Society of Arts held ship model trials, they were working within an established tradition.[168] Their object was to test the resistance of different hulls, as well as their stability, buoyancy and drift under different weather conditions. Advertisements published in 1760 called for the submission of 1:48 scale models of a 74-gun warship and a frigate, for which premiums of £50 and £30 respectively were offered, sums increased (because of the disappointing response) to £100 and £60 in 1761. Various pieces of equipment were invented by members of the Society to test the submissions: a circulating water channel to produce a constant head of water to run against the model, based on Smeaton's apparatus for testing waterwheels (discussed shortly), a form of spring balance and protractor to measure stability, a windlass for towing the models into open water and stopwatches which could record the speeds in quarter seconds. The first trials of two model 74-gun warships and four model frigates took place in September 1762 at Peerless Pool, one of a number of pleasure gardens near Old Street in the City. Trials in rough water were made at the Great Pond at Snaresbrook near Epping Forest. The results were inconclusive and it was not until July 1763 that awards were made £100 going to William Constable of Woolwich for his 74-gun model, with £60 and £20 going to two other makers.

Despite lay acceptance of models as adequate substitutes for the real thing, trained millwrights and engineers were well aware of their limitations even for explanatory purposes. On 18 May 1769 the Committee of Mechanics considered 'Mr Westgarth's hydraulick machine for raising water by water'. William Westgarth attended and a letter from John Smeaton certified that several of these machines had been erected and were at work in Northumberland, Cumberland and Durham (at the time Smeaton held one of the receiverships of Greenwich Hospital's estates in Northumberland and Durham). After inspecting the model and drawing submitted by the applicant, the Committee resolved that the machine 'was new, ingenious and effectual for the purpose of raising water in great quantities to small heights or in small quantities to great heights' and Westgarth was duly awarded a bounty of 50 guineas.

Yet the model embodied rather than demonstrated Westgarth's improvements. Nearly twenty years later, on 3 May 1787, Smeaton was awarded a silver medal by the Committee of Mechanics for the particular pains and care he had taken in describing Westgarth's 'statical hydraulic engine', complete with detailed plans and sections drawn to scale of the cyclindrical valve, subsequently published in the Society's *Transactions*. According to Smeaton's lengthy account, Westgarth's machine had first been set to work in 1765 and its maker, having constructed several more, had thought of applying for a patent and turned to Smeaton for advice. Smeaton dissuaded him because the time and

costs involved were not warranted for an invention that could only be applied in a limited number of situations. Instead, he had encouraged Westgarth to apply to the Society for a bounty, which Westgarth had proceeded to obtain, 'upon condition he delivered to the Society a *working model* and a *draught* showing the construction of the engine'. According to Smeaton, Westgarth's death not long after prevented the usefulness of the machine from being successfully exploited as it otherwise doubtless would have been:

> and as some of the most essential parts of the machine cannot be seen in the model, without its being taken to pieces; and the drawing not being accompanied with any literal explanation; nor detail of it sufficiently made out, at the request of the Society, I have now supplied those defects, that it may be published in such a manner, that the utility of it may be seen, and the means of making and applying it in a proper situation explained.[169]

Smeaton was more scrupulous in his use of models than many of his peers. Most members of the Society's committees were not in a position to know, to the same extent as a famous engineer, whether a model provided an adequate description of an invention that worked or not. The efficacy of the model as a practical tool was a hit and miss affair, with no established testing procedures that could be followed. Certainly, patent law provided no authorative guide. Models had been used since the sixteenth century as a necessary stage in applying for the grant of a privilege, in theory providing proof that a proposed invention could be put into practice. However, such models served more as promotional tools than reliable guides to the efficacy of the full-scale versions. It was assumed that they exemplified the invention in a theoretical rather than a practical sense. In 1567 Giuseppe Ceredi reported that most of the small-scale models he had seen in the offices of the Venetian Provveditori di Comun had never been put into practice.[170] Their retention was subject to the whim of rulers. In 1594 the Dresden inventor Hans Mader demonstrated one such model to the Elector of Saxony who then 'tried this device himself . . . turned away from the table where I had fixed my device and said "this man must be granted a privilege"'.[171]

Throughout continental Europe in the eighteenth century, invention tended to be at the service of the state which decided whether an exclusive privilege should be bestowed on the inventor. In the Netherlands, full drawings or written specifications had to be submitted with the application for a patent to a standing committee, or another expert body like the Admiralty.[172] In France, from 1699, specifications were regulated by statute. The Académie des Sciences examined applications for privileges, working from 1730 within the Bureau du Commerce. A repository for models and machines was established first at the Paris Observatory[173] and accounts were published in *Machines et Inventions Approuvée* (1735). After 1780, the deposit of a model was frequently made a condition of privilege, the repository (housed in the Hôtel de Mortagne after 1783 with Vaucanson's collection) thus becoming in effect a registry of patent specifications where inventions could be compared and evaluated, albeit demonstrating precedence rather than process. It also contained models made after foreign inventions, notably the illustrations to William Bailey's *The Advancement of Arts, Manufactures, and Commerce; or, Descriptions of the useful Machines and Models contained in the Repository of the Society for the Encouragement of Arts, Manufactures and Commerce* (1772).[174]

In Britain, there was no official guidance as to what constituted a patent specification and before the 1730s, no general requirement to submit one at all when registering for a patent. However, a 1663 Act of Parliament allowed the Marquis of Worcester to benefit from his 'fire-engine' for raising water provided he deposited a model of it in the Exchequer by 29 September that year.[175] The introduction of a slightly more busi-

ness-like regime was marked by an act of 1732 which awarded £14,000 to Thomas Lombe as compensation for his failure to win an extension of his 1718 patent, on condition that he deposit a model of his circular silk-throwing machines (pirated from Piedmont) in the Tower of London with a full description of their manner of working.[176] Following James Watt's notoriously generalised steam engine patent of 1769 which, as already noted, lacked drawings let alone a model, a further tightening-up was signalled by Lord Mansfield's decision in *Liardet v. Johnson* (1778), stipulating that the specification should be sufficiently full and detailed to enable anyone skilled in the art or trade to which the invention pertained, to understand and apply it without further experiment. This was the first time in Britain that the *quid pro quo* of the award of a patent was recognised as being disclosure of the invention.[177]

Although there is little sign that models or even drawings played a crucial role in the registration procedure in Britain before the nineteenth century, there is considerable evidence that they played an important part in helping juries to determine whether patents had been broken. Their role in Richard Arkwright's celebrated patent trials will be examined in relation to his portrait in Chapter 6, but models were also commissioned by Boulton & Watt when they wished to take actions against infringements of their steam engine patent. On 11 October 1792, Watt wrote to his friend and intermediary in Cornwall, the mines proprietor and manager Thomas Wilson, asking him to get a sketch made by the Boulton & Watt engineer William Murdock of the inverted engine built by one of Boulton & Watt's rivals – and ex-employee – Edward Bull: 'A hand sketch with dimensions will be sufficient which please send as soon as possible as we must make a model of it for the court, please to tell him to notice whether there are any valves in the cover of the air pump or in the piston of it.' A few days later Boulton confirmed that he was 'now busy in getting models made to plead for us'.[178]

The trial of Bull's infringement took place in the Court of Common Pleas in June 1793. Outside the court, the jury could inspect working models of Boulton & Watt's steam engine and Bull's engine based on Murdock's drawings. Inside, lawyers for the plaintiffs called ten witnesses, half of whom were F.R.S.s, whose expert testimony as disinterested men of science appeared impartial compared with the other witnesses who worked either for Boulton & Watt or, on the opposing side, as associates of Bull, mainly in Cornwall. The jury decided in Boulton & Watt's favour and injunctions were promptly issued against Bull and his fellow pirates.[179] None the less, Chief Justice Eyre reserved judgement on the question as to whether Watt's patent specification was adequate as a description of an 'organised machine' as the law required. This suggests that in fact the models, as objects which were plain to see and which could be compared, had made Boulton & Watt's case more effectively than the men of science, whose insistence on the theoretical principles outlined in the specification had rather muddied the waters.

Subsequent litigation centring on the question of whether Watt's patent described a new principle and whether indeed it was possible to patent a principle only seemed to confuse matters further, with legal opinion so divided that it was suggested that Boulton & Watt should try another court of law. In 1796 they brought an action against Jabez Hornblower, the oldest of the third generation of the family of engineers long associated with Cornwall, and his employer David Maberley, in the Court of Common Pleas. Again it seems that Boulton & Watt had a model made of one of their rivals' engines, newly installed with Watt's closed cylinder top and the separate condenser, at the Meux Brewery.[180] From the scientific witnesses, Professor John Robison provided crucial evidence, delicately negotiating the space between practice and theory but claiming Watt for the higher calling of science. He also did his best to counter the notion that Watt was acting out of low selfish motives, to appropriate knowledge for himself: 'No man

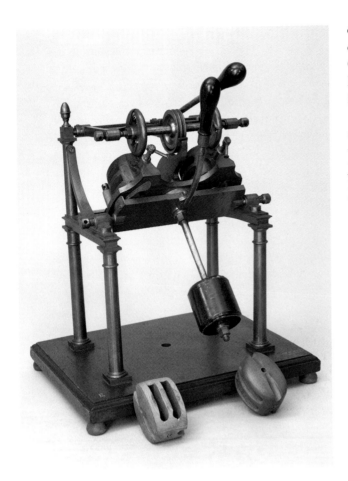

77 Henry Maudslay after Marc Brunel, model of a scoring machine, c.1802. National Maritime Museum, Greenwich, London, inv. MDL0016

could be more distant from the jealous concealment of a tradesman', driven only by greed and petty rivalry. On the contrary, like the true philosopher he was, he had shared his ideas with Dr Black and other intimate friends.[181]

Again the jury found for the plaintiffs. Hornblower and Maberley then appealed for a Writ of Error but when it was finally heard before King's Bench in January 1799 the four judges once more found for Boulton & Watt. They concluded that although Watt's specification did not cover every detail of his invention, it did describe a new manufacture to lessen the consumption of steam and fuel in steam engines, the principles of which could be understood sufficiently for an actual engine to be made by other specialist mechanics, thus fulfilling Mansfield's ruling in *Liardet v. Johnson*.[182] Boulton & Watt then turned their attention, with far less justification, to the compound steam engine patented in 1781 by Jonathan Hornblower junior, Jabez Hornblower's younger brother, and built with his backer, the Bristol ironmaster John Winwood. Again models were commissioned but in the event, wisely, Boulton & Watt did not pursue the case.[183]

Even when models proved their worth in validating invention within the circumscribed surroundings of the club and court room, they still needed to be tested in real market conditions before achieving success in production. A new invention, as represented by a model, might get nowhere when its use involved the replacement of what had existed previously and there were vested financial interests in retaining the status quo. In these circumstances the evaluation of inventions on the basis of models was challenged by those already working in the industries concerned. Without a practical guarantee of efficacy, a model could seem like a waste of time, intended merely for show rather than providing real assistance. It failed because its neat rationality could not be accommodated within the messy social network of rights and responsibilities that it was designed to aid if not to replace.

A small example makes the point. When in 1772 the fifteen-year-old Samuel Bentham endeavoured, with the encouragement of the Master Shipwright at Chatham, to gain official approbation for his invention of an improved chain pump for use on board ships, which he believed was superior to that invented and patented (no. 911) by the engine-maker William Cole in 1768 and subsequently adopted by the Royal Navy, he was snubbed.[184] Ostensibly, the Navy Board was pleased with Bentham's pump, deeming it 'effectual and simple'.[185] The Surveyor asked for a draught and a correct model of it but warned: 'These things look very pretty in a model but none of them will answer in the gross. There have been many contrivances but none will do.' Predictably, the Surveyor dismissed Bentham's efforts but the young man easily refuted the trifling technical objections made and the Surveyor conceded that 'the Board was also afraid that the captains of men of war would like it so well that they would not go to see [sic] unless they had my pumps on board, and that that would occasion trouble & expense therefore they would have nothing to do with it'. Bentham replied he had never heard so bad an answer, to which the Surveyor agreed. Characteristically, he did not give up. In February 1773

he wrote to the Navy Board requesting the honour to wait on them with the model of his improved chain pump. He said he did not understand the objections made, having shown it to some captains and others of dependable judgement who unanimously agreed that it would be a useful improvement if adopted. An audience was evidently granted but on 4 March the Navy Board wrote to inform him that although they admitted the improvements and commended his ingenuity, Cole's pump was superior. The following year Bentham received some satisfaction when he learnt from a member of the Navy Board during Lord Sandwich's visit to Chatham that they did not think Cole's pump was superior, 'but as they had contracted with Cole and had employed him they did not like to turn him off'.[186]

Bentham might not have had much luck with promoting models of his own inventions – whether in Chatham or St Petersburg – but he was quick to recognise the utility of the models designed by Marc Brunel of his patent block-making machinery. In 1800–01 Brunel worked on his drawings of the machines and commissioned scale models, together with a model steam engine to drive them, from the young engineer Henry Maudslay (fig. 77). Having failed to attract the interest of Samuel Taylor, one of the Navy's two main block suppliers, Brunel approached Bentham and with his encouragement secured a meeting with the Admiralty commissioners, exhibiting a model to them, worked by a man turning a winch. In 1802, Maudslay was duly commissioned by the Navy to make sets of the full-size machines, forty-five in all.[187] The elegant Tuscan columns used for the iron framing of the models was scaled up for the full-size machines and repeated in the turned wooden columns supporting the roof trusses in the new block mill. Eight Brunel models survive as showpieces of industrial invention and are now in the collection of the National Maritime Museum in Greenwich.[188]

Tools of Experiment

Models could be used to promote industry within the context of the polite arts and science and to represent mechanical invention principally for the purposes of gaining approval, premiums and privileges. The question remains: how useful were they in the process of invention, as experimental prototypes the testing of which had a real bearing on the outcome of a new industrial design, as opposed to rationalising the moment of invention after the event? In the fine arts, it is much easier to track a creative relationship, a terracotta model for a finished sculpture in marble, for example, sometimes bearing the finger- and thumb-prints of the artist's own hand at work.[189] There is no equivalent *prima facie* evidence in technical models of the inventor's creative or intuitive process. Crucially, the problem of scale, of encountering in the words of François Blondel, 'the resistance and obstinacy of matter', made models less than effective as experimental devices. In the real world, friction always got in the way. Ultimately, the proof of efficacy lay in the field, where full-size inventions were modified on the basis of practice and experience.

Sweden's leading mechanist, Christopher Polhem, provides a salutary case history. In 1698, he was appointed Director of Mining Engineering in Sweden and in 1700 Master of Construction in Falun, with responsibility for all the hydraulic constructions, ore hoists and horse-gins in the great copper mine. Between 1701 and 1705 he supposedly performed some twenty-five thousand experiments with hydrodynamic equipment of his own design to work out the most efficient form of waterwheel. But he was not mathematically trained, disdained mathematical analysis and, besides, lacked the instruments to make precise measurements. When he discovered that the quantities had been inaccurately measured, making the results of his experiments invalid, he simply told his assis-

tants to keep quiet about it.[190] A number of other elaborate mechanical machines were installed at Falun but the Master of Mines commented on Polhem's 'curious whims and confused concepts' even during his time as Master of Construction. His mining machinery was often impractical, frequently breaking down because it was so complicated. The model might have worked but the large-scale version did not, unless the inventor was constantly present – which Polhem usually was not – nursing his machine along.

Yet models could be put to serious experimental use by those with a more sophisticated grasp of the complex relationship between theory and practice. Having started his career as a maker of scientific instruments, John Smeaton was well aware of the role played by scale models. While drawing up plans in 1756 for his version of the Eddystone Lighthouse, he found it useful first to make models of the rock on which it was to stand, of how it was to be cut to receive the building and of the lighthouse itself. According to Smeaton, 'These models I determined should be the work of *my own hands*'; they were used to demonstrate his proposals to the proprietors.[191] The role of models in his experimental work is clearly spelt out in a paper he delivered to the Royal Society in 1759 and published the following year, 'An experimental Enquiry concerning the natural Powers of Water and Wind to turn Mills, and other Machines, depending on a circular Motion'.[192] He began by addressing the central problem of the experimental model:

> What I have to communicate on this subject was originally deduced from experiments made on working models, which I look upon as the best means of obtaining the outlines in mechanical enquiries. But in this case it is very necessary to distinguish the circumstances in which a model differs from a machine in large; otherwise a model is more apt to lead us from the truth than towards it. Hence the common observation, that a thing may do very well in a model, that will not answer in large. And indeed, though the utmost circumspection be used in this way, the best structures of machines cannot be fully ascertained, but by making trials with them, when made of their proper size. It is for this reason, that, though the models referred to, and the greatest part of the following experiments, were made in the years 1752 and 1753, yet I deferred offering them to the Society, till I had the opportunity of putting the deductions made therefrom in real practice, in a variety of cases, and for various purposes; so as to be able to assure the Society, that I have found them to answer.

Smeaton's caveat as to the utility of models was loaded in the context of the august surroundings of the Royal Society. His whole course of experimentation was driven by practical problems not hypothetical concepts; he relied on empirical observation not theoretical hydrodynamics and he tested his tangible models in the real world. Certainly, he made use of quantitative methods with regard to recording variations and reaching conclusions, but he was not working from *a priori* theoretical principles.

The comparative efficiency of the main types of waterwheel – the undershot wheel driven by the force of impulse, versus the overshot wheel driven by force of weight – was a live issue in the middle of the eighteenth century as the needs of industry increased.[193] According to conventional wisdom, their motive power was presumed to be equal but, stimulated by mill owners' practical need to extract the maximum power from frequently sluggish water supplies, Smeaton constructed a model with which the performance at various heads and flows could be tested and measured. By increasing the counterweights in a scalepan on a pulley attached to the wheel's axis until the wheel revolved at the same rate whether the water was running or not, he could record the amount of friction. As Norman Smith has explained, Smeaton's method was particularly impressive because it measured friction's effects, enabling him to assess the efficiency of a real waterwheel rather than that of a frictionless machine, as employed in

public lectures on mechanics.[194] By these means Smeaton demonstrated that an over-shot wheel was about twice as efficient as an undershot wheel.

Smeaton also made models of windmills, using a simple pendulum device to move the model against the air. He wanted to test the influence of the structure and shape of the sail, the angle of the sail relative to its plane of motion (known as the angle of weather), the quantity of surface and velocity of wind. Although he produced some useful guidelines for practising millwrights, his conclusions were not as clear-cut as they had been with waterwheels as there was no single answer for optimum effect. However, his experiments on model steam engines were more productive.[195] Around 1770 he had a small experimental Newcomen engine with a ten-inch cylinder built in the grounds of his house at Austhorpe. He made some 130 tests on it, adjusting different parts to optimise the piston loading, timing of the valves and form of the injection nozzle. Smeaton realised the benefit of insulating the piston and using a hot-well tank as a feed-water heater or heat exchanger and studied the relative evaporating power of different coals. Eventually, he felt justified in drawing up a table of the proportions and characteristics of engines for all sizes, with corresponding figures for the length of stroke, rate of working, quantity of injection water, coal consumption and resulting power and duty to be expected. In 1772 he was ready to embark on his great period of engine building.

These empirical experiments made Smeaton sceptical of theoretical mechanics and mathematical calculations conducted by those without any experience of real working machines. When, in a paper published in *Philosophical Transactions* in 1776, he considered basic questions of 'mechanic power', the relation between power and speed with particular reference to the French Academician Antoine Parent's advocacy of the undershot waterwheel, he did not mince his words: 'Some of these errors are not only very considerable in themselves', he warned, 'but also of great consequence to the public, as they tend greatly to mislead the practical artist in works that occur daily, and which often require great sums of money in their execution.'[196]

James Watt has long been claimed as one whose inventions were made on the basis of his command of theoretical principles but more recently his status as a 'philosopher' has been scrutinised and found to be more a matter of *post hoc* political convenience than an accurate reflection of the way he worked.[197] Again, he was deeply involved in the world of model-making and, like Smeaton, had an extraordinary range of practical skills. On his return to Scotland in 1756 from an apprenticeship in London as a scientific instrument-maker, he helped unpack, clean and conserve the instruments bequeathed to Glasgow University by Alexander MacFarlane of Jamaica, and was engaged by the professor of natural philosophy, John Anderson, as the repairer of instruments and demonstrator. Watt first made and repaired lecturing apparatus for Dr Joseph Black, the professor of medicine, who was also conversant with the latest theories on heat, air and vapour. Black evidently appreciated Watt as a 'young man possessing most uncommon talents for mechanical knowledge and practice, with an originality, readiness and copiousness of invention, which often surprised and delighted me in our frequent conversations together'.[198]

It was in 1759 that Watt was first drawn into the orbit of the steam engine through his friend John Robison who was fantasising about steam-driven carriages and tinkering with the design of the Newcomen engine, fruitlessly inverting the cylinder and placing it at the mouth of the pit to reduce the costs involved in building a massive engine-house.[199] In the winter of 1763–4, Watt was asked by Professor Anderson to repair a model of the Newcomen engine which belonged to the university's department of natural philosophy (fig. 78).[200] He was particularly struck by the wasteful consumption of steam involved in the engine's relatively weak performance. Having got it to work as

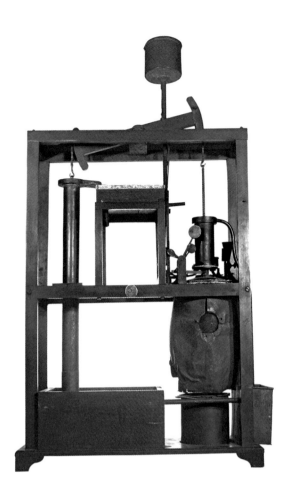

78 Model of the Newcomen engine repaired by James Watt in 1765. Hunterian Museum & Art Gallery, University of Glasgow, inv. C.29

well as he could, he started to make trials using his own models. Coming from a mechanical background, Watt was not afraid of getting his hands dirty.

At the same time, Watt had learnt from Black and others on an informal basis the importance of sustained, systematic experimental analysis. He also turned to Black for advice on his different projects. Later he was at pains to place this assistance in context, refuting the suggestion made by Robison (who had been abroad in the relevant years) and even, on occasion, by Black, of a greater dependence on gentlemen of science. He was not Black's pupil, he stated, did not have the time to attend his lectures, nor did he owe his improvements to the steam engine to Black's doctrine of latent heat. In devising his own experiments, he was guided by the principles of experimental philosophy rather than specific theories to determine what it was necessary to consider in contriving the new engine. Graciously, he conceded, 'Although Dr Black's theory of latent heat did not *suggest* my improvements on the steam engine, yet the knowledge upon various subjects which he was pleased to communicate to me, and the correct modes of reasoning, and of making experiments of which he set me the example, certainly conduced very much to facilitate the progress of my inventions'.[201] In other words, it was experimental methodology rather than theory which Watt said he had imbibed from Black and which refined, rather than conflicted with, his background in practical mechanical arts. As already emphasised, models and other experimental aids were used by artisans to test designs long before they were adopted for use in natural philosophy.

This is not the place to describe the numerous experiments using a battery of flasks, syringes and kettles, balances, barometers and thermometers by which Watt calculated the heat capacity of different materials and the steam consumption of his model Newcomen engines, finally working out where the steam was being wasted.[202] After a year of observation and calculation, he was in a position empirically to understand the nature of the problem – basically the loss of energy involved in alternately heating and cooling the cylinder. From that point on, the solution had an inevitable logic about it: the cooling process had to be removed to a separate cold container for condensing the hot steam without affecting the heat of the cylinder. It occurred to him in a flash of inspiration one spring day in 1765, while he was walking across Glasgow Green. Yet despite its beautiful theoretical simplicity, it took ten years to solve the numerous technical problems, before his engine could go into production.

During this period, the models Watt constructed on an ever increasing scale played a key role in improving the invention. By the autumn of 1765 he could boast to a friend that he had made at least two models of his 'perfect engine' to 'prevent waste of steam and consequently to bring the machine to its *ultimatum*'.[203] Watt's first backer, John Roebuck of the Carron Ironworks, helped him with experiments, procuring materials and allowing him to test Newcomen engines and boilers in his coal mines. While gaining hands-on experience in constructing and running full-scale Newcomen engines elsewhere in Scotland, he tinkered with his own model.[204] A much larger experimental version was constructed at Kinneil in the autumn of 1768 but there were still problems, not least because Watt did not understand the thermo-dynamic principles of the steam

engine – that to work, the steam must not only expand but also lose heat – and Watt did not allow his engines to cool.[205] Furthermore, he found that bores made by the best Glasgow manufacturers were in fact oval, the smallest and largest diameters varying by as much as three-eighths of an inch. Smeaton told him that neither the tools nor the workmen existed to produce his perfect engine. Nevertheless, Watt continued to work on his models until eventually news of a rival prompted him and Roebuck in 1769 to take out a patent.[206] This described the principles by which steam and fuel could be saved, outlining the main features of the engine but not the mechanism itself, as represented by drawings or a model, for no successful engine had yet been built.

When in a 'Plea before Parliament' in 1775, Watt argued that he and his partners would not receive their just reward without an extension to the 1769 patent, he mentioned difficulties that had arisen because 'the execution of large engines . . . cannot be foreseen by the trial of smaller ones'.[207] He had a point, given the time and money already spent on research and development. Roebuck had gone bankrupt and Matthew Boulton bought out his interest. In 1773, the failed Kinneil engine was dismantled and four tons of components were sent by sea to London and on to Birmingham; Watt finally settled there in 1774.[208] For the first time he had access to capital which allowed him to experiment at full scale. As noted in Chapter 2, in April 1775 John Wilkinson sent the cylinder ordered in 1774 which enabled the engine to work.[209] The following month, the patent was extended to 1800, a crucial victory for Boulton & Watt, which allowed them more time to improve their engine, albeit at the expense of others.[210]

Although Watt then concentrated on the manufacture of full-scale steam engines, he still saw the value of models as a necessary stage in the development of their different applications. In the early 1780s, he made drawings of a single-acting engine which worked a forge hammer, impressing Wilkinson sufficiently for him to order one. Watt wrote to John Turner, the engineer at Soho:

As the whole of this is a new thing and I have not been able to satisfy myself in what regards the hammer and its framing. I would advise that a model three times the size of the drawing be made immediately and [the] thing made of the same materials it is to be made of in great. The hammer ought then to be about 16 pounds in weight and the action of the whole can be seen and the faults appear.[211]

By the 1790s the experimental approach to ship design based on models was also bearing fruit, urged on by a publisher, John Sewell, and the newly founded Society for the Improvement of Naval Architecture.[212] The Society proposed to display exemplary ship models built on the 'joint opinions of able mathematicians and skilled shipwrights', to establish a new naval academy and to sponsor experiments using ship models in controlled settings to test stability, hull design and frictional drag. Over a five-year period from 1793 to 1798, a wealthy Fellow of the Royal Society, Mark Beaufoy, conducted experiments on Smeatonian lines in Greenland Dock, Rotherhithe, drawing schematic geometrical models through the water by means of weights and pulleys to calculate the effects of friction, as well as to measure speed and acceleration. On the basis of his observations and with the help of mathematical analysis, Beaufoy demonstrated that, contrary to Newtonian orthodoxy, friction not only affected the bow but also the stern and indeed the whole surface of the hull. Once again, however, the model findings were not taken up in the real world, where traditional shipwright practice still held sway, despite the best efforts of Samuel Bentham and his Office of Naval Works to engineer its reform. It was only following the publication of Beaufoy's experiments by his son Henry in 1834 that his findings received widespread recognition and were utilised in steamship design.

Rational Toys

On holiday in Matlock in the Derbyshire Dales in the summer of 1784, Dr Edmund Cartright fell into conversation with some gentlemen from Manchester on the subject of Richard Arkwright's spinning machinery and the necessity of inventing a 'weaving mill' to make cloth out of the thread it produced. They maintained that it could not be done but Cartwright had just seen the automaton chess-player in London and replied: 'Now, you will not assert, gentlemen, that it is more difficult to construct a machine that shall weave than one which shall make a great variety of moves in that complicated game.'[213] Between 1785 and 1792, Cartwright took out a whole series of patents for power looms, wool-combing and rope-making machines. He hired a carpenter and smith to make working models, which exhibited many ingenious features, and used family money to build power looms for a mill in his home town of Doncaster and for Manchester mills under licence.[214]

Of course, this anecdote cannot be taken at face value – the literal fulfilment of Dr Johnson's prediction of thirty years earlier that mechanical ingenuity might be transferred from trifles to valuable purposes. The automaton chess-player was a mechanical fraud and Cartwright's inventions were a financial failure. Yet, as a gentleman cleric he had seen in the chessman a polite guise for mechanical invention and thereby a possible route into invention for industry, otherwise divorced from his own experience. The growth of mechanical museums and more sober mechanical lectures, utilising models of varying degrees of transparency, did not in themselves represent any significant breakthrough or lead directly to new inventions but their very existence made a broader public more familiar with the basic principles of mechanics and acclimatised them to the possibility of industrial progress.

The orbiting worlds of mechanical marvels and industrial inventions brushed up against each other again in November 1790 when Sir Joseph Banks wrote to Matthew Boulton to ask whether he had had any conversation with the Baron de Roy 'on the subject of erecting fire engines on the mines of Hungary &c . . . I have a letter from him on the subject in which he tells me that Kempelen who you may remember I introduced you to and who at that time had an automaton that played chess has got the exclusive privilege for fire engines through the whole of the Emperor's dominions and in which he recommends you to enter into a partnership with him.'[215]

Ingenious men could still move between mechanical and polite spheres. In the early years of the nineteenth century, having officially retired from the steam engine business, James Watt retreated to his garret workshop at Heathfield, his Birmingham home from 1790 until his death in 1819. There he worked on a series of machines designed to make copies of sculpture, from low-relief to three-dimensional busts, which could be scaled up or down in proportion or even completed two at a time. According to David Brewster, who knew Watt personally, he abandoned these experiments on hearing that another inventor was working on a similar mechanism and was himself unwilling to go through the exhausting process of applying for a joint patent. More probably, old age prevented him from developing the machines to his satisfaction.[216] Nevertheless, Watt's garret workshop, now preserved *in toto* in the Science Museum, contains an intriguing mix of lathes and other tools, jars of chemicals and measuring devices, plaster casts and busts of himself and Rennie, death masks and classical statuary. Even allowing for some judicious posthumous re-arrangement by James Watt junior to emphasise his father's polite credentials, it exemplifies the links that still existed between the fine and mechanical arts at the end of the eighteenth century.[217]

Within the world of industry the status of mechanical models remained ambiguous. In 1816, the Halifax millwright John Sutcliffe complained of the spurious claims made as to their efficacy by scientific lecturers:

For the last twenty years gentlemen have gone through the nation giving lectures upon the application of water, and also upon mechanics, philosophy, astronomy etc., who have exhibited small models of waterwheels and steam engines, by which they have pretended to shew the best mode of applying the powers of those two great agents of nature. By these paltry models and the representations given of them the public have been greatly misled; and large sums of money have been expended to no purpose in making waterwheels after such imperfect models. I know of a number of good water-wheels, judiciously constructed, well speeded, and the water systematically applied, that some of these ingenious gentlemen have persuaded their owners were unfit for use, because in their opinion they moved too quick and consumed too much water; which they were prevailed upon to reject, and make others according to their models.[218]

Nevertheless, the practice of teaching by models continued well into the nineteenth century and beyond, albeit to progressively younger audiences.[219] Thomas Beddoes believed firmly in the principle, advocating in his *Essay on Demonstrative Evidence* (1796) the use of models or 'rational toys' to teach geometrical theorems and basic mechanics to young people along the lines, it seems, of Polhem's mechanical alphabet:

I believe parents are become sufficiently attentive to education, to give such a scheme support; and fortunately it cannot alarm any prejudice. The design is to construct models, at first, of the most simple, and afterwards of more complicated machines. The models are not to be very small, and they are to be so constructed, that a child may be able to take them to pieces and put them together again . . . I have in view not merely information in mechanics, chemistry, and technology but the improvement of the senses by presenting in a certain order and upon principle, objects of touch along with objects of sight.[220]

In a letter to his friend William Reynolds, Beddoes stated his intention to begin with the plough, 'which would afford an opportunity of introducing a vast train of ideas belonging to natural history, chemistry, and other branches of science'. Perhaps in deference to Reynolds, or even following in the footsteps of Moxon, the first manufacture he intended to take up was the iron trade. Beddoes got as far as engaging an artist to execute his models and an engraver to copy the designs when executed. He hoped to raise the money by subscription but the scheme went no further, presumably because it was too ambitious.

Models were not abandoned in higher education. William Farish, Professor of Chemistry at Cambridge from 1794 and Jacksonian Professor of Natural Philosophy from 1813, was the first at Cambridge to teach the construction and use of machines as a subject in its own right, rather than merely using mechanisms as examples to illustrate the principles of theoretical physics or applied mathematics.[221] From 1795 he gave a wide-ranging series of lectures, 'The Application of Natural Philosophy, Natural History, Chemistry &c. to the Art, Manufactures and Agriculture of Great Britain'. The first two parts of the syllabus, devoted to 'Metals and Minerals' and 'Animal and Vegetable Substances', had a strong practical orientation and the third, 'On the Construction of Machines', covered both the principles of Newtonian mechanics and the sources of motive power then available, the construction of water- and windmills, steam engines and cranes. The fourth part, 'Water Works and Navigation', examined the construction of canals, harbours and docks, as well as the building and launching of ships.

Farish lectured with the help of models, some of which, like the steam engine and waterwheel, could be set in motion. He also had models made of machines for boring cannon, rolling iron and of various mills:

The number of these is so large, that had each of them been permanent and separate, on a scale requisite to make them work, and to explain them to my audience, I should independently of other objections, have found it difficult to have produced a warehouse large enough to contain them. I procured therefore an apparatus, consisting of what may be called a system of the first principles of machinery; that is, separate parts, of which machines consist. They are made chiefly of metal, so strong that they may be sufficient to perform even heavy work; and so adapted to each other, that they may be put together at pleasure, in every form, which the particular occasion requires.

These 'Meccano' parts included axles, wheels, bars, clamps and frames, which were assembled for one lecture and then dismantled and built up again for the next. A permanent record was made of them in isometrical drawings which were subsequently published.[222]

In November 1805, the Yale Professor of Chemistry and Natural History, Benjamin Silliman, who was on a mission to Europe to buy scientific apparatus on behalf of his university, met Dr Farish in Cambridge and gave a laudatory account of his *modus operandi*. He found Farish to be 'a somewhat peculiar though very clever (in both the English and American senses), intelligent man with the most frank and friendly manners' who demonstrated 'all the most important applications of chemistry and of mechanics to the arts of life, and particularly to the manufactures of Great Britain, many of the establishments of which he has, for this purpose, visited in person'. Silliman described Farish's collection of models and machines adapted to his educational plan:

He has a small steam engine which serves, in the first place, to illustrate the theory and construction of this instrument; and, having put it in motion, he applied the moving power, thus produced, to work the rest of his machinery. He has a paper-mill and manufactures paper; a carding and spinning machine, with which he formed rolls and thread; he drives down piles, in the manner practised in the construction of bridges and wharves; he makes a hat, manufactures nitric acid, and, in short, exhibits to the young men all the leading applications of chemical and mechanical philosophy to real use. It is certainly a most happy plan, and, in the hands of so able a professor, must prove highly useful and interesting; and, it is said that Mr F— enjoys the honour of having invented and executed so important an improvement in education.[223]

As noted, Farish was far from being the first to use mechanical models for educational purposes but older examples were rarely prized or conserved. The cheap materials used to make many such models and their awkward three-dimensional bulk posed considerable problems from the moment of their manufacture. Sometimes the damage was done even before a model reached the Society of Arts. On 30 April 1789 it was reported to the Committee of Mechanics that a model of the valves of a steam engine made by Isaiah Richards of Swansea, 'having been sent by the mail coach, has been so much broken and the parts so deranged that is it adviseable the whole be returned to the inventor at the expense of the Society. And that a letter be written to Mr Richards acquainting him of the above circumstances and informing him that when he shall have repaired the model the Society will enter upon the reconsideration of its merits.' The handling of working models and subsequent neglect, once their practical use had been superseded, exacerbated their vulnerability.

As early as 1763, the Society of Arts' model collection was causing difficulties. In June that year, evidently provoked by the embarrassing breakage of a prize-winning model hand mill, the Committee of Mechanics 'considered the best method of preserving the

Society's models and machines, and most advantageously communicating them to the public'. Concern over the state of the models collection reoccurred at intervals and the need for sifting, repair and cataloguing was reiterated. The Society's own copy of its first printed catalogue, annotated in pencil with 'Found' and odd class marks, suggests spasmodic attention afterwards. Space was taken up with new inventions and older models were sold, given away or destroyed. Some ended up in other collections, such as the model of a temporary ship's rudder for which Captain Edward Packenham received a gold medal in 1789, now in the collection of the American Philosophical Society in Philadelphia.[224] Consigned at best to museums, models only came to life when the inventions to which they pertained were of relevance.

IV

Societies

Participation, Articulation

We are become members of the Society for the Encouragement of the Arts, and have assisted at some of their deliberations, which were conducted with equal spirit and sagacity – My uncle is extremely fond of the institution, which will certainly be productive of great advantages to the public, if, from its democratical form, it does not degenerate into cabal and corruption.

Tobias Smollett, *Humphry Clinker* (1771)

Lord! What inventions, what wit, what rhetoric, metaphysical, mechanical and pyrotechnical, will be on the wing, bandied like a shuttlecock from one to another of your troop of philosophers!

Erasmus Darwin to Matthew Boulton,
regretting having to miss a meeting of the Lunar Society, 5 April 1778

The number of voluntary societies and clubs of varying degrees of formality surged in Britain from the last quarter of the seventeenth century onwards.[1] These associations presented opportunities for group sociability, combining debate with conviviality and pleasure with improvement, all symptomatic of an economically dynamic, politically pluralist and increasingly urbanised society breaking through the traditional structures of corporate and community life which were slowly sinking into atrophy. Meeting in coffee-houses and inns, men of a broad range of classes – artisans and tradesmen, merchants, manufacturers and entrepreneurs, members of the professions and even the land-owning gentry – came together for social networking and conversation, usually well stoked by drink. Involvement in these communal gatherings conferred a badge of personal and civic prestige without the hierarchical rigidity imposed by state-sponsored academies. Participation also promoted the Baconian ideal of shared knowledge, enabling members to gain a reputation in fields beyond their occupational limits. Ideas were exchanged and techniques brought into the open. Societies offered a forum for the presentation, articulation and interrogation of improvements and even for their promotion and reward.

In the provinces, most societies were generalist in their interests. The Spalding Gentlemen's Society in Lincolnshire was founded in 1710 'for the supporting mutual

Facing page: detail of fig. 88

benevolence and their improvement in the liberal sciences and polite learning'.[2] It grew out of a group who met together at Mr Younger's Coffee House in the town to discuss Steele's *The Tatler* and later *The Spectator* but communications swiftly grew beyond these bounds to encompass antiquities and curiosities, poetry, history, botany and ornithology, medicine, astronomy, meteorology and mechanics. Looking back in 1745, its founder and secretary, Maurice Johnson, could pronounce: 'We deal in all arts and sciences, and exclude nothing from our conversation but politics, which would throw us all into confusion and disorder.'[3]

Sometimes members brought in mechanical devices, particularly clockwork, or introduced new inventions for discussion.[4] Not surprisingly, given Spalding's location in the fens, the latest drainage schemes were reported. They included the account communicated on 10 August 1727 of a machine invented by Mr John Ingram, a Spalding watchmaker 'borne and bred up a blacksmith in Cowbitte', for 'dreining the fens by throwing 1000 hogsheads of water in a minute' and two years later his 'large treatise in ms entitled a scheme of a plain and easy method for dreyning Deeping Fenns with a coloured map of them and the old and new dreyne proposed and a plaine [plan] of the engine'.[5] On 4 June 1730, the Society discussed the scheme invented by a group of Woolwich dockyard officers, endorsed by sea officers, 'whereby to judge of the dimension of flood gates or navigation sluices' through a table listing vessels' tonnage, maximum breadth and draught of water. The captains of Spalding and Boston vessels were able to make sage observations.[6] As recounted in Chapter 2, John Grundy senior used the Society's well connected membership as an audience to promote his increasingly ambitious drainage schemes. Yet, true to the spirit of a gentlemen's society, he lost no opportunity to stress his polite antiquarian credentials, having first ingratiated himself by presenting the Society's Museum with a plan of the town embellished with charming perspectives of 'the ten buildings most remarkable for their beauty, use, antiquity or notoriety'.[7] While working on the river Welland, he found a skull, an oak tunnel (presumably a wood-framed drain made from planks) and the hulk of a small fishing boat which he set before the Society.[8]

Other societies were more specifically concerned with economic development through applied, useful improvements in agriculture, manufacture, trade and the arts. Although their titles might suggest a particular focus, such as agriculture, their interests were usually much broader and even nudged against those of established academies of science and art.[9] Economic societies usually offered the prospect of reward for invention, in the form of cash premiums or honorary medals in exchange for making the critical information available to all. Advocacy of such schemes employed the enlightened rhetoric of progress and improvement to counter opposition based on age-old prejudices, as can be seen from a correspondence comprising three letters, circulated in 1721–2 by an anonymous writer, 'concerning the forming of a society to be called the Chamber of Arts for the Preserving and Improvement of Operative Knowledge, the Mechanical Arts, Inventions and Manufactures'.[10] Whether the letters constitute a real exchange of views or a literary conceit, they exemplify the drive to improve the mechanical arts in the early part of the eighteenth century and suggest the obstacles that stood in the way.

The first letter explained the purpose of this proposed society 'of nobility, gentry and traders', which was

> to enquire into the manner of performing any thing curious or rare in the arts, trades, and manufactures, as well abroad as at home; and to keep a continual register of the same, to invite ingenious artists and mechanicks, as well foreigners, as others, to apply to them, promote trials and experiments and to give particular rewards to those that invent or contrive any new tool or instrument in husbandry or workmanship, by

which any trade or occupation is benefited, and where the property cannot be secured to the inventor by a patent.

Subscriptions would raise the necessary funds and, possibly, the government would sanction the society and ensure its future. The writer made an explicit comparison between the Royal Society, concerned with theory, and the proposed foundation, devoted to practice. It was hoped that the Chamber of Arts would be

> as famous for the preserving and improving inventions, arts and manufactures, as our ever famous Royal Society is for promoting learning, sciences, and philosophy, and while the one is employed about curious speculations and the just reason of things, the other may in a more humble way, tho' not less serviceable, confine themselves to those in common use, and endeavour to reduce what they teach to practice in life, for the immediate benefit of mankind.

In response, the recipient, evidently a potential patron, agreed that the design was excellent, useful and worthy of patronage by the great and powerful. Well executed, it would certainly be of vast service to the public as well as a 'benefit and encouragement to all ingenious and industrious artists'. However, the writer had some significant objections. Firstly, he thought that its concerns were really the business of the Royal Society. Secondly, the keeping of registers with 'descriptions, draughts, models &c. of arts, inventions and manufactures', though excellent in theory, was impractical, 'for people will not be brought to discover their inventions and secrets in trade for fear of being detrimental in their business, by making others as knowing as themselves'. Finally, referring to the effects of the South Sea Bubble of 1720, he did not think it a proper time 'to introduce any thing now when projects in general are under so much disreputation, and so many people reduced to misfortunes, by playing with them'.

The original writer returned to the attack, stating that he had often heard such objections but, since writing his first letter, 'the Lord Bacon's Advancement of Learning fell into my hands, where the very design we are upon is painted in the most lively colours'. After quoting extensively from Bacon, he concluded: 'Thus for this great man, whose authority I hope will be sufficient to silence the peccant humours of the envious and the trifling ridicule of small wits.' Reinforcing the distinction he had already made, he argued: 'We propose only to take up things where they are left by the Royal Society; not to be enquirous into causes, but the producers of effects, not the recommenders of curious speculations, or censors of philosophy, but the preservers of useful arts and inventions.' There was therefore, he believed, no conflict of interest with the Royal Society.

To the charge of impracticality, the writer responded, 'Inventors will be rewarded by being entitled to a proportionable share of the advantages arising thereby.' Their expenses would be reimbursed 'to induce mechanicks of the most narrow and private views, to give up their secrets and inventions in trade, to be registered and preserved'. Premiums would counter craftsmen's traditional secrecy which so handicapped those seeking to improve the mechanical arts. As for the recent misfortunes, he argued that on the contrary it could be a good time to launch the scheme, 'just as religion always thrives under persecution'. The late losses might be turned to good use 'by a little encouragement to make us more industrious, more inquisitive, and more diligent, by all honest means to retrieve the ill state of our affairs'.

Despite this robust defence, nothing seems to have come of the proposed Chamber of Arts. Opposition might have come from those who still believed that trade improvements remained on the agenda of the Royal Society, although in practice it proved to be extremely wary of the world of projectors and profit. No doubt also, many mechan-

ics preferred to keep to themselves trade secrets acquired through years of experience. Nevertheless, in succeeding decades the enlightened vision of societies dedicated to the improvement of the mechanical arts did not fade but was taken up by patriotic and practical men across Europe, sometimes even with the active assistance of the state.

Encouraging the Arts

In the newly united kingdom of Great Britain, Scotland and Ireland showed the way in founding societies specifically to encourage their economic development. The Honourable Society of Improvers in the Knowledge of Agriculture was founded in Edinburgh in 1723 and was active until 1745. It supported agricultural improvement through premiums, publications and parliamentary lobbying, particularly in relation to the linen industry. In 1727 it helped to secure state funding for a Board of Trustees for Fisheries and Manufactures, in belated fulfilment of the economic promises made in 1706 prior to the Act of Union. Its impact was felt in the Scottish textile industries through the appointment of stampmasters (who controlled the quality and quantity of cloth), the establishment of spinning schools, the import of specialist bleachers from Ireland and Holland and the founding in 1760 of the Trustees' Academy in which pattern drawing was taught for the linen industry.[11] A private art academy was founded in Glasgow in 1753 by the publisher Robert Foulis. He had first observed 'the influence of invention in drawing and modelling on many manufactures' on a visit to Paris in the 1730s and determined that Scotland too should benefit from teaching in art and design.[12] The Edinburgh Society for Improving Arts and Sciences and particularly relating to Natural Knowledge, soon more conveniently known as the Philosophical Society, grew out of the Society for the Improvement of Medical Knowledge, established in Edinburgh in 1731.[13] Initially aristocratic in connection, its membership included those with considerable agricultural and mining interests. Although industrial and manufacturing subjects featured comparatively rarely among the topics for discussion, they included Lord Elphinstone's 'engine for raising any quantity of water from coal or lead mines', ventilation schemes, the mechanical efficiency of windlasses and broader mineralogical questions relating to working or prospecting for ores. Sir John Clerk presented his dissertation on coal to the Society in 1740 and three years later an advertisement appeared in the *Scots Magazine*, offering the Society's assaying services on ore samples.[14]

The Dublin Society for improving Husbandry, Manufactures and other useful Arts and Sciences (initially the word Sciences was not part of its title) was founded in 1731 by fourteen Anglo-Irish citizens of Dublin, including medical men, two clergymen and a landowning lawyer, Thomas Prior, who was the Society's prime mover.[15] By 1734 it boasted twelve bishops, sixteen peers, five judges and a number of politicians, notably the Chancellor of the Exchequer, among its 267 members. In January 1737 it launched a series of *Weekly Observations for the Advancement of Agriculture and Manufactures*. Making a virtue of what was no doubt financial necessity, the authors defended their publication in loose sheets rather than pamphlets on the grounds that it made the contents more focused and user-friendly, by not being buried among other matter. Furthermore, it could be more easily distributed and was within the reach of every reader, not just gentlemen of fortune: 'The poorer sort, the husbandman and manufacturer, are the proper objects of instruction, which can hardly ever reach them in any other method than the present . . . the majority of our common people, must have continued in their ignorance, had not a way been found of conveying knowledge to the poor at an easy rate; and to the indolent or busy readers in small parcels.' The intention of the gentlemen of the society was firmly pragmatic: 'not to amuse the public, with nice and

laboured speculations; or to enrich the learned world, with new and curious observations: but, in the plainest manner, to direct the industry of common artists; and to bring practical and useful knowledge from the retirement of closets and libraries into public view: In short, to be universally beneficial is their only end.'[16]

When fifty-two *Weekly Observations* were eventually brought together in 1738 in a single volume, they were described as 'short political essays on the present state of Ireland, in relation to our trade especially, and more particularly still, to the linen manufacture'. There were articles on flax husbandry and flax dressing, accompanied by figures in perspective showing instruments, machines and mills used by the Dutch, as well as pieces on building embankments against tides and floods, the raising of hops in bogs and the making and repair of highroads. Only one objection had reached them, the editors stated, relating to the problem of specialist trade terms:

> The ingenious author of the letters upon brewing, has been sometimes obliged in relating the several experiments he had made, to use technical expressions, which were not perhaps universally or distinctly understood. This was strictly unavoidable, without retrenching many curious observations. Chemical operations must be chemically described, and were it not for those compendious significant phrases, which have obtained in the language of the learned, 'tis not to be imagined to what bulk the relation of every little process in chemistry would swell.

Nevertheless, they believed there were few other instances in their work of writing 'too philosophical for common readers, both in the matter and expression'. Apart from the descriptions relating to the flax industry, they had kept to their general rule of speaking directly to the vulgar and delivering instructions in the most familiar manner possible.[17]

Despite or because of this avowed concern with the plain people of Ireland, the Society was increasingly short of funds. In 1738–9 the clerical landowner the Reverend Dr Samuel Madden published patriotic appeals to Irish gentlemen. Already in 1731 he had sought to encourage young students at Dublin College through 'public premiums and honorary distinctions', citing the precedent set by Jesuit schools and French academies.[18] Now he envisaged that the Dublin Society should offer premiums like the £20,000 offered by the Board of Longitude for successful methods of determining longitude or the £8000 investment in the Irish Linen Board which had produced returns of £500,000: '£20,000 per ann. in premiums, skilfully applied would set every idle hand in the nation at work, and thereby bring us in, at least, an additional million from our exports.'[19] The Society should serve 'as a sort of laboratory, and a dispensary too, to disperse universal prescriptions and medicines for every ill turn of humour, as to trade, every ill-affected or disordered part, in the body of the people, or indisposition in the national constitution, as to industry and labour'. To further its aims he proposed the establishment of an experimental farm near Dublin to undertake agricultural trials and 'the encouraging by premiums, all new inventions in manual arts and trades, such especially as contribute mostly to the welfare of our people, or the weighty substantial industry of human life'.[20]

Like the anonymous proposer of the Chamber of Arts, Madden was at pains to distinguish his proposals from the foolish or cunning schemes of shallow projectors: 'these are not projects, to make leather without hides, or butter without milk, like to which I remember were printed in the South Sea time; but plain, obvious rational designs for the general service of every landlord and tenant, tradesman, merchant or manufacturer, nay, every labourer and beggar (if there be any difference betwixt those two callings) in this nation'. Nor was he serving any private or party interest: all ranks and orders of men had an interest 'since all improvements of this kind, will naturally be productive of civility, good sense and taste, of arts and industry, and consequently of religion and virtue, which are more essentially united to them, than some people conceive'.[21]

In a postscript Madden stated that he had already procured a gentleman (himself) to pay £130 for two years, of which £30 would be offered for experiments in agriculture and gardening, £50 for the best annual invention in any of the liberal or manual arts and £25 apiece for the best picture and statue, as judged by ballot with at least two thirds of the Society's members present. The first premiums were advertised in Dublin in 1740 'to promote such useful arts and manufactures as have not hitherto been introduced, or have not yet been brought to perfection in this kingdom'. Of the claims judged in January 1741 there were prizes for examples of earthenware, artificial leather, spinning cotton, twill stockings, engines for scutching flax (beating it to remove the waste material), for a surveying instrument, as well as for the polite arts of painting and sculpture. From 1746, premiums for the best drawings by boys and girls under sixteen were also awarded and the Society paid for select students to attend a drawing school, opened also at the Society's expense. Its first master, Robert West, who had studied in Paris under van Loo and Boucher, instituted a French-style training in figure drawing from plaster casts of antique models, anatomical models and from life.

As in Scotland, when it came to drawing, the boundary between fine and applied art remained fluid but in 1756 the Society founded a second, more specialised school of landscape and ornament drawing under James Mannin, open to all whose profession depended on design: 'painters, carvers, chasers, goldsmiths, carpet-weavers, linen and paper stainers, damask and diaper weavers, their journeymen and apprentices'. Pupils were taught ornament from French-inspired engravings of foliage, flowers and scrolls.[22] The number of premiums grew to encompass a wide variety of manufactures and agricultural produce, painting and sculpture. In 1749, having obtained government support through Lord Chesterfield, the Society was incorporated by Royal Charter of George II. In 1761 it received its first Parliamentary grant and by 1767, £42,000 of government money had been distributed in the form of premiums for promoting agriculture and manufactures in Ireland. The Dublin Society's improving agenda, encouraging investment and enterprise, serves as a corrective to the more usual image of Ireland under the Ascendancy as the plaything of rapacious, often absentee landlords hell-bent on lives of spendthrift consumption.[23]

Back in London in 1738, a promoter of trading interests called Philip Peck submitted a 'Proposal for the Encouragement of Arts and Sciences' to the Royal Society.[24] A fund of a thousand pounds could, he suggested, be employed to assist people producing new and useful inventions. Although he believed in patents as a means of encouraging trade and invention, the process of obtaining them was too expensive and time-consuming, while legal enforcement was fraught with difficulties. Yet the Royal Society had no wish to act as a joint-stock company and exploit invention for profit.[25] The Anti-Gallican Association was less squeamish, being founded in 1745 'to promote British manufactures, to extend the commerce of England, to discourage the introduction of French modes and oppose the importation of French commodities'. In other words, its driving force was the mercantilist economic strategy of import substitution through the encouragement of home-grown and home-produced goods. It was a symptom of the broader patriotic movement which had long seen the French as the enemy not only in politics and religion, as manifest in armed conflict on land and at sea, but also in matters of taste and design, which had dangerously tipped the balance of trade in high value-added goods to Britain's disadvantage. Although little more than a dining club, the Association attracted considerable support from London craftsmen, keen to promote their own goods. In 1751 it began offering premiums in the manner of the Dublin Society for improvements in lace and brocade manufacture, as well as for fishing.[26]

It was therefore not especially original of William Shipley, a drawing master based in Northampton, to produce a pamphlet in June 1753 outlining proposals intended 'to

embolden enterprise, to enlarge science, to refine art, to improve our manufactures, and extend our commerce'.[27] Northampton was far from being a rural backwater and had a flourishing Philosophical Society, founded in 1743.[28] While the societies founded in the orbit of Spalding – the Peterborough Society in 1730 and the Brazen Nose Society at Stamford in 1736 – were primarily antiquarian and literary in outlook, the Northampton society concentrated on natural philosophy. It staged lectures and experiments for its members on magnetism, electricity, mechanics, hydrostatics, pneumatics and optics. Scientific instruments and models of inventions were bought or borrowed. The Society's president, the millwright Thomas Yeoman, managed the Northampton cotton mill owned by Edward Cave, the publisher of the *Gentleman's Magazine*.[29] Shipley's move to Northampton in 1747 and membership of what he described as a 'Royal Society in miniature' undoubtedly influenced his plans, as did his friendship with the energetic polymath Henry Baker, F.R.S., a naturalist, poet and the son-in-law of Daniel Defoe. Baker must have been familiar with Defoe's *The Complete English Tradesman* (1726) and *A Plan of English Commerce* (1728), which celebrated the increasing variety of consumer goods available on the market. Equally, he had serious scientific interests: he published *The Microscope Made Easy* in 1743 and was awarded the Copley Medal for his microscopical discoveries of saline particles. His other hobby horses ranged from speech therapy to cobalt and silk production, as well as printing and its related trades.[30]

The documents which promoted what became the Society for the Encouragement of Arts, Manufactures and Commerce provide insight into the varying motivation of the founders. Shipley's first pamphlet issued in June 1753 argued from the premise that the arts and sciences advanced and flourished in proportion to the rewards they acquired and the honours they obtained. He therefore suggested a scheme of premiums or cash awards, raised by subscription and paid to whoever progressed 'any branch of beneficial knowledge', exhibited the best performance in 'any species of mechanical skill' or executed 'any scheme or project calculated for the honour, the embellishment, the interest, the comfort (or in time of danger, for the defence) of this nation'. True to his times, Shipley saw the Society as a highly patriotic endeavour, 'to render Great Britain the school of instruction, as it is already the centre of traffic to the greatest part of the known world'.[31]

Seven months later, in December 1753, Shipley published in London a scheme for putting his proposals into action, with a draft constitution for a 'Society for the Encouragement of Arts, Sciences and Manufactures in Great Britain' and suggestions as to its method of operation. Its purpose was also enlarged on to encompass

> improvements in the present plans of education, in naval affairs, in husbandry, and particularly for the introducing of such manufactures as may employ great numbers of the poor, which seems the only way of lessening the swarms of thieves and beggars throughout the kingdom, and relieving parishes from the burden they labour under, in maintaining their numerous poor, as well as rendering multitudes of the unemployed lower class of people useful to the community and happy in themselves.[32]

This injection of charitable relief was probably due to the influence of Dr Stephen Hales, F.R.S., an eminent physiologist, botanist and philanthropist, with whom Baker had put Shipley in touch. Hales was another Copley medallist and inventor, as well as being an active curate at Teddington, Chaplain to the Princess Dowager of Wales and her son, later George III, and a trustee of the colony of Georgia.[33] Furthermore, Shipley believed that premiums should be given 'for the revival and advancement of those Arts and Sciences which are at a low ebb amongst us; as Poetry, Painting, Tapestry, Architecture

&c.' So even at this early stage Shipley's aims were not wholly utilitarian; true to his calling – and like Foulis in Glasgow and Madden in Dublin[34] – he also wished to advance the politer forms of art and science.

On 22 March 1754, the founding meeting of the Society was held at Rawthmell's Coffee House in Covent Garden, the first of a succession of temporary homes. The nucleus of ten members from the 'nobility, clergy, gentlemen and merchants' included four Fellows of the Royal Society: Henry Baker, Dr Hales, the merchant and antiquary Gustavus Brander and James Short, the optician and astronomer. Two influential noblemen and brothers-in-law, Lord Folkestone and Lord Romney (a kinsman of Dr Hales), also attended. They were elected as the Society's first and second Presidents, Lord Folkestone to his death in 1761 and Lord Romney until his in 1793. Significantly, Sir Jacob de Bouveries (afterwards Bouverie), created Viscount Folkestone in 1747, came from trade. His father and grandfather were well known Turkey merchants in London, descended from Flemish silk-weavers who had settled in Canterbury in 1568.[35] The remaining participants included a wealthy linen draper and the jeweller and porcelain manufacturer Nicholas Crisp,[36] so commerce and manufactures were well represented and the motive of improving them appears uppermost in the founders' minds. For Baker the whole point of the Society was 'to excite industry, and raise a spirit of emulation, that may improve our manufactures, employ our idle hands, extend our commerce and save to the nation much of that money which is continually sent abroad for the purchase of commodities that may probably be produced at home'.[37] Emulation meant more than general aspiration – specifically, the imitation of imported goods by British workers.[38]

The first premiums proposed were for the home production of madder and for cobalt. While the former was the colouring source for Turkey red in dyed and printed textiles, the latter served as the basis of a range of processes and products: when mixed with potash, sand and ground flint, it formed zaffer or blue glass which, when ground again, could be used as a vitreous colouring material in glazes and enamels and as the basis for smalt, used in painting, washing and bleaching.[39] Premiums were also to be awarded for the best drawing by a boy or girl between the ages of fourteen and seventeen made on or before 15 January 1755. As Shipley's notice to the public issued on 15 June 1754 stated, 'the art of drawing is absolutely necessary in many employments, trades and manufactures, and that the encouragement thereof may prove of great utility to the public'. The utilitarian connection made between drawing – in effect designing – and high-quality manufacture was no more than an observation based on workshop practice over the centuries. However, it acquired a particular force when it was identified as the key to satisfying consumer demand in the booming market for luxury goods, one which the French seemed to monopolise. Moreover, given the absence of a state-sponsored academy of fine arts in Britain before 1768, in its early years the Society of Arts, as it was generally known, attempted like its counterpart in Dublin to improve both the liberal or 'polite' and the mechanical arts; indeed, they were seen to be intimately connected.

Baker enlarged on the theme of import substitution in a promotional article he submitted anonymously to the *Gentleman's Magazine* in 1756, entitled, 'Advantages arising from the Society for encouraging Arts'.[40] He itemised the premiums offered which would 'produce great advantages to this nation, by employing many hands, and saving annually large sums of money', not least on imports: cobalt, madder, losh or buff (oiled ox) leather for the army; tinning copper or brass vessels with pure tin unpolluted by lead; and silk production in Georgia. But he placed particular emphasis on the premiums introduced to encourage the commercial application of drawing whereby all manner of household commodities and luxuries would be rendered desirable on the market: 'since drawing is necessary to many trades, that the general knowledge of it must conduce

greatly to the improvement of our manufactures, and give them an elegance of air and figure, which a rival nation (where drawing is much encouraged) has found, to its great advantage, capable of setting off even indifferent workmanship, and mean materials'.

Baker's elaboration of the thesis 'that drawing enlivens the conception, corrects the judgement, and supplies the fancy with a thousand varieties, which would never otherwise be thought of' was a clear recognition of the way in which novelty value was coming to dominate the world of goods, driving the engine of product innovation.[41] Fancy, variety and ingenuity in design were regarded as desirable attributes in the treatises on taste and beauty produced in the 1750s by aesthetic commentators from William Hogarth to Adam Smith.[42] These qualities were also extensively documented in a flood of prints depicting ornamental motifs and in specialised books containing patterns for particular trades. They were almost wholly dedicated to the diffusion of the taste later referred to as Rococo, featuring a heady combination of extravagant asymmetrical forms, organic scrolls and naturalistic motifs – fruit, flowers, rocks and shells – on which changes could endlessly be rung, freed of the immutable rules which bound classicism. The lightness, informality and very caprice of the Rococo style enhanced its appeal to fashionable consumers, ever demanding the latest novelty.[43]

According to Baker, the Society would not be limited to increasing the number of painters; it was 'earnestly solicitous' of producing among the boys 'ingenious mechanics, such as carvers, joiners, upholsterers, cabinet-makers, coach-makers and coach-painters, sign painters, weavers, curious workers in all sorts of metals, smiths, makers of toys, engravers, sculptors, chasers, calico-printers, etc. sailors that can take the bearing of coasts or the plans of harbours, and soldiers better qualified for becoming engineers.' Nor did he forget the girls, proceeding to enumerate a range of characteristic female occupations: 'ingenious milliners, mantua makers, embroiderers, pattern drawers, fan-painters, and good workwomen in many other sorts of business where fancy and variety are required'. Baker claimed that the Society had already trained fifty-one boys and girls, whom he anticipated would be snapped up by 'masters and mistresses who want apprentices to trades where drawing is necessary'. It is clear that, unlike Shipley, Baker was not over-concerned with encouraging the polite arts in their highest form. The focus of his interest was the training of artisans as well as naval and military engineers required to defend the country and promote its trading interests abroad.[44]

With so comprehensive and patriotic an agenda, it is not surprising that the Society succeeded in attracting a wide membership by nomination and election, despite a subscription of not less than two guineas a year. At a time when the government was still largely reactive in encouraging economic growth and employment, a voluntary society whose express purpose was to promote both was highly attractive to the urban commercial classes, not to mention the landed elite, primarily concerned with agricultural improvements but also with achieving better returns on trade and industrial enterprises undertaken on their property.[45] By 1760, members included the First Lord of the Treasury, the Duke of Newcastle, the Secretary of State William Pitt the Elder, the future Prime Minister the Earl of Bute and nearly all the senior ministers in the Board of Trade. By 1764, the membership listed in the Society's subscription books totalled 2136, of whom a tenth had titles, 99 were medical men, 66 were clergymen and 48 of naval or military background. The remainder ranged from government officials and merchants (including no fewer than 28 Russia merchants) to tradespeople (with most of the City livery companies represented), manufacturers and artisans, headed by 8 watch-makers and 7 printers.[46] By the end of the first decade of the Society's existence its membership boasted a galaxy of stars in the firmament of Georgian London.[47]

Business was dispatched by a small staff of officers, a growing number of committees set up *ad hoc* to deal with specific activities and increasingly large general meetings. For

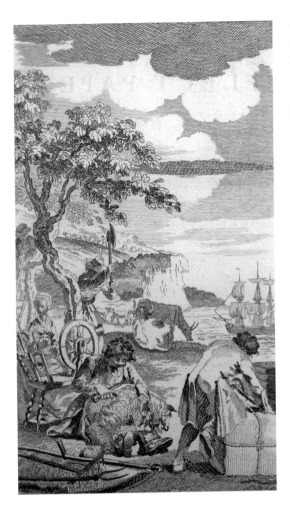

the first few years, the workings of the Society appear little short of chaotic but by the early 1760s the Committee of Premiums had been divided into six specialised standing committees dealing with the Polite Arts, Agriculture, Mechanics, Manufactures, Chemistry, and Colonies and Trade. The chairman of each was supposed not to profess the art or branch of trade that was the object of the Committee, nor after 1764 were members allowed to receive premiums. However, the former rule appears not to have been strictly enforced: Benjamin Franklin was intermittent chairman of the Committee of Colonies and Trade from 1759 to 1761; Thomas Yeoman jointly chaired the Committee of Mechanics from 1763 to 1778; the agriculturalist Arthur Young chaired the Committee of Agriculture between 1773 and 1776, and the engraver Valentine Green chaired the Committee of Polite Arts between 1780 and 1786.[48]

From the start, the Society made an effort to promote its activities through publication, following the example set by the Royal Society's *Philosophical Transactions* and the Dublin Society's *Weekly Observations*. In 1764 appeared the first volume of *Museum Rusticum et Commerciale; or, Select Papers on Agriculture, Commerce, Arts, and Manufactures. Drawing from Experience, and Communicated by Gentlemen engaged in these Pursuits*, 'revised and digested' by several members of the Society. Its frontispiece depicts a scene of contented husbandry, manufacture and trade which the Society's endeavours would presumably encourage (fig. 79). Yet the contents of *Museum Rusticum* – as the word order of its title suggests – were predominantly agricultural, a state of affairs which drew some criticism by 1766 and perhaps accounted for its ceasing publication that year.[49]

In 1765, Edward Bridgen, a City merchant and friend of Benjamin Franklin, published anonymously *A Short Account of the Great Benefits which have already arisen to the public by means of the Society instituted in London, in the year 1753, for the Encouragement of Arts, Manufactures and Commerce*, which was more broadly based, enumerating not only the agricultural improvements made with the help of Society premiums but also the manufacture of verdigris at Enfield, assorted fancy papers, plate-glass, quilting on the loom, stocking-frames, Turkey-red dye and carpet manufacture at Warminster and Exeter 'which are brought to such perfection as to need no further encouragement'. This was the stuff of product innovation, as ever motivated by the need to provide acceptable home substitutes for foreign imports.

The eminent agriculturalist Robert Dossie provided concrete evidence of his enthusiasm for the Society's agenda in *The Handmaid to the Arts*, first published anonymously in two volumes in 1758 and reprinted in 1764, dedicated to the Society. It represented 'an attempt to teach the knowledge of all such matters as are subservient to the arts of design, but yet not absolutely a part of those arts themselves'.[50] Dossie started from the premise 'that the national improvement of skill and taste in the execution of works of design is a matter of great importance to any country, not only on account of the honour which is derived to civilised nations by excelling in the polite arts, but likewise of the commercial advantages resulting from it'. If, as he surmised somewhat prematurely, the trade in 'grosser manufactures that depend on labour' was waning, 'it peculiarly behoves us to exert ourselves in cultivating those of a more refined nature, where skill and taste (in which we by no means seem naturally wanting) are required to give a higher value

to the work, and stand in the place of a greater proportion of manual operation'. The French had a head start through government encouragement and the foundation of the Académie but Britain would soon catch up – through the foundation of a well regulated Academy where youths would learn the principles of design and mature artists could undertake further study; through the pecuniary awards and honorary distinctions awarded by the Society of Arts; and finally through his book, which he hoped would diffuse 'a more general and accurate knowledge of those secondary or auxiliary arts now requisite to the practising design'.[51]

Later, the first volume of Dossie's *Memoirs of Agriculture, and other Oeconomical Arts*, published in 1768, provided a useful, if excessively rosy, summary of the Society's activities during the first dozen years of its existence. By this date, Shipley's core agenda had become even more relevant. After the protection to British manufacture afforded by the Seven Years War of 1756–63 and despite the vast territorial gains of the Treaty of Paris, the country was entering a period of political unrest and economic depression. For two days in 1765 the notoriously vulnerable and riotous Spitalfields silk-weavers had picketed Bedford House in Bloomsbury Square, carrying black flags in protest against the Duke, who had defeated a bill designed to protect their livelihood by excluding French silks from the English market.[52] In May 1768 the mechanical saw mill erected by Charles Dingley in his Limehouse timber-yard, with the Society's full encouragement and approbation, was badly damaged by a mob of five hundred sawyers who feared for their livelihood.[53]

Dossie steered clear of making any direct mention of industrial troubles but he constantly stressed the ways in which the Society had helped to cut down dependence on imported French goods and reduced unemployment, especially through encouraging the production of luxury goods the desirability of which depended on improved standards of taste. Like Baker, he was keen to encourage the type of applied design drawing he described as being 'of a mixt nature', being both polite and of the greatest consequence to commerce. Again the emphasis was on utility and the necessity of challenging French superiority in the field of design: 'The great advantage the French have over us in this particular, both with respect to patterns for silk, paintings and ornaments for coaches, and designs, for every kind of furniture which makes the upholsterers business, renders it a matter of very great moment to us, and highly worthy the attention of a body, whose views are the promoting the commerce of this country.' This explained why the Society had from early on offered premiums to the youth of both sexes, to encourage their application to the study of designs for 'weaving and ornaments' and also the best set of drawings of ornaments for the use of upholsterers.[54]

With reference to improvements in the mechanical arts (in effect combining the Society's categories of mechanics and manufactures), Dossie claimed that the Society's success was as great as in agriculture but because it related to subjects 'less commonly understood or attended to' was not as well known or well regarded by the public. There were awards for mills and engines and cranes, for pumps to extract water out of ships and for making watch fusee-chains, a trade which again had got into foreign hands.[55] A large expense had been saved by the manufacture of Turkey carpets in Britain from native wool, in imitation of those brought from the East and increasingly in general use 'from the increasing luxury of the age'. Furthermore, 'carding and spinning make a great part of the work: which, consequently, employ women and children; who are thus rendered profitable to the public, and moral in their conduct, instead of being burthensome, or loose in their way of life; as they otherwise would be'.[56]

There was an extraordinary range of other premiums for improvements in the textile industry, to support large-scale concerns as well as seemingly trivial home pursuits. They were offered for all aspects of silk production in the American colonies and for looms for

weaving stockings; making point lace and imitations of Marseilles and Indian quilting; crapes for hat bands (to cut out the Italians), milled caps (to cut out the French trade at Orleans) and women's mittens; cleaning flax to make coarse brown Osnaburg for slaves' clothing and manufacturing cloth from the stalks of hop binds. Premiums were also awarded for spinning flax, wool and cotton in workhouses, 'because here the poor are for the most part, to the public loss, maintained by the public in idleness'.[57]

Manufacturing different types of paper – for printing from copper plates, made from silk rags, marbled or embossed – was again encouraged to reduce the 'very considerable sum [that] was paid to foreigners, particularly the French'.[58] To Dossie's disappointment, some premiums had yet to be awarded, such as that for artificial flower-making, imported from Italy and France at a great price and in large quantities: 'At the same time, we have great numbers of women unemployed, who, with a moderate application, would easily attain to the art.' Knowledge of mechanics, he believed, played but a small part, while taste or fancy of mode could be picked up from imitating foreign examples. The publication of instructions would be helpful, 'as the want of knowledge is the only means of accounting for the supineness of great numbers of women, who labour under difficulties in their circumstances, from trying to get, not only an easy, but even a genteel support, if they attained to any degree of perfection in this art'.[59] Again Dossie was describing a 'mixt art' which combined both polite and mechanical features. Likewise, the procuring of cat-gut strings for musical instruments was deemed beneficial to the public in order to exclude frequently bad and exorbitantly priced foreign products, 'in a commercial light, and even for the improvement of music with us, which is not less a *polite* or *liberal art* than painting'.[60]

The Society's involvement in chemistry reveals a similar conjunction of the polite and useful arts.[61] It encompassed finding native raw materials for use in core dyeing and finishing processes such as verdigris, varnish, cobalt and saltpetre and also encouraged the search for methods of purifying onyxes and cornelians, for making leaf metal and bronze for ormolu and creating white and true red for enamels. A £10 premium for staining marble to give it the appearance of inlay was awarded in 1759. The premium for pastel crayons equal to the best foreign examples was awarded in 1767. Fine pigments used in painting were difficult to procure, due principally, Dossie maintained, to the 'ignorance or sordidness of dealers in these articles'.[62] He also considered taking casts or impressions of cameos in paste or coloured glass as being of a 'mixt nature having some dependence both on the mechanical and chemical arts'. Dossie supported its promotion as a means of improving the taste and invention of artists as well as gratifying a wider audience, through multiplying the merits of the original which otherwise might easily be lost to the modern world.[63] The general concern with artists' materials, categorised by Dossie under 'Chemical Arts', was inextricably part of a broader spectrum of artful activity, the processes of which he had described in *The Handmaid to the Arts*. Improved execution of the polite arts relied on better methods and materials, involving chemistry, manufactures and mechanics, as much as the mechanical arts required the designing and modelling skills associated with the polite arts. At the same time it was hoped that such improvements and inventions would help combat competition from abroad and unemployment at home.

Premiums for All and Sundry

An abstract given in the first volume of the Society's published *Transactions* in 1783, summarising the premiums given between 1754 and 1782, provides further insight into the Society's priorities. More than £8500 had been given for the Polite Arts, of which £2392

had gone on drawings and prints and £3016 on painting; £1547 on different types of carving; £356 on charts, maps, surveys and plans; and £84 on improvements in crayons, watercolours, ink-staining marble, needlework and penmanship. Agriculture had gained £3282 of which nearly half was given for premiums relating to planting, cultivating and curing madder. The Colonies and Trade, Mechanics (carriages, mills, cranes) and Manufactures received between £2000 and £3000 each, the latter largely relating to improvements in the textile industries, both machinery and products, and in the paper industry. Chemistry premiums totalled £1992 of which £550 had been given for improvements to dyeing and tanning.

Such a bald summary does scant justice to the rich texture of the Society's activities as revealed in its manuscript guard-books and volumes of transactions. The range of invention described therein gives the impression that the prospect of reward for ingenious machines and speculative inventions had struck a chord on every social level. A fascination with technical ingenuity and improvement, commercial innovation and enterprise was shared by an indiscriminate mix of talents and ranks. The applications poured into the Society, ranging from carefully written treatises of several pages to scribbled notes from artisans, sometimes accompanied by drawings and models. To read them is to discover the authentic voice of eighteenth-century Britain: from confident specialists with a fluent theoretical base to humble mechanics articulating in their own words and phonetic spelling projects and schemes, practical proposals and kites in the sky. Inevitably there were the chancers and losers, the desperate and downright disreputable, whose inventions in an age before professional boundaries had been set hovered on the fringe of legitimacy and teetered on the borders of madness, sent in 'on spec', not falling into any of the advertised premium categories.

Information about the premiums was spread through newspapers and journals such as the *Gentleman's Magazine* and the *Universal Magazine*. From 1772, Lord le Despencer, Postmaster General, undertook to distribute copies of the premium lists to every post office in Great Britain, Ireland and America, free of charge (an act for which he received the Society's gold medal).[64] Yet despite this open invitation to compete for profit, it required considerable courage to apply and risk being sent away with a flea in the ear. Lack of experience on the part of the lower orders from the provinces in approaching a grand metropolitan society could create confusion. The Society minutes of 2 July 1755 record that a brick-maker from Wimpole, Cambridgeshire, came to London with the express purpose of laying before the Society 'the model of a machine for the better & more expeditious manufacturing of bricks & tiles' but without reference to any advertised category of premium. After some debate, the Society's premiums committee ordered him to come in and finding he expected an immediate reward, informed him

> that according to their plan they could not give money for machines whose real utility had not been tried & properly recommended by experienced judges; that it would be most adviseble for him to apply to the brick & tile makers from whom (if his machine can be made so greatly useful as he supposed) there is no doubt he may find encouragement and as the Society could do nothing in this affair, they declined viewing the model of his machine.

The clergy and parish overseers sometimes played the role of intermediaries in vouching for the efficacy of manufacturing and invention, not least when the work was undertaken on their own premises. They also served as reliable witnesses for others. A particularly elegant certificate signed by Thomas Bowyer, the rector of the parish of Martock in Somerset, as well as two church wardens and four overseers, relates to Thomas Perrin's newly invented spinning-wheel 'agreeable to the offer of the Society in September 1760 for the encouragement of the best improvement in the common spin-

80 Certificate signed by the Rector, Church Wardens and Overseers of Martock, Somerset, for Thomas Perrin's spinning-wheel, 1762. Royal Society of Arts, PR.GE/110/12/85

ning-wheel' (fig. 80). They testified to its improved efficiency, which Perrin had gone to the expense of sending his daughter to demonstrate and prove before the Society, if they thought it proper to admit her. Johanna Perrin must have impressed the committee for a letter from Perrin, dated 10 January 1762, thanked the Society for the premium of £20 for the yarn and £10 4s for the spinning-wheel 'and my daughter Johanna joins with me for the 5 guineas the Society was so good to present her with'.[65]

On 29 November 1774, a silver medal was given as bounty to Mr De La Motte for his endeavours to further the purpose of the Society 'by instructing children in the art of making black silk lace', as testified by the minister, church wardens and bailiffs of the parish of St Leonard, Bridgenorth in Shropshire, on 16 December 1773 as well as by Thomas Littleton on 18 January 1774, who stated that De La Motte had taught 150 girls over the previous two years. Possibly the most unusual testimonial was given by Dr Minkman of King Street, Covent Garden, on 25 November 1770 on behalf of Jacob Levy and Michael Goldsmid of Poor Jury Lane, Aldgate, regarding their 'vermichelly and mackerony brought to perfection equal in goodness what is imported from Italy' and at half the price. The matter was referred to the Chemistry Committee who decided that although the making of vermicelli in England might be of public utility, the profits were so considerable to the manufacturers that it was unnecessary for them to receive a bounty.[66]

When applicants applied on their own, without the benefit of an introduction, they could appear as diffident as John Pitt with his model machines. Rather more upstanding was 'E' from Gravesend, writing on 27 October 1766, regarding his method of avoiding accidents in carriages caused by horses taking fright: 'I wish Sir I cou'd make a handsome apology for giving you this trouble but as I am one of a plain education & plain manners, I want the address proper for doing these things with a good grace, which only the polite & learned can do pleasingly, so you wil be so kind as to take the will for the deed.'[67] Most poignant are those who accompanied their inventions with hard-luck stories, such as John Giles, a silversmith until the trade had turned in the late war, who was left with four guineas and a sickly wife and who volunteered an invention on 10 April 1754 to make any metal, even lead, 'as fine a colour and lustre as standard silver'.[68] Or John Eldridge, a tanner, who first wrote to the Society in 1764 in a clear but uneducated script regarding his recipe for tanning leather without bark, using quicklime and oak sawdust instead.[69] The correspondence continued until 1768 with Eldridge all the while getting weaker and his writing more illegible: 'th[e ?]eson I want to gat sawdust for the tanners I am aficked with a uncommon pain in my head seance I had the small pox and in sted of being beter grow wors and weeken my eis but best when going about and not able to do but littel work' (fig. 81).[70]

Such cases serve as reminders of the buffeting of the labour force in the eighteenth-century city, largely unprotected from abrupt swings of the trade cycle and from illness and disease spreading in the dirty, unhealthy environment. In 1760, Daniel Pineau, a Southwark house-, sign- and floor-cloth painter, wrote in his finest calligraphic hand enclosing some patterns for wall hangings executed 'without paper or canvas on walls

Sir th[...]eson I writ to get Sawdust for the Tanners I am afiskted with a uncommon pain in my head, sean I had the small pox and in Stead of being beter grow wors and weeken my eis but best when going about and not able to do but littel work

or wainscoting which cannot harbour buggs as the paper &c. does, & being painted in oil-colours will keep their colour much longer & are not liable to the accidents that paper often meets with; as damp walls which causes the paper to fall down &c' (fig. 82).[71] 'BJ' wrote on 30 June 1767 from the bar of Bakers Coffee House, Exchange Alley, to inform the Society, 'I have contriv'd a simple easy method to make bedsteads, so that no bugs will ever atempt to come into the bed or hangings, tho the place be ever so much infested, & if they do are sure to die in the atempt, & at so very small an expence as is not worth mentioning.'[72]

The indefatigability of applicants in conjuring up products from ever more novel materials is impressive. There were musical instruments made of leather and artificial flowers made of tin.[73] Elizabeth Dodswell, a breeches-maker, wrote from Rotherfield, Sussex, on 6 February 1765: 'Worthy Genttelmen I (who am a girl about nineteen of poor parentage and smal learning) have by my own study brought to perfection an intire new language known to no man and I dare presume; that it can no more be read or understood than Lattin, French or Greek can. but I will undertake to learn any youth that can read an write the English tounge to read an write an speak this within the space of a year.' To embark on such an undertaking she needed assistance to improve her invention and meanwhile enclosed a sample of the Lord's Prayer: 'Eaf Ruepof bpicp use ik Pouaok pummabos wo epy . . .' (fig. 83).[74] Another letter 'on the demonstrating of the immortality of the Soul' was, perhaps inevitably, 'laid asside'.[75]

Not surprisingly, the Society came in for its fair share of mockery. Perhaps the most savage satire came in a pamphlet produced in 1761 by 'the Inspector', the pseudonym of Sir John Hill, a physician, actor and indefatigable scribbler.[76] Adopting the pose of a member blackballed from election, he nevertheless proposed making tanned human skin 'stripped from the bodies of different ages, conditions and sexes' available for different uses:

> The hides of brewery porters, sailors and common soldiers will make stout jack-boots and strong harnesses. The hides of the middling kind of people are fit for light summer boots, thin pumps, leather breaches and riding gloves. But the finest gloves and mittins are to be cut from the delicate skins of the fair sex, beaus and infants: such gloves will be softer and more supple than those made of kid; because the skins from whence they are to be made, are less exposed to the inclemencies of the air.

193

> Gentlemen May 14 1760
>
> I make bold to send Thos, with some Patterns which I presume will be of Service to the Publick, to Immitate Hangings. Painted in Oil-colours without Paper or Canvas on Walls or Wainscoting which cannot harbour Buggs as the Paper & does, being Painted in Oil-colours will keep their Colour much longer & are not liable to the Accidents that Paper often meets with; as damp Walls which cause the Paper to fall down &c. The floor is Painted at a Shilling pr Yard & the Un-flock at 9 Pence which considering the length of Time that Work of this kind will last makes it much cheaper than Paper & will easily clean & will look as well as when New. Likewise a Floor-cloth Painted from Wilton Carpet which it truly represents at 3s.6 pr Yard; Which as either of these two things have been brought so much to Perfection as myself, gives me Encouragement to Hope that they will meet Your Approbation
>
> I am Gentlemen Your Mo
> Humble Serva
> Daniel Pineau
>
> House, Sign, & Floor-cloth Painter near the Bridge in the Borough Southwark

> Rotherfield February 6 1765
>
> Worthy Gentlemen I (who am a girl, about nineteen of poor parentage and small Learning) have by my own study brought to perfection an intire new Languige known to no man. and I dare presume; that it can no more be read or understood than Lattin, French or Greek can. but I will under take to learn any youth that can read an write the English tounge to read an write an speak this within the space of a year but as I am oblig'd to follow my calling day ly I am unable to make any improvement thereof unless afford you Gentlemen. I thought it not impoper to send you a short pharagraph of this work for which purpose I have chosen the Lords Prayer as follows
>
> Eaf Ruepof bpiep ufe ik Pouaok prummibos wo cpy hrulo cpy nikifel belo cpy bimm wo feko ik oufep uu ic To ik Pouaok giao uu cpu fuy eaf faymy wfous uks vef giao uu eaf cfoulnidod uu bo refgiao cpol cpuc cfoulnidd uqwikdc uu uks mous uu hee ihco colcwiek wue fomiaor uu rfel oaim. vef cpik u cpo nikifel cpo hibof uk cpo 2mefy vef oaof uks oaof Ulok
>
> if you think this a matter worth your consideration you may find me by directing To Elizabeth Dadswell breches maker at Rotherfield in Sufex

82 (left) Daniel Pineau's application to the Society of Arts, 14 May 1760. Royal Society of Arts, PR.GE/110/9/6

83 (right) Elizabeth Dodswell's 'new Language', 6 February 1765. Royal Society of Arts, PR.GE/110/17/41

Hill conceded that the greatest difficulty would be overcoming prejudice so he suggested that the first to be tanned should be French troopers and when the practice had been introduced to whole regiments, the fashion would take off. Anticipating Jeremy Bentham, he even proposed that well tanned hides of great personages should be hung in public places where, like Roman statues, they would be conducive to virtue. If the Society did not accept his own hide to hang in its Great Room, then he wanted it to be used to bind two sets of his works for presentation to the British Museum and the Bodleian in Oxford. Equally edgy was his suggestion that, given the rage for Italian music, the Society should offer premiums to encourage English youths to become castrati.[77]

There were alarming devices, such as Mr Davies's invention to 'secure the pockets of passengers from the depradations of thieves' which seemed to consist of fish-hooks attached to springs hidden in potential victims' pockets but which were, in the opinion of the Committee of Mechanics, 'not a proper object of a premium from this Society'.[78] As potentially dangerous was the contraption invented by Count Berchtold, Knight of the Military Order of St Stephen of Tuscany, 'to preserve children from being overlaid or smothered by nurses, or others, where heavy soporiferous malt liquors are abundantly drunk'.[79] There were inventions for which, perhaps, the times were not ripe. A model of a 'self moving machine' turned out to be 'a skate to be fixed to the foot having three brass castors fixed to it by which the wearer is supposed to be able to move on a plain floor with great ease and velocity'. Sadly, it was resolved that this roller-skate or skate-board did 'not seem to the Committee to merit further attention'.[80]

194

Yet some mechanics who approached the Society on a speculative basis were successful. A five-guinea bounty (as opposed to the premium awarded in a designated category) was given in 1775 by the Committee of Mechanics for the improved method devised by John Sullivan, a chip hat-maker of Crown Court, Grub Street in London, for weaving window blinds, 'which will be of the greatest utillity in the Kingdom in general as they are made in immitation of the India blinds, and can be brought to more perfection, as I can make them for to fitt any common window and at much cheaper price than any window blinds yet invented'.[81] The same Committee awarded a bounty to John Mackenzie of James Street, near the Haymarket, London, for a machine on which he had been working for three years to regulate umbrellas, which 'will cast a shade to any degree at pleasure by turning the regulator and may be made to answer any open carriage by screwing the pleat on the back'.[82]

Established craftsmen approached the Society with confidence and could be active members. The watch-maker Thomas Grignion joined in 1755 and was soon proposing that a premium be given to an apprentice in the watch trade 'for the best plain watch movement' finished by hand. A clutch of London's finest clock-makers, including John Harrison and John Ellicott, begged to differ, pointing out that the process of finishing watch wheels by hand had been superseded by machine which was more accurate and cost less, so the proposal was rejected.[83] Grignion appeared to bear the Society no grudge, for in 1759 he presented it with a handsome timepiece (still in the Society's possession), 'as a means of acquainting Our worthy President, Vice President and Members of our laudable Society . . . of my utmost esteem and regard'. With becoming modesty, he drew the Society's attention to two small improvements, 'as the inventions in our art have been nearly exhausted by the many ingenious men who have practised it before me, as Tompion Quare Graham etc.' Firstly, he had increased the number of wheels without increasing the vibrations and, secondly, reduced the dead-beat escapement 'to an universal and easy theory for swing-wheels of all dimensions and which may enable workmen – though unskilled in the mathematicks, to execute this most difficult part of the machine with all possible advantage, only with a rule and compass'. Grignion also revealed, 'from a regard for truth', that the additional wheels had been suggested to him by His Grace the Duke of Argyll, 'to whose knowledge in this art I have many obligations.'[84]

Other members were not so self-effacing. As already noted, in 1764 Christopher Pinchbeck was awarded a gold medal for the self-acting pneumatic brake he had invented to prevent accidents in walking-wheel cranes. Ten years later, Pinchbeck presented the Society with a model plough for mending roads and, four years later, a pair of his patent candle-snuffers, 'having frequently with concern been a witness to the many disagreeable interruptions to yourselves and the Secretary, from the dirty and offensive circumstances attending the snuffing the candles immediately before you, with the common snuffers'. Pinchbeck became a butt for jokes on account of the latter invention. William Mason produced an 'Ode to Mr Pinchbeck upon his newly invented candle snuffers by Malcolm MacGregor' which went through at least five editions in 1777: 'Thy Candle's Radiance ne'er shall fade,/With now and then a little Aid,/From Pinchbeck's Patent-snuffers.'

The Society was a place where the polite and mechanical classes could meet, where the reserve of the gentleman, traditionally removed from practical ends, could break down. None the less, Baker was alert to the need to cater for the polite who did not wish to be associated with vulgar profit, mindful perhaps as an F.R.S. of the fastidious attitude exhibited by that august body. On 24 March 1756, he read a paper in which it was proposed to award medals as honorary premiums for those desirous of esteem rather than gain:

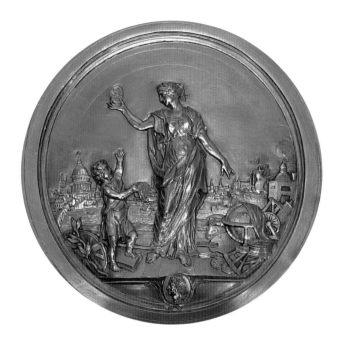
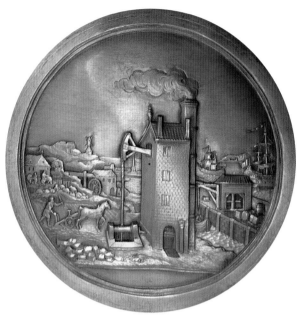

Undoubtedly your premiums in money are, in general, the best encouragement to the mechanic, the manufacturer and the planter, and to all the multitude in whom the desire of gain prevails; but may we not suppose that some honorary token of esteem would more effectually bring to your assistance the scholar, the philosopher, and the gentleman of estate? By many others too it would perhaps be preferred to money.[85]

His proposal was approved and the production of a medal commissioned from George Michael Moser.[86] The design was based in part on the ideas of the jeweller and porcelain manufacturer, Nicholas Crisp. On one side he envisaged the figure of Minerva, as mistress of the arts, receiving a boy on the banks of the Thames, with St Paul's and a ship in the background, as well as a water- and windmill; on the reverse, he proposed a central palm tree with figures representing freedom and property. Moser developed the design in his model, the stage in which the composition was finalised, thereby avoiding changes to the engraved steel die – the next stage in the process – which was costly and labour intensive. He moved the water- and windmills to the reverse and included them in a view which artfully encompassed the Society's range of activities: agriculture represented by ploughing and sheep-shearing, commerce by ships in port and a crane loading bales into a boat, while manufactures provided the central talismanic emblem of a large Newcomen engine. This conspicuous sign of progress and invention was possibly a reference to the engine used at York Buildings water works, near the Society's premises off the Strand, or perhaps it held a personal meaning: Moser's father was a Swiss coppersmith who might have been involved in the construction of such machines.[87] Even the obverse was embellished: Moser introduced a pile of navigational aids in the foreground beside the figure of Minerva, a furnace on the bank of the Thames and below the scene, a portrait profile of Newton, thereby associating the new institution with the Royal Society and its most illustrious President.

Moser's design was ordered to be chased on two gold plates, as well as in wax, at a cost of £31 18s (fig. 84). Unfortunately, the die-maker Richard Yeo discovered that the final medal would require greater relief than envisaged and thus almost twice as much gold (costing fifteen guineas) as had been budgeted for, so a chaste neo-classical design

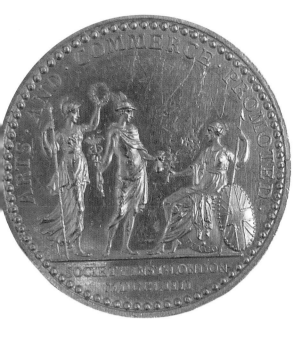

85 Thomas Pingo after a design by James 'Athenian' Stuart, Society of Arts prize medal, 1758, obverse and reverse. Royal Society of Arts

by James 'Athenian' Stuart was substituted, lacking the telling iconographic references to industry (fig. 85). The medal showed the seated figure of Britannia being honoured by Mercury, representing commerce, and Minerva, the arts. On the reverse, the recipient's name encircled a laurel wreath which enclosed the name of the category for which the medal had been awarded and the date. By 1758, gold and silver medals had been engraved and manufactured to Stuart's design by the Pingo family of engravers and medallists, thus enabling the contributions of 'the scholar, philosopher and gentleman of estate' to the Society's improving agenda to be marked in an appropriately elegant form.[88]

This move did not create a rigid division along class lines. Some well-heeled craftsmen (like Pinchbeck) opted for medals while some genteel inventors such as Thomas Gainsborough's elder brother Humphrey, a dissenting minister of Henley-on-Thames on an annual stipend of £60, went for cash. He first wrote to the Society on 5 April 1759 regarding his scheme for the improvement of timepieces: his invention of a machine with two pendulums, so constructed that if one was affected adversely, the other was less so, which he thought would be useful at sea.[89] His tide mill won a premium of £50 in 1761 and he received £35 of the £50 prize money for an improved drill-plough (or seed-drill) in 1766, after trials were held using four such examples in Brompton, then on the outskirts of London.[90] Invention seems to have run in the Gainsborough family, another brother, John, being so renowned for his mechanical ingenuity that he was known in their home town Sudbury, Suffolk, as 'Scheming Jack'.[91] Perhaps it helps to explain why their more famous younger brother, Thomas, readily agreed to take over the commission for the posthumous portrait of Lord Folkestone, over which Nathaniel Dance had dallied for two years. On 11 December 1775, Gainsborough wrote to the Society promising to 'take particular care to execute it in my best manner and to get it done by the beginning of October next'.[92]

Humphrey Gainsborough's near neighbour and friend in the country, the Anglo-Irish gentleman amateur Richard Lovell Edgeworth, sent a steady stream of inventions to the Society. A four-wheel carriage, designed in collaboration with Dr Erasmus Darwin, won a silver medal in 1767 and was followed by a reciprocating windmill, a fire-engine (for both of which he received twenty-guinea premiums), a robotic wooden horse, a carriage

with sails, an umbrella for covering haystacks, a turnip-cutter, a semaphore telegraph system and many other ingenious devices.[93] Darwin himself wrote to the Society in 1769 regarding a model of a horizontal windmill of his invention, with a vertical axis and sails rotating on a horizontal plane, but would not go to the expense of sending it up to London from Lichfield, unless there was a chance of being granted a premium to assist him in executing the larger version. He also begged that his name not be mentioned, 'as I do not court this kind of reputation, as I believe it might injure me'.[94] It is not entirely clear why Darwin felt coy about being overtly associated with mechanical invention but it seems probable that he feared that if word leaked out that he was seeking financial support from a Society which offered cash as well as honorary premiums it might jeopardise his reputation as a gentleman, physician and f.r.s.

Where Mechanical met Polite Arts

Dossie had called patterns and designs drawn for ornaments as being of a 'mixt nature' in that they combined the polite art of drawing with manufactures. Equally mixed was an idiosyncratic range of other trades – taking paste or glass casts of intaglios and cameos, making cat-gut strings for musical instruments and producing a variety of decorative and imitative finishes – because they allied the mechanical and polite arts. This overlap was also apparent in the Society's early years when professional artists such as Hogarth sat on committees to consider improvements to British paper manufacture, a category later allocated to the specialist Committee of Manufactures. Equally, applications for bounties and premiums relating to different artists' materials were considered by the Committee of Polite Arts, although they were classified by Dossie as 'chemical arts'.[95]

The paper trade demonstrates this interplay in action. Paper-making had been encouraged in Ireland from 1740 through the premiums offered by the Dublin Society, so that by 1760 the country was almost self-sufficient in paper manufacture, with sixty paper mills in operation.[96] Britain's inferior quality of paper and consequent imports from France were first raised as issues in a letter from Anthony Highmore, read on 3 September 1755, which was followed by a paper read to the Society on 28 January 1756 giving 'Hints for the Improvement of the Paper Manufacture, in regard for printing Fine Prints'. It was duly referred to a committee which included Hogarth and was also delivered to the painter for his private perusal. In comparing the advantages of French paper over English, the writer (presumably Highmore) pointed out that with English rags cut by engines, the fibres were too short so more size was required to bind them and the paper consequently hardened. Furthermore, knots in the rags were drawn through the engine and, since they projected, they rubbed the ink and made a blot. In contrast, French rags were beaten with hammers so the fibres were long and fine and held together with less size, so that the paper retained its elasticity. Any knots were then crushed by hammers and the knotless paper left the print clear. The advantages of perfecting paper manufacture in England extended to the fine arts: it would save money spent on the import of foreign prints, provide employment and make prints cheaper, so that they might be exported and earn money, 'especially as the arts of engraving are daily improving, and will be more so, provided the consumption be larger, which will consequently result from exportation'.[97] On 4 February, Hogarth and his fellow committee members were asked to draw up an advertisement for a premium to be given for the encouragement of fine paper manufacture. Improvements came slowly: a Thomas Cooke of Tottenham was awarded £25 in 1763 and again in 1764 but the first prize was not awarded until 1787, the recipient of a gold medal being John Bates of Wickham Marsh, near

86 Samples of silk rags bleached with varying success, 1759. Royal Society of Arts, PR.GE/110/8/78

High Wycombe.[98] Experiments in different types of paper-making continued until the turn of the century, demonstrating an expansion of product range beyond utility to cover the fancy or novelty trade. Benjamin Moore of Newgate Street, London, wrote on 27 December 1763 proposing to send a sample of embossed paper, 'an art, I presume, until now unknown in this kingdom'.[99] The same year £50 was awarded to Messrs Portbury & Smith for their samples of marbled paper; twenty-five years later, a silver medal was awarded to John Davis of Salisbury Court, Fleet Street, for his samples of the same product, 'superior in elegance of pattern and variety of colours to those commonly made'.[100]

A shortage of rags to make paper was a live issue throughout Europe in the second half of the century as the publishing trade grew. The quality of paper produced from silk rags was excellent, judging from the response premiums offered in 1758, but it proved impossible to bleach them to standard shades (fig. 86). From 1765 to 1772, the Regensburg naturalist Jacob Christian Schäffer published an influential series of treatises describing his experiments in paper manufacture using different raw vegetable matter. As a corresponding member of the Society of Arts, he sent in a specimen of paper made from various vegetables and was duly awarded a silver medal.[101] In 1772, the leading English paper-maker of the day, James Whatman, was asked by the Society to comment on a sample of paper made from wild cotton. He was sceptical as it was contaminated and discoloured from soil. Instead, he emphasised the importance of recycling rags, condemning the waste that went hand in hand with conspicuous consumption.[102] Thomas Greaves from Mill Bank near Warrington corresponded with the Society in 1787 over specimens of paper made from the bark of withy (willow) twigs, enclosing speckled rusty red samples. He was awarded a silver medal for his trouble and the following year received a ten-guinea award for his paper made from raw vegetables.[103]

There was constant experimentation in the production of substitute materials, which imitated traditional techniques and especially foreign luxury products, but were made at less expense. Robert Chambers's exercises in stained marble designed to resemble *pietra dura* fed the fashion for Grand Tour bibelots. A letter from Nathaniel Wallis, a joiner of Grays Buildings, Oxford Road, near Portman Square in London, dated 17 February 1774, suggests the spread of such techniques well beyond the higher orders of craftsmen: 'I beg leave to lay before you, for your inspections, two drawings of chimney pieces. One is repsending a landscrap of painting, or staind into the marble, the boundery ornaments of said landscrap, is carving in releif laid on the said groud. – the other for statiry marble.'[104]

Any number of recipes for pigments and paint-application techniques were submitted. As Sarah Lowengard's research has demonstrated, in eighteenth-century Britain, France and Germany there was a common desire to better the quality of colours, by making them more workable and durable and which, when applied to a huge variety of material objects, would render them more pleasing to the eye and the hand.[105] On

7 May 1760, Johann Heinrich Müntz, resident at Mrs Hem's, Castle Street, Oxford Market, submitted two experimental 'landskaps' as demonstrations of the revived technique of encaustic (hot wax) painting and fixing crayons, based on his treatise lately published.[106] Eighteen years later, on 12 January 1778, Robert Beesley made it known to the Society 'that by labour & practice he has found out a method of painting upon any sort of plaistered walls, subjects in landscaps, fruit, flowers and many other subjects in still life that will last a number of years, and as cheap or cheaper than paper, and by an ingredient used in the colour will destroy all buggs, that so often breed in walls and paper, as well as trouble to whole famialys in this kingdom'. After five days, he waited in vain at the Society's house to hear its verdict; by 25 March, still not having received an answer, he was driven to write in exasperation: 'I hope it may not be the outside show of a rich or poor mans coat that makes him meritorious.' On 19 November 1778 he was still wondering what the delay was, having thought he had satisfied the Society months earlier.[107] Finally on 5 March 1779, the Committee of Polite Arts voted him ten guineas, 'for his frequent attendance & producing 2 pieces of painting on wet plaister walls & executing the Committee's order at Mr Masefields'. However, Beesley pushed his luck too far some years later. On 29 April 1795 the Committee of Polite Arts took into consideration his letter 'in which he describes his method to be, by forming balls of paper or parchment into various shapes, these being dipt in paint, he dabbs them on the walls, and thus obtains a variety of shapes which he says represents rocks, birds &c.' These paint effects were considered by the Committee of Manufactures who resolved, on 16 December, that the method did not deserve any further attention.

Even highly skilled craftsmen-manufacturers could sometimes misread the scope of the Society's intentions. On 29 March 1759 the Birmingham toyman Stephen Bedford, who specialised in papier-mâché products, wrote to enquire what material should be used for the varnished coach panel premium he had seen advertised in the paper, for 'of late I have made many setts of pannells for coaches and chariots of copper so thought the newest fashion would be more acceptable but now I shall vastly excell that because I have severall setts makeing in paper which will be exact the same as Martins in Paris'. The Society minutes of 4 April record that it was ordered 'That a letter be wrote to Mr Bedford to acqaint him that the pannel to be produced to the Society must be wood.' Nevertheless, in 1763 Bedford won a premium for his French-style varnish, *Vernis Martin*.[108]

Responding to the Society's advertised premium for making carpets in imitation of Turkey carpets, on 21 March 1757 Thomas Witty of Axminster announced:

> I have herewith sent a carpet of my own manufacture made intirely of English materials, and by work people of my own instructing. I could have made a carpett much finer and consequently more beautifull, but the Society proposing to encourage making a sort which be more generally usefull and sell in materials and fineness of work as near as I can to that sort, but in order to shew there may be great improvements made by a little addition in price I have varied the colours & patterns.[109]

Unfortunately, Witty had to share the premium with Thomas Moore of Chiswell Street in the City for, while Witty's sample was deemed the nearest in staple, Moore's was the finest in pattern and colour.[110] Yet Witty did not lose out: he presented three carpets to the Society in 1758 and was awarded another premium in 1759; his carpet business celebrated its 250th anniversary in 2005.

In an age which prized French, Italian and Battersea enamels, as employed for all manner of *objets de vertu*, it is not surprising that considerable effort should have been expended on improving the art of their production, particularly the manufacture of good

vitreous colours for glazing or painting. On 10 January 1761, Isaac Narbell of Shad Thames 'inclosed three pieces of my enamell after the Venitian manner made intirely with ingredients of the produce of this kingdom . . . it has been tried by some of the best masters enamellers in London & greatly approv'd'.[111] On 8 December 1784, thanks were given by the Committee of Polite Arts to Mr Birch of 27 James Street, Covent Garden, 'who produced several paintings in enamel and two proofs of a new colour invented by him', which appeared likely to answer 'very good purposes in enamel-painting'. The 'greater silver pallet' – introduced in 1766 as a reward in the field of polite arts – was duly voted to him and the proofs of his new colour reserved for the inspection of the curious.[112]

The associated technique of glass-painting was frequently claimed to have been redis-covered, although in fact it had never been lost. William Peckitt, who became the country's leading producer of painted and stained glass, wrote from York on 4 February 1760, offering to show his work to the Society:

> through the help of Divine Goodness by great expence study & experiments for the space of above nine years [I] have fundamentally found out improved and brought to perfection in all its parts the art of painting and staining in glass scripture history, coats of arms, and other designs of the like kind, as much as could reasonably be expected to any one in that space of time and being yet not thirty years of age.

The unusually pious tone in which his application is couched is perhaps typical of a man who later published a religious tract on the origins and workings of the world, based on his understanding of the nature of light and colour gleaned from workshop practice. Nevertheless, it appears not to have impressed the Society, or his mention of the fact that he had served several noblemen and gentlemen who had been so good as to approve of his performances. He went on to patent his 'new method of composing stained glass' in 1780 (no. 1268) but his manuscript treatise on the principles of paint-ing and staining glass, initially conceived perhaps in 1760 but dated 1793, remained unpublished.[113]

On 17 September 1763 Kent-based Thomas Reeve submitted a method of preserving paintings in watercolours which involved covering them with melted white wax. 'Upon doing pictures this way I found out an additional method of making them transparent which when placed in a window has the appearance of painted glass, by which several persons have been deceived, of which I will send you some specimens.'[114] In 1781 a greater silver palette was awarded to William and Thomas Reeves for their invention of the moist watercolour cake and in February 1784, Thomas submitted some samples of an ink which he claimed was equal if not superior to Indian ink. These were sent out by the Committee of Polite Arts to a number of artists, including Paul Sandby and Thomas Malton, for their opinion. Sandby reported back favourably on 7 March, even going to the lengths of calling on Reeves to satisfy himself that the ink was indeed of his own manufacture. Malton was less impressed, considering, 'it dissolves too easily & does not sufficiently stain into the paper, but after it is dried on, will very soon wash off again with only using a soft hair brush & water, which is impossible to be done with good Indian ink'. Furthermore, it had a major disadvantage: it ran when used with colours, dirtying the tints. Meanwhile, Thomas's brother William had claimed an equal right to the invention. As a result, the Society decided to postpone consideration of Thomas's ink until a sample of William's was received and had been sent out to artists. Robert Adam wrote in with a firm endorsement, preferring its blueish cast to the brownish tinge of China ink, though conceding it should be a little less oily.[115]

In 1764 Thomas Keyse received a premium of thirty guineas for a method of fixing crayons and in 1773 twenty guineas were voted to Mr Charles Pache for applying

himself to crayon manufacture. A native of Switzerland, Pache stated he was the only apprentice and late partner of Mr [Bernard] Stoupan, a crayon-maker of Lausanne. He had been strongly advised by his friends two years earlier to come to London to set up a manufactory of crayons for painting, in which by his improvements, 'He flatters himself he has succeeded so well as to make them superior to any other whatever.' Nevertheless, he found himself so little known and had disposed of so small a quantity that he was a great loser in his undertaking. Obliged to return to his native country, he was persuaded by friends to offer first a box of his crayons to the Society '& by their assistance make him better known, and enable him to continue in this country, which is his greatest desire'. He came well armed with testimonials: from the Royal Academician Francesco Bartolozzi and the foremost continental portrait painter in pastel, Pache's fellow Swiss, Jean-Etienne Liotard. The leading English practitioner of the art, John Russell, was equally enthusiastic in his endorsement, deeming Pache's crayons 'better than any I ever saw; I believe every teint may be used without danger of changing'.[116]

The greater silver palette and twenty guineas were voted in 1794 to William Reeves's son-in-law, George Blackman, for his method of making oil-colour cakes. He had first got in touch with the Society on 19 March 1793, appeared before the Committee of Polite Arts on 17 April but by 22 May had still not heard from them. By January 1794 both Richard Cosway and Thomas Stothard had reported favourably on the new materials, the latter pointing out their advantage to the traveller 'as they are always fit for immediate use their not drying hard nor skinning over as in water and oil.' On 12 February 1794, a bounty for Blackman's oil cakes was finally agreed, on condition that he should make an actual experiment of the whole process before the Committee of Polite Arts to their full satisfaction on 5 March: 'it having been asserted that despite silver pallet and 20 guineas, would not work after kept for some time and became fully dry'. The Secretary called on Stothard again whose trial of three colours did not cause him to revise his first opinion. These delays worried Blackman, for a week later a friend wrote at Blackman's request to express his fears that his experiment, now public, would be copied by Reeves and other colourmen, 'in consiquence whereof unless he makes every vigorous exertion and that immediately to promote the sale of them in his own trade he is in danger of loosing all those advantages which he must hope will be the reward of imence trouble expence and experiment for upwards of two years'.[117]

Three primed cloths for the use of painters submitted on 14 December 1787 by a Mr Parker divided the artists to whom they were sent. On 11 January 1788, it was reported to the Committee of Polite Arts that Cosway, Stubbs and Copley thought that they would be useful if they did not crack. Benjamin West considered they were more flexible and tough than the common kind and therefore might answer some good. But Romney and Abbott believed that they were not superior to the canvases they then used. Reynolds had no opinion, presumably because it was his common practice to paint directly on an unprepared raw canvas.[118] Other advances in painting technique were rewarded. In 1796, the greater silver medal was given to Robert Salmon of Woburn for two pictures 'transferred by him from pannels to canvas and one transferred in the same manner from a plaster wall and the manner performing described'.[119] In 1798, Richard Westall and Thomas Daniell commented on the merit of Timothy Sheldrake's 'manner of painting in oil believed by him to be similar to that practised in the Venetian School', for which a greater silver palette was voted.[120] The award is perhaps surprising in view of the scam perpetrated by Mary Anne Provis on the President of the Royal Academy, Benjamin West, and other Academicians in 1796. She convinced them that she had rediscovered the secret of Venetian painting from a manuscript acquired by her grandfather in Italy, a secret that would be divulged to sixty initiates at ten guineas a time. Many fell for the ruse – includ-

ing Stothard and Westall – but when the results were unveiled at the 1797 Academy exhibition, they were poorly received and the experiment was not repeated.[121]

Over the years, the Society attracted a variety of aids to draughtsmanship. As already noted, in 1763 Edgeworth brought to the attention of the Society a portable camera obscura which, as it easily fitted in a man's pocket, was intended for foreign travel.[122] On 10 February 1768, Robert Waddington of Downing Street, Westminster, sent in a specification of an instrument constructed for the drawing of perspective views accurately and readily, based on a plane table of the best construction.[123] More than thirty years later Edward Mussenden started to plague the Society from Fleet Prison with a similar construction, a variant on the perspective device known as Alberti's veil.[124] 'During my imprisonment I have applied myself with great attention and diligence to the study of mechanicks', he wrote in July 1794, announcing that he had invented 'an instrument to copy paintings and drawings with the most minute exactness, by an invariable perspective rule'. On 12 November he received a response which 'to my no small surprise informed me that the invention I proposed had been known at least five hundred years'. Even when released from prison Mussenden continued to claim the originality of his device, asserting that no doubt it frequently happened 'in the course of ingenious experiments that two persons may hit upon the same idea'.[125]

How Polite were Polite Arts?

From its earliest years the Society's promoters maintained that it encouraged improvements in every branch of the polite arts. Defining the polite arts as 'those which depend on design and taste; and are called by others the FINE ARTS', Dossie had observed by 1768 the amazing success of those premiums 'on the youth whose genius was turned to studies of this nature: and the incitement of emulation, arising thence, produced the most assiduous and spirited exertion of their talents'.[126] He was exaggerating, of course. Yet, as Shipley had intended, great store was placed by the Society on improving the polite arts. His personal agenda as a drawing master (his school shared premises with the Society) happily accorded with the interests both of metropolitan artists who were keen to belong to some society and of those polite members who, supposedly from loftier, more disinterested motives, wished to improve the higher arts.

Within the Society the mechanical arts served the polite arts through encouraging innovation in techniques and materials. The efforts of the polite arts to improve the mechanical arts through the application of taste were more problematic, with the ends of the polite arts alone coming to dominate the agenda, shorn of their useful application. During the first fifteen years of the Society's existence there was a constant tension between the pragmatic ends of art, tied in with trade and manufactures, and high art as a means of bestowing taste on the nation at large, creating some confusion in the minds of the public and even its members as to the Society's core purpose. This tension is visible in the third volume of Dossie's *Memoirs*, published in 1782, when he returned to the subject of the polite arts. He affirmed it had been the general resolution of the Society to raise them out of that languor into which they had sunk through well concerted measures 'to render the degree of success that might be obtained immediately applicable to commercial objects'. The country was far behind others 'as to elegance in patterns for manufactures, fabrics, ornaments of dress and furniture' and exports suffered from the opinion that British products were devoid of taste and beauty. These defects had called for a remedy in the form of drawings premiums but initially it was not clear how these should be framed. They 'produced a number of claims, in which invention was discovered, but not what is called taste, or that display of judgement

resulting from a well regulated imagination'. In the end, he said, the Society persevered with both ends, offering premiums for drawings of human figures, birds, beasts, fruit 'all connected with designs of ornaments for the trades, and equally leading to the higher department of which drawing is the basis'.[127]

This 'all-purpose' approach to art training was typical of the age. The drawing school founded by the Dublin Society in 1746 offered to train youths in drawing as the basis for painting, sculpture and other allied practices, notably ornament for manufactures.[128] Robert Foulis intended that the School of Art he founded in Glasgow in 1753 should cover not only the arts of painting, sculpture and print-making but also serve the needs of the Army and Navy, as well as industry and manufactures.[129] Nevertheless, among the many advocates of training in draughtsmanship, there were different shades of emphasis. The manual of careers advice for metropolitan parents, Richard Campbell's *The London Tradesman* (1747), adopted a pragmatic stance, citing the example of the French king who had erected academies to teach drawing *gratis* in all the great cities of his dominions. He clearly shared the reservations expressed by Pepys with regard to the danger of artisans getting above themselves:

> By being learned to draw, I would not be understood, that it is necessary for every tradesmen to be a painter or connoisseur in designing; no, but I think it absolutely necessary, that every tradesman should have so much knowledge of that art as to draw the profile of most common things; especially to be able to delineate on paper a plan of every piece of work he intends to execute.[130]

In contrast, John Gwynn's *Essay on Design* (1749) proposed a national academy 'for educating the British youth in drawing', along the lines of the Paris Académie Royale des Beaux-Arts, established by Colbert in 1664, which had conferred honour and distinction on the liberal arts: 'We are apt enough to imitate the French in their fopperies and excesses: let an emulation of them in what is noble and praise-worthy at least keep pace with our pursuit of their fashions.'[131] Nevertheless, he acknowledged, 'there is scarce any mechanic, let his employment be ever so simple, who may not receive advantage from the knowledge of proportion, and more still from a little taste in design'.[132] Drawing, Gwynn concluded, was the 'animating soul' of all other skills, as practised in the supremely inventive art of the painter, sculptor or architect and by the whole body of mechanics employed in fashioning or ornamenting the various utensils of life.

The plan for an academy of painting and sculpture which the sculptor Henry Cheere brought before the Society of Arts on 19 February 1755 tactfully encompassed both levels of artistic activity, albeit organised on a scale of value:

> From architecture and all its ornaments external and internal, from painting and sculpture, graving and chasing, planting and gardening and all the various performances, in which art and genius, elegance of fancy, and accuracy of workmanship are confessedly united, it will descend to the subordinate branches of design: in utensils of all sorts, plate and cabinet work, patterns of silks, jewelling, garniture, carriage building and equipage and down even to toys and trinkets, it will expect to find the same manifestations of propriety and elegancy and will reject whatsoever is apparently irreconcilable with the true standards of use and beauty.

This academy would make due allowance for students who could not aspire to the highest arts:

> That as several of the inferior parts of drawing are of great use to the manufactures of this kingdom, and many of the students whose capacities or genius may not lead them to the perfect study of the human figure: it will be necessary that some of the

above mentioned professors be well skilled in ornaments – fruits, flowers, birds, beasts &c as that they may not only be enabled to judge but if necessary to instruct the students therein.[133]

Although these proposals were not taken up, nevertheless, during the 1750s and 60s the Society of Arts did fulfil on an informal basis many of the functions of an art academy, with the increasing emphasis on a high art agenda, no doubt encouraged by the growing artist membership over the first five years of its existence. Cheere was the first artist to be elected and he in turn nominated William Hogarth, who was duly elected on 31 December 1755. Other leading artists joined the Society, precipitated by self-interest. Negotiations which had been dragging on since 1749 with the Society of Dilettanti over the formation of an exhibiting academy had broken down by 1755 because the Dilettanti, made up entirely of gentlemen of taste, wished to maintain control over the artists.[134]

The Society's manuscript minute books and Dr Templeman's manuscript record of its early transactions track the rapid growth in the number of premiums offered and the serpentine path woven between practical ends and high art ideals, following the vagaries of contemporary notions of design instruction.[135] After the successful experience of the first-year drawings premiums offered simply for the best drawings in two age categories (under fourteen and between the ages of fourteen and seventeen) it was decided that for the second year, 1755, premiums were to be offered in three categories (to be submitted before January 1756): first, for the best drawings by boys and girls under fourteen as proof of their abilities; second, for the 'best fancied and most useful designs proper for weavers, embroiderers or calico printers, drawn by boys and girls under seventeen and of their own invention'; and third, for the best 'military drawings, plans, or designs of fortifications, harbours, or fortified places, made by persons under the age of twenty years'. But on 12 March 1755 doubts were raised about the wording of the last category and a member was dispatched 'to consult proper persons, and get their opinions against the next meeting'. Two weeks later it was reported back that in the opinion of a Colonel Napier, 'as the young people at Woolwich Academy are encouraged in such matters by the hopes of preferment, such premiums may be better bestowed for some other subject' and the category was dropped.

As first proposed on 21 January 1756, premiums offered for the third year, 1756–7, were to fall into the same categories but they were by no means uncontested. At the same meeting 'several young ladies and girls' petitioned the Society for separate awards, as they felt intimidated by the boys: out of the ten premiums awarded in the first year, only two had gone to girls and in the second year only two out of fifteen. A committee of the membership decided that the petition had some merit, so for 1756–7 the sexes were divided, with separate categories for girls under fourteen and under seventeen 'for the most ingenious and best fancied designs composed of flowers, fruit, foliage or birds, proper for weavers, embroiderers or callico weavers'. The girls were still not satisfied: there were now no exclusively female categories for the best drawings, as there were for boys. They presented a further petition on 2 February 1757 but nothing seems to have come of it, presumably on account of the encouragement a 'best drawing' category for girls might have given them to pursue careers as professionals in the higher arts. The study of antique statues, even live models, deemed essential in high art training, and to which boys gifted in draughtsmanship might aspire, breached female codes of decorum. A woman's accomplishment in the sphere of drawing was seen to extend to decoration and imitation (drawing after prints) but rarely to creation. The second half of the century saw an increasing stress in female education on the domestic realm, removed from worldly accomplishments.[136]

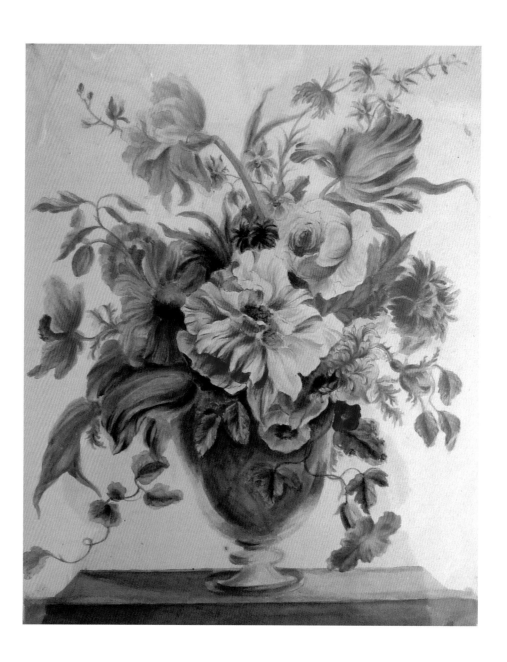

87 Mary Moser, prize-winning flower piece, 1759. Royal Society of Arts, PR.AR/103/14/31

Nevertheless, on rare occasions girls' efforts were singled out by the Society for particular approbation. In 1759 Miss Mary Moser received not only the first premium for her flower piece but a silver medal 'as a further reward for her extraordinary merit'. Her drawing was to be handsomely framed and glazed (fig. 87). Mary Moser (1744–1819) was the only surviving child of George Michael Moser, the immigrant Swiss engraver, chaser, medallist and drawing master.[137] Although her talents were exceptional, she was typical of the young women artists who applied for the Society's premiums in that they tended to be the daughters or sisters of professional artists: Mary Strange, the daughter of the engraver Robert Strange; Ann Pars, the sister of the portrait and landscape artist William Pars; Sophia Burnet and Mary Vivares, who both came from families of engravers.[138]

The girls were not the only ones to question the way in which the polite arts were developing in the Society. On 28 January 1756, Hogarth presented a paper which he had drawn up containing 'some hints relating to the premiums for drawings for the future'. Although the paper he delivered to the Society has never been found and may never have existed in any formal sense, on his own admission it was not far removed

206

from manuscript notes towards an 'Apology for Painters', which have survived.[139] From a comparison between the sentiments he expressed in retrospect and the actions of the Society in 1757 it is possible to surmise the reasons for Hogarth's resignation the same year.

Firstly, he thought it a waste of time to entice young people with premiums into entering the fine arts, a field which was already crowded with practitioners who found it difficult to make a living.[140] He outlined an alternative career trajectory which paralleled that of the 'Industrious 'Prentice' in his *Industry & Idleness* print series of 1747. What was the point of foregoing the pleasures of youth, he asked, 'in a laborious study for empty fame when his next door neighbour perhaps a brewer or porter or haberdasher of small wears shall accumulate a large fortune become Lord Mayor, member of Parliament and at length get a title for his heirs'.[141] Secondly, Hogarth stood up for the country's commercial values and even for its taste: 'it is proof rather of the good sense of this country that the encouragement has rather been to trade and mechanics than to the arts'. English manufactures were as good as if not better than those of the French but prejudice would not allow it.[142] The reason the country did not produce such goods was not for want of ability 'as some coxcombs would have it' but because as a trading nation we could buy 'curiosities' ready-made from abroad.[143]

Although more obliquely expressed, the third problem Hogarth appears to have had with the ethos of the Society probably loomed largest. He deplored the tendency of 'this great society' as he (perhaps sarcastically) described it, to pander to 'people of leisure' who joined because they were tired of public amusements and found themselves in good company and 'amused with the formal speeches of those who still had more pleasure in showing their talents for oratory'.[144] In particular, Hogarth was passionately opposed to the perceived superiority of the upper classes in matters of taste. Those who went to France or Italy for their studies were the worse for going, 'talking of the antiques in a kind of cant in half or whole Italian to the great surprise of the standers by and bring over wonderful copies of bad originals adored for their names only'.[145] This was an obvious swipe at the Society of Dilettanti but it was also directed at the Society of Arts where it seemed that the opinions of gentlemen of taste were increasingly holding sway, as reflected in a growing bias towards high art premiums. One or other or all of these differences of viewpoint precipitated Hogarth's resignation.

The fourth-year premiums for boys included those for drawings after prints and plaster casts, for the best models in wax, clay or any other composition and for medals. A further refinement might have been the straw that broke Hogarth's back: 'As an honourable encouragement to young gentlemen or ladies of fortune or distinction, not exceeding sixteen years of age, who entertain or amuse themselves with drawing, the Society propose to give a silver medal for the best performance in drawing of any kind; and also a silver medal for the second best.' This provision for 'honorary drawings', as they were called, paralleled the award of honorary medals by the other committees. The young amateurs who practised art as a polite recreation would be happy, it was thought, to expect approbation but not payment. In contrast to the stringent requirements placed on apprentices and young uninstructed persons to draw under invigilation at the Society, 'Such young gentlemen and ladies are not expected to draw at the Society's office, unless agreeable to themselves, but are expected to give sufficient proof, that the drawings produced are their own performance without the least assistance or correction by any other hand, to be produced and determined as above.'[146] No doubt the Society was cannily attempting to retain the support of polite society through flattering their offspring, as drawing was already firmly on the curriculum for genteel youth and needed no further encouragement. Robert Dodsley's standard educational manual *The Preceptor* (1748 and many succeeding editions) thoroughly approved of the accomplishment as being not

merely ornamental but entertaining and improving even for those who did not intend to make the art of design their employment.[147]

Hogarth's antipathy to 'young people of fortune' who assumed the virtues of taste after the minimum of study was well documented in his 'Apology' and by the end of 1757 he had resigned from the Society, his name vigorously struck through in the membership book. In contrast, looking back from the vantage point of 1782, Dossie presented the standard deferential view of rank. The rapid progess made in the superior departments of the arts could be ascribed, he believed, not only to premiums but also to the gold and silver medals offered to 'young nobility, gentlemen and ladies of distinction':

> It did so fortunately happen, that the claims sent in by those noble persons, surpassed even sanguine expectation: their productions were works of taste and elegance: the example raised a flow of emulation: the young artists saw how much it was their interest to exert themselves, and vied with contendants so much their superiors in rank, as well as merit; to whom, as judges and protectors of the arts, they might some day look up for favour and patronage.[148]

Lady Louisa Augusta Greville, the sister of the Earl of Warwick, won the first silver medal in 1758 for a view of the priory of Warwick.[149] In 1759, Lady Louisa was again the subject of Society commendation, a gold medal being awarded for her drawing of the ruins of Nettley Abbey, taken from nature. Medals were awarded to young gentlemen and ladies, the children or grandchildren of peers or peeresses, for their 'honorary drawings' until well into the 1780s and the rigidity of this division between amateur and professional is illustrated by an incident which took place in 1782. The silver medal for an honorary drawing was adjudged to Mr Thomas Stewart of No. 1 Union Street, Bond Street, but when it was discovered that he was a student at the Royal Academy and intended to be a professional in some branch of the polite arts, his entitlement to a silver medal was revoked and the Society presented him with a lesser silver palette instead.[150]

By the end of 1757 the premiums had taken an even more pronounced bias in favour of academic art education. Taste as defined by the Grand Tour was encouraged through premiums for drawings after the plaster casts of antique and old master sculpture, largely made by Joseph Wilton and the architect Matthew Brettingham in Rome and displayed in the Duke of Richmond's new gallery designed by William Chambers in his palatial Whitehall residence.[151] Furthermore, from 28 February 1758, Wilton and Cipriani, who had been appointed keepers of the Duke's collection, offered tuition every Saturday to vetted boys over the age of twelve.[152] The same year, premiums were also awarded for drawings in chalk after living models at the academy of artists in St Martin's Lane. By 1759, premiums for history and landscape painting had been introduced for fully fledged professional artists. The establishment by 1760 of separate standing committees confirmed the growth in Society business but also, perhaps, an increasing desire to draw a line of demarcation between polite and mechanical arts.

These developments were one way of ensuring the continued interest of the polite membership and, for a time, of professional artists who were keen to establish an academy. As Shipley commented in retrospect, 'Had we not patronised these very entertaining and extensive subjects [the Polite Arts] . . . this Society had not now existed.'[153] Nevertheless, there was some grumbling. In August 1759, one member, the Irish linen merchant and amateur naturalist John Ellis, complained to a friend that 'Our Society has of late become a mere society of drawing, painting and sculpture, and attends to little else, as you may observe by a list of the premiums for this years which I shall send to you.'[154]

Certainly, during the period of Shipley's active association with the Society, polite arts premiums were by far the largest in number and value of those paid out.[155] The first

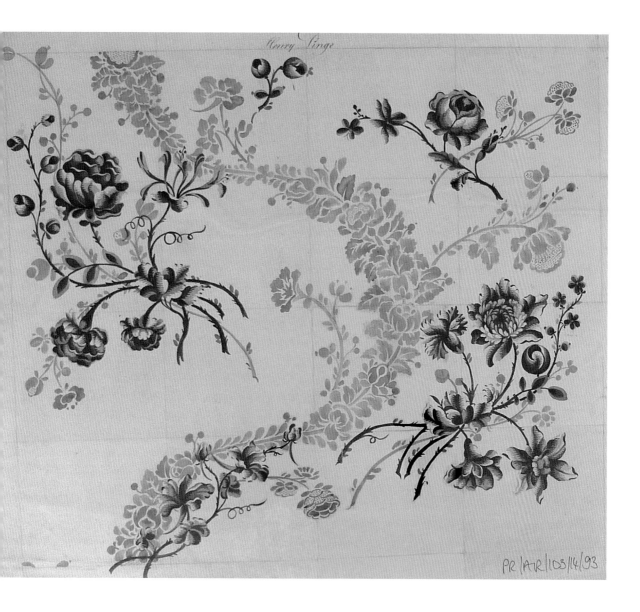

Henry Pinge

PR/AR/103/14/93

prize-winner of £5 in the under fourteen-year-old category, announced in January 1755, was Richard Cosway, who was twelve at the time. Shipley took young Cosway under his wing and the boy was awarded a premium on four other occasions, an achievement which exploited to the full the expanding range of awards.[156] He became a fashionable painter, working mainly in miniature, and hardly representative of the height of achievement of the British school in this period.[157] Nevertheless, especially in the years before the foundation of the Royal Academy in 1768, the Society offered step-by-step incentives to follow an art education of sorts and the polite-arts premium winners were by no means undistinguished.

In effect, Shipley's school groomed young artists for the Society's premiums. John Smart and William Pars, both of whom became portrait artists, Pars later turning to landscape watercolours, alternated with Cosway in winning prizes. Thomas Banks, Joseph Nollekens and John Bacon more or less swept the board in the modelling classes, while the children of the engraver Thomas Pingo – Henry, Lewis, Mary – carried off a series of premiums for designs for brocaded silks (fig. 88). Lurking in the Society's register of premiums are others who later achieved considerable fame: John Russell, Michael Angelo Rooker, Francis Wheatley and William Hodges. Early winners of the valuable

209

89 James Gandon, drawing of applied ornament, 1757. Royal Society of Arts, PR.AR/14/122

prizes for history painting included Robert Edge Pine, John Hamilton Mortimer and George Romney, while Anthony Devis, George Barret and Thomas Jones all won landscape premiums. Richard Earlom and William Sharpe later became leading engravers. In 1766, James Tassie was awarded the premium for gem engraving and, in 1775, Thomas Bewick was joint winner of that for wood engraving.[158] At best, the Society's prizes served for aspiring young artists as a crucial boost, encouraging them to pursue their future careers; at the very least, Hogarth's worst predictions do not appear to have been confirmed.

It is more difficult to determine the effect of the Society's premiums for ornamental drawings after birds, beasts, flowers and foliage fit for 'weavers, calico printers or any art of machinery' and the 'best drawing fit for cabinet-makers, coach makers, manufacturers of iron, brass, china or earthen ware, or for any other mechanic trade'.[159] Many such prize-winners, while competent practitioners in their field, remained obscure. There are cases like that of Ozias Humphry, who was destined to be a lace-pattern designer but who, having received training under Shipley and won a premium, became a successful miniature and portrait painter.[160] John Bacon was originally apprenticed to the porcelain manufacturer and Society founding member, Nicholas Crisp, but was encouraged by his premiums to turn to sculpture. Other premium winners, like the watch-makers Thomas Grignion junior and Benjamin Vulliamy or the goldsmith William Wakelin, stuck to the family business. Several of the girls may well have helped in family firms, at least until they were married. Elias Durnford, who was skilled at geometry, perspective and flower-drawing, became an engineer, as did James Jones. None the less, scores of young hopefuls who applied for premiums are lost from public view.

Only a small selection of premium drawings survive in the Society's archives for the period before 1800 and their quality is not outstanding. Some are half-finished and were probably executed in the Society's rooms as proof of competence. The watercolours are tinted drawings in the style of the period, the flower drawings of Mary Moser being the most promising. There are drawings of Rococo ornaments for candelabra, mirrors and carvings by both girls and boys, copied after engravings (fig. 89). A recent analysis of the designs for woven silks suggests that aesthetic considerations took priority over feasibility of manufacture, although a master weaver and two mercers sat on the committee judging the entries. No effort was made in Shipley's school to train young people for specific branches of the mechanical arts and no premiums were awarded for designs on point paper, ready for transfer to the loom.[161]

Correspondence confirms, nevertheless, the extent to which the Society in the mid-eighteenth century was associated with the encouragement of drawing by the young, albeit for purposes ill-defined. A Thomas Martin junior of Calder Bridge wrote to the Society on 2 February 1760:

> I am a young man in the county of Cumberland that has a great inclynation to drawing and espesily by copper-plates such as birds beasts plants and flowers &c but for want of time and money I never got any instruction relating to this art of drawing. My father a linen weaver by trade and sels all his goods to London and I am one of

the same craft and work for him. Therefor I have very little time to spend in this curious art of drawing . . . in reading the [Universal] Magazine for June 1759 I found a great number of premiums proposed by the Society for the Incouragement of Arts. Therefore I hope it will not be taken amiss in sending this my specimen of the painted finch, nutmeg plant butterfly and the man of the woods which I desire you take care to get to the Society before the third Thursday in February 1760. And you'll greatly oblige me your Humbel Servt.'

Somewhat anxiously, the boy added in a postscript, 'I desire you would send me a letter and let me know whether these things have got safe to hand or no and hope approve of pray excuse a vulgar way of inviting I being brought up in the countery and young under the age of 18.' A page of coloured drawings accompanied the letter, still in the Society's safekeeping (fig. 90).[162] With the greater insouciance of superior status, Mr Edmund Saunders of Tavistock wrote on 22 March 1761 enclosing a tight little drawing after a Bowles print of Naples, executed by his thirteen-year-old son. 'As I am no judge of things of this kind nor of the rules of the worthy Society for which you are Secretary', Saunders *père* did not know 'whether such trifles are thought worthy their attention but was inform'd that for the encouragement of youth they had among many other premiums offer'd one for the best drawing of any kind by boys under 14'. His letter was read at the Society but he got a dusty response.[163]

On 28 February 1759 the Committee of Premiums decided that a large premium of a hundred guineas should be given for the best original piece of history painting containing no fewer than three human figures, as big as life, and fifty guineas for the second best. The subject would be picked by the Society and six titles were given, three relating to national history and three to the classics.[164] But the Society as a whole disagreed with the

choice of subjects and confined them to English history (expanded to encompass British history in 1762 and Irish history in 1763).[165] At the same time, the premium for the best original landscape painting, executed to a specified size, was confirmed. A further condition for each category was 'That proof be made to the satisfaction of the Society that the whole of each picture, either in history or landscape painting, has been painted in England', but there was no age limit. The results in both categories would be exhibited, a decision facilitated by the availability of the impressive Great Room converted to William Chambers's design at the Society's Denmark Court premises, off the Strand, the construction of which could well have contributed to the decision to award the painting premiums.

Chambers was elected a member of the Society on 16 January 1757, proposed by the engraver Charles Grignion. Having returned from studies in France and Italy, he doubtless saw the well-connected new Society as a useful base for networking and promotion. He drew up ambitious plans for a much larger building centred on an Egyptian Hall intended for use as a gallery 'for candidates attending the Society' and a colonnaded oval meeting room, flanked by committee rooms and offices. Beyond these, on either side of two internal courtyards, lay two hundred-foot-long galleries, one for paintings and drawings and the other for 'machines and mechanical performances'. The exterior of the building would have had colonnades and arcaded loggias in advanced neo-classical taste but nothing came of his plans.[166]

Martin Myrone's survey of the premiums offered by the Society for historical art from 1760 to the end of the century tracks their somewhat erratic course.[167] In the first year, artists submitted a range of no fewer than twenty-eight subjects drawn from English history. Robert Edge Pine won the first premium of a hundred guineas; the second was disputed between George Romney and John Hamilton Mortimer and eventually awarded to the latter. In 1766–7 the premium was suspended, resumed in 1768–72 and then in 1773 suspended for five years before being resumed for one final year in 1779 when the subject again was stipulated.[168] No premium was awarded in 1780 or thereafter. Other premiums for historically inspired art were not extended beyond 1770: bas-reliefs in clay (1760–70); historical bas-reliefs in Portland or Purbeck stone (1761–6); historical bas-reliefs in marble (1762 and 1764–8); historical paintings in chiaroscuro (1763–6). Only historical drawings premiums lasted the course from 1764 to 1799. The fall-off in interest can be attributed mainly to the foundation of the Royal Academy but as nearly all the prizes for drawing in relation to manufactures had also ceased by the late 1770s, no doubt part of the reason for the decline was lack of funds.

Nevertheless, until well into the 1760s suggestions for additional polite arts premiums flowed without cease. A letter signed 'Britannicus', dated 27 February 1759, proposed premiums for engraved and mezzotint portraits, as well as for landscape and history engravings. Another, signed 'a Lover of Arts' and dated 6 March 1759, suggested a premium for chasing a historical piece. On 7 March 1759, premiums for figures and groups in bronze and engravings in wood were also referred to the Committee of Premiums. On 30 May 1759, Joseph Taylor attended the Society and wished to be informed of the subject selected for engravings in intaglio after a naked figure. His inquiry was referred to the Committee along with consideration of medallions, for which the first premiums were offered on 16 January 1760 for a design of Liberty and her attributes on the face and the Barons obtaining Magna Carta at Runnymede on the reverse. The pronounced democratic bias of the subject matter was doubtless due to the republic sympathies of Thomas Hollis, f.r.s. and f.s.a., who served as chairman of the Committee of Polite Arts from 1760 to 1762.[169] By April 1760, the Committee was considering premiums for bas-reliefs carved in Portland stone and marble, as well as statues in marble and architectural drawings. On 16 April it was reported that the Committee wished to award premiums for the best original statue of a naked figure as large as life and for bas-

reliefs wrought in white marble; for the best cameo engraved on an onyx representing the Meleager in the Duke of Richmond's Gallery; and for a drawing of an original perspective view of Bramante's Temple after the plan and elevation given by Palladio, to all of which the Society acceded, except for the Bramante–Palladio option.

The materials employed and the subjects selected for premiums continued to subdivide. By 1764, there were fifty separate awards for different types of drawing and another fifty for different types of modelling and engraving. On 8 April 1765 there was even a proposal to establish an annual Rome scholarship (lasting four years) for a young person under the age of twenty-one who had obtained from the Society one or more premiums that indicated a 'genius for historical painting', preference being given to those who showed the greatest merit in drawing 'a human figure or figures from a statue, cast, group, model or basso relievo'. Again, the London Society was seeking to follow the example of the Dublin Society which awarded travel bursaries to young artists. The motion was agreed by the Committee of Polite Arts on 20 May 1765 but when it came before the Society on 2 April the following year, objections were raised, the decision was postponed and nothing more was heard of it.

According to Dossie, the practice of holding exhibitions of premium winners, more than any other, kept the minds of young artists intent on study for the space of a year and made them strive to excel in preparing a 'new performance from which some additional honour and reputation was to be derived'.[170] The opportunity to present the prize-winning entries in enhanced surroundings came with the completion of Chambers's Great Room. In March 1759, the history and portrait painter Robert Edge Pine proposed hiring it to exhibit works from professional painters and sculptors, a proposal supported at a meeting of artists held on 12 November at the Turk's Head coffee-house, also in the Strand. The shilling entrance fee, which it was proposed would form the basis of a provident fund for artists, was modified after discussions with the Society to a sixpence catalogue cover charge, which, it was hoped, would exclude riff-raff, foot soldiers, livery servants, porters and women with children. On 22 February 1760 the request for the Great Room from Francis Hayman, chairman of the committee formed by the artists, was approved.

The 1760 landmark exhibition, consisting of 130 works by 69 artists, drew 20,000 visitors in the two weeks of its duration. *A Catalogue of the Pictures, Sculptures, Models, Drawings, Prints, &c of the Present Artists. Exhibited in the Great Room of the Society for the Encouragement of Arts, Manufactures, and Commerce, on the 21st of April, 1760* included portraits, landscapes and history pieces but also works representative of the Society's wider remit. Philip Mercier contributed 'A Sketch of the Distribution of the Premiums at the Society for the Encouragement of Arts, Manufactures, and Commerce', Miss Moser 'A Piece of Flowers in Water Colours' and Charles Catton two ornamental coach patterns. Richard Cosway showed a portrait of his mentor, William Shipley. There were sculptures, models and engravings, besides designs for bridges, monuments, medals and seals.

Such a broad miscellany was not to everyone's taste. The problem was that the Society's premium history paintings got most of the publicity – Pine's *The Surrender of Calais* and Casali's *The Story of Gunhilda* – and were scattered among the other exhibits, leading many to believe from the labels that they were judged the best pictures overall. It was irritating to artists of the stature of Joshua Reynolds and Richard Wilson who, not unnaturally, wished to make alternative arrangements 'lest any man should a second time suffer the disgrace of having lost that which he never sought'. In future, the professional artists also wanted to restrict visitors to single admission by catalogue (hoi polloi had shared catalogues to crowd into the first exhibition). Their request was turned down by the Society which effectively put an end to its collaboration with Pine and Hayman's group. The majority of artists severed their connection with the Society, exhibiting the

following year at the Great Room in Spring Gardens as the newly established Society of Artists of Great Britain. In 1765 they were awarded a Royal Charter and became known as the Incorporated Society of Artists, leading after further acrimonious splits to the foundation in 1768 of the Royal Academy of Arts.[171]

Some artists remained loyal to the Society of Arts, taking the name in 1763 of the Free Society of Artists, but their exhibitions lacked the cachet of the breakaway group. Their 1761 exhibition is typical in that it included a number of flower and fruit pieces possibly intended as designs for manufactures, as well as drawings, engravings, sculpture, furniture, needlework and stained marble figures. The 1762 exhibition encompassed designs for ornament and botanical studies, seals, needlework and shell-work. It was the Free Society's mixed shows as much as those staged by the Society of Artists, not to mention the rivalry between them, that were mocked in Bonnell Thornton's 'grand exhibition' of a fictional 'Society of Sign Painters', open to the public between 22 April and 8 June 1762, for a shilling entry fee. Thornton was a hack journalist and wit, a friend of Hogarth and leader of the Nonsense Club which championed demotic forms of British culture against the pretensions of connoisseurs. London's large, elaborate street-signs were often painted by skilled artists and as such had served as a popular art gallery long before the advent of public exhibitions. They were thus recognised, with varying degrees of approbation, as a 'truly English' art form. By their very nature as business or trade signs connected with commerce, they marked another junction where fine and mechanical arts met. Yet in the early 1760s they were under threat, less from the closeting of polite art in special exhibitions than from local government legislation which ordered their removal on the grounds of street orderliness and safety. Therefore Thornton's exhibition, possibly staged with Hogarth's help, can be interpreted on many levels: part cynical money-raiser, part satirical attack on high art cosmopolitanism and part parody of mixed art shows; equally, perhaps, it was a truly patriotic and nostalgic review of an art form that was about to disappear.[172]

In 1762 a proposal was made by the Committee of Polite Arts to form a permanent repository or gallery, in the belief that it 'would especially contribute to the advancement of the arts of painting and drawing in various branches of the polite arts and in its consequences improve in many articles the ornamental manufactures of these kingdoms'; but nothing came of it. Instead, the Free Society exhibitions continued to provide a showcase for art skills and novelties: in 1764, engraving on silver in bas-relief by Mr Barraud of Tottenham Court Road,[173] three coach panels submitted by Stephen Bedford of Birmingham, one of papier mâché ('being the first ever made in England'),[174] newly invented gilt paper presented by Mr Moore of Newgate Street, London, and Mr Dermot's Bow shaking figures, in imitation of the Chinese. Unlike the Royal Academy exhibitions which soon banned cut-paper and shell-work or 'any such baubles', the Free Society attempted to attract young artists and more overtly entertaining confections, such as portraits woven in hair.[175]

Even though the Society of Arts stopped holding exhibitions in 1764 and curtailed its association with the Free Society after further quarrels,[176] it retained a broad understanding as to what constituted polite arts, attracting fancy work and novelties frequently submitted by women whose endeavours hovered uneasily between genteel pursuits and attempts to earn an honest crust. The examples of needlework 'of religious and allegorical design, landskips and a flower piece' submitted by Miss Mary Hare in February 1772 were accompanied by a letter humbly begging that Committee of Polite Art members 'will make generous allowances for the defects their better judgement may enable them to discover, and kindly impute it to the want of years, and experience in the person who at an early age, without ever receiving the least instruction in drawing should from her own single genius, and with no other pattern or directions . . . meet with some fav-

ourable encouragement'. She was awarded a bounty of five guineas for her 'industry and application'.[177]

Following an audience at Windsor and an exhibition at Wyatt's Pantheon in 1785, the celebrated Miss Mary Linwood was awarded a silver medal for three specimens of needlework, submitted to the Society on 11 March 1786, 'with worsted in a singularly beautiful manner, the subjects a hare after nature, a piece of still life – and a head of King Lear after Sir Joshua Reynolds . . . as an example of useful and elegant employ-ment'.[178] Other hopefuls sent in flowers made from straw and even from artichokes. In the case of busts made of tow-covered leather, the Committee 'resolved it was new and ingenious, and as it is a more exact representation of flesh than either wax or plaster, it is probable it may hereafter be well applied to the making of lay figures for the use of painters and sculptors, and for forming likenesses in the manner of model-ling in wax, it being in the opinion of the Committee superior to that material'. Miss Knight, the inventor, was awarded a silver medal, leaving a specimen of work with the Society.[179]

Besides encouraging genteel accomplishments, the Society continued fitfully to support drawing for manufactures. On 23 November 1768 premiums in designs for orna-mental furniture were agreed and by 1775 there were premiums for drawings of machines. Yet, between 1765 and 1774, twenty-three artists resigned, including Devis, Cosway, Basire and Vivares, while only ten were elected and they were of minor status. There was also a decline in the number and value of premiums. The 1778 Register of Premi-ums confirmed that since the foundation of the Royal Academy, the premiums had been confined 'chiefly to the encouragement of young beginners, who may intend to be future professors; and to others in a higher sphere of life, who may hereafter become the patrons or patronesses of the finer arts'. Dossie conceded in 1782 that the new institution of the Royal Academy gave 'an additional support to the superior and scientific parts, namely, to painting, sculpture, and architecture'. Nevertheless, he maintained that the united endeavours of the Royal Academy and Society of Arts had produced 'a complete and permanent establishment to the arts': 'The more eminent parts directed, rewarded, and openly commended by the Royal Academy, appear to belong to that body; while the branches regarding fabrics and manufactures, original objects of the plan devised for promoting trade and commerce, remained to be shaped, fostered, and encouraged by the Society.' He even went so far as to attribute the Society's loss of engagement with high art to the perfection it had attained: 'in the process of time, the prizes were so ably contended for, and so liberally adjudged, that no further incitement seemed requisite, than that patronage from the public, which the young artists then became entitled to, from the open commendations and rewards of the Society'.[180]

As early as the third paragraph of his first Discourse, delivered on 2 January 1769, the first President of the Royal Academy, Sir Joshua Reynolds, made explicit the funda-mental difference in philosophy between the Society of Arts and the new Academy. Observing somewhat caustically that 'elegance and refinement' were the 'last effect of opulence and power', he nailed his colours to the mast of high art: 'An Institution like this has often been recommended upon considerations merely mercantile; and an academy, founded upon such principles, can never effect even its own narrow purposes. If it has an origin no higher, no taste can ever be formed in manufactures; but if the higher arts of design flourish, these inferior ends will be answered at once.'[181]

Reynolds's restatement of the supremacy of academic values was consciously pitched to exclude the grubby activities of commerce based on raw experience from which he believed – contrary to Bacon – that general ideas could not be abstracted. While the Society of Arts had viewed art principally as a utilitarian vehicle for patriotic endeav-our and commercial profit, Reynolds saw such ends as elevating particular interest –

even those of a particular nation, Britain – over universal values; they were therefore corrupting influences on art. Painting was a liberal profession, not a mechanical trade. In his first discourse Reynolds opposed 'mechanical felicity' in drawing as narrow, servile imitation, which he considered a 'species of fallacious mastery'. He even called it 'unscientifick'. The drawing appropriate to a liberal art was dependent on general (scientific) principles of truth and beauty, abstracting the intellectual from the sensual. His distinction between the liberal and the mechanical was represented in the Discourses by an opposition between the mind and the hand, between principle and mere practice.[182]

It was a goal to which many artists aspired but, inevitably, the exigencies of the market and bitter truths of earning a living made it a less than realistic goal in practice, even for Reynolds himself. Nevertheless, gradually Reynolds's smooth cosmopolitan certainties, secured by the rules of international neo-classicism and a royal seal of approval, triumphed over the national, commercial 'mixt' art which had been vigorously endorsed by the Society of Arts and its membership. The commercial classes who had a vested interest in extending the polite realm to cover as many mechanical activities as possible came to be marginalised. Taste was reserved not only for patrons and connoisseurs but also for an oligarchy of professional artists of reputation and distinction who sought to elevate themselves above the vibrant world of trades, manufactures and the mechanical arts.

Diffusion Abroad

The Society of Arts put out feelers to established learned societies on the continent and endeavoured to obtain their publications. On 5 August 1761 – in the middle of the Seven Years War – the Secretary, Dr Templeman, reported that the Society's order from abroad of *Recueil des Machines [et Inventions] approvées par l'Académie Royale des Sciences* and *Theatrum Machinarum*, had arrived.[183] Five years later, the Society's Registrar, William Bailey, informed the Society that Count de Shulenburgh

> had left with him some specimens of scarce and valuable grass seeds, corn, plants, & fossils &c which he had collected from all parts of Germany, Russia, &c &c and which he desired the Society to accept. His Excellency had also a very large collection of manuscripts, drawings and models of machines used in mines, agriculture, manufacturers &c, models or copies of which His Excellency generously offered the Society. He also lent four folio books illustrated with copper plates entitled *Descriptions des Arts et Métiers*, published at Paris.[184]

These were the long-gestated volumes on the arts and trades published from 1761 by the French Académie Royale des Sciences and therefore of particular relevance to the Society of Arts, whose reputation had clearly spread abroad. In 1765 Edward Bridgen claimed that other nations had tried to copy the Society but either from the nature of their government or through 'want of a proper spirit' they were obliged to limit themselves to only a part of its activities. Nevertheless, foreigners of all ranks had thought it an honour to be admitted corresponding members, 'from some of whom this society has been benefited by their communications; particularly by the society of Rennes in Brittany, and Bern in Switzerland, and by other learned societies in France'.[185]

By the end of the first decade of the Society's existence there were 120 foreign corresponding members elected by ballot, of whom 10 were living in Ireland, 7 in Scotland, no fewer than 46 in North America and another 8 in the West Indies, 11 in Italy, 10 in the German lands, 7 in France and another 7 in Denmark. The following decade saw

almost no diminution in support except in North America, which can be explained by the growing unpopularity of British rule. That was compensated for by a growth in European members, particularly from France with whom relations were more cordial than in the previous decade. In the third decade came a general decline, apart from in Ireland which was experiencing a surge in the spirit of improvement, accompanying partial independence.[186]

The Society of Arts' international network scarcely differed from that of the Royal Society, linked by common threads of curiosity and investigation. Templeman became a corresponding member of the Académie Royale des Sciences in 1762, duly conducting correspondence on matters such as grasses, winter vegetables and the planting of woods. In June 1764, the celebrated botanist and agronomist Henri-Louis Duhamel du Monceau presented his work *L'Exploitation des Bois* to the Society as a particular mark of his esteem, together with another treatise on the clothier's art from the *Descriptions*, of which he was chief editor.[187] Thanks were returned and seeds of the best kind of fir, which he requested, were procured and sent to him. In August, Duhamel reported that he was still working on the *Descriptions*, some volumes of which he proposed to present to the Society for comment by members on their omissions and faults. He concluded his letter by expressing the sentiment that scholars of all nations should unite to further the peaceful coexistence of nations and the diffusion of knowledge to the people.[188]

This spirit of enlightened collaboration for the public good continued throughout the 1760s in correspondence with Duhamel and through his gifts of books on grain conservation, madder and fruit cultivation, using as intermediaries his nephew Auguste-Denis Fougeroux de Bondaroy and the astronomer Jérôme-Lefrançois de Lalande, who was in England for three months in 1763. In return, the Society supplied Duhamel with more fir and pine seeds.[189] The rapport between the Society's agricultural agenda and the French belief in agriculture as the source of national wealth received further confirmation on 15 October 1766 when a M. du Pont of the Royal Society of Agriculture at Soissons and Orleans sent the Society a present of *Journal de l'Agriculture, du Commerce et des Finances*. Pierre Samuel du Pont de Nemours made his name in the early 1760s with his writings on the French economy, notably *Physiocracy* (1768) which, in its advocacy of low tariffs and free trade, influenced Adam Smith. Thanks were duly returned and back numbers purchased to complete the set. On 15 August 1767, du Pont wrote from the residence of Anne-Robert-Jacques Turgot, then Intendant of Limoges, to enquire whether the Society had accepted or rejected the project he had proposed through the English ambassador in February, namely the foundation of a Professorial Chair in Oeconomical Science which 'would be equally glorious for the Society, honourable and useful for England, advantageous for all Europe, and even for the whole world'. He himself would be pleased to contribute. Nothing came of the idea, not least because the Society was not attached to any university, but du Pont continued to correspond and send books to the Society until 1769.[190]

A belated manifestation of this *entente cordiale* with what had been the more progressive corners of the *ancien régime* came on 27 October 1790 with the presentation by the émigré Pahin de la Blancherie of François Ebaudy de Fresne's *Traité d'Agriculture* (1788) and the journal *Nouvelles de la Republique des Lettres et Arts*, edited by the donor. In 1779 Pahin had established a Salon de la Correspondance in Paris which rivalled the official Salon of the Académie Royale de Peinture et de Sculpture. Like the exhibitions staged by the Free Society of Artists in London, it threatened the Académie's assertion of liberal status by including alongside paintings, sculptures, prints and drawings, curiosities of nature, mechanical contrivances and items of manufacture – two-headed calves, anatomical models, patent locks, microscopes, landscapes executed in hair –

which were promoted and sold on the open market.[191] On 9 November 1791 the Society of Arts' Secretary reported that M. de la Blancherie had delivered to him a bill of landing for three cases containing the bust of Dr Franklin in terracotta, a bust of M. Peronnet (Jean-Rodolphe Perronet, the French civil engineer) in plaster and a pedestal in scagliola, which he begged the Society to accept from his collection. Freight charges of £6 12s 3d were duly paid and the fitting up and placing of the said busts referred to the Committee of Polite Arts. The works can still be seen at the Society.

In February and March 1767, J. H. Ziegler wrote from Winterthur to report on a variety of machines, including a sketch of one near Zurich for drawing up water. The same year, Thorman d'Oron, Secretary of the Society of Economy at Bern, founded in 1759, asked for news of agricultural advances and improvement of arts, 'filled with veneration towards a body of such respectable citizens, who under the most happy constitution, occupy themselves without regard to hindrances or difficultys, for the good and felicity of all nations. Your example shall be our model and we promise our selves in our limited sphere if not the same success at least the same zeal wich distinguishes you upon a larger stage.'[192] German scholars, inventors and improvers, either as individuals or more often as members of the numerous *Gesellschaften* founded in the aftermath of the Seven Years War, were no less keen to establish relations.[193] A letter from Dr Johannes Pauli of Hamburg presented the plan of a patriotic society which he had established in 1765, modelled both on the Society of Arts and the Societé Royale d'Agriculture de la Generalité de Paris, founded in 1761.[194] The Hamburg society was one of the few patriotic societies – which were mainly concerned with manufactures and commerce and of a mercantilist bent – not initiated by the state. Writing as a weak child in need of education from a wise and enlightened mother, Pauli asked the Society to send its publications and proposed a journal to which all European inventors and philanthropists would contribute. In 1767 he founded a school on the Shipley model which started with the education of sixteen young craftsmen in design for industrial purposes. The students increased in number and the curriculum was enlarged to include physics, chemistry, mechanics and other scientific subjects.[195]

As in France, German economic societies were mainly concerned with the improvement of agriculture influenced by physiocracy, although their distinction from patriotic societies was not clear-cut. In Saxony, the Economic Society of Leipzig (Leipziger Oekonomische Gesellschaft), founded in 1764, invited anyone to join with an interest in the welfare of their countrymen: farmers, peasants, artisans, craftsmen, foresters and gardeners. It established committees of manufactures, mineralogy, chemistry and mechanics. Writing from Dresden in August 1767, its secretary, David Gottlob Tescher, confirmed the agreement made with the Society of Arts to exchange publications, even offering members the facility of writing under the Leipzig Society's auspices when they wished to publish anonymously. Two years later, Tescher wrote to thank the Society of Arts for *De Re Agraria* (presumably *Museum Rusticum*), sending in return a publication on honey and a description of Saxon mining techniques, published by Saxony's newly established academy of metallurgical sciences.[196] Appropriately for a city long associated with trade and book fairs, the Leipzig Society also arranged exhibitions to coincide with its Easter and Michaelmas meetings and formed a repository of drawings, samples and models of machines and implements, including Perrin's spinning machine and Hales's ventilator for drying wheat, the latter contributed by Duhamel.[197]

Some of the Society's German contacts represented societies founded with the backing of their more enlightened rulers, such as the Academy of Useful Sciences (Akademie Gemeinütziger Wissenschaften) founded in 1754 in Erfurt under the protection of the Elector and Statthalter of Mainz. On 26 July 1766, its secretary, Sigismund Lebrecht Hadelich, the mayor of Erfurt, professor of philosophy and a corresponding member of

the Society of Arts, wrote in German (which was translated) with samples of cotton and fine stockings, manufactured out of 'our new invented country cotton wool'. This, he maintained, would grow anywhere, especially in a bog or marshy ground, and was spun into yarn by orphans. Another notable corresponding member was the agronomist Baron Jacob Ernst von Hinüber, who had helped to found the Royal Economic Society of Electoral Brunswick-Lüneburg in Celle in 1764. As the Elector, George III backed the Celle Society with generous subsidies – which the London society must have envied[198] – as well as granting it free postage and freedom from censorship. In 1765, the Margrave Karl Friedrich of Baden-Durlach founded a strongly physiocratic Society of Useful Sciences for the Advancement of the Common Good in Karlsruhe, attracting illustrious advisors from abroad, offering premiums in agriculture and chemistry and establishing schools of industry. Karl Friedrich had visited England as a fifteen year old in 1743 on a European grand tour and was a member of various economic societies, including the Society of Arts from 1767. The Karlsruhe Society's president, J. J. Reinhardt, became a corresponding member in 1769.[199]

Good reports of the Society of Arts spread to Russia via the Russian statesman and reformer Jacob Johann Sievers (1731–1808). The memorandum he addressed to Empress Catherine II in 1765, which led to the Free Economic Society of St Petersburg, concluded:

> during my stay in England I witnessed the formation of the famous Society for the Encouragement of the Arts, the Sciences and Agriculture. At the beginning, the Society distributed prizes of a dollar for sketches, pieces of embroidery or other small items from English schoolchildren. Its total capital did not amount to fifty guineas. I heard people ridicule the undertaking. Now it distributes several thousands pounds sterling and equips ships in order to send seeds and produce from Europe to America. Any moderately affluent Englishman wants to be a supporter and feels flattered to see his name printed in the list of supporters and encouragers of the Arts, the Sciences and Agriculture.[200]

In Philadelphia too, in 1766, the American Society for Promoting and Propagating Useful Knowledge was founded, superseding one established in New York two years earlier on the lines of the Society of Arts, and offering premiums.[201] Its establishment coincided with the reorganisation of the American Philosophical Society which had been dormant for two decades and the two merged in 1768 to form the American Philosophical Society for Promoting Useful Knowledge.

Diversification at Home

The completion of the Society's new home in 1774, designed by the Adam brothers as an 'elegant and established residence', would, James Adam assured his clients, 'give the Society a great appearance of permanency and éclat' (fig. 91).[202] Its Great Room, decorated with paintings by James Barry and substantially completed by 1783, was intended to promote the Society's role in advancing both the polite and mechanical arts but it seems to have had little galvanising effect.[203] In the last quarter of the eighteenth century, as the impact of the Royal Academy grew, only twenty-four fine artists were elected members. Over the same period, the polite arts premiums declined below those awarded for chemistry and agriculture and even from 1797 below those for the colonies and trade. In 1778 the offer of premiums for designs for calico printers stopped, marking the virtual abandonment of the Society's direct concern with promoting drawing for manufactures, although the objective was still proclaimed. Apart from feeling financial constraints, the Society might have taken the view that there were now

91 Adam brothers, elevation of
the Society of Arts, c.1774.
Royal Society of Arts,
AD.MA/305/14/1

other means – private drawing schools and self-help manuals – by which this end could
be achieved. The premiums for history and landscape painting came to an end in 1780,
for the Royal Academy of Arts provided sufficient encouragement in these genres. Nev-
ertheless, there was still a surprisingly impressive field for drawings prizes offered to
young beginners. In 1784 the thirteen-year-old prize-winner was Thomas Lawrence
(who wrote a neat letter from Bath to thank the Society for its bounty, given for his
picture of the Transfiguration);[204] in 1793, Joseph Mallord William Turner; in 1798,
William Westall; and in 1800, John Sell Cotman, while Robert Smirke won a prize for
architectural drawing in 1797.

Besides the Royal Academy, other specialised societies were beginning to cream off
the Society of Arts' natural constituency, notably the Society of Civil Engineers, founded
in 1771 under the presidency of Thomas Yeoman. In the early 1740s Yeoman had prac-
tised as a millwright in Northampton, running a cotton-spinning mill, making other
machines – notably Dr Hales's ventilators – lecturing on electricity and surveying the
river Nene as a preliminary to making it navigable. Returning to London in the late
1750s, he was elected a member of the Society of Arts in 1760 and a Fellow of the Royal
Society four years later. He was much more active in the former than the latter, advis-
ing the Society of Arts on in-house ventilation and buildings repairs and proposing a
wide range of new members, including the ironmasters Abraham Darby and Richard
Reynolds.[205] His co-chairmanship of the Society's Committee of Mechanics from 1763
to 1778 evidently did not hinder his acceptance of the presidency of the new Society of
Civil Engineers, presumably because he viewed their functions as being different – the
one to discuss, test and report on the entries for mechanical premiums submitted by a
wide range of entrants, from gentlemen amateurs to humble artisans, while the other
was intended to serve as a professional club for engineers.

The engineers involved in canal construction often met in the Houses of Parliament and Courts of Justice as they nursed through the legislation that enabled their projects to start. John Smeaton felt that the interests of a profession then in its infancy could be better served with friendly meetings where they could get to know one another:

> That thus, the sharp edges of their minds might be rubbed off, as it were by a closer association of ideas, no way naturally hostile; might promote the true end of the public business upon which they should happen to meet in the course of their employment; without jostling one another, with rudeness, too common in the unworthy part of the advocates of the law, whose interest might be, to push them on perhaps too far, in discussing points in context.[206]

They agreed to meet once a fortnight at 7 pm at the King's Head, Holborn, from Christmas 'or so soon as any of the county members come to town' to the end of the sitting of Parliament but, despite the payment of a shilling forfeit for absenteeism, attendance was irregular. At one point, when only two turned up – the Secretary William Jessop and the newly elected Christopher Pinchbeck in the chair – it was resolved 'by each of them, all of them and both of them', that 'circular letters be issued inviting all the reputable and ingenious mechanics that can be found in this metropolis or elsewhere to join a Society which if properly supported might become *one* of the most respectable in the Kingdom'.[207] During the first twenty years of its existence the Society elected about sixty-five members, of whom fifteen were the leading practising civil engineers of the day and the others were 'either amateurs, or ingenious workmen and artificers, connected with, and employed in, works of engineering'.[208] Judging from its sketchy minutes, it functioned principally as a social club with only one or two formal presentations on engineering theory and practice.[209] More typical were the evenings spent 'cannallically, meckanically, naturally and sociably' or in 'some agreeable and much useless conversation'.[210] The Society continued in this manner until May 1792 when its activities temporarily ceased because of a tiff between Joseph Nickalls and Smeaton and Smeaton's death in April the following year.

A rosy retrospective history of the Society written by John Rennie and others in 1812, to preface a three-volume edition of Smeaton's collected reports, associated its establishment with 'a new era in all the arts and sciences, learned and polite' which had commenced around 1769, in other words, with the founding of the Royal Academy: 'The learned societies extended their views, their labours, and their objects of research. The professors of the polite arts associated together, for the first time; and not less honourable to real merit than to the *public*, and the throne, which have, with one accord, promoted their prosperity.'[211] The authors went on to outline the wider geo-political and economic circumstances in which knowledge had been advanced: the enlargement of military and naval establishments, the extension of manufactures on a new plan 'by the enterprize, the capital, and, above all, by the science of men of deep knowledge and persevering industry engaged in them'. This had produced a new demand, for internal navigation, 'To make communications from factory to factory, and from warehouses to harbours, as well as to carry raw materials, to and from such establishments. Hence arose those wonderful works, not of pompous and useless magnificence, but of real utility, which are, at this time, carrying on to a degree of extent and magnitude, to which as yet there is no appearance of limitation.' These canals, together with harbours, improved at municipal not government expense, 'gave rise to a new profession, and order of men, called Civil-Engineers'.[212]

The authors specifically compared the situation of engineers abroad, where they formed an academy or were part of one, with that in Britain 'where the formation of *such artists* has been left to chance; and persons leaned towards the public call of employ-

ment, in this way, as their natural turn of mind took a bias. There was no public establishment, except common schools, for the rudimental knowledge necessary to all arts, naval, military, mechanical, and others.' Civil engineers were a self-created set of men 'whose profession owes its origin, not to power or influence; but, to the best of all protection, the encouragement of a great and powerful nation, – a nation become so, from the industry and steadiness of its manufacturing workmen, and their superior knowledge in practical chemistry, mechanics, natural philosophy, and other useful accomplishments'.

Such high-flown sentiments would have found favour with members of the best-known improving society founded in the eighteenth century outside London. The Lunar Society was established officially in Birmingham in 1775, although the core participants – Erasmus Darwin, Matthew Boulton and William Small – had been gathering at Darwin's Lichfield home or Boulton's at Soho for dinner, conversation and the perusal of instruments, plans, models and inventions since the mid-1760s. Again there was an overlap of membership of or involvement with the Society of Arts. Richard Lovell Edgeworth's designs for improved carriages brought him into contact with Darwin, who had been tinkering with vehicles for several years, building a phaeton and a post-chaise to his own design with greatly improved steering and springs. He had travelled, he claimed, more than ten thousand miles in each of them 'and found no inconvenience from the new manner of turning in either of them'.[213] While the Society was considering Edgeworth's invention, the two men met in Lichfield and Darwin was able to write to Boulton of his new 'mechanical friend' who impressed him with his conjuring tricks.[214] Eventually, on 8 April 1767, Edgeworth received a silver medal for 'a new contrivance in four-wheeled carriages', as noted, the first of several rewards he received from the Society.

Darwin was perhaps the linchpin of the group which brought together industrial entrepreneurs such as Boulton, Wedgwood and Darwin's long-time friend James Keir, who manufactured glass at Stourbridge and established a successful chemical works at Tipton, near Birmingham. The other Birmingham-based participants were James Watt, the gun-maker Samuel Galton junior and the physician William Small, who had taught Thomas Jefferson at the William and Mary College, Williamsburg, and was advised to settle in Birmingham by Franklin, who forwarded a letter of introduction to Boulton commending him as 'both an ingenious philosopher, and a most worthy honest man'.[215] The watch-maker and geologist John Whitehurst was based in Derby while the gentleman amateur Richard Edgeworth and his eccentric radical friend Thomas Day came from Lichfield. The natural philosopher Dr Joseph Priestley joined when he took up a living in Birmingham in 1780. Eight were already or became Fellows of the Royal Society but, with the exception of Edgeworth and Day, they were still primarily doers and makers, men of business rather than gentlemen of leisure, although with success they acquired the property associated with enhanced status. As Wedgwood remarked, 'I scarcely know without a good deal of recollection whether I am a landed gentleman, an engineer or a potter, for indeed I am all three by turns, pray heaven I may settle to something earnest at last.'[216] They moved most comfortably in the worlds of practical arts, chemical or mechanical experiment and commercial, profitable production. As Jenny Uglow writes of her panoramic survey of Lunar activities, 'This book smells of sweat and chemicals and oil, and resounds to the thud of pistons, the tick of clocks, the clinking of cash, the blasts of furnaces and the wheeze and snort of engines.'[217]

Something of the inventive playfulness of their exchange is captured in a note from Boulton in Darwin's commonplace book, dated 3 September 1771 and witnessed by Keir and Small, which promised to pay Darwin 'one thousand pound upon his deliv-

ering to me (within two years from the date hereof) an instrument called an organ that is capable of pronouncing the Lords Prayer, the Creed, & Ten Commandments in the vulgar tongue, & his ceding to me, & me only, the property of the invention with all the advantages thereunto appertaining'. The joking reference was to Darwin's half-finished mechanical speaking machine which he had built to test his theory of phonetics. It comprised a wooden head with lips and a tongue of soft leather, covering bellows attached to hollow reeds, which could pronounce individual words such as mama and papa.[218]

Men from the Lunar circle were willing to help adjudicate different Society of Arts premiums, even if they were not members. On 16 December 1765 Dr Small reported on the iron drill-plough he had seen, which won a prize together with that designed by Humphrey Gainsborough. In May 1771, a specimen of clay, brought by John Howard from the Stuttgart porcelain factory and sent on to Wedgwood, was judged by him not to differ essentially from clays already found in Britain. Wedgwood did not join the Society of Arts until 1786, although his partner Bentley, with a shrewd assessment of its networking value, attended committee meetings from 1765 and was elected a member in 1770. In 1779, John Whitehurst was invited to test the proposals of Thomas Hatton, a London clock-maker, for a universal standard of weights and measures, which so stirred Whitehurst's interest that he composed a complex mathematical treatise on the subject. In 1785, Whitehurst attended the Society to examine a new clock escapement. James Keir was willing to advise the committee of chemistry, even though his own processes – like those of Wedgwood – remained secret. In March 1786 the Society sent him samples of fossil alkali from Bombay to test, which he did but without any positive outcome.[219]

When Darwin's bid to the Society in 1769 for help to build a horizontal windmill met with no success, he offered the model somewhat half-heartedly to Wedgwood, who needed a source of power to operate a flint mill for grinding colours, although he advised him to wait until it could be powered by steam. Nothing happened for ten years but then in 1779 Darwin showed his model to Whitehurst, an expert mechanic, who proposed some improvements. Darwin also benefited from Watt's detailed technical calculations, on the basis of which Edgeworth helped Darwin to experiment on the mill over the summer. Once the design was finalised, the mill was duly installed at Etruria where it worked for thirteen years before being superseded, as Darwin had predicted, by steam. Nevertheless, the process shows the way in which the Lunar Society worked, through experiment and informal consultation among its members in an enlightened spirit of collaboration.[220]

The commonplace book kept by Darwin from 1776 to 1786 reveals the range of his mind, his fascination with machines and inventions, from the utilitarian to the whimsical, most of which never got as far as being referred to the Society of Arts.[221] Like many ingenious men, he had exhibited inventive tendencies when very young, making an alarm for his watch and conducting electrical experiments of his own devising.[222] He was full of ideas, though less securely capable of executing them, lacking practical engineering experience. Darwin might even have regarded the open demonstration of mechanical know-how as a threat to his status as a professional man, a learned physician. The volume contains many medical observations but also data on the weather and winds, botany, hydraulics, optics and mechanics. There are notes and musings on perpetual motion and weighing machines, pumps capable of producing a constant stream of water, multi-mirror telescopes and diving bells filled with washed air (referring to 'Priestley's experiment that air which has been breathed by being washed in water becomes fit to breath again'), ploughs and automatic ventilators for greenhouses. Pages covered with notes and sketches juxtapose the down-to-earth useful and the fanciful

Water-closet constructed like those in London, so as to have by Mr Whitehurst little or no smell in the following simple manner.

a pail of water & pour'd down it cleans it at once

see 113.

front 12 = 12 back

Lead or Copper

floor

Pit

5

5

earthen pot 12

wooden beam to support the pot

Pit.

artificial Bird

Let a watch-spring be fix'd with one end to a frame & the other wrapped round an axis, at each end of the axis let a wheel be put with teeth of such form & situation that they have move a wing, like a bat's wing, or like a ladies fan, one tooth carrying it downwards, another carrying it towards the body, another carrying it upwards, & a fourth outwards again from the body. NB. one edge of the wing is to be fastened to the body & the other to a kind of fan-stick made of a porcupine quill. the tail of feathers spread out & being oblique to the action of the wings, or rather to it's intended track in the air.

body of the bird wing tail

wing

porcupine quill or fine steel wire

a. the notch to let the tooth escape after having depress'd the wing.
b. the notch to let the tooth escape after having raised the wing.
x the center of motion of the wing

the oblique part of the tooth a in it's descent pushes the wing from the body. the other part depresses it, & then escaped. If b does the same on the contrary side of the axis x,

of the wing-stick, & in consequence pushes the wing-stick nearer to the body of the bird, & then raised it. No teeth are concentric circles may be about four or six in number, these on the internal circle of the same shape but a finer size.

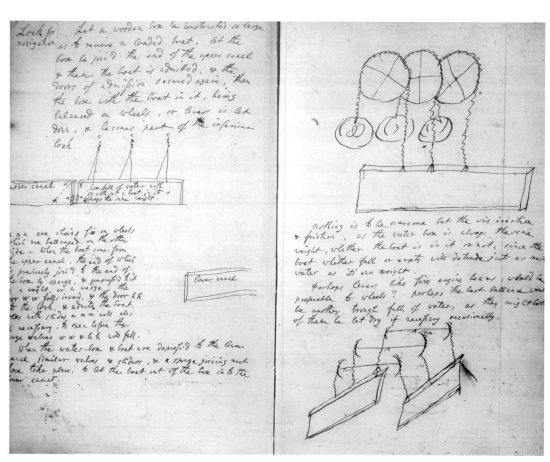

Lock for navigation.

Let a wooden box be constructed so large as to receive a loaded boat. let the box be joined the end of the upper canal & then the boat is admitted, & the doors of admission secured again, then the box with the boat in it, being balanced on wheels, or levers is let down, & becomes part of the inferior lock.

upper canal box full of water with or without a boat in it is always the same weight.

a a are chains fix on wheels which are balanced on the other side. when the boat comes from the upper canal, the end of which is previously joined to the end of the box by sponge, & compressed but a weight, or a wedge, the or ww falls inward, & the door hh of the lock, & admits the boat.

les with slides a m m will also necessary, to open before the large valves w w & h h will fall.

When the water-box & boat are depress'd to the lower canal similar valves & slides, & a sponge joining must here take place, to let the boat out of the box into the lower canal.

lower canal

nothing is to be overcome but the vis inertia & friction, as the water box is always the same weight, whether the boat is in it or not, since the boat whether full or empty will obtrude just as much water as it's own weight.

Perhaps levers like fire engine beams would be preferable to wheels? perhaps the best balance would be another trough full of water, as they might both of them be let dry if necessary occasionally.

visionary: a water-closet designed by Whitehurst 'where no water can be had' followed by a clockwork artificial bird with wings worked by a watch spring powered by a bottle of compressed air (fig. 92).[223] Several ingenious devises were clearly designed to amuse his children, such as the 'factitious spider' which moved by means of rotating magnets hidden under a plate.

Many of Darwin's ideas were 'in the air' at the time. He worked for years on perfecting a 'bigrapher' or mechanical copying machine based on the pantograph principle, only to be pipped at the post in 1779 by Watt who, as noted, devised and patented a chemical method.[224] He thought about how to decrease friction in cotton-spinning machines at the time when the installation of Arkwright's patent inventions in brand new mills was gathering pace. In the early 1780s, he was puzzling over the means by which the reciprocating motion of a steam engine could be converted into rotative motion when Watt was patenting devices to achieve the same effect, including the sun and planet motion devised by Boulton & Watt's Cornish agent William Murdock.[225] While he was working on his flying bird, Joseph Banks was writing to Boulton to try to discover more about the steel rods being made in Birmingham for wings to enable men to fly.[226]

On another flight of fancy, Darwin mused on the correspondences between scales of colour and of music, considering the possibility of constructing a 'luminous harpsichord' in which the coloured rays produced by coloured glass or prisms attached to the keys of the instrument created a light show on a darkened wall, as the musician played: 'by this means the luminous music would soon become a language similar to the sonorous music'. Such notions had first been articulated by the Jesuit Louis-Bertrand Castel, who argued that as colours and sounds were related in that both were produced by vibrations, they could be linked aesthetically in 'ocular harpsichords'; Darwin had probably got hold of a copy of his *L'Optique des Couleurs*, published in Paris in 1740. The wooden men Darwin proposed to use for playing chess, worked by springs and wheels – 'A great deal of complex machinery should be show[n] to amuse the ignorant' – were presumably inspired by Kempelen's mechanical Turkish chess-player. Practical tips for whitening ivory and cleaning paste gems, gleaned from the jewellers of Birmingham, jostled alongside experiments with cucumbers and vine leaves, irresistibly recalling the eight-year project of one of the projectors in Swift's Academy of Lagado 'for extracting sunbeams out of cucumbers'.

Nevertheless, in considering the use of a 'water-box' to lower boats on canals by means of levers or wheels, in place of the conventional locks, he appears to have been a few years ahead of his day.[227] Such a lowering device was first implemented successfully in 1788, by means of an inclined plane on the Ketley Canal. Darwin himself made a telescopic candlestick: 'The above I executed in tin Nov 1 1781. The snuffers are held very well, & pressing down the sconce as b) permits the candle ends to be burnt out. I design to make one of the many joints like a screw-out telescope, so that a candle may be raised or sunk at pleasure.' He also conducted his own windmill experiments. On 6 August 1779, he compared the revolutions made by the naked vertical sail of a windmill with a horizontal sail, with and without a board on top, and concluded that the latter produced the best results: 'NB I made all these experiments with great accuracy, such as was quite satisfactory to myself.'

In 1782, after something of an inventive lull brought about by his move from Lichfield to Derby, he wrote to Wedgwood: 'It is so long that I had existed here without seeing a mechanical philosopher, that I almost forgot that there were such beings.'[228] 'Mechanical philosopher' precisely identifies his own status, that of a gentleman philosopher with a strong bias towards experimental mechanics, not concerned with profit through patent but with a mind capable of creative speculation. Most of his co-lunaticks were more down to earth, wishing as industrialists to benefit commercially from advances in mechanics, chemistry and even the polite arts. The fluid relationship

between the mechanical and polite arts experienced during the course of the Society of Arts' operations was played out at the same time in the factories of Boulton and Wedgwood. The colliery owner and famous blue-stocking Elizabeth Montagu, to whom Boulton was distantly related by marriage, urged him in language which would not have come amiss in the Society of Arts 'to triumph over the French in taste and to embellish your country with useful inventions and elegant productions'.[229] Boulton's products and those of Wedgwood, marketed in London showrooms and salerooms, competed for fashionable attention in the same metropolitan arena as the exhibitions of the Royal Academy, its rival the Incorporated Society of Artists, the Free Society of Artists and the shows of Cox and Merlin.[230]

Like the Society of Arts, Boulton and Wedgwood straddled the polite and mechanical arts, exploiting the standards of taste and refinement associated with the former to enhance the sales appeal of their products and indeed dividing their wares into useful and ornamental. Their careers exemplify the capacity of men of industry in the eighteenth century to improve their products through experiment and rationalisation. As a master potter, Wedgwood had a keen interest in the creation of new ceramic bodies and finishes.[231] A lifelong friend of Joseph Priestley, he amassed a working library which contained not only books on antiquities but also on chemistry, mineralogy and the proceedings of scientific institutions, which were abstracted by his assistant to ensure he was *au courant* with the latest reports. He developed a strong line in ceramic products for chemists, apothecaries and surgeons, notably a stable stoneware mortar. In 1769 he took out his only patent – for a matt red 'encaustic' enamel with which he could decorate his black basalt vases.[232] Over thirty-five years he conducted nearly five thousand trials, noted down in his experiment books. Between 1771 and 1777 the books record the systematic tests he made of colours and clay bodies, comparing the effect of different quantities of materials and kiln conditions, to produce the Jasper body capable of emulating the effects of cameo.[233] Helping Keir in 1776 to improve the quality of his glass, Wedgwood devised experiments which determined that its streakiness was caused by the different specific gravity of glass at different heights and could be cured by constant stirring.[234] His pyrometer established the heat of the kiln during firing, enabling him to achieve greater control.[235]

Similarly, Boulton ranged from experiment in the mechanical arts to speculation in the natural sciences. After his death, his friend James Keir described him as

a proof how much scientific knowledge may be acquired without much regular study, by means of a quick and just apprehension, much practical application, and nice mechanical feelings. He had very correct notions of the several branches of natural philosophy, and was master of every metallic art, and possessed all the chemistry that had any relation to the objects of his various manufactures. Electricity and astronomy were at one time among his favourite amusements.[236]

Boulton was deeply committed to improving the quality of his manufactures. His earliest notebook, dating from the 1750s, contains recipes for different finishes – waxes, varnish, enamels and imitation tortoiseshell – as well as notes on scientific instruments and astronomy.[237] By the late 1760s he was preoccupied with producing cast ornaments embellished with fire or mercurial gilding to a standard that would rival French ormolu. Although the process was well known, the art of applying colour to the gilt work after the initial gilding was not, and his notebook for the period again contains recipes and notes on the subject, culled from books or conversations with different craftsmen.[238] At the same time, encouraged by his fellow lunaticks, Boulton undertook at least some of his own chemical experiments. On 2 October 1772, Keir wrote to Boulton from Stourbridge to confirm that his order of chemical glasses would be executed as speedily as

possible, 'especially those for your own experiments as I well know the impatience of my fellow-schemers, and I should also be sorry to check by delay your present hobby-horsicality for chemistry'.[239]

The attainment of fashionable effects and finishes was intrinsic to the success of Wedg-wood's and Boulton's products. Like many of the products for which premiums were offered by the Society of Arts, they imitated in native materials expensive foreign models, in their case classical vases in aristocratic collections, and the copies were sold back to the very patrons who had lent the originals. As Boulton wrote to Mrs Montagu, 'Fashion has much to do in these things, and as that of the present age distinguished itself by adopting the most elegant ornaments of the most refined Grecian artists, I am satisfied in conforming thereto, and humbly copying their style, and modelling new continuations of old ornaments without presuming to invent new ones.'[240]

Wedgwood and Bentley also realised the additional cachet that association with the newly founded Royal Academy could bestow on them. Wedgwood wrote to Bentley in 1771: 'I wrote to you in my last concerning busts, I suppose those at the Academy are less hackneyed and better in general than the plaister shops can furnish us with', going on to add, 'besides it will sound better to say this is from the Academy, taken from an original in the Gallery of so and so, than to say we had it from Flaxman [senior]'.[241] Nevertheless, Wedgwood was quick to appreciate the gifts of John Flaxman junior, who just failed to win the Royal Academy's premium for sculpture. Wedgwood employed him from 1775 to 1787 to supply models for portrait medallions and figure subjects and in a more menial capacity on mechanical tasks. Yet Flaxman exhibited at the Royal Academy and always made it clear to Wedgwood that working on the potter's products took second place to commissions for 'large monuments'. He used the money he received from Wedgwood to finance his long-delayed journey to Rome.[242] The relationship between commerce and the arts might run smoothly from the point of view of the manufacturer but increasingly artists aspired to fulfil the academic ideals proclaimed by Reynolds in his *Discourses* and, like the engineers, to promote their professionalism, independence and ambition as a separate body.

If ineligible for membership of the Royal Academy, exclusively reserved for practitioners of the fine arts, the Midlands industrialists could maintain their philosophical activities in the metropolis and even gain scientific cachet. In the 1780s Wedgwood was an active member of a philosophical society – of which Boulton, Priestley and Watt were also honorary members – that usually met in the Chapter coffee-house, north of St Paul's, and later the Baptist's Head. The assembled company of medical practitioners, natural philosophy lecturers and amateurs, makers of scientific instruments and manufacturers exchanged information, discussed experiments and listened to reports on the latest industrial improvements.[243] There were sessions on mineral extraction and welding, steam and water power, pumps and drainage, ballooning, document copying, fire-proofing, the manufacture of sulphuric acid and ceruse (white lead) and a patent for taking impressions in glass from copper-plate engravings. In 1781 Wedgwood explained his newly invented pyrometer to the assembly. Three years later, the Portuguese natural philosopher and industrial agent Jean Hyacinthe Magellan reported on Wilkinson's steam-driven trip hammer. In December 1786, the company heard a report on the experiments made by Dr Black in the royal dockyards to test the strength of Cort's iron, which compared well with Swedish iron. Even when it fared badly, the report concluded, this was probably due to other causes, as at Deptford: 'workmen like to *think*, and when any difficult question is proposed to them and insisted on, they often get in a bad humour, and give such an answer as may damn the business. Besides there may be a suspicion of defect in the workmanship, to clear themselves of which they would be glad to throw the blame on the iron.'[244]

Wedgwood also communicated his paper on his pyrometer to the President of the Royal Society, Sir Joseph Banks, and it was read to Fellows on 9 May 1782. Three weeks later his name was put forward by James 'Athenian' Stuart for election 'as a gentleman likely to prove a useful and valuable member'. He was elected in January 1783, presenting three further papers and analysing a sample Banks had supplied of clay from Sydney Cove, New South Wales.[245] Five members of the Lunar Society were proposed for election in 1785 (Boulton, Watt, Withering, Keir and Galton), most probably as part of a deliberate strategy to boost their credibility in the legal cases which they anticipated, in defence of Boulton & Watt patents, and to enlist the Society's support in the cause of patent reform.[246]

From March to June the same year, a series of meetings, variously chaired by Wilkinson, Boulton and Wedgwood, was held at the London Tavern to protest against William Pitt's Irish free trade proposals. They precipitated the formation of a General Chamber of Manufacturers of Great Britain, with Boulton in the chair, to oppose the removal of protective regulations.[247] Scores of petitions were sent to Westminster from the soap boilers, tallow chandlers, curriers, tanners, potters, clothiers and other trades. When push came to shove, the Lunar Society manufacturers reverted to type, abandoning any pretence of disinterested scholarship or gentlemanly collaboration. As Boulton wrote to Watt in 1778, *au fond* they were not 'anxious about the honour of acquiring gold medals nor of making an éclat in philosophical societies. We will not merely talk about a thing but we will actually do it.'[248]

In the final decades of the eighteenth century literary and philosophical societies sprang up in provincial centres, dissatisfied with the metropolitan near-monopoly on knowledge. The laws of the Literary and Philosophical Society of Manchester, founded in 1781, stated that the subjects of conversation should comprehend natural philosophy, theoretical and experimental chemistry, polite literature, civil law, general politics, commerce and the arts. Religion, the practical branches of medicine and British politics were prohibited.[249] Although the Society was aware of the trend towards specialisation and the narrow claims of utility, at least some of its members still attempted to retain a broader view. Thus the radical Liverpool lawyer William Roscoe submitted a paper in 1787 'On the comparative excellence of the Sciences and Arts' which argued: 'There is perhaps no circumstance more injurious both to our improvement and happiness, than a propensity to engage, and persevere, in the study of particular branches of science, without first taking an enlarged and general view of our nature and destination, by which we ought to ascertain, and arrange in due succession the proper objects of our pursuit.' Roscoe pleaded on behalf of both natural philosophy and the polite arts of poetry, music and painting as the means of promoting virtue and advancing moral rectitude.[250]

During the early years of its existence, the Manchester Society heard papers on a broad range of topics, including antiquarian concerns, medicine and meteorology. Increasingly, however, thanks to the arrival in 1793 of John Dalton in Manchester as the professor of mathematics and natural philosophy at the dissenting Manchester Academy, experiments on colour, dyeing and bleaching were reported, of obvious interest to the cotton industry. Dalton became the Society's president from 1817 to 1844. During these years Manchester's foremost engineers were elected members of the Society, such as the mechanical inventor Richard Roberts, who was a leading figure in the launch of the Manchester Mechanics' Institution in 1824.[251] Societies founded in other cities further reflected regional concerns: at Derby (1783), Newcastle (1793), Birmingham (1800), Glasgow (1802), the Bristol Institution for the Advancement of Science, Literature and the Arts founded in 1808, Plymouth (1812), the Liverpool Royal Institution (1814), the Royal Geological Society of Cornwall (1814), Leeds (1818), the Philosophical Society of Cambridge (1819), the Yorkshire Philosophical Society (1822), Sheffield (1822) and others

at Bath and Exeter. Science and art cohabited within their programmes. The Geological Society of Cornwall successfully fused geology and mining in its papers, its membership drawn from the cultured gentry and mine adventurers.[252] The Bristol Institution, based from 1823 in a fine new building in Park Street designed by Charles Robert Cockerell, housed not only a laboratory but casts of antiquities and from 1824 staged exhibitions of works by Bristol artists and old masters.

These multi-purpose literary and philosophical societies might even be seen as the Society of Arts reborn under more elevated titles, so as not to be associated with cruder manifestations of ingenuity. Writing in January 1820 to his brother and fellow Boulton & Watt engineer, Henry Creighton damned with faint praise the contents of the latest number of the *Transactions* of the Society of Arts, which 'contained nice . . . trash to be sure – a pisspot with 3 . . . handles and a few certificates of its vast superiority would get a premium without doubt . . . Spied one for a mousetrap and concluded with saying as usual that one was deposited in the Society's rooms.'[253] By this time, it seems, the Society of Arts appeared to have lost its larger sense of purpose and degenerated into the sponsorship of mechanical trivia.

In retrospect, it is clear that the most successful eighteenth-century inventors and entrepreneurs bypassed the premium route when seeking to exploit their discoveries, opting rather to protect them through secrecy or through patents. Thus Wedgwood, Boulton & Watt, Wilkinson, Clay and Arkwright took the latter route and barely encountered the Society of Arts. A key consideration was to decide whether the rewards to be gained from a patent would outweigh the time and cost of taking one out – between £120 and £350, depending on the geographical spread.[254] As already noted, late in the 1760s Smeaton had advised the hydraulic engineer William Westgarth against applying for a patent because the time and cost involved did not outweigh the number of cases in which the invention could be properly applied. He recommended instead applying to the Society of Arts who were by 'handsome premiums and bounties, encouragers of all useful inventions and improvements'.[255] In other words, the Society's premiums were more appropriate for improvements and inventions with a small market; those with a broader application and greater potential for profit benefited from patents. Nevertheless, too much can be made of the contrast: patents were taken out for consumer goods of precisely the same type as those for which premiums were awarded, goods imitating more expensive foreign models or embellished with novel ornament.[256]

The Society of Arts' encouragement of innovation across a vast range of specialised products and ingenious novelties demonstrated the way in which the polite and mechanical arts, design and manufacture, could work together in harmony. The Society also brought classes together, subverted the authority of gentlemen amateurs and substituted a degree of practical expertise. In encouraging independence from French models, it boosted a patriotic confidence in British trade and manufactures; capitalising on free enterprise rather than restrictive privilege, it even became a source of envy to the French. It stimulated many inventions and improvements and, although they did not lead to revolutionary discoveries, helped ensure among a wide spectrum of society that the potential of projection and innovation gained acceptance, even trust, and was seen as preferable to tradition and stagnation. Dangling the carrot of reward, it preached the enlightened gospel of shared knowledge for the common good to the lowest social level and remotest corner of the provinces. It also contributed towards the development of a national school of fine art which came into its own in the 1760s, preparing the ground for the foundation of the Royal Academy of Arts in 1768. Nevertheless, there was nothing inevitable about this outcome. At the Society, fine and applied artists met on equal terms, not distinguished by an academic hierarchy of ascending value, but working alongside each other for the encouragement of the arts as a whole.

Plate 4

Elevation of a Receiver & Distributor which was erected at the London Bridge Water Works in the Year 1780 instead of the High Tower which was consumed by Fire October 29 1779

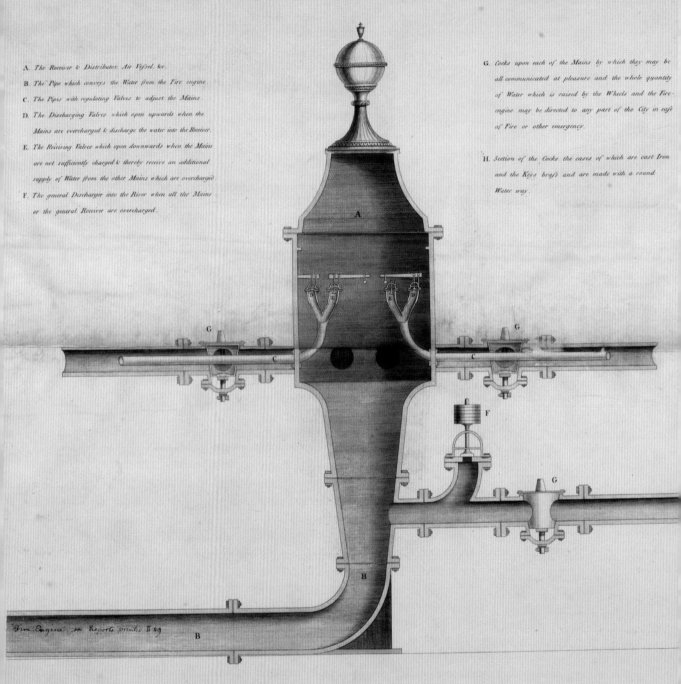

A. The Receiver & Distributor, Air Vessel &c.

B. The Pipe which conveys the Water from the Fire engine.

C. The Pipes with regulating Valves to adjust the Mains.

D. The Discharging Valves which open upwards when the Mains are overcharged & discharge the water into the Receiver.

E. The Receiving Valves which open downwards when the Mains are not sufficiently charged & thereby receive an additional supply of Water from the other Mains which are overcharged.

F. The general Discharger into the River when all the Mains or the general Receiver are overcharged.

G. Cocks upon each of the Mains by which they may be all communicated at pleasure and the whole quantity of Water which is raised by the Wheels and the Fire-engine may be directed to any part of the City in case of Fire or other emergency.

H. Section of the Cocks the cases of which are cast Iron and the Keys brass and are made with a round Water way.

Fire Engine see Reports printed H 89

Engraved by Woodfall

To the Trustees & Managers of the London-Bridge Water Works this Plate is most humbly inscribed by their faithful & obedient humble servant

John Foulds chief Millwright

V

Publications

Rational Explanation, Visual Exposition

Many even among the illiterate may here find place, and be of use to men of the profoundest learning; they will find an amanuensis in me, who shall even think it an honour to be dictated to by some who can neither write nor read.

Numerous things . . . are not extant in books, libraries, and cabinets of virtuosi; but hid in shops, garrets, cellars, mines, and other obscure places, where men of learning rarely penetrate: rich fields of science lie thus neglected under ground; trades, craft, mysteries, practices, short ways, with the whole vast apparatus of unwritten philosophy.

Ephraim Chambers, *Some Considerations offered to the Publick, preparatory to a Second Edition of Cyclopaedia: or, an Universal Dictionary of Arts and Sciences* (*c.*1735)

Around 1664, Jean-Claude Hindret, a *mercier* or haberdasher, was sent to England by Jean-Baptiste Colbert, Louis XIV's chief minister, to investigate the machine that had been invented by the Reverend William Lee in 1589 to knit stockings. On his return he produced an album of drawings to illustrate the report he submitted to Colbert.[1] Hindret enjoyed a more appreciative royal reception than Lee had had for his original invention seventy-five years earlier. His machine was refused a patent by Queen Elizabeth on the grounds that the exclusive privilege of making stockings was too important to grant to any individual and the machine would threaten the livelihood of all the hand-knitters of worsted stockings. A more limited monopoly relating to silk stockings was ruled out, for Lee's first machine was incapable of producing silk stockings as fine as those imported from Spain. By the time he had perfected his invention ten years later, his court connections had faded. A short-lived move to Rouen foundered because of the disruption caused by religious intolerance and the hostility of the guilds.[2] In contrast, in 1667 Hindret was appointed to direct the first royal manufactory for the production of silk stockings established in Paris by Colbert.

Moreover, the album itself was one of the points of departure for two monumental illustrated compilations which attempted to change the nature of the relationship of the sciences, the liberal and the mechanical arts: the *Descriptions des Arts et Métiers faites ou approuvées par Messieurs de l'Académie Royale des Sciences* and, even more expansively, the

Encyclopédie, ou Dictionnaire raisonné des Sciences, des Arts et des Métiers, par une Société de Gens de Lettres, which was intended to cover the whole domain of human knowledge. Although the main focus here is Britain, to discuss British publications on the arts of industry in isolation from their more comprehensive French counterparts would not do justice to the realities of eighteenth-century publishing.

The burgeoning print culture concerned with trades was international in character. As in the case of Lee and Hindret, although the French works exploited the field to the full, they were anticipated by the English experience in several respects. Both the *Descriptions* and the *Encyclopédie* were inspired by the Baconian programme of knowledge which encompassed the practical, mechanical arts under the faculty of memory, the source of historical knowledge. As discussed in Chapter 1, Bacon's belief in the importance of writing descriptions or 'histories' of the mechanical arts or 'trades' as an essential step towards their improvement was taken up by the Royal Society in its early years. Although the interest of the Society proved short-lived, a few associated publications enjoyed a longer life, notably Evelyn's *Sculptura* (1662) and *Sylva* (1664), as well as Joseph Moxon's pioneering *Mechanick Exercises* (1677–80 and 1683–4).

If works describing trades were generally believed to contribute to the cause of science, they were also related more tangibly to the genre of mercantilist 'improvement literature' for which there was a buoyant market in the mid-seventeenth century. These works were concerned with increasing the country's wealth and strength in the face of foreign competition – particularly from France and the Dutch Republic – not least through advocating various improvements to agriculture, trade and industry. Under Oldenburg's editorship in the 1670s, *Philosophical Transactions* contained reviews and listings of improvement literature, classified under the general heading of 'the growth of Ingenuous Arts', while Evelyn collected such works and in 1687 classified them together with those on the mechanical trades as 'Historiae Materiarum et Oeconom: Rei Rustici Mechanologica, Etc.'[3]

Meanwhile, across the Channel, in 1675 Colbert charged the Académie Royale des Sciences he had founded in 1666 with the task of gathering a description of all the arts, industries and professions. To further this end, a Compagnie des Arts et Métiers was instituted in 1693 and also assigned the task of producing the design for a new typeface for the Imprimerie Royale.[4] Yet not until the reorganisation of the Académie in 1699, incorporating the Compagnie, did the practice of technical reportage gain some momentum. The Hindret album inspired several drawings executed in 1708 by P. de Rochefort for a projected publication on 'Art de faire les bas', although it never saw the light of day.[5] Nevertheless, from 1713, drawings of technical processes were executed on a more systematic basis under the direction of the naturalist and metallurgist René-Antoine Ferchault de Réaumur.[6]

The difficulties – both social and practical – which stood in the way of the successful execution of such a programme are familiar from Chapter 1. In France, even when, with the arrival of Réaumur, there was a director willing to organise the commissioning of work on a long-term basis, the project proved so inordinately lengthy and Réaumur such a perfectionist that nothing was published during his lifetime. Furthermore, there was no precedent for the most appropriate format. How should complex, dynamic processes of manufacture, the nuances of the judgement of the eye and hand, be captured and recorded on paper? Only Denis Diderot combined the background, philosophy, organisational skill and sheer energy to rise to the challenge and to produce between 1751 and 1772 the most comprehensive description of European industry that had ever been realised.

Yet Diderot's own account in the *Encyclopédie* 'Prospectus' (1750) of the difficulties he had overcome cannot be taken entirely at face value. In the first half of the eighteenth

century, the production of general works, periodicals, handbooks and manuals on trades, written by skilled artisans as well as genteel observers, grew from a trickle to a sizeable flow. In fact, the publication around the middle of the century of so many dictionaries and encyclopaedias encompassing the arts and sciences, including the mechanical arts, presupposed the existence of such a literature, on which compilers relied. They also attempted to record oral testimony and manual practice. If artisans were reluctant to consign their practices to paper, then at the very least writers could benefit from their collaboration to explain trade processes. In their prefaces, the authors frequently touched on the same issues that Diderot was to stress: namely, the difficulties of communication they had encountered and how they had risen to the challenge in order to enlighten their target audience and reconcile the sensitivities of both polite and vulgar. They all placed an emphasis on rational explanation based on observation and practical experiment. They cited prior authorities, both historical and contemporary, usually to argue that their work not merely supplemented but superseded what had gone before, overcoming the inadequacies of their rivals. They ranged across frontiers, including excerpts in translation from foreign sources as well as from English texts. Publication represented the assertion of authority over the trades in question and, in bringing home to readers the skills involved, also boosted the status of industry.

Moreover, these works were usually illustrated, and the plates they contained were a key part of their appeal. Publishers commissioned engravers to reproduce images culled from a wide range of sources, often going to considerable trouble and expense to acquire them. Engraving was a proud and free occupation, regarded on the highest level as being a liberal art. A fine reproductive engraving after a painting could take months, even years, to complete and its maker could be paid more than a painter. However, as the eighteenth century progressed, there was an increasing demand for general engravers to take on commercial work relating to an expanding range of goods. The growth of trade provided a showcase for their skills. They were required not only for the reproduction of pictures but also as part of the finishing process for other luxuries, such as textiles, silverware and gemstones. Furthermore, they created a paper trail tracking the course of commercial transactions from bills of exchange, share certificates and banknotes, to charts and maps promoting new roads and canals, to advertisements, trade cards and visiting cards.

The shortage of good engravers in England was met by skilled immigrant artists from France, Italy and later the German states. Several engravers accumulated sufficient capital to become important print publishers themselves. Yet the wide variations in quality and the infinite number of reproductions of a single image deepened ambiguities in the status of engravers and indeed of their productions. Were engravers fine or mechanical artists? Should engravings be read as poetic and ideal or objective and substantial? Publications on the mechanical arts encompassed both forms of image, the one claiming association with the liberal arts, the other with the purified geometry of the sciences. In the still unified world of knowledge, both fed the appetite for information on every level of society.

Technical Manuals

The Artificial Clockmaker, 'A Treatise of Watch, and Clockwork: wherein the Art of Calculating Numbers for Most Sorts of Movements is explained to the capacity of the Unlearned', was first published anonymously in 1696 by William Derham, the vicar of Upminster, Essex. According to his preface, the work was first drawn up 'in a rude manner, only to please myself, and divert the vacant hours of a solitary country life'. By publication the author hoped to reach both a genteel and trade audience, 'purely in hopes of its doing some good in the world, among such, whose genius and leisure lead

them to mechanical studies, or those whose business and livelihood it is'. As persons of quality frequently had time on their hands and 'for want of innocent, do betake themselves to hurtful pleasures', he hoped his book would 'initiate them in other studies, of greater use to themselves, their family, and their country'. For those working in the trade, he believed his work to be a charity, 'because there are many (although excellent in the working part) who are utterly unskilled in the artificial part of it', meaning the mathematical theory. Nobody had treated the subject plainly and intelligibly 'as to be understood by a vulgar workman': 'I have often wondered at it, that so useful and delightful a part of mechanical mathematics should lie in any obscurity, in an age where in such vast improvements have been made therein, and when many books are daily published upon every subject.'

Derham acknowledged the work of predecessors, notably William Oughtred's appendix to the treatise *Horological Dialogues*, published in English in 1675 and more completely in Latin two years later: 'What Mr. Oughtred had wrapt up in his algebraick obscure characters, was afterwards put into plainer language, by that excellent mathematician Sir Jonas Moore, with some additions of his own; which you have in his *Math. Compend.* and since then by Mr Leyborne, in his *Pleasure with Profit*.'[7] But Derham had found from experience that such treatises were understood by very few workmen. Furthermore, while they dealt only with watchwork, he had added his own calculations on the clock part and also a historical section which had not been attempted before, as far as he was aware.

Also acknowledged was the assistance of friends in writing his book as well as 'L. Br. . . .', 'a judicious workman in White-chapel, who drew me up a scheme of the clockmaker's language'. For the history of modern inventions, he had also been assisted by Dr H[ooke] and Mr T[ompion], 'The former being the author of some, and well acquainted with others, of the mechanical inventions of that fertile reign of King Charles the II and the latter actually concerned in all, or most of the late inventions in clockwork, by means of his famed skill in that, and other mechanick operations.' He concluded with an apology to those who sought to keep the trade a mystery, at the same time inadvertently revealing who he believed his main readers would be: 'If I have at any time invaded the workman's province, it was not because I pretend to teach him his trade; but either for gentlemen's sakes, or when the matter led me necessarily to it.' *The Artificial Clockmaker* was a model of Baconian collaboration, uniting applied mathematics and mechanical arts principally for the benefit of the genteel. It helped to get Derham elected to the Royal Society in 1703, was translated into German and French, running into four editions by 1734.

The spirit of the History of Trades was to persist well into the eighteenth century, as demonstrated in the case of Dr William Brownrigg. Having received his medical training in London and Leyden, he was the first to undertake a systematic investigation of poisonous gases in Cumberland coal mines, under the patronage of Sir James Lowther (Brownrigg married the daughter of Lowther's chief estate steward, John Spedding), leading to his election as a Fellow of the Royal Society in 1742.[8] In 1748, he published *The Art of Making Common Salt*. The preface to his work explicitly updated the Baconian agenda, championing mechanical arts for his own times:

It is an old remark, *that all arts and sciences have a mutual independence upon each other*. The philosopher borrows many experiments from the mechanic, which assist him in his searches into nature; the mechanic avails himself of the discoveries of the philosopher, and applies them to the uses of mankind. Thus men, very different in genius and pursuits, become mutually subservient to each other; and a very useful kind of commerce is established, by which the old arts are improved, and new ones

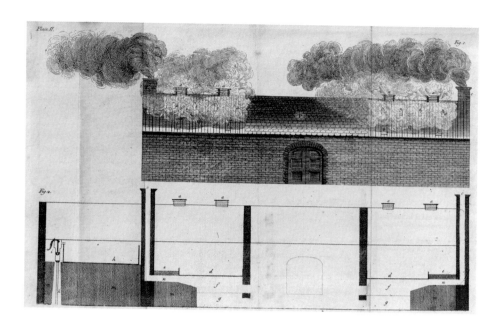

93 Elevation and section of a marine 'saltern' from William Brownrigg, *The Art of Making Common Salt*, 1748

daily invented, and the knowledge of nature is continually advanced, and brought nearer to perfection. Those trades therefore and occupations of life, which formerly brought honour to their inventors, ought not now to be treated with contempt, because grown vulgar and common; but rather, for their general usefulness, should be held in the greater esteem; and in a particular manner they demand the regard of philosophers, who have been taught by the noble Verulam [Bacon], that *the history of mechanic arts is a necessary part of that knowledge, upon which alone, as on a firm basis, can be built that true science of nature, which is not taken up in vain and fruitless speculations, but effectually labours to relieve the necessities of life*.[9]

Among these vulgar arts that of making salt, Brownrigg observed, had been thought worthy of the notice of many great and learned men, both ancient and modern, including Cato, Pliny, Agricola and Frederick Hoffman. The Royal Society soon after its institution had supported the view that this art was capable of improvement, especially as practised in Britain, 'as may be gathered from the inquiries and suggestions of Dr Beale, and the histories of several methods of making salt, which were then published by that Society'.[10] There had since been improvements in the methods of boiling salt in England but the art was still practised with greater skill and success by the Dutch 'as the superior goodness of the fish, cured with their salt, doth sufficiently prove'. Even Parliament had recognised that great sums of money annually paid to foreigners could be saved by its improved manufacture at home. These considerations induced Brownrigg to give a brief account of the various methods of making salt now used in Britain and in other countries where the art was practised with more success, and also to attempt several further improvements for use in the British dominions. Brownrigg appended 6 plates to his work: a plan of salt pans; three depicting plans and sections of a marine 'saltern' with its boiling houses and furnace; a plate from Agricola of a German salt house; and finally figures representing the salt pans and the tools formerly used in Cheshire (fig. 93).

Many of the publications relating to particular trades represented attempts to rationalise them through the application of mathematical principles, above all, accurate measurement. The standard eighteenth-century primer, William Hawney's *Compleat Measurer* (1717), taught arithmetic, the measurement of all sorts of building materials 'and what methods and customs are observed therein'. It went through sixteen editions

by 1789 despite competition from more sophisticated guides to applied mathematics. Not surprisingly, the authors of such works were usually surveyors or teachers in the new naval and military academies. Edward Hoppus, the author of *Practical Measuring* (1736), was the surveyor to the London Assurance Corporation. John Robertson, who wrote *General Treatise of Mensuration* (1739), was appointed a master at the Royal Mathematical School of Christ's Hospital in 1748 and was headmaster at the Royal Naval Academy in Portsmouth from 1755 to 1766. Charles Hutton, who was responsible for *A Treatise on Mensuration* (1770), was the professor of mathematics at the Royal Military Academy, Woolwich.[11]

As mentioned in Chapter 2, between 1650 and 1750 there was a substantial growth in the number of works devoted to surveying, sometimes designed to promote the new products of instrument-makers. These were complemented by works devoted to other aspects of applied mathematics, notably navigation, fortification and gunnery, again tied in with descriptions of new instruments. Captain Samuel Sturmy's *The Mariner's Magazine, or Sturmy's Mathematical and Practical Arts*, first published in 1669, is an early example of the genre, covering not only navigation and trigonometry but surveying, gauging, astronomy, dialling, gunnery and fortification.[12] Nicolas Bion's reference work, *Traité de la Construction et des Principaux Usages des Instrumens de Mathématique* (Paris, 1709), which contained a section on gunnery, served as the basis for an English edition of 1723 by Edmund Stone who added specifically English instrument types.[13] The German-born mathematician John Muller wrote his *Treatise containing the Elementary Part of Fortification, regular and irregular* (1746) and its successor, *The Practical Part of Fortification* (1755), for the use of the Royal Academy of Artillery at Woolwich, where he was the professor of fortification. Illustrated with copper plates which formed the basis of the students' copying exercises, his works went through numerous editions.[14]

Practical mathematics also formed the basis for builders' measuring and price books. The former, like Hawney's work, usually included descriptions of instruments, such as carpenters' rules, tables of measurements or ready-reckoners. Two price books were available to builders in the immediate post-Great Fire period: Stephan Primatt's *The City and Country Purchaser and Builder* (1667) and the *Platform for Purchasers, Guide for Builders, Mate for Measurers*, produced by the indefatigable William Leybourn in 1668. The standard eighteenth-century work was first published around 1733 by a Colchester carpenter, William Salmon, under the title *The Country Builder's Estimator; or, The Architect's Companion*. Enlarged as *The Builder's Guide, and Gentleman and Trader's Assistant; or a Universal Magazine of Tables* (1736), it was reissued in one form or another for forty years, performing the invaluable practical service of allowing the reader to calculate the amount of timber, bricks, paving or tiling he might need for a project and the cost. By publishing these charges – which could be adjusted to allow for regional and temporal variations – Salmon asserted that it was possible to expose those builders who cheated customers or fellow workers, damaging the reputation of the trade. His guide, he said, promoted justice and honest industry, the arts and sciences and improved the nation's trade.[15]

Carpenters' manuals began to appear in England in the 1730s, probably necessitated by the increasing variety of building forms which exceeded the experience of local tradesmen. The popular pocket-size edition of *Ancient Constitutions of the Free and Accepted Masons* (1729) contained a speech delivered by Edward Oakley at the Carpenters' Arms, Silver Street in the City of London, on 31 December 1728, exhorting the fraternity to provide such books 'as be convenient and useful in the exercise' of their crafts. A response of a kind was supplied by Ephraim Chambers, whose translation of Sébastian Leclerc's *Traité d'Architecture* (1714) appeared in 1732, complete with 181 plates engraved by John Sturt, representing the orders, ornaments, doorways, windows, niches, balustrades and

examples of those 'to be avoided'. It was prefaced with fulsome dedications to the worshipful companies of bricklayers, masons, joiners and carpenters.

The first English books on carpentry appeared in 1733: Francis Price's *Treatise on Carpentry* and James Smith's *Carpenter's Companion*. Price's work presented clear directions facing each plate. The orders were added to a second edition of 1735, adapted from James Gibbs, *Rules for Drawing the Five Orders* (1732), and the work was renamed *The British Carpenter*, going through six editions, the last in 1768.[16] Smith chose the format of a continuous systematic text unrelated to the plates which, although of little practical value to craftsmen, served the needs of dictionary compilers over the century.[17] Price's more practical information was incorporated into several general builders' manuals and books of instruction, most of which also ran through numerous editions.

Demand for decorative examples as well as practical instruction was fed by the buoyant market in pattern books which added a gloss of polite taste to the mathematical rules of measurement and the orders. The engraver and publisher Robert Pricke was the pioneer of builders' pattern books in England, his efforts arising directly from the Great Fire. His business enabled him to bring together continental – mainly French – material, which he copied and engraved himself, notably in *The Architect's Store House* and *The Ornaments of Architecture*, both published in 1674.[18] Carpenters' pattern books produced by Abraham Swan and William Pain answered the demands of artisans from 1745 to the end of the century for decorative as well as structural models. Their chief purpose was to furnish the 'ignorant and uninstructed' with an ever increasing number and variety of examples to serve as a 'comprehensive system of practice': a hundred designs and examples were given on sixty folio plates in Swan's *British Architect: or The Builder's Treasury of Stair-Cases* (1745) and several hundred in his *Carpenter's Complete Instructor* (1768), which first appeared in 1759 under the simple title *Designs in Carpentry*.[19] Pain produced eleven books of designs between 1758 and 1793, including *The Builder's Companion*, published in 1758 with 77 folio plates, and four years later with 102 plates encompassing 700 designs.[20]

Although it was generally accepted that plates were more expressive and instructive than words, there was a wide gulf between the mass of builders' and carpenters' pattern books and the elite volumes of fine engravings recording the works executed by a particular architect, from Inigo Jones to the Adam brothers, or ideal designs destined for discriminating patrons of architecture. In the preface to his *City and Country Builder's and Workman's Treasury* (1740), Batty Langley expressly criticised the plates in William Kent's *Designs of Inigo Jones* (1727) as being 'of no more use to workmen, than so many pictures to gaze at; not so many rules, or examples to work by, or after; unless to such, who understand the architecture thereof, as well as their authors, who designed them'.[21] Langley championed English craftsmanship and although most of his numerous publications were unoriginal and carelessly composed, they met an enormous demand, with a geographical spread of subscribers from craftsmen across the country. He appealed directly to men who did the daily work of building as 'the best proficients in the world' despite the 'great disregard shown to English artists and industry' by the nobility and gentry.[22]

Thomas Chippendale appears to have been attempting to answer Langley's criticism when he wrote somewhat defensively in the preface to *The Gentleman and Cabinet-Maker's Director* (1754):

I have given no design but what may be executed with advantage by the hand of a skilful workman, tho' some of the profession have been diligent enough to represent them (especially those after the Gothic and Chinese manner) as so many specious drawings, impossible to be worked off by any mechanic whatsoever. I will not scruple to attribute this to malice, ignorance, and inability: And I am confident I can con-

vince all Noblemen, Gentlemen, or others, who will honour me with their commands, that every design in the book can be improved, both as to beauty and enrichment, in the execution of it

– by himself. Billed as 'a New Book of Designs of Household Furniture in the Gothic, Chinese and Modern Taste as improved by the politest and most able artists', the *Director* was issued primarily as a furniture catalogue for Chippendale's own bespoke products, rather than a manual for use by other artisans. He further emphasised his polite credentials by commencing his work with the orders, the mathematical science of proportion which formed the basis of taste, for

> without any acquaintance with this science, and some knowledge of the rules of perspective, the cabinet maker cannot make the designs of his work intelligible, nor show, in a little compass, the whole conduct and effect of the piece. These, therefore, ought to be carefully studied by every one who would excel in this branch, since they are the very soul and basis of his art.

In the preface to *The Cabinet and Chair-Maker's Real Friend and Companion* (1765), produced by the cabinet-maker Robert Mainwaring, he conceded that several treatises and designs for household furniture had lately appeared, 'some of which must be allowed by all artists, to be of the greatest utility in assisting their ideas for composing various designs'. Yet in general, he asserted, 'the practical workman has not been much instructed in the execution of these designs', a gap in the market which his own work was intended to fill. Like Chippendale, he started with the orders but stated that he had based his selection not only on the merit of the design but also the facility of putting it into execution:

> Those who write upon a subject and unfold its mystery, ought to be practically acquainted with it; a superficial drawing or engraving is not enough to teach others how to go to work, the foundation rules for practice are wanted. A late very ingenious author says, 'If all books upon arts and sciences, manufactures and mechanics, had been, or could be written by the respective professors thereof, things would appear in another light; we should perhaps not have the finest language in those performances; but we do not want that; plain truth and common sense is what is required; if a guide leads us the right way, we need not mind his dress.'[23]

True to his principles, Mainwaring went further than Chippendale in including scaled plans in his plates, 'explaining the true manner and method of striking out all kind of bevel work relative to chairs, by which the practical workman will see at one view the foundation rules for obtaining his art'. According to the carpenter and joiner Thomas Skaif, journeymen preferred to be instructed in 'the modes and peculiar manner' of doing a difficult piece of work 'than have the pleasure of casting his eye upon a fine plate that only represents such works when done'.[24] His own 290-page *Key to Civil Architecture* (1774) contained practical rules for executing works in every taste.

Nevertheless, cheap all-picture pattern books without instruction proliferated, their plates culled or plagiarised from multiple sources, intended to serve as bench books for artisans requiring the latest examples of applied ornament for value-added products.[25] This type of digest had first appeared in English in the late seventeenth century. The Huguenot engraver Simon Gribelin published *A Book of Severall Ornaments* in London in 1682, soon after he had arrived from France, and his *Book of Ornaments Usefull to Jewellers, Watckmakers and All Other Artists* followed in 1697.[26] By the 1740s such works were almost wholly dedicated to the diffusion of the Rococo taste combined with fanciful motifs drawn from other anti-classical styles, notably chinoiserie and gothic. The

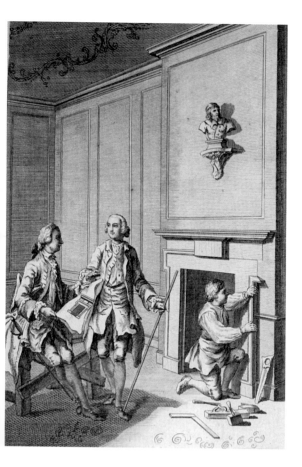

94 Isaac Taylor, frontispiece to Thomas Milton, *The Chimneypiece Maker's Daily Assistant*, 1766

master carver Matthias Lock produced a whole series of compilations of ornament in the 1740s, some billed as drawing books for youth and others as applied designs for looking-glass frames, chimney-pieces, sconces, tables, panels, clock cases and stands.[27]

Occasionally, trade guides and pattern books were prefaced with a title-page or frontispiece depicting craftsmen at work, a feature well established by the seventeenth century in, for example, the title-page to Sturmy's *Mathematical and Practical Arts*, engraved by Thomas Cross, or the frontispiece to William Badcock's *A Touch-stone for Gold and Silver Wares*, a history of assaying as a protection against fraud first published in London in 1677. Salmon's *The Builder's Guide* was embellished with a frontispiece engraved by Benjamin Cole depicting a gentleman holding the guide and directing three carpenters to fell and plank trees. The title-page of John Carwitham's little guide to *Various Kinds of Floor Decorations* (1739) was framed by dangling trophies made up of the tools of the trade with workmen stamping, cutting and pressing an assortment of floor finishes below. Isaac Taylor's frontispiece to *The Chimneypiece Maker's Daily Assistant* (1766) shows an architect with a measuring rod and a patron with a design drawing supervising the construction of a chimneypiece by a joiner, who is measuring up the fireplace and fixing the moulding, with his plane and saw beside him (fig. 94).[28]

Such scenes were also represented on the trade cards that were an attractive feature of eighteenth-century marketing and promotion. The term used in the eighteenth century was shopkeepers' bills, for they were used both as advertisements and bills in the modern sense. They survive in infinite variety as evidence of the hundreds of goods and services catering for all sorts of needs.[29] Scarcely in existence before 1700, they enjoyed a heady efflorescence between 1730 and 1770, buoyed up on the curves and billows of Rococo ornament. They were part of a rich world of printed ephemera encompassing labels, book plates and invitation tickets that shared the same engraving styles and engravers (who were usually associated with the silver trade), the great majority of designs ultimately derived from a small number of prototypes.[30] Trade cards served not simply as statements about places of sale but unequivocally drew attention to any special qualities or distinctive features, novelty or variety, that merited patronage. Within fashionable cartouches, some incorporated the old signboard used over the premises being advertised. Others included illustrations of the goods on sale. Still others depicted the shop, retail and wholesale departments and even methods of production.

A design for the goldsmith Peter de la Fontaine, supposedly by Hogarth, shows the furnace and workshop on the left and a retailer with his assistant selling to customers in the shop on the right. The trade card for the printers William and Cluer Dicey, at the Maiden-head in Bow Churchyard, included vignettes of a letterpress and rolling press.[31] That of Maydwell and Windle's cut-glass warehouse in the Strand featured two vignettes depicting workers at the glass-cutting and glass-winding machines (fig. 95).[32] The elaborate Rococo trade card of R. Brunsden, tea dealer, grocer and oil man, balanced sugar loaves and tea caddies on stands set within the cartouche, while within chinoiserie pavilions men were shown roasting chocolate beans, cracking their shells to extract the cocoa nibs which were then ground by a horse-powered mill (fig. 96).[33] In

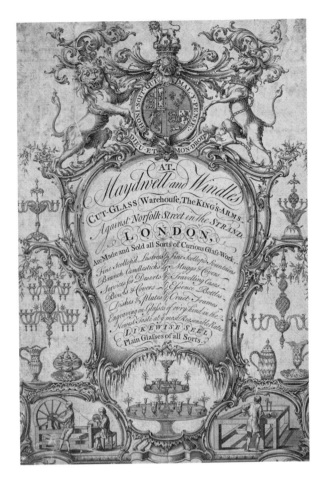

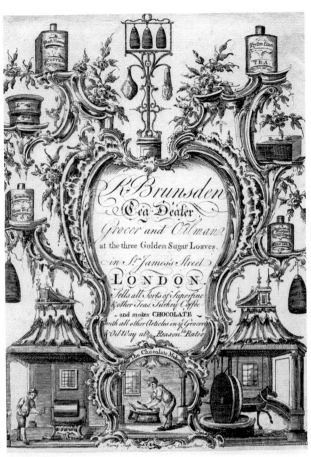

the frame of the trade card for Bickerstaff and Walsh's floor-cloth warehouse, designed by Walsh himself, figurative scenes depict various stages in the production, sale and hanging of wallpaper.[34] Some were allegorical: Charles Nicholas Cochin's engraving after Jacques de Lajoue's painting *La Pharmacie* (1735) was adapted by Robert Clee for use as a trade card by his Panton Street neighbour, the chemist Richard Sidall.[35]

Occasionally, artists and engravers initiated more ambitious forms of promotion. In about 1730 the German-born apothecary Ambrose Godfrey-Hanckwitz commissioned two unusually realistic and detailed engravings of the Golden Phoenix Laboratory he had built in Southampton Court, Maiden Lane. It could have been a promotional tool for his phosphorus manufacturing business or possibly marked his election as a Fellow of the Royal Society (fig. 97).[36] George Bickham's engraving after Louis Philippe Boitard's drawing, *The Merchant Taylors*, was possibly intended as the first of a series of decorative prints devoted to the metropolitan trades (fig. 98). The master tailor, dressed in a gown, turban and slippers, measured up a client in the front shop, which was separated by a window and door from the workroom where journeymen sat working cross-legged on a table lit by large windows.[37] Around 1750, Bickham also published a series of six comic prints inspired by French prototypes depicting various tradespeople – an apothecary, barber, butcher, maid, tailor and victualler – in the form of the tools they used.[38]

On 9 August 1767, Wedgwood wrote to Boulton to remind him of

a scheme of dispersing abroad the patterns of our manufacture . . . by means of engraved prints of all the articles we make accompanying one piece of the manufac-

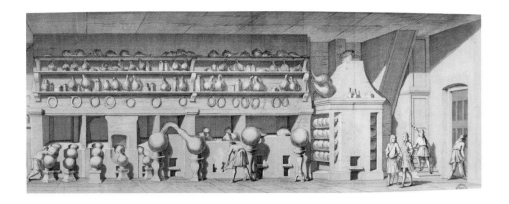

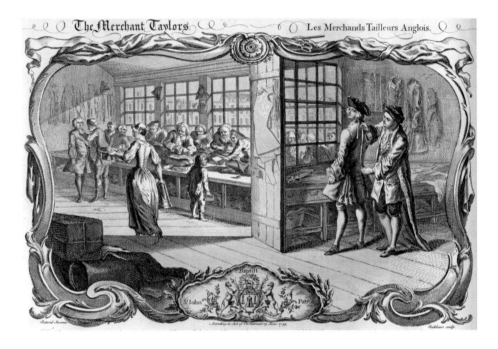

7 (top) Ambrose Godfrey's
Golden Phoenix Laboratory,
Maiden Lane, c.1728. City of
Westminster Archives Centre

8 (bottom) George Bickham
after Louise Philippe Boitard,
The Merchant Taylors, 1749.
British Museum, Department of
Prints and Drawings

ture. The thought pleased me much, both as I apprehend it would be the quickest and most eligible mode of extending the knowledge of our manufacture abroad where patterns could not with any sort of convenience be sent in specie, and likewise as I am fully persuaded a *considerable*, and *profitable* branch of commerce may be as it were erected by this new mode of showing the world what we have to dispose of.[39]

Wedgwood pursued the idea, producing *A Catalogue of different Articles of Queen's Ware* in 1774, with ten plates illustrating thirty-five shapes from a much larger range, bound separately from the text which was published both in English and French.[40] He was not alone in producing illustrated catalogues of his wares: as noted, Chippendale's *Director* had been published twenty years earlier and by the 1760s Birmingham manufacturers were sending out trade catalogues of metal fittings for furniture.

If prints were crucial as a means of diffusing and promoting new architecture, styles of ornament and fashions in decoration and the applied arts, they could also be used to promote new mechanical inventions. Henry Beighton used his drawing skills to promote Newcomen's engine, showing it at work in a 'polite' rustic setting in 1717. Thomas Barney presented the engine in action in a colliery, 'The Steam Engine near Dudley Castle, Invented by Capt. Savery and Mr Newcomen. Erected by the latter 1712'. A further

engraving was made by Sutton Nicholls in 1726, possibly of that used for pumping at York Buildings Waterworks in the Strand in London.

On 12 December 1738 *Read's Weekly Journal* announced: 'Curiously engraved on a Copper Plate by Mr Toms after the drawing of Mr Gravelot, A Perspective View of the Engine now made use of for driving the Piles of the New Bridge at Westminster . . . to be had at Slaughter's Coffee House, and Mr Hardings, both on the Pavement in St. Martin's Lane' (fig. 99).[41] The engine thus elegantly drawn in perspective and engraved, with a number of details enlarged and described in a scroll of references, was none other than the pile-driver invented by James Vauloué. No doubt the Huguenot network had brought him in contact with his co-religionists Charles Labelye, the builder of the bridge, and the artist Hubert François Gravelot. They anticipated the market for prints of the bridge itself, complete with scaffolding, engraved by Richard Parr after drawings by Samuel Wale and published by the bookseller John Brindley in 1747, 'for the ornament of gentlemen and ladies apartments, nobleman's halls &c, in the country'.[42] Labelye himself intended to produce a three-volume work on Westminster Bridge: the first on its history, the second on 'the principles, on which the works of Westminster bridge are founded; the methods whereby they were executed; and the application of mechanics, hydrostatics, and other branches of pure and mix'd mathematics to practice', intended to be 'chiefly for the use of engineers, architects, ingenious artificers and such other persons', and the third 'a very considerable number of plates' including perspective views of the bridge and the chief machines used, 'not folded, bound up or sewed in with the books' so as to be more 'ornamental' as well as instructive.[43] In the event, only the first volume was completed and Labelye left for Paris in 1752.

The latest innovation associated with London Bridge Waterworks was also reproduced in print form in 1780. An elevation and plan of the receiver and distributor made by the ironfounders Birkbeck and Ball were drawn by John Foulds, the chief millwright and surveyor for the company, and issued as two prints dedicated to the trustees. They had just been erected to replace the 'high tower' which had been destroyed by fire on 29 October 1779. The elevation was contrived to look as elegant as a Boulton classical urn, while the plan showed the elaborate pipe-work from the different mains, 'on each of which there is a communicating cock together with the feeding pipe from the fire engine' (fig. 100).[44]

By the middle of the eighteenth century there was a wealth of engraving talent in London – Benjamin Cole, Matthias Darly, Thomas Major, Charles Grignion (both Major and Grignion worked in Gravelot's studio), Edward Rooker, Paul Foudrinier, John Sturt – adept at reproducing the Rococo style as well as all manner of architectural and technical subjects. It is this buoyant network of engravers, many of Huguenot origin or trained under French masters with swift access to what was going on abroad, who provided the basis for the production of dictionaries and encyclopaedias of arts and sciences which form the main focus of this chapter.

Encyclopaedic Compilations

The numerous dictionaries and encyclopaedias (the words were largely interchangeable in the period[45]) published during the course of the eighteenth century, including the *Encyclopédie* itself, were symptomatic of an enlightened desire to understand the whole world of knowledge and to organise and classify it in a manner which made it readily accessible. In order to facilitate this endeavour, as well as to sugar the pill, these works were usually illustrated.[46] Despite the increasing quantity and variety of printed matter and boastful claims to pre-eminence, they all relied to a greater or lesser extent on

99 William Henry Toms after Hubert François Gravelot, *A Perspective View of the Engine now made use of for Driving the Piles of the New Bridge at Westminster*, 1738. The Royal Society

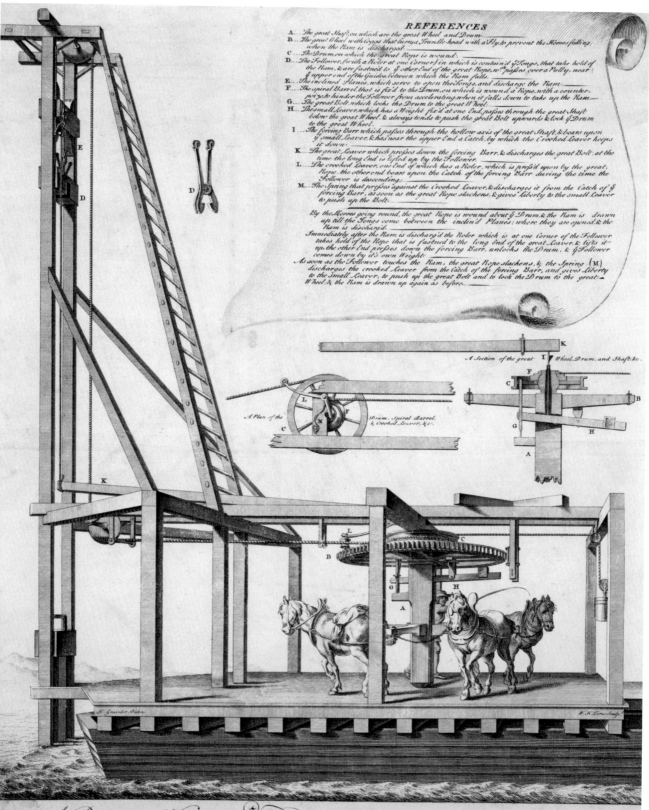

REFERENCES

A. The great Shaft, on which are the great Wheel and Drum.

B. The great Wheel with Coggs that turns a Trundle-head with a Fly, to prevent the Horses falling, when the Ram is discharged.

C. The Drum, on which the great Rope is wound.

D. The Follower, (with a Roler at one Corner) in which is contain'd ye Tongs, that take hold of the Ram, & are fasten'd to ye other End of the great Rope, wch passes over a Pulley, near ye upper end of the Guides, between which the Ram falls.

E. The inclined Planes, which serve to open the Tongs, and discharge the Ram.

F. The spiral Barrel, that is fix'd to the Drum, on which is wound a Rope, with a counterpoise, to hinder the Follower from accelerating, when it falls down to take up the Ram.

G. The great Bolt which locks the Drum to the great Wheel.

H. The small Leaver, which has a Weight fix'd at one End, passes through the great Shaft below the great Wheel, & always tends to push the great Bolt upwards & lock ye Drum to the great Wheel.

I. The forcing Barr which passes through the hollow axis of the great Shaft, & bears upon ye small Leaver, & has near the upper End a Catch, by which the Crooked Leaver keeps it down.

K. The great Leaver which presses down the forcing Barr, & discharges the great Bolt, at the time the long End is lifted up by the Follower.

L. The crooked Leaver, one End of which has a Roler, which is press'd upon by the great Rope, the other end bears upon the Catch of the forcing Barr during the time the Follower is descending.

M. The Spring that presses against the Crooked Leaver, & discharges it from the Catch of ye forcing Barr, as soon as the great Rope slackens, & gives liberty to the small Leaver to push up the Bolt.

By the Horses going round, the great Rope is wound about ye Drum, & the Ram is drawn up till the Tongs come between the inclin'd Planes; where they are opened & the Ram is discharg'd.

Immediately after the Ram is discharg'd the Roler which is at one Corner of the Follower takes hold of the Rope that is fasten'd to the long End of the great Leaver, & lifts it up, the other End presses down the forcing Barr, unlocks the Drum, & ye Follower comes down by it's own Weight.

As soon as the Follower touches the Ram, the great Rope slackens, & the Spring (M) discharges the crooked Leaver from the Catch of the forcing Barr, and gives Liberty to the small Leaver, to push up the great Bolt and to lock the Drum to the great Wheel, & the Ram is drawn up again as before.

A Section of the great I Wheel, Drum, and Shaft, &c.

A Plan of the C Drum, Spiral Barrel, & Crooked Leaver, &c.

A Perspective View of the Engine, now made use of for Driving the Piles of the New Bridge at WESTMINSTER: most Humbly Inscrib'd to the Honble Commissioners for Building the said Bridge, by the Inventor. — James Vauloue, Watch-Maker.

Published by James Vauloue Proprietor November 8th 1738. and Sold by Him at the Golden Sugar Loaf in Panton Street near Leicester Fields. Price one Shilling.

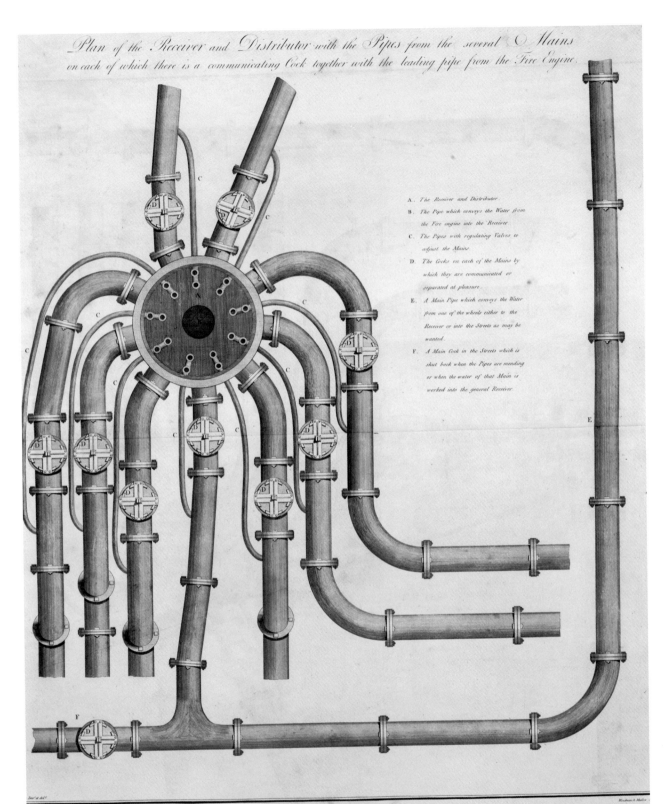

Plan of the Receiver and Distributor with the Pipes from the several Mains on each of which there is a communicating Cock together with the leading pipe from the Fire Engine.

A. The Receiver and Distributor.

B. The Pipe which conveys the Water from the Fire engine into the Receiver.

C. The Pipes with regulating Valves to adjust the Mains.

D. The Cocks on each of the Mains by which they are communicated or separated at pleasure.

E. A Main Pipe which conveys the Water from one of the wheels either to the Receiver or into the Streets as may be wanted.

F. A Main Cock in the Streets which is shut back when the Pipes are mending or when the water of that Main is worked into the general Receiver.

To the Trustees & Managers of the London-Bridge Water Works this Plate is most humbly inscribed by their faithful & obedient humble servant

John Foulds chief Millwright & Surveyor.

Published as the Act directs July 1st 1785 by John Foulds.

common sources. Their specialist text input, such as it was, was usually produced by Grub Street scribblers and indigent clergymen, plodding workhorses who could turn a grammatical sentence. Given the logistics of getting such works together, there was simply no time for indulging in first-hand observation and experiment.

As is well known, the *Encyclopédie* was first intended to be a French translation of Ephraim Chambers's *Cyclopaedia, or An Universal Dictionary of the Arts and Sciences* of 1728, which was itself an expansion of John Harris's *Lexicon Technicum or an Universal English Dictionary of Arts and Sciences* of 1704. Judging from the number of editions and reprints published, both these earlier works were best-sellers by the standards of the time. There were nine hundred subscribers to the first edition of Harris's work and twelve hundred to the supplement of 1710. The first edition to Chambers's *Cyclopaedia* had just under four hundred subscribers but it went through many subsequent editions before 1800.[47] Initially, these works were only sparsely illustrated, mainly on the grounds of cost. In the preface to the fourth edition of the *Lexicon Technicum* (1725), which included illustrations of scientific instruments newly available on the London market, besides standard depictions of architectural orders, anatomical details and fortifications, Harris still found it necessary to apologise for their scarcity: 'I would have had also at the end of the book . . . some more and larger copper-plates in anatomy, and of the outside, rigging, and the section of a ship: but the undertakers could not afford it at the price proposed, the book having swelled so very much beyond the expectation.'

The inclusion of 'arts and sciences' in their titles affirms that both the *Lexicon Technicum* and the *Cyclopaedia* were intended to encompass the whole range of human knowledge: the sciences as advanced by Newton and the liberal and mechanical arts. Yet, as Richard Yeo has pointed out, the liberal arts and sciences received much more thorough treatment than the mechanical arts.[48] The author of *Lexicon Technicum* might have acquired the nickname 'technical Harris' but the technical skills referred to in his *Lexicon* were those relating to aspects of applied mathematics which had already received considerable coverage in dedicated publications: architecture,[49] optics and perspective, shipbuilding and navigation, fortification and gunnery. Those arts dependent on manual skill received minimal coverage although, typically, printing was covered in some depth because Harris could draw on Moxon's *Mechanick Exercises*.

Chambers's *Cyclopaedia* had many more entries on arts and manufactures than the first volume of the *Lexicon Technicum* but even so he appealed for contributions from the unlearned for a second edition, emphasising that 'numerous things' hidden in workshops, mines 'and other obscure places' constituted rich, though neglected, fields of science.[50] These aspirations were not fulfilled and George Lewis Scott, F.R.S., the second editor, noted the continued inadequacy with regret in the preface to its *Supplement* of 1753, pinpointing the cause of the problem:

> With regard to manual arts and manufactures, whether depending on chemistry or mechanics, so eminently and extensively beneficial to mankind, it were to be wished, that more complete information, than is to be found here, or in any books extant, could be given the reader. It is indeed to be lamented that there are so very few good writers on those important subjects; but it is no wonder that those who understand and practise them best, should have the least leisure or inclination to communicate them to others.

Scott derived some comfort from the knowledge that the French had not got any further:

100 Woodman and Mutlow after John Foulds, *Plan of the Receiver and Distributor with the Pipes from the several Mains on each of which there is a communicating Cock together with the leading pipe from the Fire Engine*, 1788. The Royal Society

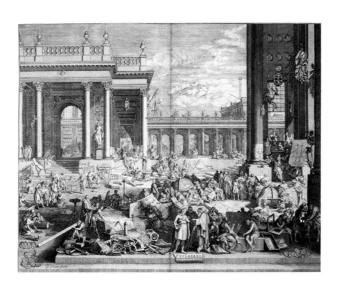

About half a century past, an illustrious foreign academy formed the noble design of composing a History of Arts; but little or nothing has as yet appeared in consequence thereof, and their ingenious secretary justly represents the difficulty of the undertaking in so strong a light, that what he has said may well serve as an apology for the CYCLOPAEDIA, and SUPPLEMENT, if they should be censured as defective on this head.

There was the same dearth of material in the plates. The *Cyclopaedia*'s splendid double-page frontispiece was engraved by John Sturt in reverse, with some modifications, after Sébastien Leclerc's print 'L'Académie des Sciences et des Beaux Arts' of 1698 (fig. 101).[51] It presented in allegorical form not only the grand libraries of both academies, loosely based on their premises in the Louvre, but also in the foreground a host of practical activities arising: calculation and measurement, drawing and observation, experimentation and discussion. Sturt introduced busts of famous men of science, from Galileo and Bacon to Boyle and Hooke, as well as medals of Aristotle, Pliny and other classical authors. The dedication to the French king was replaced with a scroll labelled *Cyclopaedia*. However, the first edition contained fewer than twenty plates illustrating different branches of applied mathematics: astronomy, hydraulics, mechanics, optics, architecture, surveying and geography. Depictions of a printing press and the processes of coining and grinding are the only representations of mechanical arts. Subsequent editions of the *Cyclopaedia* made valiant efforts to remedy this deficiency but the additional plates were still related mainly to mathematically based skills which were easy to copy from other sources.[52]

Dennis de Coetlogon's *An Universal History of Arts and Sciences: or, A comprehensive Illustration, Definition, and description of All Sciences, Divine and Human; and of All Arts, Liberal and Mechanical*, begun in 1740 and completed in 1745, contained good-quality plates but, again, these ranged over the sciences and did not include depictions of the mechanical arts. *The General Magazine of Arts and Sciences* (1755) was produced by the scientific lecturer and instrument-maker Benjamin Martin and purported to contain matter 'philosophical, philological, mathematical, and mechanical'. Its frontispiece, drawn by Samuel Wale and engraved by Charles Grignion, depicted a lady and gentleman looking up at the stars from a library containing a globe and a telescope, with a bust of Newton above the door. Other plates were devoted, not surprisingly, to scientific experiments and assorted instruments.

Practitioners of the mechanical arts were not entirely overlooked by industrious compilers. An artisan could find more useful guidance in the trade manuals which were sometimes called dictionaries, such as Richard Neve's *The City and Country Purchaser, and Builder's Dictionary* (1703). By the middle of the eighteenth century there were also several manuals of applied art techniques on the market, usually with pretentious Greek- or Latin-based titles to reinforce their scholarly credentials. The earliest English art recipe book was produced by an apothecary, William Salmon, couched in the language of one divulging arcane mysteries. His octavo volume *Polygraphice; or The Art of Drawing, Engraving, Etching, Limning, Painting, Washing, Varnishing, Colouring and Dying* was first published in London in 1672, went through three further editions before 1685 and eight by 1701. Like a model Baconian, the author asserted in the preface that he had gathered together, corrected, improved and elucidated material: '*And in a word, the whole*

Art we have reduced to certain heads; *brought under* a certain method; *limited to* practical rules; *and made it* perspicuous, *even to a very mean understanding.*' Furthermore, '*there are many excellent secrets, not vulgarly known; which fell into our hands from several special friends (whose exquisite knowledge in these kind of mysteries doth truly declare them to absolute masters thereof) which for the public good are freely communicated to the world*'.

John Stalker and George Parker's *Treatise of Japanning and Varnishing* (1688) was more wide-ranging than its title suggested, although it targeted the newly fashionable market for interior decoration using exotic and oriental patterns. It contained recipes for varnishing, gilding, burnishing, separating and refining metals, painting mezzotint prints, counterfeiting tortoiseshell and marble, staining or dyeing wood, ivory and horn. A hundred patterns for japanware were included, engraved on twenty-four copper-plates. The authors wrote as practitioners, affirming that 'What we have delivered in this treatise, we took not upon trust, or hearsay, but by our own personal knowledge and experience.' But they addressed a polite audience, particularly ladies who might wish to take up the art of japanning and more generally those who wanted to distinguish between 'good work and rubbish, between ignorant knave and an artist'.[53]

Richard Neve published *Apopiroscopy: or a Compleat and Faithful History of Experiments and Observations* under the pseudonym T. Snow in 1702. It included not only 'Chymical and Curious' recipes but matters 'Mechanical; and in several Arts, Sciences and Professions'. In his 'Prolegomenon', Neve cited Bacon, Boyle and others to support the case for an 'experimental and observational history' of the arts and inventions. He referred to those arts which had been lost since the classical world, 'A catalogue of which, if it were make public, it might prove very useful, to excite some ingenious wits, in this inquisitive age to retrieve them again.' Neve conceded that progress had been made in these fields by Hooke, Boyle and others and he repeated Boyle's arguments in countering the charge that the description of mechanical arts was injurious to tradesmen. *Apopiroscopy* contained experiments and observations culled from sources ranging from classical (Pliny, Ovid, Virgil) to near contemporary (Boyle, Evelyn, Grew, Leybourn, Moxon), starting from natural materials and progressing to their use in different trades: for example, from felling timber to carving, staining, inlaying and gilding wood.[54]

Its more extensive successor, *Dictionarium Polygraphicum: or, The Whole Body of Arts Regularly Digested*, first published in two volumes in 1735, was compiled by John Barrow, a teacher of mathematics and indefatigable compiler of encyclopaedias.[55] It considered both liberal and mechanical arts, encompassing the theoretical (or scientific) principles on which the arts were based and 'the materials employed in those mechanic arts which have a place in this work'. In effect, it served as a practical manual for apprentice or amateur artists, paralleling its sister publication, *The Builder's Dictionary: or, Gentleman and Architect's Companion* (1734), which combined coverage of the mathematical sciences employed in architecture with all aspects of building practice.[56] The frontispiece, engraved by W. H. Toms after J. Devoto, celebrated the liberal arts, as personified by an artist sitting at an easel and a sculptor showing a gentleman patron his work in a classical setting. The lady seated on the left was surrounded by apprentice goldsmiths and possibly gilders, while in the background a dyer plied his art in a tub. Yet, just as the *Cyclopaedia* plates were biased towards applied mathematical sciences, so the fifty-odd copper-plates in the *Dictionarium Polygraphicum* were biased towards the fine arts. Largely taken from drawing manuals, they illustrated perspective, shadows, 'landskip', japanned ornament, anatomy, expression, drapery and mechanical aids such as the camera obscura. Rudimentary depictions of glass-making tools and furnaces constituted the sole attempt to illustrate a trade process.

In its very title, John Hoofnail's *New Practical Improvements, and Observations on some of the Experiments and Considerations Touching Colours, of the Honourable and Judicious*

Robert Boyle, Esq., so far as they relate to Tinctures and Pigments, etc (1738) emphasised its polite and scholarly antecedents in order to appeal to its intended audience, 'Gentlemen and Ladies that amuse themselves with Painting in Water Colours', as well as, if secondarily, to 'Designers and Limners, etc'. But its applied-art credentials were promoted in later editions, for the title was changed to *The Painter's Companion; or, a Treatise on Colours. Shewing how to make the Several Sorts from their Proper Ingredients; together with the best method of colouring maps, prints, views &c.*

Another compilation, Godfrey Smith's *The Laboratory, or School of Arts* (1738), drew principally on German sources. It 'faithfully exhibited and fully explained' first, 'A variety of curious and valuable experiments . . . relating to gold and silver'; second, 'choice secrets for jewellers'; third, 'several uncommon experiments for casting in . . . metals; likewise in wax, plaister of Paris, wood, horn, &c'; fourth, 'The art of making glass . . . together with the method of preparing the colours for potters-work or Delft ware'; fifth, 'A collection of very valuable secrets for the use of cutlers, pewterers, brasiers, joiners, turners, japanners, book-binders, distillers, stone-cutters, limners, &c'; finally, 'A dissertation on the nature and growth of saltpeter'. The half-dozen rudimentary plates, engraved by James Hulett, were confined to depictions of laboratory equipment, apart from two small scenes, one representing the kiln for preparing ashes to make glass and the other a home demonstration in polite company of the art of blowing glass in miniature. In the preface, Smith stated that while the book was in the press he was told that its publication would give offence to tradesmen whose 'mysteries' would thereby be laid open to everybody, but he skilfully countered these arguments and berated those selfish and ill-natured masters who kept 'apprentices ignorant of the most essential parts of their business'. Candidly admitting that his motive for publication was to 'get money in an honest way', he may well have succeeded, for publication of *The Laboratory* continued for the rest of the century, the sixth edition coming out in 1799.

Robert Dossie's *The Handmaid to the Arts* (1758) further enlarged what had become a standard genre. By this date, in the second full year of the Seven Years War, as outlined in Chapter 4, the author could relate his efforts to a patriotic mercantilist agenda and to the growing market for luxury goods – the contents covered the fields for which premiums were to be offered by the Society of Arts. The first volume was devoted to 'Materia Pictoria': descriptions of the substances from which colours were formed; methods of priming cloths and cleaning pictures; the theory and practice of enamel painting; painting on glass; gilding enamel and glass by vitreous colours; the method of taking off mezzotint prints on glass; the art of washing maps and prints; mechanical means for making sketches of designs after nature and other notes on casting, gilding, silvering, bronzing, japanning, lacquering and staining. Volume two added descriptions of the preparation of inks, sealing wax and cements of every kind; engraving for prints based on Charles Nicolas Cochin's 1745 revised edition of Abraham Bosse's *Traicté des manières de graver en taille douce* (1645); a dissertation on the 'nature, composition and preparating of every sort of glass, as well coloured as transparent' and consequently the kinds manufactured for the imitation of precious stones; the nature and manufacture of porcelain or china and the best method of preparing papier mâché for different purposes. There was an appendix on the art of weaving tapestry, paper hangings, the manner of preparing glazes for stone and earthenware, the 'lost' art of encaustic painting and the method of converting glass vessels into porcelain. The emphasis on the last was a reflection of the growth during the 1740s and 50s of soft-paste porcelain manufactures in France and England.[57]

As is clear from its title, William Lewis's *Commercium Philosophico-Technicum; or, the Philosophical Commerce of Arts: designed as an Attempt to improve Arts, Trades, and Manufactures* (1763–5) had a similar mercantilist bias. It specialised in chemistry applied to

industry, starting with a 'history of gold, and of the various arts and businesses depending thereon'. The work then considered experiments on the conversion of glass vessels into porcelain and more general experiments using furnaces and other chemical equipment. It contained a splendidly appropriate folded frontispiece, engraved by Pierre Canot (a London-born engraver of French extraction) after Samuel Wale, showing the interior of a laboratory full of retorts, mortars, pulleys and balances and a large illustration of a glasshouse pinned on the wall. There were also four engraved plates illustrating in diagrammatic form different types of furnace.

Dossie went out of his way to criticise almost every book previously written on subjects he had covered, which were 'egregiously defective in matter, form and veracity'. Nor did he believe that those 'ostentatious works', the encyclopaedias and other such dictionaries, were any better:

> for indeed it is surprising how shamefully silent these books, which profess to comprehend every thing relating to subjects of this kind, are with respect to most of the essential articles; even those where the writings of others had they been industriously consulted, would have furnished what was required; nor is the French Dictionary now publishing, in the least an exception to this . . .

He went on to criticise the *Encyclopédie* article published on the colour carmine which was culled from outdated sources.[58]

This criticism of French efforts in the field of the mechanical arts followed on that implied five years earlier by George Lewis Scott, when he mentioned the difficulties encountered by the Académie's 'noble design of composing a history of arts'. Réaumur was in his seventies and the drawings and prints depicting *arts et métiers* commissioned by the Académie had been mounting up for years in the studios of draughtsmen and engravers awaiting publication, as had text descriptions in manuscripts on assorted trades. They were more than ripe for exploitation. In a letter written in 1756, the year before he died, Réaumur described his life work and went on to record that he had had 150 folio-size plates engraved with excellent results and many more drawings had been completed. However, he blamed the faithlessness, negligence and in some instances the death of his engravers for the theft of the proofs and their re-engraving for the *Encyclopédie*.[59] Réaumur himself never made his accusations public, perhaps only too aware of his own role in contributing to the disloyalty and negligence of his engravers, not to mention their demise, on account of the forty-year delay in publication. After Réaumur's own death Pierre Patte, who had worked for the publishers of the *Encyclopédie* checking the plates and putting them in order, alleged that its principal editor, Diderot, had bribed Réaumur's engravers to let him have proofs of their plates.[60] He appended a list of some seventy subjects for which he alleged the publishers of the *Encylopédie* did not possess original drawings, merely Réaumur's engravings. The publishers refuted the accusation and pointed out that Patte had been sacked from the *Encyclopédie* on two unspecified charges.[61] Inevitably, the Académie itself became involved and in January 1760 four of its members were prevailed on to issue a certificate stating that none of the drawings and plates for the *Encyclopédie* inspected by them was copied from Réaumur's plates. This certificate prefaced all eleven volumes of plates published between 1762 and 1772. Furthermore, Diderot made sure that each individual volume contained an approbation signed by one of the Academicians testifying that the plates with their explanations were all engraved after original drawings.[62]

Possibly they protested too much. Certainly, later commentators have concluded that there was at least some truth in the accusations that Diderot made use of the plates prepared for the *Descriptions*, albeit not to the extent that Patte had stated. Yet, other sources were also used and sometimes were improved on. To expect otherwise would be to fail

to understand the conditions of print publishing of the day. The borrowing, plagiarism or downright theft of images was far from uncommon in eighteenth-century Europe where laws on copyright were only gradually being instituted. As Richard Yeo has shown, the status of dictionaries and encyclopaedias with regard to copyright was ambiguous. On the one hand, authors and booksellers were not backward in claiming crown privilege in France or Germany or protection under the literary Copyright Act of 1710 in England. They did so on the grounds of the originality of the presentation of the work, its internal organisation and the skills employed in abridging the writings of others. On the other, they appealed to the traditional licence afforded all lexicographers to copy and extract, reinforced by the Baconian idea of science as a collaborative pursuit whose findings should be widely disseminated and the Enlightenment belief in the openness of knowledge. The terms and doctrines of the arts and sciences were, in effect, common property.[63]

A similar ambiguity of authorship conditioned the use of plates. The print privilege in France which, since the mid-seventeenth century, had regulated to some extent the publication of prints, still left any engraver or printseller free to print the plates he had himself engraved, or others in his stock, on a home press.[64] Moreover, as is evident from the history of the Hindret volume, both the *Descriptions des Arts et Métiers* and the *Encyclopédie* relied on drawings produced decades earlier. In 1748, Diderot borrowed the Hindret album from the Bibliothèque Royale. The drawings it contains can be compared with Diderot's preparatory notes for the article on 'Bas' in the *Encyclopédie*.[65] In this instance, as Jacques Proust has pointed out, they provided the key not only for Diderot's treatment of the stocking machine itself but for the treatment he proposed for all machines in the *Encyclopédie*. Although he prided himself on the visits he and his collaborators made to artisans, here they were not fundamental to the conception of the article. Instead, Diderot acknowledged a M. Barrat, ironsmith and maker of the stocking machines, less perhaps through the technical demonstrations he laid on than through the explanations he gave to Diderot of the Hindret drawings.[66] So Diderot could have argued (although he did not explicitly do so) that the plates, like his whole encyclopaedic enterprise, were intentionally collaborative, in the manner approved by Bacon.

To take another example, the nine drawings illustrating an album on the manufacture of paper in the Auvergne, executed by Pierre-Paul Sevin in 1693, were among the first works commissioned for the *Descriptions des Arts et Métiers* project.[67] In 1698, Gilles Filleau des Billettes, one of the Academicians in charge, entrusted them to Charles-Louis Simonneau, who produced the engraved plates that remained unpublished for more than half a century. Yet, from the assemblage, Jérôme Lalande chose the illustrations for his *Art de Faire le Papier* (Paris, 1761), published as part of the *Descriptions des Arts et Métiers* and Diderot made his selection for the *Encyclopédie* plates (volume 5, 1767), adding others by contemporary artists and engravers, Patte and Louis-Jacques Goussier.

If Diderot had access to the drawings and plates awaiting publication by the Académie, it is possible that they were available to other publishers outside the country. The royal print privilege codified in 1723 only applied within France. As noted, Chambers copied Leclerc's engraving for his *Cyclopaedia* frontispiece without acknowledgement. While copies after Watteau prints, engraved by Claude du Bosc, were prosecuted and confiscated in Paris in 1734 because they contravened the privilege granted to the collector and connoisseur Jean de Jullienne, they were sold freely in London.[68] London print publishers and engravers – George Bickham, John Tinney, Elisha Kirkhall, Robert Sayer, Thomas and John Bowles, Henry Overton, John King – thought nothing of lifting designs from other prints, mostly French, although they complained loudly when they themselves were pirated.[69] An Act for the Encouragement of the Arts of Designing, Engraving, Etching &c (Hogarth's Act) was eventually passed in 1735, along the

lines of the literary Copyright Act of 1710, forbidding unauthorised copies for a period of fourteen years, but it did not extend to foreign works.

Only a generation after the revocation of the Edict of Nantes had forced French Huguenot craftsmen to migrate to Protestant Europe, artists and craftsmen of French descent living in London still kept in touch with their fellow workers in France. Take, for example, the Grignion family. The refugee watch-maker Daniel Grignion (1684–1763) came to London from Poitou but sent his sons, Charles (who died in 1808), an engraver, and Thomas (1713–1784), a watch-maker, to Paris to be trained.[70] In 1743, Hogarth himself went to Paris to recruit French engravers of whom one, Simon-François Ravenet, joined Bernard Baron and Louis Gérard Scotin le jeune, who were already in London, to produce the prints after *Marriage-A-la-Mode*; all three had worked together in the 1720s and 30s on Jullienne's edition of Watteau. As Hogarth revealed in the 1744 advertisement for the *Marriage* prints, his original intention to send his paintings to Paris for engraving 'was judged neither safe nor proper' following the outbreak of war with France but, evidently, it did not stop Ravenet from travelling to London.[71] Given these networks, it is not surprising that engravings of mechanical arts in the style of the *Descriptions des Arts et Métiers* should first have been published in London. Their production in the late 1740s may also help to explain why Scott, in his preface to the 1753 *Cyclopaedia Supplement*, should feel self-conscious about its neglect of the field of 'mechanical arts and manufactures'.

In 1747, an enterprising London publisher and bookseller, John Hinton, launched the *Universal Magazine*, following it in 1752 with a *New and Universal Dictionary* and a *Supplement* published three years later. These works were not on anything like what became the scale of the *Descriptions des Arts et Métiers* and the *Encyclopédie* but they contained plates illustrating the mechanical arts, some of which come from French sources. Hinton was based at the King's Arms in Newgate Street from the mid-1740s to about 1753 and then at the King's Arms (from 1766, no. 34) in Paternoster Row until his death in 1781.[72] He was a member of the Court of Assistants of the Stationers' Company and according to Nichols's *Literary Anecdotes*, he died very rich.[73] He specialised in publishing religious tracts, maps, medical texts and music, with a sideline in translations from the French.

The *Universal Magazine of Knowledge and Pleasure*, as its title-page proclaimed, contained 'News, Letters, Debates, Poetry, Musick, Biography, History, Geography, Voyages, Criticism, Translations, Philosophy, Mathematicks, Husbandry, Gardening, Cookery, Chemistry, Mechanicks, Trade, Navigation, Architecture and other Arts and Sciences', which it deemed might render it 'Instructive and Entertaining to Gentry, Merchants, Farmers and Tradesmen', and to which occasionally would be added 'an Impartial Account of Books in several Languages and of the State of Learning in Europe. Also of the Stage, New Operas, Plays, and Oratorios'. It was published monthly from June 1747, priced 6d. Each biannual volume had an allegorical frontispiece on the subject of the arts and sciences, the first captioned snappily 'from Art and Science true Contentment springs/ Science points out the Cause, Art the Use of things'.

Hinton seems to have had a clear idea of his target audience, appealing in the introductory address to those of the middling sort: 'the adventurous *merchant*, the industrious *tradesman*, the skilful *mechanick*, the toilsome *farmer*, and the careful *housewife*'. He did not emphasise the plates, referring formulaically to 'maps and several other decorations' which would occasionally be interspersed, engraved by the best hands. Nor does there does appear to have been any predetermined ambition to privilege the mechanical arts. Nevertheless, from the first number, the description of a mechanical art or trade was nearly always included, accompanied by an illustration. It is likely that they were inspired by Réaumur's endeavours, yet to be published, knowledge of which would have spread through the Huguenot artists and engravers.

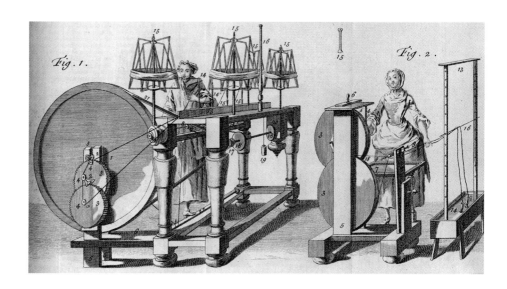

102 'A Draught of the Silk-Windles or the method of Winding and Twisting Silk for the Weavers' from *Universal Magazine*, 1747

The first plate which appeared in June 1747 was conventional enough, illustrating a printing press, letter case and composing stick clutched by a disembodied hand. The *Cyclopaedia* had published something similar years earlier, also culled from Moxon. It accompanied an article on the art of printing which purported to be written by a correspondent from Temple Bar and the following month an 'admirer' wrote in from Spittlefields (*sic*): 'As the history of the art of printing met with so kind and general a reception; and your scheme admits all parts of knowledge to be conveyed to the public by your means, I presume the art of weaving will be no less acceptable, and deserve a place in your magazine.' Significantly, this article referred to the invitation that William III had given to the best French weavers (that is, Huguenots) whom Louis XIV 'had, imprudently, and contrary to the rules of all good policy, forced out of his dominions'. The writer also sent in 'an exact draught and explanation' of 'The Ribbon Weaver in his Loom', the different parts of the loom being keyed into the text.

These epistles were surely a literary conceit, modelled on the correspondence received and published by other journals of the day. Presumably as a calculated bid for women readers, the female winders and doublers of Spitalfields 'wrote in' the following month to: 'desire you will please to lay our case, usefulness, and abilities, before your readers, who so much contribute to the silk trade of the nation, in general, and to the ornamental part of every lady in the nation in particular'. Tracing the origins of silk manufacture back to Pamphila, the daughter of Platis, king of Kos, they claimed that it could not be carried on 'without the help of our poor industrious hands'. The detailed technical description of their work that followed related to a plate depicting the winding and twisting machinery in action, worked by two women (fig. 102). Their article concluded: 'Thus gentlemen, we have readily explained our art, and the manner of performing it as well as our education will permit, and hope that your readers will excuse the want of that politeness, which cannot be expected from those of our low degree of life.'

All three plates are stylistically of a piece, depicting the machines in neat perspective. None showed workshop settings, the figures being isolated on the blank page. This format changed with the publication in September 1747 of Grignion's engraving 'The Glass-Makers at Work', accompanying an article on the art of making glass which purported to come from a correspondent in Southwark (fig. 103). Grignion had studied in Paris under the print-maker Jacques-Philippe Le Bas, as well as in James Street, Covent Garden, under Gravelot. Although it is not signed, Gravelot was responsible for the

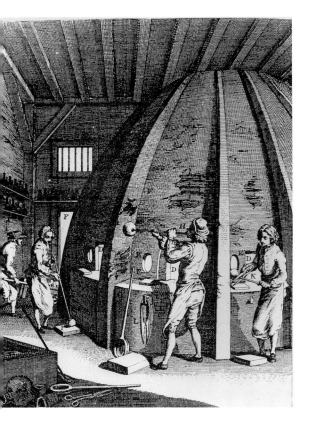

drawing of the glasshouse made, presumably, before he returned to Paris in 1745. The design is of the standard of draughtsmanship and engraving that Huguenot artists displayed in their illustrations to literary texts. Its comparatively realistic setting was novel and had more in common with Réaumur's illustrations than anything hitherto produced in London. It initiated a series of depictions of trades in workshop settings in the *Universal Magazine*, albeit of varying quality.

In November 1747 the magazine contained a much cruder plate depicting 'The Several Methods of blowing and casting Plate Glass with the Men at Work'. Two glasshouses were depicted in the same setting, the first a version of the Gravelot–Grignion scene, the second 'the latest improvement of method of casting or running large looking-glass plates', as invented by Abraham Thévart in France around 1688. 'The Art of Grinding and Polishing of Plate Glass' (broad glass) followed in June 1748. It is impossible to discern any logic in the choice of subject matter: why glass-making should be covered three times and other trades not at all, except on account of the ready availability of the images, probably from a French source. Few of the other illustrations had any claims to topicality and none specifically identified a location. Yet the space given in Hinton's magazine to the mechanical arts was new and may perhaps be seen as a dry-run in miniature for the *Encyclopédie*.

Coverage was also given to the sciences and fine arts. The Abbé Nollet's electrical experiments, practical chemistry laboratories, a medical surgery and lectures in geography, astronomy and experimental philosophy were all illustrated in early volumes of the *Universal Magazine*. The first view of the practical chemistry laboratory appears fairly realistic, full of apparatus and with a chemist at work by a furnace, a labourer beating drugs in a mortar and an apothecary's shop in the background; the second less so, or certainly old-fashioned for the time, with the chemist dressed in the robes of a philosopher and exotic beasts suspended from the ceiling. In 'The First Lecture in the Sciences of Geography and Astronomy' the lecturer was again decked out in a philosopher's gown, surrounded by globes, charts and scientific instruments. It accompanied an article supposedly written by a correspondent from Christ's Hospital who claimed: 'It has always been my pleasure to consult the benefit of young gentlemen, and to promote their knowledge in some part of learning, that might form them for business and polite conversation.' Two months later in August 1748, 'The First Lecture in Experimental Philosophy' showed a group of gentlemen watching the lecturer demonstrating the properties of different metals when exposed to flour of brimstone or aqua fortis.

It is highly unlikely that the scene bore much resemblance to the lectures given by, for example, Desaguliers or that the geography and mathematics lectures depicted were related to their conduct in the Royal Mathematical School at Christ's Hospital. The room where the experimental philosophy lecture takes place is not a pub or coffee-house where lectures were given to a general audience. Nor does it approximate to the premises of the Royal Society in Crane Court, Fleet Street, where Desaguliers kept company with other Fellows and learned amateurs. It simply suggests the ideal ambience for such lectures, before a gathering of gentlemen in a learned setting, to give a superficial gloss of fashionable science to the publication.

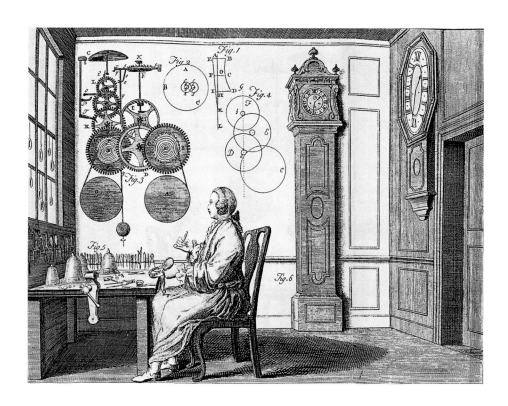

The *Universal Magazine* also covered those trades which, through their connection with the politer forms of art and science, were considered worthy of inclusion. 'The Art of Making Clocks and Watches' appeared in February 1748, a depiction of a watchmaker dressed genteelly in wig and dressing-gown seated on a mahogany chair at a worktable (fig. 104). It exhibits a degree of detail possibly observed by one well acquainted with the trade. Perhaps the artist was Charles Grignion and the young man represented his brother Thomas, in French-style déshabillé.[74] However, the naturalism of the scene is undermined by the figures rendered geometrically and in perspective on the wall in a gap where the panelling has conveniently been omitted. Intended to represent the wheelwork of a spring-driven clock, they were loosely based on the frontispiece engraved by J. Mynde for the 1734 edition of Derham's *The Artificial Clockmaker*. The accompanying commentary by 'Philo Chronos' of the Strand provides a somewhat garbled explanation, although the correspondent followed Derham in appealing to both polite and trade audiences:

> a description of an art, which, though its principles are but little known, is carried in the pocket of every gentleman, and become the genteelest piece of furniture in almost every cottage; I hope also to add improvement to some artists themselves, who being bred entirely in the manual operation, have never had opportunity to dive into the mathematical principles, upon which their work performs so many and just revolutions.

He proceeded to explain every figure using mathematical terms and equations, attempting like Derham himself to connect the mathematical sciences and mechanical arts.

Visual arts were also represented: in October 1748, 'The Art of Etching and Engraving' (fig. 105) and the following month 'The Art of Limning'. The engravers and artists responsible were keen to raise the status of their trades by claiming them firmly for the liberal arts. The text accompanying the print-making plate asserted:

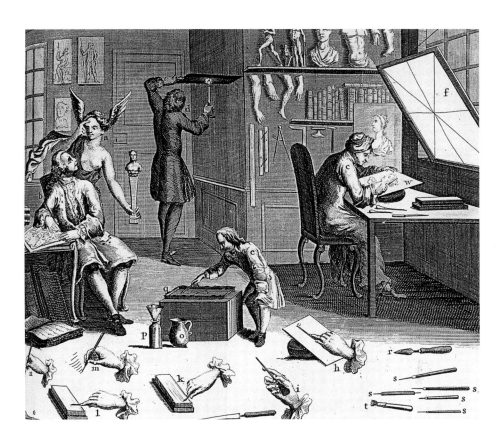

The principles of this art, though of so modern a date, are the same as those of painting. For if an engraver be not a perfect master of design, he can never hope to arrive to a degree of perfection in this art. His pieces, may, indeed, be finely engraved, but they will always want both the justness of the outlines, and the beautiful expression of the picture imitated. Therefore in the draught annexed, I have represented a genius a) inspiring the draughtsman b) with the design, which he afterwards cuts with his graver.

In the image a number of descriptive devices are all keyed into the text. The setting is ostensibly realistic, an engraver's panelled workroom with one of the engravers seated at a table working on a plate before a window, the light from it filtered by a screen.[75] Shelves of books, plaster casts, tools, frames and pictures line the walls. Other engravers work on different stages of print-making but there the realism of the scene ceases. An allegorical figure of 'genius' flies in to inspire the draughtsman while the foreground is given over to tools, some of them held in disembodied hands. 'The Art of Limning' similarly combines the realistic with the diagrammatic, incorporating a large chart of Charles Le Brun's codified expressions of emotion on the wall behind the painter who works on a portrait of his sitter, possibly intended to represent Frederick, Prince of Wales.

These images of fine and mechanical arts are stylistically related and their direct connection to the text, supported by figure references, suggests that they were produced specially for the magazine. The same, however, cannot be said for the majority of the illustrations. Several appear closer to French designs of the period, as already noted, including 'The Art and Mystery of Making Wax and Tallow Candles', 'True Representation of the Diamond Cutter's Wheel or Mill' and the plates devoted to woollen manufacture, tobacco manufacture, tanning and paper-making, ploughing, wine- and cider-making.[76] A strong French influence pervaded the entire work. Already by October 1751 Hinton was printing a 'Description of a Silver Mine in Potosi Province of Peru

translated from M. Diderot's Encyclopaedia'. Although none of the plate volumes for the *Encyclopédie* or the *Descriptions* volumes appeared before the 1760s, he seems to have got his hands on some of the plates or at least their sources.

By 1752 the impetus to illustrate the mechanical arts in the *Universal Magazine* had more or less dried up, probably because Hinton diverted plates of this type to his new dictionary project and decided to confine his *Magazine* principally to antiquarian illustrations. The first number of *A New and Universal Dictionary of Arts and Sciences* appeared on 4 May 1751 and the work was completed the following year. John Barrow was the author and he dedicated it to the Earl of Macclesfield, the President of the Royal Society. He also wrote the preface which, having considered the history and progress of the arts and sciences, concluded with a free precis of parts of Diderot's 'Prospectus' for the *Encyclopédie*, which had been published six months earlier, in November 1750:

> The mechanic Arts required no less pains and attention. Too much has been written on the Sciences; too little on most of the liberal Arts; and scarce any thing at all on the mechanic Arts. We have done all in our power, as far as it was consistent with our original design, to supply these defects. And as the want of a habit of writing and reading treatises on the mechanic Arts renders a clear explication of them difficult, we found it absolutely necessary to embellish our work with plates; and the reader will find more than double the number in this dictionary, though a single volume, than in any other work of this nature in the English language. It might be shown by a thousand instances, that a dictionary, merely consisting of the most accurate definitions of Arts, would still require plates, to prevent vague and obscure descriptions: How much more necessary then must their assistance be in an universal dictionary of Arts and Sciences? The bare view of an object, or its figure, often conveys more information than whole pages of words.

Hinton and Barrow were not alone in attempting to plagiarise the *Encyclopédie* the moment it was published. As soon as its French publishers learnt that plans for a pirate edition were afoot in London, they crossed the Channel in an attempt to negotiate but evidently returned to Paris empty-handed. The quarto ten-volume translation with 'improvements' proposed by Sir John Ayloffe Bart., F.R.S., F.S.A., announced in the *Gentleman's Magazine* in January 1752 and intended for completion by Christmas 1756, seems not to have appeared at all.[77] When the *New and Universal Dictionary* was advertised in the London papers also in January 1752, it too promised to include 'A translation of all the discoveries and improvements contained in the *Encyclopédie*, now publishing in Paris, by M. Diderot'. This was a ridiculous puff, given that the *Encyclopédie* had not got beyond its second volume, letters CEZ, by the end of 1751 and only to volume four, letters CONS–DIZ, by 1754, the date of Hinton's *Supplement*.

Nevertheless, the title-page of the *New and Universal Dictionary* billed itself as 'A complete BODY of ARTS and SCIENCES, As they are at present cultivated. Extracted from the Best Authors, Transactions, Memoirs, &c. in several Languages. And Illustrated with a great Number of COPPER-PLATES, Engraven by the best Hands'. The engraving of more than half the sixty-one plates is credited to Isaac Basire of St John's Court, near Red Lion Yard, Clerkenwell. He was the son of James Basire of Wardour Street, Soho, a Huguenot refugee from Rouen. The composite nature of the majority of plates, comprising a number of figures relating to articles arranged alphabetically, suggests that he was closely involved in the production of the *New and Universal Dictionary*. Two plates are credited to James Basire, Isaac's elder son, who worked for the Society of Antiquaries and the Royal Society.[78] One (plate 51) shows the new piers and porters' lodges on the west side of the Royal Hospital at Greenwich in plan and elevation with 'a scale of feet for finding the dimension of any particular part (which we have been at the expense of having drawn on purpose

for this work)'. Conversely, this suggests that the majority of the images (as opposed to the engravings) were not drawn specially for the *New and Universal Dictionary*.

The allegorical frontispiece was engraved by Nathaniel Parr and is a simplified version of the frontispiece to Chambers's *Cyclopaedia*, itself based on Leclerc. Isaac Basire ranged wide over predictable subject matter relating to applied mathematics and anatomy. Many of the sixty-one plates were diagrammatic in style, showing an elevation of the exterior of an object, the item in section and details of the parts. A number of relatively new scientific instruments and machines were represented: a portable air pump as well as the common variety, Neale's patent globes, the water clock invented by Maurice Wheeler then on show at Don Soltero's Coffee House in Chelsea[79] and, inevitably, Vauloué's pile-driving engine used in the building of Westminster Bridge. Of course, the last was based on Toms's engraving first published in 1738 after a drawing by Gravelot. The one full-page perspective of a workshop 'scene', a rather crude illustration of a chemical laboratory, was credited to Nathaniel Parr. That depicting 'The several methods of blowing and casting Plate Glass with the Men at Work', already used in the *Universal Magazine* in 1748, was reproduced once more.

In 1754, Hinton published *The Supplement to the New and Universal Dictionary of Arts and Sciences*. Again the compiler and writer was John Barrow and again the preface drew attention to its concentration on mechanical arts and the familiar communication problem between classes, translated virtually word for word from the *Encyclopédie* 'Prospectus':

as little help in the mechanic Arts could be acquired from books, we were obliged to have recourse to workmen themselves, observe them at their work, learn their various terms, and clear up and methodise what they delivered; and as many of them were unable to explain, in an intelligent manner, the machines they employed in their various Arts, we were obliged also to take their machines to pieces, in order to explain their construction, and shew the uses they are applied to.

Clearly, Samuel Johnson was taking on this passage, or indeed Diderot's original boast in the *Encyclopédie* 'Prospectus' (both derived from the sentiments expressed by Chambers in the 1730s when seeking contributions for a second edition of the *Cyclopaedia*), when he conceded in the preface to *A Dictionary of the English Language*, published a year later in 1755:

That many terms of art and manufacture are omitted, must be frankly acknowledged; but for this defect I boldly allege that it was unavoidable: I could not visit caverns to learn the miner's language, nor take a voyage to perfect my skill in the dialect of navigation, nor visit the warehouses of merchants, and shops of artificers, to gain the names of wares, tools and operations, of which no mention is found in books.

Hinton was one of the consortium of booksellers who backed the production and publication of Johnson's *Dictionary*.

The role of illustration was highlighted by Barrow:

Every person must be sensible that an attempt of this kind could not be executed without the assistance of copper-plates; and accordingly the reader will find in the Dictionary and Supplement *One Hundred* and *Seven* folio plates, engraved by the best hands. And several of those relating to mechanic Arts are actual perspective views of places where their respective works were carried on, and the men are represented in their proper attitudes, as they perform the various operations. By this method a mechanic Art, which it would be almost impossible to convey an adequate idea of by words, is easily apprehended.

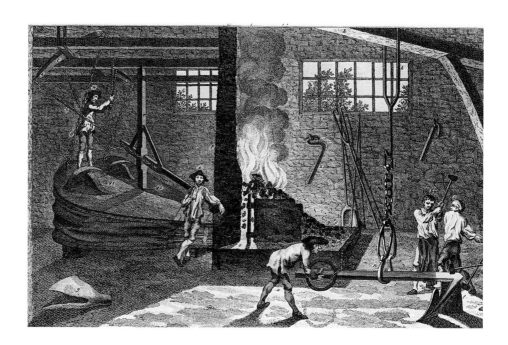

Barrow even used Diderot's words to pre-empt any criticism of the shortcomings of the plates:

> But as there are objects so familiar that it would be ridiculous to give drawings of them; and, on the other hand, some of the mechanic Arts have machines so complicated that no figures could usefully represent them; we have therefore, in the first case, trusted to the reader's understanding and experience, and in the last referred to the objects themselves. In short, we have endeavoured to observe a proper medium, and to represent only that which was necessary, and, at the same time, could be usefully conveyed by figures. To treat any one Art at full length, and give it all the possible plates, would alone require numerous volumes. It would, for instance, be unnecessary to represent in plates the several stages a piece of iron passes through before it is formed into an anchor [the example of a needle was used by Diderot]. The whole process indeed must be described; but we have represented in our figures only the most momentous actions, or address of the artists, which are easy to draw, but very difficult to explain in words. We have, in short, chiefly confined our plates to essential circumstances; which, when once well represented, necessarily shew the rest.

Following an allegorical frontispiece by Picart,[80] engraved by F. M. LaCave, the *Supplement* proceeded to publish articles which showed considerable familiarity with French sources, often citing Réaumur.[81] The first plate included a number of new inventions: improvements to the ventilation of hospital wards introduced by Duhamel du Monceau and Stephen Hales, as well as Smeaton's improved air pump of 1752 which had appeared in *Philosophical Transactions*.[82] Most of the plates wholly devoted to the mechanical arts, representing artisans at work in particular locations, seem to have been produced in England, developing the style of illustration first seen in the *Universal Magazine*, here presented on a larger scale and informed by Diderot's new emphasis on site visits. Stylistically they have some affinity with the work of the young Anthony Walker, who trained under John Tinney, an engraver and seller of prints imported from France. The 'Method of Making Anchors' (plate 2), for example, gives the impression of having been based at least in part on a real forge, so idiosyncratic is the layout of the setting (fig. 106).

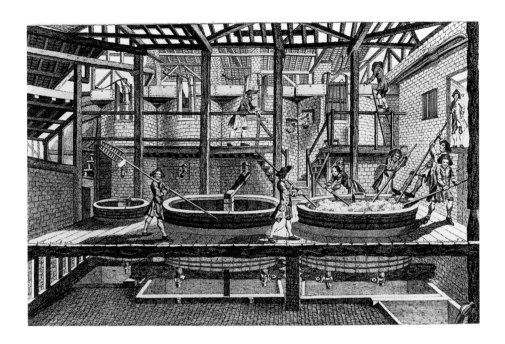

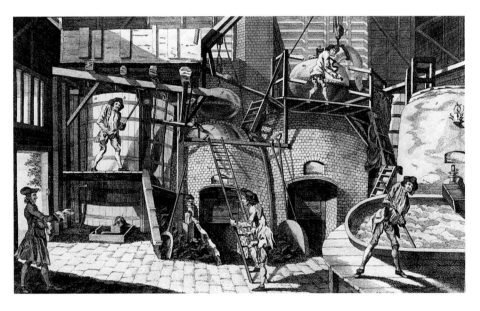

The same can be said of the depictions of the brewhouse (plate 7) and the malt distillery (plate 29; figs 107 and 108). Each plate was keyed into the accompanying description which made use of and explained the vocabulary specific to the trade. Thus figure 6 in the brew-house plate depicted 'men mashing, or stirring with utensils, called oars, the malt and water in the mash-tun' and figure 9 showed 'Cocks for letting the wort, or, as brewers call it, the goods, out of the mash-tuns, into the under-backs'. Again, in the malt stillhouse, figure *n* showed 'A machine for stirring the liquor, or, as the brewers call it, wash, in the still'. Two plates (12 and 19) representing the printing room and dye-house of a calico works must have been based on an English manufactory for its manufacture was prohibited in France until 1759 (figs 109 and 110).

These illustrations combined as many stages of manufacture as was superficially plausible in a single setting. The brew-house was partly depicted in section, cut through to reveal the 'under-backs' beneath the floorboards. Hat-making was depicted in three

259

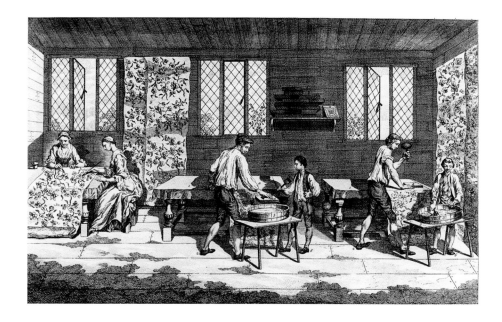

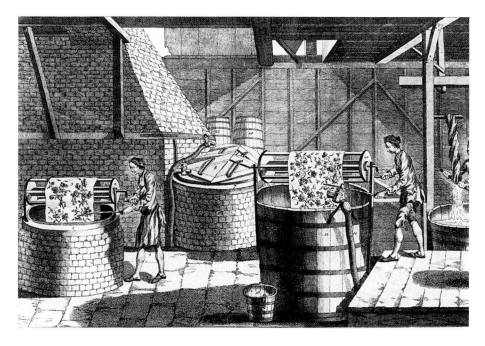

109 (top) 'Printing-Room of a
Calico Works'. *Supplement to
the New and Universal
Dictionary*, 1754

110 (bottom) 'Dye-house of a
Calico Works'. *Supplement to
the New and Universal
Dictionary*, 1754

stages on a single plate divided vertically into three sections showing different settings, thereby fulfilling to some extent the promise to illustrate the 'most momentous actions' or 'essential circumstances' of the trade and rationalising Hooke's efforts of the previous century (fig. 111). Through the use of artistic conventions regarding perspective, shading and staffage, all gave the appearance of representing reality rather than being abstracted diagrams based on mathematical principles; in other words, they were depicted as arts rather than sciences.

The illustrations for rope-making (plates 35 and 39) are stylistically distinct and it is not surprising to find that they were taken directly from *Traité de la Fabrique des Manoeuvres pour les Vaisseaux, ou l'Art de la Corderie perfectionné* (Paris, 1747), written by Duhamel du Monceau in his capacity as Inspecteur-Général de la Marine and in the spirit of experimental inquiry fostered by the *Descriptions* endeavour (fig. 112).[83] Its illus-

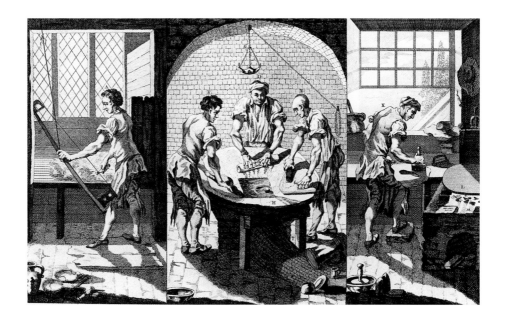

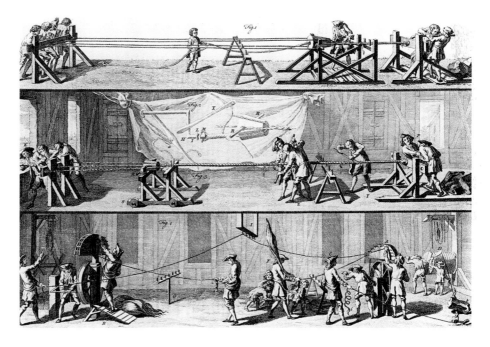

trations also followed the guidelines set by Réaumur, showing not only exterior views of the roperies but workers using machines to execute different tasks, as well as details of the machines themselves. At least some of the originals were drawn and engraved by P. Soubeyran, according to the signature on the vignettes heading chapters 6 and 7, and the artist probably visited the main royal dockyards for the purpose.[84] Figure 3 on plate 35 of the *Supplement* was re-engraved by James Basire from plate 1 to chapter 8 of *L'Art de la Corderie*. The three sections of plate 39 were re-engraved by Basire who did not bother to reverse them to ensure the plates when printed faced the same way as the originals, a procedure which would have wasted valuable time.[85] Figure 4, the bottom section, was taken from the chapter 6 of *L'Art de la Corderie* and showed an early stage in the process when the strands of hemp fibre were spun into yarn. The middle section, showing the preparation of a cable formed out of three ropes, reproduced plate 2 to

chapter 8. The top section, showing a four-rope cable being 'shroud-laid' or wrapped round a central strand, corresponds to the plate for chapter 9. Needless to say, although the accompanying article on rope-making referred to Réaumur's consideration of the relative strength of different types of rope in a *Mémoire* of the Académie, Duhamel du Monceau's name was not mentioned. Hinton also stole from 'The Manner of Watering, Breaking & Heckling of Hemp' and 'The Manner of Dressing Hemp', which appeared in the *Universal Magazine* in 1756, from Duhamel's work. They re-appeared in volume one of the *Encyclopédie* plates, published in 1762, under 'Culture et Travail du Chauvre'.

A more extensive selection of the same plates was used to illustrate 'Corderie' in the *Encyclopédie*, volume 3 of the plates, in 1763, although with significant differences. In *L'Art de la Corderie* and the *Supplement*, details of the setting are given: a workshop with windows overlooking the sea (rope-making usually took place in or near a naval yard), while the making of the shroud-laid cable takes place in the open. Furthermore, behind the three-rope cable, the draughtsman created a fanciful cartouche, tied like a sheet to the beams of the shop, on which details of the equipment and tools used were given.[86] In contrast, the *Encyclopédie* illustrations are suspended in space and the details of the machines and equipment used in the process are recorded with geometric precision, more appropriate for a work which purported to represent the rational, comprehensive and universal.

A flurry of other illustrated English dictionaries and encyclopaedias followed Hinton's *New and Universal Dictionary* and its *Supplement*, the majority encompassing set subjects where, presumably, illustrated material was readily available. *A New and Complete Dictionary of Arts and Sciences; comprehending all the branches of useful knowledge, with accurate descriptions as well of the various machines, instruments, tools, figures, and schemes necessary for illustrating them . . . The whole extracted from the best authors in all languages. By a society of gentlemen*, was published in four octavo volumes by W. Owen at Homer's Head in Fleet Street in 1754–5. The introduction claimed that it was constructed on a very different plan from that of Chambers or even Bacon, 'with all the improvements of the ingenious authors of the French Encyclopaedia', which it deemed too complicated. It also downplayed the more extravagant claims made for plates, although delineating 'the many mathematical schemes, figures, machines, instruments, animals, plants, and other curious productions of nature', and conceded that 'their properties, construction, and various uses must be learned from the description given of them under their respective articles'.[87]

The frontispiece to the first volume, devised by Samuel Wale and engraved by Charles Grignion, depicted Minerva instructing a boy from a book, presumably on navigation as there is a ship in the background. The remaining three hundred plates were 'curiously engraved by Mr. Jefferys, Geographer and Engraver to His Royal Highness the Prince of Wales'.[88] The promise of illustrations of the tools, instruments and machines used by workmen was to some extent fulfilled.[89] Yet although the plates were specially engraved by Thomas Jefferys, the sources were largely familiar, dating back to the earliest generation of Newcomen engine prints (plate 91), engravings after Gravelot's drawings for Vauloué's pile-driving machine (plate 90) and glass-makers at work in reverse (plate 113), diagrams of Smeaton's air pump (plates 219 and 220) first published in *Philosophical Transactions* and copied in the *New and Universal Dictionary Supplement*, as well as the ribbon-weaver's loom (plate 233) and other plates from the *Universal Magazine*.

In 1759, *A New Universal History of Art and Sciences, shewing their origin, progress, theory, use and practice, and exhibiting The Invention, Structure, Improvement, and Uses, Of the most considerable Instruments, Engines, and Machines, with Their Nature, Power, and Operation, decyphered in Fifty Two Copper-Plates* was published in two quarto volumes by J. Coote at the King's Arms in Paternoster Row, presumably a neighbour of

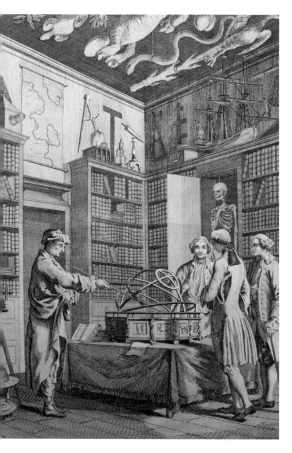

3 Benjamin Cole after
Samuel Wale, frontispiece to *A
New Universal History of Arts
and Sciences*, 1759

Hinton. Its frontispiece, again by Samuel Wale, engraved by Benjamin Cole, depicted a natural philosopher lecturing three gentlemen on an orrery in a library (fig. 113) and was possibly a source for Wright of Derby's famous painting of a similar scene exhibited at the Royal Academy seven years later. The introduction mentions the Royal Society and for the first time the 'flourishing SOCIETY for Promoting ARTS and MANUFACTURES, which is supported by Gentlemen of great Eminence for Birth and Learning, and begun with a noble Design to encourage *Art* and *Industry*, and to discover the necessary Means to improve *Agriculture* and the *Manual Arts*, as well as other Branches of Useful Knowledge'.

In the first volume the plates covered a few mechanical arts, chiefly engraved by Cole, including a diagrammatic representation of clockwork and a currier's workshop. The second volume contained rather more, including a fine folded illustration of glass-making by Cole after the Gravelot image – who was there identified for the first time as the original draughtsman – as well as the much cruder depiction of plate-glass-making, both of which had first been published in the *Universal Magazine*. Three plates depicting a tanner's workshop, a loom and a throwster's mill (the process of twisting and doubling silk thread) driven by horse power were drawn by S. Marenia and again engraved by Cole.[90]

In sum, even in the 1750s, at a time when the *Encyclopédie* was far from complete and had yet to publish any plates, and when publication of the *Descriptions* had not even begun, London publishers were prepared to jump the gun and produce, albeit on a modest scale, English dictionaries which for the first time included depictions of mechanical arts and the processes of manufacture. Diderot and even the Académie itself could not prevent the pirating of particular texts and illustrations in England; they could only ask customs to confiscate copies at the borders. Yet, the very scale of the *Encyclopédie* distinguished it from all its rivals and deterred others at first from large-scale theft. It is central to the modern understanding of the pan-European agenda of rationalising the mechanical arts.

The French Connection

Undaunted by the experience of others, Diderot attempted to incorporate the entire realm of mechanical arts within the world of knowledge of the *Encyclopédie*, organised under the great ordering principle of reason. His ambition was to encompass tacit, physical and sometimes inefficient work practices within an elite literary format in order to make them rational and productive. Although he conceded that the distinction conventionally made between the liberal and mechanical arts was well founded, he maintained that it had had disastrous consequences, degrading and depreciating highly useful and estimable people. Bacon, he asserted with pardonable exaggeration, regarded the mechanical arts as the most important branch of true philosophy. Colbert believed that the industry of the people and establishment of manufactures represented a country's greatest resources. What a *bizarrerie* it was that those on whom people relied for the necessities of life should be so scorned![91]

As Diderot pointed out in the 'Prospectus', Chambers had added scarcely anything to the understanding of the mechanical arts; he had read books but had not taken the crucial step of making site visits to workshops.[92] In contrast, Diderot asserted that he and his associates would have recourse to the most skilled workers in the kingdom at their places of work, questioning them, writing down what they said, developing their thoughts, drawing out the correct terms, laying out tables of these terms and defining them, talking with those who had produced the text, checking with others that which had been imperfectly, obscurely and sometimes unreliably explained. It was even proposed that the reporters should become apprentices themselves, taking machines apart and putting them back together in order to teach others how to make them properly: 'Dans un attelier, c'est le moment qui parle, & non l'artiste.'[93]

In accordance with the Baconian tree of knowledge in which arts, crafts and manufactures came under the heading 'uses of nature', the description of each trade would follow a logical path from raw material through preparatory stages to product; then the tools and machines employed would be presented, both in their constituent parts and assembled together. The workmanship and principal operations involved would be illustrated in one or several plates, sometimes only with the hands of the artisan in action and sometimes the whole person. Finally, the terms peculiar to the art would be defined as exactly as possible. As the 'Prospectus' continued (in words already encountered in the preface to the *New and Universal Dictionary*), given that people were little used to writing and reading works on the arts, it was difficult to explain them in an intelligible manner; hence the need for figures: 'Un coup d'oeil sur l'objet ou sur sa représentation en dit plus qu'une page de discours.' Thus, the emphasis placed on illustration as an intrinsic part of the whole endeavour, bound in with the text, was spelt out from the start. Draughtsmen had been sent to ateliers to make studies of machines and tools: 'On n'a rien omis de ce qui pouvoit les montrer distinctement aux yeux.'[94] Diderot conceived of the programme along clear, rational lines, privileging materials, products, machines and operations.

Where a machine merited being shown in detail on account of the importance of its use and multiplicity of its parts, in the first figure as many of its elements would be assembled as could be observed without confusion; then other elements would added gradually, so that the most complicated machine could be understood without difficulty for the mind or eye. Sometimes it was preferable to learn about the machine first and then the work process, sometimes the other way round; further reflections on this matter were to be found in the article on 'Art', also written in 1750, to which the reader was referred at this point in the 'Discours Préliminaire'.

Diderot's article on 'Art' was more or less exclusively devoted to the mechanical arts and enlarged on his purpose. He proposed that a general treatise should be written on them, in effect a Baconian 'History of Trades' which combined the efforts of philosophers and artisans. Only the former could explain through their reasoning powers the origin of trades, the meaning of phenomena and the solution to difficulties, guiding through step-by-step synthesis those who were less gifted and articulate towards improvement. He advocated the adoption of a systematic approach whereby when a complex machine like a clock was used to produce a simple result, the result would be presented first, which would not puzzle the mind or burden the memory, and then the machine would be described. When a simple machine produced a very complex action, as in the textile trades, then the machine would be described first so that the results made sense. This synthetic approach was undoubtedly inspired by the volume of Hindret drawings of a stocking machine that Diderot had found in the royal library. They built up the machine from its core, allowing parts to be seen clearly before adding layers which hid them, sheet by sheet.[95]

Yet, as the son of a master cutler, Diderot was well aware that the mechanical arts could not be reduced to the abstract mathematical and mechanical principles espoused by his co-editor, d'Alembert. Elements of mathematics and more specifically geometry were necessary for most trades but paradoxically, he asserted, they were in fact the simplest of the issues with which artisans had to grapple in practice. Although their horizons were limited, they dealt with the irregularities of natural materials, differences in elasticity and stiffness, softness and hardness, the effects of air, water, cold, heat, dryness and so forth. Much could not be quantified and indeed, Diderot pointed out, in a jibe which recalls Swift, those who only understood abstract as opposed to applied geometry were usually maladroit. How many bad machines had been proposed by people who assumed that levers, wheels, pulleys and so on worked in a machine as they did on paper and could not distinguish their outlines from the effects of the machine in the hand of a worker? There was the problem of friction which could upset calculation. Some machines succeeded on a small scale and not full-size and others vice versa. What were the optimum dimensions for a watch, a mill or a ship? Diderot believed that these questions would be solved primarily through applied geometry and age-old handling skills (*manouvriere*), assisted by the nimblest kind of abstract geometry. It was impossible to achieve anything if applied and intellectual realms, artisans and philosophers, remained separate. Only by their working together in open collaboration would problems be solved, although even then, he did not underestimate the difficulties.

One major problem Diderot anticipated encountering was the language of the arts – both the dearth of appropriate words and the abundance of synonyms. A tool might have many different names or was only known by a generic name without any qualifier to describe its purpose. Sometimes the slightest difference in a tool was enough for artisans to invent a new name; other tools had no names; still others might share a name even though they had nothing in common. The language of description changed from one manufacturer to another. Yet Diderot believed that as complex machines were only combinations of simple machines and as all machine movement was either linear or circular, a good logician familiar with the arts would be able to create a grammar of the arts. First weights and measures would have to be standardised and then the forms and uses of instruments and tools. It was the lack of exact definitions and the quantity of words employed, not the diversity of actions, that made the arts difficult to talk about with clarity. The only remedy was to study the arts at close quarters, a practice which conferred both profit and honour. In which system of physics or metaphysics would one observe more intelligence, more wisdom and better results than in a machine producing gold wire or making stockings? What mathematical demonstration was more complicated than the mechanism of certain clocks?

Thus Diderot tempered d'Alembert's abstract mathematical logic with a firm commitment to experience in the real world. It was time for artisans to receive the recognition they deserved. The liberals arts had sung their own praises quite enough; they should sing those of the mechanic arts and stop them from being vilified through prejudice. If artisans thought better of themselves, they would produce better products. Rulers should protect them from poverty. Academicians should visit their ateliers and gather together their practices and promote them through their writings. By such means workers would be encouraged to read, philosophers to think usefully and great men finally to put their authority and bounty to good use. *Savants* would learn not to dismiss inventions too hastily and artisans would be inspired to make sure that their inventions did not die with them.

Diderot's materialist philosophy brought him face to face with the problem of representation. As he himself acknowledged, there was a vast gulf between the tacit skills of artisans, the workings of real machines, not to mention the language used to describe

them, and his proposed treatise and grammar of the mechanical arts. In so far as the *Encyclopédie* aspired to fulfil these functions, he must have realised that it fell far short. The information gained on site visits could never be wholly distilled into text and image, for many other senses besides sight – touch, smell, sound, even taste – were combined in the production process, as part of complex systems of intuitive knowledge which could not be observed and set down in clearly defined stages and rules. Little allowance could be made for the atypical – for experiment, problem solving and innovation. Without animation, it was impossible to recreate movements in the images. His work was more of an attempt to mediate between the ideal and reality, one further reflected in the plates. He proposed to confine them to the most important actions of the workers and to those stages in the operation which were easy to draw but difficult to explain. The *Encyclopédie* was never intended as a glorified do-it-yourself manual. According to Diderot, the purpose of the plates was two-fold. They provided serious readers with the opportunity to satisfy their curiosity by reproducing the experience of witnessing the workers in action and thereby the better to appreciate their value. For artisans, the plates helped to rationalise processes and contributed to an understanding of the philosophical or mathematical principles which would enable them to advance their arts towards perfection.[96] Diderot's was an expansive vision, more broad-brush than nitty-gritty detail.

In his 'Prospectus' of 1750, Diderot boasted that the plates would far exceed those in the *Cyclopaedia*, promising more than six hundred. In the event there were nearly 2900, which appeared in ten parts (eleven volumes) from 1762 to 1772 under the title *Recueil de Planches sur les Sciences, les Arts libéraux et les Arts méchaniques, avec leur Explication.*[97] At least they impressed readers by their quantity. In his article on 'Encyclopédie' published in 1755, by which time a thousand plates had been completed (but not published), Diderot emphasised their difference from those found in the books on machines of Ramelli and Leupold and even from the illustrations of inventions approved by the Académie des Sciences. His plates represented machines which were actually in use: 'Il n'y a rien ici ni de superflu, ni de suranné, ni d'idéal: tout y est en action & vivant.' They were specifically designed by Diderot to overcome the problems posed by the static format of publication, not only through pictorial analysis of machines and their parts but through recording processes. Nevertheless, towards the end of his lengthy account of the editorial problems involved, he admitted that he had experienced difficulties in dealing with artisans, some of whom were unable to describe their work, while others were actively misleading. He urged government action to make guilds divulge their secrets without exception. The watchwords of an encyclopaedia should be '*communia, propriè; propria, communiter*', loosely translated as collaboration and order.[98]

It was impossible to fulfil these high ambitions in practice. The three-way relationship of the articles, the plates and the descriptions of the plates keyed to the same reference system could not be maintained with any consistency. Lapses of time from the publication of the articles, the commission or acquisition of the drawings to publication of the plates a decade or more later meant that frequently the cross-references in the original articles were rendered meaningless by the plates as published, which could only be understood through the shorter descriptions in the plate volumes. To be on the safe side, in the main articles editors frequently resorted to a simple 'voyez les planches'.

These practical difficulties were exacerbated by the conventions of the visual communication adopted – drawing and engraving – which got in the way of the rational explanations that Diderot had promised. Even at the time, the status of drawing and engraving in the academic hierarchy militated against their being considered merely as transparent media for recording reality. Far from being counted among the mechanical

arts, in the tree of knowledge drawn up by Diderot and d'Alembert engraving was listed along with other fine arts – poetry, drama, allegory, music, painting, sculpture – under that branch of human understanding called imagination. As a sister art to painting and sculpture, engraving was free from enforced organisation into a professional community or guild. From 1654, the best engravers could become members of the Académie Royale de Peinture et Sculpture.[99] The leading engraver of the day, Charles Nicolas Cochin the younger, drew a frontispiece to the *Encyclopédie* in 1764, probably at the behest of the printer-publisher Lebreton, and exhibited it at the Salon of 1765. Engraved by Louis Benoît Prévost in 1772, it was issued following the completion of the great work (fig. 114). Its design took its cue from the tree of Diderot and d'Alembert, with all the Arts and Sciences turning to Truth from whom they received enlightenment, although, significantly, Cochin did not precisely identify the mechanical arts.[100] The thirty-nine plates devoted to design (volume 3, 'Dessein'), were composed under the direction of Cochin – who also drew the introductory vignette depicting an academic drawing class – to illustrate the treatise on design written by Prévost.[101] These plates were based on life drawings and exercises by leading French artists: Fragonard, Bouchardon, Jouvenet, Le Brun, Boucher and Poussin. This was the company which France's leading engraver wanted to keep.

The long article 'Gravure' in the *Encyclopédie*, drafted by the rich amateur Claude Henri Watelet in 1757, was based with due acknowledgement on Abraham Bosse's *Traicté des Manières de Graver en Taille Douce* (1645) and particularly Cochin's revised and extended third edition, *De la Manière de Graver à l'Eau Forte et au Burin et de la Gravure en Manière Noire* (1745). Watelet also provided a commentary, drawing on his own experience to emphasise, for example, the dangerous fumes created by the manufacture of the acid used for biting the plate and that air should circulate freely in the place where the acid was being heated. Classified as part of the *beaux-arts*, engraving was, he concluded, a very difficult art:

> il demande beaucoup d'exercice du dessein, beaucoup d'adresse à conduire les outils, une grande intelligence pour se transformer, pour ainsi dire, & prendre l'esprit de l'auteur d'après lequel on grave. Il faut encore de la patience sans froideur, de l'assiduité sans dégoût, de l'exactitude qui ne soit pas servile, de la facilité sans abus: ces qualités si nombreuses enfantent beaucoup de graveurs, & leur union si difficile faire qu'il en est fort peu d'excellens.

Prévost's more concise explanation accompanying the nine plates devoted to engraving (volume 5, 'Gravure') echoed Watelet's article by arguing vigorously against the consideration of engravings as mere copies:

> La gravure doit être précédée par l'étude du dessein, cet art en est la base: c'est le germe du goût qui doit la vivifier. Nul sentiment, nul progrès en gravure sans une expérience consommée dans la pratique du dessein. Enfin la seule différence qui soit entre ces deux arts, s'il est vrai qu'il y en ait une, ne consiste que dans les moyens d'opérer, la matiere sur laquelle on opere, & le chemin plus court ou plus long qu'il faut tenir pour arriver au même but; tous leur est égal ailleurs, principes, harmonie, goût, intelligence, ils on chacun la nature pour modele.[102]

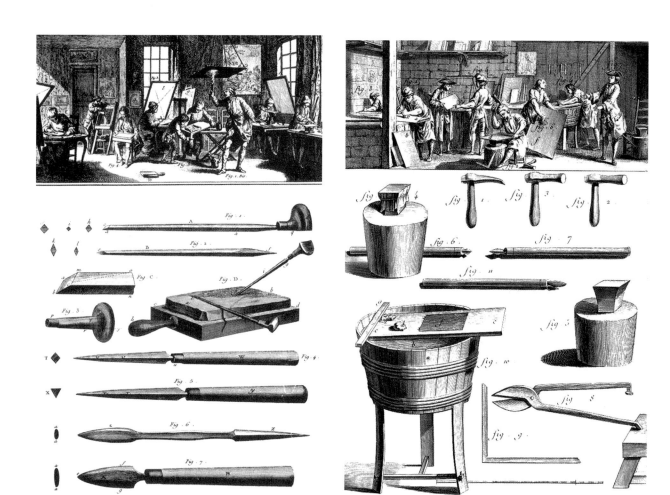

115 (left) Robert Benard after
Charles Nicolas Cochin,
'Gravure en Taille-douce',
Receuil, vol. 5, Paris 1767

116 (right) Robert Benard
after Desgerantins,
'Chaudronnier Planeur', *Receuil*,
vol. 3, Paris 1763

The vignette of the busy engraving studio, engraved by Robert Benard, shows etchers and engravers about their different tasks in a setting more carefully delineated than most, with wallpaper, curtains and an assortment of paintings and plaster casts on display, as if to boost the credentials of the trade to be a liberal art without resorting to any flying figure of 'genius' (fig. 115). It was peopled with workers engaged in different tasks taken directly from Cochin and Bosse.[103] The succeeding plates, drawn by Prévost himself and engraved by Benard, covered not only the tools employed in all aspects of the engraver's trade but also examples of prints produced after academic works, thereby emphasising the taste required to execute them. With the help of the plates Prévost explained the processes, described the tricks of the trade, criticised practices of which he disapproved and recorded the acid bath enclosed with a lid invented by Watelet which safeguarded artists during the etching process.[104] Such an informed overview of an art was unusual for, almost uniquely (the same could be said of the printers), its practitioners were firmly in control of the way in which they were represented. This was no transparent window onto the world of engraving but one highly conditioned by the engravers' view of their own status and by conventions established over the preceding century. Diderot could not afford to alienate a trade on whose collaboration the future of his great enterprise entirely depended. Significantly, the engraver shown picking up a copper plate from the makers (volume 3, 'Chaudronnier') had the appearance of a gentleman and wore a sword (fig. 116).

It was to be a long-standing grievance for engravers in England that from its foundation in 1768 the Royal Academy of Arts excluded engravers from membership on the grounds that they were mere copyists, lacking originality and thus excluded from the

highest honours.[105] In France, engravers could be Academicians and the 'Chaudronnier' plate appeared to present them as liberal artists. However, against the views advanced by engravers themselves must be balanced those of Diderot who seems to have taken very little interest in engraving as an art compared with painting.[106] In his reviews of the Salons he rarely dealt with prints. Even when he discussed the leading engraver of the day, Cochin, he was chiefly concerned with his drawings. When he first came to consider engravings at all, after a visit to the Salon of 1765 in the company of the engraver Pierre Philippe Choffard, the author of another learned treatise on the art, he concluded that only knowledge of technical criteria was necessary to judge them, as opposed to consideration of the inventive or imaginative capacity of paintings to fulfil the highest poetic or ideal ends. Nevertheless, Diderot recognised engraving's fundamental role in diffusing knowledge of paintings and thus taste. Engraving was not a negligible art: it transmitted to posterity the reputation of painters, developed taste and served as a reference but ultimately its role was that of faithful transcription. According to the mechanical view of the world which had been promoted in philosophy since Descartes, what passed through the eyes entered the mind unmediated.

Thus, in effect, even at the Salon Diderot seems to have considered engraving more of a mechanical than a fine art, an attitude which explains his overall emphasis on the mechanical clarity and utility not the beauty of the *Encyclopédie* plates. The five draughtsmen and engravers who undertook the bulk of the work were not on the high level of Cochin but were mainly ornamental print-makers and book illustrators and as such controlled by the Communauté des Libraires rather than the Académie Royale de Peinture.[107] Louis-Jacques Goussier, J. R. Lucotte and Radel executed most of the drawings with Prévost and Defehrt undertaking many of the engravings. From volume 4, Robert Benard directed the execution of the plates. None except Prévost made his mark outside the specialist world of the *Encyclopédie* and, although they were all capable of highly competent technical drawing, none appeared to aspire to the vision of engraving as a liberal art exhibiting the highest poetical standards of design. Instead, their aim was clear outline engraving using rules and other geometrical instruments to produce clean orthogonal perspectives, elevations and plans of those aspects of trades which could be represented easily: materials, products, tools and machine parts.

Goussier was Diderot's chief assistant on the mechanical arts, his articles being designated by the symbol D.[108] He was born in Paris, studied art and mathematics, led a bohemian existence and served as the model for the unconventional Gosse, *original sans principes*, of Diderot's *Jacques le Fataliste*. He earned his living by teaching mathematics and acting as an assistant to publishers, men of letters and scholars. His collaboration on the *Encyclopédie* began in 1747, possibly having been recruited by d'Alembert. For the seventeen volumes of letterpress he provided more than sixty-five articles, including many descriptions of instruments and machines. For the eleven volumes of plates, he was the main designer, with hundreds of works ascribed to him. He also wrote the commentaries for many of them, some of which, like the forty-five-page 'Forges', were lengthy articles.

A number of designs attributed to Goussier were copied from the unpublished collection of the Académie des Sciences but many more were created or improved by him. His forte was systematic mechanical drawing usually accompanied by precise measurements, as, for example, with his designs for 'Papeterie' for which he also contributed the main article and the plate descriptions, based on information supplied by the director of the large paper-making establishment at Langlée, near Montargis, which he also visited. As John Pannabecker has pointed out, Goussier systematised the complex art of paper-making into a smooth process from rags to paper, ignoring the difficulties which French artisans experienced when working the latest Dutch machinery.[109] The tendency

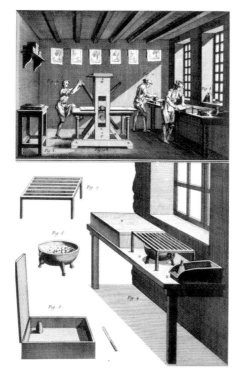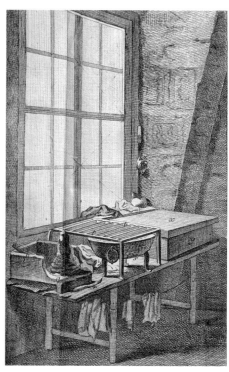

in his vignettes for the figures to be out of scale with the settings, most noticeably in those devoted to the art of enamelling and painting on enamel (volume 4, 'Emailleur') with small women and over-large men, implies that these could have been added by another artist, Goussier having first designed the setting and machinery. Typically, he himself removed details which suggested a workshop atmosphere or the messiness of a particular process. For example, his drawing of a printer's table and heating grill for 'Imprimerie en taille douce' (volume 7) is taken directly from plate 19 in Cochin's edition of Bosse but reduced to a linear system with all the idiosyncrasies taken out – notably the rag wrapped round the ink-ball and other rags lying on the table and suspended on a line attached to the legs (figs 117 and 118).

Diderot and Goussier collaborated closely on the *Encyclopédie* for at least twenty years. They worked together at the publishers and Goussier also visited Diderot at home and even in prison at Vincennes in 1749. He accompanied Diderot to ateliers to illustrate trade techniques while Diderot made notes on them. Diderot also sent him on trips not only to Langlée but also to Cosne-sur-Loire, Champagne and Burgundy, where he gathered information on the manufacture respectively of anchors, iron and glass. His desperate requests for money Diderot must have found trying but he described him in a letter of May 1768 as 'un homme d'un mérite rare'.[110] Tribute was also paid to the accuracy of his drawings in the 'Discours Préliminaire' (p. xliv), combining drawing skills with knowledge of mechanics.

J. R. Lucotte was second only to Goussier in the contribution he made to the plates. The son of a master ironsmith, he was mainly employed as a draughtsman, producing more than 650 designs (for which 5 drawings are known), 47 explanations and 12 articles mainly connected with the building and joinery trades. He studied architecture at the Ecole des Arts instituted by the architect Jacques-François Blondel, which included among its teaching staff artisans and advanced students. Lucotte was capable of producing highly technical plates, such as those for carpentry (volume 2, 'Charpenterie'), furniture-making (volume 7, 'Menuiserie en Meubles') and different weaving looms

(volume 11, 'Tisserand'). Yet he (or his assistants) could also be perfunctory, reducing figures to little mannikins. He was not above copying directly from Charles Plumier's *L'Art de tourner* (1701) and Blondel's *Architecture française* (1752–6).[111] In 1772 he published *Vignole Moderne, ou Traité Elementaire d'Architecture*, a second volume in 1781 and a third in 1783, when he also produced the plates for *Art de la Maçonnerie*. Of the seventy-seven categories of illustration specifically denounced by Patte, more than twenty per cent were by Lucotte.

Much less is known about Radel who was evidently an architect and *ornemeniste* who worked also for the master joiner Roubo fils, illustrating his *Traité de la Construction des Théâtres Anciens et Modernes* (Paris, 1777).[112] Some of the finest plates in the whole series were undertaken by Radel: for example, the two pages devoted to the interior of an upholsterer's and the series devoted to the manufacture of Gobelins tapestries (both volume 9, 'Tapissier'). Defehrt, employed by the Libraires Associés as an engraver for the *Encyclopédie* plates, also remains obscure despite completing 378 plates for the first five volumes, not always accurately.[113]

The plates usually follow a similar format, first developed for the *Descriptions des Arts et Métiers* and refined along the lines Diderot set out in his 'Prospectus', to illustrate the workmanship and principal operations. For the first plate in each sequence a vignette at the top showed the scene in a particular *attelier* (as atelier or workshop was consistently spelt at the time), *boutique* (shop) or *salle* (room), while below was a selection of *outils* (tools) or machines used in the manufacturing process, often drawn to scale, in perspective, section and plan. The vignettes, as Diderot had proposed, focused on the most important steps in the process of manufacture rather than presenting a flow of the process of production in a 'cartoon strip' series of frames. Nevertheless, they conveyed something of the milieu in which the craftsmen worked, opened out to public view as if on a stage.

This theatricality of presentation was not new. It is evident in many of the plates for the Abbé Nollet's *Leçons de Physique Expérimentale*, published in a series of volumes and impressions between 1743 and 1764. There, the inclusion of elegant furnishings on which various scientific instruments were placed, as well as demonstrators and the audience of amateurs, nobles and ladies who attended his lectures, served to ensure that potential purchasers were not put off by the dry rigours of science.[114] Even the plates to Gallon's *Machines et Inventions* (1735) occasionally featured people, as in the illustrations of M. Pascal's arithmetic machine and M. Maillard's extraordinary gondola pulled by a clockwork sea horse.[115] Similarly, the *Encyclopédie* vignettes humanised what would otherwise have been a dry compendium of tools and machines. For lay readers they represented its most obviously attractive feature. They also seemed to provide visual evidence supporting Diderot's claim to site visits. The vignettes attempted to fulfil his ambition to provide serious readers with the experience of witnessing the workers in action. Yet, despite the superficial appearance of naturalism, they were, as explained in relation to engraving, highly stylised, suspended in time and usually generalised in place, frequently combining several operations in a single image which in reality would have taken place sequentially. They did not convey the mess and the grime of the workshop, the depiction of which would have obscured representation of the work processes. Instead, they represented 'perfect' actions without any hint of accidental occurrences sometimes described in the texts, especially those composed by practitioners of the arts concerned.[116] There was no element of arbitrariness or disorder to threaten the harmony of the encyclopaedic endeavour. In effect, the process was purified, as Diderot intended, to make it more readily comprehensible and to reveal what should no longer be hidden.[117]

Subsequent plates in a particular sequence contained more tools and sometimes a range of *ouvrages* (products) for example, pieces of furniture, silverware, carriages or

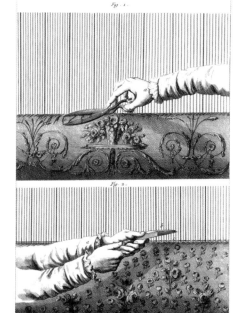
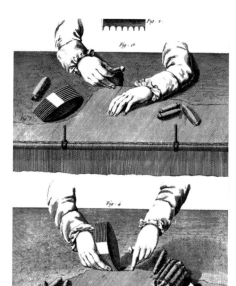

119 (left) Robert Benard after
Radel, 'Tapis de Turquie',
Receuil, vol. 9, Paris 1771

120 (right) Robert Benard
after Radel, 'Tapisserie de Basse
Lisse des Gobelins. *Receuil*, vol.
9, Paris 1771

wrought-iron gates, creating plates which differed little from those to be found in pattern books. The tools and machines were usually drawn in orthogonal perspective to enable the viewer to recognise them and then in 'exploded' views and 'cutaway' sections to aid understanding of processes that otherwise would have remained unseen, drawing the viewer in easy stages towards understanding, as Diderot had proposed in his article 'Art', 'sans obscurité ni fatigue à la connaissance d'un tout fort compliqué'. These technical plates were mostly devoid of human beings except for single figures or disembodied hands working particularly complex manual processes usually connected with textile manufacture. Seven high-quality drawings dating from the 1750s, demonstrating the different stages of carding and spinning cotton by hand (processes soon executed by machine), were used as the basis of illustrations for the section on cotton in 'Oeconomie Rustique'.[118] By far the finest were those engraved by Benard after Radel to depict various stages in carpet and Gobelins tapestry manufacture, showing pairs of hands making knots and velvet, holding sheers, as well as weavers working looms (figs 119 and 120).

The *Encyclopédie* divided 'Manufactures' into those which were *réunies* (amalgamated/large-scale) and those which were *dispersées* (scattered/cottage). According to the article, amalgamated manufactures required a large number of hands and followed set patterns of work. They made useful products allowing for some variation but were not subject to the vagaries of fashion. Either they had to make profits or were protected by the government. Regulated by the clock, workers were more controlled but better fed. In contrast, cottage industries were worked by families, employed children, made little profit and were more vulnerable. The greatest quantity of plates seems to have been devoted to the most luxurious trades or to the largest industries – textiles, iron, glass – although this pattern was distorted where Diderot had access to large quantities of visual material. Yet, besides the coverage of grand royal manufactures like Gobelins, the *Encyclopédie* plates also give a strong impression of the *petits maîtres* who provided a predominantly Parisian clientele with specialist luxury goods. Eight plates were devoted to artificial flower-making (volume 4, 'Fleuriste Artificiel'), ten plates to a dealer in arms (volume 4, 'Fourbisseur'), eleven plates to the jeweller (volume 8, 'Orfèvre Jouaillier') and twenty-four to the tailor (volume 9, 'Tailleur d'Habits'). Although the vignettes are

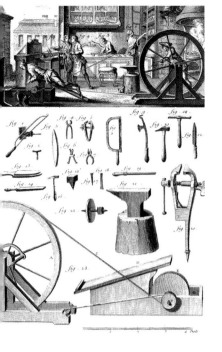

stylised, they generally convey with the help of perspective, shading and occasionally circumstantial detail, men, women and sometimes children in the attitudes and surroundings of their work.

Workshops or ateliers contrast with elaborately decorated luxury shops comprising a *boutique* and *magasin* (first-floor showroom). In the workshops, manual labour, tools and materials are shown, sometimes in a space open to the street. The shops usually have a glazed frontage,[119] a sales-counter, display cabinets and shelving embellished with decorative panelling, mirrors and seating. Sometimes a genteel transaction between proprietor and customer is depicted taking place.[120] Nevertheless, these plates did not aspire to rival the elegant 'fine art' prints of social manners enacted in decorative interiors by Moreau le Jeune and others. In contrast to the subtle play of light, shade and atmosphere conveyed in the latter's works, the *Encyclopédie* shops were usually depicted in a basic fashion, preternaturally clean and tidy with a simple source of light from a window.[121] A specific place is rarely suggested in the plates or their accompanying description. On only one occasion, in relation to a small vignette of a cutler's workshop (volume 3, 'Coutelier'; fig. 121), was it stated specifically that it represented a Paris boutique, perhaps to make clear that it did not depict the cutler's business of Diderot's father in the provinces.

Locations were otherwise only given for large-scale industries, such as the ironworks at Fordenberg or royal manufactories. The greatest care was taken with state enterprises, as noted, the plates by Radel depicting the tapestry manufacture at Gobelins (volume 9, 'Tapisserie de Haute Lisse des Gobelins') and the related dyeing establishment (volumes 9 and 10, 'Teinture de Gobelins') and the same artist drew in plan and section the four halls of the Verrerie Royale near Paris (volume 10, 'Verrerie'). But certain luxury trades were missing: 'Marchande des Modes' and 'Porcelaine' manufacture only appeared in a perfunctory fashion in the *Supplement* of 1777, despite being covered in the letterpress volumes, in the latter case possibly because the new manufactory at Sèvres was still in the course of construction when the plates were being commissioned.

The figures in the vignettes are anonymous, with little sense of individuality other than their dress, and they do not, on the whole, communicate with one another. They sometimes wear a form of work-clothing, such as aprons in the needle-making workshop (volume 1, 'Aiguillier') or the protective tabards and visors worn by the workers in the crown glass factory (volume 10, 'Verrerie en Bois, grande verrerie'). Some indication is given of social hierarchies, albeit without any signs of friction. In the vignette for roofing (volume 1, 'Courreur'), an architect in genteel attire is depicted giving orders to the foreman, who holds a set-square and gestures in the direction of his workmen who are busy re-tiling a roof. In the background a man flees from falling tiles – an extremely rare if not unique instance in the *Encyclopédie* plates of an accidental event disturbing the smooth flow of labour. In the carpenter's timber-yard (volume 2, 'Charpentier') the *maître compagnon* receives orders from the master. The master blowers in the crown glass factories of Normandy (volume 10, 'Verrerie en Bois, grande verrerie') are described as *gentilhommes*, a status they had enjoyed from the fourteenth century when the monopoly was acquired by four families, while those working in the 'petite verrerie' are simply *ouvriers*.[122]

Among the women employed in the spinning industry, a distinction is made between the *ouvrière* who use thread-reeling machines (volume 4, 'Fil Devidoirs') and the *femmes* using spinning wheels ('Fil Roue'), the latter being better dressed, perhaps because the art also qualified as a genteel amusement. Sometimes women are depicted in mixed sex settings: in the gold-beater's workshop (volume 2, 'Batteur d'Or') there are four men

and two women. Some trades are an exclusively female preserve, conducted in more feminine surroundings, such as the embroiders' atelier (volume 2, 'Brodeur') or the feather dealer and hat dresser (volume 8, 'Plumassier-Panachier'). In a few plates, the manager or owner seems to be a *maîtresse*. For example, in the cutler's boutique (volume 3, 'Coutelier'), she arranges the products on the counter. Again, in the jeweller's shop (volume 8, 'Orfèvre-Bijoutier') the *maîtresse* is at the weighing counter, selling pieces of jewellery. Children are included in some plates, working in the atelier for making artificial flowers (volume 4, 'Fleuriste Artificiel'), cutting up rags in the great royal paper factory of Langlée (volume 5, 'Papetterie') and assisting spinners and weavers at the Gobelins tapestry factory (volume 9, 'Tapisserie de Haute Lisse des Gobelins').

Can these images be seen as propaganda on behalf of technical advance or even, as some have argued, prophetic of the dehumanisation of labour that accompanied the Industrial Revolution? Was the *Encylopédie* essentially an 'early capitalist utopian vision', an attempt to remove the inefficient and inarticulate world of work from workers to management?[123] As already noted, Diderot intended to introduce scientific principles into the illustrations through geometric exactitude and measurement, applied to tools and machines which are supposedly deconstructed and reconstructed according to a synthetic method. Yet the vignettes have a more complex message. They are rational to the extent that the worker is no longer portrayed as the instrument of God animating theatres of machines but as a social force specially adapted to a given section of organised work. In contrast to the allegorical figures to be found in encyclopaedic frontispieces, including that of the *Encyclopédie*, the artisans depicted in the *Encyclopédie* plates are firmly earthbound. They offered general reassurance that the trades depicted were clean, safe and that man's skills played a key role in the processes represented. However, to go further and assert, as some commentators have done, that the workers are impersonalised and neutralised, presented as docile self-sufficient automata executing scientifically determined tasks with the help of efficient machines, is to ignore the graphic conventions of the day. The plates were extremely varied in quality and culled from a wide range of sources, some dating back half a century. Any perceived lack of individuality in the mannikin-like figures is due to artistic shortcomings rather than sociological manipulation, whether conscious or unconscious. They should not be judged by the standards of life drawing in the academy, still less as transparent, objective representations of reality.

It cannot also be argued convincingly, on the basis of the plates, that specialised arts and skills were losing out to industries based on the division of labour, in which workers acted as cogs in increasingly mechanised operations. Diderot included a huge variety of *petits-maîtres* and the attention devoted to large-scale factories, although lavish, was of royal monopolies not of capitalist enterprises. They rarely reflected the industrial innovation that was taking place in these years, even in France. Jean-Rodolphe Perronet's contribution is the exception that proves the rule. He wrote serious articles on economics and gave an informative account of the slate quarries and coal mines of Anjou for volume 6 of the plates. The drawings of a pin-making factory, accompanied by five pages of explanation (volume 4, 'Epinglier'), are based on a memoir and three drawings describing pin manufacture at Laigle in Normandy, which Perronet made in 1741 when he was Ingénieur des Ponts et Chaussées at Alençon and sent to Diderot in 1759.[124] It is regarded as a landmark in the study of the divison of labour. Although Perronet did not explain the usefulness of this method of work for the economy in general, as Adam Smith did in his *Wealth of Nations* (1776), he discussed the many different kinds of workers involved in the process and he went beyond technical description to note the costs and time of many operations, the hazards associated with some, the pay-scale for individual jobs, as well as the costs and profits of the completed product.[125]

Furthermore, at a time when only a handful of Newcomen steam engines existed in France, Perronet submitted a detailed and exact report of one in operation near Saint-Guillain in the province of Hainaut in the Austrian Netherlands, written by his fellow engineer Mandoux and including an estimate of the machine's construction cost; it was illustrated in volume five of the *Receuil* with detailed plans, a section and perspective, classified under 'Hydraulique', a subsection of 'Mathématiques'.[126] On the basis of this paper Diderot wrote the article 'Feu (Pompe à)' for volume 6 of the letterpress. Yet, in general, given the origins of some of the plates, several decades prior to publication, it is not surprising that the *Encyclopédie* was scarcely in the van of representing technical progress. Even when new research was commissioned, there was no guarantee that the significance of innovations would be picked up. For instance, in his treatise on 'Forges', Goussier did not discuss coke-smelted iron, pioneered by the Darbys at Coalbrookdale.

The *Encyclopédie* was not intended as a bid to apply new theories to industry in order to change it. Its radical element did not come from a prophetic vision of industrial revolution or advanced capitalism but from its attempt to map the world of knowledge according to new boundaries determined by reason. Thus it included the mechanical arts within this framework and its efforts to explain their processes visually relied on the same balancing act between applied mathematical sciences and polite arts already discussed. Despite the weakness of the technical information collected by Diderot and his associates, the *Encyclopédie* provided an optimistic overview of productive labour and a method, however imperfect, for describing and organising it. Its rehabilitation of the mechanical arts was linked of course to Diderot's criticism of guilds and corporations. He hoped that the *Encyclopédie*'s analytical method would facilitate understanding, leading to the possibility of work being freed from restrictions, legal and otherwise. For Diderot, invention should not be closeted by secrecy and privilege but opened up through methodological analysis, imitation and translation. The *Encyclopédie*'s technical contribution might have been limited but its rational analytical methodology had a long-lasting influence on ideas about manufactures, at least in France.[127] It cannot be condemned for being excessively backward-looking nor should it be praised for being prophetic. The colossal quotidian process of description undertaken was enough to guarantee its status, in Baconian terms, as a key instrument of progress, judged by the criteria of public utility, shared discussion and evaluation. It exemplified the Baconian faith in progress through classification based on empirical experience and observation, on the belief that processes could be changed for the better if their principles were understood and that artisans would improve their skills if they knew the reasons for them. According to the tenets of the time, the *Encyclopédie* served as the crucial first stage in the process of generating technical innovation.

Further French Connections

The *Descriptions des Arts et Métiers*, 'faites ou approuvées par Messieurs de l'Académie Royale des Sciences', eventually started to appear in 1761, 'avec Approbation & Privilège du Roi', thanks to the organisational powers of Duhamel du Monceau. In his treatise, *L'Art de la Corderie Perfectionné* (1747), he had demonstrated his capacity, in an exemplary Baconian manner, to analyse the processes involved in a manufacture, to set up empirical research experiments and thereby to establish the principles by which they could be improved. The Académie's own project was similarly Baconian: 'd'examiner & de décrire successivement toutes les opérations des Arts méchaniques, persuadée que cette entreprise pouvoit également contribuer à leur progrès & à celui des Sciences'. Martine Jaoul and Madeleine Pinault have demonstrated how Duhamel and his nephew,

Fougeroux de Bondaroy, based at Duhamel's chateau of Denainvilliers, south of Pithiviers, undertook the arduous 'scientific' work of compiling, correcting and editing a mass of notes, manuscripts, drawings and plates to create some rapport between the world of *savants* and the world of industry prior to publication.[128]

In the preface to the first volume to appear, Duhamel's *Art du Charbonnier* (1761) (which also served as an *avertissement général*), presumably written by Duhamel, it was asserted that if the arts had been born and slowly advanced century by century through the gropings of industry, well before the establishment of learned societies, nevertheless, the most rapid progress had been made at a time when and in countries where the sciences had been cultivated most successfully. Progress in the arts of horology, artillery, navigation, scientific instrument manufacture and many other arts of the day, it claimed, had not been due to chance but to the efforts made to improve geometry, mechanics, chemistry, optics, astronomy and others. The geometrician, mechanic or chemist could help the intelligent artisan overcome obstacles that he had not managed to solve, showing him ways of making new inventions useful. At the same time men of science could learn from the artisan which parts of the theory should be applied to clarify practices and to secure sound rules, for the successful outcome of uncertain, delicate operations depended on the judgement of the eye or the turn of the hand. In other words, even the Académie acknowledged that the mechanical artists undertook the fine-tuning of experimental innovations, working in partnership with gentlemen of science.

Yet despite their illustrious pedigree, in so far as generalisations can be made from more than eighty different titles, the *Descriptions* and their plates seem to exaggerate the more wayward features of the *arts et métiers* in the *Encyclopédie*. Ostensibly, there was a conscious effort to explain them according to scientific principles but the personal predilections of the authors influenced the choice of subject matter. Furthermore, practical difficulties hindered the production of the plates, resulting in idiosyncratic visual treatments. Considering that the enterprise had been going since the start of the century, it is surprising how few illustrations had been prepared by 1761 – about two hundred plates according to the 'Avertissement' and presumably rather more drawings. There does not appear to have been any overall logic to the order of publication.[129] No doubt pragmatic decisions were made on the basis of the texts and illustrations ready for printing. The result is a series of volumes of varying weight, depth and quality, on a semi-miscellaneous spread of subjects. However, although there were overlaps with the *arts et métiers* content of the *Encyclopédie* (the *Descriptions*, of course, excluded subjects of philosophy, politics, religion and literature), on the whole the two enterprises complement rather than duplicate each other.

For *L'Art de Charbonnier* the plates, engraved by Lucas in 1717, were corrected by Patte in 1760, a practice which was often repeated. Coverage of other large-scale industries included paper-making (1761), slate quarrying in Ardoise (1762), iron mining and smelting (1762), silk-dyeing (1763), tanning (1764), sugar refining (1764), coal mining (1768–76), silk manufacture (1772–7) and distilling (1773). Eight of the forty contributors were members of the Académie itself, including Duhamel, Fougeroux de Bondaroy and Lalande. Their skills as philosophers, expertise in various branches of the sciences, travels and correspondence ensured that they were well placed to update Réaumur's earlier research.

Efforts were made in several *Descriptions* to keep at least some of the plates relatively topical. The lengthy *L'Art d'Exploiter les Mines de Charbon de Terre* (1768–79), written by the physician Jean François Clement Morand,[130] was illustrated with sections of mines, types of coal including fossils and maps of the location of coal mines in different countries culled from numerous sources (including Agricola) and engraved mainly by Claude Fessard in 1765. The second part, published in 1776, went into the practical

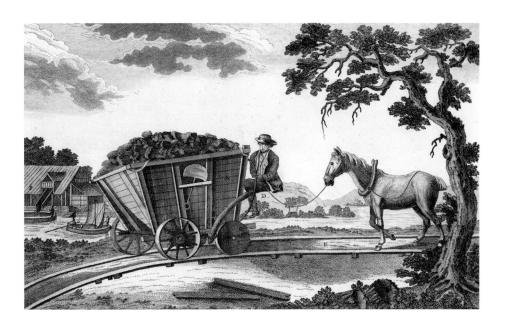

aspects of coal mining both industrial and domestic, including steam engines and miners' lamps. The sixty-five plates published in 1777 covered tools and equipment, methods of extraction and chimneys. Three plates (identified collectively as plate 34) were specifically described as being drawn by William Beilby at Newcastle in 1773: two images showed a *grand machine*, a horse-whim used for lifting coal, and the third, a perspective showing a coal wagon running on rails (*route planchiée*) with a man sitting on the brake as it went downhill and a horse being led on a rein behind (Fessard must have misunderstood the drawing, for one of the horse's hooves rests on the rail), with a Tyneside coal staithe in the background (fig. 122). Plate 35 showed Carlisle Spedding's flint mill (*rouet à fusil*) in plan, section and as operated by a boy. It supposedly lessened the risk of explosion by lighting an underground seam with a shower of sparks created by rotating a thin steel disk against flint at high speed. Other plates depicted in elevation, section and plan parts of the Newcomen engine used to pump water out of Griff Mine, Warwickshire, and in greater detail one at the mine of Fresne near Condé. Morand attempted to make comparisons in the specifications and effectiveness of French and English examples. The European travels of men like Lalande and Gabriel Jars, published reports and private correspondence, scientific and economic societies, all helped to spread news of the latest mining methods and machinery.[131]

In other volumes, the time-lag was more difficult to disguise. The advertisement for Lalande's *Art de Faire le Papier* (1761) conceded that M. Desbillettes had been given the task of describing the process at the end of the previous century, that eight plates had been engraved (by Simonneau) in 1698 and a description read to the Académie in 1706. For the published work, the plates had been retained with some inevitable changes. But the draft text was abandoned in favour of an updated version, with submissions by different authors from different provinces as well as by the author himself. Furthermore, the description was promised of a new type of cylinder mill, used mainly in Holland, albeit first illustrated in an engraving made in Amsterdam in 1734.

However, the limitations of this very engraving awakened in the author, presumably Duhamel or Lalande himself, strong views that went to the heart of the whole endeavour. It had been accompanied by the simplest notes in Dutch which provided no explanation; indeed, the design itself deliberately hid the salient features and so altered the proportions as to render imitation useless. As a result, the description of the machines

and processes used at the celebrated paper factory of Langlée, given by one of the owners, M. de Mélié, was all the more important. They had been improved on the basis of twenty years' experience and did not suffer from low dissimulation, jealous fear and the selfish zeal which prevented the arts from being better known and had been the sole impediment to their improvement.

Echoing Diderot, the author then launched into an impassioned plea to open up the arts for the enrichment of the nation.[132] Hitherto, the vast majority of artisans had kept their working methods secret. They placed personal interest before the common good, the glory of the citizen, the improvement of arts and even the self-satisfaction of being useful. Many really believed that foreigners would benefit if they were to disclose their trade practices. In response the author asserted that sharing knowledge to improve the arts was preferable to staying eternally in a state of mediocrity and routine from which there was no escape. The arts depended on the sciences but the sciences could not understand the arts on their own. In ateliers, they had found, 'un détail rebutant, un langage bizarre, une défiance choquante, une routine aveugle, des vues bornées, des pratiques superstitieuses, une ignorance profonde sur les forces de la nature & sur les principes de l'Art'. However, the more intelligent, confident and affluent artisan was able to share what he knew, and thus render to *savants*, artisans and the arts a most important service. Others – presumably men of science – would be able to progress onwards, summarise the techniques, cut out the redundant research and experiments, improve the arts, enrich the country and serve humanity.

According to the author, the successful gathering of information about *arts et métiers* required publicity, reciprocity, confidence and the openness which could only be found in academies. Directly addressing artisans, he pointed out that if they were tempted to frustrate the foreigner, they would necessarily also frustrate their finest fellow citizens, for they too would be deprived of knowledge. Let enemies profit while the nation was enriched, he urged, rather than losing advantages through reticence. The benefits of the arts and sciences working together were apparent from the *Descriptions* themselves, in getting rid of the veil covering many curious things. Perhaps by these means there would be a revolution in the mechanical arts comparable to that which had occurred in the sciences in the previous century. The plates by Patte supported Lalande's conscious drive to improve on what had gone on before. They depicted both the Dutch mill and the factory of Langlée in plan and elevation (Goussier had drawn the same factory in plan and perspective for *L'Encyclopédie*), an elevation and plan of the cylinder paper mill used there, together with details of its chassis and roller. Yet there were still limitations for, as was noted, it was not possible to provide a scale because the diversity of objects represented was too great.

In some instances, the authors did receive and acknowledge the help of artisans. Thus in the preface to the *Art de la Teinture en Soie* (1763) the distinguished chemist Pierre-Joseph Macquer mentioned not only the assistance of his predecessors at the Jardin du Roi (where he held a professorship) and at Sèvres and Gobelins (where he acted as consultant) but also the generous help of one particular artisan who had kept nothing from him: 'Je souhaiterois beaucoup pouvoir le nommer ici avec les éloges qu'il mérite à si juste titre; mais sa modestie me prive de cette satisfaction, & le porte à vouloir demeurer inconnu.' The commercial benefits of dyeing were well known but while its practitioners had made some improvements, there were still many difficulties to overcome and defective processes to resolve, Macquer hoped, through collaboration between the most enlightened men of science and most intelligent artisans.

Another successful alliance between *savant* and artisan was demonstrated in the description of *L'Art du Coutelier en Ouvrages Communs* (1772). It began with a favourable report by Fougeroux de Bondaroy apropos a visit he had made in 1763 to a co-operative

enterprise of iron and steel workers at St Etienne-en-Forez, south-west of Lyon. However, the bulk of the volume was given over to the precise and detailed text supplied by Jean-Jacques Perret, a master cutler in the Rue de la Tifferanderie, Paris. He showed himself easily capable of organising his treatise along rational principles, dividing the cutler's work into four parts: the making of blades, the working of handles, the joining together of the two parts and the making of nails. A large number of high-quality plates were used to illustrate the text, drawn by Goussier and engraved by Benard. One outstanding double page (plate 12) depicted a cutler's boutique complete with armoires where the products could be locked away to reduce damage from humidity. Other plates produced under Perret's guidance, drawn and engraved by Pierre-Claude de la Gardette, depicted the wide range of products including surgical instruments, some signed by Perret as maker. Through his innovations in the field of surgical instruments, he became one of the most distinguished anatomists of the day, as well as being the provost of the cutlers of Paris and he wrote a number of other treatises on the art of instrument-making.[133]

The art covered most extensively by the *Descriptions*, with no fewer than 382 plates, was undertaken entirely by an artisan. *L'Art de Menuisier* (1769–75) by Jacques-André Roubo the younger, Compagnon Menuisier,[134] was prefaced by laudatory (if somewhat patronising) remarks from Duhamel addressed to his polite readership:

> Je puis assurer qu'il regne beaucoup d'ordre & de clarté dans cet Ouvrage; qu'il est écrit dans le style convenable à la chose; & je suis persuadé que ceux qui liront cet Art, seront surpris de voir au Titre qu'il a été fait par un Compagnon Menuisier. Que l'Académie seroit satisfaite si dans tous les Arts il se trouvoit des Ouvriers capables de rendre aussi bien les connoissances qu'ils ont acquises par un long exercice! Moins ce phénomene est commun, plus il fait d'honneur au sieur Roubo, & de plaisir à l'Académie, dont l'unique objet est le progrès des Arts & des Sciences. Ces considérations ont engagés les Libraires à rien épargner pour la perfection des Gravures.

Roubo stated that the work was organised in a manner that would facilitate the improvement of the mechanical arts. He also paid tribute to the late Duc de Chaulnes who supported his establishment and gave him work.[135] According to the letters, Roubo devised and drew most of the plates which far exceeded in range and quality any comparable English work. They demonstrated first an extraordinary command of geometry and perspective and then covered the wood-yard, profiles of different mouldings, joints, tools, window and door frames, parquet, panelling, bookshelves, choir-stalls, confessionals, pulpits, organ lofts and staircases. The third part described the specialised work of frame-making for carriages and furniture – from chairs to beds, tables, bureaux, buffets, screens, both plain and elaborately decorated – and then the art of the cabinet-maker, covering different woods, tools and designs for marquetry. The fourth and last part was devoted to the art of trellis-making or garden joinery, starting with the orders of architecture and going on to depict trellis-work of varying degrees of elaboration, culminating in a geometric elevation of an outdoor *salon de treillage* with galleries in two different styles of decoration, one Rococo and the other neo-classical.

For *L'Art du Fabriquant d'Etoffes de Soie* (1773–7) a member of the trade was also engaged – Jean Paulet, draughtsman and silk manufacturer (like his father) from Nîmes. The whole process of spinning and weaving was accompanied by clear, large-scale plates by Goussier, engraved by Benard and Paulet. This inclusion of luxury trades in a compendium of arts and sciences could be justified, no doubt, on the grounds that ultimately their progress depended on applied geometry, mechanics and chemistry, as did many other 'arts', from mining to paper-making. *L'Art du Distillateur* (1773), written by one of Paris's leading pharmacists, Jacques-François Demachy (1728–1803) of the

Académie des Curieux de la Nature, the Academies of Science of Berlin and Rouen and Maître Apothicaire of Paris, was dependant on chemistry, as were the arts of silk-dyeing and soap-making. The illustrations for distilling by Goussier ranged from technical processes to genteel products, from depictions of chemical laboratories to a lemonade shop fitted out in a luxurious style with mirrors and chandeliers.

Even the magnificent treatise devoted to the *L'Art du Facteur d'Orgues* (1766), written by the Benedictine monk and organ-builder François Bedois de Celles, from the Congregation of Saint-Maur, the Abbey of Saint-Denis, and a member of the Académie Royale des Sciences of Bordeaux, was highly technical, based on complex geometry and mathematical calculation.[136] Numerous plates included two huge (a four-page fold-out) engravings drawn and engraved by de la Gardette under the direction of Patte. The finest depicted in perspective the superb Rococo exterior decoration of the great 6666-pipe, 66-stop organ at the abbey of Weingarten in Swabia, Germany, completed in 1750 after thirteen years' work by Joseph Gabler of Ravensburg.

For many of the smaller *métiers*, however, the connections between the arts and sciences were more tenuous. The commissioning and publication of the *Descriptions* does not appear to have been based on any preconceived hierarchy of industry. On occasion, the endeavour seems to have more in common with the whims of seventeenth-century virtuosi than the designs of eighteenth-century rationalists, which is not surprising given its lengthy gestation period. Why Duhamel should have wished to devote space to *L'Art du Cartier* (1762) is not immediately clear, other than that there happened to be four plates on deposit in the Académie, made by Simonneau in 1697. He arranged for these to be corrected by Patte who added a fifth. Duhamel also got his own memoir of the art checked by M. Raisin, a celebrated card-maker of the Rue Croix-des-Petits-Champs in Paris, who showed him round his atelier and furnished him with notes, thus allowing him to improve the text.

As with the *Encyclopédie*, many arts were represented because they provided commodities for fashionable living rather than as evidence of the progress achieved through the application of rational principles. It is difficult to see any scientific connection in the description of the art of shoe-making (1767) which went into the history of the craft but not into the anatomy of the foot. *L'Art du Perruquier* (1767) by François-Alexandre de Garsault similarly lacked any justification on the grounds of science. But at that moment the *maîtres-perruquiers* were in the middle of a major battle with the *coiffeurs* who wished to avoid their jurisdiction and attempted (successfully) to do so on the grounds that theirs was a superior 'liberal' art, requiring knowledge of the principles of composition and indeed genius, compared with the purely manual practice of the wigmakers. Thus the *Descriptions* volume may have represented a valuable weapon of retaliation for the wig-makers.[137]

Motivations for writing *L'Art de Faire des Chapeaux* (1765), composed by no less a savant than the Abbé Nollet, also arose out of contemporary social conflicts. The loss of Canada in 1761 during the Seven Years War marked a turning point for the hatting trade. The import of beaver pelts by the Compagnie des Indes was drastically curtailed, threatening wage rates and age-old trade practices embedded in law. Nollet's treatise provided the recipe for the *eau de composition* solution which turned hare fur into an acceptable felt substitute. Organised on scientific principles from raw materials to final embellishment, the work represented a rational advance on the arcane mysteries of the craft which the corporation of hatters struggled, with decreasing success, to defend.[138] Both wigs and hats were used to demarcate hierarchies in public life and, as an elite organisation itself, the Académie might well have felt that the future of both trades fell within its remit, albeit in the former case appearing to support the retention of legal privileges and in the latter not.

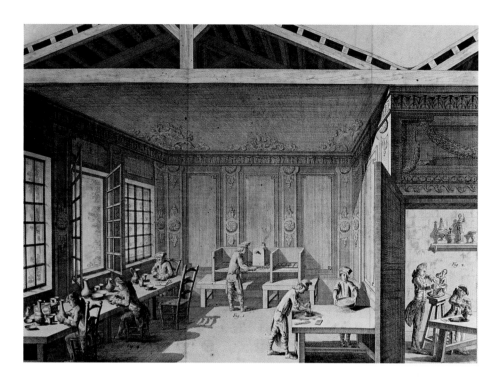

3 Pierre-Nicolas Ransonette,
'Art de la Porcelaine' from
icolas Christiern de Thy,
omte de Milly, *L'Art de la
orcelaine*, Paris 1771

The introduction to the description of *L'Art du Tailleur* (1769) justified its represen-
tation under the auspices of the Académie on purely nationalistic grounds: that the
natural taste of the French in this field was recognised all over the continent and the
description of best practice would further benefit the nation. French leadership in
matters of taste probably also accounted for the *L'Art du Brodeur* (1770), written and
illustrated by Augustin de Saint-Aubin, *dessinateur du Roi*, whose ten plates included a
border design for the Dauphin's *habit de mariage*. Even *L'Art du Paumier-Raquetier et de
la Paume* (1767, royal tennis racket-making) by François-Alexandre de Garsault, a gen-
tleman of science, skilled horseman and veterinarian, was gamely justified on the
grounds that the manufacture was an art and the exercise it provided for the users
improved fitness and health, especially in a military context.[139] Yet health could scarcely
justify the inclusion of the art of making tobacco pipes by Duhamel (1771).

Rather more basic was the *Description et Détails des Arts du Meunier, du Vermicelier
et du Boulenger*, complete with an abridged history of bread-making and a dictionary of
these arts (1767) by the physician Paul-Jacques Malouin. This was justified on Diderot-
like grounds that the most necessary arts were frequently taken for granted.[140] If the art
of bread-making aroused less curiosity because it was common and simple, it was rele-
vant to more of humanity because bread was the prime necessity for the people as
their staple food. The inclusion of an extensive general treatise on fish by Duhamel
(1769–77) was justified on similar grounds, 'tant pour la subsistance des hommes, que
pour plusieurs autres usages qui on rapport aux arts et au commerce'.

L'Art de la Porcelaine (1771) was dedicated in fulsome terms to the King as protector
of the sciences and useful arts in the form of the royal manufactory of Sèvres. Its author,
Nicolas Christiern de Thy, Comte de Milly, was a soldier and amateur chemist. His text
had been begun as a memoir on the industry in Germany (in other words, hard-paste
porcelain) read before the Académie.[141] Its plates, drawn and engraved by Pierre-Nicolas
Ransonette, were paid for by the Comte. The most elaborate (plate 8) was a double page
depicting an atelier where the painters, sculptors and modellers worked, an elegantly
panelled room with open windows (fig. 123). It seems that the Comte oversaw the project

with a beady eye, for he took the trouble to state in a footnote that the muffle furnace where the colours were blended had been misplaced in the plate by being depicted on the table whereas it should have been supported with bricks attached to the floor of the kiln. The walls should have been placed out of the sun and lifted to the height prescribed in his memoir where the description of the furnace and its proportions were correctly given.

Thus the *Descriptions* complemented the *Encyclopédie* in describing and rationalising the practices of industry and championing the combined efforts of the arts and sciences. Nevertheless, the impetus to publish had largely faded by the end of the 1770s and Duhamel du Monceau died in 1782. Only five volumes were published in the 1780s and prices were reduced.[142] By this date the whole endeavour, initiated nearly a century earlier, was beginning to look decidedly old-fashioned.

Towards a New Rationalism

In the Louvre there is a large portrait in pastel of the Marquise de Pompadour by Maurice-Quentin de la Tour (inv. 27614), which was exhibited at the Salon of 1755. She is surrounded by symbols of her role as the protector of the arts: a viola de gamba, a portfolio of drawings, a globe and a number of books, including volume three of the *Esprit des Loix* and volume four of the *Encyclopédie*. One of the prints on the table, clearly identifiable as 'Représentation de l'establissement de graveur en pierres fines et des divers instruments' and marked 'pompadour sculpts', comes from Pierre-Jean Mariette's *Traité des Pierres Gravées* (1750) and was again reproduced in 1767 in volume five of the *Receuil*. The treatise was a volume owned by Madame de Pompadour, gem-engraving an art she strongly supported and etching one she practised.[143]

Madame de Pompadour had been in favour of the *Encyclopédie* from the start, protecting it against the *arrêt* from the Council which suppressed the first two volumes and, according to Voltaire, advancing its cause with Louis xv.[144] The main attack on the *Encyclopédie* was directed at its political and religious beliefs, or the lack of them, rather than its espousal of *arts et métiers*. Nevertheless, the discussion and depiction of the mechanical arts had to run the gauntlet of traditionalists who disapproved of the whole idea of filling so ambitious a work with sordid details of trades. In 1754, the anonymous author of *Avis au Public sur le Troisième Volume de l'Encyclopédie* objected strongly to the space devoted to such articles: who on earth would want to read fourteen folio pages on the hat? In his *Préjugés Légitimes contre l'Encyclopédie* (1758) the critic Abraham de Chaumeix was contemptuous of Diderot's inclusion of articles of this type; his idea of an encyclopaedia was one which considered the larger philosophical questions relating to humanity.[145]

In contrast, the reception of the *Encyclopédie* in Britain was far from hostile. Early British owners included the libraries of Oxford and Cambridge colleges and the Scottish universities, as well as such leading men of letters as Dr Johnson, Dr Charles Burney and David Garrick.[146] As in the 1750s, imitation was the sincerest form of flattery. The most ambitious attempt at plagiarism was *The Complete Dictionary of Arts and Sciences in which the whole circle of human learning is explained, and the difficulties attending the acquisition of every art, whether liberal or mechanical, are removed, in the most easy and familiar manner*, printed for the authors in three folio volumes in 1764–6. It is generally known as Croker's *Dictionary* since the theological, philosophical and critical branches were composed by the Reverend Temple Henry Croker, the chaplain to the Earl of Hillsborough.[147] The production of yet another English dictionary was justified on the grounds of the various improvements that had lately been achieved in almost

every branch of learning. Reference was again made to the work of the Society of Arts and specifically its role in offering premiums for improvements 'and many curious machines constructed, models of which are now deposited in the custody of the Society, for the benefit of mankind'. The editors therefore proposed to give 'elegant designs and accurate descriptions of the most useful of these machines, and which, we humbly hope, will be considered as a very useful part of our undertaking'.

Inevitably also, both Chambers's *Cyclopaedia* and the ongoing *Encyclopédie* were cited, the editors promising that everything valuable in them would be contained in the *Complete Dictionary*, augmented by discoveries and improvements made since those works had been compiled. Moreover, the production of illustrations of the mechanical arts, in particular, was described in words with which Diderot would have been all too familiar – boasting of its superior count of 150 plates compared with works which contained only 30:

> we have been therefore obliged to have recourse to workmen themselves; who being often incapable of describing with precision the arts they profess, it became necessary for us to clear up and methodise their thoughts; learn the proper terms of their art; define them; and describe the various instruments and machines used in their respective occupations. This has rendered it necessary to augment the number of plates, as the bare view of an object often conveys more information than whole pages of words.

The plates were keyed to the text and were predominantly of a composite nature, designed with considerable care. Some, as promised, depicted new inventions, such as the machine for grinding and polishing glass plates invented by Mr Burroughs of Southwark for which the Society of Arts had awarded a premium of £70 (plate 27). Predictably, Vauloué's pile-driving engine and Smeaton's air pump were represented (plates 63 and 2 respectively) and they were not the only plates taken from earlier sources. The full-page plate of the brew-house (plate 24) is to be found in the *Universal Dictionary Supplement*. In the third volume (1766), a reel and ribband weaver's loom (plate 109) was derived from the *Universal Magazine*, while the tapestry weaver (plate 126) was a version of the crude cut in Owen's *New and Complete Dictionary*. But it was the distinctive French bias of many plates, comprising a small vignette of the place of manufacture at the top of the plate with the diagrammatic representation of tools and machines below, which was most noticeable. Card-making for manufactures (plate 34) was derived from the plates for *L'Art du Cartonnier* (1762) of the *Descriptions* (1762) and charcoal-making (plate 38) from *L'Art du Charbonnier* (1761). The first three volumes of the *Receuil* (1762–3) were thoroughly rifled for images covering mohair and metal button-making (plates 28–30), copper-plate engraving (plate 45), drawing (plate 55) and gilding (plate 70); the trades of the currier (plate 48) and the cutler (plate 49); diamond cutting (plate 53); stocking weaving (plate 123) and woollen manufacture (plates 141–6); cider-making (plate 50), sugar (plate 123) and tobacco manufacture (plates 128–30). Ingeniously, the editors managed to stretch the plates, which had only reached as far as D by the end of volume 3 of the *Receuil*, to embellish the whole spread of their alphabetically arranged entries.

This blatant plagiarism and the many other deficiencies of the *Complete Dictionary* did not go unremarked. A scathing notice which appeared in the *Monthly Review* in 1769 compared the work unfavourably with Chambers's *Cyclopaedia* which at least had been executed 'with *honest* care and judgement'.[148] In contrast, the *Complete Dictionary* clandestinely puffed pirated articles as its own. The reviewer also ridiculed the pretensions of the *Complete Dictionary* to be up to date in the arts and sciences. Under the entry on 'Canal', for example, Dutch, French and even Chinese examples were given 'but not a word of our own inland navigations, tho' so curious and recent that

it is difficult to account for the overlooking them: nor are any of the principles given, upon which these useful works are constructed and depend'. This comment was, perhaps, unfair, for the *Complete Dictionary* predated the publication of *The History of Inland Navigations* (1766) which described in detail the Duke of Bridgewater's famous canal and promoted others still to be built, illustrated with engraved plans and perspectives.

Not only did the *Monthly Review* reviewer pour scorn on the pretensions of the *Complete Dictionary* to cram all the contents of the *Encyclopédie* into three folio volumes, but he was equally sarcastic with regard to the usefulness of the plates:

> The authors of the Encyclopaedia have given elegant cuts of every common utensil, according to the pompous manner of French writers. It should appear as if that grand work was cautiously prepared against some expected general desolation, which like another deluge is to destroy all traces of every mechanical art; when the Encyclopaedia, happily preserved, will teach a new race of men to restore them.

Displaying the common prejudice that illustrations were little more than infantile diversions, the reviewer continued, 'They give not only common tools, as files, hammers and shears, but a perspective view of tradesmen's shops, where perhaps you see the maker trying a pair of shoes on the feet of the wearer, or a boy turning a wheel for grinding razors; all of which may do very well to amuse children.'

As the reviewer pointed out, many of the plates in the *Complete Dictionary* were copied from the *Encyclopédie* 'with what propriety, we leave our readers to determine'. He went on to question the very purpose of the exercise:

> for our parts we are at a loss to guess why we are to be shown men making charcoal or chocolate, stocking weavers or turners at work, &c. Even if the utility of such exhibitions were admitted, there is not a fourth part of the manufacturers and handicrafts exhibited; and there is one omission in particular, besides others we might instance, for there is no plate shewing how to dip matches.

Sarcasm was also vented on the social relationships depicted in the plates. With regard to the interior of the brew-house, first published in the *Universal Dictionary Supplement*, the author drew attention to the miller leaning on the doorpost 'with one hand in his bosom and the other arm what is called *a kimbo*' and the master brewer 'leaning over a rail in a white apron and ruffles' seemingly talking to him, 'but we are left uncertain whether they are married men or bachelors'. As for the copper-plate workroom, he drew attention to the engraver with a bag wig and sword who, coming to collect some plates, 'expands his arms in an attitude of disappointment' while the workman was showing the plate 'with an air of expostulation'. This was, he conceded, but conjecture, 'for as the engraver's sword is hung at his right hand, we are not sure but every article in the plate may be equally wrong' (fig. 124).

The mirror images – which were quicker and therefore cheaper to reproduce – confirmed the slapdash nature of the enterprise. Reference to the original of 'Chaudronnier Planeur' in volume 3 of the *Receuil* plates (see fig. 116) reveals much less of a confrontational interchange between engraver and workman, the conjectured stand-off the result of the coarsening of expression that had occurred in the transfer. None the less, the writer in the *Monthly Review* could not resist twisting the knife further:

> In plate 55 [taken from Cochin's drawing for the *Receuil* plate] we are amused with a group of scholars in a drawing school or academy; and though the editors say in their prefatory advertisement that 'the bare view of an object often conveys more information than whole pages of words' this plate contains no information excepting that

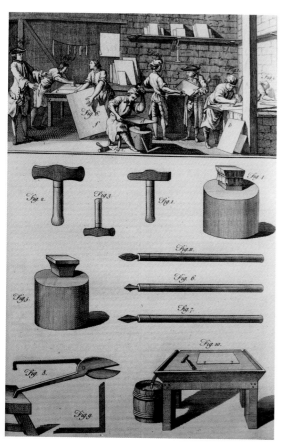

124 John Lodge after Benard after Desgerintins, 'Plate XLV Copper-Plate' from *Complete Dictionary of Arts and Sciences,* 1764–6

it is better to draw with the left hand than with the right; all the scholars having their pencils in their left hands.

These jibes were symptomatic of the author's fundamental doubts about the purpose of all such illustrations of the mechanical arts, throwing cold water over the Baconian cause which Diderot had advanced with such determination:

> Mechanical professions, in general, are not upheld by books, but by the uninterrupted wants of mankind; and if each trade or manufacturer requires a course of practical initiation, and if our authors profess themselves indebted to the communications of artisans, it will now be presumed that any one, for instance, can commence *turner*, merely from the reference to two figures of a turner at his lathe and wheel, which occupy one plate, or from the views of several kinds of *lathes* under *that* article, which fill half of another. The latter, in our opinion, were necessary, and sufficient; for in subjects of handicraft, the *general* principles of the art are all that books can be supposed to convey.

Croker's *Dictionary* was financially a failure, for its principal author was declared bankrupt in 1773 and retired to become the rector of St John's on the Windward Island of St Kitt's. Nevertheless, his example seems to have acted as a spur to shoals of bored clergymen who evidently had nothing better to do than to produce dictionaries. The Reverend Thomas Cooke, for example, accompanied by Messrs Hinde, Squire and Marshall, the last a gardener to the Earl of Shelburne, produced *A New Royal and Universal Dictionary of Arts and Sciences: or, complete system of human knowledge* in two folio volumes in 1770–71. The publisher, J. Cooke of the Shakespeare's Head, 17 Paternoster Row, London, stated that its hundred copper plates were based on original drawings made from real objects by the most eminent artists and even claimed fourteen years' copyright on the basis of the great expense he had thereby incurred. In fact, most of the plates are familiar, including depictions of trades copied from volumes 2 to 6 of the *Receuil* plates.[149] Only occasionally, in the most blatantly French cuts, did the engraver bother to change any feature for an English audience, inserting English playing cards for the French examples in the original (volume 2, plate 1). In the cannon foundry, by contrast, the fleurs-de-lys remained in place over the touch hole (plate 18).

The Reverend Erasmus Middleton, the lecturer of St Bennet's, Gracechurch Street, and of St Helen's, Bishopsgate, together with William Turnbull M.D., Thomas Ellis, the gardener to the Bishop of Lincoln, and John Davison, were responsible for *The New Complete Dictionary of Arts and Sciences; or, an Universal System of Useful Knowledge,* published in two folio volumes in 1778. Sold by Alexander Hogg of 16 Paternoster Row (and thus presumably Cooke's neighbour), the title-page claimed the usual affiliation with Chambers, the *Encyclopédie* and the Society of Arts with its premiums and models. Maintaining that it was the cheapest and best of its kind in the English language, it naturally relied on the standard sources of illustration, executed in a yet more perfunctory fashion. For example, plate 54 was a direct copy of two plates from the *Receuil* plate in volume 5, 'Marbreur du Papier', squashed together on one plate with only half the tools represented, whereas the *New Royal and Universal Dictionary* had copied both plates. Similarly, plate 62 was based on 'Peinture en Email' but reversed and further degraded

so that the setting has almost no credibility left.[150] Other plates were rearranged or printed with the vignette at the bottom of the page rather than the top, in a half-hearted attempt to disguise the source.

By the late 1770s the head of steam built up behind the publication of *arts et métiers* plates in encyclopaedias had dissipated. Diderot's great work of rationalising the mechanical arts and laying out them out in both scientific and artistic form for all to understand had lost its way through endless plagiarism and condensation, to the point where the plates were barely fit to adorn cheap primers for children. They satisfied the needs of neither gentleman *savant* nor intelligent artisan. In 1777, the prospectus for a quarto reprint of the *Encyclopédie*, conceived by French, Swiss and Liègois booksellers and containing 546 plates (compared with 2900 in the original), stated as an excuse for omitting nearly all those depicting *arts et métiers* that readers were not interested in seeing endless illustrations of hammers, anvils, bellows, lancets and a thousand other familiar things. The vignettes were more ornamental than instructive; they did not convey the workers' variety of movement or mobility of hand. When an engraving of a Lyon silk-weaving workshop was shown to the workers themselves, they did not recognise it. The plates added to the cost of publication and, besides, the Académie was covering trades which were available at a more moderate cost in dedicated *Descriptions* volumes.[151] When Samuel Bentham consulted Princess Dashkoff's copy of the *Encyclopédie* in St Petersburg in 1783, while working on his invention of a pile-driving engine, he could get no assistance from it.[152]

Perhaps the most remarkable use of the volumes was made by Madame de Genlis, when in 1782 she was appointed governess to the children of the Duc and Duchesse de Chartres, including the future king Louis-Philippe. Believing that the art of observation should be developed as early as possible, she proceeded to decorate her house at Belle-chasse with educational paintings and maps. In 1783 she also had a series of scale models built of the workshops and their contents depicted in the plates to the *Encyclopédie* and the *Descriptions des Arts et Métiers*. They are believed to have been built by the engineer brothers Jacques-Constantin and Augustin-Charles Périer, with the assistance of François-Etienne Calla, who was also an engineer and a student of Vaucanson. The thirteen that survive today in the Musée des Arts et Métiers include an interior of a miniature chemical laboratory, an atelier for making nitric acid, a joiner's shop, a nailsmith's, a forge and foundry, and workshops for making pots and tiles, china and porcelain.[153]

By the 1770s, the trend in treatises describing technical and industrial innovation was towards more mathematically based forms of description, eradicating figures of artisans at work in favour of strict projections ruled by geometry. In France this style of drawing was promoted in the state engineering and artillery schools. The results are evident in the first volume of Gabriel Jars's *Voyages Métallurgiques*, based on the author's travels through Germany, Sweden, Norway, England and Scotland between 1757 and 1769, published posthumously in Lyon in 1774, and the two subsequent volumes published in Paris in 1780 and 1781. Jars, the third son of a major Lyon mine owner, trained at the Ecole des Ponts et Chaussées. Under Perronet, the school fostered planning and mapping skills not only in the drawing office but on the job and ran courses on mathematics, hydraulics and technical aspects of construction.[154] Jars was dispatched to inspect and report on the government mines in Brittany, Alsace and other parts of France; and after undertaking the relevant technical language courses in Freiberg, Saxony, he made a three-year study of the mines of Central Europe with another Pont et Chaussées engineer, François Guillot-Duhamel. In 1764, he was sent to Britain and spent fifteen months touring the country's mines and ironworks. Jars represented a new kind of scientifically trained government expert of a type wholly absent in Britain. He was required to make a thorough examination of coal and iron production and usage to determine best prac-

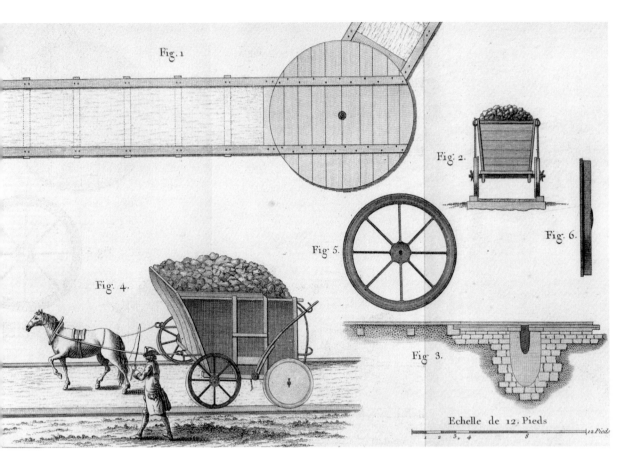

Fig. 1

Fig. 2

Fig. 5

Fig. 6

Fig. 4

Fig. 3

Echelle de 12. Pieds

125 Louis le Grand, engr., plate v from Gabriel Jars, *Voyages Métallurgiques*, vol. 1, Lyon 1774

tice, as well as their regulatory framework, with a view towards assessing whether French industries would do better in a freer legislative environment. On his return to France he was able to introduce the British practice of using coke rather than charcoal to smelt iron in blast furnaces, at least on an experimental basis. While his premature death in 1769 curtailed his industrial activities, *Voyages Métallurgiques* is a monumental account of the mid-eighteenth-century coal and iron industries of Europe, unmatched as to geographical spread and depth of observation by any other industrial survey of the time.[155]

The work contains more than sixty plates, drawn to scale, neatly engraved by Louis le Grand (volume 1) and under Benard's direction (volumes 2 and 3), after Jars's own mechanical drawings – plans, sections and perspectives – of furnaces, railways, wagons, pits and galleries, veins, hydraulic machines and steam engines, horse-whims, salt pans and pottery kilns throughout northern Europe. Plates 5 to 9 in volume 1 referred to British mines and forges, represented with much greater precision than the later perspectives after Beilby used to illustrate Morand's volumes *L'Art d'Exploiter les Mines de Charbon de Terre* in the *Descriptions* (fig. 125). Yet both French works were a considerable advance on the crude representations of a coal wagon, coal-pit and boring machine reproduced in the *London Magazine* in 1764–5 and 1777–8, after drawings submitted with descriptive accounts by a mining engineer, Edward Barras, of Chester-le-Street, for the edification not only of those 'concerned in those works' but also 'every curious and ingenious reader'.[156]

Even in Britain, however, the trend was towards more technical forms of drawing. William Bailey's *The Advancement of Arts, Manufactures and Commerce* (1772) represented the useful models and machines in the Society's repository. Published in quarto and in 1776 in a folio edition, 'carefully corrected and revised' by Alexander Mabyn

Bailey, who succeeded his father as register or registrar to the Society of Arts, it was a prestige venture dedicated to the King and with lists of subscribers and honorary prize-winners. It was clearly inspired by Gallon's quarto compendia of *Machines et Inventions Approuvées par l'Académie Royale des Sciences, depuis son Etablissement jusqu'à présent*, six volumes of which were published in 1735 and a seventh in 1777, comprising nearly five hundred plates. The work was illustrated with fifty-five copper-plates after Bailey junior's own drawings and the preface emphasised that 'care has been taken to represent not only the whole machine, but every material part of it, in such various points of view, as to enable the artisan to construct it from the description. To this end more plates than one have been found necessary in the explanation of some machines . . . To the perspective views, geometrical plans are also farther added, to facilitate the comprehension of the workman who would copy them in practice.'

Like Jars, Bailey used both projective and perspective techniques of mechanical drawing. As the machines and models represented were housed in the artificial arena of the Society's model room, as opposed to working environments, no setting was indicated. Nor were artisans or other sources of power – horse, water, wind, steam – introduced to demonstrate how the machines worked. Bailey's careful perspectives were engraved with neat grids of shading and with the parts keyed to the text. Several were also drawn in plan, usually to a scale of one inch to a foot. The plate of Mr Evers's model windmill for threshing and grinding corn, made to a scale of an inch and a half to a foot, was drawn in two elevations and two plans, with a perspective view of the threshing floor. Again, in the Manufactures section, Mr Unwin's stocking frame was drawn in perspective and detailed front and back elevation and plan, to a scale of four inches to a foot, and was as fine as any of the plates for Gobelins in the *Receuil* but devoid of the human presence to work the machine (fig. 126). In the Mechanics section, pride of place was given to Mr Stanfield's model of a saw mill, which was drawn in perspective, and the frames drawn in perspective, geometrical elevation and plan. Mr Burroughs's machine for grinding and polishing glass, taken from a model made to a scale of one inch to a foot and drawn in perspective and geometrical plan, effaced the hackneyed images which had been reissued many times. The model of Pinchbeck's crane, made to a scale of a quarter of an inch to a foot, was also drawn in perspective and parts in plan. This first volume concluded with assorted pumps and ventilating machines.[157]

It might be expected that dictionaries and encyclopaedias would also begin to reinforce their authority with precise mechanical engravings, rather than the degraded plates in a mishmash of styles cobbled together in earlier works. Yet the first edition of the *Encyclopaedia Britannica* was not encouraging in this respect. Published between December 1768 and August 1771 in Edinburgh by the engraver Andrew Bell and the master printer Colin Macfarquhar, in the form of twenty-four-page numbers, the three-volume set was issued in 1771. The plan and all the principal articles were devised and written or compiled anonymously by a learned Edinburgh printer, William Smellie, who was paid £200 for putting it together.[158] Like the Foulis brothers in Glasgow, he combined the mechanical arts of his trade with considerable scholarship, particularly in languages, the sciences and medicine.[159] Nevertheless, Smellie was well aware of the general level of dictionary-making, he himself joking he had 'made a Dictionary of Arts and Sciences with a *pair of scissars*, clipping out from various books a *quantum sufficit* of matter for the printer'.[160] Although the proposals printed in 1768 promised 'full descriptions of the various machines, instruments, tools, figures, &c. necessary for illustrating them', there was no extended treatment of the mechanical arts and coverage of industrial innovation was patchy. An exception was the entry on 'Canal', which not only mentions the Duke of Bridgewater's canal but also, more topically, the Forth–Clyde Canal first surveyed by Smeaton which was even then being cut.

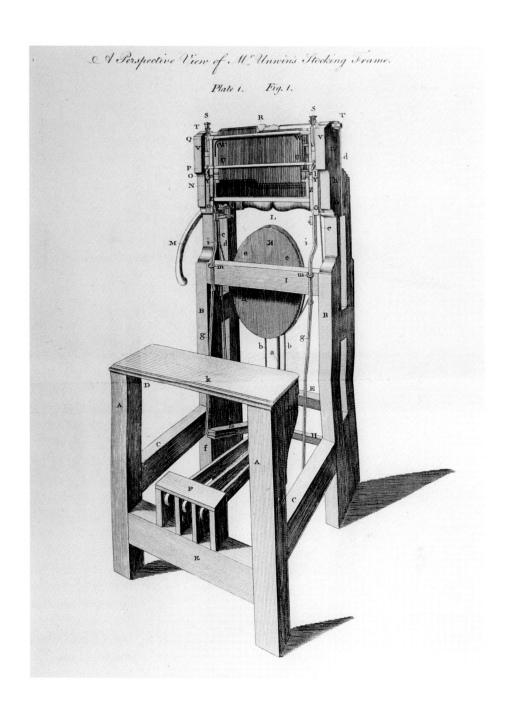

A Perspective View of Mr Unwin's Stocking Frame.

Plate 1. Fig. 1.

6 J. Caldwall after
Alexander Mabyn Bailey, 'A
Perspective View of Mr Unwin's
Stocking Frame' from Alexander
Mabyn Bailey, *The Advancement
Arts, Manufactures and
Commerce*, 1776

As proprietor and engraver, Bell took considerable care with the 160 plates. Indeed, the quarto format was adopted because if, as was first proposed, the work had been printed in octavo, it would have resulted in an inconvenient number of volumes (not a problem which worried the proprietors later) and the copper-plates 'would be too small to give satisfactory views, or convey adequate ideas of the objects they are intended to represent'.[161] Most of the plates were composite, covering several figures relating to the articles written in alphabetical order, although occasionally a single plate covered different examples of the same object, such as the plough. Natural history and anatomy figured strongly. Architecture plates were derived from rich sources of treatises on the orders and building design books, astronomy from treatises on scientific instruments and gunnery and fortification from the usual sources. Of the tiny proportion of plates relating to particular trades, the manufacture of glass was illustrated with the standard

images of glass-makers at work derived from Gravelot and prints depicting the manufacture of plate glass, by then at least thirty years old. Those for the printing press were nearly a hundred years old, culled from Moxon.[162]

The five-volume edition of Chambers's *Cyclopaedia* (1778–88), compiled by the Presbyterian minister Abraham Rees, incorporated in a single alphabet the original work, the *Supplement* and more than 4400 new articles written by the editor, including many on 'modern improvements' in science and industry, as well a much more comprehensive index. Although the subtitle still billed the work as a 'Universal Dictionary of Arts and Sciences', Rees's preface emphatically referred to it as a 'Scientific Dictionary' and a 'Dictionary of Science' and claimed it as 'a foundation for farther discoveries and improvements . . . In this latter view of its importance and use, it may not be improperly compared to a map of science, in which the line that terminates the terra incognita is distinctly marked out for the direction of those, whose ingenuity and industry are employed in extending the boundaries of knowledge, and in exploring those regions that are still unknown.'

Furthermore, Rees drew attention to the improvement that he had made on Chambers's selection of plates:

> The Proprietors think themselves happy, that the extensive sale of this edition had enabled them to cancel most of the old plates, and to be at the expense of new engravings; and to increase the number of new plates, far beyond their original design. The ingenious artist [Isaac Taylor], who has had the conduct of this business, has executed it with an attention and accuracy which, it is hoped, will give satisfaction to the Public.[163]

Instead of crowding different subjects on one page, the figures in the 148 plates, published in volume 5, were grouped together under a single broad title, even if the particular references were widely scattered by alphabetical order in the work. An 'Arrangement and Analysis of the Plates' provided the key. For example, plate 6 of Hydraulics and Hydrostatics covered figures depicting a river, Archimedes' screw, siphons, springs and steam engines. Unfortunately, this organisational advance was only skin-deep, for the plates could not keep up to date with Rees's text. He provided a detailed description of James Watt's improvements to the 'Steam Engine' but these were not illustrated, nor were Arkwright's patents for spinning cotton, although Rees mentioned them ('Spinning'). He was also abreast of the latest progress of canals, observing their manifold benefits for agriculture and manufactures, for drainage and water supply, besides 'giving employment to the industrious labourer, as well as the ingenious artisan'. He was aware that Mr Verbruggen, the head founder at Woolwich, had much improved the method of boring cannon from solid casts by boring them horizontally ('Foundery'). Yet no plates were readily available to illustrate any of these advances and the fact that there was a gap of five years between publication of the last volume of full text (in 1783) and the final volume of plates (1788) suggests that it was difficult enough getting together those that did appear.

Despite Rees's best efforts, the results scarcely constituted a unified pictorial encyclopaedia.[164] The distinguished physician John Rotherham, who reviewed the work in the 1786 *Monthly Review*, noted that Rees, being accustomed to scientific research, had greatly improved on his predecessors, not only through the historical accounts he had given of several sciences but also the concise descriptions he had given of new discoveries and of those who had made them. However, he found the engravings wanting. Not that the *Encyclopédie* was considered a worthy precedent in this regard: 'The Editors of that Dictionary have crowded their work with a number of slight descriptions of the most uninteresting machines that have been invented.' To make an encyclopaedia as useful as possible, Rotherham believed,

it should contain, beside the descriptions of machines, an analysis of them, pointing out their advantages and disadvantages, with the respective reasons for their construction; and the general problems, implied in each construction, with their solutions, should be extracted. None of these things have as yet been done, in a complete and satisfactory manner, in any treatise on mechanics, or in any of the many Dictionaries of Arts, &c. that have been published.

Even Gallon's *Machines et Inventions* was wanting. The best model for such a work, Rotherham advised, was William Emmerson's *Principles of Mechanics* (1754), the thirty-two plates of which mainly comprised geometrical figures: 'let no one however undertake this arduous task whose mathematical knowledge is in any respect incomplete'.

Nevertheless, Rotherham allowed that Rees had attended to the mechanical as well as the liberal arts: 'he has in this edition considerably increased the articles *Agriculture, Architecture, Baking, Brewing, Carpentry, Dying, Tanning, Gardening* &c.' Rotherham admired Rees's

method of expressing common things in a manner that even the learned may profit by them, and the ignorant be instructed. When a lexicographer accomplishes this intention, we think he has not only done his duty, but even every thing that can be expected of him. When he has given an history of the Art, the improvements that have been gradually made in it, the usual methods of practising it, and the reasons upon which it is founded, little else remains to be done. As in the dictionary of a language, the letters, which are the elementary principles of words, are supposed to be known; so in a dictionary of arts, the elementary principles of science are presupposed. The consideration of this circumstance points out to us the boundaries where a scientific dictionary ought to begin; but perhaps it is not so easy to determine where it must end. The Editor has much increased and improved the work he set out with, and when we find that he has faithfully recorded the material advances that have been made in science, we may safely conclude that he has arrived at the end of his journey.[165]

Rees rose to the challenge. He went on to produce his own *Cyclopaedia; or Universal Dictionary of the Arts, Sciences and Literature* which, when published in forty-five volumes between 1802 and 1819, including 849 technical plates in four of the six separate volumes of plates,[166] finally constituted a successor for the machine age, worthy in its scope of ambition of Diderot's great *Encyclopédie*.

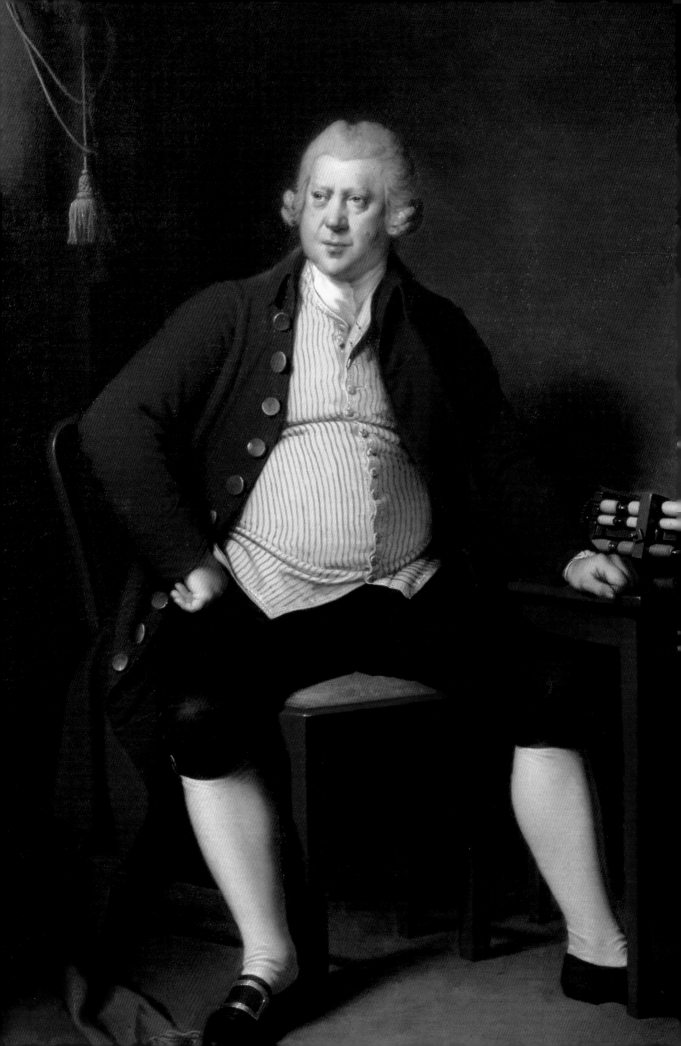

VI

Empirical Portraits

I would rather see the portrait of a dog that I know, than all the allegorical
paintings they can show me in the world.

Samuel Johnson, 'Apophthegms, Sentiments, Opinions',
in *The Work of Samuel Johnson*, ed. Sir John Hawkins (1787–8), vol. II

Portrait is the historical record of great men and beautiful women, existing at a
certain time; but as the finest expression in portrait must be seen before it can
be done, there is an end of invention, the highest quality of genius . . . The
historical painter's effort is a portrait of what he imagines; the portrait painter's,
of what he sees.

Benjamin Robert Haydon, giving evidence before the
House of Commons Select Committee on Arts and Manufactures, 1836

Until well into the eighteenth century, it was generally taken for granted that painting
faces was a mechanical art and its practitioners were mechanical artists. Yet, as the
century progressed, the struggle by artists to raise the status of portrait painting gained
momentum. Furthermore, it acquired a peculiar resonance in relation to portraits of
mechanical men – entrepreneurs, manufacturers, inventors and artisans – whose status
was also at issue. The means already examined by which such men described and ratio-
nalised their work brought them into the public realm and even into polite society. So
the commission of portraits as their status rose paralleled the rise in status of the art
itself and of the artists who painted them. In effect, portraiture provides another example
of the fluid boundaries between the mechanical and liberal arts in the age of Enlight-
enment. This chapter explains how portraits celebrating men of mechanical ingenuity
were informed by broader considerations than those pertaining to taste and aesthetics
narrowly conceived. By recovering this context, the paintings acquire an added reso-
nance of meaning.

Conventionally, establishment wisdom on aesthetic concerns is represented by the third
Earl of Shaftesbury, who considered himself to be an authority on taste which, for him,
was synonymous with virtue and a defining attribute of the gentleman. As a virtuoso he

believed that the ancients provided the consummate models in art, reviving the Greek concept that harmony and proportion were the ultimate foundations of beauty and morality. Portraiture was antithetical to such beliefs because, for Shaftesbury, as for continental theorists of art extending back to Alberti, the literal copying of nature necessarily involved the abandonment of the quest for beauty, a high heroic ideal which improved on common life: 'The mere face painter, indeed, has little in common with the poet; but, like the mere historian, copies what he sees, and minutely traces every feature and odd mark.'[1] The practice of portraiture stunted an epic artist's potential: 'the subjecting of his genius, narrowing of his thought, contraction of his idea, deadening of his fancy, constraining of his hand, disaccustomed him in the freedom of his pencil, tying him down to copying, translating, servilely submitting to the lords and ladies, etc., his originals'. Portrait painters were 'mere mechanics' since their art required 'no liberal knowledge, genius, education, converse, manners, moral science, mathematics, optics, but [is] merely practical and vulgar. Therefore not deserving honour, gentility, knighthood conferred.'[2]

This last jibe was directed at Godfrey Kneller, knighted in 1692 and made a baronet by George I, who supposedly ran his portrait practice as a trade, based on the semi-industrial division of labour. According to an eighteenth-century newspaper report, his 'picture-manufactory' was

> established upon as regular principles as the fabricating of carpets at Kidderminster . . . To execute as many pictures as he could get orders for in the shortest space of time was his only object, and to facilitate their progress he appointed each assistant to his peculiar province. When he had finished the face and sketched in the outlines of the shoulders etc., the picture was given to the artist who excelled in painting a hat, and when the hat was fixed upon the head or tucked under the arm, the canvas was consigned to the painting of the periwig, who, having given eternal buckle to the flowing white curls which hung in ample ringlets on each shoulder, turned it over to another who gave the glossy blue velvet coat that a further industrious artisan ornamented with curious worked buttons, each of them wrought up with all the laborious accuracy of the German school. One excelled in the delineation of the laced handkerchief and point ruffles, while the broad gold lace which decorated the scarlet waistcoat was the forte of another.[3]

Although this was a gross exaggeration, nevertheless the barb stuck. In his *Letters on the English and French Nations*, first published in Dublin in 1747, Abbé le Blanc singled out Kneller for 'the judgement he showed in choosing England for the place to exercise his talent in: it is the only country where he could possibly gain so much credit and honour: anywhere else they would not bestow the name of painter on him'. He went on to castigate the ever growing number of portrait painters in London:

> I have been to see the most noted of them; at some distance one might easily mistake a dozen of their portraits for twelve copies of the same original. Some have the head turned to the left, others to the right: and this is the most sensible difference to be observed between them. Moreover, excepting the face, you find in all, the same neck, the same arms, the same flesh, the same attitude; and to say all, you observe no more life than design in those pretended portraits. Properly speaking, they are not painters: they know how to lay colours on the canvas, but they know not how to animate it. Nature exists in vain for them, they see her not: or if they see her, they have not the art of expressing her.[4]

The satirist John Shebbeare, writing in the guise of a visiting Jesuit, Batista Angeloni, pursued the matter in his *Letters on the English Nation* (1755). Although he allowed portraiture to be in principle a liberal art, he considered that the English

have almost reduced face-painting to a mechanic art, and make portraits as they make pins; one forms the head, another the point. I dare say, the time will come, when there will be as many painters to finish a whole length figure, as there are now trades to equip a beau: the face-painter, the wig-painter, the clothes-painter, the linen-painter, the stocking-painter, and the shoe painter. For money is the pursuit, and honour very little called into question . . . it is probable . . . that this liberal art will be reduced to as mechanical an operation as making hobnails, that fortunes may be made with the utmost expedition.[5]

The categories of painting which could be considered liberal as opposed to mechanical varied from writer to writer but it was generally understood that history painting belonged to the former category and portraiture to the latter. Even Shaftesbury did not extend his disdain for portraitists to all practitioners of painting: it was 'otherwise with the men of invention and design'.[6] Painting was a mechanical skill, even a 'vulgar science' when all it amounted to was imitating particular features, but when an artist aspired to represent more serious and noble ends, relating to 'history, human nature and the chief degree and order of beauty', he allowed it to be part of rational life.[7]

Shaftesbury's ideal of high heroic painting devoted to noble ends was normally associated with art of the classical world and hence with its revival in Renaissance Italy. Its opposite, the servile copying of common nature was, also by convention, identified with Dutch art.[8] 'Painting in the Dutch manner' was shorthand for works which did not simply depict humdrum subject matter but resulted from a particular way of looking at the world. This was conditioned by a powerful tradition of naturalism in northern European painting going back to the fifteenth century, enhanced in the sixteenth and seventeenth centuries by theoretical and practical advances in optics, in the form of treatises on perspective and scientific instruments. It was a truism of contemporary English art theory that Dutch artists failed to select and improve on art to create an ideal but merely imitated it, choosing mundane subjects and including excessive detail compared with the Italians. Horace Walpole was typical of his class in condemning the 'servile imitation of the Dutch'. Dutch paintings were 'drudging mimics of nature's most uncomely coarsenesses' and he could scarcely credit that 'their earthen pots and brass kettles carry away prices only due to the sweet neatness of Albano, and to the attractive delicacy of Carlo Maratti'.[9] Aspiring painters should, he believed, avoid the literal imitation of imperfect nature.

While Shaftesbury's presumption of the authority of virtuosi in matters of taste was increasingly challenged as the century progressed,[10] the principles he took for granted remained very much alive. In his *Essay on Original Genius* (1767), the Scottish writer and cleric William Duff maintained

> that as the power of invention is the distinguishing ingredient of original genius in all the fine arts, as well as in science; so, in whatever degree invention is displayed in either of these, in the same degree originality of genius will always be discovered. This distinction will exclude all portraits in painting, however excellent, and many descriptive pieces in poetry, though copied from nature, from any pretensions to originality, strictly considered.[11]

So both through *a priori* principle and *de facto* execution, portrait painting in Britain was regarded as a mechanical art. Yet these views did not curb the country's appetite for portraits commissioned on an institutional, familial and individual basis. Churned out in a standardised format as a routine business, they did not pretend to represent beauty or exercise the artist's genius, invention and learning. The Reverend James Granger bracketed painters and mechanics together in his *Biographical History of England, from*

Egbert the Great to the Revolution (1769), a catalogue of engraved British portraits, organised first according to the reign in which sitters flourished and then subdivided in each reign into twelve classes, from the royal family downwards. Class x comprised 'painters, artificers, mechanics, and all of inferior professions, not included in the other classes'. Immediately above them, Class IX comprised 'physicians, poets, and other ingenious persons, who have distinguished themselves by their writings'. Below them, Class XI comprised ladies listed according to their rank (although women who practised professions – for example, as poets or artists – were included alongside the men) and finally Class XII 'chiefly of the lowest order of the people, remarkable from only one circumstance in their lives; namely such as lived to a great age, deformed persons, convicts, &c.'[12]

Granger's taxonomy did not replicate the body politic, still less did it represent an attempt to reflect and preserve the social order.[13] By classifying the illustrious 'in every rank, and in every profession', Granger wished primarily to facilitate cross-comparisons within classes for ease of reference: 'statesmen, heroes, patriots, divines, lawyers, poets, and celebrated artists, will occupy their respective stations, and be remembered in the several periods in which they really flourished'.[14] As his biographical history only went as far as the Glorious Revolution, it was scarcely intended as a commentary on social realities a century on. If Granger deplored the lack of organisation in the print collections he had seen, in which 'the poetaster frequently takes place of the poet, and the pedant of the man of genius', his own system contained surprising anomalies, if viewed in hierarchical terms. Classes IX and X, in particular, comprised loose assortments of men of letters and science, artists and tradesmen of widely differing social status. Thus for the reign of Charles II, the printer Joseph Moxon features as hydrographer to his Majesty and an 'excellent practical mathematician' in Class IX, 'Men of Genius and Learning', while Sir Christopher Wren is consigned to Class X, 'Artists &c', as an architect, alongside painters, sculptors, engravers, an actor, writing masters, print- and booksellers, the watch-maker Thomas Tompion and Richard Collins, the supervisor of the excise in Bristol and author of *The Country Guager's* [*sic*] *Vade Mecum* (1677).

One route for artists out of this muddle was to conflate their practice with gentrification and its attendant liberal values, so that status simply ceased to be an issue. The portrait painter Jonathan Richardson, the son of a London silk-weaver, was one of the first to challenge prevailing orthodoxies, even if he could barely improve the quality of his own art (as opposed to his art collection) to meet his theoretical ideals. His *Essay on the Theory of Painting* (1715, revised edition 1725) was written in an informal non-rhetorical style 'only as a painter, and a gentleman', supposedly for his own diversion and his son's improvement, although the second edition was more ambitiously intended 'to serve the public and the art of painting'. In this role he wanted to reform the English view of painting merely as interior decoration, 'one part of our ornamental furniture' and as such, 'a pleasing superfluity; at best, that . . . holds but a low rank with respect to its usefulness to mankind'.[15] Richardson urged that the mechanical 'Dutch' qualities of painting like neatness, high finish and gay, vivid colours should not be confounded with the whole end of art, for these qualities required 'no more genius, or capacity, than is necessary to, and frequently seen in ordinary workmen; and a picture, in this respect, is as a snuff-box, a fan, or any other toy'.[16] Unless consumer taste acknowledged the existence and importance of painting's extra-ornamental qualities, he believed, neither the social status nor the professional incomes of native artists would improve.

As far as portraiture was concerned, Richardson articulated the case for seeing it as a liberal art. A work should show more than commonplace appearance; like history painting it should serve as a moral exemplar, based on the same understanding of human character. Painting was to be considered a liberal profession despite being a paid employ-

ment (here, he pointed out, artists were in good company with the clergy, courtiers and lawyers) because of the intellectual abilities required to practise it well and its usefulness to humankind. Richardson's intellectual concept of invention referred primarily to history painting but, mindful of his own practice, he extended the argument to portraiture, maintaining that 'the invention of the painter is exercised in the choice of the air and attitude, the action, drapery and ornaments, with respect to the character of the person', serving as the outward form of personality.[17] The artist's choice of the representational mode of the sitter paralleled invention in historical subjects. He or she had to mediate between flattery and exact likeness, ensuring that character was still visible while glossing over physical defects. Appropriate ornaments and background should be selected to enhance the sitter's essential character traits. Richardson maintained that not only history painters but also portraitists were required to demonstrate profound insight into human nature and its spiritual potential, to discern and depict noble qualities in real mortals. Thus arose the status of portrait painting as a liberal art.

Boosting his calling even further, Richardson went so far as to argue that it was more difficult for a face painter to succeed than a history painter: 'To be a good face-painter, a degree of the historical, and poetical genius is requisite, and a great measure of the other talents, and advantages which a good history-painter must possess: nay some of them, particularly colouring, he ought to have in greater perfection than is absolutely necessary for a history painter.' It was not enough, he went on,

> to make a tame, insipid resemblance of the features, so that everybody shall know who the picture was intended for, not even to make the picture what is often said to be prodigious like: (This is often done by the lowest of face-painters, but then 'tis ever with the air of a fool, and an unbred person;) a portrait painter must understand mankind, and enter into their characters, and express their minds as well as their faces; and as his business is chiefly with people of condition, he must think as a gentleman, and a man of sense, or 'twill be impossible to give such their true, and proper resemblances.[18]

Therefore Richardson claimed liberal status for portrait painting not only on intellectual but on social grounds, an assumption that its practitioners must be as genteel as their subjects, at least as portrayed. The most skilled portrait painters preserved likeness and elevated character:

> To divest an unbred person of his rusticity, and give him something at least of a gentleman; to make one of a moderate share of good sense appear to have a competency, a wise man to be more wise, and a brave man to be more so, a modest, discreet woman to have an air something angelical, and so of the rest; and then to add that joy, or peace of mind at least, and in such a manner as is suitable to the several characters, is absolutely necessary to a good face-painter; but it is the most difficult part of his art, and the last attained.[19]

According to Richardson's tenets, the portrait of a mechanist or artisan, whatever the rudeness of his appearance in the world, would have the air of a gentleman. Richardson had one eye firmly on posterity. 'A portrait', he wrote,

> is a sort of general history of the life of the person it represents, not only to him who is acquainted with it, but to many others, who upon the occasion of seeing it are frequently told, of what is most material concerning them, or their general character at least; the face, and the figure is also described and as much of the character as appears by these, which oftentimes is here seen in a very great degree.[20]

To sit for one's portrait was 'to have an abstract of one's life written, and published, and ourselves thus consigned over to honour, or infamy'.[21] Portraits gave not only the persons

but the characters of great men: 'The air of the head, and the mien in general, gives strong indications of the mind, and illustrates what the historian says expressly and particularly. Let a man read a character in my Lord Clarendon . . . he will find it improved by seeing a picture by Van Dyck.'[22] Thus Richardson refuted Shaftesbury by aggrandising the importance of the role of both historian and portrait painter, arguing that the reproduction of external appearance as an act of perception could also provide a gauge of the mind.[23]

William Hogarth, Richardson's junior by thirty years, is usually seen as opposed to everything the older painter stood for, yet as Carol Gibson-Wood has pointed out, they both emerged from the class of London tradesmen, were in part self-taught and shared a chauvinism with regard to English art and dismay over the then prevailing taste of the picture-buying public for foreign imports.[24] In his 'Apology for Painters' Hogarth went so far as to assert, with gloomy pragmatism, that it was proof of the good sense of the country that encouragement had been given to trade and mechanics rather than the arts. A great painting required the genius of a Shakespeare or a Swift; it was better to be a successful brewer or haberdasher than a mediocre painter condemned to starvation.[25]

Hogarth's aesthetic principles, as presented in *The Analysis of Beauty* (1753), were based on empirical observation of the inherent beauty of certain forms, not on metaphysical ideals derived from a privileged system of knowledge. His subject was not the province of 'mere men of letters' who quickly lost themselves in speculation as to what constituted moral beauty. Instead it 'actually requires a practical knowledge of the whole art of painting (sculpture alone not being sufficient) and that to some degree of eminence'; in other words, the knowledge possessed by someone like himself. He certainly distinguished himself from 'common face painters and copiers of pictures' who believed that any attempt to discern rules in either art or nature was 'all stuff and madness'.[26] Hogarth himself distilled formal, even scientific, principles of beauty, illustrated with figures like 'those a mathematician makes with his pen'. These fundamental principles were 'FITNESS, VARIETY, UNIFORMITY, SIMPLICITY, INTRICACY, and QUANTITY . . . *all which co-operate in the production of beauty, mutually correcting and restraining each other occasionally*'.[27] Observation of the human form confirmed Hogarth's central thesis that the serpentine line was the line of beauty and grace.[28] He emphasised the study of anatomy, the movement of muscles and the surface of the skin, for ultimately beauty was derived from nature, not from the blind veneration of antiquity, still less from the machines of his contemporaries, such as Harrison's timepieces or Vaucanson's duck; 'in nature's machine, how wonderfully do we see beauty and use go hand in hand'.[29] Hogarth applied his serpentine-line thesis to the human face, attitude or stance and action but modified it on the basis again of close observation of different types and characters. For Hogarth the common maxim, as parroted unquestioningly by Richardson, that the face is the index of the mind was contradicted in the real world by those whose true character was disguised through hypocritical self-control or accidental circumstances. He recognised the usefulness of Le Brun's schematic representations of the passions and the rules of graceful deportment but he was more interested in deviations from the norm, being so conversant with the rules that he could invert and even break them with impunity.

Yet Hogarth's views were disputed and his portraits far from universally admired. Paul Sandby waged a savage campaign in satirical prints against the pretentiousness of Hogarth's theories compared with the coarse 'Dutch' manner of his paintings.[30] Far from being elevated to the level of polite society, through judicious editing and the use of historical, literary and classical references, as Richardson had advocated, Hogarth's portraits were seen to be too close to nature for comfort. Moreover, his somewhat recalcitrant manner, antipathy to the established social order and the idiosyncratic nature of his art did nothing to enhance the status of artists themselves.

No one was more conscious of the ambivalent position occupied by portrait painters or did more to raise their professional status than Sir Joshua Reynolds, born the son of a Devon parson schoolmaster. Following Richardson, Reynolds acknowledged in his *Discourses on Art*, delivered to students at the new Royal Academy schools from 1769 to 1790, the low status of the art he himself practised, portraiture, lumping it alongside genre painting 'and perhaps of not so great merit'. The 'correct and just imitation' of the sitter had a certain value but a student should aim higher, to history painting. If obliged to descend to the lower end of portrait painting, he should bring to the task grandeur of composition and character 'that will raise and ennoble his works far above their natural rank'.[31]

Like Shaftesbury, Reynolds believed that to err on the side of Dutch 'minuteness' was the besetting sin of portrait painting; it was the representation of the overall idea of a person that constituted real excellence: 'Even in portraits, the grace, and, we may add, the likeness, consists more in taking the general air, than in observing the exact similitude of every feature.'[32] Reynolds underlined the need to generalise from the particular in the manner of experimental philosophy.[33] If a portrait painter wanted to raise and improve his subject, 'he has no other means than by approaching it to a general idea. He leaves out all the minute breaks and peculiarities in the face, and changes the dress from a temporary fashion to one more permanent, which has annexed to it no ideas of meanness from it being familiar to us.' Nevertheless, he acknowledged the difficulty of ennobling the character of a countenance 'at the expense of the likeness, which is what is most generally required by such as sit to the painter'.[34] That is, the wishes of the client might well take precedence.

In 1772, Reynolds elaborated on the process of mediation between the mundane and the ideal to produce a general effect, a portrait in the historical style, which was 'neither an exact minute representation of an individual, nor completely ideal'. There was a need for consistency: 'every circumstance ought to correspond to this mixture . . . Without this union, which I have so often recommended, a work can have no marked and determined character, which is the peculiar and constant evidence of genius. But when this is accomplished to a high degree, it becomes in some sort a rival to that style which we have fixed as the highest.'[35] Four years later, he returned to the subject to advocate rising above 'local and temporary prejudices' in favour of qualities that were 'more durable and lasting'. Dress should combine 'something with the general air of the antique for the sake of dignity' with 'something of the modern for the sake of likeness. By this conduct [the portraitist's] works correspond with those prejudices which we have in favour of what we continually see; and the relish of the antique simplicity corresponds with what we may call the more learned and scientific prejudice.'[36] Empirical face painting might be enough for the mechanical artist – both mechanic and face painter – but for those who aspired to higher things, 'antique simplicity' reflected the 'scientific' aspirations of both artist and sitter.

Reynolds demonstrated what he meant with a concrete example, a statue of Voltaire by Jean-Baptiste Pigalle, which depicted the writer 'entirely naked, and as meagre and emaciated as the original is said to be'.[37] The consequence was that, though intended as a public ornament and a public honour to Voltaire, it remained in the sculptor's shop, 'not having that respect for the prejudices of mankind which he ought to have had'. Thus Reynolds introduced the notion of public decorum into his recipe for the successful portrait; mean exactitude was not welcome in the public arena.[38] Yet he made clear that he deplored the declamatory style of portrait painting practised by the French and in particular Hyacinthe Rigaud 'with its total absence of simplicity in every sense'. Noting the exaggerated attitudes advocated by Roger de Piles, whose *Principles of Painting* had been first translated into English in 1743, he concluded: 'such pompous and

laboured insolence of grandeur is so far from creating respect, that it betrays vulgarity and meanness, and newly acquired consequence'.[39] Moderation, decorum and appropriateness to station were the qualities that Reynolds professed to admire.

From his earliest writings Reynolds made a sharp distinction between Italian and Dutch art, reserving the palm of glory for the former. Nevertheless, especially following his visit to Flanders and Holland in 1781, he allowed that Dutch artists possessed technical skill – in colouring and composition, the skilful management of light and shade and indeed all the mechanical parts of art: 'Painters should go to the Dutch school to learn the art of painting, as they would go to a grammar-school to learn languages. They must go to Italy to learn the higher branches of knowledge.'[40] Yet by the 1780s the market for Dutch art in England was enjoying one of its periodic revivals, a fashion led by the Prince of Wales, the future George IV. Contrasting estimates as to its worth – the low value accorded by art theory and the much higher valuation of the marketplace – can be seen in terms of the age-old conflict between morality and commerce. Reynolds's exhortatory discourses were addressed to an audience of students, who had yet to be inducted into the wicked ways of the metropolis, and to the cultured elite, who still needed to be convinced of the theoretical status of artists. They little reflected the material, not to say materialist realities of Reynolds's own practice. This was conducted on semi-industrial lines, the master rising as regularly as clockwork and putting in a seven-hour day, frequently seven days a week, completing an average of well over a hundred commissions a year.[41]

As President of the Royal Academy and the country's leading portrait painter, Reynolds was also thoroughly implicated in the world of exhibitions, where portraits formed a major draw, were widely discussed in newspapers and periodicals and reproduced and disseminated in print form. If anything elevated the status of portrait painters, it was their canny concentration for exhibition purposes on contemporary social leaders and celebrities, drawn from those securely anchored in the highest ranks of society and those striving to join them through merit or notoriety: a heady mix of royalty and the aristocracy, naval and military heroes, politicians, writers, actors and even artists. In the public arena of the exhibition gallery, a marriage of convenience was solemnised where the fame and fortune of sitter and artist rose together.

'This seems to be a portrait painting age!' exclaimed the hack writer William Combe in his introduction to *A Poetical Epistle to Sir Joshua Reynolds* (1777), a vulgarised version of Reynolds's own sentiments. Whether through fashion, the increase in sentiment, the spirit of luxury which pervaded all ranks and classes of men, or the ingenuity of portrait painters, no tradesman's parlour was now considered furnished, Combe asserted, if family pictures did not adorn the wainscot. In previous ages most portraits, 'from the insipid and uninteresting style in which they were generally painted' were considered 'mere trash and lumber by all who were ignorant of the originals. But, by the genius of many modern professors of eminence, that insipidity is vanished; and, by their hands, a portrait is now interesting even to the stranger, and, where its colours are of a lasting nature, will be interesting to future ages.'[42] Combe attributed this increased interest to the 'addition of character, whether historical, allegorical, domestic, or professional': 'for by seeing persons represented with an appearance suited to them, or in employments natural to their situation, our ideas are multiplied, and branch forth into a pleasing variety, which a representation of a formal figure, however strong the resemblance may be, can never afford'. For Combe, portraits were a class of consumer goods the demand for which had increased with affluence, fancy and fashion and for which artists catered with an ever increasing variety of aspirational guises placed on display for appreciation by the general public.

The intensification of the marketing and promotion of portraits has been thoroughly examined in relation to Reynolds and the growth of exhibitions in the second half of

the eighteenth century.[43] Yet the Irish painter James Barry, like earlier English theorists, still claimed a moral role for painting. His treatise, *An Inquiry into the Real and Imaginary Obstructions to the Acquisition of the Arts in England*, planned in Rome and published in London in 1775, espoused the cause of history painting in the face of a corrupt taste for foreign imports and lesser painting genres like portraiture. He attributed its undeveloped state in England not, as foreign critics made out, to any deficiency in national climate or imagination, but more plausibly to the Reformation: 'It is then no great matter of wonder that the English were remarkable for nothing but portraits, and that Vandyck, Lely, &c. who had been born and educated in great historical schools abroad, were better qualified to succeed in this, or any other branch of the art, than a few scattered ignorant natives, who were never educated for it.'[44]

Quoting Bacon, he argued that it should always be remembered that the smaller branches of art, the 'lines and veins', were part of a larger knowledge and that 'many particular sciences become barren, shallow, and erroneous, while they have not been nourished and maintained from the common fountain'. Barry had in mind the vogue for 'Portraits of ourselves, of our horses, our dogs, and country-seats: being attached to little things, we came naturally to admire and to over-rate the little men who succeeded in them.' Following the views advanced by Richardson that a good portraitist required 'a degree of the historical and poetical genius' because he had to understand people's characters and minds, Barry came to the opposite conclusion, arguing that history painters made the best portraitists. He was not against the art of portraiture per se: 'there is no part of it trifling or mean in itself, it only becomes so when it gets into the hands of men of contracted powers, who debase those things by separating them from the noble qualities which should support and make them of consequence'.[45] Naturally, the study of history, in its large and noble character, should lead the way: 'The prime object of study to a history-painter being the entire man, body and mind, he can occasionally confine himself to any part of this subject, and carry a meaning, a dignity, and a propriety into his work, which a mere portrait-painter must be a stranger to, who has generally no ideas of looking further than the likeness and in its moments of still life.' The reverse case, that a portrait painter could paint history, was 'too palpably absurd to need any refutation'.[46]

Barry deplored the English practice of contracting and splitting art into small lots, 'fitted to the narrow capacities of mechanical uneducated people':

> We have looked upon the arts, as we do upon trades, which may be carried on separately, and in which seven years apprenticeship was the best title. After what Horace has so long ago pronounced about the inutility of genius without learning, it is surprising how it could so universally enter into the heads of our people, that an illiterate man could make any thing of true art. Labour and industry might give him success in the mechanical modes of working; but where is he to turn himself to, for the acquisition of that comprehensive thought, that necessary knowledge of all the parts of his story, and the characters who act in it; that power of inventing and adding to it, and that judgement of making the old and new matter consistent and of one embodied substance?[47]

It followed that an artist's education comprised not only a thorough knowledge of the human form and a power of delineating it but also a knowledge of history, the peculiar characters, manners and customs of humankind.[48]

Like Shaftesbury, Barry concluded that a good society necessarily produced good art, stressing the importance of education and a free, public-spirited government in the cultivation of a moral climate suitable for the promotion of the arts. Since the state of a nation's character determined the quality of its painting, painting was a measure of a

society's worth. It was also a guide to and expression of a people's greatness. Therefore, the promotion of history painting was not an incidental luxury but was fundamentally concerned with a nation's moral fibre. History painting should have pride of place in the development of the English nation, in its churches and even its houses: 'It is a vulgar error that our rooms are not sufficiently capacious; it is our minds that want expansion.'[49] Artists should rise above mere mechanical excellence, and turn to 'the nobler flights of dignity, elegance, poetical fancy, knowledge, and judgement'.[50]

To summarise, during the eighteenth century there was a debate as to the nature and status of portraiture. Did it depend on mundane standards of verisimilitude recording outward appearance – 'what you see is what you get' – or could a more prestigious, generalised style be developed, a grand manner akin to history painting, that was capable of suggesting character and even genius in the sitter, inducing right-minded emulation on the part of the viewer? To enhance the status of portrait painters, the latter course was clearly preferable. It appeared to work when sitters were leaders of society and capable, in theory at least, of embodying the highest moral attributes. It could even succeed when sitters possessed a genius founded on the workings of the mind, for which artists could depend on well tested strategies of representation. However, men closely aligned with mechanical arts represented a fresh challenge. Aspiring artists might easily lose caste and clients by choosing to portray mechanical men and thus being associated with vulgar, servile Dutch-style subject matter. Yet, given the information about such men covered in previous chapters, it should not be surprising that in the mid-eighteenth century there evolved a hybrid type of portraiture which managed to achieve an empirical likeness but which also did justice to the sitter's ingenuity and indicated the means whereby he had contributed to the public good. Artists did so partly by relying on forms of portraiture derived from the apparatus adopted to depict learned gentlemen of science but they also dissolved commonplace distinctions between mechanical and liberal arts and science, repudiating traditional hierarchies in the affirmation of their own skills. They demonstrated that it was possible to portray men of industry and create images of unprecedented artistic force. As Reynolds attempted to accomplish in the more showy realms of metropolitan society, they elevated both themselves and their subjects to a new status.

Men of Science

By the eighteenth century there was an established tradition of painting portraits of men of science, encouraged by the formation of academic and scientific institutions. Throughout the seventeenth century, Thomas Bodley's Library in Oxford, which had opened in 1602, attracted benefactions and bequests of portraits of distinguished men, including its founder, chancellors, librarians, astronomers, professors and musicians, on the model of the Leiden University Library. In Cambridge, after the Restoration, portrait sculpture was intrinsic to Wren's concept of the Library at Trinity College. At the end of the bookcases Wren envisaged busts of ancient and modern authors whom members of the college might aspire to emulate, as well as illustrious members of the college itself. The practice was taken up in many eighteenth-century university and scholarly libraries.[51]

The 1740 Bodleian catalogue by Andrew Durcarel lists 142 portraits of what had become the 'Public Gallery in the Schools in Oxon', the first public institution of its kind. By 1759 visitors could purchase a catalogue and promenade round the Upper Gallery as one of the sights on an Oxford tour. Wren's Library at Trinity was also open to the public. The Royal Society and Royal College of Physicians commissioned por-

traits of their members, just as the Corporation of London in 1670 commissioned por-
traits from John Michael Wright of the judges appointed to arbitrate on boundary dis-
putes arising from the Great Fire.[52]

In these commemorative works, intended to compensate for the departure of the
worthy originals and cast lustre on the institutions with which they were associated,
the sitters look intelligent rather than foolish and gentlemanly rather than vulgar, as
one might expect, confirming at least to a limited extent Richardson's belief that it was
possible for artists to give not only the appearance but also the mind and character of
great men.[53] Gentlemen of science were by definition amateurs, concerned with the
public good, not narrow self-interest, and possessing a range of experience which
allowed them to exercise a generalising and abstracting rationality. The ideal was of a
man who was liberally educated, whose vocation was science as an intellectual-cum-
philanthropic recreation, to which he might devote most of his time without ever sur-
rendering his claim to be a private gentleman of wide culture. To be thought to be
pursuing science for money was distasteful. Of course, such an ideal was frequently far
from the truth but in matters of presentation, it explains why comparatively few men
of science were depicted actively involved in the experimental production of knowl-
edge, as opposed to claiming ownership of the fruits of that production. Bacon's view,
annexed from the arts, that the pursuit of science was a co-operative venture involving
empirical observation and experimentation, was rarely reflected in portraits of men of
science before the nineteenth century. Artistic conventions for the most part lagged
behind scientific practice, weighed down by archaic forms of gentlemanly decorum and
canonical authority.[54]

Nevertheless, portraits of men of science were often accompanied by the physical
manifestation of their knowledge, in the shape of papers and books, or by busts of their
mentors, both ancient and modern. The very pose, sometimes highlighted by a motto,
could suggest the way in which the portrait should be viewed, acting out a role recog-
nisable by those acquainted with higher forms of art. Robert Walker's portrait of John
Evelyn, painted in 1648 during a two-year separation from his young wife (he married
Mary Browne in 1647 when she was barely thirteen), shows the sitter in the conven-
tional pose of a melancholic lover and reclusive scholar, in simple neglected dress, with
his head resting on his right hand and his left hand resting on a skull. The inscription
in Greek above his head can be translated as 'Repentence is the beginning of wisdom'.
Evelyn's individual character is subsumed beneath a general and highly stylised repre-
sentation of pious retreat, isolated from the world and the temptations of the flesh.[55] As
has frequently been observed, Dürer's *Melancholia* (1514) provided the prototype pose to
suggest not merely a medical state but, according to humanist thought, an introspective
condition that played an important role in creative activity. Furthermore, the print sug-
gested that divine knowledge and inspiration could be mediated and revealed through
the tools displayed for mechanical analysis and mathematical calculation, if man could
but apply himself to using them.[56]

Kneller's portrait of Evelyn executed some forty years after Walker's, in 1689, is alto-
gether more worldly.[57] It was commissioned by Pepys who specified that Evelyn, as the
latter related, should be 'holding *Sylva* in my right hand; it was upon his long and earnest
request; and is placed in his library; nor did K[neller] ever paint a better and more mas-
terly work'. Evelyn had, as it were, parted from the cloister in order to do good in the
world through his most useful publication, in which the country was encouraged to
restock its woodlands to rebuild the Navy, a cause dear to Pepys's heart. In a modest
way the portrait thereby reinforced Bacon's advocacy of usefulness and open communi-
cation in science, as represented in the design Evelyn had suggested more than twenty
years earlier for the frontispiece to Thomas Sprat's *History of the Royal Society* (1667).

Portraits of Isaac Newton underwent a similar process of transformation, emerging from the study into the world. One of the earliest was painted by Kneller in the same year he painted Evelyn, 1689, but it is widely different in character.[58] Executed two years after the publication of *Principia Mathematica*, when Newton was visiting London from Cambridge, it conforms to the image of the melancholic natural philosopher. The painting was intended for private display in Newton's own house along with several other portraits and busts and only his close friends would have seen it, whereas that painted by Kneller thirteen years later in 1702 is far better known because it was widely reproduced. By then Newton enjoyed prominent metropolitan status as Master of the Mint and lived comfortably in Westminster. Aged sixty, Newton chose to have himself presented in a sumptuous red gown and elegant full-bottomed wig as a learned gentleman of the world, at ease in his own home and ready to receive visitors. The long robes traditionally associated with religious and scholarly retreat received a fashionable fillip when merchants imported the 'Indian' gown or banyan from the East. It enabled the wearer not only to move freely indoors but was also thought conducive to the easy and vigorous exercise of the mind.[59] Newton commissioned engravings of this image as gifts for colleagues at home and abroad. Around 1721, a third Kneller portrait showing Newton as an elegant bewigged gentleman, gloves in hand and sword by his side, was sent to the French mathematician Pierre Varignon, as a diplomatic contribution to Newton's negotiations for a *de luxe* French edition of the *Opticks*.[60]

These works demonstrate that, contrary to the sneers recorded earlier, Kneller was perfectly capable of producing a broad range of portrait types, carefully nuanced to convey individual personalities. In 1701 he took the trouble to go to Oxford for a sitting from the elderly John Wallis, whose portrait Pepys wished to present to the university, 'towards immortalising the memory of the person (for his name can never die) of that great man and my most honoured friend'. In the resulting full-length portrait, Kneller also took care to place a diagram from Wallis's *Opera Mathematica* (1699) on the table beside him, together with a gold medal awarded in 1691 by Frederick III, the Elector of Brandenburg, for his services as a cryptographer.[61]

In Newton's case, portraits were used to advance his fame and reputation well beyond the university and well before the inauguration of public art exhibitions in the middle of the century. Newton sat for more than twenty busts and portraits, paying large sums of money for several of them himself, which suggests that he placed a high value on promoting his talents not only within his own circle but also in the wider world. Even in his seventies, he sat several times to the sculptor David Le Marchand, commissioning an expensive bust and an ivory plaque which he kept in his dining-room where his friends could admire them. In 1717, he donated a large portrait of himself by Charles Jervas to the Royal Society, having initiated the practice of recording the term of a presidency in gold letters across the top.

As Patricia Fara has observed, Newton and his contemporaries were conscious of the traditional role portraiture played in confirming networks of power and patronage. The Master of Trinity College, Cambridge, Richard Bentley, commissioned James Thornhill's first portrait of Newton (about 1709–12), thereby acknowledging Newton's co-operation in letting him publish a second edition of *Principia* (Cambridge, 1713), with considerable financial and social advantages for Bentley himself, and in supporting his case for important College reforms. The artist presented Newton sitting unwigged in a gown like a venerable sage, gazing out into the landscape as if lost in thought, his hand near his heart in the traditional gesture of truth. However, Newton commissioned Thornhill to paint a second version, showing him in a different gown and in the oratorial pose of a Roman senator. This was the version, in which he assumed the robes reserved for the classical authorities he had displaced, from which Newton decided prints should be made.[62]

The apotheosis of Newton commenced with his splendid funeral and gained momentum with the magnificent marble monument installed in Westminster Abbey in 1731. It was carved at a cost of £700 by Michael Rysbrack from an initial design by William Kent, having been commissioned by John Conduitt, who had married Newton's wealthy niece. Backed by a large pyramid, a symbol of eternity, the figure of Newton seems to be declaiming, yet his horizontal posture and the mournful depiction of Astronomy (Urania) on top of the globe indicate that he is speaking from the grave. His elbow rests on four tomes, commemorating his treatises on gravity, light, theology and ancient chronology. Astronomy's globe shows the path of the 1680 comet that played a crucial role in Newton's theoretical work, while its constellations indicate how he had dated the voyage of the Argonauts. At his feet lies a chart depicting the solar system, the source of inspiration for all his endeavours. On the sarcophagus bas-relief, industrious cherubs represent Newton's innovations in the applied arts of chemistry and coinage. Alexander Pope composed the famous epitaph: 'Nature and Nature's Laws lay hid in Night./God said, let Newton be! And All was Light.'

Rysbrack's monument was only the first of a succession of works which established Newton as a leading figure in the national pantheon, boosting the claims of the body politic – particularly the Whig Party – to enlightened knowledge. His bust was included among those which George II's wife, Caroline of Ansbach, installed in the Hermitage, designed by Kent in Richmond Park and intended to represent the cream of the country's intellect. Newton also featured in a second collective monument to national genius, the Temple of British Worthies, installed in Lord Cobham's garden at Stowe in Buckinghamshire. Perhaps the most spectacular conflation of Newton with patriotism in a high art format was as part of the series of commemorative paintings of heroes who had emerged since the Glorious Revolution of 1688 'to the reputation and credit of the British nation', commissioned in 1728 by the Irish entrepreneur Owen McSwiny.[63] The Newton allegory represents a divine ray of light shining over his funerary urn, displayed in a suitably impressive colonnaded cathedral and refracted by a prism. This vision takes place before a congregation of weeping scientific muses and the rather less attentive ancient and modern philosophers who are busy benefiting from the great man's discoveries by deploying diagrams and instruments. Painted in Italy the year after Newton's death by the Venetian artists Giovanni Battista Pittoni and the Valeriani brothers, this huge picture was one of twenty-four elaborate allegorical images of famous British men, including Boyle, Locke and the Duke of Marlborough. While McSwiny sold the originals to a wealthy clientele, engravings after them were produced for a wider public.

In the more cloistered environs of Cambridge, Newton's posthumous fame was further consolidated when the Master of Trinity, Robert Smith, commissioned the marble statue of Newton completed in 1755 by Louis-François Roubiliac, which still stands in the antechapel, an early example of a secular commemorative statue erected in a public location. By contrast with Kneller's portraits and Rysbrack's monument, Roubiliac portrayed Newton as a young and energetic university lecturer. As if such a work was not enough to inspire or cow the fellows and undergraduates, Smith also refurbished the College library according to Wren's wishes with sculpted busts supplied by gift. An earlier Roubiliac bust of Newton was among the first to arrive and was placed in a prominent position across the aisle from Bacon. This met the approval of the celebrated blue-stocking Elizabeth Montagu: '[that] so fine a Temple of the Muses should be adorned with all the arts of the ingenious as well as the studious nine [muses] especially in an age that honours the polite arts more than severe science.'[64]

Busts and engravings of Newton swiftly became a form of visual shorthand for advertising their owners' intellectual pretensions. In 1732, John Conduitt commissioned Hogarth to paint a scene from Dryden's play *The Indian Emperor*, ostensibly depicting

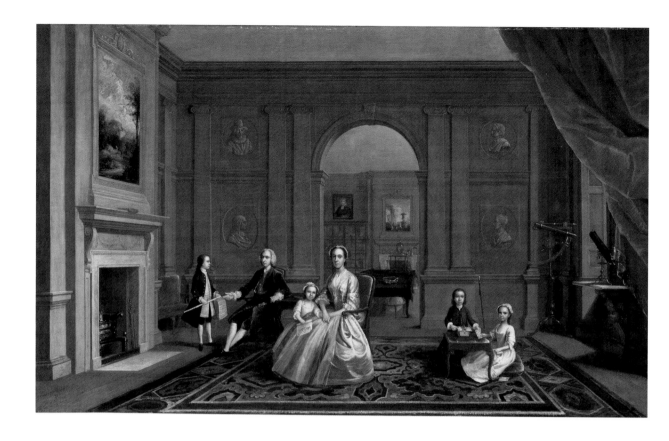

127 Arthur Devis, *John Bacon and his Family*, c.1742. Yale Center for British Art, Paul Mellon Collection

a children's theatrical performance but replete with hidden and overt references to his close relationship with Newton, most prominently a bust of the great man on the mantelpiece. When the wealthy Northumberland landowner John Bacon had his London house redecorated in the early 1740s, he ordered four grisaille medallion portraits, of Milton, Bacon, Pope and Newton, for inclusion on the walls of his drawing-room and then commissioned Arthur Devis to paint a conversation piece of his family in this setting (fig. 127).[65] By 1769, James Granger could list more than twenty engraved images of Newton, suitable for inclusion in collections of heads or for glazing and hanging in studies. Rysbrack and Roubiliac produced expensive marble busts of Newton for about £40 a head for Fellows of the Royal Society, while John Cheere sold plaster copies of the Roubiliac busts for two guineas each. Wedgwood's range of portrait medallions included five of Newton, two in basalt and three in jasper ware, all produced prior to 1780. They were intended to be part of 'a suite of eminent moderns, naturalists, amateurs, etc., [to] form a constellation, as it were, to attract the notice of the great, and illuminate every palace in Europe'.[66]

When Benjamin Franklin had his portrait painted by David Martin in 1766–7, at the behest of Franklin's friend, the Edinburgh wine merchant Robert Alexander, he was depicted as a gentleman of science wearing spectacles and perusing papers, propping up his chin with his thumb to aid concentration. The table before him was loaded with papers, books and, almost inevitably, a bust of Newton.[67] In 1789 Thomas Jefferson sought to acquire copies of portraits of Bacon, Locke and Newton whom he considered 'the three greatest men that ever have lived, without any exception'. As noted in Chapter 4, Pahin de la Blancherie presented busts of Franklin and Perronet to the Society of Arts in 1790. Portrait prints of such heroes were acquired through correspondence and exchange, serving to cement relationships between like-minded men and assuring them that they belonged to an international community of knowledge.[68]

If Newton's memory was perpetuated through his ubiquitous image, his message and more broadly that of the new experimental philosophy was diffused, as related in Chapter 3, by a stream of lecturers equipped with axiomatic models and instruments. The air pump was the most emblematic of such machines, its notoriously temperamental performance having long ceased to require coaxing by ingenious demonstrators. It was therefore no longer the restricted property of a few privileged individuals but was commercially available on the open market.[69] Introduced into portraiture, it betokened a keen interest in natural philosophy, both on a professional and increasingly an amateur level. Not surprisingly, it first appeared in engraved form in the background to William Faithorne's engraved portrait of Robert Boyle, commissioned in the summer of 1664. It can be spotted in Evelyn's design for the frontispiece to Sprat's *History of the Royal Society*. In the portrait of the scientific instrument-maker Jan van Musschenbroek and his younger brother Petrus, painted by H. van der Mij in 1715, an air pump is visible on the shelf along with a pair of Magdeburg hemispheres, all made in their Leiden workshops.[70] To underline their scholarly credentials, the two men are shown engaged in a philosophical discourse over a celestial globe, armed with books and suitable instruments.

Scientific instruments increasingly found their way into genteel portraiture. Arthur Devis's portrait of the Bacon family shows their drawing-room as furnished with an air pump, microscope and terrestrial and celestial globes. A reflecting telescope and a transit quadrant on a stand were conveniently placed by the window. Around 1740 William Robertson painted a conversation piece of the family of Sir Archibald Grant of Monymusk, depicting the gentlemen engaged in drawing fortifications, surrounded by bookshelves loaded with shells, minerals, books and scientific instruments including reflecting and refracting telescopes, a microscope, ring dial, dividers, a protector and a pair of gunner's callipers.[71] In Paris, the amateur Joseph Bonnier de la Mosson commissioned his portrait from Jean-Marc Nattier in 1745, ensuring that he was shown reading a volume (which, from the way he points at it, he might also have commissioned) and with his natural history specimens in jars and mechanical models half revealed on shelves behind a drawn curtain.[72] A small portrait of a gentleman amateur of about the same date, possibly by the French artist Jean-Baptiste van Loo who was in England from 1737 to 1742, depicts him holding a manuscript in one hand and resting his elbow on a table on which an orrery is placed. The shelves behind carry instruments – two microscopes, a telescope, a dial and quadrant – and handsomely bound volumes.[73]

Wenzeslaus Wehrlin (known in Italy as Venceslao Verlin) made something of a speciality of this type of portrait. In 1768 he painted an amateur dressed in a loose embroidered gown and turban seated in his study before a harpsichord covered with prints, small pieces of sculpture, fine boxes, glass bottles, funnels and alembic heads, mills, rules and callipers. At his feet a putto blowing bubbles gestures to an array of instruments and scientific accoutrements, including a Culpeper-type microscope, a globe, a mortar and pestle, more chemical glassware and a skull wearing glasses. The wall behind is decorated with a painting of the Roman *campagna* and two large engravings of pastoral scenes after Watteau (fig. 128).[74] Wehrlin worked in Florence, where in 1771 he painted George Nassau, the third Earl Cowper, with his family at the Villa Palmieri on the slopes of Fiesole. Here Cowper established the suite of five rooms for scientific experiments in which the family are depicted, surrounded by an array of instruments.[75] Nor was a polite interest in scientific instrumentation confined to gentlemen. In the 1770s, Dmitri Levitsky was commissioned by Catherine the Great to paint a series of large-scale portraits of the young ladies of the Smolny Institute for Noble Girls, the future maids of honour of the Empress. While others in the series are depicted dancing, acting or playing music, Ekaterina Ivanovna Moltshanova was painted in 1776 sitting looking

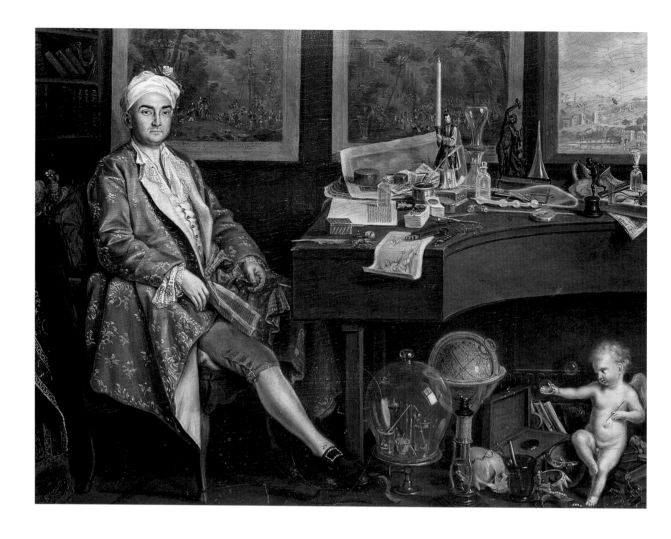

pleased with herself, holding a small book in one hand and exclaiming with the other as if to express her delight in having mastered an understanding of the air pump that sits on a table beside her (fig. 129).[76]

These works help to place Joseph Wright of Derby's large-scale paintings of the *Orrery* and the *Air Pump* within a European context and to highlight their full innovatory force. Although not intended as group portraits, the paintings combine the representation of human character with moral purpose, fulfilling Richardson's highest claims for portrait painting. They also demonstrate those qualities of sociability and collaboration already explored in relation to gentlemanly and philosophical societies. *A Philosopher giving that Lecture on the Orrery, in which a lamp is put in place of the Sun* was exhibited at the Society of Artists in 1766 and bought by Wright's friend Washington Shirley, the fifth Earl Ferrers (fig. 130). It was engraved by William Pether and published by Boydell in 1768.[77] As already noted, the subject had been used as the frontispiece of *A New Universal History of Arts and Sciences* in 1759. There the philosopher demonstrated the workings of the orrery with a pointer to three gentlemen in a library or cabinet of curiosities replete with books, scientific instruments, a magic lantern, model ship, telescope and strange beasts suspended from the ceiling. It thus combined the trappings of a seventeenth-century *Wunderkammer* with the more rational approach to knowledge represented by the orrery, one of the means by which Newton's law of universal gravitation, first published in *Principia* in Latin and comprehensible only to mathematicians, was made accessible to the public.[78]

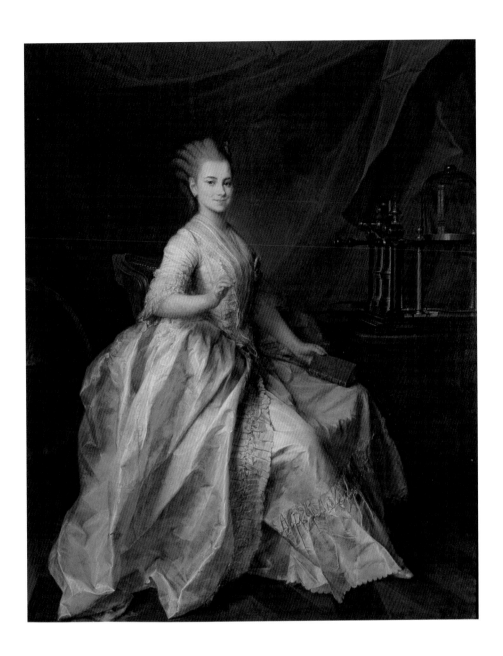

Wright's painting depicts a demonstration to a lay middle-class audience, rather than to gentlemen amateurs. The group was probably made up of Wright's own friends: the man taking notes has been identified as Peter Perez Burdett and the philosopher wearing the familiar garb of a man of science, a loose gown, bears some resemblance to Erasmus Darwin. More than is perhaps seemly for the representation of 'stern science', in the manner of seventeenth-century Dutch artists Wright delights in recording the pleasures of the world as manifest in its physical material surfaces: the rich red and green damask of the philosopher's robe, the yellow-striped waistcoat of the note-taking figure, the fashionable straw hat and pearls of the lady on the right.[79] In Wright's painting the sun, usually represented by a brass ball at the centre of the system, has been replaced by a wick burning in a jar of oil in order to demonstrate an eclipse, not to mention Wright's skill in recording the effects of candlelight.

Ferrers was himself a man of science – his observations on the Transit of Venus were well known and led to his election as a Fellow of the Royal Society in 1761 – and had constructed his own orrery. Wright depicts a grand orrery, complete with concentric

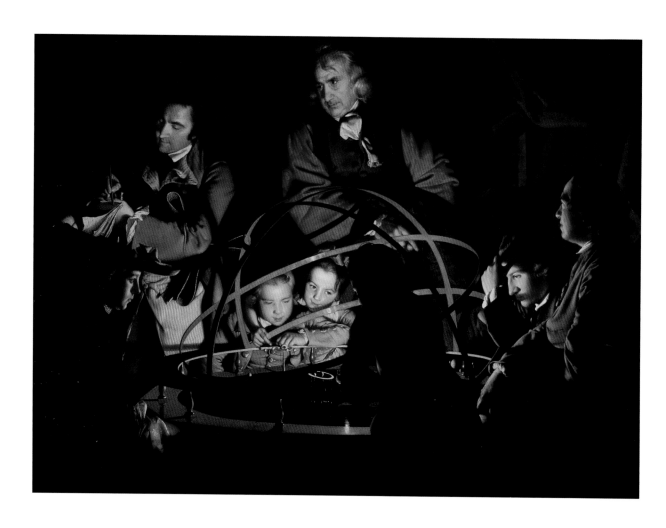

A Philosopher giving that Lecture on the Orrery, in which a Lamp is put in place of the Sun, 1766. Derby Museums & Art Gallery

armillary hemispheres. As the reactions of the audience confirm, the instrument combined education with entertainment: even the three children are gripped with eager curiosity. The profounder implications of the theory are captured in the expressions of the grown-up spectators, lost in thought as to the meaning of universal order and their own tiny, fleeting part in it. Ultimately, they are contemplating not simply the solar system but the operation of God. The light at the centre of the world signifies both the sun and ultimate knowledge, the light of divine truth and revelation. These spectators are rendered in the very act of being enlightened.

In 1768, Wright painted *An Experiment on a Bird in the Air Pump* and exhibited it the same year at the Society of Artists (fig. 131).[80] Its engraving by Valentine Green was published twice the following year. Again, the occasion depicted takes place at night, allowing Wright to unify once more the velvety surfaces of the painting round a dramatic light source. It is an even larger canvas than the *Orrery* (183 × 244 cm compared with 147 × 203 cm) and focuses on the instrument which had become the *pièce de résistance* of travelling scientific lecturers. Wright depicts the moment when the bird, in this case a costly cockatoo, is suspended between life and death as air is progressively removed from the pump. Serving as God's representative on earth, the demonstrator holds the bird's life in the balance.

The reaction of the fashionably dressed assembly to this moment of suspense varies and the range of ages suggests a conscious effort on Wright's part to cover the Ages of Man, specific as to appearance yet generalised as to role. While the little boy on the left is fascinated, the two girls on the right display a becoming empathy with the suffering

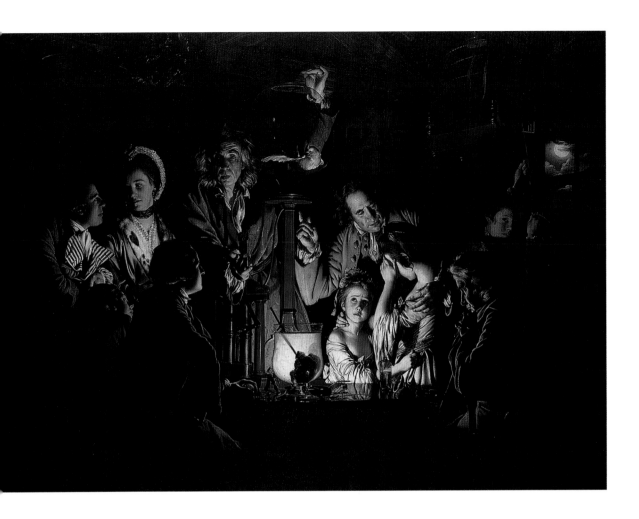

of the small creature and are comforted by their father who explains the experiment to them. On the left the young couple exchange knowing looks as if mutually apprehending their own future. The objective detached gaze of the man on the left is contrasted with the elderly man on the right, sunk in contemplation of his own imminent mortality. This theme is echoed in the part of a human skull in the large glass jar of fluid lit by the candle which stands on the table directly below the bird. A tall phial of liquid, a cork and a pair of Magdeburg hemispheres are also placed on the polished surface of the table, thereby creating a self-contained still life serving its traditional role as a *memento mori*.

Although Wright here too probably used his friends as models – the couple have been identified with Thomas Coleman and Mary Barlow, the lecturer with the Derby clock-maker and Newtonian natural philosopher John Whitehurst – he succeeded in tran-scending the genre of the portrait and conversation piece to create modern moral paintings in which the inevitability of death is presented in the context of the laws of nature, as understood by the new science. The paintings spotlight the Baconian activi-ties of empirical observation and experiment. For all the commercialism inherent in public demonstrations of natural philosophy, dependent on showy displays of scientific instruments in action, these two works possess the imagery and solemnity of religious paintings.[81] The easy sociability and refined dress of the spectators, lovingly recorded by the artist, do not divert from profounder references to the transcendent theme of God the creator and the meaning of life. While Wright's technique was itself based on metic-ulous observation, it did not limit his capacity to convey moral gravitas, contrary to

received wisdom with regard to painting in the Dutch manner. Alongside these works, Charles-Amédée-Philippe van Loo's paintings of scientific experiments being explained to aristocratic audiences appear lightweight, Rococo renderings of entertaining party tricks.[82]

In 1771, Wright exhibited a third scientific subject at the Society of Artists, *The Alchymist, in Search of the Philosopher's Stone, Discovers Phosphorus, and prays for the successful Conclusion of his Operations, as was the custom of the ancient Chymical Astrologers*.[83] Dutch genre paintings of alchemists in their laboratories, notably by Thomas Wyck, were known in England and Wright of Derby even owned one. The discovery of phosphorus around 1670 was an accidental alchemical by-product (one of those chance discoveries predicted by Bacon) like porcelain, which stimulated the research of Robert Boyle and his contemporaries into the nature of combustion. So although the alchemist is dressed in sober yet rich robes of an indeterminate period, the painting had a modern resonance and Wright went to considerable lengths to ensure that he correctly represented the chemical apparatus. He also seems to have followed the account of the manufacture of phosphorus given in Pierre Joseph Macquer's chemical treatises published in French in 1749–51 and translated into English as *Elements of the Theory and Practice of Chemistry*, published in 1758.

French state support for chemistry in the second half of the eighteenth century permitted eminent practitioners to emerge from book-lined studies and be portrayed using their experimental apparatus, a realm hitherto avoided because of its associations with alchemical practice. Jean-François Gilles (called Colson) painted Georges Balthazar Sage, the eminent chemist and mineralogist, in 1777, the year he took up a teaching post in the new Collège de Pharmacie.[84] He is shown in the dress of a gentleman sitting in his home laboratory, where he gave free courses on mineralogy based on his own collection of more than five hundred specimens, some of which are arranged on the shelves behind him. A large furnace in the background also suggests the practical application of his knowledge: in 1778 he was given a newly created chair in experimental mineralogy at the Hôtel des Monnaies where later the Royal School of Mines was founded, in 1783, with Sage as its first director. In contrast to the alchemist in Wright's picture, who is kneeling before the phenomenon he is about to witness, like a saint before a divine manifestation, Sage is sitting comfortably alongside his equipment, clearly in control.

The most glamorous portrait of a chemist at work is Jacques-Louis David's large depiction of Antoine Lavoisier with his wife, Marie-Anne Pierrette, dating from 1788. The calm, grey classical setting, Lavoisier's sober dress and his wife's cool muslin, present a newly rational face of chemistry – the diametrical opposite of the hot, smoke-filled atmosphere of the alchemist's laboratory. Madame Lavoisier is seen as something more than the traditional alchemist's apprentice, appropriately in the role of muse and intellectual companion, for Lavoisier relied on her for translations from English and other languages and she had a working knowledge of chemistry. Having studied drawing with David, she made sketches of Lavoisier's laboratory and prepared the thirteen plates for Lavoisier's seminal *Traité Elémentaire de Chimie* (1789). The portrait celebrates Lavoisier's work as a chemist through the introduction of the apparatus but its size and cost mark his wealth and status as a leading tax farmer and *régisseur des poudres*, the director of the national gunpowder manufacturing monopoly, a post which utilised his scientific and administrative abilities.[85]

In 1787, David Martin was commissioned by the Royal Medical Society of Edinburgh to paint Joseph Black (1728–99), then the Professor of Medicine and Chemistry at Edinburgh. He is depicted in mid-lecture, wearing a black academic gown and holding up a large glass test tube with one hand, an open book on the table before him.[86] However, most men of science were content with portraits which presented them in the dress and

manner appropriate to men of breeding and intellect or as members of traditional professions, not accompanied by the 'ornaments' of their invention. The Reverend Stephen Hales was painted by Thomas Hudson in clerical dress and, in the early 1770s, Thomas Gainsborough portrayed one of his mechanically inclined elder brothers, the Reverend Humphrey Gainsborough, in clerical attire with his eyes raised heavenwards as if hoping for divine inspiration, with no sign of his many inventions.[87] The mechanical philosopher Erasmus Darwin reveals nothing of his mechanical interests in the two portraits Wright painted of his friend around 1770 and in 1792–3, the first giving him the air of a concerned physician and the second, deferring to his growing fame as a writer, with prominence being given to the over-large quill pen in his hand.[88]

During the course of the eighteenth century gentlemen of science emerged from the shadows, ceased to be scholar recluses and participated in the world. Newton and his posthumous reputation secured the status of science within the elevated realms of elite discourse and public lecturers brought its cerebral achievements before a broader public. Yet, with the exception of the works just described by Rysbrack, Wright of Derby and David, the commemoration of Newton and his successors in portraiture remained determinedly quotidian, not rising to the challenge and creating pictures with the visual imagination or 'poetical genius', character or moral resonance to which the most ambitious painters aspired.

Men of Industry

If Granger is taken as a rough guide to the number and type of portraits produced in the sixteenth and seventeenth centuries and some indication of the public eminence of the sitters,[89] then it seems that practitioners of the mechanical arts in England were rarely honoured with portraits unless they themselves were painters, sculptors or engravers. Although Granger conceded that there were some illustrious persons represented by 'meanly engraved heads' and others whose merit derived merely from the painter or engraver, he failed to consider the possible existence of figures worthy of inclusion who did not feature in his work for lack of an image, asserting instead that engraved portraits took in 'almost all persons of distinction, especially from the reign of Henry VIII to the Revolution'.[90] The closer the system got to Granger's own era the more difficult it became to classify people according to his system and, as already noted, he himself never advanced in published form beyond the reign of James II. In extending Granger's design to organise his own collection covering subsequent reigns, his correspondent and fellow enthusiast for heads, Richard Bull, complained in 1770 of 'the great number of prints of persons who were of little or no eminence, from the time of the Revolution and particularly in the reign of George II', with the result that for the latter he switched to sorting his heads alphabetically.[91]

When the Reverend Mark Noble eventually came to publish a sequel to Granger in 1806, he explained that his decision to stop short of the period first intended, venturing no further than the reign of George I, was to avoid exciting 'uneasy apprehensions or sensations in the minds of those whose families and near connections might be affected by the relation'.[92] Yet it is surely more likely that the classification system had outlived its uses. In Noble's compilation for the reign of George I, classes IX and X had become even more mixed bags. 'Men of Genius and Learning' (IX) included physicians, surgeons, an apothecary, empirics (that is, quacks), chemists, poets, writers, historians, a biographer, antiquaries, mathematicians, a geometrician, an astrologer and miscellaneous authors. 'Artists' (X) encompassed history and portrait painters, architects, engravers, musicians, actors, writing and dancing masters, printsellers, tradesmen and

mechanics. Granger's initial reference in the last class to 'inferior professions' was tact-
fully removed, although some of those included were represented in ways not far
removed from commercial advertising. One 'very rare' portrait, noted by Noble for the
reign of George I, was of John Lofting, a London merchant, the inventor and patentee
of the fire engine, 'as we are informed by the engraving; in one corner of which is a view
of the Monument, and in another, the Royal Exchange. &c. The engines are represented
as at work, with letterpress explanations.'[93]

Henry Bromley produced *A Catalogue of Engraved British Portraits, from Egbert the
Great to the Present Time* in a single volume in 1793, adopting a simplified version of
Granger's system to amalgamate the aristocracy and gentry into two rather than four
classes. Class VII now became 'Literary Persons' and class VIII 'Artists, Actors, Writing
Masters, Tradesmen &c'. For the period of Queen Anne and George I, class VIII still
mainly consisted of painters, engravers, printers, printsellers, writing masters and musi-
cians, as well as odd tradesmen and publicans. For the reign of George II, class VIII
included, for the first time, 'Mechanicians' in the title and the entries in this section had
grown from four pages to eight. Admittedly, 'Mechanicians' were still few and far
between: they included two portraits of the chemists Godfried Hanckwitz (1718) and
his nephew Ambrose Godfrey (1736), two mezzotints of the clock-maker George
Graham, the 'Ingenious Mechanick' Christopher Pinchbeck (one from his shop bill) and
two mezzotints of the carpenter John Sturges, presumably after the portraits by John
Vanderbank, one of which depicted him in oriental dress.

The greatest challenge was presented by the still current reign of George III. Class VIII
was extended to twenty pages and mechanicians featured more strongly, especially clock-
and watch-makers. They included a mezzotint of John Barlett and Thomas Phelps, in
Lord Macclesfield's Observatory at Shirburn Castle (1778); the printer John Baskerville;
Edward Beetham, the maker of machines for washing linen (an oval mezzotint after a
painting by his wife); the instrument-maker John Bird (1776); James Brindley, 'Geometr.
to the Duke of Bridgewater', represented in a 1770 mezzotint by R. Dunkarton after F.
Parsons; the letter-founder William Caslon, in a mezzotint by J. Faber after a painting
of 1740 by F. Kyte; John Ellicot, F.R.S., a mezzotint by R. Dunkarton after a portrait by
Nathaniel Dance; John Harrison, the inventor of the time-keeper from the *European
Magazine* of 1788; the distiller Thomas Langdale; Thomas Liddiard, jeweller; several
prints of Vincent Lunardi, the 'Secretary of Embassy to the Neapol. Ambassador, and
Aëronaut'; John May, a shipbuilder in Holland; Thomas Mudge, the watch-maker, in a
mezzotint of 1772 by C. Townley after Dance; William Neild, saddler; Thomas Nowell,
a tinplate worker and Common Councillor for Farringdon Without, in a livery gown,
holding a glass of hock (an altered plate); Christopher Pinchbeck, toyman; Jesse
Ramsden, 'optician', in a 1791 mezzotint by Jones after Robert Home; James Sadler,
'cook' at Oxford[94] and aeronaut (1785); William Shipley, the 'painter and projector of
the Society of Arts and Manufactures' by William Hincks; John Smeaton, the 'geome-
trician' and F.R.S. with a view of the Eddystone lighthouse, after a painting by Mather
Brown; Edward Snape, farrier to the King; Edward Spry, shipwright at Plymouth; Henry
Stockman, artisan to Lord Boringdon; Robert Street, shoemaker of Bloomsbury; and
Josiah Wedgwood by Joshua Reynolds, engraved by W. Halman, in 1787.

There was no consensus as to how such a miscellany of men of widely different trades
and stations should be portrayed. Desire to show the basis of a man's achievement could
be overtaken by the wish to demonstrate that the sitter had risen to the status of a gen-
tleman or even a man of science, unsullied by any suggestion of labour for gain. The
minuteness of detail inherent in depicting specific goods and inventions in the 'Dutch'
style was, as already emphasised, condemned by eighteenth-century theorists, for it was
at odds with aspirations to heroic Italianate generalisation. Mundane considerations such

as local market conditions and the availability of competent portrait painters also entered the equation and helped determine whether a man splashed out on more than a basic head and shoulders. None the less, certain general observations can be made.

The prominence of clock-, watch- and scientific instrument-makers as subjects of portrait engravings – as opposed to other high-caste craftsmen like gold- and silversmiths or skilled joiners – requires some explanation. Thomas Tompion was possibly the first to be singled out for this distinction, portrayed by Kneller 'in a plain coat, looking at the inside of a watch' (fig. 132) and reproduced as a mezzotint by John Smith in 1697. Noble records that by 1806 the original picture was in the possession of 'Mr Dutton, Watchmaker in Fleet-street', having been passed from master to apprentice over several generations of clock-makers.[95] Its display may well have encouraged other clock-makers to commission portraits of themselves, not least for advertising purposes. Their necessary involvement with engravers on metal in the production of clock- and watch-plates facilitated the diffusion of the images in print form. Isaac Wood's portrait of Christopher Pinchbeck senior, from which a mezzotint was made by John Faber junior, is similar in format to the Tompion portrait. Typically the sitters were depicted with a clock or watch of which they were particularly proud or an innovation they had made. Tompion's successor in business (and nephew-in-law), George Graham, was painted in 1739 by Thomas Hudson sitting in front of the longcase pendulum he had designed and the image was diffused as a Faber mezzotint.[96] The royal optician John Dollond held one of his patent lenses in his hand in his portrait by Benjamin Wilson, which was exhibited at the Society of Artists in 1761.[97] Thomas King's portrait of John Harrison, dating from 1765–6, shows him seated surrounded by his inventions, including the H3 timekeeper (1759) and behind him the precision gridiron-pendulum regulator, which he built to rate his other timepiece (fig. 133). When the picture was engraved by Peter Joseph Tassaert in 1768, the pocket watch he held in his right hand was changed into the famous H4 chronometer of 1760 for which in 1765 he won half the £20,000 prize offered by the Board of Longitude. As Dava Sobel has pointed out, while Harrison was sitting for his portrait, his famous timepiece was in the hands of the Admiralty who declined to return it until its eligibility for the remainder of the prize had been determined. Neither did Tassaert have access to H4 but by 1768 it would have been perverse to have omitted it.[98]

As with engravings after portraits of gentlemen of science, mezzotint portraits of leading scientific instrument-makers strengthened the credentials of those who acquired such prints – and even the instruments made by them – to membership of a scientific community. In the mezzotint engraved and published by Valentine Green after 'Lewis' in 1776, Harrison's fellow Board of Longitude beneficiary, John Bird, who was renowned for the delicacy and accuracy of his instruments, points to his design for the famous eight-foot-radius brass mural quadrant, installed at the Royal Observatory in 1750, on the table before him. Jesse Ramsden, a third beneficiary of the Board, was painted by Robert Home sitting beside his dividing engine with the altazimuth circle he made for the observatory in Palermo in the background. In his left hand he holds a rule and in his right dividers, as if explaining a particular detail of the engine to the viewer (fig. 134). The painting was commissioned by the artist's brother, the surgeon Sir Everard Home, with whom Ramsden had collaborated on optical experiments. Evidently, the sitter objected to the fur-lined coat which he was depicted wearing, as he had never owned one, but nevertheless a mezzotint was made after the portrait with no alteration in dress.[99] Martin Archer Shee exhibited his portrait of the pioneering chronometer man-

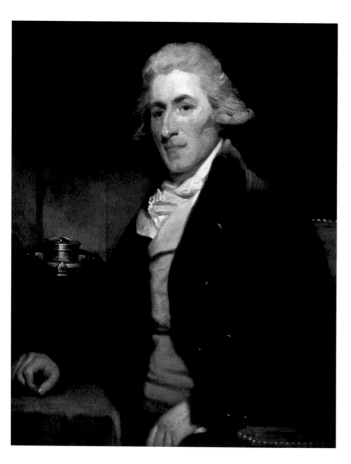

135 Martin Archer Shee, *Thomas Earnshaw*, 1798. Science Museum, London

ufacturer Thomas Earnshaw at the Royal Academy in 1798 (fig. 135). It must have been good publicity for Earnshaw's shop on High Holborn, which was London's major source of simple, cheap instruments intended for private use or for issue to naval officers. Earnshaw's own key contribution to the development of marine chronometers was the spring detent escapement of 1782, which was submitted for patent registration the following year. Although of humble Lancashire origins, Earnshaw is portrayed as a gentleman of means with powered hair and with his famous marine chronometer on a case on the table behind him.

The reputation of these men was known throughout Europe in enlightened circles and the relative openness of London's scientific community ensured that they enjoyed a privileged position as craftsmen, for gentlemen of science relied on their skill and knowledge. James Bradley, the Astronomer Royal, recognised that his own advancement of astronomy 'has principally been owing to the advice and assistance given me by our worthy member Mr George Graham; whose great skill and judgement in mechanics, joined with a complete and practical knowledge of the uses of astronomical instruments, enable him to contrive and execute them in the most perfect manner'.[100] Graham's work for Bradley, for his predecessor as Astronomer Royal, Edmond Halley, and for Samuel Molyneux's private observatory at Kew, naturally recommended him to the President of the Royal Society, George Parker, the second Earl of Macclesfield, who commissioned him to stock his own new observatory at his country seat of Shirburn Castle, Oxfordshire, in 1739 and evidently was sufficiently impressed to acquire, if not commission, a portrait of him. The most able makers – Graham, Ramsden, John Troughton, James Short, John Dollond and Nairne – became Fellows of the Royal Society and published in *Philosophical Transactions*. Dollond, Ramsden and Troughton were awarded the Society's highest prize, the Copley Medal. Some of these men were manager-manufacturers on a relatively large scale: Ramsden employed the unusually large number of forty to fifty workers at his premises in Piccadilly and was on friendly terms with his titled clients at home and abroad, despite their being frequently driven to exasperation point on account of his notorious delays in delivering the instruments they had commissioned.[101]

Portraits of such men and mezzotints after them added lustre to the libraries of gentlemen scholars and philosophers. Lord Macclesfield not only possessed the Hudson portrait of George Graham but commissioned portraits from Hogarth of himself and his then elderly tutor William Jones, a distinguished mathematician who had known Newton and Halley. Jones is seated in the same manner as Newton, in Vanderbank's 1725 portrait, which was well known in its engraved form (by Vertue) as the frontispiece to the third edition of *Principia Mathematica*, published in 1726, the year before Newton's death.[102] Macclesfield himself wears a splendid silk-damask coat and breeches, set off by large cuffs and a waistcoat in a gold-ground silk covered with an extravagant flower and foliate pattern, a reference to the family connection with the silk mills of Derby and Macclesfield. He leans forward in an animated manner, perhaps thereby cre-

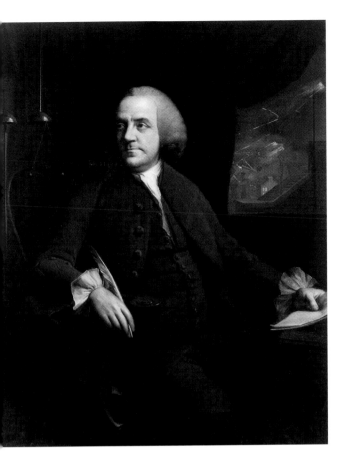

ating a scientific conversation in visual form with the other luminaries hanging in his library.[103] To these works was added in the 1770s the privately printed mezzotint by James Watson of the artisan assistants in Macclesfield's observatory. It depicts Thomas Phelps with John Barlett, the former looking through a telescope and the latter watching him. According to the inscription, Phelps was born in 1694, started out as a stable boy but owing to his extraordinary genius became 'Observer', as did John Barlett, born in 1721 and originally a shepherd, who became 'Assistant Observer'.

Portraits on this level rarely rose above being workmanlike records or 'copies' of makers and instruments; their humdrum format did not aspire to do justice in aesthetic terms to the 'invention and design' of the sitters. Leading provincial artists presented sitters with empirical clarity, as is evident in the portraits Wright of Derby painted in Liverpool, where merchant families valued conspicuous displays of wealth in their houses, furnishings, dress and jewellery but were less affected by delusions of intellectual grandeur and the loftier aspirations of portraiture itself.[104] The City-based artist Mason Chamberlin painted London's merchant and dissenting classes with workmanlike honesty, free of

36 Mason Chamberlin, *Benjamin Franklin*, 1762. Philadelphia Museum of Art

West End pretensions. In his 1762 portrait of Benjamin Franklin, the subject sits as a man of business at his desk, quill pen and paper in hand (fig. 136). He had been in England since 1757 acting as agent for the Pennsylvania Assembly in their grievance against the Penn family's claim to tax exemption. The painting was commissioned by Franklin's friend and neighbour in Craven Street, Philip Ludwell III, a Virginian planter who had moved to London in 1760 and presumably wanted a memento before Franklin returned to the colonies. One or other ensured that due recognition was given to the electrical experiments for which Franklin was already famed.[105] He is depicted listening intently to two small bells which sound when the connecting rods are charged by the lightning rod. Two cork balls suspended from one of the bells swing apart, having been electrified and repelled. Outside the 'window', Franklin's pointed lightning rod is seen performing its job efficiently, the roof to which it is attached remaining stable, while a house and a church steeple in the distance, not fitted with his device, are shown collapsing under a jagged lightning strike, as occurred in electrical experiments using model steeples and thunder houses. Franklin was pleased with the image, ordering a replica for his son and sending copies of Edward Fisher's engraving, commissioned by the painter after his portrait, to friends and colleagues. He was taken particularly by the alertness of his expression, as captured by Chamberlin, commenting of the engraved copy that it 'has got so French a countenance that you would take me for one of that lively Nation'.[106]

John Singleton Copley's portrait of the silversmith Paul Revere, dating from 1768, constitutes another example of the provincial, or rather colonial, empirical mode of portraiture, well suited to its subject (fig. 137).[107] Revere is shown half-length, seated behind a highly polished table and dressed simply in a shirt and waistcoat, contemplating a teapot of his own manufacture with his engraving tools set beside him as if preparing to complete the work. His over-large head and right hand only reinforce the impression

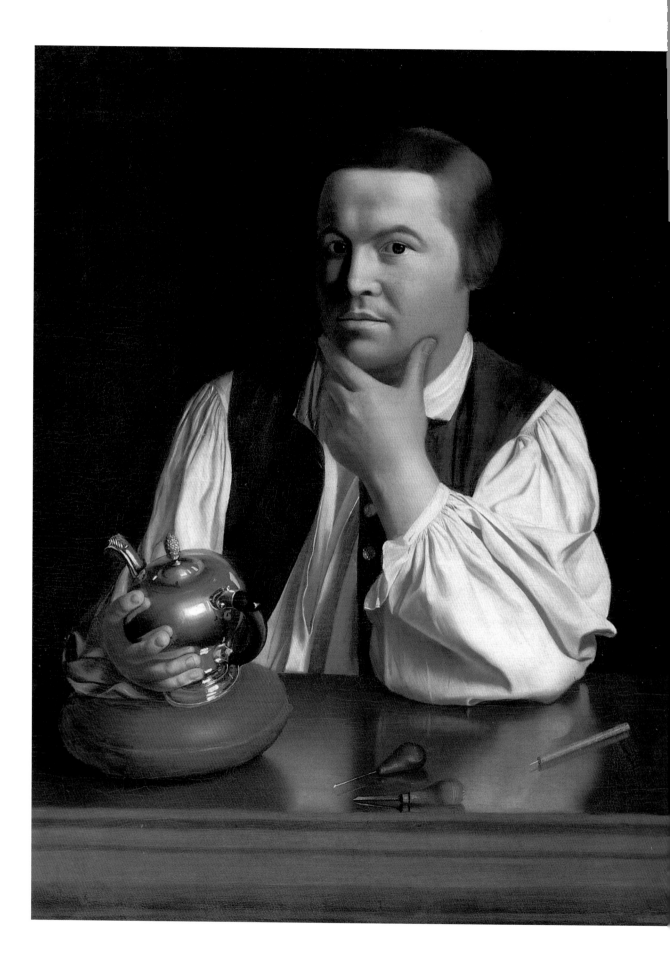

that this is an ingenuously honest image of a successful artisan. Although he is in informal working dress, his linen is spotless and his waistcoat adorned with the gold buttons that were a speciality of his trade. The polished surface of the table is perhaps intended to signify that he is seated in the front of his shop, rather than at his workbench. The teapot he cradles represents the height of his achievement – he had only made seven by this date – as well as hinting, perhaps, at his radical politics.[108]

By the time this picture was painted, Copley, Revere's fellow artisan, had become Boston's leading painter. The son of poor Irish immigrants and briefly the stepson of the artist and engraver Peter Pelham, Copley had learnt to provide the dynamic merchant community of which he was a part with the image they wanted to present to the world. In his early portraits, his sitters were posed in the manner of fashionable English prototypes by Kneller or Hudson, imported into the colony in print form. True to his sitters' values, he carefully inventoried the material signs of their worldly success in the clothes they wore and furniture they acquired. Thus, according to the standards set by English art theory, Copley was doubly vulnerable to the charge of being mechanical, through the lack of invention in his poses and the intense materiality of his gaze. Yet his portrait of Revere was inventive in its modest way, his technical skill in recording light and reflection mirroring the sitter's own mastery of technique. It was not intended for anything other than private consumption and its iconic status was achieved only decades later when Revere had won fame as a founding father of the new republic and his proud self-presentation as an artisan was seen as the defining mark of colonial independence, not to be cowed by decadent European hierarchies of art or society.

Inspired by extensive reading of art theory, Copley himself wished for higher things, complaining to an unknown correspondent in about 1767 that 'the [American] people generally regard [painting] no more than any other useful trade, as they sometimes term it, like that of a carpenter, tailor or shoe-maker, not as one of the most noble arts in the world'.[109] His ambitions must have been fired by the favourable reception of his portrait of Henry Pelham at the Society of Artists in London in 1765. Even Reynolds praised Copley's talent but considered it needed correction, 'before your manner and taste were corrupted or fixed by working in your little way at Boston'. There was, he deemed, 'a little hardness in the drawing, coldness in the shades, an over minuteness'. For Copley's fellow American, Benjamin West, who had already crossed the Atlantic, the portrait was 'too liney, which was judged to have arose from there being so much neatness in the lines'.[110] In effect Copley's portrait was too 'Dutch' in manner, too tied to quotidian facts and the hard linearity of engraving. It lacked the chiaroscuro and grand illusionistic generalisation to which the most ambitious artists should aspire.

The criticism courted by artists in painting leading artisans in the 'Dutch' manner is again confirmed by the reaction in 1772 to Johan Zoffany's painting depicting the optician, spectacle- and microscope-maker John Cuff, working at his bench with an elderly assistant standing behind him (fig. 138).[111] He is looking up, his trademark spectacles precariously balanced on his turban, from polishing a lens of a size which suggests that it was destined for a telescope. The tools of his trade are ranged on or round his bench or on the wooden shelves and wall behind him. Although made bankrupt in 1757, Cuff received payments made on behalf of George III in 1771 and 1772, which may help to explain this unusual commission, painted just before Cuff's death. As noted in Chapter 3, the King had been educated in the principles of natural philosophy and had acquired fine collections of clocks and scientific instruments. In 1769 he gathered with his court in the new Kew observatory to observe the Transit of Venus. Cuff was present with the King's clock-maker Benjamin Vulliamy, Cuff's fellow scientific instrument-maker Jeremiah Sisson and the King's newly appointed private astronomer, Stephen Demainbray.

137 John Singleton Copley, *Paul Revere*, 1768. Museum of Fine Arts, Boston

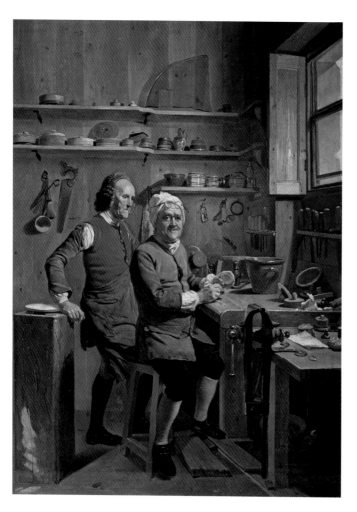

138 Johan Zoffany, *John Cuff and his Assistant*, 1772. The Royal Collection

Zoffany painted Cuff's portrait in the mode of a Dutch or Flemish genre painting, in dull browns and greys and meticulously observed detail, like the scenes of common life by Brouwer, Teniers and ter Borch. That arch-aesthete in the Shaftesbury mode, Horace Walpole, inevitably found the artist's minute fidelity to nature distasteful. The painting was, he said, 'extremely natural, but the characters too common nature, and the chiaroscuro destroyed, by his servility imitating the reflexions from the glasses'.[112] The accurate accumulation of detail was at the opposite extreme to the style of portraiture advocated by Richardson and Reynolds. Yet it is of the same type as Zoffany's earlier genre work, *The Porter and the Hare*, exhibited at the Society of Artists in 1769 and commended by Walpole who, it seems, could accept in genre what he could not accept in a portrait. Paintings which depicted real men in their work settings, going about the actual process of manufacture, were highly unusual and it is now perhaps easier to understand the reasons why.

The portrait of Benjamin Vulliamy, painted some twenty years later, perhaps by Benjamin West or John Francis Rigaud, possibly answered some of Walpole's concerns.[113] The famous clock-maker is depicted at his desk, making designs in an open volume. Presumably, he is meant to be in his Pall Mall shop, a space attuned to prevailing standards of taste and refinement. He is dressed as a gentle-man in his coat, not his shirtsleeves. One of his elegant neo-classical clocks, the ormolu case surmounted by a globe and flanked by a putto and classical female figure in biscuit porcelain (produced by William Duesbury's Derby porcelain factory), sits beside him and, on the shelf behind, an unfinished face and movement are protected by a glass dome. This was the public face that Vulliamy wished to present: he was the designer, undertaking rational work, not the maker in any hands-on sense: he employed more than twenty men to follow his instructions. On her visit to London in 1786, Sophie von la Roche was duly impressed by her encounter with Vulliamy himself. She was full of praise for the 'works of exquisite beauty and perfection' to be found in his shop: 'All the images are Greek figures in "biscuit porcelain" and Mr Vulliamy's physiognomy and gentle modest person hide a store of Greek ideas and moral allegory.'[114] Similarly, Rigaud's portrait of Vulliamy's fellow shopkeeper Thomas Bentley, Wedgwood's partner and the manager of his London business, which was exhibited at the Royal Academy in 1773, shows him surrounded by the smart accoutrements of neo-classical learning. He is reading Socrates, while on the table lie plaques of Socrates and the Three Graces, with learned tomes behind, including Xenophon's *Memorabilia*.[115]

It was easier for a painter to accommodate technical or industrial achievement if it had occurred outdoors, for the sitter could be portrayed according to standard practice in a landscape setting with minor modifications, the significance of which only became apparent on closer inspection. If a backdrop of rolling acres betokened gentrified possession, it could also be used to signify more specific forms of control, particularly as exerted by engineers in both military and civil spheres. Field Marshal George Wade was

322

139 (left) 'The Most Noble
Francis Egerton, Duke of
Bridgewater and Marquis of
Brackley', frontispiece to
Richard Whitworth, *Advantages
of Inland Navigation*, 1766

140 (right) Francis Parsons,
James Brindley, 1770. National
Portrait Gallery, London

portrayed in a work attributed to Johan van Diest standing proudly before his greatest feat of construction in Scotland, the winding Corrieyairack Pass completed in 1731 between Fort Augustus and Dalwhinnie and Ruthven.[116]

The relationship between sitter and backdrop could also be nuanced to betoken the allocation of roles. Francis Egerton, the third Duke of Bridgewater, was depicted in an engraving published in 1766 as the frontispiece to Richard Whitworth's *Advantages of Inland Navigation*, gesturing elegantly in the general direction of the most spectacular improvement he had made to his estates, Barton Aqueduct, which carried the Worsley Canal over the river Irwell. The actual builder of the Bridgewater Canal, James Brindley, was painted around 1770 by Francis Parsons against the same backdrop, armed with his level and resting on his theodolite.[117] Brindley was depicted actively at work while the engraving of the Duke signified ownership and beneficence rather than physical involvement and was augmented with appropriate Latin tags (figs 139 and 140).[118]

The growing professionalism and aspirations to gentlemanly status of surveyors and engineers in the second half of the eighteenth century ensured that they could be accommodated within the standard portrait genre to little disturbing effect. The artists with whom they felt most comfortable usually had strong regional links and few problems introducing iconography specific to the sitter's calling. In 1765 Joseph Wright of Derby painted his friend Peter Perez Burdett with his first wife Hannah.[119] Ostensibly, it is a glorious depiction of the somewhat rakish Burdett with his well dressed lady out on a country walk. Yet he holds a fine telescope for he was at this point in the middle of making a survey for his map of Derbyshire.

As noted previously, Bromley classified Smeaton as a mechanician, yet when around 1779 Romney painted his portrait for the Member of Parliament Sir Richard Sullivan, after a version by 'Rhodes' in the Royal Society, the artist took care to exchange Smeaton's working dress for elegant informal attire, with a red fur-trimmed hat and brown fur-trimmed gown over a black waistcoat. Smeaton holds dividers in his right hand as if interrupted in mid-design for the Eddystone Lighthouse which features prominently in the background (fig. 141).[120] By this date Smeaton enjoyed the highest professional status and had sat for several artists at the behest of satisfied clients. In 1783 he was painted by Mather Brown with a water-mill wheel behind him, as commissioned by a Mr Hilbert. By the end of the eighteenth century, portraits of the great engineers had settled on an appropriate format which credited them with the conceptual work underlying their master projects, as betokened by the introduction of design drawings set on a table, yet distanced them from the site and the physical labour involved in their completion. Thus Shee exhibited a portrait of John Rennie at the Royal Academy in 1794, seated at a table holding a drawing and with a view of the Lune aqueduct on the

141 George Romney after Rhodes, *John Smeaton*, *c.*1779. National Portrait Gallery, London

Lancaster Canal in the background (fig. 142).[121] James Northcote's portrait of Marc Brunel, completed in 1813, exhibited all the accoutrements of a professional engineer.[122] Brunel wears the gentlemanly garb of a fur-lined velvet gown over his day dress. Both hands rest proprietorially on a pile of drawings for his block machinery and the Maudslay model of his mortising machine sits on the table behind them.

Ownership of mines was an increasingly important source of landed wealth although it was rarely acknowledged in portraiture. An early exception is the portrait painted by Philip Mercier in 1742 of Sir William Lowther with his second wife, Catherine Ramsden, in front of Swillington House, Yorkshire, and beyond it, the estate colliery.[123] Another is the three-quarter-length portrait Wright painted around 1780 of Francis Hurt, who came from an old Derbyshire gentry family with interests in lead mines.[124] Hurt developed lead-smelting works, chiefly at Wirksworth, three miles south of Cromford, and unexpectedly inherited the family estate at Alderwasley Hall in 1767. He chose to have himself depicted in a somber brown coat enlivened by a brocade-edged cream waistcoat, sitting beside a table with a piece of paper and a lump of lead ore on it. To introduce a piece of galena, the type of lead ore most commonly found in Derbyshire, was not in any way to lose social caste, as some commentators have assumed, for mineralogical and geological interests were those which any gentleman could own. The inclusion of references to minerals was a matter for congratulation in a region like Derbyshire, famed for its mineral wealth and geological interest. Around the same time Wright painted his friend John Whitehurst, F.R.S., a Derby clock-maker by trade and an authority on geology, drawing the 'Section of the Strata at Matlock High-Tor', illustrated in the

appendix to his celebrated work, *Inquiry into the Original State and Formation of the Earth* (1778).[125] James Hutton was painted by Henry Raeburn in about 1790, seated quietly beside a table of geological specimens – a carefully observed still life composed of a shell, two examples of mineral veins, a druse, a septarian nodule and a breccia.[126] Hutton came from a merchant background, was educated at the universities of Edinburgh, Paris and Leiden and took up farming before developing business interests in Edinburgh including property, a salammoniac plant using household soot and membership of the Forth and Clyde Canal Committee. His knowledge ranged across chemistry, philosophy, phonetics, meteorology and agriculture but it was his work in geology that gained him fame, after the delivery of a seminal paper, 'Theory of the Earth', at the Royal Society of Edinburgh in 1782.

When Matthew Boulton was painted in 1792 by the Swedish artist Carl Fredrik von Breda, at the behest of John Rennie, he was portrayed sitting with a magnifying glass in his right hand and a cameo in his left, with an array of mineral specimens including

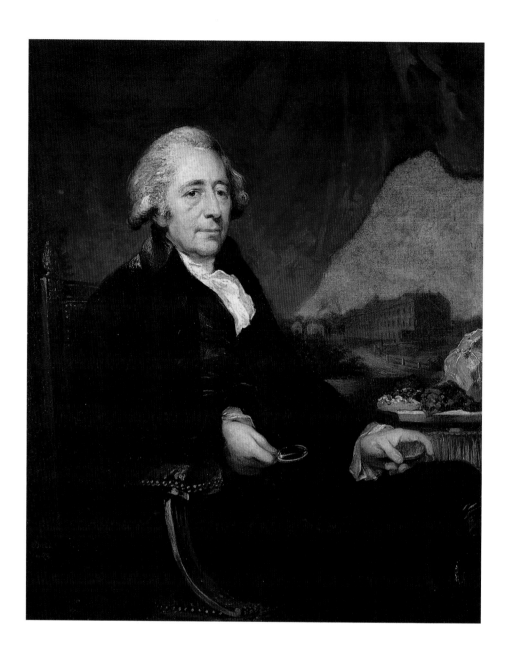

143 Carl Fredrik von Breda,
Matthew Boulton, 1792.
Birmingham Museum & Art
Gallery

bluejohn fluorspar on the sideboard behind him. In the distance was a view of the
famous Soho factory which, from the outside, resembled a fine country house (fig. 143).
The portrait of Boulton by Sir William Beechey, exhibited at the Royal Academy in
1799, converted him more completely into a gentleman of science for he sits, soberly
dressed, with a magnifying glass in his right hand and a polished sample of bluejohn in
the other, presumably from the sample of the stone preserved in the bell-jar in the back-
ground.[127] Breda's companion painting of Watt, also painted for Rennie, showed him
sitting with a melancholy thoughtful expression, hand to head, and dressed with cleri-
cal severity, as the archetypal man of science (fig. 144).[128] Dating from 1792, it is the ear-
liest known portrait of Watt, who coyly protested that he did not think his countenance
was worth procuring. Nevertheless, the drawing on the neo-classical table beside him
represented the latest Lap engine, developed in 1788, so he was at least aware of the
advantages of promoting achievement.

144 (facing page) Carl Fredrik
von Breda, *James Watt*, 1792.
Science Museum, London

A more overt reference to the industrial potential of minerals can be found in John
Opie's portrait of the Truro merchant and leading mine adventurer Thomas Daniell,

326

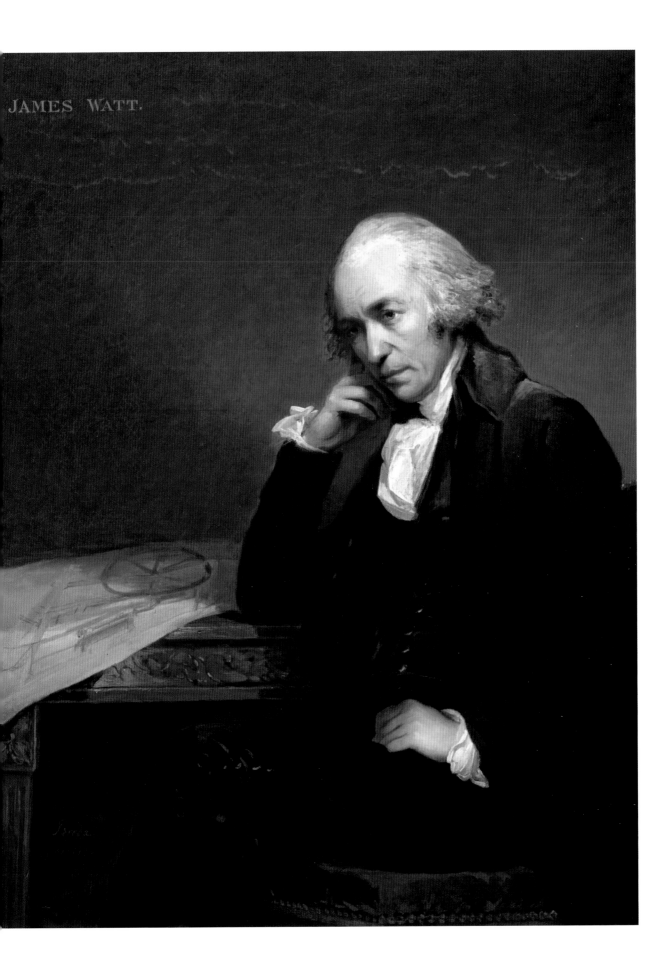
JAMES WATT.

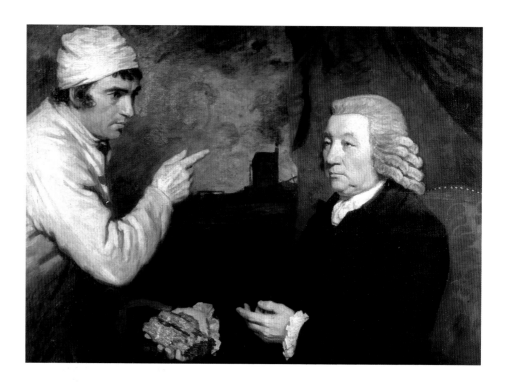

145　John Opie, *Captain Morcom and Thomas Daniell*, 1786. The Royal Institution of Cornwall, Royal Cornwall Museum, Truro

exhibited at the Royal Academy in 1786 (fig. 145). He is depicted being shown a specimen of copper ore by a mine captain or foreman, Joseph Morcom, possibly the man who made trials of pumping engines with Richard Trevithick. Morcom points out of the window to the outline of an engine-house and boiler, to indicate that the ore comes from this source. Possibly it is intended to represent Wheal Towan at St Agnes with which both Morcom and Daniell were associated, although the mine soon closed for more than a decade because of competition from the mines of Anglesey. The son of a Cornish mine captain, Opie was largely self-taught as an artist, enjoying a short-lived success in the 1780s as 'the Cornish wonder'. He would have been perfectly familiar with the subject matter and possibly the sitters but his Rembrandtesque chiaroscuro and naturalism were as much a handicap as a virtue. Opie was often damned on the grounds of coarse execution and lack of refinement, one critic writing that 'Could people in vulgar life afford to pay for pictures, Opie would be their man'. Even his mentor, Dr John Wolcot, eventually bemoaned the lack of elegance in Opie's work, asserting that he was 'too fond of imitating coarse expression . . . He too much resembles a country farmer who, never having tasted anything beyond rough cyder, cannot feel the flavour of burgundy or champagne.'[129]

Vulgar life was frequently omitted from portraits as industrialists acquired the trappings of gentility, as might be expected. In the early 1770s, Gainsborough depicted the successful Spitalfields brewer Sir Benjamin Truman in a pastoral setting, albeit conveying his forceful personality as a businessman in the firm set of his countenance and the grasp of his fist round his stick.[130] Around 1776, Gainsborough painted the great ironmaster John Wilkinson in a similar manner, resting under a tree while out on a walk (fig. 146). Stubbs took the setting more seriously when in 1780, on a visit to Etruria, he painted Wedgwood with his wife Sarah and seven children in the grounds of their house. He worked so slowly on this meticulously detailed if rather wooden conversation piece that Wedgwood was astonished at the patience and time required 'and me thinks I would not be a portrait painter upon any conditions whatever. We are all heartily tired of the business and I think the painter has more reason than any of us to be so.'[131] Nevertheless, he and his wife succumbed to the ordeal again in 1782

146 (facing page)　Thomas Gainsborough, *John Wilkinson*, 1776. Gemäldegalerie, Berlin

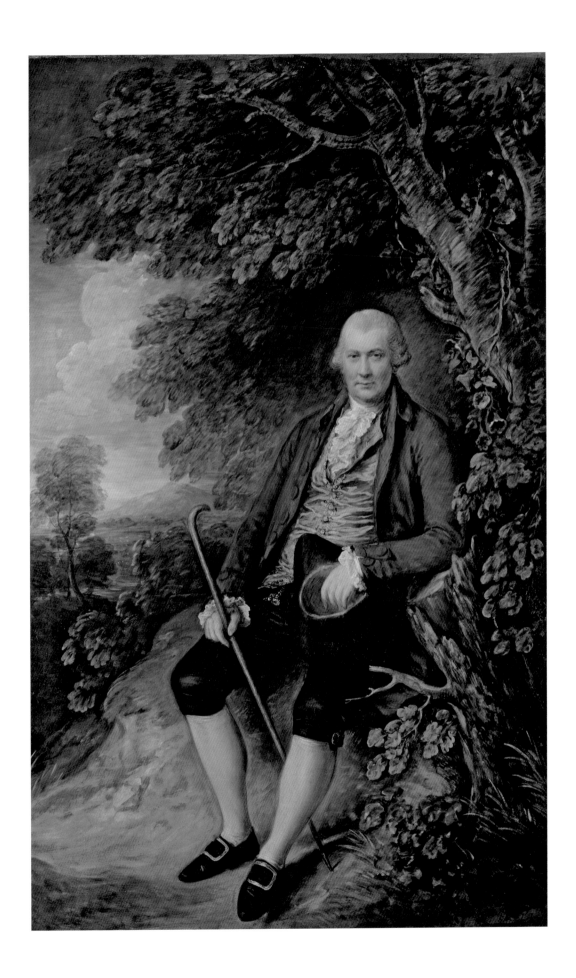

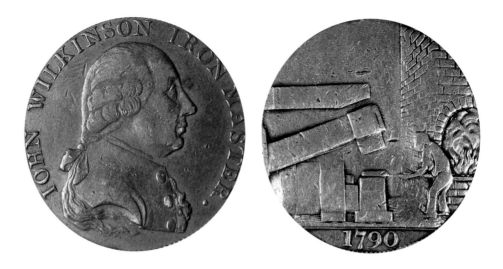

when they were painted in companion half-lengths by the rather speedier Reynolds.[132]
As a man whose trade depended on the manipulation of fashion, Wedgwood wished
to present a genteel front to the world, rather than the character of an industrious
chemist and businessman.[133]

In the products of Wilkinson and Wedgwood, portrait heads of men of industry were
even presented in the polite classical guise of coins and medals. From 1787 to 1795, to
compensate for the Royal Mint's suspension of copper coinage production in 1775,
Wilkinson issued a series of halfpenny trade tokens mostly manufactured at Boulton's
mint (fig. 147). On one side they were stamped with Wilkinson's head in profile and the
letters 'JOHN WILKINSON IRON MASTER' together with the sites of his forges and foundries:
Willey, Snedshill, Bersham and Bradley. On the other, the motifs changed, alternating
between the practical and the polite: they included an ironworker holding metal under
the Boulton & Watt steam-driven trip hammer of which Wilkinson was particularly
proud (1787) and the god Vulcan hammering at a rather less advanced anvil (1790). Typ-
ically for Wilkinson, the tokens served not only a practical purpose, supplementing the
shortage of small change, but they also promoted him as the great ironmaster and made
him a tidy profit. As the *New London Magazine* of December 1787 sarcastically observed:

> In Greece and Rome your men of parts,
> Renowned in arms, or formed in arts,
> On splendid coins and medals shone,
> To make their deeds and persons known.
> So, Wilkinson, from this example,
> Gives of himself a matchless sample!
> And bids the *Iron Monarch* pass,
> Like his own metal wrapt in brass!
> Which shows his *modesty* and sense,
> And *how*, and *where* he made his *pence*:
> As *Iron*, when 'tis brought in taction,
> Collects the *copper* by attraction,
> So, thus in *him* 'twas very proper,
> To stamp his brazen face – *on copper*.[134]

To promote his products, Wedgwood produced portrait medallions in basalt ware from
1771 and from 1775 in jasper, of Greek and Roman luminaries, caesars and popes, Euro-
pean royalty and the nobility, men of science and of letters, based on a wide variety of

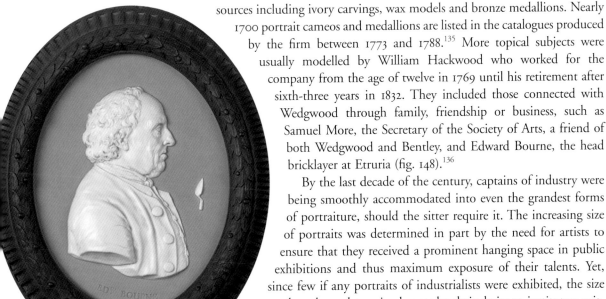

sources including ivory carvings, wax models and bronze medallions. Nearly 1700 portrait cameos and medallions are listed in the catalogues produced by the firm between 1773 and 1788.[135] More topical subjects were usually modelled by William Hackwood who worked for the company from the age of twelve in 1769 until his retirement after sixth-three years in 1832. They included those connected with Wedgwood through family, friendship or business, such as Samuel More, the Secretary of the Society of Arts, a friend of both Wedgwood and Bentley, and Edward Bourne, the head bricklayer at Etruria (fig. 148).[136]

By the last decade of the century, captains of industry were being smoothly accommodated into even the grandest forms of portraiture, should the sitter require it. The increasing size of portraits was determined in part by the need for artists to ensure that they received a prominent hanging space in public exhibitions and thus maximum exposure of their talents. Yet, since few if any portraits of industrialists were exhibited, the size must have been determined more by their desire to institute a suitable array of 'ancestral' portraits in the country houses they were acquiring for themselves.[137] Wright painted a full-length (229.8 × 138.4 cm) of Charles Hurt, who inherited his father's lead works and established his own lead-smelting business at Wirksworth.[138] Ostensibly, he looks like a gentleman out for a walk with hat, gloves and cane but the landscape background is perhaps intended to represent the source of his interests and industrial wealth. He studied mathematics and astronomy but also developed considerable technical skills in mining, especially the construction of soughs to extract water from the mines, and in 1797 helped save the life of a trapped miner. In the early 1790s Wright painted an even larger (243.9 × 152.4 cm) full-length portrait of Samuel Oldknow, the greatest manufacturer of fine muslins in the country (fig. 149).[139] The son of a Lancashire draper and small-scale cotton manufacturer, he had built grand steam-powered mills at Stockport outside Manchester and a handsomely designed cotton mill at Mellor in Derbyshire. Cultivated and aesthetically minded, he is painted in a self-consciously relaxed manner, quietly yet elegantly dressed, leaning against a column in a socially acceptable posture. He holds a scroll of paper in his right hand and his arm rests on a bolt of muslin, marked with the red thread decreed by government regulation.[140]

North of the Border, in his full-length portrait (236.8 × 150.5 cm) of William Forbes of Callendar, painted in 1798, Raeburn revealed nothing of his sitter's origins as an Aberdeen coppersmith (fig. 150).[141] William won a government contract, with his elder brother George, to sheathe the hulls of ships in copper and made a fortune in the process. He stands nonchalantly by an open window, which overlooks a Scottish landscape, staring not a little haughtily at the viewer. Raeburn lights the scene dramatically so that the piles of paper are in sharp relief on the table beside him, one of which is being consulted by Forbes. The business to which he is attending was related to the forfeited estates of Callendar and Linlithgow which he bought at twice their estimated value in 1783. Down in Anglesey, Thomas Williams, the chief agent from 1785 of the Mynydd Parys copper mines, branched out into smelting and shipping to such an extent that he became known as the 'Copper King'. He was painted in the 1790s at the height of his power and as the Member of Parliament for Great Marlow by young Thomas Lawrence in a work intended to hang in his Berkshire country seat. No reference is made to copper; instead he is depicted as a country gentleman out for a stroll, with the conventional pillar and curtain partly screening the landscape.[142]

149 (left) Joseph Wright,
Samuel Oldknow, c.1790. Leeds
Museums and Art Galleries

150 (right) Henry Raeburn,
William Forbes of Callendar,
1798. Private collection

Henry Thomson painted Richard Pennant, the first Baron Penrhyn and founder of the great Bethesda slate quarries, around 1800 in a huge full-length portrait (594 × 299.5 cm) (fig. 151).[143] He stands pointing to a map of his new route over the mountains from Capel Curig, eventually incorporated into Telford's Chester to Holyhead road. The foreground suggests the accoutrements of a study, complete with chair, table, inkwell and dog, but a curtain is parted artfully to reveal a mountain landscape, at the bottom of which is a row of houses along the road including the Royal Hotel, built by Pennant to the designs of Wyatt, in order to develop the tourist trade. He was truly lord of all he surveyed.

Even when commissioning Wright, Gainsborough, Raeburn or Lawrence, not all captains of industry required them to turn their character and interests into a visual presentation that would meet the exacting cosmopolitan standards of generalised gentility ordained by Richardson or Reynolds. Modes of presentation in portraiture were determined more by personal inclination than by class aspiration. Late in the 1780s, Wright portrayed the successful hosiery manufacturer Jedediah Strutt, on a modest scale in the sober dress and cogitative pose of a dissenter.[144] From 1780 to 1789 another self-made man, the great London brewer Samuel Whitbread I, commissioned nine half-length portraits of 'Gentlemen of the Firm of Whitbread', three each from Gainsborough, Romney and Gainsborough Dupont. They included portraits of his principal brewer Samuel Green the Elder (1781 by Gainsborough) and Thomas Phillips, a cooper (1789 by

332

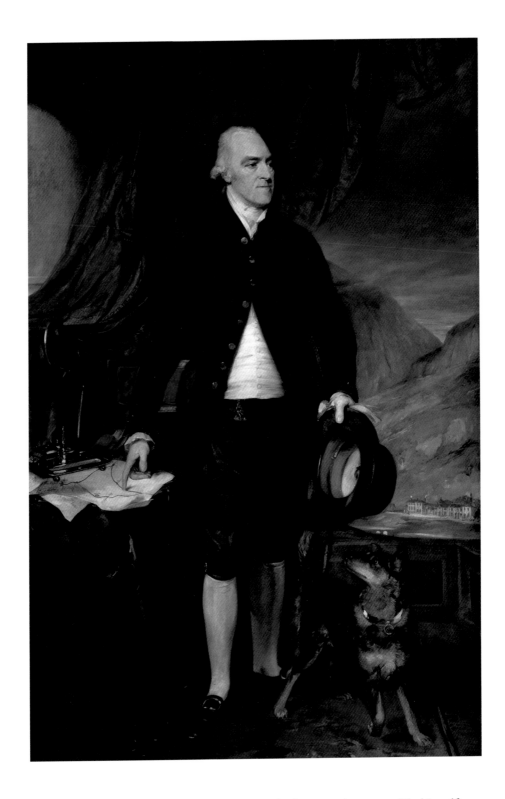

Gainsborough Dupont) who had worked in the brewery since 1755. He himself was painted by Beechey in a sturdily unpretentious manner and the portrait was framed to match the rest of the series, as part of the working team.[145]

There were still plenty of artists of moderate talents churning out likenesses and sitters who wished for their achievements to be spelt out clearly rather than partly disguised under some aesthetically pleasing cover. Nothing is known of the A. Reddock of Falkirk who around 1790 painted the Scottish farmer Andrew Meikle, holding a pencil over a

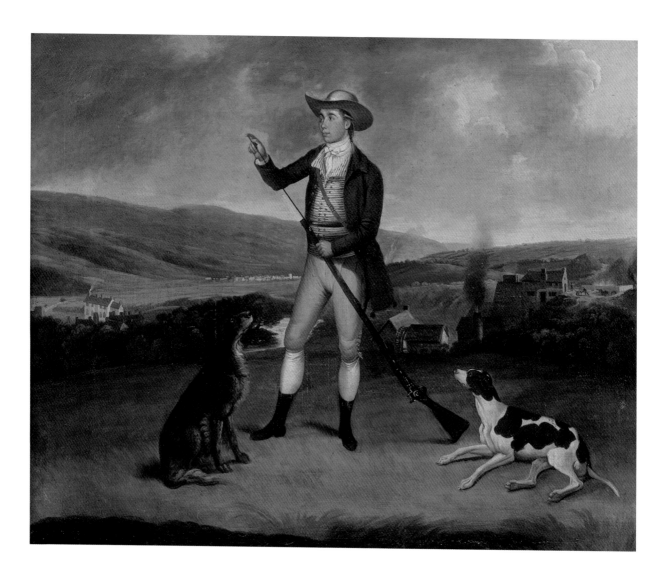

diagram of the threshing machine of his invention.[146] In about 1790, Samuel Homfray, one of the founding ironmasters of Merthyr Tydfil, commissioned a portrait from William Williams of himself out shooting with his dogs but the countryside behind him includes smoke rising from an ironworks, either the Cyfarthfa forge and boring mill, which he leased from 1792, or Penydarren, begun in 1784 (fig. 152).[147] Other Welsh ironmasters found Birmingham artists to paint their portraits. In 1788, Moses Houghton – who worked as a decorator of enamels and japanned ware at Henry Clay's factory – painted a portrait of John Bedford, the ironmaster of Cefn Cribwr, Bridgend, the blast furnaces of which can be seen through the window in the background.[148] Around 1800, the Merthyr ironmaster Richard Crawshay commissioned his own portrait from the sturdily provincial Richard Wilson and hung it in the parlour of Cyfarthfa House, alongside portraits he had commissioned of two other leading ironmasters, John Wilkinson, his slightly older contemporary, and the most impressive member of the younger generation of ironmasters, William Reynolds, creating what amounted to a portrait cartel (fig. 153).[149] While Crawshay is depicted in his Sunday best seated in a conventional study setting complete with pilaster, curtain and volumes on the table beside him, Wilson's portrait of Reynolds presents him as a Quaker gentleman out for a walk, yet holding in one hand the plan for the 'first iron aqueduct' cast to Telford's design at Reynolds's Ketley works. In the background can be seen the inclined plane he built on

334

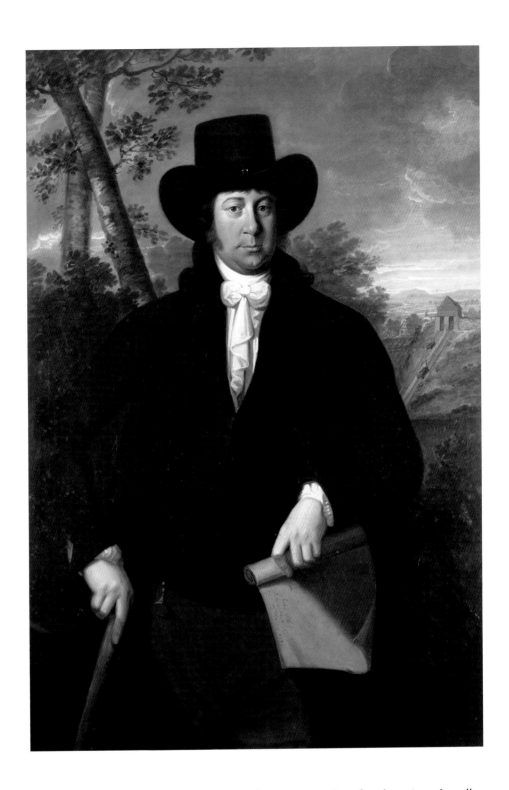

53 Richard Wilson, *William Reynolds*, *c.*1800. Ironbridge Gorge Museum Trust, Coalbrookdale

his own Ketley Canal in the 1790s, carrying boats seventy-three feet down into the valley where his ironworks were located. Reynolds studied under Joseph Black in Scotland, was conversant with the latest developments in electricity, read the works of Priestley and was keenly interested in geology, so he could equally well have been depicted as a gentleman of science. John Wilkinson was portrayed wearing an old-fashioned wig in a head and shoulders portrait by Lemuel Francis Abbott. The physiognomy and form of the ironmaster, aggrandised by Gainsborough and through his own coinage, was shrunk to fit into a Welsh parlour.

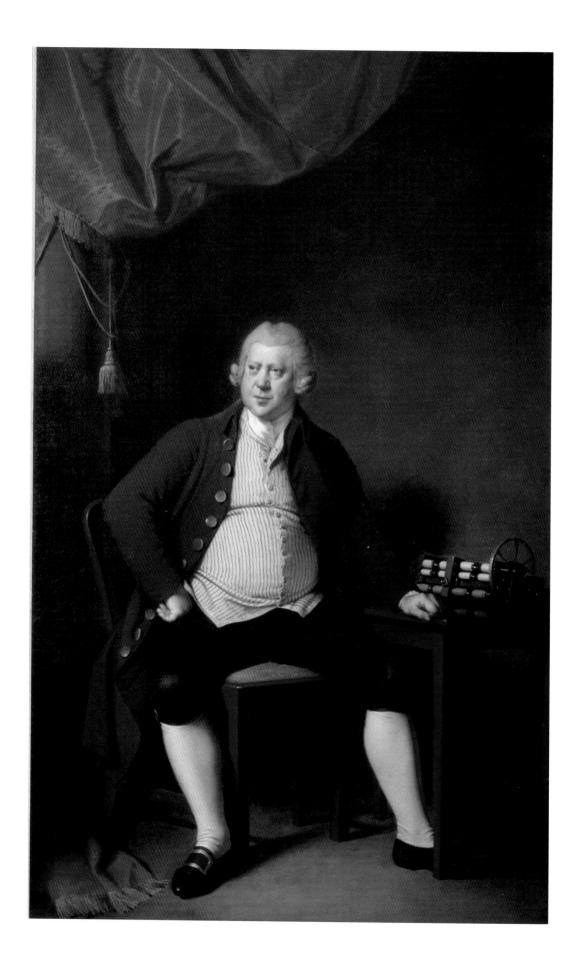

The Mechanic as Hero

In 1789–90, Wright of Derby painted a full-length portrait of Sir Richard Arkwright (fig. 154), an altogether more public image than the three-quarter-length portrait which Wright had completed some five years earlier for Arkwright's daughter Susannah Hurt.[150] However, the grand manner implicit in its size (241.5 × 152.4 cm) was subverted by its defiant 'Dutchness' in presentation, which may be explained in part by the character and circumstances of the patron. On the face of it Arkwright had every reason to see himself as a social success. He had risen from the trade of barber and peruke-maker in Preston, Lancashire, to become, it was generally acknowledged, one of the greatest improvers of the manufactures of the country, a position based on his invention and development of the cotton-spinning frame. In 1786 he had received a knighthood, having buffed up his polite credentials by presenting a loyal address at a levee to mark George III's escape from an assassination attempt. The following year, he was appointed the High Sheriff for Derbyshire, the oldest secular dignitary held under the Crown. At the same time he began to build a suitably stately home, Willersley Castle, across the Derwent from his mills at Cromford which were, however, screened from view by a limestone crag. He also invested in a modern London house, number 8 Adam Street, Adelphi, and sat for portraits commissioned from the American artist Mather Brown as well as from Wright.[151]

Yet Wright's portrait has frequently been seen as epitomising 'Lancashire man': plain, vulgar, gross, ruthless.[152] Arkwright himself was, according to Wright, 'much pleased with the execution of his picture'[153] and at least one contemporary, Wright's friend John Holland, believed it hit Arkwright's character. Certainly, it stands out for its defiant physicality in the company of the genteel sitters who now surround it in Derby Art Gallery. The size of the canvas and swag of fabric on the left recall grand-manner portraiture but the chair on which Arkwright sits and the table alongside are ostentatiously plain. The striped waistcoat covering his belly is the only concession to fashion. Perhaps it was the same one which he donned at the last minute to receive his knighthood. Prior to the ceremony, a lady visiting Sir Joseph Banks in Soho Square found Arkwright there in 'black wig, brown frock, worsted stockings and boots'. Banks, whom Arkwright asked to accompany him, inquired about his dress: 'Mr Ark— proposed going as he was, for he was not afraid they were but men and so was he. However, it was agreed he should take off his boots and return with good shoes at the proper hour.' 'Little fatty' subsequently appeared, the lady reported, 'a beau with a smart powdered bag wig so tight that coming over his ears it made him deaf; a handsome striped satin waist coat & proper coat with a sword'. Incapable of adopting the custom of kneeling before the King, he evidently 'crimpt himself up in a very odd posture which I suppose His Majesty took for an easy one so never took the trouble to bid him rise'.[154]

The awkwardness of Arkwright's posture is evident in Wright's portrait and repays closer scrutiny. Rules of deportment in polite society insisted on a pleasing arrangement of limbs when standing and seated. At the height of the French influence on taste in the middle decades of the century, illustrated posture books and series of engravings showed aspiring gentlemen and ladies how to stand and sit in the approved manner.[155] Gentlemen were supposed to sit leaning forward slightly as if taking an active role in conversation. Legs were kept loosely together, crossed at the ankles or one set in front of the other. French dancing and fencing teachers drilled those aspiring to master the latest cosmopolitan fashions in self-presentation but Hogarth was not alone in finding such artifice at odds with the 'easy behaviour and unaffected grace' born of rank and fortune.[156] In his paintings the artist frequently contrasted the plain sincerity of the British with the mincing manners of the French. Furthermore, although Hogarth

frequently imitated French prototypes of portraiture, he effortlessly produced his own variations, converting them into something new and specifically British.[157]

His great portrait of Captain Coram of 1740 was a conscious riposte to the French style of portraiture introduced by Jean-Baptiste van Loo, who had arrived in London in 1738.[158] Although derived in composition from Hyacinthe Rigaud's portrait of the great financier Samuel Bernard (which Hogarth would have known from the 1729 engraving by Pierre-Imbert Drevet), his painting breathed new life into the hollow conventions of Baroque rhetoric. Hogarth retained the terrace setting with its column and some of the billowing background drapery but the mighty French fleet assembled in the sea beyond was replaced by a small collier, and the balustrade and elaborately carved table replaced by simple English furniture. Bernard sports a full-bottomed wig, velvet suit and silk sash. Coram's limbs are arranged in roughly the same way but he is unwigged and wears plain comfortable clothes, his red greatcoat unbuttoned, his dangling legs barely reaching the floor. His complexion is ruddy from exposure to wind and sun, his countenance shrewd yet good-natured. He grasps the seal of the Foundling Hospital in his right hand, its royal charter rolled up on the table behind. The globe on the ground is turned to show the Atlantic which he had crossed on many voyages. The hat beside his right foot is a reference to those supplied to Coram by the Hatters' Company, eternally grateful for his help in pushing a protectionist Hat Act through Parliament in 1732, to prevent competition from the colonies. Coram, Hogarth suggests, was at home in the world on his own terms.

At the time, Hogarth's work was more often associated with Dutch or Flemish art than with French on account of the low characters and humour of his modern moral subjects. In the second half of the century, Zoffany was frequently seen as Hogarth's successor. He was known to be an admirer of Hogarth – Zoffany arrived in London in 1761, two years before Hogarth's death, and they might have met in the circle of the St Martin's Lane Academy – and he owned a fine set of Hogarth's prints.[159] For Horace Walpole, Zoffany's strength lay in drawing 'scenes in comedy, and there he beats the Flemish painters in their own way of detail'.[160] As 'the Hogarth of Dutch painting', his talent was 'representing natural humour. I look upon him as a Dutch painter polished or civilised. He finishes as highly, renders nature as justly, and does not degrade it, as the Flemish school did, who thought a man vomiting a good joke; and would not have begrudged a week on finishing a belch, if mere labour and patience could have compassed it.'[161]

Yet for Walpole, Zoffany was at his best when depicting theatrical scenes, where low life was viewed at one remove, mediated through the artifice of comedy.[162] Zoffany often depicted the actor David Garrick playing humorous characters. In his painting of a scene from the play *The Farmer's Return* (1762), Garrick in the title role sits comfortably in an armchair smoking a pipe with his crop resting on his thigh, his legs still in riding boots inelegantly stretched apart. The farmer has just returned from seeing the coronation of George III and from a pilgrimage to Cock Lane to see the ghost – he teases his wife by saying that the ghost had doubted her fidelity. When the work was exhibited at the Society of Artists, Walpole commented that it was 'Good, like the actors, and the whole better than Hogarth's.' Hogarth had recorded the scene in a sketch, engraved by James Basire, in which the farmer was much more boorish, with his legs farther apart and a beer mug in one hand and a pipe in the other. Zoffany's picture was preferable, as a modified version of the familiar Dutch or Flemish 'merry company' genre of tavern scenes, with off-duty soldiers relaxing and drinking, painted in dull browns and greys.[163]

Thus in a male portrait, the pose with 'legs apart at ease' invariably represented a down-to-earth pragmatism and lack of Frenchified pretension. In Zoffany's portrait oeuvre, the most surprising subject for whom it was adopted was George III.[164] Soon after he arrived in London from Germany in 1769, Zoffany established a connection with the royal family,

probably through Lord Bute. His first works were conversation pieces composed in a charming if conventional manner but in 1771 he painted a three-quarter-length portrait of the King with unprecedented frankness set against a plain, unadorned backdrop. Although the King is in General Officer's uniform, decorated with the riband and star of the Garter and the Garter round his left leg, the pose is extremely informal. His hat and sword have been laid aside on the table and his right arm rests casually on the arm of the chair, while his left hand rests on his thigh and his legs are spread wide apart in a manly open gesture that is the very opposite of refined. Both look and pose conspire to suggest that he is alert and energetic, a practical unpretentious man of action.

Contemporary critics deemed the portrait decidedly undignified. When it was exhibited in 1771 in the first Royal Academy of Arts exhibition to be staged in the old Somerset House, Horace Walpole noted it as 'very like, but most disagreeable and unmeaning figure'.[165] Robert Baker, in the first pamphlet to be published on an Academy exhibition, considered 'the posture, though it might do well enough for the picture of a country-squire, is not quite suited, I think, to the dignity of the person represented'.[166] Remarkably, its closest precedent was Hogarth's memorable image of John Wilkes, published in 1763. Intended as a caricature which likened Wilkes to the devil, the print was in fact bought by the supporters of 'Wilkes and Liberty!' Zoffany knew Wilkes and later painted a portrait of him with his daughter Polly. Yet politically, he was royalist and on Hogarth's side against Wilkes's brand of rabble-rousing.[167] Perhaps in his royal portrait Zoffany intended to convey the subliminal message that liberty was protected by the King.

Despite Zoffany's use of the pose in group portraits of exclusively male domains, it retained its associations with uncouthness.[168] In Samuel de Wilde's picture of about 1787, William Parsons in the role of the tailor Snarl is so depicted, sitting in his shop in *The Village Lawyer*, a farce by George Colman senior.[169] By the end of the century the pose had coalesced round the symbol of John Bull, who wore no wig, sported an open great-coat and big travelling boots, carried a blunderbuss in one hand and a pot of foaming porter in the other and was accompanied by a bulldog baring his teeth at any Frenchman in sight.[170] All these connotations are suggested by the forthright posture adopted by Arkwright. Like Hogarth's Captain Coram, Wright was presenting a self-made British man of rock-like character, defying the pretensions of the French and the genteel orthodoxies of Reynolds and his followers.

In his earlier depiction of Arkwright, Wright had portrayed him sitting easily with one arm resting on the chair-back and looking somewhat quizzical but by no means hostile and directly at the viewer. His pose in the full-length is much more tense. A particularly odd feature is the way in which he locks himself to the model sitting on the table beside him, namely the rollers which formed the crucial part of both his patents, covering his spinning and carding processes (numbers 931 of 1769 and 1111 of 1775). Everything speaks of his desire to guard the security of his invention. He looks to one side, alert against intrusion. One hand is on his thigh, betokening strength, and the other fist is placed, somewhat threateningly, on the table in front of the rollers, while one foot is caught behind the table-leg, preventing it from moving. The rollers are not put there merely as symbols of a polite accomplishment but of ownership. In order to understand the full significance of their presence in the painting, the battles Arkwright had undertaken in the 1780s to safeguard his patents must be examined. They spotlight the means previously explored by which mechanical men sought to describe and rationalise their inventions, namely through models and, more equivocally in the case of Arkwright, through drawings.

The success of Arkwright's enterprise was intimately bound up with experimentation on models of machines, as was confirmed in the three trials that tested his patents of the spinning and carding processes, the first in 1781 and two in 1785.[171] Both Arkwright

and his erstwhile partner Thomas Hayes (sometimes written Highs) used John Kay, a clock-maker from Warrington, to make models to perfect a spinning machine using rollers. In the third and final trial, *Rex v. Arkwright*, in which Arkwright was prosecuted by the Crown by means of a writ of *scire facias*, a form of summons occasionally used for official annulment of a patent, Hayes testified that he employed Kay 'to make a small model, with four wheels, of wood, to show him the method it was to work in, and desired him, at the same time, to make me brass wheels, that would multiply it to about five to one'.[172] Kay told Arkwright about this invention; Arkwright asked him to make a wooden model which he took to Manchester. Some of the most interesting evidence came from other mechanics whom Arkwright employed to improve on the prototype. John Haggett, the superintendent of a cotton manufactory, was employed by Arkwright 'from the first beginning of those machines, for which this patent was obtained, and in trying experiments from the directions I got from him'. Arkwright gave directions 'by chalking on a board sometimes, and crooking of lead and wire and things in that shape'. Haggett was employed to make the crank which he said had never been used before and he also testified that Kay made the rollers to Arkwright's directions. Thomas Bell, a joiner (who had testified in the 1781 trial to having assisted Arkwright for five years on a '100 dozen experiments'[173]), had also made parts of the patent machine. When asked whether the machine was invented over time or the pattern given to make it all at once, he replied, 'From time to time, and sometimes it would be pulled all to pieces and new ones supply their places.'[174]

If models were of key importance in the process of research and development of the invention, they were also produced in court to demonstrate to a non-specialist, London-based judge and jury the tangible existence of the machines and how they worked. In all three trials in Westminster Hall counsel relied on the production of spinning machines or working models of spinning machines whirring away to make their case to the jury, albeit with different outcomes. The first prosecution of 1781 was brought by Arkwright against Charles Lewis Mordaunt, the owner of a small cotton factory, for building machines from his specification without authority. A model of Arkwright's patent carding machine was introduced into the case by the prosecution. Unfortunately, as witnesses for the defence were quick to point out, it did not correspond to the patent specification and drawing because it included further improvements and the case was dismissed as a nonsuit by Lord Mansfield.[175] As an apologia published on Arkwright's behalf in 1782 conceded: 'if Mr Arkwright had been aware of any improper defect in his specification, he never would have exhibited (as he did) his machines in their full perfection before his enemies in open court'.[176]

Arkwright was much more successful when he introduced machine models in the second case, in which he won his suit against Peter Nightingale for the same offence, heard before Lord Loughborough in the Court of Common Pleas on 17 February 1785. Arkwright's counsel, Serjeant Adair, introduced a model of the carding machine in use before Arkwright's invention, to show how it differed from a model of Arkwright's. The jury was treated to a demonstration of how the cotton was cleaned, reduced to a rope-like form called a sliver and then twisted into a filament, a process known as roving. In the third trial, *Rex v. Arkwright*, counsel for the prosecution Edward Bearcroft ruefully referred to this demonstration of roving in the second trial:

> It is done by a very ingenious contrivance, I admit, and the very contrivance that was the destruction of us in another place . . . My learned friend showed the machinery with such skill and address, and performed the operation so well, he tickled the fancy of the jury like so many children, that it was impossible to put them out of love with their plaything to the end of the cause, till they finally decided in its favour.[177]

Bearcroft thus confirmed the roles of the model described in Chapter 3 here – that of useful tool and polite toy – and how the general public could, in their innocence, conflate the two.

So effective was the device that Bearcroft took a leaf out of Adair's book in the third trial and also produced model machines to demonstrate the points he wanted to make to the jury, requiring their 'extreme patience, and very close attention'. It was impossible, he continued, on a subject of this kind, for an advocate to convey by words alone the ideas underlying comprehension of the case:

> If I speak in the terms of art that are used by the manufacturer, I might probably with the few lessons that I have had, misapply them myself. If I should have the good luck to avoid doing that, if I only use the language of the manufacturer to you, who are not manufacturers, you would not comprehend me, it would really be like trying an English cause in another language; of necessity therefore we must have recourse to the machines – and to your ocular inspection; desirous, as undoubtedly you are, to give a judgement upon the true grounds, you will grudge no patience or attention in examining the parts sufficiently, in order to attain a perfect acquaintance with it, that you may be able to follow the arguments and the evidence that will afterwards be given.[178]

Bearcroft had had models made of both the first and second patent machines, the first for spinning, the second for carding and roving. As far as the spinning machine was concerned, Bearcroft allowed that it was 'a clever thing' but maintained that the key element, the rollers, were not Arkwright's invention but Hayes's, who communicated it to Kay who in turn told Arkwright. Furthermore, Bearcroft sought to demonstrate that the second machine was simply an extension of the first, that spinning, carding and roving were one and same process, by employing men to demonstrate that the rollers of the first machine could be used for carding or roving. The cylinders used in the carding element in the second machine, Bearcroft maintained, were not Arkwright's invention nor of anyone who could now be traced; even the crank had already been in use.[179]

Furthermore, models were referred to in the 1785 cases (albeit not shown) as testimony on Arkwright's behalf to prove that an 'ingenious mechanic' could make the machine on the basis of the specification drawing for the second patent. In the second trial, Adair for the prosecution produced four witnesses 'of skill and mechanical knowledge' who all said they had achieved this. He was perfectly prepared for two of these models to be introduced in court but the presiding judge Lord Loughborough intervened, presumably fearing further time-consuming technical analysis: 'I don't think the production of the two models will carry the matter further than the two witnesses swearing they are their models, and that they produce the same effect.'[180]

Bearcroft, nevertheless, did not hesitate to point out in his summing up for the defence that none of the witnesses could produce the models they said they had made. Moreover, Charles Wilkinson, the draughtsman responsible for the second specification drawing, had been forced to admit that he did not have a model on which to base it. Instead, the drawing had been composed on the basis of a couple of meetings with Arkwright, his production of some of the parts, little sketches Arkwright had made and verbal descriptions.[181] In the final trial, Wilkinson conceded that the best way to make a specification drawing was from the machine or a model, as indeed it emerged had been the case in Arkwright's first patent specification (fig. 155).[182] As Bearcroft pointed out in his closing statement for the Crown, 'That is the specification of his first patent, there he does all I wished him to do here, all that a man does who fairly means to disclose the things he does, that is to say, there is that exact drawing of the machine itself, the perspective, in such a situation, you can best see the most of its parts.'[183] Why did

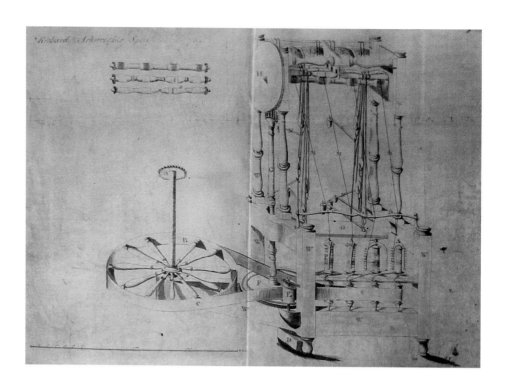

155 'Richard Arkwright's Specification 1769' drawing for Patent no.931, 1769. The National Archives

Arkwright not show Wilkinson the second model if he wanted to communicate his invention to the public?

Thus the model of the rollers sitting on the table beside Arkwright in his portrait was more than a mere token of his business interests: it was intrinsic to its success, as part of the research and development process and as tangible proof of ownership of the patent which could be comprehended by all. In contrast, the inadequacies of the specification drawing submitted as part of his second patent were the root cause of his defeat in the final trial (fig. 156). At both the 1785 trials there were two key witnesses with regard to the production of this specification: the draughtsman Wilkinson, a former master of an academy at Nottingham, and William Crofts, the clerk to Francis Evans, a Nottingham attorney, who provided the written specification. In *Arkwright v. Nightingale*, Crofts provided useful evidence for the defence when he recalled:

> I observed to him that it was not specified so perfectly as I thought it might have been, from the opinion I had of Mr Evans, as a draftsman, they [the parts] not being connected together as a machine; and Mr Arkwright said, he looked upon the specifications rather as a matter of form, and that for some time past, they had not specified them so perfectly as they should do, and for this reason, that, in his opinion, the invention might be taken abroad, as the specifications were not locked up; and that he wished it to appear as obscure as the nature of the case would admit, and he did not doubt but that it was sufficient to answer his purpose.[184]

Crofts' testimony against Arkwright grew even more robust in the final trial. While in *Arkwright v. Nightingale* he merely suggested that he thought the specification 'might be more clearly expressed', in *Rex v. Arkwright* he was more explicit. He said he warned Arkwright that the drawings were imperfectly done and would not answer the intended purpose: 'He told me, that he meant it to appear to operate as a specification, but as obscure as the nature of the case could possibly admit', for he wished the invention not to be taken abroad during the fourteen years covered by the patent. Crofts said he told Arkwright that he might have occasion to repent it.[185] As Bearcroft anticipated in his

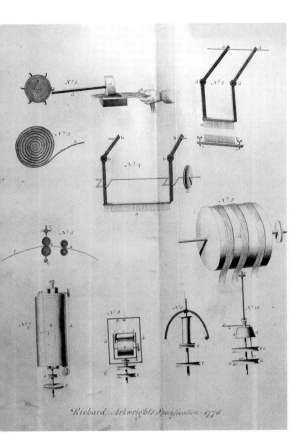

56 'Richard Arkwright's
specification 1776' drawing for
patent no.IIII, 1775. The
National Archives

opening address for the Crown, Crofts 'was so struck with the singularity of the instructions, and the lameness of the specification, and its inadequacy to convey the idea of a new invention, he himself said, "I don't think this will do"'.[186]

Bearcroft comprehensively laid into the ten figures that comprised the specification, picking off each part in sequence. Some figures were irrelevant, others represented nothing new, othere replicated parts of the first patent while vital parts were missing.[187] Bearcroft's mechanical witnesses, who testified that they were accustomed to making machines from drawings, pointed to further shortcomings. There was no scale and no mention of the relative velocity of the rollers.[188] For the defence, Adair sought to shine a positive light on the representation of the machine in parts, based on the traditional distinction between simple and complex machines: 'we all know, the more important part of the mechanical powers have been discovered, rather than invented, many centuries ago, many thousand years ago; so if you trace things up to their source, to their first constituent parts, I don't think any man could produce that, which would deserve the name of a new invention'. The wheels, pulleys, axles, rollers, cylinders and a variety of other mechanic powers, such as screws and wedges, and everything in mechanics – not one of the parts was new: 'it is the combination of those powers in the machine, and producing the effect of them; that, and that alone, constitutes the inquiry of that kind to be a new invention; or, otherwise, that is a new invention in a machine, which consists of a new combination of old parts'. Witnesses had shown how the feeder, crank, the cylinders, the rollers, the roving box were in use before 'but have they ventured to produce any one witness, to say, before the date of Mr Arkwright's patent, he ever saw such a machine as we shall now produce to you?'[189] Adair could have cited Mansfield's judgement in *Morris v. Johnson* (1776) that an improvement to an existing machine or process could be patented if it constituted a major advance; otherwise 'That objection would go to repeal almost every patent that ever was granted'. But perhaps he was constrained by the logical conclusion of such an argument – that if the originality of the machine lay in Arkwright combining old parts in a new way, a drawing should have been made to show how all the parts fitted together.[190]

For the prosecution, Bearcroft put a cynical interpretation on the presentation of the machine in parts. Arkwright's first specification drawing had shown that he could disclose an invention when he pleased and fear of disclosure to the French had been potentially as great then as it was six years later. The real reason why the second specification was presented in such a manner, omitting the important parts of the specification, was that Arkwright did not wish any man living to realise that in truth they were the same.[191] In his summing up for the jury, Judge Buller did not go quite as far. He noted that the very ingenious men called for the prosecution had testified that they could not make the machine from the specification, while several respectable men for the defence claimed that they could. The difference was that most if not every one of the latter had looked and seen how the machines were worked by the defendant and had not got their knowledge from the specification and plan alone. He directed that if the jury should be of the opinion that the specification was not certain enough, 'it may have the effect of induc-

ing people who apply for patents in future times, to be more explicit in their specifications, and consequently, the public will derive a great benefit from it'.[192] The jury immediately found against Arkwright, whose second patent was annulled (the first had already lapsed). This verdict reinforced the growing case law, notably Mansfield's judgement in *Liardet v. Johnson* (1778), which made the award of a patent conditional on submission of a clear specification.

On 21 October 1785, the *Daily Universal Register* (*The Times*) carried an advertisement on its front page, headed 'Exhibition of Arkwright's Patent Engines':

> Among the various Arts which have adorned this or any other nation, no one has surpassed, perhaps not equalled, both for their general utility and greatness of invention, The Machines lately invented in Lancashire for spinning Cotton, by which amazing discovery, inanimate matter is made to perform that work which heretofore has required the finest finger.
>
> A Gentleman attending (in Westminster-hall) the last trial betwixt the King and Mr. Arkwright touching the validity of his Patent, was so much struck with the operation of those engines, which were then exhibited in the Court, as to induce him to procure (at a great expense) a complete set of those machines for the entertainment of the curious at large. The whole of which, with the process of manufacturing cotton, will This Day, and every Day This Week, be exhibited at the Exhibition Room over Exeter-change, where proper persons will attend from Ten in the Morning till Eight in the Evening, both to work as well as to explain them. Admittance, One Shilling.

The presentation of his machines as yet another of the shows of London was perhaps a defiant reaction by Arkwright to the trial verdict, supporting his claim as to the openness of his patent specification. Wedgwood reported having a conversation with Arkwright in September 1785, finding him much disgusted with the treatment he had received in his trial and threatening 'as they would have his machinery made public, to publish descriptions and copper plates of his own'. Wedgwood sought to dissuade him from such a step, 'representing how unjust it would be, that a whole nation should suffer for the imprudent conduct of a few, for his opponents were few indeed in comparison with the great body of people who would be benefited by having his admirable inventions confined to ourselves'.[193] Arkwright was in effect pointing to the contradiction that existed between patent legislation, which was designed eventually to foster a free trade in invention, and the statutes enacted mainly between 1750 and 1786 which prohibited the export of machines and tools.[194] By 1790, the date of the portrait, Arkwright had presumably calmed down but he still claimed the machine as his own. So he sits establishing his rights in Derby Art Gallery. In the same rooms his son, Richard Arkwright II, was portrayed by Wright with his wife and child in a much more genteel guise, as befits one who was on the way to becoming, through clever investments, the richest commoner in England.

The Progress of Human Culture

If Sir Richard Arkwright ever looked out of his first-floor drawing-room windows on John Adam Street, he would have seen the toings and froings of the Society of Arts (of which he was a member from 1782) further down the street. The Society's elegant permanent residence had been completed in 1774 to the design of Robert and James Adam. Soon, an active artist member of the Society, the mezzotint engraver Valentine Green, 'made a proposal to engage ten of the first artists to produce each in his own manner, and in oil colours, a subject remarkable in English history: those pieces, made all of one

size, were intended to decorate the great meeting room of the Society, in honour of its having been the first and meritorious promoter of the arts'.[195]

Painters were to be chosen from the membership of both the Society and the Royal Academy, to demonstrate that established merit was not excluded. The historical scenes were to be painted, it was hoped, by Barry, Cipriani, Dance, Kauffman, Mortimer, Reynolds, West and Wright (all except Mortimer and Wright were Academicians) and 'allegorical subjects relative to the Institution and views of the Society' by Romney and Penny.[196] However, on 27 April 1774, Green reported that the artists in question had desired him to acquaint the Society 'That they find themselves honoured by the distinction the Society made of them in naming them to decorate the new room but as the mode of raising money by exhibition would be disreputable to them and from the nature of their engagements with their respective Societies they are sorry they cannot comply with the present proposals of the Society.'[197] The Academicians were indeed bound by restrictive rules which hindered them from exhibiting beyond the walls of the Academy but they were also as likely as not put off by the 'disreputable' and potentially risky payment arrangements from the profits of an exhibition after it had closed. Underlying these concerns was the danger of associating with a Society whose ends were in part commercial and by this point, according to Reynolds's tenets, somewhat *déclassé*.

Therefore, it must have come as a welcome surprise when in March 1777 James Barry proposed that he should undertake the entire decoration of the Great Room without a fee, if the Society provided the canvas, paint and models. The subject he suggested was 'a series of historical representations, illustrating the rise and progress of arts and knowledge among mankind, from the earliest period to the present times'. After much delay and financial hardship on the part of the artist, the work, entitled *The Progress of Human Culture*, was substantially complete when in 1783 the Great Room was opened to the public and Barry received the proceeds of its first exhibition. The same year he published his own account and catalogue on which the following is based. Later guides published during his lifetime did not meet with his approval.[198]

Barry had reason to be grateful to the ethos espoused by the Society of Arts, as represented by its sister institution in Dublin, at least in its support of high art. He was awarded a premium for history painting when at the age of twenty-two he submitted a picture, *The Baptism of the King of Cashel by St Patrick*, to an exhibition staged by the Dublin Society. The work was bought for the Irish House of Commons and the young artist attracted the support of Edmund Burke who financed his travels first to London and then to Rome. Barry returned to London in 1771 determined to promote history painting based on the principles of classical art.[199] Yet, with little hope of encouragement from individuals or the established Protestant Church, he turned to private institutions for support, above all the Society of Arts, perhaps unaware as a relative newcomer that it was by this date a somewhat eccentric choice.

The Society had largely abdicated its responsibility for high art to the Royal Academy. Barry had little time for the manufacturing interests and commercial society with which it was associated, a distaste first expressed in his *Inquiry* of 1775 with regard to portrait painters and restated in the introduction to his *Account* of the pictures in 1783. The paucity of historical painting in the country could be attributed not to any insurmountable difficulty in the undertaking itself, 'as from the servile, trifling views of the public, the particular patrons, or more properly the employers of the artists who . . . were intent upon nothing but the trifling particulars of familiar life'. Portrait painting was acceptable, he conceded, when it was confined within its proper channels: 'like others, I feel myself interested in the portrait of an ancestor, a parent, a friend, of a benefactor to his country or species, of a wise, a great, or a beautiful personage.' Neverthe-

less, he believed that 'from our too eager attention to the trade of portraits, the public taste for the arts has been much depraved, and the mind of the artist often shamefully debased'. Unfortunately, it provided the only means for an artist of achieving fame and fortune: 'by which is obtained a fashion, a fortune, and, upon true commercial ideas, a rank and consequence; as the business and resort of the shop, and the annual profits of it are the only estimates which generally come under consideration'.[200]

For Barry, historical painting was about more than the hackneyed subjects and outworn inventions which had long since been exhausted by the accumulated ingenuity and industry of artists on the continent. Nor was he advocating novelty for its own sake 'but a novelty full of comprehension and importance'. The higher exertions in art required an effort and knowledge on the part of both artist and spectator: 'It is an absurdity to suppose, as some mechanical artists do, that the art ought to be so trite, so brought down to the understanding of the vulgar, that they who run may read.' When art was levelled to the immediate comprehension of the ignorant, 'the intelligent can find nothing in it, and there will be nothing to improve or to reward the attention even of the ignorant themselves, upon a second or third view'.[201] In his letter to the Society of 1793, Barry further glossed this passage, urging the necessity of 'avoiding the trite vulgar matter that is found in Dutch drolls and a multitude of performances in all the schools of art by the artists without intellect, which are no less disgusting to the intelligent than useless to the ignorant' and which it was ridiculous to consider 'wise and scientifical'.[202] Once again, Dutch painting was equated with a mean pragmatical style lacking the capacity to aspire to higher, generalised, scientific principles.

According to his 1783 *Account*, in the series of six pictures that Barry painted for the Society of Arts he endeavoured 'to illustrate one great maxim or moral truth, viz. that the obtaining of happiness, as well individual as public, depends on cultivating the human faculties'.[203] Today they appear a curious blend of past and present, a mix of the allegorical and topical, seemingly driven by whim rather than by any over-arching unity. Yet at the time, the creation of history paintings out of contemporary events and the introduction of modern dress into grand-manner compositions were still relatively novel. Francis Hayman had achieved popular acclaim (perhaps in Barry's view from 'the rabble') with his patriotic works *The Surrender of Montreal to General Amherst* and *Lord Clive receiving the Homage of the Nabob*, painted in the early 1760s for Vauxhall Gardens in London. Edward Penny's modest account of *The Death of General Wolfe*, exhibited at the Society of Artists in 1764, had been overtaken by Benjamin West's epic rendering of the same subject, exhibited at the Royal Academy in 1771. Admittedly, Barry's subject matter for the Society of Arts was much broader than that of conventional military heroism or the humanity displayed in the course of British imperial conquest.[204] Yet in a still unified world of knowledge, the liberal and mechanical arts could coexist and indeed, it was thought, benefited from cross-fertilisation. Barry's failure to encompass both was not one of conception but of execution.

Scenes from Greek mythology were depicted in the first three paintings, charting a vision of human progress informed by the writings of J. J. Winckelmann on Greek art and civilisation, which were first published in the 1760s and made rapidly available throughout Europe in translation. They need not concern us here. In the other three paintings Barry brought the cycle more openly into the modern British age, avoiding the Saxon and medieval subjects submitted for history painting premiums. The first of his British subjects, *Commerce, or the Triumph of the Thames* (fig. 157), combines classical allegory with modern figures and objects in a manner for which there were precedents even in British art, notably Thornhill's ceiling for the Painted Hall at Greenwich. Early in the 1760s, Hayman had painted *The Triumph of Britannia* for Vauxhall Gardens, framing his portraits of admirals in a series of medallions which bobbed along in the

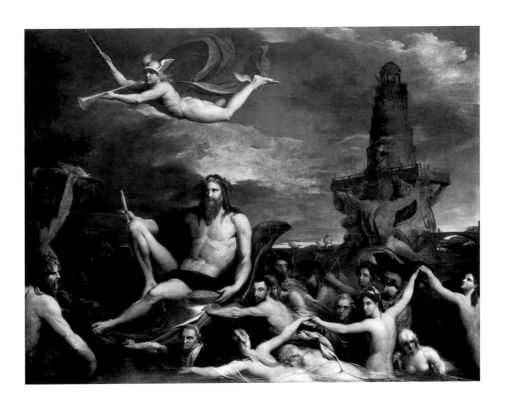

hands of nereids who accompanied Neptune's chariot carrying Britannia.[205] In the Society's own annals, 'The Birth of Commerce' from Glover's poem 'London' had been suggested as a subject in the first premium competition for historical paintings.

Barry represented Father Thames steering himself with one hand and holding in the other a mariner's compass, 'from the use of which modern navigation has arrived at a certainty, importance, and magnitude, superior to anything known in the ancient world; it connects places the most remote from each other; and Europe, Asia, Africa, and America, are thus brought together, pouring their several productions into the lap of the Thames'. He was carried along by great English navigators – Drake, Raleigh, Cabot and Captain Cook (who died in 1779) – loosely in the character of tritons, while behind them nereids bore 'several articles of our manufactures and commerce of Manchester, Birmingham, &c', of which rolls of calico and mathematical instruments are the most prominent. Although ostensibly a peaceable presentation of the progress of the arts and knowledge, while varnishing and cleaning the painting in 1801 Barry added a mausoleum, observatory, lighthouse and bridge born aloft by British sailors in the form of tritons. This 'naval pillar' was his contribution to the competition launched by the Duke of Clarence and others to erect a monument to commemorate the country's recent victories at sea.[206]

According to the artist, the fifth subject represented 'The distribution of premiums in a society, founded for the patriotic and truly noble purposes of raising up and perfecting those useful and ingenious arts in their own country, for which in many they were formerly obliged to have recourse to foreign nations', which constituted 'an idea picturesque and ethical in itself, and makes a limb of my general subject, not ill-suited to the other parts' (fig. 158).[207] A select group of officers and members of the Society are joined by a large cast of distinguished visitors and patrons, distributing awards. Initially, Barry asked the Society to select in order of preference between forty and fifty members to serve as a record for posterity but, in the end, his selection was determined more by the likenesses available and his personal choice of those who had contributed to the

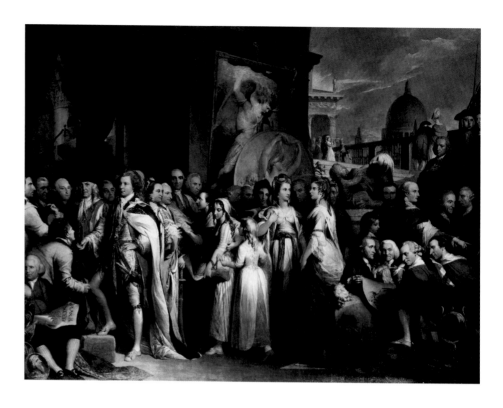

advancement of English culture, not necessarily related to the Society of Arts. Nevertheless, with the Society's approbation he managed to include the founder William Shipley, two presidents, twelve of the thirty-two vice-presidents, the secretary Samuel More, six ordinary members and two lady members, besides five non-members.

A seated William Shipley in the left-hand corner holds the founding instrument of the Society. Behind him, Arthur Young, representing the Society's agricultural interests, is depicted producing a specimen of corn for Lord Romney, the president, in peer's robes, who gestures towards the crouching farmer who presumably grew it. He is being presented to the Prince of Wales wearing the Garter robes with one foot precariously and somewhat unconvincingly on a bale of cotton – particularly when compared with Wright's portrait of Samuel Oldknow, leaning elegantly on his bolt of muslin. The machinery on show behind the prince was more plausible, drawn from Bailey's *The Advancement of Arts, Manufactures and Commerce* or even the specimens on which the plates were based in the Society's model room. Also included are Pinchbeck's crane and Westgarth's hydraulic machine, Almond's loom and parts from a winnowing machine, a machine for ventilating mines and a jack.

The centre group commences on the left with a female member, the Duchess of Northumberland, behind whom stand two vice-presidents, Sir George Savile and Earl Percy. Next to the latter, in profile, stands 'a distinguished example of female excellence, Mrs Montagu, who is earnestly recommending the ingenuity and industry of a young female [weaver], whose work she is producing'.[208] Behind her are the Duchesses of Rutland and Devonshire (who were not Society members but showed off Barry's portrait skills even if, in the case of the Duchess of Rutland's, it was based on a portrait by Reynolds) whose attention is drawn by Dr Samuel Johnson to Mrs Montagu as worth their notice and imitation. In his *Letter to the Dilettanti Society* of 1797, Barry made a special point of emphasising the importance of female education, as demonstrated in 'the many interesting and universally acknowledged accomplishments of our amiable Princesses', wishing that more had followed the example of Her Majesty the Queen: 'I

am happy to have long since taken such notice of this wise, graceful specimen of female education, as to have interwoven it with my work on the necessity of human culture, at the Adelphi'. Barry was referring to his proposed portraits of the King and Queen, which he suggested should replace the spaces over the fireplaces then – and still – occupied by portraits of the first Presidents, Lord Romney by Reynolds and Lord Folkestone by Gainsborough. He intended to paint His Majesty 'looking on the solar system, as completed by the discovery of the fortunate Mr. Herschell, who might be pointing out the situation of the Georgium Sidus'. The Queen was to be employed 'in one of those amiable acts of real female worth, in which her Majesty is so very distinguished, and which will ever be followed by the love and veneration of the wise and good'.[209]

In his picture, Barry placed more emphasis on patronage, both intellectual and social, of the country's manufactures than on the manufacturers themselves. The actual producers – a farmer, boy draughtsman and young woman weaver – are all presented in the subsidiary role of suppliant. Mrs Montagu, Dr Johnson and Arthur Young represented a class of intermediaries with the intelligence to bring improvements in British agriculture and manufactures to the attention of leaders of fashion who could promote them, a marketing model practised by Wedgwood and Boulton. Yet for Barry it was about more than fashion. The great and wealthy were co-partners in the great goal of 'raising a superstructure of art', for without their concurrence, nothing could be done. Too often they had fallen for flattery and cunning, instead of the liberal, unrestrained employment of men of extensive genius. Proper patrons should employ proper artists, like Barry himself, to establish the reputation of the arts in England and their own reputations for posterity.[210]

The third group on the right, against a background of part of the waterfront of Somerset House and the dome of St Paul's, included the Dukes of Northumberland and Richmond, the first and second Earls of Radnor, who were all vice-presidents of the Society, as well as Barry's erstwhile friend and patron Edmund Burke. The art patron William Locke, the physician Dr William Hunter (professor of anatomy at the Royal Academy until 1772), Northumberland and Radnor examine the drawings of a boy who has won a premium silver palette, also enviously regarded by an unfortunate loser with a portfolio under his arm. Typically for Barry, the drawing visible is one made after the antique rather than a piece of applied design. Barry was at one with Reynolds in assuming that 'If it has an origin no higher, no taste can ever be formed in manufactures; but if the higher arts of design flourish, these inferior ends will be answered of course.'[211] He was firmly against the practice of offering premiums for inferior branches of art, in other words design for manufactures, as 'the most likely to bring about the speedy destruction of whatever is valuable in the arts, particularly in that of painting'. Barry argued strenuously for academic training based on the antique and the ideal, for which larger premiums should be offered to 'formed artists', and 'to annihilate all those juvenile premiums'. He railed against the 'mechanical culture' offered by the free art academies of France. The 'great majority of base, uneducated, indigent' people who attended them 'must necessarily destroy and contaminate every thing valuable, and reduce this liberal art, this sister of poetry and child of philosophy, to a mere trade.'[212] This virtually amounted to biting the hand that, if it did not exactly feed him, certainly provided him with four walls on which to work. As far as art education was concerned, Barry was by implication accusing the Society of being worse than useless, in fact of endangering the progress of the arts in England.

Nevertheless, he introduced into the lower corners of the picture examples of the agricultural, commercial and manufactured goods for which the Society had offered premiums: specimens of cotton and indigo, madder and cochineal, iron gun-barrels and a gun harpoon for whaling, English carpets, maps and charts and with characteristic self-

interest, 'large paper of a loose and spongy quality, proper for copper-plate printing, which is, and has long been a very great desideratum', given that the price of French *grand aigle* and *colombiez* was, according to Barry, six times the price that paper of the same quality might be manufactured in England.[213] In 1801 he added to the left-hand corner his own designs for coins and medals, a subject of long-standing interest for Barry as well as for the Society, for which he had proposed a design in 1798.[214] Furthermore, ever immodest, on the right in a prominent position in front of the kneeling Northumberland and Radnor, he introduced a Grecian-style hot-water urn of his own invention which he offered as an improvement on the vulgar and ill-contrived versions in general use. It epitomised Barry's confident belief that the highest form of art could improve even the humblest object, emphatically not the reverse.[215]

In the last picture, *Elysium and Tartarus, or the State of Final Retribution*, Barry sought to bring together 'those great and good men of all ages and nations, who were cultivators and benefactors of mankind' (fig. 159).[216] They encompassed the whole tribe of arts and sciences gathered in groups. On the left are the leading men of science – Sir Francis Bacon, Copernicus, Galileo and Newton – who with two angels are examining a solar system. Roger Bacon, Archimedes, Descartes and Thales form a second group, clustering round the ancient geometrical problem of the cylinder, sphere and cone. Above Bacon, Columbus holds a chart of the western world he discovered. The groups move from classical philosophers and legislators – Sir Thomas More, William Molyneux and Robert Boyle – to religious thinkers including Confucius and Brahma. Behind Columbus appear Shaftesbury, Locke, Zeno, Aristotle and Plato. Special prominence was given to William Penn, whom Barry praised 'as a most perfect model of equal and impartial privilege and justice, of Christian meekness, forbearance, and brotherly affection, and consequently of the most finished, truest, and most useful national policy, particularly amongst people who may be unfortunately divided in matters of religion'.[217]

A miscellany of famous rulers was next introduced and 'those patrons of men of genius', including 'Lorenzo de Medicis, Louis XIV, Alexander the Great, Charles I, Jean Baptist Colbert, Leo X, Francis I and the illustrious Lord Arundel'. There was a large group of writers – classical, medieval and modern – and, scattered among them, leading artists of the Italian Renaissance but also Inigo Jones, Wren, Rubens, Van Dyck, Le Sueur, Le Brun and Hogarth. In his *Account*, Barry saw the need to defend his inclusion of Hogarth, despite the fact that foreigners had 'justly observed, that [he] is often so raw, and uninformed, as hardly to deserve the name of artist'. Yet Barry recognised that the undoubted merit of Hogarth's work entitled him to an honourable place among the artists: 'his little compositions considered as so many dramatic representations, abounding with humour, character, and extensive observations on the various incidents of low, faulty, and vicious life, are very ingeniously brought together, and frequently tell their own story with more facility than is often found in many of the elevated and more

noble inventions of Raphael, and other great men'. Furthermore, Hogarth's inexhaustible fund of invention and his satire, which was always 'sharp and pertinent' and often 'highly moral', was 'seldom if never employed in a dishonest or unmanly way'.[218] He also singled out for praise Cipriani, Dance, 'that ingenious Proteus Gainsborough', the 'ever to be admired Zoffany, and the masterly Wright of Derby', only regretting the lack of support for stretching them to undertake some great historical work.[219] In 1798 Barry added Reynolds, who had died six years previously, pointing to Michelangelo.

Those who abused power were shown being cast into the eternal flame of Tartarus, including a warrior, a glutton, a spendthrift, a 'detractor' or scandalmonger, a miser and an ambitious man who wore the Garter, 'the most intelligible characteristic of vanity' (somewhat tactlessly, as the only two figures wearing the Garter in the cycle were the Prince of Wales and the Duke of Northumberland in the *Distribution of Premiums*). To these he added an enraged absolute monarch, one of the popes who grasped after earthly power and dominion and a Covenanter, 'that execrable engine of hypocrisy, injustice, and cruelty'.[220] Barry reinforced the message of the cycle once more, that good government was necessary for human progress in all fields, above all in art which depended on enlightened patronage.

The *Elysium* constitutes the first attempt to synthesise in a single canvas the intellectual history of the whole of humanity, inaugurating a genre that blossomed in the nineteenth century. In artistic terms it can scarcely be considered a success. Furthermore, it is pertinent to note who is absent from this Valhalla of genius reaching back to ancient times. Where were the leading mechanics, engineers and captains of industry who might have been expected to figure in such a composition, in the heart of such a place as the Society for the Encouragement of Arts, Manufactures and Commerce? Where were John Smeaton, James Watt, Matthew Boulton, Josiah Wedgwood, Jedediah Strutt, Richard Arkwright? As has been seen, Barry's main agenda was to boost the claims of history painting in England through the flattering inclusion of past and potential patrons, the great and the good who were the cultivators and benefactors of humankind. On the face of it, those responsible for turning the wheels of commerce and manufacture could be made to fit the bill, provided such 'lines and veins' of labour were not divided off but recognised as part of the unity of knowledge, as represented on the highest level by history painting. Only with the guidance of leaders in taste could the mechanical arts work together with the fine arts for the common good. According to Barry's tenets, mechanical men should find a place in his painting because of their capacity to promote civic virtue and resist corruption and because their inventions constituted a public benefit for humanity.

Viewed in this light, by the 1790s Barry could in theory have included at least Wedgwood, Boulton and Watt, whose reputation for public works as well as private gain might have won them admittance into the Pantheon. Where were the classical urns and vases that poured out of Soho and Etruria? Where was the steam engine or the spinning machine? The fame of their inventors had spread abroad and certainly by the 1790s their portraits had been painted by artists of whom Barry approved. Yet so all-consuming was his creative vision that he failed to accommodate Smeaton's Eddystone lighthouse in his painting of *Commerce* – Smeaton's publication of his own work on the subject in 1791 might have inspired Barry's fanciful 'naval pillar' – nor did he seize the chance to include Abraham Darby's iron bridge in his monument, the model of which had formed a splendid addition to the Society's model room since 1787.

It is difficult to avoid the conclusion that Barry was so wedded to advancing an idealised view of the classical world with its attendant patronage that he missed the key advances of his own age. His additions to the works over twenty years only succeeded in making them more egotistically, idiosyncratically personal, not more relevant to the

age in which he lived. The prints he made with a number of variations after the works and first published in 1792 were not well received, on account principally of their crudity of finish. Barry's prime focus of interest is confirmed by the large details of groups from the Elysium he subsequently chose to publish as separate prints: the figures were in the main historical and classical, representing legislation, justice (both on earth and divine) and philosophy, science and exploration.[221]

At the Society of Arts, Barry created a series of paintings of striking originality out of the grand tradition of heroic monumental figurative art. However, in some ways his work was symptomatic of the breakdown of the very tradition on which it sought to build. Despite his best efforts, the series straddled the divide between historical and contemporary subject matter in an uneasy fashion. His desire to produce an art which required effort and knowledge on the part of the viewer, raised above the understanding of the vulgar and immediate comprehension of the ignorant, produced a series the meaning of which was at best hermetic, only comprehensible with the help of his own published account and at worst dangerously close to self-conscious mystification. In the final analysis the paintings are more private than public and it is Barry's idiosyncratic take on his subject that gives them their peculiar interest.

A useful comparison can be drawn with ceiling designs made by Benjamin West in the late 1780s for the Queen's Lodge, built by Sir William Chambers between 1778 and 1782 on the south terrace of Windsor Castle. According to an 1805 catalogue of West's works, the subjects comprised:

Genius calling forth the Fine Arts, to adorn Manufactures and Commerce, and recording the names of eminent men in those pursuits.
Husbandry aided by Arts and Commerce.
Peace and Riches cherishing the Fine Arts.
Manufactory giving support to Industry in boys and girls.
Marine and Inland Navigation enriching Britannia.
Printing aided by the Fine Arts.
Astronomy making new discoveries in the heavens.
The four Quarters of the World bringing treasures to Britannia.
Civil and military Architecture defending and adorning Empire.[222]

The designs were realised and installed in 1789 by a confectioner called Haas (or Hawes) using the Italian technique of stained marble plaster or *marmorino* and, although the Lodge together with its ceiling was demolished by George IV in 1823, some of West's sketches for the project survive.[223] West would undoubtedly have seen Barry's paintings in the Great Room of the Society of Arts and although the suggestion that they were a source has been made, it is much more probable that West's subject matter was instigated by the King himself or at the very least West's familiarity with his interests, ranging as they did across the fine and mechanical arts, literature and the sciences including astronomy, navigation, geography and agriculture. Farington's report in 1803 of a royal tiff arising from the King's later discovery of the Queen's removal of the work during his illness suggests that he had a proprietorial interest in it.[224]

Moreover, the works had little in common with Barry's heavy portentousness, or indeed to West's own serious historical style, but were allegorical in a light decorative manner. The sketches, most of which were exhibited at the Royal Academy, indicate some departure from the description cited.[225] West's centrepiece, *Genius calling forth Arts and Sciences* (fig. 160), focuses on the presiding male figure of Genius and three female figures representing Painting, Architecture and Sculpture (leaning on a profile relief of George III). Music is visible in the middle distance, while figures representing the scientific pursuits of Navigation, Geography and Astronomy cluster round the edges. A

telescope is trained on a planet surmounted by the letter H, the conventional sign for Uranus, which had been discovered by Sir William Herschel in 1781.

Agriculture or *Husbandry aided by Arts and Commerce*, exhibited with *Genius* at the Royal Academy in 1790, was represented by a harvest scene. Unlike Stubbs's *Haymakers* and *Reapers*, exhibited at the Royal Academy in 1786, the figures are clad in a loosely neo-classical fashion rather than contemporary dress but the 'arts and commerce' are embodied in the windmill, visible in the distance. *British Manufactory; a Sketch* ('Manufactory giving support to Industry in boys and girls') exhibited at the Royal Academy in 1791, celebrates the arts and manufactures in which the country had excelled (fig. 161). The background is devoted to spinning and weaving scenes employing child labour, while the principal focus is on 'vasomania', as catered for by the products of Soho and Etruria. Specimens – including the Portland Vase, a copy of which Wedgwood had finally succeeded in producing in 1790 – are being admired by neo-classical nymphs and cherubs. *Marine and Inland Navigation enriching Britannia* also survives, although it was not exhibited. The presence of a sailing ship of contemporary design is the only element to break the spell of an otherwise classical allegory.[226]

West went further than Barry in considering the relationship between the fine and mechanical arts. He was certainly at one with Barry in claiming history painting as the highest vocation for an artist and in considering that philosophical insight and moral purpose distinguished him from the humble mechanic.[227] None the less, in his second

161 Benjamin West, *British Manufactory: a Sketch (Manufactory giving support to Industry in boys and girls)*, c.1791. Cleveland Museum of Art

lecture as President of the Royal Academy in succession to Reynolds, delivered in 1794, West provided an economic as well as an artistic justification for drawing the human figure, believing that it should be taught as an elementary essential in education. While among the youth of the noble and opulent classes it would implant 'that correctness of taste which is so ornamental to their rank in society', it would also 'guide the artisan in the improvement of his productions in such a manner as greatly to enrich the stock of manufactures, and to increase the articles of commerce; and, as the sight is perhaps the most delightful of all our senses, this education of the eye would multiply the sources of enjoyment'. According to West:

> The cultivation of the sense of sight would have such an effect in improving even the faculty of executing those productions of mechanical labour which constitute so large a portion of the riches of a commercial and refined people, that it ought to be regarded among the mere operative classes of society as a primary object in the education of their apprentices. Indeed, it may be confidently asserted, that an artisan, accustomed to an accurate discrimination of outline, will, more readily than another not educated with equal care in that particular, perceive the fitness or defects of every species of mechanical contrivance; and, in consequence, be enabled to suggest expedients which would tend to enlarge the field of invention. We can form no idea to ourselves how many of the imperfections in the most ingenious of our machines and engines would have been obviated, had the inventors been accustomed to draw with accuracy.[228]

354

In advancing such a view, West showed himself to be as cut off as Barry from the advances which had already been made in the practice of the mechanical arts. Yet his lack of awareness of the standards of draughtsmanship attained by inventors of machines and engines is perhaps symptomatic of the growing division between the arts, reinforced by the claims made for history painting by Reynolds, Barry and all those like himself struggling in the closing decades of the eighteenth century to establish a British school of history painting. By the turn of the century, these attitudes had hardened into a hostility towards anyone involved in commerce and industry. Fighting to uphold the cause of history painting, in 1805 the artist Martin Archer Shee published his *Rhymes on Art; or, The Remonstrance of a Painter*. All patriotic interest on the part of the government in the cultivation of British genius appeared to be at an end. It was a mistake to conceive that the arts, 'left to the influence of ordinary events, turned loose upon society, to fight and scramble, in the rude and revolting context of coarser occupations, can ever arrive at that perfection which contributes so materially to the permanent glory of a state'. Shee reiterated Reynolds's arguments, though without the latter's confidence in their inevitable victory. He argued at a time of war, when he felt beleaguered by what he termed, 'a commercial as well as a political Jacobinism'. He countered the laissez-faire attitudes and principles of free trade, which backed market forces of supply and demand, with the view that the principles of art and those of trade were incompatible: 'With those who would leave the arts, unassisted, to find their level in society; who consult Adam Smith for their theory of taste as well as of trade; and who would regulate the operation of *virtù* on the principles of the pin manufactory; with all those, in short, to whom this world is but one vast market – a sales-shop of sordid interests and selfish gratifications, arguments drawn from the importance of the arts as objects of taste and refinement, will have little weight.'[229]

Such inflammatory language opened up the Academy and its claims of privilege to attack in the self-same terms. In a series of articles written for *The Champion* in 1814, William Hazlitt dismissed Reynolds's views on portraiture and in particular the oversimplified distinction he made between the general and particular which only existed in the realm of abstract ideas. For Hazlitt, the Royal Academy was a 'society of hucksters', a 'mercantile body, like any other mercantile body, consisting chiefly of manufacturers of portraits, who have got a regular monopoly of this branch of trade, with a certain rank, style, and title of their own, that is, with the King's privilege to be thought artists and men of genius'.[230]

VII

Industrious Scenes

High where old *Don* with interrupted Waves,
Thro' fertile Meads his flow'ry Margin laves,
Where *Nymphs* and *Swains* together oft repair,
To breathe their *Passions* and the Evening Air.
There Smoke envelop'd *Sh—ff—d* long has stood,
The dusty Empire of the *Lemnian* God.
The *Cyclops* here th'eternal *Anvils* ply,
Alternate *Hammers* make the *Sparkles* fly:
The glowing Mass, the breathing *Bellows* heat,
The Sweating Slaves, the fiery Substance, beat;
With rustick *Song*, resounds, the homely Cave,
And the vex'd *Metal* hisses in the Wave.
Not with more Glee the Sooty Godhead smiles,
On flaming *Ætna* or th'*Æolian* Isles;
Where his grim Slaves from *Neptune* sprung, conspire,
To forge Jove's *Bolts* from *Water, Air* and *Fire*.
 Anon., *Axiomatici; or, The British Burgo-Masters; A Poem* (c.1749)

In the atmosphere of diffused Marxism . . . that pervades British academe, it is
the anonymous and amorphous movements of cash and labour that are felt to
be most powerfully real. But that's a bum feeling in the Gorge, where it is
hardware and brickwork, water and iron, that matter. Grand statistical
overviews mean nothing here; everything is specific, unique, local and peculiar
– because of the landscape.
 Reyner Banham, 'Iron Bridge Embalmed', *New Society*, 6 September 1973

The tradition initiated in the sixteenth century of drawing the distinctive features of the
British landscape was closely allied to that of surveying and mapping property, exam-
ined in Chapter 2. There was no perceived conflict between map-making and picturing,
between mathematical calculation and empirical observation, for they were based on a

common appreciation of the knowledge to be gained from accurate description. Painters and map-makers shared the medium of drawing by which they could make records.

Mapping was the means whereby men imposed order on the environment. Within the Board of Ordnance, the mapping skills required to control territory were frequently redeployed on the design of fortifications or details of ordnance production and extended to making perspectives of the sites in which they were operational. Outside the military sphere, the detailed picturing of the land provided further evidence of acquisition and control, produced for the same owners who commissioned estate maps and surveys. Following the Restoration of 1660, Dutch immigrant artists such as Jan Siberechts and Leonard Knyff were able to service the buoyant market for estate portraits, large-scale yet meticulously detailed bird's-eye views or prospects of English country houses firmly anchored in their surrounding land. They included not only the hallmarks of agricultural improvement – enclosed fields, neat coppicing and so on – but also, occasionally, signs of industry.[1]

Maps and topographical prints and drawings were produced by the same artists and sometimes were even drawn and printed on the same sheet. As with 'heads', it was a fashionable pursuit of the elite in the eighteenth century to make collections of all these forms of pictorial record, carefully classified by geographical region.[2] George III's Geographical Collection is a case in point, now divided among the Royal Library, the British Library, the Admiralty Library and the British Museum's Department of Prints and Drawings.[3] Largely acquired during the King's lifetime or that of his uncle, Prince William, the Duke of Cumberland, but with some items dating back to the sixteenth century, it encompassed maps, military plans, maritime charts, architectural schemes, topographical views and ephemera, in both printed and manuscript form, arranged by area in alphabetical sequence and housed loose in atlas-like folders. The collection was supposedly of strategic importance, the King being supreme commander of British forces, but, as Peter Barber has suggested, it also appealed to George III's love of collecting facts for their own sake and to his patriotism. He identified not only with the history and traditions of his country, as represented in the depiction of sites and finds of antiquarian interest, but also with its progress, made manifest in images depicting agricultural and manufacturing improvements.

The rough division of the collection after 1811 into some 50,000 works of topography and smaller military (4000 works) and maritime (3000 works) collections initiated the break-up of material which had hitherto been seen as a homogenous whole. This split was reinforced when in 1823 George IV presented the Geographical Collection, mistakenly conceived of as part of the King's Library, to the British Museum, causing a storm of protest in the royal household.[4] Within the British Museum, the topographical collection was not kept together but distributed among the departments of maps, manuscripts and prints and drawings. This division was further formalised when maps and manuscripts became part of a new British Library, founded by Act of Parliament in 1972, and were moved to St Pancras in 2003, leaving those items deemed to be primarily of aesthetic rather than topographical interest in Bloomsbury.

The mindset conditioning these decisions echoes the pecking order of artistic worth long established in academic circles. Although landscape and genre were not highly rated in the hierarchy of art, landscape in the generalised classical manner of Nicolas Poussin, Claude Lorrain and Gaspar Dughet was much preferred by Reynolds to the meticulously detailed records of nature and common life made by the Dutch. He described the difference in an essay which appeared in *The Idler* in 1759:

> The Italian attends only to the invariable, the great and general ideas which are fixed
> and inherent in universal nature; the Dutch, on the contrary, to literal truth and a

minute exactness in the details, I may say, of nature, modified by accident. The attention to these petty peculiarities is the very cause of this naturalness so much admired in the Dutch, which if we suppose it to be a beauty, is certainly of lesser order, that ought to give place to a beauty of a superior kind, since one cannot be obtained but by departing from the other.[5]

In his fourth Discourse, delivered in December 1771, Reynolds recommended that painters should follow Claude in creating pictures from composites of drawings made of various beautiful scenes and prospects, omitting 'accidents of nature' which 'were contrary to that style of general nature which he professed, or . . . would catch the attention too strongly, and destroy that quietness and repose which he thought necessary to that kind of painting'.[6] By depicting the universal and ideal, the arcadian pastoral paintings of Claude revealed the immutable order of the cosmos, wrested out of chaos. They represented a lost golden age where pleasure and idleness predominated, where action gave way to virtuous contemplation.

The works of Claude and his followers were collected by the British aristocracy, educated to believe in the supremacy of classical civilisation. As David Solkin demonstrated in the catalogue for the exhibition 'Richard Wilson: The Landscape of Reaction' at the Tate Gallery in London in 1982, any British artist who wanted to command the attention of such cultivated buyers had to be conversant with that civilisation, preferably acquired first hand by a spell in Italy. During the course of his lengthy Italian sojourn, between 1750 and 1757, Wilson became a landscape painter in the grand manner of Claude and Dughet, committed to the notion of ideal beauty and the Virgilian pastoral, personified by the contemplative shepherd, as the appropriate model for evoking the rural existence. On his return to London he came close to monopolising the demand not only for Italian views but also for representations of the English and Welsh landscape cast in a classical light.

As noted in the Introduction here, since the 1980s a considerable literature has evolved which analyses the relationship between English landscape painting and the prevailing ideology or power structure.[7] When Wilson received commissions to paint landed estates, he clothed the English countryside in the language of classicism but the figures he introduced were rarely shown gainfully employed. They reinforced a fictional account of the countryside as a place primarily for leisured rustic pursuits, including music-making and dancing or, more commonly, just resting. Narrow economic or material concerns were barely represented. As Solkin pointed out, even when labourers were included as staffage, for example, Wilson's *View of Cassiobury House from Moor Park*, dating from the mid-1760s, they were depicted admiring the view rather than toiling to complete their task of enclosing the land. In other words, they seemed to be enjoying their work as if it were an act of beneficence on the part of their landlord, in this case the Scottish entrepreneur Sir Lawrence Dundas.[8] Wilson's version of England and Wales possessed the attributes of a pastoral golden age where all classes worked together in a harmonious community.

Nevertheless, by this time the market for landscapes was changing. As with his views on portraiture, Reynolds was describing his aspirations for a British school of landscape art rather than reality. What relevance did the immutable past of the ancients have for those with neither the education nor inclination to appreciate representations of the grand style, for a society bent on agricultural and economic improvement, which believed as much in the virtues of industry as in those of leisure? From the 1740s, there was a growing interest among English collectors in the 'common' landscape art of seventeenth-century Holland – the naturalistic views of Ruisdael, Hobbema, Wynants and others.[9] Furthermore, British artists, notably Thomas Gainsborough, began to paint

rural scenes in a naturalistic manner, in part derived from 'little Dutch landskips' but also responsive to the concerns of his Suffolk patrons who were not hidebound by classically grounded notions of style and taste.

In fact, Reynolds did not propose the complete abandonment of the close study of nature as the basis for landscape painting. By 1780 he was advising the master mariner Nicholas Pocock, who had just produced his first seascape in oils: 'I would recommend to you, above all things, to paint from nature instead of drawing; to carry your palette and pencils [brushes] to the water side. This was the practice of Vernet, whom I knew in Rome; he then showed me his studies in colours, which struck me very much, for that truth which those works only have which are produced while the impression is warm from nature.'[10] Then, in the fourteenth Discourse which Reynolds gave in 1788, following Gainsborough's death, he conceded: 'the style and department of art which Gainsborough chose, and in which he so much excelled, did not require that he should go out of his own country for the objects of his study; for they were every where about him; he found them in the streets, and in the fields; and from the models thus accidentally found, he selected with great judgement such as suited his purpose'. Gainsborough had imbibed the language of art from his study of the Flemish school, from which he learnt 'the harmony of colouring, the management and disposition of light and shadow', but the judgement and taste he exercised were his own.[11]

Wilson and Gainsborough adapted respectively Italian classicism and Netherlandish naturalism for the English market. Neither found much room to accommodate the encroachment of industry into a landscape setting. Yet during the eighteenth century, a host of travellers unself-consciously recorded in journals and sketches the latest developments in industry and manufactures on the tours they made round the country. Most of them made no sharp divide among objects of scientific curiosity, aesthetic beauty and mechanical ingenuity. They moved easily between *dulce* and *utile*, from admiring newly built country houses to newly built manufactories, from descending into mines to collecting fossils and were awed equally by mountains, ironworks and quarries. No change of perceptual framework was involved. They used the same words to describe their experiences, 'curious' and 'entertaining' being particular favourites, comfortably secure in the belief that all demonstrated the country's natural advantages, progress in the arts and sciences, agriculture, manufactures, economy and consequent well-being. The production of such written records was so common that industrial tourism can almost be described as a literary genre.

This happy state of affairs was rarely reflected in landscape painting. Indeed, the aesthetic pleasure in contemplating landscape through its association with other natural and painted landscapes, especially those described by Horace and Virgil, was expressed with notorious stridency by the Reverend William Gilpin. In 1768 he started to tour different parts of the country, making sketches and recording his observations which were circulated among friends, who encouraged him to publish them. His *Observations on the River Wye . . . relating to picturesque Beauty*, published in 1782, was followed by seven more tours over the next seventeen years, covering different parts of country. Gilpin's aim was to evolve a code of practice for viewing landscape scenery based on those qualities which made objects pleasing in painting. Inevitably this meant a generalised overview, not the examination of minutiae. Value was placed on roughness and indistinctness, not common detail. So averse was Gilpin to anything that intruded on his vision of England that he did his best to exclude it. The monastic ruins of Tintern came close to fulfilling his picturesque ideal of nature but the vulgar regularity of the gable ends 'hurt the eye' while the 'poverty and wretchedness of the inhabitants' and the 'loathsome little huts' where they lived round the site appalled him. In order to avoid seeing them, the visitor was advised to view the ruins from further away.[12] Gilpin did

note the presence of great ironworks within half a mile of the abbey but only to consider the furnace smoke 'issuing forth from the side of the hills' permissible because in 'spreading its thin veil over a part of them, [it] beautifully breaks their lines, and unites them with the sky'.[13]

Usually Gilpin betrayed a shallow indifference to the industries he accidentally came across. In Borrowdale in Cumberland he was almost tempted to get closer to view a lead mine, 'feeling a friendly attachment to this place, which every lover of the pencil must feel, as deriving from this mineral one of the best instruments of his art; the freest and readiest expositor of his ideas'. Yet, as the sun was setting it was too late 'nor indeed did it promise more on the spot, that it discovered at a distance'.[14] He was dismissive of the Cornish tin industry: 'We had not . . . the curiosity to enter any of these mines. Our interest was only on the surface.'[15] His search after picturesque beauty did not admit the spirit of scientific enquiry, or profounder considerations as to geological strata, still less the mechanical means of mineral extraction. As Stephen Copley has pointed out, Gilpin justified his travels principally in terms of amusement, albeit of a kind – particularly in the remoter regions – which allowed him to escape from the dirt, temptation, luxury and corruption of the city.[16]

He could countenance the inclusion of some peasant staffage but not into a landscape which was savage and untamed: 'In grand scenes, even the peasant cannot be admitted if he be employed in the low occupations of his profession; the spade, the scythe, and the rake are excluded.' Utility was inimical to aesthetic pleasure: 'In a moral view, the industrious mechanic is a more pleasing object, than the loitering peasant. But in a picturesque light, it is otherwise. The arts of industry are rejected; and even idleness, if I may so speak, adds dignity to a character.'[17] Hence his approval of those who in a later generation would be called the undeserving or idle poor – gypsies, beggars, peasants. Gilpin found it hard to hide his disdain of Boulton's Soho Manufacture: 'it is difficult to keep the eye in humour among so many frivolous arts; and check its looking with contempt on an hundred men employed in making a snuff box'.[18]

The illustrations in his works, usually monochrome ovals in aquatint, were not topographical images but arrangements of natural elements organised according to Gilpin's interpretation of the correct principles of picturesque beauty. Inevitably, they were read not simply as guides for the viewer but as guides for the correct painting of nature. In effect, Gilpin embraced Reynolds's exhortation to the artist to rise above 'all singular forms, local customs, particularities and details of every kind'.[19] By so doing, both the artist and the traveller in search of the picturesque would draw the line between the ennobling dignity of his own intellect and the 'mere mechanick'. At the start of the nineteenth century Henry Fuseli, as Professor of Painting at the Royal Academy Schools, could dismiss topography as 'that kind of landscape which is entirely occupied with the tame delineation of a given spot'. Instead he recommended to students the ideal landscape of the Italians, of Poussin, Claude, and Wilson, even of Rubens and Rembrandt, who spurned 'this kind of mapwork'.[20]

To summarise, in the eighteenth century there existed a theoretical divide between, at one extreme, empirical topography rising out of the map-making tradition and, at the other, the conventions associated with ideal or picturesque landscape. On the face of it, only the former could be put to industrial use, as those involved in map-making and ordnance and other trade professionals observed with a knowledgeable eye and delineated the processes of industrial production in an empirical, even mechanical manner. Yet for the purposes of marketing and consumption, picturesque formulae had their uses. Entrepreneurs concerned with promoting industry frequently sought for commercial reasons to wrap their industrial processes in a polite guise, the better to attract purchasers. Furthermore, there were a few professional artists who attempted to incor-

porate industry into the artistic hierarchy of the day in the face of prevailing academic opposition not only to the world of mechanical production but also to that of commercial consumption. They struck a chord with the growing band of tourists who, unlike Gilpin, were perfectly ready to accommodate the country's industrial development and find it both entertaining and instructive.

Ordnance Surveying

If any body was responsible for pioneering the empirical investigation and representation of the industrial landscape of Britain it was the Ordnance Office. From Tudor times military surveyors and engineers were expected to be able to make 'projecting' views or designs in perspective of the properties in their care.[21] By the middle of the seventeenth century there was no shortage of men who moved easily between mathematical calculation and empirical observation, making both cartographical plans and pictorial prospects. The most accurate renderings of bird's-eye perspectives were executed by artists from abroad, notably Wenceslaus Hollar, who attempted to map London prior to the Great Fire, made parallel prospects of the city both before and after the Fire and ground-plans of the areas destroyed. Having been granted the title of 'scenographer to His Majesty', in 1668 he petitioned successfully to be attached to Lord Henry Howard's expedition to Tangier, acquired as part of Catherine of Braganza's marriage dowry, where he executed a series of splendid panoramic watercolours as well as smaller prospects, which were etched and published in 1673.[22] From 20 December 1673 until the end of 1680, Robert Thacker received £60 per quarter in the Ordnance Office 'for his encouragement, being employed in drawing draughts of His Majesty's principal fortifications and other matters concerning his Majesty's forts and houses'.[23] He also went to Tangier, producing twenty-two 'draughts actually surveyed and the prospects taken on the place for His Majesty's particular use', which were engraved by him and first published in 1675.[24] Thacker was responsible for eleven views of the new Royal Observatory (built with funds from the Ordnance Board) which were engraved by Hollar's friend and pupil, the gentleman amateur Francis Place.[25]

Both Hollar and Thacker worked in the Ordnance Office with Sir Jonas Moore, who was responsible for a succession of practically orientated mathematical publications dealing with all aspects of fortification, gunnery, land surveying and navigation.[26] The successor to Moore and his son as Surveyor General, from 1682, was the Lille-born surveyor, cartographer and military engineer, Sir Bernard de Gomme, who had served since 1661 as Chief Engineer. In reorganising the Board of Ordnance, which involved codifying and rationalising its estates and services, he drew up a job description for Chief Engineer which emphasised that the successful candidate should not only be well skilled in all parts of mathematics but also able

> to take distances, heights, depths, surveys of land, measures of solid bodies, and to cut any part of ground to a proportion given . . . and to be perfect in architecture, civil and military . . . to draw and design the situation of any place, in their due prospects, uprights, and perspective . . . To keep perfect draughts of . . . the fortifications, forts, and fortresses of our kingdoms, their situation, figure, and profile . . . To make plots or models of all manner of fortifications, both forts or camps, commanded by us to be erected for our service.[27]

The skills acquired by an Ordnance Engineer are vividly demonstrated by Thomas Phillips's drawings for 'The Present State of Guernsey with a short accompt of Jersey and the Forts belonging to the said Islands' (1680), produced by Gomme as Chief Engi-

neer and Assistant Surveyor, Captain Richard Leake as Master Gunner of England and others under the auspices of the Lieutenant General of His Majesty's Ordnance, Colonel George Legge (from 1682, Baron Dartmouth).[28] Their work anticipates the Dummer 1698 Survey of the Royal Dockyards and in its combination of theatrical title-pages, bird's-eye views and prospects, with measured plans and statistics, answered the same imperative, to catch royal attention by packaging technical detail as courtly entertainment, in this case to secure funds for the repair of national fortifications.[29]

Opportunities for formal training in military and naval surveying increased in the early decades of the eighteenth century. From the 1690s the 'mathematics' at Christ's Hospital were taught 'The construction and use of right lined and circular maps, the practice of drawing for laying down the appearance of lands, moles and other objects worthy of notice.'[30] A succession of drawing masters came from the Lens family of artists. Their *New and Compleat Drawing Book*, first published in 1750, included a frontispiece with a portrait of Edward Lens, who took over from his father Bernard Lens II in 1725, supported by two 'mathemats' in their distinctive coats, one holding a prospect and the other a map, with drawing aids and a palette and brushes on the floor before them. The contents confirmed that technical, mathematically based drawing was never wholly separate from drawing based on direct observation: the plates intended for copying included life drawings, prospects of fortresses and harbours and even classical landscapes.[31] However, the School's examiners at Trinity House were not impressed when Alexander Cozens, appointed as drawing master in succession to Edward Lens in 1749, made more headway in teaching the polite art of classical landscape composition than in the mathematically based skill of recording prospects accurately in perspective. Drawing exercises associated with navigation produced at Christ's Hospital under Cozens were compared unfavourably, from a technical viewpoint, with those produced at the new Naval Academy in Portsmouth, founded by George II in 1733.[32] At the Royal Military Academy, founded at Woolwich in 1741, officer cadets were trained for the two Ordnance services of the Artillery and Engineers not only in gunnery and fortification but also the gentlemanly accomplishments of fencing, dancing, French and drawing. The staff of five included a drawing master; the first was John Fayram and following his death, from December 1744, Gamaliel Massiot, who was paid £54 15s per annum to teach three mornings a week 'the method of sketching ground, the taking of views, the drawing of civil architecture and the practice of perspective'.[33]

A more humdrum course of training was followed in the Ordnance Board's own Drawing Room at the Tower of London.[34] It seems to have emerged as an active force in military cartography in 1717 when George Michelson and Thomas James were first paid on a regular quarterly basis to make draughts and models under the military commander Colonel Albert Borgard. Among their more notable successors were John Peter Desmeretz who became an assistant draughtsman in 1725 and the Jerseyman Clement Lempriere who was promoted to senior draughtsman in 1727.[35] However, it was not until 1752 that the Drawing Room was formally established as a permanent branch of Ordnance, mainly concerned with draughting and copying fortification plans, as well as topographical maps connected with road building and plans of docks and harbours. From 1741, its role overlapped with that of the Military Academy at Woolwich and although it was more practically orientated, its training could lead to a commission in the Artillery and Engineers, often known as the 'Scientific Corps'.[36] There was also some overlap of personnel. John Muller, born in Germany in 1699, worked in the Drawing Room before becoming the Chief Master of the Woolwich Academy in 1754 and its Professor of Fortification and Artillery until his retirement in 1766.

The Board surveyed its own establishments[37] and such was its fund of draughting skill that detailed visual records were made of its manufacturing departments, produced

as a means of instruction for the officer cadets. Its oldest manufacturing department was at Woolwich, where the 'Warren' was first used for proof of ordnance in 1651 and the estate of Tower Place acquired for storage in 1670. A Laboratory (later the Royal Laboratory) was built at the Warren in 1695–6 for the manufacture of ammunitions and the Royal Brass Foundry, designed by Vanbrugh or Hawskmoor for the manufacture of brass ordnance, was established in 1716, following a fatal explosion at John Bagley's foundry in Upper Moorfields. In the eighteenth century, Woolwich contained both civilian and military members of the Ordnance. The Royal Regiment of Artillery and the Royal Military Academy were based in the Warren and much of the work in the factories was classed as military employment.[38] Not surprisingly, there was a convergence of interests, training and duties. The gunners under the Master Gunner of England not only manned the guns for proof and carried out artillery practice at the exercising butt but also undertook all the elementary munitions work required, acting as fireworkers when the occasion demanded.

Conventional surveys of Tower Place survive from early in the eighteenth century, demonstrating its piecemeal development over the years.[39] Tower Place itself was a mansion with a hexagonal Tudor tower on five floors at its south-east corner, commonly known as Prince Rupert's Tower.[40] The Laboratory comprised a series of workshops round an open rectangular square with a fountain playing in the middle. Sheds were also constructed by the river, on Prince Rupert's old fortifications, where gun carriages were either repaired or scrapped, known as the new Carriage Yard. The 'Great Pile of Buildings' later known as Dial Square was a three-part complex connected by brick walls to form two courts or squares between the blocks.[41] This series of workshops on a pleasant riverside site was recorded in two fine plans of the Warren, surveyed and drawn in July 1749 by John Barker at the Royal Military Academy, embellished with allegorical drawings in grisaille: a female figure instructing two putti from a globe, one reading and the other looking at fortification plans, and a view of the Arsenal with two more putti busy firing a cannon directly at it.[42]

By mid-century, under pressure from the War of Austrian Succession, the Laboratory was placed on a proper footing with a Comptroller, Charles Frederick, and a Chief Firemaster, at first James Pattison and then from 1749 Captain Thomas Desaguliers, assisted respectively by a clerk and mate, in charge of more than sixty men. Around this time a series of drawings, executed in watercolour and body colour, was produced depicting the manufacture of munitions within the Laboratory, possibly to help with the training undergone by the Academy cadets (fig. 162).[43] Muller's *Treatise of Artillery* (1757), specifically intended for the use of the Woolwich Academy, confirms that the cadets were instructed in the workings of the Laboratory.[44] Drawing and copying artillery pieces and the processes of manufacture round the Warren also featured in their curriculum. Unfortunately, the records for the royal ordnance factories in this period have not survived, so the identity of the artist responsible for the Laboratory drawings must remain a matter of conjecture.[45] Perhaps they were made by Barker or by Massiot himself.

Three exterior and six interior views give an overview of the different aspects of work in the Laboratory with great clarity and graphic immediacy. For all the uncertainties of scale and perspective, the artist showed considerable skill in lighting each work and in capturing the workshop conditions, the tools and skills used by the men – a mixture of gunners and civilians.[46] He clearly knew the workings of the Laboratory inside out, with regard both to its personnel and practices. His training in empirical draughtsmanship was combined, perhaps, with a desire to describe as clearly as he could the processes and skills involved, for didactic purposes. This is at least in the same world as Hooke's felt-making workshop, if not in the more schematic, rationalising climate of the *Encyclopédie*.[47] The process of recording the art of gunpowder manufacture was far from

162 Anon., *Gunpowder and Shell Manufacture in the Royal Laboratory, Woolwich Warren*, c.1750. National Maritime Museum, Greenwich, London

364

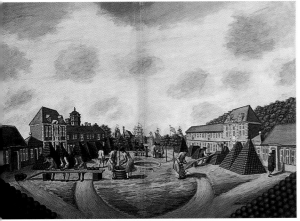

The Great Pile and Basin Court

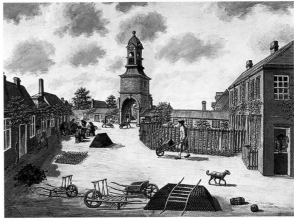

Moving Shells

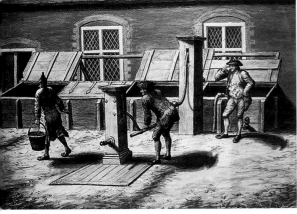

Pumping Water

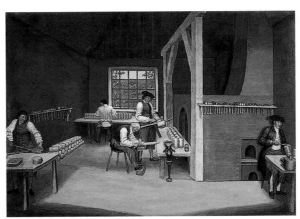

Interior of the Tinsmiths' shop

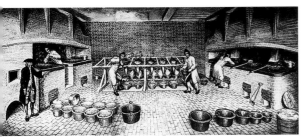

Purifying Salt-petre

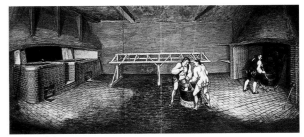

Interior of the Furnace room

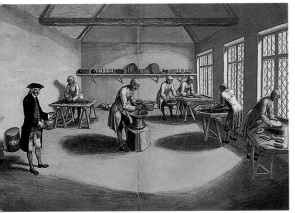

Incorporating Gunpowder

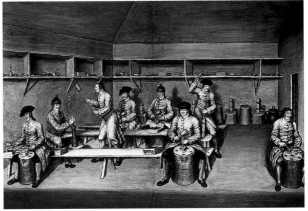

Driving Fuses

novel. Illustrated firework books produced for the training of gunners, or even perhaps as prospectuses or business profiles for master gunners, survive from the fifteenth century.[48] The most famous illustrated treatise in print, Vannoccio Biringuccio's *Pirotechnia* (1540), remained the standard work on the production of ordnance until the early eighteenth century. Information concerning improved production methods was a common topic in scientific circles: Thomas Henshaw read two papers, on saltpetre and gunpowder, to the Royal Society in 1662, which were subsequently published in Sprat's *History of the Royal Society* (1667).[49]

The three exterior views suggest the semi-rural, informal nature of the thirty-one acres of the site. Prince Rupert's Tower is visible in the background to the depiction of the Great Pile and Basin Court looking north, with ships on the Thames in the distance. Some of the workers are civilians dressed in shirts, breeches, stockings, waistcoats and tricorn hats. Gunners are distinguished by their blue coats, waistcoats and breeches; a number wear the coarse loose surtouts which were handed out for laboratory work, cooking and fatigue duties.[50] The artist records the care with which the shells were injected with gunpowder and then rolled along wooden troughs and placed in position on the pyramids. One man is working a mechanical device for drawing fuses.[51] Another view shows the *ad hoc* methods of moving shells and other materials round the site using different types of wheelbarrow. A third view shows the water pumps in use.

Two scenes are devoted to metal-working. A long view shows the interior of the forge, the workers busy in waistcoats and aprons, their wigs removed and possibly stored in the long wooden chest under the pegs where their hats and overcoats are hanging. One man is carefully pouring metal into a mould, another is filing at a workbench, a third hammering on an anvil and a fourth standing by the forge. The foreman wearing a hat stands by the door. Another view shows the tinsmiths' shop. Here tin canisters for shot were made from sheet metal and their tops soldered on. Each man is undertaking a different stage in the process, with an impressive array of hammers and other tools slotted into shelves round the walls.

Two images show some of the stages involved in purifying and processing the saltpetre, used in the manufacture of gunpowder. It was brought from the East Indies in small crystals and its impurities were removed when it was dissolved in water, boiled, skimmed and, on the point of crystallisation, passed through filtering bags into cooling vessels. The artist depicts this process being undertaken by gunners wearing surtouts and bonnets in a brick-lined room with stoves on which the liquid saltpetre is being heated. Two men are busy skimming the steaming liquid; two more are engaged in pouring it from the coppers into the filtering bags, which are also visibly steaming, and the foreman is on hand to oversee proceedings. Another scene shows the saltpetre being heated again in a cauldron over a charcoal fire and boiled until the water evaporates. It was then worked about with paddles shod with gun metal, as shown in the centre of the image, until it could pass through a hair sieve. Having been spread out to dry on sheets of paper, it was finally rendered fit for service in rockets, which required the use of very fine saltpetre.

No drawing in the series details the processing of sulphur and charcoal, the other two basic ingredients required for gunpowder manufacture; they might have been bought ready prepared.[52] Nor is there any representation of the formation of mill cakes through crushing, grinding and compacting the three ingredients together using a water- or horse-powered stamp or edge-runner mill, a process later known as incorporation. Instead, the artist depicts one man incorporating the ingredients using an old-fashioned pestle and mortar, a technique which had been mechanised by the mid-sixteenth century. In the same image the artist illustrates the process of corning or granulating the mill cakes, under the eye of the same watchful foreman who supervised the saltpetre purifi-

cation process. The men are wearing hoods in addition to their protective surtouts, to guard against impurities. They use two-handled wooden rockers to pulverise the powder on large beech trays set on trestles, so that it could pass through a lawn sieve, as demonstrated by the man at the window on the right. All the grit and loose dust had to be removed from the corned powder and then it was dried for use. Finally, the artist depicts the process of driving fuses, undertaken predominantly by gunners. The fuse composition of gunpowder was placed in composition boxes. A fuse case of well seasoned beech was placed in a copper socket in an elm block, cut at a convenient height for driving. Then a ladle full of fuse composition was put in the case and pushed down by the men using drifts, made of iron and tipped with brass, struck with mallets. Separate sheets showing the tool and mould used for making powder pellets further suggest that the draughtsman had a didactic purpose.

Perhaps it was considered too dangerous to allow the young and possibly none too clean cadets anywhere near some stages of the process of manufacture, although not all parts of the Laboratory were out of bounds: the process of driving fuses was depicted from life in the notebooks of artillery cadets until well into the nineteenth century. Yet instruction through copying illustrations was also part of the cadet course. A comprehensive series of illustrations taken from a 1796 instruction manual depicts the work undertaken by the Royal Gunpowder Factory at Faversham.[53] The original manual is lost but two contemporary student copies survive, one of superior draughtsmanship entitled *Royal Laboratory Courses*.[54] Although their dry linearity lacks the charm of the watercolours, the illustrations indicate a larger operation and a more mechanised process, using different types of powder mill. The majority of drawings relate to the Faversham works but one of a hand-screen is based on an example in the repository at Woolwich.

It was the Ordnance's surveying activities that had the greatest impact on the art of representing industry. The best-known outcome of its overall mission to establish control was the Survey of Scotland, made between 1747 and 1755 at a scale of one inch to a thousand yards. During the 1745 Rebellion, the hundreds of miles of military roads built from 1724 by Field Marshal Wade, as commander-in-chief for North Britain, proved useful to both sides.[55] After Culloden, the government needed little convincing as to the importance of opening Scotland's most inaccessible parts through surveying the Highlands, prior to the establishment of military posts connected by roads. The Survey was originated by Lieutenant-Colonel David Watson, who had assisted Wade in supervising road construction and who, in 1747, was serving as Deputy Quarter-Master General for North Britain, based at Fort Augustus. His vision of the Survey extended beyond control, for he was 'an engineer, active and indefatigable, a zealous promoter of every useful undertaking, and the warm and steady friend of the industrious'.[56] It was seen by Watson as a means of realising the political, economic and social advance of Scotland and incorporating the country into the state territory of Great Britain.

Much paraphernalia of mathematical calculation was duly delivered north: a brass astronomical quadrant, a second-hand theodolite, compasses, protractors and other drawing instruments, four Gunter's chains, twenty-four oak poles spiked with iron, a squared drawing board and four-foot rule, iron reels and stakes, horizontal scales, leads and lines. Twenty yards of scarlet bunting and linen to make flags no doubt advertised their progress to bemused Highlanders.[57] A drawing made by Paul Sandby of a surveying party in the Highlands near Loch Rannoch shows that a team comprised eight men: a surveyor, a non-commissioned officer and six soldiers – one to carry the instruments, two to measure with the chain, two to act as guard and one as batman (fig. 163). The original protraction of the North, in eighty-five numbered rolls, was undertaken during the summer months. Surveyors used the waterways as their principal waymarks, while

the mountains were sketched in by eye. Winters were spent in the Ordnance Drawing Room at Edinburgh Castle, making the fair copy in sheet form.[58] Surveying the North was completed in 1752 and the South was added in 1752–5.

The Survey was led by William Roy, who trained as a civilian surveyor in the Ordnance Office in Edinburgh and, through acting as Watson's clerk, became practitioner engineer in 1755. Of the draughtsmen who worked with him the best-known are the Sandby brothers, the sons of a prosperous Nottingham stocking manufacturer. Thomas Sandby began working in the Ordnance Drawing Room at the Tower in 1742, travelling to Scotland the following year and again in 1745 as a civilian draughtsman with the British army under the Duke of Cumberland. In 1746, on the Duke's return to Windsor, Sandby entered his household as 'draughtsman and designer' to make maps, views and architectural studies. Sandby's talent inclined more to perspectives than plans and his views of the Battle of Culloden and Fort Augustus were succeeded by other detailed military scenes.[59] Nevertheless, he retained that precise line and exactitude with regard to the recording of machines which one might expect from one in the Ordnance, contributing in 1750 to a history of his home town two detailed drawings in perspective of a stocking frame to accompany an account of the manufacture of the origin, progress and state of the manufactory of frame-worked stockings.[60]

Paul Sandby was also employed as a draughtsman in the Board's Drawing Room.[61] Following his brother, he became a draughtsman to the military survey of Scotland from 1747 to 1755, responsible for the eventual presentation of the fair copy of the map.[62] In keeping with his Tower training, Sandby shaded the mountain ground in relief, aligning his brushstrokes with the direction of the slope and using progressive gradations of tone to model increasing steepness and height, thus enhancing the basic mathematical calculations through painterly means. The results gave the required impression of accessibility and comprehensibility, suitable for presentation to officers of state in London. Yet even at the time some recognised that this was an illusion. Looking back at the end of his career, William Roy thought that the final manuscript Survey (which was never engraved and published) possessed much merit and perfectly answered the purpose for

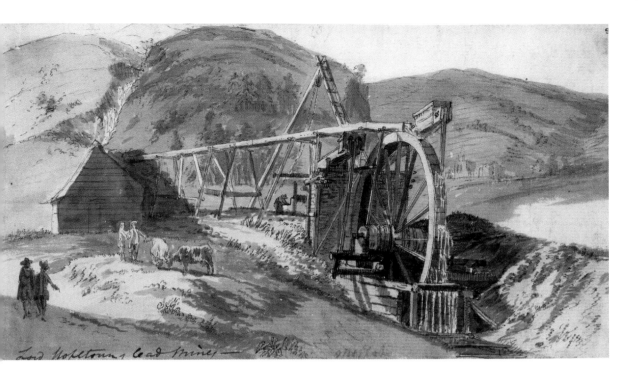

Lord Hopetoun's Lead mines —

which it had been intended, yet he admitted that, 'it is rather to be considered a magnificent military sketch than a very accurate map of a country', pleading lack of time for its imperfections to be remedied.[63] By 1807, despite its vast extent, it was thought to be on too small a scale to be useful.[64]

Nevertheless, the personnel employed on the Survey were able to employ the skills they had acquired on a wider canvas.[65] While in Scotland, Paul Sandby developed a talent for drawing people and topography, making picturesque views of castles, bridges and ruins that he visited in an official capacity or on private commissions for Scottish landowners, which he worked up into finished watercolours and prints.[66] He had a freer, more inflected line than his brother, influenced in part by the lighter French Rococo style of draughtsmanship associated with the St Martin's Lane Academy, as well as his natural gift for caricature.[67] Yet some drawings testify to the interest in mechanical devices of an Ordnance employee. In one rapid pen and watercolour sketch he recorded a large wooden fulling mill used to clean cloth, in open country in Fife.[68] In 1751, probably while recording the estate of the Duke of Queensberry at Drumlanrig, he made an on-the-spot watercolour of 'Lord Hopetoun's Lead Mines' at Leadhills in South Lanarkshire (fig. 164). The mountain scene is dominated by a large waterwheel powering a pump to drain the mine, with a hand-turned bucket winch for raising the ore in the background.[69] Based in London and with his brother in Windsor during the 1750s and 60s, he exploited his topographical and figural skills in a stream of publishing projects, ranging from satires to 'Cries of London' to topographical prints, developed from a rich fund of figure studies and views executed in watercolour and body colour.[70] Sandby became a founder member of the Royal Academy of Arts in 1768 and the same year was appointed as the chief drawing master at the Royal Military Academy, Woolwich, a post he held until his retirement in 1797.

In 1764, major changes had been made at the Military Academy.[71] Under the direction of a lieutenant governor, the first master became professor of fortification and artillery (Dr Pollock, and from 1777 to 1816, Isaac Landmann, the late professor of the Ecole Militaire in Paris), the second, professor of mathematics. An additional master

taught classics, writing and arithmetic and two model masters were also employed. The textbooks were specified: Gregory's *Practical Geometry*, Vauban's *Treatise of Fortifications*, Muller's *Elements of Fortification* and *Attack and Defence of Fortified Places*.[72] Landmann took on the bulk of the technical teaching, covering practical geometry and mathematics; the arts of surveying and levelling; the science of fortification and the rudiments of military architecture, including the method of making plans, elevations and sections of military buildings; the theory of artillery; the principles on which ordnance and carriages were constructed and the method of forming exact draughts of the same, according to the tables used by the Office of Ordnance.

These projective draughting skills were separated from the skills taught by Sandby. By 1776, the chief drawing master's duties were to 'teach the best method of describing the various kinds of ground, with its inequalities, as necessary for the drawing of plans; the taking of views from nature; the drawing of civil and military architecture, and the practice of perspective'. He was specifically instructed to introduce into his designs 'every kind of military building such as old castles, square and round towers, picturing the same as well as modern fortifications in perspective'. Under him, the second drawing master (Massiot until his death in 1776; from 1782, Robert Davey) was to teach 'the first rudiments of drawing in black lead and Indian ink, copying landscapes, military embellishments, and the elements of perspective'. The pupils were to place all their drawings and the substance of their lessons, fairly transcribed, in books or portfolios.[73] By 1792, the second drawing master was expected to teach figure drawing, 'the several parts of the human figure, from drawings by the master', as well as the basic theory and practice of perspective. With Sandby, the cadets advanced further, to the art of making copies from drawings 'which qualifies them for drawing from nature, teaches them the effect of light and shade, and makes them acquaint [*sic*] also with aerial perspective'. They were then 'to proceed to take views about Woolwich and other places, which teaches them at the same time to break ground, and forms the eye to the knowledge of it'.[74] Sandby produced many pencil sketches and finished watercolours of the Woolwich and Charlton area (where he took lodgings), some of the latter doubtless intended for his students to copy.[75]

In 1770 the Swiss Douai-trained gunmaster Andrew Schalch who for an astonishing fifty-three years had run the Royal Brass Foundry from the year it was built, 1717, finally retired. He was replaced after lengthy negotiations by the Dutch master gunfounder Jan Verbruggen and his son Pieter, who brought with them from The Hague the latest models and instruments. Jan Verbruggen had trained as an artist, mainly of seascapes, as well as making a name for himself as a gunfounder in his home town of Enkhuisen in West Friesland. In 1755 he was appointed the Master Founder at the National Heavy Ordnance Foundry at The Hague, where his son Pieter joined him after having studied law at Leiden University. Pieter Verbruggen became sole master of the Woolwich Foundry after his father's death in 1781, until his own death in 1786.[76]

Cannon masters were notoriously conservative: before 1750 they (and the Ordnance Office) had obstructed the adoption of Abraham Darby's coke-smelting process.[77] Besides, huge costs were involved in changing specifications of weaponry required by a whole army. Nevertheless, capitalising on their status as a new broom after Schalch's long reign, the Verbruggens succeeded in getting the Woolwich foundry furnaces more or less reconstructed. The vertical boring engine used by Schalch was replaced by two new horizontal boring machines, one for cannon, the other for mortar, and a third was added in 1776 for lighter guns.[78] Rejections of brass ordnance dramatically decreased: from 27.2% in the years 1756–63 under Schalch to 2.6% in 1775–82 under the Verbruggens.[79] The boring engines remained in operation until well into the nineteenth century and were still being examined and recorded, with varying degrees of proficiency, by cadets in their artillery course notebooks.[80]

On 6 July 1773, fresh from his successful visit to Portsmouth and the review of the Fleet off Spithead, George III accompanied by Queen Charlotte visited the Warren, having progressed by royal barge down the Thames. In 1765, the Chief Firemaster and Colonel Commandant of the Royal Regiment of Artillery, Thomas Desaguliers, had provided the King at his command with a splendid manuscript 'Account of the Present State and Service of the Artillery', so the King was well primed for the visit.[81] The work contained clear briefing notes and statistics on the different pieces of ordnance, the requirements for land service, sea service, service in the field and for sieges, the order of a royal artillery review and the works executed in the Royal Laboratory. Although beautifully illustrated with fine pen, ink and grisaille wash sections, plans and perspectives of pieces of ordnance drawn to scale, none of the plates depicted the process of manufacture, only the finished goods. In 1765, Desaguliers was perhaps embarrassed by the state of the brass foundry under Schalch.

Eight years later, he had more to boast about. On stepping ashore the royal party was greeted with a salute of guns and received by George, Viscount Townshend, the Master General of Ordnance, with Desaguliers and the Verbruggens in attendance. The new foundry was shown off and the different processes involved in casting brass guns were examined, followed by a visit to the top-secret boring room where the first horizontal boring engine had just been completed and was claimed as the best in Europe.[82] In the Royal Military Academy the King 'saw a very curious model of a fortification, together with the lines of approach, parallels and saps, explained by the Inspector of the Academy, Captain Smith'. The party then viewed drawings and other exercises undertaken by cadets in the upper Academy, explained by Dr Pollock, Professor of Artillery and Fortification. A breakfast banquet was held in the Great Room followed by the review.[83]

Sometime after this visit, probably around 1778, a series of fifty drawings was produced depicting in meticulous detail every stage of work in the Royal Brass Foundry (fig. 165).[84] Unlike the watercolours made in the Royal Laboratory, these are by someone with a complete mastery of draughtsmanship and perspective, not to mention the technique of tinted drawing as practised by the Sandbys. Forty-four of the drawings relate to the preparation of models, the making of moulds, firing the furnaces, casting cannon and the preparation of the rough casting for boring and machining. The new furnace installed by the Verbruggens features, bearing a plaque of George III's cypher and the year 1772. In this image, Jan Verbruggen and some guests are shown watching the molten bronze from the tapped furnace being poured into the moulds. Six drawings relate to the Verbruggens' specific contribution to the machine manufacturing of British ordnance: their improved horizontal boring machine.

Representations of cannon foundries were not uncommon by this period. In France, Colbert's initiative to encourage the development of forges and foundries to prove cannon bore resulted in the completion of visual surveys, perhaps intended to provide the government with reassurance that under the inspectorate which he had installed such works were humming along smoothly.[85] In the public sphere, volume five of the *Receuil* of the *Encyclopédie* (1767) contained no fewer than twenty-five plates (including five double pages) explaining the workings of an old-style cannon foundry which employed a vertical boring machine, drawn by Goussier and engraved by Benard. If not acquainted with these plates, the Verbruggens would have been familiar, from their time in The Hague, with the illustrations to a manuscript 'Traité d'Artillerie' produced by a Swiss-born Captain of the Dutch Artillery, David Emanuel Musly, for the personal instruction of William V of Holland, on the occasion of his coming of age in 1766.[86] Four young artists from the *Kunstkammer* of the Confrerie Pictura were employed to produce the 154 illustrations under the direction of Musly himself, as is carefully inscribed under

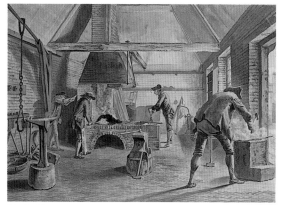

The Smithy

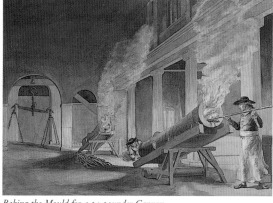

Baking the Mould for a 24-pounder Cannon

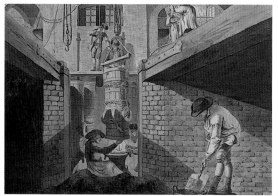

Aligning the Moulds in the Great Furnace Pit

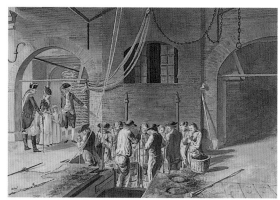

Compacting the Earth in the Great Furnace Pit

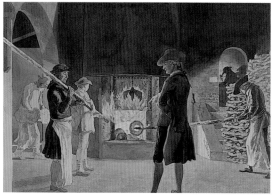

Feeding the New Furnace

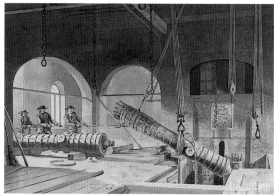

Hoisting a 24-pounder Casting out of the New Furnace Pit

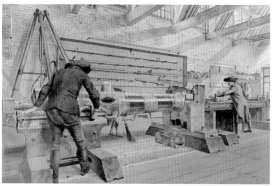

Boring a 24-pounder in the Cannon Machine-shop

Working on a Light Calibre Cannon at Night

each drawing. They detailed the workings of the foundry but also sweetened their palatability by introducing court notables and artillery officers admiring and approving stages of the process, unperturbed by the smoke and heat, with ladies teetering dangerously close to the edge of the furnace pit, seemingly oblivious to danger and decorum. As a technical treatise it had its limitations: despite the fact that it was addressed to the Prince of Orange, Musly did not describe the horizontal boring operation, for he believed he was not entitled to do so.[87]

Cannon foundries were also represented in oil paintings, usually to mark some form of princely patronage. There is a spectacular painted overview of the cannon foundry at Douai, dating from about 1775, and executed by Johann Ernst Heinsius. It was commissioned by the foundry's Commissaire-Général, Jean-François de Bérenger, who provides the central focus of the work, undertaking the crucial operation of tapping the furnace. In 1775 de Bérenger was ennobled and the presence in the picture of ladies, gentlemen and even children in pushchairs interacting with the workers celebrates this alliance between the *ancien régime* and heavy industry.[88] In Liège in the 1780s, at the behest of the enlightened prince-bishop François-Charles de Velbruck, his court painter and director of the newly founded art academy, Léonard Defrance, produced a series of industrial 'night subjects' depicting forges, foundries, printing works and tobacco factories. Executed in a style derived from Dutch genre painting, they were usually framed as visits, with fashionably dressed bourgeois visitors watching the activities of the workers from the shadows. Familiar no doubt with the *Encyclopédie*, the prince-bishop evidently saw no reason to ignore the industrial activities of his lands. The Walloon speciality of nail-making featured, as did the rolling and slitting mills which provided the iron rods from which nails were made.[89] In Sweden in the same years, Gustav III's court painter Pehr Hilleström painted not only the copper mines of Falun but also blast furnaces and foundries in the provinces of Uppland and Södermanland, sometimes with distinguished visitors inspecting the work in progress. With their small scale and careful description these pictures were again dependent on the Dutch genre model and were technically accomplished in their rendering of different forms of light. They also commemorated those industries for which Sweden was famed throughout Europe.[90] All these works appeared to confirm that the *Encyclopédie* had fulfilled its mission, persuading the elite to take manufacturing seriously as a worthy subject of polite instruction and entertainment.

Yet the Woolwich watercolours differ from these works both in style and mood. They are not tidied up for royal patrons; they are unaffected by courtly language; they are not concerned with dramatic lighting effects simply as a means of demonstrating artistic prowess. It is their naturalism that is most striking. The beams, brick walls, wooden floorboards, the windows and shutters, even the different types of glass in the window frames, the shelves of calipers and other tools, the stacks of templates, the coats hanging up on hooks are all observed and drawn with consummate skill. Men go about their allotted tasks in working clothes, unconstrained by a viewing public. Instead, it feels as if we viewers are sharing the space with them as they methodically undertake every stage of the process, snatching the odd moment for rest. There is a pride in the way the foundry is kept in order and a shared discipline about the way the men go about their work – at least to the extent that a process dependent on the judgement and experience of small teams of highly skilled men ever could be. The smoke, heat and danger associated with all foundry work can still be felt. Close observation and personal involvement on the part of the artist is surely confirmed by the technical assurance with which the machinery is drawn and individual personalities recorded, from the Verbruggens themselves down to the human swift, or the man wriggling inside the mould to check for flaws, and even occasional onlookers, probably including Townshend. Who was the artist responsible?

The drawings have usually been ascribed to either Jan or Pieter Verbruggen themselves. Jan's training as an artist and possible semi-retirement in the period when the works were executed might support the hypothesis. Both Jan and Pieter are depicted in some of the drawings and the inclusion of the date 1772 and royal cypher on the furnace suggest that they were at least closely connected with the commission. An unfinished drawing of the back of the Brass Foundry survives in the British Library, with figures – an elegant group of ladies, soldiers, a gentleman and a boy – drawn in a closely similar style to the main series. It bears a monogram which could be interpreted as PV; further on in the same volume of extra illustrations to Edward Hasted's *History of Kent*, there is an unfinished pen-and-wash drawing of piles of cannonballs in a wooded setting, inscribed below with 'Bottom of the Rookery Woolwich Warren Verbruggen' while the verso records 'Woolwich Common P. Verbruggen'. Unfortunately, there is not sufficient detail to tell whether it is by the same hand as the back of the Foundry drawing, or indeed the main Foundry series, but it appears to confirm that one of the Verbruggens, probably Pieter, was drawing on the site.[91]

To the present day the drawings have been kept in the Verbruggen family but it seems that the attribution in family papers to one or other Verbruggen only goes back as far as 1914.[92] On stylistic and circumstantial grounds there is much in the drawings to connect them with the Sandby circle. They demonstrate an extraordinary command of perspective and spatial credibility which recall the work of Thomas Sandby. The men have individual idiosyncrasies of stance, dress and feature with odd touches of humour which Paul Sandby could capture in his informal figure studies.[93] Both brothers were extremely well versed in recording technical data accurately and convincingly. Furthermore, Paul Sandby was on the spot, in the Warren, just a few hundred yards away at the Royal Military Academy. There was presumably no security check to stop him walking into the Foundry to watch what was going on and even record the scenes he found as a favour to the Verbruggens. James Fittler's engraving after Sandby of the exterior of the Foundry with cannon lined up in the foreground, which appeared as plate 21 of George Kearsley's *The Virtuosi's Museum* in December 1779, even has close affinities with the watercolours in date, style and subject matter. The horses in this work waiting for the beam-scale at the entrance to the Foundry are shown being loaded in the first drawing of the Foundry series. It is possible that Pieter was a friend or pupil of Sandby, which would explain the stylistic link, but it is also possible that they were executed by Sandby or one of his pupils or assistants, such as Michael Angelo Rooker. An engraving of 1775 by Rooker after Sandby of the Royal Military Academy with Prince Rupert's Tower (demolished in 1786) behind, and piles of cannonballs and cannon in the foreground, was published as plate 22 of *150 Select Views*, published by Boydell in 1781.[94] Perhaps Sandby was thinking of a more substantial publication. Around 1780 he proposed to publish by subscription six prints, in the then novel technique of aquatint, mainly comprising views of Woolwich Common and Sandpits, but they never appeared.[95]

Although increasingly concerned with the production of picturesque views, Sandby never wholly lost his interest in industry. In 1793 he was commissioned to paint Turkey Paper Mills, near Maidstone in Kent, the largest in the country, by the owner James Whatman II, who was about to sell up. The serene large-scale view he created in opaque watercolours was exhibited at the Royal Academy in 1794 as *A View of Vinters at Boxley, Kent, with Mr. Whatman's Turkey Paper Mills* (fig. 166). While being careful with regard to the detail of the mill buildings, Sandby incorporated them into a traditional genre of estate portraiture, set in a fertile and productive landscape, emblematic of peace and prosperity. There is none of the industrial activity associated with the paper-making itself, merely smoke rising from the chimneys and one tiny figure pushing a wheelbar-

row.[96] Undoubtedly there are problems in attributing the Foundry drawings directly or solely to Paul Sandby. Most unusually for the artist's working methods, there do not appear to be any preliminary figure studies. By this period, he was painting more often than not in body colour, while his watercolours are usually embellished with a pen-and-ink outline. Neither technique is used in the Foundry series. More fundamentally, they seem too good for Sandby, who could be repetitive and even perfunctory, using staffage in his scenes drawn decades earlier. Although several drawings are unfinished there is no trace of the slapdash here.

Within Sandby's circle, the most likely candidate is Michael Angelo Rooker who, as already mentioned, was responsible for engraving one of Sandby's Warren views. Rooker was a highly competent artist in his own right. In his antiquarian studies he could capture the particular qualities of brick and stone yet he always enlivened his subjects with freshly observed figures. That he was also capable of drawing machines and mechanical operations with the breadth and facility displayed in the Foundry series is suggested by three works. In 1778 he drew 'The Apparatus and Part of the Great Cylinder in the Pantheon', the experiment conducted by Benjamin Wilson to create an electrical storm and prove that his version of the lightning conductor was better than that of Franklin.[97] Here Rooker records the cylinders, the experimenters and the grandiose setting with the graphic conviction of the Foundry series. Then in 1779 he painted his own work space, at the Theatre Royal Haymarket, following his appointment as a scene painter. The manner in which the lofty studio is drawn, with its beams, pulleys, pots of colour and pans of size, is even closer in style to the Foundry drawings. He himself, wearing protective clothing, is at work on a landscape flat or backdrop. As with some of the Foundry drawings, the watercolour is unfinished, requiring deeper tints to bring it into focus.[98] Finally in 1780, Rooker was commissioned to paint the first view of the cast-iron bridge at Coalbrookdale, a subject to which I shall return. He therefore had the skill if not the opportunity to undertake the Foundry drawings but until definitive documentary evidence appears, their authorship remains unproven.

There was a fund of artistic talent in the Warren: on 23 February 1783 the Surveyor General approved payment of an account for £30 17s for framing several drawings and paintings presented by Sandby, Landmann, Verbruggen and others.[99] Despite the differences of emphasis, there was an overlap of concerns in teaching the theory and practice of artillery and fortification, with Landmann as well as Sandby making drawings of the adjacent Royal Laboratory and Foundry. In the mid-1790s, Landmann produced a short manuscript treatise on bronze gunfounding, the notes for which, made mainly in 1793, were accompanied by vivid sketches of men at work on the founding and boring process.[100] Again, the combination of teaching methods is demonstrated in the 'Course on Artillery' notebooks made by cadets in this period, which survive in the archives of the Royal Artillery Regiment. They contain not only calculations and lists of diameters of shells, recipes for grapeshot and descriptions of guns of various weights, illustrated with careful measured pen, ink and wash drawings – mainly copied from Muller's *Treatise of Artillery* – but also watercolours and doodles of the cadets' own devising representing the Royal Laboratory and Foundry at work.

Meanwhile, the Tower Drawing Room was also turning out officer engineers with draughting skills.[101] Under Townshend, a training school was instituted at the Tower for the lower ranks of draughtsmen. In 1776, Henry Gilder, a protégé and servant of Thomas Sandby and reckoned by Paul to draw 'remarkably well', was appointed as a 'second class' draughtsman to teach 'Military architecture and the practice of perspective, and is likewise to instruct the finest draughtsmen in the drawing of plans and breaking of ground'.[102] In 1777 he accompanied the mathematics master Reuben Burrow and Drawing Room staff to survey the coast of south-east England. Gilder's view of Harwich and the landguard fort was, as he reported, 'drawn on the spot' and depicted the three surveyors at work with a theodolite.[103] William Payne, one of Gilder's students, served as a draughtsman, fifth class, from 1776 to 1778. After working under Captain Thomas Page of the Royal Engineers at Sheerness, he was sent to Plymouth to draw plans for strengthening the fortifications. At the same time he developed his skills by making tinted drawings of the surrounding scenery. Precise topographical documentation in pen outline was increasingly augmented with delicate colour washes and picturesque framing effects. However, in his views of slate, stone and marble quarries he retained an engineer's eye for rock formations and the labour and machines required to work them. The small figures involved in sawing the stone and loading packhorses are well observed, not standardised staffage. Payne sent two finished watercolours of quarries to the 1788 Royal Academy exhibition, where they were bought for Stourhead by the gentleman banker, landowner, antiquary and indefatigable traveller both at home and abroad, Sir Richard Colt Hoare (fig. 167). A more dramatic view, *Quarry on the Banks of the Plym*, exhibited the following year, received praised from no less than Sir Joshua Reynolds, perhaps as much because it represented his home territory as for its superficial kinship to the art of Salvator Rosa.[104]

Gilder's appointment was short-lived for when Charles Lennox, the third Duke of Richmond, became Master General of Ordnance in 1782, the Corps of Engineers was restructured and the establishment of the Tower Drawing Room reduced on the grounds that it seemed ill-calculated for instruction. Since 1759, Richmond had employed professional surveyors in his household establishment to map his estates at Goodwood, as an integral part of their management, and he procured positions in the Drawing Room for two of his own estate surveyors, Thomas Yeakell and William Gardner. Yeakell became the Chief Surveying Draughtsman in 1782, a post taken over on his death in 1787 by Gardner, who was in charge of the Ordnance's second triangulated and topographical survey of Kent, Hampshire and East Sussex. In 1790 the Duke decided to continue triangulating surveys as a formal Board of Ordnance undertaking, thereby instituting the Ordnance Survey. The trigonometrical survey signalled the state's full

acknowledgement of cartography as a mathematical science concerned with the objective presentation of geographical features. In 1800 the Drawing Room at the Tower was finally wound up, having largely outlived its usefulness.[105]

Nevertheless, the tradition of military draughtsmanship continued in the wider world. Reuben Burrow, who had earlier been transferred to the Royal Military Academy with four Tower draughtsmen, was recruited from there to join the geodetic survey of India.[106] As Kim Sloan has pointed out, the India Office Library, now part of the British Library, contains more than eleven thousand drawings by British artists, all but a thousand by amateurs, of which nearly half were drawn during their leisure time and the rest in their official capacity as engineers, surveyors or gunners in the manner for which they had been trained in the Tower or at Woolwich.[107] Some ventured into the higher realms of art. Having spent the 1760s and 70s recording the topography of America, Captain (later Lieutenant General) Archibald Robertson of the Royal Engineers completed a series of large-scale grisaille tinted drawings of assorted Welsh castles set in classical landscapes, complete with nymphs and shepherds.[108]

More to the point of this work, through its training, surveying and engineering activities, the Board of Ordnance had encouraged the recording of industry, notably its own. The keen observation and meticulous draughtsmanship of its staff resulted in records of industrious landscapes equivalent to the Dutch style of empirical portraiture. As Rooker's obituarist observed in the *Gentleman's Magazine* on 3 March 1801:

> That he did not give the effect to his drawings which is the present prevailing fashion and to which in general every other merit is sacrificed arose not from his incapacity but from principle – he adhered to a clear and decided manner of representing the object before him which he delineated with the perspicuity of a Flemish master. His drawings will bear the minutest inspection and his subjects being usually views of particular places he considered it improper to add or omit any object as either necessarily destroy the truth of the represented.

A final, tantalising example, arising out of Samuel Bentham's visit to Russia in 1805, serves to highlight the importance of empirical clarity in industrial observation. In

377

March 1807, Bentham's draughtsman William Heard reported from St Petersburg to Simon Goodrich on the improvements made by Franz Hattenberger, the Director of the Imperial Porcelain Factory, to the manufacture of china and pottery: 'During Paul's time [he reigned 1796–1801] Hatt had been employed by him to make drawings for a cannon foundry, Hatt having proposed to make cannon much lighter than usual by converting the inner and outer surfaces into steel, by which means less thickness of metal than is customary would suffice.' These drawings, he continued, 'had all the embellishments which could be given by figures, drapery, landscape, architectural ornament &c., but they were too gaudy to be pleasing, and if there was good in the contrivance of the furnaces, it was lost in the decorations'. Clearly, technical detail was obscured by the imperative to present it in a courtly guise. Nevertheless:

> Some drawings for a private iron foundry which Hatt has lately made, may I think be called perfect, there were plans elevations and sections to work from; various internal views of the foundry in full work to a scale of about an inch to a foot with all the different persons employed, the workmen had all the air and character of those I have seen in similar employments, those who were watching the operations going on had their eyes fixed on the particular object and all of them designed with so much taste that the drawings were as pictures perhaps the best I have ever seen of manufacturing concerns. The same may be said of drawings for saw mills.[109]

Sadly, I have been unable to trace them.

Professional Observation

The rich visual records of industries related to the Ordnance should not be taken to imply that it was easy to record manufactories in the wider world. For strangers, there was the problem of getting in to view industrial works and then having the nerve to make studies *in situ* without being thrown out as a spy. Only those who were part of the Ordnance department were in a position to examine its workings at close quarters over a protracted length of time. The class of visitor, most frequently from abroad, whose purpose was to gather varying degrees of industrial intelligence on behalf of governments or family businesses could scarcely expect to be welcomed with open arms. Nevertheless, British manufacturers were by no means united in their desire to exclude such men. While they sought to keep some processes secret, they were at the same time eager to show off their manufacturing facilities and their products, often with an eye on potential export markets.[110]

Visitors usually found it prudent to disguise to some degree the professional nature of their interest by adopting an overtly disinterested pose, in keeping with codes of gentlemanly behaviour. Yet at the same time they sought to recognise the key elements in what they were observing, to record them speedily in notes and snatched fragmentary sketches, sometimes prior to acquiring detailed technical drawings, models or even the machines themselves. Site visits were not the time or place for making elaborate drawings of a shop floor or complete machines. As the Russian military engineer Nikolai Ivanovich Korsakov commented in 1776, 'si vous etes admi à voir leur machinerie et leur ouvrages, c'est qu'il ya de leur interet, mais on ne vous permet pas de lever un plan de la moindre chose. Tous ceux que je donne ici ne sont point tirés des machines qu'ils representent; car cela n'est pas permi.'[111] Nor were the resulting drawings and explanations intended for publication: they remained in private archives or were deposited in the learned or industrial societies with which their author was connected, largely neglected until the twentieth century. Nevertheless, they testify to the draughting skills that many men involved in industry had acquired as part of their education.

Collectively these illustrated accounts present an extraordinarily detailed, wide-ranging picture of Britain in the eighteenth century, covering regional industries – mines, furnaces and foundries, textiles, glass and pottery manufactories – as well as the cities and towns, country houses and antiquities. Owing to the importance of the iron trade between Sweden and Britain, in the first half of the eighteenth century the most informative accounts come from Swedish visitors. During the course of the seventeenth century, Baltic bar iron, reputedly the best in the world, had been imported in increasing quantities into London and in the 1720s Bristol Quakers developed a west-coast route so that it could be transported up the Severn to the West Midlands metalwork manufactures. 'Voyage iron', a bar of lesser quality, was also bought for export to west Africa in exchange for slaves. Swedish iron was crucial for the development of British industry and trade; equally, the British market was crucial for Swedish ironmasters and merchants, presided over by the state Board of Mines (Bergskollegiet).[112] Anxious to protect a market that took up more than half its exports, the Board sent a succession of metallurgists to visit British forges, foundries and mines, as Britain strove to develop its own iron and copper industries and to foster their development in the American colonies. As early as 1696 the mining expert Thomas Clescher inspected the copper-smelting works of Elton and Wayne at Bristol. In the notebook he kept, he made drawings in plan and section of the reverberatory furnaces at Conham outside Bristol.[113] The Swedish consul in London in the 1710s and early 20s, Jonas Alströmer, made extensive tours of the country in 1714–15 and again in 1719–20, looking at industries in the Bristol region and textile manufacture, developing his own woollens business on his return to Sweden in 1724. In 1720, he was one of the earliest to record the first Newcomen engine in action at Dudley Castle, Wolverhampton, and bought a copy of Thomas Barney's 1719 engraving of the engine yet without appreciating the significance of the invention or passing on what he had seen.[114]

The mining engineer and accountant Henrik Kalmeter overlapped with Alströmer on his visit to England in 1719–21. On the basis of this and another tour made in 1723–5 as the official representative of the Bergskollegiet, he thoroughly recorded industry in England, Scotland, France, Germany and Holland in a daily journal comprising five volumes of 700–800 pages each which were translated into a series of official reports.[115] An excellent linguist, Kalmeter sometimes switched to the language of the country he was in, observing in the Scottish section, for example, the 'very wholesome' temperature of the air and attributing the longevity of the people to the weather, being 'neither extraordinarily cold, nor in summer too hot'.[116] Although he concentrated mainly on mining and the metalwork industries, he also covered the wool trade, imports of iron and timber and slate quarrying. Small samples of a wide range of local textiles with equally local names are stuck into the pages: Honiton kerseys, Shepton Mallet druggits and shalloons; Barnstaple bays in brilliant red; Stourbridge narrow cloths, copellos and tannies; serge de Nîmes and grosgrain, single and double duroys, sagathees and best midlings, mocks, Chudleighs, harmbrolts, yardwrights and more. He also included letterpress trade cards and manuscript memoranda relating to industrial processes – the methods of making tar, looking-glasses, flint and crown glass, and of lifting coal – accompanied by neat perspectives of the furnaces and tools employed.[117] In Cornwall he saw four Newcomen engines being erected and at Elswick mine, Byker outside Newcastle, that being erected for the Ridleys by a fellow Swede, Mårten Triewald, and his sixteen-year-old partner, Samuel Calley or Cawley (the son of Newcomen's partner John Calley), which provided the route by which details of the workings of the Newcomen engine and steam technology were brought to Sweden.[118]

Following the Peace of Aix-la-Chapelle in 1748, a further wave of Swedish visitors landed on British shores. Samuel Schröder, who served on the staff of the Bergskollegiet

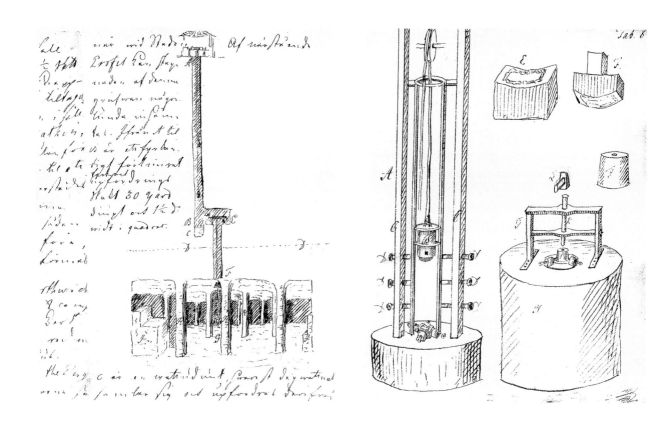

168 (left) Samuel Schröder, drawing of Northwich salt mine from *Dag Bok*, vol. 1, 1748, f.120. Kungliga Biblioteket, Stockholm, MS X303

169 (right) Samuel Schröder, drawings of button and buckle stamping tools, Birmingham from *Dag Bok*, vol.1, 1748, f.249, tab 6. Kungliga Biblioteket, Stockholm, MS X303

from 1738 to 1771, was in England and Wales in 1748–9 as part of a European tour that covered Denmark, Holland, France and Germany and lasted until 1751. Although the two volumes of his journal devoted to England inevitably contained extensive coverage of those industries using Swedish iron, especially round Birmingham, his range of interests was much broader. In London he saw John Harrison's submissions to the Board of Longitude and John Ellicott's compensation pendulum (of which he made a drawing[119]), the Royal Society and Society of Antiquaries, the Royal Observatory, Chelsea Physic Garden, the cabinets of Sir Hans Sloane and Dr Richard Mead, the paintings and prints of Hogarth, the royal palaces, hospitals and pleasure gardens. On his journey north he found time to see the 'palaces' of Chatsworth and Wentworth (Woodhouse) and the Petrifying Dropping Well at Knaresborough, as well as the mines, glass- and ironworks of the north-east. He diligently noted down a Stuart loyalist drinking song, a Sheffield cutlers' protest poem and the articles of an apprenticeship agreement of 1742 with a Birmingham gunsmith.[120] Schröder also travelled to the north-west, recording the plan of Liverpool docks, the retorts used for copperas or oil of vitriol and a diagrammatic section of Northwich salt mines which he went down in June 1749 (fig. 168).[121] He ended his account by transcribing the evidence submitted to the 1736 Parliamentary Select Committee relating to the decline in the market for iron produced in the Midlands in the face of competition from Sweden, Russia and America. To accompany his lengthy exploration of Birmingham manufactures he appended a series of twelve detailed orthographic drawings of machines and tools from Samuel Lloyd's slitting mills, John Taylor's button manufactory and assorted lock- and gunsmiths (fig. 169).[122] However, Schröder reserved his most ambitious artistic representations for the mines of the Harz mountains in the state of Hannover. Not only did he include a pen-and-wash prospect of the villages but also, in the tradition of the horizontal cut-out plan maps of Swedish mines, he took vertical sections of the shafts with cut-out sections, so that by turning each page the reader could see further into the tunnelling until eventually the miners were revealed

working on different levels, excavating with hammers, mallets and drills, pushing wheelbarrows or climbing ladders.[123] In Saxony too, Schröder made a section of the blast furnace used at Altenberg tinworks and meticulous sections of the Freiberg mine shafts lined with brickwork, drawn to scale.[124]

The Swedish ironmaster Reinhold Rücker Angerstein had a vested interest in discovering both the mineral deposits and methods of working them. On his extensive tour round Europe in the 1750s, a journey he made with the backing of the Bergskollegiet and the Jernkontoret (Society of Ironmasters), he made small lively sketches to illustrate the text in his pocket notebooks, covering aspects of industry that particularly intrigued him.[125] After his death the text was transcribed by an official called Ohrgren in the Bergskollegiet and the drawings copied by the engineer Orre to create a fair copy in eight morocco-bound volumes for the Jernkontoret library. A comparison between Angerstein's surviving pocket notebooks in the Riksarkivet (Swedish State Archives) and the fair copies in the Jernkontoret confirm that Orre copied the original drawings faithfully but tidied them up and when Angerstein's drawing was unclear, simply left details out. For example, Orre omitted the second figure in Angerstein's drawing of the screw used in the Royal Mint and he also made the remaining man considerably more elegant (figs 170 and 171). As an engineer, Orre was more at home producing technical drawings of machine parts in line and neat cross-hatching. He cannot be blamed for the lack of credibility in many of the town prospects for he could only copy what Angerstein had noted down and the ironmaster rarely had the time to draw prospects which conveyed the lie of the land, the setting of human habitations or even the buildings themselves in any degree of detail.[126] Thus Orre was often working in a visual vacuum.

Undoubtedly something was lost in translation. Whereas only the first and last pocketbooks seem to have survived from Angerstein's travels in England and Wales, those relating to the Netherlands demonstrate how gifted an artist he was, if he had time to sit down and work up what were presumably on-the-spot observations made in pencil.

172 Orre after Reinhold
Rücker Angerstein, fair copy of
a sketch of a coal mining field,
Wednesbury from *Dagbok öfver
Resan genom England åren 1753,
1754 och 1755*, vol. 2, fig.37.
Jernkontoret, Stockholm

His pen-and-wash drawings of the forges and foundries of Liège and Valenciennes have a vigour and atmosphere entirely drained from the copies. Orre flattened Angerstein's effects for he had no first-hand knowledge of the hierarchy of importance of the different elements in Angerstein's drawings. Angerstein could suggest or emphasise; Orre evened out the extremes to produce a safe neutrality. As a result, the drawings in the fair copy confined within their neat borders lack the creative spark of the originals.[127]

Nevertheless, Angerstein's travels are extraordinary in their scope and the drawings he made are sometimes the only visual records available of particular scenes and processes. In the environs of Birmingham, he drew the machine parts used in rolling mills, the making of saw blades, gun locks and the different stages of button manufacture as Schröder had done five years earlier, despite encountering a hostile reception from the button manufacturers.[128] He also recorded the surface appearance of coal mines round Wednesbury which continued to smoulder long after they had been abandoned. Although other visitors commented on this sight, they were so taken with its approximation to a volcano that they failed to note, as Angerstein did, that attempts were made to prevent the fire from spreading by building chimney stacks over some of the old shafts (fig. 172).[129] In the neighbourhood of St Austell in Cornwall he saw numerous tin-streaming sites and included a drawing of a water-powered stamping mill and a series of rectangular buddles which provide a useful record of the dressing of tin and copper at that date.[130] His coverage of the industries of Bristol included glass furnaces and potteries, salt- and soap boilers, pipe factories, lead-smelting furnaces, tinplate, copper, brass and steel works. He drew William Champion's zinc-smelting furnace at Warmley near Bristol (a process patented in 1738 'but still kept very secret'), half in perspective, half in section, like an igloo within an open structure of circular arcaded form.[131] In Wales, he visited ironworks at Caerleon, Abercarn and Pontypool as well as coal mines near Newport. At Pontypool, although he knew that 'everything is kept very secret and that all strangers are forbidden from approaching the works', he was caught making drawings in the ironworks and mills for rolling and tinning sheets and drawing wire by the owner, Mr R. Hanbury M.P., who castigated the workmen who let him in and directed a stream of abuse in broken French at Angerstein.[132]

In the north-east, he depicted and reported in detail on the salt works at Shields and the glass works at South Shields, breaking through an irregular hole in the wall of the latter to show the working parts – the circular glasshouse – within.[133] At Newcastle he drew the staithes used to deliver coal to boats from the steep banks of the Tyne and a coal wagon on a downward slope with its attendant sitting on the shafts to slow its progress.[134] Angerstein also depicted a coal wagon on tracks descending to the staithes by the harbour of Whitehaven.[135] Here he drew a section of the Lowther coal workings extending under the sea and the chequerboard construction mode of the workings, leaving solid pillars of rock. He provides one of the earliest visual records of Carlisle Spedding's ingenious flint spark machine in action, a primitive version of a miner's safety lamp (fig. 173).[136] On the River Severn, he drew a gravity incline delivering coal down a steep slope to waiting boats, just before the winding man in his drum-house at the top of the incline let the speed increase so much that the wagons were smashed.[137]

3 Orre after Reinhold
Rücker Angerstein, fair copy of
sketch of coal workings and
Carlisle Spedding's spark
machine, Whitehaven from
*Dagbok öfver Resan genom
England åren 1753, 1754 och 1755*,
vol. 3, fig. 266. Jernkontoret,
Stockholm

Angerstein's account is illustrated with numerous drawings of lime kilns, reverberatory furnaces, pottery kilns and glass furnaces. Not surprisingly, considerable space is devoted to the iron trade, for he visited as many blast furnaces as he could. Only at the Clifton furnace near Workington and the Coalbrookdale furnaces did he find evidence of coke as opposed to charcoal-smelting, although he was not permitted entry to the former works. Yet he did not have to travel far from central London to find foundries. One in Southwark manufactured garden rollers, naves for large carriage wheels, bombs and cannonballs, rolls for iron-rolling mills, weights, pots and cauldrons, flat-irons, grates, grills and fences. He duly made drawings of a garden roller, boot scraper and the mould for casting iron pots.[138]

Drawings by Angerstein of the interiors of forges and tinplate works give some indication of the layout of the different components: one of Bromford Forge near Birmingham shows three hearths – two finery and one chafery – together with the water-powered bellows and forging hammer.[139] At Crowley's bar-iron forge at Swalwell, three miles outside Newcastle, he saw the first cylinder-blowing engine in the country, built in 1748 and comprising two cast-iron cylinders, which soon superseded the traditional leather bellows.[140] He was particularly interested in rolling and slitting mills, used mainly in the production of nail rods and iron bands. At Coalbrookdale he was impressed by the large steam engine cylinders he saw being made and possibly was the first to depict the horizontal boring of cylinders for steam engines.[141] The prospect of Coalbrookdale is just about recognisable, showing the two furnaces, one of the millponds, the steam engine for pumping water back up to the Upper Pool and the large early Georgian Rosehill House and Dale House on the slope above the pond. As with Shröder, Angerstein's observations were not confined to industry. He digressed to consider the credibility of Dr Stukeley's theories on Stonehenge, accompanying his own views with a detailed drawing or drawings which Orre, lacking any knowledge of the site, rendered in an especially fanciful manner.[142] Angerstein was interested in the coal strata at Wednesbury, the rock strata at Portland, Scarborough and Whitby and the cliffs of Cornwall.[143] He occasionally visited country houses such as Wollaton Hall near Nottingham and Wentworth and recorded the method of erecting a column, to be dedicated to Minerva, at Gibside outside Newcastle.[144]

Later Swedish travellers to Britain included Erik Geisler, a *merksheider* (mine viewer) from the Swedish copper mines at Falun who arrived in 1772, lettering precise measured drawings in his notebook to key in with his descriptions.[145] He managed to get into Carron Ironworks near Falkirk and drew the bellows (fig. 174). Geisler also drew a section of the steam engine used at Hartleypans. To compensate for having missed meeting Smeaton at his home at Austhorpe outside Leeds, he drew his workshop lathe and a model of the Eddystone lighthouse.[146] At Ecton's copper works seventeen miles from Bakewell, which belonged to the Duke of Devonshire, he drew the mine in section and plan. He made a section of Huntsman's steel works in Sheffield. In Southwark he recorded an iron-smelting furnace and another horizontal cannon-boring machine.[147] Again, his trip was not all work: he found time to draw a ground-plan of Wyatt's newly completed Pantheon in Oxford Street and, alongside details of a lead-rolling mill, an ingenious space-saving bed which could be pulled down out of a wardrobe (fig. 175).[148]

Angerstein was not the only Scandinavian to be caught spying. Acts passed from 1696 onwards which banned the export of machinery, tools and skilled workmen were fla-

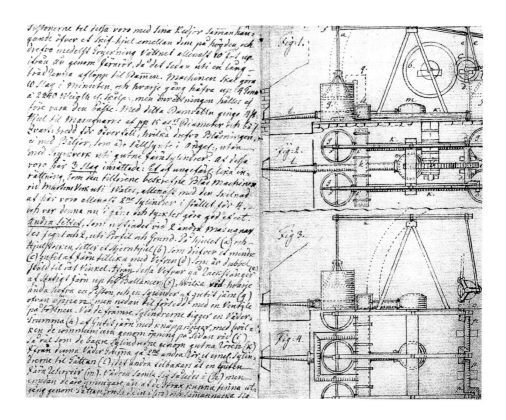

grantly violated by, among others, the mathematician and civil servant Jons Mathias Ljungberg, who was arrested in 1787 just as he was loading the fruits of three years' technical espionage onto a ship bound for Denmark.[149] The Strasbourg-born Charles Albert spent half the 1790s imprisoned in Lancaster Castle for having attempted to recruit workmen in the newly mechanised cotton-spinning mills, but not before he had despatched vital drawings to France on the basis of which a mill was built and flourished through orders for uniforms from the French army.[150]

Those with the right professional connections, however, even if they were foreigners, were passed on through a network of like-minded individuals, linked by academic fraternity or religious affinity. Thus Barthélemy Faujas de St Fond, the professor of geology at the Museum of Natural History in Paris, found his friendships with Joseph Banks and Benjamin Franklin extremely useful when he travelled through England and Scotland in 1784. Although he was not allowed into the largest manufactory of oil of vitriol at Prestonpans, thanks to a physician acquaintance he did get permission to see Carron, which he believed to be the greatest iron foundry in Europe and where he was shown everything except the place where the cannons were bored. Nor was the recipe for the steel-coloured varnish used to coat the cannons divulged and, as he was not allowed to take notes on the spot, he was obliged to spend the night going over his observations.[151] Nikolai Ivanovich Korsakov, who was sent to Britain in 1775 by the St Petersburg Engineer Corps to learn about canal building, studied in Oxford for a year and was fortunate to have a letter of introduction to John Smeaton supplied by Alexander Baxter, the Russian Consul-General in London. On his way north, Korsakov made detailed notes and sketches from memory of industrial sights – mills, foundries, steam engines and other machines as well as canals – and through Smeaton he received a warm reception from Robert Mackell, the resident engineer on the Forth and Clyde Canal. Baxter also provided him with letters of introduction to Wedgwood, Boulton and Wilkinson, among others.[152] Yet, again, Korsakov was not allowed to see the cannon-boring machine

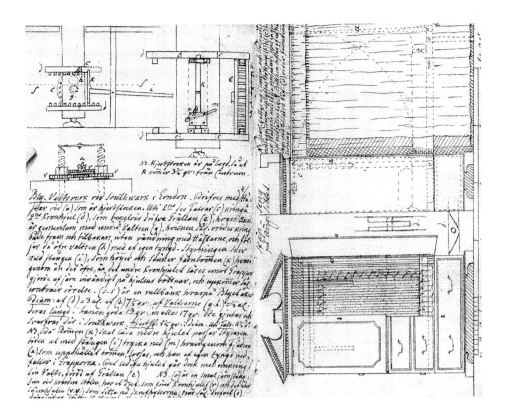

75 Eric Geisler, lead rolling mill machinery and pull-down ed, London from *Journal*, 772. Kungliga Bibliotheket, Stockholm, MS 243.2, ff.46-7

at Carron. At the end of the Napoleonic Wars, the managers at Carron were still suspicious. Evidently Prince Nicolas of Russia was refused entry but the French naval engineer Charles Dupin adopted the guise of an 'amateur' when requesting to visit the foundry: 'Are you a salesman, maker, manufacturer? – No! and with no interest in any business at all! Why are you travelling? – As a friend of the sciences and the arts, for my education. – Let this gentleman come in!'[153]

Americans proved especially observant, anxious not to miss new developments which could help their young country, and used a network of family or business connections on whose help they could rely for admittance.[154] The young merchant, Jabez Maud Fisher, a Philadelphian Quaker, usually travelled with one or more Friends who acted as guides and contacts. The only barrier to entry he encountered took place in August 1776 at Arkwright's cotton-spinning mill in Cromford: 'We . . . made a very humiliating application to one of the proprietors for a sight of it, but all our intercessions were fruitless. We were somewhat mortified at this event, this mill being the greatest curiosity in the mechanical work in Great Britain.'[155] Given Arkwright's patent battles, his attitude to visitors comes as no surprise. Even in 1789 after the loss of the patents and despite the presentation of a letter of introduction, Charles Mordaunt and Thomas Cartwright were curtly dismissed by the great man: 'He knew none of us, and had no time to talk', so they went on to see other mills.[156]

Joshua Gilpin, a Delaware-based paper manufacturer, arrived in England in 1795 and stayed for five years, following up his interest in the paper business and particularly bleaching paper stuff with chlorine, as introduced by Claude-Louis Berthollet. During this time Gilpin kept detailed journals (sixty-two in total) of his observations, covering art and antiquities as well as roads, canals and manufactures. In them he also made drawings which served as aides-memoires of what he had seen. They range from sketches of a sarcophagus and statue in Charles Townley's London home to a whole journal devoted to drawings of the Giant's Causeway in Ireland.[157] Gilpin made many drawings in plan and

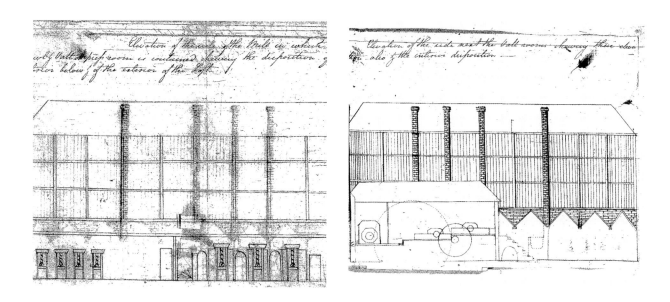

elevation of the different paper mills he visited, from Scotland to Kent and Hertfordshire
and on to Ireland. Although he did not have an engineer's capacity to produce detailed
technical drawings, as a commercial manufacturer he was particularly interested in
improvements made in the design and layout of different mills and how water power facil-
itated the works (fig. 176). Yet he was also fascinated by any novel industrial process: the
Duke of Bridgewater's coal mines at Worsley, which he drew in section, the horse-whim
used at Northwich salt mine, the tarring pit for ropes, the method of holding ships on
the stocks and the boiler for bending wood at Portsmouth dockyard and the stages in
pin-making at Gloucester. He paid special attention to the ironworks run by his fellow
Quakers in Coalbrookdale and its environs, making detailed drawings of the puddling
furnaces, the bellows and Wilkinson's cylinder-boring machinery at Bradley.[158]

Thomas Peter Smith, the young Secretary of the American Philosophical Society in
Philadelphia, travelled through northern Europe between 1800 and 1802 pursuing his
mineralogicial and chemical interest and, increasingly, associated industrial concerns.
Although he died at sea on his return to America, he left his specimens and four note-
books of his travels to the Society. The last notebook, covering his period in England
and Wales from October to December 1801, contains detailed accounts of glass manu-
factories in and around Bristol making flint glass and black glass bottles, as well as ele-
vations of the furnaces. He visited a pipe manufactory and drew a diagram of the basic
machinery used for making the bowls, noting that in Holland they were made by hand.
Smith saw copper and lead-rolling works and described in detail the 'excellent new
invention for rolling wire', drawing the pair of tongs used to pull the large wire. At
Neath he visited two copper works: 'As I had the opportunity of viewing the second
much better than the first, on account of the director in the first having the complai-
sance to accompany me and explain the whole of the different operations and in the
second I had the advantage of being left entirely with the workmen.' Again he made a
detailed description and drawings, in section and plan, of the reverberatory furnace.[159]
Visiting the coal mines two miles north of Neath, like other visitors he was impressed
by the iron rails used to guide the horse-drawn wagons, taking measurements and
making drawings of both the rails and carriages (fig. 177). He noted that they much pre-
ferred 'what they call draws to rail roads', the difference being that instead of the guard
being on the wheel to prevent the carriage slipping off, it was built into the rail itself.
He also drew a plan or 'horizontal section' of the coking ovens.[160]

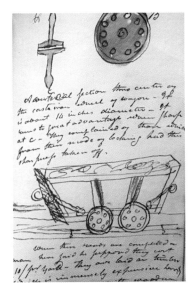

77 Thomas Peter Smith,
notebook with drawings of
railways, a wagon and wheel,
Neath, 1801. American
Philosophical Society,
Philadelphia, MS 914 SM6

After visits to Gloucester and Worcester, where he toured the porcelain factory, he
went to Birmingham, evidently with introductions to James Watt senior and junior. His
position with the American Philosophical Society seems to have opened many doors,
for he dined on successive days with Watt junior, with whom he shared an interest in
mineralogy.[161] He also dined and spent evenings with Matthew Boulton and other
members of the Lunar Society, including James Keir whose coal mines he visited. At
Coalbrookdale he stayed with William Reynolds and inspected Lord Dundonald's tar
works, the iron mines and coking, iron and steel works. As he commented, 'This country
is full of rail roads. It was here they were first introduced into general use . . . Mr R
thinks them preferable to canals in all situations.' He noted that their measurements dif-
fered from those used at Neath and that the guard was not as thick, while the wagons
that ran on them had much wider bodies.[162] Armed with a letter of introduction, Smith
spent a couple of days in the company of Josiah Wedgwood's nephew and partner,
Thomas Byerley, examining not only the Wedgwood potteries but others in the neigh-
bourhood. He then travelled north to view the Northwich salt mines, Liverpool and
Manchester, arriving in Newcastle on 16 December. Again, the Birmingham connection
opened doors, 'having brought a letter from Mr Watt the director of the Walker col-
liery descended with us'. They visited the Win Dyke, which was notoriously dangerous
because of the frequent explosions: 'We went into a drift they are driving. The men had
neglected the conductors of air and the place was so full of inflammable air that the
candles strongly indicated its presence. The director said if we had come a few minutes
later it is probable the two men would have been blown up.'[163] Nevertheless, Smith
found time to draw a section of the seam. He went on to visit more glasshouses, the
new iron bridge at Sunderland, a Sheffield scissors manufacturer and Derby, where he
spent the day with Erasmus Darwin and visited the porcelain manufactory before return-
ing, just after Christmas, to London.

On a humbler level, the Royal Navy mechanist Simon Goodrich managed to see
mechanical and engineering works in the Midlands in 1799 because his boss, Samuel
Bentham, had a wide circle of friends in manufacturing circles, notably the Strutts and
Darwins in Derby. However, he encountered problems around Manchester where the
cotton manufacturers with their new Boulton & Watt steam engines were 'shy' of
showing them to strangers.[164] At Ketley, he learnt that strangers were also excluded from
Reynolds's works and so he thought it best to apply to him in person. Unfortunately,

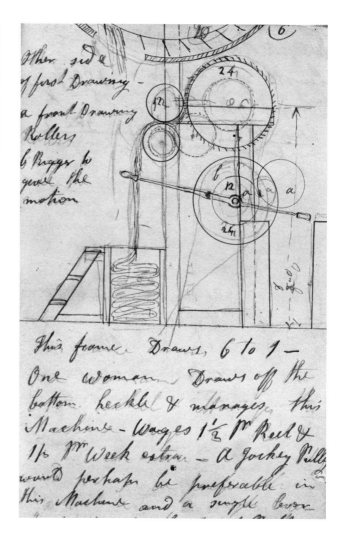

178 (left) Simon Goodrich, journal with drawing of a steam engine, 1799. Science Museum Library and Archives, Science Museum, Swindon, Goodrich, EI, f.56

179 (right) Simon Goodrich, notebook with sketches of machinery in Grimshaw's ropery, Sunderland, 1803. Science Museum Library and Archives, Science Museum, Swindon, Goodrich, DIO, ff.20-1

the owner was not at home and the foreman 'dared not permit me to inspect them without a line from Mr Reynolds'.[165] When he did encounter novel machine parts, he made technical notes and drawings which he sent to Bentham, making a fair copy for himself, incorporating neat mechanical drawings. These included a plan and elevation of a railway which he first encountered at Chapel-en-le-Frith; single wheel-bearings and cast-iron hot-air stoves in cotton factories; the means by which steam power was transferred from an engine to a pump two hundred yards from it; and a fixed steam engine used to draw up coal from pits (fig. 178). The last may be compared with those free-hand drawings, possibly made by Reynolds's apprentices, of the same sight (see fig. 55).[166]

This was the first of many travels that Goodrich recorded in his journals. The memoranda he made on a journey in 1803 to the north and west of England, with the General and Mrs Bentham and for part of the way with Marc Brunel, is packed with observations.[167] On the way through Derby, Leeds and Darlington, Goodrich made drawings of assorted cranes and spinning machinery. The chief object of the journey was Grimshaw's ropery in Sunderland which Bentham hoped to duplicate in Portsmouth. Grimshaw explained the whole to them 'in the most satisfactory manner' and Goodrich went through each operation accompanying his description with diagrams (fig. 179). On the way back through Sheffield, Derby and Stockport, Goodrich was able to make further sketches, this time getting into Reynolds's ironworks at Ketley to draw a section of the furnace used to convert iron into steel.

Access to Bentham and Goodrich's own places of work, the royal dockyards, seems to have been relatively relaxed, foreigners being allowed in even during periods of war with the French and the Americans.[168] The elegant appearance of the Block Mills at Portsmouth and the display of 'well arranged machines' inside were purposely intended by Samuel Bentham to reconcile public opinion to 'the introduction of a general system of machinery'.[169] They proved so popular that work was impeded by the flow of visitors. Lord Nelson visited them in September 1805; in 1814, a royal party was headed by the Prince Regent, accompanied by the Emperor of Russia, the King of Prussia, Marshal von Blücher and others, who were duly impressed by Brunel's machines. Maria Edgeworth, the novelist daughter of Richard Lovell Edgeworth, wrote of her visit in 1822: 'Machinery so perfect appears to act with the happy certainty of instinct and the foresight of reason combined.'[170]

When the Swedish iron producer Eric Svedenstierna summed up the experience of his visit to Britain in 1802–3, he was speaking for others. There was, he said, no land where one could travel with every comfort of life and with less obstruction and questioning:

> but just so there are few lands where a more careful eye is kept upon those who direct their attention to factories and mechanical institutions. At the same time I noticed with satisfaction that as a Swede one could always expect a more open behaviour than could several other foreigners, who in recent times, through the secret import of models, and by tempting away the workmen, &c, have aroused the most reasonable suspicions against themselves . . .

However, he found, 'The Englishman is, on the contrary, in no way reticent when he encounters someone who knows what he is talking about, and one can be fairly certain that neither out of loquaciousness nor out of deceit will he say more or less than he knows.' This was not entirely the case. Reynolds politely refused him entry to his ironworks, where Svedenstierna particularly wanted to see the puddling process (Reynolds was reputedly experimenting in adding manganese to make steel), because he did not have a letter of introduction.[171]

Industrial Tourism

In the Ordnance Department, the accurate representation of industrial scenes arose directly from the imperative to command and control the land. For those whose primary concern was to understand industrial processes with a view to their duplication, usually abroad, the records made were usually snatched and furtive, rarely worked up with the intention of publication. Yet there was another more leisurely way of viewing industry which developed in the eighteenth century, as part of a gentlemanly education and as a source of patriotic pride in the progress of the nation. Daniel Defoe's *A Tour through the Whole Island of Great Britain* served to introduce the country to its inhabitants for a good part of the eighteenth century.[172] First produced in three volumes between 1724 and 1726, it was subsequently issued in revised and updated versions roughly twice a decade until the ninth edition was reached in 1779.

It was the comprehensiveness of the *Tour* rather than industrial detail which provided a spur for the generations of genteel tourists who followed.[173] A visual equivalent was provided by Samuel and Nathaniel Buck, who made sketching tours of England and Wales every summer, as the basis for a series of nearly a hundred engraved panoramic prospects of 'cities, sea-ports and capital towns', published between 1728 and 1753.[174] The Bucks were at home in the world of antiquaries, producing an even more extensive series of engrav-

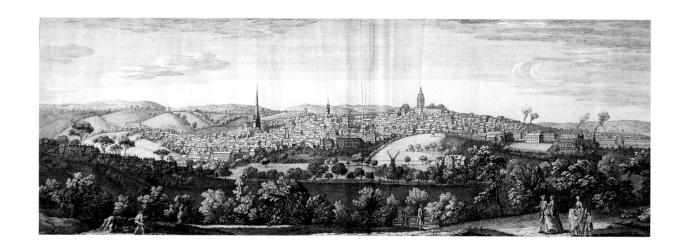

ings (423 in all) of the country's monasteries, abbeys, castles and ruins. In their prospects of cities and towns, they highlighted the churches, schools and other public buildings and the grandest houses but, like their fellow members in the Spalding Gentlemen's Society, they did not ignore the trades and industries associated with local economies.

Most towns are shown surrounded by windmills. *The East Prospect of Birmingham* (1753) includes the smoking chimneys of the town's steel and brass works (fig. 180). Baptist Mills Brass Works and Kingswood Colliery are just visible in *The North-West Prospect of Bristol*, while *The South East Prospect* of the same city (both 1734) includes the distinctive chimneys of numerous glass works, some smoking, although the letters ignore them. Derby's famous silk mills are plainly visible in *The East Prospect of Derby* (1728), by the river. For Leeds, *The South-East Prospect* (1745) shows extensive tenter grounds where woven cloths were dried and stretched. *The South West Prospect of Liverpool*, viewed from the Mersey, included its copperas, glass- and sugar-houses. Those of the royal dockyards (1738–9) were laid out with their wharves, storehouses, rope works, officers' dwellings, as was the business of the main commercial ports. However, there is no visible sign of the coal mines in the prospects of Newcastle upon Tyne (1745) or of the cutlery trade in Sheffield (1745), despite being mentioned in the text. Industrial sites were there if one looked for them but the overwhelming impression produced by the Bucks' views is of a country of neat prosperous conurbations which survived on the basis of their ancient foundations, boosted by trade, agriculture and commerce, rather than on industry and manufacture.

Prospects produced locally were sometimes more forthcoming, particularly when their production was connected with local landed interests. An *East Prospect of Whitehaven*, engraved by Richard Parr after the painting commissioned by Sir James Lowther from Matthias Read, was published in 1738 and dedicated to the landowner (fig. 181). It demonstrates, with the help of a key, the workings of Lowther's model town even more clearly than the painting, presented as an integrated landscape with polite and industrial landmarks alongside each other if not exactly intermingling. Among the features pointed out were the hurries for shipping coal alongside the harbour. The main wagon-way is also clearly visible and tiny covered gins representing the coal-pits can be seen in the far distance. There are two rope walks and a windmill on the east side of the town nearest the viewer and on the west, again in the distance, bottle works, copperas works and a large 'fire engine', with steam coming out of the chimney. Otherwise, the prospect was designed to demonstrate Lowther's wealth and paternal philanthropy: his magnificent house, formal gardens which featured a cascade, churches and chapels, a fine granary and 'Sir James Lowther's Arms Houses for poor Colliers and their Widows', crouching

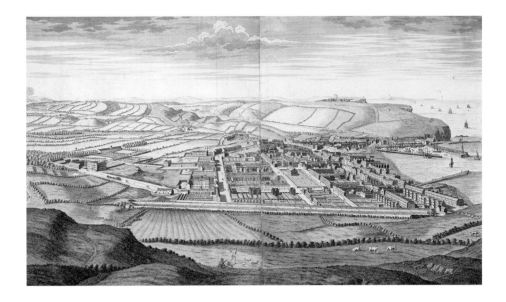

in gratitude beside the main highway to his residence.[175] Again, a south prospect of Newcastle, sketched by J. Bailey and drawn and engraved by James Fittler, was dedicated to Sir Matthew White Ridley, the Mayor of Newcastle, and the Council and engraved at their common expense. Smoke was shown rising from a Tyneside furnace while in the foreground on the Gateshead bank two draughtsmen are shown sketching as a nearby coal-wagon, with a man sitting on its brake and towing the horse, is about to travel down the slope on a wagon-way to the hurries (fig. 182).

Something of this integrated vision was recommended by Sir John Cullum, the Suffolk antiquary, botanist and divine, in commencing the journal he kept of a tour of the North and the Midlands in 1771 with a short disquisition on the benefits of travel.[176] It was, he said, generally reckoned a very agreeable, as well as an improving way of spending time but it had, like all other pleasures, potential inconveniences, not least the choice of company and the narrow focus of interest shown by companions who were practitioners of a particular art: the architect being confined to buildings, the farmer to agriculture and so on: 'Yet I think, the curiosity of a gentleman, who ought to be able to speak pertinently upon every subject, should pervade every production of nature and art.' Besides paintings, sculpture, the plantations and waters of an estate, the terms of architecture and famous persons of a parish, 'he should visit also as many manufactories as come within the compass of his tour: in these he will find the mechanical powers applied in such measure as will both surprise and please him'. In short, the rule he wished to recommend was 'that he would make as many things as he possible can, the object of his rational inquiry and amusement'.

Many of the genteel travellers who explored Britain in the eighteenth century appear unconsciously to have followed Sir John's advice, making no sharp distinction among objects of scientific curiosity, aesthetic beauty and mechanical ingenuity. The majority were members of the lesser gentry, who had just left university or had taken holy orders. Although lacking the means to embark on a Grand Tour abroad – or prevented from so doing in the 1790s by war with France – they took to the road before settling down. Their journeys had an educational purpose and incurred the obligation to record observations in journals, the majority of which were never published. Although clearly and grammatically composed, they had few pretensions to literary style. Typically, the emotions expressed were of pleasure and pride in human progress and improvement, often clothed in the language of sentiment. Increasingly, as the century progressed, the fashionable terms of the sublime and picturesque entered their vocabulary and industrial concerns were viewed in this light, influenced by what was considered appropriate in painted landscapes.

The aesthetic determinant of the prospect, strengthened by picturesque considerations, ensured that the main manufacturing cities were viewed from a distance with moral approbation. For Sir Richard Colt Hoare, 'The situation of Halifax reminded me much of Bath; built in the same coloured stone, hills around it and fine valley. Not the seat of luxury and dissipation but of industry and commerce and in this respect widely different.'[177] Yet many genteel tourists were not satisfied with viewing industry from afar, wanting to see what went on at closer quarters, in the same way that they wished to secure entry from housekeepers to peruse the paintings in country houses. First-hand accounts suggest that the grander visitor, armed with appropriate tickets or letters of introduction, experienced little difficulty in being shown round most works, an owner's customary deference sometimes boosted by hopes of publicity or even patronage. Schooled on encyclopaedias which featured the mechanical arts, proud of the country's progress, they were intent on investigating industrial processes. Mines, foundries, forges – no manager was safe from the enquiries of the diligent gentleman (and occasional lady) tourist. Some managers actively encouraged this interest by introducing warehouse shopping, as was the case at Bedford's japanry works in Birmingham, Boulton's Soho and the china manufactories of Derby and Worcester.

To what extent did industrial tourists make visual records of what they had seen? The more scientifically inclined or trained were capable of comprehending the workings of machines to the extent of drawing parts.[178] Cullum who, like many clergymen, was an accomplished botanist as well as an antiquary, included diagrammatic drawings in the journal he kept of the tour he took in June 1771 of stamping and chasing processes and the workings of a tilt hammer in Sheffield, the Duke of Bridgewater's canal and the salt mine at Northwich.[179] Charles Hatchett, the only child of a prosperous Long Acre coachmaker in London, became an outstanding mineralogist and Fellow of the Royal Society. On the tour of the country he made in 1796, he sketched as aides-memoires details in diagrammatic form of manufacturing processes that interested him. They ranged from a plan of a reverberatory furnace at a St Austell tin mine, keyed into his description of its workings, to the method of stacking wares in the furnace at the Worcester porcelain factory. He drew details of crucibles, tools and furnaces in Birmingham brass-houses; the iron and cannon foundry at Coalbrookdale; the kiln profile and plan of Lord Dundonald's tar works; a colliery shaft and the foundry section and ground-plan of Marshall's steel works in Sheffield; sections of a cannon cast at Walker's great ironworks in Rotherham; the Sunderland iron bridge; rollers used in the lead works at Newcastle; wagons at Heaton colliery; a section of Leadhills mine, south of Lanark; and many mineralogical observations.[180] Eighteen-year-old Thomas Philip Robinson, the third Lord Grantham, also recorded machine parts, notably a drawing made on a 1799 visit to Birm-

ingham of the machine for making whips, keyed into a list of its parts and description of its workings. He became the First Lord of the Admiralty, Lord Lieutenant of Ireland and the first President of the Royal Institute of British Architects.[181]

These gentlemen tourists were sufficiently au fait with mechanics to understand how machines worked. The attempt to view and record industry more generally, in the light of picturesque theory, was initiated when tourists hired artists to record their progress and the sites visited round the country. One of the first to undertake this role was the ever enterprising Paul Sandby, who made at least three trips to Wales in the early 1770s: to the north of the Principality with the greatest Welsh landowner Sir Watkin Williams-Wynn, from the base of his country seat Wynnstay, and in 1773 to South Wales in the company of botanists led by Joseph Banks.[182] The result was a series of views published by the artist in three parts, in 1775, 1776 and 1786: *XII Views in Aquatinta from Drawings taken on the Spot in South-Wales* (1775) was the first book of views executed in aquatint to be published in England, paving the way for a stream of others devoted to the antiquities and natural beauties of the Principality.[183] Despite being in aquatint rather than mezzotint, the plates resemble in their rich chiaroscuro and classical composition those of Richard Earlom's *Liber Veritatis* after Claude landscape drawings (with which they were almost contemporary). Closer to home, the influence can be discerned of Richard Wilson who, during the 1760s, painted the Welsh landscape in the classical manner he had imbibed in Italy.[184]

Sandby could adapt his topographical style which, as discussed earlier, was grounded in surveying, for the tastes of a polite audience. Yet he managed to incorporate one semi-industrial scene, the Iron Forge between Dolgelli and Barmouth in Merionethshire, as part of the second set of aquatints published in 1776 (fig. 183). The exterior of the forge, with its undershot waterwheel powering the tilt hammer within, is viewed from a low viewpoint which emphasises the massiveness of the building, although its emblematic power is somewhat undermined by the cat chasing birds on the roof. A watercolour by the artist of what might have been the same forge, drawn from the unreversed viewpoint so that the water flows in a different direction, indicates the ways in which Sandby might have dramatised the scene (fig. 184) for the print. The watercolour is in calm pas-

393

184 Paul Sandby, *The Iron Forge at Barmouth*, c.1775. British Museum, Department of Prints and Drawings

toral mode. No smoke gushes from the chimney and a gentleman artist – possibly Sir Watkin – sits on the rocks sketching (significantly positioned so as not to have the forge in his line of sight), sheltered by a servant holding an umbrella.[185] Sandby's versatility is further demonstrated in his watercolour *View of the Copper Works at Neath*, produced in 1779, possibly for a Mr Vernon of Briton Ferry from whose garden, according to the title, the works were observed.[186] Set in an oval border and embellished with pastoral figures, the works appear to be sited in an arcadian idyll, indistinct in the distance under a veil of picturesque smoke. Yet Sandby could incorporate Welsh industry into finished works with more conviction, as in a landscape with a horse-gin prominently in the foreground and smoke rising from the adjacent copper-smelting activity (fig. 185).

The first technological wonder to be described and recorded in picturesque terms was the Duke of Bridgewater's canal, serving his colliery at Worsley outside Manchester. It was not the first canal navigation scheme to be undertaken in the kingdom but it was certainly the most celebrated.[187] In the later 1750s, wanting to increase output from seams which were getting deeper and beginning to fill with water, the Duke commissioned a survey from one of his junior agents, John Gilbert. Gilbert concluded that if a tunnel sufficiently large to carry canal barges could be drilled into the mines, boats would be able to transport coal directly from the mine to market in Manchester. The springs inside the hill would provide a head of water for the canal and the mine could be drained. To carry coal to Castlefield in Manchester, the canal was designed to cross the River Irwell at Barton by the first barge aqueduct in England, which was completed in 1761, James Brindley acting as the resident engineer.

In 1766, *The History of Inland Navigations. Particularly those of the Duke of Bridgewater, in Lancashire and Cheshire; and the intended one promoted by Earl Gower and other Persons of Distinction in Staffordshire, Cheshire, and Derbyshire* was published in London, one of two promotional tools published that year (Richard Whitworth's *Advantages of Inland Navigation* with its frontispiece depicting the Duke of Bridgewater gesturing in the direction of Barton Bridge being the other). The editor was fulsome in his praise for the young Duke and his patriotic venture, reprinting newspaper accounts which described the enterprise in terms traditionally reserved for the picturesque and sublime.

394

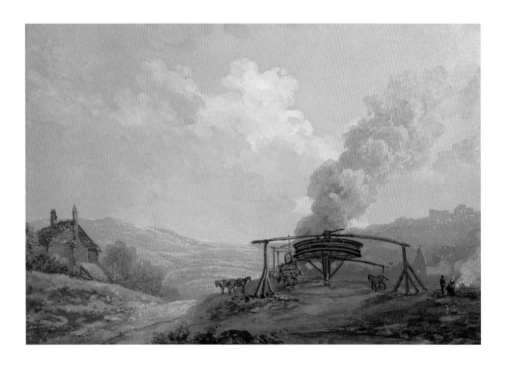

For one writer, the Canal had given more pleasure than the 'artificial curiosities of London' and the 'natural curiosities of the Peake'. The view of Barton Bridge rising in the air, as high as the tops of the trees, afforded a 'mixture of wonder and delight'. Another recommended the Canal to the notice of the intelligent viewer rather than classical ruins or the 'wild and awful scenes of nature at Landrindod or at Matlock'. Trips on the underground section of the canal 'rendered still more awful by solemn echo', gunpowder explosions and ghostly miners' songs of merriment were invariably couched in the language of the sublime – Burke's *A Philosophical Inquiry into the Origin of our Ideas of the Sublime and the Beautiful* had been published ten years' earlier – and compared to Hades, with a host of other classical references thrown in.[188] These accounts set the tone for those written by the following shoals of visitors to the Duke's noble works.[189]

The most striking early views were the two aquatints made by Wright of Derby's surveyor friend Peter Perez Burdett, one of Barton Bridge and the other of Worsley Basin after drawings by 'J. J. Rousseau' (fig. 186). The French philosopher stayed at Wootton Hall, Staffordshire, from March 1766 to May 1767 and, it is surmised, could easily have seen the attraction during his visit. Burdett pioneered the use of aquatint in Britain and these may well have been his first attempts at exploiting a medium from which he hoped to benefit commercially. His 'Vuë de l'Aqueduc du Duc de Bridgewater' pictures Barton Bridge framed by the arch of a fictitious bridge but thereby aligning the image with views of Westminster Bridge and the Thames by Canaletto and Samuel Scott, dating from the 1740s and 50s.[190] In his *Six Months Tour through the North of England*, published in four volumes in 1770, Arthur Young was also full of praise for the Duke and included six engraved plates devoted to Barton Bridge and its environs. Although these were firmly in the empirical mode, unembellished by picturesque refinements, Young's

accompanying account was lyrical: 'The effect of coming at once on to Barton Bridge, and looking down upon a large river, with barges of great burthen sailing on it; and up to another river, hung in the air, form altogether a scenery somewhat like enchantment, and exhibit at once a view that must give you an idea of prodigious labour.'[191]

Mines of all description held a particular attraction for many genteel visitors, inspired by the fundamental nature of mineral wealth and the curious, potentially sublime experience of venturing underground. Even aristocrats were prepared to don miners' garb and to be taken on guided tours of the Northumberland coal-pits.[192] More intrepid visitors to Cornwall descended tin and copper mines.[193] The mines of Whitehaven enjoyed a major scenic advantage, enabling tourists, as John Croft wrote to young Ralph Radcliffe in 1759, 'the having one day ascended into the regions of the air above the clouds [Skiddaw]; and the next descended into the bowels of the earth, a hundred fathom under the bed of the sea furnished an idea not the least romantic that will occur in your travels'.[194] The Reverend John Dalton made a similar point in *A descriptive poem, addressed to two ladies, at their return from viewing the mines near Whitehaven . . .* (1755). These ladies were Margaret and Katherine Lowther and in the poem Dalton contrasted the sylvan charms of their family home, not to mention the picturesque charms of the Lake District, with the sublime experience of exploring the family mines.[195]

Yet British mining inspired little by way of visual record that can be compared to the wealth of material illuminating the mines of continental Europe from medieval times onwards.[196] The awful sight of open-cast mining at Wednesbury, where acres of land smouldered away for decades, was frequently compared in words to the outpourings of Etna and Vesuvius.[197] However, while the regular cycle of eruptions of Vesuvius from 1770, notably the great eruption of 8 August 1779, occasioned many visual and verbal records,[198] the fiery landscape of Wednesbury was left to burn itself out. The salt mines of Northwich, first discovered in 1670, were a more salubrious draw, increasingly so for those seeking picturesque effects. When artfully lit with a mass of candles, the translucent rock salt of the central rotunda, its cupola supported by regular colonnades, glittered like a scene from fairyland, an effect enhanced by the roar and tremor of gunpowder. Visitors were thrilled.[199] Even with the special lighting effects, though, the salt mines of Cheshire – as opposed to those of Poland – were not accorded their visual due.[200]

An exception was made for Parys copper mine on the island of Anglesey, first exploited in 1768. For Peter Oliver, touring North Wales with his niece in August 1780, it was nothing less than an 'English Potosi'.[201] From the Reverend Richard Warner came a characteristically fulsome account of his visit in 1798, highlighting the reason why the Anglesey mine received so much attention not only from visitors but also from artists:

> Unlike all the mines we had hitherto seen, the wonders of this abyss are not concealed by a superficial crust of earth, but all is open to the day. The bowels of the mountain are literally torn out, and the mighty ruin lies subjected to the eye. Standing on the edge of the excavation, the spectator beholds an awful range of huge caverns, profound hollows, stupendous arches, gloomy passages, and enormous masses of rock, not improperly compared . . . to the cavern of Cacus, after Hercules had exposed the secret recesses of his subterranean retreat to the light of the sun.

Amid this striking scenery the miners could be observed 'engaged in their curious, but perilous occupations':

> Some sticking to the sides of the rock, or seated on the narrow ledges of precipices, which gape beneath them to the depth of one or two hundred feet, tearing the ore from the mountain, and breaking it into smaller masses; others boring the rock in order to blast it; whilst a third party are literally *hanging* over the abyss below them,

drawing up and lowering down the ore buckets, supported only by a frame of wood-work, which quivers like an aspen leaf with the operation carrying on upon it. While contemplating this very unusual sight, we heard, ever and anon, loud explosions – gunpowder. These reports varied, increased, and multiplied amongst the passages and caverns of the abyss, completed the effect; and united with the scene of rocky ruin below us, excited the idea of the final consummation of all things – of nature sinking into universal wreck.[202]

When Sir Richard Colt Hoare visited Parys mines for the first time in June 1801, he was almost lost for words to describe 'the singularly romantic and picturesque forms of this mountain', considering it 'one of the most sublime and interesting scenes I ever beheld'.[203] He was scarcely less impressed when he revisited the site in August 1810: 'The first aspect of this mountain strikes you with horror, from its barren appearance and the first look into the chasm of the mine must strike everyone with astonishment. The artist and colorist will view this interior with rapture and his pencil will hardly know where to begin as where to end.' He had never seen 'more majestic scenery than the interior of these mines affords. The fantastic shapes of the rocks and caverns assume a peculiar character of beauty from the vivid tints of the stone, and heightened by the machinery and engines employed in these works.'[204] John Skinner, an antiquarian clergyman, also stressed the educational merits of the exposed site:

A stranger not acquainted with mining concerns cannot do better than take his first lesson at this place, there being no necessity of descending into subterranean abodes to grope out for information by candlelight, incommoded by damp, dirt and foul vapours, for all is here worked open to the day and by taking his station in one point he can command a view of the whole proceedings from the beginning to the end and receive every satisfactory explanation almost without moving from the spot.[205]

In his posthumously published work, *Cambria Depicta: A Tour through North Wales, illustrated with Picturesque Views* (1816), Edward Pugh noted the changes wrought between his two visits in 1800 and 1804: 'the great and lofty pyramid of copper ore had been destroyed, and also the arch, which at that time was a grand object, has been since converted into pans, kettles, and penny-pieces. When these were standing, this chasm presented a more formidable appearance, sufficently grand to entice strangers to visit it from all parts of Great Britain.' Nevertheless, he could still recommend a visit to pro-fessional painters, especially 'those who are alive to, and know the value of, scenery so sublime'. Pugh encouraged his readers to go down to the bottom with the assistance of a guide: 'A view of the hollow from above is rather defective, it should be viewed from below: Even ladies, with trifling assistance, may easily go down.' True to the author's advice, the volume included two aquatints after his drawings of the mine, both viewed from below, the one in the year 1800 with the pyramid dramatically rising to the sky and the second in 1804 from the same viewpoint with the pyramid reduced to an insignificant heap.[206]

A succession of professional artists also did justice to the mines. In the summer of 1792, Robert Fulke Greville, the son of Earl Brooke and later the Earl of Warwick, himself a talented amateur draughtsman, made a tour of North Wales accompanied by Julius Caesar Ibbetson and John 'Warwick' Smith. Smith had long been smitten with Wales, returning at least a dozen times between 1784 and 1806 and recording Parys and the adjacent Mona mine both from ground level and the bottom of the pit, the depth emphasised by the length of rope suspending the buckets from the pulleys (fig. 187). Justice could be done to the variegated colour of the rocks – different shades of grey and ochre, the latter from the ironstone – in watercolour. Ibbetson's views of the scene con-

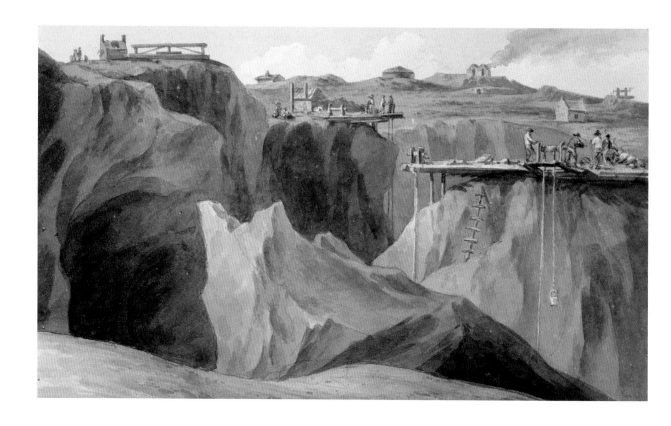

centrate more on the workers – the men hammering away, winding pulleys or clinging to ropes descending to the floor of the mine (fig. 188).[207] They were reproduced as part of a series of prints produced by J. Baker illustrating Welsh life and landscape, entitled *Picturesque Guide through Wales* (1794–7).[208]

While fulfilling the rules of picturesque composition, both Smith and Ibbetson were working in the style of topographical description which, as evident from the work of Ordnance draughtsmen like William Payne, could accommodate industrial detail. Both produced other scenes of industry. Around 1800 Smith depicted the open tin mine at Carclaise, St Austell, a whitened cliff of excavation cut into the Cornish moorland.[209] During a stay in Glamorgan in 1789 under the patronage of the Earl of Bute, Ibbetson travelled with him to Merthyr Tydfil to see the 'most stupendous ironworks'. Either on this occasion or his later trip with Smith and Greville in 1792, he painted a shadowy interior view of the works, with the workers handling the red-hot iron (fig. 189).[210] Similarly, although the aquatint views by John Hassell of coal works near Neath and copper works near Aberavon in Glamorgan, published by Francis Jukes in 1798, appeared in the guise of picturesque topography, they included a considerable amount of industrial description.[211]

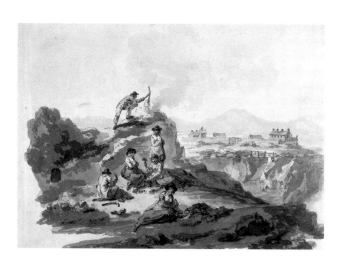

188 (below) Julius Caesar Ibbetson, *Miners at Menai, c.*1792 National Museum of Wales, Cardiff

The popularity of Wales on the tourist circuit was encouraged by the publication of Henry Penruddock Wyndham's *A Gentleman's Tour through Monmouthshire and Wales* (London, 1774; Salisbury, 1781, incorporating a further tour of 1777) and Pennant's *A Tour in Wales, 1770 (or rather 1773)* in 1778.[212] Wyndham saw himself as a pioneer, maintaining that he did not meet a single travelling party during his first six-week

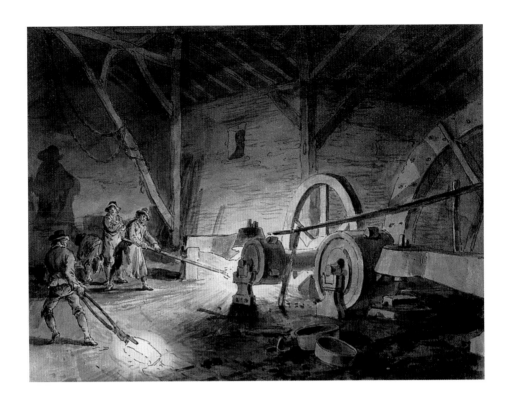

journey through Wales: 'We must account for this from the general prejudice which prevails, that the Welsh roads are impracticable, the inns intolerable, and the people insolent and brutish.'[213] Although he was mainly concerned with antiquities, on his two journeys Wyndham noted the Principality's industrial development: the copper works at Aberavon; Swansea's trade in coal, pottery and copper; the immense copper works, iron forges, tin works and coal mines in and around Neath; and the water-powered mills for battering brass and iron and for other manufactories at Holywell in Flintshire.[214] Thomas Pennant was a land-owning antiquarian whose wide-ranging industrial interests predated the fashion for searching after narrow picturesque effects. *A Tour in Wales* was illustrated with plates after drawings of castles, abbeys, bridges, country houses and the natural beauties of mountains, lakes and waterfalls, which Pennant commissioned from Moses Griffith and John Ingleby. Visitors following Pennant's lead would also encounter industries based on Wales's natural resources, in some of which he had a financial interest. Griffith, the more accomplished topographical artist, was employed by Pennant full-time, while Ingleby, a 'limner' from Halkin in Flintshire, was paid per drawing.

In Pennant's *The History of the Parishes of Whiteford and Holywell* (1796) three of the six plates illustrating the section on Holywell parish were engraved after industrial scenes by Griffith. The frontispiece was of 'River Bank Smelting-Works'. The two other views showed the 'Copper and Brass Works, and . . . the lower Cotton Works' and the 'Two Upper Cotton Works' (fig. 190). As engravings, all were neat, sharp, topographical prospects, tidied up for the viewer. Ducks swim on the placid surface of the mill reservoir which, according to the

399

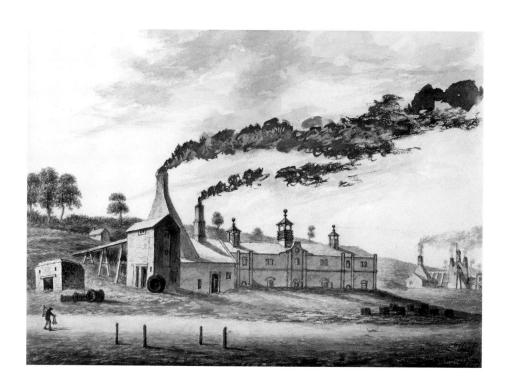

text, was well stocked with trout, stickleback and eel and there is little sign of the
'tremendous volumes of thick black smoke' which, again quoting the text, arose from
the making of brass.[215] Typically, Pennant did not express disapproval with regard to the
inroads that Thomas Williams's Greenfield Copper and Brass Company had made on
the stream, rather the reverse: in digging the foundations for the brass melting-houses,
a Roman hypocaust had been discovered. As he pointed out, in Wales industry and
antiquity could coexist: 'within little more than one mile from the fountain of St Wene-
frede, at Holywell . . . Britain may be challenged to show, on an equal space, a similar
assemblage of commercial buildings, or of capitals employed in erecting and in carry-
ing on their several objects'.[216] Below the mills on the banks of the Dee estuary lay (and
still lie) the remains of the Cistercian foundation of Basingwerk Abbey.

The two upper cotton mills, then belonging to the Cotton Twist Company, had been
erected in 1777 and 1783. Old Cotton Mill, the earlier, was built by John Smalley, a
distant relative of Arkwright, a fellow Preston man and one of Arkwright's partners until
1777 when they quarrelled so badly that he was bought out.[217] His second or Greatest
Cotton Mill, erected in six weeks, was 40 yards long, 10 yards wide and 6 storeys high,
lit by 198 sash windows 'which nightly exhibit a most glorious illumination'.[218] The extra
illustrations to Pennant's work contained further watercolours by Griffith of the Cres-
cent Mill, erected in 1790, so called because of the gilded crescent on top of its cupola,
and of the Greatest Cotton Mill, as well as Ingleby's depictions of Bagillt Upper Mill,
Nant-y-Moch, and Dee Bank smelting mills and fire-engine, the last with, for once, an
impressive display of black smoke gushing from the chimneys and a distant view of
vitriol works along the coast near Holywell from Pen-y-brin House (fig. 191).

Four years earlier, in 1792, the London publisher John Boydell published a set of *Four
Views on Holywell Stream*, engraved after drawings made by Ingleby, representing Green-
field Brass Mills and assorted cotton mills near Holywell. In the accompanying descrip-
tion, Holywell's pilgrim days three centuries before were compared with 'this busy
period' when, 'Industry and her numerous children, rushed almost instantaneously on
the amazed world' as a result of the discovery of copper at Parys. These mills (two built

400

92 (top) John Ingleby, *The Cotton Factory near Mold, Flintshire*, 1796. National Library of Wales, Aberystwyth

93 (bottom) John Ingleby, *lyn-y-Pandy [Rhydalyn], or the Black Valley,... between Ruthin and Mold*, 1796. National Library of Wales, Aberystwyth

and one in the process of erection) of the Cotton Twist Company were, the writer asserted, far superior to any other in Great Britain. The views were justified not only because 'These have produced improvements in mechanics unknown before' but also because 'The passion of the fair sex for this species of manufacture has whetted the genius of our artists, and produced an elegance of pattern and a variety beyond what one would have thought the human invention could ever have produced. Here omnipotent Fashion superseded the Diva Winefreda.'

In 1796, Ingleby drew further scenes in North Wales, possibly for a projected Pennant work which was never realised because Pennant died (figs 192 and 193). In one of two

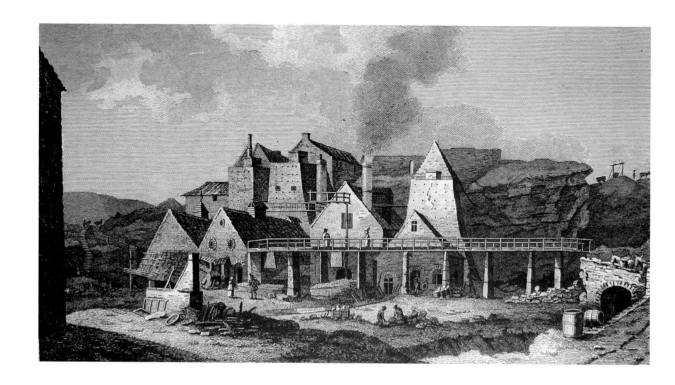

194 After Richard Colt Hoare,
'Blaenavon Ironworks' from
William Coxe, *An
Historical Tour in
Monmouthshire* (1801)

watercolours he made of the environs of Mold in Flintshire, he depicted himself drawing and a stonemason at work in an open shed. Prominently placed in the valley by the Alyn was a fine new cotton factory set down in the open country like an excessively tall doll's house. Another drawing was of Llyn-y-Pandy (Rhydalyn), or the Black Valley between Ruthin and Mold, 'with the Fire Engine & great Promontory become perfectly black from the Smoke'. This was a lead mine on the east side of the Alyn gorge, owned by John Wilkinson and worked with the help of a Newcomen engine.

The Reverend Richard Warner thoroughly approved of the industrial developments he encountered on the two 'Walks' through Wales he made in the summers of 1797 and 1798, conceiving that nature and industry could achieve an equilibrium of harmonious effects.[219] At Holywell, he found a large corn mill, four cotton manufactories, two copper and brass works run by the Mona and Parys companies, hammer mills, a mill for drawing copper wire, a calcinary of calamine and a building for making brass: 'With all the noise, bustle, and appearance of business produced by these numerous manufactories, the little valley in which they stand may yet be called a *picturesque* scene, the only instance of that sort of beauty we had ever seen, blended with so much mechanism, and so many specimens of human art.'[220] The interior workings of iron and copper foundries presented other objects of wonder, which inevitably caused visitors to reach for their classical and Biblical references. For Warner, visiting an iron forge in the valley of Tintern at night, 'We saw Virgil's description realised, and the interior of Etna, the forges of Cyclops, and their fearful employment, immediately occurred to us.'[221] Sir Richard Colt Hoare, visiting Blaenavon ironworks, near Abergavenny, found

the noise of the forges, the fire and thick volumes of smoke occasionally bursting forth from the furnaces, the numerous mules, asses and horses employed in carrying the lime, coal etc., the many cottages and habitations disposed all around; together with the very picturesque forms of the buildings, being very irregular, massive and ?decisive in their forms, produced a new and pleasing effect and a perfect contrast to the deserted castles and solitary abbies we have lately been visiting.[222]

402

Hoare's drawing of the exterior of the works was engraved along with his studies of abbeys and castles for William Coxe's *An Historical Tour in Monmouthshire* (1801; fig. 194). Such sights were admired from Carron to Coalbrookdale. Britain had acquired its own Etna and Vesuvius, its palaces of Pluto and forges of Vulcan.[223]

Advertising himself as a 'Pictural Delineator of Estates', the Quaker land surveyor Thomas Hornor undertook commissions for surveys combining plans with panoramic views for a number of landowners in the Vale of Neath, South Wales. He offered 'a faithful and interesting picture of the various features of the property, comprehending the prospects which it commands, as if beheld in a camera obscura or from a lofty eminence'.[224] Furthermore, in 1817 he produced a series of expensively bound albums of watercolours describing a two-day journey through the valley, executed with the help of a graphic telescope and accompanied by his observations on the scenery. On the face of it, Hornor recoiled from signs of industry. He was careful to station himself on the western bank of the river Neath, 'whence the place appears to tolerable advantage', and did not include a view of the ruins of the abbey, because they were now 'deficient in the unison of surrounding objects'. Yet although the views he took were overwhelmingly rural, he implicitly attacked Gilpin in his rejection of the interventions of man. In depicting Aberdillas (Aberdulais) Mill, a well-known tourist spot on account of the adjacent falls, he wrote:

> taste has vented many a sad and bitter complaint against the profanation of the scenes of nature by the parallel lines of art, but without entering the wide field of association we may venture to affirm that the perception of utility is well entitled to be a source of pleasure and that there is but little wisdom in converting by an arbitrary rule an object calculated to excite agreeable emotion, into a cause of disgust – As the effect on the nicer senses the soft gliding of a vessel is at least as agreeable as the rumbling of wheels, and the bright line of a canal which in a mountainous country is always gentle and flowing, will not lose in comparison with that of a brown and often straight road.

He defended his inclusion of a tinplate manufactory – little more than a collection of houses – again on the grounds of 'the doctrine of utility', for it gave employment to 'a number of the surrounding female cottagers [and] diffuses among them those means of comfort which the imagination delights to associate with their condition'.

Furthermore, Hornor did not stint in his admiration for the iron and coal industries of Merthyr Tydfil: 'The walk through the place is full of interest, every part abounding with displays of ingenious contrivance and wonderful mechanism which contrasting with the neighbouring rude and barren mountains realizes those apparent contrarieties of luxury and leafless desolation.'[225] In another album he enlarged on the sights to be seen:

> At night the view of the town is strikingly singular. Numbers of furnaces and truly volcanic accumulations of blazing cinders illuminate the vale, which combining with the incessant roar of the blasts, the clangour of ponderous hammers, the whirl of wheels and the scarcely human aspect of the tall gaunt workmen seem to realise without too much aid from fancy many of our early fears.[226]

Hornor was not above introducing touches of fancy into his work and when he depicted the rolling mills at Merthyr in a small watercolour, he chose a dramatic night scene lit by the furnaces, albeit prosaically inscribed 'men rolling iron bars and stacking them for exportation' (fig. 195).

Aberdulais Mill was also depicted by the antiquary John George Wood, in *The Principal Rivers of Wales Illustrated* published by subscription in 1813 (fig. 196). Wood's work owed its origin, he said, to the accidental encounter with a native of Wales who offered

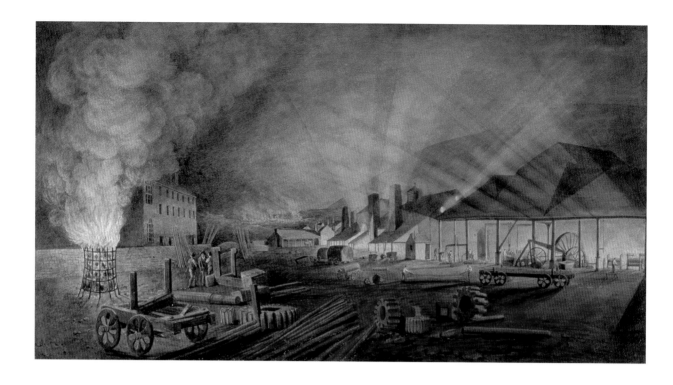

195 Thomas Hornor, *Rolling Mills*, c.1817. National Museum of Wales, Cardiff

his services as a guide to that 'romantic country', inspiring the idea of an illustrated guide to its rivers. The views accompanying the text were all drawn from nature by the author himself: 'he therefore ventures to answer for their accuracy, to the most minute particular'.[227] Given its aristocratic subscription list – the royal family took five copies – it might be supposed that Wood confined himself to the usual picturesque sights of the Principality. Certainly, the older mills and foundries scattered throughout the land were viewed in a picturesque spirit. Yet in describing the course of rivers flowing south through the 'stupendous mineral basin' of South Wales he did not stint in his descriptions and illustrations of the much more recent, large-scale development of the coal, iron and copper industries.

Merthyr Tydfil attracted Wood's full descriptive powers, both in text and image: he traced its development from a small village in the mid-eighteenth century to its state in 1801, with a population of nearly eight thousand, second in Wales only to Swansea. Seventeen blast furnaces produced a total of 44,200 tons of pig iron and 27,000 tons of bar iron, all shipped to Cardiff. Cyfarthfa was the largest ironworks in the country. Merthyr had something of the character of a gold-rush town. According to Wood, its external appearance was 'very inferior, being chiefly composed of the huts and cottages of the workmen, belonging to the various iron-works, erected upon the spur of the occasion, without plan or design, producing a confusion and irregularity in their relative positions, the natural result of such a proceeding'. Of late, he acknowledged, some good houses had been built, 'with a due regard to symmetry and proportion' and some attention paid to the general appearance of the streets. Nevertheless, 'This prevailing mode of building, added to the known habits of the lower

196 (below) John George Wood, 'Aberdulais Mills' from *The Principal Rivers of Wales Illustrated*, 1813

97 John George Wood,
Penydarran [*sic*] Iron Works'
from *The Principal Rivers of
Wales Illustrated*, 1813

orders of the Welsh, render it unnecessary to mention its state with regard to cleanliness; indeed, the enormous furnaces, pouring forth incessant clouds of black smoke, contribute their share towards the dirt and filth so generally observable throughout the place.'

From this general condemnation Wood excluded the splendid mansion built by the ironmaster Samuel Homfray at Penydarren, 'sufficiently removed from the town by the extent of the pleasure-grounds, and contains all the conveniences and luxuries requisite for the residence of a family of wealth and importance'. The gardens were abundantly productive:

> The hot-houses, grape-houses, &c, furnish their respective fruits in profusion, and walks laid out with taste and judgement, present several points from whence the silver Taff, winding through the long accumulation of dingy buildings, may be seen to great advantage; and the singular effect of the fire from the numerous iron works viewed by night, where the immense column of flame, the incessant noise of hammers, and the continued buzz of voices, impresses the minds with a sensation perfectly new, and not easy to be defined. The effect is still heightened by a near approach to the works, where, through a long range of building, innumerable human beings are seen busily employed in their various occupations; some stirring the liquid metal in a kind of oven, others drawing heated masses along the ground, and others again carrying bars of red hot iron, which as they pass through the rollers, may be compared to the windings of so many fiery serpents: add to all this, the strong reflexion of the fire upon the figures covered with the black dirt of the works, and it will not be surprising that such a scene should recall to the recollection the fabulous descriptions of the infernal regions and their inhabitants.[228]

Merthyr could only be absorbed into a gentlemanly sensibility, framed by tasteful surroundings or apocalyptic associations. In following the Taff to Cardiff, 'An occasional retrospective glance', Wood wrote, 'presents the darkened atmosphere of Merthyr Tydfil in the distance, like the smoking ruins of some vast city, a prey to the devouring element.' Nevertheless, Wood produced three views of Merthyr: a long prospect; Cyfarthfa Iron Works clearly showing the four smoking blast furnaces, the foundries, a wagon-way crossing the canal and overhead aqueduct; and Penydarren Iron Works with its blast furnaces set among the hills and its associated rail and tramways and canal (fig. 197). All display a documentary conviction which is curiously at odds with the sentiments expressed in the text. It seems that Wood's commitment to 'accuracy, to the most minute particular', the desire to complete a topographical record, got the better of his class sensibilities. His detailed account of industrial developments at Neath and at Landwyr on

the Tafwy, naming owners of mills and works, describing improvements here, the introduction of 'Bolton and Watts' *(sic)* engines there, confirm his commitment to dispassionate reportage. The plates included both prospects and close-ups of the copper works near Swansea, revealed as a forest of smoking stacks (fig. 198). Yet in the end Wood left no doubt as to where his real sympathies lay. In discussing Pontcysyllte, Telford's magnificent canal aqueduct over the river Dee, he concluded: 'The banks of the river are finely wooded, and the valley rich; but the spirit of trade has totally changed the face of the country in the neighbourhood of the canal, and converted the peaceful cottage of the peasant into the noisy manufactory, the smiling corn-field into a receptacle for the refuse of foundries and forges.'[229]

Industrial Promotion

The owners of industries did not serve merely as passive hosts to tourists who wished to satisfy their curiosity or be entertained by mechanical novelty and elemental power. As the Duke of Bridgewater's famous canal had demonstrated, the alliance of industry with the trappings of politeness could be a useful marketing ploy. Contemporaries were astonished not only on account of its spectacular feats of engineering in the form of Barton Bridge and the underground tunnel but also by the fact that it had been undertaken by an aristocrat: 'When the influence of exalted rank, and the power of large possessions, are thus nobly and usefully exerted, they confer additional lustre on the possessor: and such a laudable application of the gifts of fortune is so rare, that it ought not to pass unnoticed.'[230] The imprimatur of rank could reconcile society at large to industrial progress, its products and their impact on the landscape.

As touched on in Chapter 4, Boulton and Wedgwood ruthlessly exploited the cachet of the upper classes and royalty to sell their wares in the highly competitive ambience of London shows. In March 1773, Josiah Wedgwood and his partner Thomas Bentley received a commission via the British consul in St Petersburg, Alexander Baxter, from the Empress Catherine II of Russia.[231] They were asked to supply a pottery dinner and

dessert service for fifty people, the pieces of which were to be decorated with views of Britain. The order arose out of the perception on Catherine's part, fostered by her French philosopher friends, that Britain represented human progress in politics and economics, agriculture and industry, the arts and sciences. Her service would constitute the physical manifestation of her identification with such values. The unostentatious material of pottery and the nearly monochrome decoration of the works epitomised the fashionable cult of rustic simplicity appropriate to its destination, the Empress's new gothic Kekerekeksinensky (frog marsh) Palace on the outskirts of St Petersburg.

From Wedgwood and Bentley's viewpoint, the production and ornamentation of the service presented a logistical challenge on an unprecedented scale (by its completion, 952 pieces decorated with 1244 different views), which Wedgwood reckoned could not be met in less than two to three years 'if the landskips and buildings are to be tolerably done, so as to do any credit to us, and to be copied from painters of real buildings and situations'.[232] He even doubted whether his workmen could rise to the challenge, writing to Bentley on 9 April:

> Dare you undertake to paint the most embellished views, the most beautiful landskips, with Gothique ruins, Grecian temples, and the most elegant buildings with hands who never attempted anything beyond huts and windmills, upon Dutch tile at three halfpence a doz! – And this too for the first Empress in the world? – Well if you dare attempt and can succeed in this, tell me no more of your Alexanders, no nor of your Prometheus's neither for surely it is more to make *Artists* than mere *men*.[233]

Thirty artists drew on every available source of images in printed form, notably the Bucks' *Antiquities* (1726–42), Thomas Smith's *Prospects of Derbyshire* (1743), William Bellers's *Views of the Lakes*, engraved by Jean-Baptiste Claude Chatelain and others (1752–4), William Woollett's *Views of Gardens* of the late 1750s, Chatelain's views of Stowe engraved by George Bickham junior (about 1769) and Boydell's views of London. The artist Samuel Stringer was sent on visits to the estates of Wedgwood's neighbours in Staffordshire while other artists, landowners and gentlemen tourists like Pennant made loans of drawings for the decorators to copy. The exhibition of the service in London in June 1774 nudged more to supply drawings for the 150 views still to be painted.[234]

The 'Frog Service' was in effect a testimony to the united efforts of mechanical and fine artists and was viewed prior to export at Wedgwood's new Greek Street showrooms, one among competing metropolitan attractions promoting the polite and ingenious arts. Visitors examined the scenes closely, as if perusing a series of topographical prints.[235] The nobility and gentry were keen to ensure that their own estates, both houses and gardens, were represented. Above all, in their totality, the views constituted a grand visual tour of the nation, exhibited in public for the first time. The self-flattering image presented was of a land of picturesque variety, a nation with a venerable history of liberty manifest in its antiquities, especially its gothic remains, and fortunate in having a ruling class prepared to invest profits from agricultural improvement and industrial progress in stately homes and landscape gardens in the best classical taste. Yet of the thousand views painted, only a tiny fraction represented industry itself. Prescot glass works in Lancashire could be made out on two tureen lids, based on a 1744 print engraved by W. H. Toms after a distant prospect by William Winstanley, which devoted more attention to picturesque features in Lord Derby's Knowsley Park. Views of a charcoal-burner's hut in the Forest of Dean and of Kingswood Colliery, Bristol were evidently based on single drawings. Two dishes were decorated with views of the Bridgewater Canal, after the Burdett aquatints.[236] Four more pieces were painted with scenes based on two 1758 prints depicting Coalbrookdale.[237] It is to this showplace of eighteenth-century industry and its commercial promotion through landscape art that I now turn.

From a picturesque viewpoint, Coalbrookdale enjoyed many natural advantages. Its
setting above the Severn Gorge was magnificent, especially when looked down on from
high vantage points. The Bath-based artist Thomas Robins made the earliest known
drawings of the district in a sketchbook dating from the 1750s, recording boats and
ferries on the Severn, packhorses on the roads and at least one inclined plane.[238] But the
region's assets were first actively promoted in the two perspective views made by Thomas
Smith and George Perry, engraved by François Vivares and published by Perry and Smith
in 1758 (figs 199 and 200).[239] These are the prints that were used – split into four images
– in the Frog Service. As the Clerk or Agent of the Coalbrookdale Company, Perry also
composed a descriptive prospectus to accompany the publication of the engravings.[240]
This 'short and general account' was intended to provide 'a tolerable idea of a place so
remarkable, that it is presumed few persons of curiosity who have taken the pains to
examine it on the spot, have ever found themselves disappointed'. Perry proceeded to
describe Coalbrookdale's geographical location, with its abundant supplies of coal, iron-
stone and limestone. He drew attention to the fossil shells and corals daily dug up in
the limestone quarries, and in the ironstone, perfect impressions of fern and other plants
and, more rarely, even fir cones: 'These have been of late years much in request, and
have found place in the cabinets of the most curious persons.' Iron manufacture, he
emphasised, had developed comparatively recently and now employed more than five
hundred people. 'The face of the country shows the happy effects of this flourishing
trade', he continued:

> the lower class of people, who are very numerous here, are enabled to live comfort-
> ably; their cottages, which almost cover some of the neighbouring hills, are thronged

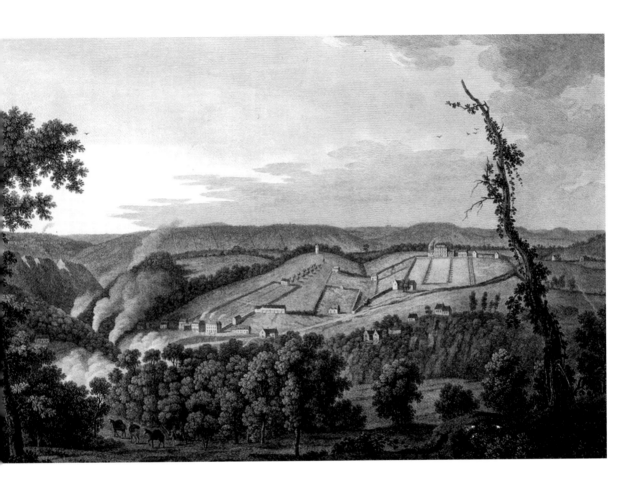

with healthy children, who soon are able to find employment, and perhaps cheerfulness and contentment are not more visible in any other place. A pleasing proof this, that *Arts* and *Manufactures* contribute greatly to the *Wealth* and *Power* of a Nation, and that *Industry* and *Commerce* will soon improve, and people the most uncultivated situation.

Perry elaborated at length on the picturesque possibilities of Coalbrookdale's surrounding hills and woods but the presence of industry provoked intimations of the sublime:

The beauty of the scene is in the mean time greatly increased by a near view of the Dale itself; *Pillars* of flame and smoke, rising to a vast height, large *Reservoirs* of water, and a number of *Engines* in motion, never fail to raise the admiration of Strangers; tho' it must be confessed that all these things joined to the murmuring of the Waterfalls, the noise of the *Machines*, and the roaring of the *Furnaces*, are apt to occasion a kind of Horror in those who happen to arrive on a dark night. . . .Upon the whole, . . . there are perhaps few places where rural prospects, and scenes of hurry and business are so happily united as at Coalbrookdale. *Barren Rocks, Hills* and *Woodlands*, put one in mind at first sight, of the lonely *Retreats of Melancholy*, and *Contemplation*; whilst the works in the Valley, the hurry and crowd of the inhabitants, and the various employment of the workmen, display a lively view of one of the most active scenes of business that can be imagined.

In other words, Coalbrookdale was a total experience, encompassing the polite and mechanical arts and natural philosophy, the picturesque and the sublime.

409

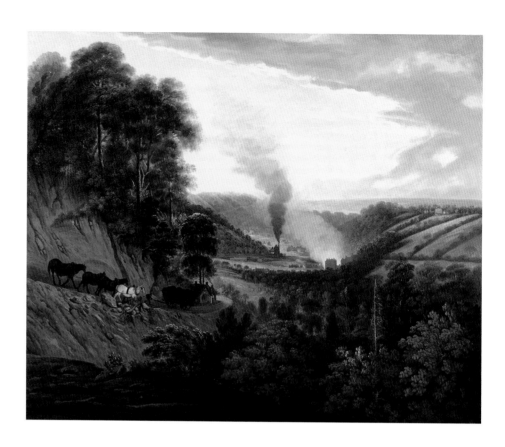

The first plate Perry described shows a near prospect of the upper works, with several furnaces and the principal houses belonging to the proprietors, while 'near the foreground is represented a large *Cylinder* on its carriage, supposed to be seventy inches diameter, ten feet long, and weighing about six tons; being the real dimensions of one lately cast at this *Foundery*, and sent to *Cornwall*'. Plate II was taken from the top of the precipice called the White Rock, 'including a general view of the Dale, and adjacent country, looking south-west, with a team of packhorses carrying coal or iron ore down to the furnaces through the woods'. The proprietors' houses were again identifiable in the foreground; clouds of smoke rose from the works sunk deep in the valley and beyond them, part of Broseley was visible in the hills.

Perry ended by thanking on behalf of the proprietors 'all such persons of quality and gentry, who by the following subscription, have encouraged the publication of a work, originally intended only for private amusement'. The subscribers listed numbered approximately five hundred, including members of the aristocracy, the clergy, Oxford dons, M.P.s, F.R.S.s and, of course, Quaker ironmasters. Abraham Darby took twenty copies. Richard Reynolds senior of Bristol and junior of Ketley (Abraham II's son-in-law) ordered four copies each. Jonathan Hornblower of Truro wanted six, presumably because he had ordered the cylinder being transported in plate I. However, the prints were not published simply for amusement. Their publication coincided with a massive expansion of the works at Coalbrookdale, caused in part by the demand for arms needed in the Seven Years War, and the proprietors had reason to be proud of their operations.[241] Crucially, the Company also needed to renegotiate the renewal of the lease on the land, due to expire in 1759. It is the lawsuit which arose in relation to part of this land which seems to have occasioned the publication of the prints, dedicated to advertising the 'happy effects' that art and manufactures, industry and commerce in Coalbrookdale had brought to the nation, enhancing its wealth and power.[242] The prints and Perry's prospec-

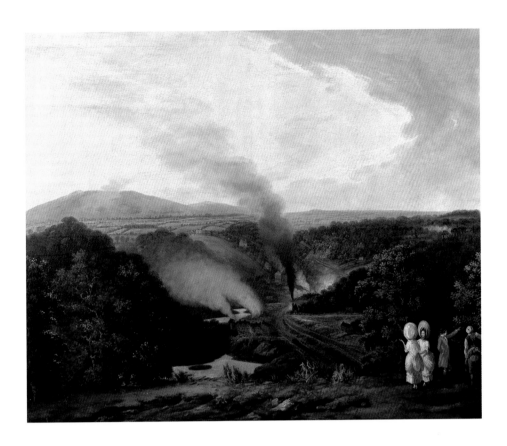

tus were saying, in effect, that the Coalbrookdale Company was a patriotic endeavour, the future of which should not be placed in jeopardy.

On 4 November 1757, John and Rose Giffard, landowners of part of the Coalbrookdale site, filed a Bill of Complaint in the Court of Chancery against Thomas Goldney, Abraham Darby II and Richard Ford II, the principal partners in the Coalbrookdale Company. Aided and abetted by Brooke Forester and John Wilkinson, who had formed the rival New Willey Company, they hoped to obtain compensation from the Company and a better return on their estate from its operations in future. In May 1758 Goldney and his partners responded in full to the Bill of Complaint and in November 1759, Perry prepared a detailed map of Coalbrookdale for submission in the case for the defence. The publication of the prints was part of the effort to rally support for the Company. After attempts to reach a compromise came to nought, Goldney and the partners filed their own Bill of Complaint against the Giffards, using remarkably similar language to that used by Perry in the prospectus, asserting that 'the works at Coalbrookdale are of very great public utility being one of the most capital if not the greatest iron foundries for cast-iron in the kingdom'. Eventually, following a trial under common law at Shrewsbury Assizes in 1762, the Coalbrookdale Company bought out the opposition interest and agreed to pay an increased rent for their sole occupation of the site.[243]

The proprietors had learnt some useful promotional lessons which were pursued in succeeding decades. Coalbrookdale views in a self-consciously picturesque manner were first painted by William Williams in 1777 and exhibited at the Royal Academy the following year.[244] They depicted the valley in the morning and the afternoon (figs 201 and 202). The first was taken from the top of Jiggers Bank and showed a team of horses being used to brake a loaded coal wagon descending Coalbrookdale valley on rails in the direction of the Severn. In the centre of the picture a pumping engine sends a plume of dark smoke into the shimmering morning light, merging with the lighter smoke drift-

ing across from the furnaces. The afternoon view from the top of Lincoln Hill stretching across to the Wrekin, overlooked the Lower Furnace Pool and Upper Forge Pool, with the Lower Furnace in between and smoke from the Upper Furnace rising towards Dale Road.[245] Two ladies clad in the latest fashions gesture airily over these human incursions on the landscape, while a gentleman in hunting dress points out a tree to a labourer or servant. On 1 May 1778, the *Morning Chronicle* commented favourably, if patronisingly, when the views were first exhibited at the Academy: 'Mr William Williams's Views of Colebrook Dale, &c are true representations of the places described in them, and as they are to be sold, would appear very proper ornaments in the dining-room of one of the proprietors of the iron-works there situated.'

By this date Coalbrookdale was firmly established on the industrial tourism circuit.[246] In 1776, Jabez Fisher arrived at night and was awestruck by what he saw, inevitably comparing the view from the summit of the hill overlooking Coalbrookdale to 'all the horrors that Pandemonium could show' and the light from the furnaces to 'Etnas and Vesuvius's': 'My lodging room commanded a very extensive view of this great theatre. From my bed I could look down upon the craters of the burning mountains; the house of my host being situated on an elevation which gave every desirable advantage to the novel scene.' As a fellow Quaker, Fisher was fortunate to be staying with Abraham Darby III and the following day the ironmaster took the visitors on a 'general survey of the furnaces, forges, and other conveniences for the manufacture of iron'. But it was the plans for works which had yet to be executed which drew his greatest admiration:

> a far greater and more wonderful piece of architecture is now in agitation by the enterprising owners of these works, a fabric which England or the whole globe cannot equal. This is an iron bridge across the river Severn to consist of one arch only. This will be a regular circle. The span from side to side is near [196] feet. Abraham Darby has made a very elegant and complete model of the plan on a scale of ¼ inch to a foot, by which it appears so easy, practicable and simple that an act of parliament is passing for his effecting it. The whole will be of cast iron without an ounce of any other sort of material about it. It may be taken to pieces at any time, and should it ever be out of order it will very easily be rectified.[247]

Undoubtedly the greatest boost to the reputation of Coalbrookdale as a worthy sight of industrial tourism was the construction between 1776 and 1781 of the first cast-iron bridge in the world. The ostensible reason for building the bridge was increased industrial traffic but it was also a daring public-relations stunt, advertising the versatility of cast iron and the skills of Darby and his Coalbrookdale Company. The site chosen was the most dramatic point of the gorge and the bridge's semicircular design would be reflected in the water to form a perfect circle. Its construction was suggested by the Shrewsbury joiner turned architect, Thomas Farnolls Pritchard, who first wrote to John Wilkinson on the subject in 1773 and produced a design in 1775 for local businessmen. Darby estimated it would cost £3200, which was raised from shareholders, but the modified design as built cost more than £6000, the difference burdening the ironmaster and his Coalbrookdale Company with mortgage debt. The only hope of a return was from tolls, the extra business his ironworks might thereby attract and, of course, from industrial tourism.

Darby might have gained reassurance from earlier bridges, which had received their share of public notice and approbation. Westminster and Blackfriars bridges were considered considerable feats of urban engineering and architecture, harking back to Roman precedents. Their rustic equivalent spanned the dangerously swift river Taff in a single stone arch at Pontypridd, built in 1750 by William Edward, 'a common mason', over a framework constructed by a local millwright, Thomas Williams.[248] All were commem-

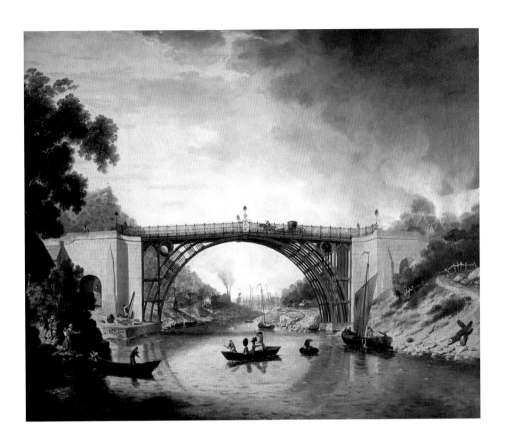

203 William Williams, *The Cast Iron Bridge near Coalbrookdale*, 1780. Ironbridge Gorge Museum Trust, Coalbrookdale

orated in prints. But a bridge of cast iron was wholly novel. Its ogee arches, circles and eyelet braces to the arches combined to form a delicate latticework of iron girders and the parallel spring of the ribs of vaulting from the stone abutments created a rhythm as exciting in its way as that of gothic fan-vaulting.

The Swedish artist Elias Martin recorded the bridge under construction in an atmospheric monotone watercolour, dated 1779, which showed the simple wooden frame in place, against which each arch of the span was tied in two halves.[249] Even before it was completed with the stone abutments, new roads and toll-house, Darby was determined to record his achievement for posterity, organising what was in effect a media campaign. In October 1780, three months before the Bridge opened on New Year's Day 1781, he paid William Williams ten guineas for a view of the Iron Bridge itself (fig. 203). As in the artist's overviews of the valley, the scene was graced with the presence of the gentry. Two fashionable ladies sit in a barge being instructed on the wonders of the bridge by a gentleman who stands pointing to it with his cane as a post-chaise is crossing. Common life was also included: a couple of naked figures are swimming from a trow moored on the north bank, a man is rowing a coracle, a woman is about to join a child in a ferry on the south bank and more trows and smoking furnaces are visible in the distance.[250]

Darby also commissioned Michael Angelo Rooker to produce a watercolour of the bridge, as the basis for a print (fig. 204).[251] Rooker emphasised the picturesque aspects of the site rather more than Williams, removing any sign of smoking furnaces from the background and reducing the foreground staffage to standard peasant types and a man in a coracle in the middle of the river. The engraving was published in 1781 with a dedication from the Coalbrookdale Company to George III.[252] Darby took the trouble to spend eighteen shillings on advertising and to arrange for the print's distribution in London and through Shrewsbury booksellers, as well as in Coalbrookdale. Subscribers who bought the polite landscape perspective were offered as a free gift 'an elevation of

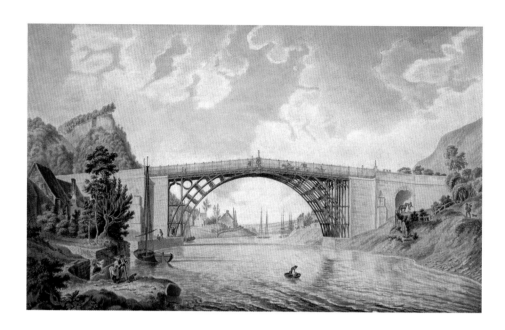

204 Michael Angelo Rooker,
*The Cast Iron Bridge near
Coalbrook Dale*, 1780. Aberdeen
Art Gallery & Museums
Collections

the bridge with its principle parts etc on a sheet the same size as the print'.[253] Besides
technical data – measurements, method and time of construction – the letters drew
attention to the antiquarian interest of the coracle depicted midstream: 'The small boat
seen in the view near the middle of the river is called a corracle, and is used on this river
and others in Wales. . . . Vessels of this kind were used in Britain so early as the inva-
sion of Julius Caesar. See Caesar's Commentaries also Campden's Britannia vol. 1 p. 657.'
Rooker's image was also reproduced 'by permission of the proprietors of the print' on a
souvenir linen handkerchief.[254]

The Iron Bridge attracted a stream of other artists in the 1780s.[255] On 1 February 1788
a remarkable set of six engravings was published by the Boydells after paintings by
George Robertson, presumably to cater for the tourist market.[256] Unusually, Robertson
focused on the bridge's neighbouring coal-pits and ironworks, albeit within the roman-
tic setting (fig. 205). Visitors flocked to Coalbrookdale, alerted by its visual representa-
tions and by the display of the model that Darby presented to the Society of Arts in
London in 1787.[257] William Reynolds made considerable efforts to keep the walks
through the surrounding woods in good order and even to embellish them in accor-
dance with picturesque theory, as Colt Hoare noted with appreciation in 1801: 'At one
extremity a rotunda commands a fine view of the adjacent country; as does, near the
other extremity, a Doric building embosomed deep in a fine grove of oaks.' The 'roaring
explosion' of the nearby cannon foundry produced a 'fine effect'.[258] Warner was rap-
turous about 'this romantic spot' with its walks, the one leading to:

> a plain Doric temple, through a thick shade, occasionally opening and disclosing the
> rocky banks on the other side of the dale; from whose bosom the ascending smoke,
> curling up in vast columns from the foundries that are unseen, suggests the idea of
> mists arising from the agitation of a cataract; a notion strengthened by the incessant
> din of the volcanic operations below . . . the second, which is led along the narrow
> ridge of an eminence agreeably planted with evergreens, which shut out the immense
> lime-stone pits to the left-hand, and interrupt the sight of a deep precipice to the
> right. This walk terminates with a *rotunda*, a most classical building, placed at the
> point of the promontory; whence a view of great extent, diversity, and curious com-
> bination, is unfolded. Immediately under the abrupt height on which it stands,

Lincoln Hill and the Iron Bridge, Coalbrookdale

The Iron Bridge, Coalbrookdale, from the Madeley side

The Iron Bridge Coalbrookdale, from Lincoln Hill

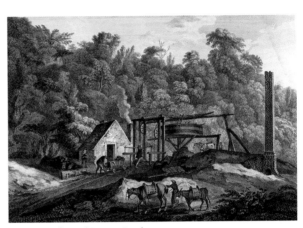

The Mouth of a Coal Pit near Broseley

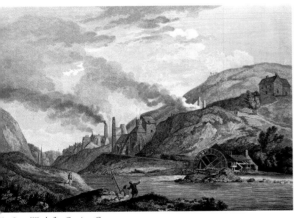

An Iron Work for Casting Cannon

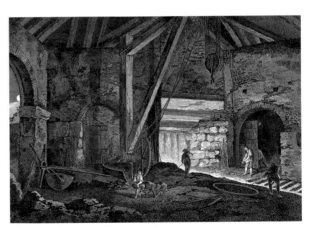

The Inside of a Smelting House at Broseley

205 Francis Chesham, James Fittler and Wilson Lowry after George Robertson, *Coalbrookdale*, 1788. Ironbridge Gorge Museum Trust, Coalbrookdale

yawning caverns disclose themselves, the entrances into the limestone quarries, from whence ever and anon wagons drawn by horses, and laden with the product of the mine, are seen to issue; and in their neighbourhood a series of pits stand ready to receive the stone, vomiting smoke and burning flame. Carrying the eye a little further, it takes in the iron-bridge, the river and its shipping. Beyond this it reposes in distant vales, and upon the fertile meadows of Shropshire . . .[259]

Coalbrookdale provided a model of nature and artifice, antiquity and progress. In 1791 the Anglophile Prince Leopold III Friedrich Franz of the central German state of

Anhalt-Dessau added a small version of the Iron Bridge to his park at Wörlitz. The flat lands of the Elbe did not present quite the dramatic possibilities of the Severn gorge but with its neo-classical mansions, villas and temples, artificial volcano and gothic house, Wörlitz was created by the Prince and his architect, Friedrich Wilhelm von Erdmanns-dorff, as a theme park of European culture, symbolising ancient liberties and modern progress.[260] By the end of the century, there were other cast-iron showplaces. The wealthy merchant banker, freemason and from 1790 M.P. for Durham, Rowland Burdon, was the chief instigator behind the much larger cast-iron bridge completed at Wearmouth in Sunderland in 1796. It engineer was Thomas Wilson and the iron was cast at Walker's in Rotherham, of which Burdon was a director.[261] It too inspired promotional prints, notably three by J. Raffield after drawings by Robert Clarke. One depicted the component parts of the bridge made by a method patented by Burdon; the second showed the bridge under construction using a novel method of scaffolding.[262] A cast-iron bridge manufactured at Coalbrookdale on the same pattern as the original was installed in 1797 over the River Parrett at Bridgwater. An iron bridge was even proposed on George III's estate over the Thames, linking Windsor and Datchet, but nothing came of it.[263]

Coalbrookdale was not the only industrial site to cultivate the picturesque for promotional purposes. As 'the beehive of England and the toy-shop of the globe', Birmingham attracted genteel visitors to view its horse-whip manufactories and gunsmiths, japanners and button-makers.[264] But the greatest draw was Matthew Boulton's Soho manufactory, its principal building completed in 1767 to the design of William Wyatt. It presented to the world a Palladian front of elegant proportions, with a hipped roof crowned by a cupola. Behind it were the forges, furnaces and a huge waterwheel which provided the motive power for the production of toys, silver and ormolu vases. In her letter to Boulton following her visit in October 1771, Mrs Montagu could barely contain herself at this inspiring juxtaposition of art, science and industry: 'The pleasures I received there, was not of the idle and transient kind which arises from merely seeing beautiful objects. Nobler tastes are gratified in seeing Mr Boulton and all his admirable inventions. To behold the secrets of chymistry, and the mechanick powers, so employed, and exerted, is very delightful. I consider the machines you have at work as so many useful subjects to Great Britain of your own creation: the exquisite taste in the forms which you give them to work upon, is another national advantage.'[265] Industry was elevated to a higher moral sphere, in which utility and taste combined to fulfil the interests of the nation. Jabez Fisher extolled Soho's manifold attractions, including Boulton's house with its beautiful gardens interspersed with canals 'which are nothing more than his mill dam and his races, which he has ingeniously constructed to answer the *Dulce* as well as the *Utile*', and a quarter of a mile away,

> his great and wonderful manufactory. The front of this house is like the stately palace of some duke. Within it is divided into hundreds of little apartments, all which like beehives are crowded with the sons of industry. The whole scene is a theatre of business, all conducted like one piece of mechanism, men, women and children full of employment according to their strength and docility. The very air buzzes with the variety of noises. All seems like one vast machine.[266]

Like Reynolds at Coalbrookdale, Boulton successfully softened the impact of his manufactory by improving its surroundings. In Stebbing Shaw's *The History and Antiquities of Staffordshire* (1798–1801) the account under Handsworth was illustrated by two plates, drawn and engraved by Francis Eginton, of the Soho Manufactory viewed in close up and Soho House from the far side of the lake (fig. 206). The accompanying descriptions began with a eulogy by Erasmus Darwin composed for the Reverend Mr Feilde in 1768 when Feilde was preparing a *History of Staffordshire*: 'the transformation of this place is

206 Francis Eginton, 'N.E.
View of Soho Manufactory'
from Stebbing Shaw, *The
History and Antiquities of
Staffordshire*, 1798–1801

a recent monument to the effects of trade on population'. The beautiful garden, exten-
sive pool and large waterwheel worked a prodigious number of different tools: 'Mr
Boulton, who has established this great work, has joined taste and philosophy with man-
ufacture and commerce; and, from the various branches of chemistry, and the numer-
ous mechanic arts he employs, and his extensive correspondence to every corner of the
world, is furnished with the highest entertainment as well as the most lucrative employ-
ment.' Having considered the products of the factory, Shaw concluded:

> No expense has been spared to render these works uniform and handsome in archi-
> tecture, as well as neat and commodious, as exhibited in the annexed plate. The same
> liberal spirit and taste has the great and worthy proprietor gradually exercised in the
> adjoining gardens, groves, and pleasure-grounds, which at the same time that they
> form an agreeable separation from his own residence, render Soho a much admired
> scene of picturesque beauty. Wandering through these secluded walks, or on the banks
> of the several fine lakes and waterfalls which adorn them, we may here enjoy the
> sweets of solitude and retirement, as if far distant from the busy hum of men. In
> scenes like these the studious and philosophic mind occasionally finds a most agree-
> able and salutary asylum.[267]

The pottery and china manufactories were no less assiduous in courting visitors
through presenting a suitably elegant façade. Wedgwood's manufactory of Etruria, built
to the design of Joseph Pickford in 1767–73, was a classical three-storey range with a
central pediment over three bays breaking forward, topped by a large octagonal cupola.
Visitors were impressed not only by the 'handsome' factory but also by Wedgwood's
'elegant mansion' and even the neat brick workmen's houses 'very prettily arranged'.[268]
If many manufactories were converted from workshops, houses, sheds, barns and small-
scale water-mills, the more ambitious custom-built factories in the second half of the
eighteenth century displayed some aesthetic pretensions. 'Model' factories were even
built on landed estates: in the mid-1760s, Sir James Lowther commissioned Robert
Adam to produce plans for a model village and linen manufactory.[269] Lleweni Bleach

Works in the Vale of Clwyd was built to the design of Thomas Sandby by the Honourable Thomas Fitzmaurice in 1785 for treating linen from his Irish estates. Pennant was duly impressed:

> The building, in which the operations are carried on, is in form of a crescent: a beautiful arcade four hundred feet in extent, with a *loggio* in the centre, graces the front; each end finishes with a pavilion. The drying loft is an hundred and eighty feet long; the brown warehouse and lapping room each ninety feet; and before it are five fountains, a prettiness very venial, as it ornaments a building of Dutch extraction. But this is without parallel, whether the magnitude, the ingenuity of the machinery, or the size of the bleaching ground is to be considered . . .[270]

Naturally, Moses Griffith recorded the works in watercolour (fig. 207) and in 1795 an aquatint was produced by Thomas Malton after a painting by Thomas Walmsley, dedicated to the Corporation of Liverpool, where the linen was sent for sale.

If these model manufactories were in keeping with the aesthetic standards of their owners, then less well-born entrepreneurs were determined to follow their lead in a bid for social acceptance. Jennifer Tann's exploration of the Boulton & Watt archive has uncovered woollen mills and starch factories, breweries and corn mills constructed with well proportioned Palladian façades, complete with pediments, *oeil-de-boeuf* and Venetian windows.[271] A metropolitan showplace like the Albion Mills rose up from a rusticated base alongside the Thames to the designs of the architect Samuel Wyatt and its massive Boulton & Watt steam engines, installed under the direction of John Rennie, attracted many visitors before it burnt down in 1791.[272]

Some cotton manufacturers made an attempt to beautify their enormous mills not only to promote their products but to suggest that they were fully paid-up members of enlightened society. This public front was frequently at odds with the secrecy of the processes that went on inside. Yet even Arkwright's Masson Mill (1783) on the River Derwent displayed more architectural elements than the earlier Cromford mills, its brick walls embellished with stone quoins and window dressings and the front articulated with three central bays, with a small lunette window between Venetian windows on each floor. Published in 1803, the aquatint after J. Parry's west view of Samuel Oldknow's Mellor Mill, Derbyshire, was dedicated to the proprietor by the print-maker Francis Jukes and his co-publisher Vittore Zanetti of Manchester (fig. 208). The seven-storey brick building had two wings at each end with pediments set with roundels adorned with the owner's

initials and the date of completion (1793); the central entrance block boasted Venetian windows and was topped with a cupola and sundial. Mellor Mill's front driveway led down to a bridge over a river and a gatehouse, and a broad spread of lawn extended to woodland. In the centre foreground, the artist depicted a group of toddlers playing happily together, while an older boy and girl shared a no doubt edifying schoolbook. On the pathway, there were more children gambolling amid the fashionably dressed couples (the ladies presumably wearing muslin) strolling and admiring Oldknow's noble design. As the scale of child labour in the cotton factories increased, the print suggested that Oldknow had bent over backwards to provide every amenity for his small employees.

For marketing purposes, even the toughest work processes could be presented in an attractive and genteel format, especially when allied to a patriotic cause. On 23 November 1785, a comparatively new member of the Society of Arts, William Hincks (proposed on 25 February 1784) wrote in a neat hand to the Secretary, Samuel More, begging leave to present to the Society a set of twelve engravings, 'representing the process of the linen manufactory of Ireland in all its different stages, with perspective views of the principal machines in use; the different views as well as the machinery, were drawn on the spot by me, and were (except the engraving two small plates) the first of my performances in that way' (fig. 209). Thanks were duly returned to him and on 2 December 1785 it was resolved by the Committee of Polite Arts to recommend to the Society that the prints be properly bound and lettered and carefully preserved in the Society's repository.

Little is known about Hincks and he is usually described as a self-taught miniature artist from Waterford. In the 1770s, he was based in Dublin, enrolled at the Dublin Society's school of landscape and ornament drawing and exhibited at the Society of Artists in William Street.[273] Between 1781 and 1797 he showed assorted works at the Royal Academy, submitted from various central London addresses, and with the Free Society of Artists in 1782. Besides painting portraits, he produced a set of illustrations for an edition of *Tristram Shandy* and some allegorical designs. In 1784 he showed at the Royal Academy 'Britannia, Hibernia, and Scotia, exhibiting the names of their great commanders in the late war' and three years later, published a print entitled 'The Increasing Grandeur of the British Nation' as well as 'Hibernia, attended by her brave Volun-

Ploughing, Sewing the Flax Seed and Harrowing

Pulling the Flax, Ripling the Seed, and Boging or Burying it in Water

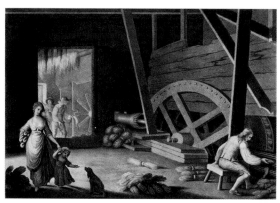

Taking the Flax out of the Bog

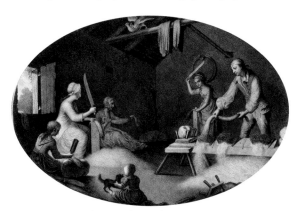

Beetling, Scutching and Hackling the Flax

Perspective View of a Scutch Mill

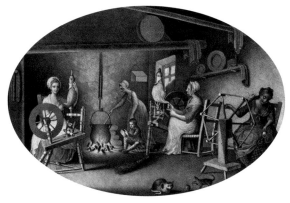

Spinning, Reeling with the Clock Reel and Boiling the Yarn

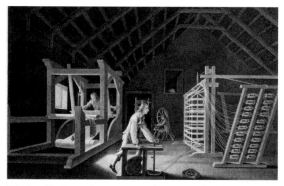

Winding, Warping, with a new improved Warping Mill, and Weaving

The Brown Linen Market at Banbridge

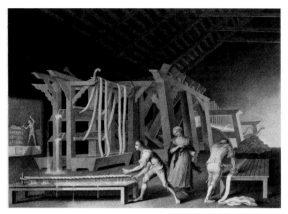

Complete Perspective View of all the Machinery of a Bleach Mill

Perspective View of a Bleach Green

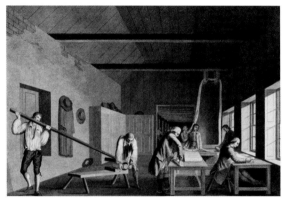

Perspective View of a Lapping Room

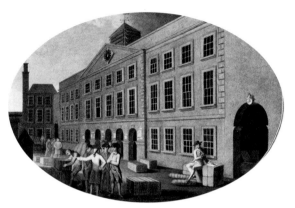

Perspective View of the Linen Hall in Dublin

209 (facing page and this page) William Hincks, *The Irish Linen Industry*, 1783. British Museum, Department of Prints and Drawings

teers, exhibiting her commercial Freedom'. These subjects provide some indication of Hincks's politics, which are confirmed by the fulsome dedications of the Irish Linen Industry prints to the Protestant Ascendancy in Ireland, including the Lord Lieutenant General and General Governor of Ireland, Prince Edward (the Duke of Kent, the fourth son of George III) and leading representatives of the Anglo-Irish nobility. Plate II was dedicated to Irish M.P.s and the 'Glorious Volunteers of Ireland, the Protectors of our Liberty and Commerce' and the third plate to the Trustees of the Linen Manufacture (Board) and the Dublin Society, described as 'the Encouragers of the Arts and Manufactures of Ireland'. Hincks was an Anglo-Irish patriot who revelled in the measure of independence won for the country in 1782. The purpose of the plates, first published in 1783, was as much to promote the peaceful progress of manufacturing in Ireland as to demonstrate Hincks's drawing and engraving skills.

This was an opportune moment since the future for Ireland looked hopeful. During the first half of the eighteenth century, writers and polemicists supported the growth of the linen industry in the country, following the removal in 1696 of English import duties on plain Irish linen cloth.[274] Flax growing was well suited to small enclosed holdings and the damp climate was beneficial for spinning, weaving and bleaching. The greatest progress was made in Ulster where tenants enjoyed security of tenure, reasonable rents and at least a customary right to sell on the goodwill of a holding. Around 1700, new production techniques were introduced by French Huguenots, notably Samuel-Louis Crommelin, who was invited to form a Society or Royal Corporation for the linen trade on the basis of a partnership with the government. Crommelin passed on his expertise in *An Essay towards the Improving of the Hempen and Flaxen Manufactures in the Kingdom*

of Ireland (Dublin, 1705), illustrated with sections and perspectives showing French and Dutch looms and the tools needed for flax dressing. Others recounted their experiences in essays and pamphlets: Thomas Prior advocated the extension of tillage for flax as part of a wider campaign to promote economic and agricultural improvement. These efforts bore fruit, as already noted, in the foundation of the Dublin Society, of which Prior became chairman and which offered premiums for flax cultivation.[275] The Irish linen trade grew from 520,000 yards exported in 1705 to 11,200,460 yards by 1750. Besides the domestic demand for bed, bath and table linen, undergarments and shirts, there was a rising export demand for sacking and slaves' clothing and the export market in yarn was further stimulated by the expansion of the English cotton industry which, for much of the eighteenth century, depended on linen warp for the manufacture of calicoes.[276] This growth was helped by government action: duty-free imports into England and the establishment of the Linen Board in 1711 to oversee and regulate the industry nation-wide. Numerous semi-official reports were published from the middle decades of the century, while the Proceedings of the Board of Trustees of the Linen Manufacture in Ireland were published from 1784 onwards.[277] By 1770, the cloth exported rose to 20.6 million yards, and yarn exports to 33,400 hundredweight (compared with 18,500 in 1740), seven-eighths of which went to Britain.

The American war precipitated an economic depression, as exports to America and France were made illegal. It also reminded the landed Anglo-Irish Ascendancy where their true interests lay and a movement was instigated to provide England with troops from the Irish military establishment, replacing them with a home guard of Volunteers to serve against American privateers and the threat of French invasion. Yet, despite their ostensible purpose, they were also used as a means – most conspicuously through rallies on College Green – of seeking greater constitutional independence and economic freedom, under the all-purpose watchword of patriotism.[278] Subjected in the early 1780s to extreme political pressure, the British government made some political and trade con-cessions which, although largely cosmetic, boosted the morale of the Irish parliament: the Bank of Ireland was founded in 1783 and a separate Post Office the following year, while harbour improvements benefited Ulster.

During this period of burgeoning national self-consciousness, the English artist Francis Wheatley (who was in Ireland avoiding creditors) obtained some important, fashionable commissions representing key events in the Volunteer movement.[279] The artist also painted portraits, landscapes and scenes of rustic genre – Irish fairs, fishermen and gypsy encampments – executed with characteristic fluency and elegance.[280] Hincks's Irish Linen Industry prints are stylistically close to Wheatley's work, clothing accurate observation in the guise of the picturesque, and producing graceful depictions of working women in a mode which Wheatley later popularised in his *Cries of London*. Moreover, the example of Wheatley, in seeking patronage from Anglo-Irish grandees and getting his major works engraved, might well have convinced Hincks that there was a market for his own project within the same constituency. Possibly the work of George Barret, the most influential Irish landscape artist in the second half of the eighteenth century, encouraged Hincks to emphasise the picturesque in his outdoor settings rather than give the more accurate picture of what was, by this date, well enclosed territory. In their sequential development the views also recall the finest vignettes in the *Ency-lopédie* illustrations, those that were based on first-hand observation and knowledge of the industries concerned.[281]

The twelve plates were first published by Hincks in London, as the centre of the worlds of politics, art and fashion, where they were most likely to have an impact.[282] In general the series follows the simplest self-sufficient model of production, with the farmer weaver growing his own flax and his wife and children helping to harvest and

spin it into linen yarn; then he wove the cloth and took it for sale at the local market.[283] The first three plates present the traditional agricultural cycle from sowing to harvesting the flax, conveyed through picturesque pastoral means. Although the settings were identified in the letters – and in discreet sightings of buildings associated with the Anglo-Irish Ascendancy – the laborious and uncertain nature of the crop was subsumed beneath a bucolic idyll. The men toiling knee-deep in bogs (lint-holes or flax dams), where the cut flax was submerged for days to soften, had the appearance of classical shepherds more than Irish labourers.

Two traditional cottage interiors, where the flax pith was 'scutched' or separated from the skin and spun into thread, contrasted with three plates that introduced machines into the process, suggesting the start of a mill-based system which eventually eliminated the independence and self-esteem enjoyed by workers. But all was not quite as it seemed. The water-powered scutch mill depicted in the fifth plate was far from being the great improvement that Hincks's letters claimed; the machines were so dangerous to feed and yielded such poor results that it was safer and more economical to scutch by hand.[284] The seventh plate might have depicted winding, warping 'with a new Improved WARPING MILL' and weaving in a 'model' custom-built shed. Yet the weaver is not using the flying shuttle first applied in Ireland to linen manufacture in 1776. Plates IX and X showed respectively 'a complete Perspective View of all the Machinery of a Bleach Mill, upon the newest and most approved Constructions' and the same mill set in the picturesque landscape of County Down, with the linen pegged out on the grass to dry.

The remaining prints seem to suggest that the cloth progressed smoothly to inspection and sale: from the brown (unbleached) linen market at Banbridge in County Down (one of many such markets established by the Linen Board) to the Lapping Room in Dublin, where the cloth was measured, folded into lengths or laps and sealed under close supervision, prior to its going to the Linen Hall, the subject of the final plate. The process had not always been as modestly efficient and placidly above-board as it appeared in Hincks's plates. Apathy and corruption had been revealed in the Linen Board: the drapers and factors using the Linen Hall paid no fees, so the cost of running it was dead weight on the Board's resources. Misappropriation of funds was revealed in 1781 by a committee of the Irish House of Commons, which also exposed payments by weavers and drapers for brown and white seals.[285] The inspection of both brown and white linen had become a formality which served not as a guarantee of quality but a source of revenue for sealmasters. In the late 1770s new trustees were added to the Board, such as John Louth, who had a strong interest in the linen trade. The Regulating Act of 1782, drafted by the Chancellor of the Irish Exchequer, John Foster, brought the industry under firmer control. All seals were surrendered by 1 August 1782 and new ones issued only on certain conditions. Seals and sealmasters were thenceforward to be strictly regulated; all bleachers had to be registered with the Linen Office; new itinerant inspectors were appointed and heavy fines imposed by magistrates for transgressions. The Trustees' conduct was also regulated: they were to meet regularly and to take measures against fraud and waste.

Therefore, Hincks's Irish Linen Industry series can be seen as an act of faith in a newly purified industry, which indeed thrived under its new regulation. By 1795 the quantity of linen exported was three times what it had been in 1780, aided by the opening of the white linen hall in Belfast in 1785. It is not known how successful the Hincks series was as a promotional or marketing tool but the plates were republished in 1791 so they must have been quite popular among certain classes.[286] On 22 February 1786, Hincks presented the Society of Arts with a miniature portrait in watercolours of William Shipley, its founder, for which he was thanked personally from the chair and on 1 March his

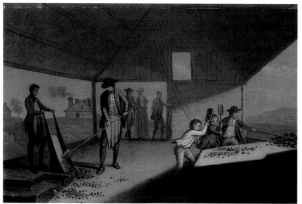

Pounding the Ore

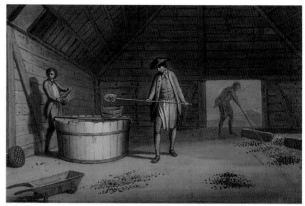

Washing the Ore

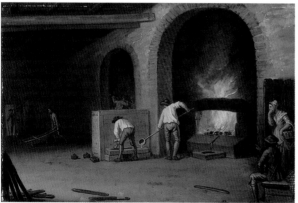

Smelting the Ore

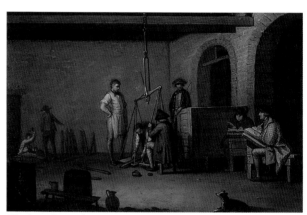

Weighing the Lead Bars

210 David Allan, *Lead Processing at Leadhills*, 1786. National Galleries of Scotland, Scottish National Gallery

offer to make an engraving from it was accepted; it was used as a frontispiece to the fourth volume of the Society's *Transactions*. Hincks continued to be a member until 1793 and then seems to have disappeared from public view.

In 1786, James, the third Earl of Hopetoun, undertook a tour of inspection of the mines at Leadhills, in the Lowther Hills north of Dumfries, on land owned by the Hope family since 1638. The visit probably instigated his commission of four cabinet pictures depicting different stages in the processing of lead from the Scottish artist David Allan (fig. 210). Despite being, at about five hundred metres above sea level, the second highest village in the British Isles, Leadhills was not cut off from the improving agenda of the age. The leaseholders were an English investment group, the Scotch Mines Company, essentially an offshoot of the Sun Fire Office in London, incorporated by royal charter in 1729. In 1734 the Company installed the scholar and mathematician James Sterling as the mine manager, a task at which he proved remarkably successful until his death in 1770, turning the mines into an orderly and profitable business. By comparison with conditions in the coal mines, workers were treated well as the management needed to attract and retain skilled English miners and smelters. They were allowed to build their own houses and keep smallholdings. They had a chaplain, schoolmaster and surgeon and access to charitable and pension funds in sickness and old age. In 1741 the first subscription library in Britain was opened at Leadhills (and is still in existence), supplied with books by Sterling and the second Earl of Hopetoun. Undoubtedly this was an attempt to keep the miners from drink and other forms of dissipation in an isolated and inhospitable part of the country but it seems to have worked. In 1784 the chaplain found the workers 'in general a decent,

424

intelligent, docile people'. According to the seminal account of lead mining in Scotland, Leadhills was the 'most perfect example of paternalism in the industry'. It was also the first and only example of a Scottish business directed from England before the nineteenth century.[287]

As with other Scottish landowners, the second and third Earls of Hopetoun were by no means passive partners in the business of exploiting the mineral wealth of their estates. In 1770 the second Earl sent ores for assaying to Joseph Black, the Professor of Chemistry at Edinburgh University, and two years later, his son sent samples of sand to Black for the same purpose.[288] The second Earl had been elected a Fellow of the Royal Society in 1728; the third was elected a Fellow of the Royal Society of Edinburgh (founded in 1783) in 1786. Among the latter's proposers was the pioneering geologist James Hutton. The mineral surveyor John Williams, the author of *The Natural History of the Mineral Kingdom* (Edinburgh, 1789; second edition, 1810), was the manager of Leadhills mines in his early career. When passing through Leadhills for the first time, he found 'The most beautiful masses of lead ore I ever beheld.' The principal veins were four to ten feet thick and one (retained by the Hopes as late as 1768), fourteen feet thick. Late in the eighteenth century, the Leadhills mines yielded a return, at £20 a ton, of £48,000 per annum.[289] It may be the case that the third Earl was proud of the enterprise – as a source of profit (from a quota of every sixth bar), a showcase of enlightened industrial paternalism and an appropriate subject for gentlemanly scientific enquiry – and thus deemed its processes worthy of recording in art.

Like Hincks, David Allan does not belong in the premier league of British artists. The son of an Alloa shore-master (who supervised the export of coal from the mines of his employer, the Mar Erskines), he began his training at the age of eleven at the Foulis Academy in Glasgow and went to Italy in 1764 under the patronage of Lord Cathcart. Besides aspiring to history painting and portraiture in the manner of Pompeo Batoni, he was also attracted by Italian genre painting, following in the footsteps of the Bamboccianti, a group of painters in seventeenth-century Rome who specialised in small works depicting contemporary life. Yet when he returned to Britain more than ten years later, he found that he was outclassed by established London artists who, under the leadership of Reynolds, were more or less monopolising the market in fashionable portraits which were shown to best advantage in the new public art exhibitions, above all, those of the Royal Academy. Instead, he relied on patronage principally from an aristocratic Scottish cousinage, producing conversation pieces in the manner of Zoffany and picturesque scenes of Roman carnivals and Neapolitan dances, the latter inspiring him to paint a companion work in 1780 of a Highland dance.

Allan's lead-mining paintings recall encyclopaedic illustration in their sequential depiction of an industrial process, and more specifically the Irish linen series, in showing close observation in a picturesque guise, with the outdoor settings romanticised and the workers rendered improbably graceful. The first in the series shows a shed where young boys are busy pounding or dressing the crude ore, which has been dragged from the mine on sleds. Allan cut away the walls of the shed to present the landscape beyond and the Earl and Countess standing on the threshold. The second depicts the sieving and washing of the broken ore. The third shows the smelters at work, with a woman onlooker shielding her mouth from the toxic fumes. The final work shows the weighing of the finished lead ingots under the beady eye of the company's head clerk and Lord Hopetoun's bailie. Allan's modest and humorous depiction of Scottish industry did not extend to technical description per se. If that were the case he would surely have included a representation of the mines themselves with their three steam engines, newly introduced to help with pumping operations.[290] Instead, estate portraiture, polite and picturesque tourism and patriotic improvement all to some degree must have played a role

in motivating the commission of the works. They served to promote industry in an acceptably genteel and sanitised manner, possibly on the walls of Moffat House, which was the administrative headquarters of the Hopetoun estates in south-west Scotland, built in the 1760s on the high street of the fashionable spa of Moffat.[291]

Industrial Accommodation

It has been seen how ordnance surveying led to the visual representation of related industrial processes. Then industrial espionage and industrial tourism generated more informal kinds of visual record. In the mass of illustrated works celebrating picturesque travel, some space was found for industrial scenes, appropriately packaged. The acceptable face of industry could also be used as a promotional tool. Did these forces encourage the accommodation of industry within landscape and genre paintings intended for public exhibition? It was not as if industry had been wholly absent from the landscape tradition. From the sixteenth century, Flemish and German landscape artists painted mountain scenes featuring mines and miners.[292] Mining activity was occasionally represented in English estate prospects, as in Matthias Read's depiction of Whitehaven (see fig. 181).[293] Nevertheless, these small signs of industry were not picked out for emphasis. In puncturing the land with holes and huts, mills and forges, human efforts were almost entirely eclipsed by the natural environment.

There were, however, Dutch genre paintings of workshops, showing artisans at close quarters, especially metal-workers – blacksmiths or alchemists. So Joseph Wright of Derby was not breaking new ground when he decided to compose pictures based on the forges and foundries of his native Derbyshire. These were cottage industries, worked on a scale which had barely changed since medieval times, not the ironworks that by the 1760s were growing into the large-scale developments at Coalbrookdale, Rotherham, Carron and South Wales and which evoked for visitors the image of hell. Around 1770 Wright made detailed pen-and-ink studies of a glasshouse and iron forge (figs 211 and 212).[294] His initial preoccupation appears to have been the opportunities such interiors afforded for the treatment of different types of light, an interest already demonstrated in the *Orrery*, *Air Pump* and the *Academy by Moonlight*. For his painting of a blacksmith's shop, as he jotted down in his account book, the light would radiate from the bar of iron, from candlelight used by the farrier to shoe the horse and from moonlight to 'illumine some part of the horse if necessary'. Yet he also detailed the specific figures he planned to include: the stranded traveller with his servant who urgently needed a horse shod, as well as two farriers making the shoe. Furthermore, in a curious echo of the *Monthly Review*'s description of the miller from Croker's *Dictionary*, with one hand in his bosom and the other arm akimbo, Wright also envisaged that 'an idle fellow may stand by the anvil, in a time-killing posture, his hands in his bosom, or yawning with his hands stretched upwards – a little twisting of the body'.[295]

In their careful representation of workshop tools and practices, Wright's forge paintings also demonstrate an enlightened appreciation of the mechanical arts and even an encyclopaedic cast of mind. As already noted, the philosopher lecturing on an orrery was used as a subject for encyclopaedic frontispieces. It seems hardly coincidental that volume 7 of the *Recueil* of the *Encyclopédie*, which contained dramatic double-page engravings of iron forges, both a farrier and heavy smithy ('Maréchal Ferrand' and 'Maréchal Grossier'), appeared in 1769 (fig. 213). I am not proposing that Wright crudely copied the *Encyclopédie* plates, but if they suggested the subject matter to him, he realised that it had to be elevated above the level of encyclopaedic illustration to make it acceptable to exhibition audiences.

The Society of Artists of Great Britain, of which Wright was a member, was organised on broadly democratic lines compared with the closed Crown-validated elite of the Royal Academy. Moreover, its exhibitions, as they developed in the 1770s, tolerated a far greater range of artistic activities, including works by engravers and copyists, portraits in human hair and so forth, excluded from the Academy shows. Lacking a spokesman with the lofty aspirations of Reynolds, the Society did not appear to be circumscribed by an aesthetic programme based on the traditional academic hierarchy. The most talked-about pictures in its exhibitions tended to be on a fairly small scale and were highly particularised renderings of modern subjects executed in the Dutch manner. With his known aversion to aristocratic 'whimminess' and metropolitan cliques, Wright no doubt felt more comfortable in the freer surroundings of the Society of Artists.[296] He could push the boundaries of subject matter beyond the confines of convention and,

from a practical viewpoint, as a bigger fish in a smaller pool, he could control how his paintings were hung and even mark in the catalogues those which were available for sale.[297]

Wright's first painting of *A Blacksmith's Shop*, dated 1771, demonstrates how the subject had developed from his initial ideas (fig. 214).[298] Three men work at the anvil while a fourth bends over the horse's hoof to inspect it by candlelight with the traveller and his servant. Instead of the 'idle fellow' he had first envisaged, Wright introduces two youths, one dressed as an apprentice looking on attentively, the other – echoing the reaction of one of the girls in the *Air Pump* – recoiling and muffling his face with his hands from the sensations of light, heat, noise and smell. An older man is seated in the shadows on the right, leaning on his hammer in a meditative posture. Wright universalised his subject into an allegory on industrial education. The child with all his terrors is trained into an obedient apprentice before flowering into heroic, physically mature labour. Yet the three central figures are not representations of brute force. Wright invests these men with expressions of concentrated intelligence and monumentalises a moment when honed skills and judgement are required to accomplish successfully as a team a complex and mutually dependent series of actions. This is labour raised to the level of calculation, eminently worthy of enlightened admiration on the part of the viewer. Even though physically redundant, the older man is not wholly removed by Wright from the scene. Instead, he ponders his wealth of experience and, presumably, is always ready to offer advice and guidance.

This elevated view of labour is reinforced by the setting, a ruined redundant church, a once grand stone building with Romanesque arches (that on the left embellished with an angel) and pilastered walls, prevented from collapse through the improvised installation of a brick buttress, horizontal wooden beam and rough roofing (there is a gaping hole in the rafters). Whether it was a real setting or not, it was surely intended to emphasise the spiritual dimension to labour, as productive of good works. After all, the first image a stranger would see in a church was usually a large painting opposite the main door of St Christopher carrying the Christ Child. The blacksmiths are performing a similar 'good Samaritan' role for the traveller in distress. Yet Wright does not abandon the everyday world. He records the wood piled up outside the window to feed the forge, the horseshoes nailed to the wall, the forge bellows, assorted tools scattered about and the men's coats heaped hastily together on a single hook. The chiaroscuro dims the presence of such details: they are not described didactically as illustrations of tools but modulated to contribute convincingly to the overall atmosphere of the workshop.

A second version of the scene, exhibited in 1772, was further distanced from gritty reality and altogether more painterly (fig. 215). The central crossbeam has been removed. Now the customer appears to be a woman mounted on her horse with two men standing by her in attendance. The two boys have been replaced by a girl and two toddlers, whose presence in such a potentially dangerous setting would scarcely have been allowed by any sane blacksmith. While the two girls shield themselves from the heat, sparks and noise, the little boy remains cheerful, as if about to disturb the old man's contemplation. Wright, for some reason – perhaps the wish of its buyer, the Edinburgh merchant and banker Robert Alexander – has softened the parameters of the work, by introducing notes of youth and sentiment, contrasting with the physical strength of the men. This work was more calculated to appeal to a genteel, even female, audience.

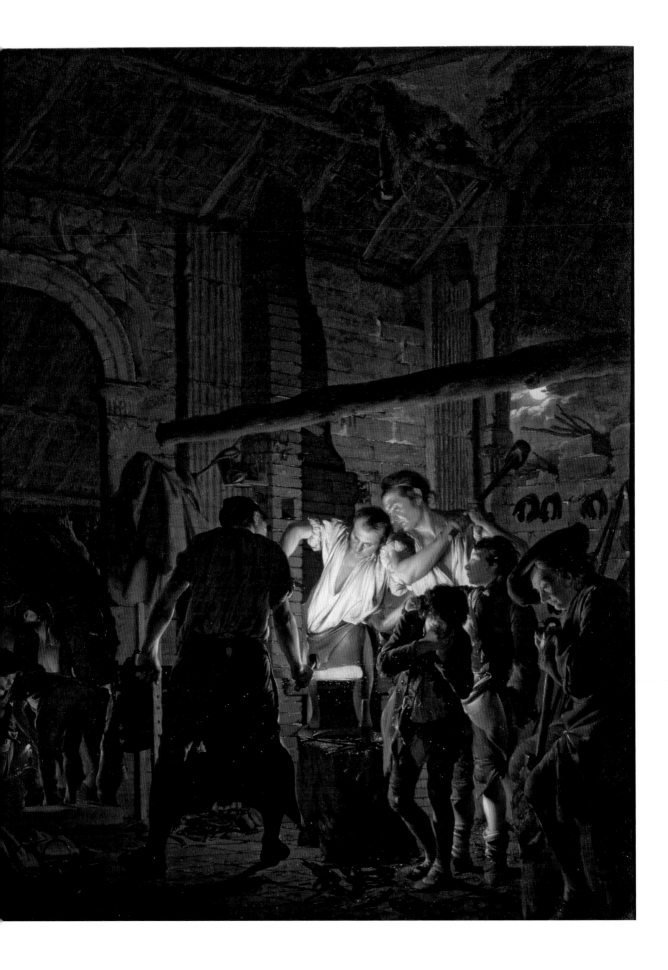

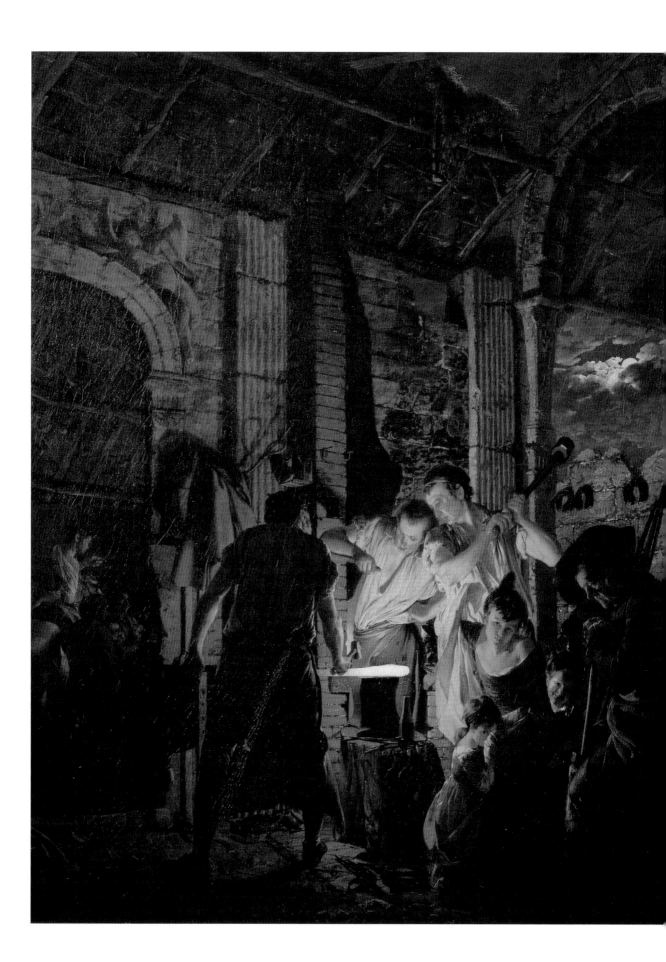

Wright's two paintings of *An Iron Forge*, dated 1772 and 1773, also demonstrate the artist's ability to combine keen mechanical observation – specifically the water-powered tilt hammer – with figures which again elevated the common nature of the subject matter (figs 216 and 217). These works did not represent the latest advances in iron manufacture, as developed by great ironmasters like Wilkinson. Wright was not painting a large-scale cannon foundry but a domestic forge run as a small-scale family business, barely bigger than a blacksmith's. Again, the figures are universalised to include not only the ironmaster and his assistants but also his wife, children, woolly dog and, presumably, aged father. The master is more concerned with the welfare of his wife and girls than the tricky operation his assistant is performing. Here the emphasis is not on the back-breaking toil of the assistant but on the power of the master, whose heroic status is further enhanced by the warm and protective sentiments he exhibits towards his family. Kitted out confidently in his ersatz turban and striped waistcoat, he is truly master of all he surveys, both paterfamilias and, on a modest scale, captain of industry. The womenfolk too betray a reasonable degree of affluence in their dress: the hair, clothes, stockings and pumps of the elder girl in particular represent a simple version of fashionable attire.

In 1772 the first *Iron Forge* was exhibited with the second *Blacksmith's Shop* at the Society of Artists' glamorous new home, the Lyceum on the Strand.[299] The reviewer of the *Morning Chronicle* could not have received the message more clearly: 'The face of the principal figure in the Iron Forge has the *Apollo* and *Hercules* as truly blended as we have seen, and the child in the woman's arms in the same piece, is a model of prattling innocence.'[300] Based on an on-the-spot drawing, the setting's specificity was softened by the glow from the iron bar, although evidently not sufficiently for the *Morning Chronicle* reviewer, who complained: 'we think the reflection too strong, and the sparks of the fire too regular'. Note how this comment echoes Horace Walpole's reaction to Zoffany's painting *John Cuff and his Assistant* (see fig. 138), exhibited at the Royal Academy the same year: 'extremely natural, but the characters too common nature, and the chiaroscuro destroyed, by his servility imitating the reflexions from the glasses'.[301] The *Morning Chronicle* reviewer was saying the same thing, that no matter how ennobled the core sentiment, broadly conceived effects of light and shade were infinitely preferable to Dutch-style fidelity to nature arising from too sharply defined detail.

Wright's final iron-working picture, *An Iron Forge viewed from without*, was sold in 1773 to Catherine the Great through the agency of the Russian consul Alexander Baxter and Peter Perez Burdett.[302] In breaking through the wall of a house in section to reveal the industrial process within, Wright was adopting a conceit used for nativity scenes and also, as shown in Chapter 5, commonly adopted in technical and encyclopaedic illustration. Yet here the sharp contrast between the golden glow of the interior and the cool white light of the moonlight is wholly theatrical, the inner working not enclosed by the stone barn of the iron forge drawing but a cottage *orné* of rustic simplicity, of the model being built on English landed estates. By these means Wright retained the picturesque qualities of the setting at precisely the time that Wedgwood was working on the Empress's Frog Service. The steep wooded banks and glittering waters of the Derwent were of a piece with the prospects of Derbyshire after Thomas Smith which adorned several dishes and plates.[303] In contrast to Bentley's lyrical description of the county (of which he was a native) produced for the Empress, Wright cut away the picturesque trappings to reveal the industrial heart of the land.

The forge is the same as that depicted in the earlier painting but the figures differ significantly. Here the dominant figure wearing a hat and leaning on a long stick, standing clear of the bending worker, may not even be an ironmaster.[304] He could be a

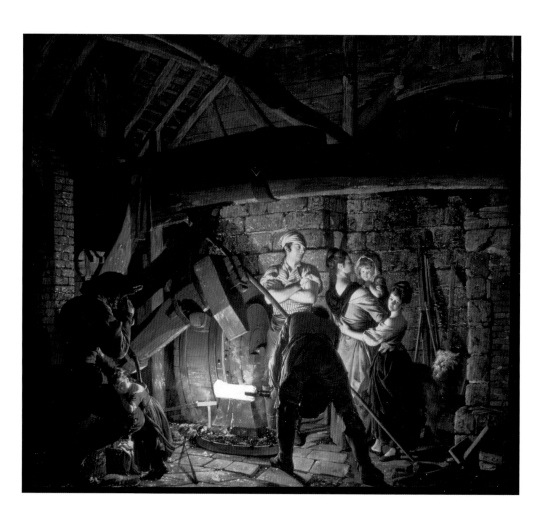

customer who commissioned the job being undertaken, although he does not seem to be following its progress. Instead he looks quizzically at the older man in the leather apron who is leaning against the wall watching the worker positioning the iron on the anvil under the hammer. This action is also being observed by a woman in picturesque déshabillé, holding a child in her arms. For all their physical proximity, Wright suggests a greater social distance between the elegantly shod man and the woman and the men, compared with the relationships portrayed in the earlier works. Perhaps it is an image of the contribution made to human progress by all parts of society – rich, poor, old, young, men, women – or maybe the work had a more personal meaning for Wright, as proposed by David Solkin. At least it can be said that in all his forge paintings Wright elevated skilled labour to the level described, rationalised and promoted by its most articulate practitioners. He demonstrated that even comparatively lowly, traditional rungs of the mechanical arts could be represented within the world of the polite arts. Could the same be said for the large-scale industries being developed throughout the country?

Richard Arkwright built his first cotton-spinning mill at Cromford, south of Matlock in Derbyshire in 1771. The mill was operational by 1774 and a second mill was built in 1776–7. Between 1777 and 1783, further mills were built by Arkwright at Birkacre, Bakewell, Wirksworth, Rocester and Cressbrook, as well as at Belper with his first partner Jedediah Strutt. In 1783, he began the construction of Masson Mill at Matlock Bath. The mills along the river Derwent were sited in one of the most beautiful valleys in the Derbyshire Peak District, close to Matlock Tor, popular with those in search of the sublime. As noted in Chapter 6, in 1778, Wright's clock-maker friend John Whitehurst published his *Inquiry into the Origin and Formation of the Earth* on the basis of reports on continental earthquakes and volcanoes and his own observations made in the outcrops, mines and boreholes of Derbyshire. His pioneering 'Section of the Strata at Matlock High Tor', illustrated in the appendix, exposed a fissure which, he believed, reached down to the subterranean fire that was the main cause of land formation. The Peak District thus afforded the opportunity not only to admire the surface beauty of nature but also to ponder its inner workings and indeed the meaning of life.

These concerns were not confined to men of science but were promoted as popular attractions. In 1778–9, the Drury Lane Theatre staged the first run of a spectacular scenic pantomime, 'The Wonders of Derbyshire', designed by Philip de Loutherbourg in a joint venture with Richard Brinsley Sheridan. As the first stage production specifically to feature the vogue for landscape tourism,[305] the rudimentary plot served merely as an excuse for elaborate scene changes. Based on drawings the artist had made on a tour the previous summer and on local fables of the origins of landscape told during scenic tours, de Loutherbourg produced twenty-one sets to illustrate a magical story.[306] Accompanied by dramatic lighting and sound, the audience was guided through the major sites, including Matlock bathed in a Claudian sunset and later moonlight, Dovedale also by moonlight, Chatsworth House and gardens, the lead mines of Castleton and nearby the famous cavern of Peak's Hole (commonly known as the Devil's Arse).[307]

The artist was evidently criticised for introducing the lead mines as 'wonders' but the anonymous author ('A Derbyshire Man') of a small pamphlet giving an account of the scenes in the show, published a few weeks after the first performance, wrote a spirited defence in suitably genteel terms: 'This county abounds in lead; the mines here portrayed, lie betwixt Buxton and Castleton. They are famous, not only for their romantic situation, and the riches they produce, but likewise for those petrefactions, and mineral substances from which are made the beautiful vases, urns, &c. &c. we so often see and admire.'[308] A supernatural creature called Salmandore or 'Genius of the Peak' rose from his 'haunts profound' to bestow supernatural gifts on miners for divining valuable minerals. In a spectacular final transformation scene, a brilliant palace and gardens were

216 (top) Joseph Wright, *An Iron Forge*, 1772. Tate Gallery, London

217 (bottom) Joseph Wright, *An Iron Forge Viewed from Without*, 1773. State Hermitage Museum, St. Petersburg

conjured up out of another horrid cave, that of Poole's Hole. The main drop before the curtain went up, showing a panorama of the Peak District's mountains and waterfalls, was used by the theatre for many subsequent seasons.

Wright himself capitalised on the picturesque tourism of Derbyshire. Having demonstrated his own interest in geological phenomena in his paintings of volcanoes and caves in Italy in the mid-1770s, he returned to Britain to paint Matlock Tor in both daylight and moonlight.[309] During the 1780s Wright frequently painted the verdant beauties of the Derwent valley, combining the rocky outcrops along the banks with rich vegetation and, on one occasion, the distant but distinctive profile of the pumping engine-house and stack of a lead mine.[310] At some point in the 1780s he also painted Arkwright's first mills glowing at night on the bed of the dark valley beneath a spookily dramatic moonlit sky (fig. 218).[311] As already noted, for most visitors, his mills remained a mysterious closed book to which entry was forbidden. Yet the sight of these huge buildings suddenly springing up throughout the land initially provoked astonishment and even wonder. As also noted, the mills of Arkwright's erstwhile partner and rival John Smalley were celebrated in Boydell's *Four Views on Holywell Stream* (1792) and Pennant's *History of the Parishes of Whiteford and Holywell* (1796; see fig. 190). William Day completed a watercolour around 1789 which emphasised the rustic setting of the Cromford mills and they featured on a dish of Derby porcelain decorated by Zachariah Boreman, who made a series of watercolours of the Derwent valley and its mills, while employed by the manufactory.[312] Essentially, though, these were all works of topography.

It seems that Wright's main concern was not topographical for it is difficult to reconcile the three buildings discernible in Wright's image with the layout of the Cromford site: the warehouses between the lower and upper mills were set at right-angles, not parallel to them, as indicated. Instead, predictably, Wright concentrated on different lighting effects, the dramatic creamy white moonlit clouds contrasting with the blackened green rocks, road and vegetation in the foreground. The rosy glow of the mills seems almost welcoming, a beacon of warmth and order. It has even been suggested that the

lights from the windows which so captured visitors' imagination – until night work (between the hours of 9 pm and 6 am) was made illegal in 1803 – may have alluded to their illumination on festive patriotic occasions by their loyalist owner.[313] Nevertheless, the work does not appear to have been commissioned by Arkwright nor was it exhibited in London. Instead it attracted local buyers. One version was bought by Daniel Parker Coke, the M.P. for Derby and a staunch defender of the factory system. The other, according to tradition, was given by the artist to a friend and neighbour, Thomas Haden, an eminent Derby physician. Wright was surely celebrating in general terms the presence of the mills in the valley, just like Erasmus Darwin in 'The Love of Plants', part of his epic poem *The Botanic Garden* (1789). Among the manifold illustrations of human progress, Darwin singled out the 'curious and magnificent machinery' in Arkwright's mills, 'where Derwent rolls his dusky floods/Through vaulted mountains, and a night of woods.'

Whatever the feelings of local men, some visitors to the site had a more ambivalent reaction. In 1789 the Honourable John Byng visited Cromford, by then a village crowded with cottages, supported by the 'three magnificent cotton mills': 'There is so much water, so much rock, so much population, and so much wood, that it looks like a Chinese town'. But he sneered at Arkright's Willersley Castle, then under construction, as 'a grand house in the same castellated style one sees at Clapham . . . It is the house of an overseer's surveying the works, not of a gentleman wishing for retirement and quiet.' On a return visit the following year, he remarked:

> speaking as a tourist, these vales have lost all their beauties; the rural cot has given place to the lofty red mill, and the grand houses of overseers; the stream perverted from its course by sluices, and aqueducts, will no longer ripple and cascade. Every rural sound is sunk in the clamours of cotton works; and the simple peasant (for to be simple we must be sequestered) is changed into the impudent mechanic: the woods find their way into the canals; and the rocks are disfigured for limestone.

Nevertheless, he was not entirely unimpressed: 'These cotton mills, seven storeys high, and filled with inhabitants, remind me of a first rate man of war; and when they are lighted up, on a dark night, look most luminously beautiful.'[314] On his 1801 visit the Reverend Warner was more sanguine. He considered the great cotton mill 'adding to the inartificial beauties of nature an interesting picture of animated industry . . . whose operations are so elegantly described by Dr Darwin, in a work which discovers the art, hitherto unknown, of clothing in poetical language, and decorating with beautiful imagery, the unpoetical operations of mechanical processes, and the dry detail of manufactures'.[315] It seemed as if mechanical forms of industry and polite forms of art could still, just about, coexist.

No artist was better equipped to exploit the vogue for industrial tourism than Philippe Jacques de Loutherbourg, drawing on his early studies in theology, mathematics and engineering in Strasbourg, his reputation as a landscape and marine painter in Paris and his employment as a theatrical scenographer in London. On the basis of tours of Derbyshire, the Lake District and Wales, in the 1780s the artist exhibited landscapes and seascapes at the Royal Academy which were fluently executed in a self-consciously picturesque style, and the effects of the weather captured with extraordinary facility, if little feeling. Such works were frequently criticised for their French artifice, gaudy colours, over-precise finish and varnish 'as high as a Birmingham tea-board.'[316] In other words, they were showy to the point of being gimcrack. Nevertheless, in several paintings the figures were more than a token presence and suggested a passing engagement with local industries. His *Labourers near a Lead Mine*, exhibited at the Academy in 1783 and based on his Derbyshire travels, shows a miner's family in a mountainous landscape extracting the lead, washing the rocks and loading the cart, albeit in a leisurely manner. Pos-

sibly it was a variation on the scene of lead mining he had painted for 'The Wonders of Derbyshire' pantomime.[317] De Loutherbourg's *A Slate Quarry near Rydell Water, Cumberland*, exhibited at the Academy in 1785, again focused on labourers, here depicted breaking the quarried rock into blocks, then slabs which were split into slates with a hammer. Others encourage the straining horses into carting their heavy load of slate out of the quarry.[318]

As Peter Coxe, the cataloguer of his posthumous sale remarked, de Loutherbourg combined 'deep and powerful insight into the detail of things . . . with the clearest views for his general purpose'.[319] Surviving letters written by the artist to David Garrick at the Drury Lane Theatre in the early 1770s confirm his command of all the stages involved in creating theatrical effects, from making models for sets to devising stage machinery.[320] This technical facility is evident in the sketches he made of copper- and ironworks in South Wales and steam engines and iron foundries in and around Coalbrookdale, revealing a sure sense of how engine-houses worked, with the piping to the boiler-houses, and the different types of stack or chimney. These fire-engines and their housing have been noted in numerous technical drawings but here their presence is observed within a real landscape setting (fig. 219). Although more sophisticated than the rough sketches retained in William Reynolds's scrapbook of winding and pumping-engine plant, they retain the same convincingly jumbled *ad hoc* character, far removed from the tidy norms of technical draughtsmanship.[321] The drawings provided the scaffolding, as it were, for more generalised theatrical effects.

Coalbrookdale was much greater than an aggregate of technical parts. As already observed, it constituted England's equivalent of Etna or Vesuvius, the smoking forges and flaming furnaces on a dark night resembling volcanoes. In contrast to the placid hand of rationality imposed by the iron bridge, and the picturesque woods and mountains, the furnaces provided the effect of a descent into Hell, into Pandemonium, a subject with which de Loutherbourg had more than a passing interest. In 1781 the artist had opened his own miniature theatre, the Eidophusikon, where he could reproduce impressions of sun and moonlight, fire and volcanic eruptions through the ingenious use of mechanical, lighting and sound effects, magic-lantern slides and painted transparencies.[322] The finale to the 1782 season was the scene from *Paradise Lost*, captured in

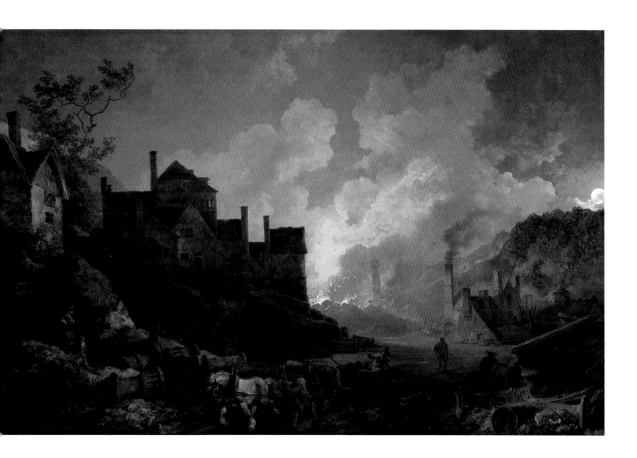

a watercolour by Edward Francis Burney, of 'Satan arraying his Troops on the Banks of
a Fiery Lake, with the Raising of the Palace of Pandemonium'. According to the engraver
W. H. Pyne, 'a chaotic mass rose in dark majesty, which gradually assumed forms until
it stood, the interior of a vast temple of gorgeous architecture, bright as molten brass,
seemingly composed of unconsuming and unquenchable fire'. The scene was accompa-
nied by 'preternatural' sounds; a great roll of thunder, and a series of terrible groans
which 'struck the imagination as issuing from infernal spirits'.[323] In 1784, de Louther-
bourg became one of the founding members, with Blake and Flaxman, of 'The Theo-
logical Society for the purposes of promoting the heavenly Doctrines of the New
Jerusalem by translating, printing and publishing the writings of Emanuel Swedenborg'.
His flirtation with alchemy, chemistry, pharmacy, faith-healing and freemasonry was
encouraged by a short-lived friendship in 1786–7 with the notorious Count Cagliostro.[324]
De Loutherbourg's *Coalbrookdale by Night*, exhibited at the Royal Academy in 1801, rep-
resented the culmination of these interests, creating a magnificently sublime drama of
the furnaces at Bedlam, designed to evoke the feelings of awe and horror that visitors
experienced on site (fig. 220).

 It is difficult to reconcile the vision of hell presented by the artist with the tame brick-
work remnants of Bedlam which stand beside the road today. The furnaces were built
in the 1750s near a sixteenth-century house called Bedlam, at the base of an outcrop of
coal and ironstone. They were incorporated in the Coalbrookdale Company in 1776 and
when the Company split in 1796 they were given to William Reynolds. Bedlam became
a key site in his operations: he added a new furnace and superintended the works, which
produced the best cast iron in the country. In his painting, de Loutherbourg orches-
trates the site like one of his stage designs. Yet contemporary maps show that the work
had a topographical basis. The group of buildings on the right are the furnaces proper

with the smiths' shop and joiners' shop nearest the viewer. Immediately behind them stand the engine-house with two chimneys and the furnace and casting-house to the right. Red smoke and yellow flames billow forth from the extensive coke hearths situated above the furnaces. Iron castings lie around the scene in profusion and in the foreground a pair of horses are pulling a cart loaded with pig iron. The 'wing' rising up on the left-hand side, silhouetted against the flames, represents the workers' cottages, seemingly about to be consumed by fire.

By 1800, the production of iron was crucial not only for the manufacture of steam engines and railways of industry but also for armaments in the war against Napoleon, as Reynolds was well placed to exploit. Undoubtedly, *Coalbrookdale by Night* was intended to be a highly patriotic national image, a worthy sequel to de Loutherbourg's painting *The Battle of the Nile*, exhibited at the Royal Academy in 1800 and anticipating other patriotic works of contemporary history which he exhibited in subsequent years.[325] But the artist's orchestration of the scene can also be seen in the context of turn-of-the-century millenarianism. As Stephen Daniels has pointed out, Coalbrookdale's hellish reputation was further advanced by the vicar of the parish in which the Bedlam works were situated, the Swiss-born theologian of Methodism, John Fletcher. In his sermons he specifically referred to his environs, where the 'Sons of Vulcan' laboured in a 'confused noise of water falling, steam hissing, fire-engines working, wheels turning, files creaking, hammers beating, ore bursting and bellows roaring . . . while a continual irruption of flames ascending from the mouths of their artificial volcanoes, dazzle their eyes with a horrible glare . . . Our earth's the bedlam of the universe, where reason (undiseas'd in Heaven) runs mad.'[326] Themes from the Book of Revelation, which had inspired artists since the 1770s, rose to a crescendo in the long-gestated but ultimately abortive scheme proposed by the President of the Academy, Benjamin West, for the Chapel Royal at Windsor Castle, dedicated to Revealed Religion.[327] In 1798, de Loutherbourg produced a painting of *The Opening of the Second Seal (or The Vision on the White Horse)* to serve as the basis of an illustration for Thomas Macklin's edition of the Bible. Although evidently based on a study by West, it demonstrates that de Loutherbourg had not lost his taste for spooky effects. The two horses with their riders representing the Conquerer and War emerge frighteningly from an immense and undefined hole in the clouds stained red with blood and fire.[328]

Not surprisingly, given contemporary events across the Channel, George III was not alone in scenting the whiff of revolution in millenarianism and his firm rejection of any '*Bedlamite scene from the Revelations*' effectively vetoed West's grand scheme for the Chapel Royal. As the century drew to a close a mass of anti-Jacobin imagery represented the threat of insurrection, massacres and regicide as part of an apocalyptic nightmare.[329] Thus, for all its appeal to contemporary materialist preoccupations – polite tourism, theatrical spectacle, industrial progress – de Loutherbourg's painting can also be seen as coming with a prophecy, a profoundly pessimistic message about the immanent dangers of industrialisation, the waging of a war of conquest that constituted an industrial revolution. The Reverend Warner read the message only too clearly when he wrote in 1801 of his visit to Coalbrookdale:

> a scene in which the beauties of nature and processes of art are blended together in curious combination. The valley which is here hemmed in by high rocky banks, finely wooded, would be exceedingly picturesque, were it not for the huge foundries, which, volcano-like send up volumes of smoke into the air, discolouring nature, and robbing the trees of their beauty; and the vast heaps of red-hot iron ore and coke, that give the bottom 'ever burning with solid fire', more the appearance of Milton's hell than of his paradise.[330]

Neither Wright's painting of Arkwright's mills nor de Loutherbourg's vision of Coalbrookdale at night were on a sufficiently grandiose scale to set precedents; as noted earlier, Wright's work was not even exhibited in the eighteenth century. Despite the interest of tourists in industrial progress, the smoke and dirt attendant on large-scale mills and foundries was beginning to pollute towns and could not be readily accommodated in picturesque norms. Stephen Daniels has shown how the landscape gardener Humphry Repton attempted to tidy up the environs of cities to which successful merchants and manufacturers were retreating from their businesses. Repton himself was a failed textile merchant and entrepreneur who appreciated that the landscape gardener 'must possess a competent knowledge of *surveying, mechanics, hydraulics, agriculture, botany*, and the general principles of *architecture*'.[331] But his background and opinions do not seem to have reconciled him to intrusive signs of industry.

Working in 1795 at Blaise Castle, built in the 1760s on the outskirts of Bristol by a sugar merchant, Thomas Farr, Repton was appalled to find that a steam engine intended to raise water had been installed in a mock-gothic castle on the summit of Blaise Hill, 'exposing the Genius of the place to all the horrors of fire and steam, and the clangour of iron chains and forcing pumps'.[332] At Leeds, the model water-powered, gas-lit woollen mill built by the great army contractor Benjamin Gott at Armley was suitably landscaped to frame the view from the owner's villa with trees and water meadows, so that it looked from the outside like a well proportioned country house (fig. 221).[333] Where industrial sites could not be disguised, as at Wingerworth in Derbyshire, Repton proposed the introduction of a lake to provide a distraction from the 'smoke and flame of [the] foundry', although he also suggested to the owner that it could serve a practice use, to supply water for canals 'and other circumstances of advantage, in this populous and commercial part of the kingdom'. The view he created showed the squire and his wife on the terrace admiring an overwhelmingly rural prospect only marginally disturbed by the smoke billowing from the ironworks in the distance.[334]

In 1791 the first number appeared of *The Copper-Plate Magazine or Monthly Cabinet of Picturesque Prints, consisting of Sublime and Interesting Views in Great Britain and Ireland, beautifully engraved by the Most Eminent Artists from the Paintings and Drawings of the First Masters*. The younger generation of artists was represented, including J. M. W. Turner and Thomas Girtin, as well as established figures such as Paul Sandby and Edward Dayes. The main engraver, John Walker, was also a contributing draughtsman and served from the second volume as the magazine's publisher. By 1798, 250 plates had been produced and they could be bought bound in five volumes, reissued between 1795 and 1802.[335] Country houses featured strongly, showing improvements to the surrounding parkland, and towns were also represented but here the changes wrought by industry were scarcely evident.

One exception was Turner's view of Nottingham, published in 1793, which showed the Castle on the rock looming over the town, taken from the vantage point of the new Nottingham Canal, on which construction had only begun the previous year. Instead of genteel visitors, Turner depicted working figures – one group occupied with the balance beam of a lock gate, others with the rigging of a barge, while carts suggested the increased business brought by the canal, a point emphasised in the accompanying text (fig. 222).[336] Yet in general the text stressed the antiquity of the towns represented and their natural advantages. When it drew attention to manufactures and, on occasion, the clouds of smoke they produced, these features were not represented in the prospects. Although by this date Manchester had become the largest and most opulent town in Lancashire, with many 'spacious and airy' streets, mills and warehouses, the plate published after William Orme emphasised the town's antiquity by showing Cheetham's College, the collegiate church and the grammar school.[337] Turner's view of Sheffield was a distant prospect from which one would never guess 'The houses . . . have in general a dingy appearance from the continual smoke of the forges.'[338] Even when it came to renowned industrial sites, the magazine, as it were, averted its eyes. At Cromford, it featured the 'elegant structure' of Arkwright's residence, Willersley Castle, open for inspection on Mondays and Thursdays, not the mills.[339] At Soho, naturally, the text drew attention to Boulton's 'extensive and handsome edifice for manufacturing buttons' and remarked on his resolve to make his works 'a seminary of taste'.[340] The only other

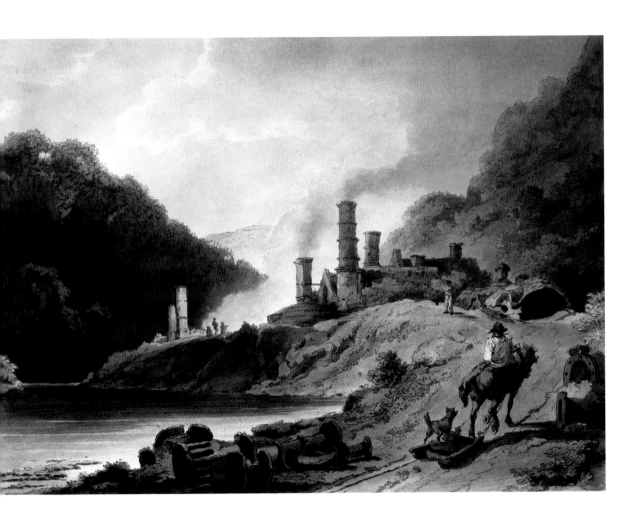

industrial works featured was the peculiar choice of Ayton Forge on the river Derwent, five miles from Scarborough, an exterior view showing the chimney and waterwheel. Nevertheless, the text stressed 'Every prospect near it is grotesquely rural.'[341] For the last plate of all, Sunderland Bridge, opened in 1796, was hailed as a 'sublime work, the wonder of the present age . . . projected from massive abutments of rusticated masonry (supported and backed by native rocks), at a height of sixty feet above low water mark'.[342]

Gilpin's publications encouraged a rash of illustrated publications devoted to the scenery of Great Britain, utilising the graphic media of aquatint, lithography, wood and steel engraving. They were overwhelmingly devoted to castles, churches, antiquities and natural beauties. The principal bibliographical catalogue of such works executed in aquatint and lithography between 1770 and 1860, compiled on the basis of the library of J. R. Abbey, lists for Birmingham nothing between a 1791 view of 'Houses after the Birmingham Riots' and C. Radclyffe's 'Views in and near Birmingham' of about 1840.[343] Elsewhere, the industrial wonders of the age were barely represented. A comparatively tame view of an 'Iron Work Colebrook Dale' by de Loutherbourg, depicting Bedlam Furnaces viewed from downstream, was worked up and aquatinted by William Pickett for inclusion in the artist's *Romantic and Picturesque Scenery of England and Wales* (1805) – the first time the word 'romantic' appears together with 'picturesque' in the title of a book (fig. 223).[344] Yet the inclusion of industrial scenes in fashionable compilations of this type was the exception rather than the rule.

By 1813, Thomas Hornor could observe that 'The arts of surveying and landscape painting, which seem to have been united in former days, are now distinct.'[345] While

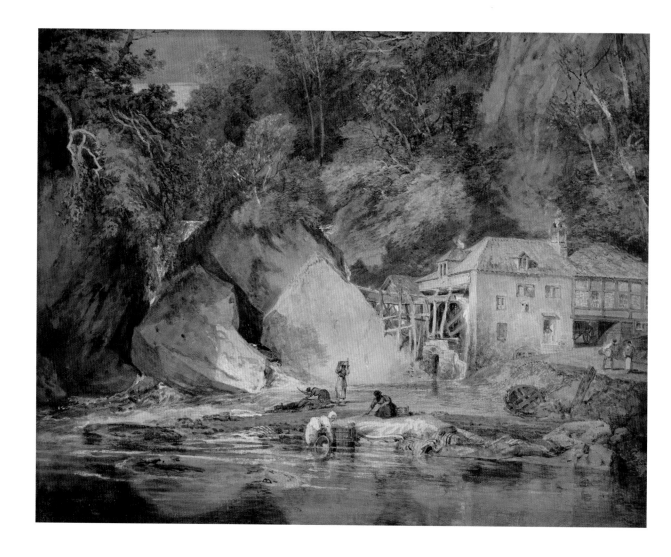

224 J. M. W. Turner,
Aberdulais Mill, Glamorgan,
1796–7. National Library of
Wales, Aberystwyth

he maintained a rigorously empirical approach to landscape in panoramic form, a new style of watercolour was emerging which arose from artists' interest in reproducing atmospheric effects, in expressing their own emotions and individual moods and thereby raising the status of the medium to that of painting in oils. Schooled in the topographical tradition, throughout his life Turner could make pencil drawings as immaculately precise as any by Sandby or Thomas Malton, from whom he had received lessons in architectural perspective. His sketchbooks confirm that he was fascinated by mechanical detail, in how things worked and the tools of the trade. He undertook several sketching tours of Wales in the 1790s, reading Pennant's *Tour* by way of preparation as a guide to the sights. Some of his on-the-spot studies provided the basis for finished works commissioned from patrons, such as the detailed drawings of Cyfarthfa Iron Works made in 1798 for Anthony Bacon, the illegitimate son of the founder of the works.[346] In commissioned watercolours Turner was able to demonstrate his increasing mastery of composition and generalised atmospheric effects.

One need only compare his watercolour of Aberdulais Mill, executed on the basis of a pencil drawing in his South Wales sketchbook of 1795, with that of Wood in *The Principal Rivers of Wales* (fig. 224 and see fig. 196).[347] Turner's watercolour is not merely a work of precise topography, still less of picturesque effects for their own sake, but a harmonious rendering of the scene as a whole. Even the mill is an organic part of the landscape, growing as if by accretion beneath the rocks and trees, absorbed into its

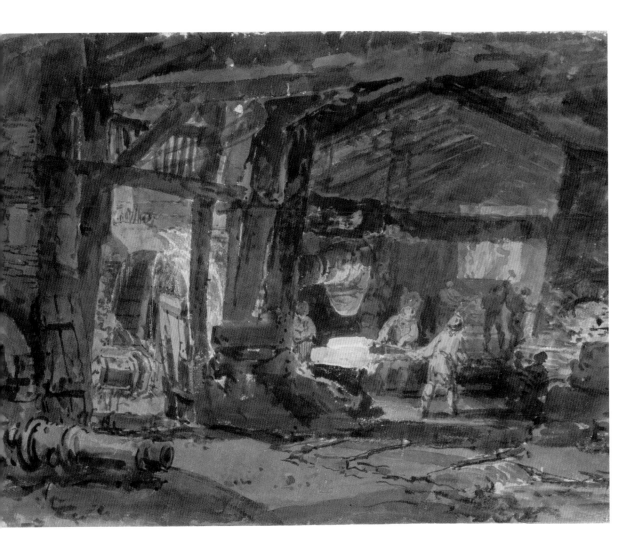

225 J. M. W. Turner,
Ironworks, Merthyr, 1798. Tate
Gallery, London

setting. Although half hidden by the rocks, the falls themselves and the pool below where women are busy, evidently beating and rubbing blankets, are rendered to brilliantly naturalistic effect. Wood described the mill from Turner's vantage-point and his own view of the scene, reproduced as a soft-grown etching, was taken from the riverbank at approximately the spot where the washerwoman in a blue skirt is placed in Turner's watercolour. As a result, the full extent of the mill is blocked and the falls are invisible, but the stilts of the waterwheel trough are more legible. Nevertheless, Wood's view confirms the remarkable accuracy of Turner's and his capacity to compose for optimum visual impact.

Again, compare Ibbetson's view of the inside of Cyfarthfa Iron Works of about 1795 with Turner's small watercolour of the interior of a cannon foundry, dating from 1798 and probably also at Merthyr (fig. 225 and see fig. 189). Even with its atmospheric lighting and characteristically lively figures, Ibbeton's work retains a linear clarity that is obscured in Turner's image with its febrile brushwork. Yet despite his summary observation of momentary effects, Turner still conveys an astonishing amount of visual information – the *ad hoc* nature of the building, the waterwheel visible outside and the vast bulk of the tilt hammer about to crash down on the glowing white-hot metal drawn fresh from the furnace.[348] Similarly, Wood's precise prospects of the copper works at Swansea contrast with the views that John Sell Cotman painted on his Welsh tour in 1800, the factory chimneys hazy in broad monochrome washes of smoke.[349] Based in

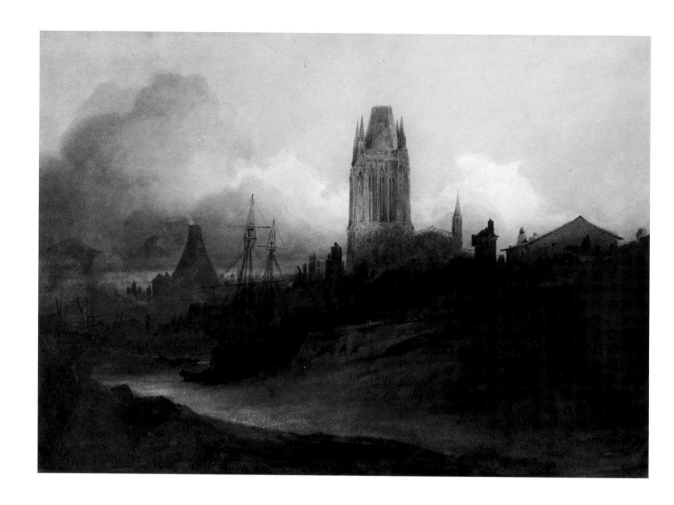

226 John Sell Cotman, *St Mary Redcliffe, Bristol*, c.1801. British Museum, Department of Prints and Drawings

Bristol, he painted the truncated spire of St Mary Redcliffe there emerging from the smoke of adjacent glassworks (fig. 226). At Parys, François-Louis Francia produced a watercolour study of the cavernous depths of the mine, the massive bulk of the rock, the inner life of nature, emphasised by the tiny figures working it, the rickety stage from which the buckets were lowered and the windswept tree clinging to the precipice edge. The composition of Francia's finished watercolour echoed that of the title page to Piranesi's *Carceri d'Invenzione* (1749–50), reinforcing the sense of horror aroused by sublime effects (fig. 227). By the turn of the century, the art of description and rationalisation was being replaced by an art of evocation and imagination in which human industry and mechanical ingenuity were dwarfed by the elemental forces of nature.

227 (facing page) François Louis Francia, *Parys Copper Mine, Anglesey*, c.1800. The Morgan Library & Museum, New York

444

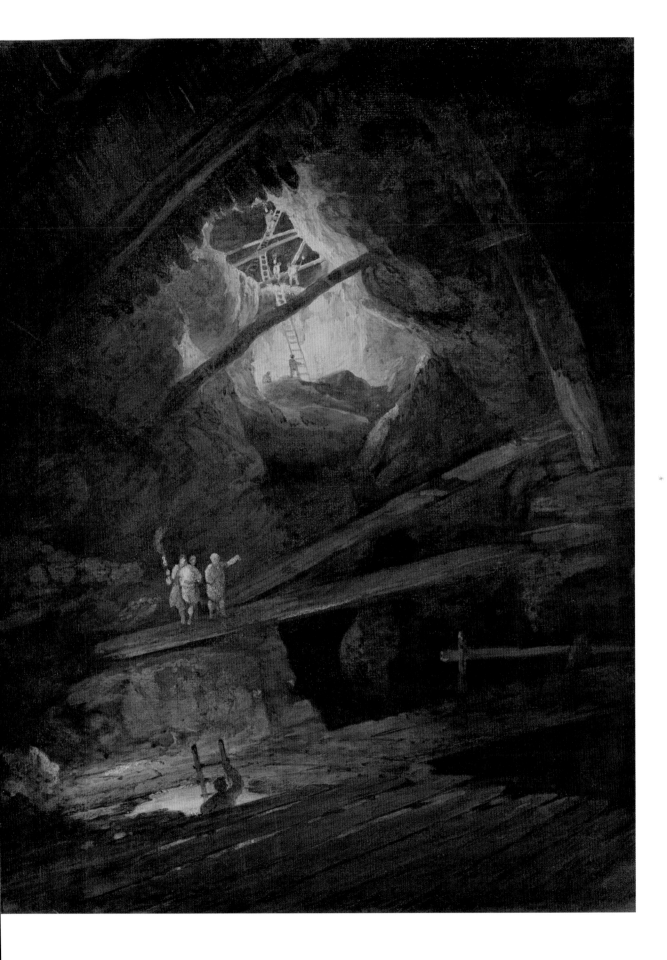

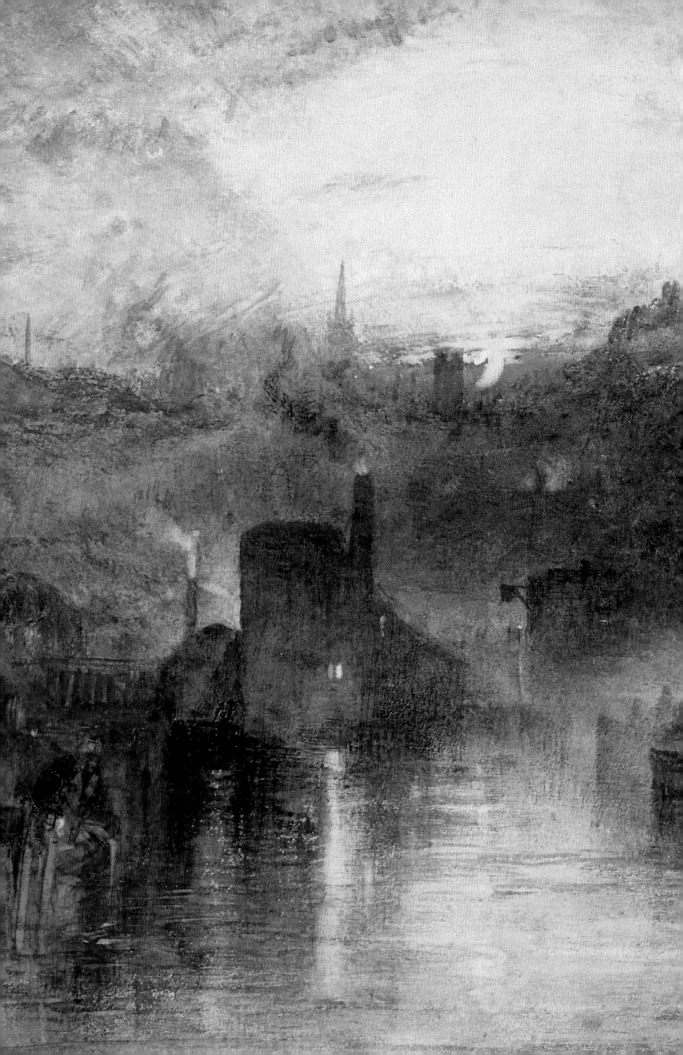

VIII

The Arts Divided?

You can teach a man to draw a straight line, and to cut one . . . and to copy
and carve any number of given lines or forms, with admirable speed and
perfect precision . . . but if you ask him to think about any of those forms . . .
he stops; his execution becomes hesitating . . . he makes a mistake in the first
touch he gives his work as a thinking being. But you have made a man of him
for all that. He was only a machine before, an animated tool.

> John Ruskin, 'The Nature of Gothic', in *The Stones of Venice* (1851–3)

Since my return to England I have been told that those who are conversant
about machines use many terms concerning them which show that their vitality
is here recognised, and that a collection of expressions in use among those who
attend on steam engines would be no less startling than instructive. I am also
informed, that almost all machines have their own tricks and idiosyncrasies;
that they know their drivers and keepers; and that they will play pranks upon a
stranger. It is my intention, on a future occasion, to bring together examples
both of the expressions in common use among mechanicians, and of any
extraordinary exhibitions of mechanical sagacity and eccentricity that I can
meet with.

> Samuel Butler, *Erewhon* (1872)

The church is now a Museum of Trades. The arts and trades are to be
worshipped here; utilitarian minds will be satisfied at last.

> August Strindberg, *Sleepwalker Nights in Broad Daylight* (1883), on the Museum
> of the Conservatoire National des Arts et Métiers in St Martin des Champs, Paris

In his memoirs, *Passages from the Life of a Philosopher* (1864), the mathematician, inventor and indefatigable promoter of science, Charles Babbage, recalled being taken as a boy by his mother to several exhibitions of machinery. He was so interested in the devices at Merlin's Museum in Hanover Square in London that their maker took him to his

workshop in the attic to show him two 'uncovered' female figures in silver, about twelve inches high. One walked, bowed and used an eye-glass with a 'singularly graceful' movement and the other was a dancer with a bird on her forefinger which wagged its tail, flapped its wings and opened its beak: 'This lady attitudinized in a most fascinating manner. Her eyes were full of imagination, and irresistible.' The works were the *chefs-d'oeuvre* of the artist: they had cost him years of labour and were even then not finished. Yet Babbage never forgot seeing them and at the 1834 sale of Merlin's successor, Thomas Weeks, who had a mechanical exhibition in Cockspur Street, he bought the silver dancer for £35:

> I proceeded to take to pieces the whole of the mechanism, and found a multitude of small holes which had been stopped up as not having fulfilled their intended object. In fact, it appeared tolerably certain that scarcely any drawings could have been prepared for the automaton, but that the beautiful result arose from a system of continual trials.

Babbage repaired and restored all the mechanism of the 'Silver Lady', placed her under a glass case on a pedestal in his Marylebone drawing-room, where she was viewed by those attending his Saturday evening soirées, forming a striking contrast with the unfinished portion of the Difference Engine, No. 1, which was in the adjacent room. Every part of the latter mechanism had been drawn up on paper before being manufactured and put together.[1] It was, therefore, according to its creator's tenets, based on mathematical theory, rather than the hands-on trial and error mode of mechanical invention practised by Merlin. Babbage implied that his methods were those of the future, those of Merlin – no matter how impressive – of the past. Unfortunately, few of his circle could keep up. Decked out in brilliant attire by Babbage's lady friends, the silver dancer attracted a 'gay but by no means unintellectual crowd' while his Difference Engine stood nearly deserted: 'two foreigners alone worshipped at that altar'.[2]

The Silver Lady symbolises the ambivalent status of the arts of industry in the early decades of the nineteenth century. There was no single moment when machines ceased to be viewed benevolently as examples of human ingenuity, evolved not only to assist in work but to provide wonder and delight, diversion and entertainment. There was no sudden announcement heralding the view that machines should be regarded henceforth as impersonal calculating engines, replacing artisans' mastery of material knowledge with automatic actions serviced by semi-skilled and unskilled labour. These changes in attitude came about gradually during the first half of the nineteenth century; and even as the triumph of the machine seemed absolute, its victory was being undermined.

During this period, the Romantic notion of genius further privileged notions of mental creativity and self-expression in the higher arts and sciences over dogged routine and hard-won experience associated with the mechanical arts. Boosted by the status of the Royal Academy, fine artists made increasingly exclusive claims on the domain of 'art', resisting associations with commerce and industry. As noted in Chapter 6, for the portraitist and Academician Martin Archer Shee, who published *Rhymes on Art* in 1805, 'The principle of trade, and the principle of the arts, are not only dissimilar but incompatible. Profit is the impelling power of the one – praise, of the other.'[3] In the preface to the second edition he asserted that it had become the fashion 'to view every thing through the commercial medium, and calculate the claims of utility by the scale of "The Wealth of Nations", that it is to be feared, the Muses and Graces will shortly be put down as unproductive labourers, and the price current of the day considered as the only criterion of merit'. Yet, he exhorted, 'let us not justify the taunts of our rivals, and deliver up all our ideas to the dominion of trade; let us reserve a few old fashioned sentiments in this general sale of our faculties and understandings; let us, if possible, keep

some few spots dry in this commercial deluge, upon which wit, and taste, and genius, may repose'.[4]

Shee's lurid vision of a 'commercial as well as a political Jacobinism' was in essence a defence of bastions of privilege like the Royal Academy against utilitarians who supported a free trade in art. It can also be seen as a reinforcement of the case made for the liberal education needed by the fine artist as opposed to the mechanical and even the scientific skills required for industry. While fissures were widening between the fine and mechanical arts, so they were narrowing between the mechanical arts and the sciences. The increasingly vocal lobby of gentlemen of science and scientific societies encouraged the view that industrial progress was dependent on science and production determined by inexorable, mathematically based rules. Yet, as Babbage's experience of showing the Silver Lady and the Difference Engine demonstrated, the general public was not necessarily ready to accept rhetoric claiming the primacy of the higher forms of science and art. Furthermore, the mechanical arts still had a role to play in pushing industry forward, despite the best efforts of gentlemen of science to appropriate and the fine arts to eliminate their territory. The impact or otherwise of these efforts can be tracked in an overview of the media covered in previous chapters: drawings, models, societies, publications, portraits and scenes of industry as they developed in the early decades of the nineteenth century.

Drawings

By the end of the eighteenth century, mechanical drawing for British industry had become less pictorial and more mathematical. Patent drawings no longer included human figures and other polite embellishments but, in the wake of *Liardet v. Johnston*, were more dedicated to clear exposition.[5] This phenomenon occurred despite the fact that, unlike in France, there were no state schools of design or engineering apart from the instruction given in the military and naval academies. The draughting skills required to plan and implement the growing number and scale of surveying and civil engineering projects ensured that there was no shortage of opportunities for learning on the job, especially as the profession of engineering tended to run in families. Joseph Mitchell and William Provis produced drawings for Thomas Telford not only of sections of the banks and lock gates on the Caledonian Canal but also of the wagons, wheels, wheelbarrows, pulley blocks and even the links of the bucket-chain of a dredging machine used in its construction.[6] John Rennie sometimes used his sons George and John to make design and record drawings of his schemes, which ranged from bridges, harbours and lighthouses to the London and West India Docks.[7] The vast undertaking of the new docks provided work for leading engineers, their assistants and thousands of navvies over the first three decades of the nineteenth century. Like the royal dockyards, they were a catalyst for innovation in industrial management practice, requiring precise design drawings which still survive in the archive of the Port of London Authority.[8] Some of Henry Maudslay's most illustrious employees, although from widely disparate backgrounds, were talented draughtsmen.[9] Richard Roberts, who trained with Maudslay from 1814 to 1816 and developed into perhaps the greatest mechanical inventor of the nineteenth century, could tell a House of Lords select committee as late as 1851 that 'I make my own drawings, and my draughtsman copies them afterwards, and fills in the details.'[10]

In France, technical drawing had been rationalised using the methods of mathematical analysis by Gaspard Monge into a system he called descriptive geometry.[11] At its simplest, this involved reducing solid objects to their abstract core, laid out in two dimensions as points and lines in space projected onto planes of infinite extent. Lacking a fixed viewpoint and conforming to a set of strict rules, such drawings eliminated signs of individuality on the part of the draughtsman, thus creating the illusion of objectiv-

ity which all could understand and, if necessary, obey.[12] Monge first applied his system in the 1760s as a teacher at the Ecole du Génie, the government academy for military engineers at Mézières, but extended it beyond drawings for fortifications and artillery to stone-cutting and eventually to carpentry. His goal was the creation of a universal system of technical drawing, a common language through which engineers and artisans could communicate. Although his methods proved highly influential in France, they were considered a military secret and it was not until 1799 that his lectures were published as *Géométrie Descriptive*, intended to promote the system as the key element in the technical instruction of the nation.

At the Conservatoire National des Arts et Métiers, based from 1799 at the decommissioned priory of St Martin des Champs in Paris, the machine models from the collections of Vaucanson, the Academy of Science and others were displayed alongside technical drawings to explain how they worked. The Conservatoire's Ecole Gratuite de Dessin Appliqué à la Mécanique, called the 'Petite Ecole', formally established in 1806, taught descriptive geometry according to Monge's principles, increasingly geared towards machines and instruments, as well as figure and ornamental drawing for textiles.[13] Under the inspectorate, then the presidency of François, Duc de La Rochefoucauld-Liancourt, the Conservatoire followed a middle path between the artisan world of the eighteenth century and the increasingly mechanised industry of the nineteenth century. Younger generations of men of science, notably the naval engineer Charles Dupin, advocated a more advanced scientific education for adults, inspired by the example of the Andersonian Institution in Glasgow – which Dupin visited in 1816 – where free evening courses of science lectures were given to working men.[14] In 1819 Dupin was appointed as professor of mechanics at the Conservatoire along with Nicolas Clément-Desormes and Jean-Baptiste Say as, respectively, professors of chemistry and industrial economy. Despite opposition prior to 1830 from reactionary politicians who questioned the need to educate workers at all, the Petite Ecole trained thousands of students whose skill in technical drawing helped supply a new layer of mid-level technicians to the machine-building industries of the nineteenth century.[15]

In France these state-supported innovations served to create a division of labour between design or ownership of design and its execution, between theory and practice. It was assumed that engineers could define tasks and communicate them with such rigour that the practical skills of fitters and others would be superfluous.[16] In Britain, despite links with France through Dupin, design and technical education followed a different course. George Birkbeck, who in 1805 as Professor of Natural Philosophy at the Andersonian Institution first introduced the courses on elementary science for working men, was certainly aware of developments abroad. As President of the London Mechanics' Institution (inspired by the Glasgow Mechanics' Institution which had seceded from the Andersonian in 1823), Birkbeck published Dupin's endorsement of the Monge method, *Géométrie et Mécanique des Arts et Métiers et des Beaux-Arts* (Paris, 1826), as *Mathematics practically applied to the Useful and Fine Arts, adapted to the State of the Arts in England*, subtitled *Geometry and the Arts* (1827). He used the preface to emphasise the role played by Dupin's visits to the Glasgow and London institutes in persuading the French authorities to adopt similar courses on science.[17] Best practice could travel in both directions: Birkbeck hoped that Dupin's work would become the textbook used on courses in Britain. In his gloss on the text, he frequently contrasted the superior practical skills of Britain with the superior theoretical, scientific knowledge in France, which he urged British workmen to copy.

His hopes were not fulfilled, for while mechanics' institutes provided lectures on science and political economy, with reading rooms and circulating libraries for more general subject matter, they did not give instruction in the Monge geometry which,

Dupin believed, if universally spread through workshops and manufactories and made the basis of manual operations, would lead to the improvement of manufacturing industry.[18] Instead, British training in draughtsmanship for artisans followed the traditional path of elementary geometry and, according to trade, the classical orders, figures and animals or flowers and ornaments, based on the more general proposition that the universalising properties of drawing would encourage progress in design. Even these limited aspirations were threatened by an increasingly academic view of art education. By 1800, the Academy established in Edinburgh in 1760 by the Board of Trustees for the Encouragement of Manufactures in Scotland, with the intention of teaching drawing to artisans, had become a fine art school, the casts of ornament replaced with casts of classical figures. Its distinguished alumni included David Wilkie and William Allan and although coach-painters, house-painters, manufacturers and at least one budding engineer, James Nasmyth, were numbered among the forty students, it was conceded that 'instructions generally given to them are adapted to the higher branches of the fine arts, and are therefore not calculated to produce designers for ornamental works'.[19]

At the London Mechanics' Institution, classes for teaching geometrical and mechanical drawing were set up, 'that is, drawing to scale with the aid of mechanical instruments' including the rules of perspective; for teaching the drawing of ornament; and for the human figure and landscape.[20] Charles Toplis, one of the Institution's vice-presidents and the director of a Museum of National Manufactures in Leicester Square, was eloquent in his advocacy of education in the 'arts of design' before the 1835 House of Commons Select Committee on Arts and Manufactures, believing that they should be taught to all classes of operative after the first elements of reading, writing and arithmetic. While acknowledging the importance of education in the 'principles of mechanical science' for the engineer, builder, carpenter and mechanist, and equally in chemistry for operatives in manufacturing industry, he considered that 'to a very large proportion of the individuals engaged in both branches, some practical skill in the art of design is either absolutely needful, or would be eminently useful. All works of construction require to be preceded by a design on paper, or a proportional delineation, which is often to be done by the workman himself.' Instead of promoting descriptive geometry, Toplis associated drawing with traditional colouring and modelling skills – the 'careful cultivation of the eye' in matters of taste demanded by a highly civilised society, particularly with regard to luxury products: 'Whatever partakes of the nature of ornament will only be appreciated in a refined age, as it is characterized by grace and elegance of design and by delicacy and precision of execution.'

His response culminated in an impassioned plea for government support for both technical and design education:

The formation of schools of elementary science, of academies for the arts of design, and of museums for the collection of models of construction, of specimens of skilled workmanship, and of examples of tasteful design and graceful form, cannot fail to advance, in a conspicuous degree, both the fine and useful arts of the country. Our national greatness rests on the skilled industry of our people; it must be a part of sound domestic policy to foster, by every means within our reach, the talent which gives currency and importance to our indigenous products, and draws within the vortex of British manufacture the raw material of other climes, to be spread again over the world, enhanced in value by the labour, skill and taste of British artisans.[21]

Toplis conceded that there were limitations to the classes given at the London Mechanics' Institution: its location in Chancery Lane meant that most of the students were lawyers' clerks who received general groundwork in the arts of design, not the applied training in particular branches of manufacturing art given in the free French

drawing schools for artisans.[22] Joseph Clinton Robertson, the editor of the *Mechanics'*
Magazine from 1823, asserted before the Committee that the classes had not been par-
ticularly effective in improving the taste of artisans on account of their want of system
or direction.[23] In his experience, although most mechanics could comprehend perfectly
any geometrical drawing put in front of them, they had no occasion to practise the art
themselves because of the extent of the division of labour in industry; so learning to
draw was a waste of their time. The great object with every English manufacturer was
quantity, yielding the greatest profit: 'He lays out himself accordingly to supply those
that are the most in demand the world over; and those that are in demand among
mankind at large, will in the nature of things always be of the least tasteful description;
that is to say, till the bulk of mankind are much more cultivated than they are now, or
are likely soon to be.'[24] It was public education in the principles of design and taste
rather than specific education for artisans who, in Robertson's experience, tended to be
in advance of the rest of the community in this respect, though thwarted by the demands
of the customers. Yet he was not in favour of government interference in design educa-
tion, rather of the removal of government obstructions to the diffusion of design, such
as the heavy tax on drawing paper.[25]

Despite such detractors, the reforming Whig government was sufficiently impressed
by the case for the importance of design for the country's manufactures that it gave the
first national grant of £1500 for art education, to establish a Normal School of Design,
in anticipation of the 1835–6 Select Committee report. This grant was made only two
years after the first government grant for any sort of education. But given the heavy
weighting of witnesses towards representatives of the fine arts and manufacturers of
'fancy' goods requiring ornamental patterns, schools of elementary science – as proposed
by Toplis – were not pursued. The only engineer witness, James Nasmyth, made an idio-
syncratic contribution to the second session in 1836, arguing that the 'arts of design in
connexion with mechanical science' for machines would best be improved not by further
instruction in geometry which, according to Nasmyth, was picked up on the job, 'so
that mechanics who have never studied it as a science are found quite fit to receive ideas
of the most refined kind, because their daily occupation bears so closely upon the most
abstruse points'. Rather, their taste in the arts of designing would be furthered by access
to exhibitions within factories of beautiful works of art, both ancient and modern, on
the grounds that, 'In the majority of instances, the most economical disposition of the
materials coincides with such a form as presents the most elegant appearance to the eye.'
Nasmyth contended that the chaste economy of classical forms resulted in the greatest
strength and greatest economy of materials, as required alike by the framework of
machinery and the building of manufactories. He made these observations on the basis
of having been all his life 'in companionable contact with the working mechanic, and
being moreover the son of an artist of some celebrity [Alexander Nasmyth]. I have in
the union of those two advantages, been enabled to see the intimate connexion that
exists between the arts of design and practical mechanics.'[26] Nevertheless, the schools of
design set up throughout the country in the wake of the grant provided little opportu-
nity for advancing such an insight. There was still no consensus as to what was meant
by design education and until 1850 they suffered from a confusion of teaching methods,
exaggerated in their effects by administrative conflicts.[27]

John Buonarotti Papworth's initial syllabus, confined to drawing and modelling orna-
ment along the lines already taught at mechanics' institutions, proved a failure, as did
the technical classes based on geometry and the vocational courses instigated by William
Dyce. They were upstaged when a Society for Promoting Practical Design was estab-
lished in 1838 in St Martin's Street by Leicester Square by Benjamin Robert Haydon, the
radical M.P.s William Ewart, Joseph Hume and Thomas Wyse and other members of

the Select Committee who had favoured the broader-based system of art education. It organised lectures in anatomy, design and colour, as well as classes in drawing from the antique and a female model, which proved extremely popular. The schools established after 1840 in the provinces, financed by government contributions matched by those of local manufacturers, could only flourish where there was money to spare and this was usually where the schools were not urgently needed. Those founded in Norwich or York, little connected with manufactures, were more bent on providing a genteel fine arts training. In Manchester, the large-scale manufacturers who could afford to buy foreign patterns and saw little point in aiding lesser rivals also favoured academic training, as was successfully developed under the mastership of John Bell. Further disputes as to the nature of art and design education resulted in the resignations of both Dyce and Bell in 1843. Dyce was replaced by Charles Heath Wilson, an extreme historicist who wanted to turn the schools of design into museums where students could make exact copies of historical ornament, obliterating Dyce's influence. Apart from the methods adopted by George Wallis, who as the Master in Manchester from 1843 to 1845 introduced much more liberal classes in design, encouraging originality and fitness for purpose, the schools of design were a failure in their attempts to create a productive relationship between the fine and mechanical arts. There were successive lurches in policy between a high art training with figure drawing at its core and a narrow, applied drawing based on principles which could prove wholly unsuitable for manufacture. Denigrated and marginalised by both industrialisation and academicism, the government schools of design failed to promote the kinds of drawing that could be of use to industry.

Models

As is suggested by the case of the Silver Lady, fascination with mechanical models did not diminish in the nineteenth century. Exhibitions of models and machinery remained popular in Paris and London, although utilitarian ends were usually promoted over polite aesthetics and rational entertainment. Thus in Paris, in addition to the Cabinet des Machines de Vaucanson which was part of the Conservatoire National des Arts et Métiers, exhibitions were organised under the Directorate to show off the products of French industry, the first in 1798 and a second in 1801. Although efforts were made to include the fine arts, artists rejected the opportunity as being beneath their dignity. The second exhibition, lasting six days, was staged in temporary arcades erected in the court-yard of the Louvre.[28] Among the 120 exhibits presented, selected by the jury from all parts of the country, was the first public display of Jacquard's loom, adapted from a punched-card system devised by Vaucanson.

The process whereby the mechanical principles underlying works of fancy and illusion were harnessed for useful purposes was emphasised once more in Sir David Brewster's *Letters on Natural Magic, addressed to Sir Walter Scott, Bart* (1832):

> The passion for automatic exhibitions, which characterized the 18th century, gave rise to the most ingenious mechanical devises, and introduced among the higher orders of artists habits of nice and accurate execution in the formation of the most delicate pieces of machinery. The same combination of the mechanical powers which made the spider crawl, or which waved the tiny rod of the magician, contributed in future years to purposes of higher import. Those wheels and pinions, which almost eluded our senses by their minuteness, reappeared in the stupendous mechanism of our spinning-machines, and our steam engines.[29]

By way of example, Brewster described John Duncan's tambouring machine, James Watt's statue-carving machine and Babbage's calculating machinery. Famed for his dis-

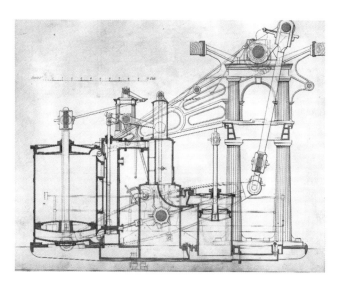

228 'Engines of the Steamers, Clyde, Tweed, Tay and Teviot by Caird & Co. Greenock', from John Bourne, *A Treatise on the Steam Engine*, 1853

coveries in the field of optics and as a scientific instrument-maker (he invented the polyzonal lens and the kaleidoscope), David Brewster was a natural mechanic and still part of a world which could acknowledge mechanically based invention as applied equally to ornamental manufactures, the polite art of sculpture and the purest form of mathematical science.

While Thomas Carlyle famously proclaimed it to be 'the Mechanical Age . . . the Age of Machinery',[30] machinery did not crush other forms of achievement in the first half of the nineteenth century. Widely different types of model and machine, seen from today's vantage point, continued to be shown in the same venues. The incorporation of models and machines used in industry into exhibitions where more frivolous ornamental items were displayed helped to soften the social impact of the former and promote them in an unthreatening manner to a public still potentially vulnerable to the appeal of Luddism. Moreover, machine-makers like Maudslay were sufficiently proud of their products to incorporate in the framing not only practical lessons learnt from basic carpentry – such as the cross-braces used to strengthen the block machinery – but architectural elements in the form of Tuscan columns and, by the 1830s, gothic arches as part of the structure of marine steam engines (fig. 228).[31]

These developments were not uncontested. In the wake of Pugin's criticism of cast iron in *The True Principles of Pointed or Christian Architecture* (1841), for '*disguising* instead of *beautifying* objects or utility' and its mechanical repetition of form, the engineer Samuel Clegg junior published *Architecture of Machinery: An Essay on Propriety of Form and Proportion with a View to Assist and Improve Design* (1842). The object of his enquiry, the author stated, was 'to endeavour to point out certain rules for design, by attention to which the many irregularities in *construction* and *form* so constantly met with in machinery are to be avoided; and to explain the correct principles of "taste"'. To this end he agued that 'Every part and detail of a machine should have a distinct *meaning* with reference to the duty they have to perform' and that 'if the general style of the engine will not admit of *architectural* contour, lay it aside entirely, and be content with relieving the *mechanical* contour'. The simplicity of the Tuscan mouldings rendered the order more applicable to the uses of the mechanist than either the Grecian or Roman Doric which was never used with any propriety. Plates 5 and 6 contrasted the Doric columns of the Parthenon and Paestum with their use in the framing of marine steam engines: 'The contrast is sufficiently severe, though made without comment. Like James Nasmyth, Clegg advocated an engineering aesthetic in which the 'beauty of proportion in machinery is sequent upon the use of those figures which possess the greatest strength with the least possible matter'.[32]

Nasmyth and Clegg were ahead of their time, as the confusion of contents in contemporary shows confirms. In 1828, a 'National Repository' was opened in the King's Mews, Charing Cross, under the auspices of George Birkbeck and the London Mechanics' Institution, 'for the purpose of annually exhibiting to the public the new and improved productions of artisans and manufacturers of the United Kingdom'. In view of its historic role, the Society of Arts was invited to become involved but decided against doing so.[33] The Repository displayed a dizzying range of new and old inventions, ornamental, industrial and scientific novelties, models of steam engines and metropolitan improvements. However, after an initial impact, it proved unable to refresh its displays sufficiently to attract visitors and when in 1831 the King's Mews were demolished to

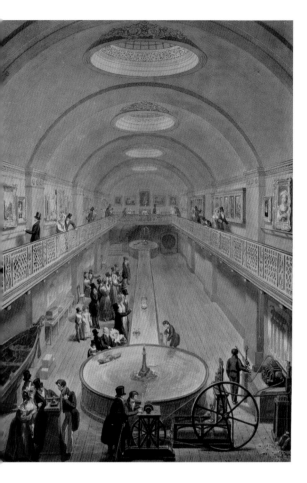

make way for the new National Gallery, it moved to a small room in Leicester Square, where it was known as the 'Museum of National Manufactures and of the Mechanical Arts' run, as noted, by Charles Toplis.[34]

The next venture of this sort was more promising, boasting the fashionable title of the National Gallery of Practical Science but more familiarly known as the Adelaide Gallery (fig. 229). Its sponsors included an inventive American, Jacob Perkins, the wealthy philanthropist Ralph Watson and the engineer Thomas Telford. Despite the title, its avowed purpose differed little from the all-encompassing ambition of its predecessor, 'to promote . . . the adoption of whatever may be found to be comparatively superior, or relatively perfect in the arts, sciences or manufactures . . . [and] the exhibition of works of art, and of specimens of the rare productions of nature'. Its scientific credentials were represented by 'specimens and models of inventions and other works' which afforded 'every possible facility for the practical demonstration of discoveries in natural philosophy'. In 1834 its sponsoring body, renamed the Society for the Illustration and Encouragement of Practical Science, received a royal charter.[35]

Based in an arcade off the Charing Cross end of the Strand, the Adelaide Gallery was a long narrow room with an open gallery on the upper level. More than two hundred items – machines and models, paintings, sculptures and tapestries – sent in for display, were ranged round the room in no particular order. Down the centre of the gallery ran a seventy-foot-long tank filled with six thousand gallons of water in which were placed clockwork models of steamboats driven by paddle-wheels. Perkins's steam gun was set off every hour and lectures were given on the latest forms of air and land transport. From 1839 there was also a display and daily demonstration of daguerreotypes. Yet by the early 1840s it too had run into financial difficulties, turning increasingly to live entertainment, including performances by Tom Thumb and assorted infant prodigies, soirées, dance demonstrations and concerts.[36] Within five years the gallery had become the Royal Marionette Theatre.

One reason for the Adelaide Gallery's change of focus was the founding in 1838 of the rival Polytechnic Institution with a more structured scientific agenda. First envisaged as a Gallery of Arts and Sciences, its moving source was the engineer, inventor and aeronautical pioneer Sir George Cayley.[37] A founder member of the British Association for the Advancement of Science (of which more later), Cayley roped in like-minded spirits and opened the Polytechnic in Upper Regent Street, gaining the accolade of a royal charter in 1839. Not only did it give free space and publicity to the latest inventions but it also staged topical lectures and demonstrations on science and medicine for the general public in a 500-seat lecture hall, organised teacher-training classes in different sciences and instruction for naval officers in engineering and navigation, and for railway engine drivers. A well equipped laboratory and workshop were made available for 'private experimentalists and patentees who may require assistance'. The usual magpie miscellany of novelties was displayed in a galleried great hall, clearly copied from the Adelaide Gallery but on a much bigger scale (fig. 230). Anything the Adelaide Gallery did, the Polytechnic sought to do better: it had two canals holding ten thousand gallons of water with lock-gates, waterwheels

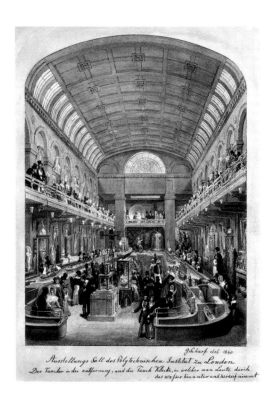

Ausstellungs Saal des Polytechnischen Institut zu London
Der Taucher in der entfernung, und die Tauch Klocke, in welcher man Leute durch
das Wasser hinunter und herauf nimmt

230 George Scharf, *The Polytechnic Institution, London*, 1840. British Museum, Department of Prints and Drawings

and, best of all, a full-size three-ton cast-iron diving bell which could submerge five or six passengers in the water by means of a crane.[38]

Mechanics' institutions staged exhibitions throughout the country.[39] Between 1837 and 1845 thousands came to shows which, for a modest entry charge and with late-night opening, combined instruction with entertainment. The catalogue of articles in the 1839 exhibition staged in the newly constructed Derby Mechanics' Institution (founded in 1825) demonstrates the ambition of such events, extending to more than 1750 separate items in nine separate rooms, contributed by local collectors, manufacturers and members of the aristocracy and gentry.[40] Its lecture hall contained 'a large and splendid collection of paintings, articles of statuary, sculpture, natural history, and models of various kinds' (fig. 231). The 1134 works ranged from Titians to Wrights of Derby (some starred for sale), to antiquities and ethnographic curios ('Three Poison Bottles from Africa'), china figures and snuff-boxes, specimens of needlework, coins and medals, models of ships and steam engines. Its second room contained a large Columbian printing press, a copper-plate printing press at which men were working, apparatus for stereotyping with specimens of stereotype plates and casts and a 'small hot-water apparatus in action, for ascertaining the consumption of Gas'. The corridor, 'tastefully decorated with flags and banners belonging to the Institution', contained 'Mr Hunt's confectionary stall, with fire and water fountains, railway &c.' Here also were some models of machinery and buildings, 'electro-magnetic apparatus, braiding and tagging machines (with boys at work,) and a glass blower, in a hermitage'.[41] More pictures and busts were displayed in the hall and staircase, including a number of drawings of railway bridges and works. The fourth room contained prints and drawings, 'a choice collection of minerals, cases of birds, coins, &c' and a lace-maker at work. The fifth room contained a working Jacquard loom, to demonstrate the method of weaving figured silks. In the sixth room, besides the collection of framed prints, minerals, fossils and other objects, a person was modelling figures in clay. The seventh room contained philosophical apparatus – pneumatic, electrical, magnetic, electro-magnetic and galvanic – on which experiments in natural philosophy were performed at stated times. Amid the engravings and curiosities in the eighth room was a silk-velvet loom and a model of a lead mine, 'made by a miner boy, 10 years old'. The last room contained preserved specimens of natural history, human and other skeletons.

Shows at mechanics' institutions in the mill towns of Yorkshire followed the same pattern, with varying degrees of participation from local gentry and manufacturers.[42] In Halifax, the Institution co-operated with the local Literary and Philosophical Society in 1840 to stage an exhibition devoted to the 'different departments of science and art', which attracted a hundred thousand visitors. The same year Bradford staged its own show which included machinery and scientific apparatus, manufactured goods of all kinds, geological and ornithological specimens, pictures and statues, antiques and curios, even a baronial hall with armour and weapons from the Tower of London and, not least, a grotto and cavern complete with exotic plants, fowl, a lake and a waterfall.[43] The organisation of railway excursions in the 1840s only enhanced the popularity of these shows.[44] Their extraordinarily heterogeneous character and their evident success among the respectable working classes provided a three-dimensional parallel to the useful, non-political and supposedly morally beneficial knowledge promoted in the institutions themselves and the publications of the Society for the Diffusion of Useful Knowledge (to be discussed later).

456

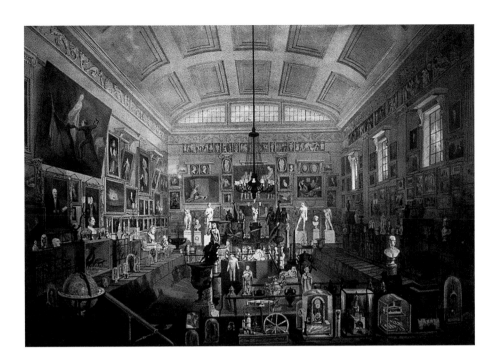

Even the British Association for the Advancement of Science put on exhibitions of manufactures and inventions to coincide with their annual meetings, the first at New-castle in 1838, then in Birmingham, Glasgow and Manchester. Not all manufacturers were willing to participate, those of Birmingham displaying a characteristic reluctance to open their doors to *savants*. James Watt junior simultaneously sneered at the Associ-ation's promotion of mechanical science and its 'crowd of attendant sciolists and suck-ling mechanics' and feared for the theft of exclusive inventions.[45] Like his father, Watt was an instinctive protectionist with regard to patented manufacturing processes but he also was irritated by the pretensions of the Association to subsume industrial activity under its own scientific umbrella.

The Association's shows were subject to more public ridicule. Dickens was quick off the mark in his 'Full Report of the Second Meeting of the Mudfog Association for the Advancement of Everything' which appeared in *Bentley's Miscellany* in 1838. This was held at 'Oldcastle' and included a 'Display of Models and Mechanical Science'. It fea-tured Mr Crinkles's pick-pocketing machine and, more pointedly, Mr Tickle's newly invented spectacles, 'which enabled the wearer to discern, in very bright colours, objects at a great distance, and rendered him wholly blind to those immediately before him . . . a most valuable and useful invention, based strictly upon the principle of the human eye'. Tickle was astonished that the President had yet to hear of it, 'when the President could not fail to be aware that a large number of most excellent persons and great states-men could see, with the naked eye, marvellous horrors on West India plantations, while they could discern nothing whatever in the interior of Manchester cotton mills.' Mr Blank exhibited a model of a fashionable annual, composed of copper-plates, gold leaf and silk boards and worked entirely by milk and water. After a week of feasting and feeding Professor Woodensconce declared: 'this is what we meet for; this is what inspires us; this is what keeps us together, and beckons us onward; this is the *spread* of science, and a glorious spread it is'.[46]

Dickens was not alone in his mockery. In 'A Little Talk about Science and the Show-Folks' (1843) Albert Smith shed crocodile tears for the passing of fairground entertain-ments and facetiously predicted:

The time is fast approaching when our very nurseries will be the schools for science; when our children's first books will be treatises on deeply scientific subjects; and when even their playthings will partake of the change. The Dutch toys will be thrown aside for the Daguerréotype; the doll's house will be a model of the Adelaide Gallery; and the nursery carpets and morning dresses will be burnt full of holes by the acid from the doll's galvanic trough or hydrogen apparatus . . . Noah's arks will assume the form of chemical-experiment boxes; the beasts and birds will turn to rows of labelled reagents, and Noah and his family, sticks, little round hats and all, will be transformed into test-tubes and spirit lamps. The magic-lantern will be cast aside for the gas-microscope.'[47]

In fact, the reverse process was taking place, for science proved not to be a sufficient draw on its own. The Royal Victoria Gallery for the Encouragement and Illustration of Practical Science opened in Manchester in 1840 with an impressive collection of exhibits, had failed by 1842 despite its programme of demonstrations and lectures. In *Gavarni in London* (1849), Albert Smith reported more accurately on what had happened to the Adelaide Gallery:

The oxy-hydrogen light was slily applied to the comic magic-lantern; and laughing gas was made instead of carbonic acid. By degrees music stole in; then wizards; and lastly talented vocal foreigners from Ethiopia and the Pyrenees. Science was driven to her wit's end for a livelihood, but she still endeavoured to appear respectable. The names of the new attractions were covertly put into the bills, sneaking under the original engines and machines in smaller type . . . But, between the two stools of philosophy and fun, Science shared the usual fate attendant upon such a position – she broke down altogether. Her grave votaries were disgusted with the comic songs, and the admirers of the banjo were bored with the lectures. So neither went to see her; poor Science declined into the *Gazette* [went bankrupt] and . . . fled to America.[48]

Ever suspicious of the claims of science, Dickens applauded this development. In 'The Amusements of the People', which appeared in *Household Words* in March 1850, he wrote:

The Polytechnic Institution in Regent Street, where an infinite variety of ingenious models are exhibited and explained, and where lectures comprising a quantity of useful information on many practical subjects are delivered, is a great public benefit and a wonderful place, but we think a people formed *entirely* in their hours of leisure by Polytechnic Institutions would be an uncomfortable community. We would rather not have to appeal to the generous sympathies of a man of five-and-twenty, in respect of some affliction of which he had no personal experience, who had passed all his holidays, when a boy, among cranks and cogwheels. We should be more disposed to trust him if he had been brought into occasional contact with a Maid and a Magpie; if he had made one or two diversions into the Forest of Bondy; or had even gone to the length of a Christmas Pantomime. There is a range of imagination in most of us, which no amount of steam engines will satisfy; and which The-great-exhibition-of-the-works-of-industry-of-all-nations, itself, will probably leave unappeased.

Societies

Societies proliferated in the early decades of the nineteenth century, a phenomenon which, according to Carlyle in 'Signs of the Times', was the result of the mechanical age which had downgraded individual endeavour – the 'obscure closets' of men like Roger

Bacon, Kepler, Newton and the workshops of Faust and Watt. In 1793 the Society of Civil Engineers was reorganised and renamed the Smeatonian Society with three classes of member: engineers or full members, honorary members who were gentlemen with mechanical interests and, another honorary class, 'various artists . . . connected with civil engineering'. The famous makers of scientific instruments Jesse Ramsden and Edward Troughton were elected as 'artists'. Sir Samuel Bentham was elected as an honorary member. Yet the Society was still one of aspiration rather than achievement. Nor was the status of its members set in stone although a hierarchy was developing, based on age, experience and social standing, with an increasing divide between practical mechanists and consulting engineers.

Nevertheless, there was still plenty of scope for misunderstanding and hurt pride. When first seeking to employ Rennie in 1784 Watt got his status wrong, wanting a man who was sober, of moderate ambition and content with the 'station of a confidential servant', free from self-conceit and the unfocused ingenuity of the amateur.[49] Watt's friend John Robison, by then the Professor of Natural Philosophy at Edinburgh University, hastened to reassure him but emphasised that Rennie was already a successful millwright and was actively pursuing academic studies at the university: 'In this situation it cannot be ascribed to self-conceit that it would be with some reluctance that he would sink from his present station, even in this poor country into that of a mere journeyman or, at best what we call a foreman.'[50] Artisans could be touchy if they felt their expertise was undervalued. In 1790, Lieutenant General Roy made the mistake of asserting in a Royal Society meeting that Jesse Ramsden's instruments were not well made. Ramsden wrote to the Society's Council to protest, denying that he had said he would do the gentlemanly thing and not respond:

> nor would it be consistent with common sense, that a Tradesman or Mechanic, should suffer his professional character to be publicly traduced in so respectable a place as a meeting of the Royal Society and not to make any reply. It would to all intents be allowing the justice of those accusations, but for which there is in this case not the smallest foundation.[51]

Rennie himself was criticised by those lower down the pecking order. Simon Goodrich complained to a friend in 1807, when Rennie arrived with other engineers as members of the Board of Revision constituted by the Admiralty to inspect the workings of Portsmouth dockyard during Bentham's absence in Russia:

> I am an obscure individual, and if the tide of prejudice runs against the General I must necessarily be carried along in the same current, an object not worth notice . . . How can I who am only called a mechanist pretend to contradict any general assertion of those who are called engineers, or if I have truth on my side, how shall I be able to prove it to those that are not capable of understanding the business.[52]

In his diary Goodrich wrote: 'his [Rennie's] observations convince me that he is deficient in experience and judgement about such matters [the main dock pumps] or that he willingly slanders'.[53]

Goodrich believed in the combination of theory and practice in a mechanist's education. As noted in Chapter 2, although in 1807 he appointed a new master of the metal mills because of his practical experience, he encouraged him to study metallurgy and mechanics 'to make himself fit for the situation in respect to science and knowledge of principles with which I am aware he is unacquainted', to learn from experienced workmen, to 'network' with his peers and even to undertake study trips.[54] He continued to be engaged with and champion the cause of those who really knew about machines until his retirement.[55]

The engineers further strengthened their professional standing in the first half of the nineteenth century – as Penelope Corfield has pointed out, it was 'the first case of conscious professional consolidation outside the traditional learned professions'.[56] At the inaugural meeting of the Institution of Civil Engineers in 1818, its leading advocate, Henry Robinson Palmer, the assistant to Telford, restated their role: 'The engineer is a mediator between the philosopher and the working mechanic, and like an interpreter between two foreigners, must understand the language of both, hence the absolute necessity of possession of both practical and theoretical knowledge.'[57] Nevertheless, the Institution continued the practice of the Smeatonian Society in admitting honorary members, from 'persons who do not study the profession as a mode of subsistence, but are indefatigable in devoting their leisure to pursuits immediately of that nature'.[58] In 1819, provision was also made for the admission of corresponding members and the following year, membership soared with the election of Telford and his installation as President.

In writing to Telford in 1820, the existing membership outlined the objects of the Institution: 'To facilitate the acquirements of knowledge in engineering; to circumscribe the profession; to establish in it the respectability which it merits and to increase the indispensable public confidence.'[59] Until his death in 1834, Telford played a key role in ensuring the Institution's seriousness of purpose and organisational stability. Unlike the meetings of the earlier Society, those of the Institution enjoyed a regular attendance, eminent guests and technical discussion. Telford insisted that 'talents and respectability' should be preferable to numbers, deploring the 'too easy and promiscuous admission' which inconvenienced most societies.[60] None the less, by 1828 membership had risen to 134 and the same year the Institution obtained a royal charter, giving it a legal entity and enhancing its claims to represent the whole profession. In 1837 it moved into premises in Whitehall, conveniently close to the political and administrative heart of the nation.[61] Ten years later, the rapid growth in the number of railway engineers precipitated the foundation of a separate Institution of Mechanical Engineers, formalising the increasing specialisation of the engineering profession. The separation of engineers from surveyors was the last to be instituted, with a group of surveyors forming the Land Surveyors' Club in 1834, ostensibly to improve standards of education and enhance their professional status but, in practice – as with the earlier Society of Civil Engineers – it turned out to be more of a convivial drinking club. The Institution of Chartered Surveyors was founded in 1868.[62]

In the wider world, British gentlemen of science looked enviously across the Channel at the willingness of the French government, starting in the Revolution and continuing into the Napoleonic era and later, to involve men of science and elite engineers in shaping policy.[63] Yet, in contrast to the French pursuit of narrow expertise, the British scientific elite valued the cultivation of polymathy – Sydney Smith famous quipped of William Whewell that science was his forte and omniscience his foible – still attempting to fulfil the Enlightenment ideal of mastering the universe of knowledge. Nevertheless, the early decades of the nineteenth century witnessed the rapid expansion of the spheres of scientific activity, albeit with an overlapping membership of participants. Wide-ranging debates were held on the nature of science, its philosophical, theological and moral concerns as well as on how it related to society. A myriad clubs, societies, associations and institutions, reviews and periodicals regarded science as a vital part of their agenda and helped to embed it in the general culture.[64]

As mentioned in Chapter 4, the final decades of the eighteenth century saw literary and philosophical societies springing up in provincial centres, to combat the perceived metropolitan near-monopoly on knowledge. London, with its size and capital status, where sufficient numbers of the leisured classes with a range of loosely scientific interests could form a self-validating consensus, afforded much greater scope for specialisation.[65] New learned societies were established: the Linnaean Society in 1788, the

Geological Society (1807), the Astronomical Society (1820), the Zoological Society (1828), the Geographical Society (1830), the Statistical Society (1834) and the Meteorological Society (1839). The Royal Institution, founded in 1799 by a group of improving Tory landlords to promote agricultural improvements, was originally intended as 'a grand repository of all kinds of useful mechanical inventions', with the purpose, according to the wishes of its most active proponent, Sir Benjamin Thompson, Count Rumford, of educating artisans and working men.

Provincial industrialists were at first sceptical, Matthew Robinson Boulton reporting to Boulton senior in 1800 the fears of the 'British Manufacturer':

> Instead of diffusing general knowledge it will strike him as an institution for diffusing the benefits of his capital and industry . . . It may be a very pleasant amusement for the nobility and other idle loungers who have never added an iota to the purse of the nation by the sweat of their brow, to diffuse the inventions, advantages acquired by the perseverence and painful study of grovelling mechanics; but how will it be relished by the inventor himself. [66]

Yet because its impressive premises in Albemarle Street also contained a lecture theatre and laboratory for 'teaching the applications of science to the useful purposes of Life', it swiftly became a centre for the promotion of experimental science.

The Boultons also had little to fear from the schools and colleges of science, philosophical societies, literary and philosophical or scientific societies, chemical and philosophical societies, offering courses of lectures and discussion groups to broadly popular audiences.[67] On the most prestigious level, the Athenaeum was founded in 1824 by John Wilson Croker, an M.P. and the secretary to the Admiralty, as a club for 'Literary and Scientific men and followers of the Fine Arts'.[68] More typical were the small organisations that Dickens made fun of in *The Posthumous Papers of the Pickwick Club* (1836–7), which supposedly was launched in 1827 with a paper delivered by Pickwick himself entitled 'Speculations on the Source of the Hampstead Ponds, with some Observations on the Theory of Tittlebats'.

By the 1820s the Benthamite belief in science as a tool with which to further the progress of industry and construct an ordered society had manifested itself in the foundation of mechanics' institutions, serving those normally excluded from literary and philosophical societies.[69] As already noted, the original impulse had come from Scotland, with the success of Birkbeck's elementary courses on science for working men at the Andersonian Institution in Glasgow and from 1821 at the Edinburgh School of Arts. The secession of the Mechanics' Class from the Andersonian in 1823 to form the Glasgow Mechanics' Institution was followed by the establishment, with Birkbeck's blessing, of an Institution in London in November the same year. According to their backers, the diffusion of scientific knowledge among artisans would contribute to the progress of industry, for the chances of discovery in the arts and science would be multiplied indefinitely when working men were made familiar with science.[70]

The luminary most closely associated in the popular mind with the diffusion of such 'useful knowledge' was the Whig lawyer Henry Brougham, who had first come to public prominence in London in 1820 with his successful defence of Queen Caroline. His highly influential pamphlet *Practical Observations upon the Education of the People, addressed to the Working Classes and their Employers* was published in 1825 for the benefit of the London Mechanics' Institution and went through many editions.[71] In it he wrote of the difficulties in the way of the education of working classes, above all, their lack of money and time. The former difficulty could be combated through the encouragement of cheap publications such as the *Mechanics' Magazine*. He also advocated the use of lectures, especially those in mechanical philosophy and chemistry, 'both as being more inti-

mately connected with the arts, and as requiring more explanation and illustration by experiment'. Mathematics, astronomy and geology were also of great practical use, not to mention moral and political philosophy.

Dogged devotion to self-improvement and, more particularly, the emergence of scientific genius from humble beginnings were recurring themes in Brougham's public pronouncements.[72] In the preliminary treatise which launched his Society for the Diffusion of Useful Knowledge in 1827, *A Discourse on the Objects, Advantages and Pleasures of Science* (1827), Brougham claimed that few great discoveries had been made 'by chance and by ignorant persons', citing as evidence not only Watt, whose improvements to the steam engine 'resulted from the most learned investigation of mathematical, mechanical, and chemical truths' but even Arkwright who, according to Brougham, had 'devoted many years, five at the least, to his invention of spinning jennies [*sic*], and he was a man perfectly conversant in every thing that relates to the construction of machinery'. He conceded that Arkwright had not received anything like a scientific education but even this awkward fact was glossed favourably for science: 'If he had, we should in all probability have been indebted to him for scientific discoveries as well as practical improvements.' Mindful presumably of his backers, who included Whig grandees, Brougham did not ignore the pleasure to be gained from learned curiosity and acquiring knowledge for its own sake, 'a pleasure peculiarly applicable to those who have the inestimable blessing of time at their command'. He concluded that the pleasures of science went hand in hand with the solid benefits derived from it.[73]

Science figured prominently in the cheap publications subsequently produced by the Society, each treatise containing 'an exposition of the fundamental principles of some branch of science – their proofs and illustrations – their application to practical uses, and to the explanation of facts or appearances'. Yet the activities of mechanics' institutes themselves suggest that scientific topics were not necessarily high on the list of working men's interests. The response to a general questionnaire circulated in 1826 revealed that library loans of works of general literature, especially history, were more popular than loans of scientific books.[74] Brougham's high-minded dismissal of the short-term amusement provided by novels and newspapers in favour of the higher truths of science was not shared by those whom he sought to influence.

The early years of Manchester Mechanics' Institution, established in 1824, provided little evidence to the contrary. Its rules stated that the Institution was formed 'for the purpose of enabling mechanics and artisans, of whatever trade they may be, to become acquainted with such branches of science as are of practical application in the exercise of that trade; that they may possess a more thorough knowledge of their business, acquire a greater degree of skill in the practice of it, and be qualified to make improvements and even new inventions in the arts which they respectively profess'.[75] Heavily influenced by the work of John Dalton in the city, it staged lectures in mechanics and chemistry but they were not a success for lack of suitable models, apparatus and, perhaps, the old bugbear of an appropriate language of communication. The short-course classes were more successful, covering chemistry, mechanics, physics, astronomy, geology, geography and natural history.[76] Yet, as in London, the majority of participants were clerks or warehousemen who could afford the subscription of five shillings a quarter and whose working hours were shorter. The Manchester New Mechanics' Institution, founded in 1829 with a cheaper subscription of sixteen shillings a year, had a broader membership. Offering elementary instruction in all kinds of drawing, arithmetic and mathematics, it also staged scientific lectures, in which extensive use was made of visual aids, including models of and practical experiments with steam engines. Furthermore, lectures were given on politics and political economy and although it closed in 1835, it forced the city's main Mechanics' Institution to be more liberal with

regard to politics and to democratise its constitution, with a higher proportion of its council elected by subscribers.[77]

By 1850, more than five hundred mechanics' institutes were firmly established throughout the country. Yet they had ceased to be regarded as the means of instruction for the masses. Instead they attracted the lower-middle and upper-working classes, clerical workers and supervisors, in search of newsrooms, libraries and guest lectures, concerts and exhibitions, tea parties and social outings.[78] As Mabel Tylcote concluded, the mechanics' institutes represented an attempt to bring modern science to the new industrial towns: 'They were compelled instead to offer, in elementary classes, the keys to every kind of learning, and to give instruction in the humanities rather than science.'[79]

If the advocates of science failed to insinuate their doctrines into the fabric of industrial life on an artisan level, that did not stop them promoting their agenda within the establishment. In the preface to his *Reflections on the Decline of Science in England* (1830), Babbage damned the Royal Society and its misgovernment, asserting that England had fallen behind other nations in the realm of abstract science, 'on whose more elementary truths its wealth and rank depend'. He believed that the subject was so fundamental that it should be extended to cover political economy and applications to arts and manufactures, blaming the latter for being too undeveloped to render the application of the former successful.[80] Babbage's proposal of government inducements of profit or honour for the disinterested pursuit of science, freed from social and commercial pressures, was supported in the pages of the *Quarterly Review* by David Brewster who, as the impecunious inventor of the kaleidoscope, had a particular grudge against the expensive and inefficient patent laws ('a tax on genius'). Lacking posts within the universities, inventors were forced to 'squeeze out a miserable sustenance as teachers of elementary mathematics in our military academies' or waste time 'in the drudgery of private lecturing'.[81]

This partisan view was soon contradicted by an anonymous tract entitled *On the Alleged Decline of Science in England* (1831), written by an 'eminent scientific foreigner' (Gerrit Moll, Professor of Physics at Utrecht University). He contrasted the rarefied French treatment of mathematical science with the useful discoveries and ingenious mechanical contrivances made by Englishmen with only a smattering of arithmetic to support their fund of ingenuity.[82] Then Babbage returned to his crusade in his treatise *On the Economy of Machinery and Manufactures* (1832), once more asserting 'that the arts and manufactures of the country are intimately connected with the progress of the severer sciences'. In a passage which effortlessly conflated the mechanical arts with the applied sciences, he stated: 'The applied sciences derive their facts from experiment; but the reasonings, on which their utility depends, comes more properly within the province of what is called abstract Science.' The improvement of a country's manufactures 'must arise from the combined exertions of all those most skilled in the theory, as well as in the practice of the art; each labouring in that department for which his natural capacity and acquired habits have rendered him most fit'.[83]

Babbage's and Brewster's complaints about the status of science were played out against the contested election of a new President of the Royal Society, in which royal privilege appeared to triumph over knowledge, and led to their founding in 1831 of the British Association for the Advancement of Science.[84] The Association's peripatetic *modus operandi*, holding its annual meetings in different towns round the country, articulated the claims of science as a superior form of knowledge, abstract and universal, in the tones of gentlemanly voluntarism. It satisfied many needs 'as a form of rational amusement, as theological edification, polite accomplishment, technological agent, social anodyne, and intellectual ratifier of the new industrial order'.[85] Physical sciences reigned supreme and the spheres of natural history, zoology, botany, horticulture, medicine and engineering or social science played subservient roles. With a genteel membership suppos-

edly not concerned with professional aggrandisement or profit, it sought to demonstrate that science was a source of power and authority, a 'neutral' court of appeal, the objective and impersonal means towards desirable ends for the common good.

The relationship of the Association with industry is particularly telling. In 1832 Babbage painted a rosy picture of the meetings which, he believed, could not fail to promote productive intercourse among men of science, wealthy landowners and great manufacturers. He even envisaged that 'the sons of our wealthy manufacturers, who, having been enriched by their own exertions, in a field connected with science, will be ambitious of having their children distinguished in its ranks'.[86] When Whewell addressed the meeting held in Cambridge in 1833, he memorably defined the relationship between science and the mechanical arts to the advantage of the former. Although he conceded the chronological priority of art, in the Baconian sense of practical experimentation, he reserved a higher role for science:

> Practice has always been the origin and stimulus of theory: Art has ever been the mother of science; the comely and busy mother of a daughter of far loftier and serener beauty . . . there are no subjects in which we can look more hopefully to an advance in sound theoretical views, than those in which the demands of practice make men willing to experiment on an expansive scale.[87]

Industry and invention lay from the start within the territory claimed by the British Association but they were scarcely reflected in the locations of the first three meetings – York (1831), Oxford (1832) and Cambridge (1833) – or in their proceedings, where fleeting mention was made of the mechanical arts under the section devoted to 'mathematical and physico-mathematical sciences', associated with hydraulics or mathematical instruments.[88] Only at the 1835 meeting in Dublin was engineering represented with any force, generating a subsection within mathematics and physics for 'mechanical science applied to the arts'. The same year, it was decided to hold meetings in the new industrial towns to secure the involvement of manufacturing and commercial interest from whom some, like Babbage, sought sponsorship. At the Bristol meeting in 1836 an entirely new 'Section G' was created entitled 'mechanical science', thereby further demoting the role played by the arts, implicit in Whewell's address. Science and theory expressed in the universal code of mathematics were to have precedence over art, regarded as personal and, it was still alleged, often secretive application and practice. Section G was controlled by academics rather than men of business or practical men.

Yet, as Jack Morrell and Arnold Thackray have suggested, with the widening gap between rich and poor and the 'condition of England' on the political agenda, it was also in the interests of manufacturers to pay lip-service to the claims of science which gave a cloak of disinterested respectability to their activities. Equally, a forward-looking belief in the mathematical sciences served engineers seeking an intellectual articulation and rationalisation of their experience and further enhanced their status as a distinct profession, mediating between the natural philosopher and working mechanic. The successive changes of name adopted by the higher education engineering classes at King's College, London, are significant. Founded in 1838 as the Class of Civil Engineering and Mining, mainly to serve the needs of the railways, in 1840 it became the Department of Civil Engineering and Architectures and Science, as Applied to Arts and Manufactures. In 1844 it was designated the Department of the Applied Sciences.[89]

At successive British Association meetings, manufacturers and engineers provided visible evidence of works in progress which had given rise to scientific research – geological exploration in the wake of railway construction, for example – as well as exciting spectacles, such as the laying of the foundation stone for the Clifton suspension bridge at Bristol in 1836 and visits to manufactories.[90] They appeared to demonstrate

the union of theory and practice in the cause of progress, fulfilling Bacon's dream of applying knowledge for the benefit of humankind. Yet the views expressed at British Association meetings as to the benefits of science were far from being wholly utilitarian. Science had a greater, more universal goal: the disinterested pursuit of truth attended by moral and intellectual improvement. Section G was largely peripheral to these ends and by the mid-1840s was nearly extinct.[91]

In anticipation of an expected accord between the mechanical arts and the severer sciences under the auspices of the British Association, Babbage asserted in 1832 that 'the wild imagination of the satirist' had been exceeded by reality: 'as if in mockery of the College of Laputa, light almost solar has been extracted from the refuse of fish; fire has been sifted by the lamp of Davy; and machinery has been taught arithmetic instead of poetry'.[92] He was not to know that a satirist as brilliant as Swift was to pour scorn on the Association and its rhetorical humbug. In 1837, Dickens launched his 'Full Report of the First Meeting of the Mudfog Association for the Advancement of Everything'.[93] Dickens reserved especial venom for a 'Section D', mechanical science, linking railway engineers (such as George Stephenson) with fraudulent speculation in an all too topical and potentially libellous barb:

> Mr. Jobba produced a forcing-machine on a novel plan, for bringing joint-stock railway shares prematurely to a premium. The instrument was in the form of an elegant gilt weather-glass of most dazzling appearance, and was worked behind, by strings, after the manner of a pantomime trick, the strings being always pulled by the directors of the company to which the machine belonged. The quicksilver was so ingeniously placed, that when the acting directors held shares in their pockets, figures denoting very small expenses and very large returns appeared upon the glass; but the moment the directors parted with these pieces of paper, the estimate of needful expenditure suddenly increased itself to an immense extent, while the statements of certain profits became reduced in the same proportion. Mr. Jobba stated the machine had been in constant requisition for some months past, and he had never once known it to fail.

A member expressed his view that it was extremely neat and pretty but he wished to know whether it was not liable to accidental derangement? Mr. Jobba said that the whole machine was undoubtedly likely to be blown up but that was the only objection to it.[94] Dickens had captured the flashier claims of projectors over the centuries in one ever-topical *mise en scène*.

Publications

In contrast to its earlier reputation for secrecy, by 1800 Birmingham was so proud of its reputation that a successful japanner, James Bisset, produced *A Poetic Survey round Birmingham; with a Brief Description of the Different Curiosities and Manufactories of the Place*.[95] To his poems, Bisset appended a *Magnificent Directory*, 'comprising the Names, &c of upwards of Three Hundred Professional Gentlemen, Merchants, Bankers, Tradesmen, Manufacturers, &c of Birmingham: elegantly engraved in superb and emblematic plates'. This 'literary and commercial iconography', as the 1808 edition dedicated to the Prince of Wales described it, may be seen as the *ne plus ultra* of engraved trade-card compilations, before the genre was overtaken by cheaper forms of printed advertising matter. In a letter enclosed in the finely bound first edition which the author presented to George III, Bisset stated that the work was written 'to promote the commercial interests' of the inhabitants of Birmingham.[96] He envisaged that it would be used as a guide

for strangers or travellers anxious to gain permission to see the most noted manufacto-
ries. Instead of being thrown aside like most trade cards, he believed it would 'become
an object of curiosity, and will, doubtless, be sought after with avidity, by all patroniz-
ers of the liberal arts'.

Bisset's *A Poetic Survey* comprised two poems, the first the 'Survey' proper and the
second the more fanciful 'Ramble of the Gods through Birmingham', in which Apollo,
Mercury and Bacchus visited the different manufactories, starting inevitably with 'Old
Vulcan's Smithy'. The twenty-four plates[97] making up the *Magnificent Directory* cover
an extraordinary range and combination of pictorial modes, including allegory, land-
scape and architectural perspectives, encyclopaedia-style illustrations of factory exteriors
and interiors, tools and products in a style intended to be 'both useful, elegant and orna-
mental'. In some plates the trades (or professions as Bisset always called them) were listed
on a scroll set against of view of the particular street or part of the town where they
operated. Other trades including the printers of the work, Swinney and Hawkins, were
favoured with views of their works and machines. The polite credentials of Bisset's own
profession, the japanners, were emphasised with classical motifs. There was a splendid
view of Soho Manufactory beneath which were listed the family of companies run by
Boulton. Whitmore's, 'Engineer in General' in Newhall Street, was represented with a
massive royal arms, as well as rollers, hammers, pliers and so on in front of a neat neo-
classical building (fig. 232). Mr Thomason had a whole page to himself comprising an
illustration of his patent carriage steps and his patent cocks for gun and pistol locks,
enclosed in a classical frame, and a view of the manufactory and warehouse. The button-
makers' scroll was ornamented with the tools of their trade, a stamp, presses and a lathe.
An introductory map was provided, showing Birmingham's expansion along the main
turnpikes, the canal system and the sites of major industries; its reference scroll was set
against a picturesque landscape of the type assiduously cultivated by Boulton and Wedg-

wood. Under Bisset's eccentric lead, the language of polite arts was used to demonstrate that the mechanical arts, as practised by Birmingham manufacturers, were as worthy of notice as the traditional genteel professions.

In stark contrast to Bisset's laudable endeavour, by the closing decades of the eighteenth century, encyclopaedias were becoming more scientifically orientated, the majority lacking the concern with *arts et métiers* which had distinguished the *Encyclopédie*. Its French successor, the massive *Encyclopédie Méthodique* initiated in 1782 and eventually extending to 158 volumes of text and 51 of plates by its completion in 1832, was in essence a set of specialist treatises arranged alphabetically, so that every science had its own system and dictionary of terms.[98] Long treatises or 'systems' dedicated to anatomy, astronomy, optics, electricity, chemistry, natural history, mineralogy and other sciences also justified the claim made by the *Encyclopaedia Britannica* to be composed on an entirely new plan. Instead of fragmenting the sciences under narrow technical terms arranged in alphabetical order, they were organised as larger treatises, in the belief that they ought to be 'exhibited entire', according to their common principles.[99] Furthermore, although the first edition (1768–71) was compiled by a single author, William Smellie,[100] the third edition, published in eighteen volumes between 1788 and 1797, with a *Supplement* published in 1801, involved outside contributors. John Robison covered topics relating to mixed mathematics and its applications to building, navigation and the steam engine, the last account constituting the first history of the steam engine to appear in English.[101]

As Richard Yeo has pointed out, in the early decades of the nineteenth century encyclopaedias were perhaps the most sensitive public forum in which the implications of specialisation were confronted. Six volumes of the *Supplement* (1815–24) to the fourth, fifth and sixth editions of the *Encyclopaedia Britannica*, edited by the Edinburgh lawyer Macvey Napier, marked a further shift towards a work collectively written by experts rather than assembled by a compiler or written by generalist natural philosophers like Robison. The absence of the Baconian tree of knowledge from the earliest edition of the *Encyclopaedia Britannica* was made explicit in the 'Preliminary Dissertation' to the first volume of the *Supplement* of 1815, composed by Dugald Stewart.[102] He argued that such trees of knowledge were fundamentally flawed, confusing a conceptual taxonomy of the arts and sciences with a historical account of their development and that the attempt to classify sciences on the basis of a 'logical division of our faculties' was doomed to failure. Furthermore, the advances in the sciences since Bacon had given rise to connections that would have been inconceivable in earlier knowledge systems. Stewart allocated the role of defining the content of these sciences, their principles and the boundaries between them, to the specialist authors of particular entries.

There were those who mocked futile attempts to keep up with the exhaustive coverage of an ever increasing range of specialisations.[103] However, the charge of superficiality levelled at encyclopaedias was countered with the authority of named expertise. The division of intellectual labour implicit in encyclopaedic specialisation anticipated the professionalisation of British science. The basic premise of Chambers's *Cyclopaedia*, the inherent unity of knowledge accessible to one mind, could no longer be sustained, as Alexander Blair recognised in an article which appeared in *Blackwood's Magazine* in 1824: 'Knowledge is advanced by individual minds wholly devoting themselves to their own part of inquiry. But this is a process of separation, not of combination.'[104]

Under the munificent ownership from 1812 of the leading Scottish publisher, Archibald Constable, the *Encyclopaedia Britannica* offered generous inducements to 'the most eminent men, in the different departments of science' to contribute original articles incorporating the latest advances in knowledge. The naming of these distinguished contributors in the prospectus was designed to counter the appeal of Brewster's *Edinburgh Encyclopaedia* (1808–30), which had already scooped the pool of expertise in Edin-

burgh. Authorship, suppressed by tradition in periodicals, was positively celebrated in the encyclopaedias 'to increase the confidence of the public in such undertakings'.[105] The specialists in turn saw participation under their own names as a chance to further their reputations, authorship being seen increasingly as a mark of scientific credentials, carrying weight with peer groups such as the Royal Society as well as the general public. Editors of rival encyclopaedias, sometimes armed with advisors on scientific topics, vied to contract the best authors who, in their articles, further competed by including their own theories and research findings, airing and sometimes courting controversies.[106] Babbage fulfilled this role on the *Encyclopaedia Metropolitana* (about 1825–45), edited by the Reverend Edward Smedley.

While scientific specialisation was fostered by successive editions of the *Encyclopaedia Britannica*, other compendia had a more pronounced bias towards practical invention. The *Repertory of Arts and Manufactures*, published in ninety-six numbers or sixteen octavo volumes between 1794 and 1802 under the editorship of John Wyatt III,[107] contained original communications, specifications of patent inventions and selections of 'useful practical papers' culled from transactions of European philosophical societies and illustrated with 334 plates depicting apparatus and machinery. In establishing 'a vehicle by means of which new discoveries and improvements, in any of the useful arts and manufactures, may be transmitted to the public', the *Repertory* served a useful function for it continued on and off under various titles as a guide to patents until 1862, by which time a reformed Patent Office had copied 14,399 patent rolls and some 1500 drawings in lithographic form for publication as *Letters Patent and Specifications of Letters Patent from March 2nd, 1617 to September 30th, 1852*.[108]

Abraham Rees's *Cyclopaedia: or, Universal Dictionary of Arts, Sciences and Literature*, which first appeared in 1802 and was originally projected at twenty volumes, extended to thirty-nine volumes of letterpress, augmented by five volumes of plates and a one-volume atlas, by the time it was completed in 1819.[109] Rees had evidently taken to heart the comments made by a critic of his edition of Chambers's *Cyclopaedia* in 1786, that 'To make a collection of this kind as advantageous as possible, it should contain, beside the descriptions of machines, an analysis of them, pointing out their advantages and disadvantages, with the respective reasons for their construction; and general problems, implied in each construction, with their solutions, should be extracted.'[110] His own *Cyclopaedia* rose to the challenge. As a reviewer for the *Philosophical Magazine* noted, the articles were written either by people engaged in the 'art or manufacture' treated, or by 'scientific persons' who had qualified themselves for the task by combining 'minute investigations and inquiries carried on in the most extensive of the laboratories, workshops, manufactories and public works' of the country with study of the relevant research in 'original works' and the 'learned transactions and scientific journals'. The numerous plates of machines and apparatus had 'a minuteness of detail, and a degree of accuracy in the drawing and engraving' without parallel in any work then extant.[111]

From the hundred specialist contributors whom Rees engaged, the Farey family made a major contribution.[112] They operated as a single business, combining the surveying skills of the father, the engineering know-how of three brothers – John, Joseph and Henry – and the draughting skills of three sisters, Sophia, Marianne and Ann, supervised when necessary by their mother, Sophia. John Farey senior (1766–1826), a land steward, mineralogical surveyor and technical writer, contributed articles on canals, geology, measures, music and other subjects. At the age of thirteen, John Farey junior (1791–1851) began a systematic study of industrial machinery in the London area, visiting mills and machine-makers and making detailed drawings of steam engines, textile machines, lathes and the position of machinery in the layout of manufactories.[113] In 1805, he started to produce drawings for Rees's *Cyclopaedia* and the same year, aged fourteen, was elected a member

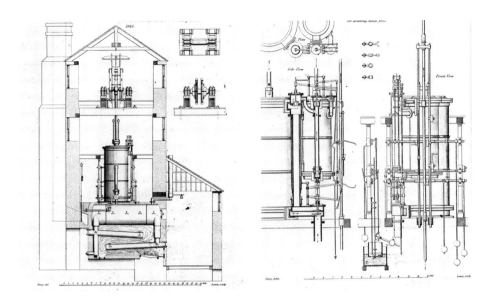

of the Society of Arts, where he served for some years on the Committee of Mechanics. He also contributed about forty articles including those on scientific instruments, the steam engine, machinery and entire technical processes such as the manufacture of cotton, the manufacture of ships' blocks, mill-work and printing.[114]

Farey junior's reputation as a technical draughtsman was based on the quality of his observation and understanding of the machines and processes he drew with the help of assorted mechanical aids: a camera lucida to establish the vanishing points of a machine's perspective, his own invention of a device called an elliptograph for circular machine parts in perspective and special drawing rules which he called centrolineads, with which straight lines could be drawn to a hidden vanishing point. The clarity of his lines made them relatively easy for the engraver, frequently Wilson Lowry, to copy and for a general audience to understand.[115] He produced drawings of 'machines, philosophical instruments and experiments and tools in the arts and manufactures' for a host of other encyclopaedias.[116] Farey also illustrated and contributed to periodicals, including the *Journal of the Society of Arts*, the *Philosophical Magazine*, as well as technical works like Olinthus Gregory's *Treatise on Mechanics* (1806), George Gregory's *Dictionary of the Arts and Sciences* (1806) and John Smeaton's *Reports* (1812).[117]

With talents that went well beyond technical draughtsmanship, Farey felt qualified to explain both the processes and principles relating to almost all the mechanical arts.[118] He swiftly gained respect as a patent specification draughtsman and technical writer, offering a comprehensive service to prospective applicants for patents: 'To advise and assist [inventors] to put their plans in execution, make their working drawings, find them proper workmen, tools, and old machines to alter for first trials, and to assist in their experiments.'[119] He also acted as a consulting mechanical engineer, frequently appearing before courts and government commissions as an expert witness. Farey's *Treatise on the Steam Engine* (1827) represents the culmination of his expertise (fig. 233).[120] It was originally planned as a two-volume work, the first dealing with the history up to the death of Watt in 1819 and the second, describing more modern patterns of engine and the scientific basis of steam technology, 'intended to form a course of instruction for professional students in the practice and principles of making steam engines'.[121] However, the second volume never appeared in his lifetime, probably because his target readership of professional engineers was too small and competition from much cheaper publications aimed at the general reader was too great to make it a viable proposition.[122]

Prominent among the latter were Charles Frederick Partington's *An Historical and Descriptive Account of the Steam Engine* (1822), Robert Stuart's [Meikleham] *A Descriptive History of the Steam Engine* (1824), Thomas Tredgold's *Treatise on the Steam Engine* and George Birkbeck's *The Steam Engine theoretically and practically displayed*, both published in 1827.[123] While Partington, as a lecturer at the London Institution, described the steam engine as 'one of the most valuable applications of science to the arts and manufactures of a great commercial nation', Meikleham, as a practising architect and steam engine fabricator (he described himself as a 'Civil Engineer'), explicitly rejected the role played by science. He commenced his *History*, which was dedicated to Birkbeck and intended for the working mechanic and general readers, by quoting Hornblower (presumably Jonathan) 'who said 20 years ago "that the most vulgar stoker may turn up his nose at the acutest mathematician in the world, for (in the action and construction of steam engines,) there are cases in which the higher powers of the human mind must bend to mere mechanical instinct"; and the observation applies with greater force now than it did then'. The fact was, he continued,

> that science, or scientific men, never had any thing to do in the matter . . . The honour of bringing it to its present state of perfection . . . belongs to a different and more useful class. It arose, was improved and perfected by working mechanics – and by them only; for tradition has preserved to us the fact of Savery having begun as a working miner; Newcomen was a blacksmith, and his partner Cawley a glazier; Don Ricardo Trevithick was also an operative mechanic; and so was the illustrious Watt, when he began, and after he had made his grand improvements.[124]

Tredgold trained as a carpenter and in 1820 published *Elementary Principles of Carpentry*, which included the mechanical principles relating to weight and pressure as part of the 'science of construction'. He claimed to have made the hitherto inaccessible or obscure researches of men of science the groundwork of a practical treatise, 'for when [science] is applied to the useful arts, it extends the view of the artist, substitutes certainty for uncertainty, security for insecurity; it informs him how to raise the greatest works with confidence, and how to produce stability with economy, or, in its own language, how to obtain a maximum of strength with a minimum of materials'. Countering the use of virtuoso geometrical forms for their own sake, Tredgold's treatise was an early plea for the 'just economy of materials' and 'simplicity of design which is most easy in the execution, and forms the most economical and the most durable structures'.[125]

This scientific bent in devising textbook formulae and rules was further demonstrated with the publication of Tredgold's *Practical Treatise on the Strength of Cast Iron and other Metals* (1824), his *Principles of Warming and Ventilating Public Buildings* (1824) and the *Practical Treatise on Railroads and Carriages* (1825). By the time *The Steam Engine* was published, Tredgold also called himself a 'Civil Engineer' (he was a member of the Institution). According to its title-page, this work comprised 'an account of its invention and progressive improvement; with an investigation of its principles, and the proportions of its parts for efficiency and strength: detailing also its application to navigation, mining, impelling machines, &c. and the results collected in numerous tables for practical use'. In his preface, Tredgold revealed that he was all too aware of the scientific lobby's complaints over their lack of patronage:

> forgetting that research will always be estimated by its immediate utility; and while they continue to confine their attention to abstract knowledge, while they do not devote a greater part of their time to its application to the wants and the welfare of society, they must be contented with a small share of those advantages which result from combining with practical skill, the power afforded by abstract reasoning.

34 Paul Pry [William Heath], *The March of Intellect*, 1829. British Museum, Department of Prints and Drawings

Nevertheless, in his own application of science to art, he hoped that he had added to 'the stores of pure science; and, so far from being insensible to the value of abstract research, I wish it to be pursued with redoubled vigour by those who have spirit to break through the prejudices of existing systems, and study from nature'.[126] He commissioned Joseph Clement to provide the illustrations, which were produced with the help of the instrument which Clement, like Farey, devised for drawing ellipses, securing him a gold medal from the Society of Arts in 1818.[127]

Farey criticised Tredgold's theoretical statements because they were based on simple model experiments, with no guarantee that they were sound when applied in the real world. Furthermore, he asserted that the engine proportions, on which Tredgold based some of his theorems, were wrong. Nevertheless, Tredgold seems to have cornered a market in steam engine literature, for his work went into a second revised, posthumous, edition in 1838 and was translated into French and Spanish.[128] Only two parts of Birkbeck's *Steam Engine* were ever produced at six shillings each. Claiming to supersede the deficiencies of earlier works, Birkbeck asserted that his publication would consequently 'form a manual or guide for the machinist, the manufacturer, the merchant, the statesman, and the philosopher'. Predictably, Birkbeck prioritised theory and in his 'Introductory Dissertation on Steam' cited Black's experiments on latent heat and Robison's mechanical philosophy as sources of inspiration for Watt. He concluded that of the many experiments undertaken to determine the relative power of steam, produced under pressure, those of Dalton, expressed algebraically, were the most accurate. Yet his promise of undertaking further experiments and publishing them in a subsequent part was never fulfilled. Even the plates illustrating different engines in perspective, section and plan, drawn by the civil engineers Henry and James Adcock, which Farey conceded were produced in a 'more expensive and attractive manner' than his own, evidently did not attract sufficient customers to sustain the work.

Collectively, however, these works made steam a byword for progress. The caricaturists had a field day conjuring up steam-powered carriages, ships and flying machines in tableaux which also included manifestations of the mechanistic forms of popular education known, with varying degrees of irony, as 'the march of intellect' or the 'march of mind' (fig. 234).[129] Charles Knight, the publisher of the *Penny Magazine* (1832–45) and

Penny Cyclopaedia (1833–43) for Brougham's Society for the Diffusion of Useful Knowledge, produced treatises which effortlessly blended the practices of industry with the principles of science and political economy.[130] A rash of *Mechanics' Magazines* appeared in the 1820s, with varying degrees of connection with the mechanics' institutes. The first and most long-lived was owned and edited by the patent agent Joseph Clinton Robertson from 1823 until his death in 1852. Issued weekly at a cost of 3d, the *Mechanics' Magazine* was intended to fill a gap in the market, of a 'periodical publication, of which that numerous and important portion of the community, the mechanics or artisans, including all who are operatively employed in our arts and manufactures, can say, "This is ours, and for us"'. It promised to present a digest of other periodical publications, both British and foreign:

> of whatever may be more immediately interesting to the British artisan; such as accounts of all new discoveries, inventions, and improvements with illustrative drawings, explanations of secret processes, economical receipts, practical applications of mineralogy and chemistry; plans and suggestions for the abridgement of labour; reports of the state of the arts in this and other countries; memoirs, and occasionally portraits of eminent mechanics, &c. &c.

It also intended to include 'a due portion of lighter matter, which those who toil most stand in need of, to relieve and exhilarate their minds – as, essays on men and manners, tales, adventures, poetry &c', as well as communications from 'intelligent mechanics' – everything in fact except politics, for 'party and factious purpose we despise'. Inevitably, it commenced with a wood engraving of James Watt to illustrate the memoir on his life which followed.[131]

While the radical unstamped press viewed such efforts as placebos to reconcile the working classes to their political and economic powerlessness, gentlemen of science were quick to jump on the bandwagon to convey the message to a broader audience.[132] Babbage's *On the Economy of Machinery and Manufactures* (1832) offered practical advice 'On the Method of Observing Manufactories' and provided an all-purpose model for inquiries. Warning visitors not to take information at face value from a workman or to trust the numbers given if a foreman was present, he counselled visitors to rely on their own observations and judgement.[133] Although he argued that the progress of machinery and manufactures depended 'on the combined exertions of all those most skilled in the theory, as well as in the practice of the art', the real purpose of his treatise was to promote science which, he asserted, had been shamefully neglected in England, compared with its status abroad.[134]

Edward Baines seems to have followed Babbage's advice, contributing what was claimed as the first history of cotton manufacture, 'that stupendous source of wealth and of employment', to the great work on which his father, Edward Baines M.P., had embarked, his *History of The Country Palatine and Duchy of Lancaster* (1834–6).[135] Although Baines junior disputed the claims of the 'hair-dresser' Arkwright to have invented the cotton-spinning machine, he allowed him his due as an entrepreneur:

> in improving and perfecting mechanical inventions, in exactly adapting them to the purposes for which they were intended, in arranging a comprehensive system of manufacturing, and in conducting vast and complicated concerns, [Arkwright] displayed a bold and fertile mind and consummate judgement; which, when his want of education, and the influence of an employment so extremely unfavourable to mental expansion as that of his previous life, are considered, must have excited the astonishment of mankind.[136]

This section was illustrated with a series of engravings after drawings by Thomas Allom. The first depicted 'The Factory of Messrs Swainson, Birley & Co near Preston

The Factory of Messrs Swainson, Birley & Co., near Preston Lancashire

Carding, Drawing and Roving in a Cotton Mill

Mule Spinning in a Cotton Mill

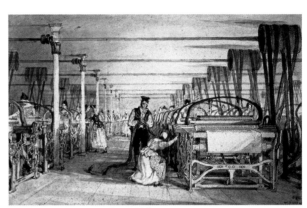

Power Loom Weaving in a Cotton Mill

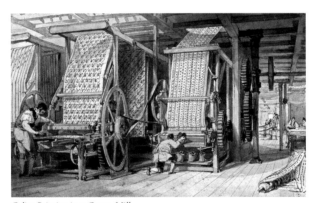

Calico Printing in a Cotton Mill

35 Thomas Allom, drawings for Edward Baines junior, *History of the Cotton Manufacture in Great Britain* (1835). Science Museum, London

Lancashire'. Its great slab of a building (according to the caption, 7 storeys high, 158 yards long, 18 yards wide, with 660 windows containing 32,500 panes of glass) had a castellated entrance block and was framed in a rustic setting. Allom also presented neat factory interiors showing carding, drawing and roving operations, and spinning, weaving and calico printing (fig. 235). An engraving of Wright's portrait of Arkwright and perspectives, plans and elevations of machines, including patent drawings, also featured and the section was completed with a view of Stockport, showing a forest of smoking chimneys rising beyond the rural foreground.

The contribution made by Baines junior was so well received, as his father proudly noted, that it was expanded into a separate *History of the Cotton Manufacture in Great Britain* (1835), which was also published in the United States and translated into German. It exhibited a messianic faith in the benefits bestowed through the fruitful exploitation

473

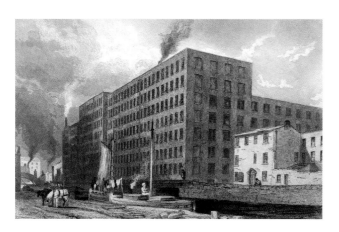

of the arts and science which was applied with peculiar force to the cotton industry as 'the very creature of mechanical invention and chemical discovery, and which has, in its turn, rendered the most important service to science, as well as increased the wealth and power of the country'. The work could 'therefore claim attention from the man of science and the political philosopher, as well as from the manufacturer and merchant.' Baines junior was peculiarly sanguine about the effects of the industry on the condition of the working classes, stoutly maintaining that the grounds for objection to factory labour – that it was unhealthy, severe and destructive to morals and life – were grossly exaggerated. Despite the long hours, he argued that factory labour was light and the conditions of hand-loom weavers were much worse. Yet he acknowledged the 'necessity of a better system of education, by which not merely the elements of knowledge, but the principles which govern social relationships, and the higher principles of morals and religion, should be taught to the whole population'.[137] The *History* included a few more illustrations, notably a somewhat grim view of cotton factories in Union Street, Manchester, showing their rudimentary, unadorned construction as the barest brick boxes, with a dingy canal in the foreground (fig. 236).

Andrew Ure, the professor of practical science from 1805 at the Andersonian Institution in Glasgow and the author of a *Dictionary of Chemistry* (1821) and a *New System of Geology* (1829), travelled round the manufacturing districts in 1834. The following year, he produced *The Philosophy of Manufactures: or, An Exposition of the Scientific, Moral, and Commercial Economy of the Factory System of Great Britain* for Charles Knight. In analysing 'the principles of manufactures' and expounding them in a simple manner, his publications would, Ure hoped, 'diffuse a steady light to conduct the masters, managers, and operatives, in the straight paths of improvement, and prevent them from pursuing such dangerous phantoms as flit along in the monthly patent-lists'. His work was submitted to the public 'as a specimen of the manner in which the author conceives technological subjects should be discussed'.[138]

The frontispiece, engraved by Joseph Wilson Lowry after a line drawing by James Nasmyth of the power-loom factory of Thomas Robinson of Stockport, suggested a factory floor of pristine cleanliness and orderliness, the elegant regularity of the machines dominating the tiny figures of an overseer and girl in the middle distance (fig. 237). Starting with 'General Principles of Manufactures', the work progressed to the Scientific Economy, Moral Economy and Commercial Economy of the Factory System. Ure countered the view that 'physico-mechanical science' had lent itself to 'rich capitalists as an instrument for harassing the poor, and of exacting from the operative an accelerated rate of work' by asserting that factory loom operatives had almost nothing to do compared with hand-loom weavers who lived in a miserable manner:

> The constant aim and effect of scientific improvement in manufactures are philanthropic, as they tend to relieve the workman either from the niceties of adjustment which exhaust his mind and fatigue his eyes, or from painful repetition of effort which distort or wear out his frame. At every stem of each manufacturing process described in this book, the humanity of science will be manifest . . . New illustrations of this truth appear almost every day.

So fulsome was Ure's panegyric for the factory system that at times it reads like a Dickens parody. He credited Arkwright with 'training human beings to renounce their

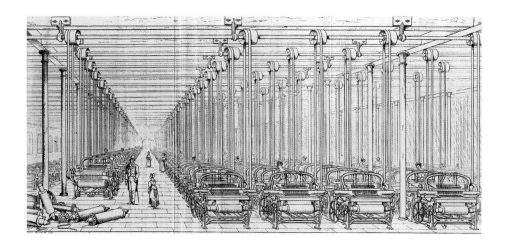

desultory habits of work, and to identify themselves with the unvarying regularity of the complex automaton'. Ure applauded the employment of children, for making them 'most docile and obedient' with watchful eyes and nimble fingers. Yet he credited the contribution made by 'enlightened manufacturers' who were, he believed, 'much better acquainted with the general economy of the arts, and better qualified to analyse them into their real principles, than the recluse academician can possibly be, who from a few obsolete data, traces out imaginary results, or conjures up difficulties seldom encountered in practice'.[139] Ure's *The Cotton Manufacture of Great Britain systematically investigated*, published by Knight in 1836, included 150 original figures of plans and elevations of machines and again celebrated the factory system whereby 'The reluctant tasks of our colonial slaves have been converted into the cheerful labours of free men.'[140] Then in 1839 he produced a complete *Dictionary of Arts, Manufactures, and Mines: containing a clear exposition of their principles and practice*. In the preface he demarcated the respective roles of science and art, the former being principles 'derived from primary materials, transformations by mechanical and chemical agencies into general objects of exchangeable value', leaving the latter, 'on the one hand, to the mechanical engineer, that of investigating the motive powers of transformation and transport; and, on the other hand, to the handicraftsman, that of tracing their modifications into objects of special or local demand'. Embodying the results of his long experience at the Andersonian Institution, the work would, he hoped, make a 'valuable contribution to the literature of science serving the manufacturer, metallurgist and tradesmen, merchants, students of chemistry and physics, capitalists, gentlemen at law, legislators and the general reader'.

The works of Babbage, Baines and Ure were understandably popular with manufacturing entrepreneurs for aggrandising their role, basing observations on tours of their enterprises and conferring on them the status of science. Babbage's *Economy of Machinery* even received a generally favourable review in *Cobbett's Magazine* in 1833 but with significant changes of emphasis.[141] The work was, 'G. W.' wrote, the 'emanation of a mind habituated to mathematical precision and arrangement, directed to a subject not previously treated with such exactness'.[142] Yet the reviewer was taken less by the 'principles of generalisation to which his other pursuits had naturally given rise', more by 'the perpetual occurrence of anecdote and illustration. The whole work, indeed, is very much like the note-book of an intelligent traveller who, to the record of a fact observed or a principle deduced, has added an anecdote exemplifying the importance of its application, or the circumstances by which it is elicited.'

While Babbage condemned the neglect of science in England, the author of the review condemned the neglect of the mechanical arts. Foreigners flocked to see the construc-

tion of a railway between Manchester and Liverpool or the Thames Tunnel but this enthusiasm for progress in the arts of industry was not reciprocated among the English. Accounts of palaces and picture galleries in Paris were considered sufficient: 'the rest is little better than a blank'. The reviewer proceeded to lash out against the lack of knowledge regarding the mechanical arts among students of science. There was still a prejudice against them in England:

> This feeling or retarding influence we take to be the distaste, nay the contempt, which is instilled into all, for the mechanical arts and their cultivators. . . . it may not be denied that amongst us 'being mechanical' has ever been synonymous with being vulgar. There is an all but universal abhorrence of the workshop. Man and boy will wade up to the middle to pluck a water-lily, or devote a day to a fruitless chase after the Emperor of Morocco, and yet will be horrified at the idea of entering a workshop, which to his mind, presents no other idea, than that of a disagreeable compound of noise, and smoke, and dirty-looking men – in short, 'unwashed artisans'. The consequence is, that even amongst our greatly learned, an extraordinary ignorance prevails, as to the production of the commonest articles of daily use. There are doubtless exceptions – many men who like Mr. Babbage, do not think their dignity is compromised, or their time misspent, in making themselves acquainted with 'processes which nearly or remotely have been fertile sources of their possessions', or that science is degraded, by being made to minister to the development of new sources of wealth in the useful arts. But these are truly exceptions.[143]

There were multiple proofs of this neglect, the author asserted. Harking back to the Arkwright patent trials, he noted, 'nothing is so common as to see a whole court, labouring to understand the relation of some simple manufacturing process, which the astonished mechanical witness vainly endeavours to impress upon legal stupidity'. The prejudice not only retarded progress in the mechanical arts but also deprived the cultivation of science of half its value. Multitudes were now devoted to the observation of nature and cultivation of the curious but little to the useful. Ladies studied flowers and insects yet 'one spark of curiosity has never been excited in the minds of the fair students as to the production of the spider-like fabrics in which they are adorned, or the colours, or the texture, of the garments in which they take so much delight'. As for men:

> Many a youth of much fame for science in his little circle will repeat all the experiments set down for him in Dr Joyce, and then wonder what is the use of chemistry. The dyer is his next door neighbour, but the dyer's vat is the only place in the parish he has never explored. He will die of *ennui*, and yet it will remain undiscovered.[144]

If some dire calamity should swallow up London, he speculated in a belated coda to the *Monthly Review* of 1769,[145] and a single specimen of the fashionably scientific should be preserved to tell the tale of its fate, what would be the account rendered by the great establishment showplaces of St Paul's, the British Museum or the Zoo:

> but of the real elements of the city's wealth and splendour, its ships and ship-building, its docks and harbours, the workers in brass, and forgers of iron; nay of every thing except the mere toys of art, the inquirer would in vain seek for information. If, like another Herculaneum, our city should become one great quarry, with the learned of assembled nations for its labourers, to how many of the ingenious contrivances which are now in operation, would our Cicerone be able to fix a name or assign a use?[146]

Portraits

In the final decade of his life, James Watt seems to have been concerned with leaving behind a suitable image 'to convey some idea of my person and countenance to those who may think me worth remembrance'. In 1812 he commissioned a three-quarter-length portrait from Thomas Lawrence, the President of the Royal Academy, but it was still incomplete in 1815 and reports from friends and family intimated that it and a proof of the engraving made after it by Charles Turner (using experimental copper plates supplied by Watt) were far from satisfactory.[147] He next turned to Henry Raeburn, possibly on the recommendation of John Rennie, a half-length of whom had been painted by the artist in about 1810. Watt commissioned a copy of this work for himself and his own half-length portrait from Raeburn, sitting for him in the autumn of 1815 during a brief visit to Edinburgh. Both engineers are represented with sober strength, the dramatic contrasts of light and shadow making Watt (then aged seventy-nine) appear gaunt. Although Watt's initial reaction on his return from Edinburgh was moderately favourable ('though it does not come up to my ideas of my own face [it] is more conformably to them than any of the others and by my friends is said to be a good likeness'), the finished picture was considered too gloomy – 'it frowns too much'.[148] Instead, the definitive likeness of Watt was a marble bust by Watt's friend Francis Legatt Chantrey, completed for the sitter in 1814 and used as the basis for numerous later versions and copies (fig. 238).[149]

Chantrey presented Watt in the guise of a classical sage, his head leaning forward, his mouth set firm, his eyes somewhat narrowed and directed to one side and his brow furrowed as if ruminating on some particularly tricky problem. The drapery enfurled over his shoulders and chest completed the impression of the sitter's membership of the canon of worthies, both ancient and modern. Watt, the surveyor and mechanic, was represented as nothing less than the elder statesman of science. Although Watt expressed reluctance when responding to Chantrey's request to exhibit his bust at the Royal Academy in 1815 – 'I am not over fond of exhibiting myself either in person or by proxy' – he immediately ordered several plaster casts for distribution to friends and colleagues and began to make arrangements for the work to be engraved. In 1818, the year of his completion of Waterloo Bridge, John Rennie also commissioned a marble bust of himself from Chantrey and the results were reckoned by some to be the sculptor's masterpiece (fig. 239). Bigger and even more forceful than the bust of Watt, it was praised as a 'head

238 (left) Francis Chantrey, *James Watt*, 1816. Private Collection

239 (right) Francis Chantrey, *John Rennie*, 1818. National Portrait Gallery, London

of extensive capacity and thought'.[150] Yet despite the trappings of classicism in the loose toga-like drapery, Chantrey also conveyed Rennie's dynamism, giving him the windswept hair of an outdoor man, the mouth set firm and slight movement of the head off-centre perhaps suggesting he had just noticed in his beady Scottish way a detail of workmanship on site that was not up to scratch. This was a classical bust but with subtle intimations of the modern world.

Rennie's bust was a private commission which, although exhibited at the Royal Academy in 1818, Edinburgh in 1822 and the Art Treasures exhibition in Manchester in 1857, remained in the family until it was donated to the National Portrait Gallery in 1881. A public testimonial of the rising status of mechanics and their posthumous repositioning is demonstrated by the commission in 1824 of a gigantic statue of James Watt, again from Chantrey, for inclusion in that British valhalla of Westminster Abbey.[151] The process of sanitising Watt's reputation had gathered pace after his death in 1819, which inevitably occasioned a rash of hyperbolic obituaries including one composed for the *Encyclopaedia Britannica* by his son, James Watt junior.[152] Tredgold's strictures regarding Watt's abilities and business ethics were removed from the second, posthumous edition (1838) of his *Treatise on the Steam Engine* and the earlier favourable account of Jonathan Hornblower's contribution omitted.[153] Watt junior also distributed copies of Chantrey's busts of his father to his friends, as well as to Handsworth parish church, where the great man was buried, to Greenock, his birthplace, and to Glasgow University, the site of his early experiments. Thus the public and the private character of Watt was buffed up for immortality. His monument in Westminster Abbey represented the culmination of this process.

The unprecedented nature of its installation in 1834 was expressed retrospectively by Dean Stanley in 1868:

> Well might the standard-bearer of Agincourt, and worthies of the Courts of Elizabeth and James, have started from their tombs in St Paul's Chapel, if they could have seen this colossal champion of a new plebeian art enter their aristocratic resting-place, regardless of all proportion, or style, in all the surrounding objects. Yet, when we consider what this vast figure represents, what class of interests before unknown, what revolutions in the whole framework of modern society, equal to any that the Abbey walls have yet commemorated, there is surely a fitness even in its very incongruity.[154]

Stanley's reservations were in part aesthetic – the 'vast figure' violated the ancient architecture of the Abbey – but there were also residual traces of that snobbery towards mechanics, when introduced into the company of monarchs, courtiers, generals, admirals and of course Sir Isaac Newton. Yet Stanley conceded that the figure of Watt symbolised a hitherto unrepresented coalition of interests which had been responsible (at least by 1868) for a social revolution. The nature of those interests can be discerned from those who raised the £6000 needed to pay for the monument. As Christine MacLeod has pointed out, they constituted an alliance of reforming 'men of science', manufacturers and liberals for whom Watt and the steam engine embodied the progress of the sciences of industry and political economy.

Prominent among those attending the public meeting staged in February 1824 to launch the fund-raising campaign were government ministers in a private capacity and members of the Athenaeum. As the President of the Royal Society, Sir Humphry Davy claimed that Watt was not only 'a great practical mechanic' but 'was equally distinguished as a natural philosopher and a chemist'. His improvements were no accident but were 'founded on delicate and refined experiments'. Nevertheless, Davy allowed that Watt was not limited to 'abstract science' but 'brought every principle to some practical use'.[155] Such views accorded with the line promoted by Brougham in his advocacy

240　Samuel Lane, *Thomas Telford*, 1822. The Institution of Civil Engineers

of mechanics' institutes and the Society for the Diffusion of Useful Knowledge. Other parties at the meeting emphasised the commercial advantages of steam power, notably the Prime Minister, Lord Liverpool, and the President of the Board of Trade, William Huskisson. They were supported by the manufacturing interest, which was represented on the monument committee by Robert Peel and his father, members of the Strutt, Arkwright and Wedgwood families, the Leeds woollen manufacturer Benjamin Gott and others. Manchester featured prominently on the committee with nine cotton-spinners – all members of the Manchester Literary and Philosophical Society, headed by its President, John Dalton. Subscriptions rolled in from Birmingham canal proprietors, London brewers, merchant houses, dock and steam-ferry companies, Welsh ironmasters and a Cornish mines developer. Only the mechanical engineers were conspicuous by their absence (with the exception of Henry Maudslay), still possibly sore from patent disputes and more immediately from government and Manchester opposition to repeal of the machine export ban.[156]

Watt was not the only engineer to cultivate his reputation and thereafter to be eulogised. In 1822 Thomas Telford commissioned a large-scale portrait of himself from Samuel Lane, as perhaps befitted his new status as the first President of the Institution of Civil Engineers (fig. 240). He is depicted sitting at a table with one of his greatest achievements, the Pontcysyllte aqueduct, visible through the window behind. In the year of his death in 1839, a large statue of Telford was also placed in Westminster Abbey, modelled by Edward Hodges Baily. He wears a sort of wrap or overcoat, with protractor in hand, resting on volumes entitled *Civil Engineering* and *Inland Navigation* (referring to Telford's achievements, not works he wrote). While the sculpture of Watt was later removed to Scotland, that of Telford remains in the north transept of the Abbey, keeping company with the actors John Kemble and Sarah Siddons. In the second half of the nineteenth century, commemorative stained-glass windows were installed in the north aisle of the nave to Robert Stephenson (his portrait surrounded by those of five fellow engineers – John Smeaton, James Watt, John Rennie, Thomas Telford and George Stephenson), Isambard Kingdom Brunel (now in the south aisle), Joseph Locke (no longer *in situ*), Richard Trevithick and Sir William Siemens (the latter also removed).

With the diffusion of portraits, statues and biographies of Watt, Arkwright, Telford and others, invention gained an unprecedented public profile. It was seen to be born of individual genius in its romantic sense and cultivated through a combination – in varying degrees – of scientific principle and dogged practice. The aggrandisement of invention was supported by those like Carlyle who viewed its rugged individualists as being involved in an elemental struggle to tame nature. As he wrote in *Chartism* (1839), looking back to Wright's famous portrait, Richard Arkwright, 'was not a beautiful man; no romance-hero with haughty eyes, Apollo-lip, and gesture like the herald Mercury' but 'a plain almost gross, bag-cheeked, potbellied Lancashire man, with an air of painful reflection, yet also of copious free digestion'. Nevertheless, 'what a Historical Phenomenon is that bag-cheeked, potbellied, much enduring, much inventing barber!'[157] Neither had Watt a heroic origin or any kindred with the princes of this world. Yet Carlyle advised his readers to admire what was admirable, not what was dressed up as admirable. It was a theme to which he returned in *Past & Present* (1843) with reference to Brindley.

Christine MacLeod has comprehensively demonstrated how the commemoration of these 'heroes of invention' served the purpose of a number of Victorian interest groups:

479

those lobbying for patent law reform on the basis that individual endeavour ought to receive its just reward; a sentiment which surfaced in the middle decades of the century that men of peaceful achievement ought to receive their due as well as military commanders and politicians; and by the 1860s, others campaigning for the extension of the franchise to working men on account of their skill, ingenuity and inventiveness.[158] Equally, the very acknowledgement of the key role played by these eighteenth-century men of industry confirms that the methods they adopted to pursue their goals, as described in this book, had not been undertaken in vain. They would scarcely have been remembered if they themselves had not described and rationalised their work for the benefit of the generations who followed. In his presidential address to the Institution of Civil Engineers in 1846, Sir John Rennie rehearsed at length the generations of engineers and their achievements since the days of Smeaton, Brindley and Watt. He drew attention to the role played by drawing and modelling in the training of engineers and the combination of theory and practice on which their profession was based. Looking back to their humble beginnings, he remarked 'what triumphant progress we have made!'[159]

The new engineering institutions consolidated their credentials by lining their premises with portraits of their most illustrious members, as had long been the practice in the Royal Society. By mid-century, besides his collection of machines and models, the Keeper of the Patent Office, Bennet Woodcroft, had accumulated – with the approval of Prince Albert and the Commissioners of the Great Exhibition – a collection of portrait paintings, engravings, miniatures and medallions which he billed as a 'Gallery of Portraits of Inventors, Discoverers and Introducers of Useful Arts'. They constituted a group readily recognisable to readers of this work: Arkwright, Baskerville, Samuel Bentham, Boulton, Brindley, Cartwright, Crompton, Desaguliers, Dollond, Harrison, Kay, Lee, Peel, Rumford, Smeaton, Strutt and Watt. By 1859 the list had extended to include the Arnold family, Bird, Black, Brunel, Foudrinier, Graham, Maudslay, Mudge, Pinchbeck, Ramsden, Telford, Trevithick and Whitehurst.[160]

This collection inspired John Timbs to produce *Stories of Inventors and Discoverers in Science and the Useful Arts* (1859), one of a clutch of publications produced the same year which celebrated the skills of leading inventors.[161] By far the most successful were compiled by the leading Victorian advocate of self-improvement, Samuel Smiles: *Self-help* (1859), the *Lives of the Engineers* (1862) and *Industrial Biography: Iron Workers and Tool Makers* (1863). As a spur to his own generation, Smiles constantly stressed the achievements (if not the financial rewards) brought about through the perseverance and hard work, courage and integrity of his subjects.[162] Woodcroft's collection also enabled an enterprising engraver, William Walker, to publish in 1862 a group portrait of those luminaries who were alive at the turn of the nineteenth century, as if gathered together in the library of the then newly founded Royal Institution. The work was designed by Sir John Gilbert, the individual figures drawn by John F. Skill after the portraits available and engraved by Walker and his associates. Inevitably, a central position was occupied by Watt, seated at a table with Boulton and surrounded by a group of fellow engineers – Brunel, Maudslay, Mylne, Murdock, Rennie, Telford. On the right of the picture there was a cluster of pioneers in the textile industry: Samuel Crompton, Edmund Cartwright and Charles Tennant. Leading natural philosophers, chemists, astronomers, geologists, botanists and three scientific instrument-makers also featured but not to the same extent as the engineers. Nevertheless, although it seems that Walker's first idea for the title might have been 'Great Master Minds of the [Eighteenth?] Century' with a subtitle 'A Century of Invention', it was published as *Men of Science Living in 1807–8*.[163]

Scenes of Industry

Even before Napoleon was safely incarcerated on St Helena, a stream of visitors crossed the Channel from the continent, bent on seeing for themselves the reported advances in British manufacturing and mechanisation.[164] From 1814, the Prussian government sent a number of its civil servants on tours of investigation, notably, in 1826, the architect and Privy Councillor for Public Works in Prussia, Karl Friedrich Schinkel and his friend Peter Christian Wilhelm Beuth, who was the director of the state agency for trade and industry (Technische Deputation für Gewerbe). Schinkel's purpose was to inspect details of museum buildings in connection with his projected Museum am Lustgarten (Altes Museum) and Beuth's was to secure information which might be useful for the development of Prussian industry. In 1821, in his inaugural address as the founder to the Association for the Encouragement of Trade and Industry in Prussia (Gewerberein), Beuth named the Society of Arts in London as the model for its foundation.[165] Both men expanded their interests beyond the original aims and benefited from each other's viewpoint.

Beuth had visited Britain in 1823 when he alerted Schinkel to its industrial wonders in a letter written from Manchester:

> It is only here, my friend, that the machinery and buildings can be found commensurate with the miracles of modern times – they are called factories. Such a barn of a place is eight or nine storeys high, up to forty windows long and usually four windows deep . . . A mass of such buildings stand in very high positions dominating the surrounding area; in addition a forest of ever higher steam engine chimneys, so like needles that one cannot comprehend how they stay up, present a wonderful sight from a distance, especially at night when the thousands of windows are brightly illuminated with gas light.[166]

In 1826, they travelled together to Paris, London, Leeds, Edinburgh, Glasgow, Manchester, Liverpool and Bristol, with a detour to Birmingham and the West Midlands on the way north and taking a break from their urban itinerary in the Hebrides. The 75-page journal Schinkel kept is in the tradition of those already mentioned.[167] Little impressed by more showy elements of British architecture, notably Nash's Regent's Park, Schinkel was fascinated by new machinery and the extensive use of cast iron in building structures, first viewed in the warehouses of the London and West India Docks. His visual notes on the exposed use of iron columns, roof trusses and brackets supported his application of these new building techniques in Prussia (fig. 241). Practical knowledge relating to machines, tools and industrial processes acquired on visits to foundries, mills and potteries was also put to use. He made notes of the machines used in the Royal Mint, Joseph Bramah's hydraulic presses, smelting methods, machines for planing, producing springs and his locksmith's workshop. Schinkel also recorded the means used in the construction of Maudslay's workshop (where one iron roof had just collapsed), and the foundry tools and hammers within, as well as the sawmill, smiths' shop and anchoring equipment in the Royal Arsenal. The two Prussians seem to have been well received, Schinkel noting Bramah, 'that pleasant gentleman', had an overseer show them round, while Maudslay, 'a stout friendly man', took them round himself.[168] They were refused entry to Strutt's cotton mill at Belper but were received kindly in Leeds by Mr Gott, 'a dignified and refined old gentleman, who has made millions in cloth manufacture'.[169]

Yet Schinkel also noted the chaotic unplanned nature of this industrial expansion, which offended his sense of beauty and order. His initial romanticised impression of Birmingham, 'which looks Egyptian with the pyramids and obelisks of the factory fur-

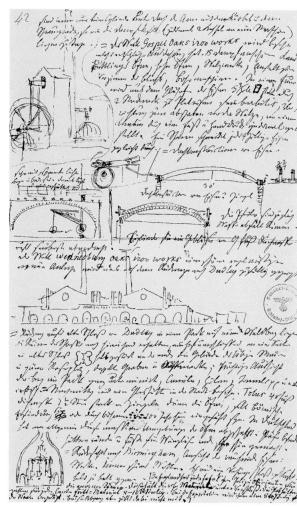

naces', gave way to a 'very melancholy impression' the following day, a Sunday, as he walked round 'the cheerless town, with much poverty to be seen': 'The sight of an English industrial town like this is most depressing: nothing pleases the eye, and there is also the Sunday silence.'[170] Dudley with its 'thousands of smoking obelisks' overwhelmed him and Gospel ironworks was of horrific proportions, its iron roof shuddering with vibration from fifteen steam engines, hammers, furnaces and rolling mills. He was more impressed by Wednesbury Oaks Iron Works, a 'fine new well laid-out plant' and was so taken with the impressive plants and beautiful surroundings of 'Hetruria' and the Potteries that he was moved to draw a prospect of them with the 'wonderfully Egyptian-oriental forms' of the bottle kilns (fig. 242).[171]

The industrial wonders of the eighteenth century were no longer of interest. Schinkel was taken with Arkwright's Willersley Castle but ignored his Cromford cotton mills. He passed by Coalbrookdale on a stagecoach without bothering to stop. It was Manchester with the mushroom growth of its mills and canals and the ruthless control of its labour supply – six thousand Irish workers had been transported back home due to the shortage of work – that both fascinated and appalled him (fig. 243):

Since the war four hundred new factories have been built where three years ago there were still fields, but these buildings appear as blackened with smoke as if they had been in use for a hundred years. It makes a dreadful and dismal impression: mon-

strous shapeless buildings put up only by foremen without architecture, only the least that was necessary and out of red brick.[172]

Yet Schinkel was alive to the beauties of more recent feats of civil engineering, notably Telford's suspension bridges at Conway and Menai, making careful prospects of their whole situation. The great Menai suspension bridge was a 'wonderful, daring work. No shuddering, which might have been detrimental, as we drove across. I drew the whole scene, to record the hugeness of the thing . . . Bought an account of the construction.' He was equally impressed by Telford's Pontcysyllte aqueduct, canals and road construction.[173] Schinkel could reconcile landscape and industry provided the latter was neatly planned and on an appropriate scale. While driving in a chaise to Wotton-under-Edge in Gloucestershire he noted:

> The road through the valley is the loveliest sight one can imagine: a succession of country houses lying together and ranging from very small to middle-sized with adjoining gardens and parks, set in the most varied positions on slopes and in the valley, interspersed with streams, millponds and canals, woods, meadows and green hillsides. Factories (all textile mills) and small churches alternate, hidden behind tall lime trees, elms, larches.[174]

With so much industrial change taking place in the first half of the nineteenth century, it is not surprising that concerted efforts were made to reconcile the public through the publication of topographical prints which viewed massive incursions into a hitherto pristine landscape in the best possible light. A magnificent series of aquatints of the new London docks was produced by William Daniell between 1802 and 1813, aimed at the directors of the companies that were building them and a wider audience, both at home and abroad, for whom the scale of the enterprise was the subject of astonishment and awe 'at the greatness and might of England'.[175] The first view to be published by the artist depicted the vast expanse of the West India Docks on the Isle of Dogs, constructed, as the letters proudly stated, in little more than two years between 1800 and 1802 and covering an area of thirty acres, 'a scene so highly interesting to every well-wisher to the prosperity and glory of this Country' (fig. 244). Indeed, so anxious was Daniell to catch the market that he worked off a plan published by John Fairburn in 1802 and introduced some warehouses, housing and a section of the canal that were never built. Nevertheless, the print, dedicated to the chairman and directors of the West India Dock Company, proved to be a success; Daniell was reported to have made more than two hundred guineas from it and he was encouraged to pursue his scheme. A view of the London Dock at Wapping followed in 1803, again dedicated to the chairman and directors. Once more it anticipated the dock's completion, being based on the survey and architectural drawings of Daniel Alexander and Fairburn's 1802 map. The Brunswick Dock, Poplar, better known as Perry's Dock, Blackwall, with its prominent 117-feet-high mast-house, followed in 1803. A print of the new East India Dock, constructed to the

243 Karl Friedrich Schinkel, McConnell and Murray cotton mills, Union Street, Ancoats, Manchester, 1826 from *Tagebuch*, 1826, f.62. Zentralarchiv, Staatliche Museen zu Berlin

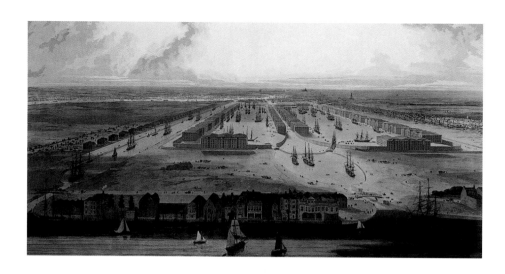

244 William Daniell, *An Elevated View of the New Docks & Warehouses now Constructing on the Isle of Dogs*, 1802

north by John Rennie and Ralph Walker between 1803 and 1806, was first published in 1808, the directors of the company buying twenty copies each for their own use. Another print of London Dock was produced the same year and the final print in the series, the Commercial Dock at Rotherhithe, was published in 1813.

The promotion of other engineering feats followed a similar pattern. Even the smouldering wasteland of Wednesbury resorted to marketing techniques. *A Plan and Section of a Coal Work, with the Strata commonly met with in sinking, near Wednesbury, Staffordshire*, was drawn by Thomas Westwood, engraved by Francis Eginton and published by Westwood on 7 April 1806 (fig. 245). The text described the works and identified the different geological strata, presumably aimed at an educated general audience. Yet, although the overall impression is of a neat, regular, well organised form of employment, the artist clearly had problems in attempting to relate the plan to the elevation on the same sheet and encompassing two different scales. A second version attempted to resolve the discrepancies in viewpoint more effectively. *A Perspective Plan and Section of a Coal Work* . . . is undated but presumably from the same source (fig. 246). Realising that having plans on both sides of a section of shaft was confusing, the artist tilted the plans of the mine works forward to present them in perspective.[176] Overall, geometry and geology contrived to create a polite impression of the industry.

Early in the 1820s a series of prints was published of the new Hetton Colliery at Durham, seemingly at the behest of the projector and manager, Arthur Mowbray. One, in particular, published in Sunderland, explained why he was proud of the enterprise (fig. 247). It combined in a single print three perspectives: a panoramic view of 'the horizontal, inclined and self-acting planes with the locomotive and other engines used on the railway' and two smaller vignettes of the colliery works and 'the self discharging depot on the banks of the river Wear near Sunderland'. The text claimed that the whole enterprise and specifically the main seam, sunk in 1822 to a depth of 268 yards, formed 'a new era in the History of Mines and of Geological Science':

245 (facing page top) Francis Eginton after Thomas Westwood, *A Plan and Section of a Coal Work, with the Strata commonly met with in sinking, near Wednesbury, Staffordshire*, 1806. Science Museum Library and Archives, Science Museum, Swindon, Reynolds, 127

246 (facing page bottom) Francis Eginton after Thomas Westwood, *A Perspective Plan and Section of a Coal Work, with the Strata commonly met with near Wednesbury, Staffordshire*, c.1806. Science Museum Library and Archives, Science Museum, Swindon, Reynolds, 128

The opinions of mineralogists, as well as the majority of the scientific professional gentlemen, were, that coal did not exist, or if it did exist, that it deteriorated both in quality and thickness under the magnesian limestone, but this colliery has been sunk thro' a bed of this stone 58 yards in thickness and so far from being deteriorated, the coal is superior both in its quality and the thickness of its seams.

Those responsible for this triumph over the views of 'scientific professional gentlemen' were all listed: Mowbray himself as projector and manager, Thomas Wood, 'Accomp-

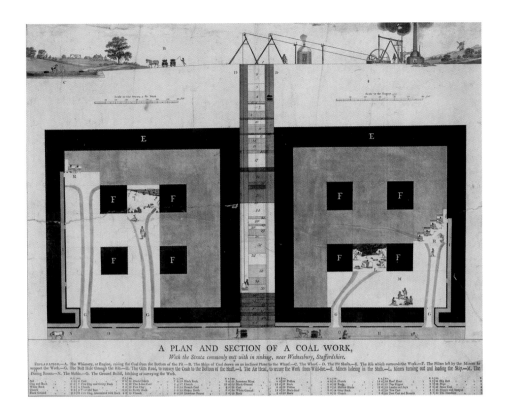

A PLAN AND SECTION OF A COAL WORK,

With the Strata commonly met with in sinking, near Wednesbury, Staffordshire.

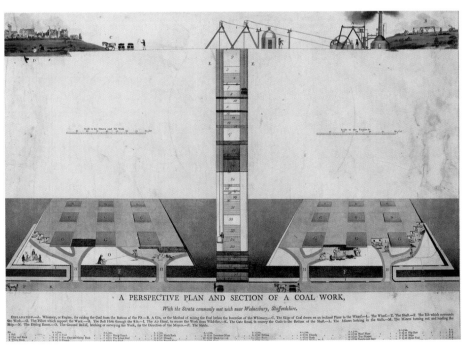

A PERSPECTIVE PLAN AND SECTION OF A COAL WORK,

With the Strata commonly met with near Wednesbury, Staffordshire.

tant', and Robert Stephenson, engineer, 'to whom the Manager owes many obligations for fixing and improving the machinery and for his skill and attention in the sinking, as also to Mr Wood for his diligence and accuracy not only as Accomptant but for assisting in the levelling and arranging of the wagonway, for the self-acting planes &c.' The print listed the names of the assistant viewer, master sinker, master mason, master foreman and smith, master wright and master foundrymen and 'all other men employed

Hetton Colliery in the County of Durham.

PERSPECTIVE VIEW of the WORKS of the COLLIERY, the HORIZONTAL, INCLINED and SELF-ACTING PLANES with the LOCO MOTIVE and other ENGINES used on the RAIL WAY and the STAITHS and SELF DISCHARGING DEPOT on the BANKS of the RIVER WEAR near SUNDERLAND.

Section of the Pit and STRATA Sunk through

Scale of Yards

247 *Hetton Colliery in the Country of Durham*, c.1822. North of England Institute of Mining and Mechanical Engineers. Wat/31/34

247 *Hetton Colliery in the Country of Durham*, c.1822. North of England Institute of Mining and Mechanical Engineers. Wat/31/34

248 (facing page top and bottom) James Duffield Harding, *Hetton Colliery*, c.1822. North of England Institute of Mining and Mechanical Engineers, Wat/31/32. Ironbridge Gorge Museum, Coalbrookdale

in the colliery for their skill and attention in many difficulties, and for their general good conduct'. Across the bottom of the print was a section of the pit and the different strata sunk through to the coal in the Hetton or Wallsend seam.[177]

Hetton Colliery was also the subject of three lithographs, drawn by James Duffield Harding and printed by Hullmandel, again presumably commissioned by Mowbray (fig. 248). Although the scenes closely relate to the panorama and vignettes in the print just described, Harding did his best to reconcile industry with the landscape. The impact of the belching smoke of the colliery stacks and the steam engines was softened by vegetation and the massive bulk of the staithes by the masts and rigging of the colliers moored in the river. Corresponding to the panorama, the third image looks like a rustic pastoral but in the distance the mine can be discerned and trains pull wagons of coal to the inclined plane and then haul the wagons to the Wear, crossed by the landmark Sunderland Bridge.[178]

The opening of new bridges, canals and tunnels was celebrated with the publication of prints in the media of aquatint or the newly invented lithography. Marc Brunel's Thames Tunnel triggered an entire souvenir industry, ranging from mugs and medallions to peep shows and other games. Railway promoters were equally inventive.[179] Ackermann and Company were the leading publishers of railway prints during the first decades of the railway boom.[180] Their first success in 1831 was with two 'long prints', aquatints after Isaac Shaw, depicting 'Travelling on the Liverpool and Manchester Railway'– 'A Train of the First Class of Carriages, with the Mail' and 'A Train of the Second Class for outside Passengers' – neat profiles of the trains carrying genteel, smut-free travellers. *Coloured Views on the Liverpool & Manchester Railway*, also published in 1831, comprised aquatints made after drawings by Thomas Talbot Bury, featuring profiles of the train and topographical perspectives of the line. Bury's views minimised the disruption the railway caused, the surrounding landscape positively enhanced by his picturesque treatment of the tunnels, cuttings and embankments (fig. 249). The prints offered reassurance as to the benefits of travel by steam locomotive and served as attractive souvenirs for those who climbed aboard.

Again after Thomas Talbot Bury, *Six Coloured Views on the London and Birmingham Railway* came out in 1837 but Bury's pristine topography was outclassed by the thirty-

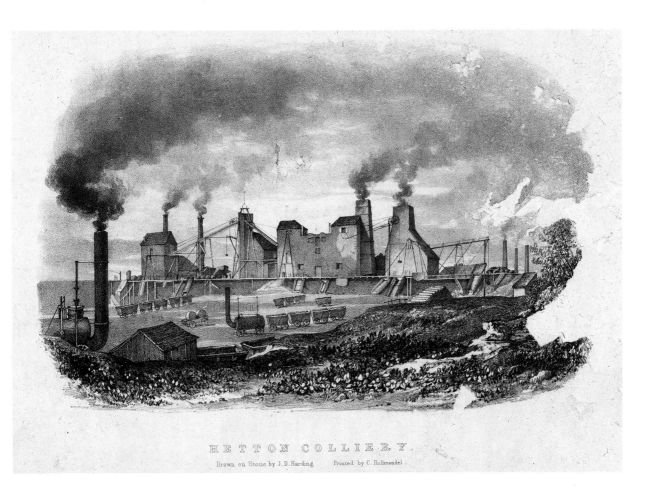

HETTON COLLIERY.

Drawn on Stone by J. D. Harding Printed by C. Hullmandel.

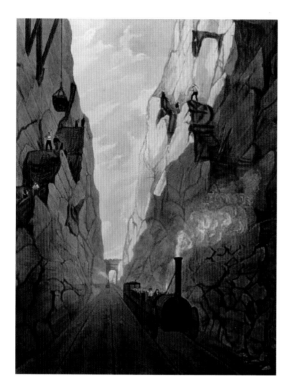

six lithographs, published in four parts by the topographical artist and engraver John
Cooke Bourne in association with Ackermann in 1838–9. Cooke Bourne had witnessed
the excavation of the London and Birmingham Railway as it made its inexorable progress
through Camden Town and onwards into Middlesex, drawing pen-and-ink studies on
the spot of navvies digging, carrying, hauling, building – and occasionally resting –
watched by groups of curious onlookers. He converted these into a series of sepia wash
pictures, which served, at the suggestion of the journalist and antiquarian John Britton,
as the basis for the prints.[181] Collectively they convey with documentary realism the
massive scale of disruption but they also record the engineering feats involved in con-
structing, for example, Tring Cutting or Kilsby Tunnel, the latter lit dramatically by its
ventilation shafts (fig. 250). Bourne's views of Isambard Kingdom Brunel's completed
railway were published as *The History and Description of the Great Western Railway* in
1846. Rather than focusing on the progress of the works, it provided a showcase for the
architectural features that Brunel had incorporated down the line – viaducts held aloft
on Egyptian piers, tunnel entrances in the form of Roman triumphal arches or
Romanesque portals, stations with Tudor hammer-beam roofs – in conscious succession
to the great builders of the past.

Bourne was not alone in making studies of the massive engineering projects as they
were under way. The artist George Scharf, who arrived in London from Bavaria in 1816,
earned a living by producing drawings for scientific bodies and learned journals. His
draughtsmanship was deemed sufficiently accurate for him to be commissioned in 1830
by John Rennie junior to produce three drawings depicting the demolition of old
London Bridge and the construction of Rennie's replacement. Scharf spent three years
working on site and in the studio but by the time they were complete, Rennie denied
that he had ordered them. Instead, Scharf offered them to the London Bridge Com-
mittee who bought them, after much haggling, for £30. The surviving drawings, water-
colours and two lithograph long views record not only the buildings that were about
to be pulled down but gangs of demolition workers, masons measuring and chiselling

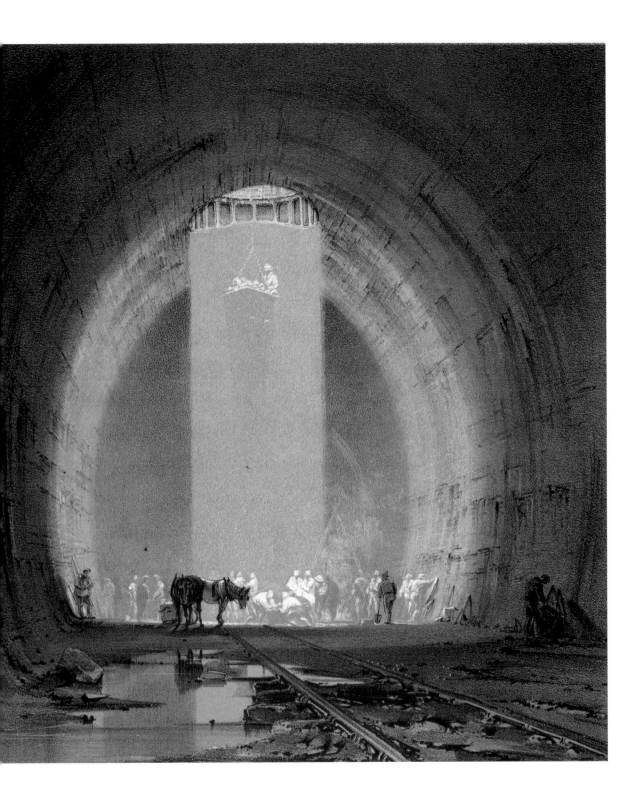

250 John Cooke Bourne, 'Working Shaft – Kilsby Tunnel July 8th 1837', from *Drawings of the London and Birmingham Railway, with a Historical and Descriptive Account by John Britton, F.S.A.*, 1839

the stone for the new bridge and the blocks being moved with winches, pulleys and by manual labour (fig. 251). Scharf was an indefatigable sketcher of people whom he hoped to incorporate into what he called 'arranged compositions' but only a few of the thousands of studies were ever worked up in this way, notably views of the laying down of new London gas and drainage pipes (fig. 252).[182] He exhibited at the Royal Academy and other galleries but in more than forty years he never sold a single picture. Where a market existed for industrial sights, it tended to be local: John Petherick and Penry

489

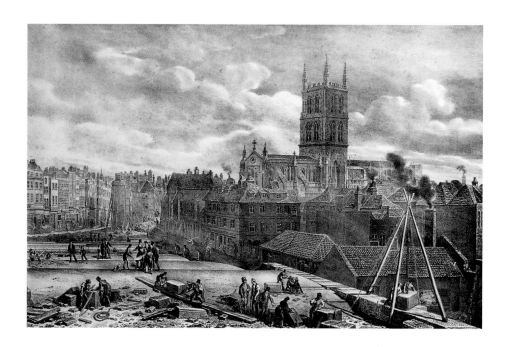

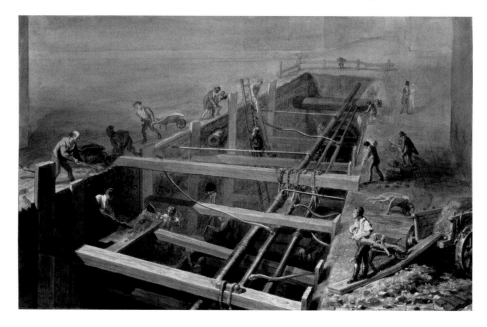

251 (top) George Scharf, *A View of High Street Southwark being The Ancient Roadway leading from Old London Bridge taken July 1830, previous to its Removal for the New Line of Approach* (detail). Guildhall Library, Corporation of London

252 (bottom) George Scharf, *Building the New Fleet Sewer*, 1825. British Museum, Department of Prints and Drawings

Williams painted industrial scenes in South Wales and the Newcastle-born artist Thomas Harrison Hair recorded the coal mines in the north-east. Petherick's most extraordinary pictures were of the ironworks at Rhymney, the blast furnaces and regulator designed in the mid-1820s in the Egyptian Revival style by the physician, geologist and amateur architect John MacCulloch for the second Marquis of Bute (fig. 253).[183] Williams was a native of Merthyr, painting scenes for the ironmaster William Crawshay II (fig. 254). Hair's watercolours were published as etchings first in 1839 and then in an enlarged edition as *A Series of Views of the Collieries in the Counties of Northumberland and Durham* (1844; fig. 255).[184]

In the exhibitions staged by the Academy and even by the watercolour societies the subject of industry could only be approached, if at all, obliquely, or in a highly metaphorical way. It is not immediately obvious that Constable's famous paintings of the river

490

53 John Petherick, *Bute Furnaces, Rhymney, c.*1830

Stour were of a waterway rendered navigable for the purposes of trade by locks, banking and dredging activities undertaken by commissioners who included successive generations of the Constable family. The river served as Constable's greatest source of inspiration: 'the sound of water escaping from mill dams . . . willows, old rotten banks, slimy posts, & brickwork. I love such things . . . As long as I do paint I shall never cease to paint such places.'[185] Constable was also attracted to new civil engineering projects. He was on the Thames in June 1817 when the Prince Regent opened Waterloo Bridge and the sketches he made served as the basis of a series of studies and eventually the completion of the large-scale painting exhibited at the Royal Academy in 1832. The Chain Pier at Brighton caught his attention in the mid-1820s, resulting in a magnificent six-footer, exhibited in 1827, in which the 'dandy jetty' served to symbolise modernity and the development of Brighton as a fashionable resort, in contrast with its traditional role as a fishing port, represented by men working amid their nets and boats in the foreground.[186]

Turner made detailed drawings of different industrial scenes in his travel sketchbooks. His studies of Leeds with its factories and chimneys were transformed into a panoramic watercolour in 1816, including the token figure of a cloth-worker in the foreground carrying a bundle of newly woven cloth to be dried by the tentermen in the sun.[187] The detailed pencil drawing he made of *'The Hurries'*, showing the loading of coal boats at North Shields, served as the basis for a dramatically moonlit watercolour in 1823, *Shields,*

on the River Tyne. For the dining-room of his patron, the third Earl of Egremont at Pet-
worth in Sussex, he painted in the late 1820s *Chichester Canal* and *The Chain Pier,
Brighton*, two projects in which Egremont had invested. His watercolour of *Dudley,
Worcestershire*, a dazzling evocation of smoking engine-houses, glowing furnaces and the
barges of the Black Country canals, resulted from the sketches he made in 1830 in the
Midlands for his *England and Wales* print series (fig. 256).

Yet the only images of industry by Turner that would have been known to the public
in his own day were *The Fighting 'Temeraire' tugged to her Last Berth to be Broken Up*
(1838) and *Rain, Steam and Speed* (exhibited in 1844). A veteran of Trafalgar, the

256 J. M. W. Turner, *Dudley, Worcestershire*, 1830. National Museums Liverpool, Lady Lever Art Gallery

Temeraire was sold out of the Royal Navy in 1838. Stripped of her masts, she was towed up the Thames by two steam tugs to the wharf of her new owner, the ship-breaker John Beatson. Turner never saw this sad progress. Instead, his painting is an imaginative recreation, drawing on memories and sketches, which marks simultaneously the passing of the heroic age of sail and the birth of the new age of steam, in the shape of the tug which tows the ghostly vessel with her masts still in place upriver against a symbolic setting sun. It would be equally futile to ally the structure of *Rain, Steam and Speed* to the precise calculations Isambard Kingdom Brunel made for Maidenhead Bridge over which the train travels. Again it is a supremely visual metaphor for the new age. Steam power in the form of the blackened engine speeds towards the viewer chasing nature before it, in the shape of a hare. Below, on the bank of the Thames, a ploughman trudges through the rain behind a horse-drawn plough. Turner allied the grand-manner aesthetics of Reynolds, the idea of a historical sublime in landscape, with the immediacy and modernity of the watercolour. These two great paintings have roots in topographical reportage, certainly, but so spun as to form a shimmering blur of theatrical illusion.

The Great Exhibition and its Aftermath

The Great Exhibition, staged in Hyde Park, London, in 1851, attempted to reconcile many of the tendencies outlined in the preceding pages and has rightly been described as a 'cultural battlefield'.[188] Yet it can also be seen as the last triumphal representation

493

of the arts of industry, the grand finale of the old unified world of knowledge. Its organisation, at least, was relatively unaffected by the aggrandising agendas espoused by champions of the fine arts and pure sciences. It grew out of the exhibitions of machines and manufactures that had been staged throughout the country in the early decades of the nineteenth century, themselves successors to those held in the eighteenth century. Although credit for its conception has been much disputed, the claims to parentage of the Society of Arts have the greatest credibility. In 1844, the new secretary of the Society, Francis Whishaw, a railway engineer, suggested 'a Grand Annual Exhibition of Manufactures' and the following summer toured the country eliciting support from manufacturers, recruiting the Scottish marine engineer John Scott Russell, who in turn recruited the reforming bureaucrat Henry Cole to help develop such exhibitions.

Cole is one of those eminent Victorians whose achievements are so vast and wide-ranging that it is difficult to imagine how he found the time and energy to accomplish fthem. Involved as a young man with the group around John Stuart Mill known as the philosophic radicals, whose watchword was reform, he had applied his extraordinary talent for political agitation to the goal of reforming his own institution, the Public Record Office, as well as working in support of causes as varied as the penny post, uniform railway gauge, Grimsby docks and patent law reform. He was also an entrepreneur under the trade name of Felix Summerly, producing everything from tourist guides and children's books to tea sets and bread boards, not to mention the first Christmas card ever published. In 1846, he submitted a Felix Summerly simple white tea service, manufactured by Herbert Minton, for the premium offered by the Society of Arts for model manufactures intended to improve the taste of the nation, and won a prize.[189] Having joined the Society, Cole went on to help stage the exhibitions which took place in 1847, 1848 and 1849 in the Society's Great Room with ever increasing success.[190] At the same time, Cole was involved in the reform of the schools of design which were in a state of crisis. Through political lobbying in person and in his journalistic mouthpiece, the *Journal of Design*, he criticised the schools' bias towards high art and argued that they should become more practical, geared towards the needs of manufacturers. The staging of an international exhibition of arts and manufactures was central to his improving agenda.[191]

In 1849, with the French government's latest annual exhibition of arts and manufactures providing a handy precedent, the Society of Arts petitioned Parliament to ask for a public building in which to hold an international exhibition. Crucial to the success of the project was the support of Albert, the Prince Consort, the President of the Society from 1843. At a meeting with the Prince at Buckingham Palace on 30 June 1849 – where the Society members Cole, Scott Russell, the agricultural surveyor Francis Fuller and the builder of the royal residence of Osborne, Thomas Cubitt, were present – it was agreed that the proposed exhibition should be large and should embrace foreign productions. A formal minute was prepared at the Prince's request when most of the difficult initial questions had been settled. The exhibits would be divided into four major divisions which, as corrected by the Prince, led on logically the one from the other. Sticking to a standard taxonomy of knowledge, they commenced in a Baconian manner with 'Raw Materials of Manufactures' – specimens of natural resources drawn from home, colonial and foreign sources. These were followed by 'Machinery and Mechanical Invention' and then by 'Manufactures', thus moving logically from process to product. The latter were first conceived of as 'Decorative Manufactures' but the Prince crossed out the word 'decorative', presumably because he understood quality of design as being intrinsic to their merit. Finally came 'Sculpture connected with Architecture and Plastic Art Generally', which further confirmed that both fine and mechanical arts were still seen as closely connected

and mutually beneficial, specifically the application of modelling skills to manufactures, as Robert Dingley had emphasised a hundred years earlier.[192]

It was probably the Prince who suggested the Hyde Park site. By the end of the summer, the campaign had enough support for Albert to ask the Home Secretary formally for a Royal Commission. On 1 January 1850, a Royal Commission was appointed to promote 'Arts, Manufactures, and Industry, by means of a great Collection of Works of Art and Industry of all nations, to be formed in London, and exhibited in 1851'. The Commission was packed with peers, politicians and notables, the presidents of the Royal Academy and Royal Society, the Institution of Civil Engineers and the Geological Society and a smattering of leading industrialists, businessmen and bankers.[193] It was far too large and unwieldy a body to take decisions and no member of the Executive Committee – to which the players from the Society of Arts including Cole had been consigned – had a seat on it. The indecisiveness of the former and frustrations of the latter were modified to some extent by the appointment of an Assistant Commissioner, Lyon Playfair, a Scottish chemist and talented committee man, to act as liaison between the two bodies.[194]

This is not the place to describe the difficulties encountered in the building of the Crystal Palace, but it is apposite to emphasise the crucial role played by civil and mechanical engineers in its construction. The young landscape architect (and director of the Midland Railway) Joseph Paxton made his winning set of drawings with the help of the contract engineers Fox and Henderson of Smethwick, the mathematician and civil engineer Peter Barlow and the railway engineer Robert Stephenson. Admittedly, the architect Charles Barry altered Paxton's initial proportions and the mouldings of the columns to accord with Italianate precedents but it was Charles Fox who masterminded the fast-track construction methods his firm had acquired over years of experience on cast-iron railway shed and bridge construction.[195] Iron modules formed the framework of the building. The glazing bars were standardised and mass-produced, as were the sheets of glass. Sappers and miners from the Royal Engineers helped with the planning and organisation involved in filling the building with the exhibits.[196] At the same time, the historicist architects Matthew Digby Wyatt and Owen Jones enriched the interiors to temper the impact of raw engineering, just as some of the machines on show were framed with architectural ornament and painted cheerful colours.

Playfair was responsible for dividing the Prince's original scheme – simplified to raw materials, machinery, manufactures and fine arts – into a further thirty classes which appeared manageable, at least on paper, and provided the basis for the classification system used for the three-volume *Official Descriptive and Illustrated Catalogue*, published in five parts from May 1851, in which entries supplied by exhibitors were revised and corrected by a team of 'scientific gentlemen' to eliminate inaccuracies.[197] In practice, it was a different matter. The physical structure of the building prevented any attempt at elucidating principles, making connections between raw materials, manufacturing processes and products, let alone connecting them with Playfair's class xxx, 'Fine Arts, Sculpture, Models and the Plastic Arts generally, Mosaics and Enamels, illustrative of the taste and skill displayed in such applications of human industry'. As the steam-power source was in the north-west corner of the building, all the heavy machinery had to be grouped on the north side, raw materials in the south and manufactured goods in the centre. With more than a hundred thousand exhibits provided by nearly fourteen thousand exhibitors, of whom nearly half were foreign, it was impossible to discern any principles in the display.

Nevertheless, against all odds, the Great Exhibition was a brilliant success, a glorious spectacle seen by more than six million visitors. It acquainted the general public with the power and even the beauty of machines – notably Hibbert, Platt and Sons' cotton

machines clattering away – which were normally closeted in factories. De La Rue's envelope-making machine proved to be a major draw: operated by a system of cams and similar mechanisms, it could produce 30,000 envelopes per day compared with the 3000 folded and pasted in the same time by hand. Yet these technical wonders were not divorced from demonstrations of human ingenuity which still relied on hand skills. As in the eighteenth century, novelty and multi-purpose gadgetry of all kinds attracted popular attention rather than more solemn attempts at didacticism through learned explanations of higher artistic and scientific principles. The public visited in the spirit of curiosity and wonder, as consumers of the vast and unprecedented international emporium of goods on show in every conceivable style and taste, not as serious students of art and science. Although the three-volume *Official Catalogue* was a sales disaster at three guineas, the shilling version sold nearly 300,000 copies and unofficial illustrated guides were produced in periodical form.[198]

The catch-all attitude to the world of manufactures espoused by Cole and Prince Albert did not meet with universal acclaim. Ralph Nicholson Wornum, the art critic and schools of design lecturer, criticised the Exhibition in his winning submission to the *Art Journal* in 1851, 'The Exhibition as a Lesson in Taste', for an essay competition on the topic of 'the best mode of rendering the Exhibition of the Works of Industry of All Nations . . . practically useful to the British Manufacturer'. Taste, he began, was the paramount agent in all competitions involving ornamental design. Having analysed the principles and styles of ornament, he reached the conclusion that the Renaissance style had produced the best specimens but was little represented in the Exhibition; nor was Classical art. So for all the wonder evoked by the displays of 'bewildering magnificence and endless wealth', the main impression conveyed to the critical mind must be 'a general want of education in taste'.[199] Cole's own *Journal of Design* reprinted an article from *The Times* under the title 'Universal Infidelity in Principles of Design', along with another piece from the *Morning Chronicle* which argued: 'what we want are canons of taste – laws of beauty – principles and axioms of propriety'.[200] The British manufactured goods on show seemed to confirm the views advanced before select committees concerned with arts and manufactures since 1835, namely that their makers were more concerned with quantity than quality, with mechanical reproduction rather than tasteful invention.[201]

Nor was the scientific community satisfied. The science component of the exhibition was generally considered to be the wealth of raw materials on display – minerals and vegetable substances – as well as electrical appliances.[202] Charles Babbage, his nose out of joint on account of the lack of involvement of the British Association for the Advancement of Science, produced a short work entitled *The Exposition of 1851; or, Views of the Industry, the Science and the Government, of England* (1851). He started combatively by asserting that England had 'invited the judgement of the world upon its *Arts* and its *Industry*; – science appeals to the same tribunal against its *ingratitude* and its *injustice*'.[203] Drawing attention to the Association's own experience in organising exhibitions, he believed that had the views of its founders been supported, the exhibition naturally would have been led by 'the science of the country . . . to guide with some reasonable prospect of success that gigantic undertaking, and to elicit from it the many invaluable services it might be expected to render to civilization'. As it was, he condemned the organisers as ignorant and the Society of Arts as languishing for years in a state of premature decay despite the presidency of the Prince Consort.[204]

William Whewell was more conciliatory, as befitted his establishment position as Master of Trinity College, Cambridge. In November 1851, he delivered a lecture entitled 'The General Bearing of the Great Exhibition on the Progress of Art and Science' in a series on the results of the Exhibition, organised at the Society of Arts on the suggestion of the Prince Consort.[205] Whewell modestly conceded that he had the least

right to speak, having no connection with the great event except as a mere spectator, one of the many millions to attend. However, in restating his inductive view that although Art was the mother, she had produced in Science 'a daughter of far loftier and serener beauty', he managed to work the exhibits round to science. They were expressions of the human mind from which underlying laws could be discovered, albeit retrospectively: 'We must now consider what it is that we have admired and why; must try to analyse the works we have gazed upon, and to discover the principles of their excellence.'[206] Yet rather than enlarge on scientific principles, he noted the paradoxical nature of the goods on show from an aesthetic viewpoint. While recognising that 'man is, by nature and universally, an artificer, an artisan, an artist', he believed that lessons of taste could be learnt from works produced by 'rude tribes, savage hands' in the 'infancy of art', as opposed to the 'coarse and ordinary works' derived from the country's superiority in mechanical ingenuity and mechanised power to supply the wants of the many.[207]

Whewell usefully outlined the confusion of categories employed by the French from 1806 to classify exhibits in their shows.[208] In contrast, he praised the divisions adopted in the Great Exhibition, determined by good sense and commercial experience, not mere technical rules. He mused on the value and advantage of 'a permanent and generally accepted classification of all the materials, instruments and productions of human art and industry' so that 'the manufacturer, the man of science, the artisan, the merchant, would have a settled common language, in which they could speak of the objects about which they are concerned'. Then he speculated on 'how immensely the construction, adjustment, and repair of wheel-work would be facilitated' by the standardisation of parts. With the right classification – the names of tools and machines and their relationship to each other fixed – general propositions would be possible: 'may we not expect that on such grounds, the very language of Art and Industry, and the mode of regarding the relations of their products, shall bear for ever the impress of the Great Exhibition of 1851?'[209]

As Whewell hurried to a conclusion he spoke briefly about the future effects on art and science which must be produced 'by this gathering of so many of the artists and *scientists* (if I may use the word) of the world together; by their joint study of the productions of art from every land, by their endeavours to appreciate and estimate the merits of productions, and instruments of production; of works of thought, skill, and beauty'. They were students together at the Great University in 1851,

> a University of which the Colleges are all the great workshops and work-yards, the schools and societies of arts, manufactures, and commerce, of mining and building, of inventing and executing in every land – Colleges in which great chemists, great mechanists, great naturalists, great inventors, are already working, in a professional manner, to aid and develop all that capital, skill, and enterprise can do. . . . May we not expect that from this time the eminent producers and manufacturers, artisans and artists, in every department of art, and in every land, will entertain for each other an increased share of regard and good-will, of sympathy in the great objects which man's office as producer and manufacturer, artisan and artist, places before him.[210]

Such ideals must have appealed to the Prince Consort who was even then ruminating as to what should be done with the Exhibition profits of £150,000–200,000. He first proposed that the twenty-five acres (about ten hectares) of land purchased in Kensington Gore should be devoted to four institutions corresponding to the great divisions of exhibits for the 'furtherance of the industrial pursuits of all nations'. Each institution would have a library, lecture rooms, exhibition hall, discussion and meeting rooms and gardens. All aspects of knowledge would be incorporated. Thus Raw Materials would

be subdivided into metallurgy, chemistry and physiology. Machinery would embrace 'polytechnic science' and its subdivisions. Manufactures would comprise a school of design and chemistry as applied to manufactures. The Plastic Arts of architecture, antiquities and sculpture would also be taught. Furthermore, he proposed that nearly all the learned societies – Geological, Botanical, Linnaean, Zoological, Microscopical, Agricultural, Polytechnic, the Societies of Civil Engineers, Arts, Manufacture and Commerce, of Architects, Antiquaries, Archaeological etc – 'containing as they do all that this country possesses of talent and experience in these branches', be united on the site. Even the National Gallery, the contents of which were in danger from the pollution of central London, was not immune from his intoxicatingly grand vision.

The Prince was aware that his scheme required much testing of both a theoretical and practical kind. Playfair was cautiously supportive as to the basic concept of technical and practice instruction for 'those engaged in the prosecution of Arts and Manufactures', and the inclusion of societies for the promotion of abstract and applied science, which were 'in their very nature and objects cosmopolitan' and would fit well with the proposed international character of the new institution.[211] In December 1851 the Commission acquired a further charter with the objective of pursuing 'measures . . . which may increase the means of industrial education, and extend the influence of science and art upon productive industry'. The purchase of the South Kensington estate precipitated the beginnings of a collection culled from assorted sources to form a permanent museum of art and science with a strong didactic intent. As the Prince Consort wrote to Lord Derby: 'I am fully convinced that we cannot afford any longer to be the only country which gives no facilities to its industrial population for the study of Art and Science and that the Government cannot divest itself of its responsibility towards the Nation in this respect.'[212]

A core collection of £5000 of goods displaying the highest standards of design was bought from the Great Exhibition and displayed at Marlborough House. First known as the Museum of Manufactures, it was renamed the Museum of Ornamental Art in 1853 when it became part of the newly founded Department of Practical Art under the auspices of the Board of Trade. The Prince persuaded Aberdeen to transfer the Museum of Practical Geology, a collection of stones and mining equipment. Material relating to 'animal products', the 'domestic and sanitary economy' of the working classes, building materials, architecture, sculpture and the Sheepshanks collection of paintings, all came to rest in the temporary iron sheds known as the Brompton Boilers, on the South Kensington site. The Prince also lured the collection of patent and premium models formed by Bennet Woodcroft who, in 1847, was briefly appointed Professor of Descriptive Machinery at University College London. Although Woodcroft was unsuccessful as an academic, his position recommended him to the Society of Arts as a suitable recipient of their collection of models and machines, the trustees of the College having undertaken to repair and preserve them. When in November 1852 he was appointed as the Assistant to the Commissioner of Patents to make the newly reformed patent system work, he took the collection with him, adding it to those models submitted over the decades by patentees. The following month, he was summoned to Windsor to meet the Prince Consort, who recognised the educational potential of establishing a collection of models of new inventions.[213]

Woodcroft was enthusiastic, augmenting his collection with gifts ranging from steam locomotives to screw propellers solicited from bodies such as the Institution of Civil Engineers and northern manufacturers. The models were housed in a shed with separate access from the rest of the museum complex, as Woodcroft and the Patent Commissioners refused to charge for admission as part of their ambitious programme of public access to and encouragement of invention.[214] Here they languished, 'crumbling

fragments' of 'worm-eaten wooden . . . machinery', until 1883, when the Patent Museum was handed over to the South Kensington Museum.[215] In the main 'Boilers', as in the Great Exhibition, the Prince's original scheme of classification for the displays overall was lost in what was likened to a bric-a-brac bazaar. The only visible rationale was that of generally useful knowledge.

Much to royal annoyance, David Brewster publicised the Prince's grand ambitions for an 'Industrial University' in a wide-ranging article that appeared in the *North British Review* in 1852.[216] It brought together for review twelve publications, including the First Report of the Commissioners for the Exposition of 1851; assorted treatises on the education of the industrious classes (including a lecture delivered at Putney College by Lyon Playfair entitled 'On the Importance of studying Abstract Science with a view to its Future Practical Application'); a report from Paris on the Ecole Centrale des Arts et Manufactures founded in 1829; one from the headmaster of the Government School of Design at Sheffield; lectures from the School of Mines on the subject of science applied to the arts and those on the results of the Great Exhibition delivered before the Society of Arts at the suggestion of Prince Albert.

The article was certainly flattering to the Prince. Brewster attributed the 'higher and nobler motives' he had brought to the Exhibition to his superior foreign education, uniting 'with elegant acquirements of literature and the fine arts a sound knowledge of the physical and natural sciences, and of the mechanical arts with which, in foreign lands, the sciences have long been associated'. Being in a position to speak the truth without giving offence, and advocate reform without fear, the Prince 'conceived of the idea of turning the attention of the nation to the state of its manufacturing arts, and giving a new direction to its science, and a fresh impulse to its industry'.[217] Brewster reviewed the 'feeble and ill-directed efforts' to improve the industrial and scientific arts in the first half of the century, compared with the situation in France. He hoped that, through the intervention of the Prince, state aid for science would be achieved, as 'the only true foundation of the industrial arts', thereby effecting a complete revolution in the nation's educational, scientific and industrial institutions.[218]

Citing passages from the Queen's speech at the prorogation of Parliament, touching on the threat of foreign competition and claiming the support of manufacturers from Birmingham and Bristol, Brewster confidently anticipated the announcement in the Commissioners' Second Report of the new 'Great Industrial Institution', similar to the Ecole Centrale des Arts et Manufactures: 'The Institution will of course consist of a College or University, with laboratories and workshops, a museum and a library. An ample staff of professors carefully selected, and uniting practical with theoretical science, will deliver regular courses of lectures.' Honorary or emeritus professors – 'men of high name and lofty acquirements' – would also lecture occasionally.[219]

It is significant that, when Brewster described the contents of the associated museum, they comprised only three parts: raw materials; tools, scientific apparatus, instruments and models; and working machines. He made no reference to the 'plastic arts' (although he did anticipate the move to the site of the National Gallery) or to manufactured goods. He believed that the institution and affiliated schools of industry in the provinces should be government-assisted rather than self-supporting. Finally he raised the question of the relationship between abstract science and art: 'What are the influences which they mutually exert upon each other? And to what extent is abstract science, independent of its applications, to be introduced into the curriculum of study?'

Brewster referred back to Whewell's lecture and noted that practical men, 'not defective in judgment, and especially civil-engineers, have spoken and written rather contemptuously of the value of abstract science in the professions depending on chemical, mathematical, and mechanical knowledge'. Yet he ventured to assert of the equation,

'an ounce of practice is a worth a ton of theory', that the reverse was much more frequently the case. Quoting Playfair, he argued 'that the time is past when practice can go on in the blind and vain confidence of a shallow empiricism, severed from science like a tree from its roots'. He called on the support of Liebig and Humboldt and maintained that the teaching of abstract science was indispensable if the country wanted to outstrip foreign competition. 'We are all now agreed . . . that the time has arrived when science must be united with skill in the advancement of the Industrial Arts, and that this union can be only effected by a grand effort, individual and national, to establish upon a permanent basis a metropolitan university of arts and manufactures.'[220]

The government bowed to the wishes of the Prince and Playfair at least to the extent of changing in March 1853 the Department of Practical Art, which Cole had contrived to create through his machinations in relation to the schools of design, into the Department of Science and Art, with Playfair as co-director in charge of Science. The government School of Mines with its Museum of Practical Geology came within the control of the new Department and science schools and classes were established as a fledgling counterweight to the existing schools of design. A further manifestation of industry within an academic context took place north of the border in Edinburgh. In 1855, George Wilson, a private lecturer in chemistry with a background of teaching in mechanics' institutes, was appointed the director of the newly created Industrial Museum of Scotland and later the same year, through the lobbying of Playfair and others, was appointed the Regius Professor of Technology at the University of Edinburgh. Even the use of the word 'technology' was novel and possibly suspect. The University's Professor of Natural Philosophy, J. D. Forbes, worried about the use of the term ('for the first time I believe in Britain') as the title of a chair. 'Technology' was not in Johnson's *Dictionary* and as far as its etymology was concerned, 'it might apparently entitle the Professor to lecture on any subject within the faculty of Arts'.[221]

Wilson explained that he intended to give a systematic course of lectures on applications of science to the industrial arts and particularly the chemical arts. Moreover, in the lecture he gave to the Philosophical Institution in Edinburgh in 1856, he defined the purpose of the Industrial Museum. It was intended to be a repository for all the objects of useful art along the lines already determined in the Great Exhibition, including the raw materials with which each art dealt, the finished products into which it converted them, drawings and diagrams explanatory of the processes through which it put those materials, models or examples of the machinery with which it prepared and fashioned them, and the tools which specially belonged to it, as a particular craft. The Museum's broader agenda was decidedly upbeat, tracing the progress of the arts both at home and abroad through an assortment of pre-existing architectural, agricultural and economic, antiquarian and geological collections. However, the initiative was short-lived, lacking momentum after Wilson's death in 1859. The post of Professor of Technology lapsed as science-based courses became more specialised and theoretical. In 1861, the name of the Museum was changed to the Educational Museum of Science and Art, diminishing into a collection of applied arts which was largely deaccessioned in the twentieth century.

Back in London, Playfair felt that Cole was 'drawing to the Department of Art what ought to belong to that of Science' and Cole was certainly the dominant partner when the Museum was formally opened in the Brompton Boilers in 1856 and the Department of Science and Art passed from the Board of Trade to the Committee on Education of the Privy Council. From 1858, when Playfair returned to Edinburgh, Cole was the sole secretary of the Department as well as the Director of the Museum. Under his autocratic rule and with the energetic assistance of the first curator, the young connoisseur John Charles Robinson, the Museum began to collect 'art manufactures' or decorative

arts, supposedly illustrative of the highest principles of design. Before long they were ransacking (Cole's word) Europe for block purchases of the collections of connoisseurs.[222] The change of name from Museum of Manufactures to Museum of Ornamental Art in 1853 anticipated this shift in emphasis; from 1857 it was simply known as the South Kensington Museum. Even contemporary manufactures came to be seen through the model of 'art workmanship'. Workshops or ateliers were established in 1858. Directed by Captain Francis Fowke of the Royal Engineers, the staff and students designed and decorated with mosaics, ceramics and terracotta the new buildings being erected on the site. These works provided exemplars which supposedly combined practical science and ornamental art, where lessons drawn from the art of the past were reinterpreted for the industrial age.

In an attempt to make sense of what Cole himself described as a 'refuge for destitute collections', the 1860 edition of the *Guide* to South Kensington regrouped them into a Science Division and an Art Division. The notes Cole made on a visit to the Conservatoire des Arts et Métiers in Paris in 1864 suggest that he was already contemplating a separate museum of scientific inventions 'as distinguished from a museum of fine arts', which would not be limited to patent models but would embrace illustrations of practical science in physics, chemistry, metallurgy and construction of all kinds. His afterthought, 'Great space requisite', partly explains why such plans were not realised for another half century. Furthermore, as there were no guiding principles as to what 'scientific' material constituted, the Scientific Division remained a ragbag of pre-existing collections, lacking the clearer – albeit increasingly oriented to high art – philosophy which Cole and Robinson provided for the Art Division. The question of the nation's technical and vocational education remained unresolved for decades. There was widespread disagreement as to its relationship to science and art, coupled with a laissez-faire assumption that technical training, insofar as this meant practical workshop techniques, was a private, commercial issue, not a public responsibility.

The 1862 International Exhibition, staged at South Kensington, encompassed besides industrial and mechanical departments, a department of fine arts which was inspired by the success of the Manchester Art Treasures exhibition of 1857 and controlled by the Royal Academy. The 'Art Designs for Manufacture' were dominated by Cole's clique at South Kensington, although the machinery in motion, larger and heavier than that in the 1851 exhibition, was particularly spectacular, eliciting favourable notice on aesthetic as well as utilitarian grounds.[223] While Cole busied himself with the main exhibition, Robinson organised a counter-attraction in the form of a vast loan exhibition entitled 'The Art Wealth of England'. The contrast struck many between the mass-production with 'marvellous automata of engineering skill' in Cole's show and the more tranquil atmosphere of Robinson's exhibition, where it could be seen how 'the artist's mind and the labour of a life can spiritualise material'.[224]

These shifting taxonomies were scrutinised by the art and literary critic Sidney Colvin in the entry he contributed on 'Art' to the ninth edition of *Encyclopaedia Britannica* (1875) and still used in the eleventh edition of 1911. He summarised the traditional distinction made between Science and Art: 'Science consists in knowing, Art consists in doing. What I must do in order to know is Art subordinate to or concerned in Science. What I must know in order to do is Science subordinate to or concerned in Art.' Yet he concluded by noting that in recent times the general distinction between useful arts and those whose end was pleasure had been replaced by a usage which appropriated the term to the latter alone:

First as the liberal or polite arts, and then as the fine arts, the languages of modern Europe have separated from the class of arts which exist only for use, the class which

exist only or chiefly for pleasure. They have gone further, and have reduced the number which the class-word is meant to include. When Art is now currently spoken of in this sense, not even music or poetry is frequently denoted, but only architecture, sculpture, and painting by themselves, or with their subordinate and decorative branches.

There were victims of this appropriation:

in correspondence with this usage, another usage has been removed from the class of *arts*, and put into a contrasted class of *manufactures*, a large number of industries and their products, to which the generic term Art, according to our definition, properly applies. That definition covers the mechanical arts, which can be efficiently exercised by mere habits, rote, or calculations, just as well as the fine arts, which have to be exercised by a higher order of powers. But the word Art, becoming appropriated to the fine arts, has been treated as if it necessarily carried along with it, and as if works to be called works of art must necessarily possess, the attributes of individual skill and invention expressing themselves in ever new combinations of pleasurable contrivance. The progress of what an older nomenclature called the mechanical arts – the consequence of inventions for making production easier and more rapid by the application of physical agencies and the economising of human labour – has led to the multiplication of products all alike, all equally bearing the stamp of habit, rote, and calculation, and all equally destitute of those properties of individual contrivance and pleasurableness. And so works of Manufacture, or the products of machinery, which bear only very dully and remotely the mark of their original source in the hand and brain of man, have come to be contrasted with works of Art which bear such marks vividly and directly.

Colvin described the exclusive realm of art for art's sake, whereby individual creativity and originality of invention were set at a premium. In contrast, through the mass production of manufactures by machines using a divided and de-skilled labour force, cut off from any involvement in creative design and innovation, the mechanical arts had forfeited their right to be considered arts at all. For a century, the 'mechanical kingdom, or reign of pure manufacture, had spread apace in Europe, engrossing an ever larger field of human production'. Yet, what goes round comes round. Of late, he suggested, there were signs of 'a reaction in favour of an extension of the kingdom of Art, or at least of endeavours to bring reconciliation and alliance between the two'.

As a friend and admirer of John Ruskin, Colvin would have sympathised with Ruskin's criticism of the effects of industrialisation, which turned men into machines and provoked social unrest, in contrast to medieval times when men were free to express themselves within a communal value system. He would have been aware of Ruskin's impact on a generation of young men whose training in the architecture of the Gothic Revival brought them into contact with specialist firms still offering the skills required for the production of decorative fittings. The firm of Morris, Marshall, Faulkner & Co, founded in 1861, was modelled on workshop practice rather than mass manufacture, bringing together painters, cabinet-makers, weavers and other skilled workers to make domestic furnishings. By the 1880s and 90s, as Colvin had anticipated, the 'Arts and Crafts' philosophy was being promoted by organisations based in London, provincial cities and rural colonies both in Britain and abroad. Moreover, not all manifestations of this movement – notably the Wiener Werkstätte – rejected machines as sources of evil but used them to rationalise production. After the First World War, at the Bauhaus which Walter Gropius was called on to establish in Weimar, he revived the concept of the unified arts of design created through teamwork, making no distinction between artist and artisan.

In the modern world, he believed, the design process was neither exclusively intellectual nor practical but an integral part of the stuff of life. For the three-year training programme, each student entered a particular workshop within the school, learning both the grammar or principles and the art or craft of design and making samples for mass production. Using this system, far from turning men into machines, as occurred through the industrial division of labour, machines were subject to the human mind, revitalising the process of manufacture. For the first time since the eighteenth century, the fine and mechanical arts were reunited to bear abundant fruit.

Notes

Introduction

1 The publications covered in Judith A. McGaw, 'Inventors and Other Great Women: Towards a Feminist History of Technological Luminaries', *T&C*, XXXVIII (1997), pp. 214–31, focus on the nineteenth and twentieth centuries.

2 For a summary of Sir Arthur Elton's career see Michael A. Vanns, *Witness to Change: A Record of the Industrial Revolution. The Elton Collection at the Ironbridge Gorge Museum* (Hersham, 2003), pp. 31–44.

3 Klingender 1947, p. v.

4 Near-contemporary works giving technically driven explanations of the human condition (both positive and negative) include Sigfried Giedion's *Mechanization takes Command* (1948); Lewis Mumford, *Technics and Civilisation* (1934) and *Art and Technics* (1967). Humphrey Jennings's *Pandaemonium, 1660–1886: The Coming of the Machine as seen by Contemporary Observers* (1985) was based on texts collected between about 1937 and Jennings's death in 1950, edited by Mary-Lou Jennings and Charles Madge.

5 Klingender 1968, p. xiii.

6 Ken Baynes and Alan Robinson, *Work* (1970). The Arts Council of Great Britain's last engagement with a social history topic, 'Coal: British Mining in Art 1680–1980' (1982–3), toured coal-mining districts during the phase of pit closures and withdrawal of state subsidies which led to the bitter confrontation between the government and the National Union of Miners of 1984–5.

7 Barrie Trinder, *The Industrial Revolution in Shropshire* (1973), with two revised editions in 1981 and 2000; Trinder, *The Making of the Industrial Landscape* (1982). The first edition of *The Industrial Revolution in Shropshire* coincided with the opening of the Ironbridge Gorge Museum Trust's Blist Hill open-air museum, the First International Congress on the Conservation of Industrial Monuments and an upswing in local history courses for adults. Trinder was employed by Shropshire Education Committee to teach adult education classes. He also attended the seminars run by E. P. Thompson at the Centre for the Study of Social History at the University of Warwick.

8 Raphael Samuel, *Theatres of Memory. Volume I: Past and Present in Contemporary Culture* (1994), pp. 27–39, 337–77. By the time Samuel's long-incubated book appeared, more historians were engaged with visual sources and material culture than he was prepared to grant for the purposes of his argument against narrow 'academic' research.

9 For an analysis of the way in which the historiography of the subject reflected contemporary preoccupations see David Cannadine, 'The Present and the Past in the English Industrial Revolution 1880–1980', *Past & Present*, no. 103 (1984), pp. 131–72, Martin Daunton, *Progress and Poverty: An Economic and Social History of Britain 1700–1850* (Oxford, 1995) and Roderick Floud and Paul Johnson, eds, *The Cambridge Economic History of Modern Britain. Vol. I: Industrialisation 1700–1860* (Cambridge, 2004), which, are among the latest general studies. William Hardy, *The Origins of the Idea of the Industrial Revolution* (Victoria, B.C., and Oxford, 2006) gives a clear exposition of the context which led to Arnold Toynbee's series of lectures on the 'Industrial Revolution' at Oxford in 1881–2, synthesising for the first time in a single concept technological, economic, social and cultural issues which had preoccupied earlier commentators.

10 Patrick O'Brien, *Provincializing the First Industrial Revolution* (Working Papers of the Global Economic History Network, no. 17/06, 2006), pp. 27–34.

11 See Celina Fox, 'Pictures from the Magazines', with Michael Wolff, in H. J. Dyos and M. Wolff, eds, *The Victorian City* (1973), vol. 2, pp. 559–82; Fox, 'The Development of Social Reportage in English Periodical Illustration during the 1840s and 1850s', *Past & Present*, no. 74 (1977), pp. 99–111; Fox, *Londoners* (1987), pp. 185–99. See also Julian Treuherz, *Hard Times: Social Realism in Victorian Art* (Manchester, 1987).

12 Neil McKendrick, John Brewer and J. H. Plumb, *The Birth of Consumer Society: The Commercialization of Eighteenth-century England* (1983) was the first treatment in print of the subject, followed by John Brewer and Roy Porter, eds, *Consumption and the World of Goods* (1993); Ann Bermingham and John Brewer, eds, *The Consumption of Culture 1600–1800: Image, Object, Text* (1995). Linda

Levy Peck, *Consuming Splendor: Society and Culture in Seventeenth-century England* (Cambridge, 2006) argues that the taste for consuming luxury goods was alive, well and growing in the Stuart period.

13 For a useful résumé see Maxine Berg and Elizabeth Eger, eds, *Luxury in the Eighteenth Century: Debates, Desires and Delectable Goods* (Basingstoke, 2003), pp. 7–27. For transatlantic comparisons see John Styles and Amanda Vickery, eds, *Gender, Taste and Material Culture in Britain and North America, 1700–1830* (New Haven and London, 2006).

14 Jan de Vries, 'Between Purchasing Power and the World of Goods: Understanding the Household Economy in Early Modern Europe', in Brewer and Porter 1993, pp. 85–132.

15 Maxine Berg, 'From Imitation to Invention: Creating Commodities in Eighteenth-century Britain', *Economic History Review*, LV (2002), p. 2.

16 The project owed its framework to a wide range of historical approaches, from themes first raised in Paul Langford, *A Polite and Commercial People: England, 1727–1783* (Oxford, 1989) and developed as histories of pleasure and culture in Brewer and Porter 1993; Bermingham and Brewer 1995; Roy Porter and Marie Mulvey Roberts, eds, *Pleasure in the Eighteenth Century* (Basingstoke, 1996); John Brewer, *The Pleasures of the Imagination: English Culture in the Eighteenth Century* (1997).

17 Resulting publications include Maxine Berg and Helen Clifford, eds, *Consumers and Luxury: Consumer Culture in Europe 1650–1850* (Manchester and New York, 1999); Berg 2002; Berg and Eger 2003; Berg, 'In Pursuit of Luxury: Global History and British Consumer Goods in the Eighteenth Century', *Past & Present*, no. 182 (2004), pp. 85–142; Berg, 'Consumption in Eighteenth- and Early Nineteenth-century Britain', in Floud and Johnson 2004, pp. 357–87; Berg, *Luxury and Pleasure in Eighteenth-Century Britain* (Oxford, 2005).

18 Pamela O. Long, *Openness, Secrecy, Authorship: Technical Arts and the Culture of Knowledge from Antiquity to the Renaissance* (Baltimore and London, 2001). Pamela H. Smith, *The Body of the Artisan: Art and Experience in the Scientific Revolution* (Chicago, 2004). Lissa Roberts, Simon Schaffer and Peter Dear, eds, *The Mindful Eye: Inquiry and Invention from the late Renaissance to early Industrialisation* (Amsterdam, 2007).

19 Patrick O'Brien, 'The Micro Foundations of Macro Invention: The Case of the Reverend Edmund Cartwright', *Textile History*, XXVIII (1997), pp. 201–33.

20 Joel Mokyr, *The Lever of Riches: Technological Creativity and Economic Progress* (Oxford, 1990), pp. 81–112, 239–44.

21 For a summary of these claims and counter-claims see Neil McKendrick, 'The Role of Science in the Industrial Revolution: A Study of Josiah Wedgwood as a Scientist and Industrial Chemist', in Mikulás Teich and Robert Young, eds, *Changing Perspectives in the History of Science* (1973), pp. 274–319.

22 Ibid., p. 313.

23 Margaret C. Jacob, *The Cultural Meaning of the Scientific Revolution* (New York, 1988), Larry Stewart, *The Rise of Public Science: Rhetoric, Technology and Natural Philosophy in Newtonian Britain, 1660–1750* (Cambridge, 1992), Jacob, *Scientific Culture and the Making of the Industrial West* (Oxford, 1997), Stewart, 'A Meaning for Machines: Modernity, Utility and the Eighteenth-century British Public', *Journal of Modern History*, LXX (1998), pp. 259–94, Jacob and Stewart, *Practical Matter: Newton's Science in the Service of Industry and Empire 1687–1851* (Cambridge, Mass., 2004).

24 From the Greek *techne*, meaning every kind of handwork, and *logia*, denoting a subject of study.

25 As Stewart 1998, p. 271 n. 49, recognises but considers irrelevant: 'It matters not a whit that such schemes were largely ineffectual; those like Belidor and Desaguliers were convinced that great strides were being made.'

26 Ibid., p. 262, who allows, p. 291, that the merging of the mechanical and the philosophical was founded on a broad agenda of improvement.

27 *Pace* Jacob 1997, pp. 3–4.

28 John Barrell, *The Political Theory of Painting* (New Haven and London, 1986). Although its hold on art historians was powerful, it was modified in some of the essays in John Barrell, ed, *Painting and the Politics of Culture: New Essays on British Art, 1700–1850* (Oxford, 1993).

29 The approach was pioneered by John Barrell, *The Dark Side of the Landscape: The Rural Poor in English Painting, 1730–1780* (Cambridge, 1980), David H. Solkin, *Richard Wilson: The Landscape of Reaction* (1982), Michael Rosenthal, *Constable: The Painter and his Landscape* (New Haven and London, 1983), Ann Bermingham, *Landscape and Ideology: The English Rustic Tradition* (Berkeley, Cal., 1986), Simon Pugh, ed., *Reading Landscape: Country–City–Capital* (Manchester, 1990), Andrew Hemingway, *Landscape Imagery and Urban Culture in Early Nineteenth Century Britain* (Cambridge, 1992), Christiana Payne, *Toil and Plenty: Images of the Agricultural Landscape in England, 1780–1890* (New Haven and London, 1993), Michael Rosenthal, Christiana Payne and Scott Wilcox, *Prospects for the Nation: Recent Essays in British Landscape, 1750–1880* (New Haven and London, 1997), Peter de Bolla, Nigel Leask and David Simpson, *Land, Nation and Culture, 1740–1840: Thinking the Republic of Taste* (Basingstoke, 2005), Ann Bermingham, *Sensation and Sensibility: Viewing Gainsborough's Cottage Door* (New Haven and London, 2005).

30 David H. Solkin, *Painting for Money: The Visual Arts and the Public Sphere in Eighteenth-century England* (New Haven and London, 1992).

31 German historians and museum curators, with a strong tradition of cultural history, have covered the Industrial Revolution but principally through the medium of paintings. Monika Wagner, *Die Industrielandschaft in der englischen Malerei und Grafik 1770–1830* (Frankfurt am Main, 1979), Sabine Beneke and Hans Ottomeyer, *Die Zweite Schöpfung: Bilder der industriellen Welt vom 18. Jahrhundert in die Gegenwart* (Berlin, 2002). Tim Barringer, *Men at Work: Art and Labour in Victorian Britain* (New Haven and London, 2005) is an illuminating study of the complex relationship between art and labour in theory and practice in the mid-nineteenth century, covering material touched on in Klingender's concluding pages.

32 Wiebe E. Bijker, Thomas P. Hughes and Trevor J. Pinch, eds, *The Social Construction of Technological Systems: New Directions in the Sociology and History of Technology* (Cambridge, Mass., 1987).

33 Joel Mokyr, *The Gifts of Athena: Historical Origins of the Knowledge Economy* (Princeton and Oxford, 2002), pp. 28–77. *History of Science*, XL, part 2, no. 148 (2007) is a special issue devoted to reflections on this work. My conclusions have most affinity with those of Liliane Hilaire-Pérez, 'Technology as a Public Culture', pp. 135–54. The channels of description, rationalisation and communication I describe may also be seen to correspond to the concept of 'capture' which Robert Friedel introduces into his compendious survey, *A Culture of Improvement: Technology and the Western Millennium* (Cambridge, Mass., and London, 2007).

34 J.D. Marshall, 'Kendal in the Late Seventeenth and Eighteenth Centuries', *Transactions of the Cumberland and Westmoreland Antiquarian and Archaeological Society*, LXXV (1975), pp. 188–257, S.D. Smith, ed., *'An Exact and Industrious Tradesman': The Letter Book of Joseph Symson of Kendal 1711–1720* (Oxford, 2002).

1 *The History of Trades*

1 Peter Sternagel traces the use of the term *artes mechanicae* in the plural, as a distinct category, to John the Scot's commentary on Martianus Capella's 'Marriage of Philology and Mercury', dating from the middle of the ninth century. *Die Artes Mechanicae im Mittelalter: Begriffs- und Bedeutungsgeschichte bis zum Ende des 13. Jahrhunderts* (Kallmünz über Regensburg, 1966), p. 30.

2 Whitney 1990 identifies the writings of Hugh of St Victor (d. 1141), Vincent of Beauvais (d. 1264), Robert Kilwardby (d. 1279) and Roger Bacon (1214–92) as key texts through which the mechanical arts were integrated within prevailing systems of thought.

3 Wilhelm Treue et al., eds, *Das Hausbuch der Mendelschen Zwölfbrüderstiftung zu Nürnberg: Deutsche Handwerkerbilder des 15. und 16. Jahrhunderts* (Munich, 1965).

4 For a survey of those still visible in English churches, see www.paintedchurch.org.

5 Robert Kilwardby recognised the interdependence of the speculative sciences and mechanical arts (defined as practical sciences) in *De Ortu Scientiarum* (c.1250). The crafts provided empirical knowledge of physical conditions, the causes of which were explained by theoretical science. Whitney 1990, pp. 118–23.

6 Long 2001. J.V. Field, *The Invention of Infinity: Mathematics and Art in the Renaissance* (Oxford, 1997), Bennett and Johnston 1996, J.A. Bennett, 'The Challenge of Practical Mathematics', in Stephen Pumfrey, Paulo L. Rossi and Maurice Slawinski, eds, *Science and Popular Belief in Renaissance Europe* (Manchester, 1991), pp. 176–90.

7 Kemp 1990, pp. 8–98, Frank D. Prager and Gustina Scaglia, *Brunelleschi: Studies of his Technology and Inventions* (Cambridge, Mass., 1970), Samuel Y. Edgerton, Jr., *The Heritage of Giotto's Geometry: Art and Science on the Eve of the Scientific Revolution* (Ithaca, N.Y., and London, 1993), pp. 108–47.

8 Frank D. Prager and Gustina Scaglia, eds, *Mariano Taccola. and his Book 'De Ingeneis'* (Cambridge, Mass., 1971), Gustina Scaglia, ed., *Mariano Taccola. De Machinis: The Engineering Treatise of 1449* (Wiesbaden, 1971), Lon R. Shelby, 'Mariano Taccola and his Books on Engines and Machines', *T&C*, XVI (1975), pp. 466–75.

9 A preparatory volume, *Opusculum de Architectura*, is in BM, P&D (1947-1-17-2), containing 81 parchment sheets with drawings of designs for machines, both civil and military, some embellished with allegorical figures. It was probably compiled by the artist early in the 1470s to obtain preferment from Federico da Montefeltro, Duke of Urbino.

10 Paolo Galluzzi, *Renaissance Engineers from Brunelleschi to Leonardo da Vinci* (Florence, 1996) provides the best illustrated survey of the works of Sienese engineers and Leonardo da Vinci.

11 There is also a manuscript version, BL, Add. MS 17921, with some variation in the illustrations, dating from the end of the sixteenth century.

12 Martha Teach Gnudi and Eugene S. Ferguson, trans. and eds, *The Various and Ingenious Machines of Agostino Ramelli* (1976).

13 Smith 2004, pp. 82–93.

14 Ibid., pp. 74–80.

15 Ex Rhys Jenkins collection; present whereabouts unknown.

16 E.g., Robert Recorde, *The Ground of Artes* (1543), Leonard Digge[s] *A Boke named Tectonicon* (1556) and William Bourne, *A Regime[nt] for the Sea* (1574) and *Inventions or Devises* (1578), all of which we[nt] through many editions.

17 William Eamon, *Science and the Secrets of Nature: Books of Secre[ts] in Medieval and Early Modern Culture* (Princeton, 1994).

18 In her survey of this world, *The Jewel House: Elizabethan Londo[n] and the Scientific Revolution* (New Haven and London, 2007[)] Deborah E. Harkness also cites the notebooks written in debtor[s'] prison by the merchant Clement Draper relating to medicin[e,] mining and chemistry.

19 A.C. Crombie, *Styles of Scientific Thinking in the European Trad[i]tion: The History of Argument and Explanation especially in the Math[]ematical and Biomedical Sciences and Arts* (1994) vol. 1, pp. 424–68[0] provides a comprehensive overview of the artist and experiment[s] in this period.

20 Antonio Pérez-Ramos, *Francis Bacon's Idea of Science and the Make[r] Knowledge Tradition* (Oxford, 1988).

21 *Francis Bacon*, ed. Brian Vickers (Oxford, 1996), pp. 177–8.

22 In proposing such a course Bacon was possibly influenced by th[e] lectures and writings of Bernard Palissy which he might hav[e] encountered in Paris. In his *Discours admirables* (Paris, 1580), Paliss[y] championed the cause of artisan knowledge, in which experimen[]tation and practice took precedence over book learning. Smi[th] 2004, pp. 100–06.

23 Bacon 2000, p. 81.

24 Ibid., pp. 149–52.

25 Ibid., pp. 222–38.

26 Bacon 1659, p. 36.

27 The most comprehensive account is given by Webster 1975, wh[ich] shows that Bacon's writings were by no means the only philosoph[]ical influence on these schemes.

28 Ibid., pp. 47–8.

29 Ibid., pp. 67–77, 374–5.

30 *The Advice of W.P. to Mr Samuel Hartlib for the Advancement of som[e] Parts of Learning* (1648). Sharp 1977, vol. 1, pp. 81–2, 171–3, 213–1[] vol. 2, pp. 396–7. Webster 1975, p. 363.

31 The most succinct account of Bacon's Legacy to the Royal Socie[ty] is given in Antonio Pérez-Ramos, 'Bacon's Legacy', in Mark Pelt[]nen, ed., *The Cambridge Companion to Bacon* (Cambridge, 1996[)] pp. 314–20; also William T. Lynch, 'A Society of Baconians? Th[e] Collective Development of Bacon's Method in the Royal Society o[f] London', in Julie Robin Solomon and Catherine Gimelli Marti[n,] eds, *Francis Bacon and the Refiguring of Early Modern Thought: Essa[ys] to Commemorate 'The Advancement of Learning'* (Aldershot, 2005[)] pp. 173–202.

32 The standard account is Ochs 1985. Also Walter Houghton, 'Th[e] History of Trades: Its Relation to Seventeenth-Century Thought [as] seen in Bacon, Petty, Evelyn and Boyle', *Journal of the History [of] Ideas*, II (1941), pp. 33–60. See esp. Hunter 1981, pp. 87–112, o[n] 'utility and its problems' to which this account is indebted.

33 *The Correspondence of Henry Oldenburg*, ed. A. Rupert and Mar[ie] Boas Hall (Madison, Milwaukee and London, 1965), vol. 1, p[p.] 430–32.

34 RS, CL.P, vol. 3, 'Mechanicks', Trades, part 1.

35 BL, Add. MS 78339, formerly Evelyn MS 65. For Evelyn's studies i[n] the 1650s see Hunter 1995, pp. 66–98.

36 BL, Add. MS 78339, f. 126v.

37 Ibid., ff. 182v–186v.

38 BL, Add. MS 78340, f. 326.

39 Ibid., f. 327.

40 In *Sculptura* (1662), p. 139, Evelyn again advocated the use of images to expound 'all the sciences by them [prints] alone, and that with as much certitude, and infinitely more expedition, than by the most accurate method that was ever yet produced'.

41 BL, Add. MS 72897, item 27, ff. 151–154v, reprinted in *Petty Papers* (1927), vol. 1, pp. 205–7.

42 BL, Add. MS 72865, items 7 and 8, ff. 108–17, *Petty Papers* (1927) vol. 1, pp. 208–14.

43 Hooke, 'The Preface', *Micrographia* (1665).

44 Ibid. Hunter 1989, pp. 279–338.

45 RS, CL.P, vol. 20, 96, probably read on 21 February 1666 when Pepys heard it and pronounced it 'very pretty', *The Diary of Samuel Pepys*, ed. Robert Latham and William Matthews (1972), vol. 7, p. 51. The illustration is inscribed 'This draught must not be inverted' and parts are marked 'This is not to be copied in the plate'.

46 See the note by Robert Waller in RS, CL.P., vol. 20, 96. The process described by Hooke survived virtually unchanged until the mid-nineteenth century. Rosemary Weinstein, *The History of the Worshipful Company of Feltmakers* (Chichester, 2004), pp. xvii–xix.

47 RS, CL.P, vol. 20, 40, read on 25 July 1666.

48 Ibid., vol. 20, 42.

49 Ibid., vol. 20, 50a, reproduced in D. R. Oldroyd, 'Some Writings of Robert Hooke on Procedures for the Prosecution of Scientific Inquiry, including his "Lectures of Things requisite to a Ntral History"', *NRRS*, XLI (1987), pp. 156–9.

50 Hooke 1705.

51 Michael Hunter, 'Hooke the Natural Philosopher', in Bennett, Cooper, Hunter and Jardine 2003, pp. 117–24.

52 Hooke, 'General Scheme', in *Hooke 1705*, pp. 24–6.

53 Ibid., p. 27.

54 Ibid., p. 35.

55 Ibid., pp. 57–61.

56 Ibid., pp. 61–5.

57 Sprat 1667, pp. 117–18.

58 John Wilkins, 'To the Reader', *Mathematicall Magick: or the Wonders that may be performed by Mechanical Geometry* (1648).

59 P. B. Wood, 'Methodology and Apologetics: Thomas Sprat's *History of the Royal Society*', *BJHS*, XIII (1980), pp. 1–26.

60 Sprat 1667, pp. 378–403.

61 Ibid., pp. 403–12.

62 *Boyle Works* 1999–2000, vol. 6, p. 401.

63 Ibid., p. 396.

64 Benvenuto Cellini, *Due Trattati, uno intorno alle otto principali arti dell'oreficeria, l'altro in materia dell'arte della scultura* (Florence, 1568). Georgius Agricola, *De re metallica* (Basel, 1556). Agricola can be more accurately described as a humanist and physician, albeit one who practised in Bohemian and Saxon mining towns, rather than the artificer Boyle took him to be.

65 *Boyle Works* 1999–2000, vol. 6, pp. 397–9.

66 Ibid., pp. 468–72.

67 Ibid., pp. 399–400. Boyle thought of Cornelis Drebbel (1572–1633) as a 'mechanician and chemist', not a tradesman. In fact, Drebbel was trained in the Netherlands as a painter, engraver and cartographer. He was also a skilled lens-grinder and optical instrument-maker. From about 1607, he operated a dye works in Stratford-le-Bow. L. E. Harris, *The Two Netherlanders: Humphrey Bradley and Cornelis Drebbel* (Cambridge, 1961), pp. 121–223.

68 *Boyle Works* 1999–2000, vol. 6, pp. 418–22.

69 Ibid., pp. 472–3.

70 Ibid., pp. 502–3. Calcium hydroxide is still used in depilatories, but not arsenic trisulphide.

71 Ochs 1985, p. 133.

72 Petty's manuscript versions are in BL, Add. MS 72897, item 1, ff. 1–37.

73 RS, CL.P, vol. 3, part 1, 4, read 8 January 1662, and 2, read 14 May 1662. For *Sculptura* see Antony Griffiths, 'John Evelyn and the Print', in Frances Harris and Michael Hunter, eds, *John Evelyn and his Milieu* (2003), pp. 106–8.

74 RS, CL.P vol. 3, part 1, 18.

75 RS, CL.P vol. 3, part 1, 19, 22 and 26.

76 *PT*, IX (1674), pp. 93–6.

77 Ibid., I (1666), pp. 330–43. Georgius Agricola, *De Re Metallica*, trans. Herbert Clark Hoover and Lou Henry Hoover (New York, 1950), p. 217. Boyle referred to Agricola by name in *Of the Temperature of the Subterraneall Regions: As to Heat and Cold* (1670) and in *Some Considerations Touching the Usefulness of Naturall Philosophy* (1671). *Boyle Works* 1999–2000, vol. 6, pp. 340, 398. See also Pamela O. Long, 'The Openness of Knowledge: An Ideal and its Context in 16th-Century Writings on Mining and Metallurgy', *T&C*, XXXII (1991), pp. 353–5.

78 *PT*, I (1666), p. 330.

79 See e.g. the account given in response to Oldenburg's commission by Dr Edward Brown of the mines, minerals, baths etc of Hungary, Transylvania, Austria et al. in *PT*, V (1670), pp. 1189–96 and 1042–51.

80 Ibid., VI (1671), pp. 2096–113; XII (1678), pp. 949–52.

81 John Ray, *Collection of English Words* (1674), appendix, covered smelting and refining silver in Cardiganshire, Wales, an account given by the master of the silver mills, Major Hill, in 1662; the preparing and smelting of tin in Cornwall; iron works at the furnace and forge; wire-work at Tintern, Monmouthshire; vitriol; red lead; allom at Whitby, Yorkshire, 'as we saw, and partly received from the workmen'; salt at Nantwich, Cheshire, and sea salt. In the second edition of 1691 Ray added, p. 210, 'I dare answer for the half of them, having seen them myself many years ago in my travels through England and Wales.' He referred the reader to further accounts written since 1674 and published in *PT* 'which being more operose may be useful to undertakers of such works'.

82 *PT*, XVII (1693) pp. 695–9, 737–45; 865–70.

83 Ibid., III (1668), pp. 743–4; V (1670), pp. 1056–65. Slightly ominously, Evelyn noted: 'Something (tis possible) may happen to be out of order, by reason of the long journey it hath passed; but their ingenious curator [Hooke] will soon be able to reform, and, if need be, improve it.'

84 Robert Hooke, *Lectiones Cutlerianae, or a Collection of Lectures: Physical, Mechanical, Geographical and Astronomical* (1679), p. 16.

85 Hunter 1989, pp. 311–14.

86 Jagger 1995, who points out that four votes were cast against Moxon, an unprecedented occurrence. Moxon 1962, pp. xix–lv. Sarah Tyacke, 'Map-Sellers and the London Map Trade c.1650–1710', in Helen Wallis and Sarah Tyacke, eds, *My Head is a Map: Essays & Memoirs in Honour of R. V. Tooley* (1973), pp. 66–8, 80.

87 Moxon 1962, pp. xlv–vi.

88 Nevertheless, 'The Doctrine of Handy-Works' was used as a sub-title.

89 Adrian Johns, *The Nature of the Book: Print and Knowledge in the Making* (Chicago and London, 1998), pp. 79–93, 105–8.

90 Modern technology has rendered the work more accessible. N. W. Alcock and Navy Cox, *Living and Working in Seventeenth-century England* (2000) is a CD-ROM which enables The Academy of Armory to be browsed by subject, combining the original drawings in BL Harley MS, the published work of 1688 and the remaining part of Book III and Book IV, published by the Roxburghe Club in 1905. The 2500 images and the related text are comprehensively indexed for ease of navigation.

91 Ochs 1985, pp. 151, 158 n. 66. Her quantitative study of *Philosophical Transactions* indicates that interest in the trades programme was at its height between 1660 and 1670, on the decline between 1670 and 1678 and almost non-existent after 1688.

92 Hooke to Boyle, 6 October 1664, in *Boyle Correspondence* 2001, vol. 2, p. 344.

93 Sprat 1667, p. 71.

94 Evelyn to Boyle, 9 May 1657, in *Boyle Correspondence* 2001, vol. 1, pp. 212–13.

95 Evelyn to Boyle, 9 August 1659, in ibid., p. 363.

96 Robert Boyle, *The Excellency of Theology, compar'd with Natural Philosophy* (1674) in *Boyle Works* 1999–2000, vol. 8, p. 57.

97 A view based on communications with Michael Hunter.

98 See John T. Harwood, 'Rhetoric and Graphics in *Micrographia*', in Hunter and Schaffer 1989, pp. 119–47. Jardine 2002, pp. 96–101 traces the origins of the microscopic examination of living things to the circle of Wilkins in the late 1640s and the making of measured drawings after them to Wren, whom Hooke fulsomely credited in his introduction: 'there scarce ever met in one man, in so great a perfection, such a mechanical hand, and so philosophical a mind'.

99 Hooke, 1680s, Bowood House, Petty MSS, H[8] 16, quoted in Hunter 1989, p. 313.

100 John Evelyn, *Sculptura* (1662), pp. 145–8. Evelyn proposed instead to demonstrate the technique to any 'curious and worthy person' and to prepare a fuller account for the archives of the Royal Society. For a summary of the literature on the early mezzotint see Griffiths 1998, pp. 193–4, 211–12.

101 MacLeod 1988, pp. 185–8.

102 Lisa Jardine, *Ingenious Pursuits: Building the Scientific Revolution* (1999), pp. 151–7, 317–25.

103 Sprat 1667, pp. 71–2.

104 Thomas Hobbes, 'Considerations upon the Reputation, Loyalty, Manners, and Religion of Thomas Hobbes' (1662) in *The English Works of Thomas Hobbes of Malmesbury*, ed. Sir William Molesworth (1839–45), vol. 4, pp. 436–7. For a full exploration of this conflict see Shapin and Schaffer 1985.

105 Michael Hunter, *The Royal Society and its Fellows 1660–1700: The Morphology of an early Scientific Institution* (Oxford, 2nd ed., 1994), pp. 25–34.

106 '*Brief Lives*', chiefly of Contemporaries, set down by John Aubrey, between the Years 1669 and 1696, ed. Andrew Clark (Oxford, 1898), vol. 2, p. 305. For Petty's shipbuilding activities, in particular his efforts to construct a double-bottomed boat or catamaran, see Sharp 1977, vol. 1, pp. 242–50.

107 As when the wealthy dilettante Edmund Wylde failed to show up to demonstrate his technique for softening steel without fire. Thomas Birch, *The History of the Royal Society of London* (1756–7), vol. 1, pp. 416, 428, 434, 460.

108 Abraham Hill, *Familiar Letters* (1767), 12 March 1663, pp. 96–7, quoted in Hunter 1981, pp. 94–5.

109 Sir Henry Sheeres, Bodleian Library, Oxford, Rawlinson MSS, A 341, f. 25, quoted in Hunter 1981, p. 107.

110 RS, Early letters, S.1.2, Peter Smith to John Beale, 18 September 1655, quoted in Hunter 1995, pp. 106–8.

111 *The Diary of Robert Hooke M.A., M.D., F.R.S., 1672–1680*, ed. Henry W. Robinson and Walter Adams (1935), p. 235, 2 June 1676.

112 Jonathan Swift, *Gulliver's Travels* (1726), part 3, 'A Voyage to Laputa', ch. 4. For an extended commentary see John Christie, 'Laputa Revisited', in John Christie and Sally Shuttleworth, eds, *Nature Transfigured: Science and Literature, 1700–1900* (Manchester, 1989), pp. 45–60, Pat Rogers, 'Gulliver and the Engineers', *Modern Language Review*, LXX (1975), pp. 260–70.

113 Shapin 1994 explores the grounds for the authority of gentleman philosophers, focusing on Boyle.

114 J. A. Bennett, 'The Mechanics' Philosophy and the Mechanical Philosophy', *History of Science*, XXIV (1986), pp. 1–28, is a key article in this debate.

115 Iliffe 1995. See also Steven Shapin, 'Who was Robert Hooke?', in Hunter and Schaffer 1989, pp. 253–85. The tercentenary of Hooke's death in 2003 occasioned the publication of a crop of illuminating studies of his life: Stephen Inwood, *The Strange and Inventive Life of Robert Hooke 1635–1703* (2002), Lisa Jardine, *The Curious Life of Robert Hooke: The Man who Measured London* (2003), Bennett, Cooper, Hunter and Jardine 2003.

116 Jim Bennett, 'Hooke's Instruments', in Bennett, Cooper, Hunter and Jardine 2003, pp. 63–104.

117 Hunter 1989, pp. 313–14, Shapin 1989, pp. 268–9, 274–6.

118 John Flamstead, Cambridge University Library, Royal Greenwich Observatory, MS 1.50 (K), f. 203, quoted in Iliffe 1995, p. 317.

119 Jagger 1995, pp. 200–02. As a Fellow, Moxon was effectively barred from becoming printer to the Society, a disqualification which might have alienated him from it. He never paid his subscription.

120 Shapin 1994, pp. 389–92.

121 Sprat 1667, p. 83.

122 Pumfrey 1995, p. 139.

123 Shapin 1994, pp. 355–407. See also Steven Shapin, '"A Scholar and a Gentleman": The Problematic Identity of the Scientific Identity in Early Modern England', *History of Science*, XXIX (1991), pp. 279–327.

124 John Aubrey, '*Brief Lives*' (Oxford, 1898), ed. Andrew Clark, vol. 2, p. 140.

125 See Jardine 2002, pp. 63–101 for Wren's relations with Petty and Wilkins.

126 Stephen Wren, *Parentalia* (1750), p. 183.

127 *Evelyn's Diary* (Oxford, 1955) vol. 3, p. 110, Jardine 2002, pp. 106–9.

128 'The Life of Dr Robert Hooke', in Hooke 1705, p. ii.

129 *Evelyn's Diary*, vol. 3, p. 416, Barbara J. Shapiro, *John Wilkins 1614–1672: An Intellectual Biography* (Berkeley and Los Angeles, 1969), pp. 199–200.

130 For an articulate account of this way of processing information see Ferguson 1992.

131 For similar works published in the middle decades of the seventeenth century, both before and after the Restoration, see Sharp 1977, vol. 1, pp. 203–6. They all advocated state regulation of the economy, the development of the country's natural resources, improved transport and communication and the introduction of new techniques to increase agricultural and industrial output.

132 Nehemiah Grew, 'The Meanes of a Most Ample Encrease of the Wealth and Strength of England in a few years' (1707), BL, Lansdowne MS 691.

133 Stewart 1992.

34 Pumfrey 1995, pp. 131–56.

135 Miller 1999, pp. 185–201.

36 Stewart 1992, p. 215.

37 Ibid., pp. 225–7, 338, 377–8, 380. He concludes that 'For mine owners, entrepreneurs, and for the engineers and philosophers they employed, the success of their undertakings was often an illusion.'

38 Desaguliers 1744, vol. 2, p. 416.

1 Drawing: Surveying the Scene, Engineering the Machine

1 'Preface', Ferguson 1992.

2 Christopher Wren and Samuel Pepys, Christ's Hospital MSS 12,811, vol. 6, 1692, ff. 362–4, quoted in Sloan 2000, pp. 104–5. Christ's Hospital Archives, Guildhall Library, London; accessible at London Metropolitan Archives.

3 Bacon recognised *en passant* the importance of making accurate surveys in his essay 'Of the true Greatness of Kingdoms and Estates' in *Essays or Counsels, Civil or Moral*, planned and written in 1608 but not published in English until 1734.

4 Ehrman 1953, p. 619.

5 For the difficulties this division of responsibilities caused see H. C. Tomlinson, 'The Ordnance Office and the Navy, 1660–1714', *English Historical Review*, XC (1975), pp. 19–39.

6 Jonathan G. Coad, *The Royal Dockyards 1690–1850: Architecture and Engineering Works of the Sailing Navy* (Aldershot, 1989), p. 25.

7 The argument that the royal dockyards were inefficient by the standards of modern management practice, advanced in J. M. Haas, *A Management Odyssey: The Royal Dockyards, 1714–1914* (Lanham, Md., 1994), has been effectively demolished by Roger Knight, 'From Impressment to Task Work: Strikes and Disruption in the Royal Dockyards, 1688–1788', in Kenneth Lunn and Ann Day, eds, *History of Work and Labour Relations in the Royal Dockyards* (1999), pp. 1–20, Ann Coats, 'Efficiency in Dockyard Administration 1660–1800: A Reassessment', in Nicholas Tracey, ed., *The Age of Sail* I (2002–03), pp. 116–32, and Rodger 2004, pp. 408–25.

8 Deacon 1997, pp. 69–174, covering the experiments made by Boyle and Hooke among others.

9 *The Double Bottom or Twin-hulled Ship of Sir William Petty*, ed. 6th Marquis of Lansdowne (Oxford, 1931) and BL, Add. MS 72894, copies of original material now in Bodleian Library, Oxford, MS Lyell Empt. 32 and NMM, SPB/16. Also Sharp 1977, vol. 1, pp. 242–50.

10 Deacon 1997, pp. 154–74. J. A. Bennett, 'Hooke's Instruments for Astronomy and Navigation', in Hunter and Schaffer 1989, pp. 20–32.

11 A review of the subject is provided by William J. H. Andrewes, ed., *The Quest for Longitude* (Cambridge, Mass., 1996): see esp. W. F. J. Mörzer Bruyns, 'Longitude in the Context of Navigation' and Owen Gingerich, 'Cranks and Opportunists: "Nutty" Solutions to the Longitude Problem', pp. 44–7 and pp. 134–48.

12 The most comprehensive account of Edmund Dummer's career is given in Eveline Cruickshanks, Stuart Handley, D. W. Hayton, eds, *The History of Parliament: The House of Commons 1690–1715* (Cambridge, 2002), vol. 3, pp. 931–3. He also appears in the *ODNB* in a short biography by Philip MacDougall. For my account of Dummer's career in the Royal Navy see 'The Ingenious Mr Dummer: Rationalising the Royal Navy in Late Seventeenth-Century England', *eBLJ*, X, (2007), pp. 1–58.

13 NA, ADM 1/3555, ff. 359, 371–5.

14 MC, Pepys MS 1490, f. 148.

15 Ibid., MS 2910. Lavery 1981. Technically, a sheer draught is a projection of the lines of a vessel on a vertical longitudinal plane passing through the middle line of the vessel.

16 Hemingway 2002, pp. 50–54.

17 NA, ADM 1/3555, f. 375.

18 MC, Pepys Sea MS 2934.

19 Ibid., Sea MS 1074.

20 Lavery 1981, pp. 24–5.

21 Petty abstract in BL, Add. MS 72854, ff. 99–104 and 72895, ff. 1–16 (Petty MS), the latter copies of original material in NMM, SPB/16. Hooke abstract in RS, CL.P vol. 20, 70, 24 March 1685.

22 The final appearance of Petty's abstract as 'What a Compleat Treatise of Navigation should contain', drawn up in 1685 and delivered to the Royal Society in 1686, was published posthumously in *PT*, XVII (1693), pp. 657–9.

23 Hooke's tree of knowledge reflects an avowed shift in his concerns by the 1680s from describing the specifics of 'trades' to establishing the general principles behind them. Hunter 1989, pp. 312–15.

24 NMM, AND 31.

25 NA, ADM 106/58: retrospective warrant from Charles II, signed by Pepys, 12 July 1684.

26 Ulla Ehrensvärd, 'Colour in Cartography: A Historical Survey' and James Aweln, 'The Sources and Development of Cartographic Ornamentation in the Netherlands', in David Woodward, ed., *Six Historical Essays* (Chicago, 1987), pp. 123–46 and 147–73, Delano-Smith and Kain 1999, pp. 70–75.

27 BL, King's MS 40, f. 103.

28 BL, Add. MS 78299, ff. 33–34. *Particular Friends: The Correspondence of Samuel Pepys and John Evelyn*, ed. Guy de la Bédoyère (Woodbridge, 1997), C25, C28–30.

29 MC, Pepys MS 1490, f. 148. *Samuel Pepys's Naval Minutes*, ed. J. R. Tanner (1926), pp. 394–5.

30 Rodger 2004, pp. 636, 642.

31 Hemingway 2002, p. 54.

32 NA, ADM 91/1, ff. 278–79: Offices of the Comptroller and Surveyor of the Navy, General Letter Books, 7 March 1693; quoted in Evan W. H. Fyers, 'Shipbuilding Abuses in the XVIIth Century', *MM*, X (1924), pp. 382–6.

33 NA, ADM 106/2507, no. 117.

34 William Sutherland, 'Action and reaction equal in a fluid, or a specimen towards removing some untoward approved of maxims in building and equipping ships', n.d., NMM, SPB/50, reproduced in John B. Hattendorf et al., eds, *British Naval Documents 1204–1960* (Aldershot, 1993), pp. 266–9. Sutherland wrote *The Shipbuilder's Assistant* (1711).

35 Arthur MacGregor, 'The Tsar in England: Peter the Great's Visit to London in 1698', *The Seventeenth Century*, XIX (2004), pp. 116–17, 127, 137.

36 According to José P. Merino, Intendant Arnoul at Rochefort supervised the construction of a stepped stone *forme* at Rochefort in 1683–8; 'Graving Docks in France and Spain before 1800', *MM*, LXXI (1985), pp. 36–9. Coad 1992, pp. 192–200.

37 BL, Add. MS 70035, ff. 150, 188.

38 BL, Lansdowne MS 847, reprinted in Michael Duffy, ed., *The Naval Miscellany*, VI (Navy Records Society, 146, 2003), pp. 93–147.

39 BL, Add. MS 9329, a printed version of Dummer's account, with some variations and a prospect of the whole yard engraved by Kip.

40 As recently as 25 June 1694 Dummer had conceded that these took

place before the Committee of Public Accounts hearings of the charges made by the Merchant shipwright George Everett. BL, Harley MS 7471.

41 Jean Peter, *Vauban et Toulon: Histoire de la construction d'un port-arsenal sous Louis XIV* (Paris, 1995), pp. 279–90. For a recent overview of Vauban's career see Saint 2007, pp. 8–24.

42 BL, Sloane MS 4024, entries from Hooke's Diary for 28 April and 10 June 1693, transcribed in R. T. Gunther, *Early Science in Oxford, Vol. X: The Life and Work of Robert Hooke (Part IV)* (Oxford, 1935), pp. 235 and 248.

43 NA, ADM 91/1, ff. 158, 206, 211–12, 276–7, 291, 293–5, 297, 308, Surveyor's out letters 1693; ADM 106/472, Commissioner St Lo's report on the gates, 21 June 1695; ADM 2/178, p. 7, 20 February 1697. NMM, Sergison, Admiralty Orders, 82, 20–24 February 1697.

44 BL, Lansdowne MS 847, f. 27.

45 BL, Harley MS 4318. NMM, Sergison, Navy Board Minutes, 1 July 1698 record the order of a copy for the Lords of the Admiralty, presumably the present example once owned by Robert Harley.

46 The alteration was ordered during Dummer's suspension. NMM, POR/A2, 19 May 1699.

47 BL, King's MS 43, f. 1.

48 A second less elaborately finished copy of the Survey, presumably deposited by Dummer with the Admiralty, is now in the collection of rare books and manuscripts at the Yale Center for British Art, New Haven.

49 Mark Antony Lower, ed., 'Some Notices of Charles Sergison, Esq., One of the Commissioners of the Royal Navy, temp. William III and Queen Anne', *Sussex Archaeological Collections*, xxv (1873), pp. 62–84.

50 Ibid., p. 64.

51 BL, King's MS 43, Explanation, f. 2r–2v. This method of 'measure and value' quantity surveying was standard practice in the building industry of the time as a method of settling payments for new work, although less realistic presumably as a way of calculating accumulated value, given the lack of allowance for depreciation (let alone inflation) which in the case of the dockyards must have been considerable. Thompson 1968, p. 66.

52 Dummer seems to claim the design for himself, but the roof-line and pediment were influenced by those of Bethlem Hospital, designed by Hooke. Coad 1992, p. 194. Giles Worsley, 'Taking Hooke Seriously', *The Georgian Group Journal*, xiv (2004), pp. 16–17.

53 Coad 1992, p. 194, Duffy 2003, p. 121 n. 1.

54 John Fitch was granted a lifetime patent as 'Workmaster' by Charles II for the building and repair of all forts, a situation which led to poor workmanship through lack of competition. John and his more prominent brother Thomas Fitch were bricklayers by trade who exploited the opportunities afforded by the Restoration and the Great Fire of London to become major building contractors. Thomas Fitch was elected the sheriff of Kent in 1679 and was knighted the same year; he died nine days after being created a baronet by James II. Joyce Fitch and Roy Stephens, 'Sir Thomas Fitch', *ODNB*. Nigel Barker, 'The Building Practice of the English Board of Ordnance, 1680–1720', in Bold and Chaney 1993, pp. 199–214, H. M. Colvin, ed., *The History of the King's Works* (1976), vol. 5, pp. 133 and 381.

55 NA, ADM 91/1, ff. 230 and 262.

56 Ibid., f. 311.

57 For his substandard labour force on the fortifications at Hull in the 1680s, see Barker, 'Building Practice of the English Board of Ordnance', pp. 205–8.

58 NA, ADM 3/15, 15 June 1699.

59 For the Admiralty Commissioners' recommendations to the Kir see NA, ADM 2/364, 23 June 1699, Ehrman 1953, pp. 270–73, 40 4. See also the speech given by Dummer's protector, Robert Harle in Parliament on 9 March 1699, BL, Add. MS 70036, f. 10.

60 NMM, Sergison, Navy Board Minutes, 41. Until August 169 Dummer employed a model-maker named Boneland at the Na Office, 'in making models of docks, ships and vessels which, beir new inventions, could not be managed without such instructio to the artificers that were to perform them'. R. D. Merriman 'Gilbert Wardlaw's Allegations', *MM*, xxxviii (1952), p. 127, citir Navy Board correspondence to the Admiralty.

61 NA, ADM 3/15, 15 August 1699.

62 Narcissus Luttrell, *A Brief Historical Relation of State Affairs fro September 1678 to April 1714* (Oxford, 1857), vol. 4, p. 645.

63 At the end of the eighteenth century the government used sing building contractors for the construction of army barracks, givin rise to similar charges to those levelled at Dummer – high cos poor workmanship and so forth. Thompson 1968, pp. 82–5. In th Ordnance, payment was made by day work or by measurement, b the yard.

64 BL, Add. MS 70037, f. 77.

65 For Dummer's later career as a shipbuilder and the establishmer of a packet-boat service from Plymouth to the West Indies see Banbury, *Ship Building of the Thames and Medway* (1971), p. 14 and J. H. Kemble, 'England's First Atlantic Mail Line', *MM*, xxv (1940), pp. 33–60, 185–96.

66 *Calendar of Treasury Papers 1708–1714*, clxvii, no. 6, 4 Decembe 1713, pp. 93–103.

67 Baugh 1965.

68 Rodger 2004, pp. 412–13.

69 *Eighteenth Century Shipbuilding: Remarks on the Navies of th English and the Dutch from Observations made at their Dockyards 1737 by Blaise Ollivier, Master Shipwright of the King of France*, tran and ed. David H. Roberts (Rotherfield, 1992), pp. xxxvi (p. 55) an cxl (p. 143).

70 NA, ADM 3/61, quoted in Rodger 1993, p. 64. Richard Middletor 'The Visitation of the Royal Dockyards, 1749', *MM*, lxxvii (1991 pp. 21–30.

71 NA, ADM 3/61, quoted in Rodger 1993, pp. 64–6.

72 Thomas Milton is an obscure figure. He may be the same Thoma Milton who with John Crunden and Placido Columbani made th drawings for *The Chimney Piece Maker's Daily Assistant* (1766) an the same year, measured and drew the plates of Longford Castl published in *Vitruvius Britannicus*, vol. v (1771). Harris and Savag 1990, pp. 172 and 496.

73 Baugh 1995, p. 121, quoting B. R. Mitchell, *Abstract of British Hi torical Statistics* (Cambridge, 1962).

74 Baugh 1995, p. 123, quoting Jan Glete, *Navies and Nations: Warship Navies and State Building in Europe and America 1500–1860*, 2 vo (Stockholm, 1993). The number of ships of the line remained mor or less the same but they grew larger.

75 Rodger 1993, pp. xvii.

76 NMM, San 45c/5 and 6, 6 June 1773. For an account of the vis see Celina Fox, 'George III and the Royal Navy', in Marsden 200 pp. 290–312.

77 *George III Correspondence* 1927–8, vol. 3, pp. 1–2, no. 1290.

78 NMM, San 45c/13, 18 July 1773.

79 Ibid., San 45c/18, 14 August 1773.

80 *George III Correspondence* 1927–8, vol. 3, p. 82, no. 1420.

81 In 1766 Thomas Mitchell had won a premium at the Society of Arts in the category of 'Original Sea Pieces in Oils' when still a builder's assistant at Chatham. He also worked at Deptford and eventually rose to be the Assistant Surveyor to the Navy. At the same time he exhibited large battle pieces at the Free Society of Artists and the Royal Academy. See Sloan 2000, p. 118, cat. 78; the drawing catalogued as representing Deptford depicts Chatham.

82 The *Supplement* extended to territory covered by Sergison in 1698 and reports and regulations relating to the timber stores, a subject dear to Sandwich's heart. A few blank pages were left so that further material could be pasted in: it was evidently intended to include draughts of marine architecture by comparing men-of-war from the reigns of Henry VIII, Charles II and George III but these were never added.

83 NMM, SanV/5, 5 June 1771. Lavery and Simon 1995, p. 367.

84 Warmoes 1999.

85 *George III Correspondence* 1927–8, vol. 3, pp. 81–2, nos. 1418, 1420.

86 Roche 1933, pp. 145–6.

87 Bennett and Brown 1982.

88 Bennett and Johnston 1996, p. 11.

89 Leonard Digges, *A boke named Tectonicon* (1556) was reprinted twenty times in 150 years. One of the most comprehensive, dedicated collections of early works on surveying is in the library of the Royal Institution of Chartered Surveyors.

90 William Leybourn, *The Compleat Surveyor* (1674 ed.) pp. 304–5.

91 See Sarah Bendall, *Dictionary of Land Surveyors and Local Mapmakers of Great Britain and Ireland 1530–1850* (1997), pp. 42–54.

92 George Atwell, *The Faithfull Surveyour* (1658).

93 William Gardiner, *Practical Surveying Improved* (1737), p. 42.

94 [Anon.], 'A Brief Account of the most material Passages relating to the Survey managed by Dr Petty in Ireland, Anni 1655 and 1656', in William Petty, *The History of the Survey of Ireland, commonly called the Down Survey* (Dublin, 1851), ed. Thomas Aiskew Larcom, pp. xiii–xvii. The original MS of Petty's history is BL, Add. MS 72874. For an account of the survey and its chequered later history see J. H. Andrews, *Plantation Acres: An Historical Study of the Irish Land Surveyor and his Maps* (Omagh, 1985), pp. 63–111.

95 The text of ten of the post-Fire survey books (not those by Hooke, which he retained) was transcribed in the eighteenth century. Michael Cooper summarises his extensive research on Hooke's surveying activities in 'Hooke's Career', in Bennett, Cooper, Hunter and Jardine 2003, pp. 28–49.

96 For an account of the scheme see Eric H. Ash, 'Amending Nature: Draining the English Fens', in Roberts, Schaffer and Dear 2007, pp. 116–43.

97 Frances Willmoth, *Sir Jonas Moore: Practical Mathematics and Restoration Science* (Woodbridge, 1993). For the cut-price, improvised means adopted to build the Royal Observatory, with little of the state support enjoyed by its Paris precursor, see Saint 2007, pp. 40–42.

98 Sharp 1977, vol. 2, pp. 210–3.

99 NA, MP I/230 and MP II/40. James Radcliffe, 3rd Earl of Derwentwater, a grandson of Charles II, took a prominent part in the Stuart rising of 1715 and was beheaded on Tower Hill on 24 February 1716. For evidence of the use of other estate maps as working documents in estate offices over long periods of time (even 150 years) see Delano-Smith and Kain 1999, p. 119.

100 Jessica Christian, 'Paul Sandby and the Military Survey of Scotland', in *Mapping the Landscape: Essays on Art and Topography* (Nottingham, 1990), pp. 18–22, R. A. Skelton, *The Military Survey of Scotland 1747–1755* (Edinburgh, 1967).

101 For Lieutenant Colonel David Watson's original hopes for the Survey see William Roy, *An Account of the Measurement of a Base on Hounslow Heath* (1785), p. 4. For a pessimistic view of the results see Ian H. Adams, *Descriptive List of Plans: Scottish Record Office, Vol. 1: Introduction* (Edinburgh, 1966).

102 At the suggestion of Lieutenant Colonel Watson who had been responsible for the original Survey. For Watson's instructions to the surveyors see NAS, E 721/1A 80 and E 726/1–2. The main run of surveys is NAS, RHP 3398–3490. For the experiences of one of the best qualified surveyors see Ian H. Adams, ed., *Papers on Peter May* (Edinburgh, 1979).

103 Virginia Wills, ed., *Scottish Record Office, Reports on the Annexed Estates 1755–1769* (Edinburgh, 1973). I. H. Adams, 'Economic Progress and the Scottish Land Surveyor', *Imago Mundi*, XXVII (1975), pp. 13–18. For the problems encountered by the surveyor John Leslie in the annexed barony of Callander in 1775 see NAS, E 777/313.

104 For a résumé of the role of the late sixteenth-century county mapmakers see Delano-Smith and Kain 1999, pp. 66–75.

105 Smith 1990, pp. 153–77. William Ravenhill, 'Joel Gascoyne: A Pioneer of Large-Scale County Mapping', *Imago Mundi*, XXVI (1972), pp. 60–70.

106 Delano-Smith and Kain 1999, pp. 86–7. *A Map of the County of Cornwall Newly Surveyed by Joel Gascoyne*, intro. by W. L. D. Ravenhill and O. J. Padel (Exeter, 1991), pp. 26–7.

107 NA, MR 1/681.

108 E.g., a horse-gin is represented in the sophisticated decoration to Martyn's map of Cornwall. Budgen's Sussex depicted the county's iron industry; Kitchin's Northumberland (1750) included a scene of miners resting on piles of coal with a collier being loaded in the background; Taylor's Hereford (1757), the various processes involved in making cider; Armstrong's Northumberland and Durham (1769), a windmill and a coal-pit; Chapman and André's Essex (1777), a fulling mill and two cloth-beaters.

109 Smith 1990, pp. 155–67.

110 Shelley Costa, 'Marketing Mathematics in Early Eighteenth-century England: Henry Beighton, Certainty and the Public Sphere', *History of Science*, XL (2002), pp. 211–32, 'A new Plotting-Table for taking Plans and Maps, in Surveying: Invented in the Year 1721 by Henry Beighton, F.R.S. Inscribed to the Royal Society', *PT*, XLI (1741), pp. 747–61; see also BL, Add. MS 4432 (35), ff. 180–183v for a quadrant of his design.

111 Engraved by Elisha Kirkall, it was mechanically reduced to five plates covering the county and four on a smaller scale for the revised *Antiquities of Warwickshire*, published in two volumes in 1730. It was also sold separately on a scale of one inch to one mile.

112 Evidently, it was the first printed map to register coal mines; Smith 1990, p. 169.

113 For the best summaries of surveying in the second half of the eighteenth century see J. B. Harley, 'The Re-mapping of England, 1750–1800', *Imago Mundi*, XIX (1965), pp. 56–67, and Delano-Smith and Kain 1999, pp. 49–111.

114 BL, King's Top 37.31 and 32.44.

115 Tom Williamson, *Polite Transactions: Gardens and Society in Eighteenth-century England* (Stroud, 1995) makes good use of surveys and maps to illustrate the process.

116 DRO, D239. Harold Nichols, *Local Maps of Derbyshire to 1770* (Matlock, 1980), p. 119, no. 268.

117 RIC, MMP/95. J. B. Harley and E. A. Stewart, 'George Withiell: A West Country Surveyor of the Late Seventeenth Century', *Devon*

and Cornwall Notes and Queries, XXXV (1982–4), pp. 45–58, 96–114, cat. 14.

118 WRO, CR 136/C691.

119 Fordham 2001, pp. 430–41.

120 E.g., BL, Add. MS 69461 and RIC, HM/8/18, dating respectively from *c.*1700 and *c.*1720. Joseph Mills and Paul Annear, *The Book of St Day 'The Towne of Trynte'* (Tiverton, 2003), pp. 27–9.

121 See e.g. CoRO, Enys 510–11 and Enys 1743.

122 John Cornwell, *The Bristol Coalfield* (Ashbourne, 2003), pp. 44–8.

123 NLW, MS 603E. David Bick and Philip Wyn Davies, *Lewis Morris and the Cardiganshire Mines* (Aberystwyth, 1994). The seminal account of mining in Wales from the sixteenth to the early eighteenth century is William Rees, *Industry before the Industrial Revolution* (Cardiff, 1968).

124 NCS, SANT/BEQ/9/1/3 [53–4].

125 BL, Add. MS 6677, ff. 198v–199. The map is in one of the volumes devoted to Mineralia, 'legal briefs and cases and copies of proceedings in courts of law and equity and of arbitrations and agreements, all relating to mines and mining operations in the County of Derby', compiled by Adam Wolley with a view to writing a general history of Derbyshire and bequeathed to the British Museum in 1828.

126 Ironbridge Gorge Trust, Coalbrookdale, CBD 59–83–3.

127 DRO, D185. Nichols 1980, p. 269.

128 RICS, Kenney Collection.

129 Michael W. Flinn and David Stoker, *The History of the British Coal Industry. Vol. 2, 1700–1830: The Industrial Revolution* (Oxford, 1984), pp. 49–57.

130 NEIMME, 3410 Wat/20a/9.

131 Ibid., Wat/30/6–7; 31/13–14; 23/9–10; 20a/15.

132 See, e.g., the meticulous plan of land at Birtley, Co. Durham, belonging to Mrs Mary Garrick, taken on 27 December 1759 by William Brown, Thomas Stokoe and Thomas Humble, ibid., Wat/31/3.

133 Ibid., Wat/19/26.

134 As is apparent in one drawing of Parkmoor Colliery in the Durham Coalfield: 'A sketch of 5 and 6 quarter coal seams showing the extent of the workings as appears by linings and measurements made the 20th May 1774'. NCS, SANT/BEQ/9/1/3 [13].

135 WRO, CR 136 C628–9. The new mine was completed two years later but not on the site proposed by Barnes. Fordham 2001, pp. 441–2.

136 NEIMME, 3410/Wat/30/1. See also his drawings for the owners of Fawdon Colliery, ibid., Wat/26/2–4.

137 Ibid., Wat/19–38. The papers were presented to the North of England Institute of Mining and Mechanical Engineers by John Watson junior's son William in 1863.

138 Ibid., Wat/4/3.

139 F.S. Hewitt, 'An Assessment of the Value to the Economic Historian of the Papers of John Buddle, Colliery Viewer . . .', *Mining Engineer*, CXII (1962–3), pp. 406–15.

140 NEIMME, 3410/Bud/7.

141 A.J. Heesom, 'Buddle, John (1773–1843)', *ODNB*.

142 See, e.g., Buddle jr's twenty 'views' relating to Workington Colliery, dating from 1814 to 1837, NEIMME, 3410/Bud/1. According to Heesom 'Buddle', among Buddle's innovations was the introduction of an improved system of underground ventilation known as double or compound ventilation.

143 NEIMME, 3410/Bud/3, ff. 145–54.

144 Ibid., Bud/26, 31, 103.

145 Ibid., Bud/106–35.

146 See esp. ibid., Johnson, the bound volumes of reports, leases and correspondence relating to George and John Johnson and others principally relating to the Willington area where both were employed as agents. Also, NCS, SANT/BEQ/9/1/3, the William Brown collection of eighteenth-century plans of collieries and estates, three volumes presented to the Society of Antiquaries of Newcastle upon Tyne by Dixon Dixon Esq on 2 January 1856.

147 Simon Winchester, *The Map that changed the World* (2001), pp. 63–82, 129–41. Smith's crowning achievement was *A Delineation of the Strata of England and Wales with part of Scotland; exhibiting the Collieries and Mines; the Marshes and Fen Lands originally overflowed by the Sea; and the Varieties of Soil according to the Variations in the Sub Strata; illustrated by the Most Descriptive Names* (1815).

148 E.g., the Enys family tin bounds map for the parish of St Agnes drawn by the land surveyor William Terril of Redruth in May 1778 with tables listing the names of the bounds and the proportion owned by John Enys, quantified in statutory and customary measures and added up, was certified in 1781 by Henry Tregellas of St Agnes, his sons John and Josiah, and John Bennett of Kea, all tinners: 'that the bounds of this map agree with the old bound book of the ancestors of Jn. E., they having been present at the renewal of the said bounds for many years past, and the said Jn. T having been Toller and Bounder to the Enys family from 1773 till the present'. CoRO, Enys 1381.

149 Ibid., AR 18/8. There are copies of the map in the same collection 18/9/1, 18/9/2, 18/10 and 18/11.

150 RIC, B/16/1.

151 See CoRO, R4923/1–4 for notebooks containing details of the Rashleigh tin bounds from 1749 to 1814.

152 See, e.g., CoRO MRO/A/42 for a map of the Northdowns mining district by Robert Ballment, 1791, or MRO/A/51–5, of the Redruth Gwennap and St Agnes district, all surveyed by Thomas Towan and 'shewn' by Benjamin Nicholls and John Gray.

153 A. W. Skempton, 'The Engineers of the English River Navigations 1620–1760', *TNS*, XXIX (1953), pp. 25–54.

154 Now in BL, King's Top 6.1–60.

155 The loose sheet is in RS, Smeaton, vol. 6, dated 15 April 1734, inserted by John Farey. It is probably a flier for *A New Method, grounded upon Philosophical Experiments, and Mathematical Calculations, for Draining all Sorts of Low Lands* which Grundy offered to publish by subscription in 1736, or for *Philosophical and Mathematical Reasons, Humbly offer'd to the Consideration of the Publick, To prove that the Present Works, executed at Chester, to recover and preserve the Navigation of the River Dee Must intirely Destroy the Same* (1736); Stewart 1992, p. 149.

156 SGS, Minutes, vol. 2, f. 82v.

157 Ibid., f. 89v, reproduced in Dorothy M. Owen and S. W. Woodward, eds, 'The Minute Books of the Spalding Gentlemen's Society 1712–1755', *Lincoln Record Society*, LXXIII (1981), p. 22.

158 Grundy's interest in Beighton's work continued, for in September 1742 he gave an account he had had from Mr Beaton (*sic*) of Griff, Warwickshire, of the methods of making a map of that county. SGS Minutes, vol. 3, f. 127v, 30 September 1742.

159 Ibid., vol. 2, f. 103v; f. 108, 25 April 1734; f. 131, 27 March 1735; vol. 3, f. 127v, 30 September 1742.

160 Ibid., vol. 2, f. 151, 10 December 1735; f. 160, 8 April 1736; f. 168v, 16 September 1736.

161 Ibid., f. 185v, 14 July 1737; vol. 3, f. 131v, 4 November 1742; vol. 4, f. 81v, 27 November 1746 and f. 83, 4 December 1846.

162 IIbid., vol. 3, f. 5v, 6 April 1738; f. 13v, 17 August 1738; f. 30v, 5 April 1739; f. 137v, 27 January 1742.

163 SGS, Misc, vol. 4.

164 SGS, Minutes, vol. 3, f. 161, 15 December 1743; f. 187, 15 November 1744.

165 Ibid., vol. 3, f. 176v, 28 June 1744.

166 Stewart 1992, p. 126. A drawing of two swans signed by John Grundy junior and dated 14 April 1737 survives in SGS, Misc, vol. 4.

167 Skempton 1984, pp. 67–8, LUBC, MS SC13; see also SGS, Minutes, vol. 5, f. 49v, 12 October 1749, when the Society was entertained with an account of Grundy's work at Grimsthorpe.

168 Wright 1984, p. 6. The Grimsthorpe terrier, Lincolnshire Record Office, 3ANC 4/35a, includes perspective views of the castle and of Edenham Church.

169 Sixteen vols are in LUBC, MS SC1–17, and vol. 2 from the same sequence is in ICEL, 627.53. For an overview of the volumes contents see O. S. Pickering, 'The Re-emergence of the Engineering Reports of John Grundy of Spalding (1719–83)', *TNS*, LX (1988), pp. 137–43.

170 Wright 1984, p. 6.

171 Two sheets in vol. 1 are signed by Tinkler and one plan in LUBC, MS SC4 of a stone causeway is signed 'J. G. del. 1759 copy J. G. 1776'.

172 LUBC, MS SC3.

173 Skempton 1984, pp. 78–9.

174 LUBC, MS SC16, ff. 89–115.

175 Trevor Turner and A. W. Skempton, 'John Smeaton' in Skempton 1981, pp. 7–34, Smeaton 1812, vol. 1, pp. xv–xvi. The latter work, comprising 3 volumes with 74 plates, was published in 1812, under the auspices of the Society of Civil Engineers, the reports selected by committee. Vol. 4 (1814) was made up of reprints of papers read before Royal Society and other Societies, prefaced by an account of his life. The detailed editorial work was entrusted to John Farey senior assisted by his better-known son John Farey junior. A. W. Skempton, 'The Publication of Smeaton's Reports', *NRRS*, XXVI (1971), pp. 135–55.

176 Denis Smith, 'Professional Practice', in Skempton 1981, pp. 217–27.

177 Smeaton 1812, vol. 2, pp. 122–4.

178 Ibid., p. 101.

179 ICEL, 1764 Letterbook 1 August, quoted in Skempton 1981, p. 219.

180 ICEL, Machine Letters, 22 July 1791, quoted in Skempton 1981, p. 219.

181 For a detailed history of their provenance and the possible whereabouts of other Smeaton manuscripts see A. P. Woolrich, 'John Farey and the Smeaton Manuscripts', *History of Technology*, X (1985), pp. 181–216.

182 The RS volumes provided the basis for Farey's illustrations to Smeaton's *Reports*, his contributions to *Pantologia* (1808–12), Rees's *Cyclopaedia* (1819) and his *Treatise on the Steam Engine* (1827).

183 The main catalogue of the drawings is H. W. Dickinson and A. A. Gomme, *Smeaton's Designs, 1741–1792* (1950).

184 Smeaton 1812, vol. 2, pp. 122–4.

185 RS, Smeaton, vol. 5, ff. 1–37, and vol. 6, ff. 59–68. Charles Hadfield, 'Rivers and Canals', in Skempton 1981, pp. 117–22.

186 RS, Smeaton, vol. 6. The presentation copy is to be found in NAS, RHP 37949.

187 RS, Smeaton, vol. 5, ff. 65–8, Smeaton 1812, vol. 3, p. 154.

188 My account of Watt's surveying career is indebted to Hills 2002.

189 A corrected printed proof copy of the Monkland Canal scheme is in BAH, MS 3219/4/200.

190 Ibid., undated (previously MI/2/54).

191 Ibid., MS 3219/4/71/2, 8 September 1770.

192 Ibid., MS 3219/4/200 (previously MI/2/60).

193 Ibid., James Watt's Second Report on the Monkland Canal, 2 February 1770, cited in Hills 2002, p. 215.

194 BAH, MS 3219/4/200, 31 March 1770.

195 Ibid., MS 3219/4/62, 9 September 1770.

196 Ibid., MS 3219/4/129–30 and 3219/4/202 (the Report).

197 Unfinished plans and complete sections of the Crinan isthmus survive in ibid., MS 3219/4/204.

198 NAS, E730/31.3, Clerk's report, 30 January 1773. No further progress was made until John Rennie was asked to draw up a scheme for the Crinan Canal in 1793 and turned to Watt for advice.

199 Quoted from a letter of 1781 from Watt to his cousin in a private collection in Robinson 1962, pp. 195–6.

200 BAH, MS 3219/4/92/12, 12 August 1782, Hills 2002, pp. 248–63.

201 Hills 2002, pp. 279–89.

202 BAH, MS 3219/4/62 and 3219/4/135. James Muirhead, *The Origin and Progress of the Mechanical Inventions of James Watt, illustrated by the correspondence of his friend and the specifications of his patents* (1854), vol. 2, letter 123, pp. 62–3.

203 Trevor Turner and A. W. Skempton, 'John Smeaton', in Skempton 1981, pp. 24–5. The Society is discussed further in Chapter 4.

204 *English Reports*, vol. 99, King's Bench, pp. 589–91. RS, Smeaton, vol. 2, p. 31. See also Denis Smith, 'Professional Practice', in Skempton 1981, pp. 226–7.

205 Oliver Wood, *West Cumberland Coal 1600–1982* (Kendal, 1988).

206 CRO, D/Lons/W2/1/58–61. J. S. Allen, 'The 1715 and Other Newcomen Engines at Whitehaven Cumberland', *TNS*, XLV (1972), pp. 237–68; also J. V. Beckett, *Coal and Tobacco: The Lowthers and the Economic Development of West Cumberland, 1660–1760* (Cambridge, 1981), pp. 68–74.

207 CRO, D/Lons/W2/1/86. Sir James was probably referring to the London fire-engine maker Richard Newsham, who had two patents of 1721 (no. 439) and 1725 (no. 479) relating to 'a water engine for extinguishing fires', although the context seems to suggest that this engine was a pump for the mine.

208 A report prepared by the Laird of Dundass and others in April 1736 described the 'water engine' to be sited in the vicinity of the coal mine at Easter Strathore, with an accompanying perspective drawing and, two years later, a letter addressed to Lord Elphinston from Robert Ainslie contained a description and sections of a windmill proposed for the same purpose: Fife Council Archive Centre, Rothes Papers. W. G. Rowntree Bodie, 'Introduction to the Rothes Papers', *Proceedings of the Society of Antiquaries of Scotland*, X (1978–80), pp. 427–8, pls 20 and 21. See also 'A Plan of a Bobb Ginn and a Fire Engine' made by Amos Barnes in February 1734, NEIMME, 3410 For/1/4.

209 Fordham 2001, pp. 152–74, Stewart 1992, pp. 242–9.

210 SMLA, Rey, f. 91. For the close community of ironmasters, frequently tied together by Quaker affiliation, see R. A. Buchanan, 'Steam and the Engineering Community in the Eighteenth Century', *TNS*, L (1978), pp. 193–202.

211 LUBC, MS SC11.

212 Ibid., MS SC3.

213 Elevation and section are used interchangeably in one drawing of 1757; ibid., MS SC5, f. 107.

214 ICEL, 627.53.

215 LUBC, MS SC11.

216 J. S. Allen has tracked the process of designing a steam engine for the Walker Colliery, Northumberland, in 1782–3 from Smeaton's

surviving journals in Trinity House Library. In all he spent 9 days on site and *c.*62 hours on the designs, in addition to the time his assistant Henry Eastburn spent copying the drawings; J. S. Allen, 'Steam Engines', in Skempton 1981, pp. 191–2. Woolrich 1998, pp. 63–5, points out that in his designs Smeaton often left out details regarding the disposition of the doorways and access stairs connecting floors of atmospheric engine-houses.

217 RS, Smeaton, vol. 1, ff. 55v–60, 63v–64.

218 The earliest example of such a work, *Architectura mechanica Moole boek* (Amsterdam, 1686) was composed by a Swedish millwright, Pieter Linpergh (Pehr Lindberg), who travelled to the Netherlands specifically to study Dutch windmills. It contained explanations and images of the exteriors, gears and parts of different types of windmill. Although it was reprinted in 1727 it was soon superseded in the 1730s by two much more comprehensive mill-books produced by Dutch millwrights: *Theatrum Machinarum Universale, of Groot Algemeen Moolen-boek* (Amsterdam, 1734) by Johannis van Zyl, with engravings by Jan Schenk, and *Groot Volkomen Moolen-boek* (Amsterdam 1734–6) by Leendert van Natrus and Jacob Polly, with engravings by Cornelis van Vuuren.

219 The key commentaries are Wailes 1951, Paul N. Wilson, 'The Waterwheels of John Smeaton', *TNS*, xxx (1955), pp. 25–48, Denis Smith, 'Mills and Millwork' and J. S. Allen, 'Steam Engines', in Skempton 1981, pp. 59–81 and 179–94.

220 RS, Smeaton, vol. 1, f. 2.

221 Ibid., ff. 7v–9, 10–15. Wailes 1951, p. 242, Woolrich 1998, pp. 62–5.

222 ICEL, Machine Letters, 6 February 1786, quoted in Norman Smith, 'Scientific Work', in Skempton 1981, p. 63.

223 Smeaton 1812, vol. 2, p. 414, 27 June 1772.

224 Smeaton 1812, vol. 2, pp. 424–5, 1764. Smith, 'Mills and Millwork', in Skempton 1981, p. 81.

225 RS, Smeaton, vol. 2, ff. 95v–108.

226 Smith, 'Mills and Millwork', in Skempton 1981, pp. 73–4.

227 Quoted in Campbell 1961, p. 74.

228 See his letter to the Carron Company of 7 February 1782 regarding the trials he proposed for cast (rather than wrought) iron anchors, secure in the knowledge that cast-iron parts for a windmill axis and oil press had not broken; Smeaton 1812, vol. 1, pp. 409–12.

229 Smeaton 1812, vol. 1, p. 377, Campbell 1961, pp. 41, 87–91.

230 Campbell 1961, pp. 36–41.

231 RS, Smeaton, vol. 2, ff. 67–70, 75. Smeaton 1812, vol. 1, pp. 359–61.

232 RS, Smeaton, vol. 3, f. 5v.

233 Allen, 'Steam Engines', in Skempton 1981, pp. 192–4.

234 Loose sheet inserted among the drawings for Lumley Colliery, RS, Smeaton, vol. 3, ff. 25v–29.

235 Ibid., ff. 160–75, Smeaton 1812, vol. 2, pp. 435–8.

236 RS, Smeaton, vol. 3, ff. 111–25, Smeaton 1812, vol. 2, pp. 347–59.

237 The papers of Thomas Wilson (1748–1820) were sold at Bonham's on 24 March and 25 June 2003, purchased by the Cornwall Heritage Trust and deposited in CoRO.

238 RS, Smeaton, vol. 3, f. 123.

239 Ibid., ff. 125v–35v and 139v–47.

240 Hills 2002, pp. 284–7.

241 BAH, MS 3219/4/287/3/4–6, Hills 2002, pp. 350–54.

242 BAH, MS 3219/58/12.

243 Ibid., MS 3219/4/58.

244 Ibid., MS 3219/4/63 and 4/58.

245 Hills 2002, pp. 389–92, 402–6. Even after the patent was finally drafted on 25 April 1769, Watt continued to make drawings, both in his own journal and in letters to Small well into 1770.

246 Tann 1978, pp. 41–56.

247 Dickinson and Jenkins 1927, p. 129.

248 BAH, MS 3147/5/625a.

249 Ibid., MS 3147/3/533/17 and 21, quoted in Tann 1978, p. 46.

250 BAH, MS 3219/4/139, quoted in Dickinson and Jenkins, pp. 257–8.

251 Watt to Smeaton, 4 April 1778, quoted in John Lord, *Capital and Steam Power 1750–1850* (1923), p. 199 from the Tangye MSS.

252 BAH, MS 3147/5/624.

253 Dickinson and Jenkins 1927, pp. 118–19.

254 BAH, MS 3147/5/1286. The acquisition of the Thomas Wilson papers by the CoRO in 2003 has greatly added to the understanding of Boulton & Watt's Cornish operations.

255 Ibid., MS 3147/5; see e.g. 629 for the list of parts for Scott & Jefferies' engine at Malehurst, Shropshire, 1778; 648, for a colliery engine near Nantes, 1779; or 1292 for Wheal Chance Engine, 1779.

256 Ibid., MS 3147/4/326.

257 See, e.g., ibid., MS 3147/5/26, a fine set of presentation drawings for John James's cotton mill in Nottinghamshire, dating from 1788, or MS 3147/5/137, the set for Charles Clowes's Southwark Brewery of 1796.

258 See, e.g., BAH, MS 3147/5/29 depicting Thompson and Baxter's corn mill, Hull, 1789. The sections provide a rare depiction of the product itself, in the shape of a sack of corn suspended on a hook through the floors of the handsome mill building.

259 Ibid., MS 3147/5/135.

260 Hills 2005, pp. 190–211.

261 BAH, MS 3219/4/91.

262 The most comprehensive guide is provided by Tann 1970.

263 BAH, MS 3147/5/4. After a productive life of 102 years, this engine was finally replaced in 1887 and it was bought for the Museum of Applied Arts and Sciences, Sydney, Australia, where it arrived by clipper in 1888. It remains a star attraction of the Powerhouse Museum.

264 BAH, MS 3147/5/27. Gifford's requested the return of the plans and sections as soon as Boulton & Watt could part with them. The firm seems to have complied, retaining reverse copies.

265 BAH, MS 3147/5/152 contains 97 drawings relating to Albion Mills, Skempton 1971, pp. 53–73.

266 BAH, MS 3147/5/39.

267 Ibid., 5/165.

268 Ibid., 5/124.

269 Ibid., 5/142.

270 Ibid., 5/40.

271 Ibid., 5/154.

272 Ibid., 5/14.

273 Tann 1970 p. 101, quoting Gott–Sutcliffe correspondence in the Gott papers (John Goodchild Collection, Wakefield). Ironically, in May 1793, Rennie had to excuse the high price he charged Gott and Company for copying Sutcliffe's drawings for the proposed mill and for designing the machinery, 'owing to the trouble of adapting it to your other works, which have not been so well planned as [they] should have been to render the whole a complete job'. In 1795, as one of the Commissioners of Leeds water works, Gott again sought advice from Rennie as to a proper person to examine Sutcliffe's charges of above £200 which the Commission had objected to as an imposition. W. B. Crump, ed., *The Leeds Woollen Industry 1780–1820* (Leeds, 1931), pp. 208 and 217.

274 BAH, MS 3147/5/5.

275 Ibid., 5/48.

276 Ibid., 5/84. See H. R. Johnson and A. W. Skempton, 'William Strutt's Cotton Mills, 1793–1812', *TNS*, xxx (1955), pp. 179–205.

277 Tann 1998, pp. 47–72.

278 Ibid., pp. 54–8.

279 NEIMME, 3410/Wat/29/11–18; 22/21, 22/30–31; 3410/Bud/33.

280 CRO, D/Lons/7/1. Alan W. Routledge, *Whitehaven: History and Guide* (Stroud, 2002), pp. 43–5.

281 CRO, D/Lons/7/1, Portfolios: Steam Engines No. 1, Steam Engines No. 6, Bottom Bank Colliery, Patterns No. 3a and Patterns No. 4a.

282 Ibid., Portfolio: Patterns No. 3a.

283 WRO, CR136/V64–6. Newdigate made a payment of £5 to the artist on 13 October 1792. Fordham 2001, pp. 504–10.

284 Closest in style, but lacking the presence of workers, are five drawings (plans and sections) documenting the cotton mill of Bazacle, constructed by François-Bernard Boyer Fonfrède at Toulouse in 1791. They are fair copies made after originals by the *ingénieur-mécanicien* Ovide and deposited in the Conservatoire des Arts et Métiers, Paris. Serge Chassagne, 'La Filature du Bazacle à Toulouse', *La Revue: Musée des art et métiers*, no. 4 (1993), pp. 47–54. Some eighteenth-century patent drawings in the National Archives include figures working the patented invention.

285 WRO, CR136/M24. Fordham 2001, p. 514.

286 *The Correspondence of Sir Roger Newdigate of Arbury Warwickshire*, ed. A. W. A. White (Hertford, 1995), pp. lii, 313–14, 357–61. Sir Roger seems to have built the mill at his own expense, sold it to a Liverpool merchant, Mr Tipping, who promptly went bankrupt, then to a Mr Dickenson with whom he was on good terms and finally, by 1789, to Lane.

287 H. W. Dickinson, 'An 18th Century Engineer's Sketchbook', *TNS*, II (1921), pp. 132–40.

288 Ibid.

289 SMLA, Rey, 44. Another drawing, Rey, 124, shows the inclined plane at Cyfarthfa Iron Works in plan and elevation on a scale of 1:48, with a note stating 'Each carriage takes down 2 drams, a ton of coal in each'.

290 Ibid., Rey, 94. Bétancourt, born Agustín de Béthencourt y Molina (1758–1824) in Puerto de la Cruz, Tenerife, trained as an engineer, came to the attention of Charles III and received a scholarship which enabled him to study hydraulics and mechanics in Paris until the Revolution. He undertook more travels in Europe to study scientific and industrial progress including a visit to England. Boulton claimed he was a thief who, having been treated civilly at Soho, stole the design for a double engine. In 1808 he was invited by Alexander I to Russia to establish the Tula armoury and a cannon foundry in Kazan. Sebastián Padrón Acosta, *El Ingeniero Agustín de Béthencourt y Molina* (Tenerif, 1958). Bétancourt supplied Reynolds with his design for a joint for cast-iron plates (SMLA, Rey, 10), improved Reynolds's own design for a water-powered corn mill (Rey, 81) and probably also made the series of finished drawings of the mill (Rey, 99–100, 102–3).

291 SMLA, Rey, 117.

292 For a revisionist account of the relationship between Telford and Jessop and a chronology of the introduction of iron trough aqueducts see Charles Hadfield, *Thomas Telford's Temptation: Telford and William Jessop's Reputation* (Cleobury Mortimer, 1993). Telford described the Shrewsbury Canal in his article 'Artificial Canals', in Joseph Plymley, *General View of the Agriculture of Shropshire* (1803), pp. 297–302 and attributed the idea of having the Longdon aqueduct made of cast iron to Thomas Eyton, the chairman of the canal company committee, claiming the principles of construction and the manner of execution for Reynolds and himself.

293 SMLA, Rey, 1.

294 Ibid., Rey, 82 and 80.

295 Ibid., Rey, 118.

296 Ibid., Rey, 42, 48, 56–65, 115, 118.

297 Information kindly supplied by Tony Woolrich. See Science Museum, London, Science and Society Picture Library, inv. no. 1904–0120 for a photograph of a 1790 winding engine at Coalbrook, Shropshire, taken in the mid-nineteenth century.

298 SMLA, Rey, 12, 31–2.

299 Ibid., Rey, 19.

300 Stansfield 1984, pp. 60–62 and 229. Sadler was sufficiently trusted by Reynolds to be sent by him to fetch arms from Birmingham when workmen attacked Reynolds's home, The Bank, in August 1791.

301 CoRO, AD 1583/5/51.

302 SMLA, Rey, 3–9.

303 Stansfield 1984, pp. 152–3. One drawing by Venables suggests the direction taken by Sadler's innovations: it is an elevation and plan of an engine and boiler, drawn to a scale of 1:24 and dated 13 February 1796: 'W. Reynolds's idea of the application of Sadler's engine to a rotative motion, the lower cylinder communicating with the boiler – this method is applicable to rowing boats with circular oars, 1795'; SMLA, Rey, 40. In 1799 Simon Goodrich noted a Sadler pattern engine on the Bridgewater Canal, 'used to draw the limestone in carriages from the barges up an inclined plane to the lime kiln on the bank of the canal' and another used (unsuccessfully) to power a steamboat; SMLA, Good, E1, 24 November and 1 December 1799. For its introduction at Portsmouth see below.

304 SMLA, Rey, 122–3.

305 SMLA, Good, E1, entry for 7 December 1799, and E2, entries for 21 and 25 February 1803.

306 For Bentham's work in the Navy see Roger Morriss, *Naval Power and British Culture, 1760–1850: Public Trust and Government Ideology* (Aldershot, 2004), pp. 147–74. William J. Ashworth, '"Systems of Terror": Samuel Bentham, Accountability and Dockyard Reform during the Napoleonic Wars', *Social History*, XXIII (1998), pp. 63–79, Morriss 1983, R. A. Morris, 'Samuel Bentham and the Management of the Royal Dockyards, 1796–1807', *Bulletin of the Institute of Historical Research*, LIV (1981), pp. 226–40. Also Simon Schaffer, '"The Charter'd Thames": Naval Architecture and Experimental Space in Georgian Britain', in Roberts, Schaffer and Dear 2007, pp. 278–305.

307 For Bentham's time in Russia see Ian R. Christie, *The Benthams in Russia 1780–91* (Oxford, 1993); also Simon Sebag Montefiore, *Prince of Princes: The Life of Potemkin* (2000), pp. 298–311, 367–8, 395–402.

308 Simon Werret, 'Potemkin and the Panopticon: Samuel Bentham and the Architecture of Absolutism in Eighteenth-century Russia', *Journal of Bentham Studies*, II (1999, online).

309 Bentham 1862, pp. 99–100. The most detailed, if partial, account of the development of Bentham's machinery is again given by Bentham's widow, Maria Sophia Bentham (M.S.B.), in 'The Invention of Wood-Cutting Machinery', *Mechanics' Magazine*, LVI (1852), pp. 264–76, to counter what she saw as excessive claims made on behalf of Marc Brunel.

310 NMM, ADM Q 3320, 22 April 1795, quoted in Coad 2005, p. 24.

311 As Bentham wrote on 15 July 1799 to Lady Spencer regarding dockyard management, 'Unluckily for me, it was in that country [Russia] I got into the habit of thinking all things possible – for I am apt to forget that this can only be true where there is *power* to persevere.' Bentham 1862, pp. 8, 174.

312 Morriss 1983, pp. 6–7, 46–8.

313 See *General Bentham's Answer to the Comptroller's Objections July 1800*, pp. 14–7, where Bentham argued that orders for refitting of ships should come from those competent to decide such things, not those with superiority with regard to 'military ardour, skill in navigation or in naval tactics'. A copy of this publication is to be found in SMLA, Good, D5.

314 *General Bentham's Answer*, pp. 67–8. When planning his office, Bentham had in mind the appointment in each yard of competent millwrights, a title he changed in pencil to engine-makers; NA, ADM 1/3525.

315 E. A. Forward, 'Simon Goodrich and his Work as an Engineer: Part I, 1796–1805', *TNS*, III (1922), pp. 1–15; see also E. A. Forward, 'Simon Goodrich and his Work as an Engineer compiled from his Journals and Memoranda: Part II, 1805–1812', *TNS*, XVIII (1937), pp. 1–27, A. S. Crossley, 'Simon Goodrich and his Work as an Engineer: Part III, 1813–23', *TNS*, XXXII (1959), pp. 79–92.

316 SMLA, Good, A11, 16. The bundle says 1797, but the RSA archives indicate the year was 1799. Jonathan Betts, curator of Horology at the National Maritime Museum, Greenwich, London, informs me that Simon Goodrich's crank escapement is known; it is shown in the entry for Goodrich in G. H. Baillie's *Watch and Clockmakers of the World* (Methuen, 1929), though he considers it would result in fairly poor timekeeping owing to the extreme attachment of the escapement to the oscillator.

317 SMLA, Good, A1785, 1786.

318 See, e.g., ibid., C161–2, a coloured, measured plan and elevation of a design for timber-bending apparatus 'on Mr Hookey's idea' dating from c.1811, and C21, a drawing, calculations and memoranda on Joseph Bramah's fire-extinguishing engine made on the back of a printed elevation and description of Bramah's hydro-mechanical copying press (possibly patent no. 2977 of October 1806).

319 See e.g. ibid., C18–20 of the proposals for Southwark Bridge or C36a, the gates to the Queen's Dock, Liverpool, dating from 1833.

320 See ibid., A 208, a letter of 23 February 1807 written by Goodrich to his friend John Grimshaw, a Sunderland rope manufacturer, during Bentham's leave of absence in Russia, in which he confided his doubts about the corps of civil engineers sent by the Commission for Revising and Digesting the Civil Affairs of the Navy to inspect the Portsmouth yard, that they were 'not capable of understanding the business'.

321 Michael Faraday visited in 1814 'being desirous', according to his intermediary, Marc Brunel, 'of seeing the Dockyard with all that is most interesting in the various Department, I am sure that he cannot be in better hands than in yours, to enable him to see everything to advantage, I shall therefore consider it a particular favor by your accompanying him every where not omitting of course the block mill.' Ibid., A1086.

322 For Bentham's innovations in their construction see Coad 2005, pp. 27–8.

323 Bentham soon found Sadler impossible to work with and used every occasion to try to get rid of him; NA, ADM 1/3525, 14 and 16 January 1797; ADM 1/3526, 10 December 1802.

324 SMLA, Good, A182.

325 Ibid., C1a, 33.

326 See ibid., C33 of Plymouth where 'His' Majesty has been changed to 'Her', presumably after his retirement, and C34, a copy c.1826 of an 1802 plan of the same yard.

327 Ibid., C11.

328 NA, ADM 1/3526.

329 NA, ADM 140/503–4, and SMLA, Good, C15–17.

330 BAH, MS 3147/5/278; SMLA, Good, A22–5; NA, ADM 140/498, 501 4. Goodrich helpfully annotated the last drawings for his masters: 'The parts of this drawing not tinged represent works that were erected, those tinged what was proposed to be erected and the red lines the plans of a building to be erected afterwards' and 'Machinery nearly upon these lines has been erected at Portsmouth'. He also spelt out the meaning of the colours: 'Light red represents brick work. Blue iron, Brown wood. Anything crossed thus is supposed to represent any thing cut thro' or the ends of planks and beams.

331 Coad 2005, pp. 32, quoting NMM, POR A43, 9 April 1800, and A45 5 February 2002; SMLA, Good, A54, 31 January 1801.

332 Coad 2005, pp. 42–7.

333 NA, ADM 140/501–2.

334 The most comprehensive account of block-making as a manufacturing process and the Portsmouth block mills is given in Coad 2005; see also Carolyn C. Cooper, 'The Portsmouth System of Manufacture', *T&C*, XXV (1984), pp. 182–225, K. R. Gilbert, *The Portsmouth Blockmaking Machinery* (1965) and notes by the last inspector in charge of the block mills, A. Barlow, 'The Blockmill at Portsmouth Dockyard in the Eighteenth to Twentieth Century', *MM*, LXXXVIII (2002), pp. 81–9.

335 NA, ADM 1/3526, 14 April 1802.

336 Coad 2005, pp. 53–9.

337 *Mechanics' Magazine*, LVI (1852), p. 264.

338 Coad 2005, pp. 61–73.

339 NA, ADM 140/637.

340 'Machinery', Rees's *Cyclopaedia*, 22 August 1812. It was predated by Farey's account in the *Edinburgh Encyclopaedia* (1810–11). The care over the machines taken by the workmen is indeed impressive for they remained in use until 1965.

341 SMLA, Good, C76–9.

342 NA, ADM 1/3527, 24 September 1805.

343 See SMLA, Good, B10, the journal Goodrich kept between August and 23 November 1805 which details the manner in which drawings were circulated between the Navy Board and contractors.

344 SMLA, Good, C42–3. For the delays in establishing the metal mill see Morris 1983, p. 235.

345 SMLA, Good, C57–9, 61, 66–7, 72, 74–5, 82, 99–100, 100a, 118–20.

346 Ibid., A142. Whitmore's 'blunders in the copper mill machinery and constant disappointment in time promised' resulted in his loss of the contract to Fenton, Murray & Co. to supply the 30 hp steam engine; SMLA, Good, Book 12, 3 December 1805, quoted in Coad 2005, p. 96. Nevertheless, see also NA, ADM 1/3527, 18 May 1806 for Goodrich's request for an estimate from Whitmore's for assorted machinery to complete the fit-out of the metal mills at Portsmouth.

347 SMLA, Good, A50–51.

348 NA, ADM 1/3527, 1 May 1804; SMLA, Good, C148–51. Despite three years in the planning, the proposed ropery did not get the go-ahead. The Navy Board was opposed, on the grounds of lack of space and under-capacity for the cost. Morriss 1983, p. 50.

349 SMLA, Good, C26. A further version in the Admiralty records, signed by Bentham 12 January 1804, shows modifications to the boiler shape as an oblong wooden container. It is not clear whether this unwieldy machine was ever built.

350 NA, ADM 140/499–500.

351 Rodger 2004, p. 476.

352 SMLA, Good, C153a.

353 Goodrich had made a survey in 1809 of the freshwater works at

Sheerness, including the cisterns, the old well and pump-house; ibid., A272. For the new well see A388–9, 395, 433–4, 469 and C188a, 192, 194–6.

354 Ibid., A579.

355 Ibid., A608–12, A725, 725a.

356 Ibid., C200.

357 Ibid., A969. The Navy Board rewarded W. Fenwick for his improvements to the rope-making process; Morriss 1983, p. 50.

358 SMLA, Good, A476.

359 NMM, ADM BP/32C, 14 December 1812, quoted in Morriss 1983, pp. 57–61.

360 SMLA, Good, C25 (Portsmouth), 91–5 (Deptford).

361 Ibid., C153–4, 163, 166.

362 Ibid., A465–6, C194.

363 Ibid., A613.

364 Ibid., A928, C196a.

365 Ibid., A202–4; see also NA, ADM 1/3527, 13 February 1807, the documentation Goodrich sent to the Admiralty recommending Vernon's appointment which makes no reference to Vernon's lack of theoretical knowledge. Vernon was still employed in the Dockyard in 1819.

366 SMLA, Good, A491. Surprisingly, his proposals did not include consideration of steam engines.

367 See ibid., A1093 for lecture memoranda of October–November 1824.

368 A good selection survives in ibid., C259–69; see also A1748–9, notes for his lectures with rough illustrations.

369 Ibid., A1334.

370 Admiralty Library, Portsmouth, MS 239/12, ff. 3–9, 82–5, Appendices 54–6, ff. 565–618. At the time, Rennie was involved in building the new London, West India and East India Docks.

371 NA, ADM 1/3527, 9 March and 6 June 1808. Bentham's apologia cut no ice in the depths of the Admiralty. A cryptic note initialled by the Hon. W. Wellesley Pole, Secretary to the Admiralty and dated 10 June 1808, states, 'I have read all General Bentham's observations on what had been recommended by the Board of Revision – they contain nothing to induce me to alter my opinion with respect to the propriety of abolishing the Office of IG of NW, and of carrying into execution the Kings Order in Council on that subject'. A pencil addendum reads 'Unless General Bentham can be other wise disposed of, & a more able Man appointed as Civil Architect & Engineer in his room.' Bentham could not afford to turn down the Navy Board position and on 29 August 1808 he wrote to Lord Mulgrave to accept it; NA, ADM 1/3527, 29 August 1808.

372 'Memorial by Dr. John Robison relative to his first acquaintance with Mr Watt and the improvements of the latter on the Steam Engine. Written in 1796', reproduced in Robinson and Musson 1969, pp. 23–48.

373 Picon 1992, pp. 260–86. For the mixed blessings of 'science' with regard to eighteenth-century French naval architecture see Rodger 2004, pp. 409–10.

374 Bentham 1813, pp. 140–7.

375 SMLA, Good, D15.

376 NA, ADM 140/675, signed and dated 31 October 1808; ADM 140/678, signed and dated 17 July 1812.

377 *Desiderata* was written in February 1812.

378 The original drawing survives in NA, ADM 140/1404.

379 Picon 1992, pp. 260–86. Although Ledoux commissioned the engravings of plans and prospects for his utopian town from 1773, they were first published in *L'Architecture* in 1804. Bentham could

have seen them but, more probably, given the parallel chronologies, the common underlying intent of surveillance is coincidental.

380 An enormous model of the project, some 1600 square feet, is now stored at Fort Brockhurst, Gosport, in the care of English Heritage. Jonathan Coad, 'The Sheerness Dockyard Model', *Country Life*, CCII, no. 32 (2008), pp. 52–5.

III Models: Polite Toys, Useful Tools

1 RSA, PR.GE/110/8/85, 6 March 1757.

2 For an overview of the subject see MacGregor 2007, esp. pp. 213–36.

3 Bacon 2000, pp. 149–52. Francis Bacon, *Gesta Grayorum: or, the History of the Prince of Purpoole* (first ed. 1688), p. 35.

4 Bacon 1659, pp. 28–38.

5 Arthur MacGregor, ' "A Magazin of all manner of Inventions": Museums in the Quest for "Salomon's House" in Seventeenth-century England', *Journal of the History of Collections*, 1 (1989), pp. 207–12.

6 Nehemiah Grew, *Museaeum Regalis Societatis. Or a Catalogue & Description of the Natural and Artificial Rarities belonging to the Royal Society and preserved at Gresham Colledge . . .* (1681), pp. 351–84, William LeFanu, *Nehemiah Grew M.D., F.R.S: A Study and Bibliography of his Writings* (Winchester, 1990), pp. 28–43, Hunter 1989, pp. 123–55. For the search for satisfactory systems of classification see Ken Arnold, *Cabinets for the Curious: Looking Back at Early English Museums* (Aldershot, 2006), pp. 197–218. The model of Petty's twin-hulled ship survives in the Royal Society.

7 Nehemiah Grew, 'The Means of a most ample Encrease of the Wealth and Strength of England in a few Years', BL, Lansdowne MS 691, ff. 34–5, 56–7. Besides reading *New Atlantis*, perhaps Grew had heard of the exhibition staged in 1683 in Paris of 21 models of machines, specifically intended to be of use to the public, including contemporary inventions relating to mills and drainage schemes. Arthur Birembaut, 'L'Exposition de Modèles de Machines à Paris en 1683', *Revue d'Histoire des Sciences*, XX (1967), pp. 141–58.

8 The claim has been made that such scepticism was symptomatic of the English antipathy to the clockwork metaphor, because it symbolised an authoritarian concept of order, rather than according with the self-image of a nation that espoused freedom and self-regulation. Mayr 1986, pp. 122–9.

9 According to Warmoes 1999, p. 7, one of the earliest recorded military models was commissioned of the city of Rhodes in 1521 by the Grand Master of the Order of the Knights Hospitallers in preparation for the Turkish siege. Between 1568 and 1574 Albert V of Bavaria commissioned a series of wooden models of the administrative centres and fortresses of his duchy, now in the Bavarian National Museum in Munich. For other German technically oriented princely collections, see Bruce T. Moran, 'German Prince-Practitioners: Aspects in the Development of Courtly Science, Technology and Procedures in the Renaissance', *T&C*, XXII (1981), pp. 253–74. For Saxony see Syndram and Scherner 2004.

10 NA, Land Revenue Enrolments, vol. 113, p. 41, reproduced in Appendix 1 to Thorpe 1933. MacGregor 2007, pp. 220–21.

11 Warmoes 1999, pp. 8–10. They are now displayed in the Musée des Plans-Reliefs on the 4th floor of Les Invalides, Paris, and on the lower ground-floor level of the Musée des Beaux-Arts, Lille.

12 Celina Fox, 'George III and the Royal Navy', in Marsden 2005, p. 307. The model of Gibraltar, laid down to a scale of one hundred

feet to an inch, was constructed by John Byres in 1781 for Viscount Townshend, Master General of Ordnance, to show (according to the brass inscription) 'the situation of the Peninsular Fortifications and City of Gibraltar and also new Additional Works as they stood in 1779 with the Spanish Forts and Lines across the isthmus'. It and a smaller marble model of the King's Bastion, presented to George III in 1793, are now displayed in the Royal Engineers Museum, Gillingham, Kent.

13 Lavery and Simon 1995, pp. 155–8.

14 NMM, SLR 2148.

15 NMM, SLR 2151.

16 Phineas Pett, *Autobiography*, ed. W. G. Perrin, *Navy Records Society*, 51 (1918), pp. 31–2.

17 Ibid., pp. 156–7.

18 Franklin 1989, p. 170.

19 Lavery and Simon 1995, pp. 79, 85. R. J. B. Knight, 'The Introduction of Copper Sheathing into the Royal Navy, 1779–1786', *MM*, LIX (1973), pp. 299–309 and 'Early Attempts at Lead and Copper Sheathing', *MM*, LXII (1976), pp. 292–4, Randolph Cock, '"The Finest Invention in the World": The Royal Navy's Early Trials of Copper Sheathing, 1708–1770', *MM*, LXXXVII (2001), pp. 446–59.

20 *George III Correspondence* 1927–8, vol. 3, p. 10, letter 1305. NMM, San c/21. According to Lavery and Simon 1995, pp. 119–20, the framed model is possibly that of the *Intrepid*, NMM, SLR 0525. Fox, 'George III and the Royal Navy', pp. 305–6.

21 *George III Correspondence* 1927–8, vol. 3, p. 10, letter 1305.

22 Ibid., vol. 3, p. 118, letter 1490.

23 Ibid., p. 250, letter 1700. Fox, 'George III and the Royal Navy', pp. 306–7. In 1864 they were presented by Queen Victoria to South Kensington Museum and are now in the Science Museum.

24 Anne Savours, 'Russian Maritime Museums', *MM*, LX (1974), pp. 165–86, Arthur MacGregor, 'The Tsar in England: Peter the Great's Visit to London in 1698', *The Seventeenth Century*, XIX (2004), p. 126.

25 Musée de la Marine, Paris, inv. no. 9 MG 33.

26 Musée de la Marine, Paris, inv. nos 13 PA 1B, 15 PA 4, 3 AR 1, 13 PA 13, 13 PA 28, 3 PA 16, 13 PA 11.

27 Bruno de Dinechin, *Duhamel du Monceau* (Paris, 1999), p. 127, Alain Niderlander, 'Le Musée de la Marine et ses Collections', *Neptunia*, CXCIII (1994), pp. 44–51.

28 José P. Merino, 'Graving Docks in France and Spain before 1800', *MM*, LXXI (1985), p. 52, quoting Archivo Don Alvaro de Bazán, El Viso; Arsenales, Diques 1787. The model can be seen in the Museo Naval de Madrid.

29 Daniel G. Harris, *F. H. Chapman: The First Naval Architect and his Work* (1989), p. 116. The models are now in the Sjöhistoriska Museet, Stockholm.

30 Franklin 1989, pp. 4–5, 177–9. Sergison's models were sold to H. H. Rogers in 1900 and are now in the United States Naval Collection at Annapolis.

31 Kunsthistorisches Museum, Vienna, inv. no. 4146.

32 Ibid., inv. nos 4155 and 5749. *Handsteine* can be found in a number of other European collections: the Hungarian National Museum and Iparművészeti Museum, Budapest; the Esterházy Collection; the Siegerland Museum, Siegen; Museum Haus der Heimat, Freital; and the Deutsches Bergbau-Museum, Bochum. See Slotta and Bartels 1990, with an introduction to the subject by Rainer Slotta, pp. 563–88, cat. no. 244a–k; also Peter Huber, '"Die schöneste Stuffe": Handsteine aus fünf Jahrhunderten', *ExtraLapis*, VIII (1995), pp. 58–67. I am most grateful for the further information on the

examples in the Kunsthistorisches Museum provided by the curator Franz Kirchweger and by Peter Huber.

33 E.g., Kunsthistorisches Museum, Vienna, inv. no. 4141, made in Neusohl in the late seventeenth or first quarter of the eighteenth century, in which a jewelled vertical slice can be removed to reveal a cross-section of the shafts and tunnels beneath the mountain.

34 This account relies on Hollister-Short 1976, pp. 11–22, G. J Hollister-Short, 'A New Technology and its Diffusion: Steam Engine Construction in Europe 1720–c.1880, Part 1', *Industrial Archaeology*, XIII, part 1 (1978), pp. 9–41; also Simon Schaffer, 'The Show that Never Ends: Perpetual Motion in the Early Eighteenth Century', *BJHS*, XXVIII (1995), pp. 172–5.

35 Lindqvist 1984, pp. 141–70.

36 The original was destroyed with the library of the Technische Hochschule, Berlin, in 1944 but it is redrawn in Franz Maria Feldhaus, *Geschichte des Technischen Zeichnens* (Wilhelmshaven, 1959), p. 43.

37 Tab XLIV: 'Des Hrn Potters Feuer Machine zu Königsberg in Ungarn wie wohl unterschiedliches mit dem Origal different seÿn dürffte weil einer richtige Zeichnung bis dato ermangelt in zwischen uber das Haubwerck und Invention daraus zu ersehen ist.' The explanation is given on pp. 94–9. The letter of endorsement is dated 23 January 1725.

38 The engines were still in use in 1758, although not all at the same time, according to Jars 1780, vol. 2, pp. 158–61. He also reported that the 'Englishman' had made a considerable amount of money over his ten-year contract.

39 For Triewald's physico-theology see Lindqvist 1984, pp. 302–7.

40 Jirí Majer, 'Innovative Tendenzen im böhmischen Erzbergbau des 18. Jahrhunderts', *Der Anschnitt*, LII (2000), pp. 190–97; see also Theodore Ziolkowski, *German Romanticism and its Institutions* (Princeton, 1990), pp. 18–63, for the enormous influence of Abraham Gottlob Werner who taught at the Freiberg mining academy from 1775 to 1817. For the comparative backwardness of the British mining industry before the Industrial Revolution see Roy Porter, *The Making of Geology: Earth Science in Britain 1660–1815* (Cambridge, 1977), p. 53.

41 Jozef Vozár, 'Das Schemnitzer Bergwesen und die Gründung der Bergakademie', *Der Anschnitt*, L (1998), pp. 20–24. The Academy was founded in 1763 and Nicolaus Joseph Jacquin (1727–1817) of the University of Vienna appointed as its first professor. Lectures began in September 1764. In 1770 the school was reorganised as the Royal Hungarian Mining Academy. Franz Stephan's scientific interests were inherited by Pietro Leopoldo, his third son, who succeeded his father as Grand Duke of Tuscany; his collection is now in the Museo del Storia della Scienza, Florence.

42 Syndram and Scherner 2004, pp. 51, 61, 207. Mining motifs crop up in a wide variety of shapes and forms in other princely collections. See Slotta and Bartels 1990. Also the mechanical mine in a box, representing the Kongsberg mine in Norway, made for Frederik IV of Denmark, in Dan Ch. Christensen, *Det Moderne Projekt. Teknik & Kultur i Danmark-Norge 1750–1850* (Copenhagen, 1995) p. 74, and the entire mining grotto installed in 1680 on the ground floor of Kromeriz, Moravia, the country seat of the Liechtenstein prince bishop of Olmutz.

43 The most recent popular account is Janet Gleeson, *The Arcanum* (1998); see also Robert E. Röntgen, *The Book of Meissen* (Exton, Pa. 1984).

44 Dietrich Fabian, *Meissener Porzellan mit Bergmannsmotiven in 18 Jahrhundert* (Bad Neustadt, 1997); also Klaus-Peter Arnold 'Bergmännische Motive in der Meissner Porzellanmalerie', in M

Backmann, H. Marx and E. Wächtler, eds, *Der silberne Boden: Kunst und Bergbau in Sachsen* (Stuttgart, 1990), and Slotta and Bartels 1990.

45 North of the Alps, the most celebrated *jeux d'eau* were installed by Tomaso Francini for the French king Henri IV at St Germain-en-Laye around 1600; Chapuis and Droz 1958, p. 46. The pleasure palace, park and trick fountains of Hellbrunn, on the outskirts of Salzburg, still survive. They were commissioned by Markus Sittikus, Archbishop of Salzburg from 1612 to 1619. The most elaborate device, the Mechanical Theatre, representing the activities of an entire town with nearly 200 wooden figures, was erected for Archbishop Andreas Graf von Dietrichstein in 1748–52.

46 In the late 1760s Christopher Pinchbeck exhibited the Panopticon again as part of 'UTILE & DULCE, or the much improved mechanical exhibition; universally thought to be the most entertaining, cheap, and instructive amusement offered to the public.' The majority of Pinchbeck's innovations were practical: a 'pyromatical thermometer', a patent fire escape, safety devices for mines and a space-saving bookcase, all of which were for sale; Altick 1978, p. 86, citing a handbill in Westminster City Archives, St Martin's scrapbook/General, I, 126, now untraceable.

47 Ibid. pp. 60–62, citing Daniel Lysons, *Collectanea; or, A Collection of Advertisements from the Newspapers . . .* [1661–1825], vol. 2, pp. 212 and 220; Chapuis and Droz 1958, pp. 128–31; R.W. Symonds, 'A Picture Machine of the Eighteenth Century', *Country Life*, XCVI (1944), pp. 336–7. After Bridges's death in 1754, the clock toured North America but disappeared from public view in 1775; American Antiquarian Society, Worcester, Mass., Broadsides 1249 and 1254. Its dial and movement were found in Paris early in the twentieth century and are now in the British Museum, London.

48 Mayr 1986. For a virtuoso elaboration of this argument see Simon Schaffer, 'Enlightened Automata', in Clark, Golinski and Schaffer 1999, pp. 126–65.

49 Ibid., pp. 135–6.

50 Jacques de Vaucanson, *Le Mécanisme du Fluteur Automate* (Paris, 1738), trans. Jean Desaguliers as *An Account of the Mechanism of an Automaton* (1742). Doyon and Liaigre 1992; also Reed Benhamou, 'From Curiosité to Utilité: The Automaton in Eighteenth-century France', *Studies in Eighteenth-century Culture*, XVII (1987), pp. 91–105.

51 Hogarth 1753, pp. 71–2.

52 The original model of the 1743–6 Vaucanson loom and a reduced scale model, made for the 1855 Paris Exposition Universelle, are in the Musée des Arts et Métiers, Paris, inv. nos 17 and 6236.

53 Doyon and Liaigre 1992, pp. 197–203, 210.

54 The models for making calendering cylinders and chains, the calendering machine, the machine for processing organzine and an iron slide-lathe (the first machine tool to be constructed with an iron frame) are respectively Musée des Arts et Métiers, inv. nos 16, 6, 20, 667 and 12. M. Cardy, 'Technology at Play: The Case of Vaucanson', *Studies on Voltaire and the Eighteenth Century*, CCXLI (1986), pp. 109–23, Gaby Wood, *Living Dolls: A Magical History of the Quests for Mechanical Life* (2002).

55 Philip Thicknesse was soon onto its trickery in *The Speaking Figure, and the Automaton Chess-Player, Exposed and Detected* (1784). For the most recent account of the chess player see Tom Standage, *The Mechanical Turk* (2002); also Schaffer, 'Enlightened Automata', pp. 154–63.

56 As reported by the American chief justice Peter Oliver, BL, Egerton MS 2672, 31 January 1777. Some survive in the Musée d'Histoire, Neuchâtel.

57 Advertisement prefaced to James Cox, *Descriptive Catalogue* (1772–3). For Cox see Clare le Corbeiller, 'James Cox: A Biographical Review', *Burlington Magazine*, CXII (1970), pp. 351–6, and Roger Smith, 'James Cox (c.1723–1800): A Revised Biography', *Burlington Magazine*, CXLII (2000), pp. 353–6; also Catherine Pagani, 'The Clocks of James Cox', *Apollo*, CXLI (1995), pp. 15–22. Cox's mechanical swan survives in the Bowes Museum, Barnard Castle, Co. Durham; *Merlin* 1985, pp. 125–7, cat. E5.

58 See, e.g., Brian Allen and Larissa Dukelskaya, eds, *British Art Treasures from Russian Imperial Collections in the Hermitage* (New Haven and London, 1996), p. 291, cat. 124, and Jane Roberts, ed., *Royal Treasures: A Golden Jubilee Celebration* (2002), p. 328, cat. 292.

59 See, e.g., William Mason's poem comparing Cox's Museum to 'state-museum' corruption, *Satirical Poems Published Anonymously by William Mason with Notes by Horace Walpole*, ed. Paget Toynbee (Oxford, 1926), pp. 112 and 122, quoted in Altick 1978, p. 71; also Mayr 1986, pp. 102–21.

60 *Journal of the House of Commons* (1803 reprint), XXXIV (19 March 1773), p. 210. Michael Wright, 'The Ingenious Mechanick', in *Merlin* 1985, p. 53, casts doubt on the authenticity of the lottery.

61 BL, Egerton 6273, 25 October 1777.

62 Arthur W.J.G. Ord-Hume, *Clockwork Music* (1973), p. 45.

63 For the most recent account of Merlin's life see Julius Bryant, *Kenwood: Paintings in the Iveagh Bequest* (New Haven and London, 2003), pp. 208–13, cat. 47.

64 See *Merlin* 1985, pp. 123–4, cat. E2 for one such example.

65 Wright, 'Ingenious Mechanick', p. 55, pp. 61–4, cats B1–4. Peter Oliver spotted the perpetual clock in store on his visit to Cox's Museum on 25 October 1777, BL, Egerton 6273.

66 *Merlin* 1985, pp. 63–5, cat. B4.

67 Altick 1978, p. 75.

68 Solange de Plas, *Les Meubles à Transformation et à Secret* (Paris, 1975).

69 Roche 1933, pp. 139–41.

70 A. Rupert Hall, 'Further Newton Correspondence', *NRRS*, XXXVII (1982), p. 26.

71 Alan Q. Morton, 'Concepts of Power: Natural Philosophy and the Use of Machines in Mid-eighteenth-century London', *BJHS*, XXVIII (1995), pp. 63–78.

72 Paolo Brenni, 'Jean-Antoine Nollet and Physics Instruments', in Pyenson and Gauvin 2002, pp. 11–27. Although he appreciated the importance of accuracy in the mechanism, Nollet understood the role played by theatrical effect and aesthetic adornment in capturing the attention of a polite audience, as is also clear from the engravings which embellished his six-volume work, *Leçons de physique expérimentale* (1743–64).

73 Pons 1984, pp. 151–4, 157–63, C.R. Hill, 'The Cabinet of Bonnier de la Mosson (1702–44)', *AoS*, XLIII (1986), pp. 147–74.

74 'Receuil des dessins des cabinets de curiosités de la M. Bonnier de la Mosson, 1739–40', Bibliothèque d'Art et d'Archéologie, Fondation Jacquet Doucet, Paris. See Pons 1984, p. 158, no. 246.

75 Overdoors now in the Sir Alfred Beit Foundation, Russborough. Marianne Roland Michel, *Lajoüe et l'Art Rocaille* (Neuilly-sur-Seine, 1984), pp. 3, 11, 42, 184–5.

76 Scott 1995, pp. 167–71.

77 Pons 1984, p. 163, cat. no. 263. I am grateful to Anthony Turner for confirming that Bonnier was not a member of the Societé des Arts. See also Anthony Turner, 'Sciences, Arts and Improvement', in Pyenson and Gauvin 2002, pp. 29–46.

78 Emerson 2002.

79 National Library of Scotland, MS 17612/218 quoted in Emerson 2002, p. 30 n. 37.

80 Emerson 2002, p. 36. RSA, PR.GE/110/10/90.

81 In 1761 George Adams was engaged by Bute to compile a catalogue and valuation of the scientific instruments purchased by the Earl from his late uncle's estate; Millburn 2000, pp. 94–5.

82 The collection was sold in 1793; see G. l'E. Turner, 'The Auction Sales of the Earl of Bute's Instruments', AoS, XXIII (1967), pp. 213–42.

83 Millburn 2000, p. 27. See Turner, 'Auction Sales', p. 217, quoting George Adams, Micrographia Illustrata: or the Microscope Explained (1771), p. i.

84 Jane Roberts, 'Sir William Chambers and George III', in Harris and Snodin 1996, p. 41.

85 Jane Roberts, Royal Artists from Mary Queen of Scots to the Present Day (1987), pp. 8–9, 58–9. In 1761 Kirby's own The Perspective of Architecture was published at the expense of and dedicated to George III. It included some designs by the King. For a finely bound second edition see Roberts 2004, p. 229, cat. 209.

86 Roberts 2004, esp. pp. 93–108, 287–302.

87 The following account is indebted to Morton and Wess 1993, also Jane Wess, 'George III, Scientific Societies and the Changing Nature of Scientific Collecting', in Marsden 2005, pp. 313–30.

88 Morton and Wess 1993, pp. 483–5, cats E156, E157 and the Museum of the History of Science, Oxford, inv. no. 35086.

89 There are three versions: a rough draft, an incomplete fair copy (both in the SMLA) and the complete finished copy in the Royal Library, Windsor. Morton and Wess 1993, pp. 243–6.

90 Ibid., pp. 247–9, cat. P1, Lalande 1980, 27 May 1763.

91 Morton and Wess 1993, pp. 298–9, cat. M11.

92 Ibid., pp. 332–5, cats M54–9.

93 Ibid., pp. 436–8, cats E61 and E62. Millburn and King 1988, pp. 213–5.

94 See Maxime Préaud, Bibliothèque Nationale, Département des Estampes: Inventaire du fonts français. Graveurs du XVIIe siècle, vols 8–9 (Paris, 1980), pp. 334–6, no. 1309. For the growth of this collection see Roger Hahn, The Anatomy of a Scientific Institution: The Paris Academy of Sciences, 1666–1803 (Berkeley and Los Angeles, 1971), p. 123.

95 Clercq 1997, esp. pp. 151–71; also Lissa Roberts, 'Going Dutch: Situating Science in the Dutch Enlightenment', in Clark, Golinski and Schaffer 1999, pp. 364–6.

96 Clercq 1997, p. 13.

97 A. Hoving, 'Ship Camels and Water Ships', Model Shipwright, no. 76 (June 1991), pp. 32–6.

98 Museum Boerhaave, Leiden, inv. nos 9650 and 9549. Jan van Musschenbroek had evidently constructed such a machine in 1728 for the cabinet of physics. Allamand had another built in 1772 by the London instrument-maker Edward Nairne but it gave him nothing but trouble. Paauw's model stood with the Savery machine and a third steam engine constructed by William Blakey in 1777 in the courtyard of the Leiden orphanage for many years, pumping water from a well.

99 Ibid., inv. no. 10191. Models of Vauloué's pile-driver can be found in virtually every surviving eighteenth-century mechanical cabinet.

100 Ibid., inv. nos 9696 and 9693.

101 Polhem 1963; Per Sörbom and Sten Lindroth, Christopher Polhem 1661–1751 'The Swedish Daedalus' (Stockholm, 1985).

102 An early success was a water-powered winch, used from 1693 for lifting ore out of the Blankstöt shaft of the famous Stora Koppar-berg mine at Falun, the buckets of which were raised by means of spring-loaded catches on parallel vertical wooden rods. The fam of this 'Machina Nova' was extended through its depiction in Dutch engraving of 1717 by Jan van Vianem after a drawing b Polhem's assistant, Samuel Buschenfelt.

103 Polhem 1963, pp. 30–31.

104 The mechanical alphabet was destroyed by fire in 1729 but in 176 copies were made for the Royal Chamber of Models. They are nov displayed in the Tekniska Museet, Stockholm, and the Stor Museum, Falun.

105 The 'letters' of the alphabet are drawn in diagrammatic form in th notebooks of Carl Cronstedt (1709–77) and Augustin Ehrensvär (1710–72), made c.1730 on Polhem's instructions; Tekniska Museet Stockholm.

106 Invisible Technology: Technical Education at Uppsala during the 17t and 18th Centuries (Uppsala, 1992), exhibition organised by Pe Dahl. For the short-lived private laboratorium mathematico oeconomicum established by Anders Gabriel Duhre (c.1680–1739) a the royal seat of Ultuna on the outskirts of Uppsala, see Duhre Välmenta Tanckar, angående huru jag tillika med min broder ä sinnad, at . . . Uptätta et Laboratorium mathematico-oeconomicum . . (Stockholm, 1722).

107 Invisible Technology 1992, p. 12. Michael Jensen, ed., Wunderkam mer des Abendlandes: Museum und Sammlung im Spiegel der Ze (Bonn, 1994), pp. 58–9, Sten Lindroth, History of Uppsala Univer sity 1477–1977 (Uppsala, 1976), pp. 96, 128–9.

108 Elisabet Stavenow-Hidemark, ed., 1700-talet i Närbild: Anders Berc Samling (Stockholm, 1990), Ragnar Jirlow, Plogmodeller Från 1700 talet vid Lantbrukschögskolan: Studier i Maskintekniska Institutioner Modellsamling (Ultuna, Uppsala, 1948). Berch was not the only pro fessor at Uppsala to build up a collection of models: under Torber Bergman (1735–1784), there was one in the Department of Chem istry, which covered all aspects of mining.

109 Carl Knutberg, Tal om Nyttan af et Laboratorium Mechanicum . . (Stockholm, 1754), p. 14, quoted and trans. in Lindqvist 1984 pp. 26–7.

110 Michael Lindgren, 'De Kongliga Modellkammaren – en trädimen sionell upplevelse', Polhem, x (1992), pp. 360–72, Arvid Baeckström 'Kongl. Modellkammaren', Daedalus, LXXXVIII (1959), pp. 56–72.

111 See the reaction of the English traveller and mineralogist Edwar Daniel Clarke (1769–1822) quoted in Linqvist 1984, p. 23; also APS Smith, 914 Sm6, vol. 1, 27 August 1800.

112 MacGregor 2007, pp. 228–31.

113 Hunter 1995, pp. 135–47; also P. Fontes da Costa, 'The Culture o Curiosity at the Royal Society in the First Half of the Eighteenth Century', NRRS, LVI (2002), pp. 147–66, Lisa Jardine, 'Paper Mon uments and learned Societies', in Anderson, Caygill et al. 2003, pp 49–54.

114 Bennett, Johnston and Simcock 2000, pp. 13–19.

115 'A Catalogue of the Philosophical Apparatus belonging to The Reve Dr. Hornsby of Oxford', 1790, Bodleian Library, Oxford, MS Top Oxon.c.236, ff. 3–13.

116 Bennett, Johnston and Simcock 2000, pp. 19–20.

117 Museum of the History of Science, Oxford, inv. no. 19551.

118 The collection is currently divided between Firepower, the Roya Artillery Museum in Woolwich Arsenal and the Woolwich Rotunda.

119 Henry Baker Correspondence, vol. 5, f. 100, cited in Morton and Wess 1993, p. 96.

120 Stewart 1992, p. xxxiii.

121 Ibid., pp. 147–8. Desaguliers's course was advertised in the *Newcastle Courant* in 1741 as being 'particularly serviceable to gentlemen concerned in collieries &c. as knowing an infallible method to clear coal pits of dampiii

122 CRO, D/Lons/w7/1/324, quoted in Stewart 1992, p. 148.

123 Musson and Robinson 1969, pp. 104–5.

124 John R. Millburn, *Retailer of the Sciences: Benjamin Martin's Scientific Instrument Catalogues, 1756–82* (1986).

125 Millburn and King 1988, p. 109.

126 For the building of the Observatory to Chambers's design, see Roberts, 'Sir William Chambers and George III', in Harris and Snodin 1996, p. 51.

127 *A Compendious Gazetteer; or, Pocket Companion to the Royal Palaces, Towns, Villages, Villas and Remarkable Places within Sixteen Miles of Windsor* (3rd ed., 1794) seems to suggest that the two were displayed alongside each other and with, e.g., natural history specimens and minerals from the Harz mountains.

128 Jane Wess, 'Lecture Demonstrations and the Real World: The Case of Cart-wheels', *BJHS*, XXVIII (1995), pp. 79–90.

129 Morton and Wess 1993, p. 153, cat. D19. Malcolm Baker, 'Representing, Invention, Viewing Models', in Chadarevian and Hopwood, 2004, pp. 20–23, usefully compares Demainbray's Irish cart model with Sir William Chambers's state coach model.

130 Morton and Wess 1993, p. 214, cats D111–2.

131 Ibid., p. 155, cat. D22. Alan Morton, 'Concepts of Power: Natural Philosophy and the Use of Machines in Mid-Eighteenth-Crentury London', *BJHS*, XXVIII (1995), p. 75.

132 Morton and Wess 1993, p. 139, cat. D7.

133 Ibid., pp. 146–9, cats D13–16.

134 Ibid., p. 182, cat. D51.

135 Ibid., p. 181, cat. D50.

136 Demainbray in *Daily Advertiser*, 1755–8, quoted in ibid., pp. 72–5.

137 Wess, 'George III, Scientific Societies', in Marsden 2005, pp. 315, 323–4, 326. Queen Charlotte added around sixty antiquarian objects and natural history specimens, including a petrified turtle and a rattlesnake's skin.

138 I am most grateful to Dr David Connell for this reference and for showing me the collection at Burton Constable.

139 Quoted in Joao da Providência, 'Experimental Physics and Quantity Physics', in *Ingenuity and Art* 1997, p. 21.

140 Ibid., pp. 186–7, cat. 49. This piece was not part of the Colégio dos Nobres collection which suggests that it was acquired despite these strictures.

141 About half have survived. For the later history of the collection, now in the Museu de Física of the University, see Mário A. Silva, 'The Pombaline Physics Museum in the Faculty of Sciences of Coimbra', in *Ingenuity and Art* 1997, pp. 27–31.

142 Ibid., pp. 33–50.

143 Roberts, 'Going Dutch', in Clark, Golinski and Schaffer 1999, pp. 372–85. Others included the Hollandsche Maatschappij der Wetenschappen (Dutch Society of Sciences), founded in Haarlem in 1752 under the patronage of Prince William V of Orange, and the Bataafsch Genootschap der Proefondervindelijke Wijsbegeerte (Batavian Society for Experimental Philosophy) in Rotterdam (1769).

144 The following account draws on that given in *Highlights from the Teyler Museum: History, Collections and Buildings* (Haarlem, 1996).

145 See the descriptive catalogue by G. l'E. Turner, *Van Marum's Scientific Instruments in Teyler's Museum, I. Mechanics: Mechanical Models from Martinus van Marum. Life and Work* (Leyden, 1973) pp. 131–86.

146 Ibid., cats 69, 68, 70, 71, 72, 80.

147 Roberts, 'Going Dutch', in Clark, Golinski and Schaffer 1999, pp. 381–2.

148 Demainbray joined the Society of Arts in 1755 but his membership lapsed the following year.

149 RSA, AD.MA/100/12/5. In 1731 the Dublin Society of Arts made an application through the offices of William Maple, a chemist and Keeper of Parliament House, to the Lords Justices for a room or vault under the House of Parliament (now the Bank of Ireland, College Green) for the purpose of keeping their models of agricultural implements, cider and flax mills etc where they might be viewed by agricultural workers and other interested parties. The request was granted and this technical museum opened to the public on 22 February 1733. Maple served as the registrar and curator of the Society until his death in 1762.

150 RSA, AD.MA/100/12/06, f. 224.

151 Ibid., PR.GE/112/12/2, Mechanics, f. 49, 4 May, and f. 83, 30 May 1761; PR.GE/112/12/3, Mechanics, f. 3, 30 June, f. 6, 4 July; f. 15, 3 August; f. 32, 9 October; f. 34, 22 October 1761. Bailey was paid 21 guineas for explaining the models 'from morning till night' for seven weeks, at a rate of half a guinea a day. He had failed to be elected the Society's registrar in 1760 but was appointed in 1766 and served until his death in 1773. Thomas Woodin was a carver and upholsterer by trade, in partnership with Joseph Williams. He proved useful to the Society not only in supplying premises but also in fitting them out and making cases and frames for models, casts and medals.

152 Ibid., PR.GE/110/10/137. I have transcribed the letters as written, to suggest the range of accents captured in the phonetically based spelling of applicants who lacked a formal education in reading and writing. Spelling rules were by no means firmly established and some words (e.g. 'shew' for 'show') were always spelt differently from today's spellings.

153 Ibid., PR.GE/118, 25 January 1775. Hulman (or Holman) might have been a member of the Holman family of Cornwall whose mining engineering business was founded by Nicholas Holman in Camborne in 1801.

154 Ibid., PR.GE/110/4/60.

155 Ibid., PR.GE/112/12, Mechanics, 27 February 1764; PR.GE/110/23/1.

156 Only the mechanism appears to have survived; Morton and Wess 1993, cat. E61.

157 Science Museum inv. no. 1882-0029. Barrie Trinder, 'The Darby Family and the 18th Century Iron Industry', *RSAJ*, CXLVIII (2000), pp. 134–5.

158 RSA, PR.GE/118, 3 July and 11 November 1787.

159 Ibid., PR.GE/110/14/134.

160 BL, Add. MS 33564, f. 21.

161 RSA, PR.GE/110/22/121.

162 RSA, PR.GE/110/14/119, 137.

163 RSA, PR.GE/112/12, Mechanics, 18 November 1779.

164 Franklin 1989, pp. 179–81.

165 Alan Lemmers, 'The Dutch Eighteenth-century Shipbuilding Controversy Revised', *MM*, LXXXII (1996), pp. 340–46. Bentam's models, one signed by him (NM8532) and two attributed to him (MC502 and MC503) are in the Rijksmuseum, Amsterdam. The rival yard at Rotterdam under Paulus van Zwijndregt was forced to commission a model of Bentam's ship design in London.

166 Franklin 1989, p. 176. Lavery and Simon 1995, pp. 72–8, 94–5. Being more functional than decorative, they stayed in the Admiralty rather than disappearing into the homes of officials and politicians.

Today they constitute more than a third (over sixty) of the National Maritime Museum's collection, half dating from between 1700 and 1750.

167 Sprat 1667, p. 220. BL, Add. MS 2754, quoted by Lavery and Simon 1995, p. 110.

168 Basil Harley, 'The Society of Arts' Model Ship Trials, 1758–1763', *TNS*, LXIII (1991), pp. 53–71.

169 *RSA Transactions*, V (1787), pp. 79–93.

170 Marcus Popplow, 'Protection and Promotion: Privileges for Inventions and Books of Machines in the Early Modern Period', *History of Technology*, XX (1998), pp. 109–10, quoting Giuseppe Ceredi, *Tre discorsi sopra il modo d'alzar acque da' luoghi bassi* (Parma, 1567).

171 Popplow, 'Protection and Promotion', pp. 103–24, quoting Hans-Jürgen Creutz, *Die Entwicklung des Erfindungsschutzes in Sachsen im 16. Jahrhundert* (Berlin, 1978), Reg.30.3.

172 G. Doorman, *Patents for Invention in the Netherlands*, trans. Jon. Meijer (The Hague, 1942), 347.77:93.

173 A list of more than a hundred models of machines and instruments in the cabinet of the Observatory, dating from *c*.1715 to the late nineteenth century, can be found in AN, JJ, 89, f. 49.

174 Liliane Hilaire-Pérez, 'Transferts technologiques et juridiques au siècle des Lumières', *La Revue Musée des arts et métiers*, no. 12 (1995), pp. 51–60, and Hilaire-Pérez, *L'Invention technique au siècle des Lumières* (Paris, 2000), pp. 198–202.

175 Thorpe 1933, pp. 77–8, 86–7. The Marquis declared his intention of having the model buried with him but it was not found in his lead coffin when in the 1860s the first Director of the Patent Museum, Bennet Woodcroft, arranged for its opening in the family vault; John Hewish, 'The Raid on Raglan: Sacred Ground and Profane Curiosity', *British Library Journal*, VIII (1982), pp. 182–98. For the fire engine see Edward Somerset, 2nd Marquis of Worcester, *An exact and true Definition of the most stupendious Water commanding Engine* (1663); also the appendix to John Buddle, *The Marquis of Worcester's Century of Inventions* (Newcastle, 1778).

176 Anthony Calladine, 'Lombe's Mill: An Exercise in Reconstruction', *Industrial Archaeology Review*, XVI (1993), pp. 82–99.

177 MacLeod 1988, pp. 48–52.

178 CoRO, AD1583/5/49, AD1583/5/51 and AD1583/5/54.

179 Hills 2006, pp. 196–9.

180 A. P. Woolrich, 'Hornblower and Maberley Engines in London, 1805', *TNS*, LVI (1984), pp. 159–67. The model is in the Science Museum.

181 'Memorial by Dr John Robison . . .', in Musson and Robinson 1969, pp. 23–38; Hills 2006, pp. 204–8.

182 Hills 2006, pp. 208–14.

183 CoRO, AD1583/11/16; Hills 2006, pp. 208–14. Although none of Jonathan Hornblower's engines survives, Cornish engineers thought they were superior to those of Boulton & Watt. However, Hornblower's contribution has generally been downplayed or even suppressed in Watt historiography; Hugh Torrens, 'Jonathan Hornblower (1743–1815) and the Steam Engine: A Historiographic Analysis', in Denis Smith, ed., *Perceptions of Great Engineers: Fact and Fantasy* (1994), pp. 23–34.

184 Two engravings were produced of Cole's improved chain pump, drawn by Cole and engraved by Collet, one of which is dated 1771. The latter comprises two figures, the first a perspective view of the pump and the second, highly unusually and not entirely reassuringly, a section with the chain broken, giving a description of all parts and directions for repairing the chain in case of its being broken. RS, Smeaton, vol. 3, loose sheet and f. 117.

185 BL, Add. MS 33537, ff. 246–52.

186 BL, Add. MS 33537, ff. 290–91.

187 Coad 2005, pp. 50–52, 85–6; John Cantrell, 'Henry Maudslay', in Cantrell and Cookson 2002, pp. 23–4.

188 They were transferred from the Royal Naval Museum, Portsmouth

189 Bruce Boucher, ed., *Earth and Fire: Italian Terracotta Sculpture from Donatello to Canova* (New Haven and London, 2002), pp. 64–6.

190 Svante Lindqvist, 'Labs in the Woods: The Quantification o[f] Technology during the late Enlightenment', in Tore Frängsmyr, J. L. Heilbron, Robin E. Rider, eds, *The Quantifying Spirit in the Eighteenth Century* (Berkeley, Cal., 1990), pp. 300–01.

191 Smeaton 1791, pp. 70–71. Thomas Rowatt, 'Notes on Origina[l] Models of the Eddystone Lighthouse', *TNS*, V (1924), pp. 15–2[] Models of the Smeaton lighthouse survive in the Royal Scottis[h] Museum, Trinity House and Leeds Museums.

192 *PT*, LI (1760) pp. 100–74.

193 Terry S. Reynolds, 'Scientific Influences on Technology: The Cas[e] of the Overshot Waterwheel, 1752–1754', *T&C*, XX (1979), pp. 281–6.

194 Norman Smith, 'Scientific Work', in Skempton 1981, pp. 38–4[0] Reynolds, 'Scientific Influences', pp. 281–6. See Simon Schaffe[r] 'Machine Philosophy: Demonstration Devices in Georgia[n] Mechanics', *Osiris*, IX (2004), pp. 157–82, for the machine designe[d] by the Cambridge mathematician George Atwood to demonstrat[e] the motion of bodies under constant forces, later described in hi[s] *Treatise on the Rectilinear Motion and Rotation of Bodies* (1784).

195 J. S. Allen, 'Steam Engines', in Skempton 1981, pp. 179–94.

196 J. S. Smeaton, 'An Experimental Examination of the Quantity an[d] Proportion of Mechanic Power necessary to be employed in givin[g] different Degrees of Velocity to Heavy Bodies from a State of Rest['] *PT*, LXVI (1776), pp. 450–75; Smith, 'Scientific Work', in Skemp[-] ton 1981, pp. 45–9.

197 David Philip Miller, ' "Puffing Jamie": The Commercial and Ideo[-] logical Importance of being a "Philosopher" in the Case of the Rep[-] utation of James Watt (1736–1819)', *History of Science*, XXXVII[I] (2000), pp. 1–24; Christine MacLeod, 'James Watt, Heroic Inven[-] tion and the Idea of the Industrial Revolution', in Berg and Brulan[d] 1998, pp. 96–115.

198 James Patrick, Muirhead, *The Origin and Progress of the Mechani[-] cal Inventions of James Watt* (1854), vol. 1, pp. xxxv–xxxvi.

199 Hills 2002, pp. 299–300. An engraving of Robison's model appeare[d] in the *Universal Magazine*, XXII (1757) pp. 229–31, but it neve[r] worked.

200 Hunterian Museum, University of Glasgow, inv. no. G5.1.

201 The letter was published as 'History of the Origin of Mr Watt['] Improvements on the Steam Engine', *Edinburgh Philosophica[l] Journal*, II (1820), pp. 1–7, and subsequently, dated May 1814, i[n] John Robison, *A System of Mechanical Philosophy*, ed. David Brew[-] ster (Edinburgh, 1822), vol. 2, pp. iii–x.

202 Richard L. Hills, 'The Origins of James Watt's Perfect Engine['] *TNS*, LXVIII (1997), pp. 85–107, and Hills 2002, pp. 295–452. Fo[r] an illuminating account of the stages in Watt's thought process se[e] Marsden 2002, pp. 43–68.

203 BAH, MS 3219/4/56, to James Lind, 4 September 1765.

204 The piston of Watt's first model engine survives in the garret work[-] shop in the Science Museum as well as a rather crude model of th[e] whole, possibly intended for a patent trial.

205 Hills 2002, pp. 399–413.

206 In July 1768, Watt received a letter from Robison warning him tha[t]

Richard Edgeworth had conceived of a similar engine to Watt's. David Tyler believes this could have been the engine devised by Edgeworth's friend and neighbour, Humphrey Gainsborough. Gainsborough believed, wrongly, that Watt had stolen his idea. Nevertheless, thinking his engine was unique, Gainsborough applied for a patent in 1775. The ensuing dispute with Boulton & Watt was unresolved at the time of Gainsborough's death in 1776. Either his engine did indeed have a separate condenser or it was of the compound type which was further developed by Jonathan Hornblower; Tyler 2006, pp. 67–72.

207 BAH, MS 3219/4/69.

208 A variety of models used by Watt for his experiments, including the Kinneil engine (valued for insurance purposes at £30), were lost in a fire at Soho on 10–11 July 1778; Hills 2005, p. 129.

209 Jennifer Tann, 'Boulton and Watt's Organisation of Steam Engine Production before the Opening of Soho Foundry', *TNS*, XLIX (1978), pp. 41–56; Hills 2005, pp. 36–7.

210 Marsden 2002, pp. 98, 140–41.

211 BAH, MS 3219/3/18, 6 February 1782, quoted in Hills 2006, pp. 56–8.

212 Simon Schaffer, 'Fish and Ships: Models in the Age of Reason', in Chadarevian and Hopwood 2004, pp. 87–98.

213 Edward Baines, *The History of the Cotton Manufacture in Great Britain* (1835), pp. 229–30.

214 O'Brien 1997, pp. 201–33.

215 BAH, MS 3782/12/56/18.

216 *Sir David Brewster, Letters on Natural Magic addressed to Sir Walter Scott, Bart.* (1832), pp. 290–1; Hills 2006, pp. 234–7.

217 Science Museum, inv. no. 1924-792 and 793.

218 John Sutcliffe, *A Treatise on Canals and Reservoirs, and the best mode of designing and executing them* (Rochdale, 1816), pp. 67–9, quoted in Tann 1970, p. 61.

219 Gerald l'E. Turner, 'Presidential Address, Scientific Toys', *BJHS*, xx (1987), pp. 383–98, who suggested such models were used to teach impressionable adults in the eighteenth century, youngsters in the nineteenth century and schoolchildren in the twentieth century. Nevertheless, he contrasts them favourably with science centres which only show the principles, devoid of historical context.

220 Joseph Edmonds Stock, *Memoirs of the Life of the late Thomas Beddoes* (1811), pp. 126–30 and appendix no. 8. This is the earliest use of the word 'technology' I have come across. In the *OED*, its revival is attributed to Jeremy Bentham.

221 T. J. N. Hilken, *Engineering at Cambridge University 1783–1965* (Cambridge, 1967), pp. 39–43.

222 William Farish, *On Isometrical Perspective* (Cambridge, 1822).

223 Benjamin Silliman, *A Journal of Travels in England, Holland and Scotland . . . in the Years 1805 and 1806* (New York, 1810), vol. 2, pp. 241–2. Farish continued to give the course until his death in 1837, by which time the system was judged long outdated and defective by his successor to the chair, Robert Willis. Willis developed his own more extensive 'Protean mechanism' and promoted it in *A System of Apparatus for the Use of Lecturers and Experimenters in Mechanical Philosophy* (1851).

224 Robert P. Multhauf and David Davies, *A Catalogue of Instruments and Models in the Possession of the American Philosophical Society* (Philadelphia, 1961), inv. no. 58-53. It came to the Society in 1847, having been sent to the father of the donor in 1795 by Captain William J. Bell, the American consul in Hamburg.

IV Societies: Participation, Articulation

1 Peter Clark, *British Clubs and Societies 1580–1800: The Origins of an Associational World* (Oxford, 2000).

2 SGS, Minutes, vol. 1, f. 17.

3 *Antiquities in Lincolnshire; being the third volume of Bibliotheca Topographica Britannica* (1790), p. iv.

4 See, e.g., SGS, Minutes, vol. 1, f. 109, 2 March 1727; vol. 2, f. 89v, 28 June 1733; vol. 3, f. 80, 28 May 1741.

5 Ibid., vol. 1, f. 117, 10 August 1727; vol. 2, f. 5v, 10 April 1729. In this chapter I have reduced capitalisation to a minimum but retained the original spelling to throw some light on the intellectual level of the writer.

6 Ibid., vol. 2, f. 29v.

7 Ibid., vol. 2, f. 58v, 6 January 1732; f. 59, 13 January 1732; f. 66, 25 May 1732. The plan still hangs in the Society's Museum.

8 Ibid., vol. 4, f. 161, 15 December 1743.

9 James E. McClellan III, *Science Reorganized: Scientific Societies in the Eighteenth Century* (New York, 1985), pp. 38–9, who stresses the distinctive concerns of purely scientific societies but acknowledges there were overlapping interests with economic societies, particularly at the 'science–technology interface'. Some academies of science still retained the strong utilitarian emphasis displayed in the early years of the Royal Society.

10 The letters dated 17 August, 6 December 1721 and 20 January 1722 are preserved in manuscript in RSA, PR.GE/118/134/1 (1754), ff. 1–50, and annotated, presumably by Templeman, 'Mr Grignion has favour'd me with the sight of three letters'. The Society of Arts became the Royal Society of Arts in 1908.

11 Christopher A. Whatley, *Scottish Society 1707–1830: Beyond Jacobitism, towards Industrialisation* (Manchester, 2000), pp. 60–62; Duncan Macmillan, *Painting in Scotland: The Golden Age* (Oxford, 1986), p. 44.

12 Fairfull-Smith 2001, pp. 17–26.

13 Roger L. Emerson, 'Philosophical Society of Edinburgh, 1737–1747', *BJHS*, XII (1979), pp. 154–91; '1748–68', *BJHS*, XIV (1981), pp. 133–76; *BJHS*, XVIII (1985), pp. 255–303. After bitter controversy, the Philosophical Society was subsumed in 1783, under the larger, formal Royal Society of Edinburgh; Steven Shapin, 'The Royal Society of Edinburgh', *BJHS*, VII (1974), pp. 6–11.

14 Emerson 1979, pp. 176–9.

15 See Meenan and Clarke 1981, pp. 1–30. 'Royal' was added to the Society's title when George IV became patron in 1820; Kieran R. Byrne, 'The Royal Dublin Society and the Advancement of Popular Science in Ireland, 1731–1860', *History of Education*, XV (1986), pp. 81–8.

16 *The Dublin Society's Weekly Observations for the Advancement of Agriculture and Manufactures*, 1, no. 1, 4 January 1737 (Dublin, 1739), pp. 4–7.

17 Ibid., 1, no. 52, 4 April 1738, pp. 341–7.

18 *A Proposal for the General Encouragement of Learning in Dublin College* (Dublin, 1731) and an anonymous puff for the scheme, *Some Remarks occasioned by the Revd Dr. Madden's Scheme, and objections rais'd against it. By one who is no projector* (Dublin, 1732).

19 Madden 1738, pp. 231–6.

20 Madden 1739, pp. 12, 35–46.

21 Ibid., p. 53.

22 Crookshank and Glin 2002, pp. 83–92, John Turpin, *A School of Art in Dublin since the Eighteenth Century: A History of the National College of Art and Design* (Dublin, 1995), John Turpin, 'The School of Ornament of the Dublin Society in the 18th Century', *Journal*

of the Royal Society of Antiquaries of Ireland, CXVI (1986), pp. 38–50, James White, 'Art: Painting and Sculpture', in Meenan and Clarke 1981, pp. 222–5.

23 R. F. Foster, *Modern Ireland 1600–1972* (1988), pp. 184–5, 199.

24 For another of Peck's projects see *Some Observations for Improvement of Trade, by Establishing the Fishery of Great Britain; As a Proper Means to Obtain the Ballance of Trade, Employ the Poor, and Promote the Interest of the Proprietors of the South-Sea Company* (1732), dedicated to the Duke of Chandos.

25 See Allan 1979, pp. 34–5; Miller 1999, p. 187.

26 David C. G. Allan, 'The Laudable Association of Antigallicans', *RSAJ*, CXXXVII (1989), pp. 623–8, Linda Colley, *Britons: Forging the Nation 1707–1837* (New Haven and London, 1992), pp. 88–90; see also O'Connell 2003, pp. 115–18, 120 for assorted artefacts decorated with the arms of the Anti-Gallicans, inevitably featuring St George.

27 William Shipley, *Proposals for raising by subscription a fund to be distributed in Premiums for the promoting of improvements in the Liberal Arts and Sciences, Manufactures &c* (Northampton, 1753), reprinted in Mortimer 1763, pp. 9–12.

28 David L. Bates, 'All Manner of Natural Knowledge: The Northamptonshire Philosophical Society', *Northamptonshire Past and Present*, VIII (1993–4), pp. 363–77.

29 Robinson 1962, pp. 195–215 and Harrison 1997.

30 G. l'E. Turner, 'Henry Baker, F.R.S.: Founder of the Bakerian Lecture', *NRRS*, XXIX (1974), pp. 53–79.

31 Mortimer 1763, pp. 9–12.

32 Ibid., pp. 13–18.

33 See Allan 1979, pp. 126–9; also David G. C. Allan, 'Dr Hales and the Society', *RSAJ*, CX (1962), pp. 855–9 and CXI (1962), pp. 53–7 and D. G. C. Allan and R. E. Schofield, *Stephen Hales: Scientist and Philanthropist* (1980).

34 For the curriculum of the Foulis Academy – which included copying the work of old masters and print-making – see Fairfull-Smith 2001. Madden promoted the idea of premiums for the politer arts of sculpture, painting and architecture even before he broadened the field to encompass the mechanical arts; Madden 1738, pp. 231–6. The possibility of thereby reforming taste, manners and morals was uppermost in his mind: 'had half the money given by our good Catholicks to deliver their friends from Purgatory, been laid out in erecting Statues to all great and good men among them after their decease, this island had long since been as remarkable for producing persons of the highest characters, and the most distinguish'd learning and merit, as it is now for being a nursery of lazy bigots and beggars, fools and fryars'; Madden 1739, pp. 49–51.

35 The title merged with Radnor when the 2nd Viscount was created Earl of Radnor in 1765. The missing clergyman was Isaac Maddox, Bishop of Worcester, who was unable to be present but paid his subscription. For Romney see D. G. C. Allan, 'Robert Marsham, 2nd Baron Romney (d.1793) and the Society' and Richard Frampton, 'Robert, 2nd Baron Romney and The Marine Society', *RSAJ*, CXLIII (1995), pp. 67–9 and 75–8.

36 J. V. G. Mallett, 'Nicholas Crisp, Founding Member of the Society of Arts', in Allan and Abbott 1992, pp. 56–74.

37 RSA, PR.GE/110/2/103, 23 September 1756.

38 For the role of imitation as a driving force in product innovation see Berg 2002.

39 For the use of madder to produce Turkey red see Sarah Lowengard, 'Colours and Colour Making in the Eighteenth Century', in Berg and Clifford 1999, pp. 103–17. For the Society's awards, notably to the Manchester dyer John Wilson, see Lowengard 2006, 'Industry

and Ideas: Turkey Red', particularly notes 6 and 7. For cobalt, see Lowengard 2006, 'Quintessential Blues for the Eighteenth Century', pp. 8–12 and n. 21 for the Society's awards.

40 *Gentleman's Magazine*, XXVI (1756), p. 62; the MS is in RSA PR.GE/110/1/83, dated 28 January 1756.

41 For the development of household demand for an ever increasing variety of consumer goods see Jan de Vries, 'Between Purchasing Power and the World of Goods: Understanding the Household Economy in Early Modern Europe', in Brewer and Porter 1993, pp. 107 and 117 and de Vries, 'Luxury in the Dutch Golden Age in Theory and Practice', in Berg and Eger 2003, pp. 41–56.

42 Hogarth 1753; Adam Smith, *The Theory of Moral Sentiments* (1759).

43 Celina Fox, 'Art and Trade: From the Society of Arts to the Royal Academy of Arts', in O'Connell 2003, pp. 19–21. The most comprehensive guide to the style in England remains Snodin 1984.

44 When a friend suggested that a premium might be given for musical composition, although Baker acknowledged that music was 'a most delightful science', he firmly stated that it did not fall under the plan of the Society, 'which points chiefly at the procuring of improvement of the necessaries of life . . . commerce, or such subjects as can either gain money or save it to the Nation'; Baker to W. Arderon, 14 December 1764, cited in Allan 1979, p. 125.

45 For the importance of voluntary societies in Georgian London see D. T. Andrew, *Philanthropy and the Police: London Charity in the Eighteenth Century* (Princeton and Oxford, 1990) pp. 3–134; also Lee Davison et al., eds, *Stilling the Grumbling Hive: The Response to Social and Economic Problems in England 1689–1750* (Stroud, 1992) pp. xxxix–xli.

46 The most detailed analysis of membership is given in Allan 1979, pp. 64 and 95–101.

47 Derek Hudson and K. W. Luckhurst, *The Royal Society of Arts, 1754–1954* (1954), pp. 27–30.

48 For a list of Society chairman and officers in the eighteenth century see Allan and Abbott 1992, pp. 360–4.

49 See *Museum Rusticum*, V (1766), pp. 392–5, for a letter from 'friends and well wishers' in Northumberland who, although acknowledging the importance of agriculture, believed it ought 'not to supersede the obligation you are under of acting up to your proposals by giving us some strictures on the other separate articles of commerce, arts, and manufactures, which were mentioned as part of your design'. The editors denied the charge.

50 Dossie 1758, vol. 2, 'Preface', p. iii.

51 Dossie 1758, vol. 1, 'Preface', pp. v–vii. For more on this work see Ch. 5.

52 George Rudé, *Wilkes and Liberty* (Oxford, 1962), pp. 98–103. In 1766 a bill was passed once more banning the import of French silks.

53 J. H. Appleby, 'Charles Dingley's Sawmill, or Public Spirit at a Premium', *RSAJ*, 143 (1995), pp. 54–6. He was awarded a gold medal by the Society in 1768.

54 Dossie 1768, vol. 1, pp. 33–4.

55 Ibid., pp. 88–166.

56 Ibid., pp. 89–91.

57 Ibid., p. 94.

58 Ibid., pp. 91–3.

59 Ibid., pp. 148–50.

60 Ibid., pp. 132–5.

61 Ibid., pp. 166–232.

62 Ibid., pp. 229–30.

63 Ibid., p. 34–5. Gertrud Seidmann, '"A very ancient, useful and

curious art": The Society and the Revival of Gem-Engraving in Eighteenth-century England', in Allan and Abbott 1992, pp. 120–31.

64 Allan 1979, p. 186.

65 RSA, PR.GE/110/12/85, 110, 123, 127; PR.GE/110/13/3.

66 Ibid., PR.GE/110/27/174–5.

67 Ibid., PR.GE/110/23/24.

68 Ibid., PR.GE/110/5/3.

69 Ibid., PR.GE/110/15/69, 71.

70 Ibid., PR.GE/110/17/66; PR.GE/110/19/24–5; PR.GE/110/24/144; PR.GE/110/28/33.

71 Ibid., PR.GE/110/9/6. According to Pehr Kalm, *Account of His Visit to England on His Way to America in 1748*, trans. and ed. Joseph Lucas (1892) p. 51, bugs or 'wall-louse' were hardly known in England twenty years previously 'but since that time they had travelled over here from foreign countries, so that there are now few houses in London in which these least welcome guests have not quartered themselves'.

72 RSA, PR.GE/110/24/93.

73 RSA, AD.MA/100/12/16, 10 April 1771; AD.MA/100/12/23, 22 April 1778.

74 RSA, PR.GE/110/17/41.

75 RSA, AD.MA/100/12/16, 16 October 1771.

76 *Some Projects recommended to the Society for the Encouragement of Arts, Manufactures, and Commerce by 'the Inspector'* (1761).

77 Hills's final proposal, that a botanical garden should be established for native (rather than exotic) medicinal herbs, accorded with his own botanical interests and publications, which culminated in his 26-volume magnum opus, *The Vegetable System* (1761–75).

78 RSA, PR.GE/112/12, Mechanics, 19 February 1784, 1 November 1792.

79 Ibid., PR.GE/112/12, 17 March 1789.

80 Ibid., PR.GE/118, 9 November 1774, where reference is made to a 'letter on a drawing of a self moving machine' which was ordered to be laid aside for the Committee of Mechanics, 5 May 1788, when the model was produced. The 'machine' was presumably another version of the roller-skates devised by John Joseph Merlin on which, lacking a braking device, he propelled himself into an expensive mirror at one of Mrs Cornelys's masquerades in Carlisle House, Soho Square, smashing it to pieces; Thomas Busby, *Concert Room and Orchestra: Anecdotes of Music and Musicians Ancient and Modern* (1825), vol. 2, p. 137. Roller-skates probably originated in Holland c.1700.

81 RSA, PR.GE/118, 20 December 1775.

82 Ibid., PR.GE/118, 8 May 1776.

83 Ibid., PR.GE/110/2/92; PR.GE/118/134, vol. 2 pp. 139–48.

84 Ibid., PR.GE/110/10/90. See Ch. 3 for Argyll's scientific interests and watch-making activities.

85 Ibid., PR/GE/110/1/103.

86 Christopher Eimer, 'The Society's Concern with "The Medallic Art" in the Eighteenth Century', *RSAJ*, CXXXIX (1991), pp. 753–62, and Eimer, 'The First R.S.A. Medal', *RSAJ*, CXLII (1994), pp. 18–19.

87 Richard Edgcumbe, *The Art of the Gold Chaser in Eighteenth-century London* (Oxford, 2000), pp. 108–10.

88 Christopher Eimer, 'Stuart and the Design and Making of Medals', in Susan Weber Soros, ed., *James 'Athenian' Stuart 1713–1788 and the Rediscovery of Antiquity* (New Haven and London, 2006), pp. 494–7, 500.

89 RSA, PR.GE/110/7/54. In a letter to a friend of 29 January 1759 H. Gainsborough also suggested that if the pendulum was given its

impulse at the mid-point of its swing rather than at either end, the timekeeper would be more accurate. This principle of 'detachment' is usually credited to the French clock-maker Pierre le Roy, first published in 1770. In the 1770s Gainsborough designed a gravity clock, driven by small lead balls and an accurate sundial, which were described in the *Gentleman's Magazine* in December 1785 by Thomas Gainsborough's patron, Philip Thicknesse, and presented by him to the British Museum. Neither has survived; Tyler 2006, pp. 66–7, 74–7, and Roger Kendal, Jane Bowen and Laura Wortley, *Genius and Gentility: Henley in the Age of Enlightenment. Introducing the Rev Humphrey Gainsborough and personalities who contributed to the blossoming of the arts and sciences* (Henley-on-Thames, 2002) pp. 22–3; also Hugh Belsey, *Gainsborough's Family* (Sudbury, 1988), pp. 22–3, 68–9.

90 RSA, PR.GE/110/11/53–4; PR.GE/110/19/50. Tyler 2006, pp. 62–4.

91 J. Gainsborough made a pair of copper wings and tried to fly, invented a self-rocking cradle, a cuckoo that would sing all year round and a wheel that turned in a still bucket of water. He was about to sail to the East Indies to prove an invention for determining longitude when he died; see George Williams Fulcher, *Life of Gainsborough* (1856), pp. 12–17, and *Merlin* 1985, pp. 31–2, 41–2.

92 RSA, AD.MA/100/12/21, 6 December 1775; PR.GE/118, 22 and 29 November, 11 and 16 December 1775.

93 Ibid., PR.GE/110/22/146; 23/5; 23/7; 24/86; 26/75. Desmond Clarke, *The Ingenious Mr Edgeworth* (1965), and Richard Lovell Edgeworth, *Memoirs* (1820). Edgeworth became a member of the Society in 1770, allowed his membership to lapse and then renewed it in 1778, paying his subscription until 1783.

94 RSA, PR.GE/110/26/68.

95 For the meaning of chemistry in the pre-Lavoisier period see Lowengard 2006, 'Coloration and Chemistry in the Eighteenth Century'.

96 Meenan and Clarke 1981, p. 24.

97 RSA, PR.GE/118/134, ff. 178–80; PR.GE/110/1/45. See also D.C. Coleman, 'Premiums for Paper: The Society and the Early Paper Industry', *RSAJ*, CVII (1959), pp. 361–5. John Krill, *English Artists Paper, Renaissance to Regency* (1987), pp. 64–101, and Leonard N. Rosenband, 'Becoming Competitive: England's papermaking apprenticeship, 1700–1800', in Roberts, Schaffer and Dear 2007, pp. 348–77. For the French paper industry see Gillispie 1980, pp. 444–59. French paper was considered the best for printing and packaging but inferior to Dutch for drawing and stationery.

98 *RSA Transactions*, VI (1788), pp. 167–70.

99 RSA, PR.GE/110/14/135.

100 Ibid., PR.GE/118, letter to the Society, 19 March 1788; reported in the published *Transactions*, VII (1789), pp. 117–19.

101 A copy of Jacob Christian Schäffer, *Muster und Versuche Papier zu machen* (Regensburg, 1765–7) is in the Society's archive, SC.EL/1/144. He also produced *Sämtliche Papierversuche* (Regensburg, 1772) and *Erweis in Musterbogen das neuen Papierarten von Pappelwolle, Baumblättern . . .* (Regensburg, 1772), which demonstrated the use of his products as wallpaper.

102 RSA, PR.GE/118, 4 December 1772. In 1746 the Dublin Society had offered a premium for the collection of rags and 5000 lb of rags were gathered from the city and country to supply the raw material for Dublin mills; Meenan and Clarke 1981, p. 24.

103 *RSA Transactions*, VI (1788), pp. 161–6 and VII (1789), pp. 111–16.

104 RSA, PR.GE/118, 17 February 1774. An undated letter from a D. McCarthy at Bartlett Buildings, Holborn, announced that he had discovered 'the art of making artificial stone, resembling the Port-

land or any other kind, but far superior in whiteness hardness and durability . . . at a price greatly below that of Portland or any stone used in building'. RSA, PR.GE/110/16/148.

105 Lowengard 2006, esp. 'Parameters of Color Quality'. For broader fields of experimentation undertaken by dyers see Simon Schaffer, 'Experimenters' Techniques, Dyers' Hands, and the Electric Planetarium', *Isis*, LXXXVIII (1997), pp. 456–83.

106 RSA, PR.GE/110/8/145. Müntz's *Encaustic: or, Count Caylus's Method of Painting in the Manner of the Ancients . . .* was published in London in 1760. The Comte de Caylus's *Mémoire sur la peinture l'encaustique et sur la peinture à la cire* had been published in Geneva in 1755 and was widely reviewed; see Lowengard 2006, 'References to Encaustic Painting in Europe, 1754–1800', based on Danielle Rice, 'Fire of the Ancients: The Encaustic Revival in Europe', Ph.D. dissertation, Yale University (Ann Arbor, 1979), pp. 254–63.

107 RSA, PR.MC/105/10/223, ff. 618–19.

108 Ibid., PR.GE/110/7/50; PR.MC/105/10/543. For the growth of a home-grown varnish and lacquer trade encouraged by the Society's premiums and patent registration see Berg 2002, pp. 18–20. For the French lacquerware it was intended to replace see Anna Czarnocka, 'Vernis Martin: The Lacquerwork of the Martin Family in Eighteenth-Century France', *Studies in the Decorative Arts*, 2 (1994), pp. 56–74.

109 RSA, PR.GE/110/6/78.

110 RSA, PR.GE/118/134, vol. 2, p. 168.

111 RSA, PR.GE/110/10/132. Narbell's efforts predate the famous and costly experiments made by George Stubbs in painting enamels on copper and eventually through Wedgwood, in 1780, on large white earthenware plaques.

112 RSA, PR.GE/118, 8 December 1784.

113 RSA, PR.GE/110/11/8. [William Peckitt], *The Wonderful Love of God to Men or Heaven Opened in Earth* (York, 1794). Peckitt's 'The Principals of Introduction into that Rare but Fine and Elegant Art of Painting in Staining in Glass' (1793) is in York Art Gallery, MS f. 31. For Pickett's experiments with coloured glass and those of his contemporary George Berg see Lowengard 2006, 'William Peckitt, George Berg: Vitreous-Color Experiments in Mid-Century Britain'.

114 RSA, PR.GE/110/14/119; AD.MA/100/12, 21 September 1763.

115 Ibid., PR.GE/112/12, Polite Arts, 24 February, 30 March 1784; PR.GE/118, 16 February–27 April 1784.

116 Ibid., PR.GE/118, 10 February 1773.

117 *RSA Transactions*, XII (1794), pp. 271–9.

118 M. Kirby Talley, Jr., '"All Good Pictures Crack": Sir Joshua Reynolds's Practice and Studio', in Nicholas Penny, ed., *Reynolds* (1986), p. 66.

119 *RSA Transactions*, XV (1797) pp. 243–62.

120 RSA, PR.AR/103/10/190.

121 The embarrassing episode was memorably satirised in James Gillray's caricature, *Titianus Redivivus; – or – The Seven-Wise-Men consulting the new Venetian Oracle. – A Scene in ye Academic grove. No. 1* (1797).

122 RSA, PR.GE/110/14/134.

123 Ibid., PR.GE/110/25/32.

124 It was used by Alberti for the direct transcription of the linear disposition of objects as they appeared to the eye on the intersecting plane. It comprised a piece of muslin woven in a regular grid of checks stretched over a frame which, when placed in front of objects, guided their faithful transcription onto paper squared up in the same manner; Kemp 1990, p. 169.

125 RSA, PR.AR/103/10/ff. 132–5.

126 Dossie 1768, p. 29.

127 Dossie 1783, pp. xix–xxi.

128 Crookshank and Glin 2002, pp. 85–6.

129 Fairfull-Smith 2001, p. 23.

130 Richard Campbell, *The London Tradesman* (1747), p. 20. He was probably relying on the article written in 1745 by Antoine Ferrand de Monthelan entitled 'Projets pour l'établissement d'écoles gratuites de dessein' which was widely circulated to general approbation in 1746–8. In 1676 the French Crown had approved the establishment of schools of painting and sculpture in the provinces under the control of the Académie but only two appear to have been founded – Reims in 1677 and Bordeaux in 1689 – and these soon closed. Campbell might have conflated them with the drawing schools founded privately in the provinces in the eighteenth century which were subsequently restructured as academies of painting, sculpture and design; Reed Benhamou, *Public and Private Art Education in France, 1648–1793* (Oxford, 1993), pp. 90–112. For the influential school established by Jean-Jacques Bachelier in 1766 for the children of artisans see Ulrich Leben, *Object Design in the Age of Enlightenment: The History of the Free Drawing School in Paris* (Los Angeles, 2004).

131 John Gwynn, *As Essay on Design* (1749), p. 43.

132 Ibid., p. 22.

133 RSA, PR.GE/110/28/3 and No. 5 in PR.GE/118/134, vol. 1, 'A Plan for an Academy for Sculpture and Painting'. It is not clear who composed this but it was probably a joint effort by members of the St Martin's Lane group led by Francis Hayman.

134 Sidney C. Hutchison, *History of the Royal Academy* (1968), pp. 31–2.

135 Anna Puetz, 'Design Instruction for Artisans in Eighteenth Century Britain', *Journal of Design History*, XII (1999), pp. 217–39 provides the fullest account based mainly on contemporary drawing books but little work has been done on art schools in the provinces. Hilary Young, 'Manufacturing outside the Capital: The British Porcelain Factories, their Sales Networks and their Artists 1745–1795', ibid., pp. 266–7, mentions a 1759 report stating there were two or three drawing schools in Birmingham, where thirty or forty Frenchmen and Germans were employed to instruct youths in the arts of designing and drawing.

136 Sloan 2000, pp. 212–18. For the growing 'feminisation' of decorative drawing technique in the late eighteenth century and thus the marginalisation and denigration of its practitioners see Ann Bermingham, 'The Origin of Painting and the Ends of Art: Wright of Derby's Corinthian Maid', in Barrell 1992, pp. 135–64, and Bermingham, *Learning to Draw: Studies in the Cultural History of a Polite and Useful Art* (New Haven and London, 2000), pp. 208–27.

137 Until her marriage Mary Moser worked as a professional artist and became a founding member of the Royal Academy. The only other woman founder member was Angelica Kauffman. Like Kauffman, Moser continued to paint after her marriage but unlike her ceased to paint professionally and exhibited as an 'honorary painter' under her married name, Mary Lloyd. See Sloan 2000, p. 213, on the question of drawing after marriage. It seems to have depended on individual circumstances and the wishes of the husband.

138 Dossie 1782, pp. 399, 402–3.

139 BL, Add. MSS 27,993, reproduced in Kitson 1968, pp. 54–5.

140 William Hogarth, 'Apology for Painters', in Kitson 1968, II, lines 39–43, IX, 415–27.

141 Ibid., VIII, 267–76.

142 Ibid., XIII, 484–9.

143 Ibid., IX, 307–13.

144 Ibid., II, 210–35. For further complaints about oratorical show-offs, see Allan 1979, pp. 51–2.

145 Hogarth, 'Apology', in Kitson 1968, XVII, 582–99, XVIII, 600–10, XIX, 627–39.

146 In April 1759, the 21-year-old Nollekens was locked in a room for more than three hours on two days to produce sketches which proved the originality of his work; his original submission was suspected of having been improved by his master, Joseph Wilton. R.S.A, PR.GE/112/12, Polite Arts.

147 *The Preceptor: containing a general Course of Education. Wherein the First Principles of Polite Learning are laid down in a way for trying the Genius, and advancing the Instruction of Youth* (1748), vol. I, pp. 367–84. Students were led on a ten-stage course, progressing from the use of materials and drawing lines, squares and circles to flowers, faces, figures, drapery, the passions, landscape and buildings, aided by ten engravings.

148 Dossie 1782, pp. xxi–xxii.

149 An etching of the Priory at Warwick after Louisa Greville's own drawing features in Richard Bull, *Etchings and Engravings, by the Nobility and Gentry of England; or, by Persons not exercising the Art as a Trade*. A collection of her work in the British Museum includes copies after drawings by Italian masters and Paul Sandby, from whom she (like her brothers, George Greville, 2nd Earl of Warwick, and the mineral collector Charles Greville) probably had lessons. Sloan 2002, pp. 157–8, 197–8.

150 RSA, PR.GE/118/Honorary Drawings 1782.

151 Joseph Wilton sold a collection of busts to the Dublin Society in 1757 at a cost of £219 15s, part of which still survives in the Society's collection.

152 Harris and Snodin 1996, p. 176. Joan Coutu, '"A very grand and seigneurial design": The Duke of Richmond's Academy in Whitehall', *British Art Journal*, I (2000), pp. 47–54. For a description of the experience of drawing in the Richmond gallery see the account given by Ozias Humphry reproduced in Brewer 1997, pp. 295–9.

153 Quoted by D. G. C. Allan, 'Artists and the Society', in Allan and Abbott 1992, p. 103.

154 Reprinted in Sir J. E. Smith, *A Selection of Correspondence of Linnaeus and other Naturalists* (1821), vol. I, p. 459.

155 According to Allan in Allan and Abbott 1992, p. 102, the number of premiums offered for the Polite Arts grew from 22 in 1758, out of 122, to 106 out of the 380 offered in 1764. They constituted during these early years by far the largest proportion of premiums awarded: 39 out of 51 in 1758 and 99 out of 147 in 1764.

156 In 1757, Cosway won second prize in the under-17 category for the best design for use by weavers; in 1758, he came second to John Smart in the under-18 category for a drawing of a human figure in plaster; in 1759, he won fourth prize for his copy of a cast of *The Fighting Gladiator* in the Duke of Richmond's gallery; and in 1760, he won first prize, worth 10 guineas, for the best drawings of a human figure after life drawn at the St Martin's Lane Academy.

157 Stephen Lloyd, *Richard and Maria Cosway: Regency Artists of Taste and Fashion* (Edinburgh, 1995), pp. 20–21.

158 See Allan, 'Artists and the Society', in Allan and Abbott 1992, pp. 95–119.

159 RSA, PR.GE/118/134, vol. I, no. 18, pp. 58–67.

160 See Brewer 1997, pp. 295–321; also Moira Thunder, 'Improving Design for Woven Silks: The Contribution of William Shipley's School and the Society of Arts', *Journal of Design History*, XVII (2004), pp. 9–11. I am not convinced, on the evidence presented, by the author's argument that Shipley's school and the Society of Arts were more influential in improving design for woven silk than previously thought.

161 Ibid., p. 11. In France technical drawing on the more specialist level was taught by the manufacturers rather than in the free drawing schools.

162 RSA, PR.GE/110/8/95.

163 Ibid., PR.GE/110/11/21.

164 The subjects were: '1 Boudicia relating her Injuries to Cassibelan and Paulinus in the presence of her two Daughters; 2 Queen Eleanora sucking the Poison out of King Edward's Wound after he was shot with a poison'd Arrow; 3 Regulus taking Leave of his Friends when he departed on his Return to Carthage; 4 The Death of Socrates; 5 The Death of Epaminondas; 6 The Birth of Commerce as described by Mr Glover in his Poem called London.'

165 For Samuel Johnson's discussion of portraiture and history painting see John Sunderland, 'Samuel Johnson and History Painting', in Allan and Abbott 1992, pp. 183–94.

166 John Newman, 'Somerset House and Other Public Buildings', in Harris and Snodin 1996, pp. 106–7. The plan of the Society of Arts building is in the British Architectural Library, RIBA, at the V&A. Unfortunately, the Little Denmark Court building he converted had structural problems and was in danger of collapse by 1762. Yet the President's chair he designed in 1759–60 for the Great Room (one of the earliest English essays in neo-classical furniture) still survives; Hugh Roberts, 'Sir William Chambers and Furniture', in Harris and Snodin 1996, p. 163.

167 A manuscript copy of Myrone's survey is kept in the RSA Library.

168 'The Lady Elizabeth Grey, petitioning Edward the Fourth to restore (in favour of herself and children) the forfeited lands of her husband, Sir John Grey, slain at the battle of St Albans; at which interview the king became so enamoured of her beauty as afterwards to make her his queen.'

169 J. L. Abbott, 'Thomas Hollis and the Society 1756–1774', in Abbott and Allan 1992, pp. 38–55; also W. H. Bond, *Thomas Hollis of Lincoln's Inn: A Whig and his Books* (Cambridge, 1990). The boards of Hollis's books were stamped with daggers and caps of liberty.

170 Dossie 1782, p. xxiii.

171 Brian Allen, 'The Society of Arts and the First Exhibition of Contemporary Art in 1760', *RSAJ*, CXXXIX (1991), pp. 265–9; also Matthew Hargraves, *'Candidates for Fame': The Society of Artists of Great Britain 1760–1791* (New Haven and London, 2005), and Holger Hoock, *The King's Artists: The Royal Academy of Arts and the Politics of British Culture, 1760–1840* (Oxford, 2003).

172 For the fullest discussion see Jonathan Conlin, '"At the Expense of the Public": The Sign Painters' Exhibition of 1762 and the Public Sphere', *Eighteenth-Century Studies*, XXXVI (2002), pp. 1–21; also Bindman 1997, pp. 194–5, cats 124, 125, Celina Fox, *Specimens of Genius Truly English* (1984), and Altick 1978, p. 102.

173 Francis Gabriel Barraud or possibly his elder brother Philip Barraud, from a family of Huguenot watch-makers originally from Angoulême; Murdoch 1985, p. 252, nos 369–70.

174 The Birmingham printer John Baskerville (1702–75) experimented with paper panels as a base for japanware, in imitation of oriental lacquer, but it was his apprentice Henry Clay who in 1772 obtained a patent (no. 1027) for making tough heat-resistant paper panels which could be moulded into different shapes; Jane Toller, *Papier Mâché in Great Britain and America* (Newton, Mass., 1962), pp. 17 and 25.

175 The preface to the catalogue of the exhibition staged by the Free

Society at 28 Haymarket in 1783 stated that the Society was a 'nursery of young artists, whose works, if placed near those of a Royal Academician, may make no very respectable figure, yet the dawning of genius deserves protection'. It would also show works from artists belonging to other Societies sent in by gentlemen 'who are desirous of contributing to the entertainment of the public, and do service to this Society'.

176 Nevertheless, the RSA holds the Free Society's archives.

177 RSA, PR.GE/118, 14 and 28 February 1772.

178 *RSA Transactions*, V (1787), p. 229; Altick 1978, pp. 400–01.

179 RSA, PR.GE/112/12, Polite Arts, 7 April 1798.

180 Dossie 1782, pp. xix–xxi.

181 Reynolds 1975, p. 13; see also Barrell 1986, pp. 69–82.

182 For the development of Reynolds's views on the role of art in commercial society see Barrell 1986, pp. 69–112.

183 Presumably vols 1–6 of Jean Gaffin Gallon's *Machines and Inventions . . .* (1735) and Jacob Leupold's *Theatrum Machinarum* (1724). Lord Bute allowed his copy of the English translation of the latter to be transcribed.

184 RSA, AD.MA/100/12/11, 11 June 1766. I have been unable to trace which member of the extensive von der Schulenburg family this might have been.

185 Edward Bridgen, *A Short Account of the Great Benefits which have already arisen to the public by means of the Society instituted in London, in the year 1753, for the Encouragement of Arts, Manufactures and Commerce* (1765), pp. 6–7.

186 As analysed by Allan 1979, pp. 104–7, 173–9, 252–7.

187 Probably *Traité des arbres et des arbustes qui se cultivent en France en plein terre* (1755) and *Art de la draperie*, published in 1765 as part of the *Descriptions*.

188 RSA, PR.GE/110/16/189.

189 RSA, PR.GE/110/18/112; PR.GE/110/19/14; PR.GE/110/23/53; PR.GE/110/26/64.

190 Ibid., PR.GE/110/24/108; PR.GE/110/26/96, when du Pont presented his *Les Ephémérides du Citoyen, ou Bibliothèque raisonné des Sciences morales et politiques*.

191 Laura Auricchio, 'Pahin de la Blancherie's Commercial Cabinet of Curiosity (1779–87)', *Eighteenth-Century Studies*, XXXVI (2002), pp. 47–61. The proposed foundation of the Salon de la Correspondance was welcomed in 1778 by the Académie des Sciences, on the recommendation of a sub-committee which included Benjamin Franklin.

192 RSA, PR.GE/110/24/76–8, 81.

193 Lowood 1991, who states that 53 of the 62 societies established between 1760 and 1769 were predominantly economic in purpose, dedicated mainly to the improvement of agriculture, industry and the useful arts. Hans-Joachim Braun, *Technologische Beziehungen zwischen Deutschland und England von der Mitte des 17. bis zum Ausgang der 18. Jahrunderts* (Dusseldorf, 1974).

194 RSA, PR.GE/110/19/11. For the Paris Society of Agriculture see Gillispie 1980, pp. 368–87.

195 Hans-Joachim Braun, 'Some Notes on the Germanic Associations of the Society of Arts in the Eighteenth Century', in Allan and Abbott 1992, pp. 237–52.

196 RSA, PR.GE/110/24/104; PR.GE/110/26/101. The Freiberg Bergakademie was established in 1765.

197 Lowood 1991, pp. 124–31 and 267–70.

198 The Society of Arts certainly looked enviously at the Dublin Society with its parliamentary grants and royal patronage, which it tried in vain to achieve for itself. The reasons for its own lack of success in achieving royal patronage in the eighteenth century seem to have been more to do with bad timing than any conscious disdain for manufacturers on the part of the monarchy: first the death of George II and then the strength of the Society of Artists' lobby, which succeeded in gaining royal incorporation in 1765, leading to the foundation of the Royal Academy of Arts in 1768; David G. C. Allan, 'In the Manner of one in Ireland: the Society of Arts and the Dublin Society from its Earliest Years to 1801', *RSAJ*, CXXXVII (1990), pp. 835–7.

199 RSA, PR.GE/110/26/98; Lowood 1991, pp. 138–9.

200 Jacob Johann Sievers, *Memoirs*, vol. 1, pp. 187–9, quoted in J. A. Prescott, 'Further Notes on the Russian Free (Imperial) Economic Society', *RSAJ*, CXVI (1968), pp. 68–70; A. G. Cross, 'Early Contacts of the Society with Russia', in Allan and Abbott 1992, pp. 265–75.

201 An American Philosophical Society set up by Franklin in 1743 lasted little more than a year. For American relations with the Society see D. G. C. Allan, '"The Present Unhappy Disputes": The Society and the Loss of the American Colonies, 1774–1783', in Allan and Abbott 1992, pp. 217–36.

202 RSA, PR.GE/118, 5 and 13 November 1771.

203 See Ch. 6 below.

204 RSA, PR.GE/118, 21 April and 14 May 1784.

205 Harrison 1997, pp. 53–68.

206 Smeaton 1812, vol. 1, p. vi.

207 SCE Minutes 1893, 27 May 1774.

208 Smeaton 1812, vol. 1, p. vi.

209 E.g., Smeaton presented his treatise 'On Experimental Enquiry concerning the Natural Powers of Water and Wind' at the Society on 3 May 1782.

210 SCE Minutes, 3 April 1778 and 26 May 1780.

211 Smeaton 1812, vol. 1, p. ii.

212 Ibid., vol. 1, pp. iv–v.

213 RSA, PR.GE/110/23/5. Rather than the whole front axle swivelling on a central spindle, in Darwin's design the front axle stayed parallel to the back and only the front wheels turned, facilitating a smaller turning circle and enabling a shorter and lighter carriage to be built with greater stability. In 1817, Georg Lankensperger, coachmaker to the King of Bavaria, explained his invention of the same moveable axle to the London printseller Rudolph Ackermann. With Lankensperger's agreement, Ackermann promptly applied for a patent, which was given in his name. Ackermann's axle, as it became known (even being used in motorcars) thus deprived two inventors of their due recognition; see *Observations on Ackermann's Patent Moveable Axles for Four Wheeled Carriages* (1819).

214 Quoted in King-Hele 1999, pp. 65–6.

215 BAH, MS 3782/13/53/26, Benjamin Franklin to Matthew Boulton, 22 May 1765.

216 Wedgwood Museum archives, E25-10859, Josiah Wedgwood to Thomas Boulton, 2 January 1765.

217 Uglow 2002, p. xix.

218 King-Hele 1999, pp. 102–3.

219 Robert S. Schofield, 'The Society of Arts and the Lunar Society of Birmingham', *RSAJ*, CVII (1959), pp. 512–14, 668–71.

220 King-Hele 1999, pp. 80–81, 85, 100, 157–60.

221 Darwin recorded his thoughts in 'Bell's Common-Place Book, formed generally upon the Principles Recommended and Practised by Mr Lock'. It is currently on loan from Down House (English Heritage), housed in the library in Lichfield Cathedral, next to the Erasmus Darwin Centre.

222 King-Hele 1999, p. 6.

223 According to Clive Hart, 'Erasmus Darwin's Model Goose', *Aeronautical Journal of the Royal Aeronautical Society*, LXXXIX (1985), pp. 17–21, this deserves a special place in the history of aviation as the first description of a model with both a power plant and an intended flight cycle of the wings.

224 King-Hele 1999, pp. 138, 152–5, 331, and Hills 2005, pp. 190–211.

225 Hills 2006, pp. 13–52.

226 On 11 December 1783 Boulton replied, 'That one Whitmore hath been employed to make the rods and part of the wings, that Mr Thos Gill hath made a great number of springs 8 ft long, each weighing only a few ounces, that George Donnisthorp hath made a great many wheels and pinions all under the direction of one *Miller* a Scotchman who is said to be the inventor of this unknown machine. Some persons say it is for *swimming* and others for *flying* but I am told that Miller hath never declared positively what he intends it for'; BAH, MS 3782/12/6/5/10.

227 Darwin, Common-Place Book, ff. 58–9, which is undated but prior to August 1779.

228 King-Hele 1999, pp. 183–4. On 4 March 1783 Darwin wrote to Boulton, announcing 'we have establish'd an infant philosophical society at Derby, but do not presume to compare it to your well-known gigantic philosophers at Birmingham'; BAH, MS 3782/13/53/91. Derby already had an active scientific community, possibly encouraged by the renowned showpiece silk mills; Paul Elliot, 'The Birth of Public Science in the English Provinces: Natural Philosophy in Derby, c.1690–1760', *AoS*, LVII (2000), pp. 61–100.

229 Elizabeth Montagu to Matthew Boulton, 31 October 1771, BAH, MS 3782/13/53/45.

230 See Malcolm Baker, 'A Rage for Exhibitions: The Display and Viewing of Wedgwood's Frog Service', in Young 1995, pp. 118–33, Goodison 2002, pp. 163–74, and Jenny Uglow, 'Vase Mania', in Berg and Eger 2003, pp. 151–62.

231 John Caldecott, 'Josiah Wedgwood: Scientist', and John Tindall, 'Josiah Wedgwood: Chemist', in Wedgwood 1978, pp. 16–23.

232 For the technical difficulties involved see Lowengard 2006, 'Sources, Materials, Techniques', p. 18, referring to Wedgwood MS E18266-25 and 26-19117, f. 112.

233 Young 1995, pp. 37–8.

234 Uglow 2002, p. 298.

235 Josiah Wedgwood, *Description and Use of a Thermometer for Measuring Higher Degrees of Heat, from a Red up to the Strongest Heat that Vessels made of Clay can Support* (1784).

236 James Keir, 'Memorandum of Matthew Boulton', 3 December 1809, quoted in Goodison 2002, p. 17. For a comprehensive account of Boulton's activities see Mason 2009.

237 Ibid., p. 17, citing Boulton's notebook, 1751–9.

238 Ibid., pp. 135–49, citing Boulton's notebook for 1768–75.

239 James Keir to Matthew Boulton, 2 October 1772, BAH, MS 3782/12/65/3.

240 Matthew Boulton to Elizabeth Montagu, 16 January 1772, quoted in Nicholas Goodison, 'Matthew Boulton's Bacchanalian Vase', *Connoisseur*, CXCV (1977), pp. 82–7.

241 Quoted in Aileen Dawson, *British Museum: Masterpieces of Wedgwood* (1995), p. 38.

242 David Bindman, 'Wedgwood and his Artists', in Anderson, Cargill et al. 2003, pp. 68–71. For Wedgwood's relations with other artists see Uglow 2002, pp. 323–35.

243 Trevor H. Levere, 'Introduction' to T. H. Levere and G. l'E. Turner, *Discussing Chemistry and Steam: The Minutes of a Coffee House Philosophical Society 1780–1787* (Oxford, 2002), pp. 4–12. The minutes are MS Gunther 4, Museum of the History of Science, Oxford.

244 Levere and Turner, *Discussing Chemistry*, pp. 171–2.

245 Caldecott, 'Josiah Wedgwood', in Wedgwood 1978, p. 19.

246 An argument made convincingly by Miller 1999, pp. 191–201.

247 The Boulton papers, MSS 3782 in BAH, contain a series of printed leaflets relating to the Chamber, commencing with *Treaty with Ireland. Propositions made at Meeting of Manufacturers from various Parts of the Kingdom, held at the London Tavern, March 7, 1785* (chairman John Wilkinson), with Queries on the proposed interchange of Trade with Ireland. They also include an *Abstract of the Emperor of Germany's Edict in prohibiting the Importation of Foreign Goods into his Dominions. Dated at Venice, the 25th September 1784.* Although the manufacturers succeeded in wrecking Pitt's bill, the Chamber was soon undermined by its own disunity over the 1786 free trade treaty signed with France which Wedgwood and the northern manufacturers largely welcomed.

248 Boulton to Watt, 3 July 1778, quoted in Jennifer Tann, 'Marketing Methods in the International Steam Engine Market: The Case of Boulton and Watt', *Journal of Economic History*, XXXVIII (1978), p. 368.

249 *Memoirs of the Literary and Philosophical Society of Manchester*, I (1785), pp. xii–xiii.

250 *Memoirs of the Literary and Philosophical Society of Manchester*, III (1790), pp. 241–2.

251 R. S. Hills, 'Richard Roberts', in Cantrell and Cookson 2002, pp. 67–8.

252 Roy Porter, 'The Industrial Revolution and the Rise of the Science of Geology', in M. Teich and R. M. Young, eds, *New Perspectives in the History of Science* (1973), pp. 320–43.

253 Quoted in Tann 1998, pp. 51.

254 MacLeod 1988, p. 76.

255 *RSA Transactions*, V (1787), pp. 179–210.

256 Berg and Eger 2003, pp. 21–5.

V Publications: Rational Explanation, Visual Exposition

1 *Album du métier à faire des bas*, 51 folios with 25 drawings in pen, black ink and watercolour, Paris, Bibliothèque Nationale, Cabinet des Estampes, Lh. 32; Pinault 1984, cat. 102, pp. 83–5.

2 Milton and Anna Grass, *Stockings for a Queen: The Life of the Revd William Lee, the Elizabethan Inventor* (1967), pp. 109–58. The 1611 contract Lee made with Pierre de Caux, a Rouen entrepreneur, was lost for nearly 300 years and the machines, although installed in Rouen, were returned to England; hence the need for Hindret's mission.

3 Geoffrey Langdon Keynes, *John Evelyn: A Study in Bibliophily and Bibliography of his Writings* (Oxford, 1968), pp. 297–303.

4 Alice Stroup, 'The Political Theory and Practice of Technology under Louis XIV', in Bruce T. Moran, ed., *Patronage and Institutions: Science, Technology and Medicine at the European Court, 1500–1750* (Woodbridge, 1991), pp. 211–34.

5 According to Pinault 1984, p. 85, they are in the Académie des Sciences, Paris, Archives, Enquêtes du Régent.

6 For Réaumur's life, work and position in the history of science see the introduction by Cyril Stanley Smith to *Réaumur's Memoirs on Steel and Iron* (1722), trans. Anneliese Grünhaldt Sisco (Chicago, 1956), pp. vii–xxxiv.

7 Jonas Moore's *A Mathematical Compendium; or Useful Practices in Arithmetick, Geometry* . . . was published in 1674 and was on to a third edition by 1690. William Leybourn's *Pleasure with Profit: consisting of recreations of diverse kinds, viz. Numerical, geometrical, mechanical, statical, astronomical . . . Published to recreate ingenious minds, and to induce them to make farther scrutiny into these sciences* was published in 1694.

8 J.V. Beckett, 'Dr William Brownrigg, F.R.S.: Physician, Chemist and Country Gentleman', *NRRS*, XXXI (1977), pp. 251–71.

9 The point was repeated by the apothecary William Watson as the reason for abstracting the work at length in *PT*, XLV (1748), pp. 351–72, the subject matter 'falling in so exactly with that Institution [the Royal Society], in which we are so desirous of distinguishing ourselves'.

10 The Revd John Beale (F.R.S. 1663) is better known for his *Aphorisms concerning Cider* (1664) but he did make suggestions for experiments on salt water in Somerset; RS, Domestic Manuscripts 5/72A and 80B. Salt production was the subject of many observations made at home and abroad and submitted to the Society during its early decades including those, as described in Ch. 1, by Hooke.

11 Harris and Savage 1990, pp. 233–4, 238–41, 393–5, 241–2, cats 327–46, 359–71a, 348–50, 374–7.

12 Bennett and Johnston 1996, p. 51, cat. 41.

13 Ibid., p. 43, cat. 32.

14 Harris and Savage 1990, pp. 326–7, cats 584–6.

15 Ibid., pp. 41–5, 380–81, 404–7, cats 75–92, 380–81, 724–6.

16 Ibid., pp. 38–40, 375–7, cats 703–13.

17 Ibid., pp. 426–7, cats 834–7.

18 Ibid., pp. 379–80, cats 718–19.

19 Ibid., pp. 450–54, cats 860–75.

20 Ibid., pp. 338–46, cats 612–63.

21 Batty Langley, *City and Country Builder's and Workman's Treasury* (1740), introduction. Harris and Savage 1990, pp. 276–7, cats 449–54.

22 Batty Langley, *The Workman's Golden Rule* (1752), quoted in Harris and Savage 1990, pp. 269 and 280, cats 473–4.

23 Mainwaring was quoting Johann Henry Müntz, *Treatise on Encaustic Painting* (1760), p. 16.

24 Thomas Skaif, *Key to Civil Architecture* (1774), pp. 127–8, quoted in Harris and Savage 1990, p. 40.

25 The most useful survey of ornament and the printed image is given in Michael Snodin and Maurice Howard, *Ornament: A Social History since 1450* (New Haven and London, 1996), pp. 18–61.

26 Griffiths 1998, pp. 271–2, cat. 188. Gribelin's two books were republished under new titles in 1700 and 1704; Sheila O'Connell, 'Simon Gribelin (1661–1733) Printmaker and Metal-Engraver', *Print Quarterly*, II (1985), pp. 27–38.

27 Snodin 1984, p. 157, cats E19, L4–5, L10–14, L17–20; pp. 72 and 162–7.

28 Harris and Savage 1990, p. 172, cat. 158.

29 Ambrose Heal, *London Tradesmen's Cards of the XVIIIth Century* (1925; New York, 1968) provides a comprehensive guide to trade cards as illustrations of topography or contemporary history. The British Museum had more than 15,000 examples chiefly from the collections of Heal and of Sarah Sophia Banks (1744–1818), the sister of Sir Joseph Banks.

30 Michel Snodin, 'Trade Cards and the English Rococo', in Hind 1986, pp. 82–103.

31 O'Connell 2003, pp. 94–5, cat. 1.77.

32 Ibid., pp. 165–7, cat. 3.50.

33 Ibid, pp. 258–9, cat. 5.90.

34 Snodin, 'Trade Cards', in Hind 1986, pp. 98–9, citing the example in the British Museum, Banks Collection 30.1.

35 O'Connell 2003, p. 253, cat. 5.80.

36 Celina Fox, *Londoners* (1987), p. 115.

37 O'Connell 2003, p. 98, cat. 1.84. The original Boitard drawing is in the Royal Library, Windsor. A second drawing from the series, depicting a wigmaker's shop, has been brought to my attention by Lowell Libson.

38 *BM Satires*, 2469–72; O'Connell 2003, pp. 97–8, cat. 1.83. Nicolas de l'Armessin (1640–1725) produced a famous series of 'Habit de . . .' prints in Paris c.1680.

39 Josiah Wedgwood to Matthew Boulton, 9 August 1767, BAH, MS 3782/12/81/33.

40 Young 1995, p. 86, cat. D54.

41 Copies survive in the Guildhall Library, London, and in BL, King's Top, 26, f. 418.

42 O'Connell 2003, pp. 127–9, cat. 2.37.

43 Charles Labelye, *A Short Account of the Methods made use of in laying the Foundations of the Piers of Westminster Bridge* (1739) and *The Plan of a Work* (1744), p. 8, quoted in Harris and Savage 1990, pp. 258–61. A small book of drawings made by T. Gayfere, master mason, in 1739 during the construction of the bridge, is in ICEL, 624.62 (421.3).

44 The prints are in the RS, Smeaton, vol. 2, ff. 163v–166.

45 As Headrick points out, in theory it is easy to distinguish between dictionaries and encyclopaedias but in practice there is no clear way to differentiate them and in the eighteenth century many reference works called themselves by both names; Headrick 2000, pp. 142–80.

46 See esp. Philip Stewart, 'Illustrations encyclopédiques: de la *Cyclopaedia* à l'*Encyclopédie*', *RDE*, XII (1992), pp. 70–98.

47 Headrick 2000, pp. 171–3.

48 Yeo 2001, pp. 149–56.

49 For an analysis of the treatment of architecture and allied arts and crafts in eighteenth-century British encyclopaedias see Terence M. Russell, *The Encyclopaedic Dictionary in the Eighteenth Century: Architecture, Arts and Crafts, Vol. 1: John Harris Lexicon Technicum, and Vol. 2: Ephraim Chambers Cyclopaedia* (Aldershot, 1997).

50 Ephraim Chambers, 'Considerations', p. 4. In the 'Advertisement' which prefaced the second edition of 1738, Chambers attributed his failure to produce a much expanded edition improved along the lines proposed in 'Considerations' to booksellers' fear that Parliament would pass a bill ordering improvements to new editions to be printed separately, which could not be done without great loss.

51 As noted above, Chambers's translation of Leclerc's *Treatise on Architecture* was published in 1732 with plates by Sturt; Maxime Préaud, *Bibliothèque Nationale, Départment des Estampes: Inventaire du Fonds français, Graveurs du Xviie siècle*, vols 8–9 (Paris, 1980), pp. 235–8, cat. 859.

52 Yeo 2001, p. 153.

53 John Stalker and George Parker, *Treatise of Japanning and Varnishing* (1688), p. xii.

54 Harris and Savage 1990, pp. 331–3, cats 590–93.

55 See below for Barrow's *New and Universal Dictionary* (1751/2) and its *Supplement* (1754). He was also responsible for a *History of Discoveries . . .* (1756) and a 4-vol. *Naval History of Great Britain* (1758). The 2nd edition of the *Dictionarium Polygraphicum* (1758) was prefaced with a dedication to the Earl of Macclesfield, President of the Royal Society.

56 Harris and Savage 1990, pp. 128–30, cats 65–6. Terence M. Russell, *The Encyclopaedic Dictionary in the Eighteenth Century, Vol. 3: The Builder's Dictionary* (Aldershot, 1997).

57 Soft-paste porcelain is usually formed of a mixture of clay and ground-up glass or frit. It was called 'soft' because it tended to slump in the kiln under high temperatures. The first soft-paste porcelain in England was demonstrated by Thomas Briand at the Royal Society in 1742. He established a factory with Charles Gouyn at Chelsea in 1743. A second factory was founded at Bow in 1744.

58 Dossie 1768, vol. 1, p. xxii.

59 Lough 1971, p. 87.

60 *Année littéraire*, VII (1759), pp. 345–6, quoted in Lough 1971, p. 88.

61 *Observateur littéraire*, V (1759), p. 216; also *Mercure*, I (January 1760), p. 176, quoted in Lough 1971, p. 88. Patte also had a vested interest in denouncing the *Encyclopédie* as he was then working for the Académie. For his subsequent career in architecture and town planning, notably his publication *Mémoires sur les objets les plus importants de l'architecture* (Paris, 1769), see Picon 1992, esp. pp. 186–210.

62 Approved by Antoine de Parcieux and after his death in 1768 by the mathematician Etienne Bézout. The 7th vol. of plates, published in 1769, did not contain an approbation, presumably because of the delay in finding a replacement for de Parcieux.

63 Yeo 2001, pp. 195–220.

64 Fuhring 1985.

65 Bibliothèque Nationale, MS n. a. fr. 24.932, ff. 78–91.

66 See 'Discours Préliminaire des Editeurs', p. xliv, where M. Barrat is credited as an 'ouvrier excellent dans son genre, a monté & demonté plusieurs fois en presence de M. Diderot le *métier à bas*, machine admirable'. Jacques Proust, 'L'Article BAS de Diderot', in Duchet and Jalley 1977, pp. 245–78.

67 Académie Royale des Sciences, Paris, Bibliothèque de l'Institut, MS 2393, as cited with further examples in Pinault 1984, pp. 90–97, no. 110f.

68 Fuhring 1985, p. 185.

69 See Valpy 1989 who describes the row which broke out between George Bickham, who used designs for musical headpieces taken from the French (notably Watteau), and Benjamin Cole, who blatantly copied the format.

70 Murdoch 1985, p. 250, cat. 365. The family name was originally Grignon.

71 Simon 2007, pp. 27–36.

72 Ian Maxted, *The London Book Trade 1775–1800* (1977), p. xxx.

73 John Nichols, *Literary Anecdotes of the Eighteenth Century* (1812–16), vol. 3, p. 441.

74 A chalk portrait drawing, now in the BM, P&D, of Thomas Grignion made by his brother Charles 'in 1737 on Thomas's return from Paris, aged 24 years', shows Thomas dressed as a fashionable young gentleman with wig and sword; see n. 70 above.

75 Compare with Watteau's drawing of 1719–20 of a French engraver in London working at his table; British Museum, 1874-8-8-2279, reproduced in Snodin 1984, pp. 41–2, cat. C1.

76 It is a thankless task to trace the source of every plate but 'The Art and Mystery of Making Wax and Tallow Candles' which appeared in May 1749 may be compared with the plates to Duhamel's *L'Art du Cirier* (1762) and *L'Art du Chandelier* (1764). Duhamel stated that he had found the drawings on which the plates were based in the depot of the Académie. Typically, in June 1752, ten years after their appearance in London, Hinton included an illustrated description of Vaucanson's automata, 'from a Memoir, presented by

77 *Gentleman's Magazine*, XXII (1752), pp. 46–7. The editors were extremely sceptical of the fashion for 'voluminous dictionaries'.

78 James Basire was elected as an engraver to the Society of Antiquaries in 1769 and the following year persuaded Whatman to produce a special 'antiquarian' paper. From 1770 he was also responsible for engraving most of the plates for *PT*, where plates signed 'Bazire' were published well into the nineteenth century. He took on William Blake as an apprentice in 1772. See also *William Blake's Writings* (Oxford, 1978), ed. G. E. Bentley, Jr., vol. 2, p. 1038, for Gravelot's comment to Basire: 'de English may be very clever in deir opinions but dey do not draw'.

79 A coffee-house in what is now Cheyne Walk which also contained a small museum started from duplicates supplied by Sir Hans Sloane from his collection; Altick 1978, pp. 17–19.

80 Presumably, the French émigré engraver Bernard Picart (1673–1733).

81 Réaumur is directly cited in the articles on hat manufacture and rope-making.

82 Smeaton only made two air pumps, one for himself and another for Joseph Priestley which was destroyed in the Birmingham riots of 1791. The principles were first explained in a letter from Smeaton accompanied by 'some draughts, and letters of reference, in order to explain myself more fully', read at the Royal Society on 16 April 1752 and published in *PT*, XLVII (1751–2), pp. 415–25, pl. 18. Perhaps Basire was already working for the Royal Society as well as for Hinton and used the opportunity to recycle his engravings.

83 Jacques Gay, *La Fabrication des cordages au XVIIIe siècle* (Jonzac, 1987), Bruno de Dinechin, *Duhamel du Monceau* (Paris, 1999), pp. 80–81, Gillispie 1980, pp. 337–44.

84 The vignettes heading chs 8–11 represent the corderies at Brest, Rochefort, Toulon and Marseilles.

85 Engravers were paid by piecework and it was quicker to reproduce the images in reverse; see Henri Cornaz, 'Fortunato Bartolomeo de Felice and the *Encyclopédie d'Yverdon*', in Donato and Maniquis 1992, pp. 39–47, who also explains the process of making reduced copies of engravings.

86 Similarly, the depiction of a family brewery in the *Universal Magazine*, II (January 1748, opp. p. 39), incorporated an exterior view in one corner of the interior perspective by using the decorative device of a *trompe-l'oeil* scroll to show it.

87 *New and Complete Dictionary*, p. iv.

88 For Thomas Jefferys's trade card see O'Connell 2003, p. 172, cat. 3.67. Jefferys was a successful publisher as well as an engraver until he nearly went bankrupt in 1766 having over-extended himself with a scheme to publish county maps. He was rescued by Thomas Sayer who took over much of his stock. Significantly, in 1768 Jefferys and Sayer were arrested in Paris by the Commissioner of Police and Inspector of the Book Trade supposedly for selling indecent prints but perhaps also for competing with French publishers; M. Pedley, 'Gentlemen Abroad: Jefferys and Sayer in Paris', *The Map Collector*, XXXVII (1986), pp. 20–22.

89 *New and Complete Dictionary*, p. xvi.

90 Cole and M. Marenia or Marini worked together on the headpieces to *British Melody* or *Cole's Musical Magazine*, a plagiarism of Bickham's *Musical Entertainer*; see Valpy 1989, pp. 54–9.

91 Diderot, *Encyclopédie*, entry on 'Art'.

92 Diderot, 'Prospectus', reprinted in 'Discours Préliminaire', p. xxxv.

93 Ibid., p. xxxix. Significantly, Barrow's preface to the *New and Universal Dictionary Supplement* never claimed to check the accuracy

of its descriptions of the mechanical arts or to provide a rationale for the ordering of their explanation.

94 'Discours Préliminaire', pp. xxxix–xl.

95 Proust, 'L'Article BAS', in Duchet and Jalley 1977, pp. 245–78; see also Jean-Luc Martine, 'L'Article ART de Diderot: machine et pensée pratique', *RDE*, xxxix (2005), pp. 41–79.

96 'Discours Préliminaire', p. xl.

97 The title was changed because of the revocation in March 1759 of the privilege granted to the *Encyclopédie*. The work was placed on the papal index, Pope Clement xii warning that all Catholics who owned it should have it burnt by a priest or face excommunication. Yet, although the Directeur de la Librairie ordered the confiscation of Diderot's papers and an Arrêt du Conseil required the publishers to refund subscribers and close their accounts, the government allowed them to apply the money to a *Recueil de mille planches . . .*, in other words, the plates of the *Encyclopédie* under a new title. On 8 September 1759 the *Receuil* received a new privilege and the plates were published from 1762 to 1772. In 1765, the last ten volumes of the text appeared all together under a false imprint, purged by the printer publisher Lebreton without Diderot's knowledge.

98 *Encyclopédie*, vol. 5, pp. 635–48.

99 Fuhring 1985, pp. 176–7.

100 Cochin himself had more or less given up engraving by 1757; Michel 1984, pp. 494–5, cat. 148.

101 Cochin's vignette of the drawing class was first used in Charles-Antoine Joubert, *La Méthode pour apprendre le Dessin* (Paris, 1755).

102 For an important interpretation of the contributions made by Watelet and Prévost which, however, makes no allowance for the status of engraving as a fine rather than a mechanical art, see Pannabecker 1998, pp. 50–56.

103 Figs 1, 1b, 3 and 5 are taken directly from the vignette heading the second part of Cochin, and 6 and 7 from the vignette introducing part three; fig 2 is a reverse image of Bosse pl. 6.

104 Pannabecker 1998, pp. 52–62. The machine with its neatly enclosed acid bath, agitated by means of a pendulum device, makes a stark contrast to pl. 6 of Bosse's treatise, 'Manière de jetter l'eau-forte sur la planche'. Here an apprentice, protected only by an apron, used a jug to pour the acid down a plate supported on a board set diagonally against a wall. It rested on a wooden trough with trestle legs into which the acid drained, splashing through a hole into a cauldron set below it. Sébastien Leclerc, the editor of the 2nd edition of Bosse, published in 1701, recommended using a much simpler acid bath which could sit on a table or the artist's knees. His plate depicting the method was included by Cochin in the 3rd edition.

105 Celina Fox, 'The Engravers' Battle for Professional Recognition in Early 19th-Century London', *London Journal*, ii (1976), pp. 3–31.

106 Michel 1984, pp. 484–8.

107 Francoise Gardey, 'Notice sur les dessinateurs et les graveurs', *L'Universe de l'Encyclopédie* (Paris, 1964), pp. 37–41, Madeleine Pinault, 'Aux Sources des planches de l'*Encyclopédie*: la description des arts et métiers', thesis, Paris: Ecole Pratique des Hautes Etudes, ive section, 1984, and Pinault, 'Diderot et les illustrateurs de l'*Encyclopédie*', *Revue de l'art*, no. 66 (1984), pp. 17–38. Neither Charles-Nicolas Germain de Saint-Aubin (1721–86) nor Jean-Michel Moreau le Jeune (1741–1814), who dominated French print-making in the second half of the eighteenth century, were employed on the *Encyclopédie*. For the relative status of different types of engraver see Griffiths 2004, pp. 11 and 58–9.

108 Georges Dulac, 'Louis-Jacques Goussier Encyclopédiste et "Origi-nal sans principes"', in Jacques Proust, ed., *Recherches nouvelles sur quelques écrivains de Lumières* (Geneva, 1972), pp. 63–110, and Kafker and Kafker 1988, pp. 164–77.

109 Pannabecker 1998, pp. 44–9. The reasons for French lack of success were learnt by Nicolas Desmarest, an inspector in the Corps of Manufacturing Inspectors at Limoges, on a journey he undertook with Trudaine's authorisation to Holland in 1768. He presented his findings in two papers which he read before the Académie Royal des Sciences in Paris in 1771 and 1774, with the purpose of reforming the French paper industry; Gillispie 1980, pp. 444–7.

110 To Falconet, May 1768; Denis Diderot, *Correspondance*, vol. 8, January–December 1768 (Paris, 1962), p. 38.

111 Reed Benhamou, 'The Sincerest Form of Flattery: The Professional Life of J. R. Lucotte', *Studies on Voltaire and the Eighteenth Century*, ccxlix (1987), pp. 381–97; see also Kafker and Kafker 1988, pp. 235–8.

112 Possibly Radel was also responsible for the superb series of plates for Roubo's *L'Art du Menuisier*, published as part of the *Descriptions* in 1769, which are attributed to Roubo himself.

113 Madeleine Pinault Sørensen and Bent Sørensen, 'Recherches sur un graveur de l'*Encyclopédie*: Defehrt', *RDE*, xv (1993), pp. 97–112.

114 Paolo Brenni, 'Jean-Antoine Nollet and Physics Instruments', in Pyenson and Gauvin 2002, pp. 14–17.

115 Gallon, *Machines et Inventions* (1735), vol. 4, pl. 262, and vol. 6, pl. 410.

116 Pannebecker 1998, pp. 56–8, cites the example of Brullé, or possibly Claude-François Simon, who contributed the article on 'Imprimerie' or letterpress printing. Both men were printers by trade and could introduce examples of best and worst trade practice to which only an experienced craftsman would have been privy.

117 For a detailed study of two plates, relating to a bronze foundry and silk calendering (pressing between rollers to achieve a glazed finish), see Georges Benrekassa, '*Auctur in pictura*: réflexions sur deux planches de l'*Encyclopédie*', *RDE*, v (1988), pp. 104–18.

118 The original drawings are in the Paris Musée des Arts et Métiers, Portefeuille industriel, no. 174.

119 But not in the case of the weighing-scale-maker's shop (vol. 2, 'Balancier') and that of the cork-cutter (vol. 2, 'Bouchonnier') which open directly onto the street.

120 See Carolyn Sargentson, *Merchants and Luxury Markets* (1996), pp. 131–3 and 191–2, for a commentary on the plates for 'Le menuisier en meubles', vol. 7, 1769, pl. 1, and 'Le tapissier', vol. 9, 1771, pl. 1.

121 Except in the case of the enameller who always drew his curtains in order better to see his flame (vol. 4, 'Emailleur').

122 For French achievements in plate-glass manufacture (as opposed to British pre-eminence in flint glass) and the monopoly Compagnie des Glaces see Harris 1997, pp. 323–58; also Claude Pris, 'La Glace en France aux xviie et xviiie siècles: monopole et liberté d'entreprise dans une industrie de pointe sous l'ancien-régime', *Revue d'histoire economique et sociale*, xl, nos. 1–2 (1977), pp. 5–23.

123 As argued by Cynthia Koepp, 'The Alphabetical Order: Work in Diderot's *Encyclopédie*', and William H. Sewell, Jr, 'Visions of Labor: Illustrations of the Mechanical Arts before, in, and after Diderot's *Encyclopédie*', in Steven Kaplan and Cynthia Koepp, eds, *Work in France: Representations, Meaning, Organization, and Practice* (Ithaca, N.Y., 1986), pp. 229–86.

124 Ecole Nationale des Ponts et Chaussées, now Ecole des Ponts Paris-Tech, Marne-la-Vallée, Bibliothèque ms 2385, pl. 2, f. v. The dossier was also sent to Duhamel du Monceau in 1761 who published *L'Art de l'Epinglier* in 1764, with additional drawings by Patte.

125 Ironically, Smith used Alexandre Deleyre's article 'Epingle' from letterpress volumes of the *Encyclopédie*, not Perronet's superior research on the subject. As Quaestor of Glasgow University between 1758 and 1764, Smith acquired for the Library the first 7 vols of the *Encyclopédie* for £18, which did not include the plates or Perronet's text; University of Glasgow Library, Quaestor accounts, MS Gen 1035/219. Smith gave lectures on the division of labour at Edinburgh in the late 1740s, before the publication of the *Encyclopédie*.

126 See Hollister-Short 1976. For the reasons why France failed to make use of the steam engine as part of a coal economy see Harris 1997, pp. 287–322.

127 Antoine Picon, 'Gestes ouvriers, opérations et processus techniques: la vision du travail des encyclopédistes', *RDE*, XIII (1992), pp. 131–47.

128 Jaoul and Pinault 1982 and 1986. Sadly, the collection of manuscripts, drawings and preliminary plates which had remained virtually intact at Denainvilliers until the 1950s has been sold and dispersed among numerous public and private collections.

129 *Pace* Simon Schama, *Citizens* (1989), p. 191, who says that the volumes began with the luxury crafts and rapidly expanded to consider more industrial processes. The rationale is further obscured by variations in the order of binding different copies: the Bodleian's loosely by title in alphabetical order, which makes no sense at all; the Science Museum Library's copy (inherited from the Museum of Practical Geology, received 1844) more logically by type of trade; the King's Library copy bound chronologically so that some multi-volume *Descriptions*, published over several years, are split up, while the plates are in the final volume. For its availability in American libraries and differences in binding order see Cole and Watts 1952, p. 2 n. 2 and p. 4 n. 4.

130 For Morand's reputation and achievement see Gillispie 1980, pp. 349–50.

131 See Lalande 1980 for his account of visiting the steam engines used at Chelsea and York Buildings water works, the models of machines in the Society of Arts and others. For French attempts to understand English mining technology see in particular the tour made in 1761 by Gabriel Jars of the Ecole des Ponts et Chaussées and his reports for the Académie; Harris 1997, pp. 222–37.

132 The sentiments were repeated in the preface to *Art du Tanneur* (1764), p. iv.

133 For help given to Fougeroux de Bondaroy by other manufacturers see Jaoul and Pinault 1982, p. 357.

134 For an account of the art of the *menuisier* and the overlap of his activities with the art of the sculptor see Scott 1995, pp. 13–20. Roubo's father was also a cabinet-maker; he made sure his son studied mathematics and mechanics as well as design.

135 Michel-Ferdinand d'Albert d'Ailly, Duc de Chaulnes (1714–69), was a member of the Académie des Sciences and enthusiastic inventor of, among other things, a microscope and a dividing engine.

136 Gillispie 1980, pp. 352–4.

137 See Scott 1995, p. 75, who cites *Mémoire pour les coiffeurs de dames de Paris: contre la communauté des maîtres barbiers-perruqiers, baigneurs, étuvistes* (Paris, 1769) and E. and J. de Goncourt, *La Femme au dix-huitième siècle*, ed. Elisabeth Badinter (Paris, 1982), pp. 280–81.

138 Michael Sonenscher, *The Hatters of Eighteenth-Century France* (Berkeley, Los Angeles and London, 1985).

139 See Thierry Bernard-Tambour, 'Les Maîtres paumiers du roi au xviiie siècle', *Versalia*, III (2001), pp. 64–75. Garsault also referred to a treatise written by a M. Bellot, 'bachelier de la faculté de

médecine', who recommended royal tennis as a cure for rheumatism.

140 Efforts by *savants* to teach bakers how to bake bread culminated in 1782 in the establishment of the Ecole gratuite de la Boulangerie. Steven Laurence Kaplan, *The Bakers of Paris and the Bread Question 1700–1775* (Durham, N.C. and London, 1996), pp. 51–4.

141 Gillispie 1980, p. 348.

142 Cole and Watts 1952, pp. 21–4.

143 Elise Goodman, *The Portraits of Madame de Pompadour celebrating the Female Savante* (Berkeley, 2000), pp. 128–30; also Xavier Salmon, ed., *Madame de Pompadour et les arts* (Paris, 2002), pp. 215–67.

144 *Oeuvres de Voltaire*, ed. M. Beuchot (Paris, 1832), vol. 48, pp. 57–60, and Yeo 2001, p. 230.

145 Lough 1971, p. 86.

146 Lough, *The Encyclopédie in Eighteenth-century England, and Other Studies* (Newcastle upon Tyne, 1970), pp. 2–3.

147 The medicinal, anatomical and chemical articles were by Thomas Williams; the mathematical sections by Samuel Clark and the other parts 'by several other gentlemen particularly conversant in the Arts of Sciences they have undertaken to explain'.

148 *Monthly Review*, XL (1769), pp. 1–24, signed N – a contributor who has yet to be identified.

149 E.g., pl. 4 is a direct copy of 'Minérologie, Travail de l'Alum' from vol. 6 of the *Receuil* plates; pl. 29, representing melting and refining furnaces used in the copper works of Saxony, from vol. 6, 'Metallurgie, Travail du Cuivre'; pl. 45 is a mirror image from 'Glaces soufflées' in vol. 4; pls 53 and 54 mirror images from vol. 5, 'Marbreur de Papier'; pl. 74 from vol. 4 'Peinture en Email', etc.

150 Other borrowings include Burrough's machine for grinding and polishing plate glass from Croker's *Dictionary* and from the *Encyclopédie*, 'Confiseur', 'Chaudronnier', 'Glaces soufflées', 'Glaces', etc.

151 The editors' advertisement is reprinted in the *Encyclopédie* (Lausanne and Berne, 1781), pp. lxxxv–lxxxvi; Raymond Birn, 'Enlightenment to Revolution: The Changing Face of the Encyclopédie', in Donato and Maniquis 1992, pp. 29–30.

152 BL, Add. MS 33564, f. 4v. If Bentham was consulting the *Encyclopédie* plates, he would have found the basic mechanisms outlined in pls xx and xxi in vol. 2 under 'Charpente' but he must have been familiar with more advanced versions like Vauloué's famous engine. For Russian enthusiasm for the *Encyclopédie* see Joseph H. Denny and Paul M. Mitchell, 'Russian Translations of the *Encyclopédie*', in Kafker 1994, pp. 335–86.

153 Dominique Ferriot, *Madame de Genlis ou la passion de la pédagogie* (Paris, 2002); Dominique Julia, 'Madame de Genlis et l'Education des Princes', *Musée des Arts et Métiers: La Revue*, XXXV (2002), pp. 16–27.

154 Picon 1992, pp. 102–11.

155 Gillispie 1980, pp. 427–35.

156 *London Magazine*, XXXIII (1764), pp. 144–5; XXXIV (1765), pp. 40–41; XLVI (1777), pp. 464–7; XLVII (1778), pp. 136–7. The magazine did not even get Barras's name right in 1765, when he was called E. Sarral, presumably a mistake in transcribing his handwriting.

157 The plates for vol. 2, published after Bailey's death by his son in 1779, were not of as high a quality and toned using aquatint rather than line, printed mainly in sepia and then the iron parts overpainted extremely crudely in grey, or yellow for brass.

158 Frank A. Kafker, 'William Smellie's Edition of the *Encyclopaedia Britannica*', in Kafker 1994, pp. 145–82; also Kafker's introduction to the 1997 reprint.

159 S. W. Brown, 'William Smellie', *ODNB*; Richard B. Sher, 'Introduction' to the 1996 ed. of Robert Kerr, *Memoirs of the Life, Writings and Correspondence of William Smellie*, vol. 1 (Edinburgh, 1811; Bristol, 1996).

160 Ibid., vol. 1, pp. 362–3.

161 'Advertisement' from *Proposals for Printing, by Subscription, a Work, intitled Encyclopaedia Britannica* (1768).

162 For the history of the 2nd to the 4th edition see Frank A. Kafker, 'The Achievement of Bell and Macfarquhar', *British Journal for Eighteenth-Century Studies*, XVIII (1995), pp. 139–52.

163 'Preface', *Cyclopaedia* (1778), vol. 1, p. iv.

164 Stephen Werner, 'Abraham Rees's Eighteenth-century *Cyclopaedia*', in Kafker 1994, pp. 183–99.

165 [Rotherham] 1786, pp. 321–31, 401–8.

166 The two other plates volumes were devoted to natural history and an atlas.

VI *Empirical Portraits*

1 Shaftesbury 1732, vol. 1, pp. 144–5.

2 Anthony, Earl of Shaftesbury, *Second Characters or the Language of Forms*, ed. Benjamin Rand (Cambridge, 1914), pp. 135–6. The treatise in which Shaftesbury wrote most expansively on the fine arts, 'Plastics', composed *c*.1712 near the end of his life, remained in manuscript until this publication.

3 William T. Whitley, *Artists and their Friends in England 1700–1779* (1928), pp. 4–5. J. Douglas Stewart discounts such stories: the artist's studio was a fairly loose congeries of assistants, pupils and later members of Kneller's academy and although the artist re-used poses, he never lost his power of invention; *Sir Godfrey Kneller and the English Baroque Portrait* (Oxford, 1983), pp. 82–3. Even in the eighteenth century Kneller's distinguished background and education were well known: the son and grandson of German court surveyors, Kneller attended the university of Leiden and studied painting in Holland and Italy before coming to England. See the account of Kneller's life by B. Buckeridge added to the 3rd ed. of Roger de Piles, *The Art of Painting* (1750), pp. 393–8.

4 Abbé le Blanc, *Letters on the English and French Nations* (Dublin, 1747), vol. 1, pp. 114–16.

5 Batista Angeloni [John Shebbeare], *Letters on the English Nation* (1755), vol. 2, pp. 52–3.

6 Shaftesbury 1732, vol. 1, pp. 142–5.

7 Ibid., vol. 3, pp. 398–9.

8 For the most comprehensive account of this view see Mount 1991. The term 'Dutch art' was often used loosely to include that of Flanders and thus Netherlandish art as a whole.

9 Horace Walpole, *Aedes Walpolianae; or a description of the Collection of Pictures at Houghton-Hall, Norfolk, the Seat of the right Honourable Sir Robert Walpole, Earl of Orford* (1752), pp. x–xi.

10 For Bernard Mandeville's attack on Shaftesbury's cultural and moral elitism in the *Fable of the Bees* (1729) see Solkin 1993, pp. 13–9. Shaftesbury's account of instructing a minor artist in the art of historical composition was ridiculed by William Tooke in 'Observations on Lord Shaftesbury's Letter from Italy, concerning the Art, or Science, of Design' (1769), appended to his translation of *Pieces written by Mons. Falconet and Mons. Diderot on Sculpture in General, and particularly on the Celebrated Statue of Peter the Great, now finishing by the former at St. Petersburg* (1777).

11 [William Duff], *An Essay on Original Genius* (1767), p. 190.

12 Granger 1769, vol. 1, 'Plan of the Catalogue'.

13 Marcia Pointon, *Hanging the Head: Portraiture and Social Formation in Eighteenth-century England* (New Haven and London, 1993), p. 56. Peltz 2004, pp. 7–8.

14 Granger 1769, 'Preface'.

15 Richardson 1725, p. 3.

16 Ibid., pp. v–vi.

17 Ibid., p. 78.

18 Ibid., pp. 21–2.

19 Ibid., pp. 185–6.

20 Jonathan Richardson, *An Essay on the whole Art of Criticism as it relates to Painting* (1719), p. 45.

21 Richardson 1725, p. 14.

22 Ibid., p. 10.

23 Carol Gibson-Wood argues in *Jonathan Richardson: Art Theorist of the English Enlightenment* (New Haven and London, 2000) that Richardson was much influenced by Lockean empiricism but this sentiment at least was commonplace long before the age of Locke.

24 Ibid., p. 231.

25 Kitson 1968; Hogarth, VIII, lines 267–76.

26 Hogarth 1753, pp. iii–iv and xi.

27 Ibid., pp. 2–3 and 11–12.

28 Ibid., pp. 50–67.

29 Ibid., pp. 70–72.

30 For the fullest description of Sandby's campaign see Bindman 1997, pp. 168–87.

31 Reynolds 1975, III (1770), p. 52.

32 Ibid., IV (1771), p. 58–9. He returned to the theme in XI (1782), p. 200, again arguing: 'The very peculiarities may be reduced to classes and general descriptions; and there are therefore very large ideas to be found even in this contracted subject.' The artist may 'labour single features to what degree he thinks proper, but let him not forget continually to examine, whether in finishing the parts he is not destroying the general effect'.

33 Mount 1991, pp. 104–5, identifies Reynolds's views on Dutch art with a 'scientific' approach and suggests his condemnation of minuteness, the magnification of detail facilitated by the microscope, was influenced by Dr Johnson's views on the subject. Yet Reynolds was in fact advocating the adoption of scientific method as proposed by Bacon, viz. generalisation on the basis of empirical observation of the particular.

34 Reynolds 1975, IV (1771), p. 72.

35 Ibid., V (1772), pp. 88–9.

36 Ibid., VII (1776), p. 140.

37 Pigalle's marble *Voltaire Naked* (1776) is in the Louvre, Paris. The subscription for the statue was organised by Diderot who proposed the great man should be depicted naked because he believed flesh was more beautiful than the most beautiful drapery and because the subject was thereby distanced from the crowd, recalling a simpler, more innocent age. Pigalle modelled the head from life and the body from than of a veteran soldier, albeit modifying his emaciated form with flowing drapery. In 2007, the work was loaned to the Royal Academy exhibition 'Citizens and Kings: Portraits in the Age of Revolution 1760–1830'.

38 Reynolds 1975, VII (1776), p. 140.

39 Ibid., VIII (1778), pp. 149–50.

40 Sir Joshua Reynolds, *A Journey to Flanders and Holland*, ed. Harry Mount (Cambridge, 1996), p. 110.

41 Martin Postle, '"The Modern Apelles": Joshua Reynolds and the Creation of Celebrity', in Postle 2005, pp. 24–5. For Edward

Blakeney's put-down of Reynolds 'as if he had been upon a level with a carpenter or farrier' see *The Early Journals and Letters of Fanny Burney*, vol. 3, part 1, 1778–79, ed. Lars E Troide and Stewart J. Cooke (Oxford, 1994), pp. 414–15.

42 [William Combe], *A Poetical Epistle to Sir Joshua Reynolds* (1777), 'Introduction'.

43 See esp. Mark Hallett, 'Reynolds, Celebrity and the Exhibition Space', in Postle 2005, pp. 34–47; also Marcia Pointon, 'Portrait! Portrait!! Portrait!!!', in Solkin 2001, pp. 92–109.

44 Barry 1775, p. 70.

45 Ibid., pp. 129–30.

46 Ibid., pp. 130–34.

47 Ibid., pp. 140–41.

48 Ibid., p. 143.

49 Ibid., p. 131.

50 Ibid., p. 151. For the fullest analysis of Barry's thought see Barrell 1986, pp. 163–221.

51 E.g., the library of Trinity College, Dublin, initiated with the commission of 14 busts from Peter Scheemakers in 1743 and the Codrington Library, All Souls College, Oxford, completed in 1751.

52 David Piper, *The Royal College of Physicians of London: Portraits*, ed. Gordon Wolstenholme (1964); Vivien Knight, 'First Art Commission for Guildhall', in Mireille Galinou, ed., *City Merchants and the Arts 1670–1720* (2004), pp. 145–58.

53 Richardson 1725, p. 10.

54 Ludmilla Jordanova, *Defining Features: Scientific and Medical Portraits 1660–2000* (2000). For an illuminating Anglo-American study see Fortune and Warner 1999. For a literature-based approach see Roslynn D. Haynes, *From Faust to Strangelove: Representations of the Scientist in Western Literature* (Baltimore and London, 1994). For an international overview see Steven Shapin, 'The Image of the Man of Science' in Roy Porter, ed., *The Cambridge History of Science, vol. 4: Eighteenth-Century Science* (Cambridge, 2003), pp. 159–83.

55 NPG. Hunter 1995, p. 67.

56 Giulia Bartram, *Albrecht Dürer and his Legacy* (2002), p. 188, cat. 128.

57 Private collection; Richard Wendorf, *The Elements of Life: Biography and Portrait-Painting in Stuart and Georgian England* (Oxford, 1990), pp. 75–7.

58 NPG. The most recent summary of the material is given in Fara 2002, pp. 30–58; see also Haskell 1987, pp. 1–15.

59 For a discussion of banyans and the scholarly image see Fortune and Warner 1999, pp. 50–65.

60 A version at Petworth, Sussex, signed and dated 1720, may be a replica.

61 Oxford University Examination Schools; J. R. Tanner, ed., *Private Correspondence and Miscellaneous Papers of Samuel Pepys, 1679–1703* (1926), vol. 2, p. 257, 26 March 1702, quoted in Annette Peach, 'John Wallis (1616–1703)', *Oxford Portraits*, online ed., 2006.

62 Fara 2002, pp. 35–6. The second version is at Woolsthorpe Manor, near Grantham, Lincolnshire, Newton's birthplace and home.

63 Fitzwilliam Museum, Cambridge; Haskell 1987, pp. 4–13.

64 David McKitterick, ed., *The Making of the Wren Library* (Cambridge, 1995), p. 120, quoting a letter written by Elizabeth Montagu to her husband, 25 July 1753.

65 Ellen G. D'Oench, *The Conversation Piece: Arthur Devis and his Contemporaries* (New Haven, 1980), pp. 45–6, no. 6.

66 Fara 2002, p. 57. Reilly and Savage 1973, pp. 257–9.

67 Pennsylvania Academy of Fine Arts, Philadelphia. Fortune and Warner 1999, pp. 26–9.

68 Ibid., pp. 112–25, and *The Papers of Thomas Jefferson*, ed. Julian P. Boyd (Princeton, N.J., 1950–), vol. 14 (1958), p. 561.

69 Shapin and Schaffer 1985, pp. 256–9.

70 Boerhaave Museum, Leiden.

71 Private collection, Scotland. Dr A. D. Morrison-Law, 'Sir Archibald Grant's Cabinet of Curiosities', paper delivered to the XXII Scientific Instruments Symposium, Mariners' Museum, Newport News, Virginia, 1 October 2003.

72 National Gallery of Art, Washington, D.C.

73 Science Museum. The painting could also be the work of Thomas Frye or George Knapton.

74 I am most grateful to Alastair Laing for sending me his catalogue notes.

75 Private collection, Paris.

76 For the involvement of women in science in the eighteenth century see Patricia Fara, *Pandora's Breeches: Women, Science and Power in the Enlightenment* (2004).

77 Egerton 1990, pp. 54–5, cat. 18; David Fraser, 'Joseph Wright of Derby and the Lunar Society', in ibid., pp. 16–19.

78 The first orrery seems to have been made by George Graham and Thomas Tompion *c.*1709 but its name derives from a similar instrument made for Lord Orrery by John Rowley *c.*1712.

79 Horace Walpole asserted that even in the Venetian school, notably Veronese, there was something 'which touches extremely upon the servile imitation of the Dutch: I mean their ornaments of dress and gaudy embroidered garments'. *Aedes Walpolianae*, pp. xxii–xxiii.

80 The most comprehensive survey of recent literature is given in Judy Egerton, *National Gallery Catalogues: British School* (1998), pp. 332–43.

81 See David Solkin, 'ReWrighting Shaftesbury: The Air Pump and the Limits of Commercial Humanism', in John Brewer and Susan Staves, eds, *Early Modern Conceptions of Property* (1995), pp. 73–99, where he argues that the capacity of art to provide moral lessons was adapted by George Turnbull in his *Treatise on Ancient Painting* (1740) to the modern Newtonian age.

82 Van Loo painted a large picture of one of the inventors of the air pump, Otto von Guericke, showing it off to a small aristocratic audience (1771) and another of the workings of the globe electrical machine (1777), both in the Yusupov collection at Archangelskoe outside Moscow.

83 Derby Museum and Art Gallery; Egerton 1990, pp. 84–6, cat. 39; see also John Emsley, *The Shocking History of Phosphorus: A Biography of the Devil's Element* (2000), who comments on p. 16 that although Wright's painting expresses the wonder of discovery, it exaggerates the intensity of the light emitted by phosphorus.

84 Musée des Beaux-Arts, Dijon.

85 Metropolitan Museum of Art, New York. W. A. Smeaton, 'Monsieur and Madame Lavoisier in 1789: The Chemical Revolution and the French Revolution', *Ambix*, XXXVI (1989), pp. 1–4.

86 On loan to the SNPG.

87 Hudson, NPG. Gainsborough, private collection, London.

88 Darwin College, Cambridge (*c.*1770) and private collection (1792–3); Egerton 1990, pp. 220–22, cats 144–5.

89 Granger's coverage was considered at the time of its production to be reasonably comprehensive. The 'Preface' of the Rt Hon. Thomas Grenville's copy in the BL, 614.k.21, is annotated to the effect that far from there being many omissions by the author, it was surprising that there were so few.

90 Granger 1769, 'Plan of the Catalogue' and 'Preface'.

91 Peltz 2004, pp. 17 and 72, letter 19, 9 December 1770.

92 Noble 1806, pp. iv–v. It was published two years after the 4th

edition of Granger. The 5th and final edition, with 400 additional lives but only going as far as the Revolution, appeared in 1824.

93 Ibid., vol. 3, p. 430.

94 Sadler was the son of a pastry chef and confectioner and inherited his father's business.

95 Ibid., vol. 1, pp. 315–16. Viscount Midleton, the Curator at the British Horological Institute which now owns the work, has kindly informed me that this was probably Matthew Dutton, whose father William was apprenticed to George Graham, who was in partnership with Tompion.

96 A red chalk study for the portrait was sold by Sotheby's on 28 November 2001, lot 166, for £24,650.

97 Untraced. His son Peter Dollond was painted by John Hoppner c.1790, with one of the firm's telescopes mounted on a stand behind him; Yale Center for British Art, New Haven.

98 Science Museum. Dava Sobel, *Longitude* (1996), pp. 126–37.

99 McConnell 2007, pp. xiii, 233–5, and Roy Porter et al., *Science and Profit in Eighteenth-Century London* (Cambridge, 1985), p. 7. The painting was bequeathed to the Royal Society by Sir Everard Home's son.

100 J. Bradley, 'A Letter to the Rt. Hon. George, Earl of Macclesfield, concerning an apparent motion in some of the fixed stars', *PT*, XLV (1747), p. 1.

101 McConnell 2007, pp. 7 and 53–65.

102 Elizabeth Einberg, *Hogarth the Painter* (1997), p. 36, and Fara 2002, pp. 31–2.

103 Simon 2007, pp. 165–6.

104 Jane Longmore, 'The Urban Renaissance in Liverpool 1760–1800', in Barker and Kidson 2007, pp. 1–20.

105 Franklin was awarded honorary degrees from Harvard and Yale in 1753, became a member of the Society of Arts in 1755, the Royal Society in 1756 and in 1762 received an honorary doctorate from Oxford.

106 Philadelphia Museum of Art. Fortune and Warner 1999, pp. 74–9, and Dorment 1986, pp. 38–44.

107 Boston Museum of Fine Arts. Rebora and Staiti 1996, pp. 246–9, cat. 46.

108 Revere joined the Sons of Liberty in 1765. In 1767 the Townshend Acts imposed import duties on tea, inevitably curtailing the demand for the luxury equipment associated with tea.

109 Paul Staiti, 'Accounting for Copley', in Rebora and Staiti 1996, pp. 35–8.

110 Ibid., p. 39.

111 Royal Collection. Millar 1969, vol. 1, p. 152, cat. 1209, and Jane Roberts, ed., *George III and Queen Charlotte: Patronage, Collecting and Court Taste* (2004), p. 186, cat. 160.

112 Horace Walpole's annotated catalogues of Royal Academy exhibitions (1772), p. 25, Rosebery collection.

113 An identical clock to that displayed is now at Syon House, Middlesex.

114 Roche 1933, pp. 100–02.

115 Wedgwood Museum, Barlaston.

116 SNPG.

117 NPG. Ingamells 2004, pp. 69–70, cat. 6170.

118 'Perrupit Acheronta Herculeus Labor', from Horace, *Carmina*, I.3.36, was inscribed above the canal entrance into the mine.

119 Národní Galerie, Prague. Egerton 1990, pp. 87–91, cat. 40.

120 NPG. Ingamells 2004, pp. 439–41, cat. 80, and Desmond Shawe Taylor, *The Georgians: Eighteenth-century Portraiture and Society* (1990), pp. 73–4.

121 SNPG.

122 NPG. Walker 1985, vol. 1, p. 70.

123 Hugh Belsey, *Love's Prospect: Gainsborough's Byam Family and the Eighteenth Century Marriage Portrait* (Bath, 2001), p. 31, cat. 2. The painting is owned by Sir Timothy and Lady Clifford.

124 Private collection. Egerton 1990, p. 203, cat. 129.

125 Private collection. Ibid., pp. 225–6, cat. 147.

126 SNPG. Thomson 1997, pp. 66–8, cat. 10.

127 Private collection; cited by Ingamells 2004, pp. 64–6.

128 This first version was owned by Rennie. Another version is in the Science Museum and a third in the NPG; Ingamells 2004, pp. 475–80, cat. 186A.

129 John Jope Rogers, *Opie and his Works* (1878), pp. 19–20.

130 Tate Britain. As William Vaughan noted, Gainsborough also recorded the name of the maker in the crown of Truman's hat, possibly a sly reference to 'trade'; *Gainsborough* (2002), pp. 121–2. By his will Truman tied the painting to the premises of his brewery in Brick Lane for as long as any descendant of his was connected with the business.

131 Wedgwood Museum, Barlaston. Wedgwood to Boulton, 23 October 1780, quoted in Uglow 2002, p. 332.

132 Wedgwood Museum, Barlaston; see Ingamells 2004, pp. 479–80.

133 The wealthy Foudrinier family of paper-makers and stationers were similarly dependent on market tastes and were depicted in the mid-1780s seated out of doors in an elaborate conversation piece, attributed to John Downham, probably set in the gardens of their home in Stratford Grove, Putney; ibid., p. 518, cat. 6091.

134 'Epigram. On Mr Wilkinson's Copper Money', *New London Magazine*, III (1787), p. 662. Wayne Turner, 'John Wilkinson's Trade Tokens', *Broseley Local History Society Journal*, II (1974) and further comments by P. Criddle in ibid., VIII (1980).

135 Reilly and Savage 1973, p. 29.

136 Ibid., pp. 69 and 251; John Thomas, 'Josiah Wedgwood's Portrait Medallions of Fellows of the Royal Society', *NRRS*, XVIII (1963), pp. 45–53.

137 Ingamells 2004, pp. xv–xvi.

138 Private collection. Egerton 1990, p. 208, cat. 134.

139 Ibid., pp. 201–2, cat. 128.

140 Oldknow's business came unstuck during the revolutionary wars and he was saved from bankruptcy by partnership with Arkwright George Unwin, *Samual Oldknow and the Arkwrights: The Industrial Revolution in Stockport* (1924; 2nd ed., Manchester, 1968).

141 Thomson 1997, pp. 116–17, cat. 31.

142 NMC.

143 Lord 1998, pp. 76–7.

144 Derby Museum and Art Gallery. Egerton 1990, pp. 205–6, cat. 131.

145 Private collection. Stephan Deuchar, *Paintings, Politics and Porter: Samuel Whitbread II (1764–1815), and British Art* (1984), pp. 2–4.

146 NPG. Ingamells, pp. 336–7, cat. 5001.

147 Lord 1998, pp. 52–3.

148 NMC. Lord 1998, p. 53. The painting shows three blast furnaces whereas only one was built, the over-optimism indicative of Bedford's lack of success in business. As his correspondence with the Society of Arts in 1767 and again in 1779–80 suggests, he was more interested in experimenting to improve the quality of cast and bar iron; RSA, PR.GE/110/24/117, 10 October 1767, and PR.GE/118, 7 December 1779, 2 February and 29 May 1780. The remains of the furnace can still be seen and Bedford's correspondence is in the NLW; Philip Riden, *John Bedford and the Ironworks at Cefn Cribwr* (Cardiff, 1992).

149 Lord 1998, pp. 53–4. The Crawshay portrait is in the NMC. The Wilkinson portrait is in the Ironbridge Gorge Museum.

150 The three-quarter-length was purchased by the NPG and the Harris Museum & Art Gallery, Preston, in November 2008.

151 The Wright portrait is in Derby Museum & Art Gallery. Fitton 1989, pp. 182–223, and Egerton 1990, pp. 197–8, cat. 126. The Mather Brown portrait is in the New Britain Museum of American Art, Conn.

152 See the comments of Thomas Carlyle and Francis Espinasse quoted in Fitton 1989, pp. 202–3. For the views of the Lunar Society see Hills 2006, pp. 192–6. Both Boulton and Watt disliked Arkwright as an ignorant bully but they were prevailed on to support him, realising that they were all vulnerable to attack 'from the ingratitude of mankind': in other words, infringement cases defended on the grounds of the inadequacy of the patent specification.

153 Quoted without source from Wright's letter to Arkwright's son, 21 January 1790; Egerton 1990, p. 198.

154 From an account written by Wilhelmina Murray, quoted in Fitton 1989, p. 184.

155 See, e.g., Francis Nivelon, *Rudiments of Genteel Deportment* (1737) and two series of six engravings, by Major and Grignion after Gravelot, published on the same theme in 1743.

156 Hogarth 1753, pp. 138–40.

157 For an extended discussion of the role of 'imitation' in Hogarth's portraits see Simon 2007, pp. 153–60.

158 The Foundling Museum, London.

159 Victoria Manners and G. C. Williamson, *John Zoffany, R. A. His Life and Work: 1735–1810* (1920), pp. 137 and 288, from the posthumous sale of his property, 9 May 1811.

160 Walpole to Horace Mann, 20 September 1772, *Horace Walpole's Correspondence*, ed. W. S. Lewis et al., vol. 23 (1967), p. 435.

161 Walpole to Mann, 17 April and 12 November 1779, ibid., vol. 24 (1967), pp. 92–3 and 527.

162 See Mount 1991, pp. 60–68, who argues that by mid-century comedy in art was being asked to obey the same rules of decorum as the high genres. For a reading of Hogarth and theatre in the context of French criticism see Simon 2007, pp. 99–146.

163 It is unlikely that Zoffany or the King found a precedent for the pose in the Royal Collection since most of such paintings were purchased by George IV. Nevertheless, in the collection acquired from Consul Smith in 1762 there were works by van Ostade and Steen which suggest that the King was generally familiar with the genre; Christopher White, *The Dutch Pictures in the Collection of Her Majesty the Queen* (Cambridge, 1982).

164 Royal Collection.

165 Walpole's annotated catalogue of RA exhibition, 1772, p. 25, Rosebery collection; Millar 1969, vol. 1, p. 148, cat. 1195.

166 [Robert Baker], *Observations on the Pictures now in Exhibition at the Royal Academy, Spring Gardens, and Mr Christie's by the Author of the Remarks on the English Language* (1771), pp. 20–21.

167 I am most grateful to Penny Treadwell who allowed me to read her research on Zoffany's early career in England, which was greatly boosted by the patronage of his fellow Germans, the royal family. In the 1790s his hatred of mob violence in France was evident in his art. William L. Pressly, *The French Revolution as Blasphemy: Johan Zoffany's Paintings of the Massacre at Paris, August 10, 1792* (Berkeley and London, 1999).

168 Francis Hayman is so depicted in Zoffany's painting of the Royal Academicians (1771) and the Hon. Felton Hervey, Groom of the Bedchamber to the Duke of Cumberland, in a variation of the pose in *The Tribuna of the Uffizi* (1772).

169 Geoffrey Ashton, *Pictures in the Garrick Club*, ed. Kalman A. Burnim and Andrew Wilton (1997), pp. 23–4, no. 39.

170 E.g., 'Politeness' by Gillray, probably issued in 1779; *BM Satires*, no. 5612.

171 For the fullest account of the trials from the point of view of patent law see John Hewish, 'Prejudicial and Inconvenient? A Study of Arkwright's Patent Trials 1781 and 1785', in *Rex v. Arkwright: An Exhibition at the Science Reference Library to mark the Bicentenary of a Famous Trial and its Influence Today* (1985); also John Hewish, 'From Cromford to Chancery Lane: New Light on Arkwright's Patent Trials', *T&C*, XXVIII (1987), pp. 80–6, Oldham 1992, vol. 1, pp. 730–37 and 763–7, and Francis Buller, *An Introduction to the Law relative to Trials at Nisi Prius* (5th ed. corrected, 1790), pp. 75–6.

172 *Rex v. Arkwright* 1785, p. 58.

173 Oldham 1992, vol. 1, p. 763.

174 *Rex v. Arkwright* 1785, pp. 160–61.

175 The evidence from witnesses in the first trial is given, in summary only, in Lord Mansfield's notes; see Oldham 1992, vol. 1, pp. 763–7.

176 *The Case of Mr Richard Arkwright and Co. In Relation to Mr Arkwright's Invention of an Engine for Spinning Cotton, &c. into Yarn; stating his Reasons for applying to Parliament for an Act to Secure his Right in such Invention; or for such other Relief as to the Legislature shall seem meet* (1782), p. 3.

177 *Rex v. Arkwright* 1785, p. 19.

178 Ibid., pp. 12–13.

179 Ibid., pp. 15–20 and 25–6. For a summary of evidence with regard to the originality of Arkwright's inventions see Fitton 1989, pp. 11–21. On the basis of Richard L. Hills's research, Fitton concluded that two essential features are to be found in Arkwright's spinning machine which did not appear in earlier models: the rollers were placed at the correct distance from one another to allow the staple length of the fibres to be drawn successfully, and weights attached to the top rollers ensured that the correct pressure was exerted to ensure even drafting and yarn; Richard L. Hills, *Development of Power in the Textile Industry: Pre-1700–1930* (Ashbourne, 2008), pp. 23–4.

180 *Arkwright v. Nightingale* 1785, pp. 17*–24*.

181 Ibid., pp. 2*–3*.

182 *Rex v. Arkwright* 1785, pp. 130–33.

183 Ibid., p. 168.

184 *Arkwright v. Nightingale* 1785, p. 31.

185 *Rex v. Arkwright* 1785, pp. 74–5.

186 Ibid., p. 30.

187 Ibid., pp. 27–30.

188 Ibid., pp. 95–6.

189 Ibid., p. 107.

190 See Oldham 1992, vol. 1, pp. 732–3.

191 *Rex v. Arkwright* 1785, pp. 168–71.

192 Ibid., p. 172.

193 Fitton 1989, pp. 142–3, quoting Wedgwood's Commonplace Book, ff. 325–6, Wedgwood Museum, Barlaston.

194 See HC 1825, v, pp. 6–9; Select Committee on the Export of Tools and Machinery.

195 Dossie 1782, p. xxvii.

196 RSA, PR. GE/112/12, Polite Arts, 18 February 1774.

197 RSA, AD.MA/100/12/27 April 1774. Barry published the process by

which he came to undertake the works in the Appendix to *An Account of a Series of Pictures, in the Great Room of the Society of Arts, Manufactures, and Commerce, at the Adelphi* (1783), reprinted in Barry 1809, vol. 2 pp. 408–15.

198 James Barry's own 1783 *Account* has been republished most recently as *The Progress of Human Knowledge and Culture: A Description of the Paintings by James Barry in the Lecture Hall or 'Great Room' of the RSA in London*, ed. David G.C. Allan (2005).

199 For a full biographical account see William L. Pressly, *The Life and Art of James Barry* (New Haven and London, 1981).

200 Barry 1809, vol. 2, pp. 307–10.

201 Ibid., pp. 313–5.

202 Ibid., p. 438.

203 Ibid., p. 323.

204 Solkin 1993, pp. 190–213.

205 It was the only one of the four large history paintings Hayman executed for Vauxhall Gardens to be engraved, by Ravenet and published by Boydell in 1765; Brian Allen, *Francis Hayman* (New Haven and London, 1987), p. 149, cat. 79.

206 Barry 1809, vol. 2, pp. 654–9.

207 Ibid., pp. 337–8.

208 Ibid., p. 339.

209 Ibid., pp. 335 and 598–9. Barry included the proposed royal portraits when he published prints after the entire work in 1791.

210 Ibid., vol. 2, pp. 345–6.

211 Reynolds 1975, I (1769).

212 Barry 1809, vol. 2, pp. 348–59.

213 Ibid., vol. 2, pp. 347–8.

214 Ibid., pp. 647–54. For Barry's proposals to both the Government and the Society with regard respectively to coins and medals see Pressly, *Life and Art*, pp. 292–4.

215 Barry 1809, vol. 2, p. 660.

216 Ibid., p. 361.

217 Ibid., pp. 369 and 439–47. In the prints issued in 1791, Barry substituted Lord Baltimore for Penn as 'really the man to whom all this praise and admiration truly belongs', having as a Roman Catholic granted freedom of religion to all emigrants to Maryland in 1632, a charter copied in 1680 by Penn (who Barry now considered to be 'a man of great depth of understanding, attended by equal dissimulation; of extreme interestedness, accompanied by insatiable ambition').

218 Ibid., pp. 385–6.

219 Ibid., p. 388.

220 Ibid., pp. 402–3.

221 For Barry's own description of the first series of prints, detailing changes from the painted works, see ibid., pp. 419–61. For a convenient summary of all the prints produced after the work see William L. Pressly, *James Barry: The Artist as Hero* (1983), pp. 85–97.

222 'Catalogue of the works of Mr West', in *An Illustrative Supplement to Pilkington's Dictionary of Painters* (1805), p. 16.

223 Helmut von Erffa and Allen Staley, *The Paintings of Benjamin West* (New Haven and London, 1986), pp. 90–93, cats 435–9.

224 Farington Diary, 27 November 1802, quoted in ibid., p. 410.

225 It could be that some details, e.g. the 'names of eminent men', were recorded in a border which lay outside the principal images and thus would not have been present in the extant designs.

226 West's pupil and friend Robert Fulton was keenly interested in canal and navigation improvements but, according to his own account, his interest first arose in 1793, by reading a paper on a canal projected by the Earl of Stanhope; *A Treatise on the Improvement of Canal Navigation* (1796), p. xiii.

227 West could be scathing about the humbler arts, warning students at Academy schools in the wake of his own loss of royal patronage: 'You must live. You cannot live by historical painting. Do you sigh for riches? Turn the whole bent of your mind – expand all of your anxious and laborious hours in becoming fashionable painters of vacant faces. Are you not equal to this? Then design vignettes for books of travel and novels, or subjects for engravers or calico rollers, or daubings upon china ware'; quoted in Stanley Weintraub, 'A Pennsylvania Yankee at King George's Court: Benjamin West', in Stanley Weintraub and Randy Ploog, *Benjamin West's Drawings from the Society of Pennsylvania* (Philadelphia, Pa., 1987), p. 10.

228 John Galt, *The Life and Studies of Benjamin West* (1816), vol. 2, pp. 94–6.

229 Shee 1805, pp. xx–xxi.

230 William Hazlitt, 'The Catalogue Raisonné of the British Institution', *The Examiner*, 3 November 1826, reprinted in *The Complete Works of William Hazlitt* (1933), vol. 18, pp. 104–11. For Hazlitt's views on art see Barrell 1986, pp. 308–41.

VII *Industrious Scenes*

1 The most comprehensive history of the genre is still Harris 1979. A useful overview is provided by Stephen Daniels, 'Goodly Prospects: English Estate Portraiture, 1670–1730', in Alfrey and Daniels 1990, pp. 9–12.

2 For the fashion see Brewer 1997, pp. 450–51 and 458–61. Peter Barber, 'King George III's Topographical Collection: A Georgian View of Britain and the World', in Kim Sloan with Andrew Burnett, eds, *Enlightenment: Discovering the World in the Eighteenth Century* (2003), pp. 162–3, cites the van der Hem collection, now in the Austrian National Library, the 113-vol. collection assembled 1719–49 by the London bookseller John Innys (1695–1778), now in Holkham Hall, Norfolk, and the 49-vol. collection assembled by the antiquary Richard Gough, now in the Bodleian Library, Oxford, divided into 61 guardbooks and portfolios.

3 Peter Barber, 'George III and his Geographical Collection', in Marsden 2005, pp. 262–89. In Wales topographical works are divided between the National Museum in Cardiff (NMC) and the National Library of Wales in Aberystwyth (NLW).

4 The upshot was that the military collection was retained at Windsor and the maritime collection went to the Admiralty before being transferred to the British Museum, as being of no strategic use. In fact the most sensitive maps were in the topographical collection and when this was discovered in 1837, the Board of Ordnance attempted to acquire them. The British Museum refused, although it agreed to seal most of them, an agreement only countermanded in the twentieth century.

5 *The Idler*, no. 79, 20 October 1759.

6 Reynolds 1975, IV (1771), pp. 69–70.

7 Introduction above, n. 29.

8 Marquis of Zetland, Aske Hall. Solkin 1982, pp. 127–8, fig. 15.

9 Iain Pears, *The Discovery of Painting: The Growth of Interest in the Arts in England, 1680–1768* (New Haven and London, 1988), pp. 168–9 and 216–17.

10 Subsequently, according to Reynolds, Vernet had become a 'mere mannerist'; quoted in David Cordingly, *Nicholas Pocock 1740–1821* (1986), pp. 181–2.

11 Reynolds 1975, XIV (1788), pp. 247–56.

12 Gilpin 1782, pp. 32–8; Stephen Copley, 'Gilpin on the Wye: Tourists, Tintern Abbey and the Picturesque', in Rosenthal, Payne and Wilcox 1997, pp. 133–55.

13 Gilpin 1782, p. 12.

14 Gilpin 1786, vol. 1, pp. 205–6; Stephen Copley, 'William Gilpin and the Black-lead Mine', in Stephen Copley and Peter Garside, *The Politics of the Picturesque* (Cambridge, 1994), pp. 42–61.

15 William Gilpin, *Observations on the Western Parts of England, Relative Chiefly to Picturesque Beauty, To Which are Added a Few Remarks on the Picturesque Beauties of the Isle of Wight* (1798), p. 196.

16 Copley, 'William Gilpin and the Black-lead Mine', pp. 50–52.

17 Gilpin 1786, vol. 2, pp. 43–4.

18 Ibid., vol. 1, p. 51.

19 Reynolds 1875, III (1770), p. 44.

20 John Knowles, *The Life and Writings of Henry Fuseli* (1831), vol. 2, p. 217.

21 L. R. Shelby, *John Rogers: Tudor Military Engineer* (Oxford, 1967), Sir John Summerson, 'The Book of Architecture of John Thorpe', *Walpole Society*, XL (1966), and Harris 1979, pp. 8–10, 16, 20.

22 Thirty Tangier drawings are known, more than half in BM, P&D, falling into two groups. The studies were transferred from the War Office to the Department of Manuscripts in 1887, and transferred to Prints and Drawings in 1932. The finished drawings are from the Sloane collection; Antony Griffiths and Gabriela Kesnerová, *Wenceslaus Hollar: Prints and Drawings* (1983), pp. 62–4, cats 100, 108, 111–13, 116–20. The eleven 'Divers Prospects' published by John Overton 'to satisfie the curious' comprised small views of the town fortifications and three long prospects from the east, south-east and south-west.

23 NA, WO 54/32-8, Quarterbooks of the Office of H.M. Ordnance.

24 BL, C 21.b.13, dated 1675 and dedicated to the Duke of York, breaks down the views, plans and letters into album form, with MS annotations presumably by Thacker himself. Map 64040, dated 1680 and dedicated to Charles II, is pasted together as advertised for sale, complete with a description of the views and of Tangier itself within an engraved border, but lacking views v and vii. See BL, Harley MS 5947, Bagford Collection, for an advertisement of 1681 proposing their sale by subscription for 20s 'neatly pasted on cloth with ledge and rollers' or for 25s 'with individual coats of arms inserted'. Only one of Thacker's views resembles those taken by Hollar but even then the treatment and medium are so different as to dispel any notion of copying. Thacker might have consciously avoided duplicating Hollar's views.

25 Richard T. Godfrey, *Wenceslaus Hollar: A Bohemian Artist in London* (New Haven and London, 1994), p. 23; also Sloan 2000, pp. 32–5. They were probably published to commemorate the opening of the Observatory in 1676. A complete set of a title plate and eleven plates is in the Pepys Library, Magdalene College, Cambridge (2972.262-9). Derek Howse, *Francis Place and the History of the Greenwich Observatory* (1975), Griffiths 1998, pp. 277–8, cat. 193, and Harris 1979, pp. 89 and 104–5.

26 E.g., Sir Jonas Moore, *Modern Fortification or, Elements of Military Architecture* (1673), *The Mathematical Compendium* (1674) and *A New System of Mathematics* (1674–8), the last designed for use in the Royal Mathematical School established at Christ's Hospital in 1673.

27 Quoted in J. B. Harley, 'The Origins of the Ordnance Survey', in Q. A. Seymour, ed., *A History of the Ordnance Survey* (Folkestone, 1980), p. 3; see also Nigel Barker, 'The Building of the English Board of Ordnance, 1680–1720', in Bold and Chaney 1993, p. 202, quoting NA, WO 55/1789.

28 BL, King's MS 48 (royal copy), and NMM, P42 (Dartmouth copy). Phillips's preliminary drawings for the survey are in the Yale Center for British Art, New Haven.

29 Phillips and Dummer probably knew each other for both were in Tangier in 1683 where Phillips made sketches of the destruction of the town and fortifications, of which large proof prints survive in the Dartmouth papers, NMM, P43. The volume comprising maps, plans and prospects of Tangier and one plan-prospect of Gibraltar includes four proofs engraved by N. Yeates and etched by J. Collins after Phillips: two depicting Tangier 'in its Rewings' and two others, a 'Prospect of Tangier coming from the Westward' before and after it was demolished.

30 Christ's Hospital MSS, f. 695, 1696, quoted in Sloan 2000, p. 104.

31 Sloan 2000, p. 62, cat. 38.

32 Ibid., pp. 105–6.

33 Hogg 1963, vol. 1, pp. 351–2.

34 Douglas W. Marshall, 'Military Maps of the Eighteenth Century and the Tower of London Drawing Room', *Imago Mundi*, XXXII (1980), pp. 21–44.

35 Examples of their survey work and proposed improvements can be found in NA, WO 78/1131, and BL, King's Top 14. Lempriere used the opportunity of working in the Tower to draw the animals in the menagerie; Murdoch 1985, p. 164, cat. 234.

36 The gunners and engineers were converted into military bodies in 1716 and 1717 respectively, the former as the Royal Artillery (from 1722, the Royal Regiment of Artillery), the latter as the Corps of Engineers (from 1787, the Corps of Royal Engineers). There were no military ranks in the Corps of Engineers until 1757 although many held ranks in other branches of the Army, alongside their responsibilities as engineers.

37 For Faversham see NA, MR 1/909 and for Waltham Abbey, MR1/593. Numerous surveys of fortifications and proposed improvements of Portsmouth and its environs survive in BL, King's Top 14 by Desmaretz and others.

38 Separation came with the transfer of the Regiment to new barracks on Woolwich Common 1778 and the removal of the Academy to new premises on Shooter's Hill in 1806. At George III's suggestion, the Warren was renamed the Royal Arsenal in 1805.

39 See esp. NA, MP H 1/463, 'A Survey of the Tower Place at Woolwich shewing in Yellow all the additions and alterations that have been made between the years 1725 and 1778'.

40 In 1667 the Prince was commissioned by Charles II to raise works and batteries on the Warren as protection against the Dutch fleet, although he never lived there.

41 For a plan of the Foundry and part of the Great Pile, dated 9 July 1717, see BL, King's Top 17.25d–e.

42 Ibid., 17.21–2. John Barker has not been traced as he appears to have had no official position in the Warren. The drawings were sent by the Ordnance Board to George III for his inspection and were not returned but placed in the royal library and thence transferred to the British Museum; see n. 4 above. Hogg 1963, vol. 1, pp. 299–301.

43 NMM, PAG 9664, PAH 4072, PAI 0744-6, PAI 7701-3.

44 John Muller, *A Treatise of Artillery* (1757), pp. 288–9.

45 The earliest extant records for the Royal Laboratory date from 1765, NA, SUPP 5/78.

46 As already noted, the main body of workers in the Royal Laboratory were artillerymen but there were a few technician civilians. An ex-soldier could become a civilian craftsman if he was qualified.

47 The manufacture of gunpowder was illustrated in the *Receuil*, vol. 6, under 'Minérologie, Fabrique de la Poudre à Canon'.

48 For the best-known example in England see Sarah Barter Bailey, 'The Royal Armouries "Firework Book"', in Brenda J. Buchanan, ed., *Gunpowder: The History of an International Technology* (Bath, 1996), pp. 57–86.

49 Sprat 1667, pp. 260–76 and 277–83.

50 Hogg 1963, vol. I, p. 337. His source, Francis Duncan, *History of the Royal Artillery* (1879), vol. I, p. 140, states that the surtouts were blue, not the case in the watercolours.

51 These machines were mentioned in the earliest Royal Laboratory book of in-letters to survive, dating from 1765 and relating to supplies destined for Minorca; NA, SUPP 5/78. For a close-up of such a machine, which worked on the principle of a corkscrew, see the drawing made at Brest in 1695 in Paris, Archives Nationales, Marine G 202, 97, reproduced in *L'Ame et la lumière: armes et canons dans la Marine royale fin xvii–xviiie siecle* (Paris, 1996), p. 48, cat. 73b.

52 The account on the state and service of the Artillery written by the Chief Firemaster, Thomas Desaguliers, for the King in 1765 does not mention these processes among the principal works of the Royal Laboratory listed; Windsor Castle, Royal Library, RCIN 1087907, 'Account of the Present State and Service of the Artillery', ff. 94–5.

53 Gunpowder had been manufactured at Faversham from the sixteenth century. The mills were purchased by the Board of Ordnance in 1759 to secure supplies during the Seven Years War; Crocker 2000, pp. 5–7. It may be that after 1759 gunpowder ceased to be manufactured at Woolwich, for in 1765 Desaguliers mentions among the works of the Royal Laboratory only the weighing and delivering of powder for proving all the ordnance that it manufactured. It also extracted saltpetre from damaged powder and unserviceable compositions and refined it for further service; Desaguliers, 'Account', ff. 94–5.

54 Centre for Kentish Studies, Maidstone, U269 o187/1. A selection of drawings is reproduced in Crocker 2000, pp. 8–14.

55 For an account of the make-up of Wade's roads, based on archaeological excavation, see G.R. Curtis, 'Roads and Bridges in the Scottish Highlands: The Route between Dunkeld and Inverness, 1725–95', *Proceedings of the Society of Antiquaries of Scotland*, CX (1978–80), pp. 479–82.

56 Roy 1785, p. 4.

57 NA, ADM 106/2187.

58 BL, King's Top 48.15-1b.

59 Oppé 1947, pp. 44–8, cats. 150–58.

60 For Thomas Sandby's gun-carriage drawings see Robertson 1985, pp. 24–5, cats 18b and 18c. For the stocking frame see Charles Deering M.D., *Nottinghamia Vetus et Nova, or an Historical Account of the Ancient and Present State of the Town of Nottingham* (Nottingham, 1751). Sandby remained on Cumberland's household staff until the Duke's death in 1765, when he became the Deputy Ranger of Windsor Great Park. It was on account of the strength of his royal connections rather than his technical abilities that he was appointed the Royal Academy's first Professor of Architecture but his skills in perspective and architectural draughtsmanship should not be underestimated. For the rest of his life Sandby continued to draw 3s a day and a half-pay allowance of £91 5s from the Board of Ordnance. For a résumé of his career see Robertson, 1987, vol. I, pp. 99–121.

61 Jessica Christian, 'Paul Sandby and the Military Survey of Scotland', in Alfrey and Daniels 1990, pp. 18–22, Theodore Feldman, 'Barometric Hypsometry', *Historical Studies in the Physical Sciences*, XV (1985), pp. 127–97, R.A. Skelton, 'The Military Survey of Scot-

land, 1747–55', *Royal Scottish Geographical Society Special Publication*, no. 1, 1967.

62 Only two other draughtsmen were employed in the six surveying teams, John Pleydell and Charles Tarrant, for the surveyors also took on cartographic work. Tarrant was posted to Scotland in 1750 and worked mainly on William Skinner's plans for the new Fort George. For an example of his brightly coloured topographical drawings see Sloan 2000, pp. 122–3, cat. 83.

63 Roy 1785, pp. 4–5.

64 Aaron Arrowsmith, *Memoir to the Construction of the Map of Scotland* (1807), p. 8.

65 E.g., in 1775 Major Hugh Debbieg of the Corps of Engineers, who had been employed for seven years on the Survey of Scotland, submitted to George III 'Remarks and Observations made upon Several of the Sea Ports in France and Spain during a Journey in those Countries in the Years 1767 and 1768'. This was, in effect, an espionage trip, employing the author's 'talent for sketching ground with sufficient accuracy for military purposes' to send home, by devious means, plans and information on new works at the ports, with his assessment of their strengths and weaknesses; BL, King's MS 41.

66 Sloan 2000, pp. 129–32, cats 90, 92, 93.

67 Robertson 1987, vol. I, pp. 129–60.

68 National Gallery of Scotland, Edinburgh.

69 Also reproduced in Robertson 1985, pp. 34, 37, cat. 29. For the enlightened management of the mines between 1734 and 1770 by the scholar and mathematician James Sterling see T.C. Smout, 'Lead Mining in Scotland, 1650–1850', in Payne 1967, pp. 103–35. For the mines' drainage problems see W.S. Harvey, 'Scottish Lead Mines', *Industrial Archaeology*, IX (1972), p. 200. A watercolour of lead-mining activities at neighbouring Wanlockhead was made by John Clerk of Eldin on a sketching tour he made of the Queensberry estate at Drumlanrig in 1775 (Dumfries Museum).

70 Robertson 1987, vol. I, pp. 161–244.

71 Hogg 1963, vol. I, pp. 364–71.

72 John Manners, Marquis of Granby, *Rules and Orders for the Royal Military Academy at Woolwich* (1764), p. 7. Further refinements were made by the Master-General, George Lord Viscount Townshend, in his *Rules and Orders for the Royal Military Academy* (1776).

73 Ibid., pp. 19 and 21.

74 William D. Jones, *Records of the Royal Military Academy* (1851), p. 46, quoting from the orders of the Lieutenant Governor of the Royal Military Academy, Benjamin Stehelin, 1792.

75 See, e.g., 'Woolwich from Power Street' and 'The Old Royal Military Academy, from Prince Rupert's Walk' in BM, P&D. A view entitled 'Royal Arsenal, Woolwich, from the green in front of the Cadet Barracks' was once in Landmann's collection; Sloan 2000, pp. 137–9, cats 97 and 98; also the view 'Lime Kiln at Charlton', in the Victoria and Albert Museum.

76 For the Verbruggens' career in Holland see Jackson and de Beer 1973, pp. 15–30.

77 Clive Trebilcock, '"Spin-Off" in British Econonic History: Armaments and Industry, 1760–1914', *Economic History Review*, XXII, 2nd ser. (1969), pp. 476–8. There was also an understandable caution in commissioning munitions of dubious reliability. Government inspectors at Woolwich commonly rejected 20–40% of Schalch's yearly output, while 10% rejection was regarded as 'a noble proof'.

78 NA, WO 47/87, 26 April 1776; WO 47/88, 29 November 1776. For an authoritative overview of the Foundry's development under the Verbruggens see Jackson and de Beer 1973, pp. 35–66; also Hogg 1963, vol. I, pp. 427–33 and 457–8.

79 Jackson and de Beer 1973, p. 64.

80 RARA. See, e.g., the notebooks of J. W. Ormsby (1828), E. W. Rodwell (1836), J. Baker (1839).

81 Windsor Castle, Royal Library, RCIN 1087907; Roberts 2004, pp. 230–31, cat. 210.

82 'Historical Chronicle', *Gentleman's Magazine*, XLIII (1773), p. 347. The journal's assertion that the horizontal boring engine was 'the most curious and the best contrived of any in Europe' was preemptive as the foundry did not start operation until a month later.

83 NA, WO 47/82, 1 July 1773; *Gentleman's Magazine*, XLIII (1773), p. 347.

84 These were first published in Jackson and de Beer 1973.

85 Jean-Daniel Pariset, *Sur l'eau . . . Sous l'eau . . . Imagination et technique dans la marine 1680–1730* (Paris, 1986), p. 14. A survey of the royal cannon foundry of St Gervais, its buildings and topographical situation, made in Grenoble on 8 May 1718, survives in the hydrographic collection of the Archives Nationales, AN, 6 JJ 89, f. 18, reproduced in Pariset, pp. 58–9, cat. 78. Here too there is an undated plan and profile of the Manufacture Royale of arms at Nouzon on the Meuse, near Charleville, showing the sequence of work in strip-cartoon fashion and embellished with little figures working the forges or proving the cannon, watched from a safe distance by the entrepreneur, commissioner or inspector; AN, 6 JJ 89, f. 19.

86 Twenty-six of the drawings are reproduced in Beer 1991, pp. 116–76. The illustrations are bound in 3 vols and conserved with the 663-page MS in the Royal Military Academy, Breda.

87 Beer 1991, p. 153.

88 Collection of Vicomte Maurice de Castex; reproduced in ibid., p. 27; also Nicolas Pierrot and Marie-Laure Griffaton, 'Peindre dans l'usine', *La Revue: Musée des Arts et Métiers*, XXXVI (2002), pp. 7–8. It can be seen, perhaps, as an indoor version of Joseph Vernet's view of 1755 depicting the arsenal or artillery park at Toulon, part of his series of paintings of the Ports of France, executed 1753–65 and engraved by Charles-Nicolas Cochin and Jacques-Philippe le Bas, published in 1760–78.

89 *Le Siècle des lumières dans le Principauté de Liège* (Liège, 1980), pp. 33–6, 70–74, 194–6, cats 68, 74, 387–90; *Autour du néo-classicisme en Belgique* (Brussels, 1985), pp. 347–65.

90 The most comprehensive coverage of Hilleström's industrial subject matter is Sixten Rönnow, *Pehr Hilleström och Hans Bruks- och Bergverks-Målningar* (Stockholm, 1929). He estimated that Hilleström painted 125 mining and forge paintings.

91 BL, Add. MS 32375, ff. 105v–106, 118v–119. I am most grateful to Dr Susan Sloman for alerting me to these drawings.

92 Jackson and de Beer 1973, pp. 69–70. Beer 1991, pp. 25–6. Unfortunately, hardly any of the letter-books relating to the Royal Brass Foundry, in NA, SUPP 5, survive from before 1793 and nothing of relevance appears to have survived in the Townshend papers in the BL, although Lord Townshend was himself a skilled draughtsman and caricaturist.

93 There is a striking similarity in the figures to those of stonemasons at work in the left foreground of Paul Sandby's aquatint of *Eton College from Crown Corner*, published on 1 January 1776; BL, King's Top 8.30d is a proof copy printed in sepia.

94 A later watercolour and gouache of the same design, extended to the right, is now in the Royal Collection; Oppé 1947, p. 55, cat. 192. Its size is 30.8 × 47.5 cm which suggests that the original was about the same size (30 × 40 cm with variations of up to 1 cm) as the Foundry drawings. The paper used for the Foundry drawings was

watermarked Villeday, a paper used by Sandby but also by many others.

95 Richard Gough, *British Topography* (1780), vol. 1, p. 471. Robertson 1985, p. 104, suggests that the pencil sketches in the British Museum, BM 1867-12, -14, -116-123, may also have been connected with the Woolwich project. They include exterior views of the Laboratory (116), the Foundry (119–20) and Prince Rupert's Tower (121–2). Sandby certainly made drawings of industrial subjects round Woolwich: see n. 75 above.

96 Theresa Fairbanks Harris and Scott Wilcox, *Papermaking and the Art of Watercolor in Eighteenth-Century Britain: Paul Sandby and the Whatman Paper Mill* (New Haven and London, 2006). Joshua Gilpin visited the mill in 1796, by which time its owners were Thomas and Finch Hollingsworth; A. P. Woolrich, 'The Travel Diaries of Joshua Gilpin: Some Paper Mills in Kent, 1796', *The Quarterly*, no. 20 (1996), pp. 19–20.

97 Patrick Conner, *Michael Angelo Rooker (1746–1801)* (1984), pp. 96–7.

98 BM, P&D, MM-6–33.

99 Hogg 1963, vol. 1, p. 383.

100 Reproduced with a translation of the Treatise in Beer 1991, pp. 177–202. Landmann produced several textbooks: the *Field Engineer's Vade Mecum* (1802), *Principles of Fortification* (3rd ed., 1806) and *Principles of Artillery* (1808).

101 Marshall 1980, pp. 22–30. Reports and specimens from the Drawing Room compiled for Lieutenant General Amherst in 1780–81 are in NA, MPH/1/14-15. They comprise maps and architectural plans, sections and elevations of fortifications, barracks, carriage sheds, etc.

102 Paul Sandby's comment was inscribed on a full-length portrait of Gilder by Sandby, sold at Christie's on 26 May 1959, lot 129, cited by Yolande Hodson, 'Prince William, Royal Map Collection', *The Map Collector*, XIV (1988), p. 11. Perhaps the Tower appointment was in part a sinecure, for Gilder was evidently also in America in 1776, recording a naval engagement in October on Lake Champlain.

103 BL, King's Top 13, 15.4.e.

104 David Japes, *William Payne: A Plymouth Experience* (Exeter, 1992), pp. 6–18, cats 73–5. Payne's drawings of a view near Plymouth Western Mills and a stone quarry at Port Eliot in Cornwall were included in Samuel Middiman's *Select Views in Great Britain* (1788–9).

105 Matthew Edney, 'Mathematical Cosmography and the Social Ideology of British Cartography', *Imago Mundi*, XLVI (1994), pp. 101–16, and Marshall 1980, p. 33.

106 Marshall 1980, pp. 25–7.

107 Sloan 2000, p. 108. For extremely competent drawing by Ordnance officers see pp. 142–5, cats 102 and 104.

108 BL, King's Top 46.34b, 34c, 46f, 47.37d, 62e, 89e. See *Archibald Robertson, Lieutenant-General Royal Engineers: His Diaries and Sketches in America, 1760–1780* (New York, 1930) for illustrations demonstrating the full range of his artistic skills from meticulously drawn plans, prospects, seascapes and battle scenes to views of Boston and Philadelphia embellished with figures in classical dress.

109 SMLA, Good A210, 22 March 1807.

110 An excellent overview of the subject is given in McConnell 2004.

111 Quoted in Cross 1977. Korsakov's journal is in the Lenin Library, Moscow.

112 Göran Rydén and Chris Evans, *Baltic Iron in the Atlantic World in the Eighteenth Century* (Leiden and Boston, 2007), Asa Eklund, *Iron Production, Iron Trade and Iron Markets: Swedish Iron on the British Market in the First Half of the Eighteenth Century* (Uppsala, 2001), and Karl-Gustaf Hildebrand, *Swedish Iron in the Seventeenth and*

Eighteenth Centuries: Export Industry before the Industrialization (Stockholm, 1992).

113 SRA, Bergskollegium archive, quoted and redrawn in Woolrich 1986, pp. 22–4.

114 SKB, MS M.218, Jonas Alströmer, 'Resa i England', 1719 and 1720, transcribed by G. H. Sträles from the original Reseberättelser in Uppsala University Library, MS. X.376–8; Woolrich 1986, p. 25, Lindqvist 1984, pp. 128–30, and Flinn 1957, p. 99.

115 Henrik Kalmeter, 'Dagbok öwer en . . . 1718–26 företagen resa till Tyskland, Holland, Frankrika och England', vols I–V are in SKB, MS M.249; his 'Relationer om de engelska bergverken, 1720–25', is in SRA, EIII:10; Flinn 1957, pp. 99–100.

116 SKB, MS M.249, vol. 1, f. 162. For Kalmeter's visit to Scotland see T. C. Smout, 'Journal of Henry Kalmeter's Travels in Scotland', *Scottish Industrial History: A Miscellany*, 4th ser., XIV (1978).

117 SKB, MS M.249, vol. 1, ff. 537–43 (tar); vol. 3, interleaved at f. 523 (glass), f. 536 (coal 'rowling'); see also vol. 3, f. 698 for a diagram of a glasshouse at Gloucester and SRA, EIII:10, ff. 347 and 419.

118 Linqvist 1984, pp. 121–7 and 199–204. For his visit to south-west England see *The Kalmeter Journal: The Journal of a Visit to Cornwall, Devon and Somerset in 1724–25 of Henry Kalmeter 1693–1750*, ed. Justin Brooke (Truro, 2001).

119 SKB, MS X.303, vol. 1, f. 120.

120 Ibid., ff. 157–8, 227, 267.

121 Ibid., ff. 337, 341, 353.

122 Ibid., tabs 1–12 following f. 249.

123 Ibid., vol. 3, ff. 749 (sections), 830 (prospect).

124 Ibid., vol. 4, ff. 1060 and 1071–4.

125 Angerstein 2001 is one of the few Swedish tours translated and published in English. It is based on vols 2 and 3 of the fair copy in the Library of the Jernkontoret, Stockholm, 'Dagbok öfver Resan genom England åren 1753, 1754 och 1755'. Two octavo pocket notebooks for England and Wales survive in SRA, FIIa: 4, labelled No. 2 London, and 5, Dover No. 7, along with other original working documents.

126 Angerstein produced perfectly good architectural perspectives of Oxford libraries and colleges, as he stayed there several days.

127 Compare the pocket notebooks in SRA, FIIa: 5, labelled Liège 6, or Valencienes 3.

128 Angerstein 2001, pp. 35–8. In Young 1770, vol. 3, p. 342, Arthur Young again singled out Birmingham, 'where I could not gain any intelligence even of the most common nature, through the excessive jealousy of the manufacturers. It seems the French have carried off several of their fabrics, and thereby injured the town not a little: this makes them so cautious, that they will show strangers scarce any thing.' Sir John Cullum noted the same reaction four years later: 'I found at Birmingham in general not much alacrity in the makers to show their workshops; very different from those at Sheffield, and other places'; SRO, E2/44/2.2, f. 11, 16 July 1774.

129 For convenience all references are to the translated version of the fair copy; Angerstein 2001, pp. 47–8, fig. 37.

130 Ibid., pp. 94–7.

131 Ibid., pp. 143–4, fig. 149.

132 Ibid., pp. 159–63.

133 Ibid., p. 246.

134 Ibid., p. 254.

135 Ibid., p. 282.

136 Ibid., p. 284.

137 Ibid., pp. 337–8.

138 Ibid., pp. 24–5.

139 Ibid., p. 36.

140 Ibid., p. 260.

141 Ibid., p. 333 n. 270.

142 Ibid., p. 203, fig. 62.

143 Ibid., pp. 71–4, 101–3, 227–35, figs 70–71, 102–3, 215, 218.

144 Ibid., pp. 198–9, 213, 273–4, figs 188, 197, 258.

145 SKB, M.243; Erik Geisler, 'Antechningar samt Journal under Resenors Norge och England Skotland 24.1. – 30.11.1772'; Torsten Althin, 'Eric Geisler och hans utländska resa 1772–1773', *Med Hammare och Fackla*, XXVI (1971), pp. 53–126. For the travels of Bengt Ferrner, an astronomer from Uppsala University who came to England as tutor companion to the son of a wealthy merchant Jean-Henry Lefebure, see A. P. Woolrich, *Ferrner's Journal 1759/1760: An Industrial Spy in Bath and Bristol* (Eindhoven, 1986). For those of Johan Ludwig Robsahm, a steel manufacturer and notary of the Bergskollegiet, who arrived in 1760 and stayed for a year see Woolrich 1986, p. 31.

146 SKB, M.243, ff. 5, 13, 17.

147 Ibid., ff. 32–3, 35, 42–5.

148 Ibid., ff. 39 and 46–7.

149 D. C. Christensen, 'Technology Transfer or Cultural Exchange', *Polhem*, XI (1993), pp. 323–5, and Woolrich 1986, pp. 36–7.

150 Gillian R. Gregg, trans. and ed., *The Précis Historique of Charles Albert: A Story of Industrial Espionage in the Eighteenth Century* (Lancaster, 1977). In 1777, at the height of the battle between Arkwright and the Manchester cotton merchants, the American loyalist Samuel Curwen, who spent the Revolutionary War in England, noted that in Manchester 'it is with difficulty one is admitted to see their works, and in many cases it is impracticable, express prohibitions being given by their masters'; *Journals and Letters of the late Samuel Curwen, Judge of the Admiralty, etc. An American Refugee in England from 1775 to 1784* (1842), 7 June 1777. The aristocratic young La Rochefoucauld brothers had a relatively easy time of it in 1785 despite being suspiciously well informed about industrial processes. In Derby, besides the famous silk mill (which they went round without permission), they saw Mr Swift's cotton mill with its new Arkwright-style cotton-carding machines. The owner 'asked nothing better than we should satisfy our curiosity though he certainly would not admit an Englishman'. In the cotton factories round Manchester, however, the brothers were not let in, because the manufacturers had had several of their inventions stolen by strangers who had made drawings of the machines. In 1795 Alexandre La Rochefoucauld established a cotton spinning manufactory in France with the help of a Scot called MacLeod; Scarfe 1995, pp. 36–45, 62–5.

151 Faujas de St-Fond, 'Travels through England and Scotland to the Hebrides in 1784', in Mavor 1809, vol. 5, pp. 25–9.

152 Cross 1977, pp. 1–20. For other young Russians who came to Britain to acquire technical expertise see A. G. Cross, *'By the Banks of the Thames': Russians in Eighteenth Century Britain* (Newtonville Mass., 1980), pp. 174–208.

153 Margaret Bradley and Fernand Perrin, 'Charles Dupin's Study Visit to the British Isles, 1816–1824', *T&C*, XXXII (1991), p. 63.

154 A useful guide is provided by Darwin H. Stapleton, *Accounts of European Science, Technology and Medicine, written by American Travelers Abroad, 1735–1860, in the Collections of the American Philosophical Society* (Philadelphia, 1985).

155 Fisher 1992, p. 250, 13 August 1776. Fisher's fellow countryman Peter Oliver, the younger brother of the Lieutenant Governor of Boston, was not admitted in July 1777, 'for they will not allow strangers to

view it'; BL, Egerton 6273, 14 July 1777. As Fitton 1989 points out, pp. 51–4, the aura of secrecy was not only a defensive reaction to the stealing of Arkwright's patents but also to potential attack by disaffected handworkers.

156 Elizabeth Hamilton, *The Mordaunts: An Eighteenth-century Family* (1965), p. 232.

157 Gilpin's original journals are held by the William Penn Archives, Pennsylvania Historical and Museums Commission, Harrisberg, Pa. A microfilm copy is in the Science Museum Library, London, B1. The Townley drawings are in journal 5, dating from March 1795, and the Giant's Causeway journal is no. 20, dating from September 1795.

158 Harold B. Hancock and Norman B. Wilkinson, 'Joshua Gilpin: An American Manufacturer in England and Wales, 1795–1801 – Part 1', *TNS*, xxxii (1959), pp. 15–28; 'Part 2', TNS, xxxiii (1960), pp. 57–66. For his studies of paper mills see A. P. Woolrich, 'Scottish Paper Mills as seen by Foreign Observers: The Travel Diaries of Joshua Gilpin, 1795, and Eric Svedenstierna, 1803', *The Quarterly*, no. 19 (July 1996), pp. 6–11; 'The Travel Diaries of Joshua Gilpin: Some Paper Mills in Kent, 1796', ibid., no. 20 (October 1996), pp. 19–24; 'Some Paper Mills in Hertfordshire, 1796', ibid., no. 21 (January 1997), pp. 18–22; 'Some Paper Mills in Ireland, 1796', ibid., no. 22 (April 1997), pp. 7–13. See also Woolrich 1986, pp. 53–60, who considers that the value of Gilpin's journals lies more in their range than their depth: as a source of detailed, accurate technical information they cannot compare to the records made by trained continental observers.

159 APS, Smith, vol. 4, 10 November 1801.

160 Ibid., 11 November 1801.

161 See the letter from James Watt jr to Smith of 30 December 1801 relating to the collection of minerals which Watt had arranged to be forwarded from Dudley to London; APS, Misc. ms collection.

162 APS, Smith, vol. 4, 26 November 1801.

163 Ibid., 18 December 1801.

164 SMLA, Good, E1, Letters to General Bentham, 'giving an Account of his Tour for the Purpose of seeing Mechanical and Engineering Works', 30 November 1799.

165 SMLA, Good, E1, 6 December 1799.

166 Ibid., 8 December 1799 compared with SMLA, Rey, 58–65.

167 SMLA, Good, E2.

168 For Jabez Fisher's accounts of Plymouth and Portsmouth in 1775–6 see Fisher 1992, pp. 93–4, 110, 125–7. For Peter Oliver's visit to Plymouth and Portsmouth see BL, Egerton 2672, 8 June 1776 and 27 May 1777. For the visits of the Louviers industrialist le Camus de Limare in 1781 see McConnell 2004. For the visit of the Rochefoucauld brothers to Plymouth, where they viewed the dockyard from a boat, see Scarfe 1995, pp.167–72. In 1789–90, although the French naval architect Pierre Alexandre Forfait (1752–1807) and Baron Daniel Lescallier found the royal dockyards closed to them, they were admitted to the yards building merchant vessels for the Greenland and East India trades and also had access to the Navy and contractors' gun parks; McConnell 2004.

169 Bentham 1813, p. 64.

170 Coad 2005, pp. 10–13 and 101–2.

171 Eric T. Svedenstierna, *Svedenstierna's Tour of Great Britain 1802–3: The Travel Diary of an Industrial Spy* (Newton Abbot, 1973), trans. E. L. Dellow, pp. 75 and 87–8.

172 The famous tours made by Celia Fiennes (1662–1741) round England between 1685 and 1712 were not published until *Through England on a Side Saddle in the Time of William and Mary* (1888).

173 Defoe was appalled by the physical condition of a Derbyshire lead miner and his family and as the episode was so aberrant felt obliged to defend its inclusion: 'If any reason thinks this [sight] . . . too low and trifling for this work, they must be told, that I think quite otherwise; and especially considering what a noise is made of wonders in this country, which, I must needs say, have nothing in them curious, but much talked of, more trifling a great deal'; *A Tour through the Whole Island of Great Britain*, vol. 3 (1726), Letter 8.

174 The best guide is provided by Ralph Hyde, *A Prospect of Britain: The Town Panoramas of Samuel and Nathaniel Buck* (1994).

175 Harris 1979, pp. 99–100 and 152. A fine copy of the print is in BL, King's Top 10.24a.

176 SRO, E2/44/1. The eldest son of a Suffolk baronet, John Cullum (1733–85) was educated at King Edward vi's School, Bury St Edmunds, and Catharine Hall (now St Catharine's College), Cambridge. He was elected a Fellow of the Society of Antiquaries in 1774 and of the Royal Society in 1775. He was a friend of the leading antiquaries of the day – Gough, Granger, Pennant – and prepared *The History and Antiquities of Hawsted and Hardwick* (1784). He projected a new *Flora Anglicana* but was unable to complete it before his death from consumption.

177 Hoare 1983, pp. 154–5.

178 I have yet to come across a woman traveller who displayed in-depth technical know-how. Dorothy Richardson confined her drawings to manifestations of the polite arts. I differ in some respects from Marcia Pointon's interpretation of the Richardson papers (RYL. Eng. ms 1125) in *Strategies for Showing: Women, Possession, and Representation in English Visual Culture 1665–1800* (Oxford, 1997), pp. 89–130, who sees Richardson as laying claim to masculine territory.

179 SRO, E2/44/1.

180 *The Hatchett Diary: A Tour through the Counties of England and Scotland in 1796 visiting their mines and factories*, ed. Arthur Raistrick (Truro, 1967); the diary at this date was owned by Mrs Anita Hatchett.

181 BRO, L31/114/2.

182 Peter Hughes, 'Paul Sandby and Sir Watkin Williams-Wynn', *Burlington Magazine*, cxiv (1972), pp. 459–67, and 'Paul Sandby's Tour of Wales with Joseph Banks', ibid., cxvii (1975), pp. 452–7. Robertson 1987, vol. 1, pp. 316–45.

183 The Hon. Charles Greville, to whom the *XII views* was dedicated, acquired details of the aquatint process from J.B. le Prince and passed them on to Sandby; Abbey 1952, pp. 343–4, no. 511; see pp. 343–57 for the range of publications on Wales in these media.

184 For a discussion of Wilson's Welsh landscapes in relation to the Celtic Revival, antiquarianism and concepts of liberty and patriotism, as well as Italian models of aesthetic harmony, see Solkin 1982, pp. 86–103.

185 Lindsay Stainton, *British Landscape Watercolours 1600–1860* (1985), p. 24, cat. 22.

186 The view was presumably made for Sandby's aquatinted *Views in South Wales* (1775–7), which includes as plate 5 'View up the Neath River from the House at Briton Ferry in Glamorganshire' (1775); Abbey 1952, pp. 343–4, no. 511.

187 J.R. Ward, *The Finance of Canal Building in Eighteenth-Century England* (1974), pp. 150–52.

188 *History of Inland Navigations* 1766, pp. 36–8 and 42–55.

189 For an early account (25 August 1768) by the Hon. James Grimston see HRO, D/EV F13/14; for Sir John Cullum's account of 1771 see SRO, E2/44/1, ff. 269–71; also American accounts in Fisher 1992, p.

83, 28 October 1775, and in BL, Egerton 6273, vol. 2, 18 and 20 July 1777. For the Rochefoucauld brothers account see Scarfe 1995, pp. 67–75; also the 1787 account in Henry Skrine, *Three Successive Tours in the North of England, to the Lakes, and great part of Scotland* (2nd ed., 1813), p. 87, and in Warner 1802, vol. 2, pp. 152–9.

190 Antony Griffiths, 'Notes on Early Aquatint in England and France', *Print Quarterly* IV (1987), pp. 262–3, and Martin Hopkinson, 'Print Making and Print Collectors in the North West 1760–1800', in Barker and Kidson 2007, pp. 85–9.

191 Young 1770, vol. 3, letter 19, pp. 251–91.

192 See, e.g., Richard Joseph Sullivan, *Observations made during a Tour through parts of England, Scotland and Wales, performed in 1778* . . . reprinted in Mavor 1809, vol. 3, pp. 109–10, who opined 'To have been in Newcastle, and men of curiosity too, without seeing a coal pit, would have been a sin of the most unpardonable nature.' Having dressed 'in the true fashion of the place', he explored the Walker mine 'with as little inconvenience, saving black faces, as if we had been moving in a drawing room'; also Michell 1845, pp. 190–2.

193 See, e.g., *The Travels through England of Dr Richard Pococke . . . during 1750, 1751 and later years*, ed. James Joel Cartwright (1888), pp. 110–16; also Fisher 1992, pp. 101–8, who descended the deepest mine, Dolcoath, on 29 December 1779 and described it in terms of undisguised horror and terror, somewhat justifiably in this instance as the ladders used for the descent were weak and dangerous.

194 HRO, D/ER/C311.

195 As a friend of William Brownrigg, Dalton was well placed to experience the sensations of going down a mine. Brownrigg even appended technical notes to Dalton's poem 'as a sort of circumstantial proof of the truth of your descriptions'.

196 The most comprehensive survey of the visual representation of mines throughout Europe is given in Slotta and Bartels 1990.

197 Stebbing Shaw, *History and Antiquities of Staffordshire*, vol. 2, part 1 (1801), p. 85. For Peter Oliver's vivid descriptions of the scene see BL, Egerton 2673, 21 May 1779 and 30 July 1780. See also the description of Wednesbury in 1792 with its blackened trees and smog in Torrington 1934, vol. 3, pp. 146–7. The mines were still burning in 1801 when the Revd Warner was suitably awestruck: 'the appearance of a *soil of fire* . . . and the no less fearful sight of vast heaps of red-hot coke on all sides, the fiend like look of the dingy workmen managing the liquid flaming metal; and the horrible din of engines and bellows, the rushing of the steam, and the roaring of the flame' could only be compared to Hell. Warner 1802, vol. 2, pp. 210–11.

198 See Emma Chambers et al., eds, *Violent Earth: The Unique Legacy of Dr Johnston-Lavis* (2005).

199 See the accounts of Oliver in BL, Egerton 2673, vol. 2, 28 July 1777; Sullivan in 1778 in Mavor 1809, vol. 3, pp. 130–31; Thomas Halsey in HRO, D/EH F1, 17 September 1783; Lord Grantham in July 1799 in BRO, L31/114/2; Hoare 1983, pp. 159–60, and Warner 1802, vol. 2, pp. 159–63.

200 A fine cross-section and perspective of Wieliczka salt mine, with workers about their different tasks, drawn by B. Müller and engraved by J. E. Nilson, was published in Augsburg in 1760 for the Saxon geologist J. G. Borlach. The mine also merits a double page by Benard in 'Minéralogie' in the *Receuil*, vol. 6, collection 7, pl. 7. William Daniell depicted an *Interior of a Salt Mine* in a print published by Cadell and Davies in London in 1807.

201 BL, Egerton 2673, 5 August 1780.

202 Richard Warner, *A Second Walk through Wales in August and September 1798* (Bath, 1799), pp. 283–95.

203 Hoare 1983, pp. 187–8.

204 Ibid., pp. 268–9.

205 BL, Add. MS. 33636, f. 103–103v.

206 Edward Pugh, *Cambria Depicta: A Tour through North Wales, illustrated with Picturesque Views* (1816), pp. 46–7; Abbey 1952, pp. 350–51, no. 521.

207 A watercolour by Ibbetson of a coal mine was possibly drawn on the same journey; *Coal: British Mining in Art 1680–1980* (1982), p. 64, cat. 26.

208 Abbey 1952, pp. 346–7, no. 514.

209 Science Museum, inv. no. 1985. 1869.

210 On the latter trip Ibbetson also recorded the workings at a small coal mine with a horse-whim near Neath and a coal staithe on the River Tawe.

211 Hassell also produced a view of Bathstone Quarries in 1798, again published by Jukes; none is recorded in Abbey. They contrast with the *Views in North Wales* (1792–4) made by the Irish artist Thomas Walmsley (1763–1806), mainly devoted to views along the Dee, some aquatinted by Hassell, which brushed industry out of existence; Abbey 1952, p. 344, no. 512; see also BL, King's Top 47.42e, 'View of the Copper-Works, Swansea, Glamorganshire' (perhaps a proof from an abortive series of views in South Wales) which renders the works, presumably somewhere in the far distance of the picturesque landscape, invisible.

212 For an overview see John R. Kenyon, 'The Tourist in Wales in the Later Eighteenth and Early Nineteenth Centuries', in *A Picturesque Tour through Wales 1685 to 1855: Watercolours from the Collection of the National Museums and Galleries of Wales* (Cardiff, 1998), pp. 15–18.

213 [Wyndham] 1774, p. iv.

214 Ibid., pp. 38, 164–5. He was quoting Pennant's *A Tour in Wales, 1770* (1773), vol. 1, p. 39, who also noted: 'The industry of this century hath made its waters of much commercial utility. The principal works on it at this time are battering mills for copper; a wire-mill, coarse paper mill, snuff-mill, a foundry for brass; and at this time, a cotton manufactory is establishing, the success of which will be an extensive blessing to the neighbourhood.'

215 Pennant 1796, p. 206.

216 Ibid., p. 273.

217 For a full account of the Arkwright–Smalley relationship see Fitton 1989, pp. 23, 25, 38–46.

218 Pennant 1796, pp. 214–22.

219 Warner 1798 and 1799.

220 Warner 1799, p. 206.

221 Warner 1798, p. 232.

222 Hoare 1983, p. 98. The question mark denotes a problem with deciphering the original.

223 For visitors' accounts of Coalbrookdale see below. For visits to the foundries run by the Walker brothers at Rotherham see those of Oliver in BL, Egerton 6293, 16 July 1776; Grantham, BRO, L31/114/2, and Warner 1801, pp. 190–99. For Carron see Fisher 1992, pp. 58–9; Sullivan in Mavor 1809, vol. 3, p. 124; John Enys, 'A Sketch of a Northern Tour' (1783) in CoRO, Enys 1800; also Elizabeth Cometti, ed., *The American Journals of Lt. John Enys* (Syracuse, N.Y., 1976), p. 87; St Fond in Mavor 1809, vol. 5, pp. 25–9; Thomas Newte, *Prospects and observations; on a Tour in England and Scotland: natural, oeconomical and literary* (1791), pp. 291–3.

224 Thomas Hornor, *Description of an Improved Method of Delineating Estates, with Sketch of the Progress of Landscape Gardening in England*

(1813), quoted in Ralph Hyde, 'Thomas Hornor; Pictorial Land Surveyor', *Imago Mundi*, XXIX (1977), pp. 23–34.

225 I consulted the BM, P&D 198.b.6* version, entitled *Illustrations of the Vale of Neath Glamorganshire by Thomas Hornor Inner Temple, 1817*.

226 Glamorgan Record Office, D/D Xfn 1/23.

227 John George Wood, *The Principal Rivers of Wales Illustrated* (1813), vol. 1, pp. v–vi.

228 Ibid., vol. 1, pp. 57–8.

229 Ibid., vol. 2, p. 272.

230 *History of Inland Navigations* 1766, p. 46.

231 This account of the Frog Service draws on the account given of its commission and detailed description of the pieces in Young 1995.

232 Wedgwood MS E25–18450, 23 March 1773, Wedgwood Museum, Barlaston, quoted by Michael Raeburn, 'The Frog Service and its Sources', in Young 1995, p. 136.

233 Wedgwood MS E25–18455, 9 April 1773, Wedgwood Museum, quoted by Gaye Blake Edwards, 'The London Decorating Studio', in ibid., p. 98.

234 Michael Raeburn, 'The Frog Service and its Sources', in ibid., pp. 134–48.

235 Malcolm Baker, 'A Rage for Exhibitions', in ibid., pp. 118–27.

236 Ibid., pp. 189–91, cats G253–8.

237 Ibid., p. 161, cats G82–5.

238 RIBA collection; Smith 1979, pp. 12–14, cat. 1.

239 BL, King's Top 36, 26a–c; Smith 1979, pp. 14–17, cats 2–4. Smith of Derby was one of the first English landscape painters and the father of the engraver John Raphael Smith. The work which first brought him to prominence was *Eight of the most Extra ordinary Prospects in the Mountainous Parts of Derbyshire and Staffordshire commonly called the Moorlands* (1743).

240 For Perry's later career in Liverpool see Martin Hopkinson, 'Print Making and Print Collectors in the North West 1760–1800', in Barker and Kidson 2007, pp. 85–7.

241 Emyr Thomas, *Coalbrookdale and the Darby Family* (Ironbridge, 1999), pp. 46–3, gives the fullest account of these crucial years.

242 I am most grateful to David de Haan for this suggestion.

243 See also Emyr Thomas, 'Coalbrookdale in the Eighteenth Century', *Ironbridge Gorge Museum Trust* (September 2001), pp. 93–9.

244 Williams was awarded a premium by the Society of Arts in 1758. For his 1757 pencil drawing of an ornamental urn see RSA, PR.AR/103/14/46. He worked as a portrait painter in Norwich in the 1760s and, having moved to London in 1766, exhibited frequently at the Royal Academy and elsewhere.

245 Smith 1979, p. 17, cats 5 and 6; Beneke and Ottomeyer 2002, pp. 154–5, cats 15.1 and 2.

246 See, e.g., Peter Oliver's reaction in BL, Egerton 2673, 26 July 1777.

247 Fisher 1992, pp. 264–6.

248 For typical comments see Wyndham 1774, pp. 29–30.

249 Collection of Skandia Insurance Company, Stockholm; reproduced in Barrie Trinder, *The Industrial Revolution in Shropshire* (Chichester, 3rd ed., 2000), p. 100, pl. 54.

250 Smith 1979, p. 18, cat. 10. The painting was purchased by the Ironbridge Gorge Museum in 1992.

251 Smith 1979, p. 17, cat. 7. Rooker travelled to Coalbrookdale early in 1780; in January 1781 he was paid £29 in fees and travelling expenses.

252 BL, King's Top 36.26f–g contains a copy not only of the completed engraving dedicated to George III 'by permission most respectfully inscribed, by his faithful and dutiful subjects – the Coalbrook Dale Company' but also an etched state before letters, perhaps used to solicit the King's permission to dedicate the work to him.

253 Smith 1979, pp. 22–3, cats 16–18.

254 Ibid., p. 25, cat. 19. For a survey of the genre see Mary Schoeser, *Printed Handkerchiefs* (1988).

255 Smith 1979, pp. 25–6 and 33–5, cats 21–5 and 35–7. Around 1790 the pastellist and indefatigable sketcher John Russell not only made a brush drawing of the bridge but also a pencil sketch of the bracing, showing details of a missing rib not otherwise recorded by artists; Birmingham City Museum and Art Gallery, Fine Art Collection. I am most grateful to David de Haan for drawing my attention to these studies.

256 Smith 1979, pp. 26–31, cats. 26–30. As Smith notes, John Boydell was the son of a Shropshire land surveyor.

257 For the reaction of polite tourists see, e.g., Byng in 1784 in Torrington 1934, vol. 1, pp. 184–5; the Duke of Somerset in 1795 in Michell 1845, pp. 18–9; Lord Grantham in 1799, BRO, L31/114/2.

258 Hoare 1983, pp. 167–8.

259 Warner 1802, vol. 2, pp. 186–90.

260 The most extensive recent treatment of the theme is Maiken Umbach, *Federalism and Enlightenment in Germany* (2000); also Maiken Umbach, 'Visual Culture, Scientific Images and German Small-State Politics in the Late Enlightenment', *Past & Present*, CLVIII (1998), pp. 110–45.

261 Thomas Paine believed the design of the bridge was based on his own design for a bridge constructed at Walker's in the late 1780s and displayed in a field in Paddington. He maintained that he was diverted from promoting it further by writing *The Rights of Man*, in response to Burke's attack on the French Revolution, and his subsequent sojourn between 1792 and 1802 in France. See his memoir, *The Construction of Iron Bridges* (1803), addressed to the Congress of the United States.

262 For a laudatory description see Warner 1802, vol. 2, p. 197.

263 John Stickney made the proposal to the Surveyor General of his Majesty's Woods and Parks on 15 May 1799, believing 'it would make an elegant appearance and has combined simplicity, durability and strength. And can be built in less time, and at a much less expense than a stone bridge'; BL, King's Top 8.28-c, letter from John Stickney to William Vaughan, 15 May 1799; see Jane Roberts, *Royal Landscape: The Gardens and Parks of Windsor* (New Haven and London, 1997), p. 143.

264 For Oliver's accounts of Birmingham see, BL, Egerton 2672, 21 August 1776, and Egerton 2673, 21 May 1779 and 19 August 1780 (reversed); also Torrington 1934, vol. 1, p. 49, and Michell 1845, pp. 7–9.

265 BAH, MS 3782/13/53/45. See Peter M. Jones, '"I had L[or]ds and Ladys to wait on yesterday . . .": Visitors to the Soho Manufactory', in Mason 2009, pp. 71–9.

266 Fisher 1992, pp. 252–7, 15 August 1776. For Oliver's account see BL, Egerton 6273, 9 July 1777; also Warner 1802, vol. 2, pp. 212–16. In the late 1740s, William Champion (1709–1789) powered the machinery of his zinc and brass mill on his estate at Warmley outside Bristol with water from the lake in his landscaped grounds. Some of the features of his garden – grottoes, a statue of Neptune – were constructed of recycled waste from the works. Although Champion went bankrupt by 1769, his house and part of the garden survive.

267 Stebbing Shaw, *The History and Antiquities of Staffordshire* (1798–1801), vol. 2, pt 1, pp. 117–21.

268 BL, Egerton 6273, 21 June 1779; see also Warner 1802, vol. 2, pp. 166–9.

269 R. W. Brunskill, 'Lowther Village and Robert Adam', *Transactions of the Ancient Monuments Society*, n.s. XIV (1967–8), pp. 57–74. Although some of the buildings were completed on a regular plan, including a small-scale crescent and square, the project failed.

270 Thomas Pennant, *Tours in Wales* (1810 ed.), vol. 2, p. 148.

271 Tann 1970, pp. 28, 55, 62, 69–70, 86, 149–69.

272 A. W. Skempton, 'Samuel Wyatt and the Albion Mill', *Architectural History*, XIV (1971), pp. 53–73, and Hills 2006, pp. 72–81.

273 Walter G. Strickland, *A Dictionary of Irish Artists* (Dublin, 1913), vol. I, pp. 485–7, *Dublin Historical Record*, XII (1951), p. 84, and XX (1964–5), pp. 36–7; Daphne Foskett, *A Dictionary of British Miniature Artists*, vol. I (1972), p. 330, and Gitta Willemson, *The Dublin Society Drawing Schools Students and Award Winners 1746–1876* (Dublin, 2000), p. 47.

274 The standard history of the Irish linen industry is Conrad Gill, *The Rise of the Irish Linen Industry* (Oxford, 1925) to which this account is indebted. Promoting the linen industry was not confined to Ireland: for encouragement in England see RSA, PR.GE/118/134/171, 19 January 1757, and PR.GE/110/2/133; see also Elizabeth Roberts, ed., *A History of Linen in the North West* (Lancaster, 1998), Alastair J. Durie, *The Scottish Linen Industry in the Eighteenth Century* (Edinburgh, 1979), and Brenda Collins and Philip Ollerenshaw, eds, *The European Linen Industry in Historical Perspective* (Oxford, 2003).

275 Desmond Clarke, *Thomas Prior 1681–1761: Founder of the Royal Dublin Society* (Dublin, 1951). Prior's *List of Absentees of Ireland, and the yearly value of their Estates and Incomes Spent Abroad, with Observations on the Present Trade and Condition of that Kingdom*, went through numerous updated editions from 1729; he advocated the extension of tillage for flax; see also his *Advantages which arise to the People of Ireland by raising Flax and Flax Seed: Together with Instructions for sowing and saving the Seed, and preparing the Flax for the Market* (Dublin, 1732). For the experience of an improving landlord see Sir Richard Cox, *A Letter to Thomas Prior Esq. showing from Experience a sure Method to establish Linen Manufacture, and the beneficial Effect it will immediately produce* (Dublin, 1749), and Prior's further scheme, *An Essay to encourage and extend the Linen Manufactures in Ireland by Premiums and other Means* (Dublin, 1749).

276 Maxine Berg, *The Age of Manufactures 1700–1820* (1994 ed.), pp. 212–13; Brenda Collins, 'Proto-industrialisation and pre-Famine Emigration', *Social History*, VII (1982), pp. 132–4.

277 See, e.g., Robert Stephenson, *Considerations on the Present State of Linen Manufacture* (Dublin, 1754) and *Journal of a Tour of Inspection (in the South)* (Dublin, 1755); *Letter to the Trustees* (Dublin, 1759). John Greer, *Report on the State of the Linen Markets of Ulster* (Dublin, 1784); see also [John Hely Hutchinson], *The Commercial Restraints of Ireland considered in a series of letters to a noble Lord* (Dublin, 1779) and John Nevill, *Seasonable Remarks on the Linen Trade of Ireland* (Dublin, 1783). Unfortunately, no early MS records of the Linen Board appear to have survived.

278 For the nuances of meaning of 'patriotism' see R. F. Foster, *Modern Ireland 1600–1972* (1988), pp. 247–57. Essentially it was a limited form of gentry nationalism, limited because its champions could not afford to forget that their rights to property and power depended on the English Crown.

279 Wheatley's *Dublin Volunteers Meeting on College Green* (National Gallery of Ireland) included portraits of leading members, notably the Duke of Leinster. *Lord Aldborough reviewing Volunteers in Belan Park* (National Trust, Waddesdon) and *Sir John Irwin reviewing Troops in the Phoenix Park* (NPG) were other examples in the same mode. *The Irish House of Commons* (Leeds City Art Gallery) marks the high point of the Irish patriotic movement, showing Henry Grattan making his famous speech of 19 April 1780 on the repeal of the medieval Poynings' Law and calling for independence.

280 Mary Webster, *Francis Wheatley* (1970), pp. 28–51; Crookshank and Glin 2002, pp. 164–6.

281 See also Ch. 5 for the plates on hemp cultivation and processing in Duhamel du Monceau's *Traité de la Fabrique des Manoeuvres pour les Vausseaux, ou l'Art de la Corderie perfectionné* (1747), reproduced in the *Universal Magazine* in 1756. In 1764 Croker's *Dictionary* published an illustration depicting the bleaching of linen (pl. XVI); Croker was Lord Hillsborough's chaplain.

282 Potential markets included not only the Anglo-Irish who divided their time between London and their Irish estates but also the London livery companies who together owned Co. Derry.

283 *Illustrations of the Irish Linen Industry* (1977) provides the most extensive modern commentary on the works. The visits that Arthur Young made in 1776–9 as the agent of Lord Kingsborough (the dedicatee of Hincks's pl. XI) and published in two volumes as *A Tour in Ireland* in Dublin in 1780 provide an unofficial gloss on the plates. As previously noted, Young was a member of the Society of Arts, serving as the Chairman of the Committee of Agriculture in 1773–6 and is prominently represented in Barry's painting of *The Distribution of Premiums*. He presented a copy of his *Tour in Ireland* to the Society and was duly thanked on 23 February 1780. See J. G. Gazley, 'Arthur Young and the Society of Arts', *Journal of Economic History*, I (1942), p. 129. Young's Irish tour and Kingsborough's reputation as a reforming landlord at Mitchelstown, Co. Cork, could explain the latter's inclusion among the dedicatees despite the fact he had no estates in Ulster.

284 *Illustrations of the Irish Linen Industry*, p. 18; Young, *Tour*, vol. I, pp. 110 and 163–9.

285 *Commons Journals*, 1779–82, pp. 320–21.

286 A set was acquired by Matthew Boulton, or his only son, and remained in the family collection, along with prints depicting feats of civil engineering, until Christie's sale at Great Tew Park, 27–29 May 1987, where it was lot 543.

287 T. C. Smout, 'Lead Mining in Scotland, 1650–1850', in Payne 1967, pp. 103–35. On a brief visit to Leadhills during the Scottish tour she made with her brother and Coleridge in 1803, Dorothy Wordsworth was impressed by the library and the 'bookishness' of the people. She was told that the village was a healthy, comfortable and peaceable place to live; *Journals of Dorothy Wordsworth*, ed. William Knight (1930), pp. 178–81.

288 Edinburgh University Library, Special Collections Division, papers of Joseph Black.

289 John Williams, *The Natural History of the Mineral Kingdom* (Edinburgh, 1789), vol. I, p. 314; (1810 ed.) vol. I, p. 250, and vol. 2, p. 452.

290 Smout, 'Lead Mining', p. 106.

291 I am most grateful for this suggestion to Helen Smailes, Senior Curator of British Art, National Gallery of Scotland, who generously gave me access to her file on the paintings.

292 Slotta and Bartels 1990, pp. 212–35; Hans Holländer, 'Die mechanische Künste und die Landschaft als Werkstatt', in Beneke and Ottomeyer 2002, pp. 40–47 and pp. 134–40.

293 See, e.g., George Lambert's view of a wooded landscape with a miner at work in the foreground, c.1733, Yale Center for British Art, New Haven.

294 The whereabouts of the glass manufactory represented is debated; it could have been at Wedgwood's Etruria, James Keir's establish-

ment at Amblecote, Stourbridge, or in Liverpool; Egerton 1990, p. 96, cats 44 and 45. The painting evidently made on the basis of the glasshouse drawings is untraced; Barker and Kidson 2007, p. 182, cats 59 and 60. For the iron forge see Egerton 1990, p. 97, cat. 46.

295 Quoted in Egerton 1990, p. 98.

296 In the late 1760s the younger members of the Society including Wright began to meet together once a week in the evening for music-making and drinking at Munday's coffee-house in Maiden Lane, London. They called themselves the Howdalian Society in memory of a friend and art lover, Captain Howdell. Three of the group, James Gandon, Thomas Jones and John Hamilton Mortimer, had all attended Shipley's drawing school. Mortimer and Wright had both been pupils of Thomas Hudson.

297 Hargraves 2005, pp. 136–7.

298 Egerton 1990, pp. 99–101, cats 47 and 48; Barker and Kidson 207, pp. 167–9, cats 41 and 42; see also David Fraser, 'Joseph Wright and the Lunar Society', in Egerton 1990, pp. 20–22.

299 Reviews do not mention the classical subject Wright exhibited that year, *Miravan . . . breaking Open the Tomb of his Ancestors in Search of Wealth*, which was possibly outshone by Mortimer's *Belisarius*. Hargraves 2005, p. 128, suggests that Wright might have intentionally displayed works representing both the higher and lower ends of the artistic spectrum as a riposte to Reynolds's fourth Discourse, delivered in December 1771, when he censured Dutch 'minuteness' and praised the painter of ideal, generalised scenes.

300 Egerton 1990, pp. 102–3, cat. 49.

301 Walpole, annotated RA catalogue, 1772, p. 25, Rosebery collection.

302 Ibid., pp. 103–4, cat. 50.

303 Young 1995, pp. 157–8, cats G58–62.

304 For a stimulating discussion of the meaning of this work and Wright's forge paintings in general see David Solkin, 'Joseph Wright of Derby and the Sublime Art of Labor', *Representations*, LXXXIII (2003), pp. 167–94.

305 Allen 1960, f. 186, points out that 'Mother Shipton', first staged in 1770, had included Yorkshire scenery.

306 Ibid., ff. 186–208, pieces together the content of the pantomime from contemporary descriptions, advertisements, reviews and reminiscences.

307 Two maquettes for the stage scenery representing the Peak's Hole survive in the V&A; Allen 1960, ff. 201–3, and Joppien 1973, cat. 83.

308 Allen 1960, ff. 197–8, quoting from *An Account of the Wonders of Derbyshire, Introduced in the Pantomime Entertainment at the Theatry-Royal, Drury Lane* (1779).

309 Egerton 1990, p. 184, cat. 113.

310 Ibid., p. 194, cat. 123.

311 Ibid., pp. 198–200, cat. 127 has been superseded for it is clear that the second version, bought at Sotheby's on 24 November 2005, lot 13, by Philip Mould and now restored, is not a copy but an autograph version in much better condition. Wright also produced a view of Cromford Bridge, a daytime view of the mills and a view of Arkwright's new gothic mansion, Willersley Castle, on the opposite bank of the river, the last commissioned by Jedediah Strutt.

312 Derby Museum and Art Gallery.

313 Daniels 1993, p. 66.

314 Torrington 1934, vol. 2, pp. 40 and 195.

315 Warner 1802, vol. 2, p. 143.

316 *Morning Herald*, 9 May 1787, quoted in Anne Puetz, 'Foreign Exhibitors and the British School at the Royal Academy, 1768–1823', in Solkin 2001, pp. 230–34.

317 Joppien 1973, cat. 49; reproduced in Stephen Daniels, 'Louther-

bourg's Chemical Theatre: Coalbrookdale by Night', in Barrell 1992, p. 215, by permission of the Duke of Abercorn.

318 Joppien 1973, cat. 50. An aquatint was made of the scene by Joseph Constantin Stadler and published by Robert Bowyer in 1800.

319 Peter Coxe, *A Catalogue of all the valuable Drawings & c . . . of James Philip de Louterbourg Esq R.A.* (18 June 1812).

320 Allen 1960, ff. 321–7, translated from the French, Yale-Rockefeller Print Collection.

321 The drawings passed from the collection of Dr Munro to Turner and formed part of the 1851 Turner Bequest, deposited at Tate Britain.

322 Ian McCalman, 'Magic, Spectacle and the Art of de Loutherbourg's Eidophusikon', in Ann Bermingham, *Sensation and Sensibility: Viewing Gainsborough's Cottage Door* (New Haven and London, 2005), pp. 180–97.

323 Ralph Hyde, *Panoramania!* (1989), pp. 115–16, cat. 89.

324 Iain McCalman, *The Seven Ordeals of Count Cagliostro: Count Cagliostro, Master of Magic in the Age of Reason* (2003), pp. 161–8 and 186–9.

325 *Cutting out of the French Corvette 'La Chevrette' by English Soldiers, with Portraits of the Officers Engaged, 21st July 1801* (exh. R.A. 1802); *Decisive Battle of Alexandria* and *Landing of the British Troops in the Bay of Aboukir* (exh. 1805); Puetz, 'Foreign Exhibitors', pp. 234–5.

326 Daniels, 'Loutherbourg's Chemical Theatre', p. 228.

327 Helmut von Erffa and Allen Staley, *The Paintings of Benjamin West* (New Haven and London, 1986), pp. 391–2, cat. 403. John Hamilton Mortimer had exhibited a characteristically terror-charged drawing of *Death on a Pale Horse* at the Society of Artists as early as 1775. For the etching by Joseph Haynes after the drawing, published in 1784, see Myrone 2006, p. 185, cat. 131.

328 Myrone 2006, p. 190, cat., 136; Joppien 1973, cat. 69.

329 David Bindman, 'The English Apocalypse', in Frances Carey, ed., *The Apocalypse and the Shape of Things to Come* (1999), pp. 212–14; Myrone 2006, pp. 177–205.

330 Warner 1802, vol. 2, pp. 186–7.

331 Humphry Repton, *An Enquiry into Changes in Taste in Landscape Gardening* (1806), pp. 121–2, quoted in Daniels 1999, p. 14.

332 Ibid., p. 233.

333 Ibid., pp. 245–50.

334 Ibid., p. 247.

335 A hundred of the engravings were retouched by Walker and printed on better paper in a volume entitled *The Itinerant* (1799).

336 Stephen Daniels points out that the judgement was somewhat premature in the case of the Nottingham Canal, as its construction ran into financial difficulties and it was fully completed only in 1802; 'Reforming Landscape: Turner and Nottingham', in Peter de Bolla, Nigel Leask and David Simpson, eds, *Land, Nation and Culture, 1740–1840: Thinking the Republic of Taste* (Basingstoke, 2005), pp. 15–21.

337 *Copper-Plate Magazine*, vol. 3, no. lx, pl. cxix, 1797.

338 Ibid., vol. 4, no. lxxix, pl. clvii, 1798.

339 Ibid., no. lxxxvi, pl. clxxii, 1799.

340 Ibid., no. lxxx, pl. clx, 1798.

341 Ibid., nos lxxxi and liv, pl. clxii, 1798. In the only sign of industrial advocacy, it added: 'The manufacture of iron at this foundry is extended as much as the situation will admit; but in the conveyance of so weighty an article the want of a navigable canal is necessarily felt as a great inconvenience.' The village of Ayton was shown in a subsequent number so perhaps the publisher had a personal reason for special pleading.

342 Ibid., vol. 5, no. cxxv, pl. ccl, 1802.

343 Abbey 1952, pp. 37–8, nos 48–9.

344 Ibid., pp. 7–8, no. 9.

345 Thomas Hornor, *Description of an Improved Method of Delineating Estates, with a Sketch of the Progress of Landscape Gardening in England* (1813), quoted in Ralph Hyde, 'Thomas Hornor: Pictorial Land Surveyor', *Imago Mundi*, XXIX (1977), pp. 23–34.

346 Tate, Turner Bequest; James Hamilton, *Turner and the Scientists* (1998), pp. 44–6.

347 NLW. The drawing on which it is based is in Tate, Turner Bequest, South Wales sketchbook, p. 6.

348 Cyfarthfa Castle Museum, Merthyr Tydfil (Ibbetson); Tate, Turner Bequest.

349 NMC.

VIII *The Arts Divided?*

1 The drawings by Joseph Clement, a skilled Maudslay-trained toolmaker and draughtsman, are now in SMLA, with Babbage's own 'scribbling books'. Some are illustrated in Doron Swade, *Charles Babbage and his Calculating Engines* (1991), pp. 8–15.

2 Charles Babbage, *Passages from the Life of a Philosopher* (1864), pp. 17–18, 365–7, 425–7; Simon Schaffer, 'Babbage's Dancer and the Impresarios of Mechanism', in Frances Spufford and Jenny Uglow, eds, *Cultural Babbage: Technology, Time and Invention* (1996), pp. 53–80.

3 Shee 1805, p. x.

4 Shee 1805, 2nd ed., pp. liv–lvi. According to his son, also named Martin Archer Shee, the work was a great success; *The Life of Sir Martin Archer Shee* (1860), vol. 1, pp. 270–71.

5 As is evident from the enrolled drawings, reproduced in lithographic form in *Letters Patent and Specifications of Letters Patent from March 2nd, 1617 to September 30th, 1852*. After 1800, not only did the number of patents increase dramatically but also the number of drawings and extent of detail provided in the specifications submitted.

6 'Sketches and Estimates of Machinery used in Constructing the Caledonian Canal and Runcorn Bridge' (1817), from the Telford archive at ICEL.

7 Rennie's report books, twelve from 1790 to 1821 and others on specific projects, ICEL.

8 Now stored at the Museum in Docklands, Museum of London; see Fox 1992, pp. 232–6, for an overview of these drawings described in detail by Alex Werner. A. W. Skempton, 'Engineering in the Port of London, 1789–1808', *TNS*, L (1978), pp. 87–108, and 'Engineering in the Port of London, 1808–34', *TNS*, LIII (1981), pp. 73–96.

9 See esp. A. P. Woolrich, 'Joseph Clement', and John Cantrell, 'James Nasmyth', in Cantrell and Cookson 2002, pp. 54–73 and 129–46.

10 HL 1851, XVIII, qu. 1281, quoted by Richard L. Hills, 'Richard Roberts', in Cantrell and Cookson, p. 54.

11 P. J. Booker, 'Gaspar Monge (1746–1818) and his Effect on Engineering Drawing and Technical Education', *TNS*, XXXIII (1960), pp. 15–36; Peter Geoffrey Booker, *A History of Engineering Drawing* (1979), pp. 128–49.

12 For the potential and the limits of this abstracted form of orthography see Alder 1998.

13 For the early history of the Conservatoire see Claude Fontanon, 'Les Origines du Conservatoire des arts et métiers et son fonctionnement à l'époque révolutionnaire – 1750–1815', and Robert Fox, 'Un Enseignement pour une nouvelle ère: le Conservatoire des arts et métiers – 1815–1830', *Cahiers d'histoire du CNAM*, 1 (1994), pp. 17–44 and 75–92. For the early history of the Petite Ecole see Alain Mercier, 'Les Débuts de la "petite école": un apprentissage graphique, au Conservatoire, sous l'Empire', and Louis André, 'César Nicolas Leblanc et le dessin des machines', *Cahiers d'histoire du CNAM*, IV (1994), pp. 27–55 and 71–91. André points out that from 1819, under Leblanc's instruction, the drawing technique advanced by the school was increasingly dry and formal, lacking the colour washes employed in earlier drawings.

14 Margaret Bradley and Fernand Perrin, 'Charles Dupin's Study Visits to the British Isles, 1816–1824', *T&C*, XXXII (1991), pp. 47–68.

15 For the differences of attitude to industrial training on the part of la Rochefoucauld-Liancourt and Charles Dupin see Charles R. Day, 'Le Duc de la Rochefoucauld-Liancourt, un philanthrope français (1747–1827)', *Cahiers d'histoire du CNAM*, 1 (1994), pp. 51–61, in response to the article by Robert Fox, 'Education for a New Age: The Conservatoire des Arts et Métiers, 1815–1830', first published in Cardwell 1974, pp. 23–38.

16 The Ecole Centrale des Arts et Manufactures, founded in 1829, extended its fields of study to cover a much broader spread of sciences and offered qualifications by examination after three-year courses. It became a more prestigious institution than the Petite Ecole, producing men who would have the intellectual and social status of the polytechniciens. Yet, as Alder 1998, pp. 518–25, has pointed out, French artillery engineers encountered serious problems in attempting to realise their idealised designs and drawings.

17 George Birkbeck, 'Preface' to Dupin 1827, pp. ii–iii.

18 Dupin 1827, p. 272–3. For the early history of mechanics' institutes see New 1961, pp. 328–46.

19 HC 1835, v, qu. 1108, evidence of James Skene, the secretary to the Board of Trustees for the Encouragement of Manufactures in Scotland; HC 1836 IX, qu. 394, evidence of Mr D. R. Hay, an Edinburgh house-painter, decorator and gilder; see also Macdonald 1970, p. 76.

20 HC 1835, v, qu. 1500; see also *Appendix, No. 3*, p. 146, which lists the subjects taught, enrolment and attendance figures. The class of 'Drawing – Architectural, Mechanical, Perspective and Ornamental', held on Monday and Thursday evenings, attracted 39 members, with an average attendance of 28.

21 HC 1835, v, qu. 1566.

22 Ibid., qus 1523, 1538, 1557.

23 Ibid., qus 1650–52.

24 Ibid., qus 1589–91 and 1598.

25 Ibid., qus 1653–64.

26 HC 1836 IX, qus 290–330.

27 Macdonald 1970, pp. 60–128.

28 *Seconde exposition publique des produits de l'industrie Française* (Paris, An 10 [1801]).

29 Sir David Brewster, *Letters on Natural Magic, addressed to Sir Walter Scott, Bart.* (1832), pp. 285–6.

30 Thomas Carlyle, in 'Signs of the Times', published in the *Edinburgh Review* in 1829.

31 Maudslay's epitaph, probably composed by Joshua Field, described him as 'a zealous promoter of the arts and sciences, eminently distinguished as an engineer for mathematical accuracy and beauty of construction'; K. R. Gilbert, *Henry Maudslay: Machine Builder* (1971), p. 31. For the classicising of the machine in the United States as well as Britain see Julie Wosk, *Breaking Frame: Technology and the Visual Arts in the Nineteenth Century* (New Brunswick, N. J., 1992), pp. 178–210.

32 Samuel Clegg jr, *Architecture of Machinery: An Essay on Propriety of Form and Proportion with a View to Assist and Improve Design* (1842), pp. 3–4, 8, 17.

33 D. G. C. Allan, 'The Society of Arts and the National Repository', *RSAJ*, CXLIII (May 1995), pp. 43–5.

34 Altick 1978, pp. 376–7.

35 Ibid., pp. 377–82. See Eugene S. Ferguson, *Early Engineering Reminiscences of George Escoll Sellers* (Washington, D.C., 1965), pp. 131–4 for a visitor's reaction to Perkins's Gallery in 1832; *National Gallery of Practical Science*, catalogue (7th ed., 1834).

36 As noted in the *Mirror of Literature*, 3rd ser., II (1847), p. 322.

37 Altick 1978, pp. 382–9; J. Lawrence Pritchard, *Sir George Cayley: The Inventor of the Aeroplane* (1961), pp. 125–7, and Ethel M. Wood, *A History of the Polytechnic* (1965), pp. 17–24.

38 Albert Smith, 'The Polytechnic Diving-Bell', in *Comic Sketches from the Wassail Book* (1848), pp. 58–60.

39 A summary of mechanics' institutions' exhibitions is given in Kusamitsu, 1980; see also Tylecote 1957, pp. 178–83 and 269–74.

40 *Catalogue of Articles contained in the Exhibition of the Derby Mechanics' Institution* (Derby, 1839). I am most grateful to David Fraser, retired Director of Derby Museum and Art Gallery, for bringing the catalogue to my attention.

41 This might have been a Mr Etty who made something of a career of touring mechanics' institution exhibitions, demonstrating the art of glass blowing; Kusamitsu 1980, pp. 80–81.

42 According to ibid., pp. 79–81 and 84–5, the willing participation of Leeds manufacturers and the gentry, including Mr Fawkes of Farnley Hall who offered the family collection of Turner watercolours, in the 1839 exhibition was exceptional; see also William West, Edward Baines et al., *A Description of some of the principal Paintings, Machinery and other Curiosities at the Leeds Public Exhibition* (Leeds, 1839).

43 Tylecote 1957, p. 238.

44 Kusamitsu 1980, pp. 82–4.

45 James Watt, 'Note upon the Meeting of the British Scientific Association at Birmingham', quoted in Morrell and Thackray 1981, p. 264; see also *Catalogue of the Illustrations of Manufactures, Inventions and Models, Philosophical Instruments, etc., Contained in the Second Exhibition of the British Association for the Advancement of Science, Held at Birmingham, August, 1839* (Birmingham, 1839).

46 Charles Dickens, in *Bentley's Miscellany*, IV (1838), pp. 209–24.

47 Albert Smith, *The Wassail-Bowl* (1843), vol. 1, pp. 75–6.

48 Albert Smith, *Gavarni in London* (1849), pp. 13–14.

49 *Partners in Science: Letters of James Watt and Joseph Black*, ed. Eric Robinson and Douglas McKie (1970), pp. 132–3, letter 94, 20 January 1784.

50 Ibid., pp. 134–5, letter 95, 10 February 1784.

51 RS, MM/3/30, 13 May 1790.

52 SMLA, Good, A 208. The Reports of the Commissioners of Naval Enquiry and Revision were published as *Parliamentary Papers* between 1806 and 1809, the first three on the Royal Dockyards in 1806.

53 Ibid., B17, 17 February 1807.

54 Ibid., A202–4.

55 See, e.g., Goodrich's letter of recommendation to the Navy Board for Pharaoh Tillet, regarding his qualification for the position of engineer on vessels overseas, on the grounds that although he could barely read or add up, 'he has great practical experience in the management of steam boat engines and is not afraid to take the charge of working them and keeping them in order'; SMLA, Good, A1365, 31 August 1828.

56 Penelope J. Corfield, *Power and the Professions in Britain 1700–1850* (1995), p. 181.

57 Quoted in J. G. Watson, *The Civils: The Story of the Institution of Civil Engineers* (1988), p. 9.

58 Quoted from the Institution's first minutes by Buchanan 1989, p. 62.

59 Quoted in Sir Alexander Gibb, *The Story of Telford: The Rise of Civil Engineering* (1935), p. 194.

60 Ibid., p. 197, quoting the Institution minutes, 3 February 1820.

61 Buchanan 1989, pp. 63–5.

62 Thompson 1968, pp. 94–100, 128–47, 182–201.

63 For the role of the Marquis de Concordet in promoting the doctrine see Charles Coulston Gillispie, *Science and Polity in France: The Revolutionary and Napoleonic Years* (Princeton and London, 2004), pp. 112–24. However, Ken Alder, *Engineering the Revolution: Arms and Enlightenment in France 1760–1815* (Princeton and London, 1997), p. 339, points out that French military engineers, trained at the Ecole Polytechnique which replaced the Ecole du Génie, made little technical progress in the face of traditional modes of production and political reaction.

64 David M. Knight, 'Science and Professionalism in England, 1770–1830', in David M. Knight, *Science in the Romantic Era* (Aldershot, 1998), pp. 121–35, and S. S. Schweber, 'Scientists as Intellectuals: The Early Victorians', in James Paradis and Thomas Postlewait, eds, *Victorian Science and Victorian Values: Literary Perspectives* (New Brunswick, N.J., 1985), pp. 1–37. For wide-ranging studies of the role played by science in the provinces (Edinburgh, Bristol, Manchester, Newcastle upon Tyne and the West Riding of Yorkshire) as well as London, see Inkster and Morrell 1983.

65 For an overview of the metropolitan world of science in the Regency period see Iwan Morus, Simon Schaffer and Jim Secord, 'Scientific London', in Fox 1992, pp. 129–42.

66 BAH, MS 3782/12/57/102/67; Morris Berman, *Social Change and Scientific Organization: The Royal Institution, 1799–1844* (1978), p. 76.

67 Ian Inkster, 'Science and Society in the Metropolis: A Preliminary Examination of the Social and Institutional Context of the Askesian Society of London, 1796–1807', *Annals of Science*, XXXIV (1977), pp. 1–32, reprinted in Inkster, *Scientific Culture and Urbanisation in Industrialising Britain* (Aldershot, 1997).

68 Sir Humphry Davy (President of the Royal Society), Sir Thomas Lawrence (President of the Royal Academy), Sir Francis Chantrey, Robert Smirke and Samuel Rogers were among its founder members and Michael Faraday was its first secretary; F. R. Cowell, *The Athenaeum Club and Society Life in London 1824–1974* (1975), pp. 8–13.

69 In 1815, Timothy Claxton, a self-educated London working man, was refused permission to join a philosophical society: 'I am a mechanic, and though that is the very reason why I wish to be admitted . . . it is the very reason also why I am not.' In 1817 he founded a mechanical institution which closed in 1820 when Claxton left the country; Timothy Claxton, *Hints to Mechanics* (1839), quoted in New 1961, p. 331.

70 George Lees, *Elements of Arithmetic, Algebra, and Geometry for the use of the Students in the Edinburgh School of Arts* (Edinburgh, 1826), pp. 2–3.

71 New 1961, pp. 336–9.

72 See, e.g., *Inaugural Discourse of Henry Brougham Esq., M.P., on being installed Lord Rector of the University of Glasgow, Wednesday, April 6, 1825* (Glasgow, 1825), pp. 44–7.

73 Henry Brougham, *A Discourse on the Objects, Advantages and Pleasures of Science* (1827), pp. 40–48.

74 New 1961, pp. 342–3. The responses to the questionnaire are deposited in the library of University College London.

75 The preamble emphasised that it was not intended to teach particular trades; Annual Report (1828), p. 23, quoted in Mabel Tylecote, 'The Manchester Mechanics' Institution, 1824–50', in Cardwell 1974, p. 55.

76 The ban on religious and political debates and the constitution, modelled on that of the Edinburgh School of Arts, which gave total power to the honorary members, exacerbating the growing social gulf between employers and workmen, contributed to the failure of the Manchester Mechanics' Institution to attract the class for whom it was intended; Mabel Tylecote, 'The Manchester Mechanics' Institution, 1824–50', in ibid., pp. 55–86.

77 R. G. Kirby, 'An Early Experiment in Workers' Self-education: The Manchester New Mechanics' Institution, 1829–35', in ibid., pp. 87–98.

78 New 1961, p. 345, who nevertheless points out that such 'white-collar workers' were just as unprivileged intellectually and earned rather less than the 'skilled labourers' among those for whom the mechanics' institutes were originally intended.

79 Tylecote 1957, pp. 262–93.

80 Charles Babbage, *Reflections on the Decline of Science in England and on some of its causes* (1830).

81 [David Brewster], 'Decline of Science in England', *Quarterly Review*, XLIII (1830), pp. 305–42.

82 [Gerrit Moll], *On the Alleged Decline of Science in England* (1831).

83 Babbage 1832, pp. 307–9.

84 The narrow victory of the King's brother, the Duke of Sussex, over the astronomer John Herschel, it has been argued, was less a symptom of aristocratic privilege than of moderation and conciliation between competing factions of a Society under attack from many quarters; Roy MacLeod, 'Whigs and Savants: Reflections on the Reform Movement in the Royal Society, 1830–48', in Inkster and Morrell 1983, pp. 55–90.

85 Morrell and Thackray 1981, p. 12.

86 Babbage 1832, pp. 312–13.

87 William Whewell, 'Address to the Cambridge Meeting', *1833 Report*, pp. xxiv–xxv.

88 Morrell and Thackray 1981, pp. 256–8.

89 King's College London, Faculty of Engineering records; F. J. C. Hearnshaw, *The Centenary History of King's College London, 1828–1928* (1928). Regular lectures in engineering at University College London commenced in 1833 and the first professor of engineering was appointed in 1841, before the appointment of one at King's; Negley Harte and John North, *The World of UCL, 1828–2004* (2004 ed.).

90 Morrell and Thackray 1981, pp. 262–4, 472–4, 505–9.

91 Ibid., pp. 265–6.

92 Babbage 1832, pp. 318–19.

93 Charles Dickens, in *Bentley's Miscellany*, II (1837), pp. 397–413.

94 Charles Dickens, 'Full Report of the Second Meeting of the Mudfog Association for the Advancement of Everything', staged at Oldcastle (Newcastle) appeared in *Bentley's Miscellany*, IV (1838), pp. 209–27. Dickens received his account of the Newcastle meeting from John Forster. Writing to thank him in August 1838, he commented: 'The Quackery is of extra strength this year I think'; *The Letters of Charles Dickens*, vol. I (1820–30), ed. Madeline House and Graham Storey (Oxford, 1965), p.301. For a further analysis of the papers and

95 other parodies of the British Association see G. A. Chaudhry, 'The Mudfog Papers', *Dickensian*, LXX (1974), pp. 104–12.

For more information about the enterprising and convivial Bisset see Leonore Davidoff and Catherine Hall, *Family Fortunes: Men and Women of the English Middle Class 1780–1850* (1987), pp. 249–50, 283, 416–19; their information about Bisset is drawn from the 5 volumes of 'Reminiscences of James Bisset' in Leamington Public Library, CR1563/246–51; also T. B. Dudley, ed., *Memoir of James Bisset* (Leamington Spa, 1904). He was such an avid collector that he opened a museum looked after by his wife.

96 BL, 289.i.24.

97 Three more plates were added when *Magnificent Directory* was published in numbers, two relating to fire offices and insurance companies and the third a miscellany of businesses, including a school for young ladies in the neighbourhood of Birmingham.

98 Robert Darnton, *Business of Enlightenment: A Publishing History of the Encyclopédie, 1775–1800* (Cambridge, Mass., 1979), pp. 419–20 and 450–51.

99 Yeo 2001, pp. 175–6 and 179–80.

100 Frank A. Kafker, 'William Smellie's Edition of the Encyclopaedia Britannica', in Kafker 1994, pp. 145–82.

101 Gaspard de Prony's *Nouvelle Architecture Hydraulique* was published in Paris in 1796.

102 Stewart's Dissertation appeared in two parts in the *Supplement*; part 1, vol. 1 (1815), pp. 1–166, and part 2, vol. 5 (1821), pp. 1–257; Yeo 2001, pp. 253–5.

103 Notably Thomas Love Peacock in *Headlong Hall* (1815) in the shape of Mr Panscope, 'the chemical, botanical, geological, astronomical, mathematical, metaphysical, meteorological, anatomical, physiological, galvanistical, musical, pictorial, biographical, critical philosopher, who had run through the whole circle of sciences, and understood them all equally well'. Panscope's supposed polymathy was based on swallowing the entire *Encyclopaedia Britannica* and he sat in a corner with a volume of Rees's *Cyclopaedia*; when he spoke he was incomprehensible.

104 [Alexander Blair], 'Advancement and Diffusion of Knowledge', *Blackwood's Magazine*, XVI (1824), pp. 26 and 32.

105 Napier, *Supplement*, vol. 1 (1815), p. 4, quoted in Yeo 2001, p. 259.

106 Ibid., pp. 271–5.

107 John Martin Robinson, *The Wyatts: An Architectural Dynasty* (Oxford, 1979), pp. 16–17.

108 John Hewish, *Rooms near Chancery Lane: The Patent Office under the Commissioners, 1852–1883* (2000), pp. 38–9.

109 Publication of a pirate American edition began in Philadelphia in 1806 and when completed in 1822 extended to 41 vols of letterpress, with the 5 vols of plates and an atlas adapted to American interests.

110 [Rotherham] 1786, pp. 403–4.

111 'Account of Dr Rees's Cyclopaedia', *Philosophical Magazine*, LVI (1820), pp. 218–24.

112 Farey's career is comprehensively covered in the following works, to which I am greatly indebted: A. P. Woolrich, 'John Farey Jr (1791–1851): Engineer and Polymath', *History of Technology*, XIX (1997), pp. 111–42, Woolrich 1998, and Woolrich 2000.

113 Woolrich 1998, figs 1 and 2. Two notebooks survive in the possession of the Farey family in America.

114 'Cyclopaedia', *Philosophical Magazine*, LVI (1820), pp. 219–20; Woolrich 1998, Appendix, p. 67.

115 The drawing devices won him prizes from the Society of Arts in 1813 and 1814. For a discussion as to the accuracy of Farey's drawings for Rees's *Cyclopaedia* see Woolrich 1998, pp. 62–5.

116 BL, Add. MS 34611, f. 43, 7 February 1814, Farey's response to the enquiries made by Macvey Napier regarding potential contributions to the sixth edition of the *Encyclopaedia Britannica* (1823). He also contributed to the *Edinburgh Encyclopaedia* (1808–30), *British Cyclopaedia* (1809), *Encyclopaedia Londonensis* (1810–24), *Pantologia* (1813), *Encyclopaedia Metropolitana* (1817–45) and other non-encyclopaedic publications.

117 For Farey's anonymous or pseudonymous technical works see Woolrich 1998, p. 50.

118 See BL, Add. MS 37184, f. 453, 15 December 1829, for the detailed breakdown of his sphere of competence which Farey gave to Edward Smedley, the editor of the *Encyclopaedia Metropolitana*. He had enough material without involving any additional research to cover virtually every branch of industry involving machinery, 'a multitude of other subjects upon which great ingenuity has been exercised' and all forms of transport and communication.

119 HC 1829, III, p. 17, quoted in Woolrich 1998, p. 57.

120 Woolrich 2000, pp. 63–106.

121 John Farey, *Treatise on the Steam Engine* (1827), p. vi.

122 Farey's *Treatise* sold for 5 guineas, compared with Tredgold's, priced at 2 guineas, Partington's at 16s and Meikleham's at 8 then 10s; see SMLA, Good, A 1303 for Farey's letter to Goodrich of November 1827, just before publication of the first volume, urging Goodrich and his professional friends to buy copies and expressing fears of competition from the sale of Birkbeck's work to general readers on account of its plates: 'I have taken great pains to make mine instructive to all those who have not as good opportunities of observation as I have had myself. It is from professional men who are competent judges that I must expect the reputation of my work to be formed amongst the public.' The second volume was finally published (with a facsimile of the first), reproduced from the page proofs with author's corrections: John Farey, *Treatise on the Steam Engine* (Newton Abbott, 1971).

123 Meikleham's *History* had gone into 5 editions by 1838. His octavo *Historical and Descriptive Anecdotes of Steam engines and of their Inventors and Improvers*, published in 2 vols in 1829 at 15s, was adorned with fine engravings of the machines, portraits and autographs of the inventors, and wood-engraved headpieces of mechanically minded putti. Other early histories of the steam engine include Dionysius Lardner, *Popular Lectures on the Steam Engine* (1828; in 1836 and later editions *The Steam Engine Familiarly Explained and Illustrated*) and Elijah Galloway, *History and Progress of the Steam Engine* (1831); H. W. Dickinson and A. A. Gomme, 'Robert Stuart Meikleham', *TNS*, XXII (1946 for 1941–2), pp. 161–7.

124 Meikleham 1824, pp. iv–vi. Trevithick was still in South America.

125 Thomas Tredgold, *Elementary Principles of Carpentry* (1820), pp. vii–x; L. G. Booth, R. J. M. Sutherland and N. S. Billington, 'Thomas Tredgold (1788–1829): Some Aspects of his Work', *TNS*, LI (1979), pp. 57–94.

126 Thomas Tredgold, *The Steam Engine* (1827), pp. v–vi.

127 A. P. Woolrich, 'Joseph Clement', in Cantrell and Cookson 2002, pp. 94–7. Clement also supplied drawings of steam engines to Partington and Lardner.

128 Woolrich 2000, pp. 70–72.

129 E.g., *BM Satires*, 15178 (1826), 15604† (1828), 15779 and 15978 (1829).

130 George Dodd's descriptions of visits to London manufactures, which first appeared in the *Penny Magazine*, were reissued in a single volume as *Days at the Factories; or, The Manufacturing Industry of Great Britain* (1843), billed as an acceptable form for young persons and supposedly already used 'in the higher classes of schools, among others in the engineering class of King's College'.

131 *Mechanics' Magazine*, I (1823), pp. 16 and 32. Other publications of the genre include the *London Mechanics' Magazine, Museum, Register, Journal and Gazette* (1823–38), *New London Mechanics' Register and Magazine of Science and the Useful Arts* (1827) and John Timbs's *Arcana of Science and Art* (from 1832, . . . *and Annual Register of the Useful Arts*), which lasted from 1827 to 1837 and then became, from 1839, the *Year Book of Science and Art*. Mechanics' magazines were published also in Glasgow and Philadelphia in the 1820s.

132 Patricia Hollis, *The Pauper Press: A Study in Working-Class Radicalism of the 1830s* (Oxford, 1970), pp. 3–25, and Yeo 1993, pp. 38–48.

133 Babbage 1832, pp. 93–7.

134 Ibid., pp. 307–20.

135 Edward Baines Esq., M.P., *History of the County Palatine and Duchy of Lancaster* (1834–6), vol. I, p. ix. In fact it was preceded by Richard Guest, *A Compendious History of the Cotton-Manufacture; with a disproval of the claim of Sir Richard Arkwright to the invention of its ingenious machinery* (Manchester, 1823), but as its title and place of publication suggest, this was more of an attack on Arkwright for having stolen Robert High's invention than a serious history.

136 Baines 1834–6, vol. 2, pp. 397–530.

137 Baines 1835, pp. 433–502.

138 The earliest use of 'technological' I have come across, meaning in this context, literally, the study or science of art.

139 Andrew Ure, *The Philosophy of Manufactures: or, An Exposition of the Scientific, Moral, and Commercial Economy of the Factory System of Great Britain* (1835), pp. 7–24.

140 Andrew Ure, *The Cotton Manufacture of Great Britain systematically investigated* (1836), p. iv. Ure made the title of his work much more explicit, stung by criticism in the *Edinburgh Review*, LXI (1835), pp. 453–72, of his *Philosophy of Manufactures* for its neglect of manufactures not undertaken by machines.

141 'G. W.', 'Mr Babbage and the Useful Arts', *Cobbett's Magazine*, II (1833), pp. 381–97.

142 Ibid., p. 383.

143 Ibid., pp. 391–2.

144 Ibid., pp. 392–3.

145 See Ch. 5.

146 'G. W.', 'Mr Babbage and the Useful Arts', pp. 393–4.

147 They were right. It passed to James Watt jr and then to the Boulton family; it was acquired through Christie's by Birmingham Art Gallery in 2006 for £302,200. For an overview of Watt's iconography see Ingamells 2004, pp. 475–9.

148 The portrait passed to Watt's daughter Margaret and thence by descent in the Gibson-Watt family. It was bought from a Los Angeles bookseller by the Huntington Art Gallery in 1963; Robyn Asleson et al., *British Paintings at the Huntington* (New Haven and London, 2001), pp. 314–17.

149 The second version, ordered by James Watt jr in 1816, struck Maria Edgeworth 'almost breathless' when she saw it in 1820, framed by an arch at the end the great gallery at Aston Hall; A. J. C. Hare, ed., *The Life and Letters of Maria Edgeworth* (1894), pp. 275–6. It was sold to a private collector at Sotheby's James Watt sale, 20 March 2003, lot 57. A third version, produced in 1816 for a cousin, Colonel Campbell, is now in Glasgow Art Gallery and a fourth is in Watt College, Greenock; Ingamells 2004, p. 478.

150 Walker 1985, vol. I, p. 410.

151 For an illuminating account of its commissioning see Christine MacLeod, 'James Watt, Heroic Invention and the Idea of the Indus-

trial Revolution', in Berg and Bruland 1998, pp. 96–115; also MacLeod 2007, pp. 91–124.

152 MacLeod, 'James Watt', p. 99.

153 Hugh Torrens, 'Jonathan Hornblower (1753–1815) and the Steam Engine: An Historical Analysis', in Smith 1994, p. 28.

154 Arthur Penryhn Stanley, *Historical Memorials of Westminster Abbey* (1868), pp. 349–50, quoted in MacLeod, 'James Watt', p. 96.

155 [Charles Hampden Turner, ed.], *Proceedings of the Public meeting held at Freemasons' Hall, on the 18th June, 1824, for Erecting a Monument to the Late James Watt* (1824), pp. 8–9, 13, 16.

156 Glasgow, Greenock and Edinburgh organised subscriptions for their own monuments; MacLeod, 'James Watt', pp. 104–6.

157 Thomas Carlyle, *Chartism* (1840 ed.), pp. 84–5.

158 MacLeod 2007.

159 *Address of Sir John Rennie to the Annual General Meeting of the Institution of Civil Engineers, January 1846* (1846), p. 106.

160 'Commissioners of Patents. Catalogue of the Gallery of Portraits of Inventors, Discoverers, and Introducers of Useful Arts, collected by Bennet Woodcroft', 1st ed. 1855, published as 'National Gallery of Portraits', *Commissioners of Patents' Journal*, 119 (1855), p. 119, 2nd ed. 1858.

161 Timbs also produced *Curiosities of Science* (1860) and *Wonderful Inventions; from the Mariner's Compass to the Electric Telegraph Cable* (1867). For Lucy Brightwell, *Heroes of the Laboratory and the Workshop* (1859), and Fredrick Collier Bakewell, *Great Facts: a popular history and description of the most remarkable inventions during the present century* (1859), see MacLeod 2007, pp. 254–5.

162 Vol. 1 of Smiles's *Lives* was devoted to early engineers – James Brindley, Sir Cornelius Vermuyden, Sir Hugh Myddleton, Capt John Perry; vol. 2 to the harbours, lighthouses and bridges of John Smeaton; and vol. 3 to the roads of John Metcalfe and Thomas Telford. Smiles followed them with *Boulton and Watt* (1865); a new 5-vol. edition of *Lives of the Engineers* (1874); *Men of Invention and Industry* (1884); and edited the autobiography of *James Nasmyth* (1885); MacLeod 2007, pp. 255–7. For an idiosyncratic account of Smiles, see Adrian Jarvis, *Samuel Smiles and the Construction of Victorian Values* (Far Thrupp, 1997). Also, Simon Dentith, 'Samuel Smiles and the Nineteenth-century Novel', in Smith 1994, pp. 47–54.

163 Walker 1985, vol. 1, pp. 605–8, cat. 1075; Archibald Clow, 'A Re-examination of William Walker's "Distinguished Men of Science"', *AoS*, XI (1956), pp. 183–93, and MacLeod 2007, pp. 225–9.

164 See W. O. Henderson, *J. C. Fischer and his Diary of Industrial England 1814–51* (1966) and Henderson, *Industrial Britain under the Regency: The Diaries of Escher, Bodmer, May and de Gallois 1814–18* (1968), describing the visits made respectively by a Swiss steel manufacturer, engineer and inventor, a Prussian civil servant and a French mining engineer.

165 Angelika Wesenberg, 'Art and Industry', in Snodin 1991, p. 57.

166 Beuth quoted in Gottfried Riemann, 'The 1826 Journey and its Place in Schinkel's Career', in Schinkel 1993, p. 4.

167 The notebook is now in the Staatliche Museen Preussischer Kulturbesitz, Berlin, and was first published in 1862–3; Snodin 1991, pp. 162–84.

168 Schinkel 1993, p. 79.

169 Ibid., pp. 134 and 145.

170 Ibid., p. 126.

171 Ibid., pp. 128–32.

172 Ibid., p. 175.

173 Ibid., pp. 184–8.

174 Ibid., p. 192.

175 E.g., [H. L. H. V. Pückler-Muskau], *Tour in Germany, Holland and England in the years 1826, 1827 & 1828*, trans. Sarah Austin (1832), vol. 4, pp. 107–9, commenting on the West India Docks and warehouses. See the entries by Alex Werner in Fox 1992, pp. 229–31, cat. 6; Thomas Sutton, *The Daniells, Artists and Travellers* (1954).

176 SMLA, Reynolds, 127–8. A further engraving representing a section of Bradley Mine near Bilston, showing a more realistic view of the underground workings, is in the collection of the Coal Factors' Society; *Coal: British Mining in Art 1680–1980* (1982), cat. 29, repro. p. 16.

177 NEIMME, 3410/Wat/31/34.

178 Ibid., 31/31–3.

179 For an overview of the industrial souvenir industry see Michael A. Vanns, *Witness to Change: A Record of the Industrial Revolution* (Hersham, 2003), pp. 75–83.

180 John Ford, *Ackermann 1783–1983* (1983), pp. 101–3. For the most recent overview of the genre see Ian Kennedy, 'The Formative Years in Europe', in Ian Kennedy and Julian Treuherz, *The Railway: Art in the Age of Steam* (New Haven and London, 2008), pp. 44–68.

181 Cooke Bourne's pen-and-ink studies are in the Elton Collection, Ironbridge Gorge Museum. The finished sepia wash drawings are in the National Railway Museum, York.

182 Peter Jackson, *George Scarf's London: Sketches and Watercolours of a Changing City, 1820–50* (1987), pp. 8–10, 71–3, 112–15.

183 Kevin Littlewood, 'Rhymney's Egyptian Revival Images and Interpretations of the Bute Ironworks, Glamorganshire, 1824–44', *National Library of Wales Journal*, XXXI (1999), pp. 11–39; Lord 1998, pp. 56–63; Derrick Pritchard Webley, *The Life and Work of Penry Williams (1802–1885)* (Aberystwyth, 1997). Littlewood and Webley attribute the works to Williams.

184 Douglas Glendinning, *The Art of Mining: Thomas Hair's Watercolours of the Great Northern Coalfield* (Newcastle upon Tyne, 2000).

185 Leslie Parris and Ian Fleming-Williams, *Constable* (1991), pp. 111–19.

186 Ibid., pp. 206–11 and 369–72 (Waterloo Bridge) and pp. 275–81 (Chain Pier).

187 Yale Center for British Art, Paul Mellon Collection. For a detailed analysis of the work see Stephen Daniels, 'The Implications of Industry: Turner and Leeds', *Turner Studies*, VI, no. 1 (1986), pp. 10–17. See also the Birmingham and Coventry sketchbook, Tate Britain.

188 Auerbach 1999, p. 5.

189 Bonython and Burton 2003, pp. 37–98.

190 Hobhouse 2002, pp. 3–7. The first exhibition in 1847 attracted 20,000 visitors; the second in 1848, 73,000.

191 Bonython and Burton 2003, pp. 99–114.

192 For accounts of the meeting see Hobhouse 2002, pp. 7–10, and Auerbach 1999, pp. 23–5.

193 The initial reluctance of manufacturers to participate in exhibitions which might threaten their commercial interests by disclosing trade secrets, unprotected by patent, was overcome in part through the involvement of local committees in the largest manufacturing towns, notably Manchester. The Great Exhibition did much to hasten the long-delayed reform of the patent system: the Patent Law Amendment Act was passed in 1852; MacLeod 2007, pp. 212–15, and Auerbach 1999, pp. 27–9 and 75–81.

194 Bonython and Burton 2003, pp. 115–44, and Auerbach 1999, pp. 32–40.

195 Saint 2007, pp. 131–4.

196 Bonython and Burton 2003, pp. 134–5 and 137–9, and Auerbach 1999, pp. 41–53.

197 Bonython and Burton 2003, p. 140, Hobhouse 2002, pp. 40, and 51–4, Auerbach 1999, pp. 92–4.

198 Auerbach 1999, p. 242 n. 9; see also *The Illustrated Exhibitor*, published between June and December 1851, and Charles Tomlinson's *Cyclopaedia of Useful Arts, Mechanical and Chemical, Manufactures, Mining and Engineering* (1854), first issued in monthly shilling parts between 1852 and 1854, which began with an introductory essay on the Great Exhibition.

199 Ralph Nicholson Wornum, 'The Exhibition as a Lesson in Taste', *The Art Journal Illustrated Catalogue* (1851), pp. i–xxii.

200 Quoted in Burton 1999, p. 30.

201 See esp. the evidence given before HC 1840, vi, the Select Committee on Copyright of Designs.

202 See Robert Hunt (Keeper of Mining Records, Museum of Practical Geology), 'The Science of the Exhibition', and Edward Forbes, F.R.S. (Professor of Botany at King's College, London), 'On the Vegetable World as contributing to the Great Exhibition', in *The Art Journal Illustrated Catalogue* (1851).

203 Charles Babbage, *The Exposition of 1851; or, Views of the Industry, the Science and the Government, of England* (1851), pp. v–vii.

204 Ibid., pp. 18–20.

205 Published as Whewell 1852. There were twelve lectures in the series devoted to mining, animal raw materials, chemical processes, food, vegetable substances, machines and tools, philosophical instruments, civil engineering and machinery generally, the arts and manufactures of India, the progress of naval architecture and the necessity for a scientific education. The provision of scientific and technical education in secondary schools, universities and at research level were recurring themes.

206 Ibid., pp. 6–8; on pp. 28–30 he modified this statement by asserting that in the case of chemistry, science was the 'whole foundation, the entire creator of the art', for chemical processes and products arose out of the theories of Scheele, Kirwan, Berthollet and Lavoisier. For the clearest exposition of Whewell's philosophy of science, which combined both *a priori* and empirical elements, see his entry by Laura J. Snyder in the *Stanford Encyclopedia of Philosophy*. For the significance of the address within the context of Whewell's philosophy, see Yeo 1993, pp. 224–30.

207 Whewell 1852, pp. 16–19.

208 In 1806 the French had classified by geographical source; in 1819 they had adopted a 'material or natural system, dividing the arts into thirty-nine heads, causing in consequence great confusion; in 1827 a purely scientific arrangement was attempted into five great divisions – chemical, mechanical, physical, economical and miscellaneous arts – but this was deemed too artificial and abstract; in 1834 M. Dupin made the division depend of the relation of the arts to man – alimentary, sanitary, vestiary, domiliary, locomotive, sensitive, intellectual, preparative, social – a system continued in 1839; in 1844 there was an attempt to unite works under the headings woven, mineral, mechanical, mathematical, chemical, fine arts, ceramic and miscellaneous and although there were further complaints of confusion, the system was retained in 1849'.

209 Whewell 1852, pp. 22–8.

210 Ibid., p. 33.

211 Royal Archives, VIC/F25/5, quoted in Hobhouse 2002, pp. 89–90.

212 Royal Archives, VIC/F25/86, 4 April 1852, quoted in Hobhouse 2002, p. 100.

213 Ibid., p. 202.

214 Burton 1999, pp. 44–56; John Hewish, *The Indefatigable Mr Woodcroft: The Legacy of Invention* (1979), and James Harrison, 'Bennet Woodcroft at the Society of Arts', *RSAJ*, cxxviii (1979–80), pp. 231–4, 295–8, 375–9. Woodcroft supervised the production of the massive *Letters Patent and Specifications of Letters Patent from March 2nd, 1617 to September 30th, 1852*, as well as comprehensive indices. Sets were sent to libraries, mechanics' institutions and so on throughout Britain and the colonies.

215 See *Descriptive Catalogue of the Machines, Models &c., in the Museum of the Commissioners of Patents at South Kensington* (1859) and *Catalogue of the Machines, Models, Manufacturered Articles &c exhibited at the Patent Museum, South Kensington* (1863). The first descriptive catalogue of the machines and models contained little that related to the eighteenth century and those items that did, some 15 out of 315, were not patent models, apart from the model of Lombe's silk machinery. By 1868 the collection included the carved chest in which Lombe's model had been brought from Piedmont. Additions made during the Patent Museum's existence as a separate body are recorded in the Patent Office Museum register in the Science Museum, Z22. Though dating mainly from the nineteenth century, they include odd eighteenth-century items: pieces relating to James Watt including his kettle, presented by Gibson Watt (942), an original printing press supposedly used by Benjamin Franklin (935) and inevitably a model of Vauloué's pile-driving machine made by James Ferguson and lent by Woodcroft himself (1361).

216 [David Brewster], 'Prince Albert's Industrial College of Arts and Manufactures', *North British Review*, xvii (1852), pp. 519–58.

217 Ibid., pp. 520–22.

218 Ibid., pp. 521–33.

219 Ibid., pp. 542–3.

220 Ibid., pp. 549–54.

221 R. G. W. Anderson, '"What is technology?": Education through Museums in the Mid Nineteenth Century', *BJHS*, xxv (1992), p. 177.

222 Burton 1999, pp. 57–73.

223 Hobhouse 2002, p. 134.

224 Burton 1999, p. 68, quoting Matthew Digby Wyatt in the *Fine Arts Quarterly Review*.

Select Bibliography

Abbreviations

AoS	*Annals of Science*
BJHS	*British Journal for the History of Science*
BM, P&D	British Museum, Department of Prints and Drawings
BM Satires	*Catalogue of Personal and Political Satires in the British Museum* (1870–1954; vols 1–5 by F. G. Stephens, vols 6–11 by M. D. George)
eBLJ	*online British Library Journal*
MM	*Mariner's Mirror*
NLW	National Library of Wales, Aberystwyth
NMC	National Museum Cardiff
NPG	National Portrait Gallery, London
NRRS	*Notes & Records of the Royal Society of London*
ODNB	*Oxford Dictionary of National Biography* (Oxford, 2004)
PT	*Philosophical Transactions*
RDE	*Recherches sur Diderot et sur l'Encyclopédie*
RSAJ	*Royal Society of Arts Journal*
SNPG	Scottish National Portrait Gallery, Edinburgh
T&C	*Technology and Culture*
TNS	*Transactions of the Newcomen Society*

Unpublished Manuscripts

AN	Archives nationales, Paris
	JJ: hydrographique service
APS	American Philosophical Society, Philadelphia
	Smith: Thomas Peters Smith journals
BAH	Birmingham Archives and Heritage
	MS 3782: Boulton (including Tew) papers
	MS 3219: Watt (including Muirhead) papers
	MS 3147: Boulton & Watt papers
	MS 3147/5: Boulton & Watt engine drawings

BL	British Library
	Add. MSS: Additional Manuscripts
	Egerton MSS
	Harley MSS
	King's MSS
	King's Top: King's Topographical Collection
	Lansdowne MSS
	Sloane MSS
BRO	Bedfordshire Record Office, Bedford
	L31/114/1–3: Grantham journal
CoRO	Cornwall Record Office, Truro
	Enys: Enys papers
	AD1583: Wilson papers
	AR: Arundell papers
	MRO: Plans of Abandoned Mines
CRO	Cumbria Record Office, Carlisle
	D/Lons: Lonsdale papers
DRO	Derbyshire Record Office, Matlock
	D: Maps
HRO	Hertfordshire Record Office, Hertford
	D/EV F13/14: Grimston tour
	D/ER/F153: Radcliffe tour
	D/ER/C311: Croft–Radcliffe letters
	D/EH F1: Halsey journal
ICEL	Institution of Civil Engineers Library, London
	627.53: Grundy papers
Jernkontoret	Society of Ironmasters, Stockholm
	Angerstein journal
LUBC	Leeds University Library, Brotherton Collection
	SCI-17: Grundy papers
MC	Magdalene College, Cambridge
	Pepys MS
NA	National Archives, Kew
	ADM: Admiralty records
	MP: Maps and plans

MR: Maps and plans, rolled
SUPP: Ordnance records
WO: War Office records
NAS National Archives of Scotland, Edinburgh
E: Exchequer records
RHP: Plans
NCS Northumberland Collections Service, Ashington
SANT/BEQ/9/1/3 William Brown Collection
NEIMME North of England Institute of Mining and
Mechanical Engineers, Newcastle upon Tyne
3410/Bud: Buddle collection
3410/For: Forster collection
3410/Johnson: Johnson collection
3410/Wat: Watson collection
NMM National Maritime Museum, London
AND: Anderson collection
P: Atlases
POR: Portsmouth papers
San: Sandwich papers
Sergison: Sergison papers
SPB: Shipbuilding
RARA Royal Artillery Regiment Archives
Cadets journals
RIC Royal Institution of Cornwall, Truro
B/16/1: Borlase survey
RICS Royal Institution of Chartered Surveyors, London
Kenney Collection
RS Royal Society, London
CL.P: Classified papers
MM: Miscellaneous Manuscripts
Smeaton: Smeaton papers
RSA Royal Society of Arts, London
AD.MA/100/12: Society Minutes
PR.AR/103/10: Polite Arts Correspondence
PR.GE/110: Guard Books
PR.GE/112/12: Committee Minutes
PR.GE/118: Transactions
PR.GE/118/134: Dr Templeman's Transactions
PR.MC/105/10: Manufactures and Commerce
Correspondence
SC.EL/1: Special Collections, Early Library
RYL John Rylands Library, Manchester
Eng. MS 1125: Richardson papers
SCE Society of Civil Engineers
Minutes
Reports
SGS Spalding Gentlemen's Society, Spalding, Lin-
colnshire
Minutes: Minutes of the Acts & Observations
Misc: Miscellany of Drawings and Prints
SKB Kungliga Biblioteket (Royal Library), Stockholm
MS M.249: Kalmeter journal
MS X.303: Schröder journal
M.218: Alströmer journal
M.243: Geisler journal
SMLA Science Museum Library and Archives, Swindon
Good: Goodrich papers
Rey: Reynolds papers

SRA Riksarkivet (State Archives), Stockholm
EIII:10: Kalmeter report
FIIa: Angerstein notebooks
SRO Suffolk Record Office, Bury St Edmunds
E2/44/1–3: Cullum journals
WRO Warwickshire Record Office, Warwick
CR136: Newdigate of Arbury papers

British Parliamentary Papers

HC 1835, V House of Commons, Minutes of Evidence from the
Select Committee on Arts and Manufactures
HC 1836, IX Ibid.
HC 1840, VI House of Commons, Minutes of Evidence from the
Select Committee on Copyright of Designs
HL 1851, XVIII House of Lords, Minutes of Evidence from the Select
Committee on Patent Law Reform

Secondary Literature

All works are published in London unless otherwise
stated.

Abbey, J. R., 1952. *Scenery of Great Britain and Ireland in Aquatint and Lithography 1770–1860 from the Library of J. R. Abbey: A Bibliographical Catalogue*
Alder, Ken, 1998. 'Making Things the Same: Representation, Tolerance and the End of the Ancien Regime in France', *Social Studies of Science*, XXVIII, pp. 499–545.
Alfrey, Nicholas, and Stephen Daniels, eds, 1990. *Mapping the Landscape: Essays on Art and Cartography* (Nottingham)
Allan, David, 1979. 'The Society for the Encouragement of Arts, Manufactures and Commerce: Organisation, Membership and Objectives in the First Three Decades (1755–84)', University of London, Ph.D. thesis
Allan, D. G. C., and John L. Abbott, eds, 1992. *The Virtuoso Tribe of Arts and Sciences: Studies in the Eighteenth-Century Work and Membership of the London Society of Arts* (Athens, Ga., and London)
Allen, Ralph G., 1960. 'The Stage Spectacles of Philip James de Loutherbourg', Yale University, Faculty of the School of Drama, Doctor of Fine Arts thesis
Altick, Richard D., 1978. *The Shows of London* (Cambridge, Mass., and London)
Anderson, R. G. W., M. L. Caygill et al., eds, 2003. *Knowledge, Discovery and the Museum in the Eighteenth Century*
Angerstein, 2001. *R. R. Angerstein's Illustrated Travel Diary, 1753–1755*, trans. Torsten and Peter Berg
Arkwright v. Nightingale, 1785. *Richard Arkwright, Esquire; versus Peter Nightingale, Esquire. Copy (from Mr Gurney's short-hand Notes) of the Proceedings on the Trial of this Cause in the Court of Common Pleas before the Right Honourable Lord Loughborough, by a Special Jury, February 17, 1785*
Auerbach, Jeffrey A., 1999. *The Great Exhibition of 1851: A Nation on Display* (New Haven and London)

Babbage, Charles, 1832. *On the Economy of Machinery and Manufactures*

Bacon, Francis, 2000. *The New Organon* (1620), ed. Lisa Jardine and Michael Silverthorne (Cambridge)

Bacon, Francis, 1659 ed. *New Atlantis: A Work Unfinished* (1627)

Baines, Edward, 1835. *History of the Cotton Manufacture in Great Britain*

Barker, Elizabeth E., and Alex Kidson, 2007. *Joseph Wright of Derby in Liverpool* (Liverpool, New Haven and London)

Barrell, John, 1986. *The Political Theory of Painting* (New Haven and London)

—, ed., 1992. *Painting and the Politics of Culture: New Essays on British Art, 1700–1850* (Oxford)

Barry, James, 1775. *An Inquiry into the Real and Imaginary Obstructions to the Acquisition of the Arts in England*

—, 1809. *The Works of James Barry*, 2 vols

Baugh, Daniel A., 1965. *British Naval Administration in the Age of Walpole* (Princeton)

—, 1995. 'The Eighteenth Century Navy as a National Institution 1690–1815', in J. R. Hill, ed., *The Oxford Illustrated History of the Royal Navy* (Oxford)

Beer, Carel de, 1991. *The Art of Gunfounding: The Casting of Bronze Cannon in the Late 18th Century* (Rotherfield)

Beneke, Sabine, and Hans Ottomeyer, 2002. *Die Zweite Schöpfung: Bilder der industriellen Welt vom 18. Jahrhundert in die Gegenwart* (Berlin)

Bennett, J. A., and Olivia Brown, 1982. *The Compleat Surveyor* (Cambridge)

Bennett, Jim, and Stephen Johnston, 1996. *The Geometry of War 1500–1750* (Oxford)

— and A. V. Simcock, 2000. *Solomon's House in Oxford: New Finds from the First Museum* (Oxford)

—, Michael Cooper, Michael Hunter, Lisa Jardine, 2003. *London's Leonardo: The Life and Work of Robert Hooke* (Oxford)

Bentham, M. S., 1862. *The Life of Brigadier-General Sir Samuel Bentham, K.S.G.*

Bentham, Samuel, 1813. *Services rendered in the Civil Department of the Navy*

Berg, Maxine, 2002. 'From Imitation to Invention: Creating Commodities in Eighteenth-century Britain', *Economic History Review*, LV, pp. 1–30

—, 2004, 'In Pursuit of Luxury: Global History and British Consumer Goods in the Eighteenth Century', *Past & Present*, no. 182, pp. 85–142

— 2005, *Luxury and Pleasure in Eighteenth-Century Britain* (Oxford)

— and Kristine Bruland, eds, 1998. *Technological Revolutions in Europe: Historical Perspectives* (Cheltenham and Northampton, Mass.)

— and Helen Clifford, eds, 1999. *Consumers and Luxury: Consumer Culture in Europe 1650–1850* (Manchester and New York)

— and Elizabeth Eger, eds, 2003. *Luxury in the Eighteenth Century: Debates, Desires and Delectable Goods* (Basingstoke)

Bermingham, Ann, and John Brewer, eds, 1995. *The Consumption of Culture 1600–1800: Image, Object, Text*

Bindman, David, 1997. *Hogarth and his Times*

Bold, John, and Edward Chaney, eds, 1993. *English Architecture Public and Private* (London and Rio Grande, Ohio)

Bonython, Elizabeth, and Anthony Burton, 2003. *The Great Exhibitor: The Life and Work of Henry Cole*

Boyle Works, 1999–2000. *The Works of Robert Boyle*, ed. Michael Hunter and Edward B. Davis, 14 vols

Boyle Correspondence, 2001. *The Correspondence of Robert Boyle*, ed. Michael Hunter, Antonio Clericuzio and Lawrence M. Principe, 6 vols

Brewer, John, 1997. *The Pleasures of the Imagination: English Culture in the Eighteenth Century*

— and Roy Porter, eds, 1993. *Consumption and the World of Goods*

Buchanan, R. A., 1989. *The Engineers: A History of the Engineering Profession 1750–1914*

Burton, Anthony, 1999. *Vision and Accident: The Story of the Victoria and Albert Museum*

Campbell, R. H., 1961. *Carron Company*

Cantrell, John, and Gillian Cookson, 2002. *Henry Maudslay and the Pioneers of the Machine Age* (Stroud)

Cardwell, D. S. L., ed., 1974. *Artisan to Graduate: Essays to commemorate the Foundation in 1824 of the Manchester Mechanics' Institute of Science and Technology* (Manchester)

Chadarevian, Soraya de, and Nick Hopwood, 2004. *Models: The Third Dimension of Science* (Stanford, Cal.)

Chapuis, Alfred, and Edmund Droz, 1958. *Automata*

Clark, William, Jan Golinski, and Simon Schaffer, eds, 1999. *The Sciences in Enlightened Europe* (Chicago and London)

Clercq, Peter de, 1997. *The Leiden Cabinet of Physics* (Leiden)

Coad, Jonathan, 1992. 'The Development and Organisation of Plymouth Dockyard, 1689–1815', in Michael Duffy et al., eds, *The New Maritime History of Devon. Volume 1: From Early Times to the Late Eighteenth Century*, pp. 192–200

—, 2005. *The Portsmouth Block Mills: Bentham, Brunel and the State of the Royal Navy's Industrial Revolution*

Cole, Arthur H., and George B. Watts, 1952. *The Handicrafts of France, as recorded in the Descriptions des Arts et Métiers, 1761–1788* (Boston, Mass.)

Crocker, A. G., et al., 2000. *Gunpowder Mills: Documents of the Seventeenth and Eighteenth Centuries* (Woking)

Crookshank, Anne, and the Knight of Glin, 2002. *Ireland's Painters 1600–1940* (New Haven and London)

Cross, A. G., 1977. 'A Russian Engineer in Eighteenth-Century Britain: The Journal of N. I. Korsakov, 1776–7', *Slavonic and East European Review*, LV, pp. 1–20

Daniels, Stephen, 1993. *Fields of Vision: Landscape Imagery and National Identity in England and the United States* (Cambridge)

—, 1999. *Humphry Repton: Landscape Gardening and the Geography of Georgian England* (New Haven and London)

Deacon, Margaret, 1997. *Scientists and the Sea 1650–1900: A Study of Marine Science* (Aldershot)

Delano-Smith, Catherine, and Roger J. P. Kain, 1999. *English Maps: A History*

Desaguliers, J. T., 1744. *A Course of Experimental Philosophy*

Dickinson, Henry Winram, and Rhys Jenkins, 1927. *James Watt and the Steam Engine* (Oxford)

Donato, Clorinda, and Robert M. Maniquis, eds, 1992. *The Encyclopédie and the Age of Revolution* (Boston, Mass.)

Dorment, Richard, 1986. *British Painting in the Philadelphia Museum of Art from the Seventeenth through the Nineteenth Century* (Philadelphia)

Dossie, Robert, 1758. *The Handmaid to the Arts*

—, 1768 (vols 1–2) and 1782 (vol. 3). *Memoirs of Agriculture and other Oeconomical Arts*

Doyon, André, and Lucien Liaigre, 1992. *Jacques Vaucanson, mécanicien de génie* (Paris)

Duchet, Michéle, and Michéle Jalley, eds, 1977. *Langues et langages de Leibniz à l'Encyclopédie* (Paris)

Dupin, Charles, 1827. *Mathematics practically applied to the Useful and Fine Arts by Baron Charles Dupin, adapted to the State of the Arts in England*, trans. George Birkbeck

Egerton, Judy, 1990. *Wright of Derby*

Ehrman, John, 1953. *The Navy in the War of William III 1689–1697* (Cambridge)

Emerson, Roger L., 2002. 'The Scientific Interests of Archibald Campbell, 1st Earl of Islay, and 3rd Duke of Argyll (1682–1761)', *AoS*, LIX, pp. 21–56

Fairfull-Smith, George, 2001. *The Foulis Press and the Foulis Academy: Glasgow's Eighteenth-Century School of Art and Design* (Glasgow)

Fara, Patricia, 2002. *Newton: The Making of Genius*

Ferguson, Eugene S., 1992. *Engineering and the Mind's Eye* (Cambridge, Mass., and London)

Fisher, Jabez Maud, 1992. *An American Quaker in the British Isles: The Travel Journals of Jabez Maud Fisher, 1775–1779*, ed. Kenneth Morgan (Oxford)

Fitton, R. S., 1989. *The Arkwrights: Spinners of Fortune* (Manchester)

Flinn, Michael W., 1957. 'The Travel Diaries of Swedish Engineers of the Eighteenth Century as Sources of Technological History', *TNS*, XXXI, pp. 95–110

Fordham, D. N., 2001. *Coal and Water: An Industrial History of Arbury* (privately printed)

Fortune, Brandon Brame, with Deborah J. Warner, 1999. *Franklin and his Friends* (Philadelphia)

Fox, Celina, ed., 1992. *London World City* (New Haven and London)

Franklin, John, 1989. *Navy Board Ship Models, 1650–1750*

Fuhring, Peter, 1985. 'The Print Privilege in Eighteenth-Century France. I', *Print Quarterly*, II, pp. 174–93

George III Correspondence, 1927–8. *The Correspondence of King George the Third, from 1760 to December, 1783*, 6 vols, ed. Sir John Fortescue

Gillispie, Charles Coulston, 1980. *Science and Polity in France: The End of the Old Regime* (Princeton and Oxford)

Gilpin, William, 1782. *Observations on the River Wye, and Several Parts of South Wales, etc. Relative Chiefly to Picturesque Beauty; made in the Summer of the Year 1770*

— 1786. *Observations Relative Chiefly to Picturesque Beauty, Made in the Year 1772, on Several Parts of England; Particularly the Mountains, and Lakes of Cumberland, and Westmoreland*, 2 vols

Goodison, Nicholas, 2002. *Matthew Boulton: Ormolu*

Granger, James, 1769. *A Biographical History of England*, 3 vols

Griffiths, Antony, 1998. *The Print in Stuart Britain 1603–1689*

—, 2004. *Prints for Books: Book Illustration in France, 1760–1800*

Hargraves, Matthew, 2005. '*Candidates for Fame': The Society of Artists of Great Britain 1760–1791* (New Haven and London)

Harris, Eileen, assisted by Savage, Nicholas, 1990. *British Architectural Books and Writers 1556–1785* (Cambridge)

Harris, John, 1979. *The Artist and the Country House*

— and Michael Snodin, eds, 1996. *Sir William Chambers: Architect to George III* (New Haven and London)

Harris, J. R., 1997. *Industrial Espionage and the Transfer of Technology: Britain and France in the Eighteenth Century* (Aldershot)

Harrison, James, 1997. '"The Ingenious Mr Yeoman" and Some Associates: A Practical Man's Contribution to the Society's Formative Years', *RSAJ*, CXLV, pp. 53–68

Haskell, Francis, 1987. *Past and Present in Art and Taste: Select Essays* (New Haven and London)

Headrick, Daniel R., 2000. *When Information Came of Age: Technologies of Knowledge in the Age of Reason and Revolution, 1700–1850* (Oxford)

Hemingway, James Peter, 2002. 'The Work of the Surveyors of the Navy during the Period of the Establishments: A Comparative Study of Naval Architecture between 1672 and 1755', Bristol University, Ph.D. thesis

Hills, Richard L., 2002. *James Watt. Vol. 1: His Time in Scotland, 1736–74* (Ashbourne)

—, 2005. *James Watt. Vol. 2: The Years of Toil, 1775–1785* (Ashbourne)

—, 2006. *James Watt. Vol. 3: Triumph through Adversity, 1785–1819* (Ashbourne)

Hind, Charles, ed., 1986. *The Rococo in England: A Symposium*

History of Inland Navigations. Particularly those of the Duke of Bridgewater, in Lancashire and Cheshire; and the intended one promoted by Earl Gower and other Persons of Distinction in Staffordshire, Cheshire, and Derbyshire, 1766

Hoare, Richard Colt, 1983. *The Journeys of Sir Richard Colt Hoare through Wales and England 1793–1810*, ed. M. W. Thompson (Gloucester)

Hobhouse, Hermione, 2002. *The Crystal Palace and the Great Exhibition: Art, Science and Productive Industry. A History of the Royal Commission for the Exhibition of 1851*

Hogarth, William, 1753. *The Analysis of Beauty*

Hogg, O. F. G., 1963. *The Royal Arsenal: Its Background, Origin and Subsequent History* (Oxford), 2 vols

Hollister-Short, G. J., 1976. 'The Introduction of the Newcomen Engine into Europe', *TNS*, XLVIII, pp. 11–22

Hooke, Robert, 1705. *The Posthumous Works of Robert Hooke*, ed. Richard Waller

Hunter, Michael, 1981. *Science and Society in Restoration England* (Cambridge)

—, 1989, *Establishing the New Science: The Experience of the Early Royal Society* (Woodbridge)

—, 1995. *Science and the Shape of Orthodoxy: Intellectual Change in Late Seventeenth-Century Britain* (Woodbridge)

—, and Simon Schaffer, eds, 1989. *Robert Hooke: New Studies* (Woodbridge)

Iliffe, Rob, 1995. 'Material Doubts: Hooke, Artisan Culture and the Exchange of Information in 1670s London', *BJHS*, XXVIII, pp. 285–318

Illustrations of the Irish Linen Industry in 1783 by William Hincks (Cultra, Holywood, Co. Down, 1977)

Ingamells, John 2004. *National Portrait Gallery: Mid-Georgian Portraits, 1760–1790*

Ingenuity and Art. 1997. *Ingenuity and Art: A Collection of Instruments of the Real Gabinete de Física, University of Coimbra* (Coimbra and Lisbon)

Inkster, Ian, and Jack Morrell, 1983. *Metropolis and Province: Science in British Culture* (Philadelphia)

Jackson, Melvin H., and Carel de Beer, 1973. *18th Century Gun Founding* (Newton Abbot)

Jacob, Margaret C., 1997. *Scientific Culture and the Making of the Industrial West* (Oxford)

Jagger, Graham, 1995. 'Joseph Moxon, F.R.S. and the Royal Society', *NRRS*, XLIX, pp. 193–208

Jaoul, Martine, and Madeleine Pinault, 1982. 'La Collection "Description des Arts et Métiers": Etude des sources inédites de la Houghton Library Université Harvard', *Ethnologie française*, XII, pp. 335–60

—, 1986. 'La Collection "Description des Arts et Métiers": Sources inédites provenant du château de Denainvilliers (2)', *Ethnologie française*, XVI, pp. 7–38

Jardine, Lisa, 2002. *On a Grander Scale: The Outstanding Career of Sir Christopher Wren*

Jars, Gabriel, 1774–81. *Voyages Metallurgiques* (vol. 1, Lyon, vols 2–3, Paris)

Joppien, Rüdiger, 1973. *Philippe Jacques de Loutherbourg, R.A. 1740–1812*

Kafker, Frank A., ed., 1994. *Notable Encyclopedias of the Late Eighteenth Century: Eleven Successors of the* Encyclopédie (Oxford)

—, and Serena L. Kafker, 1988. *Studies on Voltaire and the Eighteenth Century, 257. The Encyclopedists as Individuals: A Biographical Dictionary of the Authors of the* Encyclopédie (Oxford)

Kemp, Martin, 1990. *The Science of Art: Optical Theories in Western Art from Brunelleschi to Seurat* (New Haven and London)

King-Hele, Desmond, 1999. *Erasmus Darwin 1731–1802: A Life of Unequal Achievement*

Kitson, Michael, 1968. 'Hogarth's "Apology for Painters",' *Walpole Society*, XLI, pp. 46–111

Klingender, Francis D., 1947. *Art and the Industrial Revolution*; 1968, ed. and rev. Arthur Elton

Kusamitsu, Toshio, 1980. 'Great Exhibitions before 1851', *History Workshop*, IX, pp. 70–89

Lalande, Jerôme, 1980. *Journal d'un Voyage en Angleterre 1763*, intro. Helene Monod-Cassidy (Oxford)

Lavery, Brian, ed., 1981. *Deane's Doctrine of Naval Architecture, 1670*

— and Stephen Simon, 1995. *Ship Models: Their Purpose and Development from 1650 to the Present*

Lindqvist, Svante, 1984. *Technology on Trial: The Introduction of Steam Power Technology into Sweden, 1715–1736* (Uppsala)

Long, Pamela O., 2001. *Openness, Secrecy, Authorship: Technical Arts and the Culture of Knowledge from Antiquity to the Renaissance* (Baltimore and London)

Lord, Peter, 1998. *The Visual Culture of Wales: Industrial Society* (Cardiff)

Lough, John, 1971. *The Encyclopédie*

Lowengard, Sarah, 2006. *The Creation of Color in Eighteenth-Century Europe* (New York: Gutenberg-e)

Lowood, Henry E., 1991. *Patriotism, Profit and the Promotion of Science in the German Enlightenment: The Economic and Scientific Societies 1760–1815* (New York and London)

Macdonald, Stuart, 1970. *The History and Philosophy of Art Education*

MacGregor, Arthur, 2007. *Curiosity and Enlightenment: Collectors and Collections from the Sixteenth to the Nineteenth Century* (New Haven and London)

MacLeod, Christine, 1988. *Inventing the Industrial Revolution: The English Patent System, 1660–1800* (Cambridge)

—, 2007. *Heroes of Invention: Technology, Liberalism and the British Identity 1750–1914* (Cambridge)

Madden, Samuel, 1738. *Reflections and Resolutions Proper to the Gentlemen of Ireland . . .* (Dublin)

—, 1739. *A Letter to the Dublin Society on the Improving their Fund; and the Manufactures, Tillage &c in Ireland* (Dublin)

Marsden, Ben, 2002. *Watt's Perfect Engine: Steam and the Age of Invention* (Cambridge)

Marsden, Jonathan, ed., 2005. *The Wisdom of George III*

Marshall, Douglas W., 1980. 'Military Maps of the Eighteenth Century and the Tower of London Drawing Room', *Imago Mundi*, XXXII, pp. 21–44

Mason, Shena, ed., 2009. *Matthew Boulton: Selling What All the World Desires* (New Haven and London)

Mavor, William, 1809. *The British Tourist's or Traveller's Companion, through England, Wales, Scotland and Ireland, comprehending the most celebrated Modern Tours in the British Islands, and several Originals*, 6 vols

Mayr, Otto, 1986. *Authority, Liberty and Automatic Machinery in Early Modern Europe* (Baltimore and London)

McConnell, Anita, 2004. 'Industrial Spies (act. c.1700–c.1800)', *ODNB*

—, 2007. *Jesse Ramsden (1735–1800): London's Leading Scientific Instrument Maker* (Aldershot)

Meenan, James, and Desmond Clarke, 1981. *The Royal Dublin Society 1731–1981* (Dublin)

Merlin 1985. *John Joseph Merlin, The Ingenious Mechanick*

Michel, Christian, 1984. 'Diderot et la Gravure', in *Diderot et l'art de Boucher à David. Les Salons: 1759–1781* (Paris)

Michell, J. H., 1845. *The Tour of the Duke of Somerset and the Rev. J. H. Michell through Parts of England, Wales and Scotland, in the year 1795*

Millar, Oliver, 1969. *The Late Georgian Pictures in the Collection of Her Majesty the Queen*, 2 vols

Millburn, John R., 2000. *Adams of Fleet Street, Instrument Makers to King George III* (Aldershot)

—, and Henry C. King, 1988. *Wheelwright of the Heavens: The Life and Work of James Ferguson, F.R.S.*

Miller, David Philip, 1999. 'The Usefulness of Natural Philosophy: The Royal Society and the Culture of Practical Utility in the Later Eighteenth Century', *BJHS*, XXXII, p. 187

Mokyr, Joel, 1990. *The Lever of Riches: Technological Creativity and Economic Progress* (Oxford)

—, 2002. *The Gifts of Athena: Historical Origins of the Knowledge Economy* (Princeton and Oxford)

Morrell, Jack, and Arnold Thackray, 1981. *Gentlemen of Science: Early Years of the British Association for the Advancement of Science* (Oxford)

Morriss, Roger, 1983. *The Royal Dockyards during the Revolutionary and Napoleonic Wars* (Leicester)

[Mortimer, Thomas] 1763. *A Concise Account of the Rise, Progress and Present State of the Society for the Encouragement of Arts, Manufactures, and Commerce*

Morton, Alan Q., and Jane A. Wess, 1993. *Public and Private Science: The King George III Collection* (Oxford)

Mount, Harry, 1991. 'The Reception of Dutch Genre Painting in England, 1695–1829', Cambridge University, Ph.D. thesis

Moxon, Joseph, 1962. *Mechanick Exercises*, ed. Herbert Davis and Harry Carter (Oxford)

Murdoch, Tessa, 1985. *The Quiet Conquest: The Huguenots 1685 to 1985*

Musson, A. E., and Eric Robinson, 1969. *Science and Technology in the Industrial Revolution* (Manchester)

Myrone, Martin, ed., 2006. *Gothic Nightmares: Fuseli, Blake and the Romantic Imagination*

New, Chester W., 1961. *The Life of Henry Brougham to 1830* (Oxford)

Noble, Mark, 1806. *A Biographical History of England, from the Revolution to the End of George I's Reign*

O'Brien, Patrick, 1997. 'The Micro Foundations of Macro Invention: The Case of the Reverend Edmund Cartwright', *Textile History*, XXVIII, pp. 201–33

Ochs, Kathleen H., 1985. 'The Royal Society of London's History of Trades Programme: An Early Episode in Applied Science', *NRRS*, XXXIX, pp. 129–58

O'Connell, Sheila, 2003. *London 1753*

Oldham, James, 1992. *The Mansfield Manuscripts and the Growth of English Law in the Eighteenth Century* (Chapel Hill, N.C., and London)

Oppé, A. P., 1947. *The Drawings of Paul and Thomas Sandby in the Collection of His Majesty the King at Windsor Castle* (Oxford and London)

Pannabecker, John R., 1998. 'Representing Mechanical Arts in Diderot's Encyclopédie', *T&C*, XXXIX, pp. 33–73

Payne, Peter L., ed., 1967. *Studies in Scottish Business History*

Peltz, Lucy, 'Engraved Portrait Heads and the Rise of Extra-Illustration: The Eton Correspondence of the Revd James Granger and Richard Bull, 1769–1774', *Walpole Society*, LXVI (2004), pp. 1–161

Pennant, Thomas, 1796. *The History of the Parishes of Whiteford and Holywell*

Petty Papers 1927. *The Petty Papers: Some Unpublished Writings of Sir William Petty*, ed. Marquis of Lansdowne

Picon, Antoine, 1992. *French Architects and Engineers in the Age of Enlightenment*, trans. Martin Thom (Cambridge)

Pinault, Madeleine, 1984. *Dessin et sciences XVIIe–XVIIIe siècles* (Paris)

Polhem, Christopher, 1963. *Christopher Polhem, The Father of Swedish Technology*, trans. William A. Johnson (Hartford, Conn.)

Pons, Bruno, et al., 1984. *Le Faubourg Saint-Germain: La Rue Saint-Dominique. Hôtels et Amateurs* (Paris)

Porter, Roy, and Marie Mulvey Roberts, eds, 1996. *Pleasure in the Eighteenth Century* (Basingstoke)

Postle, Martin, ed., 2005. *Joshua Reynolds: The Creation of Celebrity*

Pumfrey, Stephen, 1995. 'Who did the Work? Experimental Philosophers and Public Demonstrators in Augustan England', *BJHS*, XXVIII, pp. 131–56

Pyenson, Lewis, and Jean-François Gauvin, eds, 2002. *The Art of Teaching Physics: The Eighteenth-Century Demonstration Apparatus of Jean-Antoine Nollet* (Sillery, Quebec)

Rebora, Carrie, and Paul Staiti et al., 1996. *John Singleton Copley in America* (New York)

Reilly, Robin, and George Savage, 1973. *Wedgwood The Portrait Medallions*

Rex v. Arkwright, 1785. *The Trial of a Cause instituted by Richard Pepper Arden, Esq; his Majesty's Attorney General, by Writ of Scire Facias, to repeal a Patent granted on the Sixteenth of December 1775, to Mr Richard Arkwright . . . at Westminster-Hall, on Saturday the 25th of June 1785*

Reynolds, Joshua, 1975. *Discourses on Art*, ed. Robert Wark (New Haven and London)

Richardson, Jonathan, 1725. *Essay on the Theory of Painting* (rev. ed.)

Roberts, Jane, ed., 2004. *George III and Queen Charlotte: Patronage, Collecting and Court Taste*

Roberts, Lissa, Simon Schaffer, and Peter Dear, eds, 2007. *The Mindful Eye: Inquiry and Invention from the late Renaissance to early Industrialisation* (Amsterdam)

Robertson, Bruce, 1985. *The Art of Paul Sandby* (New Haven)

Robertson, Edward Bruce, 1987. 'Paul Sandby and the Early Development of Watercolour', Yale University, Ph.D. thesis

Robinson, Eric, 1962. 'The Profession of Civil Engineer in the Eighteenth Century: A Portrait of Thomas Yeoman, F.R.S., 1704(?)–1781', *AoS*, XVIII, pp. 195–215

—, and A. E. Musson, 1969. *James Watt and the Steam Revolution: A Documentary History*

Roche, La 1933. *Sophie in London 1786, being the Diary of Sophie v. la Roche*, trans. Clare Williams

Rodger, N. A. M., 1993. *The Insatiable Earl: A Life of John Montagu, Fourth Earl of Sandwich 1718–1792*

—, 2004. *The Command of the Ocean: A Naval History of Britain, 1649–1815*

Rosenthal, Michael, Christiana Payne, and Scott Wilcox, eds, 1997. *Prospects for the Nation: Recent Essays in British Landscape, 1750–1880* (New Haven and London)

[Rotherham, John] 1786. 'Rees's Edition of Chambers's *Cyclopaedia*', *Monthly Review*, LXXV

Roy, William, 1785. *An Account of the Measurement of a Base on Hounslow Heath*

Saint, Andrew, 2007. *Architect and Engineer: A Study in Sibling Rivalry* (New Haven and London)

Scarfe, Norman, 1995. *Innocent Espionage: The La Rochefoucauld Brothers' Tour of England in 1785* (Woodbridge)

SCE Minutes, 1893. *Facsimile Copy of the Minutes of the Society of Civil Engineers*

Schinkel, Karl Friedrich, 1993. *Karl Friedrich Schinkel: 'The English Journey', Journal of a Visit to France and Britain in 1826*, ed. David Bindman and Gottfried Riemann (New Haven and London)

Scott, Katie, 1995. *The Rococo Interior* (New Haven and London)

Shaftesbury, Anthony, Earl of, 1732. *Characteristicks of Men, Manners, Opinions, Times* (5th ed.), 3 vols

Shapin, Steven, 1994. *A Social History of Truth: Civility and Science in Seventeenth-Century England* (Chicago and London)

—, and Simon Schaffer, 1985. *Leviathan and the Air-Pump: Hobbes, Boyle, and the Experimental Life* (Princeton)

Sharp, L. G., 1977. 'Sir William Petty and Some Aspects of Seventeenth-Century Natural Philosophy', Oxford, D.Phil. thesis

Shee, Martin Archer, 1805. *Rhymes on Art; or, The Remonstrance of a Painter*

Simon, Robin 2007. *Hogarth: France and British Art*

Skempton, A. W., 1971. 'Samuel Wyatt and the Albion Mill', *Architectural History*, XIV, pp. 53–73

—, ed., 1981. *John Smeaton F.R.S.*

—, 1984. 'The Engineering Work of John Grundy (1719–1783)', *Lincolnshire History and Archaeology*, XIX, pp. 65–82

Sloan, Kim, 2000. *'A Noble Art': Amateur Artists and Drawing Masters c.1600–1800*

Slotta, Reiner, and Christoph Bartels, et al., 1990. *Meisterwerke bergbaulicher Kunst vom 13. bis 19. Jahrhundert* (Bochum)

Smeaton, John, 1791. *A Narrative of the Building and a Description of the Construction of the Edystone Lighthouse with Stone*

—, 1812. *Reports of the late John Smeaton, F.R.S., made on various Occasions in the course of his Employment as a Civil Engineer*

Smith, David, 1990. 'County Maps of England and Wales 1700–c.1840', *Industrial Archaeology Review*, XII, pp. 153–77

Smith, Denis, ed., 1994. *Perceptions of Great Engineers: Fact and Fantasy*

Smith, Pamela H., 2004. *The Body of the Artisan: Art and Experience in the Scientific Revolution* (Chicago)

Smith, Stuart, 1979. *A View from the Iron Bridge* (Ironbridge)

Snodin, Michael, ed., 1984. *Rococo: Art and Design in Hogarth's England*

—, ed., 1991. *Karl Friedrich Schinkel: A Universal Man* (New Haven and London)

Solkin, David H., 1982. *Richard Wilson: The Landscape of Reaction*

—, 1993. *Painting for Money: The Visual Arts and the Public Sphere in Eighteenth-Century England* (New Haven and London)

—, ed., 2001. *Art on the Line: The Royal Academy Exhibitions at Somerset House 1780–1836* (New Haven and London)

Sprat, Thomas, 1667, *History of the Royal Society*

Stansfield, Dorothy A., 1984. *Thomas Beddoes M.D. 1760–1808: Chemist, Physician, Democrat* (Dordrecht)

Stewart, Larry, 1992. *The Rise of Public Science: Rhetoric, Technology, and Natural Philosophy in Newtonian Britain, 1660–1750* (Cambridge)

—, 1998. 'A Meaning for Machines: Modernity, Utility and the Eighteenth-Century British Public', *Journal of Modern History*, LXX, pp. 259–94

Stuart, Robert, [Meikleham] 1824. *A Descriptive History of the Steam Engine*

Syndram, Dirk, and Antje Scherner, eds, 2004. *Princely Splendor: The Dresden Court 1580–1620* (Dresden and New York)

Tann, Jennifer, 1970. *The Development of the Factory*

—, 1978. 'Boulton and Watt's Organization of Steam Engine Production before the Opening of the Soho Foundry', *TNS*, XLIX, pp. 41–56

—, 1998. 'Two Knights at Pandemonium: A Worm's Eye View of Boulton, Watt & Co., c.1800–1820', *History of Technology*, XX, pp. 47–72

Thompson, F. M. L., 1968. *Chartered Surveyors: The Growth of a Profession*

Thomson, Duncan, 1997. *Raeburn: The Art of Sir Henry Raeburn 1756–1823* (Edinburgh)

Thorpe, W. H., 1933. 'The Marquis of Worcester and Vauxhall', *TNS*, XIII (1933), pp. 80–86

Torrington 1934–8. *The Torrington Diaries, containing the tours through England and Wales of the Hon. John Byng (later fifth Viscount Torrington) between the years 1781 and 1794*, 4 vols

Tylecote, Mabel, 1957. *The Mechanics Institutes of Lancashire and Yorkshire before 1851* (Manchester)

Tyler, David, 2006. 'Humphrey Gainsborough (1718–1776): Cleric, Engineer and Inventor', *TNS*, LXXVI, pp. 51–86

Uglow, Jenny, 2002. *The Lunar Men: The Friends who made the Future*

Valpy, Nancy, 1989. 'Plagiarism in Prints. The Musical Entertainer Affair', *Print Quarterly*, VI, pp. 54–9

Wailes, Rex, 1951. 'Notes on the Windmill Drawings in Smeaton's Designs', *TNS*, XXVIII, pp. 239–43

Walker, R. J. B., 1985. *National Portrait Gallery: Regency Portraits*, 2 vols

Warmoes, Isabelle, 1999. *Musée des Plans-Relief* (Paris)

Warner, Richard, 1798. *A Walk through Wales in August 1797* (Bath)

—, 1799. *A Second Walk through Wales in August and September 1798* (1799)

—, 1801. *Excursions from Bath* (Bath)

—, 1802. *A Tour through the Northern Countries of England and Borders of Scotland*

Webster, Charles, 1975. *The Great Instauration: Science, Medicine and Reform 1626–1660* (2nd ed., New York and Bern, 2002)

Wedgwood 1978. *Josiah Wedgwood: 'the Arts and Sciences United'*

Whewell, William, 1852. *The General Bearing of the Great Exhibition on the Progress of Art and Science*

Whitney, Elspeth, 1990. *Paradise Restored: The Mechanical Arts from Antiquity through the Thirteenth Century* (Philadelphia)

Willmoth, Francis, 1993. *Sir Jonas Moore: Practical Mathematics and Restoration Science* (Woodbridge)

Woolrich, A. P., 1986. *Mechanical Arts and Merchandise: Industrial Espionage and Travellers' Accounts as a Source for Technical Historians* (Eindhoven)

—, 1998. 'John Farey, Jr, Technical Author and Draughtsman: His Contribution to Rees's *Cyclopaedia*', *Industrial Archaeology Review*, XX, pp. 49–67

—, 2000. 'John Farey and his Treatise on the Steam Engine of 1827', *History of Technology*, XXII (2000), pp. 63–106

Wright, Neil R., 1984. *John Grundy of Spalding, Engineer 1719–1783* (Lincoln)

[Wyndham, Henry Penruddocke] 1774. *A Gentleman's Tour through Monmouthshire and Wales in the months of June and July*

Yeo, Richard, 1993. *Defining Science: William Whewell, Natural Knowledge and Public Debate in Early Victorian Britain* (Cambridge)

—, 2001. *Encyclopaedic Visions: Scientific Dictionaries and Enlightenment Culture* (Cambridge)

Young, Arthur, 1770. *Six Months Tour through the North of England*, 4 vols

—, 1780. *A Tour in Ireland; with General Observations on the Present State of that Kingdom made in the Years 1776, 1777, and 1778 and brought down to the end of 1779* (Dublin)

Young, Hilary, ed., 1995. *The Genius of Wedgwood*

Photograph Credits

Index

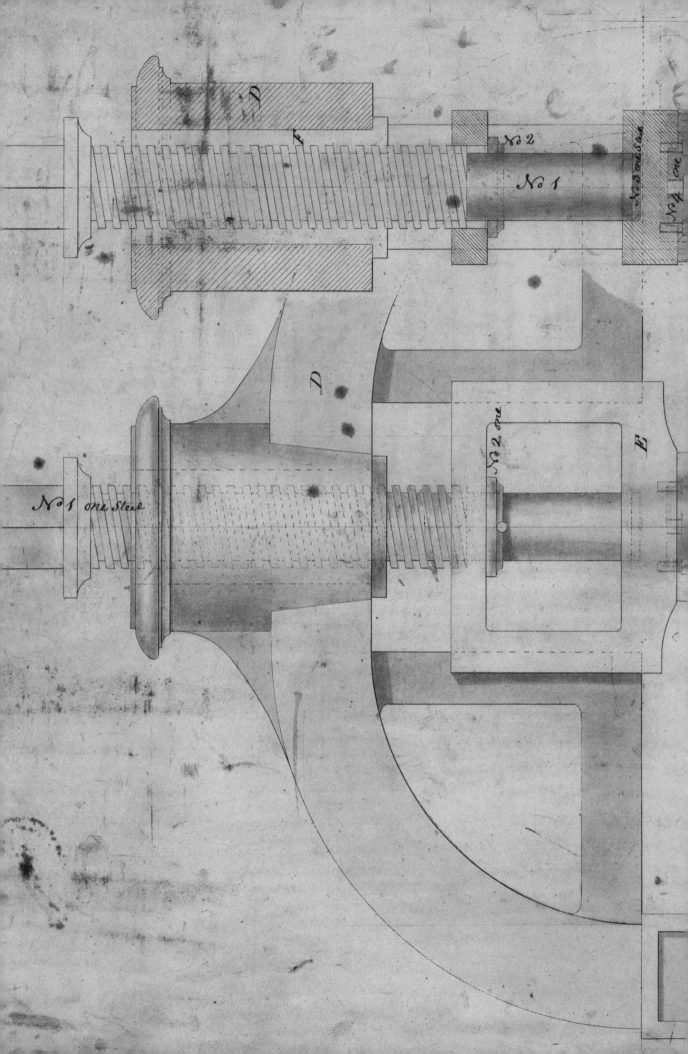